W9-CFL-482

Praise for Osman's Dream

"[Finkel's] mastery of the historical literature is obvious: The sheer amount of information packed between these two covers makes it a landmark achievement." —*New York Sun*

"With this superb book, Finkel boldly covers new ground in striving to show the Ottoman Empire from within. . . . Having spent 15 years living in Turkey, Finkel is uniquely positioned to overcome the practical hurdles to Ottoman research, but her real strength is in historiography: she has a keen ability to extract salient observations from her sources even as she renders their political motives transparent. The result is a panorama of the Ottoman Empire to rival the best portraits of the Romanovs and Habsburgs, and a must-have for history collections." —*Booklist (starred review)*

"Possibly the first book in English on the entire history of the Ottoman Empire for general readers. In [Finkel's] well-written narrative, she breaks with Western scholarship by not treating the empire as the stereotypical 'Sick Man of Europe,' preferring to let the extensive Turkish sources tell a story of an enormous, complex, multiethnic state." —*Library Journal*

"Readable survey on one of the world's great empires. . . . Finkel's text is a satisfying blend of narrative history, anecdote and character study. . . . The more we know about the Ottomans, the more easily comprehensible the subsequent history of the region they ruled becomes. Finkel's study makes a useful contribution." —*Kirkus Reviews*

"Finkel's striking innovation is to turn a mirror on the Ottomans and examine how they saw themselves and their empire. . . . A refreshingly original perspective . . . this history makes a riveting and enjoyable read for all audiences." —*Publishers Weekly*

"A magnificent new historical panorama. . . . For perhaps the first time in English, a genuine Ottoman scholar has written a clear narrative account of the great empire based mainly on Turkish rather than hostile western accounts. The result is not only a revelation; it is a vital corrective to the influential but partial and wrong-headed readings of the flagbearers of intellectual Islamophobia, such as V. S. Naipaul, Bernard Lewis and Samuel Huntingdon, all of whom continue to manufacture entirely negative images of one of the most varied empires of history . . . " —WILLIAM DALRYMPLE, *The Scotsman*

"*Osman's Dream* is a deeply sympathetic, compelling and highly readable account of the rise and fall of an immensely complex and dynamic society which, at its height was the most the most far-reaching and the most powerful Empire the world had ever seen. But it is also something more. For Caroline Finkel has not only told the history of how a band of Turcoman warriors from eastern Anatolia came to dominate so much of the world. She has also shown why that history matters, why today we are in no position to understand, not merely the modern Republic of Turkey but also modern Islam unless we also understand the past, and the present perception, of the greatest and most enduring of the Islamic states."
—ANTHONY PAGDEN, Distinguished Professor of
History and Political Science, UCLA

"How timely to have such a lucid, well-researched, and fair-minded history of the Ottoman Empire—and one too which treats it not as some exotic and alien world, but as part of our common past."
—MARGARET MACMILLAN, author of *Paris 1919*

"Osman's Dream is a treasure for anyone who wants to know exactly what happened when in the Ottoman Empire. Here at last is a reliable history that takes into full account not only the work of international and Turkish historians but also the writings of the Ottomans themselves."
—HUGH POPE, author of *Sons of the Conquerors:
The Rise of the Turkic World*

"Finkel has brilliantly woven together a highly readable survey of 600 years of Ottoman history. Well researched and beautifully written, *Osman's Dream* will be essential reading for anyone who wants to know more about the Empire that ruled for centuries over so many of our contemporary trouble spots—from the Balkans to the Arab world."
—HEATH W. LOWRY, Ataturk Professor of Ottoman &
Modern Turkish Studies, Princeton University

"The Ottoman Empire has been in the spotlight of late, and the subject of a fair few studies—some of high quality—which makes the freshness of Finkel's history the more striking. The secret, apart from an irresistible narrative style, is a generous openness to every aspect of Ottoman life and culture, and a willingness to address Ottoman problems on their terms. What has often come across as an impossibly exotic procession of Viziers, Beys and Pashas is here brought vividly home to the general reader."
—*The Scotsman*

Osman's Dream

The Story of the Ottoman Empire 1300–1923

CAROLINE FINKEL

A Member of the Perseus Books Group
New York

Copyright © 2005 by Caroline Finkel

Published in hardcover in the United States in 2006 by Basic Books,
A Member of the Perseus Books Group
Published in paperback in 2007 by Basic Books

First published in the United Kingdom in 2005 by
John Murray Publishers, a division of Hodder Headline

'Istanbul (Not Constantinople)'
Words and Music by Jimmy Kennedy and Nat Simon
© 1953 (Renewed) Chappell & Co.
All rights reserved. Used by permission.

All rights reserved. Printed in the United States of America. No part of
this book may be reproduced in any manner whatsoever without written
permission except in the case of brief quotations embodied in critical
articles and reviews. For information, address Basic Books,
387 Park Avenue South, New York, NY 10016-8810.

Books published by Basic Books are available at special discounts for
bulk purchases in the United States by corporations, institutions, and
other organizations. For more information, please contact the Special
Markets Department at the Perseus Books Group, 11 Cambridge Center,
Cambridge MA 02142, or call (617) 252-5298 or (800) 255-1514,
or e-mail special.markets@perseusbooks.com.

A CIP catalog record for this book is available
from the Library of Congress.

HC: ISBN 13 978-0-465-02396-7 ; ISBN 0-465-02396-7
British ISBN 0-7195-5513-2
PBK: ISBN 13 978-0-465-02397-4 ; ISBN 0-465-02397-5

10 9 8 7

Contents

Illustrations		vii
Acknowledgements		ix
Preface		xi
A note on spelling, names, maps and quotations		xv
A guide to Ottoman titles		xvii
Maps		xix
1.	First among equals	1
2.	A dynasty divided	22
3.	An imperial vision	48
4.	Sultan of the faithful	81
5.	Possessor of the kingdoms of the world	115
6.	The sedentary sultan	152
7.	Government by faction	196
8.	Revenge of the pashas	223
9.	Rule of the grandees	253
10.	The empire unravels	289
11.	The perils of insouciance	329
12.	The power of the provinces	372
13.	From the 'New Order' to the 'Re-ordering'	413
14.	A crisis of identity	447
15.	The Islamic empire	488
16.	The storm before the calm	526
	Sultans of the Ottoman Empire	555
	Chronology	557
	Notes	573
	Bibliography	610
	Index	642

Illustrations

1. First third of an endowment charter for a dervish lodge established by Sultan Orhan in 1324
2. The beheading of the companions of Johann Schiltberger
3. An Ottoman official and his assistant register Balkan Christian boys selected for the youth levy
4. Bayezid I held in a cage following his capture by Tamerlane at the battle of Ankara, 1402
5. Equestrian statue of Emperor Justinian that stood outside Hagia Sophia
6. View over the Covered Bazaar, Istanbul
7. The Tiled pavilion in the outer gardens of Topkapı Palace
8. Portrait of Mehmed II, 1481
9. The Grand Master of the Knights Hospitallers receives Cem Sultan on his arrival on Rhodes
10. The Castle of Bourganeuf where Cem Sultan was held
11. Süleyman I wearing the helmet-crown commissioned for him by Grand Vezir İbrahim Pasha
12. The coffin of Grand Vezir İbrahim Pasha being carried out of Topkapı Palace
13. The sacred shrine at Mecca
14. Mihrimah Sultan, daughter of Süleyman I and Hürrem Sultan
15. Underglaze-painted İznik tile
16. Detail from a minature showing three Kızılbaş being presented with caftans on giving up the red bonnets symbolizing their 'heretical' status
17. The Selimiye: the mosque of Selim II in Edirne
18. A couple apprehended by janissaries as their wine cools in a stream
19. Murad IV setting out on the Baghdad campaign of 1638
20. The Venetian bailo in Istanbul, Giovanni Soranzo, and his delegation, being led away in chains following Venice's refusal to cede Crete
21. The New mosque built by Turhan Sultan in the port district of Istanbul
22. The Chief Black Eunuch
23. The strangulation of Grand Vezir Merzifonlu Kara Mustafa Pasha
24. 'Le fameux croissant du Turc partage entre l'Imperialiste, le Polonois et le Venetien'
25. Three sons of Ahmed III being escorted to their circumcision feast

26. Tulip varieties 'That increases the Pleasure of Ahmed Efendi's Banquet' and 'Source of Joy'
27. Detail of the monumental fountain built by Ahmed III outside Topkapı Palace
28. Patrona Halil and fellow rebels
29. Detail from a scroll illustrating the route of the water supply from outside the city to Topkapı Palace
30. An Ottoman and a Russian official discuss the Dardanelles
31. Mehmed Ali Pasha of Egypt
32. Sultan Abdülmecid in uniform at the time of the Crimean War
33. Interior view of Ayasofya
34. Reverse of a medal issued by Sultan Abdülaziz
35. Ottoman military cadets
36. The palanquin symbolizing the Sultan's presence emerges from Dolmabahçe Palace at the start of the annual pilgrimage to Mecca
37. Kaiser Wilhelm II being rowed on the Bosporus, autumn 1917

The author and publisher would like to thank the following for permission to reproduce illustrations: Plate 1, İ.Hakkı Uzunçarşılı, 'Gazi Orhan Bey vakfiyesi, 724 Rebiülevvel-1324 Mart', *Belleten* V (1941) 280–1; 2, Johann Schiltberger, *Ich Schildtberger zoche auss von meiner heimat . . .* (Augsburg, 1475) n.p.; 3, Topkapı Palace Museum Library (Suleymānnāme, H.1517 f.31v); 4, Schloss Eggenberg Museum, Graz; 5, University Library Budapest (Miscellany, Cod. Ital. 3 f.144v); 6, Jürgen Franck/Cornucopia; 7, Deutsches Archaeologisches Institut, Istanbul (no. 68/154; W. Schiele 1968); 8, Topkapı Palace Museum Library (Album, H.2153 f.145v); 9, Gulielmus Caoursin, *Guillelmi Caonrsin [sic] Rhodiorum Vicecancellarij: obsidionis Rhodie Vrbis descriptio . . . de casu Regis Zyzymy: Commentarium incipit* (Ulm, 1496) n.p. [f.33r]; 10, A. Vayssière, *L'ordre de Saint-Jean de Jérusalem ou de Malte en Limousin . . .* (Tulle, 1884) frontispiece; 11, William Stirling-Maxwell, *Examples of the Engraved Portraiture of the Sixteenth Century* (London and Edinburgh, 1872) 41; 12, Topkapı Palace Museum Library (Hunernāme, H.1524 f.165v); 13, Topkapı Palace Museum Library (Futūh al-harameyn, R.917 f.14r); 14, Mazovian Museum, Plock, Poland/Muzeum Mazowieckie w Plocku (MMP/S/2); 15, The Nasser D. Khalili Collection of Islamic Art (POT1688); 16, Topkapı Palace Museum Library (Sūrnāme-I humāyūn, H.1344 f.279r); 17, Deutsches Archaeologisches Institut, Istanbul (R 28.874); 18, Topkapı Palace Museum Library (Album, B.408); 19, Topkapı Palace Museum Library (Album, H.2134 f.1r); 20, Museo Civico Correr, Venice (Memorie turche, MSS. Cicogna 1971/36); 21, G. J. Grelot, *Relation nouvelle d'un voyage de Constantinople . . .* (Paris, 1680) 283; 22, Paul Rycaut, *The Present State of the Ottoman Empire . . .* (London, 1668) 36; 23, [Jean de Prechac] *Cara Mustapha Grand Visir. Histoire . . .* (Paris, 1684) frontispiece; 24, Albert Vandal, *Les voyages de Marquis de Nointel (1670–1680)* (Paris, 1900) 258; 25, Topkapı Palace Museum Library (Sūrnāme-i Vehbi, H.3593 f.173b); 26, Turhan Baytop, *Istanbul Lâlesi* (Ankara, 1992) 58; 27, Deutsches Archaeologisches Institut, Istanbul (1+ R 21.547); 28, Rijksmuseum (SK-A-4082); 29, Topkapı Palace Museum Library (H.1815); 30, F. Muhtar Katırcıoğlu/*Yeryüzü Süretleri: F. Muhtar Katırcıoğlu Harita Koleksiyonu* (Istanbul, 2000) 156; 31 and 33, Courtesy of the Duke of Buccleuch; 32, author's collection; 34, İsa Akbaş Collection/Edhem Eldem, *Pride and Privilege. A History of Ottoman Orders, Medals and Decorations* (Istanbul, 2004) 248; 35, Deutsches Archaeologisches Institut, Istanbul (R 24.687); 36, Deutsches Archaeologisches Institut, Istanbul (7689); 37, Deutsches Archaeologisches Institut, Istanbul (R 28.558).

Every effort has been made to clear permissions. If permission has not been granted please contact the publisher who will include a credit in subsequent printings and editions.

Acknowledgements

Many colleagues and friends have generously encouraged and assisted me over the long years that *Osman's Dream* has been in the making. They have answered a multitude of queries in person and by mail; sent me articles and books both unpublished and published; read single chapters, multiple chapters, even the complete typescript; and at every turn attempted to save me from error. Without the willingness of all these people to share the fruits of their scholarship so unreservedly, I could not have embarked upon writing this book.

My greatest debt of gratitude is reserved for the staff of the Istanbul branch of the American Research Institute in Turkey: the director Antony Greenwood and his assistants Gülden Güneri and Semrin Korkmaz tolerated my presence for months at a time, as I read my way through the Institute's excellent collection of material relating to matters Ottoman – and every day for months shared lunch with me. Without the delight of my morning boat-ride across the Bosporus, and the calm of the Institute's library, I would have given up at an early stage. I began writing *Osman's Dream* in Cambridge, where Kate Fleet of the Skilliter Centre at Cambridge University gave me the run of the Skilliter Library, another oasis for the Ottomanist, and I am also appreciative of the help of the staff of the Institut français des études anatoliennes and the İslam Araştırmaları Vakfı library, both in Istanbul, and of the British Library, for permitting me the use of their rich collections.

Of the many others whose myriad assistances are discernible in my book, I mention the following by name: Gábor Ágoston, Virginia Aksan, John Alexander, Jean-Louis Bacqué-Grammont, Marc Baer, Michele Bernardini, İdris Bostan, Gregory Bruess, Duncan Bull, Robert Dankoff, Caroline Davidson, Selim Deringil, Kathryn M. Ebel, Howard Eissenstadt, Y. Hakan Erdem, Selçuk Esenbel, Suraiya Faroqhi, Cornell Fleischer, Pál Fodor, John Freely, Fatma Müge Göçek, Daniel Goffman, Yasemin Gönen, Rossitsa Gradeva, Jane Hathaway, Colin Heywood, Frédéric Hitzel, M. Şükrü Hanioğlu, Colin Imber, Robert Jones, Yavuz Selim Karakışla, Claire Ruoff Karaz, Michael Khodarkovsky, Machiel Kiel, Dariusz Kolodziejczyk, Klaus Kreiser, Donna Landry, Heath Lowry, Gerald MacLean, Andrew Mango, Nenad Moačanin, Rhoads Murphey, Oktay Özel, Burcu Özgüven, Oded Peri, Hedda Reindl-Kiel, Kahraman Şakul, Ariel Salzmann, Hamish Scott, Norman Stone, Frank Sysyn, Nabil al-Tikriti, Christine Thompson, Lucienne Thys-Şenocak, Gündüz Vassaf, Sara Nur Yıldız, Fehmi Yılmaz, Elizabeth

Zachariadou, Fariba Zarinebaf-Shahr. This list cannot hope to be exhaustive, and there are many others whose help I benefited from along the way. Two more to whom I am indebted are Joyce Matthews, who translated many of the passages of prose and poetry from Ottoman Turkish into mellifluous English, striving with singular success to catch the tone of the original; and Ara Güler, who photographed me for the publicity material.

Writing is hard; coming by illustrations is harder. I would like to thank the following, in particular, for making the process relatively painless: Filiz Çağman, Zeynep Çelik and Gülendam Nakipoğlu of Topkapı Palace Library; Edhem Eldem; Muhittin Eren of Eren Publications, Istanbul; John Scott of *Cornucopia Magazine*; F. Muhtar Katırcıoğlu; the staff of the Cultural Department of Yapı Kredi Bank, Istanbul; Giulia Bartrum of the British Museum, Dept. of Prints and Drawings; Natalia Królikowska; Krzysztof Wawrzyniak.

My commissioning editor at John Murray, Caroline Knox, provided support until the later stages of the book's passage towards publication: to her, to her successor Gordon Wise, to Caroline Westmore for her exemplary attentiveness to detail, to Cathy Benwell and Nikki Barrow, my warmest thanks are due. Preparing the book for publication in the United States was expedited by the boundless enthusiasm and energy of Lara Heimert, Executive Editor, and David Shoemaker, Assistant Editor. I would also like to acknowledge gratefully the editing skills of Liz Robinson and Elizabeth Dobson who gave the text a fluency it could not otherwise have had. Philip Mansel proposed this book to John Murray, and deserves special mention for being instrumental in initiating the writing of the Ottoman story for a general audience, an opportunity the like of which all too rarely comes the way of an academic historian. My agent Anne Engel gently urged me on when I became discouraged. The maps were drawn by Martin Collins and the index compiled by Douglas Matthews.

I set out on the Ottoman path under the expert and painstaking guidance of Victor Ménage, formerly professor of Turkish at the School of Oriental and African Studies, London University. Now, many years later, I can offer something in return for his wisdom. Another Victor, Victor Ostapchuk, with whom I share a passion for the Ottoman Black Sea and the intricacies of its defence against powers coming from the north, devoted much time to reading my typescript as it progressed and commenting on it in learned depth and detail – despite pressing matters relating to his own work and career. But most of all, I am lucky to have married a writer and journalist – or rather, an academic manqué who became a journalist – who has taught me the indisputable value of making the inaccessible accessible, and that there is usually a form of words that will convey even the most abstruse point to a general audience. To the two Victors – Vic-i büzürg and Vic-i sagir – to Andrew Finkel, and to our daughter Izzy, whose formative years have been spent entirely in the shadow of the Ottomans, I dedicate this book.

Preface

There has been an explosion of history-writing in recent years, and on the shelves of bookshops together with histories of every other time and place are now to be found Ottoman histories of varying scope and subject matter. Some are intended for an academic audience, some cover only limited periods of time, some are based entirely on non-Turkish or non-Ottoman sources. My purpose has been to try to provide for a general audience an up-to-date history of the whole chronological span of the Ottoman Empire – and beyond; my aim has been to counter the over-simplified notion that the Ottoman Empire rose, declined, and fell – and that is all we need to know about it.

Like history itself, historical research does not stand still, and the last ten or fifteen years have produced exciting new perspectives and interpretations. Nevertheless current general perceptions of the Ottoman Empire still owe a great deal to the observations and prejudices preserved in European sources written in the heat of the various confrontations between western states and the Ottomans. Characterizations of the empire as an 'Oriental despotism' or 'the Sick Man of Europe', for instance, derive from particular moments in time when such 'soundbites' suited particular purposes. Unfortunately, they have been continually repeated and recycled as though they encompass the whole history of the empire and are adequate to embrace the historical insights gained since they were coined.

Much of what passes for general history-writing about the Ottoman Empire in its varied aspects is in reality quite innocent of 'history' and reduces the Ottomans and their world to a theatre of the absurd – a parade of salacious sultans, evil pashas, hapless *harem* women, obscurantist clerics – stereotypical characters frozen into a well-worn setting which lacks all but the barest acknowledgement of the dynamics of history. It tells a timeless tale of an alien and exotic universe, and fails to inform the reader of the processes which shaped that universe. That these books sell well is evidence of general interest in the Ottoman Empire; that they are grounded neither on the more recent historical perceptions nor on the original sources is a reflection of the fact that Ottoman historians have rarely stirred themselves to write for a general audience. I hope my 'new narrative' will entertain the general reader, while at the same time serving as a modest corrective, furthering our understanding of the connections between past and present and of how we got to where we are today.

My own approach to Ottoman history is perforce coloured by long residence in the Turkish Republic, the final successor state of the Ottoman Empire, where I have lived for some fifteen years. The past is truly another country in Turkey, whose citizens have been deprived of easy access to the literary and historical works of previous eras by the change of alphabet in 1928 from Arabic script to the Roman alphabet familiar to most of the western world. At the same time, an ongoing programme to make the vocabulary more Turkish is expunging words of Arabic and Persian derivation – the other two components of the rich amalgam that was the Ottoman tongue, today in danger of becoming as 'dead' as Latin. On the other hand, works from the Ottoman centuries are now being published in modern script with simplified language, enabling modern readers to gain some understanding of what went before. The situation would otherwise be dire: imagine an English literary canon which lacked anything written before the 1930s!

It once seemed possible that, with the passing of those generations who had learnt the Ottoman language before the change of alphabet, there would be few who were able to read the voluminous documents and manuscripts which are the basic source-material for Ottoman history. However, students continue to train as historians, and learn Ottoman, and they hold university positions in Turkey and abroad alongside non-Turkish-born Ottoman specialists. Yet it has not been easy for Turks to cast off the 'official history' taught them in school, a version of their past which took its impetus from the revolution identified with the name of Mustafa Kemal Atatürk, the 'father of modern Turkey'. In the early years of the republic the Ottoman centuries were considered to be a closed book and disdained as though they had no connection with its citizens, for whom a more distant Turkic past was considered appropriate. But as the Ottoman period has receded in memory, it is becoming open to scrutiny; and although Turks have been enjoined by the gurus of education to see themselves as inheritors of a proud past which can be described but not interrogated, this too is changing. Thus official history now endorses the notion that the Ottoman dynasty was invincible and its sultans all-powerful – except those remembered with such soubriquets as 'Sot' or 'Crazy' – but little attention has yet been given to the opposition to the state and its writ which occurred from the earliest years of the empire: a reluctance to acknowledge the existence of dissent which is an abiding feature of politics in modern Turkey.

Yet, despite the practical hurdles which hinder an understanding of their Ottoman past, the citizens of the modern Turkish state are endlessly curious about their history. Political discourse is peppered with lively exchanges of a kind quite unfamiliar to western observers: varying perceptions of the past provide a rich source of reference as politicians and interest groups quibble over which version of history will best serve tomorrow's purposes (a tomorrow

that has often seemed more uncertain than it is elsewhere). Many conversations allude to topics whose roots stretch back into history. The most visible example of the past haunting the present is the 'Armenian question' – which in its current manifestation revolves around Armenians lobbying for national governments to declare the communal massacres in Anatolia in the First World War a genocide. Less obvious to outsiders are two other topics high on the Turkish agenda: the role of the military in politics, and the limits of the acceptable in religious expression. These are themes that pervaded Ottoman history, and preoccupied the statesmen and people of the past as they do today's. The historian's task is to show how the past led up to the present, or to a present that is now past. In Turkey history-writing thus becomes a more serious matter than it is in some other countries, and the writer of Ottoman history cannot enjoy the luxury of supplying entertainment at the cost of explanation.

It is customary for studies of the Ottoman Empire to end in 1922, the year of the abolition of the sultanate; in 1923 when the Turkish Republic was declared; or even in 1924, when the caliphate was abolished. I have extended my account into the republican period, to 1927, the year when Atatürk made a great speech justifying his role in the overthrow of the empire and the establishment of the republic, and setting out his vision, his dream for the future. Herein lies the conceit behind the title of my book, which alludes to a dream the first sultan, Osman, is said to have had, a dream interpreted as prophesying the birth and growth of the empire whose story I endeavour to tell. Continuing this history until 1927 also allows me to point to some of the continuities between the republic and the history of the empire: the received wisdom that the republic was a tabula rasa which bore only the imprint of the Atatürk revolution is gradually being challenged by historians.

In writing a work of such ambitious scope I have been faced with many hard choices. I make no claims to completeness – which would, after all, have been impossible to achieve. A strong narrative line seemed desirable. At some points, readers may object that it would be easier to understand what is going on if unfamiliar elements like the janissaries or the *harem* were treated separately, outside the main flow of the text. I contend that these features are integral aspects of the society which produced them, that they did not exist in a vacuum; by the same token, art and architecture arise from the complexity of society, and cannot be interpreted as isolated expressions of pure creativity. Nor does it make any sense to deal with religion in a chapter entitled 'Islam', since religion is a major dynamic force in history, and the way it is practised at any time or in any place has political repercussions. Viewing history through 'institutions' tends to freeze-frame what was dramatic, and obscure the interconnections between related events. It

has the further drawback of encouraging the reader to seize upon the very aspects of Ottoman history that have so often been treated pejoratively, without explaining how they arose and why they developed as they did. Thus is any attempt to interpret Ottoman history by the same standards as other histories hindered, and that history made to seem unique. There are unique aspects to the history of every state, of course; but to emphasize them rather than the aspects that are comparable to the history of other states seems to me to miss the point.

The 'black hole' that is Ottoman history is a cause for regret in and of itself, but more regrettable still is the present palpable 'iron curtain' of misunderstanding between the West and Muslims. This stems to a large degree from the West's 'old narrative' of the Ottoman Empire, which by extension is the narrative of many centuries of the Islamic past. To understand those who are culturally and historically different from us – rather than resorting to such labels as 'evil empire', 'fundamentalist' and 'terrorist' to mask our ignorance – is a matter of urgency. The greatest hubris is to ask why 'they' are not like 'us', to accept our cultural biases lazily and without question, and to frame the problem in terms of 'what went wrong?'

This, then, is a book intended for several audiences. I hope general readers who know little of the Ottomans apart from the 'old' narrative will find the 'new' narrative every bit as entertaining – and much more complex and satisfying, since it explains how the empire and its people saw themselves and how this perception changed over time. I have written much about the Ottomans' neighbours and rivals to east and west, so there is something, too, for those interested in territories on the Ottoman frontiers as well as further away. It is also intended for students embarking on a study of Ottoman history, who presently lack a single-volume narrative in English. I hope, indeed, that it will be read by all those for whom the long centuries of the Ottoman Empire hold a fascination.

A note on spelling, names, maps and quotations

The modern Turkish alphabet has 29 letters, of which three vowels and three consonants are unfamiliar to those who do not know the language, and one consonant is pronounced differently from English. The letters in question are these:

c as *j* in Jane

ç as *ch* in chip

ğ silent; lengthens a preceding vowel

ı as *i* in cousin

ö as *eu* in Fr. deux

ş as *sh* in ship

ü as in Fr. tu

Turkish also has a dotted capital i – İ – which I have used for Ottoman and Turkish personal and place-names, e.g. İzmir, not Izmir, but have not used, exceptionally, for Istanbul, which I have written thus and not as İstanbul as is proper.

Imposing entirely consistent systems for personal and place-names has proved an insurmountable challenge. For people who may be deemed Ottomans I have used modern Turkish 'academic' spellings: the name Mehmed, for instance, is today Mehmet in popular usage, and Bayezid, Beyazit; I have preferred the older version. I have also used the Turkish version for the names of the Turcoman rulers of, for example, Karaman and the Akkoyunlu. For Seljuks, Mamluks, Safavids and other non-Ottomans I have relied on the spelling in the *Cambridge History of Islam* (omitting indication of vowel length) except for a few individuals familiar to English readers, such as Tamerlane (properly Timur).

Place-names are still more problematic; for every watertight reason for

preferring one spelling over another, there is an equally watertight reason for preferring the second. Most places had more than one name; some places in central Europe, for instance, are known by four names e.g. Nové Zámky (mod.), Uyvar (Ott.), Érsekújvár (Hung.), Neuhäusel (Ger.). The Ottoman place-names (which have usually been retained in modern Turkish) are most familiar to me, but would have confounded English readers. I have therefore, since they have the virtue of being easy to locate, but at risk of anachronism, chosen to use modern place-names as given in *The Times Comprehensive Atlas of the World* (Millennium Edition, 2000) except in the case of some Ottoman provinces for which to use a modern name would have been an anachronism too far, and idiosyncrasy seemed a lesser sin – Uyvar is a case in point. An alternative, perhaps more familiar, place-name is often given at first mention in the text, and alternative names are also found in the Index.

Mapping the Ottoman Empire is notoriously difficult. The empire's frontiers were never entirely stable for long and, internally, provinces formed and re-formed; historians still do not have an accurate picture of which provinces existed at any time, let alone exactly where their borders lay. Any map attempting to show provinces can therefore only be impressionistic; the administrative centre of each province is, however, usually known.

Many of the passages quoted in the text have been shortened and the style of some translations by others into English from another language has been slightly revised.

A guide to Ottoman titles

Ottoman honorifics were not constant in meaning throughout the span of the empire; the definitions given below were, broadly, current until the late eighteenth century – if not beyond – but the list cannot hope to be exhaustive.

Most high-ranking Ottoman officials were accorded nicknames: some of these referred to a pronounced physical characteristic; others derived from the individual's reputation; yet others were an indication of place of origin (most of the latter end in -lı/li or -lu/lü). It is clear from contemporary sources that some of these nicknames were bestowed while the individual was still alive, but others were awarded subsequently. An example of the latter is Sultan Süleyman I's soubriquet 'Lawgiver', which did not enter common usage until after his death.

> *Agha*: used for the commanders of the sultan's regiments, notably the commander-in-chief of the janissaries, and also for the chief black eunuch – the head of the sultan's private household – among others
>
> *Bailo*: used by the Venetians for an envoy or ambassador, particularly Venice's representative at the sultan's court
>
> *Bey*: military commander; ruler of emirate; later, senior civil functionary
>
> *Çelebi*: respectful title informally given to men of letters
>
> *Despot*: used by Byzantine and other Christian princes in the Balkans
>
> *Efendi*: respectful title similar in meaning to Çelebi; also used for religious functionaries; in the nineteenth century used as equivalent to 'Monsieur'
>
> *Emir*: Muslim tribal or princely ruler of a small state (emirate)

Hetman: title used by the Cossack chief or leader; Polish military commander

Hoca: used for religious functionaries

Kadi: judge and notary

Khan: used by Tatar rulers, of the Crimea in particular

Mirza: title of Iranian princes

Pasha: highest title accorded to military commanders or statesmen

Reis: title of naval commanders

Sultan: ruler with supreme authority; also used for princes and senior females of the Ottoman house

Vezir: title of the sultan's ministers, with both military and political authority; the grand vezir was the most senior of these

Voyvode: used by the the rulers of Transylvania, Moldavia and Wallachia

Maps

1. Anatolia and Thrace in the Mid-Fourteenth Century xx

2. The Ottoman Empire in the Sixteenth–Seventeenth Centuries xxii

3. The Ottoman Empire Following the Treaty of Berlin (1878) xxiv

4. Environs of Istanbul xxv

5. Istanbul xxvi

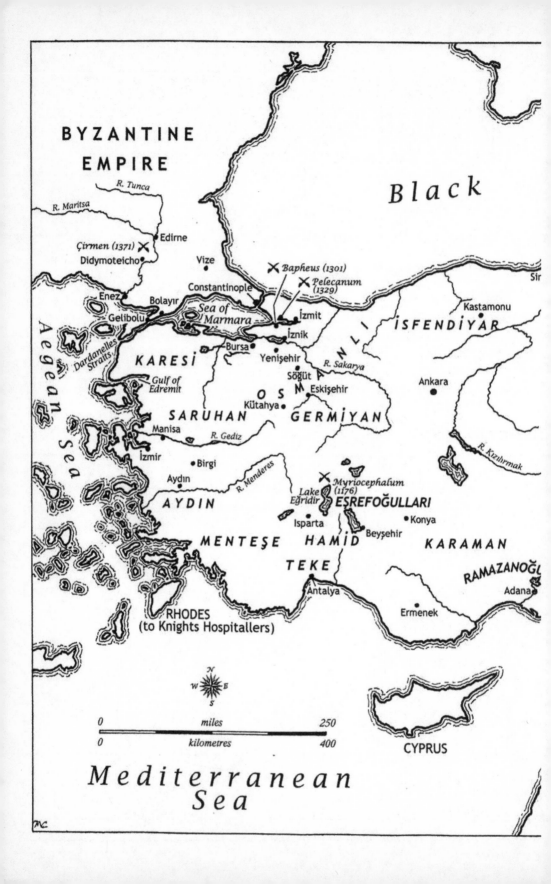

BYZANTINE
EMPIRE

R. Tunca

R. Maritsa

Çirmen (1371) ✕
Edirne

Didymoteicho

Vize

Black

✕ Bapheus (1301)

✕ Pelecanum
(1329)

Sir

Enez

Bolayır

Constantinople

İzmit

Kastamonu

İSFENDİYAR

Gelibolu

Aegean

*Sea of
Marmara*

İznik

N
L
I

KARESI

Bursa

Yenişehir

R. Sakarya

Söğüt

O S M

Eskişehir

Ankara

*Dardanelles
Straits*

*Gulf of
Edremit*

SARUHAN

Kütahya

GERMİYAN

Manisa

R. Gediz

Sea

İzmir

Birgi

Aydın

R. Menderes

R. Kızılırmak

✕ *Myriocephalum
(1176)*

*Lake
Eğridir*

EŞREFOĞULLARI

AYDIN

Konya

Isparta

Beyşehir

KARAMAN

MENTEŞE

HAMİD

TEKE

RAMAZANOĞL

Antalya

Adana

RHODES
(to Knights Hospitallers)

Ermenek

N
W E
S

0 miles 250
0 kilometres 400

CYPRUS

*Mediterranean
Sea*

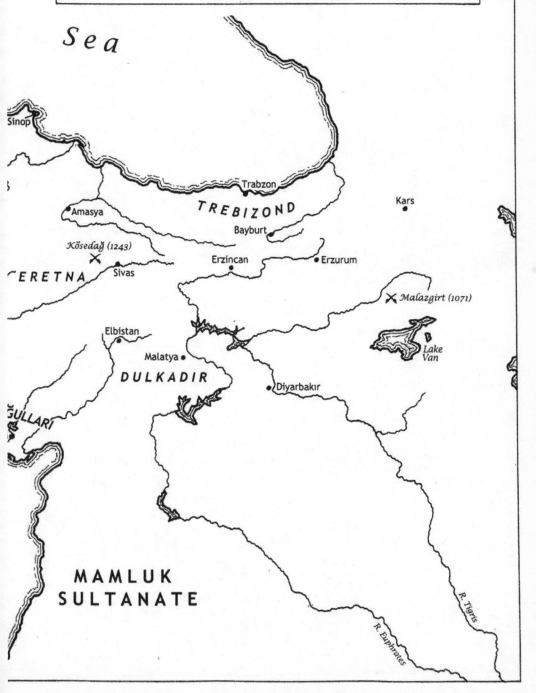

ANATOLIA AND THRACE IN THE MID-FOURTEENTH CENTURY

Sea

Sinop

Trabzon

T R E B I Z O N D

Kars

Amasya

Bayburt

Kösedağ (1243) ✗

Erzincan

Erzurum

E R E T N A

Sivas

✗ *Malazgirt (1071)*

Elbistan

Lake Van

Malatya

D U L K A D I R

Diyarbakır

...GULLARI

MAMLUK SULTANATE

R. Euphrates

R. Tigris

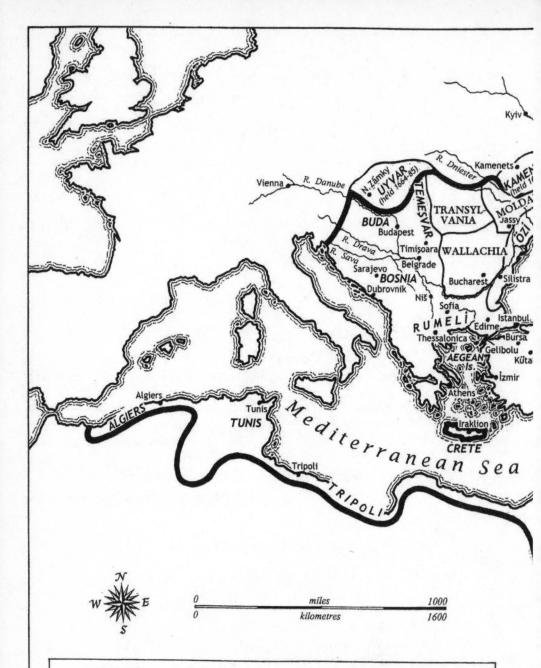

Kyiv

Vienna R. Danube N. Zámky UYVAR R. Dniester Kamenets KAMEN
 (held 1664-85) (held 1
 TEMESVAR TRANSYL- MOLDA
 VANIA
BUDA Jassy ÖZI
 Budapest R. Drava Timișoara WALLACHIA
 R. Sava Belgrade
 Sarajevo Bucharest Silistra
 Dubrovnik BOSNIA
 Niš
 Sofia
 RUMELİ Edirne Istanbul
 Thessalonica Bursa
 Gelibolu Kütal
 AEGEAN İzmir
 Is.
 Athens

Algiers Tunis
ALGIERS TUNIS Iraklion
 CRETE

 M e d i t e r r a n e a n
 Tripoli S e a
 TRIPOLI

N
W E
S

0 ———————— miles ———————— 1000
0 ———————— kilometres ———————— 1600

THE OTTOMAN EMPIRE
IN THE
SIXTEENTH–SEVENTEENTH
CENTURIES

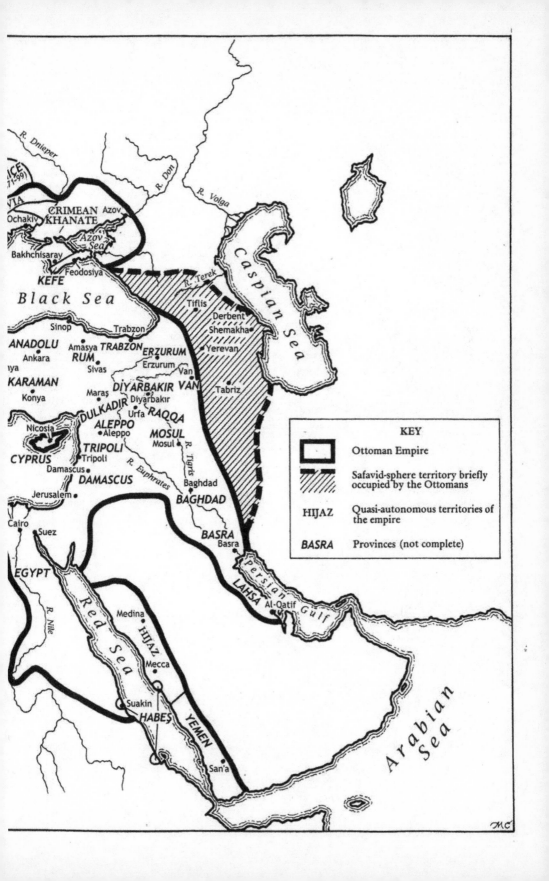

R. Dnieper

R. Don

R. Volga

CRIMEAN KHANATE
Azov

...ICE
71(99)

...VIA

Ochakiv

Bakhchisaray

Azov Sea

KEFE

Feodosiya

R. Terek

Caspian Sea

Black Sea

Tiflis

Derbent
Shemakha

Sinop

Trabzon

Yerevan

ANADOLU

Amasya *TRABZON*

Ankara

RUM

Sivas

...ya

Erzurum

ERZURUM

Erzurum

KARAMAN

Konya

Maraş

DIYARBAKIR

Van

VAN

Diyarbakır

Tabriz

DULKADIR

Urfa

RAQQA

Nicosia

ALEPPO

Aleppo

MOSUL

Mosul

R. Tigris

TRIPOLI

Tripoli

R. Euphrates

CYPRUS

Damascus

DAMASCUS

Baghdad

Jerusalem

BAGHDAD

Cairo

Suez

BASRA

Basra

EGYPT

R. Nile

Red Sea

LAHSA

Persian Gulf

Al-Qatif

Medina

HIJAZ

Mecca

Suakin

HABEŞ

YEMEN

San'a

Arabian Sea

KEY

☐ Ottoman Empire

▬ Safavid-sphere territory briefly
occupied by the Ottomans

HIJAZ Quasi-autonomous territories of
the empire

BASRA Provinces (not complete)

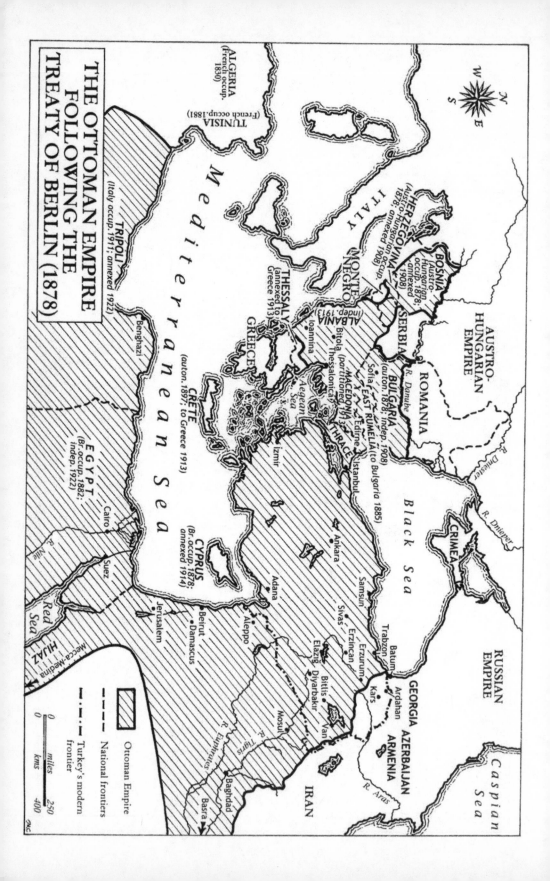

THE OTTOMAN EMPIRE
FOLLOWING THE
TREATY OF BERLIN (1878)

ALGERIA
(French occup.
1830)

TUNISIA
(French occup. 1881)

TRIPOLI
(Italy occup. 1911; annexed 1922)

Benghazi

Mediterranean Sea

EGYPT
(Br. occup. 1882;
indep. 1922)

Cairo
R. Nile
Suez

Red Sea

HIJAZ
Mecca-Medina

Ottoman Empire
National frontiers
Turkey's modern
frontier

0 miles 250
0 kms 400

ITALY

MONTENEGRO
(indep. 1908)

HERZEGOVINA
(Austro-Hungarian
1878; annexed 1908)

BOSNIA
(Austro-
Hungarian
occup. 1878;
annexed
1908)

AUSTRO-
HUNGARIAN
EMPIRE

R. Danube

SERBIA

ROMANIA

ALBANIA
(indep. 1913)

THESSALY
(annexed to
Greece 1913)

GREECE

Ioannina

Bitola
Thessaloníca

MACEDONIA
(partitioned
1913)

BULGARIA
(auton. 1878; indep. 1908)

Sofia
EAST RUMELIA
(to Bulgaria 1885)

THRACE

Edirne

Istanbul

Aegean
Sea

Izmir

CRETE
(auton. 1897; to Greece 1913)

CYPRUS
(Br. occup. 1878;
annexed 1914)

Black Sea

R. Dniester

Ankara

Adana

Aleppo

Beirut
Damascus

Jerusalem

Samsun

Sivas

Erzincan

Erzurum

Elazig
Bittis
Diyarbakir

Van

Mosul

R. Euphrates

R. Tigris

Baghdad

Basra

IRAN

Trabzon

Batum

Kars

Ardahan

CRIMEA

GEORGIA
AZERBAIJAN
ARMENIA

RUSSIAN
EMPIRE

R. Dnieper

R. Aras

Caspian
Sea

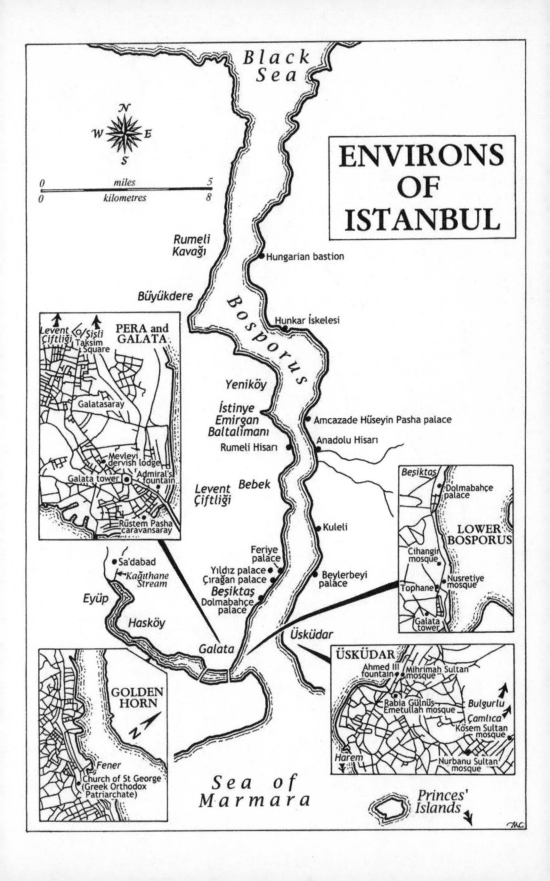

ENVIRONS OF ISTANBUL

Black Sea

N W E S

| 0 | miles | 5 |
| 0 | kilometres | 8 |

Bosporus

Rumeli Kavağı

• Hungarian bastion

Büyükdere

• Hunkar İskelesi

Yeniköy

İstinye
Emirgan
Baltalimanı

• Amcazade Hüseyin Pasha palace

Rumeli Hisarı • Anadolu Hisarı

Levent
Çiftliği Bebek

• Kuleli

Feriye
palace

Sa'dabad • Yıldız palace •
←Kağıthane Çırağan palace •
Stream **Beşiktaş**
Eyüp Dolmabahçe
 palace
Hasköy

• Beylerbeyi
 palace

Galata Üsküdar

*Sea of
Marmara*

*Princes'
Islands*

PERA and GALATA

Levent
Çiftliği o/Şişli
 Taksim
 Square

Galatasaray

Mevlevi
dervish lodge
Galata tower • Admiral's
 fountain

Rüstem Pasha
caravansaray

GOLDEN HORN

N

Fener
Church of St George
(Greek Orthodox
Patriarchate)

LOWER BOSPORUS

Beşiktaş

• Dolmabahçe
 palace

Cihangir
mosque •

• Nusretiye
 mosque
Tophane •

Galata
tower

ÜSKÜDAR

Ahmed III
fountain • • Mihrimah Sultan
 mosque

Rabia Gülnüş
Emetullah mosque •

Bulgurlu →

Çamlıca

• Kösem Sultan
 mosque

Harem →

Nurbanu Sultan
mosque

N
W E
S

0 1000
metres

Daud Pasha

Edirne gate

Mihrimah Sultan mosque

Fethiye mosque (Church of Pammakaristos)

Selim I mosque

Karaman market

Hırka-i şerif mosque

Mehmed II mosque (Church of the Holy Apostles)

FATİH QUARTER

THEODOSIAN WALLS

Has Murad Pasha mosque

Mosque of the janissaries

Hürrem Sultan mosque

AKSARAY QUARTER

Janissary parade ground

Slave market

SEA WALLS

Yedikule

Golden

Sea of Marmara

Horn

Rüstem Pasha mosque ●

EMINÖNÜ QUARTER

Queen mother's mosque
(New mosque)

Süleymaniye
mosque ●

Egyptian
(Spice)
market ●

● Tomb of
Abdülhamid I

GÜLHANE

Şehzade
mosque ●

Rüstem Pasha
theological
college ●

Valide Hanı ●

Tiled
pavilion ●

TOPKAPI
PALACE

Covered
bazaar ●

Old palace ●

Mahmud
Pasha
mosque ●

Nuru-
osmaniye mosque ●

Bayezid II
baths ●

Bayezid II
mosque ●

Tomb of Mahmud II ●

Ayasofya ●

Ahmed III
fountain ●

● Hürrem Sultan
baths

İbrahim Pasha palace ●

Tomb of
Ahmed I ●

Kadırga
palace ●

Hippodrome

Ahmed I
mosque ●

ISTANBUL

I

First among equals

THE OTTOMAN EMPIRE ended on a particular day, but its beginnings are shrouded in myth.

On 29 October 1923 Mustafa Kemal Atatürk was declared president of the Turkish Republic, a state whose legitimacy was based on popular sovereignty within finite, internationally-recognized frontiers. Turkish republicans had already demoted the Ottoman Sultan – on 1 November 1922 – so that he retained only his religious role as caliph, and on 3 March 1924 they abolished that office too, thereby abandoning altogether the notion that the state they were creating owed its existence to dynastic politics or to divine right.

Between the 15th and the 20th of October 1927 Mustafa Kemal set out in a lengthy address to parliament – so famous that it is known in Turkish simply as 'The Speech' – the reasons his generation had rejected the nation's stale and unprofitable Ottoman past. His first years in power were dedicated to a series of reforms, which he called revolutions, designed to oblige the Turkish people to abandon their imperial heritage, escape the tyranny of clerics, and embrace the modern world.

It is only more recently that Turks have been able to see their own history as something other than the story of the rise and terrible decline of an Islamic empire that at its height in the sixteenth century might have rivalled the might of ancient Rome, but that owing to some inherent flaw failed to keep pace with the Christian West. For centuries Ottoman military might intimidated the armies not just of Europe but of Iran and other Muslim states; Ottoman architects built the great mosques which dominate the skylines of Istanbul and provincial cities; the empire's legal system continued to juggle the ethnic complexities of the Balkans and the Middle East. To discover exactly how the Ottomans managed to finance and administer an empire of this scale, modern historians of an independent mind began to decipher the architects' account books and to examine the legal records; a new generation of scholars began to read between the lines of chronicles commissioned by victorious sultans, to see how the history of empire was not simply the history of its ruling family; and, perhaps most importantly, they began to look critically at the histories written – sometimes with all the sophistication

of western scholarship – in territories that had once been under Ottoman rule, and discovered that they were partial and incomplete because, seeing through a glass darkly, their authors presented national myth as historical fact, and made assumptions about the nature of the Ottoman Empire without listening to the Ottoman voice.

So by the time the Turkish Republic celebrated the seventy-fifth anniversary of its creation in 1998, it had the confidence to plan festivities on the eve of the second millennium to commemorate the founding 700 years earlier of the Ottoman Empire. But why should 1299 CE be considered the founding date of the empire? – there were no famous battles, no declarations of independence or storming of a bastille. The simplest explanations are often the most convincing: that year corresponds to the years 699–700 in the Islamic calendar.* By rare mathematical coincidence, the centuries turned at the same time in both the Christian and Islamic calendars. What more auspicious year to mark the founding of an empire that spanned Europe and the Middle East?

The early Ottomans, struggling to plant their authority, were less concerned with the date of the founding of their state than with the vision that underpinned their right to rule. To them, empire began quite literally with a dream. One night, the first sultan, Osman, was sleeping in the house of a holy man called Edebali when:

> He saw that a moon arose from the holy man's breast and came to sink in his own breast. A tree then sprouted from his navel and its shade compassed the world. Beneath this shade there were mountains, and streams flowed forth from the foot of each mountain. Some people drank from these running waters, others watered gardens, while yet others caused fountains to flow. When Osman awoke he told the story to the holy man, who said 'Osman, my son, congratulations, for God has given the imperial office to you and your descendants and my daughter Malhun shall be your wife'.[1]

First communicated in this form in the later fifteenth century, a century and a half after Osman's death in about 1323, this dream became one of the most resilient founding myths of the empire, conjuring up a sense of temporal and divine authority and justifying the visible success of Osman and his descendants at the expense of their competitors for territory and power in the Balkans, Anatolia, and beyond.

<div align="center">★</div>

* The Islamic calendar is a lunar calendar of some 354 days; each month begins when a new moon is first sighted. Day one of this calendar is 15 or 16 July 622 CE, the first day of the lunar year in which the Prophet Muhammad journeyed from Mecca to Medina after losing the support of his clan in a leadership struggle.

No one could have predicted the achievements of the Ottomans over the succeeding centuries. Around 1300 they were only one of many Turcoman, or Turkish, tribal groups of Central Asian origin vying for control in Anatolia – the land between the Black Sea, the Mediterranean and the Aegean. This had been part of the Eastern Roman Empire, which evolved into the Byzantine Empire following the split between East and West. Constantine the Great, after he came to power in 324 CE, had founded his new imperial capital, Constantinople, on the Bosporus, and the city had continued as capital of the eastern empire. Byzantium at its height had included the Balkans and extended east across Anatolia into modern Syria and beyond, but never recovered from the sack of Constantinople in 1204 by the knights of the Fourth Crusade, nor from the ensuing Latin occupation of the city between 1204 and 1261. By the early fourteenth century the empire was reduced to Constantinople itself, Thrace, Macedonia and much of modern Greece, and a few fortresses and seaports in western Anatolia.

Turcoman tribes had been bold raiders on the eastern frontier of the Byzantine Empire for centuries, long before the Ottomans came to prominence. Most successful of the earlier wave of Turcomans were the Seljuk Turks, who had gradually moved westward from Central Asia as part of a prolonged migration of pastoralist nomads into the Middle East and Anatolia at a time when Byzantium was weakened by internal disputes far away in Constantinople. The Seljuk Turks met with little opposition and in 1071, under their sultan Alparslan, they defeated a Byzantine army commanded by Emperor Romanus IV Diogenes at the battle of Malazgirt (Manzikert), north of Lake Van in eastern Anatolia, opening the way for the Turcoman migrants to move westwards practically unhindered.

Islam arrived in predominantly Christian Anatolia with the Seljuk Turks; individuals of Turcoman stock had embraced Islam from the ninth century when they came into contact – often as mercenaries – with the Muslim dynasties of the Arab heartlands; mass conversion of Turks in Central Asia was only about a century old, however. Their migration into Anatolia was a momentous event. Under Alparslan's successors the Seljuks established themselves in Anatolia, making their base not far from Constantinople, at İznik (Nicaea), until the capture of that city by the soldiers of the First Crusade in 1097 forced them to withdraw to Konya (Iconium), in central Anatolia. At around the same time the Danishmendid emirate, initially more powerful than the Seljuks, controlled a wide swathe of territory across north and central Anatolia; in the north-east, the Saltukids ruled their lands from Erzurum and the Mengucheks from Erzincan; and in the south-east were the Artukids of Diyarbakır (Amid). The Anatolia into which these Turcomans

moved was ethnically and culturally mixed, with long-established Kurdish, Arab, Greek, Armenian and Jewish populations in addition to the Muslim Turcomans. Byzantium lay to the west, and in Cilicia and northern Syria were the Armenian and Crusader states, bordered to the south by the Muslim Mamluk state with its capital at Cairo. Over the course of the next century the Seljuks absorbed the territories of their weaker Turcoman neighbours, and in 1176 their sultan Kilijarslan II routed the army of the Byzantine emperor Manuel I Comnenus at the site known as Myriocephalum, to the north of Lake Eğridir in south-west Anatolia. No longer confined to the interior of the Anatolian plateau, the Turcomans began expanding towards the coasts, gaining access to the trade routes of the surrounding seas.

The early thirteenth century was the heyday of the Seljuks of Rum as they called themselves (the geographic marker 'Rum' signified the lands of 'Eastern Rome', the Byzantine Empire) in distinction to the Great Seljuk Empire in Iran and Iraq. Stable relations between the Byzantines and the Seljuks of Rum allowed the latter to concentrate on securing their eastern borders, but this equilibrium was shattered when another wave of invaders swept in from the east: the Mongols, led by the descendants of the fearsome conqueror Genghis Khan, who sacked the lands of the various successor states of the Great Seljuk Empire that lay in their path. As the Seljuk victory at Malazgirt in 1071 had hastened the collapse of Byzantine rule in Anatolia, so a Mongol victory over a Seljuk army in 1243 at Kösedağ, near Sivas in north-central Anatolia, spelled the end of independence for the Seljuks of Rum. Their once-powerful sultan in Konya now became a tribute-paying vassal of the Mongol khan whose seat was far away at Karakorum in inner Asia. The subsequent years were turbulent as the sons of the last independent sultan Kay-Khusraw II disputed their patrimony, supported by various Turcoman and Mongol factions. Although during the last quarter of the century the Mongol Ilkhanid dynasty imposed direct administration, Ilkhanid control in Anatolia was never very strong for they, like the Seljuks, were locked in internecine struggle. The Turcomans of Anatolia resisted the Ilkhanids, and the Mamluks of Egypt and Syria made inroads into the Ilkhanid domains from the south. But the Ilkhanids were more concerned with securing the profits to be earned from customs dues on the valuable trade between India and Europe, which passed along the routes through north-east Anatolia, and all but abandoned their 'far west' to the Turcoman marcher-lords on the north-western fringes of the former Seljuk lands.[2]

By the early years of the fourteenth century Anatolia had become home to a new generation of Muslim Turcoman emirates. They often formed strategic alliances, but inevitably came into conflict as each developed its own distinct economic and political goals. In the south around Antalya

(Adalia) was the emirate of Teke, in south-west Anatolia was Menteşe, with Aydın to its north; the inland emirate of Hamid centred on Isparta, Saruhan had Manisa as its capital and northwards towards the Dardanelles lay Karesi. Germiyan's capital was Kütahya, while north-central Anatolia was the territory of the house of İsfendiyar. The emirate of Karaman occupied south-central Anatolia with its capital at first deep in the Taurus mountains at Ermenek, then at Karaman and finally at the former Seljuk seat of Konya. By mid-fourteenth century, Cilicia was home to the emirates of the Ramazanoğulları, centred in Adana, and the neighbouring Dulkadıroğulları, based to the north-east at Elbistan. In north-west Anatolia, bordering what remained of Byzantium, was the emirate of Osman, chief of the Osmanlı – known to us as the Ottomans.

We first hear of the Ottomans around 1300 when, so a contemporary Byzantine historian tells us, there occurred in 1301 the first military encounter between a Byzantine force and troops led by a man called Osman. This battle – the battle of Bapheus – was fought not far from Constantinople, on the southern shore of the Sea of Marmara: the Byzantine forces were routed.[3] Many years were to elapse, however, before the power of the Ottomans could be said to rival that of the Byzantines and many myths would arise to explain the origins of a dynasty that seemed to have sprung from nowhere.

Why did the family of Osman come to dominate its neighbours and, over the succeeding centuries, how did the Ottoman emirate, only one among many in the borderlands between Byzantine and Seljuk–Ilkhanid territory, become the sole inheritor of both these states and develop into a great and long-lived empire expanding into three continents? These questions continue to fascinate historians – and to elude conclusive answer. One reason is that the history of medieval Anatolia is still rather little known. Another is that contemporary annalists of the settled states of the region – Seljuk, Armenian, Byzantine, Mamluk and Latin – were preoccupied with their own fate: details of those against whom they fought or with whom they concluded treaties enter their accounts only fortuitously. The traditions of the Anatolian Turcomans were oral and it was only once most of their rivals had been erased from the map that the Ottomans wrote down the story of their origins, emphasizing their own history at the expense of that of long-gone challengers and their doomed endeavours to found permanent states.

There are further questions to be considered. Was the Ottoman emirate motivated above all by commitment to 'holy war'[4] (*jihād*) – the struggle against non-Muslims that was a canonical obligation upon all believers? For Muslims the world was notionally divided into the 'abode of Islam', where

Islam prevailed, and the 'abode of war', the infidel lands that must one day accept Islam – and 'holy war' was the means to bring this about. 'Holy war' had, after all, motivated the Muslim community in its early years as the new faith sought to expand and, like the proclamation of a Christian crusade, had provided inspiration to fighters down the ages. Or was it the fluid character of frontier society at this time which enabled the Ottoman emirate to gain control over extensive territories? Was the Ottoman emirate's ability to win out over rival dynasties and states due to a favourable strategic location in the march-lands of the poorly-defended Byzantine Empire, or was Ottoman expansion a consequence of political acumen and good luck? Modern historians attempt to sift historical fact from the myths contained in the later stories in which Ottoman chroniclers accounted for the origins of the dynasty, with the help of clues contained in contemporary inscriptions, coins, documents and epic poems, as well as in works in languages other than Turkish. Wherever the answers to questions about Ottoman success may lie, the struggle of the Ottomans against their Anatolian neighbours was hard fought over almost two centuries.

The geographical and climatic features of the Anatolian land mass which was home to the Turcoman emirates played a significant role in shaping their history and in the success or failure of their efforts at carving out territorial enclaves. Most of Anatolia is high, forming an elevated central plateau ringed, except in the west, by mountains rising to 4,000 metres. The terrain is gentle in the west, where the foothills of the plateau fall to the Aegean and the Sea of Marmara leaving a wide, fertile coastal plain. In the south-east the mountains give way to the deserts of Iran, Iraq and Syria. In the north and south the coastal strip is narrow and deep valleys penetrate the mountains between steep, rugged peaks. The steppe grasslands of the plateau provide rich grazing for flocks and herds but experience extremes of climate: Turcoman pastoralists – like many Anatolian husbandmen today – moved their animals to high pastures for the summer months. They traded with the settled agriculturists of the western lowlands and the coastal fringes, where soils are more productive and the climate less severe; the people of the coastal lands in turn looked to the sea for their livelihood. Thus were goods exchanged and alliances established.

The Ottomans were not the first of the post-Mongol wave of Muslim Turcoman dynasties to appear in the historical record. We hear of the Germiyan house in 1239–40,[5] well before Osman's battle against the Byzantines in 1301, while the Karamanids, named after one Karaman Bey, first appear in 1256.[6] As they began to claim permanent lands, these emerging

dynasties sought to make themselves visible in new ways, for instance by building monuments to impress would-be supporters. This, a practice of settled folk, not of nomadic pastoralists or subsistent agriculturists, can be seen as indicating the ambitions of former nomads to found a sedentary state. Evidence for the building activity of the Turcoman dynasties survives in dated inscriptions: from the mosque of the minor dynasty of Eşrefoğulları at Beyşehir in the lake district of south-west Anatolia of the year 696 of the Islamic calendar (1296–7 CE),[7] and from the now-demolished Kızıl Bey mosque in Ankara where the pulpit was repaired by the chiefs of Germiyan in 699 (1298–9).[8] The Great mosque built by the Karamanid leader Mahmud Bey in Ermenek dates, according to its inscription and foundation deed, from 702 (1302–3).[9] The earliest dated Ottoman structure of which we have record is the Hacı Özbek mosque in İznik where the foundation inscription is dated 734 (1333–4).[10]

Ottoman tradition recounts that a tribal chief called Ertuğrul settled in north-west Anatolia in the marcher-lands between the Seljuk–Ilkhanid and Byzantine Empires, and that the Seljuk sultan at Konya awarded him lands around the small settlement of Söğüt, north-west of modern Eskişehir (Dorylaeum), with the right to summer pastures for his flocks in the highlands south-west of Söğüt. If the only artefact which has come down to us from the time of Osman – an undated coin – is genuine, it suggests that Ertuğrul was an historical personage, for it bears the legend 'Minted by Osman son of Ertuğrul'.[11] And since the minting of coins was a prerogative accorded in Islamic practice – as in western – only to a sovereign, it indicates Osman's pretensions to be a princely ruler rather than a mere tribal chief, demonstrating that he had accumulated sufficient authority to challenge Ilkhanid claims to suzerainty over him and his people: the Turcoman emirates did not mint coins in the names of their own emirs while they remained under the nominal suzerainty of the Ilkhanids. The oldest surviving dated Ottoman coin is from 1326–7, however, after Osman's death, and some see this as the earliest the Ottoman state can be considered to have been independent of the Ilkhanids.[12]

The Ottomans were fortunate in their geography. Osman's lands were close to Constantinople, bringing him into contact with the governors of the Byzantine towns in north-west Anatolia, with whom he competed for influence as well as for pasture to satisfy the flocks of his followers. This proximity to Constantinople offered the promise of great rewards should that city fall, but also put the Ottomans under pressure from the Byzantine army as it sought to protect what remained of its beleaguered territory. Osman's earliest advances against Byzantium seem to have been concentrated against small settlements in the countryside rather than against the

towns. It may be that the towns were difficult to capture while the country-side offered resources which were of greater value to him and his men. The representation of this area by a contemporary Byzantine historian as prosperous, populous and well-defended is borne out by archaeological evidence.[13] Even before his first datable victory over Byzantine forces in 1301, Osman seems to have assumed control of lands lying between his father's pastures around Söğüt and İznik although he failed, despite a lengthy siege between 1299 and 1301, to take İznik itself.[14]

After his victory over Byzantine forces in 1301, Osman was impossible to ignore. The Byzantine emperor Andronicus II Palaeologus thought to make a radical alliance against the growing threat he represented by offering one of the princesses of his family in marriage to Osman's nominal overlord, the Ilkhanid khan Ghazan (whose seat was at Tabriz in north-west Iran) and then, when Ghazan died, to his brother. But the anticipated reciprocal help in men and materials was not forthcoming and in 1303–4 Andronicus employed the Spanish adventurers of the crusading Catalan Grand Company to protect his domains from further Ottoman advance. Like so many mercenary groups, the Catalans turned to raiding on their own account,[15] calling upon Turcoman fighters – though not necessarily those under Osman's control – to join them in pursuit of their own objectives across the Dardanelles Straits in the Balkans. Only an alliance between Byzantium and the kingdom of Serbia[16] checked this Turcoman–Catalan advance.

The arrival of the Turcomans in Anatolia disturbed the equilibrium of the older states. The administrative hand of the once-great Byzantine and Seljuk–Ilkhanid Empires did not reach with any authority into the region of uncertainty lying between them. But it was not exclusively warriors who inhabited these marches. The opportunities they offered undoubtedly attracted adventurers, but also people who followed the frontier simply because they had nowhere else to go. The milieu of these frontier lands where the Ottoman state had its beginnings has been described as:

> . . . criss-crossed by overlapping networks of nomads and seminomads, raiders, volunteers on their way to join military adventurers, slaves of various back-grounds, wandering dervishes, monks and churchmen trying to keep in touch with their flock, displaced peasants and townspeople seeking refuge, dis-quieted souls seeking cure and consolation at sacred sites, Muslim schoolmen seeking patronage, and the inevitable risk-driven merchants of late medieval Eurasia.[17]

The presence of dervishes, or Muslim holy men, was one of the most striking features of the marches. Like Christian monks, some wandered the

countryside while others lived in communities of their adherents and their deeds and piety were recounted in epics and hagiographies which formed part of a long oral tradition. The links of the first Ottoman rulers with dervishes are attested to by the earliest extant document of the Ottoman state, the grant in 1324 by Osman's son Orhan of land east of İznik for a dervish lodge.[18] Such lodges, like the tombs of Christian saints, formed a nucleus which attracted settlement into new areas and were an inexpensive means of securing the loyalty of the common people; dervish lodges symbolized the popular expressions of Islam which flourished in Anatolia alongside the Sunni Islam of Seljuk imperial culture. Osman may not himself have been well versed in the ways of Sunni Islam, but Orhan adopted its forms for the foundations of his state: theological colleges were built during his lifetime[19] to promote the learned form of religion to which he aspired, and the language and style of the 1324 land-grant document show that his administrators were thoroughly familiar with classical Islamic chancery practice.[20] The Ottoman sultans who followed Orhan were invariably affiliated to one of the dervish orders: coexistence and compromise between different manifestations of religious belief and practice is one of the abiding themes of Ottoman history.

Many dervish lodges were founded in north-west Anatolia. But the fluid conditions of the marches attracted the restless energies of dervishes of a non-contemplative bent, and after the mid-fourteenth century, when the Ottomans began to colonize the Balkans, they played a particularly significant role. Dervishes carried Turco-Islamic culture with them as they fought alongside the warriors of the marches, urging them on, to be rewarded with grants of vacant land or lands won from the fleeing population.[21] The variety of dervish orders is as bewildering as the history of their formation and re-formation. Among the best-known is the Bektaşi order, originally a minor sect, which later came to prominence in its connection with the sultan's elite infantry troops, the janissaries.

The devotional practices of mosque-goer and dervish could be accommodated side by side in one building, and many mosques today associated with Sunni Islamic observance once had a wider function, as a refuge for dervishes as well as congregational prayer-hall. Indeed, the mosques built in Bursa by the second Ottoman sultan Orhan and his son and successor Murad are referred to in their endowment deeds as dervish lodges.[22] The earliest surviving Ottoman structure in Europe, the public kitchen of Gazi Evrenos Bey in Komotini in present-day Greek Thrace, was built, like very many other similar establishments of the time, with small domed rooms to the side where dervishes could gather.[23]

Orhan's land-grant of 1324 shows that Islam was a component of the

public identity of the chiefs of the Ottoman emirate from the start, for in an indisputably Islamic formulation he designates himself 'Champion of the Faith', while his late father, Osman, is styled 'Glory of the Faith'.[24] No document survives to tell us how Osman referred to himself, but already in the later thirteenth century the rulers of some other western Anatolian emirates had adopted Islamic epithets for themselves – 'Victor of the Faith' or 'Sword of the Faith', for instance.[25] The first Turcoman chief of this period to identify himself as a 'Warrior for the Faith', a *gāzī*, was of the house of Aydın in an inscription recording the construction in 1312 of a mosque in Birgi in western Anatolia. By the 1330s, both the emir of Menteşe and Orhan himself styled themselves 'Sultan of the Gazis' in inscriptions.[26]

The term *gāzī*, denoting one who undertakes *gazā*, meaning 'war for the faith', or 'war against infidels', or 'holy war' (*gazā* may be considered almost a synonym for *jihād*), had been accorded to Muslim fighters in Seljuk times and before, but did not, in the early fourteenth century, have a confrontational, anti-Christian connotation. The term was widely used by the Ottomans, and when their chronicles and poems honoured Osman and his cohorts as *gāzīs* the word meant 'warrior' or 'raider', but with no more religious injunction than was inherent in the incumbent duty of every Muslim to fight against infidels.[27] Fortuitously, the Ottoman emirate bordered a Christian state, but there are no grounds for asserting that it was unique among its neighbouring emirates in embracing the ideology of 'holy war', nor does embrace of the ideology of 'holy war' provide suffi-cient account for its achievements. A recent reconsideration of the widely-accepted view that the raison d'être of the Ottoman emirate was the pursuit of 'holy war' has concluded that it was, rather, a 'predatory confederacy' comprising Muslim and Christian warriors alike, whose goal was 'booty, plunder and slaves, no matter the rhetoric used by its rulers'.[28] In this confederacy, the hypothesis continues, Turcoman fighters were in the minority: the rapid pace of conquest required willing and indiscriminate acceptance of large numbers of Christians into the Ottoman fold to meet the shortage of manpower available to create and administer the fledgling state.[29]

The religion of the early Ottoman Muslims was not exclusive: oral tradi-tions which sang the deeds of the heroes of the marches recorded not only that co-operation between Muslim fighters and Byzantine Christians was frequent, but that intermarriage was not uncommon.[30] That the Christian population of the north-west Anatolian marches continued to practise their religion freely is attested to in the letters of Gregory Palamas, Archbishop of Thessalonica, who travelled through the area in 1354 as captive of the

Ottomans.[31] Eminent Byzantines, moreover, found employment at the Ottoman court, both in Orhan's time and into the early sixteenth century.[32] Later Ottoman chroniclers, writing in a period of prolonged warfare with the Christian states of the Balkans and beyond, emphasized a religious inspiration for the early conquests of the dynasty, representing the Turcoman frontiersmen as motivated solely by a desire to spread Islam. Writing at a time when the political environment was quite different, an imperial and theocratic state of which Sunni Islam was the official religion, they attributed militant piety to these frontiersmen: it seemed appropriate to assert that it had always been thus, that the state had been created by the tireless efforts of Muslim warriors struggling against their supposed antithesis, the Christian kingdoms of Byzantium and Europe. Modern historians have too often been willing accomplices in accepting the chroniclers' version of the Ottoman past.

By the time the story of the beginnings of the Ottoman Empire came to be written down, they were a distant memory. The early years of dynasties that subsequently achieve spectacular success are often shrouded in mystery, and later traditions greatly embellish meagre truths in an attempt to provide legitimacy. Osman was described in his own time as one of the most energetic of the Turcoman chiefs threatening Byzantium, and although he failed to take İznik, his siege of this important city and his military success over a Byzantine army in 1301 must have won him prestige and renown, encouraging many warriors to throw in their lot with him and his men. However, changing times demanded legitimization of Ottoman claims both to territory and to pre-eminence over the other Turcoman dynasties of Anatolia, and it became necessary that the personal fame won by Osman in his lifetime be bolstered with more compelling grounds for Ottoman supremacy.

Many challenged Ottoman power over the centuries and it was vital that the dynasty demonstrate its rule as the natural order of things. The legend of Osman's dream proved inadequate to neutralize all challenges, however, and a more tangible legacy was needed to address the place of the nascent Ottoman state in the political history of the region. By the late fifteenth century popular epic was claiming that Osman's father Ertuğrul had been granted his land near Söğüt by the Seljuk sultan of Rum himself, a claim bolstered by a story that the Seljuk sultan had presented Osman with insignia of office − a horsetail standard, a drum and a robe of honour − as marks of his legitimacy as heir to the Seljuks. A century later still, in 1575, an Ottoman chancellor forged documents purporting to be a record of the presentation of these insignia.[33] Such stories addressed the question

of the Ottoman right to inherit the Seljuk mantle, but Ottoman sovereignty also called for a nobler lineage than that of its rivals. From the early fifteenth century, then, in the face of competing states – the Timurids, and the Akkoyunlu ('White Sheep') Turcoman tribal confederation which had moved west after the wave of migration which brought Osman's clan – the Ottomans were furnished with Central Asian descent from the Turkic Oğuz tribe and their illustrious ancestor the Prophet Noah, who was said to have given the East to his son Japheth.[34] There are hints in texts that have come down to us that Osman's family had a less than romantic past, that he was, in fact, a simple peasant. Another tradition describes his fore-bears as Arabs of the Hijaz, indication, perhaps, that the Ottomans at one time thought such a fictive genealogy would best assert their legitimacy.[35] This claim disappeared early but the dream legend, by contrast, was repeated down the ages, even until the later years of the very Ottoman Empire it had portended.

Beyond the likelihood that the first Ottoman sultan was a historical figure, a Turcoman Muslim marcher-lord of the Byzantine frontier in north-west Anatolia whose father may have been called Ertuğrul, there is little other biographical information about Osman. But his dream inciden-tally provides one more detail which is corroborated by documentary evidence: early Ottoman land deeds suggest that a holy man known as Sheikh Edebali lived at the same time as Osman, and there is some evidence that Osman married his daughter as one of his two wives.[36]

At the heart of Ertuğrul's lands at Söğüt is a small mosque bearing his name, and a tomb, said to have been built for him as an open structure by his son Osman and later enclosed by Osman's son Orhan.[37] However, since both mosque and tomb have been rebuilt so often that nothing of their original architectural form remains, no surviving buildings can with confidence be ascribed to Osman. Nevertheless, in the late nineteenth century, when Sultan Abdülhamid II sought to bolster his faltering regime by identifying it more closely with the great deeds of his illustrious fore-bears, he found it convenient to promote Söğüt as the Ottoman heartland and created there a veritable cemetery of the first Ottoman heroes. He rebuilt Ertuğrul's mausoleum and interred his purported remains in a marble sarcophagus, and added a grave for Ertuğrul's wife, one for Osman – even though he had been reburied in Bursa by his son Orhan – and graves for 25 of Osman's fellow warriors.[38] To the present day Söğüt remains a shrine and the site of an annual festival to commemorate the earliest days of the Ottomans.

Osman probably died in 1323–4, having secured for his heirs substan-tial territory in north-west Anatolia, stretching from his headquarters at

Yenişehir, the 'New City' (Melangeia), to Eskişehir, the 'Old City', with Söğüt at its centre. Yenişehir was strategically situated between İznik and Bursa, two places he had intended but failed to capture.[39] In 1326 his son Orhan captured Bursa and this important city became the new hub of Ottoman power. Like İznik and İzmit (Nicomedia), Bursa had for some time been isolated from Constantinople as a result of Osman's control of the surrounding countryside; Orhan continued his father's blockade of the city and starved the inhabitants into submission. The Moroccan traveller ibn Battuta reported that Orhan was the foremost and richest of the several Turcoman chiefs whose courts he visited during his sojourn in Anatolia in 1330–32. He further noted that Orhan never stayed in one place for long but moved constantly between the hundred or so fortresses he commanded, in order to make sure they were in good repair. When he visited newly-Ottoman Bursa, ibn Battuta found a city 'with fine bazaars and wide streets, surrounded on all sides by gardens and running springs'.[40] Here Orhan buried his father – or, rather, reburied him having moved his remains from Söğüt to this, his new capital – and his mother (who was probably not the daughter of Sheikh Edebali, but another woman). He was himself later buried here, together with his wives Asporça and Nilüfer and various family members,[41] as was his son and successor, Murad, who was killed in 1389 at the battle of Kosovo Polje in Serbia. Bursa always held a special place in Ottoman dynastic memory and continued for some generations to be the favoured place of burial for members of the royal house, even after the court moved first to Edirne (Adrianople) and later to Constantinople.

In 1327 the western Thracian frontier of Byzantium was invaded by the Bulgarian tsar Michael Shishman, whose army twice came within sight of Edirne before a negotiated settlement was reached. Relieved at having been able to withstand this danger, Emperor Andronicus III Palaeologus (grandson of Andronicus II) and the commander-in-chief of his army, Grand Domestic John Cantacuzenus (later to rule as John VI), in 1329 turned to deal with the more threatening situation to the east. They met an army under the command of Orhan at Pelecanum, west of İzmit. Orhan declined to engage in full battle on the steep northern slopes of the Gulf of İzmit, but sent a force of archers to attack the Byzantine troops. Seeing that the Ottomans would not fight, the Emperor prepared to retreat; but he delayed and was wounded, his army was forced to turn to fight the pursuing Ottoman troops, and the confrontation ended in stalemate.

In 1331 İznik surrendered to an Ottoman siege begun some years earlier. Many of its inhabitants had already deserted the city for Constantinople, and seven months after its fall ibn Battuta found it 'in a mouldering

condition and uninhabited except for a few men in the Sultan's service'.[42] The loss of İznik brought it home to Emperor Andronicus that he would not necessarily be able to ensure the survival of what remained of his empire – and most critically of Constantinople – by military means, and in 1333 he demeaned himself by going to meet Orhan who was then besieging İzmit. This first diplomatic encounter between a Byzantine emperor and the upstart leader of a new state was momentous: it resulted in once-proud Byzantium agreeing to pay the Ottomans in return for a guarantee that the Emperor be allowed to retain the little territory he still held in Anatolia.

The defences of İzmit were sound: like İznik and Bursa, it was able to withstand a long siege, and it was not until 1337 that its inhabitants succumbed to the blockade of the approaches to the city. The very length of these sieges demonstrated the strength of the Ottomans: they did not yet have gunpowder technology but they could field enough men to maintain control of territories already won, and also assign an army to remain camped outside the walls of a city over a significant period of time. The raiding tactics of Osman's forces had been appropriate to their nomadic origins: Orhan was gradually adopting the techniques of a sedentary army sustained by a settled population.

Not only the Ottomans and the Bulgars were threatening Byzantium, however. The emirate of Karesi was almost as close to Constantinople as the Ottomans, and by the 1330s had occupied territory on the north Aegean coast of Anatolia west of a line running from the Sea of Marmara to the Gulf of Edremit. Its long coastline and access to the sea gave it a strategic advantage over the Ottomans who remained as yet an inland power. Karesi's control of the Dardanelles Straits posed a real danger to the remaining Byzantine enclaves in the Balkans and on two occasions in the 1330s the Karesi Turcomans crossed over to Thrace with their horses and raided inland before the Byzantines were saved by the arrival of crusading galleys which destroyed the Karesi fleet.[43]

The Orthodox Byzantines and their Church had been branded as schismatics by the Catholic Latins since 1054; moreover the Latin occupation of Constantinople between 1204 and 1261 was still a vivid memory, and in the difficulties in which the Emperor now found himself this old rivalry flared again. Intimation that the common Christian faith of Orthodox and Catholic counted for nothing came in 1337 when the Genoese, from their trading colony at Galata (also known as Pera) across the Golden Horn from Constantinople, made contact with Orhan in support of his plans to attack the Byzantine capital. The Emperor sent a mission to the Pope indicating that he might be willing to give ground on the contentious matter of Orthodox–Catholic religious differences if help were forthcoming against

the Ottomans.[44] So sensitive was the issue of Byzantium's refusal to renounce the Orthodox faith and reunite its Church with Rome, and so wide the breach between successive popes and emperors, that there had been very little communication between them for some fifty years before this approach.

The death of Emperor Andronicus III in 1341 plunged Byzantium into civil war. Emir Umur Bey of Aydın and the Emir of Saruhan had earlier helped him with their navies to ward off Latin attacks on Byzantine possessions in the Aegean and Umur Bey now took the side of Andronicus' successor and regent for his young son, his trusted adviser John VI Cantacuzenus. Umur Bey's growing military and naval power and alliance with John enabled him to raid into the Balkans. This prompted a western crusade which in 1344 burnt his outlet to the sea, the fortress and port of İzmir (Smyrna).[45] The Ottomans also formed an alliance with the new emperor when Orhan married John's daughter Theodora in a splendid ceremony in 1346.[46]

Political correctness in its most literal sense set in early among the Ottomans: their chroniclers mention neither Orhan's alliance with the Christian Byzantine emperor John VI, nor his marriage to Princess Theodora. To have done so would have been to undermine their picture of an Islamic empire in the making. By contrast, a fifteenth-century Ottoman chronicler of the house of Aydın (which had by then vanished) did not scruple to reveal that John had had to call upon the help of Umur Bey and had also offered him one of his daughters.[47] Similar fluidity of alliances between Ottomans and Christians was characteristic of the final century of Byzantium and continued once Byzantium was no more. Just as the first Ottoman warriors formed strategic alliances regardless of religious considerations, so the mature Ottoman Empire entered coalitions with one Christian state against another as realpolitik demanded. The pervasive notion of permanent and irreconcilable division between the Muslim and Christian worlds at this time is a fiction.

By the same token, as the Ottomans made alliances with one Christian state or another, so they attacked their own co-religionists and annexed their lands. Yet conquest of their Muslim neighbours in Anatolia posed a thorny problem. Campaigns against and conquest of Christian states required no justification, for these states were considered the 'abode of war', non-Muslim regions whose absorption into the Islamic lands, the 'abode of Islam', was only a matter of time. The chroniclers were at pains, however, to avoid having to justify canonically-questionable aggression against fellow Muslims, and the motives for Ottoman expansion at the expense of their Muslim rivals were traditionally disguised. The annexation of Karesi, the first of the rival Turcoman emirates to be taken by the Ottomans, is a case

in point: Orhan took advantage of factionalism inside the emirate of Karesi in the mid-1340s, but the episode is portrayed by the chroniclers as a peaceful submission by the inhabitants.

After 1350 Ottoman activities began for the first time to impinge directly on the interests of European states. Between 1351 and 1355 Genoa and Venice were involved in a war over control of the lucrative Black Sea trade. Soon after the arrival of the protagonists of the Fourth Crusade at Constantinople in 1204, Venice had acquired a colony at Tana (Azov) at the head of the Sea of Azov, while Genoa had a number of colonies on the Black Sea shores, including at Caffa (Feodosiya) in the Crimea. These colonies were entrepôts for the export to the west of raw materials such as furs, silk, spices, precious stones and pearls. Orhan took the side of Genoa in the conflict with Venice, supplying both its fleet and its trading colony at Galata, and in 1352 concluded a treaty with his ally; his forces also assisted the Genoese when Galata came under attack from Venetian and Byzantine troops.[48]

The Genoese provided Orhan's forces with boats to ferry them across the Bosporus,[49] but it was the beleaguered John Cantacuzenus who unwittingly helped the Ottomans establish a permanent presence in Thrace. In 1352, at John's invitation, a band of mercenary soldiers referred to in the texts as 'Turks' garrisoned the Byzantine fort of Tzympe in the vicinity of the town of Bolayır, north-east of Gelibolu (Gallipoli) on the north shore of the Dardanelles. Shortly thereafter, these 'Turks' offered their allegiance to Süleyman Pasha, son of Orhan, and the Ottomans acquired their first stronghold in the Balkans.[50] The establishment of Ottoman bases in Thrace was the decisive event of Orhan's reign and its treatment by the Ottoman chroniclers is instructive. Concerned to represent the Ottoman expansion into Thrace, of which Süleyman was the architect, as proceeding from the favour of God and Ottoman skill and valour, they conveniently obscured the crucial part played by the men of the former lands of the Karesi emirate who had fought alongside him.[51]

The chroniclers were not even prepared to accord the forces of nature a role in the Ottoman conquests. Byzantine sources refer to an earthquake in 1354 – two years after the initial Ottoman forays across the Straits – which destroyed the walls of Gelibolu and ruined a number of other towns on the north-west coast of the Sea of Marmara; these were then occupied by Ottoman and other Turkish forces. The Byzantine chroniclers made much of the earthquake as an excuse for their weakness in the face of a superior foe – but there is no reference to it in Ottoman sources.[52]

These events in Thrace precipitated the abdication of Emperor John VI Cantacuzenus in favour of his son Matthew, who ruled briefly before being

succeeded by Andronicus III's son John V Palaeologus. When Orhan's youngest son Halil, still only a child, was captured by Genoese pirates in 1357, the new emperor became involved in delicate negotiations to engineer his ransom and release, thus bringing the Byzantines some respite: the next two years saw little advance on the Ottoman frontier. John Palaeologus, aspiring to unite Byzantine and Ottoman territories, married his daughter Irene to Halil – in the hope that Halil would succeed his father as, under the Ottoman system where each son theoretically had an equal chance of succeeding, he might have done. But the plan came to nothing, for it was Halil's older brother Murad who took their father's place.

Peaceful coexistence between Orhan and John Palaeologus was to prove a mirage. Orhan had intended his eldest son, Süleyman Pasha, to succeed him but Süleyman died in 1357, shortly after Halil's capture, as the result of a fall from his horse; his steed was buried next to him in Bolayır, where their graves can still be seen.[53] Murad was sent to take Süleyman's place as commander-in-chief on the Thracian frontier and with the help of local commanders he achieved further victories, so that when Orhan died in 1362 the Ottomans had occupied much of southern Thrace and were in possession of the important Byzantine city of Didymoteicho to the south of Edirne. As the frontier moved west, so did the seat of the sultan and his court – from Yenişehir to Bursa to Didymoteicho, and then to Edirne, captured sometime in the 1360s. The lands of Karesi on the northern Aegean coast of Anatolia were under Ottoman control at Orhan's death, and his domains reached as far east as Ankara (the capital of modern Turkey), captured from a rival Turcoman dynasty by Süleyman Pasha. In an inscription in the Alaeddin Mosque in Ankara[54] dating from the year of his death, Orhan is identified for the first time as 'Sultan', signifying Ottoman claims to absolute power. Other emirs of western Anatolia took up the challenge and soon adopted this title themselves: Germiyan and Karaman in 1368–9, Aydın in 1374, Saruhan in 1376 and Menteşe in 1377.[55]

The rapid expansion of the Ottoman domains under Orhan is clearly legible in the architecture of his time. The stamp of the new regime was firmest in the major cities of İznik and Bursa but some thirty mosques in the small towns and villages of north-west Anatolia also bear his name. In the cities he constructed the mosques, bath-houses, theological colleges, public kitchens, bridges, tombs, and dervish lodges that identified them as Islamic and Ottoman. Orhan also commemorated his father's conquests by building mosques and other structures necessary for Muslim life in places Osman had conquered, and many of the buildings of his time bear the names of other figures – warriors and holy men alike – who were prominent in the success of the Ottomans. Süleyman Pasha is remembered in

mosques, theological colleges and baths in the Ottoman heartland in Anatolia and others mark his conquests in Thrace, including the former church of Hagia Sophia in Vize (Bizye), which he converted into a mosque.[56] Such a change of function upon Ottoman conquest was typical, especially when a town had not surrendered but had been taken by force. The resettlement of Turkish populations in the wake of the frontier warriors slowly brought prosperity to Thrace once more. The weight of the Byzantine feudal regime had long since alienated many of the indigenous Christians from the provincial aristocracy and from their masters in Constantinople, a state of affairs exacerbated by the great destruction wrought during the civil war of the early 1340s.

The Byzantine emperors at Constantinople still hoped that western Christendom would rescue them from the Ottomans who, it was clear from their expansion into Thrace, did not intend any permanent accommodation. Yet whenever an appeal for western aid was made, the same conditions were attached to the response – the Orthodox Byzantines must abandon their schismatic ways and accept the Church of Rome. What help did reach Constantinople was dictated by the political, diplomatic and commercial concerns of individual states. In 1364 John Palaeologus turned to the fellow Orthodox state of Serbia, a potential ally which was by now also threatened by Ottoman expansion; but Serbia had lost its former vitality following the death of its king Stephen Dušan in 1355, as his successors competed for power. Next John travelled to Hungary to seek the help of King Louis, but to no avail. The only hopeful sign was the recovery of the key Thracian port of Gelibolu by a Latin naval force in 1366 as the first strike in a modest crusade in support of the beleaguered Byzantines. A Byzantine embassy to Rome was followed in 1369 by the Emperor himself, who in his desperation promised to accept the Latin rite as the price of papal assistance; but the emptiness of papal assurances was soon revealed, for no help was forthcoming.

Byzantium was not alone in its fear of Ottoman encroachment in the Balkans. Following the conquest of Edirne in the 1360s the various successors to Stephen Dušan's Serbia felt Ottoman pressure on their southern and eastern frontiers. Realizing the consequences if the Ottomans were not halted, some among these petty rulers united to field an army, but the battle of Çirmen on the Maritsa river west of Edirne in 1371 was a disaster for the Serbian lords: defeated, they became Ottoman vassals as did the three rulers of Bulgaria who fought alongside them, and all obstacles to the advance of the Ottomans into Macedonia were removed.

The expansion of the frontier was shared with quasi-independent fighters who had thrown in their lot with the Ottomans. Four such Muslim

families were particularly prominent during the Ottoman conquest of Rumeli (the name they used for the Balkan peninsula): these were the Evrenosoğulları,* the Mihaloğulları, the Turahanoğulları, and the Malkoçoğulları. The first two of these families were Christian warriors in north-west Anatolia who had crossed to Thrace as the Ottoman frontier advanced and converted to Islam, while the Malkoç dynasty, properly known as Malković, were of Christian, Serb origin; the origins of the Turahanoğulları remain obscure.[57]

Of these families the Evrenosoğulları achieved the greatest renown. Gazi Evrenos was said to have been a former ally of the house of Karesi, and to have crossed the Dardanelles with Orhan's son Süleyman.[58] From 1361, when he captured the town for the Ottomans, he had his base at Komotini, then on the Serbian frontier, and was responsible for erecting some of the earliest Ottoman buildings in Rumeli. As the frontier advanced Gazi Evrenos moved his seat westward, lastly to Giannitsa, which he founded, and where he died and was buried in 1417.[59]

Sultan Murad remained in Rumeli following Orhan's death in 1362 until in 1373 he crossed the Dardanelles to campaign in Anatolia, accompanied by John V Palaeologus, who had recently become his vassal. Murad's son Savcı and John's son Andronicus chose this moment to rebel against their fathers who swiftly returned home, John to Constantinople and Murad to Rumeli. Murad had Savcı and his fellow rebels killed; Andronicus surrendered and at Murad's insistence was imprisoned and blinded. Little else is known of Savcı: the Ottoman chronicle tradition did not countenance Ottoman princes who contested parental authority – especially those who did so in alliance with a Christian prince.

The real loser, at least for a time, was John Palaeologus' younger son Manuel. He had been designated his father's successor soon after the revolt of Andronicus, but when the strife between John and Andronicus was eventually resolved in 1381 the succession was altered in favour of Andronicus' son, another John. Manuel fled to Thessalonica, a Macedonian city of great significance in the Byzantine world as an intellectual and artistic centre, and there set up an independent court. This was quite contrary to Ottoman interests, and his disquiet at Manuel's military activities against the Ottoman advance in this part of Macedonia prompted Murad to action. His commander Kara ('Black') Halil Hayreddin Çandarlı took Serres and other cities in southern Macedonia and in 1387, after a four-year siege, Manuel left Thessalonica and the city accepted Ottoman sovereignty – although it was not until seven years after this formal subjugation that the Ottomans,

* The suffix '-oğulları' means 'sons of' in Turkish; the often interchangeable '-oğlu' means 'son of'.

having been engaged elsewhere, removed the native Byzantine functionaries and were able to occupy the city and its hinterland and impose their administration. Soon after the fall of Thessalonica Manuel accepted that he must become an Ottoman vassal. He was punished by John V for his abandonment of the city by being exiled to the north Aegean island of Lemnos where he may have spent the next three years. In 1390 his father summoned him to Constantinople against Andronicus' son John who claimed the throne as John VII – Andronicus had died in 1385 – but Manuel persuaded his nephew to go to Genoa to seek help against the Ottomans. Returning home in 1390 John VII was expelled from Constantinople and fled to the Sultan; when John V died in 1391, Manuel succeeded him to the Byzantine throne as Manuel II Palaeologus.[60]

Kara Halil Hayreddin Çandarlı was a scion of an Anatolian Muslim dynasty which subsequently furnished the Ottomans with a number of eminent statesmen. His mosque, dating from 1385, is the oldest recorded Ottoman monument in Serres.[61] The various offices held by Kara Halil Hayreddin are evidence of the way the Ottoman state was evolving from its nomadic origins to become based on a core of secure territory behind the fluid frontier: Murad's reign is as significant for its administrative developments as for the extent of his conquests. Kara Halil Hayreddin held the post of kadı (judge) in İznik and Bursa and then became Murad's first chief justice and also his chief minister, in addition to his military command. This joint supervision over army and administration made him, in effect, the first grand vezir of the Ottoman state.[62]

In preparation for the siege of Thessalonica Murad transferred large numbers of troops to Rumeli, where those not engaged in the blockade of Manuel's stronghold operated against other petty lords of this politically-fragmented region. They pushed into Epirus and Albania, and in 1386 took the city of Niš from the Serbian prince Lazar, giving the Ottomans access to the Morava river valley, which led north-west towards Belgrade and the heart of central Europe and westwards into Bosnia and to Dubrovnik (Ragusa) on the Adriatic coast. Soon afterwards, Murad's Bulgarian vassals declared their independence of Ottoman suzerainty. Among them was John III Shishman, ruler from Veliko Tŭrnovo of the largest share of the divided medieval Bulgarian kingdom, and Murad's brother-in-law. Early in 1388 an army under Çandarlı Ali Pasha, son of Kara Halil Hayreddin, marched through the snowy Balkan passes and many of the towns of John Shishman's northern Bulgarian domains surrendered at his advance; they were returned to Shishman, but he was left in no doubt that he was Murad's vassal. However, further Ottoman incursions into Serbia in 1388 met defeat in battle at Bileća, north-east of Dubrovnik, at the hands of an alliance of Bosnian princes.[63]

Murad seems to have assumed that Lazar of Serbia had been involved in the Ottoman defeat at Bileća, and in 1389 he invaded Serbia, apparently with the intention of punishing him before continuing onward into Bosnia.[64] On 15 June Murad's army met Lazar's at Kosovo Polje, the 'Field of Blackbirds', near the town of Priština. The Ottoman force numbered some 25,000 men, the combined Serbian–Kosovan–Bosnian army roughly 16,000. When the battle ended eight hours later, the Ottomans were victorious but both sovereigns were dead. At some point during the fighting Murad had become isolated from the body of his army and one of Lazar's commanders approached him, pretending that he was defecting to the Ottomans. Instead, he stabbed the Sultan dead. Lazar was soon captured and decapitated in Murad's tent.[65]

When news of Murad's death reached Europe, King Charles VI of France thanked God in Notre-Dame.[66] But hope that this might also be the demise of the Ottomans was mere wishful thinking: Murad's son Bayezid took command on his father's death, and ensured his succession by having his brother Yakub killed in the first recorded fratricide in the history of the Ottoman dynasty; it is unclear whether Yakub was murdered while the battle still raged, or some months later.[67] Serbia became an Ottoman vassal, obliged to pay tribute and supply troops, with Lazar's son Stephen at its head. Bosnia remained independent, as did Kosovo, under its lord Vuk Branković, until 1392.

Although Kosovo Polje cost the Ottomans their sultan, the price paid by Serbia was far greater. Bayezid's victory signalled the end of the independent Serbian kingdom, and confirmed the permanence of the Ottoman presence in the Balkans. Today, more than 600 years later, the battle of Kosovo Polje still figures vividly in the Serbian national consciousness as a defining historical moment. Epic poems recited down the ages dramatized and immortalized the memory of the defeat of a Christian king by a Muslim sultan in a Christian heartland. Such epics fuelled the emotions of the Christian Serbian population of the region in the terrible wars of the late twentieth century: they saw an opportunity to remove from their midst the Muslim population still, even after so many centuries, seen by many as alien. And the Muslim population as readily responds to assert its right to remain.

2

A dynasty divided

SULTAN MURAD I died on the western frontier of his state. His son and successor Sultan Bayezid I hoped that the weakened position of Serbia and his marriage after the battle at Kosovo Polje to Olivera, sister of the new Serbian despot Stephen Lazarević, would prevent any further attacks on his Balkan possessions, for he had business in the east where his father's expansion of the Ottoman territories had made conflict with the numerous other Turcoman Muslim emirates of Anatolia inevitable. The great energy he devoted to campaigning earned Bayezid the soubriquet 'Yıldırım', 'Thunderbolt'.

The succession of Bayezid emboldened the Anatolian emirates to join an anti-Ottoman alliance headed by his brother-in-law Alaeddin Bey, emir of Karaman, the most indomitable of all the Turcoman Muslim states in its efforts to counter Ottoman expansionism. Alaeddin Bey had wed Bayezid's sister Nefise Sultan in 1378 when the balance of power between the two states was still unresolved. Dynastic marriage could be a useful diplomatic tool, but did not always guarantee the allegiance of a potential ally or secure the loyalty of a potential foe. Since the inferiority of the bride's family was implicit, the Ottomans gave their princesses in marriage only to other Muslim princes, not to Christians (although Christian and other Muslim rulers alike gave their princesses in marriage to members of the Ottoman house in its early years in hope of an alliance).[1] Nor did they give them to their partners in conquest – the Evrenosoğulları, Mihaloğulları or Turahanoğulları – fearing perhaps that this might embolden these Ottoman marcher-lords to challenge the pre-eminence of the Ottoman household.[2] Recognition of Ottoman ascendance over one rival emirate was symbolized by Bayezid's marriage to the Germiyan princess Sultan Hatun in 1381, by which he acquired the emirate of Germiyan.

The Ottomans were eager to push southwards towards the Mediterranean through Germiyan and the emirate of Hamid – supposedly sold to Murad in the 1380s – in pursuit of the reliable sources of revenue they needed if their state was to flourish. One of the main trade routes from the east crossed the Mediterranean to the south Anatolian port of Antalya and ran

north through Hamid and Germiyan to the Black Sea basin or into the Balkans.[3] Karaman was prepared to contest Ottoman attempts to control the trade routes and the customs dues and other taxes that went with the territory, and the first clash occurred in 1386, while Sultan Murad was still alive. In the Ottoman chronicle tradition, correctness required that Alaeddin be blamed for initiating hostilities, and he is therefore said to have attacked Ottoman territory at the entreaty of Murad's daughter, Alaeddin's bride; Murad did not pursue the conflict at this time.

Having secured his western frontier, Sultan Bayezid swiftly moved east. His army recovered Germiyan – apparently lost since his marriage to Sultan Hatun – and annexed Aydın, whose princess he also married.[4] He reduced the emirates of Saruhan and Menteşe at this time so that the Ottomans controlled all of western Anatolia and their domains bordered Karaman in south-central Anatolia. In 1391 Bayezid summoned his vassals Stephen Lazarević and Manuel II Palaeologus, who was now the Byzantine emperor, and together they marched east to seize the north-central Anatolian terri-tory of Kastamonu from the İsfendiyar emirs. Little more was achieved and the armies returned home by December of that year. Manuel Palaeologus appeased Bayezid, but the letters he wrote on campaign vividly convey his despair and deep unease at his invidious position:

> Certainly the Romans had a name for the small plain where we are now when they lived and ruled here ... There are many cities here, but they lack what constitutes the true splendour of a city ... that is, human beings. Most now lie in ruins ... not even the names have survived ... I cannot tell you exactly where we are ... It is hard to bear all this ... the scarcity of supplies, the severity of winter and the sickness which has struck down many of our men ... [have] greatly depressed me ... It is unbearable ... to be unable to see anything, hear anything, do anything during all this time which could somehow ... lift our spirit. This terribly oppressive time makes no concession to us who regard it of prime importance to remain aloof from and to have absolutely nothing to do with what we are now involved in or anything connected with it, for we are not educated for this sort of thing, nor accustomed to enjoy it, nor is it in our nature. The blame lies with the present state of affairs, not to mention the individual [i.e. Bayezid] whose fault they are.[5]

In the winter of 1393–4, relations between the two rulers entered a new phase when Bayezid heard that Manuel had proposed reconciliation to his nephew and rival John VII Palaeologus – who had ruled as emperor briefly in 1390 – in the hope that united they might be able to resist the Ottomans. It was John himself, eager to secure Bayezid's favour, who reported Manuel's suggestion.[6] Shortly thereafter Bayezid summoned his Christian vassals to Serres in Macedonia: they included Manuel's brother Theodore, despot of

the Morea (roughly, the Peloponnese), Manuel's father-in-law Constantine Dragaš, Prince of Serres, Stephen Lazarević of Serbia – and John VII. Their arrival in Serres was orchestrated so that each would arrive separately, unaware that the others would be present. Manuel's account makes it clear that Bayezid's invitation was not one that could be refused, and that he feared the Sultan intended to kill them all:

> For the Turk had with him those who in some capacity or other were leaders of the Christians ... wishing utterly to destroy them all; while they thought to go [to Serres] and face the danger, rather than do so later on as a result of disobeying his orders. They had indeed good reason for thinking that it was dangerous to be in his presence, especially together at the same time.[7]

Manuel's fears for their immediate safety proved groundless. Bayezid reprimanded them sternly for misgoverning their domains – perhaps to justify future incursions into their territories – and sent them on their way. In spring 1394, however, the Sultan embarked upon a siege of Constantinople, first constructing a castle at the narrowest point of the Bosporus, some five kilometres north of the city on the Asian shore; this was called Güzelcehisar ('Beauteous Castle'), today Anadolu Hisarı. The walls of Constantinople had withstood many sieges over the centuries and again defied all attempts to breach them.

It was not only to Byzantium that the Ottomans posed a threat. Bayezid also aimed to weaken Venice, which was a significant naval power with numerous colonies and possessions in the Aegean, on the Dalmatian coast and in the Peloponnese. Venice relied on trade for its prosperity and the continuing presence in the region of Florentine, Catalan, and Neapolitan outposts, each with their own commerical and political interests, made for an uneasy pattern of alliances which was complicated by the rise of Ottoman power as different Christian lords sought Ottoman help against their rivals. Sultan Murad I had inclined towards Venice in his overall strategy; Bayezid's policy was closer to that of his grandfather Orhan who had allied with Genoa against Venice.[8] Bayezid's threat to Byzantine strongholds in the Peloponnese during the early 1390s, as well as his occupation of Thessalonica in 1394 and his siege of Constantinople, were in part directed by his need to pre-empt a Byzantine–Venetian alliance.[9] The Knights Hospitallers of St John of Jerusalem in Rhodes were yet another force in the region. They were a military religious order which had emerged in Jerusalem during the crusades of the twelfth century. Following the loss of Jerusalem to the Muslims in 1187, they were based at Acre for a century before being forced to move to Cyprus with the fall of that city in 1291, and in 1306 they made Rhodes their headquarters. During the final years of the fourteenth century the

Hospitallers were engaged in trying to create a presence in the Peloponnese, and in 1397 took over Corinth from Despot Theodore, in exchange for a promise that they would resist Ottoman attacks from the north. They took control of Mistras in 1400, but Latin occupation of the capital of the despotate provoked an insurrection, and by 1404 the Hospitallers agreed to withdraw.

Bayezid's most dangerous enemy in the Balkans was the kingdom of Hungary, at this time one of the largest states in Europe. Because it had resisted the Mongol invasion of the mid-thirteenth century and served the interests of the pope by sending missionaries to stamp out the heresies of Orthodox Christianity and of the Bogomils, it was regarded as Catholic Europe's eastern bulwark.[10] Hungarian and Ottoman spheres of influence had come into collision after the battle of Kosovo Polje and Bayezid's aim now was to undermine Hungary's attempts to rally its Balkan allies. In 1393 he had annexed the rebellious John Shishman's possessions in Danubian Bulgaria to counter the raids south across the Danube of Voyvode Mircea of Wallachia, a Hungarian client. In 1395 Bayezid went into battle against Mircea, who had concluded a defence pact with Hungary – Mircea was forced to flee. The Ottoman conquest of Macedonia was completed in the same year. Such Ottoman successes in the Balkans lent urgency to Hungarian pleas for help from the West, and this time the threat coincided with a rare period of co-operation between would-be crusaders – notably the knights of France and England – and their governments. On 25 September 1396 the crusading armies met the Ottoman forces under Bayezid's command at Nikopol (Nicopolis) on the Danube. The crusaders were inspired more by the successes of their forebears than by religion. In their impatience to meet the enemy, the French knights refused to concede that King Sigismund of Hungary's Wallachian allies were more experienced in fighting the mobile Ottoman cavalry than were the cumbersome western armies, and deprived him of overall command. Notwithstanding, Sigismund's own forces came near to putting Bayezid to flight (though Sigismund himself was only saved by his vassal Stephen Lazarević); but the outcome was victory for the Ottomans.[11]

The Ottoman success at Nikopol gave Bayezid control over the Balkans south of the Danube. After the battle he crossed the river into Hungary for the first time, and his army raided far and wide. A young Bavarian crusader named Johann Schiltberger described his narrow escape from execution: the day after the battle, many Christian prisoners were killed in cold blood, but he was spared because of his youth and taken into captivity together with a number of nobles.[12] By contrast, the nobles captured with him were ransomed within nine months after the intercession of their peers

and the presentation to Bayezid of sumptuous gifts and 300,000 florins in cash.*[13]

Sultan Bayezid's successes in the Balkans did not impress his brother-in-law Alaeddin. The Karamanid ruler refused to acknowledge himself subject to the Ottomans. 'I am as great a lord as thyself,' he claimed, in the words of Schiltberger,[14] who was in Bayezid's suite as he led a victorious army against the Karamanid city of Konya after his victory on the Danube. Alaeddin paid with his life for this hubris and the Karamanid emirate lost its independence.

This annexation of Karaman relieved the pressure from one rival state, but on their eastern frontier the Ottomans were still challenged in the north by Kadı Burhan al-Din Ahmad, who had eluded Bayezid on an earlier campaign. Kadı Burhan al-Din, a poet and man of learning, had usurped the throne of the Eretna dynasty whose seat was at Sivas in northern Anatolia.[15] Whereas the Ottomans saw themselves as heirs to the Seljuk state in Anatolia and Karaman's resistance to their bid for domination was that of a rival emirate of similar Turcoman origins, Kadı Burhan al-Din represented the Ilkhanid inheritors of the Mongol empire of Genghis Khan. As the armies of Tamerlane, the already legendary Mongol ruler of Transoxiana in Central Asia, were to prove, the Mongol challenge was vastly more dangerous. The distinction between the Ottomans' subjects and those of Kadı Burhan al-Din was noted by Emperor Manuel II as he moved east with Bayezid on campaign in 1391; he referred to the Turkish population of western Anatolia as 'Persians', the common Byzantine usage at this period, but called Kadı Burhan al-Din's people 'Scythians', the word used to indicate Mongols.[16]

By 1397 Bayezid's siege of Constantinople had become a relentless blockade and Emperor Manuel again sought help from abroad to save the Byzantine capital. In June 1399, after much diplomatic to-ing and fro-ing between Paris, London, Rome and Constantinople, Charles VI of France sent a small army to aid Manuel. At its head was a marshal of France, Jean Boucicaut, one of the nobles captured at Nikopol, imprisoned and then ransomed by the Ottomans. Only by forcing his way through the Ottoman blockade could Boucicaut reach Manuel. He realized that his army was inadequate to relieve Constantinople and prevailed upon the Emperor to travel to Europe and put his case in person. In December Boucicaut began

* Schiltberger subsequently entered Bayezid's service, and six years later at the battle of Ankara was captured by 'Tamerlane', the Mongol conqueror Timur, in his victory over the Sultan; he long remained a slave of Tamerlane and his successors, but eventually escaped captivity and returned home after thirty-two years away.

the return journey with Manuel in his company, travelling to Venice by sea and thence slowly overland to Paris where the Emperor remained for six months. On 21 December 1400 he arrived in London and was escorted into the city by King Henry IV. Manuel's evident piety and sincerity won him sympathy and the exotic appearance of his suite of bearded priests was a cause of wonder wherever they went during the two months of their visit. As Adam of Usk, a contemporary English chronicler, observed:

> This Emperor always walked with his men, dressed alike and in one colour, namely white, in long robes cut like tabards ... No razor touched head or beard of his chaplains. These Greeks were most devout in their church services, which were joined in as well by soldiers as by priests, for they chanted them without distinction in their native tongue.[17]

Received by both Charles and Henry with splendour and accorded every courtesy, Manuel was convinced that whatever help he needed to resist Bayezid would be forthcoming. But the money collected for Manuel throughout England seemed to have disappeared (and the matter of its disappearance was still being investigated in 1426).[18]

Manuel returned home early in 1403 to find his world greatly changed. His city had been saved from imminent destruction by an event which seemed to presage the end of Ottoman power: the defeat at Ankara of Bayezid's army by that of Tamerlane. Bayezid's defeat turned Anatolia upside down and brought severe disruption to the Balkans. In the longer term, it also enabled Constantinople to survive as the Byzantine capital for another half-century.

Thirty years previously, Tamerlane had embarked on a series of campaigns which took him from China to Iran and culminated, as far as the Ottomans were concerned, with the confrontation at Ankara. Tamerlane saw himself as the successor of Genghis Khan and inheritor, therefore, of the Seljuk–Ilkhanid territories in Anatolia – which put him in a powerful position to exploit the divisions rife among the patchwork of local dynasties who were still independent. Bayezid, however, was encroaching upon these same lands and with Ottoman seizure of Sivas after the murder of its emir Kadı Burhan al-Din Ahmad in the summer of 1398, Bayezid's and Tamerlane's spheres of influence abutted in eastern Anatolia. In a defiant statement of his own independence from Tamerlane, Bayezid applied to the Caliph in Cairo for the title of 'Sultan of Rum', borne by the Seljuk sultans of Anatolia. Tamerlane demanded that Bayezid recognize him as suzerain but Bayezid refused unequivocally.[19] Kadı Burhan al-Din's murderer, the chief of the Akkoyunlu ('White Sheep') Turcoman tribal confederation whose base was at Diyarbakır in south-eastern Anatolia,

appealed to Tamerlane who responded in 1399 by embarking on the longest expedition of his reign. This was to last seven years.

At around the same time Bayezid was persuaded by his allies Sultan Ahmad Jalayir of Baghdad and the chief of the Karakoyunlu ('Black Sheep') Turcoman tribal confederation, centred on Van in eastern Anatolia, to organize a campaign to seize some Mamluk strongholds west of the Euphrates. This met with some success but was a bold affront to Tamerlane. In the summer of 1400, while Bayezid was occupied with the siege of Constantinople, Tamerlane took Sivas and then advanced south along the Euphrates and into Mamluk territory as far as Damascus, before turning towards Azerbaijan.[20]

Tamerlane's and Bayezid's armies met near Ankara on 28 July 1402. Tamerlane fielded some 140,000 men while Bayezid's army totalled 85,000. Among his forces Tamerlane could count the disaffected former rulers of the western Anatolian emirates whose lands had come under Ottoman control soon after Bayezid came to the throne. These rulers, the deposed emirs of Aydın, Saruhan, Menteşe, and Germiyan, had all sought refuge at Tamerlane's court while the men who had formerly owed them allegiance were now Bayezid's subjects and under his command. Bayezid's own forces of cavalry and infantry supplied the core of his army – among the latter were janissaries, *yeniçeri* in Turkish, meaning 'new force', the infantry corps which was first raised during the reign of Sultan Murad I from prisoners of war captured in the Christian lands of the Balkans and was institution-alized through Bayezid's use of the *devşirme* levy of youths among his Balkan Christian subjects to ensure a reliable source of manpower.* Also in Bayezid's army was his vassal Stephen Lazarević of Serbia, and Vlachs from recently-conquered Thessaly. Further support came from 'Tatars', who, says Johann Schiltberger in his short eyewitness account of the battle at which he became Tamerlane's captive, numbered 30,000 men from 'White Tartary',[21] suggesting that they had fled west before Tamerlane's advance from their lands north of the Caspian and Black Seas. This has recently been ques-tioned, and it seems that these 'Tatars' may instead have been Turcoman tribesmen from eastern Anatolia.[22]

The battle lasted all day. The opposing armies were drawn up in similar formation with the rulers in the centre surrounded by their infantry – in Bayezid's case, the janissaries – with their cavalry on the wings. The earliest

* From this time until the early seventeenth century Ottoman officials would periodically (but as time went by increasingly sporadically) visit Christian villages (at first those in the Balkans rather than Anatolia) to select youths for intensive education as soldiers, for admin-istrative posts, and for service in the palaces of the sultan and his senior statesmen. All the youths chosen were obliged to convert to Islam and those channelled into the military forces, in particular, were trained to be loyal only to the sultan.

account of the battle is that of a Cretan who fought with Bayezid but fled the field:

> Bayezid's army was made up of 160 companies. At first, Timur's [i.e. Tamerlane's] army routed four of these, the commanders of [three of] which were Tami Cozafero Morchesbei [i.e. Firuz Bey], the great Muslim Leader, Bayezid's son [i.e. Prince Süleyman] and Count Lazzero's son [i.e. Stephen Lazarević] . . . [the fourth] was Bayezid's. His men fought so bravely that most of Timur's troops dispersed, believing Timur to have lost the battle; but he was elsewhere and immediately sent 100,000 men to surround Bayezid and his company. They captured Bayezid and two of his sons. Only six of Bayezid's companies took part in the battle, the rest fled. Timur emerged victorious.[23]

Commentators noted that Tamerlane's army arrived first at Ankara and camped by a stream, leaving Bayezid's men and their steeds without water. Schiltberger wrote that Tamerlane had thirty-two trained elephants[24] from the backs of which he is reported to have launched the legendary liquid incendiary agent known as 'Greek fire' at the Ottoman army.[25] This might well account for the confusion which led Bayezid to believe that he had won, only to find himself encircled and defeated. The Ottoman chroniclers, however, agree that Bayezid lost the battle thanks to the desertion of many of his forces: both the numerous 'Tatars' and the troops from the once independent west Anatolian emirates who failed to fight. Bayezid and his son Musa were taken prisoner, and possibly also his Serbian wife and his son Mustafa. His sons İsa, Süleyman and Mehmed fled. Bayezid's conquests were undone in a day. Before Tamerlane's invasion his domains had stretched from the Danube almost to the Euphrates; now, Ottoman territory was roughly reduced to that bequeathed him by his father in 1389. The eight-year blockade of Constantinople came to an end. Tamerlane restored their lands to the emirs of Karaman, Germiyan, Aydın, Saruhan and Menteşe, and enforced his claim to the rest of Bayezid's domains in Anatolia in a year-long irruption of raiding and pillage.

When they came to write the story of Bayezid's defeat at Ankara, the chroniclers sought explanations for the disaster which had befallen the Ottomans. The fifteenth-century chronicler Aşıkpaşazade held Bayezid responsible for the defeat, branding him a debauchee – a view with which the Sultan's contemporaries concurred[26] – and blaming his Serbian wife for encouraging him to drink; he also criticized Bayezid's vezir Çandarlı Ali Pasha for consorting with holy men whose religious credentials were suspect.[27] Tamerlane's victory was sufficiently humiliating, but for later generations, the greatest cause for regret was the struggle that ensued among the sons of Bayezid as they vied to succeed him. With Prince Musa and

possibly also Prince Mustafa in Tamerlane's hands following the battle at Ankara, Süleyman, Mehmed and İsa acted immediately to find allies to support their individual claims to the throne. Another son, Prince Yusuf, took refuge in Constantinople, converted to Christianity and was baptized Demetrius.[28] For the next twenty years civil war brought turmoil and suffering on an unprecedented scale to the Ottoman state.

In his ignominious defeat, the once-powerful ruler Bayezid made a tragic figure. Though Ottoman chroniclers a century after the battle of Ankara, moved by his fate, wrote of Tamerlane putting Bayezid in an iron cage as he took the humbled sultan along with him on his victorious progress across Anatolia, historians consider this fanciful. More nearly contemporary Ottoman writers claimed that he died by his own hand, unable to bear the dishonour of his defeat.[29] The truth about Sultan Bayezid's fate appears to be more prosaic: he died of natural causes in March 1403 in the west-central Anatolian town of Akşehir – as Schiltberger had reported at the time.[30] His body was mummified and kept at first in the tomb of a Seljuk holy man. It is said by contemporary historians that his son Musa soon obtained permission from Tamerlane to remove the body to Bursa.[31] According to the inscription on the tomb built for him here by his son Süleyman, he was buried in 1406.[32] Several decades later the Byzantine historian Doukas wrote that Bayezid's grave was subsequently violated and his bones exhumed by the son of Alaeddin of Karaman, to avenge Bayezid's execution of his father in Konya in 1397.[33]

The defeat of Sultan Bayezid became a popular subject for later western writers, composers and painters. They revelled in the legend that he was taken by Tamerlane to Samarkand, and embellished it with a cast of characters to create an oriental fantasy that has maintained its appeal. Christopher Marlowe's play *Tamburlaine the Great* was first performed in London in 1587, three years after the formal opening of English–Ottoman trade relations when William Harborne sailed for Istanbul as agent of the Levant Company. In 1648 there appeared the play *Le Gran Tamerlan et Bajezet* by Jean Magnon, and in 1725 Handel's *Tamerlano* was first performed in London; Vivaldi's version of the story, *Bayezid*, was written in 1735. Magnon had given Bayezid an intriguing wife and daughter; the Handel and Vivaldi renditions included, as well as Tamerlane and Bayezid and his daughter, a prince of Byzantium and a princess of Trebizond (Trabzon) in a passionate and incredible love story. A cycle of paintings in Schloss Eggenberg, near Graz in Austria, translated the theme to a different medium; this was completed in the 1670s shortly before the mighty Ottoman army attacked the Habsburgs in central Europe.[34]

<div style="text-align:center">★</div>

Prince Süleyman and his followers, who included Bayezid's vezir Çandarlı Ali Pasha, took the strategic decision to leave Anatolia to Tamerlane and assume control of his father's western territories. Like the Ottomans, Tamerlane had his chroniclers, and these too observed certain conventions: concerned lest his failure to pursue Süleyman be interpreted as weakness, Tamerlane's official historian Sharaf al-Din Yazdi wrote that his master exchanged envoys with Süleyman, who acknowledged Tamerlane's suzerainty and in return was accorded a free hand in Rumeli.[35] Süleyman began negotiations with the Christian powers of the Balkans, aimed at pre-empting them from exercising their historical claims to the Rumelian domains of his weakened state which was still, however, the largest in the region. His swift action also prevented his Balkan vassals – Byzantine, Serbian and Latin – from taking as much advantage as the former emirs of Anatolia of the disintegration of the Ottoman realm. Nevertheless, by the terms of a treaty made at Gelibolu in 1403 Prince Süleyman agreed terri-torial concessions which would have been unthinkable only a few months before. In addition Byzantium was released from its vassal status, as were some Latin enclaves; had the Serbian lords not been at odds with one another, Serbia too might have emerged from vassalage. The south-western shore of the Black Sea and the city of Thessalonica were among the gains made by Emperor Manuel II, who won a further significant concession in Süleyman's agreement to come to his aid in the event of an attack by Tamerlane. With Byzantium's fear of the Ottomans thus eased, Manuel was emboldened to expel the Ottoman merchants based in Constantinople and demolish the mosque recently built there to serve their community.[36] Venice and Genoa both obtained favourable trading arrangements in the lands Süleyman controlled.[37] According to the Venetian negotiator, Pietro Zeno, Gazi Evrenos Bey was strongly opposed to the surrender by a member of the Ottoman house of lands which had been won by him and his fellow marcher-lords.[38]

The best-known version of subsequent events is that of an anonymous panegyrist of Prince Mehmed, the ultimate victor in the civil war. After the battle of Ankara Mehmed retired to his base in north-central Anatolia, re-emerging when Tamerlane himself returned eastwards in 1403. Mehmed then defeated Prince İsa in battle south of the Sea of Marmara and entered Bursa which had been in İsa's hands; his forces were subsequently involved in battles with various local lords asserting their regained independence of Ottoman rule. Prince İsa seems also to have fought a battle with Tamerlane's army in Kayseri after which he retreated into north-west Anatolia until killed by Süleyman later in 1403.[39] Prince Süleyman's Gelibolu treaty bought him a period of stability in the Balkans. In 1404 he crossed over

to Anatolia and won Bursa and Ankara from Prince Mehmed who retreated to Tokat in north-central Anatolia. Süleyman ruled both in Rumeli and in Anatolia as far as Ankara, and his future as his father's successor seemed assured; indeed, some historians consider him to have been sultan and dub him Süleyman I.

In 1409, however, a new actor appeared on the scene and threatened Süleyman's domains. His younger brother Prince Musa had been released by Tamerlane in 1403 into the safe-keeping of the Emir of Germiyan, and he in turn handed him over to Mehmed. The attack on Süleyman came from a completely unanticipated direction: Musa had sailed from the north Anatolian port of Sinop to Wallachia where he gained a foothold in the region by marrying the daughter of the Wallachian voyvode Mircea. Mircea had transferred to Süleyman his antipathy to Bayezid, and calculated that it would be to his advantage to side with Musa. Musa's campaign in Rumeli was not without setbacks, but by May 1410 he had occupied Süleyman's capital at Edirne and reached Gelibolu, causing Süleyman to return in some haste from Anatolia. Emperor Manuel saw the succession struggle as his salvation, and worked to prolong it: he had regained control of the passages between Anatolia and Rumeli as a result of the 1403 treaty and assisted Süleyman across the Bosporus. But Süleyman was soon executed near Edirne on Musa's order – while drunk, if an anonymous chronicler is to be believed – and the field was left to Mehmed and Musa.

Prince Musa thus inherited his brother Süleyman's domains in both Rumeli and Anatolia and ruled them uneasily for the next two years. Süleyman's son Orhan had taken refuge in Constantinople and, fearing that he might provide a focus for dissent against him, Musa besieged Constantinople in the autumn of 1411, an effort that came to nothing. His advisers and commanders gradually deserted him, and his brother Prince Mehmed now crossed the Bosporus with Manuel's assistance and met Musa in battle near Çatalca in Thrace; Mehmed then returned to Anatolia. Though Musa won, his lands in Rumeli were invaded in the north-west by troops of his former ally Stephen Lazarević – who paid the price the following year when Musa retaliated by attacking a number of Serbian strongholds. In 1413 Orhan landed at Thessalonica, probably with the encouragement of Emperor Manuel who hoped to distract Musa from Serbia.[40] Musa managed to capture Orhan but for some reason released him, and failed to retake Thessalonica.

Neighbouring states saw Prince Musa, with his Wallachian support, as a greater threat than Prince Mehmed. Stephen Lazarević called on Mehmed to join him in a co-ordinated campaign against Musa; Manuel also took Mehmed's part, providing vessels to carry him and his men across once more into Rumeli and supplying troops. By the time that the two armies

met to the south of Sofia, Mehmed's forces included men from the emirate of Dulkadır in south-east Anatolia, thanks to Mehmed's marriage with the emir's daughter; Byzantine troops provided by the Emperor; Serbian, Bosnian and Hungarian troops under the command of Stephen Lazarević; troops from Aydın whose support for Musa had been firm until just before the battle; and Rumelian troops commanded by the marcher-lord Gazi Evrenos Bey. Musa's army attacked strongly in battle, but eventually he was forced to flee. He fell when his horse stumbled and was killed by one of Mehmed's commanders.[41]

With Prince Musa's death in 1413 the civil war seemed once again to be over and the succession resolved in favour of Prince Mehmed, known from this time as Sultan Mehmed I. Sultan Mehmed's first concern was to win the allegiance of the various Anatolian emirates that had supported him militarily but had no desire to relinquish the independence they had regained following Tamerlane's victory at Ankara in 1402. Mehmed met with particularly determined resistance from Karaman and also from Cüneyd, emir of Aydın; Cüneyd's stronghold at İzmir was eventually taken with the help of allies who included the Genoese of Chios, Lesbos and Foça (Phokaia) and the Knights Hospitallers of Rhodes. Cüneyd was appointed governor of Nikopol on the Danube, site of Sultan Bayezid's victory against the Crusaders in 1396.[42] The appointment of former rebels to posts in the service of the state was a leitmotif of Ottoman administrative practice from these early times. The Ottomans found it more politic to conciliate defeated local lords – and, later, overly independent state servants – with a share in the rewards of government than to kill them and risk fomenting further unrest among their partisans.

Within a couple of years Sultan Mehmed had largely recovered the former Ottoman domains in Anatolia and Emperor Manuel found his position weakened accordingly. He could not afford to lose the initiative he had gained during the Ottoman interregnum by aiding one or other of the contenders for the sultanate. The only tool remaining in his hands was Süleyman's son Orhan. In a last desperate attempt to keep the Ottoman house at odds with itself he sent Orhan to Wallachia, whose voyvode Mircea had remained an implacable enemy of Ottoman power in the region. This marked the end of Orhan's usefulness as an alternative focus of Ottoman loyalty, however, for Mehmed hurried to meet him before he had gone very far and blinded him. Then, suddenly and quite unexpectedly in 1415, Mehmed's missing brother Prince Mustafa, or a very credible impostor – he was known as 'False' Mustafa – appeared in Wallachia by way of the Byzantine outpost of Trebizond on the north-east Anatolian coast. Mustafa was reported to have been taken into captivity with his

father and brother Musa in 1402, but his whereabouts during the inter-
vening years remain obscure.[43] It is tempting to believe that he was kept
prisoner at the Timurid court and that his release by Shah-Rukh, the son
and successor of Tamerlane (who had died in 1405), was timed to reignite
the Ottoman succession struggle.[44] In 1416 Shah-Rukh wrote to Mehmed
to protest at the elimination of his brothers. Mehmed defiantly proffered
the justification that 'One realm cannot shelter two *pādişāhs* . . . the enemies
that surround us are always watching for an opportunity.[45] Shah-Rukh had
himself come to power only after a struggle of more than ten years against
other contenders and, like his father, wanted weak states on his periphery.

It seemed that Mehmed's recently-reimposed authority in Rumeli would
have to face a challenge led by his brother Mustafa, whose envoys had
begun negotiations with Emperor Manuel and with Venice. Mehmed's
decision to appoint Cüneyd of Aydın to hold the Danubian frontier against
Wallachia proved ill-judged, for his former foe soon defected to Mustafa.[46]
Nevertheless the two were defeated and, when they sought asylum in the
Byzantine city of Thessalonica, Emperor Manuel was persuaded to hold
them in custody during Mehmed's lifetime.[47]

The appearance of charismatic figures and their ability to attract supporters
during times of acute economic and social crisis was as potent a force in
Ottoman as in European history. In 1416, the same year that he defeated
his brother Mustafa's challenge, Sultan Mehmed was faced with another
rebellion against his efforts to govern his Balkan provinces. This uprising
was led by Sheikh Bedreddin, an eminent member of the Islamic religious
hierarchy who was born of mixed Muslim and Christian parentage in the
town of Simavne (Kyprinos), just south-west of Edirne. Sheikh Bedreddin
was also a mystic; following theological studies in Konya and Cairo he had
gone to Ardabil in Azerbaijan which was under Timurid domination and
the home of the mystical Safavid order. Here he found a sympathetic envir-
onment for the development of his pantheistic ideas, and especially the
doctrine of the 'oneness of being'.

The doctrine of 'oneness of being' sought to eliminate the oppositions
which framed life on earth – such as those between religions, and between
the privileged and the powerless – which were considered to inhibit the
oneness of the individual with God. The struggle for 'oneness' gave the
mystic an important role for it was he, rather than the orthodox cleric,
who had the wisdom, and therefore the task, to guide man to union with
God. This doctrine was potentially highly subversive of evolving Ottoman
efforts to establish through conquest a state with Sunni Islam as its religion
and their eponymous dynasty at its pinnacle.[48]

In the climate of opposition to Sultan Mehmed Sheikh Bedreddin must have seen an opportunity to preach his creed. In 1415 he abruptly left his exile in İznik, where he had been sent after the death of Prince Musa under whom he had held the post of chief judge in Edirne, and made his way to Wallachia via Sinop on the Black Sea coast. Sheikh Bedreddin became a figurehead for those, like the supporters of Mustafa and Cüneyd, who were disappointed in Mehmed; the heartland of his support was the 'Deli Orman', the 'Wild Forest' region lying south of the Danube delta. Here, where the internecine struggles of the past years had further exacerbated the dislocation experienced as a result of Ottoman conquest, he found adherents among disaffected marcher-lords and their followers – whose local power was being compromised by the imposition of Ottoman overlord-ship – as well as among other mystics and peasants alike. The material interests of the marcher-lords and their men had been adversely affected when Mehmed revoked the land-grants Sheikh Bedreddin had made to them on Musa's behalf during his tenure as chief judge.

As Sheikh Bedreddin preached his syncretist message, his disciples Börklüce Mustafa and Torlak Kemal spread the word in western Anatolia to the consternation of the Ottoman authorities. Once tolerant of the practice of Christianity within its own ranks, the government now adopted an assimilative stance, using denigrating language in its decrees to describe those who expressed their grievances in religious terms. By stigmatizing them as 'peasants', 'ignorants' and 'wretches', both the state and its chroniclers branded this and later outbursts of popular discontent as illegitimate and intolerable. These manifestations of popular resistance obliged Mehmed to divert to their suppression resources and energy which he would have hoped to employ more productively elsewhere.

Sheikh Bedreddin's revolt in Rumeli was short-lived: Sultan Mehmed's men soon apprehended him and took him to Serres where he was judged and executed in the market-place, accused of disturbing public order by preaching that property must be communal and that there was no difference between the various religions and their prophets. Sheikh Bedreddin's teachings continued to be influential, however. Until the late sixteenth century and beyond his sectarians were perceived as a threat to the state,[49] and the doctrines he preached were common currency among anarchic mystical sects throughout the life of the empire. Most notably, they were espoused by the Bektaşi, the dervish order with which the janissaries were associated.

The name of Sheikh Bedreddin lives on in modern Turkey. It is especially familiar to those on the left of the political spectrum thanks to the *Epic of Sheikh Bedreddin,* a long narrative poem by the Turkish communist

poet Nazım Hikmet who ascribed to Sheikh Bedreddin his own inspiration and motivation in the anti-fascist struggle of the 1930s. The climax of the poem occurs when Sheikh Bedreddin's followers, proclaiming their 'oneness', meet the Sultan's army:

> To be able to sing together
> pulling the nets all together from the sea,
> together to forge the iron like a lace,
> all together to plough the soil,
> to be able to eat the honey-filled figs together
> and to be able to say:
> everything but the cheek of the beloved
> we all share together
> everywhere
> To achieve this,
> ten thousand heroes sacrificed their eight thousand.[50]

So wary of adverse reaction from the Turkish authorities were Sheikh Bedreddin's modern-day adherents, that although his bones were exhumed and brought from Greece at the time of the Greco-Turkish population exchange in 1924, they did not find a final resting-place until 1961 when they were buried in the graveyard around the mausoleum of Sultan Mahmud II, near the Covered Bazaar in Istanbul.

With his brother Prince Mustafa and his ally Cüneyd safely in Byzantine custody and Sheikh Bedreddin dead, Sultan Mehmed returned to Anatolia to try again to overcome the Karamanid state. But Karaman submitted in vassalage to the powerful Mamluks, and Mehmed had no alternative but to retreat. He managed, however, to annex the domains of the İsfendiyaroğulları of north-central Anatolia through which Sheikh Bedreddin had passed on his way to Wallachia, and to force Mircea of Wallachia to pay him tribute. As was customary for vassals, Mircea sent his three sons to Mehmed's court as hostages against his good behaviour. One of these boys was Vlad Drakul, later known as the 'Impaler', who became notorious as a vampire in the folk-legends of Transylvania.

By the time of his death in a riding accident in 1421, Sultan Mehmed had still not succeeded in restoring to Ottoman control all the territories his father Bayezid had held in Anatolia and Rumeli. Illness dogged the last years of his life, and he had ample opportunity to ponder the problems of the succession, his supreme aim being to avert a struggle such as had attended his own bid for power. His vezirs concealed his death until his son Murad, not yet twenty, could be proclaimed sultan in Bursa.

The contemporary historian Doukas reports that Mehmed had decided

to send his two young sons Yusuf and Mahmud to Constantinople, to be held as hostages by Emperor Manuel II. By this means he hoped to ensure the continuing custody of his brother 'False' Mustafa and thus eliminate the risk of any of the three joining a power struggle to succeed him. In the event, Yusuf and Mahmud were not handed over to Manuel and Mehmed's death precipitated the release of 'False' Mustafa and Cüneyd. Doukas considered that Mehmed's vezir Bayezid Pasha was responsible for the failure to hand over the two boys, insisting 'It is not good or consonant with the Prophet's ordinances that the children of Muslims be nurtured by unbelievers'.[51] With Manuel's assistance Mustafa and Cüneyd landed at Gelibolu in Rumeli, where they were supported by the most prominent marcher-lords of the region, the Evrenosoğulları and Turahanoğulları among them. But before they could reach Edirne they were met by an army commanded by Bayezid Pasha. 'False' Mustafa induced Bayezid Pasha's men to desert by revealing the scars he had, it was claimed, received at the battle of Ankara twenty years earlier. Bayezid Pasha was executed and Mustafa occupied Edirne as his capital, minting coinage there in proclamation of his sultanate, as his brothers Süleyman, Musa and Mehmed had before him.[52] The readiness of the Rumelians to go over to Prince Mustafa rather than accord allegiance to Sultan Mehmed's son and designated heir Murad II was an indication of the continuing unease with which these marcher-warriors viewed Ottoman efforts to impose unified and centralized government on the territories they themselves had conquered as partners of the Ottomans. Mustafa had proved himself their ally by opposing his brother Sultan Mehmed some six years earlier, and many had also been sympathetic to Sheikh Bedreddin's uprising.

Mustafa's next objective was Bursa. Sultan Murad planned to confront him at a point north-west of the city where a bridge crossed the river Nilüfer, and ordered the bridge to be destroyed. The two armies faced one another across the river. Murad led Mustafa to believe that he planned to march around the lake from which the river debouched, but instead he swiftly reconstructed the bridge and caught his uncle unawares. The marcher-lords deserted Mustafa, who fled. Most accounts of his end state that Mustafa was apprehended by Sultan Murad's men north of Edirne as he tried to reach Wallachia early in 1422 and, like Sheikh Bedreddin before him, was hanged as a common criminal which implied that Murad considered him an impostor. Another tradition tells that he reached Wallachia and from there went to Caffa in the Crimea and later took refuge in Byzantine Thessalonica.[53] He could not, however, have been certain even of a welcome in Wallachia, let alone the level of support he had received in his previous campaign against his brother Mehmed, for Wallachia was now an Ottoman vassal.

Another Mustafa, Murad's brother 'Little' Mustafa also became the focus of a rival claim to the sultanate. Since the death of their father, 'Little' Mustafa had been in one of the Anatolian states opposed to the Ottomans; in 1422, now thirteen years old, the boy was put at the head of an army and Bursa was besieged. When Murad sent a relieving army, 'Little' Mustafa and his supporters fled to Constantinople. 'Little' Mustafa's claim to the sultanate was soon recognized throughout much of Ottoman Anatolia, however, but thanks to the defection of Mustafa's vezir İlyas Pasha, Murad marched on him in İznik and had the boy strangled after bitter fighting.[54] Writing almost a century later, the chronicler Mehmed Neşri had İlyas Pasha justify his treachery on the grounds that his paramount concern was the maintenance of public order, and that no sacrifice was too great to attain this end.[55]

Like his father before him, Sultan Murad II began to rebuild his state, a daunting task, and he was well into his reign before he managed to stabilize the Ottoman domains. After the defeat of 'False' Prince Mustafa his fellow rebel Cüneyd of Aydın returned home to discover that his rule had been usurped. Murad had promised Cüneyd and his family safe conduct but then had them murdered, and Aydın became Ottoman once more. Menteşe was re-annexed at this time and, sometime after 1425, Germiyan, giving the Ottomans full control of western Anatolia once more. Karaman remained independent: Murad had no immediate plans to attack it, nor provocation to do so.

The years following Bayezid I's defeat at Ankara in 1402 saw the most tumultuous of all Ottoman succession struggles. The haunting memory of these events later inspired Sultan Murad's son Mehmed II, in the hope that such terrible bloodshed would never be repeated, to sanction fratricide as a means of smoothing the succession to the sultanate, a practice which brought opprobrium upon the Ottoman dynasty in later times. In the absence of contemporary accounts little is known of the path by which Osman and his immediate successors came to the throne. It was perhaps equally bloody: some chroniclers hint that Osman's bid to head the clan on the death of his father Ertuğrul was contested by his uncle Dündar, and that Osman killed him.[56] Osman's son and heir Orhan had several brothers but the chronicles mention only one, Alaeddin, whose existence is attested by the mosques, bath-house and dervish lodge he built in Bursa.[57] Orhan is alleged to have offered Alaeddin the leadership of the Ottoman emirate and Alaeddin to have refused, leaving the way open for Orhan to succeed[58] – thus Orhan's succession to Osman is explained in a seamless manner. The fate of Osman's other sons is unknown. When Orhan died he left

Murad and Halil and possibly another son, İbrahim; if there was a struggle for the succession, it has likewise been glossed over.[59] When Bayezid succeeded Sultan Murad I after the latter's death at Kosovo Polje it was reported, as noted earlier, that he killed his brother Yakub.

Although the contemporary Byzantine historian Laonicus Chalcocondylas reports that Sultan Mehmed's intention had been to divide the Ottoman domain, giving Rumeli to Murad and Anatolia to 'Little' Mustafa, from the time of the foundation of their state the Ottomans had adhered to the principle that their domains should be passed on intact to one member of the next generation. They followed Mongol practice, in that succession was not limited to any particular member of the ruling dynasty: the question of who should succeed was a matter for God to determine. The right to rule rested first and foremost on possession of the throne.[60] Sultan Bayezid fathered many sons who were in their turn prolific, and his grandsons also had claims to the succession; their periodic emergence as pretenders, often with the connivance of the Byzantine emperor Manuel II, fuelled the struggle for the throne. Throughout much of Ottoman history, neither fratricide as a tool of policy, nor the efforts of chroniclers to present the succession of the first Ottoman sultans as trouble-free, were effective in preventing the debilitating power struggles which tended to erupt on the death of a sultan. Moreover, simply to possess the throne was not enough: having established that he was God's chosen ruler, each new sultan needed to gain and keep the support of those who would enable him to exercise his rule – the statesmen and, most importantly, the soldiers of the realm – and seize the treasury which would give him the means to adminster and defend Ottoman territory.

The ability of the Ottoman house to attract and retain the loyalty of marcher-lords who were sometimes rivals and sometimes willing partners, and to encourage other states to identify with its cause, depended on its own success – which was not constant. Thirteenth- and fourteenth-century Anatolia has recently been described as a place where 'dominating, centralizing family military ascendancy . . . rebellious and factional marcher lords, and . . . fearful, doomed but complacent petty principalities'[61] vied for power, and has been compared to other medieval states – for example, the Anglo-Norman state as it incorporated Wales and Ireland in the twelfth and thirteenth centuries – in which allegiance to a dynasty or to an individual member thereof dictated the course of political history. Great power politics was another factor influencing the Ottomans and when circumstances demanded even the fiercely anti-Ottoman Karamanids found it politic to agree on a truce when they felt threatened by the stronger Mamluks.

The location of the region where the Ottomans established their state,

bordering the most moribund of the old empires, the Byzantine, brought real advantage. The far-flung territories of the Byzantine Empire – Constantinople, Thessalonica, the Morea, Trebizond – made it strategically weak. Internecine quarrels within and between the Byzantine dynasties of Palaeologus and Cantacuzenus, and Byzantine failure to attract assistance from a Europe which espoused a very different Christian tradition and the interests of whose states were invariably in conflict, made this empire vulnerable to an energetic power which relentlessly challenged its existence. In the Balkans, although the expectations which any group – be they marcher-lords, holy men or peasants – had of individual members of the Ottoman family made for periods of violent strife, broadly speaking the Ottoman dynasty retained the loyalty of those it had attracted during the conquests and successes of the fourteenth century. The Ottomans were able to take advantage of the weak states of the region, and after the end of the independent Serbian kingdom in 1389 few of them questioned Ottoman regional dominance. Moreover, Ottoman incursions into the Balkans were not unwelcome to local populations whom the new regime freed from the onerous obligations imposed by their feudal lords. In Anatolia, however, there was a real alternative to Ottoman suzerainty and here, in the years after his victory at Ankara, Tamerlane's protection allowed the Anatolian emirates to assert their separate identity. For a while, the Ottomans were hardly even first among equals, but the geographical disunity of the emirates and their lack of any common interest beyond antipathy to the Ottomans prevented the emergence of any sustainable challenge to Ottoman expansion.

The respite the Ottoman civil war brought to Venetian, Byzantine and other interests in the region came to an end as Sultan Murad II consolidated his rule. Venice had good reason to fear attacks on its overseas territories from a reconstituted Ottoman state, and was fighting for the survival of its colonies once the civil war ended. The Byzantine despotate of Morea was under threat from the Latin lord Carlo Tocco, an Ottoman vassal whose lands lay in the north-west Peloponnese. Thessalonica, under siege by the Ottomans since 1422, was ceded to Venice in the following year by Despot Andronicus on condition that its Orthodox customs be respected. Thessalonica was a vital hub of commerce and communications, but whatever hopes Venice might have had of its possession were frustrated by the Ottoman blockade. The city was hard to provision and the occupation a burden on Venice's resources. Several times Venice threatened to produce a claimant to the Ottoman throne, but proof of the descent of such claimants from Sultan Bayezid was by all accounts weaker than that for the two Mustafas, 'False' and 'Little'. One pretender, 'a Turk called İsmail', whom

the Venetians held on the island of Euboea (Negroponte), was intended as the focus of a rebellion against Murad in 1424, to divert him from the blockade of their new possession.[62] The Byzantines were equally desperate: in 1423 John VIII Palaeologus, who had been appointed co-emperor to share the burdens of state with his ailing father, Manuel II, travelled from Constantinople to seek help in the West, but once again to no purpose. In 1424, however, Manuel won some respite by concluding a treaty with Murad by which Byzantium undertook to pay tribute and also hand over some territory on the Black Sea.

Unable to come to terms with the Ottomans, Venice made overtures to Hungary, proposing logistic support if Hungary would invade the Ottoman lands. Judging that they might be willing to join an anti-Ottoman alliance, in 1425 and 1426, respectively, Murad attacked his vassal states of Wallachia and Serbia, putting paid to any hope Venice may have had of help from that quarter. On the death of Stephen Lazarević the following year, King Sigismund of Hungary frustrated Ottoman ambitions in the region by seizing the strategically important fortress of Belgrade, at the Danube–Sava confluence. Murad took the massive stronghold of Golubac, also on the Danube, but some distance to the east. Overlordship of these new acquisitions was formalized in a Hungarian–Ottoman treaty in 1428. Stephen Lazarević had been a reliable Ottoman vassal for some thirty-five years; his death brought Hungarian and Ottoman frontier outposts closer together than ever before.

Though war between Venice and the Ottomans was not officially declared until 1429, the relationship between them had been deteriorating ever since the Venetians' acceptance of Thessalonica from the Byzantines. Only when that city fell to him in 1430 did Murad agree to conclude a treaty with Venice. As soon as he won Thessalonica Murad restrained his troops from wholesale looting and swiftly expelled them from the city. The former inhabitants were resettled, including those who had fled during earlier phases of the siege. Reconstruction of the city was ordered and church property was returned to its owners; only two churches were immediately converted into mosques, an indication that the Muslim population was small at this time, probably consisting only of the garrison. Two years later Murad returned, this time taking over some Christian religious establishments and surveying the resources of the city with a view to facilitating its transformation into an Islamic centre.[63]

The great power struggle in the Balkans between the Ottomans, Venice and Hungary was Murad's major preoccupation after the fall of Thessalonica. Even before the expiry of the 1428 Hungarian–Ottoman treaty in 1431, Murad had moved to counter Venetian claims in Albania. Ottoman troops

had been invited into Albania in the 1380s during the reign of his name-sake Murad I, to help one of the local lords against a Serbian rival; their success in thwarting the latter's ambitions led to the imposition of a degree of Ottoman authority which increased both during Bayezid's reign and subsequently under Mehmed I. Albania was ruled by many lords with conflicting interests, and its incorporation into the Ottoman state was there-fore a gradual process. A cadastral survey conducted there in 1432[64] further strengthened Ottoman control, resistance to which was soon crushed.[65] The uncertain allegiance of Serbia following the death of Lazarević in 1427 provoked Ottoman attacks in the mid-1430s and the vassaldom of Serbia to the Ottomans rather than to Hungary was formalized through the Serbian despot George Branković's payment of tribute and the marriage of his daughter Mara to Murad.

With the Ottomans so deeply engaged in the Balkans, the emir of Karaman, İbrahim Bey, saw his opportunity and began to attack their terri-tory in Anatolia. Several years of strife brought Murad some acquisitions in the west of the Karamanid state[66] but Ottoman resources were unequal to its permanent subjugation at this time. Karaman enjoyed two significant advantages: its geographic location as a buffer between Ottomans and Mamluks meant that it could play one off against the other, while its predominantly tribal, nomadic population was skilful in confounding Ottoman attack in the mountainous terrain. This region, like the Balkans, proved itself the locus of a long-lasting power struggle.

In 1435 Tamerlane's heir Shah-Rukh sent ceremonial robes to the rulers of the various Anatolian states, including the Ottoman sultan, demanding that they wear them as a mark of allegiance. Murad did not feel able to refuse, but apparently did not wear them on official occasions. He fought back with a propaganda campaign of his own, minting coins with the seal of the Kayı tribe of the Oğuz Turks of Central Asia from whom the Ottoman house sought to establish its descent, a dynastic conceit which found acceptance in the east-central Anatolian Turcoman emirate of Dulkadır and among the Karakoyunlu, who unlike the Karamanids and the Akkoyunlu were partisans of the Ottomans. Like the other anti-Ottoman dynasties with strategic interests in eastern Anatolia, however, Shah-Rukh had no regard for this supposed link to the Oğuz tribe, viewing the Ottomans as upstarts.[67]

The balance of power in the Balkans occupied Murad for the remainder of his reign. Ottoman policy became more resolute, aimed at securing the Danube–Sava line west of Belgrade against Hungary by incorporating the long-time vassal state of Serbia into the Ottoman realm. That Serbia's despot George Branković was Murad's brother-in-law counted for little against the imperative of politics. A punitive invasion through the Ottoman vassal

state of Wallachia into the Hungarian province of Transylvania was followed in 1438 and 1439 by campaigns against Serbia in which the recently-built Danubian fortress of Smederevo fell to Murad. The key stronghold of Belgrade, his next target, failed to succumb to a six-month siege in 1440.

John VIII Palaeologus had been emperor in Constantinople since Manuel II's death in 1425. In 1437, he pressed for renewed consideration of the thorny issue of church union at the Council of Ferrara which had been called for the purpose. Repeatedly the centuries-old schism between Catholic and Orthodox had served as an excuse for foot-dragging among the Christian states of Europe when the Byzantines begged for support. Since Ottoman resurgence after the reconquest of Thessalonica not only put his own domains at risk but also presented a more direct threat to Venice and Hungary, John hoped the Catholics would look favourably on his proposal for union. Among the most critical theological issues dividing the two Churches were the use of leavened or unleavened bread in the service of Communion, the Latin doctrine of purgatory, not accepted by the Orthodox, and the matter of papal supremacy. In July 1439, after a year and a half of inter-mittent debate and the removal of the Council to Florence after plague struck Ferrara, the 375-year schism was brought to an end with the signing of a document of union.

At first it appeared that John had miscalculated. Union with Rome brought upon his head the wrath of the Orthodox establishment, and of most of the Byzantine population. It even provoked a joint attack on Constantinople by his brother Demetrius, despot of Mesembria (Nesebŭr) on the western Black Sea coast, and a Turkish force. Further afield, Bishop Isidore of Kiev (Kyiv), who had been made a cardinal by the Pope, was deposed and arrested when he visited Moscow, and had to flee to Italy. The patriarchs of Alexandria, Jerusalem and Antioch (Antakya) disowned the union. The Orthodox world was divided against itself, but as far as John was concerned his bold action was paying off, because the Pope was mobilizing support for the promised crusade against the Ottomans.

There was optimism in Europe that success would this time attend a united effort to contain the Ottomans. The potential gains were significant – Hungary would acquire territory in the Balkans, Serbia would regain its independence, the threat to Venice in the Aegean and Adriatic would dis-appear, and Constantinople would survive – and the omens were favourable. The capable military commander John Hunyadi, voyvode of Transylvania, held his position against two Ottoman attacks through Wallachia before being driven back by the Ottomans in the snowy Zlatitsa pass, east of Sofia, in the winter of 1443–4. The incipient anti-Ottoman revolt in northern

43

Albania of 'Scanderbeg', İskender Bey – who came of a local Christian warlord family and had been brought up a Muslim at Murad's court – and the extension of Byzantine authority in central Greece by John VIII's brother Constantine, despot of the Morea and based at Mistras, were further straws in the wind. Constantine's especial triumph was the rebuilding by spring 1444 of the Hexamilion wall spanning the Corinth isthmus, demolished in 1431 by Turkish attackers.[68] Concern at the momentum produced by the ending of the Christian schism focused Ottoman minds on the very real possibility that the crippling blow dealt their state by Tamerlane might be repeated through the united efforts of the anti-Ottoman powers of the West.

However, the interests of the central European powers – Hungary and Poland, now united under the young king Wladyslaw I and III, and Serbia, under Despot George Branković – proved to be at odds with those of the Latins of the Mediterranean. For the Latins the crusading ideal was a continuing obsession, their attitude little different now from what it had been in 1396, when French insistence on taking over the lead from the more experienced troops of King Sigismund of Hungary had been a significant element in the débâcle at Nikopol. The painful and disorderly retreat of the allied Hungarian army in the campaign of 1443–4 was another bitter experience which caused the central European neighbours of the Ottomans to question whether they really could hope to make substantial gains, or whether a negotiated balance of power might not be more to their advantage. Through contacts facilitated by the Sultan's Serbian wife Mara, the leaders Wladyslaw of Hungary-Poland, John Hunyadi of Transylvania and George Branković of Serbia sent an embassy to Murad in Edirne where, on 12 June 1444, a ten-year truce was agreed. Around this time Murad called his young son Mehmed to Edirne from the west Anatolian city of Manisa, former capital of the Saruhan emirate, where he was prince-governor of the province of Saruhan. Bemused, Murad's commanders warned him of the threat from the crusading Venetian fleet – which by mid-July was off the Peloponnese[69] – but to the amazement of all, he announced that he was giving up the throne.[70] The abdication of a sultan was unprecedented in Ottoman history. Murad II's motive for taking this step at the age of only 41 is a matter for speculation. He had suffered tribulations in recent months – for instance, the sudden death of his eldest and dearest son Alaeddin, next to whose tomb in Bursa he ordered that he himself be buried.[71] Perhaps, after an active reign of more than twenty years, he was simply tired.

Not unnaturally, Murad's withdrawal and the accession of his twelve-year-old son were interpreted by the West as a sign of weakness they could

exploit. When the Edirne truce was confirmed by Wladyslaw, Hunyadi and Branković in Hungary in August, Wladyslaw and Hunyadi swore false oaths, having been absolved in advance by the papal legate to the kingdoms of Bohemia, Hungary and Poland, Cardinal Giuliano Cesarini.[72] Between 18 and 22 September 1444 the crusading Hungarian army crossed the Danube on its eastward march and soon reached Varna on the Black Sea coast. Only George Branković had declined to take part in the advance, Serbia having been promised independence by Murad, and the return of the Danube fortresses of Smederevo and Golubac. In Edirne, a fortnight's march from Varna, fear was palpable. It was less than a year since the Hungarian army had last advanced through the Balkans and into the river valleys leading to the city. Trenches were dug to protect the city and its walls were repaired. The panic was exacerbated by dervishes of an ascetic sect of Iranian origin, the Hurufi, whose doctrines had much in common with the teachings of the heretical Sheikh Bedreddin; public buildings and private houses alike were destroyed in the commotion that accompanied the suppression of their disturbances.[73] To add to the turmoil, the Byzantine emperor John VIII released another pretender to the Ottoman throne. Finding no support in Thrace he turned north to the 'Wild Forest', south of the Danube delta, seat of Sheikh Bedreddin's revolt against Sultan Mehmed I; troops were sent against him from Edirne but he fled back towards Constantinople.[74]

When Murad appointed Mehmed as sultan in his place, he ordered his trusted vezir Çandarlı Halil Pasha to remain in Edirne with him. Members of the Çandarlı family had been first ministers of the Ottoman house almost without interruption since the reign of Murad I; this intimacy had survived both the Timurid catastrophe and the bitter civil war, and Çandarlı Halil had succeeded his father Çandarlı İbrahim Pasha in the mid-1430s. Çandarlı Halil thought Mehmed too young, and those around him unreliable. Men such as Zaganos Mehmed Pasha, Saruca Pasha, and the talented commander Şihabeddin Şahin Pasha were 'professional Ottomans'. Unlike marcher-lords such as the Evrenosoğulları or the old Muslim families of Anatolia such as the Çandarlı, they belonged to the new caste of Christian-born statesmen who had come to prominence during Murad's reign, whether Byzantine renegades or men taken in the youth-levy and converted to Islam. Sheikh Bedreddin's revolt had revealed the continuing fragility of the Ottoman state and demonstrated to Murad that the faith which he espoused must become its cornerstone. He had therefore expanded the youth-levy as a reliable source of loyal military manpower whose converted recruits professed the religion of his dynasty and his court.

Çandarlı Halil Pasha's pre-eminent position engendered much jealousy

among the clique around Mehmed, who envisaged an Ottoman state different in character from the stable balance of power in Anatolia and Rumeli towards which Murad and his counsellor had been cautiously directing it. Çandarlı Halil was reluctant to allow the enthusiastic young sultan to lead an army against the crusaders and, alarmed at the civil unrest in Edirne, felt that he had only one option – to recall Murad who had been in Manisa. Making his way from Anatolia to Edirne, Murad did not enter the city but led his army directly to the front against the Hungarians. The great battle of Varna on the Rumelian coast of the Black Sea took place on 10 November. The fleet bringing the crusaders from the West had not yet reached Constantinople, but although this left the armies of Wladyslaw of Hungary-Poland and Hunyadi of Transylvania to fight the Ottomans alone, things went badly for the Ottoman army at first. Towards evening, however, King Wladyslaw was killed, and his troops fled. The satisfactory outcome of this encounter was due as much to the effectiveness of Mehmed's commander Şihabeddin Şahin Pasha in closing the Balkan passes leading to the plain of Thrace to the enemy as to Murad's generalship. Nor was this the end: the next year a crusader fleet attacked Ottoman positions on the Danube in alliance with Hunyadi and the Voyvode of Wallachia, but again Şihabeddin Şahin Pasha led a successful defence.

During the early months of his first sultanate Mehmed had asserted his independence of his father by taking the unprecedented step of debasing the Ottoman currency, the silver asper, by more than 10 per cent.[75] A greater number of coins could thus be minted to meet the ever-increasing costs of defending and administering the Ottoman territory; but while debasement produced income for the treasury it had the undersirable effect of causing hardship to salaried state servants who received the same number of coins as before but of a lower silver content and therefore of lower worth in real terms. Murad withdrew again to Manisa after the victory at Varna but his second attempt at retirement lasted only a little longer than the first. The janissaries were the most vociferous of those affected by the debasement and in 1446 an insurrection broke out in Edirne provoked, probably, by Mehmed's meddling with the coinage. Çandarlı Halil Pasha again called Murad back to Thrace. Şihabeddin Şahin Pasha became the scapegoat and focus of janissary wrath and took refuge in the palace as the restored Sultan ordered the troublemakers to be hunted down. After this unequivocal assertion of his authority, Murad promised the janissaries salary increases as recompense for the financial distress they had suffered.[76]

The degree of independence Mehmed enjoyed while his father was in Manisa vexed contemporary commentators as much as modern historians. Some, both at home and abroad, considered that Mehmed ruled over

Rumeli, while his father was sultan in Anatolia. The Karamanids feared that Mehmed would break a treaty they had agreed with Murad in 1444, for all acts of a previous sultan had to be renewed on the accession of a new one. Although Mehmed had been de jure sultan and tried to exert his independence of his father, with schemes such as that for the conquest of Constantinople at the earliest opportunity or the debasement of the currency, his real power was limited thanks to Çandarlı Halil Pasha's success in restraining his and his clique's wilder fantasies, albeit at the cost of alienating them. Çandarlı Halil may even have encouraged the janissary uprising in order to have a reason to recall Murad; indeed, the removal of Mehmed was one of the demands which the protestors voiced. When the janissaries threatened to join the Ottoman pretender released by John VIII in 1444, who was now back in Constantinople, the demonstration was clearly getting out of hand.[77]

Mehmed accepted his removal from power and forced return to Manisa with bad grace. As a gesture of defiance against his father he had coins struck in his own name in a west Anatolian mint and attacked Venetian outposts in the Aegean in contravention of the truce. Çandarlı Halil having remained in Edirne with Murad,[78] in Anatolia there was no similarly eminent elder statesman to oversee Mehmed's activities.

Sultan Murad turned to the pressing matter of securing his borders. The Emperor's brother Constantine, despot of the Morea, had recently made gains in Attica at the expense of both local Latin lords and the Ottomans. Murad led his army south, and with his commander Turahan breached and destroyed the supposedly impregnable Hexamilion wall so recently rebuilt by Constantine. Next he attempted the reconquest of Albania, where Scanderbeg was encouraging rebellion against Ottoman authority. The Ottomans' most significant triumph came in 1448 when they routed an army mainly composed of Hungarians and Wallachians under the command of the indefatigable John Hunyadi in a second battle at Kosovo Polje, where Hunyadi's Wallachian allies deserted and he himself fled.

Emperor John VIII died in 1448 to be succeeded by his brother Constantine, who ruled from 1449 as Constantine XI. In 1451 Murad died, and his son assumed the full powers of the sultanate as Mehmed II. He and his counsellors now looked for a great victory to reaffirm their power and independence.

3

An imperial vision

THE OTTOMANS HAD ample strategic reason for coveting Constantinople, the seat of the Eastern Roman Empire since the fourth century. Byzantine control of the Bosporus had on several occasions caused serious logistic problems for sultans – or would-be sultans – and their armies criss-crossing their domains, between Rumeli and Anatolia. Morever, the costs of conquest and administration of the territories coming under Ottoman rule were mounting, and control of the profits from taxation of the rich trade between the Black Sea basin and the Mediterranean and Europe would go far towards paying for the Ottoman future. The union of the Orthodox and Catholic Churches in 1439 had serious repercussions for the Ottomans because it increased the possibility of future crusades and raised again the spectre of Latin influence in Constantinople, anathema to Ottomans and Orthodox alike. Possession of Constantinople had also a compelling symbolic value – the confirmation of empire and the victory of faith. The city featured in both sacred and secular Muslim legend, and conquest by the Ottomans would fulfil a tradition of the Prophet Muhammad, a version of which they loved to quote: 'One day Constantinople will certainly be conquered. A good emir and a good army will be able to accomplish this.'[1] Constantinople was also the 'Red Apple' – an expression the Ottomans used to describe their ultimate aspiration. By striking at the Byzantine imperial city, Sultan Mehmed II aimed to pluck an alien presence from the heart of his realm.

Before he could attempt to besiege Constantinople, following his accession in 1451, Mehmed had to secure his borders. He renewed his father's treaty with George Branković of Serbia and concluded a three-year treaty with John Hunyadi, regent in Hungary. He pre-empted a possible attack from Venice by confirming a treaty made by his father in 1446.[2] He also had to exert constant vigilance to retain his territories in Anatolia since the former emirates of Aydın, Menteşe and Germiyan were preparing to reassert their independence and fight their way free of Ottoman domination. Although technically an Ottoman vassal, the emirate of Karaman protected

various claimants to these lands and its armies moved to retake territory lost to Sultan Murad II. Learning that Mehmed intended to confront this challenge, İbrahim, the ruler of Karaman – who was married to Mehmed's aunt – sued for peace.

Mehmed had murdered his sole surviving brother on their father's death; his only known male relative and potential rival remaining was a pretender in Constantinople purporting to be his uncle Orhan. Memories of the chaos caused by the appearance of pretenders was still fresh in Ottoman minds and he had therefore agreed to pay the expenses of Orhan's continuing custody. While Mehmed was campaigning against Karaman Emperor Constantine XI sent envoys to ask for more money for Orhan's upkeep and hinted that he might release him from custody if it was not forthcoming. Mehmed bided his time in reacting to this provocation which he considered to be in breach of a treaty granted to Constantine soon after the Emperor's accession.[3]

Yet soon enough Mehmed, undeterred by the knowledge that his greatgrandfather Bayezid I had failed to reduce Constantinople even after an eight-year siege, embarked upon the conquest of which he had dreamed since his first taste of sultanic authority as an adolescent in his father's capital of Edirne in 1444–6.[4] The preliminaries to the siege and its course are among the most familiar of historical narratives. For western contemporaries, the exchange of Christian rule for Muslim in Constantinople was described as 'the Fall'. For the Ottomans, it was 'the Conquest'.

Sultan Mehmed's was the thirteenth Muslim attempt to take the city from the Byzantines, the first having been an Arab siege around 650 CE.[5] He prepared meticulously: his passage across the Bosporus was secured with the rapid construction in 1451–2 of the fortress of Boğazkesen, 'Cutter of the Strait', some five kilometres north of the walls of Constantinople. Today known as Rumeli Hisarı, this fortress stands opposite one built by Sultan Bayezid I on the Anatolian shore when he tried to take the city. Like Bayezid's fortress, Boğazkesen was planned to serve as a forward logistical base for the siege and a salient from which to cut off grain supplies coming south from the Black Sea basin. It was very modern by contemporary standards of fortification, its thick walls well able to resist the technological advances of the gunpowder age.[6] Its towers were named after, and probably paid for by, Mehmed's counsellors from his Edirne days: Zaganos Mehmed, Saruca and Çandarlı Halil Pashas.

As the beleaguered inhabitants of Constantinople watched what they had long feared slowly become reality, the Emperor, as on countless occasions in the past, sent urgent calls for help to possible allies in the West. Commerical rivalry between Genoa and Venice meant that neither of these

states was willing to bear a greater share of the burden of defending Constantinople than the other. Genoa sent troops under the able commander Giovanni Giustiniani Longo, and Constantine appointed him to command his forces along the landward stretch of the city wall; Venice rented the Emperor naval support. In desperation, Constantine ceded his western Black Sea coastal city of Nesebŭr to John Hunyadi and the northern Aegean island of Lemnos to King Alfonso of Aragon and Naples, but neither was prepared to aid the Byzantines in the coming struggle. Possible assistance from Constantine's brothers, joint despots Demetrius and Thomas in Mistras, was ruled out by Turahan Pasha's aggressive campaign into the Peloponnese in the autumn of 1452. Yet despite official indifference, many volunteers came to share the defence of Constantinople with the Byzantines.

The price Pope Nicholas V demanded for his help was the Emperor's pledge that the Eastern Church would be more resolute in its union with Rome: he sent two envoys, Cardinal Isidore, formerly of Kiev, and Archbishop Leonard of Chios, who celebrated a Mass in Hagia Sophia at which Constantine swore to the union. But if the Emperor had finally concluded that to move towards effecting the union of the two Churches was a necessary first step before he could even hope for help from the Pope – a step which could be reconsidered at leisure once the immediate danger facing the remnants of his territories was over – others, despite the life-and-death situation they faced, were unwilling to compromise their faith, and there was rioting in the streets of Constantinople. The figurehead of this latter group was the monk George Scholarius, or Gennadios, who was more afraid of divine retribution than of Ottoman conquest.* Such internal dissension was disastrous for the resolve of the populace.[7]

Once the fortress of Boğazkesen had been completed, Sultan Mehmed returned to Edirne to oversee final preparations for the siege, then marched on Constantinople. His army numbered some 160,000 men according to the Venetian merchant Niccolò Barbaro, who was present at the siege. The Byzantine statesman George Sphrantzes estimated the defenders at fewer than five thousand plus the few thousand Latins who came to the aid of the city. Sultan Mehmed came before the walls on 5 April 1453 and, with the help of his navy, surrounded Constantinople on all sides except along the Golden Horn where a boom had been laid to deny the Ottoman navy entry. Unrelenting Ottoman bombardment rent the walls on the landward side; within, Latins and Greeks were at odds over who should man the breaches.

* Gennadios was appointed patriarch, spiritual leader of the Orthodox community, after the city fell to Sultan Mehmed.

Ottoman mining operations were met by the defenders with counter-mines. Skirmishes continued on land and sea until 29 May when what proved to be the final assault on the ruined land-walls began three hours before daybreak. The third wave of the assault succeeded. With his janissaries the Sultan entered a barbican, only to be temporarily driven back before more cannon-fire opened a large breach, through which the victorious Ottoman troops flooded into the city.

The historian and administrator Tursun Bey provides the sole detailed contemporary account of the siege in the Ottoman language:

> Once the [cloud of] smoke of Greek fire and the soul of the Fire-worshipping [i.e., infidel] Prince had descended over the castle 'as though a shadow', the import was manifest: the devout Sultan of good fortune had, as it were, 'suspended the mountain'* over this people of polytheism and destruction like the Lord God himself. Thus, both from within and without, [the shot of] the cannons and muskets and falconets and small arrows and arrows and crossbows spewed and flung out a profusion of drops of Pharaonic-seeming perspiration as in the rains of April – like a messenger of the prayers of the righteous – and a veritable precipitation and downpouring of calamities from the heavens as decreed by God. And, from the furthest reaches below to the top-most parts, and from the upper heights down to ground level, hand-to-hand combat and charging was being joined with a clashing and plunging of arms and hooked pikes and halberds in the breaches amidst the ruin wrought by the cannon.
>
> On the outside the Champions of Islam and on the inside the wayward ones, pike to pike in true combat, hand-to-hand;
>
> Now advancing now feinting, guns [firing] and arms drawn, Countless heads were severed from their trunks;
>
> Expelling the smoke of the Greek fire, a veritable cloud of sparks was rained on the Champions of Islam by the infidels;
>
> Ramming into the castle walls, the trenches in this manner, They set off the Greek fire, the enemies;
>
> [In turn] they [i.e. the Ottoman soldiers] presented to the bastion their hooked pikes, Drawn, they were knocking to the ground the engaged warriors;
>
> As if struck in the deepest bedrock by the digging of a tunnel It seemed that in places the castle had been pierced from below.

* Both quotations are from the *Koran* 7:171.

By the early part of the forenoon, the frenzy of the fiery tumult and the dust of strife had died away.[8]

European and Byzantine accounts of the siege alike dwell on the daring measures taken by Sultan Mehmed to achieve his aim: the huge cannon made for him by a renegade Hungarian cannon-founder in Edirne,* the building of a siege-tower higher than the walls of the city, the dragging of his galleys uphill from the Bosporus shore near the present-day palace of Dolmabahçe, and down into the Golden Horn to avoid the boom laid across its mouth, and the construction of a pontoon bridge across the harbour from Galata to Constantinople which enabled the Ottoman forces to attack the walls on that side of the city and surround it completely.

For the Ottomans, the part played by the Sultan's spiritual guide, the mystic Sheikh Akşemseddin, was the most significant contribution to the final outcome. The Ottomans lost many troops in a confrontation in which four grain ships – three Genoese and one Byzantine – managed to run the Ottoman blockade and convey their load into the Golden Horn. Following this reverse, Akşemseddin wrote to the Sultan of the divine signs he had seen prophesying victory, which soothed Mehmed's despair and raised the morale of the besieging army.[9]

Fifty-four days after beginning his assault, Sultan Mehmed entered a city destroyed by siege and devastated by looting. Emperor Constantine was nowhere in evidence. Most fifteenth-century chroniclers, both eastern and western, agree that he was killed during the fighting, but because the where-abouts of his corpse was (and remains) unknown, legends grew up to explain its fate and various sites in the city were considered to be his tomb.[10] The task of reconstruction which faced the Ottomans was daunting. The historian Doukas reports that Sultan Mehmed summoned the Byzantine statesman Grand Duke Lucas Notaras and demanded to know why the Emperor had not surrendered the city to him, thereby preventing the damage and destruction of its fabric.[11]

The first Friday prayer after the Conquest, conducted by Sheikh Akşemseddin,[12] took place in the basilica of Hagia Sophia, Emperor Justinian's imperial church, which had been turned into a mosque. Sultan Mehmed purportedly first walked into Hagia Sophia in the company of

* Although the Ottomans seem to have adopted gunpowder technology before the end of the fourteenth century – the use of both arquebus and cannon at Bayezid I's siege of Constantinople is attested – it was not until the mid-fifteenth century, and the conquest of that city by Mehmed II, that cannon rather than blockade reduced a fortress (Ágoston, 'Ottoman Artillery' 24–5).

Tursun Bey, who saw and recorded the awe and wonder inspired in him by the interior. Transformation of the Christian Byzantine church into an Islamic Ottoman mosque required only the removal of the paraphernalia of Christian ritual – crosses and bells – and their replacement with the furniture of Muslim worship – a prayer niche, a pulpit and minarets. Later Mehmed also added a theological college to the complex. The Sultan's banners carried at the siege were displayed to commemorate his great victory, while prayer carpets supposedly belonging to the Prophet Muhammad re-defined the religious character of the church.[13] The nineteenth-century chronicler Ahmed Lutfi Efendi states that Mehmed ordered the preserva-tion of the representations of 'angel's faces' in Hagia Sophia,[14] and research has demonstrated that such sacred mosaics as the Pantocrator on the main dome remained on view until the reign of Sultan Ahmed I in the early seventeenth century, when they were painted over during a period of intol-erance towards figural representation. Other figural mosaics not visible from the central prayer space remained uncovered until the early eighteenth century.[15] The Ottomans did not even change the name of the building, but merely Turkicized it to 'Ayasofya'.

Standing outside Ayasofya, atop a column, was a colossal statue of Emperor Justinian on horseback with a golden orb in his hand, set up in 543 CE.[16] Byzantines regarded the statue as a talisman whose destruction would presage the end of Byzantium. Like many travellers – including Johann Schiltberger, who spent three months in Constantinople in 1426 on his journey home after many years in captivity in the east – the Ottomans saw the orb as a representation of the 'Red Apple'[17] and within three years of the Conquest the statue was removed, a symbolic act against any return of the defeated imperial power. Living in Istanbul in the mid-1540s the French humanist Pierre Gilles saw what remained of the statue within the precincts of Topkapı Palace: 'Among the fragments were the Leg of Justinian, which exceeded my Height, and his Nose, which was over nine Inches long. I dared not measure the Horses' Legs as they lay on the Ground but privately measured one of the Hoofs and found it to be nine Inches in Height.'[18]

Mehmed's re-creation of Byzantine Constantinople as Ottoman Istanbul did not require the destruction of all traces of former times, however. Rather, he sought to imbue the past with new meaning by converting Byzantine buildings, both sacred and secular, to new functions. Hagia Sophia was one of six churches converted into mosques after the Conquest.[19] This preservation of much that was redolent of the infidel past of the city demanded justification, however, and Mehmed subsequently commissioned a mythic history of the emperors – Solomon, Constantine and Justinian – who had built and rebuilt the city. In this text, or texts – for there were

numerous versions, written at different dates – the Islamic present was viewed as having been ordained through the prophetic tradition of the Prophet Muhammad and reinforced through the 'discovery' by Sheikh Akşemseddin of the tomb of Ayyub Ansari, a companion of the Prophet who had taken part in and died during an unsuccessful Arab siege of Constantinople in 668 CE. This miracle gave Sultan Mehmed's conquest the religious legitimacy he sought.[20]

Mehmed stamped his mark on the fabric of the city with major building projects appropriate to the Islamic way of life. Great importance was attached, for example, to the construction of a fitting tomb for Ayyub Ansari within the courtyard of a mosque built at the site where his grave was said to have been found, outside the city walls at the head of the Golden Horn in the quarter called, in its Turkicized version, Eyüp.*[21] In 1457–8 the fortress of Yedikule ('Seven Towers') was built at the entrance into the city known to the Byzantines as the Porta Aurea, the 'Golden Gate', where the land-walls run down to the Sea of Marmara. This was the gate through which the Via Egnatia, the road from Rome, capital of the Western Roman Empire, had entered Constantinople, capital of the Eastern Roman Empire. At first Yedikule housed errant Ottoman dignitaries, and from the late sixteenth century became infamous as the prison of foreign envoys.[22] Mehmed also ordered a palace to be built in the centre of the city on the site of the Byzantine Forum Tauri, where Bayezid Square and Istanbul University stand today. Like Yedikule, the palace was completed in 1458. The construction of the nucleus of the rambling complex today known as the Covered (or Grand) Bazaar began in 1460–61; part of the rent from its shops paid for the upkeep of Ayasofya.[23]

Orders for the building of two further structures signalled that Istanbul was to replace Edirne as the Ottoman imperial capital and at the same time expressed Sultan Mehmed's claims as inheritor of an imperial tradition and as the pre-eminent Muslim ruler. On the prominent site of the ancient Byzantine acropolis in 1459 was laid the first stone of a splendid palace to supersede that recently completed in the Forum Tauri; the latter now became known as the 'Old Palace'.[24] In 1463 the foundation stone of a monumental mosque complex bearing the Sultan's name was laid.

Topkapı Palace, or the 'New Palace', as the Ottomans also called it until the nineteenth century, is surrounded by a high wall and comprises three large courtyards, each with its own monumental gate, and outer gardens in which are several free-standing pavilions. The first two courtyards were for

* The neighbourhood is still a place of pilgrimage, but Ayyub Ansari's mosque and tomb have been much altered over the centuries.

the public ceremonies and rituals of the court, while beyond the third gate was a private zone reserved for the sultan and his household. The plan of the palace resembles that of an Ottoman military encampment, with the sultan's inner sanctum at the core of a multiplicity of other structures arranged according to institutional function and hierarchy. This layout, very different from contemporary western palaces, expressed through architecture the sultan's separation from his subjects. Despite various rebuilding programmes over the centuries, the palace complex preserves essentially the same form today.[25]

His palace provided Sultan Mehmed with seclusion. Here he cultivated an aura of mystery and power, which regulations issued towards the end of his reign were designed to enhance. The new rules ensured that sultans would thereafter be less visible to their people than Mehmed's forebears, appearing in public – even before their courtiers – on fewer occasions.[26] These rules constituted a manual for court protocol, stipulating hierarchy and precedence among the sultan's statesmen and officials, the titles by which they should be addressed, the order in which they would kiss the sultan's hand on religious festivals. There was no provision for the sultan to appear in public: he was to be hidden behind a curtain from the gaze of his statesmen when they met, four times a week, to present petitions to him.[27] For the next century, sultans appeared before their court only on two annual religious holidays.[28]

Sultan Mehmed embellished his new buildings in a variety of styles which reflected his subsequent conquests. The two-storey Tiled pavilion was built in the palace grounds to commemorate a successful outcome to a campaign in eastern Anatolia following the death in 1464 of the Karamanid ruler İbrahim Bey, and in particular the advantage gained by the Ottomans over the Akkoyunlu ruler, Uzun ('Tall') Hasan. Craftsmen from Karaman who settled in Istanbul after the campaign were responsible for its decoration, and its splendour inspired many florid poems.[*29]

Mehmed's mosque complex was built on a hilltop site in the quarter to the west of the Golden Horn known as Fatih ('the Conqueror') in his honour. The Church of the Holy Apostles, the burial site of generations of Byzantine emperors, was demolished to make way for it. The mosque was situated in a courtyard on the north and south sides of which were ranged eight theological colleges, the four in the north named for the Black Sea, those in the south for the Mediterranean, in Turkish Ak Deniz ('White Sea'). There were also a hospice, a dervish lodge and a caravansaray, and Mehmed built a market, a bath-house and many shops whose rents would

* Today the Tiled pavilion stands divorced from its original context, opposite the nineteenth-century bulk of the Istanbul Archaeological Museum and no longer within the gardens of the palace.

provide for the upkeep of these institutions and contribute financial support to their charitable functions. Intended to rival Ayasofya, the main dome of the mosque at the heart of Mehmed's complex was likewise supported by half-domes which raised it high above the prayer hall beneath. As fate would have it, the architect of Mehmed's mosque was over-ambitious in his attempts to surpass Ayasofya, for the building proved to be poorly-constructed, and legend maintains that he was executed.[30] This mosque complex was completed in 1470 and became the prototype for such complexes of the Ottoman 'classical age' in the following century.*

Mehmed set about repeopling Constantinople. People of all religions were attracted by favourable taxation and the opportunities for a better life promised by the revitalized metropolis. When tax and other inducements proved inadequate attractions the Ottomans had no qualms about uprooting and resettling their subjects if it suited their economic or political aims, and on no occasion was resettlement used to greater effect than in post-Conquest Istanbul. Whole communities – Muslims, Jews, and Armenian, Greek and Latin Christians – were forcibly brought to the city over the succeeding years. In keeping with the pattern of Ottoman conquest thus far, Muslim deportees came exclusively from west and central Anatolia, and from Thrace, while Christians and Jews came from across Anatolia and the Balkans; the Latin Christians were a discrete group, transported from the former Genoese colony of Caffa in the Crimea when it was annexed in 1475.[31] Former Greek residents of Byzantine Constantinople were offered houses and land to encourage them to return.[32] The number of Muslims in the city was increased by deporting Muslims from other parts of the state rather than by converting existing Christians or Jews. At upwards of 75,000 souls by the end of Mehmed's reign,[33] the population of Constantinople was half as large again as it had been when the devastated city became his in 1453.

From 1459, Sultan Mehmed adopted a highly effective way of altering the physical appearance of Istanbul so that observers would at once be aware that they were in an Islamic city. In addition to the obvious new landmarks such as his own mosque and palace and the minarets with which he embellished Ayasofya, he ordered his statesmen to found new neighbourhoods, each to be built around a mosque complex which would provide Muslim immigrants to the city with the infrastructure to order their new lives. Besides a mosque these complexes, like his own, included a variety of other structures – perhaps a school, a theological college, a public kitchen, a bath-house, a caravansaray or a mausoleum for the founder – a mix of charitable institutions and the

* The dome finally collapsed in a devastating earthquake in 1766, when a major rebuilding programme was undertaken; the mosque we see today dates from this time.

commercial institutions necessary to provide revenue for their upkeep.[34] Examples are those founded by Mahmud Pasha Angelović (a former Byzanto-Serbian noble, who was twice appointed grand vezir), which lies just outside the Covered Bazaar on the slope that falls away to the Golden Horn, and by Mehmed's favourite Has Murad Pasha, a convert of the Palaeologan dynasty, in Aksaray, near where Istanbul University stands today. The practice of establishing new neighbourhoods in this way continued apace in the reign of Mehmed's son and successor Bayezid II, and beyond.[35] New immigrants to Istanbul often gave to their new urban neighbourhood the name of the area from which they came. The quarter near Mehmed II's mosque where arrivals from Karaman settled is still called Karaman Pazarı; the neighbourhood of Aksaray recalls the area of central Anatolia whence settlers came following Ottoman annexation of the Karamanid emirate.

Two days after Constantinople fell, the Genoese colony of Galata across the Golden Horn from Istanbul surrendered, hoping to preserve the independence it had enjoyed in Byzantine times and which Mehmed had guaranteed. But Mehmed changed his mind once the city was his, and although the colony was granted certain privileges its people, like other non-Muslim subjects of the Ottomans (as of other Islamic states), became subject to a poll-tax. In justification of his change of policy Mehmed reminded the Galatans that some among their number had fought on the side of the Byzantine defenders during the siege of Constantinople.[36] He also ordered the Galata Tower to be reduced in height by seven and a half metres to make it less visible a sign of alien presence.[37]

The city's Byzantine name, rendered in Turkish as Kostantiniyye, continued to be used alongside the newer 'Istanbul'.* Istanbul was punningly rendered as 'Islambol', 'abounding with Islam', and also called Âsitâne-i Saâdet, the 'Threshold of Felicity', or Dersaâdet, the 'Abode of Felicity', among other names. Istanbul was only adopted as the city's official name in 1930 and the transition immortalized in the song:

> Istanbul was Constantinople
> Now it's Istanbul not Constantinople
> Been a long time gone
> Old Constantinople still has Turkish delight
> On a moonlight night
> Ev'ry gal in Constantinople
> Is a Miss-stanbul, not Constantinople

* Istanbul is seemingly derived from classical Greek *eis tin polin* ('to the city'), which was then spoken in colloquial Greek as *stin poli*, signifying both 'to the city' and 'in the city' (that is, within the walled city), the latter meaning being the most relevant as indicating the 'downtown' area, rather than the suburbs.

So if you've a date in Constantinople
She'll be waiting in Istanbul
Istanbul!!
Even old New York was once New Amsterdam
Why they changed it, I can't say
(People just liked it better that way)
Take me back to Constantinople
No, you can't go back to Constantinople
Now it's Istanbul, not Constantinople
Why did Constantinople get the works?
That's nobody's business but the Turks'
'stanbul!! [38]

The fall of Constantinople to the Ottomans was a matter of horror for the Christian West, which feared an ever more aggressive policy of conquest. The Pope made attempts to raise crusading armies to recover the city for Christendom.[39] Although, as before, they never resulted in a united front against the Ottomans, they were always a consideration in Sultan Mehmed's policy-making. His success had serious repercussions for the maritime economies of the West. Ottoman control of the Bosporus drove a wedge through the strategic and trading zone comprised by the Black, Aegean and Mediterranean seas and opened up vast resources to the Ottomans. Like Constantinople before it, Mehmed's new imperial capital needed food and materials to support the flourishing and vital community he envisaged: much of what was needed came from the Black Sea basin.

For the Genoese and Venetian colonies whose economies relied on the Black Sea trade for their survival, the outlook was bleak. The very year after the conquest of Constantinople Mehmed sent a fleet of 56 ships to 'show the flag' in the Black Sea. Failing to take the Genoese fortress of Bilhorod-Dnistrovs'kyy (Cetatea Alba) at the mouth of the Dniester, the Ottoman ships continued to the Crimea where with the support of Hacı Giray, Tatar khan of the Crimea, they harassed the Genoese outpost of Caffa; by dint of agreeing to pay an annual tribute, it was able to retain a measure of independence, at least for a while.[40] Having lost control of a major trade route along which grain, in particular, travelled from the Black Sea basin to feed their city-state, the Venetians were fortunate to have concluded a treaty with Mehmed in the same year. Under its terms they were permitted to trade in Istanbul against payment of customs duty, and also to maintain a colony there.[41]

The joint Ottoman–Tatar action against the Genoese was a harbinger of their future close, if often difficult relationship. The Tatar Giray dynasty which ruled Crimea until its conquest by the Russian Empire in the late

eighteenth century had emerged in the fifteenth century by asserting its independence from its overlords, the Tatars of the 'Golden Horde' who controlled the western part of the Mongol Empire created by Genghis Khan, and came to occupy a special place in Ottoman history. The Giray traced their genealogy to Genghis Khan and could thus claim the sort of political legitimacy to which the Ottomans could only aspire: Tatar superiority in the pecking-order of Central Asian dynasties gave them a unique prestige among Muslim states and caused the Ottomans not a little concern.[42]

During the first decade after the Conquest, Sultan Mehmed focused his attention almost exclusively on the Balkans. His first major campaign after 1453 was against Serbia, the buffer between Ottoman and Hungarian territory and the route by which Hungarian influence could penetrate the Balkans and Hungarian armies threaten his north-western frontier. The conquest of Serbia and its full incorporation into Mehmed's empire took five years. Although the Ottomans captured and briefly held a couple of Serbian fortresses in the Morava valley in 1454, they failed to take Smederevo, the important stronghold guarding the Danubian route east of Belgrade. The objective of the following year's campaign was very different: the Ottoman army moved through the south of Serbia to capture the silver-mining district of Novo Brdo, providing themselves with an essential resource in short supply elsewhere in their territory. In 1456 Mehmed commanded the siege of Belgrade, the fortress whose strategic position at the confluence of the Danube and Sava rivers made it the key to Hungary: that he failed to take it in a combined land and amphibious operation owed more to its impregnable and strongly-fortified site than to the numerous but motley crusader army which came to its relief. It remained in Hungarian hands until 1522.

John Hunyadi died of plague soon after the siege of Belgrade, but his spirited defence of the castle earned him a legendary place in Hungarian history. A period of turmoil in Hungarian domestic affairs followed his death; his son Matthias Corvinus eventually succeeded to the throne in 1458. George Branković of Serbia had died in December 1456; his son Lazar soon followed him, leaving no male descendant and a power vacuum which invited Hungarian incursion. Serbia had first become an Ottoman vassal state after the battle of Kosovo Polje in 1389, but while its rulers adopted a cautious policy towards their masters, for many Orthodox notables Ottoman rule was preferable to that of Catholic Hungary.

The leader of the pro-Ottoman faction in Serbia was Michael Angelović, brother of Mehmed's recently-appointed grand vezir, Mahmud Pasha. These brothers belonged to a minor branch of the Serbian despotate; Mahmud Pasha had probably entered Ottoman service very young following

his capture by the Ottomans during the reign of Sultan Mehmed's father, Murad II, in 1427. It is likely that Michael Angelović, who became joint regent of Serbia following Lazar's death, invited Ottoman intervention in Serbia to thwart Hungarian designs, for by spring 1458 Mahmud Pasha was on his way to the fortress of Smederevo. In the meantime, however, the pro-Hungarian faction in Smederevo revolted, and Michael was captured by Lazar's wife Helen (one of his co-regents), imprisoned and sent to Hungary. The defenders of Smederevo refused to surrender and Mahmud Pasha attacked the fortress, capturing the city but not the citadel; he also made a number of other strategic conquests along the Danube. The threat of a Hungarian advance caused Mahmud Pasha to join the Sultan at Skopje in Macedonia whither Mehmed had retired after his Peloponnese campaign earlier in the year, and they checked a Hungarian attack with the help of Mehmed's exhausted troops.[43] In 1459 representatives of the pro-Ottoman faction in Smederovo handed the keys of the citadel to Mehmed who ordered its occupation. Thus Serbia finally became an integral part of the Ottoman domains.[44]

The failure of the Ottoman vassal state of Wallachia to send the annual tribute to Istanbul, and subsequent provocative actions of the voyvode Vlad Drakul, 'the Impaler', prompted Mehmed to send Mahmud Pasha across the Danube ahead of him to restore order in 1462. A successful campaign followed and Vlad's more co-operative brother Radul, who had been held hostage in Istanbul as guarantee of Vlad's good behaviour, was confirmed as voyvode in his place. Vlad himself fled to Hungary.[45]

Security from Hungarian incursions could be guaranteed only through full Ottoman control of the Danube–Sava river line which all but bisects the Balkans from the Black Sea in the east to the Adriatic in the west. North-west of Serbia and south of the Sava lay Bosnia, an Ottoman vassal state whose king, Stephen Tomašević, had also refused to send tribute to the Sultan. In 1463 Stephen petitioned for and was granted a fifteen-year truce but almost immediately the Ottoman army set off for Bosnia, entering the country from the south. Stephen fled but Mahmud Pasha caught up with him at Ključ, where he surrendered on the promise that he could go unharmed. Like Serbia, Bosnia became an Ottoman province – although it had to be defended against Hungarian attack the following year – and Mahmud Pasha next seized neighbouring Herzegovina.[46] The bad faith which had allowed the Ottomans to attack Bosnia despite a truce was again evident when Sultan Mehmed ordered Stephen of Bosnia to be executed; but his captured half-brother Sigismund converted to Islam and, as Kraloğlu ('Son of the King') İshak Bey, became a companion of the Sultan.[47] The son of the lord of Herzegovina also converted to Islam, and as Hersekzade

('Son of the Prince') Ahmed Pasha served as grand vezir under both Mehmed's son and heir Bayezid II (whose daughter he married) and his grandson Selim I.[48]

In 1455 the Ottomans had seized Genoese colonies in the Aegean: Old and New Phokaia (Foça) on the Anatolian coast north of İzmir, which controlled rich alum mines whose product was essential to the European cloth trade for its dyeing processes, and Enos (Enez), at the mouth of the Maritsa in Thrace, which derived its revenues from the salt trade. In the same year Athens was captured from its Florentine lord by the marcher-lord Ömer Bey, son of Turahan Pasha. Venetian Naxos and the Genoese islands of Lesbos and Chios agreed to pay tribute to the Sultan in 1458. Following the conquest of Serbia in 1459 Sultan Mehmed returned to Istanbul and then travelled overland to reduce the Genoese colony of Amastris (Amasra) on the Black Sea coast of Anatolia with the aid of a naval force sent from Istanbul. In 1462 Lesbos capitulated to an Ottoman siege while Mehmed was fortifying the Dardanelles to improve the security of Istanbul. He built a pair of fortresses here, at Çanakkale, formerly known as Sultanhisar ('Royal Castle'), on the Anatolian shore, and at Kilitülbahr ('Lock of the Sea') opposite it on the Rumelian shore. With the southern approaches to Istanbul now firmly in Ottoman hands, the city was protected from naval attack.

Even after the loss of Constantinople, a few fragments of the Byzantine Empire survived. These anachronistic entities included the Comnene kingdom of Trebizond which became an Ottoman vassal in 1456, and the despotate of the Morea which was ruled jointly by Thomas and Demetrius Palaeologus, who were rarely able to work together in support of a common cause. Long Ottoman vassals, for three years the Despots failed to pay tribute before Sultan Mehmed's army invaded in 1458. Last-minute payment of this levy failed to divert Mehmed from his purpose, and he marched south. Corinth, on the isthmus, capitulated after a three-month siege, and Ottoman administration was extended to most of the Peloponnese. Despot Thomas tried half-heartedly to recover some of his former possessions but became embroiled in a war with his brother. In 1460 Mehmed himself again led an army which by the end of the year had brought all the Peloponnese, with the exception of the few remaining Venetian colonies, under Ottoman control. Contemporary Greek sources report that Demetrius' daughter Helen entered the female quarters of the Sultan's inner household, his *harem*, as had Tamar, daughter of George Sphrantzes, a chronicler of Mehmed's reign.[49]

Trebizond was the maritime outlet for the trade of Tabriz, capital of Uzun Hasan, the dynamic leader of the Akkoyunlu tribal confederation

who was married to a Comnene princess. Ottoman efforts to subdue the Muslim emirates of Anatolia would come to seem insignificant by comparison with the struggle to control eastern Anatolia which was now beginning. Uzun Hasan considered Trebizond to be within his sphere of influence and late in 1460 he sent his nephew as envoy to Sultan Mehmed, cautioning him that he considered the kingdom his own prize, and warning the Sultan not to attempt to dispossess the Comnene dynasty. Mehmed ignored the warning and, supported by the armies of his Muslim vassals the İsfendiyaroğulları of Kastamonu and the Karamanids, the next year moved east with the object of annexing this last remaining Byzantine enclave in Anatolia (which small as it was called itself an empire). Uzun Hasan sent troops to hinder his progress, but little was achieved on either side in this first confrontation between these two ambitious rulers.

The Comnene lands were cut off from the Anatolian hinterland by high, inhospitable mountains. A janissary who served with the Ottoman army on the Trebizond campaign recalled the difficulties of the march – the distance, the hostility of the local population to the Ottoman advance in a region where the steep, forested terrain favoured the nimble rather than the heavily-armed soldier, hunger, and the incessant rain which turned the route to mud. He related how a camel laden with gold coins fell on the pass down to the city, scattering the treasure everywhere: Sultan Mehmed gave the order for anyone who could to pick up the gold pieces and keep them. But this was insufficient incentive:

> . . . before we came down from that mountain we had plenty of trouble: the earth was as sticky as porridge and the Janissaries had to carry the Emperor [i.e. the Sultan] in their arms all the way to the plain and the treasure camels remained in the mountains. Emperor Mehmed begged the Janissaries to make an effort to get the camels down to the plain and we had to go back up the mountain with great effort and struggle all night before we got them down to the plain. The Emperor stayed there that day resting and gave the Janissaries 50,000 gold pieces to divide among themselves and he raised the wages of the Janissary centurions.[50]

Trebizond surrendered after a six-week siege by Ottoman land and sea forces. In Islamic law, those who surrender in a military engagement should be allowed to go free; initially, therefore, the Emperor and his family were spared, and held in Edirne – but (except for his daughter Anna who entered Mehmed's *harem*)[51] were executed two years later. Blame for the Ottomans' easy victory was laid by some at the door of the Trebizond treasurer, George Amirutzes, who negotiated the surrender of the enclave with the Ottoman grand vezir Mahmud Pasha, who was his cousin.[52] Amirutzes continued his career at the Ottoman court like a number of other learned Greeks and

members of the Byzantine aristocracy. He became philosopher-royal and amanuensis to the Sultan; his major contribution was to combine into a whole the scattered charts of the classical Greek geographer Ptolemy, whose work was adopted as one of the bases of Islamic and, later, Ottoman and Renaissance cartography.[53] With the removal of the Comnene dynasty from Trebizond, Mehmed completed the reunification under Ottoman rule of all but a few pockets of the territory which had been ruled by Byzantium from Constantinople until the time of the Fourth Crusade in 1204.

Annexation of the Venetian maritime colonies remained an Ottoman objective, for although Venice was unable to pose a direct strategic threat to the Ottomans after their capture of Constantinople, it retained a nuisance value because of its strong navy. The Ottoman–Venetian relationship had always been dogged by mutual suspicion, but full-scale war had usually been avoided. Commercial considerations and the knowledge that the other crusading powers would doubtless leave it isolated made Venice reluctant to provoke the Ottomans, until their conquest of Bosnia in 1463 endangered Venetian possessions on the Adriatic. Other Venetian colonies – principally Corfu, Methoni, Euboea and Naxos – became vulnerable as the Ottomans attacked Venetian territory around Nafpaktos (Lepanto), a vital base for naval operations in the Adriatic. Emboldened by the hope that it might find an ally in Hungary, whose security was equally threatened by the loss of Bosnia, Venice declared war on the Sultan in July 1463.

In the early stages of the war much of the Peloponnese again came under Venetian control. In the autumn of 1463 King Matthias of Hungary invaded Bosnia and the next year his troops defeated an army commanded by Mehmed who retired on hearing that the King was again moving south across the river Sava. The Pope and the Duke of Burgundy made a three-year commitment to an anti-Ottoman crusade (albeit this venture was short-lived: by the end of 1464 it, like so many other alliances in crusading history, had crumbled in discord).[54] Though the Venetians failed to recapture the north Aegean island of Lesbos from the Ottomans in the same year, it was seen merely as a setback, and Venice was not inclined to accept the peace overtures of Grand Vezir Mahmud Pasha.[55]

Venice remained a problem, and not only in the Peloponnese. Between Ottoman Macedonia and the Venetian strongholds of the Adriatic coast lay the fragmented buffer of Scanderbeg's mountainous Albania. On various occasions since re-embracing Christianity and renouncing his Ottoman allegiance by rebelling against Murad II, Scanderbeg had sought Latin patronage in his bid to remain independent of the encroaching Ottomans. Naples had been his protector since 1451 but on the death of King Alfonso in 1458 he again acknowledged Ottoman suzerainty. The outbreak of the

Venetian–Ottoman war in 1463 gave him another chance to break free of the Ottomans and he offered his services to Venice. After a couple of years of localized warfare, Mehmed launched a full-scale campaign against Scanderbeg and in the summer of 1466, in only 25 days, the Ottomans built the great fortress of Elbasan where the main route linking the Ottoman Balkans with the Adriatic coast, the former Via Egnatia, reaches the coastal plain. Scanderbeg's stronghold of Krujé lay isolated to the north, no longer able to make overland contact with Venetian forces on the coast. During the winter Scanderbeg sought material help in Italy, and in the following year attacked the Ottoman besiegers of Krujé. This prompted a second campaign by Mehmed which resulted in all Albania – bar a few Venetian outposts – coming under Ottoman rule. Scanderbeg himself, for so long the leader of Albanian resistance to the Ottomans, fled to Venetian territory where he died in 1468. Although the exercise of Ottoman authority in this inhospitable region was tenuous, Hungary and Venice were no longer able to exploit the volatility of the lesser Albanian lords to their advantage.[56]

Although Mehmed II is thought of by western historians primarily as the architect of the Ottoman push into Europe, he spent much of his reign defending his eastern frontier. Uzun Hasan's caution to Mehmed over Trebizond in 1460 proved the precursor to a more aggressive policy, for he soon sent an envoy to Venice to propose co-operation in Venice's war against the Ottomans. The strongest card in his suit was his promise to repeat Tamerlane's success in breaking up the Ottoman domains: Venice agreed that he should keep whatever territory he could win in Anatolia.

By the mid-fifteenth century the long and acrimonious relationship between the Ottoman and Karamanid states had reached an impasse. The death in 1464 of Mehmed's vassal İbrahim Bey of Karaman left Karaman open to the competing claims of the Ottomans and the Akkoyunlu. Uzun Hasan seized the chance to regain the initiative against the Ottomans by intervening in Karaman on behalf of İbrahim's eldest son İshak and delivering the state to him. Both Uzun Hasan and İshak accepted Mamluk protection hoping for an ally against Mehmed's inevitable response, which was not long delayed: with Ottoman support, another of İbrahim's sons, Pir Ahmed, drove İshak to seek refuge with Uzun Hasan. The death of İshak soon afterwards deprived Uzun Hasan of his pretext for intervention in Karaman and temporarily halted his plans to emulate Tamerlane.[57]

Soon, however, while the cream of the Ottoman army was engaged on the western fringes of the empire, Uzun Hasan, on the eastern frontier, was adding huge swathes of territory to that he had acquired through his

annexation of the lands of the rival Karakoyunlu tribal confederation in 1467. Over the next two years he established his rule over Azerbaijan, Iraq, Fars and Kirman and beyond, into the Timurid homelands further east, which radically altered the balance of power in eastern Anatolia, and made Uzun Hasan a vastly more formidable rival than when he had been merely a tribal chief.[58]

In 1468 Uzun Hasan sent an embassy to the new Mamluk sultan Qa'it Bay to assure himself of Mamluk protection against the Ottomans.[59] Two contemporary writers, the Venetian historian Domenico Malipiero and the Ottoman Tursun Bey, report independently that Sultan Mehmed planned to march into Mamluk Syria in 1468.[60] However, when his vassal Pir Ahmed of Karaman failed to provide the obligatory assistance in this campaign, Mehmed directed his army against Karaman instead. It is not clear what prompted Pir Ahmed to make such a wrong-headed decision, because the forces of Karaman were no match for Mehmed, who succeeded in bringing most Karamanid territory north of the Taurus mountain range under his control. Uzun Hasan was preoccupied with his own imperial designs in the east and could not intervene to help Pir Ahmed.

From 1469, once he had despatched the Timurid ruler Abu Sa'id, Uzun Hasan was lord of the most extensive territories in the region and successor to the Karakoyunlu and Timurid states. With domains comprising most of modern Iran and Iraq and much of eastern Anatolia, Uzun Hasan was master of an empire to rival that of Sultan Mehmed and in June of that year he stated his claims to be the sole legitimate Islamic sovereign in a proclamation to Qa'it Bay.[61] This was a challenge both to the Mamluks, as guardians of the Holy Places of Islam in Mecca and Medina to which all Muslims were required to make pilgrimage, and to Sultan Mehmed's aspirations to leadership of the Islamic world. Even after his conquest of Constantinople Mehmed had been content to leave matters relating to the pilgrimage to the Mamluks, seeing his own duty as temporal, that of extending the Islamic lands.[62]

Uzun Hasan's psychological warfare intensified. He competed with Mehmed at the spiritual as well as the temporal level, referring in a letter to the Sultan of 1471 to his recent conquest Shiraz, in southern Iran, as 'the throne of the caliphate'.[63] This claim did not greatly exercise Mehmed, for the office of caliph had long fallen into abeyance, but Uzun Hasan's evocation of the spectre of Tamerlane was more alarming. One of Uzun Hasan's commanders wrote to the Ottoman governor of Sivas drawing a comparison between the Akkoyunlu leader and Tamerlane – he found Uzun Hasan superior on fourteen counts, which included the full range of attributes desirable to support a ruler's claims to legitimacy in this part of

the world. Uzun Hasan made his concerns topical, by criticizing the administrative policies of the Ottomans, such as the collection from Muslim tribesmen of the poll-tax – which was only supposed to be paid by non-Muslims – and the forced sedentarization of the tribes to make them part of the settled peasantry, which was an important aspect of the Ottoman policy of subduing eastern Anatolia.[64] Uzun Hasan's claims to ancient Turkish lineage were a determined response to Ottoman emphasis on their own Central Asian origins in histories written at this time.[65]

When Sultan Mehmed sent an army against what remained of Karaman in 1471, Pir Ahmed fled to Uzun Hasan, but Pir Ahmed's Turcoman allies failed to defend the Taurus passes against the Ottomans, and an Ottoman fleet annexed a Karamanid client enclave around the port of Alanya in south-west Anatolia. The next year the Ottomans captured Karamanid strongholds to the east of Silifke on the southern coast of Anatolia but, to the west, their own port of Antalya, 'the greatest and most famous seaport in Asia' according to Malipiero,[66] was burnt in retaliation by a Christian fleet newly allied with Uzun Hasan. The Ottoman port of İzmir on the west coast of Anatolia was burnt by a Venetian fleet that also torched Gelibolu in an audacious strike that breached the Dardanelles fortifications so recently constructed by Mehmed to protect Istanbul.

In July 1472 Uzun Hasan again announced his intention to intervene to save what remained of Karaman from the Ottomans, demanding that Mehmed withdraw and also that he hand over Trebizond. Like Tamerlane's court, Uzun Hasan's gave refuge to dispossessed Anatolian princes who there planned the reconquest of their former territories under the eye of a powerful patron: at this time Pir Ahmed of Karaman was one such and Uzun Hasan's nephew, son of the dispossessed ruler of Sinop on the north Anatolian coast, another. By the time Mehmed left Istanbul, he had learned that an army under the command of another of Uzun Hasan's nephews, Yusuf Mirza, was approaching the former Ottoman capital of Bursa, having made substantial territorial gains in its progress across Anatolia. Superior Ottoman strength forced a retreat, Yusuf Mirza was captured, and Pir Ahmed of Karaman, who was with him, fled.

An incursion by Uzun Hasan across the Euphrates into the northern Mamluk lands late in 1472 briefly served to unite Mamluks and Ottomans against him. The immediate provocation for this campaign may have been related to a conflict which arose over whether the palanquin of the Mamluks from Cairo, or that of Uzun Hasan (as possessor of the former seat of the caliphate, Baghdad), should take precedence in the ceremonies relating to the annual pilgrimage to Mecca. As a result of this campaign Uzun Hasan temporarily gained control of the Taurus passes to the Mediterranean where

his seaborne Venetian allies were active.[67] Uzun Hasan's aggressive posturing gave Sultan Mehmed good reason to fear the Venetian–Akkoyunlu pact, but his invitation to Venice and Hungary to send envoys to Istanbul to discuss peace may have been a feint to isolate Uzun Hasan from his European allies.

Uzun Hasan's incursion into Mamluk Syria in 1472 led Sultan Mehmed to think the time ripe for a full-scale campaign against the Akkoyunlu leader. On 4 August 1473 the two armies met on the Euphrates east of Erzincan in an inconclusive encounter which caused the Ottomans great loss. A week later, on 11 August, they met again at Başkent, in the mountains to the north; Uzun Hasan fled at the sight of an Ottoman army well-supplied, unlike his own, with cannon and hand-guns, and his forces were routed.[68] For a quarter of a century Ottoman familiarity with the weapons of the gunpowder age gave them the advantage over their eastern rivals.

Uzun Hasan lost little territory by his defeat, as Sultan Mehmed did not follow up his victory. For the Ottomans, the determined resistance of foes who were opposed to the extension of their rule in this direction was compounded by the logistical challenge of conducting military operations in the inhospitable terrain of their eastern frontiers. Aware of the problems of holding their gains here, Ottoman commanders often pulled back to more defensible borders. Uzun Hasan's defeat at the hands of a ruler who, like him, claimed divine inspiration had the significant effect of undermining his prestige and his claims, and Mehmed's reputation was correspondingly enhanced. As was customary after a victory, letters announcing his success to the princes of the Islamic world were despatched. Weapons in the propaganda war, these letters appropriated to Mehmed the hyperbolic epithets formerly applied to Uzun Hasan when his power seemed to be in the ascendant. Internal rebellion was a more immediate and practical consequence of Uzun Hasan's defeat.[69]

Uzun Hasan's removal from the scene gave the Ottomans the opportunity to annex the ever-troublesome state of Karaman once and for all and in 1474 the commander Gedik ('Fortress-builder')[70] Ahmed Pasha was sent with an army to conquer the Karamanid heartland in the Taurus mountains and to take the fortresses captured by the Karamanids with the help of their crusading allies. Ottoman administrative policy sought to reduce tribal chiefs to the status of provincial cavalrymen and to encourage their followers to settle in villages and towns, but the tribal population of Karaman – particularly the Turgudlu and Varsak Turcomans – proved especially reluctant to accept the new order. Hard to pacify, they held out in their mountain fastnesses beyond the turn of the century, evading Ottoman

inspectors sent as and when local conditions permitted to assess the taxable resources of the new province.

Sultan Mehmed gave the development of his navy a high priority. From earliest times the Ottomans and the other Anatolian emirates had used the seas as a line of defence. The Ottomans had built dockyards when they first gained a coastline on the Sea of Marmara in the mid-fourteenth century; once they had crossed into Thrace, the need to defend themselves against the Venetians in particular gave naval matters a new urgency. A large dock-yard at Gelibolu in the 1390s[71] was augmented by the dockyards built in the emirates of the Anatolian Aegean coast once these were annexed by the Ottomans. Yet although the Ottoman navy gradually began to enjoy successes against the Venetians and Genoese in coastal waters, and could carry out raiding expeditions over longer distances, it was no match for the warships of these two trading powers in close battle in the open seas. After he took Constantinople Sultan Mehmed established a large dockyard in the Golden Horn, using the fleet of war vessels built there to gain control of the Black Sea basin, and also to carry his ambition further afield across the Mediterranean. The new balance of power coming into being demanded versatility, and Mehmed had to meet the challenge of projecting Ottoman might over ever-greater distances at sea as well as on land.

In 1475 an armada under the command of Gedik Ahmed Pasha, now grand vezir, sailed to the Crimea and annexed Caffa and other lesser Genoese possessions as well as the Venetian port at Tana. Following the establishment of a presence in the Crimea, a smaller Ottoman fleet sailed for the north-eastern Black Sea and captured the fortresses of Kuba, near the outlet of the Sea of Azov, and Anapa, on the coast to the east of the Crimea, from their Latin lords.[72] The southern littoral of the Crimean peninsula was thereafter an Ottoman sub-province which probably also included Tana (now Azov), Kuba and Anapa. In 1478, on resolution of a twelve-year succession struggle among the sons of Hacı Giray Khan, the remainder of the Crimean lands accepted Ottoman overlordship with Mengli Giray as khan.[73]

The annexation of territory by the Ottoman Empire was not infrequently occasioned by infighting among claimants to the throne of a vassal state, as had happened when the rivalry among the heirs of İbrahim Bey of Karaman after his death in 1464 precipitated direct Ottoman intervention and hastened the end of Karamanid independence; disputes in hitherto independent states could also present the Ottomans, as the strongest power in the region, with the opportunity to intervene and impose vassaldom. The Tatars were set apart from other Ottoman vassals by their descent from

Genghis Khan; this was signified by the fact that where other vassals paid tribute to the sultan, the Tatar khan received an annual stipend and other emoluments in recognition of his unique status.[74] The Tatars had much to contribute: their horsemen were admired for their speed and agility, and played a vital role in Ottoman campaigning armies in both east and west.

Following their conquest of Constantinople and hold on the Straits the Ottomans were the strongest power in the Black Sea basin. It seems that they understood that attempting to conquer and hold the boundless, arid steppelands to the north of the Black Sea would be out of the question, and in the succeeding years they efficiently took over the Latin trading colonies situated at strategic points around its coasts to give them control of the commerce passing through them. After Crimea became an Ottoman client, Ottoman influence in the affairs of the northern Black Sea region and the ability to manipulate them to its own advantage increased.[75]

As Sultan Mehmed gradually achieved his strategic aims in the west, Ottoman territory increasingly formed a compact block, with only a few isolated fortresses remaining in enemy hands. Although Mehmed's attempts to reduce Nafpaktos failed, Krujé and Shkodër in northern Albania surrendered to the Ottomans in 1478 and 1479 respectively, the latter despite determined resistance from its Venetian garrison. Attacks on Venice – intended to forestall any Venetian military operations on the Ottoman north-west frontier – increasingly took the form of devastating raids which, in the mid-1470s, penetrated deep into Friuli towards the city itself. Uzun Hasan's death in 1478 contributed to Venice's decision to sue for the peace which was concluded in 1479. In the final stage of hostilities the Ionian islands of Cephalonia, Santa Maura and Zante, in possession of the Tocco family, clients of the king of Naples, were seized by the Ottomans. Following the peace with Venice, Ottoman raiding took a new and aggressive direction, into Transylvania and what is today southern Austria. These raids were conducted by the irregular light cavalry known as *akıncı*, who were rewarded with the lion's share of the booty they captured. A vital part of the Ottoman military, they numbered some 50,000 men, both Muslim and Christian, during Mehmed's reign.[76]

Most daring of all, however, were the major naval operations undertaken against the Knights Hospitallers of St John on the island of Rhodes in the eastern Mediterranean and the kingdom of Naples at Otranto on the Italian mainland during the summer of 1480. Rhodes was the most dangerous of the remaining Latin outposts in the Ottoman southern seas, and an anachronism in Ottoman eyes; moreover, it had aided Venice in the recent war. Apart from the nuisance value of its piracy, the strategic location of the island on the sea route from Istanbul to Egypt gave Mehmed

reason enough to wish to conquer it. The Ottomans now felt as confident at sea as their Mediterranean neighbours, and the reduction of Rhodes was seen as an essential preliminary to naval operations against Egypt and Syria in support of the land invasion of Mamluk territory which the Sultan was said by Tursun Bey to have been planning.[77] But the siege, a combined naval and land operation, and a severe test of Sultan Mehmed's navy, ended in failure. The Knights had long anticipated a siege and had reinforced the defences of the island accordingly. The Ottoman fleet was commanded by a Byzantine renegade, Mesih Pasha. He reached the harbour of Marmaris, on the Anatolian mainland opposite Rhodes, on 23 May and ferried the army of 60,000 men – who had marched overland from Istanbul – to the island, where they camped overlooking the town. After two failed assaults the Ottoman cannon and mortars bombarded the town and miners dug trenches. The defenders still resisted and rejected Mesih Pasha's offer of peace. A further Ottoman assault on 28 July failed, and the besiegers retreated with great loss of life. By mid-August two ships sent to the aid of the Knights by King Ferrante of Naples reached the island with the news that the Pope had promised to send help. This caused Mesih Pasha to embark his troops and sail back to Istanbul.

At the very time that Ferrante's two ships were sailing to assist the Knights, an Ottoman fleet under Gedik Ahmed Pasha was setting out from the southern Adriatic port of Vlorë (Valona) to attack his territory. The fortress of Otranto, only a day's sail away, fell within two weeks. The arrival of Ottoman troops on Italian soil induced frantic diplomatic activity among the Italian states, who seemed inclined for once to forget their rivalries and unite in their common defence.[78] Whether this attack on the south Italian mainland was a first step towards the fulfilment of an ambition to capture the seat of the popes at Rome remains a matter of speculation, since Mehmed had died before his intentions became clear. Among the titles Sultan Mehmed claimed for himself was that of 'Roman Caesar', signifying his aspiration to succeed to the mantle of the Byzantine Empire at the height of its greatness under Constantine and Justinian; whether it was also intended to communicate that he had designs on Rome itself is disputed. After Constantinople, the capture of Rome represented the ultimate prize. If Rome was Mehmed's goal, it is surprising that it was not mentioned by Aşıkpaşazade, a chronicler decidedly in favour of holy wars, and was referred to only in passing by other chronicles written in the fifteenth century.[79] At the very least, Mehmed did not attempt to secure his foothold on the Italian peninsula as he might have been expected to do if he indeed had designs on Rome: the next year he headed east, not west.

In the last days of April 1481, Sultan Mehmed crossed the Bosporus to the army mustering-ground at Üsküdar, ready to lead his army through Anatolia. On 3 May, only one stage further on, at a spot near Maltepe known as 'Sultan's Meadow', he died, aged 49, possibly from complications associated with his gout.[80] Although he had a history of ill-health his death was unexpected, and he had not designated a successor. His thoughts on the subject were contained in the law-code he had promulgated a few years earlier, in which he gave formal sanction to the practice of fratricide, stating that it was appropriate for whichever of his sons became sultan to do away with the others 'for the sake of the good order of the world'.[81]

Sultan Mehmed's middle son, Mustafa, had been his favourite, but Mustafa had fallen ill and died in 1474 while governing the newly-conquered province of Karaman from his seat at Konya. Two sons survived: Bayezid, who was prince-governor at Amasya, and Cem, who had succeeded Mustafa in Konya.

In his thirty years in power Sultan Mehmed had fought eighteen campaigns in person. The Ottoman Empire which he created was an extensive mass of land and sea which sat at the hub of the great trading networks of the time. Moribund and depopulated, Byzantine Constantinople had been remade as the flourishing capital of territories that included the Balkan peninsula as far as the Adriatic in the west, the Danube–Sava line in the north, and most of Anatolia. The Black Sea coast marked a relatively safe frontier beyond which there were at this time no states capable of threatening Ottoman power. Rivals still threatened to east and west, but within the limits of Mehmed's state a pax ottomanica brought a measure of internal security which was disturbed only by localized brigand activity on land and corsairs at sea.

Control of the ports of the Black Sea brought control over the trade of the vast steppe hinterland extending as far afield as Poland, Lithuania, Muscovy and Iran which, formerly so important to the wealth of Genoa and Venice in particular, now contributed to Ottoman prosperity. Silk came from the northern provinces of Iran to Bursa, the main Ottoman emporium, and from there, most of it went on to the Italian states, either as raw silk or as Bursa silk cloth. Another luxury the Italians imported was mohair from the Angora goat, while with the money they made from the sale of their silk, Iranian merchants bought woollen cloth exported from Europe. Spices from India and Arabia were in transit westwards or for use by the Ottomans.[82] A study of the customs registers of Feodosiya in the Crimea shortly after Sultan Mehmed's death – when, with the seizure from Moldavia of the Danubian port of Kiliya and the Dniestrian port of Bilhorod in 1484

and the acceptance of vassalage by the Voyvode, the Black Sea became in effect an 'Ottoman lake' – shows the range of goods being traded: cotton and cotton goods, silk goods, woollens, grain and fruit and forest products, raw minerals and worked metals, skins and hides, spices and sugar and honey, dyes and alum.[83]

Once in possession of an imperial capital, the Ottomans developed the court ceremonial to go with it. Muscovy, mainly trading through Feodosiya, exported luxury furs such as sable, ermine, black fox and lynx which became a vital component of the Ottoman royal image, used for trimming the splendid robes worn at court and presented by the sultan to high dignitaries as a mark of his favour.[84] Falconry was as much the sport of sultans as of kings, and these birds also were brought south from the steppes to the Ottoman court. The trade in slaves flourished too: the previously sporadic forays of the Crimean Tatars became more regular as they raided northwards into southern Poland and Lithuania in particular, to satisfy the demands of the Ottoman slave market at significant financial profit to themselves – one authority puts at 18,000 the number of captives seized by the Tatars in Poland in their first major raid in 1468, for instance, and in subsequent years the total could be many thousands more.[85] As the first power to establish an amicable relationship with the people of the steppes, the Ottomans effectively prevented their northern neighbours from entering the Black Sea for years to come and their imposition of stability in the region allowed them to concentrate their attention on other frontiers.[86]

Control of the commercial networks of the Mediterranean and the Black Sea allowed Mehmed to impose customs duties for the benefit of his exchequer. Strategically-deployed agents and middlemen taxed goods in transit through the Ottoman territories as well as those destined for internal consumption. Like his predecessors, Mehmed granted the trading privileges known as 'capitulations' to foreign merchants; the main beneficiaries at this time were the various Italian states. Such privileges were apt to be interrupted during times of war, and in view of the rivalry between them, favour shown to one or other of these states could be a useful weapon in the hands of the sultan.[87] Foreign merchants reckoned the customs dues imposed under the capitulatory regime a small price to pay for access to the raw materials available throughout the extensive territory under Ottoman authority. The Ottomans favoured a notional 'command economy', in which their foremost responsibilities were to maximize the wealth in the treasury and prevent shortages in the market-place – especially in Istanbul. Although this principle could only ever be partially implemented, the subordination of economic to political and social priorities which it implies serves to emphasize the different vision of their western trading partners, who seized any opportunity to increase economic

activity and profits. These two economic views complemented each other to the ultimate disadvantage of the Ottomans who could not envision that the western states' eagerness to enter into capitulatory agreements with them would, in later centuries, work to the detriment of their own economic – and political – well-being.

The Ottoman economy was overwhelmingly dependent on agriculture and continued to be so into the twentieth century: even today, 40 per cent of the population of the Turkish Republic is rural. It was only partly monetarized; the value of goods delivered to or services performed for the state and its agents was not easily quantifiable in monetary terms. Some idea of the sources of treasury revenue during Mehmed's reign is given by the contemporary historian Laonicus Chalcocondylas, who considered that the Ottoman treasury derived the greatest proportion of its income from the poll-tax levied on non-Muslims: the policy of allowing subject populations to retain their pre-conquest faith thus brought considerable financial benefit, and this in turn discouraged Muslim proselytizing. Further elements contributing to the balance sheet, he said, were taxes on livestock and agricultural produce, and on trade and mines. Tribute paid by Ottoman vassal states also entered the treasury, as well as monies from the sale of slaves – Islamic law gave the ruler a right to one-fifth of the booty captured in any war against infidels. A final item of income, reported Chalcocondylas, was represented by the 'gifts' made to the sultan by military and other state officials as he set out on campaign every spring: this revenue was again paid out directly to support the sultan's elite troops and his court and government officials.[88]

Military campaigning and the establishment of direct rule in newly-conquered territories were heavy charges on the treasury and the cost of maintaining the state grew as the Ottoman realm expanded and administration become more complex. Even before Sultan Mehmed's reign the standing army of elite troops comprised the infantry janissaries and six regiments of cavalrymen. A contemporary source informs us that at the time of his victory over Uzun Hasan at Başkent in 1473, the janissaries numbered 12,000 and the sultan's cavalry 7,500.[89] These troops were paid salaries every three months, as were the corps of cannoneers and armourers and the transport corps. By contrast, the provincial cavalrymen, who are usually referred to in English as timariots, were awarded the right to collect peasant taxes, each from a precisely-defined amount of land or fief (timar), in exchange for which they were obliged to appear on campaign with their men.

The establishment of Ottoman administration across the empire took different forms at different times and in different places. Rather than imposing a clean break with the past, the Ottomans tended to preserve pre-existing

arrangements. The model widely applied in newly-conquered areas relied on a survey of their land and resources. These assets, which theoretically remained the property of the sultan, were parcelled out to be enjoyed by various of his subjects. Peasants had the use of farmlands, and were taxed on their produce to support the provincial cavalry or charitable foundations. Land, or more properly the tax revenues deriving from it, could also be held as freehold: such outright grants were often made for dervish lodges in the early years and increasingly, as time went by, to high officers of state and favoured individuals who often converted these gifts into charitable foundations.[90]

Sultan Mehmed confiscated much freehold land, and land which supported charitable foundations, so that it could be awarded as benefices to the provincial cavalry whose manpower was so vital for his frequent military campaigns.[91] In the Balkans the dispossession in favour of provincial cavalrymen of marcher-lords who had won territory by force of arms, or of those such as dervishes who had been awarded the use of state lands, was highly unpopular. The reform had less radical effects in some areas of Anatolia where it simply meant that the status of the local, pre-existing, Muslim aristocracy was altered to that of provincial cavalrymen who retained their traditional revenues from the land;[92] it was reversed under Mehmed's successor, Bayezid II.

The rebuilding of Mehmed's new capital and supplying it with goods and services was a heavy burden on the finances at his disposal. His search for ready cash led him to debase the coinage on six occasions, but there is no record of further protests by the janissaries like those which greeted his first debasement during his brief occupation of the throne at the time of his father's abdication in 1444–6.[93]

In its heyday the governing class of the Ottoman Empire was largely composed of men who had entered Ottoman service through the youth-levy imposed upon the sultan's Christian subjects. Initially confined to the Balkans, by the end of the fifteenth century the youth-levy had been extended to Anatolia. Certain areas – Istanbul and Bursa, for example – were not liable. Albanian, Bosnian, Greek, Bulgar, Serbian and Croatian boys were preferred; Jews and boys of Turkish, Kurdish, Persian, Ruthenian (roughly, Ukrainian), Muscovite or Georgian stock were exempted, while Armenians were taken only for service in the palace, not in the armed forces.[94] At first used to connote the clan of Osman and its followers, the term 'Osmanlı' or 'Ottoman' came to signify a member of the ruling class, one of the 'sultan's servants', schooled to serve the state in war and peace. Peasants and provincials of whatever faith were subjects of this state and known as re'aya, from the Arabic word for 'flock'.

Although Sultan Bayezid I is credited with institutionalizing the youth-levy as a means of recruiting manpower for the army and the bureaucracy, new evidence suggests that the practice may have originated earlier, during the reign of his father Murad I, when it was applied not by the Sultan but by the marcher-lord Gazi Evrenos Bey in Macedonian territory conquered by his frontier forces in the 1380s.[95] Once adopted by the sultans, the success of this method of building up a professional, salaried army with strong ties of allegiance to them and the dynasty came, however, at the expense of those who had formerly been in the vanguard of conquest, the Muslim marcher-lords of Rumeli, like Gazi Evrenos himself, and their raiding troops. The term 'new force' that was used to denote the infantry of the standing army indicated the radical transformation that was under way. Over time the Ottoman governing class altered in character with the predominance of those who were Christian-born and non-Turkish in origin.

Nevertheless, Muslim marcher-lords continued to play a leading role in the conquests of the Ottoman state up to and including the reign of Sultan Mehmed II, especially in the Balkans. North-west of Thessalonica, at the heart of their domains in southern Macedonia and western Thrace, lay the seat of the Evrenosoğulları in the town of Giannitsa. Although Gazi Evrenos' sons supported the 'False' Mustafa during the struggle to succeed Bayezid I, they were pardoned by the ultimate victor, Sultan Mehmed I, and Gazi Evrenos' grandsons played crucial command roles in many campaigns.[96] In Thessaly, where Turahan Bey founded the town of Larisa, the Turahanoğulları were the architects of the Ottoman conquest. Turahan Bey, his son Ömer Bey and his grandson Hasan Bey left a rich legacy of charitable foundations in Thessaly, some sixty buildings including nineteen mosques, twelve dervish lodges, eight bath-houses and three public kitchens.[97] In Thrace lay the estates of another prominent dynasty of the early years of the Ottoman state, the Mihaloğulları. The names of scions of this dynasty occur often in the records of the Ottoman conquests in the Balkans; like the sons of Gazi Evrenos, one of the sons of the founder Köse Mihal chose to support a loser in the succession struggle of the early fifteenth century, in his case Prince Musa.[98] Although members of these and the other warrior families to whom the Ottoman dynasty owed its success continued to hold provincial office in the Balkans and enjoy the privilege of dispensing heritable fiefdoms to their followers,[99] as the system based on the youth-levy expanded, they saw their former prestige diminish.

Another group whose influence also waned during Sultan Mehmed's reign was the Anatolian Turkish religious scholar-aristocracy of which the Çandarlı family were the leading representatives. For a century from the

reign of Sultan Orhan, the Çandarlı had acted as confidants to the Ottoman sultans. Kara Halil Hayreddin Çandarlı served as grand vezir to Murad I, and two of his sons also held this post. In 1443, the grand vezir appointed by Murad II was Kara Halil's grandson Halil Pasha. Çandarlı Halil was kept on by Mehmed II as grand vezir after Murad's death, but his attempts to dissuade Mehmed from besieging Constantinople hastened his end: he was said by Muslim and Christian writers alike to have been in league with the defenders of the city,[100] and was executed soon after its capture. His untimely death can now be seen as symbolic of the diminishing role which the old Turkish families were to play in the future of the Ottoman state. Of Mehmed's seven grand vezirs, one was a Turkish-born Muslim, two were Christian-born converts raised by the youth-levy, two were Christian-born scions of the Byzantine or Byzanto-Serbian nobility, and the last was also Christian-born but of unknown origin.[101]

A footnote to the career of Çandarlı Halil Pasha is the curious episode of the pretender 'Bayezid Osman'.[102] In June 1456 Francesco Sforza, Duke of Milan, received a report concerning a young boy supposedly brother to Sultan Mehmed and said to have been entrusted by Murad II to a Latin knight, one Giovanni Torcello. The boy had come into the hands of agents of Pope Calixtus III, and reached Venice in the spring of 1456. From Venice he was taken to the Apennine fortress of Spoleto. In a work appearing in 1458, Çandarlı Halil Pasha was credited with a role in sending the boy to Italy. The truth or otherwise of this assertion remains unknowable, but the subsequent adventures of 'Bayezid Osman' are not without interest. The European rulers into whose hands he fell seem to have made little effort to press the boy's putative claims to the Ottoman throne. 'Bayezid Osman' remained in Spoleto until 1459, when he was taken along by Pope Pius II on his progress through Italy which culminated in the Congress of Mantua, at which a crusade against the Ottomans was proclaimed. In 1464 the Pope again paraded his charge in public; he had the boy, now sixteen, bid farewell to the fleet setting off from Ancona against the Ottomans, a scene commemorated in a fresco in the cycle of Pius II in the Duomo of Siena. The next year 'Bayezid Osman' was in Venice, and he later turned up at the court of King Matthias Corvinus in Buda. By 1473 he was at the Viennese court of Holy Roman Emperor Frederick III who, it seems, loved to dress in the Ottoman style, and toured 'Bayezid Osman' around his domains in his retinue. In 1474 'Bayezid Osman' married an Austrian noblewoman, and subsequently disappeared from history's view. It was a tribute to the prestige of the Ottoman dynasty that, like the vanished Byzantine emperors, Catholic monarchs embraced the role of protectors and manipulators of pretenders to the sultanate.

★

The empire Sultan Mehmed II set out to create was very different from the state his predecessors had won with such effort when the Ottoman dynasty was little more than first among its equals – the other Muslim Turkish dynasties of Anatolia. The practice of recruiting Christian converts into the Ottoman governing class came to be seen as more appropriate to his new and ambitious vision of the future direction of the imperial state. The power enjoyed by the grand vezir as the sultan's executive officer increased – although the sultan could wield the ultimate sanction of dismissal or execution. The status of the religious establishment was also enhanced under Mehmed II. The extensive area accorded in his mosque complex to theological colleges, and their situation on either side of the mosque – as though to encompass it – can be seen as symbolic of the prominence he intended the religious establishment to enjoy. By the same token, the physical distancing of the dervish lodge from the mosque – where formerly space had been provided within one building for dervish rituals alongside those of orthodox Islam – can be interpreted as a diminution of their place at the heart of religious practice.[103] Mehmed restricted the activities of those dervishes opposed to the increasingly centralized direction in which the state was moving; those prepared to support him enjoyed relatively greater acceptability.

From the time of Sultan Mehmed II the janissaries and other units of the standing army became the main tool for protecting and expanding the Ottoman domains. At their head was the sultan, although his active role as foremost of the 'warriors for the faith' was increasingly tempered by his desire to establish a centralized bureaucratic state. Inspired by Çandarlı Halil Pasha's manipulation of the janissaries in Edirne when his father Murad II was still alive, Mehmed strove to exert his authority over them, but was never able to bend them completely to his will. On his accession in 1451 he found it necessary to give in to their demands for a bonus to mark the event, a practice apparently begun by Bayezid I but from now on expected.[104] Problems arose again when the janissaries mutinied in 1455 during the winter campaign to take the port of Enez, at the mouth of the Maritsa, from the Genoese, and again at the time of the unsuccessful siege of Belgrade in the following year.[105] Mehmed's successors were no more fortunate and the dire consequences of failing to keep the janissaries in check were apparent on many occasions in the course of the Ottoman centuries.

During his last years, Sultan Mehmed undertook a programme of legislative consolidation and centralization. The architect was Karamani Mehmed Pasha, grand vezir from, probably, 1476 until Mehmed's death – the exact dates of appointment and dismissal of Mehmed's grand vezirs are disputed – who enjoyed a distinguished career in the administration of the empire.

Like the Çandarlı, he came from an aristocratic Turkish background, a descendant of the mystic Mevlana Jalal al-Din Rumi, founder of the Mevlevi order of dervishes.[106] Two law-codes are known from Mehmed's reign: the first contains penal clauses as well as regulations to do with the taxation of the subject population; the second is concerned with the forms of government and the relationship between its parts. Allusions in the codes to 'the ancient law' or 'the ancient custom' make it clear that they largely dealt with the formalizing of regulations which were already current. It is a matter of scholarly debate, however, which parts of the extant versions of these law-codes do in fact date from Mehmed's time and which clauses were inserted in later reigns by way of updating. Mehmed was the first sultan to promulgate laws applicable to areas of state life – such as public administration – which were not catered for in religious law; although neither of his codes refers to the religious law, and although their legality depended directly on the will of the sultan, their provisions do not contradict those of religious law.[107] Reviewing Sultan Mehmed's policies, the polemical, pro-dervish chronicler Aşıkpaşazade, who wrote between 1476 and 1502, held Karamani Mehmed responsible for the downturn in the fortunes of the dervishes and marcher-lords through his programme of returning state revenues to government control.[108]

Another development during the reign of Mehmed II was that a new pattern of alliances emerged, whereby the holders of the highest offices of government were tied to the Ottoman dynasty through marriage – this pattern continued to the end of the empire. As the states into whose ruling families the Ottoman dynasty had formerly intermarried with a view to commanding allegiance in a world of shifting loyalties became absorbed into the Ottoman domains – Byzantium, Serbia and Karaman, for instance – so there came about a dearth of suitable marriage partners for the sultans and members of their families. Following the execution of Mehmed's first grand vezir, Çandarlı Halil Pasha, the office seems to have been held by Zaganos Mehmed Pasha, Mehmed's mentor and confidant since childhood, who had been certain that Constantinople would fall to his master. He was a Christian convert whose daughter was married to Mehmed.[109] Zaganos Mehmed Pasha was succeeded as grand vezir by the former Serbian prisoner-of-war Mahmud Pasha Angelović, who was married to another of the Sultan's daughters. Appointed in recognition of his prowess at the failed siege of Belgrade in 1456, he held the office until 1468, when he fell victim to the intrigues of a rival, Rum Mehmed Pasha, who may have been captured at the conquest of Constantinople. A talented military commander, Mahmud Pasha accompanied Sultan Mehmed on many of his most successful campaigns.[110] Writing around the turn of the century the chronicler Mehmed

Neşri said of him that it was as if the Sultan had abdicated in favour of his grand vezir.[111] The pretext for Mahmud Pasha's dismissal from the grand vezirate appears to have been that he was selective in carrying out the deportation of the Karamanid population to Istanbul after the campaign of 1468, allowing the rich to remain behind. He also seems to have been overly well-disposed to the insubordinate Karamanid prince Pir Ahmed.[112] Rum Mehmed is chiefly remembered through the hostile eyes of Aşıkpaşazade, whose family was adversely affected by the introduction of taxes on properties in Istanbul which Sultan Mehmed, in the first flush of conquest and with the aim of revitalizing the city, had ordered should be exempt. In questioning Rum Mehmed Pasha's motives, Aşıkpaşazade resorted to the slur that he was acting as a Byzantine agent. Some of these taxes were cancelled once Mehmed's son Bayezid came to the throne in yet another change of policy.[113]

Mahmud Pasha was reinstated as grand vezir in 1472, but he never again enjoyed the Sultan's complete trust. After playing a controversial role in the 1473 campaigns against Uzun Hasan and his forces, he was dismissed in favour of an ambitious rival, another talented commander on land and sea, Gedik Ahmed Pasha, also of the Byzantine or Byzanto-Serbian nobility.[114] He was appointed to the grand vezirate in Mahmud Pasha's stead but near-contemporary observers blamed Mahmud Pasha's final demise on his bad relations with Sultan Mehmed's son Prince Mustafa. The chroniclers of the time do not note any reason for the enmity between the Prince and the Grand Vezir, nor for Mehmed's decision in 1474 to execute a man who had been the agent of his designs of conquest over many years. Prince Mustafa, it will be recalled, fell ill and died in 1474; a century later it was suggested that Mahmud Pasha had poisoned the Prince in revenge for the latter's violation of his *harem*. A contemporary document which came to light 500 years after the event gives details of a legal dispute over his will between Mahmud Pasha's daughters of his first marriage and his second wife. The second wife had apparently been divorced by Mahmud Pasha on his return from the campaign against Uzun Hasan in 1474, because he heard that she had impugned his honour by spending a night in the house of Prince Mustafa's mother when the Prince was in residence: since her husband was away and she went to the Prince's mother's house at night, a scandalous interpretation of her behaviour was unavoidable.[115] Mahmud Pasha was the injured party, but paid with his life for his failure to keep his wife under control. The life of the highest-ranking statesman in the empire was an uncertain one, even when he was a favourite of the sultan.

Sultan Mehmed's predecessors had laid the foundation for a state ruled over by an absolute sovereign and administered and protected by a slave caste

of 'sultan's servants' who served him undividedly; Mehmed's grand aspirations and ambitious vision further developed this idea. He saw himself as the legitimate heir to Byzantium and as having realized Islamic traditions that the peerless city of Constantinople would one day be Muslim; and also as the epigone of the heroes of the Classical world. He knew some Greek, and his interest in the ancients must have been widely known in contemporary political circles. It was alluded to in his own time by the Venetian Niccolò Sagundino, a native of Euboea, in his account of the Ottomans. Mehmed, wrote Sagundino, was fascinated by the Spartans, the Athenians, the Romans and the Carthaginians but identified above all with Alexander of Macedonia and Julius Caesar.[116] The Byzantine Critoboulos of Imbros (Gökçeada) wrote in the preface to his eulogistic biography that Mehmed's exploits equalled Alexander's:

> Seeing that you are the author of many great deeds . . . and in the belief that the many great achievements of generals and kings of old, nor merely Persians and Greeks, are not worthy to be compared in glory and bravery and martial valour with yours, I do not think it just that they and their deeds and accomplishments . . . should be celebrated and admired by all . . . while you should have no witness for the future . . . or that the deeds of others . . . should be better known and more famed . . . while your accomplishments . . . [which are] in no way inferior to those of Alexander the Macedonian . . . should not be set forth . . . nor passed on to posterity.[117]

Mehmed fostered this identification of himself with great warriors of the past. On his way to win Lesbos from the Venetians in 1462 he visited Troy, where he viewed the ruins, noted the advantageous location of the site, enquired about the tombs of the heroes of the siege, Achilles and Ajax and others, and remarked that they had been fortunate indeed to have been extolled by a poet such as Homer.[118] Soon after, he had the *Iliad* and the standard life of Alexander, Arrian's *Anabasis of Alexander the Great*, copied for his library.[119] The historical tradition Sultan Mehmed tried to keep alive and of which he felt himself to be part reached far back into the past, but his eyes were set on a brilliant future for his empire.

4

Sultan of the faithful

SULTAN MEHMED II established firm rule over the Ottoman domains, yet he was unable to exert a similar authority over his own household. After his death, rivalry between his two surviving sons Bayezid and Cem (known as Cem Sultan) greatly disturbed the tranquillity of the state. Bayezid was successful in claiming the throne but the challenge to his right to rule posed by his charismatic younger brother continued until Cem's death in 1495.

A second challenge was less easily dealt with, and continued to plague both Bayezid and his son and successor Selim I: although to western states the victorious Ottomans seemed a perpetual threat, the Ottomans themselves were preoccupied with danger from the east in the shape of the Safavid state of Iran and the allure it held for the Turcoman people of eastern Anatolia – whom Mehmed II had tried by force to bring into his empire.

At the time of Sultan Mehmed's death, Cem was prince-governor of the Ottoman province of Karaman from his seat at Konya and Bayezid was at Amasya, administrative centre of the frontier province of Rum which he had governed – if only in name during his childhood – since 1454. He had served as commander of the east Anatolian frontier during his father's reign and distinguished himself in campaigns against Uzun Hasan and the Akkoyunlu. His court at Amasya was a refuge for those who opposed his father, particularly during Mehmed's final years when Grand Vezir Karamani Mehmed Pasha was working to increase the authority of central government over the provinces. Whereas Mehmed had educated himself in the Classical and Byzantine legacy to which he imagined himself heir, Bayezid sought the company of teachers of Islamic science and philosophy, poets and mystics, men whose intellectual roots lay in the east.[1]

Islamic practice requires that corpses be buried as soon as possible but Mehmed II's body was neglected after it was secretly brought into Istanbul the night after he died, and it was three days before perfumed candles were lit beside it to temper the smell.[2] Karamani Mehmed Pasha had attempted to realize what he supposed to be the late Sultan's wish, the succession of

81

Prince Cem rather than Prince Bayezid, by sending both brothers notification of Mehmed's death: Konya being closer to the capital than Amasya, he hoped that Cem would arrive to claim the throne before Bayezid. But the janissaries supported Bayezid, and Karamani Mehmed's strategy enraged them. Despite the secrecy, news of Mehmed's death had spread, and when Karamani Mehmed tried to prevent the janissaries from returning to Istanbul – which they had been forbidden to do – they killed him. His murder clearly demonstrated that the janissary corps, created by the Ottoman sultans to be their loyal guard and the elite force of their army, was an unreliable monster which put its own interests before those of its masters.

The arrival of the corpse in the capital and Karamani Mehmed Pasha's murder provoked uncertainty and days of rioting. A former grand vezir, İshak Pasha, who had remained in Istanbul in the absence of the Sultan and Grand Vezir on campaign, understood the importance of the unfolding drama. He wrote begging Bayezid to hurry and seized the initiative by proclaiming Bayezid's eleven-year-old son Prince Korkud regent until his father should reach the capital. Such had been Mehmed's fear of a rival within his own family during the last years of his reign that Korkud had been held in Istanbul in case he became a focus of loyalty for those opposed to his grandfather. The proclamation of Korkud's regency quelled the looting and disorder and the pro-Bayezid faction rallied to halt Cem's advance. Bayezid's partisans included two of his sons-in-law who held positions of influence in ruling circles: the governor of Rumeli, Hersekzade Ahmed Pasha, and Sinan Pasha, governor of Anadolu province, who was instructed to block the routes between Konya and the capital. It seems that Sinan Pasha intercepted the messengers sent by the unfortunate Karamani Mehmed to Cem in Konya.

Although Bayezid could be assured of an enthusiastic welcome once he reached Istanbul, Cem had strong support in Anatolia. Cem's army moved from Konya towards the old Ottoman capital of Bursa, meeting with resistance from Bayezid's partisans along the way. Bayezid made the journey from Amasya to claim the throne with some apprehension, but arrived in Istanbul and was proclaimed sultan on 22 May 1481. Mehmed's embalmed body had lain in Topkapı Palace; following Bayezid's arrival it was borne to his mosque for burial.[3] An anonymous and possibly contemporary French report describing the funeral procession provides the curious detail that an effigy of the Sultan was carried atop the coffin. A modern comparison between the ceremonial at Mehmed's funeral and that of the founder of Constantinople, Emperor Constantine the Great, in 337 CE, invites the conclusion that even in death Mehmed nurtured the image of himself as legitimate heir to the capital and empire of the Byzantines.[4] Whereas earlier

sultans and high-ranking members of the Ottoman dynasty had been buried at Bursa, Istanbul, capital of Mehmed's empire, now became the site of sultanic burial, wherever death might have occurred.[5]

Defying his brother's army, Cem established himself at Bursa, where he pursued his claim to the throne by minting coins and having the sermon at the Friday prayer read in his own name. Aware of his weak position, however, he sent his aunt as emissary to suggest to Bayezid that they partition the empire between them.[6] Sultan Bayezid refused, but took seriously the possibility that Cem's popularity might endanger his rule in Anatolia, and recalled the experienced commander Gedik Ahmed Pasha from Otranto. Gedik Ahmed was at Bayezid's side when the brothers met in battle at Yenişehir, east of Bursa; Cem was forced to retreat to Konya, where he arrived on 25 June pursued by Bayezid. Although Cem's army included troops from Karaman and tribesmen who resented Karaman's recent incorporation into the Ottoman state[7] it was not safe for him to remain in Anatolia and, taking his family and advisers with him, he went south across the Taurus mountains to Adana, seat of the Ramazanoğulları, clients of the Mamluks.[8]

Bayezid appealed to his father-in-law Alaüddevle, ruler of neighbouring Dulkadır, to apprehend Cem. That this appeal was ignored demonstrated that Cem was perceived as a real challenger for the throne whom Dulkadır – which like the Ramazanoğlu emirate was a buffer state between the Ottomans and the Mamluks, aligning itself first with one and then with the other of these great powers – could not afford to alienate. From Adana Cem continued to Antakya and then Aleppo, where he entered Mamluk territory, reaching Cairo in late September.[9]

Cem and his entourage, which included his mother Çiçek Hatun, his wife and his immediate household,[10] were greeted with great warmth and ceremony in the Cairo of Sultan Qa'it Bay. Cem made the pilgrimage to Mecca, and on his return to Cairo was approached by a Karamanid prince, Kasım, brother of Uzun Hasan's protégé Pir Ahmed. Like many dispossessed princes before him Kasım saw opportunity in a disputed succession and in the hope of regaining his own ancestral territories proposed to Cem an offensive alliance against Bayezid. Cem accordingly returned to Anatolia early in 1482, to meet Kasım and his army in Adana. They besieged Konya, where Bayezid's eldest son, Abdullah, had been appointed prince-governor in Cem's place, but were beaten off by Abdullah and Gedik Ahmed Pasha. Cem and Kasım marched towards Ankara, but news of Bayezid's own approach from Istanbul compelled them to retreat into Cilicia. Here Cem received an envoy from Bayezid offering him a sum of gold and the opportunity to retire to Jerusalem – but Cem had no intention of withdrawing.[11]

It is not clear why Bayezid thought Cem might agree to settle in Jerusalem, a city deep inside Mamluk territory. Not only were relations between the Mamluk and Ottoman states less than cordial, but Jerusalem was still claimed by western monarchs harbouring dreams of continuing the crusade in Greater Syria. King Ferrante of Naples styled himself 'King of Jerusalem' in letters to Sultan Bayezid negotiating the Ottoman withdrawal from Otranto in 1481–2,[12] and Charles VIII, who became king of France in 1483, was even more ambitious: he not only used the title 'King of Jerusalem' but also, like Mehmed, imagined himself the successor to the Byzantine emperors.[13]

As it had after Tamerlane's defeat of the Sultan's namesake Bayezid I in 1402, the Ottoman Empire again seemed in danger of being partitioned. Kasım Bey of Karaman, less optimistic than Cem about the prospect of successfully pursuing Bayezid across Anatolia, proposed that Cem should instead sail to Rumeli and foment rebellion there (perhaps he had in mind the example of Musa, son of Bayezid I, some seventy years before). But Cem could count on no natural constituency in Rumeli, and had no intention of continuing his struggle from there. His support lay in Anatolia; outside this region he would have ranged against him all the resources of the regular army inherited by Bayezid as the legitimate sultan.[14] Obtaining a safe-conduct from the Knights Hospitallers of St John on Rhodes, Cem set sail with a suite of some thirty companions and servants from the Mediterranean port of Korikos (Corycos) on the south coast of Anatolia and reached Rhodes on 29 July 1482. Kasım had appealed to the Knights for weapons to further his Rumelian adventure but they, reluctant to antagonize Bayezid openly, refused to supply him.[15] Cem spent a month in Rhodes during which time he authorized the Grand Master of the Order, Pierre d'Aubusson, to negotiate with Bayezid on his behalf.[16] He then sailed for France where the Knights could keep him safe from his brother.

At around this time Cem sent Bayezid a couplet in which he expressed his sense of injustice and sadness at his situation:

> A-smile on bed of roses dost thou lie in all delight,
> In dolour's stove-room mid the ashes couch I – why is this?

To which Bayezid replied:

> To me was empire on the Fore-eternal day decreed,
> Yet thou to Destiny wilt yield thee not – why, why is this?
> 'A pilgrim to the Holy Shrines am I' thou dost declare,
> And yet thou dost for earthly Sultan-ship sigh – why is this?[17]

The very day after Cem quit Rhodes for France, ambassadors left the island for the Ottoman court. The Knights were considering how to rally support for a crusade against the vulnerable Sultan, but finding no allies,

hastened to renew their peace treaty with the Ottomans. This treaty, ratified by the end of the year, was broadly similar to that agreed on Mehmed II's accession. Possession of Cem gave the Knights enormous leverage over Bayezid and confidence that the siege of 1480 would not be repeated, at least for the present. Furthermore, they could afford to betray Cem's trust: rather than acting to protect Cem from Bayezid, d'Aubusson charged his envoys in a secret memorandum to intimate to Bayezid that he was willing to discuss Cem's position. Bayezid was alive to the harm Cem might do as the figurehead of a Christian offensive against his empire and, as the secret memorandum had promised, the envoy he sent to take the treaty to Rhodes for ratification by the Grand Master struck a further bargain: reminiscent of the deal between Mehmed II and the Byzantine Emperor Constantine XI over the pretender Orhan, it stipulated that the Knights would keep Cem under guard in France in return for an annual payment by Bayezid of 40,000 gold ducats.[18]

Cem reached Nice on 17 October 1482, and allegedly expressed his amazement at his exotic surroundings in the following couplet:

> How wondrous nice a town this town of Nice,
> Where none is questioned, whate'er his caprice![19]

Two executions followed Cem's departure west. Gedik Ahmed Pasha, former grand vezir and grand admiral, had incurred Bayezid's displeasure for his failure to apprehend Cem when he fled to Egypt; now that the immediate threat posed by Cem had receded, Bayezid had Gedik Ahmed murdered in Edirne. In Istanbul İskender Pasha, warden of the city, was ordered to strangle Cem's young son Oğuz (like Korkud, he had been kept in Istanbul as a hostage since Mehmed II's time), but found himself unable to carry out the grisly murder with his own hands. He administered poison instead.[20]

Bayezid feared Cem was either plotting on his own or, worse, being used by his enemies for their own ends. But Cem's enforced move to France took him further from the throne. Any offensive mounted by Kasım from Rumeli would, he knew, be foiled by the Ottoman fleet, which was under Bayezid's control. Cem also understood that he could expect no help from the West. The Italian states were reluctant to adventure against a proven foe – Naples had regained Otranto, but the shock of the Ottoman seizure of the fortress in 1480 persuaded the King to strike a peace[21] – and though while he was in Rhodes Cem might have envisaged the possibility that King Louis XI would back him, France proved uninterested in promoting a crusade against Bayezid.[22]

From Nice, Cem was moved inland, from castle to castle in south-east

France, his captors motivated by the substantial annual sum they received from the Sultan to guarantee his confinement. Bayezid sent various agents to ascertain his brother's whereabouts and report on what he was doing.[23] One such was a seaman named Barak, who in 1486 travelled from Istanbul across Italy bound for France, a hazardous journey during which he was robbed. He reached Genoa from where he was taken to Turin to see Charles, Duke of Savoy, who, having met Cem earlier and tried to help him escape, was at first suspicious of Barak but agreed to give him a guide if Barak could pay his expenses. Barak failed to raise enough money and took ship from Genoa, intending to return to Istanbul. Alighting on the coast at Rapallo, south of Genoa, however, he overheard a significant conversation – possibly in a tavern: Cem was to be transferred by the Knights to Italy. This prompted Barak to return to Genoa where he managed to raise the money he needed to continue his quest and, with the guide provided by the Duke, set off westwards from Turin; they crossed the Alps by the Mont Cenis pass, following reported sightings of 'Turks' by local informants, until they reached the remote fortress of Bourganeuf in central France, some forty kilometres west of the town of Aubusson, birthplace of Pierre d'Aubusson, Grand Master of the Knights of St John. As Barak reported to his interrogators after his return to Istanbul:

> We asked the tavern-keeper 'Is it time for mass?' . . . 'Yes', he replied. He [i.e. his guide] took me to the church. On entering the church we saw a lot of Knights, each reading from a book in his hand. I stood in a secluded corner. The man conducting me came up and pulled me by the shoulder, and we went out of the church. We saw a number of men in turbans outside the castle by the moat. I saw six persons in turbans. He himself [i.e. Cem] was wearing a garment of black velvet and was chatting with a man with a full beard – he looked like a civilian. He himself had his beard cut short and had let his moustaches grow long, but his face was pale: I asked [my guide] about this and it appears that at that time he had just recovered from illness.[24]

This was as close as he came to Cem. There was no further help from Charles of Savoy, who had a rebellion on his hands, and Bayezid's agent Barak seems to have returned to Istanbul.[25]

Spurred on by Cem's mother Çiçek Hatun, who had remained in Egypt after her son left, the Mamluk sultan Qa'it Bay had on various occasions during the early months of Bayezid's reign corresponded with the Knights of Rhodes about the possibility of having Cem sent back to Cairo, but this was always refused.[26] He intensified his efforts after 1485 when Mamluks and Ottomans were at war, and in 1487–8 approached King Charles VIII of France through an agent of Lorenzo de' Medici and offered 100,000 gold ducats for the return of Cem to Cairo.[27] But by this time the nego-

tiations of which Barak had overheard mention were under way: the Pope, Innocent VIII, was seeking to persuade King Charles that the interests of Christendom would be best served if Cem were handed over to him. In March 1489 Cem reached Rome and the Vatican; he was 29 years old.

With Cem in his hands, the Pope began to rally support for an ambitious crusade against Bayezid, and in autumn 1489 sent an envoy to Qa'it Bay to initiate negotiations for Mamluk help.[28] Qa'it Bay, still hoping to have Cem returned to his custody, promised Innocent that the former Crusader kingdom of Jerusalem could be re-established if he sent Cem to Egypt.[29] But in 1490 Matthias Corvinus – who had tried for years to gain custody of Cem, whether on his account or on behalf of Qa'it Bay[30] – died, and a new diplomatic era began. Ambassadors were exchanged between Bayezid and the Pope and an agreement eventually reached which was essentially the same as that between the Knights of Rhodes and Bayezid. The Pope undertook to be Cem's custodian and not to use him against Bayezid, in exchange for which he would receive an annual sum of 40,000 gold ducats – and Christian relics such as the head of the lance that had pierced Christ's side at the crucifixion, preserved in Istanbul since the fall of Constantinople. The bargain was concluded with much bad faith on both sides.[31]

As Cem's years in captivity went by, boredom set in. In the impregnable tower constructed to house him at Bourganeuf – which survives today – his life in exile with only a few servitors for company began to pall, and his zest for pursuing his quarrel with his brother waned.[32] Once he had arrived in Rome, considerable sums were spent on his comfort but Cem wanted nothing so much as to return to his homeland, or failing that, he wrote, to live out his days in Iran, the Arab lands or India.[33] Even with the possibility of a crusade looming, he told the Pope that he could not abandon his faith 'even for the rule of the whole world'.[34] In letters taken to Bayezid from Rome, Cem expressed his great desire to leave his prison, and must have been sincere when he said that he was ready to forget their differences and swear allegiance to his brother.[35]

As a captive in Rome, Cem might have been aware of a drama being played out even further from his homeland that would have repercussions there. On 2 January 1492 the city of Granada in Andalusia in southern Spain, seat of the Islamic Nasrid dynasty, fell to the armies of Ferdinand of Aragon and Isabella of Castile; a month later a magnificent pageant was enacted in Rome to celebrate the Spanish victory. The fall of Constantinople was still fresh in the minds of Christendom, and the triumph over the 'Moors' was welcomed as some revenge for the many tribulations suffered

at the hands of the Ottomans.[37] Sultan Mehmed II had received a delegation of Andalusian Muslims seeking his protection in 1477,[37] the year before the Spanish Inquisition officially began, and Bayezid offered them asylum after the fall of Granada. Although not forced to make the choice between conversion or emigration until 1501, many accepted this offer, and within a few years three large churches in Thessalonica were converted into mosques to serve those who took refuge with the Ottomans.[38] After various vicissitudes, the remnants of the Andalusian Muslim community were expelled from the Iberian peninsula between 1609 and 1614.[39]

The Jews of Spain, called Sephardim, were less fortunate. They had been under pressure long before the Inquisition and many had converted to Catholicism. However, the Inquisition tested the sincerity of converts and many were found wanting and put to death. Practising Jews were expelled from Spain in 1492 and emigrated to Portugal, France, and other countries of Europe. Many went to live in the Ottoman Empire, where they found Greek-speaking Jews, called Romaniotes, and German Jews, called Ashkenazim, who had also been expelled from their homelands. Sultan Bayezid welcomed the Spanish Jews, reportedly with the observation: 'Can you call such a king [i.e. Ferdinand] wise and intelligent? He is impoverishing his country and enriching my kingdom'.[40] The greatest wave of Jewish immigration into the Ottoman lands took place between 1492 and 1512 in the wake of the persecutions which spread across Europe during this period. Bayezid wished these refugees to concentrate in provincial centres, and there were soon Sephardi communities in many towns of the empire. They were not welcomed in Istanbul, however, and new synagogues in the capital were closed down and prominent Jews encouraged to convert to Islam.[41]

The equilibrium established in 1490 by the agreement reached between Innocent VIII and Bayezid concerning Cem did not last. The Ottoman pretender was used as a pawn in European politics as Charles VIII attempted to make good his claim to the Kingdom of Naples.[42] In 1492 Innocent was succeeded by Alexander VI, and the new pope had a pressing reason for standing by the agreement with Bayezid, to whom he wrote of the French king's plans:

> . . . the king of France is pushing on toward Rome with the greatest land and sea forces, supported by the Milanese, Bretons, Portuguese, Normans and others in order to wrest from us Jem Sultan, the brother of his Highness, and to seize the kingdom of Naples and oust King Alfonso.[43]

Bayezid's reply to the Pope, together with money sent to Rome for Cem's pension, was intercepted and made public, a damning condemnation of the

Pope as an ally of the enemy of Christendom. Charles, who was at Florence, moved south through Italy and reached a terrified Rome on the last day of 1494. He demanded that Cem be handed over to him. Pope Alexander agreed under duress, on the understanding that it should be for six months only, and against payment of a surety. Cem was duly transferred into Charles's custody and continued towards Naples with the King's army.[44]

King Alfonso of Naples, successor to King Ferrante, turned to Bayezid for help. According to a contemporary Venetian writer, the Sultan truly feared that Charles might take Cem into the Balkans and raise the people of the region against him: the Ottoman ambassador to Venice recorded that the French King counted on support from disinherited scions of the noble houses of Byzantium and Serbia and Scanderbeg's Kastriota clan. The Sultan reinforced the Dardanelles defences and prepared his fleet. Panic spread in Istanbul where he inspected the walls and set up gun positions to defend the city.[45]

Two days after Charles and his army reached Naples, Cem died there in the night of 24–25 February 1495 at the age of 36, after thirteen years in exile. There were rumours that poison had brought about his end, but it seems that he died of natural causes. Even in death he found no rest. Bayezid sent a messenger to request that the body be sent to him in exchange for further Christian relics in his possession: without the body, he said, he had no proof of Cem's demise. Charles moved the corpse to the strong fortress of Gaeta on the coast north of Naples, and when in November 1496 the French withdrew from Gaeta the coffin was handed over to Prince Frederick of Naples in exchange for French prisoners in Neapolitan hands. Naples needed the Sultan's support against its enemies, and Bayezid threatened to nullify the peace between them if Naples did not send the body to Istanbul. Further threats brought results, and by early 1499 Cem's body was on its way to Istanbul, crossing the Adriatic from San Cataldo in the heel of Italy to Vlorë on the Albanian coast. From there it was borne home, probably by sea, met with great pomp after passing Gelibolu, and taken to Bursa. Here Cem was finally interred alongside his eldest brother Mustafa, in the funeral complex of his grandfather, Sultan Murad II. His tomb can still be visited.[46] The extraordinary story of Cem's life captured the imagination of writers in both east and west and has continued to provide inspiration to the present.[47] He is depicted as a tragic figure on an epic scale, a true Renaissance prince – educated and articulate and the author of well-regarded poetry – who realized the folly of his political ambitions too late to save himself from elegant captivity and a mysterious death.

<div align="center">★</div>

With Cem buried, Sultan Bayezid was free at last, but this episode in Ottoman history was remarkable for heralding a change in the style of Ottoman diplomacy vis-à-vis the Christian powers. Unlike the diplomatic agreements of the past, whereby one state would mediate relations with the Ottomans on behalf of others whose interests were affected, negotiations over Cem's custody had been conducted individually with each state. Bayezid had been able to exploit the rivalry between them and, from the mid 1480s, direct bilateral relations with the European states began to outweigh the collective agreements of the past. The first Ottoman envoys were sent to European courts at this time – to France in 1483, to Muscovy in 1495 and to the Holy Roman Emperor in 1496–7.[48] Although both Christian and Muslim states depicted their relations as being perpetually hostile, Cem's odyssey demonstrated the extent to which political expediency rather than religious ideology dictated their attitude. It was apparent to all that Charles VIII's France was a far more immediate threat than the Ottoman Empire to peace in Italy, and the Ottomans exploited this situation with acumen.

The years during which Bayezid was occupied with the fate of Cem also demonstrated that despite Mehmed II's remarkable achievements, the integrity of the Ottoman Empire could not be taken for granted. Cem's departure for Rhodes in July 1482 had given Sultan Bayezid some respite from domestic turmoil. Prince Kasım of Karaman, who had made common cause with Cem, sought a pardon from the Sultan and in return for renouncing his claims to independence was appointed governor of the southern Anatolian province of İç-il (roughly, Cilicia), formerly part of the emirate of Karaman.[49] An elderly man, he died in 1483. Karaman could now be administered as an integral part of the Ottoman domains but the situation remained tense. As late as 1500, Bayezid was forced to despatch troops to defeat another claimant to Karaman, Kasım's nephew Mustafa, who appeared from Iran with an army in support of an uprising there.[50]

In the competition for the allegiance of the Turcoman tribal population living in the buffer region between Mamluks and Ottomans, Sultan Qa'it Bay had resisted the temptation to exploit Cem, but Cem's period of refuge with the Mamluk sultan in 1481 had been an augury of conflict to come. Besides the Karamanid tribes, now at least nominally Ottoman, though disaffected, there were the still-independent emirates of the Dulkadıroğlu and Ramazanoğlu dynasties, who controlled territories with shifting boundaries from their centres at Elbistan and Adana respectively and relied on Mamluk or Ottoman support for their continued existence.

The first Ottoman–Mamluk war began in 1485 when, with the blessing of his son-in-law Bayezid, Alaüddevle of Dulkadır besieged the Mamluk

city of Malatya, west of the Euphrates in south-east Anatolia. Bayezid sent reinforcements to support Alaüddevle when the Mamluks retaliated; the Mamluks were defeated but went on to win a second encounter shortly afterwards.[51] The Mamluk ruler went out of his way to taunt Bayezid by confiscating gifts sent to him by the Shah of the Deccan (in peninsular India) as they passed through Mamluk territory.[52] In the summer of 1485 Bayezid despatched an army under the new governor of Karaman, Karagöz ('Black-eye') Mehmed Pasha, against the Turgudlu and Varsak Turcomans, tribes who had been fiercest in their resistance to Ottoman annexation of Karaman and had supplied men for Cem's army in its attempt to reach Istanbul in 1481. Karagöz Mehmed captured the fortresses of the Tarsus–Adana area, whose strategic location controlling the route from Anatolia to Syria earned them the epithet 'key to the Arab lands'.[53]

Sultan Qa'it Bay acted decisively to contain the Ottoman threat to his domains. In March 1486 Mamluk troops clashed on a battlefield near Adana with a combined force of Karagöz Mehmed's units from Karaman and an army sent from Istanbul under the command of Bayezid's son-in-law Hersekzade Ahmed Pasha, now governor of Anadolu. Karagöz Mehmed and his men fled (he was later arrested and executed) and Hersekzade Ahmed was captured and sent to Cairo. The Mamluks took control of Adana, Tarsus and the Cilician plain.[54] The following year the grand vezir, Daud Pasha, led into the field an imperial army joined this time by Alaüddevle's forces from Dulkadır. Against Alaüddevle's advice, the original plan to march against the Mamluks was abandoned and the army redirected to suppress an uprising of the Varsak and Turgudlu tribes. Having succeeded in this, Daud Pasha returned home knowing that he had reduced the risk of an attack in the rear whenever the Ottomans resumed their campaigns against the Mamluks.[55]

In 1488 the Ottomans launched a two-pronged attack on the Mamluks by land and sea. Hersekzade Ahmed Pasha, lately freed from captivity in Cairo, commanded a fleet in support of the land operations, while the army was commanded by the governor of Rumeli, Hadım ('Eunuch') Ali Pasha. As it moved into disputed territory, the army captured a number of fortresses from the Mamluks and their clients. Both antagonists attempted to attract assistance from the West – because of its treaty relations with the Mamluks Venice refused Bayezid the use of Cyprus as a base, while Qa'it Bay approached the other Italian states with equal lack of success.[56] There was relief in Rhodes when the Ottoman fleet sailed by without making any demands, for while the Knights of St John maintained diplomatic and commercial relations with the Mamluks, it was the Ottomans they feared.[57] Venice sent a fleet to Cyprus which prevented Hersekzade Ahmed's armada

landing; instead it docked at İskenderun on the Anatolian coast to confront the Mamluk forces as they came north through the pass from Syria. But a great storm wrecked the Ottoman fleet and the Mamluks were able to continue towards Adana unimpeded. Hadım Ali's army suffered a great defeat in the ensuing battle and fled, pursued by Turcoman tribal forces. It was small consolation that a Mamluk unit returning to Aleppo was routed by Hersekzade Ahmed. Hadım Ali withdrew into Karaman and tried to regroup his scattered forces. Many of the Ottoman provincial commanders who had fled the battlefield were taken back to Istanbul and imprisoned in the Bosporus fortress of Rumeli Hisarı. Adana castle resisted siege for three months before its Ottoman garrison handed it over to the Mamluks. Defeat cost the Ottomans the support of the few Turcoman tribes over whom they had been able to exert influence, and also led Alaüddevle of Dulkadır to be more open about his preference for the Mamluks as the stronger power in the region. The Ottomans responded by favouring his brother Şahbudak as ruler of Dulkadır, but they were unable to enforce his candidacy and he was sent by Alaüddevle as a captive to Egypt where he, too, took the Mamluk side.[58]

Yet the Mamluks were unable to exploit their advantage. In 1490 their army pushed into Karaman to besiege Kayseri in central Anatolia, only to withdraw when it was learned that Hersekzade Ahmed Pasha was marching against them. The Mamluks could no longer bear the cost of a conflict that had become bogged down in stalemate, and they faced internal opposition to the war. The Ottomans were aware that their own forces might have to confront a crusade from the West, and a peace was agreed the following year: the frontier between the two states was fixed at the Gülek pass commanding the route over the eastern Taurus Mountains, and the Mamluks retained their influence in the Adana region.[59]

The inconclusive Ottoman–Mamluk war having already ended when Cem died in 1495, Bayezid was then free to turn his attention westwards. The Venetian envoy in Istanbul saw the extensive preparations being undertaken at the arsenal in the Golden Horn in 1499, but could not believe that either his republic or its overseas territories could be the target: Venice had been careful to keep its distance from any plans for a crusade being discussed during the years of Cem's captivity, and had been at peace with the Ottomans since 1479. He thought instead, as did the Knights, that the armada would sail against Rhodes.[60]

It seemed that Bayezid had always been determined to complete his father's project of driving the Venetians from their remaining outposts. Nafpaktos surrendered to a land and sea attack on 28 August 1499 and the Ottomans fortified the narrow entrance to the Gulf of Corinth to the west

with a pair of opposed fortresses, just as they had fortified their other strategic waterways, the Bosporus and the Dardanelles. Venice itself was harassed in October by raids which came to within 30 kilometres of the city. Early in 1500 a Venetian emissary sought the return of Nafpaktos in an audience at the Ottoman court, only to be informed that the Sultan intended to take over Venice's outposts on the eastern Adriatic coast as well, and make the Adriatic the frontier between his domains and Venice; later that year, Methoni, Koroni and Pylos (Navarino) on the coast of the south-western Peloponnese fell to Ottoman naval attack.[61]

Putting aside their disputes, and after much diplomatic wrangling, Venice, the Papacy and Hungary entered into a league against the Ottomans in May 1501. Venice still retained the islands of Cyprus, Crete and Corfu, but the number of its minor possessions was dwindling. It stepped up its attacks on Ottoman territory: later in the same year a joint French–Venetian force landed on Lesbos, off north-west Anatolia, but was driven off.[62] In the following year Venetian forces landed on the south-western coast of Anatolia at Fethiye (Makri) and pillaged the surrounding area.[63] Despite the assistance of its allies Venice could not improve upon these paltry shows of strength; it sued for a peace, and a treaty concluded in 1503 saw Bayezid closer to attaining his goal of driving Venice out of the Balkans.

Sea-power had won the Venetian war for Bayezid, and as its end approached, he began a full-scale revamping of his navy. Lighter, more manoeuvrable ships were built and manpower was greatly increased. No major naval operations were undertaken for some years, but the fleet was employed to keep maritime routes open, protecting commercial and other shipping from the pirates, both foreign and indigenous, who operated in the waters of the eastern Mediterranean.[64]

The possession of a powerful navy opened up new vistas for the Ottomans, as it did for other European states. After Vasco da Gama rounded the Cape of Good Hope in November 1497 and reached India the following spring, Portuguese commercial interests began to threaten centuries-old Arab commercial networks in the Indian Ocean; in particular, they threatened Mamluk control of the spice trade from south and south-east Asia. Mamluk naval strength proved insufficient to protect either this trade, or trade closer to home: in the same years as the Portuguese became active in the Indian Ocean Rhodian piracy was increasing in the eastern Mediterranean, and the defeat by a Rhodian fleet of a Mamluk convoy carrying timber from the north Syrian coast in 1508 exposed Mamluk impotence at sea. The Mamluks were obliged to call on Bayezid's help, and Bayezid was thus able to achieve by friendship what he had been unable to gain by force: an acknowledgement of his superiority over the Mamluks in the Middle

Eastern power struggle. In 1510 an embassy to the Ottoman court was rewarded with substantial aid in raw materials and supplies for the Mamluk navy. In addition to their expertise in naval matters, the Ottomans possessed artillery the equal of that used by the Europeans; they provided the Mamluk navy with cannon to use against the Portuguese and also sent their own officers to command the Mamluk fleet.[65]

This inability of the Mamluks to protect their shipping against the Portuguese presented Bayezid with a magnificent opportunity to intervene in Mamluk affairs and further his own interests. His motives were various: Ottoman access to the Indian Ocean would allow him a share of the lucrative spice trade, while his support for the Mamluks would discourage them from allying with a new enemy now appearing on the eastern frontier – the Safavid shah Isma'il – and also neutralize any possible Mamluk help to his son Korkud who, unhappy with the choice of sub-province he was ordered to govern, had gone to Cairo in 1509, possibly in preparation for a challenge to Bayezid's rule. Bayezid's calculations bore fruit.

Although the Portuguese arrival in the Indian Ocean and subsequent Ottoman intervention there initiated a long struggle between the two, both powers realized considerable financial and strategic advantage from their engagement in a part of the world with which they had hitherto been little concerned. Even more importantly, Bayezid's intervention in Mamluk affairs opened the way for his son Selim's conquest of Syria and Egypt a few years later. But before that, the Safavid state of Iran presented a challenge to the foundations of Ottoman legitimacy as aggressive as any previously encountered. The struggle for pre-eminence within the Islamic world was every bit as contentious as the rivalry between Christian and Muslim states, and for the first three hundred years of its existence posed a greater threat to the empire of the Ottomans.

If the early part of Bayezid's reign was dominated by the fate of his brother Cem, his last years were plagued by the Kızılbaş ('Red Head') phenomenon. 'Kızılbaş' was a term used to describe those who wore tall red bonnets with twelve folds as a way of expressing their devotion to the Twelve Imams of Shia Islam. Unlike the Karamanids and Akkoyunlu who with the Mamluks and Ottomans espoused Sunni Islam, the new power arising on the Ottoman eastern frontier, the fledgling Safavid state, would develop an ideology underpinned by the beliefs of the minority Shia branch of Islam. Religious practice and law vary little between Sunni and Shia Islam – the main difference is doctrinal: Shia Islam limits leadership of the Islamic community to the family of the Prophet Muhammad and does not recognize the legitimacy of the Umayyad and Abbasid dynasties who had succeeded to this role.

Devotees of the 'Twelver' creed believe that the Twelfth Imam, the leader of the Muslim community, has merely been hidden from his followers since he disappeared in 940 CE and will appear again to usher in the kingdom of heaven on earth.[66] This creed was an Islamic equivalent of the messianic movements of early modern Europe.

The Safavid state took its name from Sheikh Safi al-Din Ishak, the founder of the Safavid religious order which arose in Ardabil in north-western Iran. Sheikh Safi al-Din died in 1334, and historical convention ascribes the foundation of the state he inspired to 1501, when the fourteen-year-old Safavid shah Isma'il led an army which seized Tabriz, capital of the rump Akkoyunlu state, from its ruler who was his cousin. This was the decisive battle in a long war of succession among the Akkoyunlu princes that had begun before Isma'il's birth with the death of Uzun Hasan (who was Isma'il's maternal grandfather) in 1474 and intensified during the last years of the fifteenth century. The transformation of the Safavids between Sheikh Safi al-Din's time and Isma'il's – from what a modern historian characterizes as a 'more or less conventional Sunni *sufi* organization, grad-ually acquiring disciples and property in a not especially unworldly fashion'[67] into a state exhibiting extreme antipathy to the Ottomans combined with a radical stance towards what is commonly understood as Sunni 'orthodox' Islam – is still poorly understood. Indeed, using the term 'orthodox' to describe the Islam of the Ottomans – and 'heterodox' to describe that of the Safavids – fails adequately to convey a sense of the variety of religious practices in a region where institutions to enforce 'right' patterns of observ-ance were rudimentary, and where popular beliefs were little affected by bookish Islam.

The Safavid order was founded in the rugged uplands of Anatolia and western Iran at a time when there was no effective central power in this culturally diverse region to impose the Sunni creed of the central Arab lands. The teachings of the Safavid sheikhs of Ardabil did not at first differ much from those of Sunni Islam. A key figure in the transformation in Safavid beliefs was Isma'il's paternal grandfather Sheikh Junayd, who came to head the Safavid religious order in 1447 – Junayd's militant teachings would have shocked contemporary adherents of both Sunni and Twelver Shia Islam alike.[68] Junayd became so influential that he was exiled by the Karakoyunlu leader Jihanshah, himself a Shiite, in whose territory Ardabil lay, and found refuge with Jihanshah's enemy Uzun Hasan.[69] Junayd won ready adherents among the Turcoman tribes of eastern Anatolia, north Syria and Azerbaijan at the very time that Ottoman power was reaching into these regions. He attracted, among other groups, the descendants of the followers of Sheikh Bedreddin, who some fifty years before had complicated the course of the

Ottoman civil war.[70] Yet, paradoxically, Junayd was among the holy men sent money and gifts by Murad II, whose father Mehmed I had had Sheikh Bedreddin executed.[71]

Almost half a century before Junayd came to head the Safavid order in 1447 and Sultan Mehmed II's conquest of Constantinople in 1453, Tamerlane had visited Ardabil as he returned to Samarkand after his defeat of Bayezid I in 1402. The incumbent sheikh persuaded Tamerlane to free the prisoners of war he had taken on his campaigns in Anatolia, and Tamerlane also sent letters to the reinstated emirs of Anatolia asking them to exempt these former captives from taxation. Presumably this, too, fostered an inclination among them and their descendants in favour of the Safavids.[72]

Like Mehmed II before him, Isma'il was very young when he came to the throne and again, like Mehmed, was encouraged by his advisers towards the direction he took. His aggressive adoption of an ideology for the Safavids which contrasted so markedly with that of the Ottomans was a political move with a stark religious dimension that polarized the two states and exacerbated their territorial rivalry in eastern Anatolia. To the extent that Uzun Hasan's challenge to Sultan Mehmed II had been religious, it was a challenge for primacy in the Sunni Islamic world. Competition for power in eastern Anatolia and beyond was about to become more intense and vicious than ever before. Dissidents in the region saw the Ottomans as a westward-looking Byzantine-Balkan power,[73] particularly after the capture of Constantinople, and turned east for salvation. Isma'il's message provided an avenue of protest for these reluctant subjects of the sultan – in particular the nomadic Turcoman tribes of the mountainous rim of Anatolia, whose loyalty to the Ottomans was demanded merely as the result of accidental conquest – allowing them to voice their preference for a state which extolled the virtues of rebellion. The danger for the Ottomans was that Isma'il's new populist creed attracted those whose religious and political beliefs were poorly-defined and who saw little place for themselves in the centralized Ottoman regime being built on the ruins of other Anatolian emirates which had once seemed equally viable. The disenfranchized tribal populations of the Ottoman–Iranian borderlands were a liability for the Ottomans who, while they did not want them participating in the running of their state, did not want to lose them to the Safavids who would use them to promote their own military and political interests.[74]

Safavid doctrine declared that the shah was the reincarnation of the Prophet Muhammad's son-in-law and cousin, Imam 'Ali – succession from 'Ali, at the least, was a necessary condition for succession to the Shia imamate – who was himself the manifestation of God in human form,[75]

and western travellers who visited Iran in the early sixteenth century reported that Isma'il was revered by his followers as a god.[76] The term Kızılbaş was first used in the time of Isma'il's father Sheikh Haydar. Shah Isma'il's proclamation that with the establishment of the Safavid state his adherents had at last found a territory they could call their own led thousands to rally to him in expectation of the imminent reappearance of the Twelfth Imam. He wrote of his followers that 'no one can be a Kızılbaş unless his heart is pure and his bloody entrails are like rubies'.[77] In 1502 a rumour that there were some 5,000 Kızılbaş in Istanbul prompted Sultan Bayezid to take the first measures to suppress their activity by closing the city gates and arresting suspects. Fearing that Kızılbaş sympathizers would take refuge with Isma'il, he banned movement across the Ottoman–Safavid frontier – but to little effect.[78]

While he was prince-governor of Amasya, Bayezid had patronized the emerging Halveti order of dervishes whose sheikhs had had links with Uzun Hasan and whose teachings had certain features in common with Safavid doctrine. Mehmed II, who was suspicious of holy men from the eastern provinces, had expelled an influential Halveti sheikh from Istanbul, but when he succeeded his father Bayezid invited one of the Sheikh's foremost pupils to settle in the capital, and the order flourished.[79] Bayezid's own mystical leanings may explain in part, at least, why he was anxious to avoid open conflict with his new Safavid neighbour. In the winter of 1504–5 he wrote to Isma'il to condemn his treatment of Sunni Muslims, warning him that good relations could develop only if such persecution stopped.[80] A raid into Safavid territory in 1505 by Bayezid's son Selim provoked only a mild reaction from Isma'il; the mutual wariness of Isma'il and Bayezid was still apparent in 1507, when Bayezid gave his tacit blessing to Isma'il to allow him to cross Ottoman territory to campaign against the emirate of Dulkadır.[81] Like Uzun Hasan before him, Isma'il had for some time been in contact with Venice[82] in the hope of initiating an anti-Ottoman alliance, but without success; in 1508, for example, when he renewed proposals for an alliance, Venice demurred on the grounds that it had to honour its peace treaty with the Ottomans.[83] Shah Isma'il gradually brought the former Akkoyunlu territories under his rule and by 1508 had reached Iraq and taken Baghdad, the former seat of the caliphate.

Bayezid's disinclination to provoke Shah Isma'il contrasted with his son Prince Selim's eagerness to confront what he saw as the menace of the Kızılbaş. Selim, the third of Bayezid's four surviving sons* and for many

* Sultan Bayezid had eight sons and seventeen daughters. In 1510 his surviving sons were Ahmed, Korkud, Selim and Şehinşah; Abdullah, Mahmud, Mehmed and Alemşah had died earlier.

years prince-governor of the province of Trabzon on the impoverished borderlands of the empire where the threat posed by the Kızılbaş to the integrity of the Ottoman domains was most evident, was infuriated by his father's inactivity.[84] This tension between father and son was exacerbated in 1510 when Bayezid reprimanded Selim for defeating an army led by Isma'il's brother that was marching on Trabzon itself.[85] In the same year, in a letter to his father, Selim complained bitterly about Trabzon – its inhospitability, the lack of ready supplies, and the unproductivity of the lands Bayezid had assigned for his support:

> Since no grain ripens in this province and there is always paucity and poverty, whoever is [prince-governor] is weak and helpless. Produce comes from outside. Thus, ever since I came here, grain has come by boat or from the Turcoman. There has never been much value to this place and nothing has changed. I don't even have the capacity to build my own boat . . . The upshot is that it is impossible to describe a situation of such neediness.[86]

Soon after, Selim deserted the province for the court of his own son, Süleyman – the future Süleyman the Magnificent – who was prince-governor at Feodosiya of the province of Kefe, aided in this act of defiance by his father-in-law, the khan of the Crimea Mengli Giray.[87] Selim's disobedience to Sultan Bayezid and his aggressive policy toward the Safavids shaped the course of Ottoman history over the coming years.

In 1511 the province of Teke in south-west Anatolia was the scene of a major Kızılbaş uprising led by an adherent of Shah Isma'il's teachings to whom Sultan Bayezid regularly sent alms.[88] The missionaries of this holy man – one Karabıyıklıoğlu ('Son of Blackbeard') Hasan Halife, popularly known as Şahkulu ('Slave of the Shah') – not only incited disobedience to Ottoman rule in Anatolia but also fomented rebellion in Rumeli; several were arrested.[89] Early in 1511 Bayezid's second surviving son Prince Korkud had returned from his exile in Egypt to govern Teke, only to learn that Selim had been appointed prince-governor of Saruhan, a province more desirable than Teke on account of its greater proximity to the capital. Korkud suddenly left his seat at Antalya and headed north, and Şahkulu promptly proclaimed himself rightful heir to the Ottoman throne, on behalf of Shah Isma'il. The timing of the revolt was hardly accidental: it came to a head on 9 April, which corresponded to the Shia holy day of 10 Muharrem, anniversary of the martyrdom of Imam Husayn, son of Imam 'Ali.[90] Şahkulu was hailed by his followers as Messiah and Prophet,[91] the very words anathema to the rulers of a state which saw itself as the repository of orthodox Islam. The Ottoman view of themselves as the foremost Muslim power led them to brand Şahkulu not just a rebel but a heretic.

It was a role Şahkulu was only too happy to embrace. While Prince Korkud was on the road, a band of Şahkulu's Kızılbaş followers numbering four and a half thousand attacked Korkud's retinue and killed some of his men. Local government troops who responded to the attack were forced to retreat in disarray into the fortress of Antalya. By no means all of Şahkulu's followers could fairly be described as religious fanatics: as well as peasants and tribesmen they included impoverished provincial cavalrymen who had lost their lands (to government officials and their retainers who were not strictly eligible to hold them) and also provincial cavalrymen belonging to old Muslim Turkish families dispossessed when their lands were awarded to the rising class of Christian-born Muslim cavalrymen as a reward for prowess in battle.[92]

Encouraged by his victory, Şahkulu's army of the dispossessed marched north through Anatolia setting fire to towns and villages as they went – the government accused them of burning mosques and dervish lodges, even Korans. Their numbers swollen to 20,000 men, they passed Burdur in the lake district of south-west Anatolia and reached the town of Kütahya, where they were initially put to flight by the governor of Anadolu province whose seat it was. He then found himself isolated and was captured by Şahkulu's troops, who beheaded him, impaled him and roasted him on a spit. A sergeant who witnessed the passage of the Kızılbaş reported that they attacked and plundered everything in their path, with the collaboration of the towns-folk of Kütahya:

> They destroyed everything – men, women and children – and even sheep and cattle if there were too many for their needs; they destroyed cats and chickens. They looted all the valued possessions of the [villagers] of Kütahya province – their carpets and whatever else they could find – and collected them up and burned them ... your servant Sergeant İskender witnessed all this ... the townspeople of Kütahya, in particular, behaved with great dishonour and allowed [the Kızılbaş] to destroy the means of livelihood of the [villagers] and did not [help them].[93]

The force Prince Korkud sent against the Kızılbaş was defeated, and he had to take refuge in Manisa castle. The road to Bursa and, beyond that, to Istanbul, was now open to the rebels. On 21 April 1511 the kadı (judge) of Bursa wrote to the commander of the janissaries that if he and his men did not reach the city within two days, the country was lost. Şahkulu seemed close to successfully expelling Ottoman writ from Anatolia and establishing his own authority in the name of Shah Isma'il.[94] Grand Vezir Hadım Ali Pasha was appointed to lead the campaign against Şahkulu and his followers. Near Kütahya he combined with the forces of Bayezid's eldest

surviving son Prince Ahmed, but caught up with the rebels only after a forced march through Anatolia to Sivas, where both Şahkulu and Hadım Ali were killed in the ensuing battle.[95] Many of the Kızılbaş fled east into Iran;[96] those who fell into Ottoman hands were deported to Methoni and Koroni in the Peloponnese, captured by Bayezid in 1500 during the war with Venice.[97]

Şahkulu's rebellion dramatically affected the balance of power among Bayezid's sons in their bids to succeed to his throne. The elderly Sultan – he was now about 60 – also had many grandsons, further embittering the succession contest. The logic of the prince-governor system was that it distanced princes from Istanbul, making it more difficult for them to challenge the ruling sultan; at the same time, appointments could be manipulated so that the sultan's favourite to succeed was closest to Istanbul, and upon his death would have the best chance of arriving in the capital ahead of his rivals to seize the throne. Before abandoning Trabzon in 1510 Selim had tried to secure for his son Süleyman the governorship of the province of Bolu, less than 200 kilometres east of Istanbul, but was blocked by Prince Ahmed,[98] supported by Bayezid (who himself favoured Ahmed). Selim's own appointment to Saruhan brought him closer to the capital than Ahmed, who had succeeded his father as prince-governor at Amasya, yet Saruhan was not close enough for Selim, and before his appointment to that province he had requested the governorship of a province in Rumeli, a request that was also refused, on the grounds that it was unlawful.*[99]

Selim had no intention of going to Saruhan. Leaving Süleyman's province of Kefe in March 1511 he marched through Rumeli at the head of an army. By June he had reached Edirne where Bayezid's court had been in residence since the great earthquake of 10 September 1509 – referred to in contemporary sources as the 'Lesser Judgement Day' – which had devastated Istanbul and the surrounding area. To avert a bloody confrontation with his son, Bayezid ignored his earlier ruling as to the legitimacy of prince-governorships outside the Anatolian provinces and conceded to Selim the governorship of the Danubian frontier province of Semendre (centring on Smederevo). Most critically, he also promised Selim that he would not abdicate in favour of Prince Ahmed.[100]

With the death in battle against Şahkulu of his main supporter, the grand

* The system of prince-governorships operated only in the predominantly Muslim territories of Anatolia and the northern Black Sea coastal province of Kefe. This at least had been so since the civil war of the early fourteenth century, when rebellious Ottoman princes had rallied the followers of the disaffected marcher-lords of the Balkans in support of their claims to the throne (Lowry, *The Nature of the Early Ottoman State* 141, 157).

vezir Hadım Ali Pasha, Prince Ahmed realized that his position was much weakened. Prince Selim, however, doubtful of his father's sincerity and unable to believe that Ahmed would so readily be cast aside, turned his army towards Istanbul and early in August offered his father battle in Thrace, near Çorlu, between Edirne and Istanbul. When Bayezid ordered his forces to open fire, Selim fled back into Rumeli and took ship up the Black Sea coast to Kiliya, on a mouth of the Danube. He was ordered by his father to return to Kefe. Bayezid again took up residence in Istanbul.[101]

During this time, Prince Ahmed was engaged in putting down the Şahkulu uprising, after which he moved from the Sivas area to Afyon in west-central Anatolia; hearing of the battle between Bayezid and Selim, he marched towards Istanbul, insisting he wanted to pay his respects to his father – Bayezid invited him to do so. Gathering his forces, which included tribal contingents from the province of Karaman – the very men who were so receptive to Shah Isma'il's propaganda, hoping again to seize advantage from the internecine struggles of the Ottoman dynasty – Ahmed wrote to tell the grand vezir, Koca ('Great') Mustafa Pasha, to prepare for his arrival. Against all his expectations, when he reached Istanbul on 21 September 1511 he was greeted with a janissary revolt and forced to remain in Üsküdar, on the Asian shore of the Bosporus, unable to cross to the capital where he had in fact hoped to be proclaimed sultan.[102] The Grand Vezir (who had been Bayezid's trusted envoy to the Pope to negotiate the terms of Cem's custody in Rome) was assassinated.[103] The battle-lines were now drawn: the janissaries supported Selim, and Shah Isma'il's partisans supported Ahmed.

Ahmed retreated into Anatolia, aiming to increase his support and take the capital by storm. His hopes of seizing the sultanate dashed, he openly contested his father's authority by making provincial appointments on his own account. When his repeated demands for the governorship of Karaman – now held by Bayezid's grandson Prince Mehmed, who had succeeded his late father Prince Şehinşah – were refused, he successfully besieged the prince-governor's seat of Konya. The janissaries were again instrumental in frustrating Ahmed's hopes, for when news of his victory reached Istanbul they rebelled again, demanding that Selim stake his claim as sultan and taking their ultimatum to the council of state. Their vociferous support for Selim forced Bayezid's hand and, bowing to force majeure, he appointed Selim commander-in-chief of the army. Selim set out again from Kefe, to march on Istanbul.[104]

With Ahmed in Konya and Selim in Kefe, Prince Korkud in his turn imagined that he could win the throne by getting to Istanbul first. He left Manisa and arrived quietly, reaching the city by boat, asked Bayezid to

forgive him his past disobedience, and awaited Selim's arrival. Korkud thought to buy the janissaries' support by distributing gold; they accepted it, but when Selim arrived in Istanbul in April 1512 they backed his deposition of his father.[105] For the first time the janissaries were instrumental in forcing a ruling Ottoman sultan from power; but it was by no means the last: whatever the Ottoman succession practice in theory, it was the janissaries who made and unmade sultans.

Sultan Mehmed II had greatly enhanced the status of the janissaries and Selim, who could not accept Bayezid's appeasement of Shah Isma'il's state and its Kızılbaş adherents, was heir to this legacy; the majority of his troops were Ottoman by education rather than by birth, and needed a resolute sultan to fulfil the mission for which they had been recruited. Ahmed, by contrast, was a focus for those who had been dispossessed of their former existence and saw no place for themselves in the new Ottoman state. Bayezid's brother Cem had appealed to broadly the same constituency.

Sultan Bayezid had survived an assassination attempt while on campaign in Albania in 1492 when a dervish of the anarchical Kalenderi sect lunged at him, an attack which precipitated the expulsion of the Kalenderi from Rumeli.[106] He could not survive deposition, however, and a month later died of natural causes while on the road to retirement in his birthplace of Didymoteicho in Thrace.[107]

In Konya, Prince Ahmed's reaction to Selim's deposition of their father was to proclaim himself the rightful sultan. He sent his second son Alaeddin to Bursa with an army which entered the city in mid-June 1512, sacking it and causing the population to flee. News that Selim was planning to cross the Sea of Marmara from Istanbul, supposedly to hunt, forced Alaeddin to retreat to join his father, who was by now back in Afyon. Ahmed summoned all available reinforcements, throwing Anatolia into turmoil; leaving his son Süleyman regent in Istanbul, Selim marched into Anatolia. Ahmed was most reluctant to meet his brother in open battle, withdrawing from Afyon to Ankara, and thence towards his former seat at Amasya – but there he found the city defended against him. He left a trail of destruction and disorder behind him as he crossed Anatolia and was branded a rebel by Selim.[108]

Ahmed next went southwards, his every move observed by Selim's spies, who also reported on the intentions of his supporters. Suggesting that for him to seek asylum outside the Ottoman lands would bring dishonour on the dynasty, Ahmed asked Selim for some territory in Anatolia. But Selim would not entertain the idea of giving up any part of his domains, and proposed that Ahmed seek asylum in a Muslim state. Ahmed's partisans encouraged him to take refuge with Shah Isma'il – who had sheltered

Ahmed's eldest son Murad since Selim became sultan – or in Dulkadır, or in Egypt. The new Mamluk sultan Qansawh al-Ghawri was unwilling to help so Ahmed retired to Dulkadır for the winter; Selim based himself for the season at Bursa.[109]

Despite this apparent resolution of the troubles attending Selim's succession to Bayezid, there was no trust between the brothers. Ahmed feared that Selim would return to attack him in the spring and Selim learned that Ahmed was negotiating with Shah Isma'il.[110] Ahmed again turned his forces against Amasya; this time the city surrendered to him, and in the first days of 1513 he left his fourth son Osman there as regent. He had received a number of letters encouraging him to think the sultanate could still be his, and it may be that he believed them, but they were a trap laid for him by Selim. Bent on reaching Bursa, Ahmed marched across northern Anatolia, encountering resistance as he went.[111]

Following Bayezid's death, Selim had humoured Korkud for a while. His brother was allowed to return to Manisa, from where he made repeated requests for an appointment to the island of Lesbos which Selim refused. Korkud changed his plea to the lands of Teke or Alanya, which were also refused; Selim feared that from these places on the south Anatolian coast he might, like their uncle Cem, flee to Egypt, and become the figurehead of a European crusade.[112] Early in 1513 Selim travelled south on the pretext of a hunting expedition and attacked Manisa. Korkud escaped the city and was later found hiding in a cave; he was sent to Bursa, and strangled on 13 March; he was in his mid-forties.[113]

On 4 April 1513 Selim marched from Bursa with his army, and joined battle with Ahmed at Yenişehir eleven days later. Ahmed was captured after a fall from his horse, and strangled. Amasya was soon retaken from his son Osman, who shared the fate of his cousins – the remaining sons of Korkud, Ahmed and Selim's late brothers Mahmud, Alemşah and Şehinşah – who had been executed a short time earlier.[114] The tombs of these many grandsons of Bayezid are still to be seen in Bursa and Amasya.

Now secure on the throne, Sultan Selim I was free to impose his own solution to the problem of the Kızılbaş which had in part provoked his usurpation of the throne. During the last years of Bayezid's reign Selim's open challenge to his father's authority had motivated some other members of the Ottoman dynasty to side with the Kızılbaş – his brother Şehinşah had seemed ready to join those rebelling in the name of Şahkulu, but had died before his sympathy had turned to action. Prince Ahmed's son Murad had sympathized with the Kızılbaş to such an extent that from the summer of 1511, when his father was appointed to campaign against Şahkulu and Murad became governor at Amasya in his place, he adopted their red head-

gear. Even as Şahkulu's forces were devastating wide swathes of western Anatolia, Kızılbaş sympathizers were propagandizing among the population of north-central Anatolia; indeed, the uprising had spread here too.[115]

For years the Safavids and their sympathizers had been trying to subvert Ottoman political authority in Anatolia; having disposed of the rivals for power within his own family, Sultan Selim readied himself to take on Shah Isma'il himself. Single-mindedly he prepared for what would clearly be a difficult campaign: the distance to be travelled by the army was great, the terrain inhospitable, and the Kızılbaş hostile. In the spring of 1514 he crossed the Bosporus to begin the long journey eastwards.

Like Sultan Mehmed II on the eve of the siege of Constantinople, Selim I renewed treaties with European states – Venice and Poland – and with the Mamluks, hoping thereby to avert any risk of war on two fronts. Agreement with Hungary proved more difficult, even though both parties knew it to be to their mutual advantage. The Hungarian envoy was held hostage and with his suite was taken on Selim's campaigns in Iran and afterwards in Syria and Egypt, where, for the purpose of demonstrating Selim's enormous power, he was paraded to observers as the Hungarian king.[116]

In Islamic law, the only allowable justification for the war of Muslim against Muslim is a religious one, 'to enforce the sacred law or to check transgressions against it';[117] Ottoman campaigns therefore required sanction in the form of an opinion expressed by the religious authorities that the proposed foe had departed from the path of true Islam. When the Anatolian emirates came under Ottoman sovereignty as the result of territorial disputes, chroniclers had been eager to provide the conquerors with due provocation. The struggle with the Safavids was clearly going to be not only logistically taxing but, without doctrinal sanction, illicit. The Ottoman quarrel was cloaked accordingly in religious rhetoric, their claim to be the repository of 'right religion' – in distinction to the errant Safavids – duly emphasized. As the propaganda battle against the Safavids intensified, a new vocabulary was employed to describe Isma'il's adherents:

> . . . according to the prescripts of the holy law . . . we give an opinion according to which [the Kızılbaş whose chief is Isma'il of Ardabil] are unbelievers and heretics. Any who sympathize with them and accept their false religion or assist them are also unbelievers and heretics. It is a necessity and a divine obligation that they be massacred and their communities be dispersed.[118]

The scholar-historian Kemalpaşazade (who during the succeeding reign of Sultan Süleyman I held the highest office in the Ottoman religious hierarchy, that of sheikhulislam) stated the matter more forcefully yet: in his opinion, war against the Kızılbaş was counted 'holy war', of equivalent

merit to war against the non-Muslim enemies of Islam.[119] The outright condemnation of the Safavids in Ottoman sources is in surprising contrast to the respectful terms in which Safavid historians referred to the Ottomans, seeing them as a bastion of Islam in the face of European unbelief. The Ottomans needed to execrate the Safavids in the harshest terms their religion could allow in order to justify the severity of their repressive measures.[120]

Sultan Selim carried out his religious duty with brutal efficiency. Once in possession of a juridical opinion permitting him to go to war against Shah Isma'il, he wrote to accuse his enemy of departing from the faith:

> ... you have subjected the upright community of Muhammad ... to your devious will [and] undermined the firm foundation of the faith; you have unfurled the banner of oppression in the cause of aggression [and] no longer uphold the commandments and prohibitions of the Divine Law; you have incited your abominable Shii faction to unsanctified sexual union and the shedding of innocent blood.[121]

To reduce the threat of Kızılbaş harassment along his route to Iran, Selim sent his officials to the province of Rum in north-central Anatolia to register by name the Kızılbaş who had settled there. Many thousands of the 40,000 registered were massacred, and thousands more arrested;[122] as a result no Kızılbaş agitation was experienced in the rear of the Sultan's march, nor for the next five years or so.[123] Selim also closed his frontiers with the Safavid state, forbidding the passage of merchants in either direction – this was a trade war aimed at ruining the Safavid economy by halting its export of silk to the west, but also at preventing arms, metal or specie moving into Iran from the west. As a precursor to this more drastic measure, Selim had expelled Iranian merchants from Bursa when he wintered there in 1512–13.[124]

Of advantage to Selim was the presence on Shah Isma'il's eastern frontier of the Özbek state which had been a contender for the spoils of the Akkoyunlu and the Timurids which had fallen to the Safavids. In 1510 Isma'il had driven the Özbeks back across the River Oxus, but in 1512 they again invaded his north-eastern province of Horasan and defeated a Safavid army. In the summer of 1514 Selim marched on Isma'il's territory from the west. Despite having advance warning of Selim's intentions, Isma'il could do little to prepare for this encounter, and the only tactic he could employ was a scorched earth policy in advance of the Ottoman army.

The rigours of the journey across Anatolia by Selim's army to engage Shah Isma'il in battle exhausted his troops, provisions were in short supply, and the failure to reach Isma'il triggered discontent. Despite the juridical opinion justifying the campaign, there were murmurings in Ottoman ranks

that it was wrong to fight fellow Muslims. The janissaries, never given to concealing their anger, were close to outright mutiny and fired their guns at the Sultan's tent when they were camped north of Lake Van. Soon Selim heard that Shah Isma'il's forces were assembled at Çaldıran, north-east of the lake; the prospect of imminent confrontation mollified the janissaries. In the battle that took place on 23 August 1514 Isma'il fielded 80,000 cavalry archers, many of them drawn from the tribes it was Selim's mission to subdue, including those from Dulkadır and Karaman. Selim's forces numbered some 100,000 men, of whom 12,000 were janissary musketeers. Isma'il lacked not only muskets but also cannon, of which the Ottomans had 500 which they chained together, preventing Safavid advance. Both sides suffered great losses in the ensuing battle, notably among the high command.[125] One of Isma'il's wives was captured and given to an Ottoman statesman[126] while Isma'il himself fled the field, first to Tabriz and then south-east. Selim pursued him as far as Tabriz where he arrived on 6 September, and sacked the city. It was unseasonably cold; Selim may have intended to remain in the region with a view to fighting the following spring, but the Ottoman troops, including the provincial cavalrymen, refused to winter in the east and he was obliged to turn back towards Amasya.

To assuage the rumblings of discontent in the army, scapegoats were needed. They included the grand vezir, Hersekzade Ahmed Pasha, who had seen a long career in Ottoman government service since being brought from his native land of Bosnia by Mehmed II's army in 1474. He was dismissed and his place taken by the second vezir, Dukakinzade ('Son of the Duke') Ahmed Pasha – his father was an Albanian nobleman – who was soon executed for colluding in a janissary mutiny at Amasya which had erupted early in 1515 with the aim of preventing another campaign in the east; Dukakinzade Ahmed was also suspected of corresponding with Alaüddevle, ruler of Dulkadır. Alaüddevle had refused to join the Ottomans in their war against Isma'il, and Dulkadır troops had fought at Çaldıran with the Safavid shah, who had sent a Kızılbaş force to assist Alaüddevle in launching attacks across the Ottoman frontier to cut Selim's supply lines. Selim determined to end Dulkadır's existence. On this occasion the Mamluks failed to aid Alaüddevle. Dulkadır fell to Selim's army in June 1515, and the road to Syria and Egypt was open to the Ottomans.[127]

In the wake of the Çaldıran campaign the Kızılbaş refuge of Kemah (Kamakh), on the Euphrates to the south-west of Erzincan, fell into Ottoman hands, as did, among others, the strategic city of Diyarbakır on the Tigris. Attracted to Selim's side by the prestige of his victory at Çaldıran, the Kurdish tribal lords of the region chased Isma'il's officers and officials from

the mountains of south-eastern Anatolia, and as Selim's grip on the border-lands tightened, the Ottoman sphere of influence was extended eastwards to the Erzincan–Diyarbakır line and into what is now northern Iraq. The accompanying extension of Selim's 'closed frontier' policy all but cut off Tabriz from its Kızılbaş constituency and the centre of gravity of the Safavid lands perforce shifted eastwards, to the disadvantage of Isma'il's Turcoman supporters.

But Selim could not afford to be complacent. Fresh problems arose concerning the loyalty of his own troops. A commander from Amasya wrote to complain that, because of the wretched economic conditions in the area, the land-holdings allotted to the cavalrymen of the province of Rum to finance their upkeep were so impoverished that there was a risk that they would be unable to make their appearance on campaign. In the days before the extension of Ottoman control over the other states of Anatolia, it had been permissible for a cavalryman to send a proxy to fight in his place; now, Ottoman law demanded that he go in person. Furthermore, land rights which had formerly been heritable were now bestowed at the whim of the sultan. Both changes, wrote the commander, were the cause of great dissatisfaction.[128]

Three successive reigns had failed to bring stability to the lives of the provincial cavalrymen who were such an important component of the army in battle and of the rural order in peacetime. Scholarly opinion is undecided about how far Sultan Mehmed II had effected his policy of reassigning the holdings of indigenous Anatolian families to his new breed of Christian-born cavalrymen, but it seems that the trend began in his reign. Bayezid II had reversed his father's measures, returning these holdings to their former owners and as a consequence antagonizing those whom Mehmed had favoured. Selim continued his grandfather's policies of undermining local ties by making the sultan the principal source of largesse. In the province of Karaman, for instance, he bestowed lands on cavalrymen brought in from Rumeli for the purpose of breaking up the old order of dynastic and tribal allegiances since these were proving a stronger focus for loyalty than the new imperial order he was intent on imposing.[129] Palliatives the peasant class was accorded – such as the preservation in the province of Rum of laws dating back to the days of the Akkoyunlu[130] – were not extended to the indigenous provincial cavalry, while Selim's reforms compounded the uncertainties and insecurities brought about by the suppression of the Kızılbaş and the simmering hostility against Iran.

After his defeat at Çaldıran Isma'il assumed that Selim would return in the spring to continue his campaign, and his anxiety was heightened by further Özbek attacks in the east. Selim refused to accept Isma'il's pleas for

peace, arresting and imprisoning the several Safavid envoys (they included the highest religious authority in Azerbaijan) who came as supplicants to his court.[131] Isma'il began to look for allies among the Christian powers but his appeals fell on deaf ears. Venice had had cordial relations with Isma'il from the early years of the century but had renewed its treaty with the Ottomans in 1513 and declined to offer assistance. Cem's son Murad had continued to live on the island of Rhodes after his father's short sojourn there in 1482 but had never put himself forward as a claimant to the Ottoman throne; as if to emphasize the point, he had converted to Catholicism. Yet Isma'il demanded of the Knights that he be handed over. In 1510 and 1513 Isma'il had failed in an attempt to interest Affonso d'Albuquerque, Viceroy of the Indies and the architect of Portuguese expansion into the Indian Ocean, in an attack on their common enemy, the Mamluks; he appealed again to the Portuguese after Çaldıran, and Albuquerque sent two small cannon and six arquebuses – scarcely even a symbolic gesture. Appeals to Hungary, Spain and the Pope were turned down.[132]

The Ottomans had many reasons to attempt the conquest of Syria and Egypt, and it was clear that now was the time to act. Before Çaldıran the Mamluk sultan Qansawh al-Ghawri, wanting to keep his options open, had refused to participate in an alliance with Selim against Isma'il; after Çaldıran, in 1515, he declined to enter into a pact with Isma'il against the Ottomans. Before Çaldıran Selim's attitude towards the Mamluks had been conciliatory; after Çaldıran, the Ottoman annexation of Dulkadir exposed the Mamluks to a direct attack, and the Sultan could risk more open aggression. He snubbed the Mamluks by appointing Alaüddevle's nephew and rival Ali Bey as governor of the new province of Dulkadir in his place and sending Alaüddevle's head to Cairo.[133]

Diplomacy between the great powers of the Middle East was a complicated business. The spies and agents of each – Ottoman, Mamluk and Safavid – were engaged in an endless game of disseminating propaganda and disinformation in equal measure. In 1516 Selim's army set out eastwards again from Istanbul, having spent the winter preparing for what was clearly planned to be a major campaign. Qansawh al-Ghawri believed the attack would be directed against Isma'il, as did Isma'il himself.[134] Modern scholarship is divided as to whether Selim did indeed intend to campaign against Isma'il in 1516, and only changed direction once he was well advanced. Against this, Selim's campaign of 1514 had been arduous and his troops mutinously unenthusiastic, and moreover Isma'il had been thoroughly humiliated by his defeat at Çaldıran, and could no longer sustain his claims to precedence in the Islamic world.

Ottoman chicanery reached its climax in a letter from Khayr Bak, a Mamluk official in Aleppo, who sent news to Qansawh al-Ghawri in April 1516 stating – falsely – that Isma'il, invading Ottoman territory at the head of a large army, had ousted the recently-installed Ottoman garrison of Diyarbakır, close to the Mamluk border. This inspired Qansawh al-Ghawri to march to Aleppo to see for himself what was happening, an advance which Selim disingenuously interpreted as provocation. But the Mamluks, as Sunni Muslims and guardians of the Holy Places of Islam at Mecca and Medina, could scarcely be branded heretics even in the interests of Ottoman realpolitik, so that a campaign against them was harder to justify than one against the Safavids and their Kızılbaş adherents. Although the evidence of Qansawh al-Ghawri's purported intrigues with Isma'il is little more than Isma'il's approach to him in 1515,[135] the Ottoman religious establishment agreed to support a campaign against the Mamluks on the grounds that 'who aids a heretic is himself a heretic', and that to do battle against them might be considered holy war.[136] Selim was in no mood to let the weakness of this pretext deflect him from his purpose; the Ottoman chroniclers, perhaps because they realized that the Sultan's case was canonically questionable, took pains to emphasize that the campaign was directed against the 'heretical' Safavids rather than the Sunni Mamluks.

Armed with the religious opinion he sought, Selim marched south from Malatya into Syria, and the Ottoman and Mamluk armies met north of Aleppo at Marj Dabik on 24 August 1516. In a few hours the battle was over. Although the Mamluk army was perhaps as numerous as Selim's, they had barely begun to embrace gunpowder technology and had few firearms to face the Ottoman cannon and muskets. Panic set in among his troops as Qansawh al-Ghawri fled the field, his flight marking the end of more than 250 years of Mamluk rule in Syria. The desertion to the Ottomans of the Mamluk forces under Khayr Bak, now governor of Aleppo, was another decisive factor in this crucial battle: Ottoman cunning again became evident, for it turned out that Khayr Bak had for some time been an agent of the Sultan. Qansawh al-Ghawri did not survive, but the cause of his death is uncertain.[137]

The people of Aleppo had no love for the Mamluks and rejoiced at news of the Ottoman advance; Selim's army met with no resistance as it moved south to Damascus, which surrendered. On the first Friday in the holy month of Ramadan the prayer was performed in Sultan Selim's name in the city's great Umayyad mosque, built in the early eighth century. In this way did the new, Ottoman, ruler of Syria announce his victory to the world. Selim and his advisers were at first undecided whether the army should proceed to Cairo: it was already late in the campaigning season,

and the Mamluk capital lay far across the desert. It was clear, however, that the gains already made in Syria would not be secure if Egypt remained in Mamluk hands, and Selim therefore accepted the advice of those eager to continue this outstandingly successful campaign. In Cairo, there was disagreement between the notables over whether to heed Selim's call to surrender. Tuman-Bay, the new Mamluk sultan, was in favour of reaching an accommodation with Selim, but the war party won the argument; in a battle south of Gaza a Mamluk army under the command of the dispossessed Mamluk governor of Damascus, Janbardi al-Ghazali, was outgunned and outmanoeuvred. On his march south Sultan Selim visited the Muslim Holy Places in Jerusalem, a city which, as well as being sacred to Christians and Jews, is the third most revered shrine in Islam – the site, in some traditions, of the Prophet Muhammad's ascent into heaven. A week after leaving Damascus, on 23 January 1517, the Ottoman army defeated the Mamluks at Raydaniyya outside Cairo – like the Safavids at Çaldıran, the Mamluks relied on their mobile cavalry archers who were no match for the cannons and muskets of the Ottomans. Selim briefly entered Cairo a few days later to be confronted with strong resistance which his troops could only overcome with much loss on both sides. The Mamluk commanders fled across the Nile and remained at large for some two months. Tuman-Bay was apprehended and brought before Selim on 31 March; he was killed and his body displayed in public at one of the gates of the city for all to see. Only then could the Ottoman sultan consider Cairo his and the Mamluk empire defunct.[138]

Selim's conquest of the Mamluk domains shifted the centre of gravity of the Ottoman Empire eastwards culturally as well as geographically. He was now the ruler of the Arab lands where Islam had begun, and for the first time in its history the population of the empire was predominantly Muslim. Selim was now visibly the most successful Islamic ruler of his time. He had won his throne in the struggle against the Kızılbaş heresy and thereby reinforced the identification of the Ottomans, both politically and ideologically, with religious orthodoxy. Victory over the Mamluks made him guardian of the Holy Places of Mecca and Medina and guarantor of the pilgrimage routes by which the Muslim faithful had travelled to the sites associated with the life of the Prophet Muhammad for more than eight hundred years. Possession of the sites sacred to Islamic orthodoxy could only imbue the Ottoman dynasty with greater legitimacy. This sudden Muslim predominance within the empire sealed the Ottoman tendency towards fuller adoption of the traditional Islamic practices and mores of the Arab lands: as it has been recently put: 'the question of who conquered whom is debatable'.[139]

Until its sack by the Mongols in 1258 and their murder of Caliph al-Musta'in of the Abbasid dynasty which had held the office for five centuries, Baghdad had been the centre of the Islamic caliphate. In 1260 the Mamluk general Baybars had brought an Abbasid scion to Cairo, but the caliphate had long since lost the religious authority it had enjoyed in the days when Islamic rulers had had to apply to the caliph for full legitimization of their rule. The Cairo caliphs lacked power, and retained only a shred of their former influence. The Mamluks exploited them as part of their accession ceremonial, and their titles were appropriated by Islamic rulers as an instrument in establishing their legitimacy. The title of caliph had, for instance, been used on occasion by Ottoman sultans since Murad II, but in a rhetorical sense rather than as a straightforward political–legal assertion of sovereignty over the Muslim community. Selim certainly made no claims to exercise what remained of the sacred authority of this office; the last caliph, al-Mutawakkil, was sent into exile in Istanbul, where he stayed until the reign of Selim's son Süleyman. As time went by, the issue of the caliphate came to intrigue Ottoman intellectuals, but stories that there had been an official transfer of the office to Selim when he conquered Cairo did not begin to circulate until the eighteenth century,[140] when it was necessary to counter Russian claims to protect Ottoman Christians with claims to Ottoman spiritual authority over Russian Muslims.

With Selim's conquest of Egypt and Syria, the trade blockade of Iran became easier to enforce. Despite Selim's prohibition, merchant caravans had circumvented it by passing from Iran into Mamluk territory and thence sending goods westwards by sea. After the conquest, the Mamluk trade routes both by land and sea came under direct Ottoman control. If this was a cause for satisfaction, the truth was that the Safavid and Ottoman economies had both suffered from the blockade: the silk which passed along the trade routes was the engine of the Iranian economy, and Bursa the chief market for this commodity in the Ottoman Empire. The shortage must also have been keenly felt in Italy, the end-market, where silk was much prized and where profits from the trade were vital to the economies of the city-states. Deportation was another tool Selim used in his trade war with the Safavids. The Iranian community in the newly-Ottoman city of Aleppo – the emporium in whose markets silk from Iran was sold on, especially to Venetian merchants – was suspected of maintaining ties with Shah Isma'il, and in 1518, like the Iranian community of Bursa before it, was removed to Istanbul.[141]

The conquest of the Mamluk lands promised prestige and geopolitical advantage, and opened new vistas of Ottoman expansion. Selim now had

a route to the Red Sea, and a new era of direct Ottoman rivalry with the Portuguese in the Indian Ocean began. In its heyday in the fourteenth and fifteenth centuries the Mamluk state had been as splendid as the Ottoman, thanks to the revenues derived from its control of the spice trade from the east and taxes levied on locally-grown rice, sugar and cotton; these riches would now fill the Ottoman sultan's coffers. The resounding defeat of Shah Isma'il at Çaldıran in 1514 neutralized the volatile tribes of the Ottoman south-eastern flank, and many of them came under Ottoman rule with the redrawing of the political map of the region. With the reverse suffered by their champion the Kızılbaş were subdued for the time being, but their total suppression continued to be a major preoccupation of Ottoman domestic politics throughout the sixteenth century.

Selim left Cairo in September 1517 and moved north at a leisurely pace. When Shah Isma'il's envoy arrived in Damascus with rich presents to express his master's hopes for peace, he was executed. In May 1518 Selim's army marched to the Euphrates, apparently heading towards Iran, but then without warning turned west and returned to Istanbul. His reasons for this change of direction are unknown but his decision may have been influenced by discontent among his troops at the prospect of another campaign against Iran, or by doubt that his logistic preparations were sufficient to undertake such an expedition.[142]

Observers wondered what Selim would do next. Following his annexation of the Mamluk lands, his neighbours in the west feared that he would now turn his attack on them. At the same time, his conquest of Syria had given them cause to go on the offensive themselves, the Holy Sites of Christendom in Bethlehem and Jerusalem having fallen into Ottoman hands. Although the Christian Holy Sites had been in Muslim hands since the seventh century, except for the interlude between 1099 and 1244 when they were held by the Crusaders, the Ottomans were far more threatening to the West than the Mamluks, and their possession of these sites intensified Pope Leo X's efforts to organize a crusade. He commissioned a report from his cardinals who responded in November 1517 that there was no alternative to a crusade when the enemy's aim was the destruction of Christianity. Francis I of France and the Holy Roman Emperor Maximilian I put forward their views, Maximilian proposing that a five-year Europe-wide peace was necessary before a crusade could be considered. In 1518 the Pope accordingly declared that the princes of Christendom must renounce the quarrels which so often in the past had prevented them acting in concert against the Ottomans.[143]

A flurry of diplomatic activity followed as the Pope sought ratification of this project,[144] but he was to be disappointed yet again by the lukewarm

reaction of various parties essential to its success. Venice could not afford to be involved: having renewed peace with the Ottomans in 1513 and refused to be wooed by Isma'il after his defeat at Çaldıran, in 1517 the republic had won from the Ottomans the right to continue to hold Cyprus as a tribute-paying colony, as it had done under the Mamluks.[145] Raid and counter-raid had for many years continued at a low intensity on the long Ottoman–Hungarian frontier, but in 1513 the King of Hungary had concluded a peace treaty with the Ottomans.[146] The treaty between the Ottoman Empire and Poland was renewed in 1519.[147] Perhaps the greatest hindrance to the proposed crusade, however, was the contention between Francis I of France and Emperor Charles V for mastery within Europe. The Ottomans were learning how to exploit the rivalry between the Christian powers, and the plan for a crusade collapsed.

In 1519 the scope of activity in the imperial arsenal seemed to suggest Rhodes as a likely target of Ottoman designs: since the conquest of Egypt an attack on this Christian stronghold, on the maritime route between Istanbul and Selim's new provinces, was only a matter of time. But Shah Isma'il feared the worst: although his former power was gone, he still had the capacity to annoy Selim and in the early months of 1520 he gave his blessing to a Kızılbaş rebellion that became known as the Şah Veli uprising, after a Kızılbaş leader from near Sivas where in 1511 Şahkulu had met his end in battle. Some years before, Şah Veli's father Sheikh Celal had rallied thousands of men to his side, proclaiming himself the Messiah and posing a serious threat to order in north-central Anatolia, and in 1516 and 1518 Şah Veli himself had evaded the Ottoman blockade to travel to and from Iran. The Ottoman governor of Sivas wrote to Istanbul of the scope of Kızılbaş ravages in Anatolia, where their sympathizers included members of the Dulkadırid dynasty, opposed to Selim's client Ali Bey. The Sultan mobilized his army against this renewed menace and two major battles ensued in central and north-central Anatolia. Ali Bey executed Şah Veli and had him dismembered in public, as a lesson to his supporters and a warning to those of his own men with Kızılbaş leanings.* Following this uprising, the commander of the Ottoman army was ordered to spend the summer in Anatolia with his men, in preparation for a new campaign.[148]

From Istambol's throne a mighty host to Iran guided I;
Sunken deep in blood of shame I made the Golden Heads [i.e. the Kızılbaş] to lie.
Glad the Slave [i.e. the Mamluks], my resolution, lord of Egypt's realm became:

* Sheikh Celal and Şah Veli are venerated to this day and their supposed tombs, situated to the south-west of Sivas, are apparently still standing.

Thus I raised my royal banner e'en as the Nine Heavens high.
From the kingdom fair of Iraq to Hijaz these tidings sped,
When I played the harp of Heavenly Aid at feast of victory.
Through my sabre Transoxiana drowned was in a sea of blood;
Emptied I of kuhl of Isfahan the adversary's eye.
Flowed down a River Amu [i.e. the Oxus] from each foeman's every hair –
Rolled the sweat of terror's fever – if I happed him to espy.
Bishop-mated was the King of India by my Queenly troops,
When I played the Chess of empire on the Board of sov'reignty.
O SELIMI, in thy name was struck the coinage of the world,
When in crucible of Love Divine, like gold, that melted I.[149]

The violent images conjured up by this poem by Sultan Selim – under his nom de plume, Selimi – endorse the reputation for ruthlessness he earned himself, towards enemies (such as the hapless envoys of the Safavid shah Isma'il) and also closer to home. His treatment of Isma'il's envoys may have been a response to the Shah's earlier mistreatment of one of Bayezid's envoys, reported to have been forced to watch a Sunni opponent of the Shah burn, and also to eat forbidden pork.[150] In his treatment of his own ministers, however, Selim exercised to the full his absolute power of life and death over the 'sultan's servants'. His father had rotated the office of grand vezir among seven men during the twenty-nine years of his reign; of the six men who held the office of grand vezir during the eight years of Selim's reign, he caused three to be executed. Selim is known to posterity as 'Yavuz', 'the Stern': he came to power violently, and violence marked his reign. He died on the road from Edirne to Istanbul during the night of 21–22 September 1520, leaving only one son, Süleyman, who came to the throne without crisis. Before he died he ordered his leading clerics to renew the opinion sanctioning war against Isma'il.[151]

The conquest of Constantinople had given Mehmed II the power that went with the possession of an imperial city which had exerted its fascination for centuries, a legacy he drew upon in his bold claims to be the inheritor and continuator of the glorious secular traditions of Byzantium. With his victory over the Mamluk state and his possession of the Holy Places of Islam, Sultan Selim made the Ottomans heir to an equally glorious sacred tradition. Secular and sacred traditions would together sustain the legitimacy and authority of his successors.

5

Possessor of the kingdoms of the world

[SULTAN SÜLEYMAN] HAS drawn near to [God], the Lord of Majesty and Omnipotence, the Creator of the World of Dominion and Sovereignty, [Sultan Süleyman] who is His slave, made mighty with Divine Power, the Caliph, resplendent with Divine Glory, Who performs the Command of the Hidden Book and executes its Decrees in [all] regions of the inhabited Quarter: Conqueror of the Lands of the Orient and the Occident with the Help of Almighty God and His Victorious Army, Possessor of the Kingdoms of the World, Shadow of God over all Peoples, Sultan of the Sultans of the Arabs and the Persians, Promulgator of Sultanic *Qanuns*, Tenth of the Ottoman *Khakan*s, Sultan son of the Sultan, Sultan Süleyman Khan . . . May the line of his Sultanate endure until the End of the Line of the Ages![1]

Thus run the extravagant claims recorded in the inscription over the main portal of the great mosque Sultan Süleyman I built in Istanbul in the 1560s, during the last years of his reign. He was a contemporary of the ambitious Renaissance monarchs of Europe – the Holy Roman Emperors Charles V of Habsburg and his brother Ferdinand I; Charles's son Philip II of Spain; the French Valois kings Francis I and his son Henry II – rivals of the Habsburgs; the English Tudors, Henry VIII and his children, Edward VI, Mary I and the 'Virgin Queen', Elizabeth I; and of Ivan IV, 'the Terrible', tsar of Muscovy. Shah Isma'il still ruled in Iran when Süleyman came to the throne and the Mughal emperor Akbar in India from 1556. Such European observers as the Venetian ambassadors to his court ranked Süleyman with these and called him 'the Magnificent' or, simply, 'the Grand Turk'.

The Venetian envoy to Istanbul described Süleyman on his accession in 1520:

. . . only twenty-five years old, tall and slender, but tough, with a thin and bony face. Facial hair is evident but only barely. The Sultan appears friendly and in good humour. Rumour has it that Süleyman is aptly named,* enjoys reading, is knowledgeable and shows good judgement.[2]

He was fortunate in that his accession was uncontested; yet it seems unlikely

* Meaning that Süleyman was wise; Süleyman is the Ottoman version of Solomon.

that Selim should have sired only one son when he had six daughters, and it is possible that there were brothers who were executed in 1514 to prevent a coup while Selim was on campaign against the Safavids – but whom the sources neglect to mention. Süleyman ruled the Ottoman Empire for 46 years, longer than any other sultan, and led his army on thirteen campaigns to the frontiers of his domains.

Europeans marvelled at the pace of Ottoman military conquest. Those who visited the empire during Süleyman's reign sent an eager audience at home highly-coloured accounts of their experiences, dwelling also on the grandeur and display of diplomatic relations, court ritual, and architecture. But these splendours were not what most struck his Ottoman contemporaries, and Ottoman writers of later times. Süleyman declared on his accession that even-handed justice would be the hallmark of his reign, and soon overturned some of his father's decisions which seemed to run counter to this intention. One of his first acts was to compensate the Iranian merchants at Bursa whose silk Sultan Selim had confiscated when he banned commerce with the Safavids. The craftsmen and scholars who had forcibly been deported by Selim on his conquests of Tabriz and Cairo were allowed to return home, and governors who exceeded their powers and abused their trust were punished.[3] Caliph al-Mutawakkil was permitted to return to Cairo from his enforced exile in Istanbul.[4] Such acts as these and the attention which he later gave to codifying the laws of the empire led Ottoman writers of the eighteenth century and since to describe Süleyman as 'Kanuni', 'the Legislator'.[5] The epithets 'Magnificent' and 'Legislator' highlight the differing perceptions Europeans and Ottomans had of Süleyman's reign, but they also broadly evoke its contrasting phases: from his accession until the execution in 1536 of his favourite, the grand vezir İbrahim Pasha, the Sultan lived as an ostentatious, public figure; during the remaining thirty years of his sultanate, until his death in 1566, he led a sober existence and was rarely glimpsed by his subjects or foreign visitors. A Venetian envoy in Istanbul wrote of him in 1553:

> ... [he] now drinks no wine ... only fair water, on account of his infirmities. He has the reputation of being very just and when he has been accurately informed of the facts of the case he never wrongs any man. Of his faith and its laws he is more observant than any of his predecessors.[6]

The renunciations that characterized Süleyman's later years have been attributed to the approach of the Islamic millennium in the year 1591–2, and the need he felt to prepare himself for the perfect world that was imminent.[7] It did not need the closing of a millennium to arouse expectations among the monarchs of the time and Europe, too, was awash with apocalyptic

notions which affected dreamers at all levels of society. In Spain, for example, the crusading enthusiasm of the late fifteenth century was in no way diminished by its destruction of the Islamic kingdom of Granada in 1492, for there were souls to be won in North Africa and the New World. Christopher Columbus, for instance, became obsessed with the twin goals of recovering Jerusalem from Muslim rule and converting the world to Catholicism, and saw himself as the Messiah of the last days.[8]

In 1530 the Habsburg emperor Charles V revived the idea of the Holy Roman Empire as a universal monarchy and was crowned by the Pope in Bologna: the Holy Roman Empire had been the medieval state encompassing Italy and much of central Europe that was fancifully seen as the successor to the Roman Empire and purported to unite all (Catholic) Christians under one sovereign. Soon after, in an elaborate ceremony in 1547, Ivan IV was crowned tsar of all Russia: this bold assertion of equality with the kings of Europe – on whom only the pope could confer their title – was also a statement of his claim to be heir to Byzantium and, himself, the universal monarch.[9]

With their millennium approaching, Islamic rulers had yet greater reason to promote visions of the world that matched their boundless ambitions, and did so in various ways. In India, the Mughal emperor Akbar's response was to emphasize the secular and religiously neutral character of his multi-ethnic state, and his 'pursuit of reason rather than reliance on tradition';[10] the Safavid shah Isma'il cast himself as the 'restorer of justice' and 'true religion' among his Kızılbaş followers; and his rival Sultan Süleyman also saw the pursuit of justice as the key, but in an orthodox Sunni Islamic guise.

In this climate of fierce competition, the use of grandiose titles was an effective way to publicize pretensions to universal kingship. Like his inscriptions, Süleyman's decrees, correspondence and coinage became suitable vehicles for this purpose. Following his conquest of Syria and Egypt in 1516–17, his father Selim I had referred to himself as 'world conqueror', a term indicating absolute sovereign authority in the most uncompromising way. Süleyman perpetuated this claim, and in chancery documents such as this letter to King Sigismund I of Poland-Lithuania in 1525 the territorial extent of his empire was spelled out in exaggerated terms:

> ... *padişah* of the White [i.e. Mediterranean] and the Black Sea, of Rumelia, Anatolia, Karaman, the provinces of Dulkadır, Diyarbakır, Kurdistan, Azerbaijan, Persia, Damascus, Aleppo, Egypt, Mecca, Medina, Jerusalem, and all the lands of Arabia, of Yemen, and of the many lands conquered with overwhelming power by my noble fathers and magnificent grandfathers.[11]

His father Selim's conquest of the Mamluk state gave Süleyman Jerusalem, but he was not the only one to claim it: when the French entered Naples in 1495 Charles VIII was acclaimed king of Jerusalem; Charles V of Spain also saw himself in this role (as did Philip II after him), and prophecies that he would capture the city abounded in the West.

From Süleyman's accession, his father Selim's aggressive policy in the east was superseded by one of disengagement: Süleyman sought to contain Iran, not conquer it. Envoys sent secretly to the Safavid court at Tabriz to ascertain the risk posed by Shah Isma'il established that he was preoccupied by an army of the Sunni Özbek state which lay to his east, which was again threatening Safavid territory. This left the new sultan free to set out on his first campaign[12] – in the west, where unfinished business demanded his attention. Like Shah Isma'il, European monarchs were also occupied elsewhere – Charles V with the first stirrings of the Reformation and Francis I of France with resisting Charles's claims against his territories in Italy – and unprepared for a sudden reversal of Ottoman policy after years of peace. Süleyman aimed to capture the great fortress of Belgrade which neither Murad II nor Mehmed II had been able to wrest from Hungary. Hungary was weak and isolated and unable to respond, and on 29 August 1521 Belgrade surrendered after a siege of almost two months. Some of the defenders who had hoped to remain were forcibly exiled to Istanbul where they were settled near the fortress of Yedikule; others from the towns and castles of Srem, the tongue of land between the Danube and Sava rivers, were settled in villages of the Gelibolu peninsula.[13] Several other Hungarian strongholds also fell to the Ottomans, who now had access to the route westwards along the Sava and the possibilities of water-borne transport which it offered. Possession of Belgrade after the failed sieges of 1440 and 1456 provided the Ottomans with a strong forward base for any push into the heart of Hungary.

Next it was the turn of Rhodes, another stronghold Mehmed II had failed to capture and which the Knights had feared Selim would surely attack. What the Ottomans found insupportable was not that Rhodes sheltered and supplied pirates who made attacks on Ottoman shipping, but that the Knights held as slaves many Muslims captured on corsair raids while making the pilgrimage to Mecca. Those who managed to escape from Rhodes complained of the harsh treatment they received, which often ended in death for those who did not escape or could not afford to ransom themselves.[14]

Süleyman commanded his army in person; the siege lasted five months and the Ottomans accepted the surrender of Rhodes on 20 December 1522.

The Knights had sustained great losses, and were allowed to go free; settlers from the Balkans and Anatolia soon arrived to take their place. The Knights sailed west but could find no permanent refuge until in 1530 they settled on the inhospitable island of Malta – 'merely a rock of soft sandstone' – which Charles V offered them on condition that they take responsibility for the defence of the Spanish outpost of Tripoli in North Africa.[15] The conquest of Rhodes brought the Ottomans a step closer to full control of the eastern Mediterranean basin. They failed, however, to exploit the island's commercial or strategic possibilities; the Venetian envoy Pietro Zeno noted this neglect almost immediately, observing in 1523 that 'the Sultan has no use for Rhodes'.[16] Of the large islands in the region, only Cyprus and Crete remained in non-Ottoman hands.

Selim I's victory over the Mamluks brought into the empire subjects with a history quite unlike that of the peoples the Ottomans had conquered before. Campaigns against Byzantium and the Christian states of the Balkans had to some extent been inspired by the rhetoric of 'holy war', whereby it was the duty of Muslims to extend the rule of Islam over non-believers. In Anatolia, the lesser states the Ottomans annexed were, like themselves, Turkish in origin and Muslim, sharing a common culture. The Mamluk lands required a fresh approach, for although the majority of the population was Muslim, these new Ottoman subjects were Arabs, whose culture and traditions were older than and very different from those of the Ottomans.

The Mamluk conquests were soon reorganized as Ottoman provinces and the aim was to establish a relationship which would encourage their new subjects to believe in the 'naturalness' of the Ottoman order. The preamble to the law-code of the Syrian province of Tripoli promulgated in 1519 gives an idea of how the Sultan sought to legitimize his sovereignty. It stated that the province had hitherto been held by 'tyrants' – meaning the Mamluks – from whom God had wrested power to bestow it on more worthy rulers, the Ottomans. The Mamluks were said to have misused their mandate from God; Ottoman rule, by contrast, would usher in an era of justice under the leadership of the Sultan, to whom were ascribed many of the qualities usually reserved for the Almighty.[17]

The appointment to administrative positions of prominent members of the ousted regime was another stratagem the Ottomans used to ease their assumption of power. To govern the provinces of Damascus and Egypt Sultan Selim had appointed men who had collaborated with the Ottomans – the former Mamluk governor of Damascus, Janbardi al-Ghazali, was re-appointed to the province and the former Mamluk governor of Aleppo, Khayr Bak, went to Cairo as governor of Egypt. Very soon after Selim's death, however, Janbardi al-Ghazali led an uprising against his new masters,

declaring himself sovereign and entering into diplomatic relations with the Knights of Rhodes, from whom he sought military and naval support.[18] Revealing as it did the weakness of Ottoman authority in the recently-conquered Mamluk state, only a few days' voyage east of the island, this was a further incentive for Süleyman to conquer Rhodes. He sent an army to put down the revolt, and Janbardi was killed. Khayr Bak died in 1522 and was succeeded as governor of Egypt by Süleyman's brother-in-law Çoban ('Shepherd') Mustafa Pasha, who in 1524 had to crush an attempt by the next Ottoman governor Ahmed Pasha to re-establish the Mamluk sultanate with himself at its head. Süleyman considered this so alarming that he sent his favourite, his grand vezir and brother-in-law İbrahim Pasha – married to his sister Hadice Sultan – to govern Egypt, re-establish law and order and oversee the enactment of a law-code for the province.

İbrahim Pasha had been born a Venetian subject at Parga, on the Ionian coast opposite Corfu, and after his capture by the Ottomans had served in Süleyman's household in Manisa when he was prince-governor of Saruhan. Almost as soon as he became sultan, Süleyman publicly demonstrated the favour in which he held İbrahim by building him a magnificent palace on the Hippodrome in Istanbul.* Having inherited his first grand vezir, Piri Mehmed Pasha, from his father, Süleyman appointed İbrahim to succeed him. Such promotion, of someone who was not a vezir but a senior officer of the Sultan's household, was extraordinary.

The transition from Mamluk to Ottoman rule was handled more circumspectly following the revolts in Syria and Egypt. The Egyptian law-code of 1525, couched in conciliatory tones, aimed to appease the local population and protect them against any excesses on the part of the alien Ottoman military.[19] Once the internal situation had been stabilized and dissent bought off for the foreseeable future, the Ottoman state could begin to benefit from the revenues of Egypt – 'the jewel in the Ottoman crown and an indispensable source of its financial stability', as a modern historian puts it.[20] The Ottoman province of Egypt, like the Mamluk state before it, was responsible for the organization of the annual Muslim pilgrimage to Mecca, but even after the retention of revenue for this purpose and for the upkeep of the Islamic Holy Places a welcome surplus remained to be sent annually to the central Ottoman treasury in Istanbul.

Once İbrahim Pasha had established a sound basis for Ottoman rule in Egypt, the way was open for a more vigorous effort to protect the empire's commercial and territorial interests in the Arabian Sea, the Red Sea and the Persian Gulf, with which naval assistance rendered to the Mamluks in

* The palace, somewhat altered, today houses the Museum of Turkish and Islamic Art.

the time of Bayezid II had given Ottoman captains some familiarity. While the Mamluks still ruled Egypt the Portuguese had sent fleets into the Red Sea, and the consequent loss of revenues from the spice trade adversely affected the Egyptian economy. İbrahim hoped to make the Red Sea secure for Ottoman vessels and ordered the readying of a fleet at Suez under the captaincy of Selman Reis, who prepared a report which included a lengthy description of Portuguese enclaves on the coasts of the Indian Ocean and of the abundant riches of Yemen and ports in the Red Sea, and recommended an aggressive strategy of conquest.[21]

Another seafarer who favoured a forward policy in the Indian Ocean was the mariner and cartographer Piri Reis, who had commanded part of the fleet that lent logistic support to the overland attack on Egypt by Selim I in 1516–17 and had been İbrahim Pasha's pilot on his voyage to Egypt in 1524. Piri Reis had presented Selim with a map of the world drawn by himself, and had also composed a naval manual, the *Kitâb-i Bahriyye* ('Book of Seafaring'), a detailed compendium of nautical information about the seas and coasts of the Mediterranean, prefaced by an analysis of Portuguese activity in the Indian Ocean. When İbrahim returned to Istanbul in 1525 – after only a few months in Egypt – he brought a new edition of this manual to Süleyman's attention, in the expectation that the Sultan would share his vision for expansion in the Indian Ocean.[22] But although İbrahim's energetic successor as governor of Egypt, Hadım ('Eunuch') Süleyman Pasha – who was governor for a total of twelve years – built up the Suez fleet in response to attacks by the Portuguese on both pilgrim and merchant vessels, which aroused Ottoman fears that they might occupy the Holy Places, appeals to Istanbul for action prompted only a modest response. A challenge to Portuguese supremacy in the Indian Ocean was planned for 1531 but had to be postponed because the guns and munitions were needed in the Mediterranean instead.[23] Doubtless at Hadım Süleyman's instigation, the Ottomans embarked in 1531–2 upon the digging of a canal between the Red Sea and the Nile which was intended to provide an alternative route for the spice trade, out of reach of the Portuguese. Reports in the diaries of the contemporary Venetian chronicler and archivist Marino Sanudo tell of thousands of men working on this project – which was never completed.[24]

Soon after İbrahim Pasha returned to Istanbul from Cairo, he was appointed to command the imperial army on campaign in Hungary. With the Sultan he set out for the front, and on 29 August 1526 the Ottomans emerged victorious over the army of Louis II of Hungary and Bohemia in a two-hour battle in the marshes of Mohács in southern Hungary; King Louis

was drowned while escaping and those of his forces who had not been killed fled the field. The Ottoman victory at Mohács was as momentous in its consequences as that of Sultan Murad I against the medieval Serbian kingdom at Kosovo Polje in 1389 and initiated a 150-year struggle between Ottomans and Habsburgs in central Europe.

The core territories of the Habsburgs covered much of present-day Austria, but at the end of the fifteenth century judicious choice of marriage partners made the dynasty rulers of a far-flung empire. The marriage in 1477 of the future Maximilian I of Habsburg with Mary, heir to Charles 'the Bold', Duke of Burgundy (who also ruled over the Low Countries), was followed in 1496 by that of Maximilian's son Philip to Juana, daughter of Ferdinand of Aragon and Isabella of Castile. Although sixth in line to her parents' united throne, Juana succeeded after all those with prior claim died. On the death of Maximilian in 1519, his heir Charles V, eldest son of Philip and Juana, was ruler of the kingdoms of Castile and Aragon, along with Navarre, Granada, Naples, Sicily, Sardinia and Spanish America; the dukedom of Burgundy, and the Netherlands; as well as the Habsburg lands in Austria. In 1521 Charles's younger brother Ferdinand married the daughter of Wladyslaw of the Jagiellon dynasty, king of Hungary and Bohemia, and the following year their sister Mary was wed to Wladyslaw's son, Louis [II]. From 1521 the Austrian domains of the Habsburgs were given to Ferdinand to govern autonomously as archduke.[25]

The Austria of Archduke Ferdinand was not perceived as any immediate threat by Süleyman and his advisers who associated Habsburg might with Charles V and his wars in western Europe, where the main foes of the Habsburgs were the Valois of France. From 1494, when Charles VIII of France had seized the kingdom of Naples, until 1503, when it was won by Spain, their rivalry had been acted out in southern Italy; thereafter, the focus of their struggle had shifted to the north of Italy. The battle fought on 24 February 1525 at Pavia, south of Milan, is considered decisive: his army routed, King Francis I of France was captured on the battlefield by Charles V and taken to captivity in Spain. He was released a year later after agreeing to surrender some of his territories and renouncing his claims in Italy; Francis also agreed, under duress, to co-operate against the Ottomans. While Francis was still a prisoner, a French envoy had in fact been sent to ask for Süleyman's help in freeing him and to request the Sultan's assistance against Charles, but the envoy had been murdered, together with his suite, by the governor of Bosnia. Francis's letter reached Istanbul, however, and Süleyman responded favourably. After his release, despite his undertaking to Charles, Francis was able to reply in July 1526 that he hoped to be able to reciprocate in the future.[26]

How far Süleyman thought his warm relations with Francis would result in practical assistance is unclear. The Sultan had his own reasons for marching into Hungary in 1526, and recent scholarship suggests that he had intended to do so from the time of his successful siege of Belgrade in 1521. Selim's victories had stabilized the Ottoman eastern frontier and, in any case, the war of Ottoman Muslims against their co-religionists in the Safavid and Mamluk states had never been popular among the military forces of the empire. Once the Knights Hospitallers, a long-time irritant to the Ottomans, had been driven from their base at Rhodes in 1522, the possibility of taking advantage of the fall of Belgrade to invade the Hungarian kingdom became a realistic proposition.[27]

Süleyman advanced to the Hungarian capital of Buda after his victory at Mohács, entering the city on 11 September. Sultan Mehmed II's contemporary, King Matthias Corvinus, had been a generous patron and discriminating collector of Italian artefacts – textiles, ceramics, goldwork, glass and statuary. He had also founded a library of unparalleled fame. Possession of the spoils of defunct kingdoms was an eloquent statement of superiority and the Ottoman conquerors carried rich booty back to Istanbul. Many manuscripts were seized: over the centuries some found their way back west, and Sultan Abdülhamid II is said to have returned the remainder to Hungary in 1887; a few, however, may still be in the Topkapı Palace library. The pair of monumental bronze candlesticks taken from the Cathedral of the Virgin on the Buda citadel still flank the prayer niche of Ayasofya.[28]

The future lines of the Ottoman conflict with the Austrian Habsburgs became apparent when two competing candidates arose to claim the Hungarian throne following King Louis's death. John Zápolya, voyvode of Transylvania, who was related to Louis by marriage, was elected to succeed by the Hungarian diet and crowned King of Hungary in November 1526. Meanwhile, Archduke Ferdinand had claimed the thrones of Hungary and Bohemia in right of his wife, and been elected King of Bohemia in October 1526. In November Ferdinand was also elected King of Hungary by a faction favouring Charles V; fear of the Ottomans eased his path to these thrones – to many of the Hungarian nobles, the Habsburgs seemed the dynasty most able to resist this threat. In September 1527 Ferdinand drove Zápolya out of Buda and was crowned King of Hungary on 3 November.[29]

Louis's death at Mohács had changed everything for the Ottomans, who found themselves confronting a dynasty as ambitious as their own instead of an independent Hungary, greatly weakened since the days of Matthias Corvinus. Ferdinand was now cast as the Ottoman foe in central Europe and, it has recently been argued, it was only a matter of time

before conditions would be ripe for Ottoman efforts to be directed more energetically at the Habsburgs across their common border.[30] Charles could offer Ferdinand no help against the Ottomans because in 1527 he had had to go on the defensive against a league led by France to resist Habsburg domination in Europe. The unhappy result was that Rome was sacked by his forces in May of that year and the Pope, who had joined the league, was taken prisoner. The French besieged Naples in 1528, and in 1529, in order to leave himself free to deal with the religious troubles of the Reformation, Charles agreed the Peace of Cambrai with Francis – who again agreed to renounce his Italian claims.

Ferdinand's assumption of the Hungarian throne produced a new direction in Ottoman policy. After the defeated Zápolya retreated from Buda, first into Transylvania and then into Poland, he opened negotiations with Süleyman, leading to the conclusion of an alliance between them in February 1528. As the victor at Mohács, Süleyman considered the Hungarian crown his to bestow, by right of conquest, and promised it – but not the territory itself – to Zápolya. In this the Sultan was less than sincere, seeing Zápolya's kingship as a temporary measure intended to stabilize the situation in Hungary until he could take on Ferdinand directly. On 10 May 1529 Süleyman set out with his army for Vienna. En route at Mohács, John Zápolya was received in audience by the Sultan, after which Buda was retaken from Ferdinand who had scant resources in both manpower and money to call upon, whether in the Habsburg lands in Austria or in Hungary itself. In spring 1528 he had despatched envoys to Istanbul to negotiate peace – but they had been sent home empty-handed.[31] The march was fraught with logistical difficulties caused by heavy rains and floods, and it took almost four months for the Sultan's forces to reach Buda from Istanbul, and another two weeks to reach Vienna, where they arrived in the last days of September. The operation of the Ottoman army in Hungary was always extremely arduous. Many large rivers – of which the greatest is the Danube – flow across the plains of central Europe, producing terrain that was waterlogged for much of the year before the drainage schemes of modern times made progress on land easier. Ottoman supply-lines were over-extended, and the troops were exhausted. Although in only moderate repair the city walls of Vienna withstood Ottoman assault, and after only three weeks Süleyman gave the order to retreat. His bedraggled army returned to Buda where Zápolya was crowned with the crown of the revered king of medieval Hungary, St Stephen, in a symbolic act aimed at undermining Habsburg claims to the Hungarian throne. Süleyman and his troops then continued to Belgrade and so to Istanbul. This siege of Vienna (like the one in 1683 during the wars that ended

Ottoman sovereignty in Hungary) became a metaphor for Muslim aggression against the Christian world in the minds of contemporaries and later commentators alike, defining their attitudes to the West's Muslim neighbour.

In 1532 Süleyman led another campaign into Hungary but the nearest his land forces got to Vienna was the small town of Kőszeg (Güns), some 80 kilometres to the south of the city, which capitulated only after a three-week siege. Süleyman agreed to leave Ferdinand in possession of northern and western Hungary – known as 'Royal Hungary' by contemporaries – but did not abandon his claims there.[32] That summer an Ottoman fleet off the southern Peloponnese was harried by a Habsburg armada under the command of Charles's talented Genoese admiral Andrea Doria, which seized the ports of Nafpaktos and Koroni. This reverse prompted Süleyman to improve his fleet and appoint as grand admiral Hayreddin Reis – known as 'Barbarossa' on account of his red beard – a corsair from Lesbos operating out of Algiers, who had entered the service of Selim I shortly before his death: Nafpaktos and Koroni were soon won back.[33]

After truce negotiations with Ferdinand in 1533, Sultan Süleyman sent İbrahim Pasha eastwards. The Safavid shah Isma'il, whose policies and actions had brought so much aggravation to Selim I, had died in 1524, when his son and successor Tahmasp, a boy of ten, became the victim of a power struggle among the Kızılbaş chiefs to whom the Safavids looked for support. This infighting, and frequent Özbek attacks into Safavid territory, weakened the state built up by Isma'il and reduced the possibility of Safavid incursions into Ottoman Anatolia: Ottomans and Özbeks recognized their common interest in undermining the Safavids.[34] In 1528 the Kızılbaş governor of Baghdad offered his submission of Süleyman, but was soon killed and Safavid authority re-established. The frontier between Ottoman and Safavid territories reconfigured itself as the Safavid governor of Azerbaijan province defected to the Sultan, and the Kurdish emir of Bitlis, west of Lake Van, to the Shah, but İbrahim Pasha and his army arrived in the region late in 1533 to find Bitlis again in Ottoman hands.[35]

İbrahim Pasha spent the winter in Aleppo. In the summer of 1534 he took Shah Tahmasp's capital of Tabriz. Tahmasp fled rather than face the Ottomans – like his father before him, he avoided confrontation, a tactic which added to the uncertainties of campaigning in Iran. After a three-month march across Anatolia in the summer heat, Sultan Süleyman joined İbrahim and his men in Tabriz, and they decided to pursue the Shah. Two months later, after a long march through the snowy uplands of south-west Iran, the Ottoman army reached Baghdad and the city surrendered. As the

seat of the caliphate between the mid-eighth century and the murder of the incumbent by the Mongols in 1258, Baghdad was important to the Ottoman dynasty's efforts to legitimize their claims to pre-eminence in the Islamic world. During the months that Süleyman remained in Baghdad he made a miraculous discovery that mirrored Sultan Mehmed II's finding of the tomb of the Muslim saint Ayyub Ansari at the time of the conquest of Constantinople. The religious lawyer Abu Hanifa, founder of the school of law favoured by the Ottomans over the other three law schools of Sunni Islam – the Maliki, the Shafiʻi and the Hanbali, which continued to function alongside the Hanafi school in the Arab provinces – had died in Baghdad in 767 CE; Süleyman 'rediscovered' his tomb and, asserting his sacred authority over Baghdad, repaired it, adding a mosque and hospice.* Süleyman also built a dome over the tomb of the theologian and mystic ʻAbd al-Qadir al-Gilani,[36] thereby claiming the saint for the orthodox practice of Islam, and completed a mosque begun by Shah Ismaʻil[37] which thus became a Sunni rather than a Shia sanctuary. In the course of this campaign, known as the 'campaign of the two Iraqs' (that is, 'Iraq of the Arabs' or Lower Mesopotamia, and 'Iranian Iraq', the mountainous region to the east), the most sacred shrines of Shia Islam – Najaf, where the Prophet's son-in-law ʻAli was buried, and Karbala', site of the tomb of ʻAli's son Husayn – had also fallen into Ottoman hands; Süleyman wrote of his visit to these shrines in a letter to Francis I.[38] Süleyman's temporal right to Baghdad was soon formalized by the proclamation of a law-code for the new province of the same name. At many points it resembled the Safavid code but tax burdens were eased and practices considered extra-legal by the victorious Ottomans were annulled. His aim was to demonstrate that Ottoman justice was superior to that of the vanquished Safavids.[39]

The Ottomans clashed with the Habsburgs in the western Mediterranean as well as in Hungary and the Peloponnese. Portugal had established outposts on the North African coast since the early fifteenth century and Spain, once it had annexed Granada and its ports, embarked on its own programme of aggression against the indigenous Muslim population. Spain's crusade in North Africa was termed the Reconquista, on the grounds that these lands had once been Christian,[40] and Charles V saw his enthronement in 1530 as Holy Roman Emperor as reinforcing his moral authority to press forward with the consolidation of Spanish power. The beleaguered Muslim population of North Africa addressed pleas for assistance to the Sultan – as

* A turban reputed to have been that of Abu Hanifa was on display in the treasury of Topkapı Palace in the early years of the seventeenth century (Necipoğlu, *Architecture, Ceremonial and Power* 141).

protector of the Muslim community – and an intense contest between Habsburgs and Ottomans ensued. Ottoman naval policy in these waters relied on the skills, honed by years of experience, of the corsair captains of the North African shores who were employed by the Ottoman state to redirect their energies to the struggle with Spain: Barbarossa was only the most famous among them. The corsairs sometimes overthrew those they were employed to protect: in 1534 Barbarossa seized Tunis from the Muslim Hafsid dynasty (in response to which Charles sent a fleet to retake the port and caused a massive fortress to be built nearby at La Goletta for his Christian garrison). As Ottoman authority gradually extended some way inland in North Africa, local Muslim dynasts realized that their independence could be compromised as much by Istanbul as by Madrid. The possibility of annexation by the Ottoman Empire was a prospect as unwelcome to many of them as it had been to those on the frontier in east and south-eastern Anatolia.

Süleyman and his advisers had become adept at exploiting the long-running rivalry and hostility between Charles V and Francis I, and 1536 saw another episode in what a modern historian has described – in view of Francis's undertaking to his fellow Christian sovereigns to assist in the defence of Italy in the event of an Ottoman landing there – as his 'comedy of opposition to the Turks'.[41] Since before the conquest of Constantinople, the Ottomans had extended to Venetian and Genoese merchants the privileges known as 'capitulations', by which they were allowed to establish trading communities; under the Mamluks (and under the Ottomans after the fall of the Mamluks) French, Venetian and Catalan merchants enjoyed such privileges within Syria and Egypt, and in 1536 the French negotiated the extension of their privileges throughout the Ottoman Empire – and the Ottomans were accorded similar privileges in French territories. This acknowledgement of a special relationship with France was one of the last initiatives taken by İbrahim Pasha, who was executed a month later; trade apart, the aim of the agreement was to secure the Ottomans an ally against the Habsburgs.[42] Süleyman sent an envoy to Venice proposing that it enter the Ottoman–French alliance but this was met with a refusal[43] – Venetian fear of the Habsburgs was greater than its fear of the Ottomans.

Ottoman relations with Venice had on the whole remained unaffected by cross-currents in European politics, but repeated clashes on land in Dalmatia and at sea in the Adriatic heralded a new phase. Moreover, İbrahim Pasha's execution deprived Venice of a friend at the Ottoman court. In 1537 the Sultan marched to Vlorë on the Adriatic coast apparently with the intention of launching a two-pronged attack on Italy with the help, from the south, of Barbarossa and his fleet. This might have been the chance

to conquer Rome, as its inhabitants still feared was Süleyman's aim: the Sultan's goal, Francis I said in 1531 to the Venetian ambassador at the French court, was to reach Rome.[44] Barbarossa laid waste the area around Otranto, while Sultan Süleyman attacked the Venetian island of Corfu, but when it became clear that only a long siege would yield the fortress to the Ottomans, they withdrew. The Venetians' former good understanding with the Ottomans was destroyed and Venice agreed to participate with Charles V and the Pope in a Holy League to crusade against them. On 27 September 1538 an allied fleet under Andrea Doria met the Ottomans under Barbarossa in the seas off Preveza, an Ionian coastal town south of Corfu. Barbarossa's victory laid bare the relative weakness of the other naval powers in the western Mediterranean. Faced with the disruption of the trade with the Ottomans which was essential for its prosperity – and especially the grain to keep its citizens fed – in 1539 Venice sued for peace: its expectation that a Christian alliance would serve the longer-term aim of protecting its vulnerable coastal outposts from Ottoman attack was doomed, for Charles's overriding purpose was to defend the western Mediterranean and Spain against the depredations of the North African corsairs, who were aided and abetted by Hayreddin Barbarossa. For Venice, the price of the peace eventually concluded late in 1540 was the cession to the Ottomans of its remaining fortresses in the Peloponnese, some of which it had held for three centuries, and the payment of a large indemnity.[45]

Even as the Ottoman navy was seeing action in the Mediterranean, the governor of Egypt, Hadım Süleyman Pasha – recently returned from the 'campaign of the two Iraqs' – was sailing to help a Muslim ruler across the Arabian Sea. In 1535 Bahadur Shah, the sultan of Gujarat, had been defeated by the Mughal emperor Humayun, and called on Portuguese help. He allowed the Portuguese to build a fortress at Diu, at the southern tip of the Gujarat peninsula, the entrepôt for the transmission of spices westwards from India; but once the danger from Humayun had passed, he appealed for Ottoman help against the Portuguese. Hadım Süleyman sailed from Suez with a fleet of 72 vessels and appeared off Gujarat after nineteen days at sea.[46] The Portuguese had in the interim executed Bahadur Shah, and their stout fortress held out against the Ottoman guns. News of the approach of a Portuguese relief fleet prompted Hadım Süleyman to raise the siege and make for home, but despite the failure of his mission this proved a turning point in Ottoman–Portuguese rivalry in the region for he had demonstrated that the Ottoman fleet was capable of crossing the Arabian Sea. On the way to Diu, Hadım Süleyman took the port of Aden, and the strategically-important province of Yemen was established in the south of the Arabian peninsula – albeit that the Ottoman grip there was tenuous.

Diplomacy soon ensured that control of the maritime routes into the Red Sea was in Ottoman hands; the Ottomans and Portuguese exchanged envoys following the 1538 campaign, the respective commercial spheres of the two states were recognized, and security for their merchants was agreed.[47]

There was stalemate in affairs in Hungary after 1532: the Ottomans had failed in a second attempt to capture Vienna, but Ferdinand was in no position to contemplate aggression against them. The Sultan's vassal Petru Rareş, the Voyvode of Moldavia, was suspected of collusion with the Habsburgs, and in 1538 Süleyman led an army against him, took the former Moldavian capital of Suceava, and temporarily removed Petru. He also annexed southern Bessarabia, the wide coastal strip between the mouths of the Danube and the Dniester known to the Ottomans as Bucak, and occupied the northern Black Sea littoral from the Dniester to the Boh with the fort of Cankerman (on the site of modern Ochakiv) at the mouth of the Dnieper – control of this territory was of strategic importance for the passage from the Crimea of the Tatar cavalry who were an essential component of the Ottoman campaign army. On the Dniester lay the fortress of Bender (on the site of modern Tighina) to which was affixed an inscription bearing a strikingly bold assertion of Süleyman's claims to vanquished – or partly-vanquished – states, Safavid, Byzantine and Mamluk: 'In Baghdad I am the shah, in Byzantine realms the caesar, and in Egypt the sultan'.[48]

In 1538 John Zápolya and King Ferdinand concluded a pact. They agreed that each was to have the title of king in their respective parts of Hungary but that when John died, his territory would pass to Ferdinand. On 22 July 1540, John Zápolya died, two weeks after the birth of his son, who was named John Sigismund. Hastening to capitalize on this unexpected situation before the Ottomans could respond, Ferdinand laid siege to Buda. As Charles V's brother, Ferdinand's succession to the throne of Hungary would effect an extension of the Holy Roman Empire that Süleyman could not countenance, so he promised his protection to the infant John Sigismund and in spring 1541 set out to settle scores with Ferdinand. Having raised the Habsburg siege of Buda, he brought central Hungary under direct Ottoman rule. Ferdinand retained the western and northern parts of the former kingdom of Hungary while John Sigismund – with George Martinuzzi, the Bishop of Grosswardein, as regent – was given Transylvania to rule as an Ottoman vassal.

Istanbul's relationship with the Ottoman vassal state of Transylvania was rather different from that with the long-time vassal states of Moldavia and Wallachia. Initially, in the mid-sixteenth century, no Ottoman troops were stationed in Transylvania. The voyvode of Transylvania was elected by the local diet for confirmation by the sultan, whereas the voyvodes of Moldavia

and Wallachia were the sultan's appointees. Nor was the voyvode of Transylvania required to send his sons as hostages to the Ottoman court. Transylvania's annual tribute was lower than that of the Danubian principalities, and there was no requirement to provide goods or services for Istanbul as the latter were obliged to do.[49]

The early years of Süleyman's reign were marked by extravagant displays and triumphal processions of a kind alien in many respects to previous Ottoman practice. The Hippodrome in Istanbul again became the scene of public entertainments and pageants, as it had been under the Byzantines. From royal weddings and circumcisions to the execution of non-conformist preachers, the significant rites of life and death were observed here. The first such event was the marriage in 1524 of Süleyman's sister Hadice to İbrahim Pasha, when the public celebrations lasted fifteen days. Forty days of festivities followed the circumcision of Süleyman's young sons Mustafa, Mehmed and Selim – the future Sultan Selim II – in 1530. This last occasion presented a matchless opportunity for an unambiguous statement of Ottoman power, and the tents of their defeated rivals – the Akkoyunlu, the Safavids and the Mamluks – were accordingly displayed to the crowds, while at the feast the hostage princes of the Akkoyunlu, the Mamluks and the Dulkadıroğulları were ostentatiously seated close to the Sultan.[50]

As grand vezir and brother-in-law to the Sultan, İbrahim Pasha both masterminded and revelled in these costly displays, while his supervision of the renovation of the Topkapı Palace between 1525 and 1529 gave his extravagance further rein. Mehmed II's council hall and treasury were demolished to make way for a much larger eight-domed treasury and three-domed council hall built adjoining the Tower of Justice. A striking improvement was the extensive rebuilding of the Hall of Petitions at the entrance to the third court – this is the free-standing structure which to this day bars visitors from direct access into the heart of the palace. The sumptuous decoration and furnishing of this hall was remarked by contemporaries who saw it as an exquisite harmony of silver and gold, jewels, precious textiles and marbles.[51] The French antiquarian Pierre Gilles, who visited Istanbul soon after the agreement of the capitulations with France, described the Sultan sitting on a low couch to receive ambassadors, '. . . in a little apartment built with marble, adorned with gold and silver and sparkling with diamonds and precious stones. This Room of State is encircled with a portico that is supported by pillars of the finest marble, the capitals and pedestals of which are all gilded'.[52]

The Sultan and Grand Vezir, well-informed about matters in the West, quickly received details of Charles V's splendid coronation as Holy Roman

Emperor by Pope Clement VII in 1530, and as quickly interpreted it as tending to reinforce the claim that the Holy Roman Emperor saw himself as the recreated caesar of the Roman Empire. Sultan Mehmed II had aspired to be a universal sovereign and had been seen as a rival by Matthias Corvinus, in his day the most powerful figure in central Europe, who fancied himself the new Hercules or (like Mehmed himself and, according to the Venetian ambassadors of the sixteenth century, both Selim I and Süleyman) Alexander the Great.[53] Süleyman could not leave this 'perceived challenge unanswered. From Venice İbrahim Pasha commissioned a gold helmet of four superimposed crowns surmounted with a plumed aigrette. It reached Edirne in May 1532, by way of the Ottoman tributary port-city of Dubrovnik on the Adriatic, as the Sultan was leading his army towards Hungary. The helmet-crown was prominently displayed at the audiences Süleyman gave and played its part in the carefully-choreographed triumphal parades that took place along the route to war, for the benefit of the foreign ambassadors and other observers the Sultan wanted to impress with his power. The Habsburg envoys Süleyman received at Niš seemed unaware that the turban was the headgear of sultans, and thought this gaudy regalia was the Ottoman imperial crown. Neither the timing of İbrahim Pasha's commission nor its form was accidental. The helmet-crown bore stylistic similarities to the Emperor's and also to the papal tiara – but with more tiers it symbolized a challenge to their power.[54]

İbrahim was like a brother to the Sultan, his intimate adviser and highest officer of state, and this very closeness made him enemies. In 1525 his palace on the Hippodrome was sacked in a janissary uprising in Istanbul that may have been incited by his rivals.[55] In the matter of the helmet-crown, the state treasurer criticized him for extravagance in commissioning it during an expensive campaign. The helmet-crown's absence from contemporary Ottoman written sources and miniature paintings alike indicates disapproval of its purchase. The state treasurer also took İbrahim to task for extending the 'campaign of the two Iraqs' to Baghdad at great financial cost,[56] and İbrahim used the power of his rank to have the treasurer executed.

The relationship between Süleyman and İbrahim was reminiscent of that between Sultan Mehmed II and his favourite, the grand vezir Mahmud Pasha Angelović. Süleyman could be as merciless as his great-grandfather and, like Mahmud Pasha, İbrahim was suddenly executed at the whim of his master, in March 1536, soon after his return from the 'campaign of the two Iraqs'. The Sultan had given him, as grand vezir, every latitude in both public and private arenas; now he was buried in an unmarked grave. During his lifetime İbrahim was referred to by the soubriquet 'Makbul' ('Favourite')

but, once he was dead, a play on words changed this to 'Maktul' ('the Executed'). He was little mourned: after his death, a crowd smashed the three bronze statues of classical figures he had brought back in 1526 from the palace of Matthias Corvinus in Buda and set up outside his own palace on the Hippodrome.[57] İbrahim's execution marks the end of the first phase of Süleyman's reign.

During his years as grand vezir İbrahim Pasha had had a contender for Süleyman's affections – the Ruthenian slave-girl Hürrem Sultan, Roxelana as she is known in the West, Süleyman's *haseki*, or 'favourite'. She bore him their first child in 1521 and Süleyman married her with great ceremony in 1534 after she had produced six children, five of them sons. A European witness described the wedding:

> The ceremony took place in the Seraglio, and the festivities have been splendid beyond all record. There was a public procession of the presents. At night the principal streets are gaily illuminated and there is much music and feasting. The houses are festooned with garlands and there are everywhere swings in which people can swing by the hour with great enjoyment. In the old Hippodrome a great tribune is set up, the place reserved for the Empress and her ladies screened with a gilt lattice. Here Roxelana and the Court attended a great tournament in which both Christian and Moslem Knights were engaged and tumblers and jugglers and a procession of wild beasts and giraffes with necks so long they as it were touched the sky.[58]

Hürrem Sultan was said by a Venetian ambassador to be 'young but not beautiful, although graceful and petite'.[59] Süleyman was deeply in love with her and, once she supplanted all others in his affections, faithful to her alone. His marriage to a freed slave was as much a break with convention as his swift promotion of İbrahim Pasha to the grand vezirate had been.[60]

The procurement of women – whether as war booty or via the slave trade – for the private households of the sultan and other wealthy and powerful men paralleled the youth-levy by which the Ottomans raised soldiers and administrators for the empire. The word *harem* by which these private households were known – which in Arabic means literally 'a place that is sacred and protected' – at that time signified both the quarters assigned to the women of the palace and the women themselves collectively. As their empire became 'more Islamic', the Ottomans adopted the practice of other Muslim dynasties by permitting slave concubines rather than their legal wives to bear the sultan's offspring. The politics of Ottoman reproduction had the unique feature that, from the reign of Mehmed II if not earlier, concubines were allowed to produce only one son, although they could give birth to daughters until the birth of a son curtailed their childbearing. This was presumably achieved by means of sexual abstinence or birth control, but we

are ignorant of the methods that might have been used. The humble beginnings and 'unencumbered' status of concubines meant that, unlike the royal brides of the earliest Ottoman times, they had no dynastic aspirations of their own, no potential as agents either of foreign powers or of would-be domestic rivals to the Ottoman sultans. The logic of the one-mother-one-son policy was that since all sons of a deceased sultan had a theoretically equal chance of succeeding their father, the extent to which their mothers could promote their chances of succession was critical. While Ottoman princes were serving as prince-governors in the provinces, their mothers played a vital role in preparing them for the throne; had one concubine borne two princes, however, she would have had to choose which she would ally herself with in the inevitable succession struggle.[61]

Süleyman's marriage to a concubine was shocking enough; his disregard for the one-mother-one-son norm still more so. Hürrem was accused of having bewitched him. After their marriage she moved with her children from the Old Palace into Topkapı Palace, where her apartments in the *harem* adjoined those of the Sultan – another innovation many frowned upon. The quarters assigned within the Topkapı Palace to the *harem*s of previous sultans had been comparatively small, and İbrahim Pasha oversaw their enlargement to accommodate this new 'royal family' and their retainers.[62] When they were apart, Hürrem wrote passionately to Süleyman in prose and verse, and provided him with a valuable link to palace affairs when he was away on campaign. Probably in 1525 she wrote:

> My Sultan, there is no limit to the burning anguish of separation. Now spare this miserable one and do not withhold your noble letters. Let my soul gain at least some comfort from a letter . . . When your noble letters are read, your servant and son Mir Mehmed and your slave and daughter Mihrimah weep and wail from missing you. Their weeping has driven me mad, it is as if we were in mourning. My Sultan, your son Mir Mehmed and your daughter Mihrimah and Selim Khan and Abdullah send you many greetings and rub their faces in the dust at your feet.[63]

Although Hürrem Sultan's place in Süleyman's affections was unassailable she was jealous of İbrahim Pasha, for he had been close to the concubine Mahidevran, mother of Süleyman's eldest surviving son Mustafa. As Hürrem usurped Mahidevran's position, so Mustafa's status as heir-apparent altered in favour of her sons. The celebration of the marriage between Süleyman and Hürrem sealed the fates of Mahidevran and Mustafa, and left İbrahim as Hürrem's only remaining rival. She has been suspected of complicity in İbrahim's execution, and the circumstantial evidence is persuasive.

<div align="center">★</div>

Ottoman victory over the Safavids at Baghdad and against the Holy League at Preveza, the truce with the Portuguese after the Diu campaign, and the annexation of much of Hungary, all gave only temporary break in hostilities: within a few years activity resumed on each front. In 1542 a Habsburg attack on Pest, across the Danube from Buda, was repulsed by local Ottoman forces, and in the next year Süleyman again set out westwards and took a number of strategic fortresses which were added to the province of Buda. Ottoman successes encouraged Ferdinand to sue for peace and a five-year truce was agreed in 1547 with the grand vezir Rüstem Pasha (who had married Süleyman's daughter Princess Mihrimah in 1539). Although Ferdinand still held the far northern and western regions of the former Hungarian kingdom, the truce imposed the humiliating obligation to pay an annual tribute to the Sultan.

The truce of 1547 held for a while, but when in 1551 the intrigues of Bishop Martinuzzi, the power behind the Transylvanian throne, handed Transylvania to Ferdinand, reuniting a large part of the medieval Hungarian kingdom, Ottoman retaliation was not long delayed. The governor of Rumeli, Sokollu Mehmed Pasha, moved into Transylvania to besiege the capital, Timişoara, taking a number of important strongholds on the way; the arrival of reinforcements and the lateness of the season saved the city for a while, but it fell to the Ottomans in 1552 and became the centre of the new Ottoman province of Temeşvar, comprising the western part of Transylvania. That same year the Ottomans failed to take Eger, to the north-east of Buda, despite a hard-fought assault, but the other strongholds they acquired served to consolidate Ottoman rule for the future. Two provinces – Buda and Temeşvar – were now under direct Ottoman rule, and for the first time Ottoman Hungary was a compact entity, defended by a continuous chain of fortresses, some newly-built but most captured from the Hungarians.[64]

Both Habsburgs and Ottomans had to compromise in the exercise of their rule in Hungary. Neither imperial power could by itself afford to annex, administer and defend Hungary, but had to rely on the Hungarian nobles who had survived the Mohács debacle. Many of the Hungarian nobility had become Protestant in the Reformation, and it was necessary for Ferdinand and his government to treat them with circumspection if they were to share the burden of defence against the Ottomans. The Ottomans were able to manipulate the split between Catholics and Protestants as they had earlier played off Catholic and Orthodox but, like the Habsburgs, had to accommodate the still-powerful nobles who continued to exercise many of the day-to-day functions of government in Ottoman Hungary as they did in 'Royal Hungary'.[65]

His north-western frontier stabilized with the truce of 1547, Sultan Süleyman embarked upon another campaign against Iran when Shah Tahmasp's brother Alqas Mirza defected to the Ottomans. Alqas Mirza was the governor of the Safavid province of Shirvan in the Caucasus, to the west of the Caspian Sea, and his relationship with his elder brother had always been uneasy; when Tahmasp sent a force to quell his insubordination, he fled to Istanbul by way of the Crimean port of Feodosiya. Süleyman sent Alqas Mirza ahead of him on campaign in 1548, but although the Ottoman army reached Tabriz, it abandoned the city for lack of supplies. It was clear that Alqas Mirza lacked both the local support and the ambition to usurp Tahmasp, and Süleyman returned home with little to show for his expedition except the capture of the frontier city of Van and some rich booty, including a tent commissioned by Shah Isma'il which was one of Tahmasp's most prized possessions. Alqas Mirza professed Sunni Islam but this appeared to be nothing more than a pragmatic gesture, for he soon returned home – though there were those who thought Süleyman's grand vezir Rüstem Pasha had induced him to go by casting doubt on his loyalty to Süleyman. Alqas Mirza sent a letter to Tahmasp to ask his pardon, but he was killed on Tahmasp's orders early in 1549.[66]

Taking advantage of Ottoman reluctance to campaign on their inhospitable eastern frontier, Tahmasp soon set out to regain the territories recently lost. In 1554 Süleyman retaliated, again leading his army in person. Yerevan (capital of modern Armenia) and Nakhichevan in the southern Caucasus marked the farthest extent of his campaign, during which the Ottomans copied their adversary in adopting scorched-earth tactics in the border zones from which the Safavids launched their raids. The first formal peace treaty between the two states – the Treaty of Amasya – was signed in 1555. By its terms the Ottomans kept their earlier conquests in Iraq; Süleyman's second and third Iranian campaigns, however, had brought no lasting gain and it seemed that coexistence was the most either party could hope for.

In the Mediterranean, stalemate was also in sight. An attempt by Charles V in 1541 to capture Algiers from Barbarossa's deputy there, Hadım Hasan Agha, was foiled only by a chance gale which blew up and saved the hopelessly outnumbered Muslim defenders from the mighty Spanish armada. On the other side, throughout the years of Ottoman–Habsburg engagement in the western Mediterranean, Ottoman commanders in North Africa made frequent and devastating raids on the north Mediterranean coast – in 1543, for instance, the Italian islands and the coast of Naples suffered.[67]

In 1551 the port of Tripoli – held for Charles by the Knights Hospitallers, now based on Malta – was successfully besieged in a joint operation by an

Ottoman imperial fleet and a fleet under the command of another legendary corsair, Turgud Reis. Obliged as they were by the terms of their agreement with Charles to defend Tripoli, the Knights on Malta viewed the Ottoman presence there with great unease. A joint Spanish–Hospitaller fleet reached the island of Jerba, to the west of Tripoli, in spring 1560 and built a strong fortress to serve as a forward base for ousting the Ottomans from this part of the Mediterranean, but a fleet sent from Istanbul besieged and captured the island. Ottoman confidence at sea seemed unbounded. Some years of peace ensued, but in 1565 came an unexpected reverse when an Ottoman siege of the Knights' Maltese stronghold failed.[68] Like earlier Ottoman defeats, this was hailed as a portent of the triumph of Christendom, a straw grasped at by the western powers as they sought consolation for the failure of their strategy in the Mediterranean basin.

Policing the Arabian Sea and its salients was a formidable task for the Ottomans, an exacting test of their ambitions during which their naval potential and limits became apparent. Ottoman vessels were as yet inferior to those of the Portuguese, more suitable for coastal sailing than for crossing the wide ocean. Following the Diu expedition and the accommodation reached with the Portuguese in the Arabian Sea, the rivalry between the two powers was acted out rather closer to home, especially in the Persian Gulf. The port of Basra at the head of the Gulf was taken by the Ottomans after Baghdad fell to them, offering another gateway onto the Arabian Sea closer to India than their existing ports of Suez or Aden, and a valuable site for the establishment of a dockyard. Unluckily, however, the Portuguese had since 1515 held the island trading centre of Hormoz, and thus commanded the straits opening from the Gulf into the Arabian Sea, and a less exposed passage to the southern coast of Safavid Iran and the fabled lands of the East.

In 1552 the veteran seaman Piri Reis set out from Suez with instructions to take both Hormoz and Bahrain, centre of the pearling industry and another Portuguese possession. He captured the city of Hormoz but a ship carrying essential equipment was lost and he was left without the means to prevail against the fortress. He cut short his expedition, looted the nearby island of Qeshm, and sailed with his booty to Basra.[69] The career of Piri Reis had flourished under the patronage of İbrahim Pasha; but İbrahim Pasha was long dead, and Piri Reis was no longer able to convince those in ruling circles of the value of his contribution. His failure in this mission led to execution, an untimely end for one of the greatest men of the age and a further demonstration of Süleyman's readiness to be ruthless when he deemed it necessary.

Soon after Piri Reis's execution, the Ottomans created the province of Lahsa on the southern, Arabian, shore of the Gulf, to provide a land base to support naval efforts against the Portuguese, and in 1559 a combined land and sea operation was mounted from Lahsa and Basra to take Bahrain, whose ruler had vacillated for years between his powerful Ottoman and Portuguese neighbours. Sailing from Hormoz, the Portuguese fleet repulsed the Ottoman attack on the main Bahraini fortress of Manamah, but from the jaws of disaster the Ottomans were able to snatch the consolation of an agreement whereby both parties made a strategic withdrawal, and from 1562 envoys were exchanged. In the Persian Gulf as elsewhere compromise had been reached: the Portuguese continued to control the sea passage through the Gulf, and the Ottomans the onward caravan route overland to Aleppo.[70]

Like the coasts of the Persian Gulf, those of the Red Sea are long and have few suitable anchorages. To maintain a presence in this inhospitable terrain was a daunting logistic challenge, and Ottoman jurisdiction, as in other peripheral zones of the empire, diminished rapidly outside a few strongholds. Their new province of Lahsa, for instance – like Yemen – was at first a 'paper province', where the Ottomans were under constant harassment from indigenous Arab tribes who were unused to strong central authority and prevented the Ottomans from exercising their rule in any meaningful way. They were realistic enough not to expect to do so, however; their claiming as provinces regions where imperial power made little impact on local life outside a restricted area was a gesture intended to order and classify the Ottoman world and provide a framework for its administration. The Ottomans were always fearful of becoming over-extended, and well aware of their inability to impose direct rule over the vast 'empty' hinterlands of the limited territory they needed for strategic purposes.

The lands beyond the southern limit of Mamluk rule in Egypt – Asyut on the Nile – were also terra incognita. Between Asyut and the First Cataract south of Aswan lay Nubia, and beyond Nubia the sultanate of Funj; further south still was Abyssinia, largely Christian. In his report of 1525 on Portuguese activities in the Indian Ocean, the sea captain Selman Reis had recommended the establishment of Ottoman control in Abyssinia, 'Habeş' to the Ottomans – by which he meant the western coastal strip of the Red Sea, past the straits of Bab al-Mandab, and along the southern shore of the Gulf of Aden – in order to wrest control of the spice trade from the Portuguese. He remarked on the weakness of the tribes in the region, both Christian and Muslim, and also proposed the conquest of the land between the island-fortress of Suakin, held by the Ottomans since the 1520s, and the Nile entrepôt of Atbara, a centre for the ivory and gold trade. No action was

taken at the time but in 1555, partly in response to Funj advances north-wards, Ottoman policy changed. Özdemir Pasha, sub-governor of Yemen, who had formerly served the Mamluks, was in that year made governor of the notional province of Habeş, but a campaign up the Nile launched from Cairo failed when the troops refused to proceed beyond the First Cataract. Two years later, an army sailed from Suez to Suakin and thence south to Mits'iwa, the Red Sea port for the inland city of Asmara, which was captured by Özdemir Pasha and his troops. Although much delayed, Selman Reis's objective of shutting the Portuguese out of the Red Sea was realized, and the Ottomans gained control of the customs dues on the valuable trade passing through their ports on its shores.[71]

The Ottomans had allies in their efforts to keep the Indian Ocean trade routes open. One of the most significant was the Muslim sultanate of Aceh in north-western Sumatra, a producer of pepper; when threatened by Portuguese expansionism, Aceh sought Ottoman military assistance. Ottoman troops were sent to aid the sultan against the Portuguese in 1537 and 1547, and in 1566 Aceh formally requested the protection of the Ottomans – the sultan considered the Ottoman sultan his suzerain, he said, and mentioned his name in the Friday prayer. By the next year, when an Ottoman fleet set out from Suez to aid Aceh, its ports were under Portuguese blockade; two ships laden with cannon and war matériel and five hundred men reached their destination, in a much-scaled-down version of what had been envisaged. Inadequate as it was to the task of expelling the Portuguese from these seas, the presence of this force – like Ottoman harassment in the Persian Gulf – demonstrated that the Portuguese could not act with impunity. This stout defence of their commercial interests by the Ottomans led to a recovery in the value of the spice trade passing through Egypt from the middle of the sixteenth century.[72]

In 1547 Ivan IV was crowned 'Tsar of all the Russias' in the capital of his state of Muscovy, far across the steppelands north of the Black Sea, which were home to the freebooting Cossacks and various nomadic peoples who had moved west from Asia, and a volatile region where the Ottomans had aligned themselves with the Muslim Tatar khanate of the Crimea. Until the early years of the sixteenth century, the Crimean khanate had been a staunch ally of Muscovy in defending their mutual economic and territo-rial interests against Poland-Lithuania and its steppe allies. So, too, Ottoman and Muscovite economic interests were complementary and relations friendly: in 1498, Muscovite merchants were granted the right to trade freely in the Ottoman Empire. During Selim I's reign envoys from both Muscovy and the Crimea conducted an active diplomatic campaign for

favour in Istanbul as Muscovy competed for a share of Poland-Lithuania's fur trade with the Ottomans, while the Tatars feared the encroachment of Muscovy into Muslim lands.[73] Ivan's coronation signalled to the Muslim Tatar khans of the steppe – the rulers of Crimea, Kazan and Astrakhan, whose Genghisid lineage was superior to his own – that he was their equal.[74]

Mutually advantageous Muscovite–Ottoman trade contacts continued until in 1552, only five years after his coronation, Ivan seized the khanate of Kazan on the river Volga and four years later took Astrakhan, whose capital of the same name lies on the Volga delta on the north-west coast of the Caspian Sea. The Muscovite princes had long intervened in the politics of Kazan and Astrakhan and Tsar Ivan IV was able to achieve the conquests of these khanates by supporting one warring local faction against another. The Ottomans allowed those they conquered to retain their religious practices – albeit within defined parameters – and only gradually imposed the full weight of their administration; Muscovite policy towards the first non-Christian, non-Slavic-speaking lands they annexed was uncompromising, since to come within the Muscovite embrace was above all to accept Orthodox Christianity. Attempts to force the conversion of their new Muslim subjects met local resistance, however, and on occasion Muscovite missionaries had to bow to complaints from the Ottomans and the Crimean khanate that they were undermining the Muslim faith.[75]

The alliance of the Caucasian province of Shirvan with the Ottomans between the late 1540s and its reoccupation by Shah Tahmasp in 1551 had encouraged the Ottomans to think about their strategy in Transcaucasia, and the Muscovite conquest of Kazan and Astrakhan was the first tangible sign that the strategic interests of the Ottomans and Muscovy would not always be concordant. For Astrakhan to be in Muscovite hands cast a shadow over Ottoman prestige for it removed from the sultan's protection the route passing through Astrakhan along which Sunni Muslim pilgrims from Central Asia travelled on their way to one of the Black Sea ports before continuing southwards to Mecca. The dockyard at Sinop on the Anatolian Black Sea coast soon stepped up construction of war-galleys to meet the incipient challenge to Ottoman influence on this frontier.[76]

Five of Süleyman's sons survived beyond the early years of his reign: Mustafa, born of the concubine Mahidevran, and Mehmed, Selim, Bayezid and Cihangir, all born of Hürrem Sultan. Mehmed, the eldest son of Hürrem, was considered by contemporaries to be his father's favourite, but he died prematurely in 1543, probably of smallpox. In a break with tradition he was buried in Istanbul rather than Bursa, the usual resting-place for princes. His tomb is in the garden of the Şehzade mosque complex, built by Süleyman

in his memory, the earliest important commission entrusted to Sinan, the great Ottoman architect of the sixteenth century. The rich architectural and decorative repertoire with which Sinan experimented here became more restrained later in his master's reign.[77]

In 1553 Süleyman's eldest son Prince Mustafa was executed in his late thirties. The first sultan to execute an adult son was Murad I in the late fourteenth century who caused the rebellious Savcı to be put to death. The official reason for Mustafa's execution was that he was planning to usurp the throne but, as in the case of the execution of the Sultan's favourite İbrahim Pasha, blame was laid at the door of Hürrem Sultan, who was suspected of conniving with her son-in-law and ally, the grand vezir Rüstem Pasha. It is not hard to imagine Hürrem going to any lengths to have her own son succeed his father, perhaps encouraging the ageing Sultan to suspect that Mustafa, a popular figure, would force him to step down – as Süleyman's own father Selim I had his grandfather, Bayezid II. Following the death of Prince Mehmed some years earlier the standing army had indeed considered demanding Süleyman's retirement to Didymoteicho, south of Edirne, in a close parallel with Bayezid's fate.[78] Whatever Mustafa's intentions may have been, Süleyman could carry out this summary act without compunction since he had other sons of whom none had a pre-ordained right to succeed to the throne. Mustafa was buried in Bursa and to appease the many critics of Süleyman's peremptory action, Rüstem Pasha was temporarily dismissed from office. Prince Cihangir, Mustafa's crippled half-brother, to whom he was especially close, soon died in Aleppo while campaigning against Iran. The mosque Süleyman built for him could easily be seen from the palace: much altered in appearance – thanks, most recently, to reconstruction in the late nineteenth century by Sultan Abdülhamid II – it still perches on the side of the hill in the Cihangir quarter across the water from the old city of Istanbul.

The despatch of Prince Mustafa did not bring Süleyman's family troubles to an end for, as had happened before, a pretender arose in his place, a 'pseudo-Mustafa' who headed an uprising in the Balkans. Writing from Istanbul in July 1556, Ferdinand's ambassador, Baron Ogier Ghislain de Busbecq – who was involved in the protracted negotiations for a peace in Hungary – reported that Süleyman and Hürrem's son Prince Bayezid, her favourite, was suspected of having instigated the revolt. Pseudo-Mustafa and his followers were captured and brought to Istanbul, where they were put to death on the Sultan's orders. Hürrem Sultan managed to avert the consequences of Bayezid's supposed involvement[79] but in 1558 she died. Without her moderating influence on their ambitions, open conflict broke out between Bayezid and his remaining brother, Selim.

Süleyman, apparently fearing a coup, sent Bayezid and Selim to govern distant provinces. Selim was transferred from his favourable appointment in Manisa to Konya, further from Istanbul. Bayezid was moved from his post as military commander at Edirne to Amasya, where Prince Mustafa had been before him. He was the last prince-governor appointed to serve there, for the practice of giving a prospective sultan experience of kingship in the governing of a province had fallen into abeyance by the end of the century. Bayezid understood that the contest to succeed Süleyman had begun in earnest and, as he crossed north Anatolia to Amasya, attracted to his side an army of the disaffected – provincial cavalrymen and irregulars, as well as tribesmen of south-east Anatolia – numbering some thousands of men, many of whom had been partisans of his brother Mustafa.[80]

Concerned lest Bayezid might attract support from Iran, Süleyman sought juridical opinion as to whether it was lawful to kill him,[81] and ordered the governors of the Anatolian provinces to mobilize their troops around Selim; he promised them substantial pay rises, and speedy promotion to any who would enlist. The opposing armies met near Konya, Selim's the larger and better-equipped. On the second day Bayezid fled the field towards Amasya, where he still commanded support. Despite the peace agreed with the Sultan in 1555, Shah Tahmasp offered him asylum in Iran. On hearing of this, Süleyman sent the governors of his border provinces orders to detain Bayezid but again had to resort to inducements to gain their co-operation. In July 1559, with four of his sons, Bayezid fled eastwards to Iran.[82] To the last he hoped for forgiveness, but Süleyman had been unmoved by his appeals. In desperation, Bayezid had addressed himself to Grand Vezir Rüstem Pasha:

> By God the great and munificent, from the very beginning I contracted and swore to His Excellency, the illustrious and felicitous *padişah*, who is the refuge of the world, that I did not intend [to bring] revolt and opposition and harm and ruin to the realm; I previously repented and asked from the bottom of my heart [for] God's forgiveness, acknowledging my offence [which occurred in] a malign fit of rage; I repeatedly sent apologetic letters requesting forgiveness and favour and then undertook and swore not to oppose the noble pleasure.[83]

Bayezid's asylum at Tahmasp's court appeared to the Shah a fitting revenge for Süleyman's use of his brother Alqas Mirza against him in 1547. Selim was intimately involved in the attempt to get Bayezid back and over the course of the next three years seven Ottoman delegations travelled to the Safavid court charged with persuading Tahmasp to give up the prince; in 1562 he finally succumbed, agreeing to trade Bayezid and his sons for quantities of gold coin and sumptuous gifts, of which a decorated sword, a

dagger, a belt, a chestnut horse and five Arab stallions would be presented to him when Selim received news that Bayezid and his sons were transferred into the custody of his envoys. But before this could happen they were murdered at Tahmasp's capital of Qazvin by a trusted henchman of Selim and their bodies handed over instead. In stark contrast to the posthumous favour shown to his elder brother Mehmed, the rebel Bayezid and his sons were buried outside the walls of the provincial Anatolian town of Sivas.[84]

The equilibrium achieved in Ottoman–Safavid relations with the Amasya treaty of 1555 lasted until 1578, and even Shah Tahmasp's offer of refuge to Prince Bayezid did not upset it. The Ottomans could settle their relations with foreign powers by treaty but they were never able entirely to stamp out domestic disaffection and unrest – whether religiously-inspired or not.

When he came to the throne Süleyman had proclaimed that his reign would be an era of justice, but in 1526–7 Anatolia had erupted in widespread rebellion. The immediate cause of this uprising was a survey undertaken for the purpose of assessing tax revenues in Cilicia, which was perceived by the local population as inequitable. Provincial forces proved unequal to the task of putting down the disorder and reinforcements were brought in from Diyarbakır, but the revolt spread widely in eastern Anatolia and took on overtly political–religious overtones with a call to arms issued by Kalender Shah, a Kalenderi dervish and spiritual descendant of the revered thirteenth-century mystic Hacı Bektaş. Ordering their escape route to Iran to be blocked, Süleyman sent the grand vezir İbrahim Pasha himself against the rebels whom, while he was still riding east, Ottoman forces succeeded in scattering at the cost of the lives of several provincial sub-governors who were among those killed on 8 June 1527 in a skirmish near Tokat in north-central Anatolia. In late June İbrahim Pasha and his army encountered the rebels and crushed them.[85]

Less violent forms of non-conformity were also stamped upon. In 1527 an opinion of Sheikhulislam Kemalpaşazade, the supreme religious authority in the empire, brought the death penalty for a scholar, Molla Kabız, who had argued from the Koran and from traditions ascribed to the Prophet that Jesus was spiritually superior to Muhammad. Listening to the preliminary interrogation of Kabız from behind a grille in the imperial council chamber, Sultan Süleyman remonstrated with İbrahim Pasha for having brought a heretic into his presence. Kabız refused to renounce his beliefs, and after further interrogation he was executed.[86] Kemalpaşazade gave a similar opinion in 1529 in the case of a young preacher named Sheikh İsmail Maşuki whose ideas enjoyed wide popular support. Among them

was the mystical doctrine of the 'oneness of being', that man was God, the doctrine espoused by Sheikh Bedreddin during the years of civil war a century earlier. It had been considered highly subversive by Sultan Mehmed I, and Sultan Süleyman's religious authorities found it equally unsettling. Like Sheikh Bedreddin Maşuki was charged with heresy, and executed with twelve of his acolytes in the Hippodrome. Popular opinion saw him as a martyr, and the activities of his followers were still vexing the Ottoman authorities thirty years later.[87]

The notion of how far religious expression must depart from officially-sanctioned belief and practice to constitute a heresy is decided by those holding power, not by the 'heretics' themselves. The Ottoman state defined certain beliefs as 'heretical', considering them liable to have adverse political consequences, and by the same token could be lenient when the political consequences were deemed insignificant. Thus, as the territorial struggle between the Ottoman and Safavid states abated for the time being, the Kızılbaş 'heresy' was no longer a problem that demanded military action against a neighbour but one that was gradually redefined as an internal matter. Following Süleyman's eastern campaign of 1533–5 there had been significant Kızılbaş migration into Iran, while those who remained within Ottoman frontiers were persecuted. The judicial opinion of Sheikhulislam Ebüssuud, Kemalpaşazade's successor from 1545 until 1574, was that they were apostates, the canonical penalty for whom was death – Kemalpaşazade's opinion regarding Maşuki's preachings was also supported by Ebüssuud Efendi.[88] In its effort to impose an officially-sanctioned form of Islam, the Ottoman establishment allowed domestic dissenters no quarter.

During the early part of his reign Sultan Süleyman relied for counsel solely on İbrahim Pasha and Hürrem Sultan. After İbrahim Pasha's execution Hürrem continued to be her husband's intimate confidante, together with their daughter Mihrimah, wife of Rüstem Pasha, who was grand vezir from 1544 almost without interruption until 1561. Rüstem Pasha's position as the Sultan's son-in-law gave him great power and he made many enemies. He understood the workings of the palace better than had İbrahim Pasha, and although he was implicated with Hürrem in the execution of Prince Mustafa he merely spent a brief period out of office to appease the supporters of the late prince before being reinstated. He went on to gain a reputation for increasing the revenues of the state by manipulating the coinage and the grain market, and selling offices. He amassed a huge personal fortune, and it was said by his contemporaries that the practice of taking bribes became the norm during his period in office.[89] When Rüstem died he was buried in the Şehzade mosque complex built to commemorate

Süleyman's son Mehmed, a clear acknowledgement of the regard in which Süleyman held him.

As a rich man Rüstem Pasha could afford to be a generous patron, and he funded the construction of many mosques and other sacred and secular buildings across the empire, usually employing the skills of the architect Sinan, chief imperial architect from 1538. Rüstem's own mosque is in Eminönü, the main port district of Istanbul on the Golden Horn. With land at a premium and rents high, an existing church-turned-mosque was demolished and Sinan designed Rüstem's mosque above a ground floor of shops. The accompanying religious college had to be built some distance away, on the slope above the port, while a caravansaray was constructed across the Golden Horn in the commercial district of Galata, where there were also rich profits to be made. Rüstem also built large caravansarays on the main Anatolian trade routes at Erzurum and at Ereğli, near Konya, as well as two in Thrace.[90]

It was under Rüstem Pasha's aegis that 'classical' Ottoman art and architecture reached its fullest expression. As the master-craftsmen brought back from his conquests by Selim I died their influence waned, to be replaced with that of men recruited through the youth-levy and educated specifically to serve the Ottoman house. A regular system of recruitment and promotion was introduced and artistic expression — whether on textiles and tiles or in calligraphic decoration — became more standardized as a result. Where once the subtle, abstract designs of the Iranian canon had predominated, under the influence of a more consciously orthodox Islam, the bold stylized depiction of mostly plant designs, endlessly and repeatedly blended, now held sway. Except in miniature painting, representation of humans became rare.[91] Rüstem Pasha's mosque in Eminönü is famous for the sumptuousness and variety of its tiles, in cobalt blue, turquoise, green and tomato red under a transparent glaze — among the finest products of the workshops at İznik, across the Sea of Marmara from Istanbul, which for more than a century produced tiles for the court.

Situated prominently on the spine of the hill overlooking the Golden Horn, the Süleymaniye mosque complex, built during Rüstem Pasha's tenure of office, was a fittingly imposing monument to the sultan of an orthodox Islamic empire.[92] As he became more pious in his later years, Süleyman depended on Sheikhulislam Ebüssuud to convey a sober image of the Ottoman dynasty, one considered appropriate to an Islamic world power within more or less fixed frontiers. This image of himself and his empire was not to be that of a swashbuckling conqueror like his grandfather Mehmed II, ruler of a predominantly Christian state, but rather one that would appeal to his Muslim subjects in the old Islamic lands of Egypt

and Syria and the Fertile Crescent. Unlike the earlier years of his own reign, when under the auspices of İbrahim Pasha the image of empire promoted was directed at Charles V, the Safavids were now the target – albeit less aggressively – as they had been in his father's time. Ebüssuud was an adept associate in the quest to harmonize the claims of the Ottoman dynasty to temporal power with those to leadership of the Islamic world.[93]

Although Selim I had given no prominence to the title of caliph, the guardianship of the Islamic Holy Places which followed Selim's conquest of the Mamluk lands seemed to Ebüssuud to require that the sultan assume it in its full meaning. Tradition demanded that the caliph be descended from the Qurayshi tribe to which the Prophet Muhammad had belonged, but this did not trouble Ebüssuud: he simply fabricated a basis for a claim that the Ottomans were connected to the Qurayshi. To give further weight to this sleight-of-hand, he announced that the title was hereditary. Ebüssuud was able to find support in the work of historians: already in Selim I's reign, Mehmed Neşri had portrayed the dynasty as heirs to the Prophet, while Süleyman's grand vezir from 1539 to 1541, Lutfi Pasha, writing in the 1540s, emphasized that the Ottoman sultans were the only true upholders of orthodoxy.[94] A grandiloquent inscription placed over the portal of the Süleymaniye mosque – quoted at the beginning of this chapter – immortalized Süleyman's claim to be caliph.

Ebüssuud is also credited with bringing the dynastic law of the state, *kânûn* (from which derives Süleyman's Turkish soubriquet, Kanuni), into conformity with sacred law, *shari'a*. While dynastic or secular law relied to a great extent on principles derived from customary practice and originated with the sultans, sacred law does (and did) not concern itself primarily with practical matters but with the discovery of the Law of God as revealed through the Koran and the sayings and actions of the Prophet Muhammad and his Companions; its practitioners, or jurists, sought to accomplish this by the exercise of reasoning and interpretation in the discussion of theoretical problems, or jurisprudence. The practical matters dealt with in the sacred law include the ritual obligations of Muslims – rules for the conduct of prayer and fasting – specific areas of penal justice and the regulation and maintenance of equilibrium in society according to established criteria principally based on the dichotomies between male and female, Muslim and non-Muslim, and free man and slave (individuals falling into the second of each of these categories are assigned a subordinate but clearly-defined legal status).[95]

There were thus whole areas of complex administrative practice in the Ottoman state over which sacred law had no jurisdiction. Mehmed II had been the first to codify a body of dynastic law based on the practices of

preceding sultans. Süleyman's general law-code proclaimed around 1540 was a revision and amplification of those of Mehmed II and Bayezid II, containing legislative principles for the empire as a whole on matters such as the regulation of the provincial cavalry forces, taxation (the Ottoman Empire derived the major part of its revenue from agricultural taxes) and the affairs of the minority population;[96] Süleyman also continued his predecessors' work of creating law-codes for newly-conquered territories. A state with an expanding bureaucracy to regulate its workings needed an up-to-date law to fit the times, and Ebüssuud strove to harmonize the new regulatory machinery of the Ottoman Empire with the precepts of the much older, and superior, sacred law.

Regularization of the laws of the empire was accompanied by a reorganization of the religious establishment whose members also acted as judges arbitrating matters relating to both sacred and dynastic law. In Süleyman's time the religious establishment was expanded, and its career structure regularized to provide the many well-trained men needed to staff the legal and religious offices of the empire. Süleyman's claim that the Ottoman Empire was the one true Islamic state required consistency in the implementation of law and in the statement of religious doctrine, both to counter the attractions of the 'heretical' Safavids and to assign to his non-Muslim subjects their allotted place within the Islamic legal structure. The sheikhulislam, also known as the *müfti*, had been merely the chief religious authority in Istanbul; his status was now enhanced so that he became head of the whole religious establishment, and the supreme religious figure in the state. His new responsibilities came to include the time-consuming and highly-charged business of rewards and appointments within the religious hierarchy, however, and his proximity to infighting within the body of which he was himself a product made him more rather than less vulnerable to political currents and set at nought any expectations of impartiality. In seeking legal opinions from the sheikhulislam across a wide range of issues Süleyman and his advisers intended a further consolidation of the sultan's legitimacy as supreme Muslim sovereign; they found instead that they had initiated the politicization of the office.[97]

The third senior functionary to leave his mark on the period of Süleyman's maturity was his chancellor, Celalzade Mustafa Çelebi. Celalzade Mustafa accompanied İbrahim Pasha to Egypt in 1525 as secretary of the imperial council – he probably prepared the Egyptian law-code[98] – and served as chancellor for more than twenty years from the time of the execution of İbrahim Pasha in 1536. He worked with Ebüssuud to reconcile dynastic and sacred law, establishing the chancellor as the chief authority on dynastic law. He also professionalized the bureaucracy so that, as in the religious

and artistic establishments, candidates would undergo training in order to proceed up the hierarchy.[99] As Ebüssuud was taken as a model for future holders of the office of sheikhulislam, so Celalzade Mustafa was considered the epitome of chancellors.

Celalzade Mustafa was also author of a monumental history of Süleyman's reign up to 1557, when he was forced from office by Rüstem Pasha. His work set a new tone in the presentation of the sultan and the dynasty, depicting Süleyman first and foremost as the sober ruler of a just and mature order,[100] a representation of the ideal monarch which tended to become ritualized after the creation of the post of court historiographer. The verse-form panegyric it was the historiographer's task to compose had its roots in the Iranian tradition of portraying the ruler as an epic hero which pervaded Ottoman court culture through the work of highly accomplished emigrés such as the first court historiographer 'Arifi Fethullah Çelebi, who had come to Istanbul at the time of the revolt of Shah Tahmasp's brother Alqas Mirza in 1548–9. As the sultan's right to be identified as the ruler of an Islamic empire was publicly exemplified in religious architecture and good works and in the execution of dynastic law, so his image was honed in the historical works of the time for the benefit of the few who could afford to commission them or might chance to read or listen to recitation of them – in the absence of printing these historical works could circulate only among the rich and powerful. Their loyalty could not always be guaranteed, any more than that of the poor and illiterate, and it was necessary that they too be convinced of the sultan's inalienable right to rule. Another of Süleyman's concerns in creating the post of court historiographer was the rehabilitation of his father, whose reputation for ruthlessness did not fit the image of the ideal Muslim ruler, and to this end he commissioned a number of works specifically extolling Selim's deeds; by the end of the century, Selim was duly accepted as a heroic rather than a cruel figure.[101] Writing in the early years of Süleyman's reign, his sheikhulislam Kemalpaşazade composed an elegy on Selim which was a precursor of the genre; it begins:

> He, an old man in prudence, a youth in might;
> His sword aye triumphant, his word ever right.
> Like Asef [i.e. Solomon's vezir] in wisdom, the pride of his host;
> He needed no vezir, no mushir [i.e. a general] in fight.
> His hand was a sabre; a dagger, his tongue;
> His finger an arrow; his arm, a spear bright.
> In shortest of time, many high deeds he wrought;
> Encircle the world did the shade of his might.[102]

The Ottomans became masters of the manipulation of symbolism in bolstering their claims to supremacy. Mehmed II had codified court ritual and laid down strict rules for the comportment of palace and governmental officials; Süleyman took this to its logical conclusion. No longer would the sultan eat with his courtiers, nor accept petitions personally as a matter of course. Mehmed often observed meetings of the imperial council through a latticed window high in the wall of the chamber, rather than attending them in person; Süleyman made this the rule rather than the exception. He emphasized the inferior position of visiting ambassadors by not rising to greet them; they subsequently remarked on his silence and immobility as he received them in his Hall of Petitions.[103] Süleyman rarely appeared before his people; when he did – attending Friday prayers or marching to war – the event was carefully staged to enhance the mystique surrounding him.

Conquests could not be made indefinitely, and in the second half of his reign the feasts and triumphal progresses of Süleyman's early years were replaced as symbols of the dynasty's greatness by the more permanent legacy of bricks and mortar. For the first time, royal women joined the sultan and his statesmen in demonstrating their piety to the people of Istanbul: three of the six mosque complexes erected by members of the dynasty in the capital during Süleyman's reign are associated with women – previously they had built only in the provinces. Compared with his predecessors, Süleyman's own programme of sacred and secular building – from mosque complexes to aqueducts – was extensive. There were those who regarded such lavish public expenditure with suspicion – the late-sixteenth-century bureaucrat and intellectual Mustafa Ali of Gelibolu remarked that the need for public services in a particular place was not a consideration when a decision was taken regarding pious works: what was important, he said, was that new foundations be funded by booty rather than from the public purse.[104]

The projects undertaken by the royal women of Süleyman's family were more charitable than commercial in character, including elements such as a hospital or a public kitchen, not always found in the foundations sponsored by male members of the dynasty. In the town of Manisa where she had lived with Süleyman when he was prince-governor of Saruhan his mother Hafsa Sultan built an extensive complex with a staff of more than a hundred people. Besides a mosque there was a theological college, a dervish lodge, a primary school, and a public kitchen to feed the poor; Süleyman later added a hospital and bath-house.[105] For Süleyman's daughter Mihrimah Sultan the imperial architect Sinan built a mosque complex with a clinic and a public kitchen by the landing-stage at Üsküdar, across the Bosporus

from Istanbul and the first stop along the road to war in Anatolia, and another on a high terrace next to the Edirne Gate of Istanbul through which the imperial army marched on the road to war in Europe.

Hürrem Sultan's foundations – some built at her personal instigation, others merely in her name – ensured that many thousands would have access to her philanthropy and thus be grateful for her concern (and that of the dynasty) for their well-being. They were situated at key sites in the empire: in the seats of the dynasty in Istanbul and Edirne, in the Muslim Holy Places and in Jerusalem. The earliest was the complex in Istanbul built for her by Sinan between 1537 and 1539; it was his largest commission to date and the first mosque complex sponsored by a royal woman to be built in Istanbul. The construction of a mosque complex in Hürrem's name so soon after the execution of İbrahim Pasha in 1536 was doubtless intended to improve her image; it included a public kitchen and a hospital. Shortly before her death in 1558 Sinan built a large double bath bearing her name at the edge of the Hippodrome, next to the wall of Ayasofya.

Hürrem's foundation in Jerusalem was the most splendid of all, consisting of a mosque, a 55-room lodging-house for pilgrims, a bakery, a public kitchen, a cellar, a granary, a woodshed, a refectory, toilets, an inn and stables.[106] Inherited, like Mecca and Medina, by the Ottomans from the Mamluks, Jerusalem was the place from where the Prophet Muhammad is said to have ascended into heaven. Between 1537 and 1541 Süleyman redecorated the Dome of the Rock mosque – built at the end of the seventh century – in the Ottoman manner, and extensively rebuilt the old city walls.[107]

After the Ottomans became protectors of the Holy Places of Mecca and Medina they continued the Mamluk practice of embellishing these sites. The Mamluks had jealously guarded their suzerainty here and refused to allow rival Islamic rulers the privilege of making donations, for fear that this would lend them greater prestige. They had rejected the gifts of Tamerlane's son and successor Shah-Rukh as they had Sultan Mehmed II's offer of a covering for the Ka'ba shrine. Selim I had had little time to demonstrate his respect for the Holy Places but Süleyman undertook extensive renovations. In Mecca he built four theological schools and rebuilt the minarets of the Great mosque, adding a seventh of great height. He also repaired the water supply: the number of visitors had increased and the provision of clean and plentiful water for ablutions and drinking was more essential than ever. Süleyman also donated large wax candles for the illumination of the mosque during evening prayers, and perfumes for the Ka'ba.[108] In both Mecca and Medina he caused to be built a public kitchen in Hürrem Sultan's name.

The reaction of the Ottomans to the sacred monuments of Christendom

they inherited was competition, not destruction, as exemplified by Mehmed II's construction of his own mosque in Istanbul to vie with the Orthodox Christian basilica of Hagia Sophia. Its association with the life of the Prophet apart, the attention Süleyman lavished on Jerusalem might seem out of proportion to the importance of what was in effect a small provincial town, but here he could advertise his splendour to a diverse audience. The public works he and Hürrem Sultan sponsored served to inform Muslim observers that Jerusalem was now an Ottoman city, albeit one that owed a debt to the Islamic rulers of the past. They would have been noticed also by the Christian pilgrims who travelled there at an average of almost six hundred each year over the next century[109] – but if the French ambassador M. d'Aramon is typical, they thought little of Süleyman's improvements. When he visited Palestine in 1548 in connection with the difficulties then being experienced by the Franciscans in the Christian Holy Sites, the impressions of his party were less than favourable:

> Jerusalem has been enclosed by city walls built by the Turks, but there are neither ramparts nor a ditch. The town is medium-sized and not much popu-lated, the streets are narrow and unpaved . . . The so-called temple of Solomon is at the base of the city . . . round and with a lead-covered dome; around its core are chapels as in our churches, which is all one can surmise because no Christian is permitted to enter without threat of death or having to become a [Muslim].[110]

For Venetian ambassadors Süleyman was still as 'Magnificent' at the end of his reign as at the beginning but in different ways. His personal display was now muted to a pious sobriety befitting a sultan who aspired to be the embodiment of justice; his magnificence had become more impersonal, advertised in building works and moral acts. Süleyman's reign soon came to be regarded as the golden age of the empire (a judgement until recently accepted uncritically by historians), with the corollary that what followed could be considered as nothing more than a decline from this apogee: Ottoman men of letters writing during the century after Süleyman dwelt nostalgically on the justice he had brought to the land, which they perceived to have been vitiated thereafter by corrupt statesmen and administrators. Yet while they idealized his reign as a time of order, there were some, nevertheless, who saw policies adopted by his government as containing within them the seeds of discord. Among his critics was Lutfi Pasha, who even while Süleyman was still on the throne voiced his concerns about widespread bribery, excessive military spending and the infiltration of peas-ants into the military class.[111] As grand vezir himself under Süleyman, Lutfi Pasha must have witnessed the Sultan's retreat from government – and

disapproved. He advised the Sultan not to allow his courtiers to meddle in state affairs: administering the state was, he said, the business of the sultan and his grand vezir. One of the inevitable consequences of sultanic withdrawal from public affairs was foreseen by the janissaries, who in 1558 complained of Süleyman that 'He cannot know anything about anyone by living within four walls. He places all his confidence in a host of despots . . . he is unaware of the condition of the people'.[112]

The death in 1564 of King Ferdinand, who had succeeded his brother Charles V as Holy Roman Emperor in 1558, and the accession of his energetic son Maximilian II, rekindled Ottoman–Habsburg hostilities. The immediate pretext for a new campaign was Maximilian's failure to pay the tribute he owed the Sultan. In his mid-sixties, and after an interval of eleven years, Sultan Süleyman decided to lead his army in person again. Possibly his decision owed something to the chiding of his daughter Mihrimah Sultan, who told him he was neglecting his canonical obligation to lead his army in holy war against the infidel.[113] Accompanied by Grand Vezir Sokullu Mehmed Pasha, in the spring of 1566 he marched west for the first time in 23 years. Four hours before dawn on 7 September Süleyman died under the walls of the fortress of Szigetvár in southern Hungary which his army had been besieging for a month. Szigetvár fell the next day and the area to the south of Lake Balaton was occupied.

As had often been the fate of campaigning sultans, Süleyman I died far from his capital. Only one of his sons survived him, but Selim was at his post as prince-governor in Kütahya in Anatolia: it was not the fear of a succession struggle among brothers that alarmed Sokullu Mehmed Pasha, therefore, but the possibility that a vacuum at the heart of government might excite the ambitions of claimants outside the Ottoman dynasty. Ignoring the Islamic stricture that burial and the formalities preceding it must be carried out as soon as possible, Sokullu Mehmed conducted an elaborate ruse to keep Süleyman's death a secret until Selim could be proclaimed sultan. Summoning him to travel with all haste from Kütahya, the Grand Vezir continued to conduct state business in Süleyman's name, and the letters of victory relating the fall of Hungarian fortresses to the Ottoman army were sent out as though his master were alive. The Sultan's customary attendance at Friday prayers in a hastily-erected mosque was proclaimed to the army, and his subsequent non-appearance on the pretext of his gout provoked little reaction. When bureaucrats began arriving at Szigetvár from Istanbul the troops and their officers in Hungary began to suspect that something was amiss, but Sokullu Mehmed was able, for a time, to maintain the ruse.[114]

6

The sedentary sultan

I<small>T WAS NOT</small> until some three weeks after Sultan Süleyman's death that
Selim reached Istanbul from his governorship at Kütahya. Sokullu
Mehmed Pasha had so deftly concealed the Sultan's passing that many
were surprised by his son's appearance in the capital on 29 September.
Immediately proclaimed sultan – as Selim II – he set off for the Hungarian
front three days later, but was warned by Sokullu Mehmed that he must
not continue beyond Belgrade because there was too little money in the
campaign treasury to pay the troops the donative customary on the acces-
sion of a new sultan. On the pretext of completing repairs to the fortress,
Sokullu Mehmed detained the army at Szigetvár until he was able to
announce that it was too late in the season to continue the campaign,
and the order was given on 20 October to begin the arduous march
home.[1]

News of Süleyman's death and Selim's accession had still not been offi-
cially proclaimed to the troops when the army set off the next day towards
Istanbul. Following his death, Süleyman's body had been washed and
temporarily buried under his tent; now it was exhumed in order to be
taken home. One of the late Sultan's pages was chosen to sit in the Sultan's
carriage and gesture to the troops in his character. The chronicler Mustafa
Efendi of Selanik (Thessalonica), who as a young man was present on the
Szigetvár campaign, was one of six people chosen to recite passages from
the Koran by the side of the carriage as it progressed; he describes the page
chosen to be Süleyman's double as white-faced, hawk-nosed, with a sparse
beard and a bandaged neck, and an appearance of ill-health. Mustafa Efendi
reported that although everyone was by then aware that Süleyman was
dead, no formal proclamation was made until 48 days after the event, by
which time the cortège was nearing Belgrade where the new sultan was
waiting.[2] The funeral prayers performed there in Selim's presence were
later repeated in front of his father's newly-built mosque in Istanbul, to
give the people of Süleyman's capital a last chance to remember the Sultan
and his works. Sultan Süleyman was subsequently buried in the place he
had chosen – not, as was customary, in front of the prayer-niche wall of

the mosque bearing his name, but in a tomb built in its garden, next to that of his wife Hürrem Sultan.[3]

The ceremony accompanying the accession of an Ottoman sultan was customarily modest; the new ruler was set on the throne and his statesmen swore allegiance to him. Selim II, however, unwittingly set a precedent for the future. Like his father and grandfather before him, after his confirmation as sultan he had visited the shrine of Ayyub Ansari (the Companion of the Prophet Muhammad whose tomb had been miraculously rediscovered during the siege of Constantinople in 1453) to seek the saint's blessing before departing for the front; as it fell out, Selim made this pilgrimage immediately after his enthronement, and thereafter every new sultan visited the shrine as an integral part of his accession ceremony.[4] One benefit of the pilgrimage was that it gave the new sultan an opportunity to progress triumphally through the city in full view of his subjects.

Sokullu Mehmed Pasha had barely been able to contain the troops at Belgrade where, on their first encounter with the new sultan, they demanded their accession donative – he handed out a small amount sufficient to pacify them and, promising the balance later, raised their pay and that of the various bureaucratic and service personnel also on the campaign. The march home went smoothly enough but as the army reached Istanbul, the janissaries mutinied. The Sultan and his entourage entered the city through the Edirne Gate, in the shadow of the mosque sponsored by Selim's sister Mihrimah Sultan, but when they reached their parade ground near the Şehzade mosque, the janissaries refused to continue towards the Topkapı Palace. For an hour they stood their ground; then they moved off again, then again came to a halt, this time before the baths of Sultan Bayezid II. Here one of Selim's vezirs and the grand admiral Piyale Pasha remonstrated with them; both were knocked from their horses, and the stand-off was only broken by the distribution of handfuls of gold coins. Those janissaries appointed to duty at the palace proceeded there, but once inside, they barred the gates against the Sultan. Sokullu Mehmed Pasha resolved the crisis by advising Selim that the only way out of this potentially dangerous situation was to pay the balance of the accession donative forthwith.[5]

There had been janissary insurrections before, most notably during the first sultanate of Mehmed II in the 1440s. Selim's humiliation demonstrated that to achieve a smooth passage to the throne it was not enough to be sole heir; it was still essential also to have the support of the janissaries and the other elite units of the army. In theory these corps were the servants of the sultan but in reality he was the prisoner of their whims, and without their support he could not exercise his sovereignty. Securing the allegiance of their troops was as essential for Ottoman sultans as it was for the crowned

heads of Europe. As Ottoman history amply demonstrated, deposition or regicide was the fate of the monarch who forfeited this loyalty.

Like his brothers, Selim had received training befitting a warrior-prince, and had already been exposed to the rigours of campaigning. At the age of twenty, after a short spell in Konya, he was sent to Manisa in place of his dead brother Mehmed as prince-governor of Saruhan province – the post customarily held by the favourite to succeed to the sultanate – and remained there until the conflict with his brother Bayezid in 1558 when he was sent back to Konya. After the defeat of Bayezid in the succession struggle Selim was appointed to Kütahya, where he stayed until his father's death. Süleyman had demonstrated the degree of his reliance on Selim in 1548 by leaving him as regent in Istanbul while he himself was absent on the Iranian front.[6] On that occasion Selim seems to have acquitted himself well, yet he failed to embrace his new role with much energy when faced with the total responsibility of the sultanate. The fear inspired by the ever-present threat of mutiny among his troops was matched by his fear of a coup during his absence from the capital. After he became sultan Selim never again travelled further from Istanbul than the royal hunting grounds at Edirne.[7]

Sokullu Mehmed Pasha ran Selim II's empire as the visible face of Ottoman rule, while the Sultan stayed aloof from the cut and thrust of decision-making. This remarkable man occupied the post of grand vezir continuously for fourteen years, under three sultans. He belonged to the minor Serbian aristocratic family of Sokolović ('Son of the Falconer'), and was a product of the youth-levy. During Süleyman's reign he moved smoothly up the palace hierarchy. His first significant post was as admiral of the fleet following the death of Barbarossa. He then held a number of important provincial governorships and military commands on the western and eastern frontiers of the empire until he was appointed grand vezir by Süleyman in 1565. The dangerous circumstances of Süleyman's attempt to prevent conflict among his sons allowed Sokullu Mehmed Pasha to demonstrate his value to the dynasty. He was entrusted with suppressing the revolt of the pretender pseudo-Mustafa in 1555, and in 1559, as commander of the army sent by Süleyman to support Selim against his brother Bayezid, he proved his indispensability to the future sultan. Selim owed his victory to Sokullu Mehmed, and, while the Prince did not fail to reward him, Süleyman bound him still closer by marrying him, in 1562, to Selim's daughter Esmahan Sultan (Sokullu Mehmed divorced his two other wives to free himself to accept this honour). The relationship of this able statesman and military commander with his master had echoes of that of Süleyman's hapless favourite İbrahim Pasha;

like İbrahim's, Sokullu Mehmed's special status was prominently advertised by the location of his palace, on the Hippodrome, close to that of his master.[8]

During the first years of Selim II's reign the Ottomans were occupied with small but important operations on distant frontiers. When news of Süleyman's death reached the province of Yemen in 1567 the powerful chief of the Zaydi clan, Imam Mutahhar ibn Sharaf al-Din, rallied his Shia followers in open rebellion. Ottoman authority in Yemen had always been tenuous. In this rugged and sparsely-populated terrain, it proved impossible to suppress independent local Arab chiefs, while a common profession of Islam was inadequate to secure their acquiescence to the imposition of an entirely alien regime. The construction and garrisoning of the fortresses essential to Ottoman attempts to subdue local dissent made the province expensive to control, and although the energetic governor Özdemir Pasha had made Ottoman rule more effective during his tenure between 1549 and 1554,[9] his successors proved weaker. Yemen had been divided into two provinces in 1565, but the Ottoman governor of the southern province centred on San'a was murdered and the many strongholds the Ottomans had previously secured were lost to Imam Mutahhar.[10]

Yemen was important because control of the spice route brought substantial customs revenues into the coffers of the Ottoman Empire. In 1568 a strong expedition was sent to pacify the province under the command of Sultan Selim's former tutor and confidant Lala Mustafa Pasha, a choice which showed that Selim was not entirely the pawn of his grand vezir, for Sokullu Mehmed resented Lala Mustafa's place in the Sultan's affections. To put down the uprising in Yemen Lala Mustafa needed men and supplies from Egypt but the provincial governor, another rival, Koca ('Great') Sinan Pasha, refused his requests and made it impossible for him to pursue the campaign. In a spate of petitions to the Sultan the two defended their respective positions. Koca Sinan proved the stronger, and Lala Mustafa was dismissed from command of the Yemen campaign. To mark his continuing favour, however, Selim created for him the position of sixth vezir in the governing council of the empire. Koca Sinan took over leadership of the campaign, but the logistic demands of fighting in Yemen forced him to reach a settlement with the Zaydi. The two Yemeni provinces were reunited, and by 1571 Koca Sinan was able to return to Cairo.[11] The instability in the region caused the Ottomans to look again at the possibility of building a canal to connect the Mediterranean and the Red Sea. As an imperial order enjoined the governor of Egypt:

... because the accursed Portuguese are everywhere owing to their hostilities against India, and the routes by which Muslims come to the Holy Places are obstructed and, moreover, it is not considered lawful for people of Islam to live under the power of miserable infidels ... you are to gather together all the expert architects and engineers of that place ... and investigate the land between the Mediterranean and Red Seas and ... report where it is possible to make a canal in that desert place and how long it would be and how many boats could pass side-by-side.[12]

But again the proposal went no further.

Muscovy's annexation of the Muslim Tatar khanates of Kazan and Astrakhan in the 1550s adversely affected its cordial relations with the Ottomans and altered the strategic balance in the region. The gradual penetration of Muscovy into Transcaucasia added a third power as a potential focus of loyalty for local rulers whose vacillating preferences for Ottomans and Safavids exacerbated traditional rivalries in the region. The pressure from the Tatars of the steppe, prompting local people to seek Muscovy's protection, was a further complication. In 1567, when Muscovite help was requested by one chieftain, Ivan IV obliged by building a fort on the River Terek, which rises in the central Caucasus and empties into the Caspian.[13] The Özbek and Khivan Khans responded with an appeal to the Ottomans, complaining that Muscovite control of Astrakhan blocked the route south both for merchants and for pilgrims to Mecca.[14]

Sultan Süleyman and his vezirs had shown little interest in campaigns which would take them into territory even more inhospitable than the frontier zone with the Safavids, but Selim's accession brought a change in policy. Encouraged by the Muslim rulers of the region, Sokullu Mehmed Pasha sought local advice on the feasibility of digging a canal between the Don and Volga rivers, and was encouraged to believe it would be possible. In Süleyman's time reports had reached Moscow of talk in Istanbul of constructing a riverine route between the Sea of Azov and the Caspian, but no steps had been taken to realize the project. In the second year of Selim's reign – a year after the Muscovites had built the fort on the Terek – an expedition to secure Astrakhan was in the making. Craft able to navigate the Don were built in the dockyards of Feodosiya and the necessary matériel and supplies were shipped from Istanbul to Azov. Troops were mobilized from Rumeli and northern Anatolia. Doubtful of the practicability of such a canal and afraid of the presence of Ottoman interlopers so close to his territory, the Tatar Khan of the Crimea was reluctant to participate – but unable to refuse. Muscovy offered the Safavids cannon and guns to create a diversion in the Caucasus, but the offer was not accepted.[15]

The Astrakhan campaign of 1569 was commanded by Kasım Pasha, the governor of Kefe province. The Don was so shallow in summer that even the special boats built at Feodosiya found progress up-river from the Sea of Azov difficult. The chosen site for the canal lay to the south of modern Volgograd, where the Don and Volga were still 65 kilometres apart. The land between them was hilly, and it became clear that a canal could not be cut through such terrain. The decision was therefore taken to transport the flotilla and supplies overland between the rivers, following the practice of the Cossacks of the Don. The effort needed simply to level the ground for this purpose was disproportionate, however, and Kasım Pasha decided to send his heavy equipment back down the Don to Azov, after which the force taking it there would march across the steppe to Astrakhan and meet up with him and his men who would have reached this city by following the Volga south. Ill-equipped and short of food as they were, the Ottoman forces were unable to make much impact on Astrakhan. They retired in September, sustaining further losses in men and matériel both as they returned to Azov and, owing to the seasonal storms, on their sea voyage back to Istanbul.[16]

The scheme to cut a canal to connect these two great rivers was consonant with Sokullu Mehmed's penchant for ambitious engineering projects and his interest in military logistics, but although he found a willing and tenacious lieutenant in Kasım Pasha, Kasım's intention to continue the campaign in the following year was rejected by Istanbul. Though the bold canal scheme had failed, it none the less had significant consequences. As little as the Ottomans did Tsar Ivan IV wish to get involved in a war in the steppe, and when the 1569 expedition was over he sent an envoy to Istanbul to congratulate Selim on his accession. The Russians abandoned the Terek fort, but Ivan refused to surrender Astrakhan.[17]

This amicable agreement between Tsar and Sultan reckoned without the Crimean Tatars, however. In 1571 the Tatars demanded the cession of Kazan and Astrakhan, and raided and burnt the capital city of Moscow. Selim took advantage of this new situation and sent a message to Tsar Ivan reiterating their demand, agreeing to support the Tatar Khan in a new expedition to retake the two cities. In the summer of 1572 the Tatar army again set out towards Moscow, but this time they suffered a great defeat close to the city, and the reconquest of the lower Volga was abandoned by the Crimeans and the Ottomans alike.*[18]

<div align="center">★</div>

* The project for a canal to join the Don and Volga was finally realized in 1952, along the route the Ottomans had planned to follow four centuries earlier.

Although Ottoman interest in distant adventures on land was not yet exhausted, Sultan Selim II's reign was more noted for naval activity, as he continued the active forward policy pursued by Süleyman against the Spanish Habsburgs in the western Mediterranean. Nor was Spain alone in opposing the Ottomans: in the Magreb, the Sa'di dynasty of Morocco and the Hafsids of Tunis offered Muslims alternatives to a dynasty based far away whose ability to protect its North African territories depended on the security of its maritime routes. Blocking Ottoman passage into the western Mediterranean were the Knights Hospitallers at Malta, Sicily – governed by a Spanish viceroy – and the Spanish outpost of La Goletta near Tunis.

In 1568 the Ottomans were sowing discord within the Sa'di clan in an attempt to undermine the dynasty's hold on Morocco, when the corsair captain Kılıç ('Sword') Ali – also known as 'Uluç' ('Barbarian') Ali in reference to his non-Muslim, Italian origin – in Ottoman employ at the time, sent a small army overland from Algiers which defeated the Hafsids in battle to win their territory of Tunis, although not yet the key fortress of La Goletta. Kılıç Ali had timed his expedition against these Spanish vassals well, for the Spanish armies were occupied in the Netherlands or in suppressing the Morisco revolt on the Spanish mainland. The Moriscos petitioned the Sultan for help but their uprising was put down by King Philip II's troops[19] which led to further Morisco migration into Ottoman domains.[20]

The major events of these years were the capture of Cyprus from Venice in 1571 and the defeat of the Ottoman fleet at Nafpaktos in the battle of Lepanto the same year. Venice had ruled Cyprus since 1489, having been invited there to protect the last, weak Lusignan kings against Ottoman attack. In those days, when Mamluk Egypt was a power to be reckoned with, Venice had paid Cairo an annual tribute for its most easterly possession, as it now paid the Ottomans. Friction between the Ottomans and Venice was never completely absent but outright war was usually avoided. According to contemporary Ottoman historians, it was Venetian protection for the corsairs who plagued Ottoman vessels sailing the route to Egypt which drove Selim to mount a campaign to conquer Cyprus.[21] Naval preparations were under way during 1569, the year of the ill-fated Astrakhan campaign. Sokullu Mehmed Pasha cautioned against such an undertaking, so soon after the Malta debacle of 1565, but his rivals convinced the Sultan to seek a juridical opinion authorizing the expedition, which was in breach of the peace treaty with Venice that had been renewed following his accession. Sheikhulislam Ebüssuud conveniently declared himself of the opinion that an attack on Cyprus was legitimate if the intention behind the declaration of war was the recovery of lands which had once been under Muslim

rule – as Cyprus had been, briefly, in the early Islamic period. The problem was framed thus:

> A land was previously in the realm of Islam. After a while the abject infidels overran it, destroyed the colleges and mosques, and left them vacant. They filled the pulpits and galleries with the tokens of infidelity and error, intending to insult the religion of Islam with all kinds of vile deeds, and by spreading their ugly acts to all corners of the earth ... When peace was previously concluded with the other lands in possession of the said infidels, the afore-named land was included. An explanation is sought as to whether, in accordance with the [sacred law], this is an impediment to the Sultan's determining to break the treaty.
>
> ANSWER:
> There is no possibility that it could ever be an impediment. For the Sultan of the people of Islam (may God glorify his victories) to make peace with the infidels is legal only where there is benefit to all Muslims. When there is no benefit, peace is never legal. When a benefit has been seen, and it is then observed to be more beneficial to break it, then to break it becomes absolutely obligatory and binding.[22]

This was the only occasion during the sixteenth century on which a peace treaty was broken by the Ottomans.[23]

The considerable amount of money needed by the Ottomans before they could embark upon the conquest of Cyprus was partly met by the sale of monasteries and churches belonging to the Orthodox Church in the European provinces of the empire. Orthodox Christianity had an honourable past as a bulwark against the Latins, earlier in the shape of Venice and the Papacy but now exemplified by the Catholic Habsburgs, and the functioning of the Orthodox Church within the Ottoman Empire was generally unproblematic: as long as the institution acted within the prescribed bounds of its relationship with the state, it had little cause for complaint. Sultan Selim's confiscation of Church lands in 1568 was not aimed at the destruction of the Church, but was in line with the continuing efforts of Sheikhulislam Ebüssuud – who, until his death in 1574, served Selim as he had served Süleyman before him – to streamline the land-holding system in the Ottoman domains. Once forfeit, churches and monasteries could be bought back, to the treasury's benefit. But the effects of the confiscations were uneven, the richer monasteries surviving while the poorer ones were sold to new owners who could afford to pay the price.[24]

The Ottoman treasury thus enriched, Lala Mustafa Pasha was appointed commander-in-chief of the Cyprus land forces while the fleet was

commanded by the grand admiral Müezzinzade ('Son of the Prayer-caller')
Ali Pasha – who, in the words of one modern historian, 'had never in his
life directed even a caique';[25] he was fortunate to have at his side Piyale
Pasha, who had previously served as grand admiral for fourteen years.
Though the European powers had been aware for some time that a well-
equipped and numerous fleet was being readied they were not certain
whither it was bound. Rumour favoured Cyprus, and there was palpable
unease in Venice in 1568–9 because the administration of the island was
recognized to be corrupt, and unable to stand against any Ottoman attack;
by the time the rumours were confirmed, some improvements to defences
and supplies had been made. The Sultan's envoy reached Venice in March
1570 with an ultimatum: Cyprus must be surrendered, or the Ottomans
would mount an attack. By September they had occupied the inland city
of Nicosia.

Venice was hard-pressed to find allies for the defence of Cyprus. The
Austrian Habsburgs and the Ottomans had made peace in Hungary in 1568;
the Spanish Habsburgs saw no strategic value in the island and owed Venice
nothing, for Venice had failed to provide support against the Ottomans at
Malta in 1565. In past times, indeed, Venice had always preferred to main-
tain good relations with the Ottomans rather than to participate in leagues
against them. On this occasion much effort, especially on the part of the
Pope, resulted in May 1571 in an agreement between Venice, the Papacy
and Spain, a condition of which was that Venice would go to Spain's aid
in North Africa.

In September 1571 a fleet under the command of Don John of Austria,
the illegitimate son of the former Holy Roman Emperor Charles V and
half-brother of Philip II of Spain, sailed east from Messina. It reached the
Ionian island of Cephalonia only to learn that Mağosa (Famagusta), the last
Venetian stronghold on Cyprus, had fallen to the Ottomans on 1 August
after an eleven-month siege. The reconquest of Cyprus rather than its
defence must now be the aim of the Christian allies. In the Gulf of Patras,
however, at the mouth of the Gulf of Corinth, Don John's fleet found an
Ottoman fleet that had spent the summer raiding and even capturing
Venetian islands and possessions on the Adriatic coast. Don John seized the
opportunity, and the two fleets engaged off Nafpaktos on 7 October.

Like the Ottoman failures before Vienna in 1529 and 1683, the battle
of Lepanto is an event graven on the western consciousness as having only
narrowly saved Christendom from being overrun by the 'infidel Turk'. It
was much described by eye-witnesses and later historians alike, but no
Ottoman contemporary thought to preserve his recollections for posterity[26]
– indeed, there were few survivors among the Ottoman seamen. Don John

had over two hundred galleys – oared warships armed with cannon – and six galleasses – in effect, large galleys armed with bigger cannon – while the Ottomans had an even greater number of vessels but lacked galleasses. A shift in the wind meant that the battle was fought on calm seas and heavy cannon could achieve maximum effect; fired relentlessly at the Ottoman fleet at close quarters, they proved decisive for the Christians. Most of the Ottoman fleet was burnt and sunk; wounded men and corpses rendered 'tutto il mare sanguinoso'. A violent storm blew up after the battle was over – the battle had lasted for four hours – and finished off any who might have hoped for rescue.[27]

Don John took to sea again in 1572, but Christian euphoria and plans for future attacks on Ottoman territories were to prove short-lived. The Ottomans had spent the winter rebuilding a fleet to replace that lost at Lepanto. Müezzinzade Ali Pasha having been killed in that battle the command was given to Kılıç Ali Pasha as grand admiral.[28] The two fleets skirmished inconclusively off the Peloponnese but the anticipated victory eluded the Christians. The league was beginning to fail, and did not sail again against the Ottomans in 1573 as planned. Instead, Venice sought peace through its representative in Istanbul, who had been held under house arrest since hostilities began in spring 1570.[29] As well as accepting the loss of Cyprus, Venice paid an indemnity of 300,000 ducats to the Ottomans; prisoners were exchanged and the Adriatic coast frontier set at pre-1570 limits.[30]

One man at least on the winning side did not receive what he had hoped for from this treaty: Sultan Selim's close confidant, the Sephardic Jewish banker and merchant Joseph Nasi. In recognition of his support in Selim's struggle against his brother Bayezid Nasi had been rewarded with the title of Duke of Naxos, along with the considerable customs revenues from the island's wine trade. It was said he wished now to be made King of Cyprus – contemporary European historians certainly credited him with having encouraged Selim to declare war against Venice in 1569, and it was rumoured that he had ready a standard embroidered with the arms of Venice and the legend 'Joseph Nasi, King of Cyprus' in gold letters.[31] But the Sultan chose to keep the revenues of the island for the treasury, and Nasi was disappointed.

When it came to settling their own people in Cyprus the Ottomans experienced serious difficulty in promoting voluntary immigration from Anatolia. The island lacked the attractions of newly-conquered territory on the Rumelian front, for instance, or the consolations of Istanbul following the fall of the city to Mehmed II in 1453. Moreover, the climate was uncomfortably hot in summer and grazing land was scarce. Some volunteers there

must have been, but forcible resettlement predominated: single women were sent as brides for the soldiers garrisoning the island's fortresses; skilled peasants of good reputation were transported there with promises of land and tax relief. Many of those selected as settlers hid from the authorities before they could be apprehended, while many others succeeded in returning to the mainland, a matter of obvious concern to the government, which resorted to banishing undesirables there – an early precedent for the British policy of deporting petty criminals to Australia, perhaps. Those suspected of Kızılbaş sympathies, against whom there was a new wave of vigilance in the later part of the sixteenth century,[32] were sent there, as were others considered a threat to the stability of society, including unruly religious students, brigands and minor officials who had fallen from favour.[33]

Don John – having failed in the unrewarding season of 1572 to engineer the collapse of Ottoman naval power that had been anticipated after Lepanto – retook Tunis in 1573 with a Spanish armada, and built a new fortress at La Goletta. With a fleet larger than that lost at Lepanto the Ottomans again captured Tunis in 1574, in a combined operation with the land forces of the provinces of Algiers, Tripoli and Tunis. In diplomatic moves made before the fleet set out the Ottomans sought the assistance of the Moriscos of Spain, suggesting that they ally with the Protestants of the Netherlands; an Ottoman agent was also sent directly to the Netherlands to propose an alliance for a combined strike against Spain, but nothing came of it.[34] Agents and spies throughout Europe kept Ottoman statesmen well-informed about political alliances, while Joseph Nasi's commercial connections provided the Sultan with another effective intelligence-gathering network across a wide area.

Lasting control of North Africa posed both Habsburgs and Ottomans a challenge upon which the prestige of each depended. The Ottomans had a mission to protect their co-religionists but there were clear risks in repeatedly running the gauntlet of the Spanish navy. On the other hand, though Philip II could not accept an Ottoman presence so close to the heart of his kingdom, he chose to give priority to the suppression of the Protestant revolt in the Netherlands, a complex and hugely expensive logistical undertaking. In 1575 Spain declared herself bankrupt.[35]

In 1574, the year of the Ottoman reconquest of Tunis, Sultan Selim II died after a fall in the bath. He was 50 years old. He had emulated his forebears by building a prominent, monumental mosque complex, but had broken with tradition by siting it in the old Ottoman capital of Edirne in Thrace, where he loved to indulge his passion for hunting. His father's Süleymaniye mosque symbolized the power of the Islamic religion and the

Ottoman dynasty in the imperial capital; Selim carried this message beyond the confines of Istanbul. Edirne lay on the military road to Europe and the overland route travelled by the envoys of European powers bound for Istanbul on diplomatic missions; the Selimiye – situated on rising ground at the heart of the city, on the site of a palace built in the 1360s by Sultan Murad I[36] – may be seen from all approaches. The mosque's four minarets, soaring more than seventy metres into the sky, long impressed those who passed through. A century and a half later Lady Mary Wortley Montagu, wife of the English ambassador in Istanbul, remarked that the Selimiye mosque was 'the noblest building I ever saw'.[37] The seventeenth-century traveller Evliya Çelebi adduced a characteristically Ottoman justification for Selim's choice of Edirne, relating that the Prophet Muhammad came to Selim in a dream and directed him to build there.[38] The Prophet's visitation seems to have taken place even before the death of Süleyman, since the chronogram for the Selimiye's foundation yields the date 1564–5,[*39] but it was finished only after Selim's death. It was built with the spoils of the Cyprus campaign, as the Süleymaniye had been with those of the Belgrade, Rhodes and Malta campaigns.[40] A departure from his usual scheme of a mosque with a central dome surrounded by semidomes, the Selimiye mosque with its single dome that is broader than that of Ayasofya is considered the masterpiece of the imperial architect Sinan, in which he aimed to demonstrate his skill and virtuosity by surpassing his Byzantine model.[41]

Selim's mosque complex may have been built in Edirne, but he also left his mark on the architecture and skyline of Istanbul: in 1572 he embarked upon the first major repair of Ayasofya undertaken since the appropriation of the church by Mehmed II. In the century since the Conquest the structure had become ringed around with houses and other domestic buildings, and Selim ordered that they be demolished. Subsequent inspection revealed that the buttresses were crumbling and in urgent need of repair: the historian Mustafa Efendi of Selanik noted that the building was tilting. Selim inspected the mosque in the company of Sinan and issued orders for an extensive renovation. One of the two minarets added at the Conquest had been constructed of wood, and this was to be rebuilt in brick; two further minarets were added. The Sultan roundly condemned those who considered the works unnecessary because Hagia Sophia had been built by non-Muslims.[42]

In the precincts of Ayasofya Selim ordered the construction of two

* A chronogram is a piece of writing, often an inscription or poem, in which certain letters – in the case of Ottoman chronograms these are usually in the final line – are each assigned a known numerical value; when these values are added together they produce a date.

theological colleges, as well as a mausoleum for himself. He died before his mausoleum was finished and he was buried under a tented awning on its site, the first sultan to die in Istanbul. The theological colleges were never built, and the completion of the minarets and mausoleum fell to his eldest son and successor, Murad III.[43] Selim's choice of Ayasofya for his burial was not surprising. He could hardly be buried elsewhere than in the imperial capital, nor in a mosque built by any of his predecessors, and Ayasofya was hallowed through its association with Mehmed II, the Conqueror. Selim's decision to carry out repairs to Ayasofya was neither entirely connected with his plans for his burial nor entirely fortuitous. In directing his attention to this former Christian basilica so soon after the Ottoman conquest of Cyprus he was reinforcing the Muslim ascendance demonstrated by his victory over the Christian powers, and countering any suggestion that Ottoman might had been diminished by defeat in the battle of Lepanto. By the time of Selim's death the Pyrrhic nature of this Christian victory was becoming apparent.

Sultan Selim also continued his parents' involvement with Mecca, and his work gave the Great mosque the distinctively Ottoman appearance it retains today. The enclosure lacked the space for a monumental mosque like those in Istanbul, so the galleries surrounding the courtyard were remodelled in the Ottoman style and given domes in place of their orig-inal flat roof. These works were continued during Murad III's reign, serving to impress pilgrims from all over the world with the power and munifi-cence of the new protectors of the Muslim Holy Places.[44]

Selim's death was unexpected and the transition to power of the new sultan was again handled by Sokullu Mehmed Pasha, who sent secretly to Manisa to inform Prince Murad of his father's death. The exigencies of ensuring dynastic continuity again imposed a delay before the new sultan could stake his claim to the throne; meanwhile, Selim's body was preserved on ice in the palace.[45] In another departure from custom, the funeral prayer was performed in the confines of Topkapı Palace, rather than in public in a mosque. In death as in life: the intimate and private ceremony reflected the growing distance between the sultan and his subjects. Moreover, the ritual prayer at Selim's funeral was said by the Sheikhulislam, indicating the more visible and formal role given to this official in Süleyman's reign and setting a precedent for the future.[46]

Selim's eldest son – by some twenty years – happened also to be the eldest surviving male member of the dynasty. Murad III was clearly destined to follow his father, yet to prevent any challenge to his right to succeed he took the precaution of ordering the execution of his young brothers on

his accession; they were buried alongside their father Selim.[47] Murad's Jewish 'Third Physician', Domenico Hierosolimitano, described his master's qualms over the impending murders:

> But Sultan Murat, who was so compassionate as to be unable to see blood shed, waited eighteen hours, in which he refused to sit on the Imperial throne or to make public his arrival in the City, seeking and discussing a way first to free his nine brothers of the blood who were in the Seraglio . . . In order that he should not break the law of the Ottoman state . . . weeping, he sent the mutes to strangle them, giving nine handkerchiefs with his own hands to the chief of the mutes.[48]

Murad's successor, Mehmed III, was his eldest son by some nine years and on his accession in 1595 he ordered the execution of his surviving brothers, of whom the eldest was more than twenty years younger than him. The many small sarcophagi of Murad's and Mehmed's brothers demonstrated that murder was the price of avoiding the civil strife which often attended the succession of a sultan; the public was profoundly shocked. One can be thankful that subsequent generations were less prolific and never again did so many young princes die to ensure that their brother would have a smooth passage to the throne.

The office of grand vezir had been held by Sokullu Mehmed Pasha throughout the eight years of Selim II's reign, and he continued in post under Murad III, until in 1579 he was assassinated by a disgruntled petitioner in the imperial council chamber. After his death the prestige of the grand vezirate declined: seven men occupied the post during the 21-year reign of Murad III, and as they fell in and out of favour the office changed hands among them eleven times. The grand vezir became subject to the sultan's whim, to be replaced whenever he proved unable to fulfil his master's demands. Neither Murad III nor his son Mehmed III cared to be personally involved in the running of the empire, but that was not to say that they no longer made decisions. Quite the contrary: the grand vezir's independent decision-making authority was curtailed, even in routine administrative matters. Direct contact between sultan and grand vezir became less usual, replaced by written correspondence in which the sultan indicated his decisions on a range of affairs of state – appointments, salary payments, bureaucratic administration – decisions based on summaries of the issue in question presented to him in the form of petitions.[49]

Even more than Selim II, Murad III and Mehmed III preferred to pass their days in their private quarters, rather than in the council chamber where state business was discussed, and in their own apartments they were more susceptible to the influence of favourites over whom the bureaucratic

procedures of government had little control. Subject though he was to the limitations imposed by palace functionaries and favourites, Sokullu Mehmed Pasha was able to rein in the worst excesses of the factions which flourished in this era of weak sultanic authority, reserving many influential offices for his own protégés and family members.[50] After his death, competition between those in the sultan's orbit became entrenched.

From the time of Süleyman, who publicly favoured his wife Hürrem Sultan to the exclusion of the concubines of his *harem*, the status of the senior women of the royal household was transformed. Continuing the trend started by Hürrem they became more visible, and more permanently so through their public building works. Some also gained a new and powerful role, that of *valide*, queen-mother, mother of the ruling sultan. Hürrem had died before her son Selim came to the throne, but Selim's concubine Nurbanu Sultan dominated the life of her own son Murad III after his accession and until her own death almost ten years later. Nurbanu was queen-mother in the fullest meaning of the term – she was the first to use the title officially.[51] Long thought to have been born to a noble Venetian family, captured when a child by the grand admiral Barbarossa and consigned to the imperial *harem*, it seems, rather, that she was a Greek from Corfu.[52] Hürrem had played only a modest part in diplomacy through her correspondence in Süleyman's name with the King of Poland and the sister of the Safavid Shah, but Nurbanu's influence on the international relations of the Ottoman state was more open. Foreign envoys knew how important it was to gain her favour; a visitor to Istanbul in the suite of the Venetian ambassador, Jacopo Soranzo, invited to witness the circumcision festivities of Prince Mehmed in 1582 remarked, 'the wife . . . with the queen-mother governed everything . . . one had to depend on them, or at least not have them against you'.[53]

With Murad III the royal household became still more of a 'royal family'. On his accession he moved his household to Istanbul from Manisa where as prince-governor he had lived with his consort Safiye Sultan and their children. In Istanbul, Nurbanu made her place again beside her son, moving into the *harem* at Topkapı Palace from the Old Palace – whither she had retired on Selim's death. As queen-mother, she saw to the smooth functioning of the *harem* and stood at the peak of its hierarchy. Her daily stipend was the highest in the empire, three times that of the Sultan himself. Nurbanu Sultan's transfer of residence from the Old to the New Palace was celebrated with a public procession through Istanbul.[54] Within ten years of Murad's accession the number of women in the *harem* of Topkapı Palace – concubines and servants – had doubled to more than a hundred. The *harem* quarters were rebuilt to provide more splendid apartments for the

Sultan's mother, and extra space for the growing number of women housed there. For himself Murad built a two-storey, domed bedroom–pavilion, the inner walls clad with the finest İznik tiles, and to this he added baths and a domed throne room next to his bedchamber.[55]

Whereas Selim, like Süleyman, had lived in a separate residence in the third court of the palace, only paying visits to the *harem*, Murad was immersed in domesticity – ample indication of the momentous changes occurring in the conduct of the sultan and the character of his empire. Murad was not a martial sultan, eager to lead his army on campaign, but a ruler who preferred to spend his life in the company of women. During his ten or so years in Manisa Murad had lived with Safiye Sultan as his only sexual partner in a nuclear family with their three children (of whom the future Mehmed III was the eldest). His sister Esmahan and his mother considered this monogamous relationship inadequate to ensure that there would be a candidate for the throne when the time came, however, and, probably in the early 1580s, they encouraged Murad to take concubines. He died leaving 49 children.[56]

The increase in the size and importance of the *harem* and in the authority and visibility of the queen-mother also served to enhance the position of the *harem*'s custodian, the most senior among the black African eunuchs who supervised the women living there.* Sultan Murad created (or if not created, certainly enhanced) the office of chief black eunuch soon after he came to the throne, and charged the incumbent with oversight of the endowments which supported the Muslim Holy Places, hitherto managed by the chief white eunuch of the palace who supervised the pages, the male counterpart to the *harem*.[57] The extensive endowments of former sultans Mehmed II, Bayezid II, Selim I and Süleyman I also soon came under the chief black eunuch's auspices, and he began to hold weekly audiences to deal with these matters. He controlled the flow of significant amounts of money – and enjoyed the power that went with it.[58] The grand vezir and other government ministers were also losers in the redistribution of power which resulted from the gains made by the *harem* and its senior officer. In his account of the reign of Murad III, the intellectual and bureaucrat Mustafa Ali of Gelibolu pointed out the deleterious effects of the practices which were developing, noting that because of their proximity to the Sultan the eunuchs and concubines of the *harem* were now in a position to influence appointments by exerting pressure on the political process; they even began selling appointments.[59] This would not have dismayed the

* Like the Mamluk sultans the Ottoman sultans employed eunuchs to guard their private household; apart from the sultan himself they (and mutes and dwarves) were the only adult males permitted to enter the *harem*. Little is known of their recruitment and training.

Sultan who was doubtless well pleased with the first fruits of his scheme to enhance the power of the palace; Mustafa Efendi of Selanik tells us that, soon after the assassination in 1579 of Sokullu Mehmed Pasha – until Murad III's reign, at least, the epitome of the all-powerful grand vezir – he even considered dispensing with the post altogether.[60]

Parallel to the world of the *harem* in which Murad III spent so much more time than his predecessors was that of his male favourites. Among these were men who had been with him since his years in Manisa: his tutor Hoca Sadeddin Efendi, his controller of finances Kara ('Black') Üveys Çelebi, and his spiritual adviser, the Halveti sheikh Şuca.[61] Hoca Sadeddin's father had been an intimate of Selim I while he himself had been an assistant to Süleyman and Selim's sheikhulislam, Ebüssuud; he is known today for the Ottoman history which he dedicated to Murad.[62] His son Esad Efendi became sheikhulislam in due course, maintaining the place of his dynasty at the heart of the state. Soon after Murad's accession Sokullu Mehmed set himself up in opposition to this inner circle by accusing Kara Üveys of financial irregularity. Sokullu Mehmed's scheme backfired, and his loss of prestige was plain to all: Kara Üveys was put in control of the financial administration of the empire with a seat in the governing council, while Sokullu Mehmed's appointees were purged and their possessions confiscated. Most pointedly, his cousin Sokullu Mustafa Pasha, the able governor of Buda, was executed and Kara Üveys appointed in his place. Reluctant though Kara Üveys was to accept this post so far from the seat of power, he had little choice.[63] He was later appointed governor of Egypt, and during his tenure a revolt broke out in response to the harsh financial controls he imposed on the army. The mutineers entered his council chamber and pillaged his private quarters; he was personally attacked, and members of his retinue were killed.[64]

Sheikh Şuca, an unlettered man, fostered Murad's interest in mysticism. The Sultan relied on the Sheikh to interpret his dreams and forecast his destiny. This was by no means unusual, for hand-in-hand with the official promotion of Sunni orthodoxy went an eager seeking for esoteric knowledge, and the Halveti had become the most 'orthodox' of dervish sects in the sense that they found wide acceptance among the Ottoman establishment. Sokullu Mehmed Pasha, indeed, had provided a lodge for his own Halveti spiritual adviser, attached to the mosque complex he built for his wife Esmahan in the Kadırga quarter of Istanbul.[65]

Following his accession in 1574 Murad III continued Selim II's aggressive policies in North Africa and the western Mediterranean. No immediate and radical shift in orientation was to be expected, indeed, while Sokullu

Mehmed remained in his post as grand vezir. Events moved fast in these years. Ottoman military support enabled the Sa'di ruler to be driven from power and in his place a disaffected member of the family was installed in Morocco as an Ottoman client. This victory gave the Ottomans control of the whole North African littoral, and brought them into contention with the Portuguese on the western frontiers of their empire as well as on the eastern. Even as a Spanish envoy arrived in Istanbul to seek peace with the Sultan, King Sebastian of Portugal sought help against the Ottomans from his cousin Philip of Spain; Philip equivocated, but finally provided both men and ships. In 1578 Portugal invaded Morocco; King Sebastian was killed at the battle of Alcazar and although the Ottoman client ruler was also killed, Ottoman assistance enabled his brother to succeed him. The long period of Ottoman–Habsburg warfare in the western Mediterranean came to an end in 1580 with a treaty which freed Spain to concentrate its attention northwards.[66]

Tripoli, Tunis and Algiers were by now all provinces under the nominal authority of Ottoman governors, but local leaders continued to put their own parochial interests first, and undermined any notions the Ottoman central government might have had of bringing the administration of these provinces in line with the bureaucratic norms elsewhere in the empire. The relationship of the Ottomans with these Magrebian provinces was a 'marriage of convenience' in which both parties had low expectations of the other: Istanbul anticipated little revenue from the Magreb but hoped for assistance against common enemies in the Mediterranean, while nominally Ottoman subjects in the Magreb by no means sought 'Ottomanization' or integration into the empire, and expected little in the way of central government investment and infrastructure.[67]

The Ottoman–Habsburg peace of 1580 indicated a certain equilibrium in the balance of sea power between the two empires. At the same time active Ottoman involvement against the Portuguese in the Indian Ocean was gradually waning; their attempts in 1585 and 1589 to break the Portuguese hold on the coasts of Mozambique represented the last gasp.[68]

The Ottomans were glad of the respite in the Mediterranean, for in 1578 they had become embroiled in a full-scale international crisis, war with Iran in the Caucasus. This war, which dominated Murad's reign, inaugurated a long period of belligerency between the two powers which continued until a lasting peace was finally agreed in 1639. There had been peace on this frontier since the Treaty of Amasya in 1555 but the death of Shah Tahmasp in 1576 was followed by factional infighting and a revival of Kızılbaş activity. Sokullu Mehmed Pasha had argued strongly against reopening hostilities with Iran. He was known to favour an

Ottoman presence in the Caucasus to check Muscovite expansion there but he was also alive to the logistical problems involved, and wary of the expense of campaigning in the region. Sokullu Mehmed had had enemies even before the new clique around Murad came to prominence, before the queen-mother Nurbanu Sultan and the *harem* attained their unprecedented power. His old rival Lala Mustafa Pasha revealed himself as ready to capitalize on the situation, and provided a figurehead around whom the courtiers who hated Sokullu Mehmed could coalesce. They calculated that if Lala Mustafa, the hero of Cyprus, were to be victorious in war again this would suggest that Sokullu Mehmed should be dismissed and Lala Mustafa elevated in his place. Following the decision to go to war against the Safavids Lala Mustafa was appointed commander jointly with another relentlessly ambitious rival from the days of the Yemen campaign, Koca Sinan Pasha. But their inability to work together soon led to Koca Sinan's dismissal, leaving Lala Mustafa in sole command and poised to reap the rewards for the success he anticipated.[69]

As the Caucasus was the theatre of war, the eastern Anatolian frontier city of Erzurum was the forward base for the Ottoman campaign against Iran. Having sailed to Trabzon and then marched south over the mountains, Lala Mustafa and his army mobilized at Erzurum during the summer of 1578. The Safavids and their client states in the Caucasus were in such disarray that the Ottomans were able to advance through Georgia, occupying Tiflis (capital of modern Georgia) as they went, to reach the principalities to the north. By the end of the summer, several of the princes of the region had submitted to the Ottomans, who now occupied parts of the Shirvan area on the western shore of the Caspian. Özdemiroğlu Osman Pasha – son of the former governor of the province of Habeş Özdemir Pasha – was given the unenviable task of governing this distant and vulnerable new province. With Tatar assistance he routed local and Safavid resistance but his supply lines to the Ottoman occupiers of Tiflis were cut, and he was obliged to withdraw for the winter from Shemakha, the main city of Shirvan province, to the Caspian coastal fortress-city of Derbent.[70]

Leaving his old enemy Koca Sinan Pasha behind in Istanbul proved fatal for Lala Mustafa Pasha. When Sokullu Mehmed Pasha was assassinated in 1579 the second vezir, Semiz ('Fleshy') Ahmed Pasha, husband of Mihrimah Sultan and Rüstem Pasha's daughter Hümaşah Sultan, took his place as grand vezir. Moved up the hierarchy to become third vezir, Koca Sinan was well-placed to arrange matters to his own advantage. Semiz Ahmed recalled Lala Mustafa from the front and appointed Koca Sinan commander in his stead. Lala Mustafa's protégés were accused (in some cases with justification) of corruption and dismissed from government service. He managed

to retain the post of second vezir, however, and when Semiz Ahmed died after only a few months in office, it seemed that the grand vezirate would at last be his.[71]

But Lala Mustafa did not after all achieve the promotion he so much desired: although he undertook the duties of the grand vezir, Koca Sinan was able to prevent his confirmation in office, and after a three-month hiatus it was Koca Sinan who was appointed grand vezir in August 1580. Lala Mustafa died soon thereafter. The deaths of Sokullu Mehmed Pasha, Lala Mustafa Pasha and Semiz Ahmed Pasha marked the closing of an era, for they were the last links with the reign of Süleyman. Koca Sinan was of a younger generation, the one that had risen to maturity and power under Sultan Selim II. He was more easily able to accommodate himself to government by faction, and indeed did so with acumen, becoming grand vezir a total of five times.[72]

Soon after Koca Sinan, who was still also commander-in-chief of the army, reached Erzurum in November 1580, the Safavids were suing for peace.[73] Assuming hostilities were at an end, Koca Sinan returned to Istanbul, when in fact continuing war in Georgia had prevented the conclusion of an Ottoman–Iranian peace; he was dismissed some months later and the second vezir, Siyavuş Pasha, appointed in his stead. The following years were spent securing Ottoman control in the Caucasus. In contrast to earlier campaigns against the Safavids on this frontier, this time the Ottomans attempted a permanent occupation of the region. Shirvan was only one of four new provinces created at this time.[74] The problems faced in the Caucasus were similar to those in Yemen, namely the volatility of local rulers and the inhospitability of climate and terrain. The expansion of the empire into these peripheral regions depended on the Ottomans establishing and holding fortresses, outside which they enjoyed little control. The fortress of Kars, today in north-eastern Turkey, was rebuilt as an advance base from which to supply the garrisons of the newly-conquered territory; Yerevan was also rebuilt and other smaller strongholds were secured.

Özdemiroğlu Osman Pasha remained in Derbent until reinforcements arrived from Rumeli by way of the Crimea in 1582, then marched over-land to drive the Safavids from the eastern Caucasus. The Tatar cavalry of the Crimea were essential to his ability to maintain what was a tenuous grip on the region, but in defiance of his obligations as the sultan's vassal Khan Mehmed Giray II now refused to provide sufficient troops to aid the Ottomans. Özdemiroğlu Osman therefore marched into the Crimea and, with the assistance of a fleet from Istanbul commanded by Kılıç Ali Pasha, installed a new khan. During the five years of his service on the Caucasian front Özdemiroğlu Osman was isolated from the intrigues at court; when

he returned to Istanbul he was given a hero's welcome and, to the anger of the clique around Murad who this time failed to influence the Sultan, was appointed grand vezir in the summer of 1584. He died a year later, having captured Tabriz in the course of a further campaign in the east – this time with significant Tatar help – and, for the first time ever, having held it for the Ottomans.[75]

Özdemiroğlu Osman Pasha's conquest of the former Safavid capital of Tabriz in 1585 inaugurated a new phase in the war with Iran. So great was Ottoman confidence that statesmen for a while looked favourably on a proposal from the Khan of the Özbeks, whose territory of Transoxiana lay to the north-east of Iran across the river Oxus, that his armies should push north to recapture Astrakhan from Muscovy.[76] Another front against Iran was opened in the south as the new governor of Baghdad, Cigalazade Sinan Pasha – a scion of the Genoese family of Cicala who had been captured at sea as a boy and converted to Islam – went on the offensive. He took part of south-west Iran for the Ottomans, and carved out two new provinces.[77]

The internal upheaval in Iran which followed Shah Tahmasp's death eventually ended in 1587 through the determined efforts of his grandson who came to the throne in that year. During his long reign Shah 'Abbas would go on to establish a reputation as the epitome of Safavid grandeur and greatness, but in 1588 and 1589 he was vulnerable: the Özbeks attacked Iran across the Oxus and captured the cities of Herat, Mashad and Nishapur. Shah 'Abbas sued the Ottomans for peace, the terms of which forced him to settle for the status quo. It was an expensive peace for the Safavids, as the Ottomans now held much of the Caucasus and Kurdistan – albeit at great cost. For the Ottomans, it was a more decisive result against the Safavids than they had achieved at any time since Selim I's victory at Çaldıran in 1514. The treaty established a border farther to the east and north than had been possible before, and it seemed that the century-old contest between the Safavid and Ottoman states had come to an end.

Meanwhile, Muscovy, having once established a foothold in the Caucasus, continued its expansion apace: this ever more confident state set out to colonize the region by insisting that the local chiefs – whether Christian, as the Georgians were, or Muslim – swear allegiance to the tsar; those who did not were threatened with the imminent arrival of an army. The urgency of the situation was expressed in dramatic language by the ruler of Dagestan to the Ottoman Sultan in 1589:

> . . . the cities you took from Persia . . . will not be able to defend themselves; and the Russians will unite with the Persian shah and the Georgian king, and then they will march on Istanbul from here and the French and Spanish kings

[will march in] from the other side and you, yourself, will not survive in Istanbul, and you will be captured and the Muslims will become Christians, and our faith will come to an end, if you do not intercede.[78]

This plea seems to have gone unheard but the spectre of encroachment into the Caucasus by the Muscovy of Ivan IV meant that the Ottomans could not ignore this region: like south-east Anatolia in the opening years of the century, it was one that attracted the strategic interest of a trio of outside powers.

With the confidence born of success on their eastern border, few Ottoman voices were raised against a renewal of conflict with the Habsburgs on the empire's European land frontier. Although peace had officially been made in 1568 – and the treaty renewed in 1574 and 1583 – localized hostilities and skirmishes along the extensive Croatian–Bosnian border had persisted. The Habsburg authorities had repeatedly protested about raids by local Ottoman forces, and reorganized their border defences to protect their people, but were anxious to maintain the peace and assiduously paid the annual tribute or gift – depending on the point of view – agreed in 1568, so as to give the Ottomans no pretext for launching a formal campaign. In the years since their last encounters both Habsburgs and Ottomans had come to realize that neither could hope for a decisive victory.[79]

In 1591 Hasan Pasha, governor of Bosnia, took a number of forts on the western, Croatian, section of the Ottoman–Habsburg frontier – on the face of it an independent action, but probably supported from Istanbul – and a new Ottoman fort was built on the Kulpa river at Petrinja. The Habsburgs, well aware of the neglected state of their border defences, saw this as a hostile act, but attempted by diplomatic means to avoid an escalation of the fighting. In 1593 Hasan Pasha crossed the Kulpa and besieged the fort of Sisak. Whoever held Sisak held the route along the Sava to Zagreb and into Austria; a hastily assembled relief force routed the Ottoman attackers, many of whom, including Hasan Pasha, were killed.[80]

Here was the excuse for a full-scale campaign Koca Sinan Pasha, once more grand vezir, had been seeking: in July 1593 he set off westwards at the head of the army. From the rapidity with which the Ottomans were able to react to the failure of the siege of Sisak it is clear that, just as the Ottoman navy had recovered quickly after the losses incurred at Lepanto, so the Ottoman military machinery had swiftly rebuilt itself after the recent Iranian wars. With a major offensive in central Europe in prospect, all other issues were set aside, including a naval campaign against Spain for which the Protestant powers had been lobbying, and which in 1590–1 was

already in preparation. To abandon this last in particular probably caused the Ottoman government few regrets, for their strategic goals in the western Mediterranean had been accomplished and their disengagement from that arena, symbolized by the 1580 truce with Spain, subsequently renewed. It was, in any case, clear both to the Venetian ambassador and to Koca Sinan himself that the Ottoman navy would have been unequal to another series of distant encounters at sea owing to the neglect of the fleet in recent years.[81] Unlike naval campaigns, Koca Sinan Pasha observed, land-based warfare could be far more immediate: 'One can launch a campaign on land by a mere command: everybody mounts his horse and sets off. A naval expedition is not like that ... however great the material investment and human effort, it can only be realized in seven to eight months'.[82] The war in central Europe thus begun in 1593 in such carefree haste lasted until 1606; neither side gained much from it, while the costs to both in financial terms and in damage to the fabric of the state were enormous.

By the end of the sixteenth century the character of warfare was changing in both east and west. In former times, particularly in Iran, the ability of the enemy to avoid a pitched battle by vanishing into the countryside had often thwarted Ottoman efforts to attain a decisive victory, but the recent campaigns on that front had demonstrated that a more static style of warfare was now becoming the norm, involving fortresses to be reduced by lengthy siege if territory was to be won. On the Habsburg–Ottoman border, after the truce of 1568, the Habsburgs and their partisans took refuge behind a line of strongholds intended to protect the hinterland from enemy incursions, and these had their counterparts on the Ottoman side of the frontier. In the central section of this front, on the Habsburg side stood Nagykanizsa, Győr (Raab), Komárom, Nové Zámky (Neuhäusel) and Eger; ranged against these, on the Ottoman side were Szigetvár, Székesfehérvár (Stuhlweissenberg), Buda and Esztergom, with a second line of fortresses in an arc from Belgrade to Timişoara.[83]

The gains and losses enjoyed and suffered by Ottomans, Habsburgs and Hungarians alike over the thirteen years of this war well illustrated its wearing and inconclusive nature. The first two years achieved nothing. Early in 1595 Sultan Murad III died and was smoothly succeeded by his twenty-nine-year-old son. Mehmed III inherited a state in disarray and it was clear that a new strategy was urgently needed to raise the prestige of both sultan and empire. At a meeting convened by Grand Vezir Koca Sinan Pasha it was agreed that, in a radical departure from recent practice, the new sultan, inexperienced as he was, must lead his army in battle[84] – something no sultan had done since Süleyman's final campaign in 1566. Koca

Sinan died in April 1596; in June the Ottoman imperial army set out to join the forces which had been holding the line on the frontier. Their aim was to capture the fortress of Eger which lay on the route between Austria and Transylvania which, together with Moldavia and Wallachia, had sought Habsburg protection. Eger fell and the Ottoman army with its Tatar reinforcements then encountered the Transylvanians and the main Habsburg army in the nearby plain of Mezőkeresztes on 25 October. From the closely-contested field battle which ensued, the only one of the war, the Ottomans emerged victorious – at first it seemed that they had lost, and only the fierce attack on the Habsburg forces as they plundered the Ottoman camp saved the day. The Sultan, not relishing his role as commander-in-chief, had suggested to his new grand vezir, Damad İbrahim Pasha, that he should return to Istanbul; he had to be chivvied to stand fast.[85] The English ambassador to the Ottoman court, Sir Edward Barton, was taken on the campaign by Mehmed to accompany the Habsburg ambassador to the Sultan and ensure that he and his suite were safely conveyed back to their own territory. Barton's secretary Thomas Glover described the scene following a skirmish in which the Ottoman forces came off worst:

> At which time I leave to the world, to consider what fright the Grand Signior was in, seeing all his Armie flie; yet incouraged by some about him of his chiefe Officers, caused his Banners Imperiall to march forwards upon the Christians; and he with his Bow and Arrowes shot thrice, and as some say, slue three Christians.[86]

The following years saw peace talks mooted as border fortresses continued to change hands. Wallachia again opted for Ottoman vassaldom. In 1600 the Ottomans broke through the Habsburg defensive line to the south with the conquest of the strategically important fortress of Nagykanizsa; Vienna feared another siege,[87] and the following year the Habsburgs tried and failed to retake Nagykanizsa. Pest was lost to the Ottomans and then retaken during the last desultory years of the war, and Transylvania again aligned with the Ottomans. The final year of fighting, 1605, saw Esztergom (captured by the Habsburgs in 1595) once more in Ottoman hands. By now all the protagonists were exhausted and eager for peace. The next year this was agreed – at the border village of Zsitvatorok rather than in Istanbul as was usual. This in itself denoted a concession by the Sultan, whose predecessors had customarily issued peace terms to their vanquished foes. Among a variety of provisions, each side was to retain the territory it then held – giving the Ottomans the meagre reward of only two new strongholds, Eger and Nagykanizsa – and Emperor Rudolf won the further advantage that he and his successors would henceforth be treated as equals by the sultan.

The 'tribute' paid by emperor to sultan would cease, after the payment of a one-off sum of 200,000 florins.[88]

The military response on the Habsburg side had been bedevilled by the Counter-Reformation, which had cost them the support of potential Protestant allies; while the Ottomans, after 1603, were campaigning on two fronts, as Shah 'Abbas of Iran attempted to regain the territory he had signed away in 1590. Within the empire, moreover, the multifarious domestic troubles which had been building up since the 1580s had come to a head: 1599 saw the first of a number of military campaigns directed against an alarming wave of rebellion in Anatolia and there was unrest in many other parts of the empire. That Sultan Mehmed III died in 1603 and was succeeded by his thirteen-year-old son Ahmed seemed of little consequence.

The last quarter of the sixteenth century was as difficult for European states as for the Ottomans. The warfare in which all were frequently engaged imposed budgetary strains from which each state sought its own relief, and the economies of Spain, France, England and Austria were all subject to severe disruption and over-extension; annual expenditures exceeded revenues, and innovative measures had to be sought to handle the crises. Inevitably these were accompanied by social and political upheaval – from which the Ottomans could not hope to be immune, although in their case it took a peculiarly Ottoman course.

The precise causes of the disruptions within the Ottoman Empire in the later sixteenth century are still poorly understood, and a clear hierarchy of causes and effects has yet to be distinguished. Until the sixteenth century, Ottoman economic and demographic expansion was underpinned by the revenues of newly-conquered provinces, but as conquest slowed, less coin was available to oil the wheels of this quite highly-monetarized economy. In the winter of 1585–6, in an attempt to raise more cash during the Iranian war, the Ottoman government debased the silver asper, the *akçe*, almost halving its silver content; in an economy where the amount of silver – or gold – mixed with alloy in a coin determined its value, this measure caused great financial instability.[89]

The Ottoman economy had always been open to external influences. Since early in the sixteenth century, specie – coin – from the mines of the Americas had been making its way eastwards in the course of commercial transactions, driving indigenous coins of low silver content from circulation. Following the debasement of 1585–6 those on fixed salaries paid in aspers – such as members of the bureaucracy or the military – suffered greatly, for their money now bought only half as many goods as before. Such a drastic inflation of prices exacerbated social discontent to the point

where the authorities found it impossible to force people to accept payment of their salaries in the debased coinage. Because taxes were paid largely in aspers, treasury revenues were also halved in real terms. The government tried to close the gap between state revenue and state expenditure by levying new taxes on the peasant population, and the system of tax-farming – whereby an individual or partnership paid the state in advance a sum equivalent to the tax revenue from a given source, then made the actual collection themselves (with an extra element of profit built in) – was extended. The treasury also borrowed from the personal fortunes of wealthy members of the establishment. This internal borrowing indicated a very different approach to financial management from that of the European powers – the Ottoman Empire did not raise foreign loans until the nineteenth century.* By contrast, had the Habsburgs not been supported by the financial resources of their Catholic allies, the war of 1593–1606 might have had a different outcome: the German princes within the Holy Roman Empire contributed more in 1594 to the war against the Ottomans than they had paid towards all Charles V's anti-Ottoman campaigns put together.[90]

By 1589 the adverse effects of the debasement of the asper produced a janissary revolt like that which had erupted in response to Mehmed II's manipulation of the currency during his first sultanate in the 1440s. The janissaries, who had the support of the Sheikhulislam, blamed the governor of Rumeli and the director of the treasury for paying their salaries in debased coin. Sultan Murad III sacrificed these officials to the mutineers – the first of many such episodes in which a terrified sultan found himself utterly at the mercy of competing factions close to him. (Neither Selim II nor Murad III seems to have shared Süleyman's sense of the portentous nature of the Islamic millennium; contemporary intellectuals, on the other hand, viewed this violent episode as emblematic of the breakdown of authority which would precede it.) Continuing financial instability in the last years of the century was blamed by the palace cavalry on Sultan Mehmed's mother Safiye Sultan's lady-in-waiting Esperanza Malchi, a woman who conducted the queen-mother's transactions with the outside world, and in 1600 she was murdered by some of their number.[91] Many leading statesmen of the seventeenth century became scapegoats for the continuing crisis at the heart of the state, and no sultan could afford to be at odds with the military. In a further complication, the two main corps

* Despite the Islamic prohibition on usury Ottoman lenders – at least in the Balkans and Anatolia – collected interest on loans; they employed various subterfuges to disguise it. In the later nineteenth century, when the empire was heavily indebted to the European Powers, European rules were applied, and the Ottoman government perforce abandoned all pretence of adhering to the canonical injunction.

of his elite troops, the janissary infantry and the palace cavalry, more often than not supported rival cliques. In 1582 a fight between these two groups had left several dead and brought a dramatic end to the lavish public celebrations for the circumcision of Mehmed III, then still Prince Mehmed, being held in the Hippodrome.[92]

The financial and social distress that accompanied the debasement of the coinage came at a time when the costs of warfare had reached unprecedented levels as methods of fighting changed. The provincial cavalry forces, supported by agricultural taxes paid in lieu of an obligation to appear on campaign, were less effective in an age of defensive, siege-based warfare, and as the borders of the empire expanded provincial cavalrymen lost their enthusiasm for campaigning: scarcely had they recovered from the exhausting Iranian war of 1578–90 when their services were required first on the Habsburg frontier, and then again on the Iranian. As Mustafa Efendi of Selanik wrote in 1597, they had not seen peace for twenty years.[93] Infantry – which in the Ottoman context meant primarily the musket-bearing janissaries – were more useful than cavalry in modern warfare, and their numbers grew accordingly, from almost 8,000 in 1527 to 13,500 by the time of Sultan Selim II's death in 1574 and to almost 40,000 by 1609.[94] Like other salaried state employees (whose numbers also grew inexorably) they had to be paid in cash – and on time if trouble was to be averted.

The government was in a dilemma. The rapid increase in the numbers of salaried troops could not continue indefinitely, and other sources of manpower were sought. A solution which appealed because it was cheap was to enlist men from the peasantry – the prime requirement now being Muslims who could wield a musket – to serve for the term of a campaign, after which they would be demobilized. This innovation openly flouted the fiction that peasants were disbarred from serving in the combat army, being employed only to perform various auxiliary tasks alongside the sultan's elite fighting troops and the provincial cavalry. It soon became clear, however, that even if they had not been troublemakers prior to enlistment, men already disaffected by over-taxation and their inability to make ends meet became a major disruptive element after demobilization. They retained their guns, and did not return to their previous occupation. The allegiance of these men could be bought by anyone who could pay them, be he bandit leader or fractious servant of the state. In an era of poor communications, local ties were usually stronger than loyalty to the government and its officers in far-away Istanbul, and the population's experience of the demands of central government for taxes and manpower hardly more favourable than that at the hands of the so-called rebels among whom they lived. It was primarily in Anatolia that troops were raised from the peasantry, and it

was Anatolia that suffered the most violent effects of the ensuing brigandage and outright rebellion. Having discovered provincial cavalry to be unsuited to the new style of warfare, and seeking as ever to raise money, the government ordered many of the cavalry not to present themselves on campaign but to pay a tax instead; they too became available to join in the unrest.

During its first centuries the Ottoman state had seen many challenges to its power – the resistance of the Anatolian principalities to Ottoman territorial control, the succession struggles of Ottoman princes, the rebellions of the Kızılbaş against Sunni orthodoxy, the outspoken stances taken by individual clerics or preachers, the king-making revolts of the elite army in Istanbul. The opening years of the second Islamic millennium were ones of deep crisis as uprisings against Ottoman rule were witnessed across the empire.

At the very time when the Ottoman army was engaged in fighting in both west and east, the Kurdish Canbulad clan, hereditary rulers in northern Syria, seized the opportunity to assert their independence. To declare his sovereignty Canbuladoğlu Ali Pasha, appointed Ottoman governor of Aleppo in 1606, had the Friday prayer read in his own name – and probably also minted his own coinage. Canbuladoğlu Ali had the support of anti-government rebels in Anatolia and was also encouraged by the Duke of Tuscany, Ferdinand I, who appreciated the commercial importance of Aleppo as an outlet for Iranian silk and other goods bound for European markets, and hoped to share in Canbuladoğlu Ali's good fortune. Grand Vezir Kuyucu ('Well-digger') Murad Pasha was sent against Canbuladoğlu Ali with a large army in 1607; ignoring his protestations that he was a loyal servant of the Sultan, Kuyucu Murad continued southwards to meet the rebellious governor in pitched battle. Canbuladoğlu Ali managed to escape with his life and was subsequently pardoned and appointed governor of the distant province of Temeşvar in Hungary. Kuyucu Murad Pasha was finally able to take his revenge in 1610, when he had Canbuladoğlu Ali executed in Belgrade.[95]

A one-time ally of Canbuladoğlu Ali, the Druze chief Fakhr al-Din Ma'n, controlled most of the territory covered by modern Lebanon and northern Israel and was similarly ambitious. In 1608 Fakhr al-Din concluded a treaty with the Duke of Tuscany, and in 1611 Kuyucu Murad's successor as grand vezir, Nasuh Pasha, mobilized an army to curb his growing strength. Fakhr al-Din fled to Tuscany in 1613 but returned five years later, by which time his brother Yunus had reached an accommodation with his Ottoman masters. Fakhr al-Din's continuing career of defiance of the government in Istanbul and expansion of the territories under his control ended only with his execution in 1635.[96]

The Ottoman central government also had to deal with many lesser revolts against its authority. Egypt was frequently the scene of mutiny: that of 1589 against the governor Kara Üveys Pasha was followed in 1598 by an attack on the governor at that time, Şerif Mehmed Pasha; in 1601 troops broke into Şerif Mehmed's council chamber and murdered several officials. In 1604 Hacı İbrahim Pasha was murdered – the first governor of Egypt to die in this way. It took the despatch from Istanbul of the third vezir, Hadım ('Eunuch') Mehmed Pasha, to bring an end to the military uprisings of these years, for which he earned himself the soubriquet 'Hammer of the Troops'.[97] In the European provinces, famine was the pretext for the murder of the governor of Buda in 1590,[98] while in North Africa, Tripoli and Tunis were in revolt: Tripoli was almost lost to the Ottomans before Egyptian troops were sent to restore order in 1592,[99] and the governor of Tunis was murdered by a mob around a man who proclaimed himself the Mahdi.[100]

But these events, although sufficiently alarming for the central authorities at a time when resources in money and manpower were stretched to the limit, were overshadowed by the rebellions which convulsed Anatolia during these years. They were known as the Celali rebellions, after Sheikh Celal who, as we have seen, had led a revolt in the early sixteenth century. Official documents contain vivid descriptions of a Celali raid:

> . . . several hundred horsemen and musketmen including [twenty-four names] like brigands came to the province, pillaged the goods of the poor, burnt their houses, killed more than 200 men, ran off with the young boys and virgin girls, and stole more than 50,000 sheep, goats, horses and good camels, and took stores of barley, wheat, oil, honey and other commodities: then they captured more than 300 men, torturing them day and night.[101]

Over the course of the sixteenth century the Safavid state had lost the millennarian fervour of Shah Isma'il's reign, to reach, under Shah 'Abbas, a modus vivendi with the Ottomans. As religious rivalry with the Safavids waned, those who were dissatisfied with life in the crisis-ridden Ottoman state rebelled against its authority in a different way, unencumbered by religious rhetoric. Although the term 'Celali' had originated in the context of a religiously-inspired protest movement, in the course of the sixteenth century it came to be used by Ottoman officials to describe a wide range of rebels against the state[102] – even those with no obvious religious motivation for their discontent. In the opinion of one modern historian, 'The characteristic tone of troublemakers before and during the Celali risings seems less an appeal to the higher values of society than a brash and cynical contempt for them',[103] and scholars today tend to see the Celali rebellions

of the turn of the sixteenth/seventeenth centuries as secular revolts of the disaffected from many walks of life – brigands, students of religion, provincial governors, demobilized soldiers, deserters, landless peasants. However, while it is true that, unlike many earlier Anatolian opposition movements, the Celali rebellions did not present their cause in religious terms, the fact that there were no similar uprisings in the Balkan provinces of the empire suggests, at the least, that they were more than simple armed rebellions with no link to the earlier history of religious and political opposition in Anatolia.

Problems arising from religion did not of course disappear: individuals were still charged with heresy – with having Kızılbaş sympathies, implying that the accused was Shia and owed allegiance to the shah rather than the sultan. A Kızılbaş purge was ordered before the outbreak of war with Iran in 1578 when the governor of the province of Baghdad – where there were many Safavid sympathizers – reported that there was 'no end to the heretics and misbelievers'.[104] The government in Istanbul feared fifth-column activities in this heavily Shia area. The only serious Kızılbaş uprising during the second half of the sixteenth century also occurred in 1578, when a man claiming to be Shah Isma'il appeared among the Turcomans of south-eastern Anatolia.[105]

Among the first of the 'new-style' rebels to attract the attention of the Ottoman authorities was one Karayazıcı ('Black Scribe') Abdülhalim, employed alternately in the state's salaried forces and in the retinue of a provincial sub-governor. Losing his job when his master was dismissed, he joined a militia band of which he soon became the leader and his name became linked with a series of upheavals which spread insecurity across Anatolia while most military men were campaigning in Hungary, and determined many people – both Christian and Muslim – to migrate to Istanbul. Karayazıcı issued orders as though he were the sultan and made appointments, including designating one of his followers his grand vezir, and organized his forces as though they were those of the central state. Like other leaders seeking to enhance their standing, he claimed that he was descended from the shahs and that the Prophet Muhammad, appearing to him in a dream, had bestowed upon him the right to rule. The governor of Karaman province, ordered in 1599 to put down Karayazıcı's rebellion, joined him instead. An army was then sent from Istanbul under the command of Sinanpaşazade Mehmed Pasha, son of the late grand vezir, the formidable Koca Sinan Pasha. The rebels took refuge in the city of Urfa (Edessa) in south-east Anatolia. After besieging Urfa for some two months, Sinanpaşazade Mehmed lifted the siege having cut a deal with Karayazıcı to deliver up his unfortunate ally the governor of Karaman, who was taken

back to a painful end in Istanbul. In spring 1600 Sinanpaşazade Mehmed pursued Karayazıcı across Anatolia to the city of Amasya; the rebel had, so it seems, been bought off with the governorship of the sub-province of the same name.[106]

Karayazıcı was soon moved to a new post at Çorum, and in 1601 an army under the command of Sokullu Mehmed Pasha's son Sokulluzade Hasan Pasha beat Karayazıcı's army in battle at Elbistan, south-east of Kayseri, inflicting a great blow on Celali morale. Karayazıcı died shortly afterwards and leadership of the rebels fell to his brother, Deli ('Crazy') Hasan. In spring 1602 a Celali army attacked towns in north-central Anatolia and besieged Sokulluzade Hasan in Tokat. From his base at Aleppo the Venetian consul in Syria, Vincenzo Dandolo, reported that Sokulluzade Hasan lost five million pieces of gold, his baggage train and his *harem* to the Celalis; he also lost his life. Deli Hasan and his men moved on to besiege Ankara and other towns: it was the eastern provinces that were worst affected by Celali depredations. Ottoman subjects of all classes supported them, however, as did the brother of the Khan of the Crimea, hoping for Celali backing to win the khanate for himself. In another desperate attempt to bribe their way to a solution, the government awarded Deli Hasan the rank of pasha and the post of governor of far-away Bosnia.[107]

The policy of co-opting rebels into the ruling class of the empire as provincial governors and military commanders was an imperfect way of neutralizing their energies, as a glance back at the history of the fourteenth century might have reminded the government. The Ottoman establishment seemed to have forgotten how Cüneyd, the dispossessed prince of Aydın, awarded the governorship of Nikopol on the Danube, had then taken an active and disruptive part in the civil war among the sons of Bayezid I. Deli Hasan proved no more loyal a servant despite government hopes: after a couple of seasons spent campaigning against the Habsburgs he was suspected of treasonous dealings with them and executed.[108] The historian İbrahim of Peç (Pécs), who was on the Hungarian front at the time, had nothing but criticism for the conduct of Deli Hasan's troops on campaign, in particular their insubordination: ordered to help with the building of earthworks in the course of an engagement during the last years of the Hungarian wars, they retorted, 'We have fought for years in Anatolia and nowhere did we dig ditches or construct palisades,* and we do not intend to do so now'.[109]

The removal of Deli Hasan from Anatolia changed nothing. The Ottoman

* A screen of close-set pointed sticks lashed together, set up as a defensive shield or enclosure.

government was unable to deal with the Celali rebels because sufficient forces could not be spared to put down the unrest decisively: to wage war against powerful foreign adversaries on two distant fronts took all the strategic inventiveness the state could command. The prevailing insecurity disrupted trade routes, while the passage of armies destroyed agricultural land so that tax-payers could no longer pay the dues on which the provincial caval-rymen depended to equip themselves and their retinue for participation in military campaigns. The Celali depredations in Anatolia caused so many thousands to leave the land that this exodus came to be known as 'the Great Flight'. The rich went to Istanbul, the less well-off to the relative security of the walled towns of Anatolia. Villages and agricultural lands were deserted, as drought affected much of Anatolia from 1603 and winters were unusually hard. Prices soared.[110]

Hostile military activity against the Ottoman state came from yet other quarters. The Cossacks of the northern Black Sea steppe could tie up the regular army for months at a time and, as with the Celalis, their preda-tions – at first localized – took on ever more alarming dimensions. The Cossacks first appear in the historical record in the fourteenth century, as roaming bandits or adventurers inhabiting the 'vacuum' of the steppe, where central government authority was weak, and they could pursue a way of life at odds with that of the settled population – fishing and hunting, raiding the merchants plying their trade between the Black Sea and the cities to the north, and alternately fighting or banding together for joint exploits on the steppe with the Tatars of the Crimea against Poland-Lithuania and Muscovy.

With the appearance of the Ottomans on the northern Black Sea coast in the later fifteenth century, and the ensuing symbiosis between this leviathan and the Crimean Tatars, the politics of the steppe were trans-formed and the Polish and Ukrainian nobles of the borderlands ('ukraina' means 'borderland') – who themselves barely acknowledged central govern-ment – recruited Cossack warriors to defend their estates against Tatar raids. Soon after 1538, when Sultan Süleyman led a successful campaign against his insubordinate vassal Moldavia, he designated the northern Black Sea littoral from the Dniester to the Boh a new province. Subsequent Cossack attacks on strongholds, and on herdsmen and travellers, caused the Ottomans mounting concern, as thousands of captives as well as livestock, arms and all sorts of chattels were seized, in a region where the sultan's writ was intended to bring security.[111]

In the 1550s and early 1560s the Ukrainian prince Dmytro Vyshnevetsky led the Cossacks. He organized them against the Tatars and oversaw the construction of a fortress on one of the islands below the Dnieper rapids

– some 375 kilometres upstream from the river mouth – which became their headquarters in the region. The creation of this administrative centre was the first step in the formation of a Cossack corporate identity. Vyshnevetsky offered his services to Muscovy and attacked both Moldavia and the new Ottoman province; in 1556 he attacked Cankerman – the fortress capital of the province – but left after causing much destruction to the town and its environs, and in 1563 he was captured and executed in Istanbul. These raids were considered by the Ottomans to breach the official state of peace between Poland-Lithuania and the Sultan: even before the creation of the Polish-Lithuanian Commonwealth in 1569, when the relations of the Polish king with the Cossacks as a defence force began to be regularized, complaints about Cossack incursions into zones the Ottomans considered within their sphere of influence were addressed by the Sultan to the Cossacks' nominal overlord, the Polish king.

The Cossacks gradually widened the scope of their ravages, no longer confining their attacks to the steppe. The near absolute security of the Ottoman mare nostrum that was the Black Sea, and of its shores, was rudely disrupted from the last quarter of the sixteenth century as the Cossacks of the Dnieper region set sail in their highly manoeuvrable longboats to attack settlements on the Rumelian coast, and reached the mouth of the Bosporus. In 1614 they appeared on the north Anatolian coast, raiding the port of Sinop and causing, by all accounts, a great deal of destruction. In the words of the contemporary intellectual Katib Çelebi:

> With the guidance of renegades who fled from the land of Islam, [the Cossacks] came to the fortress of Sinop on the Anatolian shore and entered that old castle by surprise and caused much damage . . . they took [with them] the goods and families that they had plundered and set out to sea.[112]

There was little the Ottomans could do against such a stealthy and swift foe.

Sultan Ahmed I came to the throne on the death of his father Mehmed III in 1603. Two years later he was persuaded by Nasuh Pasha, in charge of government efforts to suppress the Celali revolts, that only the Sultan's presence at the head of the imperial army would convince the rebels to give up their struggle – his father had, after all, been on the battlefield at Mezőkeresztes in Hungary in 1596, when the Ottomans had triumphed. But Ahmed's campaigning days ended almost as soon as they began. When he reached Bursa in November 1605 he became ill from drinking the water coming down off Uludağ mountain; as the English ambassador of the time, Henry Lello, expressed it,

... the Emperor him self coming into that ayre wch he ws not accostomed
unto and dringing of that water wch cam from the snowy hills hurte his stom-
ache that he becam sicke wthall and wished h. self at home againe for there
was noe meanes to go forwards.[113]

A Venetian report also remarked on the young Sultan's sensitivity:

Ahmed was happier in his garden than in Anatolia where wolves prowled,
where people ate grass and stinking corpses of fallen horses and camels in their
hunger, and asked for alms from those riding by.[114]

The Sultan's uncomfortable experiences inclining him to favour concilia-
tion rather than confrontation, he allowed some of the most prominent
Celali leaders and their followers, who were camped near Bursa at this
time, to enter the ranks of the Ottoman army.[115] However, once the war
in Hungary ended the following year the Ottoman government could at
last turn its attention away from the western frontiers of the empire and
concentrate all its vigour on the problems in the east – the Anatolian rebel-
lions, and the continuing war in Iran.

After Another prominent Celali leader was a man named Kalenderoğlu
Mehmed, whose first significant rebellion was in western Anatolia in 1605.
In 1607, when Grand Vezir Kuyucu Murad Pasha marched across Anatolia
to suppress Canbuladoğlu Ali Pasha's rebellion in Syria, he offered
Kalenderoğlu the governorship of the sub-province of Ankara. Kalenderoğlu
accepted, but the gates of the city of Ankara were barred against him.
Frustrated by an unsuccessful two-week siege, he headed westwards again
to attack Bursa: all but the inner fortress fell to the rebels. News of Kuyucu
Murad's victory over Canbuladoğlu Ali failed to calm the panic in Istanbul
as the people of the city anticipated the imminent arrival of Kalenderoğlu.[116]
Grigor of Kemah, an Armenian priest who followed events closely, wrote
of the fear that Istanbul might be set alight by Celalis who managed to
enter the city undetected. The Sultan ordered that all suspicious-looking
individuals be apprehended, and arrested if no one was willing to vouch
for them.[117] Manpower to resist the Celalis was sought wherever it could
be found – including, as the French ambassador of the time, M. Salignac,
reported, among the citizens of Istanbul: but they, he opined, would 'die
of fright before they fight'.[118]

After spending some time in the area to the west of Bursa, Kalenderoğlu
and his men moved south to west-central Anatolia and, in summer 1608,
turned east to resume their brigandage. Kuyucu Murad Pasha, on his
journey home from Aleppo after his defeat of Canbuladoğlu Ali, hoped to
catch the rebels in central Anatolia, between his own army returning from

the south-east and an army marching from Istanbul to meet him, as renewed efforts to bribe the Celali leaders with promises of state appointments fell on deaf ears. Despite the inherent logistical problems, Kuyucu Murad's skill and experience as a military commander and his ability to hold the loyalty of his army finally enabled him to defeat Kalenderoğlu's forces in battle at a pass deep in the Taurus mountains, north-east of Adana, on 5 August 1608.[119]

Kalenderoğlu's troops fled north-east with government forces in pursuit. Near Şebinkarahisar, north-east of Sivas, it seemed that the rebels might be annihilated but they escaped to confront their pursuers again east of Bayburt, where another battle ensued. The remnants of Kalenderoğlu's Celali army, numbering some 10,000 'musketeers and fully-armed cavalry', plus their servants and grooms, reached safety in Iranian territory in late autumn 1608. Any anxiety initially felt by their hosts at accepting these unruly fighters proved to be unfounded. Eskandar Monshi, one of the chief secretaries of the Safavid court, was a witness of their reception by the Shah's envoy and of the arrival of five hundred of their number at the Safavid capital of Isfahan. By his account they were met with feasts and celebrations wherever they went,[120] the implication being that this was a humiliation for the Ottoman Sultan.

Iran and the Ottomans were still at war, but in spring 1609 peace was mooted – although the presence of Kalenderoğlu and the other Celalis in Iran bedevilled the relationship between Sultan and Shah. Determined to eradicate any remaining rebels from Anatolia, in the campaigning season of 1609 Kuyucu Murad Pasha sent his commanders against them rather than launching a full-scale attack on Iran, and the last Celali leaders still in Anatolia were killed, with their followers. Kalenderoğlu died in May 1610 and those of his men who had followed him to Iran returned to Anatolia under the protection of Nasuh Pasha, now governor of Diyarbakır, who forged those experienced fighters into an elite brigade of musketmen.[121]

Kuyucu Murad Pasha thus achieved a victory that had eluded the Ottomans for years, and received a hero's welcome on his return to Istanbul. The many refugees who had fled the countryside for the safety of the capital, and those who had continued on into Thrace, were given three months to return to their homes. To reassure his Christian subjects, the Sultan gave orders for the repair of the churches and monasteries destroyed by the Celalis, and taxes were to be waived for three years. Grigor of Kemah, one of those affected by this order, described the perilous return journey of the displaced to their homes in north-central Anatolia, where they faced an uncertain future:

... we set out on the road like a flock of sheep without a shepherd ... we were more than 7,000 people – Armenians and Turks – and there was not enough food or animal fodder to be found along the way ... we reached Tosya without mishap but were here obliged to camp out of fear at the signs of Celali activity. [A Celali chief] with many soldiers was camped in the Hacı-Hamza plain and all the city and castle gates were closed. Later we moved off all at once, women, children and the less able men walking by an upper road and the rest of us, equipped with bows and arrows, following the main road. The Celalis were afraid when they saw how many we were and hid in their tents; some stood at their tent-door and greeted us. Thus we continued on our way without mishap to Merzifon and on to Niksar.[122]

The renewal of war with Iran in 1603 was devastating for a state whose resources were stretched to the limit; in particular, the Ottomans had no manpower available to defend territory recently won in the east. Shah 'Abbas was able to take advantage of the Ottomans' over-extension because since 1590 he had transformed his army by recruiting an elite corps of men answerable only to himself, in effect a military slave caste analogous to Ottoman practice. His aim was to reduce his dependence on the fickle loyalties of the tribal levies who had underpinned the Safavid rise a century before, and had also been responsible for much of the disorder that had attended his own succession.[123] Like Shah Isma'il before him, during the years of peace 'Abbas had also engaged in energetic but abortive efforts to gain diplomatic and financial support from the West.[124] A number of border incidents provoked the resumption of hostilities, and in September 1603, in twelve days, Shah 'Abbas marched from Isfahan to Tabriz at the head of his army. He found the city empty of its Ottoman garrison. Tabriz retaken, the Safavid armies then won back Nakhichivan, and took Yerevan after a six-month siege.

Sorely-pressed though they were on their western frontier at this time, it was clear to the government in Istanbul that they could not afford to leave the task of confronting Shah 'Abbas solely to the military forces of their eastern provinces, and in 1604 the vezir Cigalazade Sinan Pasha was appointed to head an army sent from Istanbul. He found the frontier zone depopulated and devoid of provisions, the result of the same scorched-earth tactics which had hindered Ottoman progress in the past. Reverting to the ways of his forebears, the Shah kept just ahead of his pursuers. Cigalazade Sinan and his forces, wintering in Diyarbakır and Van, came under Safavid attack and were forced to retreat to Erzurum. In May 1605 the two armies met near Tabriz. Uncharacteristically, the Ottoman army deserted the field, leaving behind most of its equipment and provisions.[125]

As the Ottomans concentrated on their domestic problems in Anatolia

during the following years, the Safavids chased the Ottoman garrisons from their remaining strongholds in the Caucasus and Azerbaijan. The fighting was over without the Ottomans having been able to put up any defence. The grand vezir Kuyucu Murad Pasha set out against Shah 'Abbas in 1610 but failed to engage him in battle and died in Diyarbakır in August 1611. A truce was agreed in the following year by the terms of which the Ottoman–Safavid frontier would revert to that agreed at Amasya in 1555 – the Ottomans were to lose all their gains from the wars of 1578–90.[126]

Before the treaty could be ratified, however, two Georgian princes sought Ottoman protection, prompting a strike by Shah 'Abbas which the Ottomans interpreted as a breach of the truce. The Shah, furthermore, had detained the Ottoman envoy at his court.[127] Nasuh Pasha, who had favoured peace with Iran, was executed in 1614 and replaced as grand vezir by a more aggressive man, Öküz ('Ox') Mehmed Pasha, who was betrothed to Sultan Ahmed's daughter. His appointment presaged a change of policy, and in August 1616 he arrived before the fortress of Yerevan at the head of a large army. His siege failed, however, and he in turn was replaced. After continuing skirmishes the Ottoman forces fell into an ambush near Tabriz on 10 September 1618 and lost, according to an informant of Eskandar Monshi, Shah 'Abbas's secretary, fifteen thousand fighters.[128] The war was over – at least for the time being – and the peace which Nasuh Pasha had worked years earlier to achieve at last became a reality.

These years – and the ones that succeeded them – were truly a 'time of troubles' for the Ottoman Empire. The work of contemporary men of letters reflected their anxiety about the manifestations of crisis they observed, which seemed to defy resolution, and predicted the imminent collapse of all that had been built during the previous three centuries. Mustafa Ali of Gelibolu was one of those who expounded his analysis of the changes which had taken place in the Ottoman polity by the turn of the millennium. Naming the four main Islamic states then in existence – the regional empires of the Ottomans, the Safavids, the Mughals and the Özbeks, all of which had been forged since the Mongol invasions of the thirteenth century and had Turkish and steppe-nomadic roots – he noted that unlike the Mughals who claimed descent from the Timurids and the Özbeks who claimed descent from Genghis Khan, the Ottomans lacked a claim to legitimacy based on descent; nor did they have a religious ideology that could be traced back to the Prophet, as the Safavids did. Indeed, he observed, their earlier claims to legitimacy based on ideologies of their descent from the Oğuz clan of Central Asia, or as inheritors of the Seljuks, or as the only true warriors for Islam, were irrelevant. What had given the Ottomans

their unquestioned legitimacy, he suggested, was first and foremost the more tangible attribute of a dynastic order committed to universal justice dispensed by a strong central authority; this, however, had been vitiated since the time of Selim II, or even earlier, when Süleyman allowed his favourites a hand in the affairs of state.[129]

As well as producing pessimistic analysis the Islamic millennium engendered a yearning for the well-ordered world which Ottoman intellectuals imagined had existed in the past: Sultan Süleyman's attempt to create the illusion of a just polity became a victim of its own success. Territorial victories were now less easy to win and the sultan had retired from active involvement in the business of government: the vicious struggle for a share in the rewards accruing to those in power must have been profoundly shocking to men raised under the old order. The Ottoman Empire was not alone, however – government by favourites became matter for criticism in Spain and France after the death of Philip II in 1598 and of Henry IV in 1610. A true king, as the author of a contemporary treatise wrote reprovingly of Philip II's son, Philip III, 'should not be content with simply having supreme power ... and then merely sleeping and relaxing; but should be the first in government, in council, and in all the offices of state'.[130]

The image of the warrior-sultan at the helm of an ever-expanding empire was becoming harder to sustain. Mehmed III was the last sultan who as a prince had governed a province as preparation for the sultanate. The theatres of war in which the Ottomans now found themselves involved were so far from Istanbul that a sultan leading his army in person might be gone for months, if not years. As long sieges came to predominate over swift field battles as the typical form of imperial military engagement, moreover, victory became even less predictable: the blow to the prestige of the dynasty in the case of a failure was more easily deflected if blame could be laid at the door of an expendable officer of state, rather than the sultan. At the same time, some grand vezirs were equally keen to avoid the invidious position of being held to account for military defeat, and equally fearful of losing office while on campaign. In consequence, the task of commanding the imperial army in battle gradually devolved on lesser vezirs, or on military commanders appointed for the term of a particular campaign.[131] Initially, contemporaries who saw the sultan first and foremost as a warrior viewed this break with earlier practice as a dangerous innovation, but by the early seventeenth century perceptions of the sultan's role had shifted to accommodate the new reality, and it was regarded as prudent for him to remain in the capital.[132]

Not all commentators moved with the times, however, and some who

saw only the undesirable consequences of the sultan's changed role expressed the opinion that he had become a marginal figure.[133] Advice manuals written by Ottoman men of letters – called 'mirrors for princes' – had a long tradition stretching back to the late fourteenth century. Like the woes they catalogued, the blessings they looked for hardly varied: a strong, just ruler; a balance between the sultan's salaried standing army of cavalry and infantry and the provincial cavalry; peace and security for the producing class so that they could afford to pay the taxes on which the smooth functioning of the state depended; and adherence to the structure of society laid out in the sultanic law as elaborated during the sixteenth century.[134] Recent events had revealed all too clearly the extent to which these ideal norms had been violated – if they had ever been even approximated. The sultan was no longer seen to be in control of state affairs; the manpower demands of the turn-of-the-century wars had necessitated the recruitment of men of the producing classes – indeed, of any who 'had a horse and could equip themselves'[135] – and these had infiltrated the sultan's elite forces, once staffed almost entirely by means of the youth-levy; and the need to pay the militia who functioned as the musketmen that were the backbone of the modern army imposed budgetary demands that severely strained the state's coffers. The various 'mirrors for princes' dwelt at length on the need to prevent the entry of 'unauthorized' outsiders into the tax-exempt class, and spelt out who should be regarded as ineligible for the sultan's service: Muslim Turks, nomads, Armenians, Jews, Kurds, Gypsies, and the ethnic groups of the Black Sea.[136] The compilers of these tracts could not accept that the gap between their ideal but imaginary state and the new reality was unbridgeable, that the traditional system of clearly stratified 'estates' they lamented was over – if it had indeed ever existed.

An event concerning the construction of an observatory in Istanbul illustrates the flimsiness of an individual's grip on power at this time. Sokullu Mehmed Pasha was the enterprising and persuasive grand vezir during whose tenure such projects as the Don–Volga and Red Sea canals were proposed; in 1574 he convinced Murad III, the newly-enthroned sultan, to order the construction of an astronomical observatory in Galata, across the Golden Horn from Istanbul. In furthering the scientific study of the cosmos – astronomy – it would also improve the accuracy of the astrology used to predict auspicious moments for various undertakings by the Sultan. But Sokullu Mehmed was assassinated in October 1579, and in January 1580 the observatory was razed after the sheikhulislam of the time, Ebüssuud Efendi's son Ahmed Şemseddin Efendi, advised Murad that observation of the stars brought bad luck, as evidenced by the ills that had befallen the Ottoman state during the past few years.[137]

As the fate of the Istanbul observatory also helps to show, the sheikhulislam was one of the state office-holders whose prestige was enhanced as that of the grand vezir diminished. As the religious hierarchy lost its former distance from secular affairs, he and his advisers became the representatives of the interests of the clergy in the political arena. They did not shrink from fighting out their struggles for patronage in public, to the distress of such traditionalists as Mustafa Ali of Gelibolu, who bemoaned the days when, as he saw it, the religious hierarchy was above politics and possessed the moral authority of the disinterested.[138] During the reign of Ahmed I the juridical opinions of the sheikhulislam became a source of law, particularly where land was concerned, and he came to be relied on for decisions which had earlier been the responsibility of the chancellor.[139] Contemporary sources show that between 1550 and 1650 almost half of those holding the three highest posts in the religious hierarchy came from eleven families: indeed the power of the family of Mehmed III's former tutor, later sheikhulislam, Sadeddin Efendi – who had been by the timorous Sultan's side at Mezőkeresztes in 1596 – was second only to that of the Ottoman dynasty itself.[140]

As the new millennium and the new century unfolded, there were hints that the state religion of the Ottomans was taking a puritanical, even dogmatic, turn. The episode of the observatory was one sign of this tendency towards inflexibility. There were others: laws restricting the apparel of Christians and Jews were issued, and the drinking of alcohol banned – albeit briefly.[141] Yet although it became increasingly intolerant of latitudinarianism in the practice of Islam, and was prepared to pursue those who went beyond the bounds of acceptability in their expression of the Muslim faith, the Ottoman Empire remained remarkable for its toleration of non-Muslim minorities whose separate – and unequal – status was guaranteed by law in exchange for payment of a poll-tax. Jews were prominent in commerce, and many were successful tax-farmers. During much of the sixteenth century they were close to the Ottoman dynasty, employed as physicians to the sultans and as diplomats; the Jewish banker Joseph Nasi advised both Süleyman and Selim II. Following the financial crisis of the 1580s, however, and the social and economic upheaval which ensued, the position of such prominent Jews altered. Envy of the wealth they had accumulated, for example, resulted in the levying of extraordinary taxes upon them, in contravention of the exemptions they had hitherto enjoyed. Mehmed III's mother Safiye Sultan's lady-in-waiting Esperanza Malchi, murdered by members of the palace cavalry in 1600, was Jewish, which might have exacerbated their fury at what they saw as her part in the currency manipulation of the mid-1580s; they also accused her of meddling

in the tax-collection process. Mehmed's immediate reaction was to appease the palace cavalry by imposing further restrictions on the customary rights of the Jews, but he lifted these two years later.[142]

Murad III continued the practice of relying on a Jewish confidant, in his case the Ragusan merchant David Passi, who had been Joseph Nasi's interpreter. Passi was at court from the mid-1580s; his advice was sought on financial matters, and also on domestic and foreign policy. It was this last which brought about his downfall, for he made an enemy of Koca Sinan Pasha, five times grand vezir, who had different ideas about who were the enemies of the Ottoman state. Koca Sinan launched a violent campaign of defamation against Passi; he not only wrote to the Sultan about Passi's supposed crimes but fulminated against all Jews and declared them unsuitable to hold positions of influence in an Islamic state; he blamed the economic problems of the time on Passi, and sought to have him executed. In 1591 Murad ordered that Passi be deported to Rhodes, which became a recognized place of exile for those who narrowly escaped execution.[143]

At the turn of the century, one of the most populous Jewish communities in the city of Istanbul was dispersed to make way for the mosque complex of the queen-mother Safiye Sultan. Situated between the port facilities on the Golden Horn and the bazaar on the hill above, this was the commercial hub of the city, where Rüstem Pasha had built his mosque and shops. A synagogue and many Jewish houses were compulsorily purchased to provide a site for Safiye's complex; it was a controversial proceeding, and the project was criticized for its expense.[144] The first stone was laid on 20 August 1598,[145] and had the work continued, it would have been the first mosque built by a queen-mother within the walls of Istanbul. The building works lapsed, however, because Mehmed III died in 1603, followed by Safiye in 1605.*

The Greek Orthodox subjects of the empire also came under pressure during these years. In 1587 they lost the Church of the Pammakaristos in Istanbul, which had housed the Patriarchate since soon after the Ottoman conquest of the city. In celebration of Ottoman successes against Iran in the Caucasus the church became the 'Mosque of Victory' (Fethiye Camii) and the seat of the Patriarchate moved to the Church of St George in the Fener district on the Golden Horn (where it still is today).[146] Provincial governors who sought to follow this example by converting churches into mosques were forbidden to do so,[147] but Koca Sinan Pasha, who founded many institutions for the benefit of the Muslim community, such as mosques,

* As we will see, the mosque was eventually completed as the Yeni ('New') or Valide ('Queen-mother') mosque in 1665, and still dominates the square at Eminönü.

bridges, fountains and bath-houses, in 1590–91, year 999 of the Islamic calendar, provided the goods and money necessary to establish a charitable foundation and make the alterations needed to transform the Church of St George Rotunda in Thessalonica into a mosque. The mosaics in the former church had not yet been covered up in 1591, when they were seen by the Venetian envoy Lorenzo Bernardo as he passed through the city.[148]

Up until the reign of Murad III, the sultan's library still contained over one hundred Greek manuscripts, and Greek manuscripts could easily be bought in Istanbul by visitors such as Ferdinand I's ambassador Baron Ogier Ghislain de Busbecq, who was in the city in the middle of the sixteenth century. John Malaxos, a Greek scholar who moved to Istanbul following the conquest of his native Nafplio by the Ottomans in 1540, catalogued eight private libraries during the reign of Selim II and found some 555 Greek manuscripts; their subsequent fate is unknown, but it is clear that the last years of the sixteenth century saw the end of Ottoman interest in their Byzantine heritage.[149]

Ahmed I undertook extensive repairs to Ayasofya, where mosaics of several Biblical figures had remained visible from the central prayer space since the Conquest. Many of these he now had covered over, choosing which to conceal according to Koranic principles. The Pantocrator in the dome, the image of Christ as God, was quite unacceptable from an Islamic perspective, but Mary is a revered figure in Islamic teaching, so the Virgin and Child in the apse were left untouched.[150] The message conveyed by this iconoclastic impulse was of a sultan seeking to find a new role appropriate to the times.

Neither Selim II, Murad III nor Mehmed III built an imperial mosque in Istanbul. Selim built in Edirne, Murad in Manisa where he had been prince-governor; Mehmed did not build a mosque at all. All three were buried, each in his own mausoleum, in the garden around Ayasofya. Sultan Ahmed I may have failed to emulate the military command of his father, however hesitant, but he followed the precedent of his illustrious warrior ancestors, constructing a monumental mosque complex in Istanbul; he was the last sultan to do so until the mid-eighteenth century. Work began in 1609, and there were those who opposed it, pointing out that it was inappropriate because imperial mosques should be built only with the proceeds of conquest.[151] This was an objection that had been raised in the past, in relation to other mosque complexes; Mustafa Ali of Gelibolu regarded such extravagance as contrary to divine law.[152] In a time of severe financial straits when foreign and domestic wars were draining the imperial exchequer, it was a project that could hardly fail to excite opposition.

The date when work began on Sultan Ahmed's mosque was not without

significance. The Ottomans were smarting from the loss of face implicit in the terms of the peace treaty made with the Habsburgs in 1606, and the loss of territory to the Safavids in the ongoing war, but the grand vezir, Kuyucu Murad Pasha, had just accomplished the suppression of the Celali rebels. It was not a conquest of the sort traditionalists recognized, but it was the only Ottoman military success of recent times, and Sultan Ahmed's mosque was its celebration. The extensive complex, commonly known today as the Blue Mosque from the predominating colour of the tiles cladding its interior, was finished in 1617, the year of Sultan Ahmed's death. It stood on a prominent site on the south side of the Hippodrome; to make way for it the palace of Sokullu Mehmed Pasha – built over the remains of the Byzantine imperial palace, opposite that of Süleyman's one-time favourite İbrahim Pasha – was demolished.

Ahmed's choice of a prominent site on which to build his monumental mosque was not the only way in which he sought to emulate Sultan Süleyman: Ottoman and foreign contemporaries alike remarked on his obsession with his great-great-grandfather. Like Süleyman, he promulgated a law-code of his own; he constructed a garden at Dolmabahçe where Süleyman had once had a garden; he ordered new editions of literary works commissioned by Süleyman; and he rode through Istanbul in procession on a richly bejewelled and caparisoned horse as his ancestor had done before him.[153] The young Sultan's mimicry of his illustrious forebear could not change the reality of the times, however, and new themes were also addressed, and new styles adopted, in the representation of the royal personage in both literary and artistic productions of the period. The eulo-gistic forms of the mid-sixteenth century which glorified a sultan's military successes gave way to narratives portraying the life of a sedentary ruler, through a wide range of events at court and across the empire. Writers now based their narratives on 'sources', both the eye-witness experience of themselves or others and the actual documents put out by a burgeoning bureaucracy. Their histories focused on the state as a whole rather than on the dynasty in and of itself, chronicling the day-to-day governance of the empire and emphasizing appointments and political affairs. By the time Ahmed I came to the throne, the post of official historiographer, charged with lauding the person of the sultan, had been dispensed with as an embar-rassing irrelevance.[154]

Selim II showed no interest in historical manuscripts; his son Murad III, by contrast, was an avid patron of the arts of the book, and during his reign some of the finest Ottoman manuscripts were produced. These were illustrated with miniatures in the traditional style as well as portraits of Murad and his forebears – he was the first to commission a series of like-

nesses of the sultans to illustrate a historical text. This series, completed before the assassination of Sokullu Mehmed Pasha in 1579, was based on portraits of the sultans commissioned by the Grand Vezir in Venice, possibly from the workshop of Paolo Veronese. At the same time, representation of the sultan on his throne became an established convention, a visual shift – from the sultan on horseback at the head of his army to an enthroned sultan – that echoed contemporary reality.[155]

Ambition for conquest was not dead, however, as an album of sultans' portraits from the reign of Ahmed I indicates. This introduced a new iconographic element in the shape of the 'Red Apple', the symbol of world conquest which had once referred to Constantinople, then to Rome, Buda and Vienna in turn.[156] When Ahmed's son came to the throne as Sultan Osman II some months after his father's death, he is said to have set off on campaign against the Commonwealth of Poland-Lithuania dressed in the armour of Sultan Süleyman,[157] as if this talisman would restore his troubled domains to their former greatness.

7

Government by faction

POLITICAL AND ADMINISTRATIVE practices which had evolved to support the ideology of an ever-expanding Ottoman Empire could not accommodate the troubles which beset it at the end of the sixteenth century as expansion slowed. Once sultans no longer routinely rode to war at the head of their armies, apprenticeship in this activity became obsolete. It is difficult to say whether the custom of educating the sultan's sons in state-craft by sending them to govern provinces in his name lapsed as a matter of policy, or simply because Mehmed III's father Murad III happened to die when none of Mehmed's nineteen younger brothers was of an age to act as a governor, and Mehmed himself then died before any of his own sons reached maturity. Mass fratricide as a tool to pre-empt rival claims to the throne – as practised by Murad III and Mehmed III – was unpopular and an alternative was sought: from the time of Mehmed III's reign, young princes were no longer accorded any public role, but confined instead to quarters within the *harem* of Topkapı Palace.* The diminished status of the princes was reflected in the small stipend they received, no more than that enjoyed by their maiden aunts, the sultan's unmarried sisters.[1]

The seclusion of the princes did not however serve to prevent the disruption which historically accompanied the transfer of power on the demise of a sultan. Previously princely contenders had themselves bid for the throne; now they became little more than pawns in the hands of rival cliques within the ruling establishment. In the absence of cadet members of the dynasty with experience of the political and military life of the empire, unrestrained factional quarrelling centred on these cliques. The tender years of many sultans at their accession also gave their contentious advisers a free hand.

Sultan Ahmed I died in 1617 at the age of 27. According to the contemporary scholar Katib Çelebi, leading statesmen agreed that the extreme youth of Ahmed's many sons disqualified them from the succession, and

* Western writers imagined them imprisoned, literally, in a 'cage' – but the Turkish-language equivalent of this term was not used until later.

196

the throne passed instead to his 26-year-old brother Mustafa;[2] in fact, Ahmed's eldest son Osman was 14, and Ahmed had been younger than that at his succession. The mass fratricides of Osman's grandfather and great-grandfather remained a vivid memory, however, and Osman was left alive. The power of Ahmed's favourite concubine, Mahpeyker, a Greek woman known as Kösem Sultan, may have been a decisive factor in keeping him from the throne: although Osman's relationship with her was warm, he was born of another mother, Mahfiruz, and Kösem, like Sultan Süleyman's wife Hürrem, had young sons of her own for whom she had ambitions.[3] Mustafa's enthronement was a break with the practice of father-to-son succession which had prevailed since the Ottoman dynasty came to promi-nence some three centuries earlier.

The architect of Mustafa's succession seems to have been the sheikhulislam Esad Efendi, who was the senior statesman in the capital at the time of Sultan Ahmed's death.[4] He proved to have made an unfortunate choice, since Mustafa was disliked by the people and considered soft in the head from the beginning of his short reign – as reported by the contemporary historian İbrahim of Peç, Sultan Mustafa would fill his pockets with gold and silver coins, tossing them out of boats and otherwise distributing them to any indigent he happened upon, which was considered most unfitting behaviour.[5] He was sultan for only three months before being deposed in a coup d'état engineered by the chief black eunuch Mustafa Agha who, on a day when the imperial council was convened for the purpose of distributing salaries, locked Sultan Mustafa in his room and brought about the enthronement of his nephew Osman in his place.[6] Mustafa I, the first sultan to be deposed by means of a palace coup rather than one headed by a member of the dynasty, spent Osman's reign confined to the *harem* as he had been before his accession.

Having been passed over so ignominiously, Sultan Osman II seemed doubly bent on regaining the initiative and re-establishing the prestige of the sultanate. He dismissed Grand Vezir Kayseriyeli Halil Pasha, who had been on campaign on the eastern front during the months of Mustafa's reign, for leading his army to defeat at the hands of the Safavids. For their part in putting Mustafa on the throne Osman also dismissed the second vezir Sofu ('Devout') Mehmed Pasha and restricted the authority of Sheikhulislam Esad Efendi. The power of appointment within the religious hierarchy, previously a perquisite of the sheikhulislam, was awarded to Osman's tutor, Ömer Efendi, to whom the young sultan remained close. Chief Black Eunuch Mustafa Agha survived the coup; he was, however, soon exiled to Egypt – the customary fate for dismissed chief black eunuchs from this time – by Osman's new appointee as grand vezir in late 1619,

the former grand admiral Güzelce ('Beauteous') Ali Pasha, whose influence over the Sultan was greater than his own. Ömer Efendi was also distanced from court at this time and sent to Mecca – he returned on Güzelce Ali Pasha's death in March 1621.[7]

In 1618 had begun the Europe-wide conflict later known as the Thirty Years' War. The Ottomans initially had a stake in the struggle, persuaded by the Protestant voyvode of Transylvania, Gabriel Bethlen, to assume the role of protector of the Hungarians against the Catholic Habsburgs, but the army of the Protestant King Frederick V of Bohemia was defeated at the Battle of the White Mountain outside Prague on 8 November 1620. Earlier that year an army had marched from Polish Ukraine into Moldavia – an incursion into the territory of an Ottoman vassal – in support of a candidate for voyvode who had been deposed by the Ottomans. Although this confrontation ended in defeat for the aggressor, the next spring Sultan Osman ordered full mobilization of the imperial army[8] – an attack on the Commonwealth offered an opportunity to strike at the Catholic cause from another direction. Some contemporary commentators blamed the outbreak of war in 1621 rather on ongoing Cossack raids across the Black Sea.[9] The guiding principle of the relations between the Ottomans and the Commonwealth was that each undertook to control their unruly steppe vassals. The Crimean Tatars and the Cossacks of Ukraine,* respectively, were essential to their suzerains as auxiliary military forces, but it was barely possible to restrain them from raiding indiscriminately in search of booty.

No sultan had led his troops in person since Mehmed III's reluctant appearance at Mezőkeresztes in 1596; Osman seized the opportunity to demonstrate that the sultan was still a warrior-king. Wary of the vacuum this would leave in Istanbul, he took the precaution of having his brother Mehmed, next to him in age, murdered before he set out. In revenge for the slights he had received at Osman's hands, Sheikhulislam Esad Efendi refused to legitimize this murder with a favourable juridical opinion; having failed to bow the highest legal authority in the land to his will, Osman sought support from the next in rank in the religious hierarchy.[10] His uncle Mustafa I remained alive, as did his younger brothers, protected by their mother, Kösem Sultan.

Osman set out on his 1621 campaign in May, the customary time of year, but was plagued by his army's lack of enthusiasm and continuing inclement weather – even the Bosporus had frozen the previous winter,

* An important group were those known in Slavic sources as the Zaporozhian Cossacks or 'Cossacks from beyond the rapids', and in Ottoman sources as 'Cossacks of the Dnieper.'

and the people of Istanbul had been able to cross the Golden Horn on the ice.[11] The Ottomans lost many pack animals and much equipment as they marched north along the military road to cross the Danube by a bridge of boats at Isaccea. The Cossacks were known to have joined the Commonwealth army – in fact, they provided at least half of its manpower[12] – and Kayseriyeli Halil Pasha, who now held the post of grand admiral, remained to guard the bridge against a possible Cossack attack.[13] With Osman at their head the main body of the army arrived on the upper Dniester before the fortress of Khotin which had belonged to Moldavia until ceded to the Polish-Lithuanian Commonwealth a few years earlier. A month was spent before the castle, and it resisted six assaults. At first Osman refused to concede defeat, but it was clear that he would not be able to hold out for the winter with his restive forces, and he was eventually persuaded to abandon the siege and march for home. Under the terms of the ensuing peace, Cossack raids on the Ottomans were to stop as were Tatar and Moldavian incursions against the Commonwealth, while the Commonwealth agreed not to interfere in Ottoman Hungary or the Ottoman vassal states of Transylvania, Moldavia and Wallachia. If the Ottomans were on the defensive, the Commonwealth was equally unwilling to provoke them further.[14]

The army was back in Istanbul in January 1622, the ignominious withdrawal from Khotin celebrated as though it had been a great conquest. Sultan Osman's scribes composed 'letters of victory' of the kind customarily issued to proclaim Ottoman success in war, and literary works extolled the campaign as such.[15] But Khotin had strained the Sultan's relations with his elite regiments to the limit, and there was growing insubordination among the janissaries and the cavalry. Soon after his return from the front, Sultan Osman announced that he intended to undertake the pilgrimage to Mecca and prepared to cross the Bosporus to Üsküdar with only a few of his troops. The facts remain obscure: sultans had rarely travelled far from Istanbul without the army, hunting trips being the most usual cause, and none had ever been on the pilgrimage; Osman's declaration was thought by those around him to have masked a plan to replace his fractious personal regiments with men recruited from the peasants and tribesmen of Anatolia and beyond – in addition to the militias already raised as musketmen since the late sixteenth century. Doubtless aware that a disaster was unfolding, Sheikhulislam Esad Efendi tried to dissuade him from leaving Istanbul, offering the opinion that the sultan was not required to perform the pilgrimage, indeed that he should remain where he was.[16] Neither his counsels nor those of the Grand Vezir or Ömer Efendi prevailed, and rumours spread that Osman intended to make Cairo the new capital of his empire.[17]

On 18 May 1622, the day that Sultan Osman was to set out on on his journey across Anatolia, a military insurrection erupted in the capital. İbrahim of Peç witnessed the ensuing events, and recorded them in chilling detail. As the people of the city gathered, he reports, the janissaries and the sultan's cavalry marched to the Hippodrome and issued a demand for the heads of the Grand Vezir, Chief Black Eunuch Süleyman Agha (successor to Mustafa Agha), and Ömer Efendi. The Sultan, still inside the palace, was warned of the seriousness of the situation, but refused to sacrifice his advisers. Meanwhile palace staff sympathetic to the the uprising opened the gates to the troops who poured into the palace in search of the former sultan, Mustafa.[18]

A former janissary left a colourful account of the exploits of six of the soldiers:

> ... while the crowd was boring through the dome [of the *harem* apartment where Mustafa was hiding] some servants fired arrows which went right among the people and cut them to pieces; those on the dome broke through it but it was impossible to descend [into the room below]; when no rope could be found, they cut the cords of the curtains of the vezirs' council chamber and three janissaries and three cavalrymen tied the cords to themselves and descended; they prostrated themselves at Sultan Mustafa's feet.

The soldiers escaped with Mustafa by the same route; the Grand Vezir and the Chief Black Eunuch were hacked to pieces.[19]

From his vantage point near the Şehzade mosque, İbrahim of Peç soon saw a huge crowd pressing around the carriage carrying Mustafa and his mother to the janissary barracks and thence to their mosque, where the janissaries acknowledged him as sultan. A kilometre away, unaware of what was going on, Osman was in the palace making new appointments and hoping that the janissaries could be won round by the distribution of gold. Sent next day to quell the disorder, the new janissary commander-in-chief was killed, as was Osman's new grand vezir. Osman himself then went secretly to the official residence of the janissary commander-in-chief, hoping to find there officers who could be bribed to support him, but he was discovered by the rebels. İbrahim watched from the window as they dressed him in rags, set him on a horse, and took him to the janissaries' mosque.[20]

An acquaintance who was present in the mosque reported to İbrahim of Peç how Osman pleaded with his captors to realize their error in restoring Mustafa, who kept rising from his place in front of the prayer-niche to see what was causing the noise outside in the street – but to no avail. Mustafa's brother-in-law, Daud Pasha, appeared with a noose in his hand; Osman grasped this as he reminded the assembly that Daud Pasha had several times

committed crimes which warranted the death penalty, and that he had been lenient towards him. Mustafa's mother took Daud Pasha's part, and only the intervention of İbrahim's informant kept the noose from reaching its mark. That afternoon Mustafa went as sultan to the palace while Osman was taken on a market barrow to the fortress of Yedikule and there strangled; one ear and his nose were sent to Mustafa's mother. Sultan Osman was buried at the foot of the grave of his father Sultan Ahmed in the crowded dynastic tomb beside Ahmed's 'Blue' mosque.[21]

The janissary who left the stirring account of Mustafa's liberation from the *harem* was at pains to demonstrate the justice of his comrades' case, and set down their several grievances. First, they strongly resented the prominence of Sultan Osman's tutor Ömer Efendi, a man of humble provincial origins and therefore alien to the janissary ethos. The immediate cause of their uprising, however, was Osman's apparent intention to replace them with musketmen recruited in Anatolia and the sultan's cavalry with cavalrymen from Syria and Egypt; they blamed Süleyman Agha, the Chief Black Eunuch, for insisting to Osman that this was a feasible notion. The proposed employment of such provincial, Muslim-born troops as the backbone of a new army severely threatened their position, and the affront was the greater, they pointed out, because these were the very men who had risen against the established order in the rebellions which had shaken the reign of Sultan Ahmed. The elite regiments also felt they had been inadequately rewarded for their efforts on the Khotin campaign; and on their return they had been humiliatingly disciplined by their officers, who patrolled the streets in disguise and sent those found to be drunk and disorderly to serve in the boats which transported building stone.[22]

Thus did an eloquent janissary explain the profound unease felt by the sultan's regiments. As they saw it, their jealously-guarded privileges, indeed their very existence, were threatened by Osman's radical plan to recruit military manpower from new sources – if that was in fact what he intended. Contemporary accounts of Osman's bloody end reflect the partisanship of their authors: most owed their positions to their links with statesmen and high-ranking bureaucrats, and they argued that Osman had brought his fate upon himself by taking the advice of unscrupulous advisers. Like their patrons, they could only disapprove of the increasing influence that functionaries in the private household of the Sultan, such as his tutor and the Chief Black Eunuch, had come to exert on the decision-making process.

Sultan Osman II was the first victim of regicide in the history of the empire; his execution left his uncle Mustafa and his own younger brothers as the only surviving males of the dynasty. Mustafa ruled for another sixteen months before being deposed yet again, this time by the very elite regiments

responsible for his restoration. The pattern was thus set for the rest of the century. Mustafa was replaced by Kösem's eldest son Murad [IV], who died in his late twenties in 1640, leaving no male heir. Murad was succeeded by his brother İbrahim, another of Kösem Sultan's sons; known as 'Crazy', İbrahim was dethroned eight years later, leaving his eldest son Mehmed [IV], aged only seven, to succeed him. On this occasion there was no question of minority being considered grounds for disqualifying a prince from succession to the throne, as at that point Mehmed was the sole other survivor of the bloodline of the Ottoman dynasty. In this period of abruptly truncated reigns and early deaths without mature heirs, it appeared doubtful whether the dynasty would survive. Mehmed IV was deposed in 1687 – like Osman, Mustafa and İbrahim, by rebellious troops. There was now a choice of possible successors: not only Mehmed's sons, but also his brothers. In the event it was Mehmed's brother, İbrahim's second son, who came to the throne as Süleyman II, followed in turn by his younger brother who ruled as Ahmed II. The principle of seniority as the criterion for eligibility to rule was emphatically established with Mehmed IV's own sons, Mustafa II and Ahmed III, who succeeded Ahmed II;[23] both were forced from the throne by janissary revolts.

One of the key political struggles in the early years of the Ottoman Empire was the resistance of much of Anatolia to the uniformity imposed by the state as its administration became more bureaucratic and centralized and its religion more orthodox. At first glance it seems surprising that the ferment against Ottoman central government should have been so much stronger in largely Muslim Anatolia than in the predominantly Christian Balkans. A partial explanation for the incongruity doubtless lay in the fact that Muslim expectations of an Islamic state were higher than those of Christians, but few received what they considered their due. The Celali revolts were only the most recent phase of the ongoing struggle between the Anatolian provinces and Istanbul. To this long-standing opposition of the military forces of Anatolia to the privileges enjoyed by those with direct access to power in Istanbul was now added a new ingredient – the tension in Istanbul itself between rival competitors for power, among whom the sultan's regiments were prominent. The murder of Osman was symptomatic of this particular struggle, which coloured domestic politics for years to come, providing a perfect pretext for the expression of provincial frustration.

Revenge for Sultan Osman's murder came from a quite unanticipated quarter, in the shape of a rebellion led by the governor of the eastern Anatolian province of Erzurum, Abaza ('Abkhazian') Mehmed Pasha. Related by marriage to the then grand vezir, Hadım ('Eunuch', also known

as Gürcü, 'Georgian') Mehmed Pasha, Abaza Mehmed had hitherto been a model servant of the Ottoman state in the execution of his various duties. İbrahim of Peç was aware that something was afoot: in 1622, as treasurer of the province of Diyarbakır, he observed messengers passing between Abaza Mehmed and his own superior, Hafız ('One who knows the Koran by heart') Ahmed Pasha, the governor of Diyarbakır, and learned that Hafız Ahmed planned to march to Üsküdar at the head of an army of provincial military commanders to settle scores with the murderers of Sultan Osman.[24] When news reached Istanbul that Abaza Mehmed had expelled the janissary garrison from Erzurum and other fortresses within his jurisdiction, he was dismissed from office. Held by Abaza Mehmed and his followers to be complicit in Osman's murder, members of the sultan's cavalry and infantry who were in Anatolia on government business found it impossible to carry out their tasks.[25] The Armenian priest Grigor of Kemah hid in the Topkapı district of Istanbul (on the land walls) from the turmoil following Osman's regicide, and received news of events in Erzurum: any janissaries who were lucky enough to be able to escape Abaza Mehmed's wrath, he was told, changed their clothes and took Armenian names so that they would not be discovered as they tried to reach Istanbul.[26]

Sultan Mustafa and the janissaries alike denied responsibility for Osman's murder. Mustafa's brother-in-law Daud Pasha had briefly been Mustafa's grand vezir after Osman's death, but this time neither his connections nor his position could save him: he was chosen as the scapegoat, and executed in an attempt to assuage the wave of discontent that was building up in Anatolia. Other officers of state who had taken an active role in Osman's deposition met the same fate. The janissaries were in control of Istanbul: in February 1623 they forced the dismissal of Grand Vezir Hadım Mehmed Pasha and the reappointment of one of his predecessors, who emptied the treasury to retain their support. Members of the religious hierarchy gathered in the mosque of Sultan Mehmed II and called for the new grand vezir's dismissal after he assaulted one of their number. Threats by the Grand Vezir and his janissary supporters failed to shake their resolve. They were attacked by thugs sent by the Grand Vezir; many were murdered and their bodies thrown into the sea.[27]

Meanwhile Abaza Mehmed Pasha, angered by his dismissal from the governorship of Erzurum and fully aware of the tense situation in Istanbul and the vacuum at the heart of government, was raising an army. Abaza Mehmed provided a focus for those in whose minds the memory of the harshness exercised by forces loyal to the sultan in repressing the provincial rebels of Anatolia and Syria in the Celali revolts was still fresh, and for those who felt cheated of the chance of being part of Osman's proposed

Anatolian–Arab army. Recruits eager to act against their rivals in the sultan's regiments were not hard to find.

Reports reached Istanbul that Abaza Mehmed Pasha was marching on Ankara with an army of 40,000 men. Emissaries from the capital failed to divert him from his course, and in May 1623 the government sent men of the sultan's regiments against him. Their commander soon realized, however, that his force was inadequate, and withdrew to Bursa rather than face certain defeat.[28] For seven months Abaza Mehmed besieged Ankara.[29] There was little money available in the imperial treasury to fund an adequate campaign against him and tax collection was impossible across the large areas he and his cohorts controlled. Solakzade Mehmed Hemdemi Çelebi was employed in the palace and witness to events in the capital at this time: he reports that the commander-in-chief of the janissaries, Bayram Agha, conspired to remove the Grand Vezir who had emptied the treasury in order to pacify his janissary supporters.[30]

Emboldened by this, the clerics whom the deposed Grand Vezir had tormented petitioned Sultan Mustafa's mother that her son was quite unequal to the demands of ruling the empire, forcefully asserting that the instability and manifold troubles now being experienced would only get worse if he remained on the throne. There were few who demurred when it was suggested that in the best interests of the state, and of themselves as servants of that state, Mustafa should be deposed and replaced by Prince Murad – at eleven, the eldest surviving son of Sultan Ahmed I. The plea of Mustafa's mother that he be spared was respected – lacking any partisans, he seemed to pose no threat – and he disappeared back inside the *harem*. When he eventually died, in 1639, no one could decide where to bury him; his body lay for seventeen hours before being ignominiously interred in a disused olive oil store in the courtyard of Ayasofya.[31]

In the five turbulent years following the death of Ahmed I, a shift had taken place in the balance of power around the sultanate. The sultan was still considered the ultimate and legitimate locus of power, but his servants and others within his orbit had thrown off the deference which had formerly characterized their relations with their sovereign and vied for advantage without restraint, a tendency encouraged by the sultan's increasing reclusiveness. This in its turn encouraged a growing vociferousness by those who sought to exercise power in his name, who might include his mother, the grand vezir, the chief black eunuch, functionaries of the palace, janissary officers, and others. Throughout these vicissitudes the Ottoman dynasty somehow retained its power to inspire devotion and enthusiasm, and was not seriously challenged; although the early eighteenth-century bureaucrat

Mustafa Naima, author of one of the major Ottoman chronicles, records that there were rumours that members of the Tatar Giray dynasty of the Crimea, who were clients of the Ottomans, planned to overthrow and replace them during the chaos of 1624.[32] Provincial protests such as that led by Abaza Mehmed Pasha, although replicated many times during the century, were not revolutionary in intent: they did not aim at the over-throw of the sultanic order, but rather at an improvement within it of the situation of the individual rebel leader and his group. Thus continued the painful transition from an empire whose sultan was first and foremost a warrior-king to one in which he was called upon – but often failed – to exercise his authority over an empire whose frontiers were becoming ever more immutable.

The relative calm which prevailed in Istanbul following the accession of the young Sultan Murad IV in September 1623 contrasted with troubles elsewhere. In Anatolia Abaza Mehmed Pasha and his army were still at large, while in Baghdad the governor had recently been killed by the locally-employed garrison troops: although nominally in the service of the Ottoman sultan, they felt little allegiance to him.[33] The governor of Diyarbakır, Hafiz Ahmed Pasha, was ordered to deal with the mutineers. İbrahim of Peç, who had previously attributed to Hafiz Ahmed plans to march on Istanbul to avenge Sultan Osman's death, was still in his service, and recorded how he cautioned him that the sympathies of the mutineers lay with the Safavids, to whom they might be ready to offer Baghdad.[34] Events only served to demonstrate İbrahim's acuity: on 14 January 1624 the fortress was handed to the Safavids by an Ottoman officer who had usurped the power of the governor. It had been in Ottoman hands for some ninety years, and its loss presaged a period of warfare with Iran which lasted until 1639.

Abaza Mehmed Pasha remained at odds with the ruling establishment in Istanbul despite the removal of Sultan Mustafa and those he held respon-sible for Sultan Osman's murder, but after his forces were beaten near Kayseri by another expedition sent out from Istanbul he withdrew east-wards to Erzurum, and sought the Sultan's pardon.[35] Hafiz Ahmed Pasha was also pardoned for the loss of Baghdad and became grand vezir early in 1626, as well as commander-in-chief on the same front, but was subse-quently dismissed for failing to retake Baghdad after a nine-month siege.[36] The Ottoman forces fought hard but were attacked from behind by tribal troops in the Shah's employ. With no hope of relief, they were over-whelmed.[37] Further north, the Safavids displayed renewed energy by winning other Ottoman strongholds and putting down rebellions of their vassals in Georgia.[38]

Responsibility for bringing this episode in the war with Iran to an end fell to Kayseriyeli Halil Pasha, Sultan Ahmed's last grand vezir, now reappointed. He was further charged with subduing Abaza Mehmed Pasha, who despite his royal pardon continued to cause disturbances in Anatolia.[39] Abaza Mehmed was like a son to the new grand vezir, but despite their lifelong association had refused Kayseriyeli Halil's request to go to the relief of a border fortress under Safavid siege; indeed, when the army sent by Kayseriyeli Halil to raise the siege had reached Abaza Mehmed's base at Erzurum, he had had its commander murdered and had plundered its supplies and equipment.[40] In April 1628 Kayseriyeli Halil was dismissed for his failure to subdue Abaza Mehmed:[41] the governorship of Erzurum was a highly sensitive post, for the province bordered the Safavid lands, and full confidence in the governor's loyalty to the sultan was essential. Eskandar Monshi, chief court secretary and biographer to Shah 'Abbas, reported that Abaza Mehmed had made overtures to the Safavids on two occasions: the Shah, however, regarded him as an opportunist.[42]

In the summer of 1628 Abaza Mehmed Pasha's rebellion was brought to an end – at least for a while – by Kayseriyeli Halil Pasha's successor as grand vezir, Boşnak ('Bosnian') Husrev Pasha, the first commander-in-chief of the janissaries to hold the post. Boşnak Husrev was ordered to complete Kayseriyeli Halil's task by mounting a campaign to retake Baghdad, and as he journeyed towards his target he encountered various Safavid forces in their common borderlands. The army arrived outside Baghdad in September 1630, but the siege to retake the city failed again and after a disastrous and costly campaign, the Ottoman army was harassed energetically by the Safavids as it retreated to winter quarters in Mardin. A campaign planned for the following season had to be abandoned; Boşnak Husrev was dismissed, and Hafiz Ahmed Pasha was rehabilitated and reappointed in his place.[43]

The scholar Katib Çelebi, who held a post in the military bureaucracy on Boşnak Husrev Pasha's Baghdad campaign, recorded how, despite its failure, and despite the hardships the troops recalled from the frontier had to endure, they wanted none other than Boşnak Husrev as their commander-in-chief, and were enraged at his dismissal.[44] Hafiz Ahmed Pasha, by contrast, was favoured by a clique around Murad IV's mother Kösem Sultan and her ally, the Chief Black Eunuch. Having held a number of high offices under Sultan Ahmed, Hafiz Ahmed was a link with Kösem's past, and he was also married to Sultan Murad's sister Ayşe. Because of Murad's youth at his accession, Kösem had an unprecedented share in the direction of the state as her son's regent, and enjoyed this power until well into Murad's reign.[45]

The dismissal of Boşnak Husrev Pasha in the first weeks of 1632 plunged

the capital into such scenes of disorder as had attended the deposition of Sultan Mustafa; the chronicler İbrahim of Peç likened the tumult to a beehive.[46] Katib Çelebi ascribed culpability for inflaming passions to Receb Pasha, Boşnak Husrev Pasha's proxy in Istanbul, who had ambitions to be grand vezir himself. Sultan Murad yielded to an ultimatum from the mutinous troops and appeared before them; they demanded Hafiz Ahmed Pasha, and he was knifed in the Sultan's presence. Receb Pasha succeeded him.[47]

The reappointment of Hafiz Ahmed Pasha as grand vezir had seen the posts of chief treasurer and janissary commander-in-chief also change hands, and the new incumbents were considered guilty in the matter of Boşnak Husrev Pasha's dismissal by their association with the palace clique, as was Sultan Murad's favourite, Musa Çelebi. Converging on the Grand Vezir's palace in the Hippodrome, the mob demanded that these three men be delivered up to them. Receb Pasha insisted that the Sultan was not concealing them, but İbrahim of Peç recorded that he soon saw the corpse of Musa Çelebi lying in the Hippodrome. The following day the janissary commander-in-chief and the chief treasurer were executed, with the Sultan's complicity. However horrific these events might sound, wrote İbrahim of Peç, the reality was even bloodier.[48] Murad's distrust of Receb Pasha was soon translated into his execution. As for Boşnak Husrev, however popular he might be with the army, Murad held him responsible for contributing to the disorder, and government agents were sent to find him in the north-central Anatolian town of Tokat, where he had been delayed on his return to Istanbul from the front. The people of Tokat resisted the agents' entry into the town but were overcome, and Boşnak Husrev was put to death.[49]

The story of Abaza Mehmed Pasha was not yet over. He had already been given a second chance, and he had again failed to fulfil his responsibilities, but in 1628 he was nevertheless appointed governor of Bosnia – far from his seat of power and his constituency. Abaza Mehmed fought campaigns in the Balkans, and in 1632 became governor of Özi, the Danubian and northern Black Sea province whence Ottoman oversight of this strategic region was exercised. He was at Sultan Murad's side in 1633 when a new campaign was being planned, but his progress from rebellious governor to royal intimate ended in 1634, when Sultan Murad could no longer resist his enemies' clamour for his execution. By Murad's order Abaza Mehmed was accorded a ceremonial funeral, and the Sultan rode in the procession; his burial in the tomb of Kuyucu Murad Pasha, who had brought the first wave of Celali rebellions to an end in 1608, was an honour signifying that in the final analysis he was not considered a rebel but remained, in the Sultan's eyes, a loyal member of the ruling establishment.[50]

The Ottoman traveller and writer Evliya Çelebi was, like Abaza Mehmed

Pasha, of Caucasian origin. In 1646 he was serving in Erzurum, and in his celebrated 'Book of Travels' he recorded the appearance there of a man claiming to be Abaza Mehmed. This man said that with the connivance of the Sultan he had escaped execution in 1634 by fleeing to Gelibolu on the Dardanelles; thereafter he had spent seven years as a corsair in Algiers, seven more years in Denmark after his capture in a battle, and three years with the Portuguese navy in the Indian Ocean, and then travelled to India and China and finally arrived back in Erzurum by way of Central Asia and Iran. Reported to Istanbul by Evliya's superior, the governor of Erzurum, the tale prompted an investigation to discover the truth of the matter (to begin with, the years did not add up!). An official was soon on his way to Erzurum with orders for the execution of the man and the governor, who had extended his hospitality to him, was dismissed.[51] The part taken by the Sultan in Abaza Mehmed's funeral had raised doubts at the time as to whether it was really his corpse in the coffin – it seemed inconceivable that Murad would so publicly display his affection for a one-time rebel. Rumour had it that the coffin must contain one of Murad's brothers, whom he had put to death, or perhaps the body of his uncle Mustafa, released in this way from his incarceration in the palace, but the Armenian priest Grigor of Kemah knew some tailors who in the course of their business would exchange gossip with the palace staff: one of the tailors claimed to have spoken with the man who had strangled Abaza Mehmed, and for Grigor that settled the issue. The death of Abaza Mehmed touched Armenians especially, according to Grigor, for he lived among them in Erzurum for a long time and showed concern for their troubles. The priest described Abaza Mehmed as 'a man who loved Christians and particularly the oppressed Armenian community; a man who served his country well and was solicitous of the weak of all [religions] without discrimination'.[52]

Sultan Murad emerged chastened and wiser from the events which shook Istanbul in the first months of 1632. He was twenty years old, and he had handled the crisis with maturity. Letters written by his mother Kösem Sultan to the grand vezir, probably in 1628, show that even then, when her son was still in his teens, she was becoming resigned to his independence of decision.[53] The demise of her son-in-law Hafiz Ahmed Pasha and of the faction sacrificed to defuse the janissary uprising left Kösem somewhat discredited, and more circumspect in exercising her power as mother of the Sultan. Until her simple-minded second son İbrahim succeeded to the throne following Murad's premature death in 1640, she withdrew from the stage of Istanbul politics.

Murad now began to play a more active role. Having displayed his

personal authority, he attempted to re-establish that of the sultanate in both government and military affairs. In the latter context, he decided to emulate his illustrious forebears by leading his army on campaign against the Safavids. Seeing the disastrous consequences of the endemic unrest in Anatolia, he determined to deal with it using both stick and carrot, countering rebellious uprisings with military might but also enacting administrative measures designed to calm the disaffection which led servants of the state and local strongmen alike to take up arms against the government. He also addressed the problem of brigandage. The stability of the four-and-a-half-year incumbency of his new grand vezir, former governor of Egypt Tabanıyassı ('Flat-footed') Mehmed Pasha, brought the factional infighting in Istanbul under control.

Ottoman intellectuals continued to put forward their views on statecraft. Surviving texts share a concern that the chaotic present in which their authors lived was a result of a breakdown in state and society. As with the advice manuals written around the turn of the century, their purpose was to guide the sultan towards restoration of what were perceived as the glories of bygone times. Their prescriptions were therefore conservative rather than innovative, recommending measures they hoped would restore the form of centralized government which they believed to have existed in the past, one in which vezirs acted in harmony as faithful servants of the charismatic sultan at their head. Caught up as they were on a wave of rapid change, it was perhaps understandable that these writers should recommend that the clock be turned back to a time when their own place in society was more secure. Just as the sultan's regiments had felt threatened by Sultan Osman's supposed intention to recruit troops from Anatolia and the east, so the intellectuals' position was eroded as new factions rose to prominence who exercised patronage among previously insignificant groups. These competing factions who sought to exercise power so abruptly in the early seventeenth century were in a position to do so because of the failure of existing arrangements for government and for preventing the growth of centres of power to rival the sultanate. Factions whose ambitions had hitherto been kept in check were now strong enough to make and unmake rulers in their fight for inclusion among the privileged military and bureaucratic office-holders whose positions brought them the financial and other rewards which were the prerogative of members of the establishment.[54]

Among the most celebrated of the advice treatises written during these years is that of a functionary in the Sultan's household known as Koçu Bey who presented his work to Murad IV in 1631. (When İbrahim succeeded his brother, Koçu Bey reworked his text and presented a revised version to the new sultan.) Among the many other aspects of state organization

upon which he touched, Koçu Bey's diagnosis of the ills at the heart of the state echoed that of earlier writers: as he saw it, the withdrawal of the sultan from visible involvement in state affairs allowed *harem* members to exert their influence; the provincial cavalry was in disarray, and most of the livings formerly assigned them to enable them to participate with their retainers in military campaigns were now in the hands of palace functionaries, *harem* women and the subject class; the consequent lack of military manpower meant that the sultan's elite regiments had to be opened up to 'outsiders' rather than remaining the preserve of those raised through the youth-levy and trained in the values of the Ottoman establishment, a change which sapped their corporate ethos and brought about, argued Koçu Bey, the disorder apparent to all.[55]

Sultan Murad shared many of the opinions expressed by the treatise writers, and was ready to act upon their strictures in the interests of stability in the internal workings of the state. However, both he and those he brought to power after the crisis which followed the dismissal of Boşnak Husrev Pasha were also aware that pragmatic rather than ideal solutions would better answer the exigencies of the turbulent times through which they were living. Murad's overriding aims were to end the provincial unrest, and to strengthen the army with a view to recapturing Baghdad, which he judged would provide an outlet for the frustrations of his elite troops.

The chroniclers İbrahim of Peç and Katib Çelebi, employed as bureaucrats in Istanbul at the time, were witnesses of Murad's reform programme. Curbs on the numbers and tax collection activities of the sultan's cavalry regiments resulted in a violent demonstration in the Hippodrome on 8 June 1632.[56] Reform of the provincial cavalry of Rumeli and Anatolia was also addressed in 1632. Inspections were ordered to ensure that state lands granted in return for military obligations were in the right hands.[57] The practice of father-to-son inheritance of military land-grants was to be abandoned, and those eligible to hold vacant land-grants were now to include members of the salaried regiments who wished to do so – according to Katib Çelebi, janissaries left their regiments in order to qualify for land-grants – men from the sultan's cavalry regiments who were based in the provinces, and also peasants, 'local youths who had demonstrated ability in warfare and combat'. Small units of land inadequate to support a soldier and his retainers were combined into larger holdings.[58] The Sultan was adamant that no land-holder should be exempt from the obligation to campaign. In his communications with his officials, he frequently expressed his fears that they were being less than honest in the execution of their duties – to the detriment of the treasury.[59]

Despite these reforms, disturbances continued in Anatolia. The activities of those execrated by the government as rebels and brigands emptied great swathes of the countryside, and in so doing destroyed the tax base of this predominantly agricultural empire. Government programmes designed to fill the treasury and furnish soldiers for the army brought further anguish to peasants who had already suffered from having to flee their villages before the unruly hordes with whom the government was in contention. If they were to have a chance of success, it was essential that the measures introduced in 1632 to reassign land-grants be accompanied by the resettlement of the peasants whose labours provided the taxes on which the cavalryman and his household survived, and which allowed him to go on campaign. Replenishment of the treasury was the greatest test facing Murad – without money, the state could not function. Grigor of Kemah suggests it was the experience of crossing Anatolia on the way to campaign in the Caucasus in 1635 that brought home to Murad the reality of the crisis in the countryside. The people of Sivas related to him how most of their number had fled to Istanbul, and they themselves were unable to meet their tax obligations. Murad immediately ordered that all who had left their homes be sent back; in Istanbul, criers went through the city telling those who had sought refuge there to leave within twenty days, on pain of death:

> The wives and children of Turks and Armenians married to local [i.e. Istanbul] women realized what a wretched situation they would face in an unfamiliar place and did not want to go with their husbands . . . The Muslims divorced their wives with a single word, as their laws allow, but now the cries of children who did not want to be separated from their mothers and fathers rose up. The city was filled with the plaints of people being separated from their loved ones and of the old, sick and infirm.

The queen-mother Kösem Sultan objected that it was not appropriate in a time of war to cause still more anguish; sparing a thought for those who were to be forced to leave behind them the new lives they had created for themselves in the capital after being driven from their lands, to face an uncertain future in a distant and devastated countryside, Murad relented. He granted exemption to the old and infirm, orphans and widows, those born in Istanbul and any who could prove they had been in the city for over forty years.[60] Sultan Murad's initial reaction to the flight from the countryside may have been grounded in emotion, but a well-considered policy was needed if the problem was to be resolved. In 1636 he ordered the preparation of a detailed report on the financial resources of Anatolia, the purpose being to identify who – in the conditions of endemic unrest which had caused the displacement of thousands of potential taxpayers – was available to be taxed.[61]

Beyond Anatolia, on the fringes of the empire, when central authority seemed weak, local dynasts flexed their muscles. In the area of modern Lebanon, the Druze clan leader Fakhr al-Din Ma'n had long held the office of military governor under the Ottomans. The Anatolian rebellions isolated him from the centre of the empire and enabled him to strengthen his hold on this region and its revenues – he was very active commercially, entering into agreements on his own behalf with European merchants. His quasi-independent status was respected by the central government as long as he remained loyal and dutifully remitted the tax-revenues from the silk and cotton grown in the region, but in 1633, considering that Fakhr al-Din had become too powerful, the Grand Vezir ordered the Ottoman governor of Damascus to arrest him and send him with his sons to Istanbul where he was subsequently executed.[62] None of the lesser families who sought to fill the vacuum left by his removal had the power to challenge the Ottomans. Fakhr al-Din's son Hüseyin was educated as an Ottoman, and after employment in the palace was sent to India in 1656 as an envoy of Sultan Mehmed IV. His name is preserved in history as the main verbal informant of the chronicler Mustafa Naima.[63]

After almost a century of struggling to impose their authority on the rich province of Yemen, and singularly failing to subdue it, the Ottomans relinquished their tenuous hold, which by the time of their departure was restricted to a narrow coastal strip. The call of the local Zaydi clan for 'holy war' inspired successive actions against the Ottomans early in the century, followed by a brief respite before further local resistance culminated in 1635 in an ignominious retreat. The Ottoman struggle to hold this distant and inhospitable land had been costly to both sides.[64] The religious orthodoxy of their imperial masters held no attractions for the native dynasties of Yemen, and the Ottoman state was no longer either willing or able to divert resources to maintain a presence in a place whose strategic value had diminished since the days of their rivalry with the Portuguese in the seas of the Indian Ocean.

In his efforts to quell the disturbances in the provinces, military offensive and administrative reform were two of Murad IV's weapons. He was also party to a campaign of moral regeneration aimed at remoulding the character of his subjects that came to influence social and political life throughout the century. Sultan Ahmed had in 1609 forbidden the growing and consumption of tobacco which English traders had recently brought into his domains, citing as his reason that people were not going about their business but spending night and day smoking in the coffee-houses. Tobacco was so popular that the ban was ineffective and had to be repeated in 1614, by

which time it was so profitable a crop that it competed for land with the traditional occupation of apiculture, and the price of honey rose accordingly. Sultan Osman had repeated the ban – reinforced with a juridical opinion – and Sultan Murad followed suit late in 1630.[65]

In March 1631 the Sultan ordered that the sumptuary laws regarding non-Muslims be enforced with renewed vigour. This was in fact a political matter, if legal in inspiration – non-Muslims were second-class subjects, to be 'treated with contempt, made submissive and humbled in their clothes and style of dress' – and it was Ahmed I who, wishing to be seen as the exemplar of right religion, had laid down which items of clothing could be worn only by Muslims. Murad restated the ban in no uncertain terms:

> Insult and humiliate infidels in garment, clothing and manner of dress according to Muslim law and imperial statute. Henceforth, do not allow them to mount a horse, wear sable fur, sable fur caps, satin and silk velvet. Do not allow their women to wear mohair caps wrapped in cloth and 'Paris' cloth. Do not allow infidels and Jews to go about in Muslim manner and garment. Hinder and remove these kinds. Do not lose a minute in executing the order that I have proclaimed in this manner.[66]

Murad's social programme found a champion in the charismatic preacher Kadızade Mehmed, a native of the north-west Anatolian town of Balıkesir, who in 1631 was appointed preacher at the Ayasofya mosque – the most prestigious appointment of its kind in the empire. On the occasion of the Prophet Muhammad's birthday which fell that year on 16 September 1633, two sermons were delivered at the Sultan Ahmed mosque in the presence of Murad IV. The first was by the regular preacher of the Friday sermon at that mosque, the respected Halveti sheikh Ebülhayr Mecdeddin Abdülmecid, known as Sivasi Efendi; the second was by Kadızade Mehmed. According to Katib Çelebi, Sivasi Efendi attempted to anticipate his rival's remarks by ridiculing his ideas, but Kadızade Mehmed's dramatic denunciation of all innovation in religious practice and belief and in social behaviour struck a chord with a congregation worn down by the disturbances of recent years.[67]

Following the prayers for the Prophet, the dispersing crowds raided the taverns of the city, and the Sultan made no move to stop them. It was around the time of this critical confrontation, too, that he ordered the closing-down and razing of coffee-houses across the empire, with the exception of those in Egypt and in Mecca and Medina. A more than usually disastrous conflagration in Istanbul had left the people of the city uneasy, and prone to gather in coffee-houses to express their anxiety, leading those in government circles to fear that another bout of sedition might be in the

offing; Murad also ordered taverns to close. Tobacco, taverns and coffee-houses were inextricably linked and, economic considerations aside, Murad's ban on tobacco of a few months earlier can be seen as an attack on the unregulated life of the coffee-houses and taverns as much as on the noxious weed itself – now he took more direct action. Sultan Mehmed III had promoted the opening of coffee-houses in cities other than Istanbul, to give people somewhere to relax; Ahmed I, on the other hand, had ordered them to be closed, but the ban could not be enforced.[68]

Debates between innovators and fundamentalists had long been a lively part of Islamic intellectual life, and the climate of austere morality which continued throughout the seventeenth century – named the Kadızadeli movement after Kadızade Mehmed – had its roots in the conservative tendency represented by Mehmed Birgevi, a scholar of Sultan Süleyman's time who in a number of treatises addressing public and private morality had promoted a puritanical strain in religious thinking. In their quest for an uncorrupted Islam shorn of the innovations which had accrued since the time of the Prophet, the Kadızadeli movement adopted Birgevi's writings as their touchstone.[69]

The Kadızadelis were particularly critical of the dervishes, but Sultan Murad seems not to have been entirely won over and to have aimed to steer a middle course; he was even-handed in the favour he showed Kadızade Mehmed and Sivasi Efendi.[70] The more 'other-worldly' dervish brotherhoods, once an arm of the conquering state in the Balkans, had long since found their role in the public sphere reduced, but the Ottoman sultans and the ruling establishment had continued in their relaxed attitude towards mainstream mystical orders; the Halveti, for instance, who had established their headquarters in Istanbul on the accession of Bayezid II, had maintained their pre-eminence under Selim I and Süleyman I.[71] Murad IV was open in his patronage of Sheikh Aziz Mahmud Hüdayi of the Celveti order (a branch of the Halveti): the Sheikh had been his father's spiritual master, and on the young sultan's succession had girded him with the sword in the ceremony at Eyüp.[72] Murad was also known to appreciate the ritual whirling of the Mevlevi dervishes, who performed for him at the palace,[73] and for thirteen of the seventeen years of his reign he employed as sheikhulislam the eminent jurist and mystical poet Zekeriyazade Yahya Efendi, a man well-known for his dervish sympathies.[74]

The Kadızadelis were as much opposed to high Islam – considering its clerics to be tainted by their association with the political life of the state – as to the mysticism and ritual practices of the dervishes. Kadızade Mehmed represented another type of cleric – neither mystic, nor member of the state religious hierarchy trained in Islamic thought, law and religion, but

one who considered his proper milieu to be the day-to-day religious life of the mosque. It was doubtless Kadızadeli rhetoric that made possible the execution of the then sheikhulislam Ahizade ('Son of the Religious Brother') Hüseyin Efendi in 1634. Ahizade Hüseyin protested when Sultan Murad ordered the execution of the kadı of İznik solely on the basis of complaints from the local people. In the Sultan's absence in Bursa he wrote to Kösem Sultan of his discomfort at Murad's action, drawing her attention to the traditional privileges and respect accorded the religious hierarchy and asking that she remind her son of this. Rumours spread that Ahizade Hüseyin was planning the removal of Murad, and when the Sultan returned to Istanbul on receipt of his mother's letter he first ordered Ahizade Hüseyin and his son, the kadı of Istanbul, into exile in Cyprus, then changed his mind and sent an executioner after them.[75] This was a shocking and unprecedented event: such punishments as execution and confiscation of goods or estates were an occupational hazard for those in the military-administrative branches of state service, but clerics of the religious hierarchy had traditionally been exempt from them – a corollary of the fiction that they remained aloof from factional intrigue. Ahizade's execution reflected the real role played by the religious hierarchy in contemporary politics and spelled out to them the price to be paid for access to the material rewards of state service. It also demonstrated that the principle of clerical inviolability was merely a principle, and that political expedience tended to override apparently immutable custom. Yet if Ahizade Hüseyin was the first holder of the office of sheikhulislam to be executed, he was one of only three such out of some 130 during the life of the empire.[76]

The later years of Murad IV's reign were dominated by campaigns against Iran, harking back to the first centuries of the empire, when the most serious challenge to its integrity had come from the east – from the Karamanids, the Akkoyunlu and the Safavids – rather than from the west. Yet although Selim I's war of annihilation against Shah Isma'il in the early sixteenth century had been briefly revived during the first part of Süleyman's reign, the Treaty of Amasya of 1555 had established respective Ottoman and Safavid spheres of influence which served to guide mutual relations thereafter. No longer did either seek universal domination but each accepted the existence of the other. Subsequent Ottoman–Safavid wars were localized border affairs resulting in little change beyond the loss or gain of individual fortresses.

However the nature of war between the Ottomans and Safavids might have changed, Sultan Murad's attempt to recapture the greatness of former times demanded revival of the tradition of sultan as warrior, and he was

determined to lead his army in war against the Safavids just as Sultan Süleyman had a century earlier. Sultan Osman II's efforts in this respect had been short-lived and far from convincing; Murad's control over the apparatus of state was more certain than Osman's, and he judged that the political gains promised by a victory on the eastern front outweighed the threat of a coup during his absence.

Shah 'Abbas had died in 1629 and his grandson and successor Shah Safi, taking advantage of the turmoil caused by the revolts in Istanbul and Anatolia, had stirred up the princes of Georgia and also sent a force to besiege the Ottoman fortress of Van.[77] Sultan Murad was not able to set out against Shah Şafi until the spring of 1635, the delay in part the result of his apparent intention of leading the Ottoman army against the Polish-Lithuanian Commonwealth in a campaign on that front in summer 1634 – for which purpose he marched as far as Edirne[78] – and in part a consequence of his troops' reluctance to go to war, which forced him to concede a period of rest before setting off eastwards.[79] Peace with the Commonwealth freed Murad for a decisive response to events on his border with Iran, and a large army was eventually despatched to support the Anatolian troops resisting the Safavids, commanded by Grand Vezir Tabanıyassı Mehmed Pasha until the Sultan was able to join it. Thus it was that the first time he ventured far from Istanbul the Sultan led his army across Anatolia by way of Erzurum and Kars to the Safavid-held fortress of Yerevan. As he went he took the opportunity to wreak summary justice for the rebellions and brigandage which had blighted his early years as sultan, executing those against whom there were complaints, who included a number of provincial governors deemed to have misused their powers.[80] Such stern disciplinary tactics also served him well in the harsh conditions of warfare on the eastern frontier, discouraging the mutinies which had so often blighted the campaigns of earlier sultans.

Yerevan had been held by the Ottomans between 1583 and 1604; it now withstood an eight-day siege before the garrison surrendered on 8 August 1635. From Yerevan Murad's army continued south to Tabriz, but the experience of previous occasions when the Ottoman army had been able to reach this city was repeated: they could not hold it, and at the approach of winter retreated to Van. A great friendship blossomed between the Sultan and the defeated governor of Yerevan, Mirgune Tahmasp Quli Khan, who became known to the Ottomans as Emirgün. Emirgün was subsequently summoned to Istanbul, where he was given a regular income, and a garden in the Bosporus village today known as Emirgan in which he built a palace 'in the Persian style'.[81] Murad spent much time in Emirgün's company and, according to Jean Baptiste Tavernier, a seventeenth-century French visitor to Istanbul, they indulged in drinking bouts together.[82]

In December 1635 Sultan Murad made a splendid ceremonial entry into Istanbul, as the warrior who had re-established the tradition of his fore-fathers. His victory was commemorated with the building of the Revan pavilion in the gardens of Topkapı Palace on a terrace overlooking the Golden Horn; the fact that Yerevan was retaken by the Safavids within eight months of Emirgün's surrender – and three months after Murad's entry into Istanbul – was not allowed to tarnish the success of the campaign. Possibly the loss of Yerevan was seen as no more than a temporary setback: news of the Safavid counter-attack prompted the sending of an army to help the Ottoman garrison retain the city, but it was too small and the weather was freezing cold. The grand vezir Tabanıyassı Mehmed Pasha, who had remained in winter quarters in Diyarbakır, was dismissed on account of the loss of Yerevan and replaced by the Sultan's brother-in-law Bayram Pasha, a former janis-sary commander-in-chief and governor of Egypt.[83]

Although they had retaken Yerevan and defeated an Ottoman army in battle, the Safavids sent an envoy to sue for peace when they heard that Sultan Murad was preparing for another campaign in the east,[84] but Murad was not to be dissuaded. Before he left Istanbul this time, he ordered that all the guilds of the city should pass before him in procession. Evliya Çelebi's lively report of this colourful ceremony suggests that he may have been present himself, but he notes that the lengthy description of it found in his 'Book of Travels' was copied from a manuscript known as the 'Description of Constantinople' in the possession of his patron and kinsman, the statesman Melek ('Angel') Ahmed Pasha (the manuscript's whereabouts is today unknown). From the Pavilion of Processions in the south-west corner of the outer wall of the palace enclosure the Sultan viewed the march-past of the guilds, representing 735 trades and professions. The descriptions of them copied by Evliya Çelebi include notes about their history and practices, and according to him the procession, like much that Murad ordered, was for the purposes of enumeration; the 'Description of Constantinople' also contained an inventory of all the buildings of the imperial city, from mosques to prisons, and the intention was that this inventory should super-sede the one ordered by Sultan Selim II some half-century earlier.[85]

The imperial Ottoman army with the Sultan at its head left Üsküdar on 8 May 1638 and travelled by way of Konya, Aleppo, Diyarbakır and Mosul to reach Baghdad in November. The fortress surrendered after a siege lasting 39 days. On taking this predominantly Shia city Murad ordered the repair of the mausoleum of the theologian and mystic 'Abd al-Qadir al-Gilani which Süleyman I had built after he took Baghdad in 1534, when he also reconstructed the shrine of the eminent jurist Abu Hanifa; Murad's atten-tion to al-Gilani's mausoleum was similarly intended to reassert the pre-

eminence of the Ottoman practice of Islam over that of the defeated Safavids. Zekeriyazade Yahya Efendi travelled to Baghdad with Murad, the first time that a sheikhulislam had accompanied a campaigning army.[86] On his return to Istanbul the Sultan celebrated his victory with construction in the palace grounds, overlooking the Golden Horn, of the Baghdad pavilion – a companion to that he had built after the Yerevan campaign.

Sultan Murad IV was also involved in another significant building project elsewhere in his empire: his name appears in an inscription as the last in a line of rulers to rebuild the holiest shrine of Islam, the Ka'ba in Mecca. Attempts had been made to strengthen its walls during the reign of Murad's father Sultan Ahmed, but a devastating flood in 1630 had brought the structure close to collapse. Rebuilding it was no straightforward task, either practically – it must be reverently taken apart stone by stone because it was considered to have been made by God – or philosophically – some religious authorities held any modern reconstruction to be unacceptable, while others held such work to be the traditional responsibility of the Sharif of Mecca rather than of the distant Ottoman sultan. Legal opinion was sought and a compromise was reached: the state provided the necessary materials and expertise (probably not locally available) and the Meccan notables received robes of honour to mark various phases of the rebuilding programme and said prayers for the Sultan and the continuation of Ottoman rule in recognition of this gesture. The prominent reference to Murad's part in the project in the inscription was a reminder to the Islamic community of the beneficent acts of the Ottoman sultans as protectors of the Holy Places.[87]

Although the Thirty Years' War in which Europe had been embroiled since shortly after the death of Sultan Ahmed freed the Ottomans to pursue their strategic interests in the east, lesser issues in the west which had remained unresolved at the beginning of the century re-emerged to demand attention during these years. One was the question of sovereignty over Transylvania, where succession to the princedom of this vassal state was contested following the death of Gabriel Bethlen in 1629 and the Ottoman force sent in 1636 to curb the over-independent stance of his successor George Rákóczi was defeated.[88] Nevertheless, in 1642 the Treaty of Zsitvatorok which had concluded the Habsburg–Ottoman war of 1593–1606 was renewed at the wish of both parties: the Thirty Years' War ended in 1648 and the Habsburgs, who were the main protagonists, were more than willing to renew the treaty again the following year.[89] The agreement between the Ottoman Empire and Venice to act against a common enemy did bring the Ottomans a small part in the Thirty Years' War. At issue was control of the Valtellina pass through the Alps northwards from Italy, essential to the Habsburgs for

communication with their north Italian and Dutch possessions. In 1624–5 Venice requested and received permission from Sultan Murad to recruit mercenaries from certain areas of Ottoman-held Bosnia, Albania and the Peloponnese to assist in the defence of its interests against the Habsburgs.[90]

The peace treaty agreed in 1623 between the Ottomans and the Polish-Lithuanian Commonwealth after Osman II's defeat at Khotin had failed to resolve the problems associated with their respective vassals, the Crimean Tatars and the Ukrainian Cossacks, but at no time did the two states engage in all-out war in these years: the peace of 1623 was uneasily maintained, even following the phoney war of 1634, and the Ottoman army, navy and local troops were kept busy on the Black Sea frontier patrolling the shores and sea-lanes and garrisoning the strongholds on the entire seaboard as Cossack raids into Anatolian and Rumelian coastlands continued unabated. Unlike the Tatars, the Cossacks were as at home on sea as on land, and the Ottoman Black Sea galleys were no match for their small, manoeuvrable craft. A special flotilla of smaller vessels was built to combat them in the shallow waters where the great steppe rivers debouch into the Black Sea, but the Cossacks were also masters of concealment and easily able to avoid battle with Ottoman vessels.[91] For three-quarters of a century, from the time it first had a presence on the northern Black Sea coast in 1475, the imperial power had 'managed' this frontier without undue concern, free to direct its resources to more troubled areas of the Ottoman domains; the subsequent turmoil in the steppe of the years when Dmytro Vyshnevetsky had led the Cossacks was merely a foretaste of the early seventeenth-century Cossack irruption into the 'Ottoman lake', when even large towns such as Feodosiya, Bilhorod, Constanţa, Varna, Samsun and Trabzon were repeatedly attacked and even sacked. Nor were settlements on the lower Danube – such as Kiliya, Izmail, Brăila and Isaccea – spared. This was of immense significance: it disrupted the supply of raw materials and food-stuffs on which the city of Istanbul and the economy of the empire depended.[92] The Cossacks also struck far inside the Bosporus on several occasions in these years: in 1624 they sacked and burned the coastal villages at least as far south as Yeniköy. The English ambassador Sir Thomas Roe witnessed the raid of 19 July 1624:

> . . . between 70 and 80 boats of the Cossacks with 50 men apiece, rowers and soldiers, watching the opportunity of the captan bassa's [i.e. the grand admiral] being engaged in Tartary, entered the Bosphorus about the break of day; where dividing themselves they sacked and burnt almost all the villages and houses of pleasure [i.e. waterside villas], on both sides of the river, as far as the castles [i.e. Rumeli Hisarı and Anadolu Hisarı] and within four miles of this city [i.e. Istanbul]. The principal places were Baiukdery [i.e. Büyükdere] and Jenichoie [i.e. Yeniköy], and Stenia on the Asia shore [i.e. İstinye, on the European

shore?]; where having made great and rich booty, they stayed until nine of the clock in the forenoon; and then all this city and suburbs having taken the alarm, the grand seignior [i.e. the Sultan] came down to the water's side . . . having not one galley ready for defence, they manned and armed all the ship-boats, barges and other small wherries to the number of 4 or 500, with such people as they could either get to row, or hope to fight; and despatched all the horse and foot in the city, to the number of 10,000 to defend the coast from further spoil; never was seen a greater fear and confusion.[93]

Roe reported that Cossack raids in the Bosporus so alarmed the government that if the imperial council was in session when news of another arrived, it 'broke up in rage and haste[ned] to send out to prevent their further invasions'.[94]

Following the Khotin war, in 1623 Mehmed Giray [III] became khan of the Crimea and the next year his brother Şahin returned there from the court of Shah 'Abbas where he had fled ten years earlier during a succession dispute. Şahin's closeness to the Shah prompted the Ottoman government to restore the brothers' rival for power, the former khan, Canbeg Giray. Canbeg travelled by sea from Istanbul but he needed Ottoman help to secure the throne, which the Ottomans, their military and naval forces already overstretched, could hardly provide. Mehmed and Şahin entered into the first-ever political alliance with the Cossacks of the Dnieper, the erstwhile mortal enemies of the Crimean Tatars, to confront Canbeg, and in July the Ottoman Grand Admiral sailed for the Crimea to assist him. Their combined forces could not resist the Tatar–Cossack attack – the Tatars surrounded them, Canbeg and his men fled, the Ottoman infantry was slaughtered, and the Tatars seized the campaign treasury.[95] Mehmed Giray remained as khan with Şahin as his heir-apparent. In 1625 the Cossacks raided Trabzon to devastating effect,[96] only one among a number of fearsome attacks in these years. A great sea battle between an Ottoman fleet and the Cossacks took place outside the Danube delta early in August: the Ottoman Admiral was saved only by a favourable wind.[97]

The Tatar–Cossack alliance alarmed the Polish government as much as it did the Ottoman, and it took steps to suppress the Cossacks lest they provoke war between the Commonwealth and their powerful neighbour. In a dispatch back to England commenting on the new regional situation that arose with this alliance Thomas Roe wrote, 'any intelligence between these two roving nations . . . will prove very troublesome to this city and state'.[98] European diplomats in Istanbul were keenly aware of the implications of developments in the Black Sea for Ottoman power in the Mediterranean and central Europe; they therefore followed them closely and attempted to influence events in ways that would favour their own

states. Thus, for the Habsburgs, difficulties in the Black Sea served to divert the attention and energy of the Ottomans from central Europe, while for their rivals – France and England – peace in the Black Sea freed Ottoman forces to engage the Habsburgs and their allies.[99]

In order to meet the Cossack threat the Ottomans decided to improve their defences in the northern Black Sea region in the hope that they could more readily hinder, if not prevent, the Cossacks from sneaking down the Dnieper into the open sea. In the course of two expeditions, one in 1627 and another in 1628, they added some new forts to the fortress complex at Ochakiv at the mouth of the river. In addition, in 1628, they were able to unseat Mehmed and Şahin Giray, despite their Cossack support.[100] The frequent succession struggles among the family of the Tatar khans of the Crimea – in which one member would seek allies among their neighbours against another – often provoked the Ottomans to intervene to ensure that their preferred candidate was on the throne.

Just as the Cossacks of the Dnieper had to negotiate their way past the fortress of Ochakiv at the river mouth in order to reach the Black Sea, the free passage of the Don Cossacks was hindered by the port city of Azov, which had been Ottoman since 1475. In 1636 the Don Cossacks laid siege to Azov with the support of their Ukrainian fellows, taking it in the next year, and leaving their champion, Muscovy, with the dilemma of whether to support them and risk inciting Ottoman anger. The Ottomans expended great efforts to recover Azov over the next few years, fearing attacks on their forts at the mouth of the Sea of Azov which if successful would allow the Cossacks another point of entry into the Black Sea.[101] A major expedition to retake Azov was mounted in 1641 when the fleet sailed forth and, together with the Tatars, besieged the fortress for many weeks even as the defenders' successful mining operations claimed many lives, until at the approach of winter they were forced to withdraw without being able to dislodge the Cossacks.[102] But Muscovy refused the defenders of Azov any support and the next year they relinquished the fortress to the relief of the Ottomans.

Muscovy remained reluctant to antagonize the Ottomans for most of the seventeenth century – being more concerned with Sweden and the Polish-Lithuanian Commonwealth – a policy which only changed with the (failed) expeditions southwards across the steppe in the 1680s during the Ottoman–Holy League wars, and Peter the Great's attack on Azov in 1696. The siege of Commonwealth-held Smolensk, south-west of Moscow, in 1632–3 had been a humiliating revelation of Muscovy's military weakness; for an army which had failed to achieve this modest goal to take on the greatest military power in the region would have been suicidal.[103] Muscovy continued to pay tribute to the Tatar khans of the Crimea – as it had in

medieval times to their ancestors, the khans of the Golden Horde; this was a reminder of its status, but that it now dared refer to this tribute as a 'gift' indicated a perceptible shift in their relations.[104] The power struggle in the steppe which had begun with the break-up of the Golden Horde in the fifteenth century was, in its broad outlines, not dissimilar from that which had taken place in south-eastern Anatolia between Mamluk Egypt, Safavid Iran and the Ottomans more than a century earlier. Both Muscovy and the Commonwealth were taking the first steps towards expansion into the steppelands which the Ottomans had for so long looked upon as a buffer zone policed on their behalf by the Crimean Tatars.

Much as the Black Sea shores of the Ottoman Empire were frequently the object of Cossack raids, so its Mediterranean and Adriatic frontiers and its shipping were harassed by corsairs from the North African littoral and the Adriatic itself – the latter known as Uskoks, and supported by the Habsburgs – who also attacked the trading vessels of Malta, Venice and other Italian republics, as well as those bearing Muslim pilgrims to Mecca or carrying slaves from Africa to Istanbul. On occasion, when the commercial loss was high and the affront too great, the Ottomans retaliated, but the generally cordial relations which existed between Ottomans and Habsburgs were maintained unless local authorities acted in the heat of the moment and took matters into their own hands.[105] One punitive response by Venice to corsair activity in the Adriatic led to an explosive incident in 1638 (while the Baghdad campaign was under way), when a North African fleet numbering sixteen ships raided the coast of Calabria. This alarmed the Venetians who sent a fleet of their own in pursuit. When the North African corsairs took refuge in the Ottoman Adriatic port of Vlorë, the Venetians blockaded the port, fired their cannon at the fortress, and seized the ships of the corsairs, sinking fifteen and sending one to Venice as a trophy. Reprisals against Venetians within the Ottoman Empire were threatened as was the cutting of trade between the two states, but wiser counsels prevailed and the incident was finally brought to a conclusion through diplomatic channels; the Bailo was released after ten months' imprisonment and, as in 1573, Venice paid an indemnity to the Ottomans.[106]

In the east, the peace agreed with the Safavids in 1639 by the treaty of Zuhab brought to an end the long Ottoman–Safavid struggle which had begun with the battle of Çaldıran in 1514. Henceforth the Ottomans were preoccupied with events elsewhere, and the peace held until the fall of the Safavid dynasty in the 1720s. By its terms the Safavids retained Yerevan and its neighbouring territories in the Caucasus while the Ottomans kept Iraq and Baghdad, and this re-establishment of the equilibrium lost since the Amasya treaty of 1555 was one of Murad IV's greatest achievements.

8

Revenge of the pashas

IN FEBRUARY 1639, on his way back to Istanbul after recovering Baghdad from the Safavids, Sultan Murad reached Diyarbakır; he was ill, and had to rest there for two months before continuing home to Istanbul. Within a year he was dead – at the age of 29 – and was buried in the crowded dynastic tomb of his father Ahmed I. His uncle, the incompetent two-times sultan Mustafa I, had died shortly before. In a departure from recent practice, Murad had waited until he was home from his various campaigns before despatching his brothers: Bayezid* and Süleyman – half-brothers to Murad and full brothers to Osman II – had met their end at the time of the celebrations marking the Yerevan campaign of 1635; Murad's full brother Kasım was killed on Murad's return from Baghdad.

Murad had spared only one brother – probably in response to the pleas of his mother, Kösem Sultan – and İbrahim, known as 'Crazy' İbrahim, became sultan. For the first time since Süleyman I succeeded his father Selim I, there were no rival claimants: Murad had no surviving son, and the direct male line was all but extinguished. İbrahim's mental health may have been in doubt, but the consequences of a complete failure of the Ottoman line can only be imagined. When he was summoned from the inner recesses of the palace, İbrahim was unable to believe that Murad was dead, and assumed that he was about to share the fate of their unfortunate brothers.

Sultan İbrahim kept on Murad's appointees as sheikhulislam and grand vezir. Zekeriyazade Yahya Efendi remained sheikhulislam until his death in 1644, after a total of eighteen years in office under three sultans. Murad's final grand vezir, Kemankeş Kara ('Black Archer') Mustafa Pasha, had nego-tiated the peace treaty which brought the Iranian wars to an end and enjoyed a relatively long tenure of office (some five years) before falling victim to factional struggle and execution, also in 1644. As the mother of a sultan who showed little inclination to participate in state affairs, Kösem Sultan

* As Osman's full brother Bayezid could be considered the rightful heir in Murad's place. His fate inspired the French playwright Racine to dramatize his story in a play first performed in 1672. Racine knew of Murad's murder of Bayezid from the despatches of Count de Cézy, French ambassador to the Sultan's court at the time of the fratricide.

again came to the fore, and again she exercised the power she had relinquished after the bloody events of 1632. Competition between the Grand Vezir and the Queen-mother was inevitable, but power struggles at the highest level were kept in check during the early years of İbrahim's reign.[1]

Kemankeş Kara Mustafa Pasha continued the reforms begun under Murad IV and his former grand vezir Tabanıyassı Mehmed Pasha; as with Tabanıyassı Mehmed's four and a half years in office, this further period of stability gave the respite from factional infighting which allowed for their continuing enactment. The exchequer was brought to concede that the resettlement of peasants on their former lands was fraught with insoluble problems, and a new tax survey was ordered which required instead that they be registered where they were presently to be found.[2] Kemankeş Kara Mustafa reduced the numbers of janissaries and cavalrymen to 17,000 and 12,000 respectively. He stabilized the currency, required that payments into and withdrawals from the treasury be made in cash, rather than by notes-of-hand,[3] and issued a detailed price code.[4] He also took measures against one of the most intractable problems of the age, the proliferation of those of no evident value to the state who nevertheless drew salaries from the treasury.

It was inevitable that such a determined grand vezir should arouse opposition, and in 1642–3 another rebellion erupted. The governor of Aleppo, Nasuhpaşazade Hüseyin Pasha, son of Ahmed I's grand vezir Nasuh Pasha, was on very bad terms with Kemankeş Kara Mustafa Pasha.[5] Nasuhpaşazade Hüseyin sheltered a troublemaker sought by the government, ignored orders sent from Istanbul, and illicitly inserted the sultan's cypher at the head of his communications – vezirs serving in the provinces were forbidden the privilege of using the cypher;[6] he also complained that the Aleppo post had cost him so much money that he could not meet his outstanding debts from the income the position brought – Katib Çelebi reported that it was around this time that senior governmental posts began to be awarded to those who could pay for them. Kemankeş Kara Mustafa appointed Nasuhpaşazade Hüseyin to the governorship of Sivas instead, but secretly ordered the incumbent governor to confront him with military force – the hapless governor was killed in the mêlée and Nasuhpaşazade Hüseyin marched on Istanbul to air his grievances. His army grew as he crossed Anatolia. At İzmit, only some hundred kilometres from Istanbul, he routed a force sent against him from the capital and pressed on to Üsküdar. Contemporary accounts of his end differ. According to one version, Nasuhpaşazade Hüseyin took ship on the Black Sea before being captured by government agents outside Ruse on the Danube and killed.[7] Another version has the Grand Vezir feigning forgiveness and promising him the governorship of the province of Rumeli before sending executioners across the Bosporus to exact punishment.[8]

Nasuhpaşazade Hüseyin Pasha had aspired to become grand vezir; another rival for Kemankeş Kara Mustafa Pasha's office was Civan ('Young Fellow') Kapucubaşı ('Gatekeeper') Sultanzade Mehmed Pasha, who had crowned a relatively successful military and administrative career by recovering the fortress of Azov from the Cossacks in 1642 while he was governor of the province of Özi on the northern Black Sea coast. Kemankeş Kara Mustafa's reforms threatened many vested interests, making his position vulnerable, and late in 1643, the Grand Vezir distanced Civan Kapucubaşı Sultanzade Mehmed from court, appointing him to the governorship of Damascus. But Kemankeş Kara Mustafa could not hope to outmanoeuvre the factions conspiring against him indefinitely: Nasuhpaşazade Hüseyin's uprising was only one symptom of the dissatisfaction his reforms engendered, and in February 1644 Sultan İbrahim gave the order for his execution. Civan Kapucubaşı Sultanzade Mehmed was recalled from Damascus and appointed grand vezir in his place.[9]

Sultan İbrahim left day-to-day matters in the hands of his vezirs, but like his brother Murad was ready to listen to the promptings of favourites. Where Murad had been encouraged by the Kadızadeli preachers to close the coffee-houses and enforce the sumptuary laws, İbrahim's ill health made him a ready prey to quackery of all sorts. In Cinci ('Demon-chaser') Hüseyin Hoca he found the spiritual adviser to suit his needs. Officially, the summit of Cinci Hüseyin's career was his appointment as chief justice of Anatolia, but the part he played in the politics of the day far exceeded the limits of that office.[10] The Sultan's preferment of Cinci Hüseyin indicated that the Sheikhulislam's position had become insecure but, providentially, Zekeriyazade Yahya Efendi died before Sultan İbrahim was inspired to remove him.

Like the corsair incident at Vlorë in 1638 which had threatened to escalate but was then defused, that which occurred in the summer of 1644 also had the appearance of one that could be resolved. Yet it sparked a war between Ottomans and Venetians that lasted intermittently until 1669. Contemporary Ottoman sources – including Katib Çelebi – report that that summer, Maltese corsairs attacked a small fleet off the island of Karpathos which lies between Rhodes and Crete. Aboard were Chief Black Eunuch Sünbül Agha, sailing into internal exile in Egypt, as was customary for chief black eunuchs when they were pensioned off, and a number of prominent pilgrims on their way to Mecca. Sünbül Agha was killed in the confrontation, and captured treasure was loaded on to a ship which docked briefly in a Cretan harbour; in recognition of the assistance they had been rendered, the corsairs presented part of the treasure to the Venetian governor-general of Crete. As one of Sünbül Agha's horses was being off-loaded for presentation to the governor of Candia its hooves touched the ground which, says Katib

Çelebi, was taken for a bad omen. After a few days the corsairs sailed west, but before they had gone very far, they scuttled the captured Ottoman boats with the loss of the remaining supplies and animals on board.[11]

News of this act of piracy provoked outrage in Istanbul, where it was considered that the Venetians of Crete had wilfully flouted the terms of the agreement that no corsair vessels intent on or guilty of attacking the shipping of the other party be given shelter. According to Giovanni Soranzo, the Venetian bailo in Istanbul, all foreign envoys in the capital were summoned to an audience with the Sultan's influential favourite Cinci Hüseyin Hoca; they were cross-examined as to the involvement of their respective sovereigns in the affair, and each ordered to make separate written statements. At first refusing to do so, they then consented, with the proviso that the truth could only be ascertained by sending someone to Crete for the purpose. Some Ottoman sailors who had survived the incident eventually made their way back to Istanbul, where they revealed that the Maltese had in fact remained on Crete for twenty days, selling their booty and taking on supplies. To the Ottomans this was no minor infringement, which could be overlooked – and it smacked of a deliberate alliance between the Venetians and their co-religionists on Malta.[12]

The other side's explanation of the incident was greatly at variance with the Ottoman version. The Venetian governor of Crete reported to the Doge that the Maltese vessels had landed only long enough to put ashore some Greeks in their company before continuing on to Malta; indeed, the officer responsible for the stretch of coast where the Maltese had landed had since been executed for being absent from his post at the time. Two such different versions of events could not be reconciled. It was clearly in Venice's interest to keep the peace, for it could not afford to defend itself or its possessions against Ottoman attack: on Crete itself, the indigenous Greek population was unlikely to rise in defence of Venetian masters for whom they had no love. There seems to have been scant discussion in the Ottoman imperial council regarding the usefulness of going to war over this incident: the bellicose stance adopted by Cinci Hüseyin Hoca was supported by Silahdar ('Sword-bearer') Yusuf Agha, another favourite of Sultan İbrahim, a Dalmatian renegade and also his son-in-law.[13] Silahdar Yusuf was promoted to the rank of pasha and appointed grand admiral in command of the combined land and sea operation.[14] With Kemankeş Kara Mustafa Pasha dead and his moderating voice silenced, the war party was in the ascendant.

Malta was thought to be the destination of the Ottoman fleet that was now making ready for sea in the imperial dockyard. Still maintaining its innocence, Venice could not believe otherwise, and was taken by surprise when the Ottoman armada arrived off Crete on 26 June 1645.[15] During

this first summer of campaigning the Ottomans took the fortress of Chania (Canea) after almost two months, allowing its defenders to go free with their lives and possessions intact, in keeping with the Islamic code of war and with Ottoman practice. The conquest was symbolized by the transformation of the cathedral into the main mosque of the city, which was named for the Sultan; of two other churches also converted, one was named for the victorious commander, Silahdar Yusuf Pasha.[16]

But Silahdar Yusuf Pasha did not long survive this promising fillip to his career. He returned to Istanbul to face criticism from the grand vezir Civan Kapucubaşı Sultanzade Mehmed Pasha with regard to his handling of the siege, and in particular of the fact that he had brought back so little booty. Although Sultan İbrahim, having listened to the arguments of both sides, proceeded to strip Civan Kapucubaşı Sultanzade Mehmed of the grand vezirate, Silahdar Yusuf found that the constancy of the Sultan's favour was not to be relied upon: when he refused to return to Crete on the grounds that winter was not the season for campaigning, and that the fleet was in any case unprepared, İbrahim ordered his execution for disobedience.[17]

In 1646 hostilities spread to another theatre of the fragmented Venetian–Ottoman frontier when the Ottomans conquered significant Venetian territory on the Dalmatian coast, only to lose some of it the following season.[18] The war on Crete was going well, however. Rethymno fell early in the year and the smaller strongholds throughout the island shortly thereafter. The siege of Iraklion (Candia), the largest city on the island, began in October 1647 (and continued for the next 22 years), and by 1648 the remainder of the island bar a couple of minor forts was in Ottoman hands; it even proved possible to impose a basic form of Ottoman administration, though the island produced little in the way of taxes as yet.[19] But Ottoman luck was about to run out. Venetian forces had landed on the island of Bozcaada (Tenedos) in 1646, and although they had been repulsed, that they could harass Ottoman shipping so close to their home base – and at a highly-strategic point along the sea route to Crete – did not bode well for the future. In 1648 a Venetian fleet blockaded the Dardanelles and for a year the Ottomans were unable to sail out into the Aegean and supply their garrisons on Crete; supplies for Istanbul were also affected. The Ottoman navy moved its base – by land – to the fortified west Anatolian harbour of Çeşme, enabling it to overcome to some extent the immobility in operations which the blockade imposed.[20] In April 1649 a new and mighty fleet was launched from Istanbul and the blockade was broken.[21]

The outbreak of hostilities between the Ottoman Empire and Venice had repercussions far away from the theatre of war on Crete. Polish exasperation with the Crimean Tatars had reached a new level in recent years

as the effort required to defend the Commonwealth against their raids diverted resources which could better have been employed elsewhere. King Wladyslaw IV had harboured plans for a 'Turkish war' since soon after he came to the throne in 1632, and now found a ready ear in the Venetian envoy to his court, Giovanni Tiepolo, who proposed to him that while Ottoman attention was focused on Crete the Cossacks, who were nominally Wladyslaw's subjects, should attack the Ottoman Black Sea coasts – a tactic that had in the past caused great consternation in Istanbul; Tiepolo also offered financial help. Wladyslaw considered that it was too dangerous to directly provoke the Ottomans and held to his view that the wiser course was to launch an attack on the Tatars which would in any case escalate into war with their Ottoman suzerain. This idea appealed to Tiepolo who in March 1646 obtained the Venetian government's promise that it would subsidize such an endeavour.[22]

Wladyslaw failed to find backing from his own government, but the Commonwealth's neighbours – Muscovy, and the Ottoman vassal states of Wallachia, Moldavia and Transylvania – all intimated that he could count on their support for his scheme which he deemed he could carry out at minimum cost using the Cossack forces at his disposal. But there was a lull in Tatar raids into Commonwealth territory at this time and the Ottoman government, aware of the great difficulty of conducting warfare on two fronts, adopted a conciliatory tone in its dealings with Wladyslaw. Most significantly, however, the constitution of Poland did not permit a war of aggression and his own government refused to budge; the King had no alternative but to bow to its will.[23]

The war with Venice was fought against a background of Ottoman administrative confusion. Once Murad IV's most senior statesmen had been removed from the scene, instability in the affairs of both palace and government marked İbrahim's reign. Although the Sultan's feeble-mindedness provided an opportunity for his mother to intervene in decision-making, she was powerless to prevent him looking to his own favourites for advice. He occupied himself in the *harem*, showing little interest in either foreign or domestic politics. Members of the government jockeyed for position as the fortunes of the factions to which they were allied rose and fell. Intrigue was the order of the day, but fraught with peril: murmurings by Salih Pasha, grand vezir from 1645, that Sultan İbrahim should be deposed and replaced by one of his sons brought him swift retribution in 1647.[24] Despite the reforms initiated by Murad IV to make it easier for the state to collect the revenues which were its due, the treasury was again empty.

Continuing unrest in the provinces was another sign of disaffection

pervading society. Anatolia was in turmoil. The life of the peasants was disrupted as much by local brigandage as by the politically-motivated rebellions of such as Abaza Mehmed Pasha and Nasuhpaşazade Hüseyin Pasha. Their response was to abandon their traditional way of life, which many did as economic conditions deteriorated, and seek their fortune as military men in the retinue of one or other pasha, or to resort to pillaging the countryside in the company of their fellows. State rhetoric made a distinction between rebellion and brigandage. Pashas were regarded as Ottomans, first and foremost, and rebellious pashas were considered as aberrant members of this ruling class for which they had been moulded by education; until and unless they proved themselves particularly recalcitrant, they were brought back within the fold, for a time, at least. Brigands, on the other hand, were social inferiors in the eyes of the state, members of the tax-paying peasant class who had illicitly renounced their ordained position in the social order, and were punished according to the criminal code. It was rare for any brigand to enter the ranks of the Ottoman elite. Rebellious pashas and brigands alike raided passing caravans, oppressed the peasantry, opposed agents of the central government charged with tax-collection, and were both loved and hated by local people. They offered the unemployed an outlet for their energies, and recruited many armed young men into their ranks; they were also the subject of contemporary ballads, which alternated between advising them to give up their lawless ways and encouraging them in their clash with authority.[25]

Typical of the brigand chiefs of these years was Karahaydaroğlu Mehmed who, taking advantage of the absence of the Ottoman troops in Crete, from the mid-1640s followed his father Kara ('Black') Haydar into brigandage; he plundered caravans along the main routes through western Anatolia, at the same time demanding the governorship of a sub-province. This was refused him, and an army under the command of İpşir Mustafa Pasha, governor of Karaman province (who had been brought up in the household of Sultan Osman's would-be avenger Abaza Mehmed Pasha and would later become grand vezir[26]), was sent to apprehend him in the winter of 1647–8 but failed, as did subsequent attempts. Karahaydaroğlu Mehmed was eventually caught and hanged in late 1648.[27] Like others of his kind, he is remembered in a popular song:

> Haydar-oğlu, can you be in your right mind?
> How could you turn rebel against Osman's most exalted domain?
> However many cruel acts you have committed in this world
> one by one you shall be called to account for all.
>
> . . .

Why would you not stay put and be peaceable?
Now it is you, your name is on everybody's tongue;
Take heed for it is at the hands of Kara-Ali [i.e. the executioner]
that you will die a death of a thousand torments.

. . .

Katib Ali [i.e. the author] says: Go tend to your own business;
they will reduce the whole world to your head on the gallows
one day black ravens will alight on your corpse;
do not suppose you can hang on to such magnificence.[28]

The rebellion of Abaza Mehmed Pasha in 1623 had erupted to avenge
Sultan Osman's murder, and Nasuhpaşazade Hüseyin Pasha's grievance was
the restriction placed upon his authority as provincial governor. Another
Anatolian uprising which similarly threatened to exacerbate the discord in
Istanbul by adding to it the quarrels of the provinces was that of Varvar Ali
Pasha, governor of Sivas. The historian and bureaucrat Mustafa Naima,
whose history was compiled half a century later, reports that in 1647 Istanbul
demanded 30,000 aspers from Sivas as a contribution to the festivities planned
to accompany the holy month of Ramadan, but after consultation with the
notables of the city Varvar Ali decided that he could not impose this burden
on local tax-payers. Other demands from Istanbul followed, including one
that a wife of İpşir Mustafa Pasha be sent to Istanbul – which Varvar Ali
refused on the grounds that the wife of a Muslim should not be handed
over to anyone other than her lawful husband – and eventually his increasing
exasperation provoked him to speak out against those he held responsible
for the disruption of rural life. He blamed the Sultan for not attending to
affairs of state, complaining that the sultanate had fallen into the hands of
the women around him, and pinpointed the brevity of governor and sub-
governor appointments as the besetting evil, for in his view, since senior
posts in the provinces could not typically be made to pay for themselves
before three years were up, each new incumbent was encouraged to make
as much money as possible, at the expense of the local people, before he
was dismissed. Varvar Ali announced that, in the interests of the smooth
running of the state, he would go to present his case in Istanbul in person.[29]

Evliya Çelebi, who was in Erzurum at this time, recorded how the governor
of the province, his current patron Defterdarzade ('Son of the Treasurer')
Mehmed Pasha, received news of Salih Pasha's execution and a warning that,
as a protégé of the late grand vezir, his own life was in danger from the new
grand vezir Hezarpare ('Thousand Pieces') Ahmed Pasha, who had succeeded
Salih Pasha five days after his death, and was intent on disposing of the many
provincial governors he considered insubordinate. Defterdarzade Mehmed
discussed the letter with his officials and asked how they would react if he

were to seize the local treasury and shut himself up in Erzurum castle, 'to become a Celali like Abaza [Mehmed] Pasha'; his attempt to expel the janissary garrison from the fortress failed, however.[30] Shortly thereafter, while at Erzincan, Evliya Çelebi reported the arrival of a letter from Varvar Ali Pasha with the news that he had been dismissed from the governorship of Sivas over the incident involving İpşir Mustafa Pasha's wife, and was marching on Istanbul with a numerous and powerful retinue which included seven other provincial governors and eleven sub-provincial governors. Varvar Ali referred to Hezarpare Ahmed's reign of terror and proposed that Defterdarzade Mehmed and his men join him on his march on Istanbul – Defterdarzade Mehmed agreed and frantic preparations began. Evliya Çelebi found himself caught up willy-nilly in the confusion, but his foremost concern was for the goods he was carrying with him.[31]

Varvar Ali Pasha's plan had been to divide the eastern provinces of the empire among the rebellious pashas, including İpşir Mustafa Pasha, but his proposed coalition did not hold. Defterdarzade Mehmed Pasha sent Evliya Çelebi with a letter to Varvar Ali, who was at the time camped south-east of Amasya, warning him against İpşir Mustafa whom he said was not to be trusted. İpşir Mustafa's successor as governor of Karaman, Köprülü Mehmed Pasha, had meanwhile been ordered to command the royalist troops sent to rout Varvar Ali's army, but before they could mobilize, Köprülü Mehmed was captured by Varvar Ali. Soon, İpşir Mustafa and his troops arrived at Varvar Ali's camp, now north of Ankara, rescued Köprülü Mehmed and had Varvar Ali executed – before Evliya Çelebi had had time to warn him of a plot hatched in Istanbul for Defterdarzade Mehmed Pasha to hunt him down, just as Varvar Ali had been ordered to kill Defterdarzade Mehmed. Evliya Çelebi endured an awkward interview with İpşir Mustafa but stoutly denied that he had any close association with Defterdarzade Mehmed, claiming that he had merely found himself on the road by chance and been caught up in the mêlée.[32]

Varvar Ali Pasha wrote a verse autobiography detailing his career as a state servant, including his recruitment by the youth-levy – which had all but ceased by the middle of the seventeenth century when janissary numbers were so great as to render it obsolete, and there was no longer any need for Christian converts to people the Ottoman ruling class. Varvar Ali's couplets are important as one of the few personal accounts of a career in the military-administrative hierarchy of the Ottoman Empire. He had been drafted by Sultan Ahmed's agents around 1600 – 'they took me weeping and in distress, I did not know what was in store for me' – and sent to Istanbul to be educated as a page in the palace service. After four years of preparation he spent ten years in training in the palace, and then became one of Sultan Ahmed's falconers, in which capacity he had a chance to impress the Sultan:

... One day it happened that on going out for the chase the Sultan
approached and himself received the falcon from my own hand;

Espying a vulture in the sky, he had no sooner loosed the falcon
for the pursuit when, felled, the prey dropped to the plain;

Addressing me at that moment, 'Pray tell' he bade,
'reveal to me your heart's desire, your wish is my command';

In reply I entreated, 'As one of your pages in the senior service,
may you grant my wish and permit me to attend you on the march'.

This was the start of a closeness to successive sultans, such as every recruit
into the Ottoman ruling class must have striven for. Varvar Ali Pasha
served Sultan Osman II on the Khotin campaign, and his reward was to
be assigned to the sultan's cavalry. He won a land-grant in the province
of Damascus, but left the cavalry in disgust over the part played by the
sultan's regiments in Osman's overthrow; he was soon appointed a janis-
sary commander in Egypt, returning to Istanbul a year later as chief of
two falconry units in turn. By about 1625 he was serving the young
Sultan Murad IV on the hunt, won his favour, became a cavalry
commander and took part in the ill-fated Baghdad campaign of 1629–30.
He was then appointed governor of Cyprus – his first significant post –
where to his regret he remained for only six months before being recalled
to Istanbul; he was next sent to govern Adana, Cyprus again, Diyarbakır
and Maraş in turn. In 1635 he accompanied the Sultan on his campaign
to reconquer Baghdad and was rewarded for his valour with money and
a *kaftan*:

... Thrice on the campaign Shah Ismail's men [i.e. the Safavid troops] I
vanquished by God's will and submitted my trophies to our sultan;

In recognition of my feat of bravery, Shah Murad Khan
awarded me aspers in the sum of four purses and a robe of honour.

Distinguishing himself both on the Yerevan campaign and in the sub-
sequent sack of Tabriz, Varvar Ali was appointed governor of Cyprus
again and, a year later, of the province of Anadolu in western Anatolia.
He was wounded leading the assault in the Baghdad campaign of 1638
and invalided out, and was then appointed governor of the province of
Rumeli. On Sultan İbrahim's succession he fell briefly from favour, but
was then sent to govern, in turn, the provinces of Van, Anadolu, Adana,
and the sub-province of Bolu, between Istanbul and Ankara. At the very
time when he was feeling most disillusioned by the frequent changes of

posting he and his peers had to endure – which doubtless lay behind his later proposal that such appointments must last longer than three years – he was sent to govern Bosnia, the homeland he had left some forty years earlier:

> . . . After three-and-two-score years [the post of governor-general of Bosnia] was attained – in short, my aspired goal I proclaimed;
>
> On the bestowal of this supreme favour,
> I became oblivious to the world, the universe entire;
>
> Should the grace of God be granted to His servant,
> a shepherd may be [transported] to a sultan's domain.[33]

Unfortunately Varvar Ali Pasha's autobiography ends here, three years before his death in 1648. The impetus that made him challenge the power of the establishment so vigorously can therefore only be guessed at. His return as Ottoman governor to the native land he had left as an adolescent was clearly a source of pride, and his brilliant career was a clear demonstration of the opportunity open to a boy such as he, removed from a poor peasant family. No doubt there were tears on both sides as such boys left home and family, but the youth-levy appears not to have aroused much resistance among the Christians subject to it – it almost seems that it may have been regarded as a legal duty owed to a legitimate monarch, rather than a tyrannical imposition. By the middle of the seventeenth century, however, its more occasional character may have made it seem akin to the impressment of men for military service – such as was practised in many contemporary western states.

The end of Sultan İbrahim's reign was a bloody affair: the chronicler Hasan Vecihi, employed in Istanbul at the time, declared that the details would fill a bound volume.[34] By 1648 all factions were united in viewing the Sultan's removal as a necessity. Even İbrahim's mother, Kösem Sultan, had come to realize that his actions were detrimental to the future of the state, both domestically and in its foreign relations. Kösem was as weary of İbrahim's extravagant and volatile ways as the rest of his circle, and also fearful for her own position, as she revealed in writing to Grand Vezir Hezarpare Ahmed Pasha, 'In the end he will leave neither you nor me alive. We will lose control of the government. The whole society is in ruins. Have him removed from the throne immediately'.[35]

Hezarpare Ahmed Pasha was widely unpopular, resented as much in Istanbul as by the provincial governors on whom the state depended for its smooth

functioning. His enjoyment of the luxuries his position brought within his reach was too overt, and he did little to exercise a moderating influence on the Sultan's excesses. Katib Çelebi, who was close to events, wrote that the Grand Vezir's presentation of sable robes to commanders returning from the Cretan campaigns provided an impetus for the uprising which led to İbrahim's deposition.[36] A gesture of such ostentation – albeit sanctioned by custom – was the ultimate affront to a people suffering the hardships brought by domestic and foreign strife: the Venetian blockade of the Dardanelles begun earlier that year meant that goods were scarce in the city.

Discontent was first expressed at the janissaries' mosque – which had played a key part in the deposition of Sultan Osman and the restoration of his uncle Mustafa in 1623 – underlining yet again the janissaries' central role in the making and unmaking of sultans. From here, on 7 August 1648, they sent word to the palace that the young princes of the next generation must be protected from harm. Hezarpare Ahmed Pasha fled but was soon caught and executed by order of the Sultan. As in 1623, the janissaries allied themselves with the religious establishment in the person of the Sheikhulislam and senior clerics, inviting them to their mosque. The next day they assembled in the Hippodrome.[37]

Casting aside the formalities of their customary deference, the janissaries and the sultan's cavalry regiments, who were invited to support them, held the Sultan himself responsible for the ills of the state. Yet though they had the monopoly of armed might in Istanbul, they did not feel able to rely on brute force alone in so momentous an act as the deposition of a sultan. They could not conceive of operating outside the framework of tacit consensus which underpinned the state, and felt they needed a juridical opinion from the Sheikhulislam to sanction their actions with canonical legitimacy. The alternative was anarchy without restraint. Their original raison d'être as the sultan's crack troops now a distant memory, the janissaries and cavalrymen had come to regard themselves as guardians of the state – a role which did not of necessity conflict with their position as the sultan's servants, but increasingly did so in practice. In an era when the authority of the sultan was weakened by the vociferousness of the factions in his orbit, they saw it as their task to perpetuate the established form of government and to ensure their place in it. Individual sultans were expendable, but the continuity inherent in the centrality of the Ottoman dynasty was an article of faith.

The Sheikhulislam deferred to Kösem Sultan in the matter of İbrahim's deposition, aware like other statesmen that she must be consulted before the final decision could be taken. They sent a message to inform her that they were all agreed he must go, and ready to swear the oath of allegiance

to the eldest prince, his son Mehmed. Kösem Sultan agreed to meet them in the palace where she went through the motions of resisting them:

> For so long you have permitted whatever my son wished [and] proved your loyalty; [and] not once has any of you admonished him or not wished him well. Now you wish to reverse the situation and criticize such an innocent one. This is an evil act.

The matter was discussed for two hours, at the end of which she seemed in despair:

> All are united in the opinion that the Sultan must be deposed; it is impossible to do otherwise. You tell me that if I don't hand over the Prince, they will enter the palace and take him by force.[38]

It was a measure of the authority which had accrued to the figure of the sultan's mother, and to the present queen-mother in particular, that it was considered necessary to win her over before the Sheikhulislam could deliver his opinion. Although she could write to the Grand Vezir privately of her true feelings, in the company of the statesmen convention required that she appear to resist them. Fearing that attempts might be made to restore İbrahim, another juridical opinion was sought regarding his subsequent execution.[39] Soon the 'Crazy' Sultan was dead, to be buried in the tomb of his deposed great-uncle, Sultan Mustafa, in the precincts of Ayasofya.[40]

If any hoped that the departure of the incompetent Sultan İbrahim and the succession of seven-year-old Mehmed IV would temper the factional struggles in Istanbul and the turmoil in the provinces, they were swiftly disillusioned. A new sultan, and especially one so young, merely brought new alliances into play. In keeping with the custom which had by now become an accepted norm, Mehmed's mother should have acted as regent on his behalf until he came of age, as Kösem Sultan had for Murad IV until he threw off her authority during the later part of his reign. This time, however, the confused events of recent years and the fact that Mehmed's mother, Turhan Sultan, was only in her early twenties, did not make for a smooth transition to a regency; the statesmen considered her too inexperienced to have any share in the exercise of power. The position of queen-mother was therefore redefined – as had happened with the right of succession in 1617, when the brother of the deceased Ahmed I rather than his son had been put on the throne: the senior female of the *harem*, Kösem Sultan, remained in the palace, and Turhan Sultan was set aside to wait her turn.[41]

Hezarpare Ahmed Pasha's successor as grand vezir, Sofu Mehmed Pasha, was the compromise candidate of those who had engineered Sultan İbrahim's deposition and in his nine months in the post, never more than a puppet

of competing factions. He was removed and executed to make way for the janissary commander-in-chief Kara Murad Pasha, whose elevation to the grand vezirate signalled that the influence of the janissaries on affairs of state would continue during Sultan Mehmed IV's minority;[42] and, indeed, a janissary commander-in-chief became grand vezir on several occasions during these years.

İbrahim's deposition no more put an end to unrest on the streets of Istanbul than it did to factional struggle. The protestors now were youths educated in the expectation of a position at court, or a career in the sultan's cavalry regiments. Lack of money to pay the salaries of the many who were eligible for the cavalry had led to neglect of these regiments in recent years – most conspicuously on the occasion of the latest change of sultan, a time when promotions into their ranks were customarily made. Supported by serving cavalrymen, the frustrated candidates pronounced that Sultan İbrahim had been wrongly executed, but the janissaries and clerics who had agreed on his deposition remained united: backed by a juridical opinion that it was an unlawful rebellion, over some days the janissaries bloodily put down the protest in the Hippodrome, where the cavalrymen and would-be cavalrymen had gathered.[43] Thus did the recent solidarity between infantry and cavalry become another casualty of the unrest as each corps pursued its own interests.

Suppression of the cavalry uprising in Istanbul which attended Sultan İbrahim's deposition provoked a violent response in the provinces. From his base at Niğde in central Anatolia Gürcü ('Georgian') Abdülnebi Agha, a former member of the sultan's cavalry, set off for Istanbul to protest on behalf of those recently massacred. Contemporary chroniclers, shaken by the crisis unfolding before them, dwelt at length on the alarming sequence of events. Abdurrahman Abdi, later Pasha, and Mehmed IV's favourite, had graduated to service in Topkapı Palace from the palace school of Galatasarayı at the very time of the massacre in the Hippodrome. Of Gürcü Abdülnebi he noted in his digest of these events that he harboured a personal grievance against the government, having been deprived of a lucrative state job. Gürcü Abdülnebi demanded the head of the Sheikhulislam whose opinion had sanctioned the killing of his fellows, and requested an opportunity to state his case before the Sultan.[44] According to the chronicler Mustafa Naima, Gürcü Abdülnebi was particularly distressed because the bodies of the protesters had been unceremoniously dumped in the sea without the necessary obsequies being performed: they had been killed, said their avenger, as though they were Christian prisoners-of-war.[45]

Gürcü Abdülnebi Agha gathered together a large force which included a brigand of the name of Katırcıoğlu ('Son of the Muleteer') Mehmed

and his band, and crossed Anatolia, reaching İznik in the summer of 1649. The government's response was to send forth an army commanded by the governor of Erzurum, Tavukçu ('Chicken-keeper') Mustafa Pasha, who was then in Istanbul. However, when it reached İzmit, two stages north of İznik, it became apparent that the governor's forces were inadequate to resist the rebels, and they returned to the capital. Instead, it was decided to station a large army at Üsküdar, just across the Bosporus from Istanbul, and in the Çamlıca hills above. When the government forces were in position the sacred standard of the Prophet Muhammad was taken from the palace at the request of the grand vezir Kara Murad Pasha to his camp at Çamlıca.*⁴⁶ The Sultan, however – or probably, as regent, his grandmother Kösem Sultan – refused to give permission for the standard to be used to rally the troops against Gürcü Abdülnebi, according to Abdurrahman Abdi, because they hoped to settle the crisis without the bloodshed which the use of this potent symbol might produce. Nevertheless, the Grand Vezir's tough yet conciliatory stance was apparently justified when further communications from Gürcü Abdülnebi moderated his demand to the dismissal of the Sheikhulislam and, when this was also refused, to senior provincial posts for himself and his associates, including Katırcıoğlu Mehmed. With the rebel army now encamped at Bulgurlu, only a short distance from the Grand Vezir's forces, he deemed it expedient to concede this reduced demand.⁴⁷ The terror engendered in Istanbul by the menacing events unfolding across the Bosporus is palpable in Mustafa Naima's account of this rebellion, although it was compiled some fifty years later, with its details of the hasty enrolment of new janissaries to fight the rebels, of orders for the city's bread ovens to work at full capacity, and of the arming of shepherds and low-lifes to police a city now empty of troops.⁴⁸

Grand Vezir Kara Murad Pasha's limited compromise with the rebels did not work. Bands of skirmishers from either side encountered one another, and after a vicious fight the rebels emerged victorious. The Grand Vezir thereupon sent his troops against Gürcü Abdülnebi's forces, and they fled into Anatolia. Gürcü Abdülnebi was apprehended at Kırşehir, east of Ankara, and his severed head was subsequently displayed outside Topkapı Palace as a warning to others who might think to challenge the Sultan.⁴⁹ Katırcıoğlu Mehmed won a pardon, entered the Ottoman military-administrative establishment, and served stints as a provincial governor before being killed in

* Apparently brought from Damascus to Istanbul in 1593–4 to provide inspiration in the war against the Habsburgs, the standard had accompanied Sultan Mehmed III to the battlefield of Mezőkeresztes in Hungary, but after the 1596 campaigning season it was not returned to Damascus (Necipoğlu, *Architecture, Ceremonial and Power* 151).

action on Crete[50] – this was a rare case of a brigand chief becoming a high-ranking state servant.

Another striking detail from Mustafa Naima's retrospective account of these events concerns the circumstances surrounding the withdrawal of Tavukçu Mustafa Pasha from İzmit before the despatch of a larger force under the command of the Grand Vezir. According to Naima, Tavukçu Mustafa and his men encountered Katırcıoğlu Mehmed and his forces at İzmit, but as Tavukçu Mustafa's janissaries took aim, Katırcıoğlu Mehmed called out to them to hold their fire, for he had no quarrel with them. At this, the janissaries emerged from their trenches, sat down with their supposed enemies, and drank coffee with them. Some of the janissaries even went behind the lines to Gürcü Abdülnebi's camp, where they met with a similarly amicable reception. Tavukçu Mustafa's men decided there was no reason for this fight, and also persuaded reinforcements arriving on the scene by boat to lay down their arms. In this version of events, faced with this insubordination among his troops, and seeing that the townspeople of İzmit supported the rebels, Tavukçu Mustafa had no alternative than to retire to Istanbul.[51]

Gürcü Abdülnebi's revolt revealed the depth of the divisions among the self-appointed guardians of the Ottoman state and within its ruling circles. The sultan's cavalry were at first at odds with the janissaries, ready to support rebels allegedly seeking revenge, like them, for the massacre in the Hippodrome. Yet the janissary rank-and-file were easily able to have amicable intercourse with the rebels. Some officials criticized the Queen-mother, as the Sultan's regent, for her refusal to sanction the use of the sacred standard against Gürcü Abdülnebi's forces; but she was supported by her ally the Chief Black Eunuch who, like her, insisted that it must be used only against non-Muslims. As it transpired, permission for it to be taken from the palace had been given by the Registrar of the Descendants of the Prophet who ignored the tradition that only the sultan had the authority to take such a decision. Another high-ranking cleric, on the other hand, was wary of the consequences of issuing a juridical opinion that it was licit to attack rebels whose grievances contained more than a grain of truth: the recent massacre in the Hippodrome demonstrated that it might produce further violence.[52] So it was that Gürcü Abdülnebi's readiness to arm himself and his supporters and to take his complaint to Istanbul was understood by the statesmen as a grievous threat to their hold on power, one all the more alarming given that the sultan's regiments seemed ready to mutiny. Yet the rebels could conceive of no other redress than the award of an office of state.

Although Gürcü Abdülnebi had brought the disquiet of Anatolia to the very heart of the Ottoman state, the resolution of his rebellion did not result in any improvement in the life of the Anatolian people. In 1650

those in possession of state land-grants were ordered to pay over half their income as an extraordinary tax,[53] a move which can only have exacerbated the already turbulent situation in the provinces. The careers of the 'rebellious pashas' brought to prominence by this turmoil tended to conform to a pattern: they alternated periods in the service of the state with periods of resistance, and when sent against others of their number, they were reluctant agents of the central power. They hoped to make the statesmen in Istanbul aware of provincial concerns, and to impose their own vision of government upon the chaos they witnessed there. When the various factions in Istanbul were sufficiently united to curtail the pashas' activities, they were able to do so; often this unity was lacking, however, and the terrifying prospect of thousands of armed men heading for the capital left little alternative but submission – to a greater or lesser degree – to the pashas' demands for inclusion, or reinclusion, in the ruling establishment. Gürcü Abdülnebi's was one of many violent expressions of deep-seated provincial resentment of the janissaries' increasing control of central power to be acted out in the immediate environs of the capital. (In England, seven years earlier, the march of a hostile army on the capital had resulted in a similar stand-off at Turnham Green, about as far from the heart of London as Bulgurlu is from the centre of Istanbul – but on that occasion the 'rebel' was King Charles I, trying to reclaim his throne, and those holding power were the members of the Long Parliament.)

One notable circumstance common to several of the rebellious pashas who rose to particular prominence between Sultan Osman's murder in 1623 and the lull in provincial disturbances which followed the appointment as grand vezir in 1656 of Varvar Ali Pasha's one-time captive Köprülü Mehmed Pasha, was their Caucasian origin. Abaza Mehmed Pasha came from Abkhazia on the Caucasian Black Sea coast as did İpşir Mustafa Pasha; Gürcü Abdülnebi was a Georgian. Derviş Mehmed Pasha, who was grand vezir in 1653–4, was also from the Caucasus.[54] Evliya Çelebi's kinsman and patron Melek Ahmed Pasha was another Abkhazian but, noting that Abkhazians were considered stingy, Evliya held that Istanbul-born Melek Ahmed should not really be counted as one.[55] Men such as these were not products of the youth-levy, for they were Muslim-born and came from a region which had not traditionally supplied recruits for the ruling establishment. The possibility of state service had been opened up to the youths of the Caucasus from late in the sixteenth century: describing the quarter of Galata around the cannon foundry, Evliya Çelebi noted that those living there came mainly from the Black Sea and from Georgia and Abkhazia; he wrote that the Abkhazians sent their children back to their country when they were merely a year or two old, to be brought up there and then returned to Istanbul

at the age of fifteen when they would be presented to the sultan's favourites or sold to state dignitaries. Melek Ahmed, Evliya wrote, had entered state service from such a background.[56]

Other rebels came from the western reaches of the empire and had been recruited through the youth-levy in the customary way: for instance, Varvar Ali Pasha was from Bosnia* and Evliya Çelebi's one-time patron Defterdarzade Mehmed Pasha was from Herzegovina. It is evident from contemporary accounts that there was tension between men of Bosnian or Albanian origin and those from Abkhazia, Georgia or the further Caucasus; men brought into the Ottoman system from the Balkans considered those hailing from the Caucasus to be interlopers[57] – and İpşir Mustafa Pasha's Abkhazian origin, for instance, was cited by Defterdarzade Mehmed when he warned the hapless Varvar Ali not to trust him.

In August 1650 Melek Ahmed Pasha was appointed grand vezir, but his term came to an abrupt end a year later as a result of his incompetence in handling a violent uprising of Istanbul tradesmen. The treasury was empty in these years, and when time came in the summer of 1651 for salaries to be paid to the janissaries, the state treasurer colluded with their officers to collect debased coin struck in the Belgrade mint and clipped coins wherever they might be found, and the shopkeepers of Istanbul were forced to exchange these for the gold coins in their possession at a loss of 30 per cent on the official rate. The gold coins were then exchanged for silver at the moneychangers, at a loss to the latter. By this means enough cash was found to both pay the salaries and allow the janissary officers a substantial profit.[58] As it happened there was more debased coin available for these financial manipulations than usual, for the insecurity of the sea-routes – presumably because of continuing Cossack harassment – meant that it was not possible to send off the pay due to the garrison at Azov.[59]

Guild leaders took their complaints to Melek Ahmed Pasha citing fourteen other levies they had had to endure that year in addition to this latest vexation. Their pleas fell on deaf ears. Melek Ahmed insulted them, calling them 'infidel cats', and ordered them out.[60] Reaction against the proliferation of debased coin came to a head in uproar in the Istanbul bazaar on 21 August. The tradesmen shut up their shops and their leaders gathered at the residence of the sheikhulislam, Karaçelebizade Abdülaziz Efendi – a former chief justice of both Rumeli and Anatolia who had played a part in the deposition of Sultan İbrahim and was therefore on bad terms with

* The printed edition of Mustafa Naima's chronicle used here refers to him as Vardar Ali Pasha, implying possibly that he came from, or at least had some connection with, the area of the river Vardar in Macedonia.

Kösem Sultan[61] – who wrote a history of his time in which he recorded his involvement in the tradesmen's uprising. The leaders of the tradesmen appealed to the Sheikhulislam to intercede on their behalf with the Sultan, but he pleaded that he could not and advised them to go once more to the Grand Vezir; their tone became menacing and he was forced to agree to write to Melek Ahmed about the matter. Omitted from Karaçelebizade Abdülaziz's account of events – but recorded by Mustafa Naima – is the fact that when the tradesmen's leaders insisted that he go before them to the palace, he went to another room on the pretext of performing his ablutions and tried to escape from his house without them noticing.[62] His horse saddled up, Karaçelebizade Abdülaziz was taken under close supervision to Ayasofya where there was gathered a crowd he estimated at 20,000.[63]

The Sultan consented to give Karaçelebizade Abdülaziz an audience but before the boy could arrive, Kösem Sultan, seeing the Sheikhulislam waiting, asked why he had been permitted to come inside. Fearfully, Karaçelebizade Abdülaziz stated his business and, after a long discussion, convinced the Queen-mother that the grand vezir's seal must be brought to her, signifying his dismissal.[64] Sultan Mehmed summoned the terrified Grand Vezir and ordered him to write a memorandum designed to bring an end to the unrest, but the crowd would accept only the Sultan's own hand. He therefore ordered that all recent impositions be lifted, indeed that nothing additional to the taxes included in the law code of Sultan Süleyman I be levied. The crowd prepared to disperse, and it seemed that the trouble was over. But there then arose a demand for the execution of sixteen people whom the tradesmen accused of embezzling state funds – mainly janissary officers, including the commander-in chief, Kara Çavuş ('Black Messenger') Mustafa Agha. The crowd also called for the dismissal of Melek Ahmed Pasha. In a naive effort to put an end to the unrest, Kösem Sultan proposed that Kara Çavuş Mustafa should replace Melek Ahmed Pasha, but when Kara Çavuş Mustafa refused to go to the palace, demanding that the seal of office be brought to him, an elderly vezir, Siyavuş Pasha, was appointed instead.[65] Predictably, Evliya Çelebi blamed others for Melek Ahmed's fall, and Karaçelebizade Abdülaziz for inciting the crowd and palace against his patron.[66]

Night came. The new grand vezir and the Sheikhulislam tried to calm the tension. They went to the mosque of the janissaries to meet the regiments' officers, where the commander-in-chief Kara Çavuş Mustafa Agha reminded Siyavuş Pasha that he was impotent without the janissaries' support. Next morning the streets were full again, and janissaries stood menacingly on every corner with drawn swords to stop the people reaching the palace. Many of the protestors were wounded, others murdered. Fear eventually dispersed the crowd, but the tradesmen refused to reopen their shops.[67]

The janissary officers determined to silence all opposition inside the palace to their domination. Their target, to which Kösem Sultan agreed for reasons of her own, was the faction around Turhan Sultan, and an element of their plan was the replacement of Sultan Mehmed with his younger brother Süleyman, whose mother was a less threatening rival than Turhan. One of Kösem's servants leaked news of a plot to poison the young sultan to Turhan's faction whereupon Turhan and her supporters decided to have Kösem assassinated. She was murdered on the night of 2 September 1651 by palace functionaries hired for the purpose.[68] With Kösem dead, Turhan's partisans now came to the fore, the most senior among them her chief black eunuch, Süleyman Agha. The new grand vezir Siyavuş Pasha was a natural ally of this faction having himself been the victim of the janissaries' brutishness on his appointment to the post only a few days earlier.

The janissary officers were able to resist the swell of popular sentiment for only a short time longer: all sections of society were set against them as indicated by events since Mehmed IV's accession. It was the janissaries who had enabled the elderly queen-mother, Kösem Sultan, to retain her grip on power, but commentators were divided as to whether she had actively sought an alliance with them, or whether she had felt constrained to humour them as the only means of preserving the integrity of the state; to some, their power seemed a lesser evil than the looming prospect of having to concede every whim of the populace.[69]

When Kösem Sultan was murdered she was nearly seventy and had been at the centre of power since becoming Ahmed I's favourite concubine some fifty years earlier. During her periods of regency in the reigns of her sons Murad IV and İbrahim and her grandson Mehmed IV she had achieved unprecedented influence over political decision-making in her role as protector of the dynasty and the state. As observers were divided concerning her motives for espousing the janissaries' cause, so they differed in their verdict on her other activities. Some reckoned that she had, most reprehensibly, amassed a great fortune through illegitimate means and that her involvement in affairs of state was to be execrated. To Mustafa Naima, however, she was a great benefactress who put the income from the lands and revenues assigned to her to good use, undertaking charitable works and construction projects as visible signs of the concern of the dynasty for its subjects.[70] Her mosque in Üsküdar is not large, and far less splendid than that of her predecessor as queen-mother, Nurbanu Sultan – who built a mosque, a theological school, a dervish lodge, a hospice, a school, a caravansaray, a bath-house, and other structures in the same quarter – but her substantial caravansaray near the Covered Bazaar in Istanbul – the Valide Han – still stands, albeit in a much dilapidated condition.

Early on the morning following Kösem Sultan's murder, the Sultan summoned his statesmen and the palace functionaries to an audience. First to speak were two high-ranking clerics, Hanefi Efendi and Hocazade Mesud Efendi, who adduced the argument that since the Ottoman sultan was the caliph of Islam any opposed to him were to be accounted rebels, and that it was proper to kill them. They recommended that the sacred standard be brought out, and that criers be sent around the city to summon all true believers; any who did not come to the palace should be punished. The Sultan seemed convinced by their reasoning and the sacred standard was taken from safe-keeping – despite the fact that those causing the disorder were Muslim. Sheikhulislam Karaçelebizade Abdülaziz Efendi was conspicuous by his absence from the palace: against advice and after much indecision, he ignored the Sultan's summons, preferring to put his trust in the janissary officers whom he greatly feared and whom he reckoned would emerge victorious from the confusion. With a number of other senior clerics he took refuge at the janissary commander-in-chief's residence, but when clerics and janissary commanders decided to move to the nearby mosque of the janissaries, they found their way impeded by rank-and-file janissaries who were many, armed, and surrounded them on all sides as they went, challenging the clerics that they had refused to attend the Sultan's audience. By this time criers had roused the people of the city against those who, in usurping the government, had overstepped the bounds of acceptable conduct. Fired up, the crowd blamed the janissaries for Kösem's murder and swore to avenge it.[71]

In his absence, Sheikhulislam Karaçelebizade Abdülaziz Efendi was dismissed. Much discussion ensued over a suitable successor; the candidate supported by Turhan Sultan's faction, his deputy Ebusaid Efendi, was appointed, and his first act was to give a juridical opinion for the execution of those who refused to rally to the sacred standard. The janissary officers, under siege in their mosque, and with no means of escaping from their predicament, were effectively isolated. Soon the streets were full of men converging on the palace, each armed to defend himself against the janissaries. Bewildered, at first the crowd bided its time, waiting to see what would happen, and before long the rank-and-file janissaries began to join the surge towards the sacred standard, trying to blend in. Ebusaid Efendi sent a letter to their officers in the corps' mosque, ordering them to appear before him. This was ignored, and the commander-in-chief, Kara Çavuş Mustafa Agha, thinking that his rank-and-file would rescue them, told his colleagues to stand fast and be ready to defend themselves if forces loyal to the new government were sent against them – however, all but the most senior officers soon slipped away. A defiant Kara Çavuş Mustafa Agha sent an ultimatum to the palace demanding the heads of a further ten officials,

in addition to four aghas of Turhan's faction he had earlier called for – as an alternative, he proposed exiling the latter to Egypt.[72]

The loyalty of the people of Istanbul proved by their readiness to rally to the sacred standard, the crowd – and the janissaries in its midst – dispersed. The negotiations that eventually ended this shocking incident must have encouraged the janissary commanders to believe they would survive, albeit in exile, but still in possession of the wealth they had amassed while in office: Kara Çavuş Mustafa Agha was appointed governor of Temeşvar, while his second-in-command, another Mustafa, was to be governor of Bosnia, and the former janissary commander-in-chief Bektaş Agha was awarded the office of sub-governor of Bursa. In the event, however, all were killed shortly afterwards at the Sultan's behest, and the seizure of their huge fortunes went some way to alleviating the state's dire financial crisis.[73] Karaçelebizade Abdülaziz Efendi, compromised by his closeness to these janissary officers, was exiled to the island of Chios:[74] his actions had manifestly undermined the fiction that members of the religious hierarchy remained aloof from politics. Three weeks of turmoil were thus brought to an end, and it was seen that the statesmen around the Sultan and his young mother had acquitted themselves well in the handling of an explosive situation.

With the ending of janissary domination of Istanbul politics began the supremacy of another clique, that of the palace aghas who had confirmed Turhan Sultan in her position as queen-mother. While officially she was the Sultan's representative during his immaturity, the primary agent of her will was Chief Black Eunuch Süleyman Agha, who had been party to the decisions taken for the restoration of order and the destruction of the janissary commanders. Grand Vezir Siyavuş Pasha had no real power, and within a few weeks was replaced by the aged and equally ineffectual Gürcü Mehmed Pasha, brother of the rebel Gürcü Abdülnebi.[75] Gürcü Mehmed was succeeded after a few months by Tarhoncu ('Tarragon-eater' or 'Tarragon-seller') Ahmed Pasha, who had been governor of Egypt between 1649 and 1651, had subsequently been imprisoned in the fortress of Yedikule on the Istanbul land walls, and had his wealth confiscated, before being ignominiously appointed governor of a Balkan sub-province.[76] His rehabilitation was engineered by Hocazade Mesud Efendi, now chief justice of Anatolia, who was deeply involved in state affairs and a powerful presence in the palace; but it was not achieved without a great deal of deliberation on the part of the Sultan and the high officers of state. Mehmed's own preference was for his tutor Deli Hüseyin Pasha, currently commanding the army in Crete, but Hocazade Mesud dominated the proceedings and, with an eloquent summary of the three critical problems facing the state – the condition of the fleet, the war in Crete, and finding the money to pay

for this war – persuaded the Sultan that Tarhoncu Ahmed, whom he reminded everyone had kept the Egyptian treasury in the black, was the only man for the job.[77]

In a radical departure from past practice Tarhoncu Ahmed Pasha was required as a condition of his appointment to undertake, in the presence of the Sultan, his vezirs and the Sheikhulislam, to resolve the three problems identified by Hocazade Mesud Efendi. Threatened with the loss of his head if he failed in his mission, Tarhoncu Ahmed set two conditions of his own. The first was that no one, whatever their status, should be exempt from his efforts to ensure that the state received the moneys due it, and that he should have full independence in this matter; the second, that he should have the power vested in him to rescind the improper appointments and preferments of his predecessor.[78]

Earlier reform efforts had typically been rooted in the attempted reimposition of norms imagined to have prevailed in past times. Now it seemed the realization was dawning that solutions designed to cope with the present were required, rather than attempts to make the present conform to the past.[79] Tarhoncu Ahmed's appointment seemed to suggest that the recent turmoil had shaken Ottoman statesmen to the core and forced them to adopt a constructive attitude, with the overriding aim of saving the state from sinking further into bankruptcy, but this rare instance of agreement was not enough to ensure that workable solutions would or could be found. Tarhoncu Ahmed's undertaking to achieve a satisfactory outcome to the Cretan war, for example, conflicted with the need to put the financial affairs of the state to rights, and he soon found himself in dispute with Grand Admiral Derviş Mehmed Pasha over the money needed to keep the fleet in readiness.[80] These were also years of plague and poor harvests.[81] Perhaps inevitably, Tarhoncu Ahmed failed to balance the budget: he remained in office for less than a year, and the terms of his contract were honoured – he paid with his life. His austere measures had not been popular and, as Evliya Çelebi observed on the appointment of Derviş Mehmed Pasha as his successor, 'the people breathed a sigh of relief . . . they celebrated each day as though it was New Year's Eve . . . everyone rejoiced.'[82] A contemporary from Baghdad, however, where Derviş Mehmed, as governor from soon after its reconquest in 1638, had adopted innovative economic measures which were often unpopular, wrote of him as a brutal tyrant.[83] Former grand vezir Melek Ahmed Pasha was swiftly rehabilitated from the disgrace that followed his ignominious handling of the Istanbul uprising of 1651; by 1653 he was second vezir and, Evliya Çelebi recorded with no trace of irony, in a position to enjoy life in his twelve mansions on the shores of the Bosporus.[84]

İpşir Mustafa Pasha, rescuer of the future grand vezir Köprülü Mehmed Pasha from probable death at the hands of Varvar Ali Pasha in 1648, also briefly became grand vezir. He had spent his early years in the retinue of Abaza Mehmed Pasha, accompanying him when he marched on Istanbul in 1623 and during his subsequent career in the Balkans. He won the patronage of Grand Vezir Kemankeş Kara Mustafa Pasha, architect of the 1639 peace with Iran, fought with Sultan Murad on the Yerevan campaign, and held the governorship of a number of provinces. His strong-arm tactics made him unpopular, but built him a reputation as the only man capable of putting down the rebellions of these years. He had declined to fight on behalf of the state against the rebel pashas who were his allies – against Derviş Mehmed Pasha, then governor of Anadolu province in 1646, for example, and against Varvar Ali Pasha in 1648 (though in the end he took the state's part on the latter occasion).[85]

In 1651, as governor of Sivas, İpşir Mustafa Pasha occupied Ankara and attempted to establish his own administration in the area, setting himself up as a champion of the sultan's cavalry regiments against the janissaries. One of the demands he addressed to the government was that the Druze of Lebanon, whose grip on the tax-farms of the area he had earlier failed to loosen, be suppressed; he was soon appointed governor of Aleppo and charged with the task of quelling Druze insubordination. His success in this, coupled with an awareness of the dramatic events in Istanbul, encouraged him to put forward his own programme for the redress of the ills besetting the government – as had the unfortunate Varvar Ali Pasha before him; he sent notice of it to the governors of the Anatolian provinces, but received scant response. Complaints of his harsh style of government in Aleppo reached Istanbul, as did reports that he planned to march on the capital and take retribution on the incumbent statesmen. Alarmed, they sought to deflect his wrath by appointing him grand vezir. At first he refused, but in December 1654 he marched from Aleppo to Istanbul to claim the office, seizing tax-farms for his own men, and exacting summary justice as he went. In an attempt to bind him to the dynasty's cause he was betrothed to Ayşe Sultan, a middle-aged, widowed daughter of Ahmed I.* İpşir Mustafa lasted only a few months as grand vezir, during which time he succeeded in alienating even his cavalry supporters, to the extent that they united with the janissaries in a rebellion which led to his execution.[86] He was only one of a succession of provincial governors who had used the opportunity afforded by distance from Istanbul to attempt to throw

* Two of her previous six husbands had also been grand vezirs: Nasuh Pasha, grand vezir between 1611 and 1614, and Hafiz Ahmed Pasha, who served in 1625–6 and again in 1631.

off central control. While serving in the provinces such men were able to build a local power-base from which it seemed possible to dictate their own terms to the government of the day. Rarely did they rise as high in the administration as İpşir Mustafa – and his hubris was followed by swift nemesis.

The war for Crete continued. While the ruling circles were engaged in so intensive an internal struggle for power there was little chance of a consistent policy. Commanders pursued their goals – as they saw them – as best they could, always uncertain whether troops or funds would reach them, and nervous that incidents of mutiny – like that in August 1649 when the janissaries demanded to be sent home after two years' service in the trenches of Iraklion[87] – might be repeated. It was not only fighting ships they needed but a high level of logistical support in men and matériel, without which they were quite unable to function. In July of 1651 – the summer which saw the tradesmen's uprising and the murder of Kösem Sultan – the first significant naval engagement of the war took place. A strong Ottoman fleet sailed south from Istanbul and met the Venetians off Santorini, an initial skirmish which was followed by a battle off Naxos in the Cyclades in which the Ottoman fleet was scattered and close on a thousand captives were taken by the Venetians.[88]

There was little activity in the Cretan war during the months of Tarhoncu Ahmed Pasha's grand vezirate, but as a former grand admiral his successor Derviş Mehmed Pasha gave it greater priority. During his term of office there occurred, in May 1654, what subsequently proved to be the first of four naval battles in the Dardanelles; it ended in Ottoman victory, but the Venetians were able to console themselves with the knowledge that the Ottomans had suffered the substantial loss of six thousand men. The new grand admiral, Kara Murad Pasha, restructured the fleet at Chios, then raided Tinos, and met the Venetians at Milos before sailing to Foça, north of İzmir, and then returning to the Dardanelles, from where he went south to Crete and was back again in Istanbul by the autumn. The Venetians may have avoided a second set-piece engagement with an Ottoman fleet in 1654, but a joint Venetian–Maltese fleet encountered the foe at the Dardanelles in June 1655; this time the Ottomans withdrew after a six-hour battle. In July, a five-week Venetian siege of Monemvasia in the Peloponnese came to nothing.[89]

Success or failure in a naval battle of the seventeenth century could lie in a shift of the wind. In the Dardanelles in June 1656 not only was the current in the Venetians' favour, but such a shift of the wind gave added advantage, bunching the Ottoman fleet against the shore of the Straits,

unable to escape the Venetian guns. The feelings of Grand Admiral Kenan Pasha were clear from his report of the circumstances of this defeat. He had been all too aware before the battle that he was undermanned: the troops of the sultan's regiments refused to serve at sea, and he had to resort to men of inferior quality. When brought to battle by the Venetians he suffered further losses through desertion, as men leapt overboard and swam to the nearby shore. He could only watch impotently as the wind blew his ships one against the other.[90] Previous attempts made by Venice to blockade the Straits and thus prevent naval supplies and manpower from Istanbul reaching Crete to reinforce the Ottoman assault on Iraklion had been thwarted, but in this disastrous encounter the Ottomans lost the strategically vital islands of Bozcaada and Lemnos. Holding them, the Venetians could control the Straits and the Ottoman outlet to the open seas of the Aegean and beyond. If the Ottomans escaped lightly in 1655, wrote Mustafa Naima, in 1656 they suffered their worst naval defeat since Lepanto.[91]

The war with Venice was not the only international crisis to occupy the Ottomans in the middle of the seventeenth century. After years of peaceful coexistence, their relationship with the Polish–Lithuanian Commonwealth was shaken in 1648 by events on the north-western frontier of the empire when the Ukrainian Cossacks, ably commanded by Hetman Bohdan Khmelnytsky, rose against their Polish masters. When King Wladyslaw was formulating his scheme to provoke the Ottomans to fight on a second front in the Black Sea while they were yet battling Venice for possession of Crete, he had secretly negotiated with Cossack leaders – of whom Khmelnytsky was one – to gauge the strength of their willingness to participate; although his hopes were dashed, the discussions upset the status quo and raised expectations of an improvement in the oppressed situation of the Cossacks within the Commonwealth. The immediate cause of Khmelnytsky's revolt, however, was the seizure of his lands by a Polish nobleman; unlike many of his fellows, Khmelnytsky refused to accept such behaviour and events were set in motion which led to outright war between the Cossacks and the Commonwealth.

Setting aside past differences Khmelnytsky and the Tatar khan İslam Giray III negotiated an alliance to bring together the formidable combination of the Cossack infantry and the Tatar cavalry; a precedent for this had been set in 1624 when the Cossacks supported Mehmed and Şahin Giray in their resistance to Ottoman attempts to reinstate Canbeg Giray as Crimean khan. One condition of Khmelnytsky's alliance with İslam Giray was that the Cossacks should burn the 3,000 boats of their Black Sea fleet, cause of so much devastation to Ottoman shores, in case they were used to harass the coasts of the khanate. The forces of the Commonwealth had no hope of

resisting the Cossack–Tatar combination; their army lost several battles and Warsaw was left vulnerable to attack. However, the Cossack–Crimean alliance was not a natural one, by reason of their very different geopolitical interests, and the Khan made sure that the Cossacks were not strengthened enough to achieve total success in their uprising. Khmelnytsky looked for other allies, the Ottoman sultan among them, and long negotiations ensued. Muscovy and the Commonwealth had signed a treaty in 1634 and Muscovy therefore could not respond to Khmelnytsky's request for help; in 1654, however, with his erstwhile Tatar ally now on good terms with the Polish king, Khmelnytsky swore allegiance to the Tsar, precipitating a war between Muscovy and the Commonwealth over Ukraine. Khmelnytsky's revolt and its bloody consequences were an important element in preparing the ground for the great power struggle in the steppe between the Commonwealth, Muscovy and the Ottoman Empire, which came to a climax over a century later with the partition of Poland, the end of the Crimean khanate and the Ottoman retreat from the northern Black Sea.[92]

In 1656 another revolt of the utmost severity convulsed Istanbul for several months, recorded in a number of contemporary accounts. According to the Ottoman Armenian Eremya Çelebi Kömürcüyan, a youth at the time, the uprising began at midday on Friday, 1 March 1656: he was sitting in a shop when a great noise erupted, and the shopkeepers began to close their shutters. The important Friday midday prayer was cancelled as officers and men of the sultan's regiments gathered at their parade ground, complaining because their salaries were being paid in debased coin – an event not in itself unusual, but the coin was so corrupt on this occasion that 1000 aspers of it was valued at less than one hundred aspers in the market-place. The troops marched to the Hippodrome, vociferously demanding that those who had deceived Sultan Mehmed by implementing the debasement be killed. Two days later the Sultan granted the leaders of the mutiny an audience; they swore allegiance to him, levelling blame at 'some black and white aghas and women' whom they held responsible for perverting his rule. The aghas of the *harem* retorted that it was he they were after which frightened the boy-Sultan so much that he trembled and began to cry. Wiping his tears he asked the mutineers what they wanted and was presented with a list of thirty-one names, including that of his mother and the Chief Black Eunuch. Still weeping, Mehmed asked that his mother be spared – this was acceptable to the ringleaders, but soon the bodies of the Chief Black Eunuch and the Chief White Eunuch were thrown over the wall of the palace into the mob below, and their mutilated corpses were strung feet up in a plane tree in the Hippodrome.[93]

The next day the troops again marched on the palace. The Sultan was unable to resist their demands: more palace officials were sacrificed and their corpses tossed over the wall to be strung up in the plane trees, while the troops forced the appointment of their own candidates to the ranking offices of state; among these was Siyavuş Pasha who became grand vezir for the second time, and Hocazade Mesud Efendi who became sheikhulislam. Some of their intended victims escaped, and a hunt for them began in the city – criers went about promising any who found them a position in the sultan's cavalry or infantry and a land-grant. Five days after the beginning of the uprising the criers ordered the shops to reopen. Eremya Çelebi recalled seeing the Sultan's nurse Meleki Hatun, who had been responsible for betraying Kösem Sultan's plot to Turhan Sultan, being taken away before she was murdered and strung up in a tree. Three days later the relatives of those hung from the plane trees were ordered to come and retrieve the corpses. The reign of terror continued during the following weeks.[94]

In late April the governor of Damascus, Boynueğri ('Crook-neck', also known as Boynuyaralı, 'Wounded-necked') Mehmed Pasha, who was in his late eighties, was summoned from his post to succeed Siyavuş Pasha who had died after a month as grand vezir. Boynueğri Mehmed had been sent to Syria to put an end to the activities of Seydi Ahmed Pasha, an ally of Melek Ahmed Pasha and a fellow Abkhazian, who had subsequently been removed from the governorship of Aleppo – where he and his men had pillaged and wrought great destruction – to Sivas. Sultan Mehmed's advisers showed some skill in handling the current crisis, which was made even more dangerous than past uprisings by the unanimity of purpose of janissaries and cavalrymen. On 9 May the Sultan ordered his troops to prepare for campaign; the janissaries and cavalrymen hoped that this would be against Seydi Ahmed Pasha. The anticipated rewards of campaigning were clearly attractive: Eremya Çelebi reported that anyone who was not eligible to be enlisted, but who falsely passed himself off as a janissary or cavalryman, had his garb ripped off. He does not explain why this should have happened, but by describing the enthusiastic common folk as 'Turks', a term of disparagement at the time, implies that the tax-exempt military were zealous in refusing to share their privileges with the tax-paying populace. Some 'Turks' dressed themselves as Armenians, recognizable by their yellow boots, their coloured fur hats and quilted turbans, their colourful jackets and silk cummerbunds; these 'Turks', by contrast, perhaps sought to avoid military service at any price, since non-Muslims did not serve as fighting men.[95]

On several occasions Eremya Çelebi saw the Sultan going about the city in disguise (as sultans not infrequently did), once passing through the bazaar only a stone's throw away from his shop. On another occasion the Sultan

ordered the beheading of a man caught smoking tobacco. It was almost two months after the anarchy began before Mehmed IV was again able to appear openly in ceremonial procession to celebrate Friday prayers in a mosque outside the palace; in veneration, the tradesmen and city people threw sand in his path so that his horse's hooves would not touch the ground.[96]

The dangerous situation in Istanbul was brought under control and a measure of tranquillity was finally restored by employing the classic strategy of divide and rule – the janissaries and the cavalrymen were made to doubt one another's loyalty to their common cause. At the time of Mehmed's first public appearance for the Friday prayer, word went around among the janissaries that Seydi Ahmed Pasha – recently arrived in the capital – had been granted an audience at the palace in the company of the officers of the sultan's cavalry. One week later the janissary commander-in-chief was executed and Seydi Ahmed was granted an amnesty – Eremya Çelebi describes the arrival of his followers in Istanbul, loaded down with the goods and weapons, including even cannon, plundered in the course of their progress through Anatolia. They did not stay long, but set off for Silistra on the Danube, a recently (and as it turned out, only temporarily) independent province where Seydi Ahmed was to be governor.[97] Deprived of the cavalrymen's support, and with their commander-in-chief removed, the janissaries gradually subsided into quiescence.

Sheikhulislam Hocazade Mesud Efendi was a victim of the violence. Twenty-two years after Ahizade Hüseyin Efendi had become the first sheikhulislam to be executed, judged guilty of meddling in politics by Murad IV in 1634, Hocazade Mesud became the second. The decision to appoint him had been forced upon the Sultan in the heat of the chaos, despite his reputation for venality and propensity, as with Ahizade Hüseyin, for meddling in politics. To Eremya Çelebi he was the scourge of the Armenian community of Bursa – as kadı in that city, earlier in his career, he had had an Armenian church pulled down, prompting the grand vezir of the time to send inspectors to the city to investigate the incident.[98] By Eremya Çelebi's account, Hocazade Mesud was punished for his activities in Bursa with five hundred lashes to his feet, and a ban on future office – which did not, however, hold him back.[99]

For several weeks during that tumultuous summer of 1656 – between the death of the aged Siyavuş Pasha in late April and the arrival from Damascus of Boynueğri Mehmed Pasha early in July – there had been no grand vezir. The disastrous sea-battle in the Dardanelles took place on 26 June, Bozcaada fell to the Venetians on 8 July and Lemnos on 20 August.[100] The subsequent blockade of the Dardanelles affected not only the war in Crete: there

was a scarcity of food and other goods in Istanbul, and prices rose. Many people addressed petitions to the Sultan, hoping to provoke him to action.[101]

At a meeting on 4 September between Sultan Mehmed and his highest-ranking statesmen and military officers a detailed plan concerning preparations and strategy for the forthcoming land and sea campaign against Venice was discussed. Although significant sums had lately accrued to the treasury from the estates of those murdered in the recent uprisings and from melting down the debased coin which had sparked the furore,[102] the state coffers were far from full. Furthermore, Boynueğri Mehmed Pasha noted, some of the revenues traditionally earmarked to defray campaign expenses were no longer in the possession of the state but had devolved into the hands of private individuals. He threatened that if this problem was not remedied, the burden of continuing the war against Venice must fall this season on individual statesmen and military officers who would bear the cost from their own pockets. Needless to say, this did not meet with approval, but when these revenues were reassigned, Boynueğri Mehmed distributed them amongst his own supporters.[103]

The Sultan was not pleased with his new grand vezir, complaining that he had achieved nothing since coming to office – and had caused much irritation besides. A week later another meeting was called. To everyone's surprise, Mehmed IV announced that he intended to lead his army on campaign in person. Boynueğri Mehmed Pasha maintained that this would add further expense to an undertaking which was in any case most inadvisable, but his protestations fell on deaf ears.[104] A few days later, he paid for his frank opinion with dismissal, and was replaced on 15 September by Köprülü Mehmed Pasha who had been without office, living in his adopted home-town of Köprü, near Amasya, since throwing in his lot with İpşir Mustafa Pasha – unwisely, as it turned out. He had returned to Istanbul with Boynueğri Mehmed in July, and settled back into the politics of central government after an absence of several years. The odd workings of fate displayed by the dismissal of Boynueğri Mehmed and the elevation in his place of Köprülü Mehmed as grand vezir fittingly inaugurated the rise of a dynasty which was to monopolize the office into the next century.

9

Rule of the grandees

OTTOMAN HISTORY OF the second half of the seventeenth century is dominated by the name of Köprülü. The appointment of Köprülü Mehmed Pasha as grand vezir in September 1656 marked the beginning of a period during which many members of his household or their protégés were to hold the office. Köprülü Mehmed remained in power until his death in 1661; his son Fazıl Ahmed succeeded him and died in office in 1676, a length of tenure unprecedented for the times. Next came Köprülü Mehmed's son-in-law, Merzifonlu Kara Mustafa, who was executed for his failure at the siege of Vienna in 1683. In 1687 another son-in-law, Siyavuş, held the office for a few months. From 1689 the younger son of Köprülü Mehmed, Fazıl Mustafa, was grand vezir until his death in battle against the Habsburgs in 1691. In 1692 Çalık ('Crooked') Ali, a protégé of Kara Mustafa, was in office for a year. Between 1697 and 1702 the son of Köprülü Mehmed's brother – thus a cousin of Fazıl Ahmed and Fazıl Mustafa – became the grand vezir known as Amcazade Hüseyin Pasha. The last member of the dynasty to be grand vezir was Numan, eldest son of Fazıl Mustafa, in 1710. Success bred success: as members of the household rose to command the empire, their opportunities for patronage increased and the networks of loyal clients they built ensured them an ever firmer grip on power. Although other statesmen held the office of grand vezir for short periods during the years of their dominance, it was not until the Köprülüs came up against the clerical dynasty of Sheikhulislam Feyzullah Efendi at the turn of the century that their fortunes declined.[1]

Köprülü Mehmed was from Albania, a product of the youth-levy and an adopted son of the town of Köprü in north-central Anatolia. He was in his seventies but his past career, while long and adequately distinguished, had not been such as to single him out from other possible candidates. He had the indisputable advantage, however, of not having been party to the chronic factional disputes which had racked the capital in recent years, and although he was living in Istanbul at the time of his elevation he held no government post there – his appointment as grand vezir came as he was about to leave for the distant province of Tripoli in Syria as its governor.

Other recent grand vezirs had also been chosen from outside court circles: Köprülü Mehmed's immediate predecessor, the octagenarian Boynueğri Mehmed Pasha, had been summoned from the governorship of Damascus,[2] and before that, the aged Siyavuş Pasha had been based at Silistra on the Danube when called to the grand vezirate – whether as governor of the province of the same name, or of Özi on the northern Black Sea coast is unclear.[3] In February 1656 the Sultan had decided to recall Deli Hüseyin Pasha from Crete, where he had served for thirteen years;[4] in the event, however, the uprising which brought Köprülü Mehmed to power began before Deli Hüseyin could take up office.

Writing half a century later, the historian Mustafa Naima reported that in fact Köprülü Mehmed Pasha had been proposed for the post of grand vezir by the queen-mother, Turhan Sultan, and her faction when the appointment of Deli Hüseyin Pasha was being discussed, and it is certain that he owed his eventual recall to court to his ties with members of her household who championed him against other possible candidates.[5] Naima's verdict on Turhan's predecessor as queen-mother, Kösem Sultan, suggests that he was comfortable with the principle of the mother of a sultan acting as regent and intervening in state decisions.[6] More than that, he felt reassured that a member of the ruling dynasty and the accepted representative of the under-age sultan – rather than an official compromised by involvement in the unrest – should have been instrumental in engineering an appointment which was to prove harshly effective in ending the ugly events which preceded it.

The administrative groundwork necessary for Köprülü Mehmed Pasha to fulfil Turhan Sultan's expectations had already been laid. Probably in 1654, and possibly at Turhan Sultan's instigation, the grand vezir's office had been moved outside the palace enclosure: distancing the grand vezir physically from palace intrigues would, it was hoped, foster a recovery of the prestige the position had lost over the past half-century.[7] Turhan and her circle proved perspicacious in their choice. There must have been those who agreed with the keeper of Melek Ahmed Pasha's seal that Köprülü Mehmed was 'a miserable wretch . . . who could not even give straw to a pair of oxen',[8] but his patrons were powerful enough to withstand the vested interests opposed to his appointment, and his arrival at the head of government after years of chaos was welcomed by many.

Köprülü Mehmed Pasha's first action on the domestic front was taken against the Kadızadelis, currently enjoying a revival. Their puritanical message had once more fallen on receptive ears during the bitter factionalism of Mehmed IV's early years, and their potential for disrupting the public order which it was the Grand Vezir's aim to re-establish was such as could not be ignored. Their spiritual authority, Üstüvani Mehmed Efendi, was a

preacher who had built a reputation in the mosques of the city, and gained entrée to the palace through his popularity among some of its functionaries. The Kadızadelis attacked the clerical establishment in general, but the force of their tirades was once more reserved for the dervishes; Üstüvani Mehmed's earliest success had occurred in 1651, when he persuaded Melek Ahmed Pasha, then grand vezir, to order the destruction of a Halveti dervish lodge in Istanbul. His acolytes, driven off by the defenders of a second lodge which they attacked, put the Sheikhulislam, Karaçelebizade Abdülaziz Efendi's predecessor Bahai Mehmed Efendi, under duress and obtained from him a juridical opinion critical of dervish practices – which was subsequently withdrawn.[9]

Within a week of Köprülü Mehmed Pasha's assumption of office the Kadızadelis threw down the gauntlet, in the form of a multi-point programme for a return to the fundamental tenets of the faith.[10] As they gathered at the mosque of Mehmed II to plan how to put their programme into effect, Köprülü Mehmed made plain his determination to rely on the 'official' institutions of the state, seeking the advice of the clerical establishment, whose position as the religious wing of the state apparatus was threatened by Kadızadeli influence in high places. Perhaps out of fear of public sentiment the new grand vezir did not execute the Kadızadeli leaders whom he rounded up, but banished them, the powerful Üstüvani Mehmed Efendi included, to Cyprus.[11]

Other victims of the purge against those Köprülü Mehmed feared or those he held responsible for fomenting unrest were not so lucky. The hanging of the Orthodox Patriarch on the grounds that he had encouraged the Christians of Wallachia to rebel against Ottoman rule was wholly unprecedented.[12] Deli Hüseyin Pasha, accused of misappropriating funds intended for the Cretan war, was initially saved from death by the intervention of Köprülü Mehmed's patrons in the Queen-mother's circle on the grounds that it was an inadmissible fate for one who had given such distinguished service for so long, and the incumbent Sheikhulislam refused to issue a juridical opinion recommending his execution. But Deli Hüseyin's supporters were soon outwitted; two years later Köprülü Mehmed invited him to Istanbul, and was able to prevail on the Sultan to order the summary despatch of his rival.[13]

It was by no means a foregone conclusion that Köprülü Mehmed Pasha would manage to hold on to power until death removed him, and his rivals clung to the expectation that if they could muster enough support, they had a chance of office. Any high-ranking Ottoman statesman who had continued to live through the recent tit-for-tat violence could count himself lucky, and the very fact of his survival tended to bolster any ambition he might have of one day becoming grand vezir. Old discontents festered, and

the aggrieved sought opportunities to express and redress them. With the aim of distancing another rival from Istanbul, soon after his elevation Köprülü Mehmed ordered Seydi Ahmed Pasha to be dismissed from the post of grand admiral which he had been awarded for his part in repulsing a Venetian attack on the Dardanelles late in the summer of 1656,[14] and to serve instead as governor of Bosnia. The sultan's cavalry, who were supporters of Seydi Ahmed, ran amok in protest; the janissaries were persuaded to take the side of the authorities against them and Köprülü Mehmed strove to present a united front, summoning to his palace the leading officers of all branches of government. The Sultan delegated to him the authority to punish the unruly, and a curfew was imposed. A number of officials of the cavalry regiments were executed, and many cavalrymen caught hiding in the caravansarays of the city and across the Bosporus in Üsküdar were beheaded. In the continuing effort to root out troublemakers all those making common cause with them were also hunted down[15] – their corpses, as Sultan Mehmed IV's confidant and chronicler Abdurrahman Abdi Pasha so elegantly put it, 'provided sustenance for the creatures of the sea'.[16]

Crete was still not won. The Venetian blockade of the Dardanelles was short-lived and in the 1657 season Ottoman ships appeared in the Aegean as usual. The Venetians were over-extending themselves in attempting to hold Bozcaada and Lemnos, close to the Anatolian mainland and far-distant from their home ports. After several months of hard-fought naval engagement in the Dardanelles, in which Köprülü Mehmed himself commanded the land army encamped on the Anatolian coast of the Straits, the Ottomans retook the islands and those deemed to have been derelict in their duty during the campaign were executed[17] – an early sign that the regime of Köprülü Mehmed Pasha was of a different order from those of recent memory. It was also true that Venice was finding the war against the Ottomans a drain on its finances. Some senators appreciated that the restoration of normal relations was necessary to allow Venetian merchants access to the Ottoman market on which they relied for a good proportion of their income – but this pragmatic view did not prevail. The Ottomans briefly toyed with the possibility of peace with Venice when the independent foreign policy being pursued by their vassal George II Rákóczi caused them to mount expeditions into Transylvania, but their demand for the whole of Crete was unacceptable to Venice.[18]

Rákóczi had set himself up as the champion of the Hungarian Protestants, and with courage derived from the agreement he had made with King Charles X Gustav of Sweden in December 1656 marched north into Poland. He managed to prevail upon the neighbouring Ottoman vassal states of

Wallachia and Moldavia to join him and this alarmed the government in Istanbul, as it threatened the existing balance of power which it was in the interests of both Habsburgs and Ottomans to maintain. A weak Commonwealth on their north-western frontier suited the Ottomans far better than a swathe of territory seized by an energetic vassal and held with Swedish support. In the event, Rákóczi's expeditions against the Commonwealth brought him no gain. In the spring of 1657, Melek Ahmed Pasha, governor of the province of Özi at the time, was ordered to bring Rákóczi and his allies into line; by late summer his forces were joined by those of the Crimean Khan, and in 1658 Köprülü Mehmed Pasha himself marched into Transylvania leading an army among whom were some thousands of men sent by the Commonwealth. Rákóczi fled, but he and the errant vassal princes of Wallachia and Moldavia were soon replaced by less independent-minded or less persuadable figures.[19]

While in winter quarters at Edirne following the recovery of Bozcaada and Lemnos and before setting out for Translyvania the following spring, Köprülü Mehmed Pasha, aiming to eliminate troublemakers before they could cause problems on the campaign, massacred many more cavalrymen who had been ordered to mobilize there. Even Mustafa Naima could not record the event with equanimity: he wrote of the banks of the Tunca river in Edirne as being strewn with their corpses.[20] Abdurrahman Abdi Pasha recorded that the winter was especially cold that year, causing much suffering – the snow was so deep that roads were blocked and provisions difficult to obtain, and wood for heating was not to be found so fruit trees were cut down to provide fuel.[21]

Köprülü Mehmed Pasha managed to bring order to Istanbul and enjoyed successes against Venice and Rákóczi, but he was still not accepted by the provincial governors of Anatolia. In late 1658, on his return from campaigning in Transylvania, he was faced with a revolt among them which would undoubtedly have brought an end to his tenure and had serious repercussions for the ruling establishment as a whole had he not overcome the rebels. As it was, the uprising concluded with the massacre of some thirty pashas – most of whom had long records of state service – which put an end for a while to the frequent revolts which had marked life in Anatolia in past decades.

The chief protagonist in Anatolia was Abaza Mehmed Pasha's fellow countryman Abaza Hasan Pasha, who was already an active dissenter before Köprülü Mehmed Pasha moved to the centre of Ottoman politics. Abaza Hasan, a supporter of the former rebel and grand vezir İpşir Mustafa Pasha, like many other Anatolian pashas, could not accept the legitimacy of Köprülü Mehmed's grand vezirate. The Grand Vezir's purge of the sultan's cavalrymen in Edirne

proved to be counter-productive as many who escaped his wrath fled, despite the harsh weather, while provincial cavalrymen who had yet to answer the call-up had disobeyed their orders to muster. In mid-summer 1658 some 30,000 gathered instead at Konya in central Anatolia, among them the governors of Damascus and Anadolu provinces and fifteen other former or serving provincial governors, with Abaza Hasan Pasha at their head. Complaining about being ordered to mobilize, the rebels announced that, 'We will continue to assemble [here] until Köprülü Mehmed Pasha is dismissed',[22] and proposed in his place the governor of Damascus, Tayyarzade Ahmed Pasha, whose father had briefly been grand vezir during the reign of Murad IV and whose brother was governor of Raqqa province in Syria. The Sultan ordered the rebels to the Transylvanian front immediately, but in vain, for they merely reiterated their fear of Köprülü Mehmed and their refusal to fight until he was removed from office – and Köprülü Mehmed Pasha had to leave Edirne for the front in mid-summer 1658 without most of the Anatolian troops. Aware of the havoc they could wreak, the Sultan thought it expedient to offer them an alternative to service under the Grand Vezir on the Balkan front and ordered them instead to the defence of the frontier at Baghdad. But Abaza Hasan Pasha ignored the order and moved west towards Bursa – intent on lending their rebellion an aura of legitimacy, his followers were ordered not to extort provisions and money from the peasantry as they went but to account for all supplies they collected.[23]

News of their approach to Bursa impressed upon the authorities the seriousness of their intentions; memories of other rebellions such as that of Gürcü Abdülnebi only a few years earlier were still fresh in official minds. The former grand admiral Kenan Pasha, Köprülü Mehmed Pasha's proxy while he was away on campaign, was ordered by the Sultan to defend Bursa.[24] A further communication from Abaza Hasan Pasha, who was described by the messenger as the 'Sultan's servant', infuriated Mehmed IV. His memorialist Abdurrahman Abdi Pasha reported his reaction:

> I greatly regret having to say this but these men are not my servants; maybe they are the Devil's. I have already ordered them to abandon their useless and perverse notions and come [before me] but because they are afraid of coming, they can go and take part in the defence of Baghdad [instead] or else stop assembling and return to their appointed [duties]. What sort of Muslims are they who continue to disobey orders? God willing, it will not be the body of only one individual I [cut to] the ground; I will murder them all.[25]

From his camp near the front the Grand Vezir sent an ultimatum: if the rebels refused to join him, he would deal with them after the campaign was over.[26]

Abaza Hasan Pasha's insurrection was a little different from previous rebellions on the part of Anatolian cavalrymen. His predecessors had couched their complaints in traditional terms, insisting on their allegiance to the Sultan while expressing contempt for his servants, whom they professed to hold responsible for the ills of the empire; in the face of Mehmed IV's refusal to so much as acknowledge his demands, Abaza Hasan wanted no part of the establishment. His intention was to create his own state: 'From now on, consider us as implacable a foe as the Shah of Iran; they [the Sultan] shall have Rumeli and we Anatolia'.[27] Such a radical declaration was all the more dangerous for being made to a young and inexperienced sultan while his grand vezir and most of the loyal troops of the empire were far away.

Abaza Hasan Pasha and his men dug in outside Bursa. He set up something resembling a provincial administration, appointing his fellows to the governorships held by those who were away on campaign with Köprülü Mehmed Pasha, as the head of an alternative government might, and taking provisions from the local people on the pretext of feeding the army. The townsfolk of Bursa assembled the arms and provisions Kenan Pasha levied from them – but they were in contact with Abaza Hasan Pasha, and supplied his forces as well. This further provoked Sultan Mehmed, who sought a juridical opinion to the effect that those who refused to join campaigns against the infidels and incited sedition were themselves worse than infidels. When the clerics refused to provide such an opinion the Sultan decided to dispense with it, and proclaimed a general call to take up arms against the rebels. The governor of Diyarbakır, Murteza Pasha, was ordered to command the anti-rebel forces drawn from those whose loyalty could still be counted on – the troops of the eastern provinces of Diyarbakır, Erzurum, Aleppo and İç-il (comprising Cilicia and Cyprus) and the Kurdish tribal leaders. Government edicts assured the Anatolian people that order would be restored, and criticism of the Grand Vezir was forbidden in the Sultan's presence. The government's ability to resist the rebels deteriorated further when Kenan Pasha was persuaded to throw in his lot with Abaza Hasan – troops sent from Istanbul to defend the coastal town of Gemlik on the road to Bursa managed to kill some of Abaza Hasan's men when they reached Mudanya, but he sent more after them to avenge the loss, and the government forces retreated back across the Sea of Marmara towards Istanbul. Trenches were dug in Üsküdar to defend the capital, as they had been at the time of Gürcü Abdülnebi's revolt nine years earlier, and cannon were emplaced.[28]

The rebel army was expected imminently, and the region was in turmoil. People barricaded themselves into their homes, while those living on the Marmara coast sent their chattels to Istanbul for safekeeping and stripped their gardens and orchards of produce in advance of the harvesting season.

Looters were active and rumours rife. Hatred of Köprülü Mehmed Pasha was widespread and palpable; according to Mustafa Naima, most people hoped Abaza Hasan Pasha would be victorious, especially the preachers, whose implacable opposition Köprülü Mehmed had earned by exiling their leader Üstüvani Mehmed Efendi to Cyprus. Some among them professed to hold Abaza Hasan to be 'the renewer of faith of the eleventh century [of the Islamic calendar]', a messianic figure come to restore the fundamentals of religion in the Prophetic tradition.[29]

The Sultan ordered Köprülü Mehmed Pasha's immediate return from Transylvania. Abdurrahman Abdi Pasha was probably at his master's side and records that Mehmed, his mother and their entourages had been in Edirne since before the campaign opened, and it was to Edirne that Köprülü Mehmed travelled, meeting with them and the Sheikhulislam and the top military authorities on 15 October 1658, three days after his arrival. Thereafter they all travelled to Istanbul, where outstanding salaries were distributed by the Sultan to those of his elite troops who remained loyal; they assembled for the purpose at Kağıthane meadow outside the city at the head of the Golden Horn, in an exercise intended to put the rebellious soldiers among them to the test: any member of the sultan's regiments who did not appear to collect his money within five days had his name expunged from the rolls.[30] The government seemed to be regaining the initiative.

For two months a rebel army and government forces had clashed in the vicinity of Kütahya in west-central Anatolia: the rebels were defeated with high losses, and a successful attack on İznik which routed government forces was not enough to restore hope to them. When word of the salary distribution reached the ears of those of Abaza Hasan's followers who came from the sultan's regiments, many of them went to Istanbul in expectation of being reinstated into the corps. However, the names of some 7,000 elite cavalrymen who had refused to participate in the campaign in Transylvania had been erased from the rolls and Köprülü Mehmed Pasha ordered the execution of any who could be apprehended. A thousand men were killed within a few days in Anatolia, as well as others who had managed to enter Istanbul too late for the roll-call, but Köprülü Mehmed was still not confident of victory and sent 5,000 janissaries to defend İzmit. The continuing massacres of cavalrymen had begun to provoke thoughts of mutiny among the janissaries, however, although they had hitherto remained united in support of the government – if only through fear. Now, protesting that they were not prepared to be party to killing fellow Muslims, they branded the Grand Vezir their enemy and suggested handing him over to Abaza Hasan. This threat was serious enough to dissuade Köprülü Mehmed from campaigning in person against the rebels, and Murteza Pasha was given command in his stead.

But Köprülü Mehmed soon had occasion to question the wisdom of his decision when Murteza Pasha at first failed to force a battle when the opportunity arose in central Anatolia and was then roundly defeated by Abaza Hasan, with losses on both sides amounting to eight thousand men.[31]

Winter came, and spies infiltrated both the government and the rebel camps. As Köprülü Mehmed Pasha considered holding secret talks with the rebels, Abaza Hasan Pasha's position was weakening. He had moved southeastwards, but finding it difficult to supply his winter quarters in Gaziantep (Aintab) on account of the snowy weather and the hostility of the people of the region who were loyal to the government, decided to move into Syria; before he had gone very far he fell into an ambush at Birecik on the Euphrates and lost more than a thousand men. From his winter quarters in Aleppo Murteza Pasha sent his agents in disguise into Abaza Hasan's camp with the promise of a pardon from the Sultan to try to persuade the rebel soldiers to desert their leader. When Abaza Hasan heard of this he pleaded with the waverers that he was fighting for their cause – but Murteza Pasha's blandishments proved irresistible to men stricken by hunger. Seeing his support melting away, Abaza Hasan accepted the senior cleric of Gaziantep's offer to intercede with the Sultan on his behalf. Murteza Pasha sent a hostage as proof of the genuineness of the offer, and Abaza Hasan and his remaining followers, who still included many formerly high-ranking officials, accepted an invitation to stay in Aleppo while their pardons were sought; Murteza Pasha swore that no harm would come to them.[32]

Their days in Aleppo passed in great amicability. Abaza Hasan Pasha was lodged in Murteza Pasha's mansion, his 31 companions and their servitors elsewhere. No response to their petition arrived from Istanbul, however, and the continuing presence of the rebels in Aleppo began to make Murteza Pasha uneasy. Finally, he gave instructions that when the cannon was fired from Aleppo fortress on the night of 24 February 1659, the rebels were to be murdered by those in whose houses they were guests. Abaza Hasan Pasha, Tayyarzade Ahmed Pasha, Kenan Pasha and some others were dining with Murteza Pasha that night – as Naima imagines the scene, companionably eating and drinking and agreeing to put past differences behind them. But as they made for the bathroom of Murteza Pasha's mansion to perform the ritual ablution before the evening prayer, twenty or thirty 'dragon-like braves' burst in and bloodily stabbed them to death. News of the massacre was immediately sent to the governor of the fortress who fired the cannon to indicate that the time had come for the less eminent rebels to be slaughtered. Their heads were stuffed with straw and sent to be displayed in Istanbul; their bodies were suspended outside one of the city gates of Aleppo.[33]

There is no direct evidence to suggest that Köprülü Mehmed Pasha was

complicit in the manner of ending Abaza Hasan Pasha's revolt, but the result surely satisfied him. The finality of its conclusion was such as to dissuade most other disaffected servants of the Ottoman state from following his example, although the provincial sub-governor of Antalya, Kör ('Blind') Mustafa Pasha, took advantage of the disorder provoked by Abaza Hasan Pasha's rebellion to foment unrest in his own area. This met with a strong government response by land and sea and Kör Mustafa, unwisely trusting in the promise of a sultanic pardon, was soon executed, as were others in Damascus and Cairo who dared to challenge Köprülü Mehmed.[34]

The Grand Vezir took no chances. Once the Anatolian rebellions had been suppressed he sent his proxy in Istanbul, İsmail Pasha – who had succeeded Kenan Pasha in the post – to the eastern borderlands to seek out any remaining there who might be considered a threat to the order of the state. No one was immune, be they provincial governor, janissary or cavalryman, judge or religious leader. The penalty was death, as was sanctioned by juridical opinion. As part of Köprülü Mehmed's attempt to impose a common purpose, İsmail Pasha's inspection team was composed of both military and religious-legal officials: and to impress upon the people that the Sultan and his ministers were fully in control, they moved through Anatolia with great ceremony. One of their tasks was to check the status of those claiming to be military men in order to ascertain that they were not in reality peasants who had sought to escape taxation by enlisting. Maximizing tax revenue was the abiding concern of Ottoman governments, and striking a balance between this imperative and the state's need for troops a compromise. İsmail Pasha's team found 80,000 guns illegally in the hands of the peasantry and seized them for the state armoury. Some Mevlevi dervishes apprehended in Konya were freed when they proved their identity, but four others who had donned dervish garb only to be revealed on closer inspection as erstwhile followers of Abaza Hasan Pasha were punished accordingly.[35]

Anatolia and the Arab provinces were subdued for the present, the Cretan war had reached a stalemate, and a change of princes had restored order to the vassal states of Wallachia and Moldavia – in Transylvania, however, George Rákóczi still refused to accept his removal by the Sultan, and with Habsburg assistance fought against the Sultan's choice as his replacement.

The young Sultan and his mother were surely complicit in the harshness with which Köprülü Mehmed Pasha had crushed domestic dissent: Mehmed had stood by his grand vezir, if only for want of any alternative. Köprülü Mehmed considered that the time was now ripe for a display of sultanic splendour and queen-motherly concern, designed to win over the Ottoman people. Mehmed IV's great passion was hunting – he acquired the epithet

'the Hunter' – and his preferred residence was Edirne, where from the sanctuary of his palace outside the town he could follow the chase free from the squabbles of the capital. He had reigned for eleven years, but he had only ever travelled between Istanbul and Edirne, and royal journeys such as these could hardly be celebrated sufficiently for the propaganda purposes which Köprülü Mehmed had in mind. Well aware of the potent symbolism of monarchy, he devised a fitting manifestation of his sovereign's majesty.

On 26 May 1659 the imperial standard was brought out from the inner recesses of Topkapı Palace and set up outside the Gate of Felicity that marked the boundary between its private and public areas. Over the next month the Sultan and his mother, as well as his vezirs and troops, crossed over to Üsküdar, and on 30 June set off with great pomp for the dynastic burial city of Bursa which they reached, at a leisurely pace and with extended stops along the way, on 29 July. Bursa had been in great peril during Abaza Hasan Pasha's revolt, and there was public rejoicing and adulation for Sultan Mehmed during his time there. The normal business of government continued: new appointments were made and justice exacted as those who had colloborated in the anti-Köprülü uprising were dismissed and the Sultan ordered the execution of those Bursans who had supplied Abaza Hasan when he was advancing on Istanbul. Having demonstrated his earthly authority the Sultan visited the tombs of his ancestors, where the legitimacy and splendour being demonstrated as his by divine right was underlined when the sacred mantle of the Prophet was put on display as the focus of a nightly ceremony.[36]

The royal sojourn in Bursa was only the beginning of the progress among his people planned by the Grand Vezir for his Sultan. From there they visited the Dardanelles. Recent naval engagements with the Venetians had demonstrated that the fortresses built on either shore by Sultan Mehmed II in the mid-fifteenth century were not adequate to prevent the passage of modern sailing vessels. Every year, according to Mustafa Naima, thirty or forty Venetian ships would anchor beyond these castles and blockade the Straits; other vessels sailing into the Straits from the Aegean, unaware of their presence, fell into the ambush. The problem had been recognized by the previous queen-mother Kösem Sultan shortly before her murder, and she had appointed an architect to look into the feasibility of constructing opposing batteries further west, towards the Aegean end of the Straits. Kösem's project for the new castles was carried forward during Turhan Sultan's regency, and by the time of her visit in late September of 1659, the fortifications were complete except on the seaward side. From the Dardanelles, the royal party travelled back to Edirne.[37] When the castles had been completed, almost two years later, the Sultan and his mother

again travelled to the Straits with great ceremony to view the work – as described by his confidant Abdurrahman Abdi Pasha, who wrote a poem to mark the 'gracious gift' of 'the mother of Sultan Mehmed Khan Gazi':

Building two fortresses, one on either side [of the Straits],
She made the lands of the people of faith safe from the enemy.
. . .
What grace, to fill in the sea on two sides,
So parallel, and thus to build the Straits anew.[38]

On 30 September 1661 Köprülü Mehmed Pasha died in Edirne after some months' illness. Like Turhan Sultan, he too was a charitable bene-factor. His endowments followed the pattern of his life and conquests in putting the Ottoman seal on newly-conquered territory. The most varied of his foundations was that on the island of Bozcaada, recaptured from the Venetians early in his grand vezirate. Here he built two mosques, a school, a caravansaray, a bath-house, a coffee-house, a stable, nine mills, a water-mill, a bakery and 84 shops. The income-generating elements of the foun-dation did not however produce enough revenue to cover outgoings and charitable works, so a number of villages and other rural sources of revenue were granted to Köprülü Mehmed to make up the shortfall, among them the taxes from two villages on the island of Lemnos, also retaken by him from the Venetians, shortly after Bozcaada.[39]

In the Transylvanian campaign of 1658 Rákóczi's stronghold of Ineu became part of the Ottoman Empire, and Köprülü Mehmed Pasha built here a mosque, two schools, nine mills and thirty shops. In his native town of Rudnik in Albania he built a mosque and school, and in his adopted home in the Amasya region, to which, before he became grand vezir, it was his habit to return during the periods when he was out of office, he established a number of other endowments, including a caravansaray at Gümüşhacıköy, north-west of the town of Amasya on the east–west trade route through north-central Anatolia, to stimulate commerce. His period of service in Syria prompted him to provide better security for the pilgimage route, and south of Antakya (Antioch), at Jisr ash Shughur on the Orontes river, he built a fort, two mosques, a caravansaray and a school – oper-ationally the most expensive of his foundations, because it served the impor-tant defensive purpose of protecting merchants and pilgrims from the raids of the desert peoples.[40]

Patronage had long been an important route to preferment in the Ottoman Empire, and sons had succeeded fathers in the high offices of state for more than fifty years – as shown by the numerous vezirs with the appellations

A-oğlu B Pasha, or X-paşa-zade Y Pasha, 'oğlu' meaning 'son' in Turkish, and 'zade' meaning 'son' in Persian. Thus the names of Özdemir-oğlu Osman Pasha and Nasuh-paşa-zade Hüseyin, for instance, indicate that this Osman was the son of Özdemir [Pasha], and Hüseyin the son of Nasuh Pasha. On Köprülü Mehmed Pasha's death his son Fazıl Ahmed Pasha became grand vezir in his stead at the unusually early age of 26 – and, in a variant of these forms, was known as Köprülüzade Fazıl Ahmed Pasha; it was the first time that a son had succeeded his father as grand vezir. Fazıl Ahmed had begun his education in theological college and graduated to hold posts in the religious hierarchy in Istanbul, but he abandoned religion for administration soon after his father became grand vezir, and was appointed to the sensitive frontier governorship of Erzurum, where a trusted man was always needed. The decision to appoint him grand vezir was taken before his father's death: knowing that his end was near, Köprülü Mehmed recalled Fazıl Ahmed from Damascus (where he was by then serving as governor) and made him his proxy.[41] Köprülü Mehmed's desire to have his chosen successor near at hand recalls the tactics of sultans of former times, and the parallel between Köprülü Mehmed's ambitions for his family and that of the Ottoman sultans for theirs during the fifteenth and sixteenth centuries strikingly illustrates the unbounded aspirations of this grandee dynasty.

Fazıl Ahmed Pasha's fifteen-year tenure as grand vezir – cut short by his premature death in 1676 – was marked by a number of military campaigns, especially on the north-western frontier, as the Ottoman Empire again enjoyed a period of expansion. Fazıl Ahmed's first objective was a fresh attempt to break the impasse with Venice over Crete, and full mobilization of the imperial army was ordered on 25 September 1662. His idea was to launch a campaign into Dalmatia in 1663 in support of local Ottoman troops whose activities against Venetian strongholds in the region – such as the fortresses of Šibenik, Split and Kotor – had been a perennial irritant to the republic. The Ottomans entertained hopes of capturing these fortresses, but by November it was apparent that the army would be heading towards Hungary rather than Dalmatia.[42]

The instability produced by George Rákóczi's activities in Transylvania seemed to have been resolved in 1660 when a large army restored Ottoman authority, winning a number of strongholds – including Oradea which had narrowly escaped capture in 1658, and now became the nucleus of a modest new province of the same name (Varad in Turkish) – and killing their troublesome former vassal.[43] A curious detail concerning the siege of Oradea linked it to the Ottoman conquest of Constantinople two centuries before: as with the statue of the mounted Emperor Justinian which 'protected' Constantinople, Oradea was 'protected' by a talisman – four bronze statues

of medieval Hungarian saint-kings, dating from the end of the fourteenth century. Contemporary Transylvanian historians recorded the Hungarians' belief that the city would never be won by another power while these statues remained in place; the Ottomans accordingly made a point of directing their firepower against them. They succeeded in destroying them – and in taking the fortress – and the wreckage was removed to Belgrade, where it was melted down to make guns – referred to ironically by the Ottomans as 'the gods of the Hungarians'.[44]

Such direct Ottoman intervention in Transylvania was a cause of grave disquiet to the Habsburgs, whose candidate to succeed Rákóczi, John Kemény, was soon driven out by Ottoman forces and Michael Apafi, a provincial magnate, installed in his place late in 1661. Kemény resisted for a while but was killed in battle in February 1662.[45] Peace between the Ottomans and the Habsburgs could not be achieved in 1662, and on 14 April 1663 Fazıl Ahmed Pasha set off from Edirne at the head of the imperial army, reaching Belgrade on 7 June. The Grand Vezir was not in the mood for conciliation, and when he met the Emperor Leopold I's envoys he reminded them of the violations of the conditions of the peace that had occurred in Transylvania and elsewhere on their common border and – such was Ottoman confidence at this time – also demanded reinstatement of the annual tribute paid by the Holy Roman Empire to the Ottoman sultan from the time of the Hungarian wars in the reign of Sultan Süleyman until the end of the 1593–1606 war.[46] No accord could be reached, however, and the envoys were imprisoned.

Fazıl Ahmed Pasha had apparently intended to march against Győr, one of the strongholds guarding the approaches to Vienna, which the Ottomans had briefly held between 1594 and 1598. Once at Buda, however, and after further fruitless talks with Habsburg representatives, his plans changed, and the Ottoman army moved north, crossing the Danube at Esztergom and arriving before the fortress of Nové Zámky on 17 August 1663; this decision both surprised and alarmed the Habsburg forces under the command of the general Raimondo Montecuccoli, whose strategy for the defence of Vienna was not yet in place but who was even less prepared for an attack elsewhere. Fazıl Ahmed's decision was both daring and aggressive, because Nové Zámky lay on the route between Vienna and Transylvania and was one of the key points in the Habsburg defence system. The defenders at first refused to surrender the castle, and the siege – in which Fazıl Ahmed's forces were supported by Cossacks and Crimean Tatars, and troops from Moldavia and Wallachia – lasted five weeks. When the garrison finally surrendered, the defenders were allowed to leave unharmed, and Fazıl Ahmed Pasha and his army returned to Belgrade for the winter. The

campaigning season of 1663 ended with what amounted to a tidying-up operation, the capture of a number of other smaller castles in the area and their inclusion in the new province known as Uyvar, based on Nové Zámky.[47]

For contemporaries in the West, the conquest of Nové Zámky carried echoes of former times and seemed to signal a resurgence of Ottoman military power and energy. Nevertheless, forces loyal to the Habsburgs were not slow to take advantage of the weeks during which Fazıl Ahmed Pasha was occupied with the siege and the subsequent winter demobilization, and in January 1664 they seized and briefly held a number of Ottoman forts in the south of Hungary. The situation was serious, however – it seemed that Vienna was again under threat, and help for the Habsburgs was forthcoming from the Pope, from Spain, from some of the German princes, and even from France, currently at peace with the Holy Roman Empire. Rather than attempting to retake Nové Zámky, Habsburg efforts in 1664 were directed against Nagykanizsa, the key stronghold on the route between Belgrade and Vienna, held by the Ottomans since 1601. The siege was lifted when Fazıl Ahmed Pasha and his army arrived, and the Ottoman army continued its advance, taking a number of other forts – including one whose razing they had demanded in the failed peace talks which preceded the Uyvar campaign – and with the intention of now besieging Győr.[48]

Whatever hopes the Ottomans might have entertained were dashed on 1 August 1664 at Szentgotthárd, north-east of Nagykanizsa on the river Rába, where they were defeated in a field-battle by Montecuccoli's forces. The traveller and writer Evliya Çelebi was with Fazıl Ahmed Pasha's army and described its difficult march towards the Rába from Nagykanizsa, shadowed by Habsburg units on the west bank of the river as it went; provisions were very short and the muddy and marshy conditions made progress extremely slow – it took five hours to cover a distance that should have taken only one hour.[49] When the army reached the eastern bank of the river opposite the castle of Szentgotthárd, the sun came out but the enemy was nowhere to be seen. Evliya Çelebi reported that the water in the river was low at that point, only as deep as a rider's stirrups, and Fazıl Ahmed sent raiders across to harry villages on the western bank. The decision to besiege Vienna was taken, despite the lateness of the season and the scarcity of provisions, and the wretched troops could not object; orders were given for a bridge to be hastily built across the river, and the army prepared to advance within two days. Evliya Çelebi was disgusted with this foolish decision – which he blamed on two of Fazıl Ahmed's commanders, the governor of Aleppo Gürcü ('Georgian') Mehmed Pasha (who had been grand vezir for a few months in 1651–2), and İsmail Pasha (who had won notoriety on account of his pitiless inspection tour of Anatolia a few years earlier).

The army's condition was like that of a water-mill deprived of water, wrote Evliya Çelebi, and he secretly took himself off to the Tatar camp to find supplies for himself and his eleven men, and grazing for his six horses.

The next day was Friday, the rest-day before battle; some thousands of Ottoman troops crossed the river to reconnoitre and learnt from captured informants that ten thousand of the enemy were concealed in nearby woods. Gürcü Mehmed Pasha and İsmail Pasha tried to convince Fazıl Ahmed Pasha that the attack should begin forthwith; although wiser counsels pointed out that many Ottoman troops were absent grazing their horses, and the presence of so few Habsburg troops must be a trick, the Pashas would not be gainsaid, and the main body of the Ottoman army was ordered to ford the river a day earlier than had been planned, and before the bridge was securely in place.

The fight went well at first. Only a few thousand more enemy troops appeared from the woods, and the Ottoman forces were able to retire with hundreds of prisoners and booty, as well as the heads of those they had killed in battle – for which, as was customary, they were rewarded. Evliya Çelebi claimed to have been present on the field, and noted that 9,760 Habsburg troops had been killed for 760 Ottoman; flush with success, Fazıl Ahmed Pasha's men raided far and wide. But then, before much of the Ottoman army could cross the bridge, the mighty Habsburg army made itself visible and was soon drawn up along the river, and fresh troops kept appearing on the battlefield – even after six hours of hand-to-hand fighting. The Ottoman fighters were, said Evliya Çelebi, 'like a mere drop in the ocean of the enemy forces', yet Fazıl Ahmed did not call upon the Tatar troops to support them because he had a grievance against the Khan's son who commanded them. Evliya Çelebi's own horse was shot from under him in the thick of battle, and he forded the river to find another; looking from the Ottoman camp back across the river at the battlefield, he could see to his alarm that the Ottoman troops were being vanquished and there was still no let-up in the fighting. At this point, Fazıl Ahmed ordered the janissaries to move to the trenches guarding the bridgehead, but when their fellows saw this rede-ployment, they assumed them to be fleeing the field. Soon, the Ottoman army was in total disarray as any who could, fled, trying to get back across the river to their own camp. Evliya Çelebi witnessed the scene:

Because the bridge had been built in a hurry, some places were tied together with the ropes used for stabilizing the cannon and when so many troops crowded onto it like ants trying to get to the other side, the bridge could not withstand it and collapsed. All the janissaries were submerged, but some were able to grasp at trees or the ropes used to fashion the bridge . . . Both banks of the river were steep and riven with crevasses and it was impossible for men

or horses to escape. Thousands dismounted but the horses were in the water and their bridles and stirrups became entangled and the soldiers got caught up among them and the mules.[50]

Some men were fortunate enough to find a way out of the mêlée, however, either by walking upon the bodies of their fallen comrades to reach the bank, or crossing the river away from the bridge; others managed to find places where the water was shallow, but these tended to be spots where enemy troops had gathered, and this carried its own risks. It was, remarked Evliya Çelebi, 'like the Day of Judgement'.

As a shift in the wind could spell the difference between triumph or disaster at sea, so difficult terrain and inclement weather, even more than the limitations imposed by the distances the Ottoman army had to travel from its bases in Istanbul and Edirne, could decide whether a military operation succeeded or failed. The Danube and its many tributaries might be useful for the transport of men and supplies, but in this part of Hungary they were liable to flooding and the surrounding plains to waterlogging – a common occurrence in the heavy late-summer rains repeatedly mentioned in the chronicles of these years. Such conditions were inimical to the movement of the thousands upon thousands of men and horses, the heavily-laden supply trains and the artillery that made up an army and, in particular, impeded the construction of, and passage across, bridges.

This defeat on the Rába forced the Ottomans into a more defensive posture, and within a few days a peace treaty with a term of twenty years had been agreed with the Habsburgs whose fighting forces were unequal to the task of deriving further advantage from their victory. Transylvania was to remain independent under Ottoman influence, and the Austrian emperor – the 'Roman' emperor, as the Ottoman version of the Treaty of Vasvar has it – again agreed to pay the sultan's treasury an annual 'gift'. Newly-conquered Nové Zámky remained Ottoman.[51] Fazıl Ahmed Pasha was subsequently scrupulous in ensuring that the provisions of the treaty were observed; the Ottomans needed a period of peace on this frontier to free them to deal with the Venetians, for the war over Crete was now in its nineteenth year.

In the suite of the Ottoman envoy Kara ('Black') Mehmed Pasha, the governor of Rumeli province, when he travelled to the Habsburg court for ratification of the treaty, was Evliya Çelebi, who has left us the earliest surviving Ottoman account of an embassy to a foreign state.[52] It seems that Fazıl Ahmed was critical of Kara Mehmed's modest apparel and retinue, telling him that as the Sultan's envoy he must confront the Emperor in fitting splendour and extravagance. Evliya Çelebi is exuberant in describing all that he saw in Vienna, and reveals a particular fascination with Leopold I,

who had succeeded his father as Holy Roman Emperor in 1658 when he was just eighteen:

> ... he is of medium height with a slim waist and neither corpulent nor solid nor skinny, a youth as hairless as a self-sacrificing young brave. God made his skull in the shape of a bonnet of a Mevlevi dervish or a gourd or a water bottle. His forehead is as flat as a board. His eyebrows are thick and black but there is a decent space between them. His eyes are as round as an owl's and reddish; his eyelashes are long and black; his face is as long as that of Mr Fox; his ears are as large as a child's slippers. His nose is as a shrivelled grape ... or as large and red as an aubergine of the Peloponnese; three fingers could fit inside each nostril and from these extensive nostrils protrude black hairs like those of the beard of a thirty-year-old brave which mix in confusion with his moustache. He has a bushy black moustache which reaches to his ears, his lips are like those of a camel (a loaf of bread could fit in his mouth); and his teeth are likewise, huge white camel's teeth. Whenever he speaks, saliva pours from ... his camel's lips and as it flows, the many [servitors] beside him wipe [it away] with red cloths like towels, and he combs his beard and moustaches continually. His fingers are like cucumbers of Langa [i.e. a market-garden area in Istanbul] ... All his dynasty is as ugly as him, and his hideous image is found in all churches and houses and on coinage ...[53]

While his grand vezir was in Hungary, Mehmed IV spent the two years of his absence between his palace at Edirne and hunting game in Thrace and Macedonia. The Sultan encouraged his favourite Abdurrahman Abdi to record for posterity every detail of courtly life, from the numbers of leopard, fox and roe deer hunted on any one day to a strongman's feat in lifting an elephant and its rider off the ground. Even when Abdurrahman Abdi fell ill, the Sultan admonished him to record the day's events.[54] Fazıl Ahmed Pasha returned to Edirne in July 1665 and the court travelled to Istanbul in easy stages by way of the Dardanelles, where they inspected the fortifications. The next pressing business was to complete the conquest of Crete.

Piracy against pilgrims and merchant ships was still rife on the seas in these years and raiding and slaving continued. At a meeting of leading statesmen the Sultan appointed the Grand Vezir to command the planned campaign in Crete, and preparations were put in hand during the winter of 1665–6. The Venetian ambassador had been held in Edirne for the past twelve years; he was now offered a last opportunity to conclude a peace. Fazıl Ahmed proposed that Venice, in exchange for retaining Iraklion, should make the Ottomans a once-only payment of 100,000 gold pieces, then an annual payment of 10,000. This and other conditions were rejected by the ambassador, and mobilization continued apace.[55]

Troops for the campaign were ordered to assemble at the ports of Thessalonica, Euboea, and Monemvasia in the Peloponnese, from where they would take ship for Crete; the janissaries travelled by sea from Istanbul, while Fazıl Ahmed Pasha and his retinue left Edirne on 25 May 1666, journeying overland through Macedonia and Thessaly to embark from Euboea. Things did not go well on the march. Many of his troops sickened and died along the way, and Fazıl Ahmed had to rest the army for two months at Thiva (Thebes); they were not able to reach Crete until the winter.[56] As the Grand Vezir set out from Edirne, the Sultan pressed Abdurrahman Abdi to tell him stories of the great victories of his forebears – of Selim I's rout of Shah Isma'il of Iran at Çaldıran in 1514, of Süleyman I's conquest of Rhodes in 1521 and of Belgrade the following year.[57]

The fortress of Iraklion still held out, and the Ottoman forces pressed the siege in 1667 and 1668. The defending garrison was exhausted and pessimistic; the help they sought from France had not arrived, and their other allies were prone to distraction by questions of precedence among the commanders of the ships of the Christian fleet – which had been supplied by Savoy, Venice, the Papacy, the Knights Hospitallers of Malta, Naples and Sicily.[58] Although Venice sued for peace in 1668 this did not stop the fighting.[59] By the spring of 1669, however, Louis XIV of France was finally ready to furnish troops for the Cretan war.[60] When they arrived, the Ottoman besiegers stoutly resisted the attack on their positions from the sea, and there were many losses on both sides. After a month and a half of indecisive fighting the French, who bore the main burden of the attack on the Ottomans, were disinclined to continue the action; although well aware that their presence must encourage the Sultan to come to a settlement more readily, they sailed for home, leaving Francesco Morosini, commander of the defending Venetian forces, no alternative but to surrender.[61] Crete, which had been held by the Venetians for four and a half centuries, passed to the Ottomans after 24 years of war; only the coastal fortresses of Spinalonga, in the east, and Suda and Gramvousa (Grabousa) in the west, remained in Venetian hands.

As he had following the Treaty of Vasvar with the Habsburgs in 1664, Fazıl Ahmed Pasha stayed on to oversee the implementation of the peace in Crete. Away from the fighting the island had not suffered greatly, and the two main export crops of olive oil and wine would recover in time.[62] The city of Iraklion was in ruins and, with the departure of the Venetians, deserted;[63] a week after the city was transferred to Ottoman hands, Evliya Çelebi called the victorious army to the Friday prayer. The fabric of the city was ordered to be repaired, and great celebrations followed.[64]

As Sultan Mehmed II had made of Byzantine Constantinople an Ottoman

and Islamic city, so Fazıl Ahmed Pasha Ottomanized and Islamicized Venetian Crete. He converted the opulent Church of St Francis into Iraklion's main mosque, and named it for the Sultan. The palace of the Venetian governor was converted for use by the Ottoman governor, and the financial officer of the new province had his base in the loggia. Other churches were converted into mosques, of which the most obvious outward sign was the replacement of the bell-towers by minarets – in choosing the most prominent church in Iraklion to be the Sultan's mosque, and adding a minaret to draw the eye towards it, Fazıl Ahmed ensured that the presence of the Ottomans was visible from afar, from both the sea and land approaches to the city. It was important to them that there should be no ambiguity about who now held the island, and prominently-sited churches in the other main towns of Chania (taken in 1645) and Rethymno (taken in 1646) also became mosques.[65]

The property abandoned by the fleeing Venetian population of Iraklion was either assigned to provide endowments to support the charitable foundations of Fazıl Ahmed Pasha and his commanders, or auctioned to the highest bidder – be he janissary, Jew or Orthodox Christian – for private use. The charitable foundations served to promote Muslim settlement, commerce and the spread of Ottoman and Islamic culture, rather as dervish lodges had in earlier times. The old policy of forced resettlement as a means of repopulating new conquests had been abandoned: settlers came to Iraklion from the Cretan countryside, and the Islamicization of the island was achieved more gradually, by conversion, rather than by bringing Muslims in from the mainland, as had been attempted unsuccessfully in Cyprus a century before. Moreover, most of those who came to Iraklion were military men, in name if not in practice, predominantly of Cretan origin and able to identify with the local people.[66]

There was another feature of this Ottomanization that differed from what had gone before, and it reflected the fact that the Ottoman dynasty had by this time lost some of its power and prestige to the Köprülü and other grandee households. There were mosques named for sultans in Cretan cities, but they were not necessarily the most important ones. Following the Ottoman conquest of Chania, its cathedral had been converted into a mosque named for the reigning Sultan İbrahim, but those serving the largest congregations in Iraklion, as in Rethymno, were sponsored by Ottoman statesmen who had participated in the conquest of the island, and by the queen-mother, Turhan Sultan, while the major patron was of course the Grand Vezir himself. Evliya Çelebi noted that a mosque named for Sultan İbrahim, during whose reign the war with Venice had begun, was being used by its end to store gunpowder, an observation that throws this shift of power into

relief. Another index of the decline in prestige of the sultanate was that unlike the mosques of earlier sultans, those on Crete had only one minaret.[67]

Calm prevailed only briefly after the successful conclusion of the siege of Iraklion brought the long Cretan war to an end. By the summer of 1670 Fazıl Ahmed Pasha was back in Istanbul, and two years later he set out again with the army towards Ukraine. The Polish-Lithuanian Commonwealth was greatly weakened by this time, the Cossack uprising which had begun in 1648 having developed, by 1654, into a war between the Commonwealth and Muscovy over the question of sovereignty in Ukraine. The Commonwealth had come under attack from all sides, including Sweden, before years of sporadic fighting ended in 1667, leaving Ukraine divided along the Dnieper with the right bank, on the west, under Commonwealth suzerainty, and the east bank, on the left, under Muscovite control. The Cossacks of Ukraine preferred independence from both the Commonwealth and Muscovy, and Hetman Petro Doroshenko, leader of the Right Bank Cossacks, sought Ottoman protection in his resistance.[68] In June 1669, after several months of negotiations to ascertain whether he was sincere in his desire to submit to Ottoman suzerainty, the Sultan sent Doroshenko the symbols customarily awarded by the Ottomans to their vassals – a horse-tail standard, a drum, a banner, and a diploma of investiture – in recognition of the Hetman's authority over all of Ukraine. Almost twenty years after Bohdan Khmelnytsky had first expressed his desire to be a 'slave of the Sultan',[69] much of Ukraine again became part of the Ottoman Empire.

Direct support for the Right Bank Cossacks seemed to offer the Ottomans another ally in the steppe besides the Tatars. In opting to support the Cossacks against the Commonwealth, the Ottomans abandoned their traditional policy in the region, that of keeping a balance between the Commonwealth and Muscovy. The Commonwealth responded in 1671 by sending forces under Hetman Jan Sobieski into Right Bank Ukraine and throwing down the gauntlet to the Ottomans; they in turn declared war, citing Polish interference in the lands of their new vassal as the casus belli.[70] The Ottoman aim was to take, as a bulwark for closer control of their northern frontier, the strategic fortress of Kamenets-Podol'skiy in the province of Podolia, situated on a bluff around which a tributary of the Dniester has incised a steep gorge, and considered impregnable; a further potential benefit was that, with Podolia an Ottoman province, the often insubordinate vassal states of Moldavia and Wallachia could be more vigilantly supervised.[71]

Seclusion in the Topkapı Palace had been the lot of Ottoman princes since the early years of the century, but Mehmed was determined that his eldest son and heir-apparent should know what was expected of a sultan.

This new campaign offered a chance to demonstrate that the Ottoman Empire could still embark on a war of territorial expansion under the command of a warrior-king, and the Sultan decided to lead the campaign in person, taking with him Prince Mustafa and, instead of his own mother Turhan Sultan, Mustafa's mother, his favourite concubine Rabia Gülnüş Emetullah.[*72]

The march northwards towards Poland was wet and hazardous. The silver carriage in which Rabia Gülnüş Emetullah rode sank fast in the clay soil at one point along the route, and she had to be rescued by the Grand Vezir. Prince Mustafa and his mother remained south of the Danube at Babadag, while the Sultan and the army continued to Isaccea where a bridge was built over the Danube.[73] Before he crossed to the northern bank, Mehmed briefly returned to Babadag to visit his family.[74] Thirty-nine days later and some four or five hours from their target of Kamenets, the army crossed the Dniester to enter Polish territory. The fortress was poorly defended and fell to the Ottomans on 27 August 1672 after nine days of heavy bombardment. When the keys had been handed over to Fazıl Ahmed Pasha, the Sultan was able to visit this latest Ottoman conquest; he ordered Abdurrahman Abdi Pasha, who was by his side out of harm's way during the fighting, to compose a commemorative poem of twenty-four couplets and a chronogram – it was usual that such a poem would later be carved in marble and displayed over the gate of the fortress.[75]

The defenders of Kamenets were granted security of life and property, the right to remain living in the fortress if they wished, and the right to worship according to their own rites, whether Latin or Orthodox; they were also allowed to keep as many churches as they needed. As was customary, a number became mosques – the Catholic Cathedral of St Peter and St Paul became the mosque of Sultan Mehmed IV, while others were named for his mother Turhan Sultan, for Rabia Gülnüş Emetullah, Grand Vezir Fazıl Ahmed Pasha, and for Musahib ('Companion') Mustafa Pasha and Merzifonlu Kara Mustafa Pasha, second and third vezir respectively. Within a short time, other marks of the new regime became evident as the charitable foundations typical of a Muslim town were established. On the first Friday after the conquest the Warrior-Sultan celebrated the prayer in his new mosque.[76]

The new Ottoman province of Kamenets (or, properly, Kameniçe),

* This was not quite without precedent: contemporary chronicles describe the Cretan campaign of 1668 as 'royal'. The Sultan did leave Edirne with the intention of travelling to Larisa in Thessaly, but his participation was little more than symbolic; he spent many months hunting in the area, and only moved to Euboea to embark for Crete in September 1669 – where he received news of the fall of Iraklion, and turned for home (Abdurrahman Abdi Paşa, 'Abdurrahman Abdi Paşa Vekâyi'nâme'si' 256–95).

constituted from the Commonwealth's province of Podolia, was, like the other provinces formed during the Köprülü years – Varad, Uyvar and Crete – rather smaller than those created during the earlier centuries of Ottoman conquest when the wholesale acquisition of new territory was easier. Kamenets was being surveyed for taxation purposes before the end of 1672, and its new administrators tried to introduce the system of land-holding whereby land was awarded to cavalrymen in exchange for their undertaking to campaign when required to do so[77] – the system which once obtained across the central lands of the empire but had fallen into abeyance. While cavalry had not entirely lost their effectiveness even in the more static warfare of the late seventeenth century, it was really the age of infantry, and the application of this old and hallowed institution in Kamenets and the other provinces conquered at this time smacks rather of an attempt to recreate the golden age of the empire than an effort to tackle the challenges of the present.[78]

The Commonwealth might have had to pay for its defeat by ceding Podolia to the Sultan and acknowledging his suzerainty over Right Bank Ukraine, and by the payment of an annual tribute – which according to Ottoman law made the Polish king an Ottoman vassal – but Ottoman attempts to impose their land regime in Kamenets were premature. The Polish king might have signed the peace treaty, but he was widely disdained and his nobles were determined to regain what they had lost. Old quarrels were forgotten and the Commonwealth's armies were hastily improved, so much so that they were able to defeat the Ottoman garrison at Khotin in 1673 before Fazıl Ahmed's relieving force could arrive,[79] but in 1675 Ottoman units caused further alarm by raiding across the frontier into Polish territory.[80] By now the Commonwealth wanted respite, and agreed revised peace terms in 1676 that relieved the Polish king from the humiliation of having to pay an annual tribute to the Sultan. However, this, and the acquisition of two fortresses in Ukraine, was far less than the Ottomans had led the Poles to believe they stood to gain from the settlement.[81]

Ottoman championing of Right Bank Ukraine had brought war with the Commonwealth – and gratifying territorial gain – but the change in the balance of power in the region provoked a reaction from Muscovy, whose forces encroached on the Ottoman protectorate, and in 1674 an army with Sultan Mehmed at its head marched north from Edirne to save Hetman Petro Doroshenko, besieged in his capital in the fortress of Chyhyryn on a western tributary of the Dnieper; the Crimean Tatars saved the day for the Ottomans whose raiders, commanded by Merzifonlu Kara Mustafa Pasha, went on to destroy forts and settlements that had acknowledged Muscovite rather than Ottoman suzerainty.[82]

★

Hostilities against the Commonwealth and Muscovy meant that not until 1675 could the recent successes of the Ottoman army be celebrated in a way appropriate to the warrior-sultan of a resurgent military power. That spring Sultan Mehmed IV decreed fifteen days of celebration in Edirne for the circumcision of his sons, Mustafa, aged eleven, and two-year-old Ahmed, and eighteen days of festivities for the marriage of their sister Hadice Sultan, aged seventeen, to the second vezir, Musahib Mustafa Pasha. Following six months of preparation, the circumcision feast took place between 14 and 29 May, and the marriage was celebrated between 9 and 27 June. Not since the marriage feasts of Sultan Süleyman I's sister Hadice Sultan to his grand vezir and favourite İbrahim Pasha in 1524, or of his grand-daughters to three high-ranking statesmen in 1562, or the circumcision feast of the future Mehmed III in 1582, had its like been seen.

Hezarfen Hüseyin Efendi, a former bureaucrat, wrote a detailed, day-by-day description of the festivities, of which he was probably a witness. Banquets, lavish gifts, theatre performances, fireworks, clowning, equestrian displays and much more besides went to make up a scrupulously orchestrated exhibition of dynastic splendour and munificence. Ottoman officials and dignitaries and the people of Edirne were invited to feasts according to their rank, and presented their offerings to the Sultan and the Princes – religious and poetic texts, silver vessels and valuable cloth predominated. When Hadice Sultan married, she received many presents from the Sultan, while the bridegroom was required to entertain the high officials of state at banquets and distribute largesse far and wide.[83] The setting for the celebrations was the open space in front of the royal palace:

... on one side twenty-two ships' masts' booms were erected and a thousand small lamps arranged on each of them with great inventiveness. [The Sultan] ordered them to be kept illuminated from beginning to end of the festivities. Seven imperial tents were erected by the Sultan. In some of them the Sultan and the Princes rested at all times while others were for the Grand Vezir and Sheikhulislam and the Chief Justices of Rumeli and Anadolu and other members of the imperial council, and in front of each tent were wooden tribunes so that the music and conversation and other amusements could be observed.[84]

The Englishman Dr John Covel, chaplain of the Levant Company, visited Edirne and its environs in 1675 and was present at the festival. Many commoners were circumcised at the same time as the Princes, and Dr Covel was an observer – indeed, he wrote, 'the Turkes would be so farre from hindring your seeing, as they would make way for you':

I saw many 100es of them (there being about 2,000 in all the 13 nights) cut ... There were many of riper yeares, especially renegades that turn'd Turks.

The common way there of turning was (as I saw several) to go before the G
Sr [i.e. Grand Seigneur, the Sultan]: and Vizier, and throw down their cap,
or hold up their right hand or forefinger; they were immediately led away by
an officer (who stands by on purpose), and cut with the rest. I saw a Russe
of about 20 yeares old, who after he had been before the Vizier came to the
tent skipping and rejoicing excessively; yet, in cutting he frowned (as many
of riper ages doe). One night we met a young lad, who askt us the way to
the Vizier. Being a country boy, we askt him what he would with him. He
told us his brother turn'd Turk, and he would goe find him, and be cut too;
and two days after he was as good as his word . . . There were at least 200
proselytes made in these 13 days.[85]

Although Fazıl Ahmed Pasha had abandoned his theological training in his
youth, he remained sensitive to its influences, and during his grand vezi-
rate the puritanical Kadızadelis who had been anathema to his father expe-
rienced a revival. As governor of Erzurum he came under the sway of
Mehmed ibn Bistan, a Kurdish preacher from Van, hence known as Vani
Efendi, a charismatic figure in the local religious establishment. Much older
than Fazıl Ahmed, Vani Efendi was a kindred spirit from the intellectual
world Fazıl Ahmed had left behind when he turned his talents to admin-
istration. The two men became friends, and when Fazıl Ahmed became
grand vezir, Vani Efendi was invited to Istanbul as his spiritual adviser. He
was later awarded the influential post of preacher at the Friday prayers in
the new imperial mosque of Turhan Sultan, inaugurated in 1665, and
continued as the Grand Vezir's spiritual guide.[86]

Vani Efendi's closeness to the Grand Vezir inevitably brought him close
to Mehmed IV, and in the chronicle of Mehmed IV's favourite Abdurrahman
Abdi Pasha his name appears as frequently as those of the Sultan's most
prominent vezirs. He was with Mehmed during the years that the court
was at Edirne, where Abdurrahman Abdi had ample opportunity to observe
him. Interestingly, there seems to have been no important conflict of ideas
between Vani Efendi and the clerical establishment in the person of
Sheikhulislam Minkarizade ('Son of the man with an aquiline nose') Yahya
Efendi, though the equal status accorded their views in matters over which
the Sheikhulislam would traditionally have had the monopoly of spiritual
authority was striking. Vani Efendi accompanied the Sultan on his abortive
military campaign to Crete, and also on the Kamenets campaign where the
former Carmelite church in the city was named as a mosque in his honour,
and he was given leave to establish a charitable foundation.[87]

Both the Sultan and his grand vezir were young enough to be suscep-
tible to the guidance of one such as Vani Efendi, and his eminence was a
boon to his less elevated followers, whose voices had been muted since the

banishment of Üstüvani Mehmed Efendi and his acolytes to Cyprus in 1656. The events of the pre-Köprülü years had done much to discredit the clerical hierarchy whose members had enmeshed themselves in the political and factional wrangles that were acted out in the capital, and the time was ripe for the resurgence of a group such as the Kadızadelis who could legitimately claim a share in reimposing morality. During Vani Efendi's ascendance the mystical orders again became a target of Kadızadeli attentions. He ordered the destruction of a Bektaşi dervish lodge near Edirne, and even forced upon the rich and influential Mevlevi lodge in Galata a general prohibition on the public performance of Sufi music and dance, which he held to be out of keeping with the tenets of orthodox belief. As in the days when Kadızade Mehmed had had the ear of Sultan Murad IV, coffee-houses were pulled down and smoking was again banned.[88]

The dervishes were at least Muslims: Vani Efendi and his followers felt far more insulted by the presence of non-Muslims in the empire, and the privileges accorded them. The production and consumption of wine, for example, were traditionally forbidden to Muslims but permitted to Christians and Jews – to the benefit of the treasury which collected a tithe. In 1670 an imperial edict was issued which abolished the office of commissioner for wine, ordered the razing of taverns in greater Istanbul, and imposed a ban on the sale of wine, not only causing financial loss to the treasury but also penalizing the Christians and Jews who handled the lucrative trade. As had happened with previous attempts to curb the wine trade, however, subterfuge and smuggling rendered the edict less than effective.[89] Perhaps it was the spectacle of 'hundreds' of people arriving every day to visit the taverns in the village of Karaağaç, a short distance from Edirne, that so inflamed Vani Efendi. Dr John Covel had first-hand knowledge of the 'Turkish' love of wine, and of the protection money earned by the janissary commander-in-chief for turning a blind eye to the debauchery at Karaağaç. All at court drank, he said, except for the Sultan and the two Mustafa Pashas – Merzifonlu Kara and Musahib.[90]

The tolerated status of non-Muslims had been codified in Ottoman law since before the reign of Mehmed II, their legally-defined niche symbolized by payment of a poll-tax. However, the eagerness with which Ottoman Christians and Jews forged links with foreign merchants and agents of foreign governments whenever the opportunity arose gave a puritan such as Vani Efendi pause, and he concluded that members of these minorities must be brought into line and rendered invisible. Traditionally the Ottoman attitude towards non-Muslim places of worship had been lenient as long as they did not exceed certain dimensions, and their repair was permitted as necessary, although reconstruction could be prohibited if or when the original building

was completely destroyed. Under Vani Efendi's influence, the ground on which had stood eighteen of the twenty-five churches burnt down in the great fires that ravaged Istanbul and Galata in the 1660s, though initially restored to Christian hands, was subsequently confiscated and sold to Muslims.[91]

In 1664, Vani Efendi succeeded in having a ban imposed on the interfaith prayers which the Sheikhulislam advised the Sultan should be said all over the empire for the success of the forthcoming campaign. In the event, the defeat of the Ottomans at the hands of the Habsburgs at Szentgotthárd made Vani Efendi's assertion that the prayers of Muslims alone would be sufficient to guarantee the success of the campaign look questionable.[92] The earlier wave of Kadızadeli activity had been intended to bring errant Muslims back to the righteous path; Vani Efendi, by contrast, sought to enforce Islamic prescriptions concerning the place of non-Muslims in a Muslim society, at the expense of traditional Ottoman leniency, and because he had the support of both Sultan and Grand Vezir he was able to see his programme put into practice.

Visible to a wider audience than Turhan Sultan's castles at the Dardanelles was what is today called the Yeni Cami or 'New' mosque, an abbreviation of its full name, Yeni Valide Camii, the 'New mosque of the Queen-mother'. It looms large on the shore of the Golden Horn in the Eminönü quarter of Istanbul and its dependencies are many: a royal pavilion, a primary school, a public fountain, a library and a market – known as the Egyptian or Spice Market – together with Turhan's large mausoleum. This mosque complex was the first built by a royal woman to be considered the equal of the great sultanic mosque complexes – those of Mehmed II, Bayezid II, Selim I, Süleyman I, the Şehzade mosque which Süleyman built for his dead son Prince Mehmed, the mosque of Ahmed I and, of course, Ayasofya.[93] The project had been initiated by Safiye Sultan, mother of Mehmed III, but abandoned when he died and she retired into obscurity. Murad IV had apparently considered going ahead with the construction, but dropped the idea. Turhan Sultan's decision to take over this site – in the commercial district of Istanbul – provided an unanticipated opportunity to subordinate the Jews.

The fire of 1660 that devastated much of the city took its toll of the Jewish neighbourhood in the port district of Eminönü; the Jews were blamed in ruling circles for starting the fire and following it their properties were expropriated and the community expelled from the area. That this was viewed as a meritorious act is made explicit both in inscriptions inside the royal pavilion of the mosque and in the text of its endowment deed: written on a tile panel in the royal pavilion is the Koranic verse referring to the Prophet Muhammad's exile of a Jewish tribe from Medina and the confiscation of their land, while Turhan Sultan's endowment deed refers

to 'the Jews who are the enemy of Islam'.[94] Thus was Islam imposed on this commercial district, a domestic parallel to the war conducted against foreign infidels. The Jews mostly moved out of sight, up the Golden Horn to another Jewish community in the Hasköy quarter,[95] and when they later drifted back to Eminönü, they were again ordered to be expelled.[96] Vani Efendi's part in this execration of Jews echoed that played by Mehmed III's grand vezir Koca Sinan Pasha when he exploited a burst of anti-Jewish sentiment in the 1590s, just before Safiye Sultan made the decision to build her mosque on the same site. Like her son and the Grand Vezir, Turhan Sultan appreciated Vani Efendi's efforts, and showed it by adding a convent for him to her mosque complex.[97]

The Jews of the empire became highly visible again in 1665 when a rabbi from the cosmopolitan commercial port of İzmir, Sabbatai Zvi, declared himself to be the Messiah. Jews in İzmir and Istanbul who believed him abandoned their commercial activities, and disputes broke out between them and their co-religionists who did not share their hopes for a 'return' to Jerusalem. Influenced by Vani Efendi, the government intervened to stamp out Zvi's activities. At first he was imprisoned in one of the Dardanelles castles, but when the clamour of his disciples disrupted public order in the locality he was taken to Edirne for interrogation by the Sultan's closest advisers, Merzifonlu Kara Mustafa Pasha, Sheikhulislam Minkarizade Yahya Efendi – who had issued a juridical opinion that Christians or Jews could be ordered to convert to Islam[98] – and Vani Efendi. The Sultan was a secret observer of the proceedings, and of Sabbatai Zvi's conversion when offered the choice between that or death.[99] Emerging as the 'new Muslim' Aziz Mehmed Efendi, a salaried court functionary, Sabbatai Zvi began to pros-elytize on behalf of his adopted religion, sowing more than a little confu-sion in the minds of his former adherents – an unlooked-for ally in Vani Efendi's crusade to minimize the prominence of non-Muslims in the public life of the empire. Unlike in Sultan Süleyman I's time, when non-conformist religious opinions could lead to execution, the Ottoman establishment was able to absorb a repentant religious trouble-maker as easily as it had earlier accommodated the contrite military rebels of Anatolia. Sabbatai Zvi's fervour for his new faith did not last, however, and he was eventually banished to Albania where he died in 1676. The movement he initiated had repercus-sions throughout Europe and the Middle East, bringing about the conver-sion to Islam of Jews and Christians across the empire.*[100]

European observers were at a loss to explain the wave of conversions

* The descendants of his followers, known as Dönme from the Turkish verb meaning 'to convert', remain an identifiable group in Turkey today.

which took place during the reign of Sultan Mehmed IV,[101] both before but especially after Sabbatai Zvi's time, when many Christians and Jews appeared in person before the Sultan, at his court in Edirne and also in the course of his frequent hunting expeditions. So numerous were they that included in a new compilation of laws drawn up by the Sultan's secretary Abdurrahman Abdi Pasha in 1676–7 was 'The Law of the New Muslim', which regularized the conversion process to comprise instruction in the articles of Islam, the awarding of coins and the appropriate clothing to the convert and, if Christian, his circumcision. Conversion permitted Jews and Christians to share in the benefits enjoyed by the majority Muslim population of the empire, and relieved them of the political and financial disabilities of their 'tolerated' status. 'New Muslim' males, like old, had the opportunity to rise to the highest offices of state; they could, among other benefits, marry whom they chose, while non-Muslim males were restricted to marrying non-Muslim women. Women and children also converted: among the advantages for women was that they could then divorce non-Muslim husbands or, if they were the household slaves of non-Muslims, eventually gain their freedom.[102]

That the court could spend so much time in Edirne, where Mehmed IV was able to indulge his passion for hunting, and his laissez-faire attitude to affairs of state, suggests that Anatolia was at last quiet, a successful outcome of the late Grand Vezir Köprülü Mehmed Pasha's violent repression of the disturbances there. Köprülü Mehmed had also laid the foundations for the stable government of his son Fazıl Ahmed Pasha by stamping out the factional struggles and palace intrigues that had characterized politics earlier in the century. Under Fazıl Ahmed, who was grand vezir for fifteen years, the holders of the highest offices of state remained remarkably unchanged. Merzifonlu Kara Mustafa Pasha had held high office under Köprülü Mehmed and continued to counsel the Sultan after Fazıl Ahmed came to power, as did the vezir Musahib Mustafa Pasha. The chief treasurer Cebeci ('Armourer') Ahmed Pasha, appointed in 1662, remained in his post for fourteen years. Sheikhulislam Minkarizade Yahya Efendi, another who came to office after Köprülü Mehmed Pasha's death, was dismissed only after eleven years' service, in 1674.

Fazıl Ahmed Pasha was 41 years old when he died of 'acute dropsy brought on by drink' while on the road from Istanbul to Edirne on 3 November 1676; he was buried in his father's tomb near the Covered Bazaar in Istanbul.[103] His brother Fazıl Mustafa Pasha, who was with him when he died, took the seal of the office of grand vezir to the Sultan, who invested Merzifonlu Kara Mustafa Pasha as the new incumbent. Merzifonlu Kara Mustafa had first come to prominence as a protégé of Köprülü Mehmed

Pasha, and during his childhood friend and brother-in-law Fazıl Ahmed's tenure he developed the intimacy with the Sultan which guaranteed his preferment. As proxy to Fazıl Ahmed, he had rarely left court, and some western diplomats suspected him of intriguing against Fazıl Ahmed.[104]

Merzifonlu Kara Mustafa Pasha's first business on becoming grand vezir was once more to defend Ottoman interests in Right Bank Ukraine from encroachment by the forces of Muscovy and Left Bank Ukraine. His harsh reprisals against the people of Right Bank Ukraine that followed the Ottoman campaign of 1674, and the tightening of Ottoman control there, made for widespread dissatisfaction with the leadership of Hetman Petro Doroshenko, who began to feel disappointed in the Sultan and uneasy about his vulnerable position between powerful neighbours. In 1676 Doroshenko sent the insignia he had received from the Sultan to the Tsar, handed his capital at Chyhyryn over to him, and was granted refuge in Muscovy. The Sultan appointed a new Cossack leader, the son of Bohdan Khmelnytsky, hero of the 1648 Cossack uprising against the Commonwealth, but he was but a pale shadow of his father and his predecessor Doroshenko. The Ottomans could not countenance the Muscovite presence in territory they counted Ottoman, and the two states were soon at war; after failing to retake Chyhyryn by siege in 1677, Merzifonlu Kara Mustafa succeeded in expelling the garrison in 1678.[105] Presented with another opportunity to prove his warrior credentials, Mehmed IV set out with great ceremony and travelled as far as the Danubian fortress of Silistra, where he remained for the duration of the campaign.[106]

Isolated, and hard to defend from any renewed Muscovite attack, Chyhyryn was demolished by the Ottomans; three new castles which would better serve their defensive needs in the region were built further east, on the Dnieper and Boh rivers.[107] When word came that Muscovy was preparing for a new assault the Sultan again readied himself to lead his troops to war, but the mediation of the Tatar Khan led Muscovy to sue for peace and in 1681 a treaty bringing to an end five years of tension on the Dnieper was signed at Bakhchisaray, the Khan's capital in the Crimea. This, the first formal treaty between Muscovy and the Ottomans, promised twenty years of peace and recognized Ottoman suzerainty of Right Bank Ukraine, except for the city of Kyiv (which, with Left Bank Ukraine, had been in vassalage to Muscovy since 1667). In the event Ottoman policy in regard to the northern Black Sea – to do there only what was required in order to preserve their heartland from attack – seemed little changed; the conquest of Podolia apart, their intervention in Ukraine had been necessitated by developments in the relationship between Muscovy and the Commonwealth which were beyond their control. By 1681 they were over-extended and

glad of a respite, and seemed to have resolved the strategic problems on their northern frontier.[108]

To the north-west, the Ottoman–Habsburg frontier had been quiet since the Treaty of Vasvar of 1664, and central Europe was at peace, Fazıl Ahmed Pasha having been content with the treaty provisions giving the Ottomans their province of Uyvar, north of the Danube. The Hungarian nobility, however, felt let down by Montecuccoli and Emperor Leopold's seeming intention of replacing constitutional government in 'Royal Hungary' with absolutist rule; a number of them were accused of trying to secure the help of the French or the Ottomans, and executed in 1671 for treason. The Counter-Reformation was imposed with more or less severity at various times during the seventeenth century, but with particular brutality under Leopold I: although the conspiracy was proto-national rather than religious in inspiration – both Catholics and Protestants had been involved – Hungarian Protestants of all classes were persecuted, and Hungary more and more came to be viewed as conquered territory to be ruled directly from Vienna.[109]

It seemed to many dissenting Protestant Hungarians that Ottoman toleration might be preferable to the bigotry of Habsburg rule and they sought refuge in the Ottoman vassal state of Transylvania. Fazıl Ahmed Pasha had always declined to involve himself in the struggles of these malcontents, and had ordered the Transylvanian prince Michael Apafi to follow the same policy. In 1678, however, the Calvinist noble Imre Thököly, a prominent voice in the Hungarian struggle against Habsburg hegemony and Catholic domination, was elected leader of the disaffected Protestants, and his success in a number of engagements with Habsburg forces gave him a swathe of territory in upper Hungary and further enhanced his prestige. By this time Leopold had come to realize that his policy in Hungary was proving counterproductive; in 1680 he made a truce with Thököly and in May 1681 convened a Diet at which he offered to reinstate a measure of local autonomy and religious toleration. Thököly refused to attend its meetings.[110] One chronicler of these years, Silahdar ('Sword-bearer') Fındıklılı Mehmed Agha, was a page at court at the time and reports the arrival there in July of Thököly's envoys, who presented an appeal for co-operation to the Sultan.[111] Early in 1682 Thököly was rewarded with a treaty of fourteen articles recognizing him as an Ottoman vassal.[112] Merzifonlu Kara Mustafa Pasha saw in him a potential tool in the fulfilment of his plans against the Habsburgs. Thus it was that when Leopold sent his envoy to renew the Treaty of Vasvar, due to expire in 1684, he found that the Ottomans were no longer prepared to consider doing so, having agreed to support the 'King of Central Hungary', as Thököly was dubbed in recognition of his new status.[113] Between the

possibilities offered by Thököly and the encouragement offered by the French envoy at the Ottoman court – France, having designs of its own in regard to the Habsburg Empire, intimated that it would not intervene in any war between Habsburgs and Ottomans – it is not surprising that the Habsburg envoy was unable to get any satisfaction in the matter of the renewal of the treaty.[114]

The Sultan was perhaps reluctant to see an escalation of tension in Hungary, but the Grand Vezir was determined, and seconded by the commander-in-chief of the janissaries, Tekirdağlı Bekri Mustafa Pasha, who pleaded that his men were eager to fight. Silahdar Fındıklılı Mehmed Agha reports that Merzifonlu Kara Mustafa Pasha went so far as to solicit false reports exaggerating the trouble on the border. He also requested a juridical opinion from the Sheikhulislam and, ignoring the inconvenient response – that war was not licit – put the Habsburg envoy, who had been intent on peace at almost any price, under house arrest.[115]

It was an opportune moment for the Ottomans to make war on the Habsburgs: they had the front-line support of Thököly while the Habsburgs were losing ground in Hungary and the French had indicated that they would not intervene; Muscovy was keen to maintain peace,[116] and the Polish-Lithuanian Commonwealth was too weak to pose a threat. By 3 May 1683 the imperial Ottoman army, accompanied by Sultan Mehmed, was in Belgrade, having for once set out early in the campaigning season. As it advanced along the Danube, Thököly's forces and those of the Crimean Khan joined it.[117] Silahdar Fındıklılı Mehmed Agha was present on the campaign and complained bitterly about the terrible rains that dogged progress from the time the army set out from Edirne on 30 March; he remarked, especially, upon the difficulty of getting the Sultan's favourite concubine Rabia Gülnüş Emetullah and eighty coachloads of ladies of the *harem* safely across the bridge over a river near Plovdiv.[118]

The original plan was that Merzifonlu Kara Mustafa Pasha should take Győr, as Fazıl Ahmed Pasha had intended in 1664. (The Habsburg envoy had refused to surrender it during the pre-campaign negotiations.) However, in a meeting held while the army was encamped before the fortress, Kara Mustafa announced that since the fortress was stronger than anticipated, it would be better to proceed straight to Vienna, rather than lose troops besieging it. He would listen to no objections, and the army moved forwards.[119] There was much to recommend this decision, for the high command of the Habsburg army, riven as it was with personal and bureau-cratic disputes, had been slow to formulate a workable defensive strategy, and slow to mobilize. In Vienna, panic set in in the first days of July, when it became clear that the Ottomans were well advanced; the Emperor and

his court deserted the city on 7 July and retreated to Passau, where they arrived on 18 July carrying their treasures with them. As they went they were pursued by Tatar cavalry who on 16 July raided an area some 100 kilometres west of Vienna.[120]

Silahdar Fındıklılı Mehmed Agha reported that when news of Merzifonlu Kara Mustafa Pasha's unauthorized action reached Sultan Mehmed in Belgrade, he was astonished by his grand vezir's blatant disregard of his explicit orders – but impotent to change the course of events.[121] Nevertheless, fortune seemed to be smiling on the Ottomans and their allies: they outnumbered the Emperor's forces and, although they had passed by Győr, they had captured a number of other strategically-placed positions as they advanced.[122]

Within a few days of arriving outside the walls of Vienna, Merzifonlu Kara Mustafa Pasha had drawn up his army to surround the city on all sides, leaving little place for a relief army to approach. The siege opened with the customary offer of safe conduct if the defenders would surrender the fortress, but this, as was also customary, was refused. The Ottoman forces entrenched themselves quickly and expertly, and the bombardment began on 14 July. Kara Mustafa, intent on missing no detail that would ensure a a successful outcome, was unhurried and systematic, but the fighting was fierce and the suspense high. One month into the siege an Ottoman mine opened a breach and the attackers were able to enter the intermediate defences of the ravelin.[123]

The consequences of an Ottoman victory weighed heavily on the minds of European princes and statesmen, overshadowed by the knowledge that appeals for united action against the common enemy had rarely been responded to in past centuries and, when attempted, had still more rarely been durable or decisive. Today's ally might be tomorrow's enemy: the mutual suspicion and the embers of old enmities militated against cohesive action. France was as good as its intimations and sent no troops to the relief of Vienna. The Polish-Lithuanian Commonwealth was the only power bound to come to the defence of the Habsburgs. The Commonwealth was still smarting from the loss of influence over the Cossacks of Right Bank Ukraine and the forfeiture of large tracts of territory in Podolia to the Ottomans embodied in the treaties of 1672 and 1676. Although the independence and privileges of the local assemblies did not, on the face of it, make it certain that any help would be forthcoming even from this quarter, the nobles of Podolia – most inclined to come to the aid of the Habsburgs because they were hopeful of regaining their lands in the event of an Ottoman defeat – swayed their fellows[124] and, united by the need for assistance against a common enemy, the Habsburg Empire and the

Commonwealth came together in an uneasy alliance, concluding a mutual defence pact in March 1683 which rendered the Commonwealth's treaties with the Ottomans untenable.

Already in June the Polish army had been on alert on its southern border, worried by Thököly's incursions from Transylvania into Polish territory as well as the advance of the Ottoman army from Buda. When the first desperate appeal from Vienna reached him in mid-July, just as the siege was beginning, Sobieski moved his court from Warsaw to Krakow without displaying any particular sense of urgency, but as details of the progress of the siege became known he worked hard to mobilize an army sufficient to the task confronting it. Failure would invite further Ottoman military action against the Commonwealth, but for Sobieski it would also represent a setback to his personal ambitions. Sobieski's army left Krakow on 15 August, and by the end of the month he was at Hollabrun, north-east of Vienna, with Charles of Lorraine, the Emperor's brother-in-law and commander of the small Habsburg army which had been harrying the Ottomans' supply line. The Bavarians to the south-west and the Protestant Saxons to the north-west of Vienna also sent troops, but no agreement had been reached with other potential allies, such as the Elector of Brandenburg.[125]

The siege had continued for nearly two months without either side gaining decisive advantage, although the defenders' position was desperate. The relief armies moved slowly to cross the Danube at Tulln and mass on the south bank to march through the the Wienerwald and approach the city from the west. The Ottomans, assuming that the mountainous and thickly-forested terrain would defy even the most determined relief force, had neglected to defend this approach sufficiently – but if they could not ignore the 60,000-strong advancing army, no more could they raise the siege, after so many weeks of effort and with the scent of victory in the air. Sobieski spent three days drawing up his forces: the Austrians were on the left, nearest the river, the Germans in the centre, and the Commonwealth troops – who were slower to take their places – on the rising ground of the right wing. Merzifonlu Kara Mustafa was greatly outnumbered, with some 30,000 men, plus an unknown number of Moldavians, Wallachians and Tatars. The fiercely-fought battle on 12 September lasted until evening; in the morning most of the fighting took place on the low ground close to the river, but once Sobieski and the Commonwealth cavalry were able to catch up with the other contingents, a co-ordinated advance became possible. By the end of the day the Ottoman army had been swept aside as the enemy line advanced and, realizing the hopelessness of their situation, those who had not been cut to pieces fled.[126] The siege was lost; as

deserted Ottoman positions were plundered, Sobieski's men secured the lion's share, including the magnificent embroidered tents of the Ottoman high command to be seen today in museums in Krakow and elsewhere in the former Polish lands.

Those of the Ottoman forces who were not killed or taken captive retreated in disorder, cold and hungry, along the road towards Győr, where they crossed the river Rába. When news of the defeat before Vienna reached the Sultan in his camp at Belgrade he was furious, threatening Kara Mustafa Pasha with execution and summoning him to appear before him; but the Grand Vezir refused to continue to Belgrade, pleading that he was ill.[127] It was clear, however, that preparations for the next season must begin soon, and Mehmed and his retinue set off back to Edirne without waiting for Kara Mustafa to reach Belgrade.[128] If the blame for the defeat – Sobieski's intervention apart – lay at Kara Mustafa's door, it was due less to his decision to march straight for Vienna than to a number of technical miscalculations on his part, such as failing to bring heavy artillery to the siege but relying instead on light guns, which were certainly more mobile and transportable but proved inadequate to breach Vienna's strongly fortified walls. Nor was he able to deal with the defenders' successful countermining operations, which hindered Ottoman forward progress during the siege.[129]

Before retreating to winter quarters, Merzifonlu Kara Mustafa Pasha reorganized the defence of the Hungarian front. He blamed the debacle on the governor of Buda, who had disagreed with his strategy of bypassing Győr and heading for Vienna at the start of the campaign, and subsequently failed to satisfy the Grand Vezir with the quality of his generalship; he was executed and his estate confiscated for the benefit of the treasury.[130]

Merzifonlu Kara Mustafa Pasha had long been a close adviser of the Sultan, but any doubts Mehmed IV might have harboured about him were given substance during his absence on campaign as plotters fabricated reports of disorder in the empire. On hearing of the defeat at Vienna, one of the plotters, the keeper of the sultan's stables Boşnak ('Bosnian') Sarı ('Fair-skinned') Süleyman Agha, announced, in the words of Silahdar Fındıklılı Mehmed Agha, that 'our enemy [i.e. Merzifonlu Kara Mustafa Pasha] is finished with; the time is ripe for revenge'; other plotters were the Chief Black Eunuch, Yusuf Agha, and the third vezir Kara İbrahim Pasha. Mehmed succumbed to the pressure from Kara Mustafa's detractors, and the Grand Vezir was executed in Belgrade on Christmas Day 1683[131] while engaged in planning a new advance for the following spring. Kara İbrahim took his place as grand vezir. Kara Mustafa's body was buried in the courtyard of the mosque opposite the palace in Belgrade.[132] Although by Silahdar Fındıklılı Mehmed Agha's account, the Sultan ordered his head to be taken back to

Istanbul for burial in his tomb near the Covered Bazaar,[133] a skull in Vienna's city museum is commonly believed to be his.[134]

Silahdar Fındıklılı Mehmed Agha made no secret of his conviction that the Grand Vezir alone was responsible both for directing the campaign against Vienna, and for the disasters which ensued, recording a significant dream:

> At that time [i.e. during the deliberations preceding the campaign] the Grand Vezir dreamt that as he put new boots on his feet, a seven-headed dragon appeared before him and walked all over him [and] bit him. And the next day he had Soothsayer Hasan Efendi interpret the dream. 'The boots you are wearing signify departure for campaign and the dragon is the Habsburg Caesar who, since he wears the crown of Noshirvan [i.e. the Sassanian king, Khusraw I], is submissive to the command of seven kings. It is best that you withdraw from this campaign or it is certain that you will regret it'.[135]

For all his conviction that Merzifonlu Kara Mustafa Pasha was responsible for the defeat at Vienna, Silahdar Fındıklılı Mehmed Agha found the intrigue at court in the Grand Vezir's absence hard to stomach. He later claimed to have had a premonition of Kara Mustafa's fate; after reporting a great storm on 13 December, he observed: 'if there is thunder and lightning in December, it portends that the ruler of that land will secretly murder a leading statesman and sequester his assets'.[136] Among the other casualties of the Vienna campaign was the Kadızadeli preacher Vani Efendi. Having shared Kara Mustafa's desire to take the city he had accompanied the army there;[137] Sultan Mehmed disapproved, and he was sent away from court to his estate near Bursa, where he died in 1685.[138]

Merzifonlu Kara Mustafa Pasha owes his place in history to his failure at the second Ottoman siege of Vienna. This ignominious Ottoman defeat was of great psychological importance for the Habsburgs and the whole of Europe. It seemed to western observers that the tide of Ottoman conquest was turning. The literary production of the time reflects the exaggerated expectations of contemporaries that the forces of Christianity would at last triumph after centuries of struggle. The Vienna debacle was certainly a blow for the Ottomans – at the time, however, they had no idea that it was merely the first in a chain of defeats which would end only in 1699 with a humiliating and highly unfavourable peace.

IO

The empire unravels

ARLY IN FEBRUARY 1684 alarming reports from Belgrade reached the
court at Edirne: the commander on the Hungarian front, Tekirdağlı
Bekri Mustafa Pasha, informed Sultan Mehmed IV that the Christian states
had entered into an alliance against the Ottomans. Muscovy, he wrote, was
planning an attack on the Crimea, while the Polish-Lithuanian
Commonwealth hoped to regain Podolia and seize Wallachia; Venice would
mount attacks in Bosnia, against Crete in the Mediterranean, and against
the coast of Rumeli and the islands of the archipelago in the Aegean;
Sweden, France, Spain, England, the United Provinces of the Netherlands,
Genoa and the Papacy were also party to the alliance. The Ottoman statesmen
gathered at Edirne expressed their fear of warfare on many fronts at once,
deciding that a commander must be assigned to each theatre while the
Sultan or the grand vezir, Kara İbrahim Pasha, remained behind to oversee
preparations for the campaigns ahead. Tekirdağlı Bekri Mustafa himself was
in poor health, and the governor of Diyarbakır, Şeytan-Melek ('Devil-
Angel') İbrahim Pasha, was ordered to Buda in his place.[1] The signatories
to the Holy League concluded in March 1684 were the Austrian Habsburgs,
Poland-Lithuania, Venice and the Papacy, and the signing of an armistice
between France and Austria in the summer of 1684[2] boded still worse, but
the following year peace between the Ottomans and the French was
renewed,[3] removing the possibility of French participation.

With Merzifonlu Kara Mustafa Pasha dead, the next prominent scion of
the Köprülü household was the second son of Köprülü Mehmed, Fazıl
Ahmed Pasha's brother Fazıl Mustafa Pasha. He had been present with Fazıl
Ahmed at the conclusion of the siege of Iraklion and had been appointed
seventh vezir on Merzifonlu Kara Mustafa's recommendation, but having
been entrusted by the Sultan with guarding the Queen-mother and the
young princes, had taken little further part in military campaigns. The close
relationship with the Sultan this implied won him further favour, but a
tide of anti-Köprülü feeling followed the Vienna defeat, Merzifonlu Kara
Mustafa's death and the appointment of Kara İbrahim Pasha as grand vezir

in his place, and in it Fazıl Mustafa lost the important post of governor of the northern Black Sea province of Özi awarded him before his brother-in-law lost his head. This frontier command went to the new grand vezir's accomplice, Sarı Süleyman, who became a pasha, and Fazıl Mustafa was deprived of active involvement in the next, dangerous stage of the war.[4]

The incompetence of the anti-Köprülü faction which now came to power brought disaster upon the Ottomans. In the course of their retreat from Vienna they lost Esztergom on the Danube north of Buda, which they had held since 1543 apart from a ten-year period when it was in Habsburg hands. During 1684 there were significant Habsburg advances into Hungary: Visegrád and Vác, two key strongholds near Esztergom, fell to them and, leaving Buda under siege, the Austrians routed an Ottoman force a day's march south of the city. In 1685 the Ottomans retook Vác, but an attempt to retake Esztergom came to nothing and the province of Uyvar – won but twenty years previously by Fazıl Ahmed Pasha – was lost. There was great rejoicing in the West.[5] Venice was also active in these years: its forces besieged and took Santa Maura, Preveza and Pylos on the Ionian coast of Greece, plus a number of other fortresses, and also Ottoman strongholds in Dalmatia.[6]

Sarı Süleyman Pasha was recalled to Edirne after the 1685 campaigning season and soon named grand vezir in place of Kara İbrahim Pasha, deemed to have neglected his task of overseeing the logistic demands of the army. The Sultan gave Kara İbrahim the permission he sought to go on pilgrimage to the Holy Places, but the gossip among his enemies suggested that his real intention was to raise an illicit army in Anatolia: his estate was seized, and he was exiled to Rhodes.[7] The rumour-mongering was of interest to the government for reports were again reaching Istanbul of unrest and brigandage among the Anatolian militia, some of whom were sacking towns and villages – when efforts to quell their disorder failed, the authorities decided that the only solution was to mobilize them for campaign.[8]

As war began to take its toll, the government contemplated the losses in men and matériel, and the accompanying drain on the treasury. Early in 1686 a war council attended by high-ranking clerics, military officers and statesmen was held in the presence of the Sultan. The prevailing sentiment was that so critical a campaign now required the presence of either the Sultan or the Grand Vezir at the front; if the Grand Vezir was in command, there was no need for the Sultan to remain in Edirne, and he should therefore return to Istanbul, to spare the people of the area the unwarranted financial burden of the court's continued presence. Mehmed IV reached Istanbul in April to find famine in his capital – and indeed, similar conditions prevailed over much of the empire, in part thanks to the

disruption brought about by the war. Prices of basic foodstuffs had risen drastically and in some parts of Anatolia people were reduced to eating roots and walnut husks. To mark the return of the court to the capital after so many years, the Sultan visited the shrine of Ayyub Ansari at the head of the Golden Horn. Thereafter, eschewing the confinement of Topkapı Palace, he chose to spend his time relaxing in the parklands along the Bosporus.[9]

Thus it was that Sarı Süleyman Pasha was appointed to lead the army to the Hungarian front, and orders were sent out to mobilize once more. Mehmed received the Grand Vezir in special audience, and presented him with the sacred standard of the Prophet, commending it and the Grand Vezir and his army to God's keeping. In a break with precedent the mantle of the Prophet – supposedly brought to Istanbul earlier than the sacred standard, following Sultan Selim I's conquest of Egypt in 1517[10] – was opened out as if to invoke the power of this sacred relic. According to Silahdar Fındıklılı Mehmed Agha, who was employed in the palace at the time and would certainly have heard about the ceremony if he had not actually witnessed it, all present were reduced to tears by the affecting scene.[11]

The 1686 campaigning season was critical for Ottoman fortunes. On 2 September the city of Buda, held since 1526 when Sultan Süleyman I conquered a large part of Hungary, fell to the besieging Habsburg army. The province of Buda had stood for almost 150 years on the Ottoman–Habsburg frontier; unlike Vienna, the city of Buda was an Ottoman city, and its loss was a considerable psychological as well as military blow. The Ottoman hold on Hungary crumbled as one fortress after another fell. When winter came and the Ottomans retired to quarters in Belgrade, the Austrians were also able to install their garrisons in some of the castles of Transylvania.[12]

The scale of the defeats suffered in 1686 was such that, for the first time ever, the Ottoman Empire sought to initiate peace negotiations with its enemies, but approaches on the part of Grand Vezir Sarı Süleyman Pasha prompted by the fall of Buda failed to elicit any interest. The previous year the commander on the Hungarian front, Şeytan-Melek İbrahim Pasha, had sent peace overtures to the Habsburg commander Charles of Lorraine after the fall of Nové Zámky, without consulting the government in Istanbul: he received no answer but his independent action was discovered and he was executed. Preparations for the 1687 campaigning season were put in hand during the winter, but before the army set out Sarı Süleyman wrote again, this time to Emperor Leopold I himself. No longer supplicants, the Habsburgs now showed themselves capable of as much preoccupation with

diplomatic niceties as the Ottomans, objecting that such letters were of no value unless they were written by the Sultan to the Emperor; furthermore, for a letter to be taken into serious consideration, it must be countersigned by the Grand Vezir and other senior government members. Such protocol was one thing; but the members of the Holy League, having pledged themselves to conclude no separate peace with the Ottomans, now placed an insuperable hurdle in the path of further negotiations: demands for the return of Podolia to the Polish-Lithuanian Commonwealth and of Crete to Venice, and Ottoman withdrawal from Hungary in favour of the Habsburgs. It was learnt in Venice that Ottoman hopes of an alliance with Iran had been dashed by the Shah; he refrained from attacking the Ottomans in the east while they were engaged in Europe, but vowed that he would retake Baghdad once the war with the Christians was over.[13]

The war had depleted the treasury, and the overriding concern of the high command was to find sufficient cash to pay the troops, albeit in arrears, for they well knew the trouble an unpaid soldiery could cause. In 1686 a new 'war contributions tax' was imposed upon the clerical establishment, hitherto exempt from such exactions; although notionally a loan, to be repaid when conditions allowed, it prompted vociferous complaints. A senior cleric who voiced the fears of his fellows that the money would be spent on the construction of further pleasure palaces like that at Edirne was exiled to Cyprus for his temerity in challenging the Sultan's decree; nevertheless, the tax was transferred to the shoulders of the townspeople of the empire and collected, at least in Istanbul, under the watchful eye of armed guards before being taken to the mansion of the Grand Vezir's proxy – where most of it disappeared. Nevertheless, the urgent need for funds prompted even members of the royal family to contribute to the war effort from the income of their estates. Silahdar Fındıklılı Mehmed Agha was a witness to the tense negotiations over the war contributions tax, and recorded how the extraordinary harshness of that winter added to the misery – people could not leave their houses for fifty days because of the cold, and he himself, when rowing on the Golden Horn, had to break the ice with an oar as he went.[14]

The Grand Vezir was still in Belgrade when news came that the forces of the Holy League were attacking Osijek, the bridgehead on the Drava that was the historical link with the rest of Hungary. The League's forces were repulsed and the Ottomans pursued their retreat northwards, but Sarı Süleyman Pasha proved a poor general, and on 12 August 1687 south of Mohács, scene of Sultan Süleyman's decisive victory against the Hungarian king in 1526, his army suffered a costly defeat. News from other fronts was similarly disastrous: the Peloponnese was lost to the Venetian navy under

the command of Francesco Morosini, defender of Candia in 1669, who in September blew up the roof of the Parthenon in Athens when trying to evict its Ottoman garrison.[15] Furthermore, the Tatar Khan did not himself join the campaign that year, pleading that Jan Sobieski had entered into a pact with Muscovy with the intention of jointly attacking Crimea.[16] Sobieski's son besieged Kamenets in 1687 but the arrival of an Ottoman–Tatar relief army scattered his forces.[17]

After their defeat near Mohács Sarı Süleyman Pasha and his army retreated south along the Danube towards Belgrade, reaching Petrovaradin on 27 August. Here they paused, and the Grand Vezir attempted revenge by sending a force back to attack an enemy position eight hours away to the north, but a tremendous storm broke as the troops were crossing the bridge over the wide, fast river, and the vanguard was stranded on the sodden northern bank with no food and no protection against the elements – an incident that proved to be the spark which ignited, with terrible consequences, the simmering discontent within the ranks. They returned over the bridge in disarray; the Grand Vezir attempted to appease them, but the soldiers demanded that he hand over the symbols of his office: the seal he held as grand vezir and the sacred standard of the Prophet entrusted to him by the Sultan.[18]

Sarı Süleyman Pasha fled: he gathered up the sacred standard and took boat down the river in the direction of Belgrade. A large gathering of troops in his tent united in blaming him in his absence for all the ills which had befallen them both individually and collectively and, as the rebellious Anatolian pashas earlier in the century might have done, they put forward their own candidate to command the army on its return to Istanbul, the elderly and experienced governor of Aleppo and son-in-law of Köprülü Mehmed Pasha, Siyavuş Pasha. The mutineers prepared a report to submit to the Sultan in which they complained of the many broken promises made to the army over the past two seasons – provisions promised but supplied in insufficient amounts, pay and financial rewards for military success pledged but not forthcoming. They also recorded their anger that once they had crossed the bridge Sarı Süleyman ordered them to be given twelve days' worth of supplies and march instead to distant Eger from Petrovaradin, rather than confronting the enemy only a few hours north; this, they said, was the last straw and, lacking any protection against the terrible rain, they had refused to obey.[19] When he fled Sarı Süleyman Pasha was accompanied to Belgrade by some high-ranking statesmen including Tekirdağlı Bekri Mustafa Pasha, who was once again janissary commander-in-chief, but most subsequently decided to return to the army at Petrovaradin. One of those who continued with him from Belgrade downstream to Ruse and then

overland towards Istanbul was the chief treasurer of the empire, Seyyid Mustafa Pasha.[20]

With a war to fight on three fronts and a major military revolt on his hands, Sultan Mehmed IV commanded Siyavuş Pasha to see to the empire's defences as a matter of the utmost urgency. He ordered the army to winter quarters in Belgrade and forbade the return of any troops to Istanbul. The soldiers, outraged, hardened their terms, demanding the execution of Sarı Süleyman Pasha and the appointment of Siyavuş Pasha as grand vezir in his place; they also refused to remain in Belgrade. Retired officers in Istanbul of whom the Sultan asked advice recommended purging the upper echelons of the army. First of all, they said, a new grand vezir must be appointed, and Tekirdağlı Bekri Mustafa Pasha should be replaced, along with all officers commanding military units at the front; arrears in pay must also be settled. Before a decision could be made on whether this was the best policy for ending the revolt, however, further letters arrived from the rebels demanding Sarı Süleyman's execution. The Sultan ordered the seal of office of the grand vezir and the sacred standard of the Prophet to be taken to Siyavuş Pasha forthwith, and they were presented to him at Niš as he was on his way back to Istanbul with the mutinous army.[21]

Among the leaders of the mutiny were officers of the sultan's infantry and cavalry regiments; allied with them were militia commanders from Anatolia. Their anger was not assuaged by the change of grand vezir, and at Niš they surrounded the tent of Siyavuş Pasha while he was holding an audience; they demanded the head of Seyyid Mustafa Pasha, whom they held responsible for not paying them and, when Siyavuş Pasha sent his men to try to quiet them, they fired at his tent. Siyavuş Pasha told Seyyid Mustafa that he himself had no authority over these armed men, and that Seyyid Mustafa must plead with them instead. When he went outside to do so, he was cut to pieces. Siyavuş Pasha narrowly escaped with his life, but other senior members of the government present at the audience were all murdered.[22]

One Receb Pasha had been appointed Sarı Süleyman Pasha's proxy in Istanbul while he was at the front; the office was a reward to a partisan and fellow Bosnian for his part in despatching Sarı Süleyman's predecessor, Kara İbrahim Pasha. Receb Pasha had designs on the grand vezirate himself, and wanted to see Mehmed IV's eldest son, Prince Mustafa, now 23, on the throne. For the first time since the death of Ahmed I in 1617 the Sultan had both sons and brothers available as possible successors; forecasting that the arrival of the mutinous army in Istanbul would bring chaos, Receb Pasha suggested to Sheikhulislam Ankaravi Mehmed Efendi that, since it might well be the intention of the rebels to depose the Sultan and enthrone

his brother Prince Süleyman in his place, it would be wise to pre-empt them by making Mustafa sultan forthwith. Perhaps the Sheikhulislam preferred the nearly middle-aged Süleyman, because he refused to give a juridical opinion sanctioning the proposed act of treason. Receb Pasha tried to have him removed, but this was to over-step his authority, and when it was reported to the Sultan he ordered the apprehension of both the disgraced Grand Vezir and his intriguing proxy. The anti-Köprülü faction was in disarray. Sultan Mehmed sent to the Dardanelles for his trusted ally Fazıl Mustafa Pasha, who had been exiled there from court: his word carried more weight than the Sultan's with the military, and Mehmed appointed him proxy to the Grand Vezir in Receb Pasha's place. Faced by the imminent arrival of the army in the capital, the Sultan acted as decisively as he could, hoping that this would pacify the troops and bring an end to the dangerous disorder.[23]

Receb Pasha fled, evading capture for the present. It was not long before Sarı Süleyman was found hiding in disguise in parkland far up the Bosporus, and executed; his head was sent to the troops on their way back from Hungary, to pacify them. It reached the new grand vezir Siyavuş Pasha and the army at Plovdiv, where they were camped after marching from Niš, on 17 October 1687. In the Grand Vezir's tent the Sultan's accompanying letter was read out to the assembled officers: they could see Sarı Süleyman's head for themselves, he wrote; Receb Pasha was being sought day and night, and faced execution when he was apprehended. He promised that pay and supplies would be provided in full, and every effort made to rectify the injustices the army had suffered at the hands of Sarı Süleyman. But, the Sultan's letter went on, it was not right that the soldiers should come to Istanbul when there was war on every hand: they must winter in Plovdiv and Sofia while additional troops were being mobilized and new financial resources found for continuing the war. But the troops were not satisfied – they found nothing new in what the Sultan had to say. They wanted further undertakings concerning the repair of captured fortresses and the pay and conditions of their garrisons. Notably, they also demanded that the Sultan should give up his habitual hunting. The mutineers were in an ugly mood: they cut the ropes of the Grand Vezir's tent, and sent the imperial standards forward to the next way-station along the road to Istanbul.[24]

The leader of the army rebels was an Anatolian, Yeğen ('Nephew') Osman, who had served on the Hungarian front under Şeytan-Melek İbrahim Pasha; when Şeytan-Melek İbrahim was executed for the loss of the province of Uyvar in 1685, Yeğen Osman had fled back eastwards with a large body of discontented soldiers who proceeded to sack town and

countryside across central Anatolia. As in earlier times, the state tried to buy his co-operation, and appointed him commander of the Anatolian militia. He had forged them into an active unit on the Hungarian front, at a time when scarcity of effective military manpower was a pressing concern. Thus it was that the award of state office had set him up to play a central role in the tumultuous events of these years.[25]

On 18 October the army left Plovdiv and eight days later reached Edirne. Yeğen Osman – now a pasha – advised his fellows that they should stop there rather than march on Istanbul; Grand Vezir Siyavuş Pasha concurred, but opposition came from the sultan's regiments, the janissaries among them, who insisted on continuing to Istanbul to force a showdown. Their menacing tone won Yeğen Osman over: it was clear that only the deposition of the Sultan would satisfy his militia and those who marched with them.[26] On the first day of the new Islamic year, a written demand for the deposition of Mehmed IV reached Istanbul from the sultan's regiments. Fazıl Mustafa Pasha had already been informed by the Grand Vezir of the troops' demand, and the Sultan had agreed to make way in favour of his son Prince Mustafa.[27] He called a meeting in the mosque of Ayasofya,[28] where the highest legal authorities of the empire and the commanders of the sultan's regiments gathered with other statesmen and notables of the city to hear the demands of the advancing army read out to them. The assembly decided, however, that Sultan Mehmed IV should abdicate in favour of his brother Süleyman. Silahdar Fındıklılı Mehmed Agha was serving as a page in the privy chamber at the time and, as he put it, 'witnessed the truth of it all':

> The Chief Black Eunuch went to that part [of Topkapı Palace] known as the Boxwood [Apartment] where Prince Süleyman Khan was confined, and invited him to leave [his quarters] whereupon, supposing that he was to be done away with, the Prince became seized with fright and refused to come out. 'Your majesty, my Sultan, fear not! By God, I swear I intend you no harm. All the imperial ministers and doctors of theology and your military servants have chosen you as the [next] sultan and are awaiting the honour of your presence. We are at your command.' His heart still in a state of unease, the Prince replied, weeping, 'If my removal [i.e. execution] has been ordered, tell me, so that I may perform my prayers in the prescribed form prior to the order being carried out. I have been confined for forty years – ever since I was a child. Rather than dying [a thousand deaths] each [and every] day, it is preferable to die [once] at the earliest instant . . .'
>
> Again placing a kiss on the Prince's foot, the imperial officer responded, 'God forbid, do not say such things, I beg you: it is not a death but rather a throne which has been set up for you.' [When the Chief Black Eunuch stated that all the Prince's servants would attend him], the Prince's companion by

his side, his younger brother Ahmed, offered reassurance, saying, 'By your leave, do not be afraid, the Agha [i.e. the Chief Black Eunuch] always tells the truth.' Upon this, the Prince emerged from the apartment. Since [he] was dressed in a robe of red satin and his feet encased in a pair of short, heavy riding boots – having had nothing to wear for years except clothes of the very meanest and poorest sort – the Agha had one of his own robes brought, a dark bluish-brown broadcloth lined with sable, [which he] draped over [Prince Süleyman's] satin robe, and [then], giving his arm to the Prince, conducted him with reverence and deference to the Pavilion of Felicity of the Privy Chamber and seated him on a throne by the pool. The Swordbearer and the pages of the Privy Chamber now came forward and, as he advanced in their company toward the imperial Audience Hall, the Prince inquired, 'Are you going to stop by the Lion House,* [all enveloped in] darkness, and execute me there?' 'Oh, my Lord', [the Swordbearer] answered, 'how can you suggest such a thing? God forbid, may it be known that your removal [from the Boxwood Apartment] was in order that you should ascend the throne. See, your servant, the Chief White Eunuch, along with the imperial messenger, is coming from the Privy Apartments to meet you.' The Chief White Eunuch extended his salutations [to the Prince] and, putting his arm through the Prince's left arm escorted him to the imperial audience hall and seated him [on the throne]. In accordance with ancient custom, the sacred turban of the Prophet Joseph, [kept safe] in the Imperial Treasury,† was brought forth and placed on the exalted head [of the Prince] and adorned with three bejewelled plumes, trailing downwards. The point to which the sun had risen was but one-and-a-half spear-lengths high: it was three o'clock.

[Prince Süleyman] ascended the imperial throne . . . and the first in line to swear allegiance was the Registrar of the Descendants of the Prophet Muhammad, followed by the [Grand Vezir's] Proxy and the Chancellor and the chief justices of the provinces of Rumeli and Anadolu and, subsequently, the Sheikhulislam [i.e. Debbağzade ('Son of the Tanner') Mehmed Efendi, who had succeeded Ankaravi Mehmed Efendi] with various doctors of theology, and the senior officers of the militia and the sultan's regiments and the rebels [sic], as well as the head of the Palace Doorkeepers and the chief officer of the Bearers of the Imperial Flask – all swore their allegiance to the Sultan. [In turn,] the Sultan extended his salutations to the [assembled body in the] imperial Audience Hall and then honoured the Pavilion of the Privy Chamber by his presence, where he was seated on a throne at the pool. Now, the servants of the treasury and the commissariat and the campaign also came to swear their allegiance. The Chief Black Eunuch, Ali Agha, came bearing an imperial rescript ordering the confinement of [the new Sultan's] brother Ahmed Khan,

* The Lion House was a former Byzantine church located outside the palace grounds to the south of Ayasofya, in the cellar of which the Ottoman sultans kept wild animals.
† Joseph's turban may still be seen in the collection of Holy Relics housed in Topkapı Palace.

the deposed Sultan [i.e. Mehmed IV], and the two princes . . . Mustafa Khan and . . . Ahmed Khan [i.e. Mehmed IV's sons]; the three were raised up and detained in the Boxwood Apartment. A secret concealed from the inmates of the court and the residents of the city [of Istanbul], the imperial writ was presented to Sultan Mehmed Khan, who said, 'I bow my head to God's wish. Once imprisoned are we then to be executed?' The Agha replied, 'God forbid, your Majesty! May that day never come. The order refers only to your being confined.' That same day, the palace heralds delivered the propitious news to the Queen-mother and were granted an untold number of gifts, and the public crier proclaimed to the city the glad tidings of the imperial accession; and the Friday sermon was orated in the name of the newly-enthroned sultan and the coinage now bore his name.[29]

Neither Mehmed IV nor his sons had previously spent much time in the palace. For most of his reign he had kept his court in Edirne, and when in Istanbul had preferred the pavilions in the royal parks to the gloom of Topkapı Palace. Mehmed must have been permitted to leave the capital after his deposition, however, because he died in 1692 in Edirne; he was buried in the tomb of his mother Turhan Sultan near her mosque in the commercial quarter of Istanbul.[30]

Mehmed's removal met the demands of the rebellious troops. Yeğen Osman Pasha remained outside the city with the militia units, and the Grand Vezir entered Istanbul with the sultan's regiments and all the bureaucrats who had accompanied the campaign to oversee its administration. On 14 November, however, once the janissaries were gathered at their parade ground and the sultan's cavalrymen in the Hippodrome, they voiced new demands, calling for Receb Pasha, who had evaded arrest for a month before being found in Çatalca in Thrace and imprisoned, to be handed over to them. Four days later, it was decided to pay them nine months' arrears of salary in the hope that this would persuade them to return to barracks, but as the cavalrymen were being paid, word came from the janissary parade ground that the janissaries refused to accept their pay unless they also received the accession donative customary when a new sultan came to the throne: the cavalrymen joined in the protest and soon the city was in uproar. Having no ready cash at their disposal, and desperate to calm the unrest, the beleaguered authorities were forced to award whatever entitlements to tax-farming rights the ringleaders desired. Yeğen Osman Pasha was appointed governor of the province of Rumeli to discourage him from entering the city, the money needed to meet the accession donative for the thousands of troops entitled to it – at least 90,000, by Defterdar Sarı Mehmed Pasha's reckoning, of whom some 70,000 were janissaries and around 5,000 were cavalrymen – was scraped together from

the remittances of some of the eastern provinces, and Receb Pasha was executed, but nothing seemed to mollify the troops.[31]

Twenty days after he was led from the obscurity of the palace, Sultan Süleyman II was girded with the sword in the now traditional ceremony at Eyüp, then made his processional entry into Istanbul through the Edirne Gate of the city, symbolically taking possession of his empire. Still the rebellion continued. Grand Vezir Siyavuş Pasha ordered the dismissal of the commander-in-chief of the janissaries and the appointment of another in his place, but news that the ringleader of the rebel janissaries had been murdered further incited both janissaries and cavalry, and in revenge they killed their new commanding officer. Knowing the Grand Vezir to be incapable of any bold move, they sought another scapegoat for their many dissatisfactions, and found him in the person of Fazıl Mustafa Pasha, whom they accused of orchestrating attempts to restore order; Siyavuş Pasha agreed that his proxy should be sent back to the defence of the Dardanelles. The rebels failed to intimidate Sheikhulislam Debbağzade Mehmed Efendi into giving a juridical opinion in favour of Fazıl Mustafa's execution, but managed to bring about the Sheikhulislam's dismissal. The new appointee as sheikhulislam was Es-seyyid Feyzullah Efendi, a descendant of the Prophet and pupil of Vani Efendi, who had swiftly worked his way up the clerical hierarchy.[32]

The long and dangerous military rebellion was reaching its climax. Mutinous troops and a mob eager to profit from the chance to riot and loot besieged the palace of Siyavuş Pasha as he met there with Feyzullah Efendi and others, stoning its walls and firing their muskets. The pressure was too much for Feyzullah Efendi who slipped outside bearing the Grand Vezir's seal which he turned over to the leader of the mutiny. Some hours later the mob managed to break into the aged Grand Vezir's palace; when he saw to his disgust that some of the rioters were entering his *harem*, and that he himself was unable to escape their fury, he tried to bar the door separating the *harem* from the public apartments – but was murdered where he stood. The rioters stole whatever they could carry and, designating the women of the *harem* as 'war booty', carried them off too.[33]

The people of Istanbul reacted in different ways to the chaos. After a shop in the Old Bazaar was looted, other tradesmen barricaded their doors. When one shopkeeper raised a piece of white cloth on the tip of a pole and called on all true Muslims to rally, a rumour spread throughout the city and its suburbs that the sacred standard of the Prophet had been brought out of the palace. Gradually a crowd gathered at Topkapı Palace: the sacred standard was paraded on the walls, and the people demanded to be delivered from the anarchy of the mutinous troops. A number of the rebel

leaders were lynched by the crowd outside the palace, and others who made their way there to join their fellows met with the same fate. A new grand vezir was appointed, the chancellor İsmail Pasha, Fazıl Mustafa Pasha's successor as grand vezir's proxy when he returned to the Dardanelles; Sheikhulislam Feyzullah Efendi and other leading clerics who had played a shabby part in the rebellion were replaced.[34] Thus ended, in mid-April 1688, the mutiny which had begun on the Danube early in September 1687. The rebels had entered the city in November 1687: after five long months of terror, a new sultan was on the throne and public order was finally restored.

Far away in Hungary, the war continued. Once the Ottoman field army had marched back to Istanbul, the beleaguered garrison troops were left behind to cope with the forces of the Holy League. During the winter of 1687 and in the first months of 1688 the Habsburgs made gains along the weakly-defended border, including Eger which the Ottomans had held since 1596. They also scored notable successes on the Bosnian front further to the west: there, mobilization of local Ottoman troops to support the garrisoned positions was not a success, for they proved only too ready to flee at the first sign of danger, and very many took refuge with the Austrians.[35]

In Istanbul, the crisis of the winter months had caused preparations for the 1688 campaign to be neglected. Grand Vezir İsmail Pasha did not take command of the army in Hungary; instead Yeğen Osman Pasha, always unpredictable, was charged with trying to turn back the tide of Habsburg success – by remaining encamped outside the walls of Istanbul with his men, he had escaped direct implication in the violent events that took place over the winter. His appointment of his own men to a number of military posts was not wholly successful: they seem to have found it difficult to abandon their old habits, for reports continued to reach Istanbul of their harassment of a peasantry whom the demands of so many years of war had left starving and impoverished. Yeğen Osman was apparently either unable or unwilling to discipline his men; the call went out for a general mobilization against them, and he was dismissed as commander on the Hungarian front.[36]

Grand Vezir İsmail Pasha held office for only two months before falling victim to infighting at court. He was replaced on 2 May 1688 by the former commander-in-chief of the janissaries and commander on the Hungarian front after the failure of the Vienna campaign, Tekirdağlı Bekri Mustafa Pasha, now recovered from his earlier ill health. Tekirdağlı Bekri Mustafa had initially deserted the Ottoman camp at Petrovaradin with Sarı Süleyman Pasha when the mutiny first began, then returned, and had thereafter spent

the months of that troubled winter away from Istanbul, at the Dardanelles fortresses.[37] With the aim of depriving the Austrians – and foes on other fronts – of the opportunity to face an Ottoman army that was ill-prepared to meet them, Tekirdağlı Bekri Mustafa set urgent preparations in hand.

The Ottoman war effort was in disarray: with the campaigning season of 1688 well advanced and little prospect of peace, there was no time for the government to devise a well-considered solution to the pressing shortage of military manpower to fight along a wide front. As in the recent revolt which had seen the field army defy orders and march en masse from the front to Istanbul, the numerous occasions on which the sultan's regiments had seemed to threaten the very survival of the prevailing order as they plunged Istanbul into tumult for weeks on end demonstrated the complete breakdown of military discipline. Moreover, the system of awarding land-grants to provincial cavalrymen on condition that they appear on campaign with their retinues no longer met even the defensive needs of the empire – indeed, for all practical purposes, the institution had long since lapsed. It seemed the best hope of ensuring that enough men were available was to again concentrate the energies of Yeğen Osman Pasha and his followers on the borders of the empire, even though their depredations on the countryside and its inhabitants suggested a reluctance to abandon their old ways. The general mobilization against them was therefore countermanded, and they were reintegrated into the fabric of the state with the award of provincial governorships and sub-governorships, on condition that they appear on campaign with men under their command. Recalcitrant individuals had traditionally been incorporated into the state apparatus as a means of refocusing their loyalties; the novelty now lay in the scale of the state's reliance on these unruly troops as the backbone of the army. To attempt to defend the empire with an unreliable force whose members owed their first allegiance to their leaders rather than to the Sultan was clearly to court further disaster. The murder by Ottoman garrison troops of the commanders of the fortresses of Iraklion, Kamenets and Timişoara between 1687 and 1689 was yet more evidence of the central authorities' loss of control.[38]

Finding money for the campaign was proving as much of a problem as finding men to fight it. The treasury was empty, so gold and silver plate was melted down in a desperate effort to raise funds for the army.[39] During the seventeenth century the Ottomans had struggled to obtain enough silver for the minting of their own coins, so had allowed the silver coinage of various European states and that of newly-conquered territories to circulate freely within the empire. Supplies of copper were more readily available, but for reasons as yet unexplained the Ottomans had all but ceased the minting of copper coinage from the late 1630s. From 1688, in the after-

math of the rebellion of the winter months, copper coinage was again minted and issued in large quantities to enable the state to pay Sultan Süleyman's accession bonus and satisfy the demands of salaried employees, notably the troops of the sultan's regiments, as well as pay for the continuing war; it was easily counterfeited, however, and not always acceptable to the merchants from whom the state obtained supplies needed to provision both Istanbul and the army, and the practice was abandoned in 1691.[40]

The seriousness of the situation was not lost on Süleyman II and his statesmen. In June 1688, however, the ambassador of the United Provinces to the Ottoman court sought an audience with the Grand Vezir and informed him that Emperor Leopold and his allies were inclined to peace. This offer of mediation as a way to bring an end to the war was prompted by the desire of William of Orange (soon to be William III of England, Scotland and Ireland) to see the Austrian troops presently engaged in Hungary freed for service in the Rhineland and the Palatinate in support of the alliance he was beginning to put together against Louis XIV of France. News of this move also reached Istanbul by way of the military commander at Belgrade and, despite his promise on his accession that he intended to lead his army in person to win back the territories his forebears had conquered at such cost,[41] Süleyman decided to send envoys to remind the Emperor of the friendship between their fathers – Ferdinand III and Murad IV, during whose reigns earlier in the century there had been peace between Habsburgs and Ottomans. It was usual to send letters announcing the accession of a new sultan to fellow monarchs, and on this occasion they went to the Mughal Sultan Aurangzeb, and to Iran, Özbekistan, Yemen, France, England and the United Provinces; and on 11 July 1688 a high-ranking chancery official, one Zülfikar Efendi, set out for Vienna, carrying Süleyman's letter to Emperor Leopold, at the head of a peace-seeking delegation which included the Chief Dragoman – literally, the 'Chief Interpreter', but in reality the principal intermediary between the sultan and foreign rulers – the Ottoman Greek Alexander İskerletzade, known in the West as Mavrocordato.[42]

But these peace overtures did not end the war, and preparations continued apace. In the absence of a firm hand to direct the war effort, the suppression of the military rebellion and the enthronement of a new sultan did nothing to improve the performance of the Ottoman army on the Hungarian front where the Ottoman presence was by now reduced to a tenuous hold on a few minor forts. The most devastating blow to the Ottomans in 1688 was the loss of Belgrade, which fell to the Habsburg army on 8 September after a month's siege. Yeğen Osman Pasha made no attempt to put up any real defence against the attackers but allowed his men to loot the city's

bazaars instead of fighting, and retreated with them well behind the front line to the safety of Niš, leaving the defence of Belgrade to the governor of Rumeli. The Habsburg army under Maximilian Emanuel, Elector of Bavaria, easily overcame Imre Thököly and some Ottoman troops in a battle outside the city. Belgrade's resistance for as long as a month was remarkable, since it was inadequately garrisoned and there was no expectation of relief – Zülfikar Efendi and his delegation happened to reach the Habsburg camp as the siege ended: his assessment was that although their weaponry was impressive, the Habsburg troops were in a parlous condition and ready to withdraw once they had secured the defence of their territory.[43] For more than a century and a half this strategically vital fortress had been the inviolable forward base from which military operations against the Habsburgs had been conducted; once it was lost, the road to Istanbul was open. The inhabitants of Belgrade fled down the Danube to escape the advancing Habsburg forces – as did the garrisons of Ottoman-held forts along the river.[44] By October Zülfikar Efendi and Mavrocordato had been arrested and were being held outside Vienna.[45]

Yeğen Osman was responsible for allowing the Habsburgs to advance so effortlessly into the Ottoman heartland, yet following the loss of Belgrade he was confirmed as commander-in-chief of the imperilled front for the next season. No other experienced commanders were available, and none who identified closely with the central government could be sure of the loyalty of their men. When the frontiers of the empire were so severely threatened, Yeğen Osman appeared to offer the only solution. Orders went out for the enlistment of Muslim men fit to fight; participation in the forthcoming campaign was also proclaimed to be the duty of non-combatants who, as tax-payers, would provide the wherewithal that would enable the campaign to proceed, and advance payment of certain taxes was demanded – an unprecedented measure adopted in a bid to fill the coffers of the state.[46]

Despite Yeğen Osman Pasha's position as the lynch-pin of Ottoman strategy in Hungary, the renewed sense of momentum engendered by the preparations to resist the Austrians encouraged Ottoman statesmen to hope that he could be outflanked. The most senior officials, from the Grand Vezir to Sheikhulislam Debbağzade Mehmed Efendi (who had been reappointed following Feyzullah Efendi's dismissal) and the commanders of the sultan's regiments, were united in the view that if Yeğen Osman and his associates were taken out of circulation, victory would follow. The government was also determined to weaken his status as a charismatic figurehead for the discontented by revoking his authority as militia leader. Within a few months he was stripped of his rank, and the companies of irregulars

which had been formed as long ago as the beginning of the century to provide essential manpower for the wars against Iran and Austria then being fought were abolished. While the fighting capabilities of these men were still needed, by forcing them to enrol in companies untainted by association with rebellion, the government hoped to undermine the attractions of opposition to the state.[47] A juridical opinion sanctioned the hunting down of any rebellious elements – which now included Yeğen Osman – and orders to this effect were sent to Ottoman provincial governors in Rumeli and Anatolia. In particular, the route between Anatolia and Rumeli by way of the Dardanelles was strongly fortified to resist any rebel forces that might try to cross over with the intention of marching on Istanbul, as had happened in the past when there was provincial unrest. The part played by Yeğen Osman and his followers in neglecting the defence of the Hungarian frontier was matched in Anatolia by the all-too-familiar acts of brigandage, hold-ups on the roads and pillaging of countryside and town.[48]

Following the fall of Belgrade, Yeğen Osman Pasha had passed the winter in Sofia; in the spring, finding that the call to arms against him severely limited his freedom of movement, he fled west towards Albania. Near Peć he and thirteen of his followers were killed by local people in whose house they had been made welcome as guests. Two of his closest allies fled in disguise to Egypt, but were caught when they arrived and returned to Edirne for execution. Similar fates awaited others who fled towards Iran but were apprehended when they reached Erzurum, and executed.[49] The Ottoman government had at last managed to get the better of rebels who were seriously hindering the smooth running of vital military operations essential to success in the war against the Holy League.

The course of the war was now affected by events far outside the Ottoman lands. The chances of a successful outcome to the delicate peace negotiations initiated by William III depended on the ever-changing fortunes of any one of the parties or potential parties to the conflict. Shortly after the notable Austrian victory at Belgrade, Louis XIV of France, in defiance of the truce of 1684 whereby he had pledged a 20-year peace with Emperor Leopold, invaded the Palatinate. The renewal of war against France in western Europe from October 1688 – known variously as the War of the League of Augsburg, the War of the Grand Alliance, the Nine Years' War, or King William's War – diverted Habsburg resources from the struggle against the Ottomans, as they found themselves having to fight determined enemies on two far-separated fronts.[50]

On 10 April 1689 the Sultan's tents were pitched in the Edirne plain. Zülfikar Efendi's peace talks having made little progress, Süleyman II was

in a position to keep his vow and earn himself the title of 'Gazi' by leading that year's campaign. The state coffers were somewhat replenished, draconian orders had been promulgated for mobilization, Yeğen Osman Pasha and his cohorts had been defeated and the unrest in Anatolia suppressed; the Sultan's presence on campaign was intended to suggest a new-found confidence in the ability of the empire to survive, but it was also a desperate measure aimed at salvaging honour and territory in the face of looming disaster. The Sultan accompanied the army as far as Sofia where the governor, Arab Receb Pasha, was appointed commander-in-chief in succession to Yeğen Osman Pasha.[51] It was rare if not unprecedented for an Arab to rise so high; this prejudice against Arabs was expressed by Defterdar Sarı Mehmed Pasha in his chronicle of these years, where he referred slightingly to Receb Pasha's origins but noted, nevertheless, that he was renowned for his courage. The problem, in Defterdar Sarı Mehmed's opinion, was that at the very time when a wise and capable commander-in-chief was urgently needed, the office went to someone who did not have good relations with the troops, failed to consult them before acting, and did not reflect on the consequences of his chosen course of action.[52]

As the events of 1689 unfolded, the fanfare attending the Sultan's 'participation' in the campaign was insufficient to mask the fact that, despite the Habsburgs being occupied elsewhere, the defensive situation in the Balkans was becoming worse than it had ever been. A new western coalition against the French – comprising Austria, England and the United Provinces – was signed on 12 May; with King William's decisive emergence onto the stage of European politics, this 'Grand Alliance' superseded the defensive League of Augsburg of 1686 between Emperor Leopold and a number of German princes. Zülfikar Efendi required new instructions to meet the changed circumstances, and sent an envoy to Edirne for the purpose.[53] The Ottomans were now inclined to accept Habsburg conditions for peace, and Zülfikar Efendi was instructed to try to persuade the Emperor to return to Belgrade, and agree a new Habsburg–Ottoman border at the Sava–Danube line. Mindful of the Holy League's determination that none of its participants should agree a separate peace, the Ottomans were also prepared to concede Venice's conquests on the Ionian coast and in Dalmatia, and the Commonwealth's demand for the levelling of the fortress of Kamenets. However, in September 1689 the new French ambassador to the Sultan's court, Marquis Castagnères de Châteauneuf, energetically sabotaged any possibility of agreement between the Ottomans and the Holy League by proposing an Ottoman–French alliance,[54] and the window of opportunity for peace was again slammed shut as the Ottomans saw a chance of recovering their position.

Meanwhile, the new commander-in-chief marched northwards with the army. As they approached Belgrade late in August, news came that there were enemy troops ahead; Arab Receb Pasha ordered his men to pursue them but they turned, and the pursuers found themselves under fire at night, immobilized in an oak forest, and unable to fight – they fled back along the road to Niš, leaving their heavy equipment behind. Arab Receb was unable either to co-ordinate the manoeuvres of his troops, to gather useful military intelligence, or even to impose discipline on his soldiers – they refused to regroup at Niš, and began to march back to Sofia to present their grievances to the grand vezir, Tekirdağlı Bekri Mustafa Pasha. In a final blow, in late September, Niš was then lost to a Habsburg force which took advantage of the Ottomans' failure to secure a bridge over the raging river Nišava.[55] The debacle at Niš accelerated the mass migration of Muslims southwards through the Balkans and into Anatolia[56] which had begun with the fall of Belgrade in 1688, and was now exacerbating the internal displacement of population already brought about by war and rebellion.

The fall of Niš brought Arab Receb Pasha's execution. With Belgrade protected by their new forward base the Austrians were able to take several Ottoman forts on the Danube, as far west as Petrovaradin. Opening a new front in Wallachia, where they met with little resistance, they advanced towards Bucharest until they were driven out by the forces of the voyvode Constantin Brâncoveanu. The Sultan's advisers recommended that he withdraw from Sofia to Plovdiv and thence to Edirne. Incited thereto, apparently, by the local Orthodox peasantry, Habsburg forces raided through Ottoman lands as far south as the towns of Skopje and Kyustendil in Macedonia. Just as Balkan Muslims sought safety in retreat into the Sultan's realms, the Orthodox sought refuge behind Austrian lines. The disloyal part played by these Christian subjects in failing to safeguard fortified positions was a matter of real concern to the Ottoman government.[57]

On 25 October 1689 the clerical hierarchy met in consultation and concluded that Fazıl Mustafa Pasha – by this time serving in Chios – must be recalled and appointed grand vezir.[58] At the time of the rebellion which precipitated Mehmed IV's deposition, Sheikhulislam Debbağzade Mehmed Efendi had demonstrated his partiality for Fazıl Mustafa by refusing to issue a juridical opinion sanctioning his execution – like his brother Fazıl Ahmed Pasha, Fazıl Mustafa had, after all, been a cleric before transferring to a career in the military-administrative elite.[59] When civil disorder threatened to tear the empire apart in 1656 senior statesmen had turned to a Köprülü to save the Ottoman domains, and so it was unanimously agreed now as they gathered in audience in the Sultan's tent at Edirne.[60] For once the change of grand vezir went smoothly – Tekirdağlı Bekri Mustafa Pasha had

served the empire well on the Habsburg front, and was allowed to retire to his estates. But unlike Tekirdağlı Bekri Mustafa, Fazıl Mustafa Pasha was not tempted by the peace the Dutch and English were trying to broker, and instead made preparations for the campaigning season ahead, which he intended should reverse Ottoman fortunes in the war.

Like his father Köprülü Mehmed Pasha before him, Fazıl Mustafa Pasha adopted stern measures when he came to power, removing from office or ordering the execution of any state officials of the previous regime who were deemed inadequate to the demands of the new, and installing his own appointees in their place. Command of the army on the Austrian front was awarded to the janissary commander-in-chief Koca Mahmud Agha, in the hope that he would encourage and inspire his own men to rediscover their legendary fighting potential. In a style reminiscent of earlier, more disci-plined times the corps was subjected to a strict roll-call, and the names of dead janissaries were removed from the rolls to prevent their fellows collecting their salary in their stead.[61] With the aim of more effective and efficient mobilization, other corps were also re-registered and their where-abouts established; troops were called up from Egypt and other North African provinces, and naval levies were ordered to ready the fleet to resist Venice. As in the previous year, a general mobilization of the Muslim population was proclaimed.[62]

A radical solution adopted to meet the manpower requirements of the army in the 1690 campaigning season was the conscription of settled and nomadic tribesmen from Anatolia and Rumeli. Five thousand men were raised from the Turcoman and Kurdish tribes of south-east Anatolia, their appearance for duty on the Austrian front being assured by the device of naming a guarantor who was to be held financially responsible if they failed to arrive at the mustering grounds at Edirne. In Rumeli a different approach was employed: nomadic tribesmen were required to participate in return for exemption from certain taxes to which they were normally subject.[63] The tribal populations of the Balkan provinces had served as auxiliaries in early times, and were accorded a role as fighting men from the reign of Mehmed II; now they were to be fashioned into more formal units and known as 'Sons of the Conquerors', an inspiring reminder of the role their forefathers had played in the Ottoman settlement of the Balkans.[64]

The Ottomans enjoyed an unfamiliar taste of success in 1690. The most forward of the fortresses held by the Austrians – Pirot, south-east of Niš on the road to Sofia – was retaken after a three-day siege.[65] Although Niš was better able to resist it too was retaken in September, thanks to the mining skill of the janissaries and other forces, and the arrival of a relief army. The defenders bargained to be allowed to leave for Belgrade, rather

than face the usual penalty of death for their refusal to surrender, and the Ottomans accepted their excuse – that although they had received a document from the attacking Ottomans, they could find no one who could read it and therefore did not know that it was the customary offer of safe-conduct.[66]

The road up the valley of the Nišava – secured by the fortresses of Pirot and Niš – was one approach to Belgrade from the Ottoman headlands; the other was the Danube valley, guarded by its line of strongholds. Here Vidin was retaken, then Smederevo and Golubac further west, and at the start of October 1690 a large army comprising the sultan's regiments, provincial cavalry troops, musketeers from Egypt, Tatars, and others arrived before Belgrade. The surrounding land was levelled and the fortress was besieged from both the Danube and the Sava side. On the seventh day the defenders' armoury was blown up and burned, and on 8 October the castle was retaken. Heavy rains and winter weather subsequently forced the Grand Vezir and his main army to abandon their efforts to move north and west along the Danube to join the governor of Bosnia in besieging Osijek, west of the Drava–Danube confluence, and that siege was therefore raised.[67] The help of French engineers and gunners – taken off French ships docked in Istanbul – in repairing Belgrade was Châteauneuf's particularly cost-effective means of bolstering the recent rapproachement between France and the Ottoman Empire;[68] local people evicted from the island in the Danube below the fortress were impressed as labourers.[69] The one significant loss for the Ottomans during 1690 was the fortress of Nagykanizsa, south of Lake Balaton in Hungary, the 'key to Germany' as it had once been known.[70]

Having assured himself that the front-line positions were well fortified and supplied and that preparations for the forthcoming season's campaigning had been taken in hand, Fazıl Mustafa Pasha returned to Istanbul after the reconquest of Belgrade. Campaigning by local troops continued over the winter: in Bosnia Austrian mortars taken from Belgrade and other castles were used to effect, and the fortress of Knin was besieged and taken; on the Adriatic, the Venetian navy arrived too late to relieve Vlorë.[71]

After the disastrous campaigning season of 1689, when Arab Receb Pasha's incompetent generalship caused mutiny among the troops, the victories of 1690 were sweet indeed, and it seemed natural to ascribe them to the presence of a Köprülü at the head of government. Even while giving his attention to military matters, Fazıl Mustafa Pasha had overseen many reforms in the administration of the empire, some in response to the exigencies of the moment but others intended to have far-reaching effects. One of his first actions as grand vezir was to repeal the tax on the production by the non-

Muslim population of wine and other alcoholic drinks (such as the anise-based *arak*) introduced in 1688 as a means of raising ready cash.[72] When serving as a provincial governor in the Aegean, far from the fevered activity on the beleaguered military frontier, Fazıl Mustafa had been able to observe events with greater detachment than if he had been a member of the inner circle of government and party to the infighting and crisis mentality of his peers. He saw that the wine tax, in striking directly at the livelihood of the peasants of the Aegean, inclined them to collaborate with the enemy; now instead of raising money by taxing production he attempted to ban consumption, so that alcoholic drinks produced inside the empire had to be exported – and subjected to an export duty – thus continuing to provide revenue for the treasury.[73] Production of tobacco had been legalized in 1646, and by the 1690s the crop was grown across the empire where climatic conditions permitted; unlike wine, both production and export of tobacco were taxed.[74] Coffee, which came into the empire from the former Ottoman province of Yemen, via Egypt, was another item which was frowned upon but had potential for generating customs revenues: its import was first taxed in Süleyman II's reign and, to provide still greater income for the treasury, a further tax was levied on its sale.[75]

In addition to hastily-conceived measures to meet the most immediate needs of the campaigning season of 1690, Fazıl Mustafa Pasha tackled a problem the Ottoman government had faced periodically in the course of the seventeenth century – the resettlement of people who had deserted their lands, usually as a consequence of war or brigandage; the government acted with persistence, in some cases still intent on forcing them to return to their homes after forty years away.[76] Landless peasants too had been offered inducements to settle abandoned lands but this policy was only partially successful.[77] Fazıl Mustafa focused what he intended should be more effective settlement schemes on two specific groups: the nomadic tribal population – which the government hoped to settle permanently – and the Christians of the empire.

The settlement of traditionally nomadic tribes had been part and parcel of the Ottoman conquests of earlier times but had long been abandoned as the period of irresistible expansion was superseded by the need for a more defensive posture. Now, in 'the reopening of ruined and unowned places to agriculture through the [forced] settlement of tribes'[78] far from the front line, Fazıl Mustafa adapted an old policy to meet present needs. From early 1691 orders went out for the permanent settlement of Kurdish and Turcoman tribes of Anatolia and further east who traditionally moved their flocks between lowland and mountain pastures, and therefore had some experience of settled life once their seasonal migration had taken

place. The tribes were exempted from extraordinary taxation in return for giving up their migratory habits and restoring the agricultural potential of the area to which they were assigned, while shepherds only – rather than the whole tribe – accompanied the herds to their summer pastures.[79]

Over the next years tribes were forcibly moved to such areas as the Euphrates bend in the Urfa–Harran area, the area between Adana and İskenderun, between Ankara and Tokat in the bend of the Kızılırmak river, and the area between Isparta and Denizli in south-west Anatolia.[80] A number of central Anatolian tribes accused of murder and pillage were moved to Cyprus, and to Raqqa in Syria where they were expected to act as a first line of defence against Bedouin attack:[81] the Ottoman state had no use for the Bedouin, considering them little better than unbelievers because they attacked the caravan routes and particularly that of the pilgrimage to Mecca. The project was not a success: tribal opposition manifested itself in rebellion, notably in 1697,[82] and as fast as lands were settled, they were again abandoned. Not only was permanent residence in one location insupportable for people used to the freedoms and rhythms of seasonal migration, but scant thought appears to have been given to the practicalities – in some locations identified for resettlement the climate was too harsh, the water supply insufficient, or the soil unsuitable for year-round agriculture.[83] In short, this was an ill-conceived plan which did not achieve its aims, and the failure of such draconian intervention in the life of the tribes illustrated the acuity of those who in the mid-sixteenth century had sternly admonished officials charged with surveying the tribes of Baghdad to respect their traditional rights.[84]

The resettlement of Christian populations who had fled their villages was more simply achieved. Permission to establish and repair churches was in the gift of the state authorities, and one of the incentives to resettlement offered by Fazıl Mustafa Pasha was a swift and positive response to such requests from Anatolia and Rumeli.[85] This was not the first occasion when the Ottoman authorities looked favourably on the desire of the Christians of the empire to rebuild their churches – nor would it be the last; although more research is needed to clarify this matter, it is clear that it was fairly routine for such requests to be granted in times of war or rebellion, when populations were forced to flee for their lives.[86] The government hoped that, with their churches repaired, Christian communities could be re-established and agriculture again made productive – and taxable.

A law introduced in 1688 and first implemented in 1691 altered the basis on which the poll-tax paid by the non-Muslims of the empire was calculated. Traditionally, the tax had been levied on individual adult males, but

could also be assessed collectively on villages or towns, and rates varied from place to place depending on the productivity of the community. Collective assessment had gradually replaced individual assessment, and although the rates were revised from time to time, inevitably revision lagged behind reality, and shared responsibility for a tax last assessed in more populous or prosperous times could place an exorbitant burden on communities depleted by war; it was certainly significant in exacerbating the disaffection of Ottoman Christian peasants in the Balkans and causing them to flee the empire for Habsburg-controlled territory. The western Black Sea port of Varna, for instance, had lost one-third of its pre-war non-Muslim population of some 1,300 households, and had a new survey not been carried out in 1685, those remaining would still have been required to pay the amount originally levied on these 1,300 households – though tax collectors might find themselves unable in practice to extract dues from stricken communities.[87]

Finding tax collection ever more difficult, the Ottoman government decided in 1688 upon reform of the system. Fazıl Mustafa Pasha energetically implemented the reform when he came to power, and from 1691 the poll-tax was once more assessed on individual adult males rather than on the community as a whole; it was levied according to the tax-payer's means, and the rates were standardized across the empire. Changing to a new system in the middle of a war must have caused confusion and cannot have been achieved very smoothly, and the problem was compounded by the fact that while those liable for this tax wanted – understandably – to pay it in whatever coinage was to hand, it had been decreed that only Ottoman gold coins and pure silver coins would be accepted. Abuses in assessment and collection of the new tax were of course prevalent, but adjustments to its operation were made over subsequent years and it continued to furnish an important percentage of treasury revenue.[88] More effective assessment gradually followed the reform, enabling the state to raise more money from its Christian and Jewish subjects. This was justifiable in the sense that the physical burden of defending the realm was shouldered by the male Muslim population, and while they suffered and died, it seemed equitable that non-Muslims should play a more significant part financially in the defence of Ottoman lands.

In 1691 Fazıl Mustafa Pasha departed for the front with a certain amount of anxiety – Sultan Süleyman II was ill with dropsy, and not expected to survive the month. However, he had had his cousin Amcazade Hüseyin Pasha appointed as his proxy, and the recent discovery of a plot among senior clerics to depose Süleyman and put Mehmed IV on the throne

again[89] should have eased his mind. Furthermore, before he left Edirne on 15 June he had presided at a meeting of high-ranking statesmen who agreed that Süleyman's middle-aged brother Ahmed had the qualifications to succeed, and that neither Mehmed – whom they said had brought nothing but ruin upon the empire during his forty-year reign – nor Mehmed's sons, Mustafa and Ahmed – who during their father's reign had, they opined, learnt to 'ride with him like unbridled lions, to eat and drink with him and to make war and music' – should be considered.[90]

Fazıl Mustafa Pasha was only a week out of Edirne when Süleyman II died there and the senior Ahmed – who like Süleyman had spent decades in confinement – was girded with the sword and proclaimed sultan in a ceremony in the Edirne mosque of Çelebi Sultan Mehmed [I], more commonly known as the Eski Cami, the 'Old mosque'.[91] The final campaign season of Süleyman's reign promised well for the future; Fazıl Mustafa seemed to be leading a reversal of Ottoman fortunes after the bleak years since the siege of Vienna. Süleyman's administrative achievements have been overshadowed by the resoluteness and military successes of his grand vezir, but the overhauling of the Ottoman administration during this long period of war was their common project,[92] and the late Sultan's most lasting monument – the more than 1,100-page-long chronicle of the events of his short reign that he commissioned, regrettably still unpublished – survives as evidence of his attention to detail and involvement in government.[93]

The Habsburgs now sought to regain Belgrade, and Fazıl Mustafa Pasha planned a rapid response to cut them off before they could reach the fortress. The Tatars had not yet arrived to join the main body of his army, but against his better judgement he decided that his men must go forward alone – or miss their opportunity. In a field battle on 19 August 1691 at Slankamen on the Danube north of Belgrade, the Ottoman army was routed and Fazıl Mustafa Pasha was killed by a stray bullet. His men retreated in disorder to Belgrade, leaving behind their artillery and the army treasury. The death of Fazıl Mustafa on the battlefield threatened a breakdown in military discipline as had occurred after the fall of Belgrade in 1688, and as they had then, many of his troops fled back towards Sofia from the front, their numbers swollen with brigands and bandits as they went.[94]

The choice of the military men and clerics at the front to fill Fazıl Mustafa Pasha's post as commander-in-chief, temporarily at least, was Koca ('Great') Halil Pasha, lately in command against the Venetians in the Peloponnese and Dalmatia.[95] The new grand vezir, however, was the undistinguished second vezir, Arabacı ('Cartwright', also known as Kadı, 'Judge', or Koca) Ali Pasha. At a meeting of the imperial council in Edirne, the Chief Justice of Rumeli proposed that Arabacı Ali should go immediately to Belgrade to

oversee preparations for the 1692 campaign. He agreed reluctantly, but it would have taken three or four months for him to get there and his departure was delayed by the onset of winter; Edirne was instead decreed winter quarters for the army and the base of operations.[96]

A new sultan and a new grand vezir brought changes. Fazıl Mustafa Pasha had been determined to win the war rather than seek peace – although briefly it had seemed that he was receptive to the idea that peace talks might be held in Belgrade[97] – but Arabacı Ali Pasha had no desire to command the army and could tacitly accept the loss of Hungary. As Ottoman presence there weakened, so Ottoman suzerainty over Transylvania had become ever more nominal, and in 1686 – the year the Ottomans lost Buda – the Transylvanian estates made known their wish to place the state under Habsburg protection if religious freedom was respected and Michael Apafi was allowed to remain as prince; in March 1688, these terms became reality.[98] Following Apafi's death in April 1690 the estates nominated his son as his successor, but the Ottomans tried to place Imre Thököly – who had consistently given them military support during the war – on the throne. In dividing the attentions of the Habsburgs this move contributed to Ottoman successes during 1690, but in 1691 Thököly was driven out by a Habsburg army and by the end of that year, so disastrous for the Ottomans, Transylvania perforce accepted Habsburg suzerainty once more. Transylvania's slide towards the Habsburgs opened up a new front for the Ottomans to defend when they had few resources to spare.

Whatever success the Ottomans enjoyed against the Habsburgs during these years was in large measure due to the leadership of Fazıl Mustafa Pasha, as well as to the fact that the intensification of the war against France in western Europe was diverting Habsburg troops from the east. Nevertheless, this coincidental combination of a favourable international situation and a capable grand vezir enabled the Ottomans to imagine that at last they might have a chance of winning the war; on the other hand, had Fazıl Mustafa been less hawkish, that same war, which cost the Ottomans so dear, might have ended many years sooner.

A period of uncertainty followed the death of Fazıl Mustafa Pasha, and by early 1692 many new military and administrative appointments had been made, a shuffling of offices that reflected the intense power struggle taking place in government circles – among the victims were Grand Vezir Arabacı Ali Pasha who was exiled to Rhodes, his estate confiscated, and Amcazade Hüseyin Pasha, who was posted to the Dardanelles. The Austrian forward base on the Danube front was now at Petrovaradin, only a few stages from Belgrade, and it was clear to the Ottoman high command that no advance

northwards was feasible at present, but that their efforts must be concentrated on holding the Danube line. In November, after the decision was taken not to further repair and improve the fortress of Belgrade at that time, the army moved back to Edirne.[99]

Anglo-Dutch efforts at mediation continued meanwhile, and shortly before the Ottoman army marched south, William III's Dutch envoy to the Habsburg court, Coenraad Van Heemskerck – who was temporarily appointed as the King's 'English' envoy to the Sultan's court alongside the Dutch envoy there, Jacobus Colyer – travelled from Vienna to Belgrade to present to Mavrocordato Austrian peace proposals made on behalf of itself and its allies. Onerous in terms of territorial concessions, these proved unacceptable to the Ottoman side, but Van Heemskerck was ordered to Edirne where he arrived early in December. He was denied an audience with the Grand Vezir until the return from England of Lord Paget, formerly William's English envoy to Vienna, now transferred to the Porte, upon whose arrival in Edirne in February 1693 a fierce battle for precedence took place. The chance of peace receded further when it became apparent that the language of the Austrian terms was far from clear. After some weeks of further wrangling between the two envoys, and with hopes of an audience raised then as quickly dashed, Paget, Van Heemskerck and Colyer were eventually summoned before the Sultan's vezirs and senior army officers on 24 March 1693 where, to their surprise, the proposals for peace with Austria Van Heemskerck had presented to Mavrocordato in Belgrade some months earlier – based on the principle known as uti possidetis, briefly, that each party should keep what it held at the time of the negotiations – were read out to torment them; this piece of theatre demonstrated that the Ottomans had, by now, no thoughts of peace.[100] Paget reported of a meeting he had with the Grand Vezir's proxy in Edirne:

> By the discourse I had with this Person, I perceived he knew not what was meant by *Uti possidetis*, nor what a Mediation was, or how a Mediator could be usefull, so that I judged they had never before heard the proposition with any regard.[101]

Despite further efforts on the part of the envoys, it was evident that there was little more they could do at that time to satisfy King William's urgent desire to see an end to the war. The dispute over matters of precedence between Van Heemskerck (who returned home in April 1694) and Paget – envoys representing different states who were both servants of the same master – clearly contributed to the failure of peace negotiations.[102]

During the winter of 1692–3 Austrian troops threatened the last remaining Ottoman strongholds in the principality of Transylvania, and operations in

1693 were therefore switched to that front. As a new grand vezir, Bozoklu Mustafa Pasha, led his army from Edirne to Ruse and crossed over the Danube into Wallachia to combine with the Tatar army, news arrived that a large Austrian force was besieging Belgrade. Having discussed the dilemma the Ottoman high command decided that the army could not both defend Transylvania and relieve Belgrade; priority was given to Belgrade, and the troops, including the Tatars, moved back westwards along the Danube, their cannon travelling by river. News of the Ottoman advance caused the Austrians to raise the siege; the poorly-secured fortress had suffered badly in the bombardment, damage that had to be made good at once for fear of further attack, but there was comfort to be drawn from the Tatar pursuit of the Austrian army as it returned to Petrovaradin, when much booty and numbers of prisoners were taken. In early September 1694 the Ottoman army was encamped before Petrovaradin with yet another grand vezir – Sürmeli ('He with kohl-lined eyes') Ali Pasha – at its head. The troops dug in and besieged this impregnable riverside fortress for 22 days, until the Danube burst its banks and filled their trenches with water, when they gave up and withdrew to Belgrade. The struggle for these two important strongholds had reached stalemate. As the contemporary chronicler Defterdar Sarı Mehmed Pasha acknowledged, the Habsburgs, although weakened, were still a force to be reckoned with.[103]

Sultan Ahmed II was 48 years old when he emerged into public life to succeed his brother Süleyman in 1691. He died on 7 February 1695 in Istanbul and was buried in the mausoleum built by his grandfather, Sultan Ahmed I – 36 members of the dynasty rest there to this day. His successor Mustafa II, son of Mehmed IV 'the Hunter', was some thirty years old and had led a freer and less cloistered life than his two uncles, Süleyman and Ahmed. Although he had spent the twelve years since his father's deposition in seclusion in Edirne, it was a less oppressive confinement than he would have endured in Topkapı Palace, and before that he had accompanied his father on campaign. Like his predecessors, he too saw the sultan's presence at the head of the imperial army as the key to victory, and in his first proclamation announced that, like his forebear Süleyman I, he would lead his troops on campaign in person. For three days his statesmen debated the matter, concluding that although the cost of the Sultan's participation would be high, it would surely be effective in turning the tide of the war to Ottoman advantage.[104]

In contrast to the qualified fervour displayed by his uncles, when Mustafa II declared that he would lead his army on campaign he meant exactly that. On 1 July 1695 he left Edirne, reaching Belgrade on 9 August. With him were Sheikhulislam Feyzullah Efendi, once his tutor, and reappointed to

head the clerical hierarchy soon after Mustafa's accession, and the incumbent grand vezir, Elmas ('Diamond') Mehmed Pasha, who had been elevated to office from a ceremonial position in the chancery. A council of war was convened at Belgrade to consider whether to besiege Petrovaradin again or to head north towards Timişoara and attempt to retake some of the Transylvanian fortresses in the area which had fallen into Habsburg hands. The Austrians were using one, Lipova, to the north-east of Timişoara, as a forward base for an attack on this key Ottoman stronghold. The reinforcement and resupply of Timişoara was a constant preoccupation of the Ottoman commanders on this front, as Austrian armies came and went from their bases further west, and it was eventually decided that, if they could retake Lipova, the Austrian supplies of food and matériel would be theirs.[105]

Sultan Mustafa inspected Belgrade's fortress and fortifications incognito, and found them in better repair than he had expected.[106] The addition of more bastions and an increased garrison improved its defences before the army moved off. Lipova was successfully recaptured, and the considerable quantity of supplies held there was transferred to Timişoara. As winter approached, the Sultan and his army travelled south through Wallachia to cross the Danube at Nikopol, where Mustafa was reunited with his *harem*, which had retreated here from Belgrade for fear of an Austrian attack. For the first time in years Mustafa wintered in Istanbul rather than Edirne, for the purpose of overseeing more closely the preparations for the 1696 campaign season.[107]

The Sultan's presence at the front seemed indeed to have assured success, and the next year promised even greater victory according to Silahdar Fındıklılı Mehmed Agha. At Sultan Mustafa's instruction he wrote a chronicle to celebrate his reign – hubristically the Sultan called it the 'Book of Victory' – and in it he recorded a miraculous discovery made in the Sultan's private treasury in January 1696: a valuable sword, and with it a bronze plate explaining its provenance, inscribed on one side in characters which were either 'Suryani' or Hebrew and on the other in Arabic. According to the inscription on the plate, the sword was made by King David and with it he had slain Goliath; it had passed through the hands of Jesus and ultimately to the Mamluks of Egypt (and reached Istanbul, we may surmise, following Selim I's conquest of the Mamluk lands in 1516–17). The discovery of the sword was held to be God's work, a manifestation of divine approval indicating that Sultan Mustafa would accomplish great deeds. Hereafter, vowed the Sultan, he would wear this sword on campaign as a talisman.*[108]

* Both the copper plate and the sword are displayed in the collection of Holy Relics housed in Topkapı Palace; I have been unable to ascertain whether the inscription referred to by Silahdar Fındıklılı Mehmed Agha is in Hebrew or Syriac, or whether a translation of it exists.

Despite the miraculous sword, the campaign of 1696 was inconclusive and unsatisfying. Sultan Mustafa intended to march his army towards Belgrade, but news that the Austrians were besieging Timişoara caused him to change his plans and head north over the Danube instead to relieve that fortress.[109] On campaign for the third time in 1697, Mustafa reached Belgrade from Edirne late in the summer, on 10 August, when serious differences of opinion arose as to what the season's aim should be. Opposing factions put forward their arguments: either consolidate their position in Transylvania, or move up the Danube to attack Habsburg-held Petrovaradin. Understandably, perhaps, the warden of the fortress of Timişoara strongly recommended the first option,[110] while the warden of the fortress of Belgrade, Amcazade Hüseyin Pasha, argued for Petrovaradin. Over the last years, in the naval war against the Holy League that paralleled the war on land, Amcazade Hüseyin had scored a number of notable successes against the Venetians in the Aegean;[111] now he argued persuasively against a campaign in Transylvania. The late summer rains, he asserted, would turn the marshy terrain to mud and make hauling the ordnance difficult, and several bridges would have to be built. He reminded the assembly of the disaster on the Rába in 1664, when his cousin Fazıl Ahmed Pasha had died in the confusion of trying to get his troops across the river.[112] Even if they were unable to take Petrovaradin they could leave it under siege; and unless Petrovaradin was wrested from the Habsburgs, it would be impossible for the Ottomans to make further conquests. His advice was ignored, and the army moved towards Transylvania.[113]

Elmas Mehmed Pasha opted to head for Timişoara. He was an unpopular man and greatly distrusted by Silahdar Fındıklılı Mehmed Agha, who in his account of Mustafa II's exploits accused him of deliberately misleading the Sultan over the previous two years by exaggerating the size of the army, claiming that it numbered 104,000 fighting men when in fact the number of effectives was closer to 50,000.[114] At first it seemed that Amcazade Hüseyin Pasha's views had been overcautious, for the Ottoman army succeeded in crossing three rivers without serious mishap, routing an Austrian force on the Tisza and taking the castle of Titel which they demolished for lack of troops to garrison it.[115] Sultan Mustafa then crossed the Tisza safely to the Timişoara bank – but part of the army under the command of the Grand Vezir was attacked from the rear before they could follow. Austrian troops under Prince Eugene of Savoy – often recognized as the greatest general ever to serve the Habsburgs – destroyed the bridge at Senta which the Grand Vezir's forces could have used; in a vicious battle, Elmas Mehmed and many of the most senior figures in the Ottoman military-administrative establishment were killed. Silahdar Fındıklılı Mehmed Agha,

who had crossed the river in the Sultan's party, chronicled his master's horror as he watched from the further bank, not yet aware of the scale of the disaster.[116]

When Sultan Mustafa ordered the men that remained to secure the bridge, they fled and hid in the reeds. Taking only what they could carry on horseback, the Sultan and those few with him, who included his mentor Sheikhulislam Feyzullah Efendi, set off for the safety of Timişoara: without pausing to rest along the way, they reached it two days later. The imperial tent had been left on the battlefield, but the sacred standard and the mantle of the Prophet were safe. Silahdar Fındıklılı Mehmed Agha mourned a chest full of his own possessions, lost in the mêlée.[117]

Thus the Ottomans paid the price for ignoring Amcazade Hüseyin Pasha's advice. Having remained behind to protect Belgrade from enemy attack, he was now appointed grand vezir in place of Elmas Mehmed Pasha. In a changed international context, the battle at Senta proved to be the catalyst for peace after fourteen years of war, the struggle between the Grand Alliance and France which had occupied Habsburg troops in the west having ended in 1697, leaving Austria free once again to deploy all its forces against the Ottomans. The peace negotiations which had waxed and waned fitfully since Zülfikar Efendi's arrival in Vienna in 1688 – where he had stayed for four years, some of that under arrest, before returning home – were finally brought to a conclusion as the members of the Holy League, well aware that the death of the sickly Charles II of Spain might at any moment plunge them again into conflict with France, strove to secure Austria's eastern frontier and free the Habsburg troops in case action against Louis XIV was to be renewed.

The complexities of the relationships between the European states themselves and between them and the Ottoman Empire at the end of the seventeenth century were reflected in the peace negotiations. Amcazade Hüseyin Pasha had not been inclined to peace when he became grand vezir following the rout at Senta, and well knew that military inactivity would be interpreted as a lack of resolve and thus weaken Ottoman bargaining power in the negotiations being mooted, so Sultan Mustafa ordered preparations for the campaign of 1698 to proceed as usual while he waited in Edirne. Amcazade Hüseyin, meanwhile, set out with the army for the frontier at Belgrade, and had reached Sofia when the Emperor's envoys arrived at Sofia with the written proofs of the peace proposals which the Ottomans had demanded. William III's English and Dutch envoys at the Sultan's court, Lord Paget and Jacobus Colyer, travelled to Belgrade ahead of the army with the Ottoman envoys, the chancellor Rami ('Archer') Mehmed

Efendi and the chief dragoman Alexander İskerletzade (Mavrocordato). Meanwhile hostilities continued: the Tatar army arrived from the northeast, successfully harassing Austrian positions and raiding into Poland.[118]

The mediating envoys and their entourages were waiting at Belgrade when the Grand Vezir arrived with the army. The very location for the peace talks was a matter for dispute: the Ottomans declared themselves unable to accept the Austrian invitation to meet on conquered Hungarian territory, while the Austrians refused to accept a meeting on Ottoman soil. A compromise was found in the village of Sremski Karlovci (Karlowitz), situated on the Danube between the two empires' respective forward positions of Petrovaradin and Belgrade – significantly, perhaps, it was much closer to Petrovaradin than to Belgrade. Dwellings and stables to house the delegations were hastily constructed, and the two Ottoman envoys, together with Paget and Colyer and an escort of 2,000 troops, arrived there on 20 October 1698. With winter approaching, meanwhile, the Grand Vezir led his army back towards Istanbul, leaving the negotiators to hammer out the peace.[119]

The Ottomans had not at first thought to make peace with all members of the Holy League, only with Austria, but at Paget's insistence agreed to do so.[120] The talks eventually involved nine principals – two Ottoman, two Austrian, one Polish, one Muscovite, one Venetian, one Dutch and one English – and their entourages. Every day for four months the delegations met in the richly-adorned Ottoman tent. The time-wasting tactics of the Muscovite and Venetian envoys in particular caused the Ottoman envoys much frustration, but even so small a matter as the physical appearance of the documents submitted by their erstwhile adversaries could breed disgust. The accreditation of Rami Mehmed Efendi as Ottoman representative in the peace talks took the form of a single large sheet of paper bearing the Sultan's cypher enhanced with gold, inside a silver envelope contained in a brocade purse wrapped in a heavy napkin, which was handed over to the Habsburg ambassador with great ceremony. The corresponding Austrian document was by contrast a few scrappy pieces of paper sealed with ordinary wax.[121]

The provisions of the Treaty of Karlowitz left the Ottomans deprived for ever of much of the European territory they had until recently called their own. The principle underlying the negotiations was uti possidetis, so that it was the exceptions to this principle requested by the various parties that remained to be agreed. The Ottomans concluded separate treaties with each of their adversaries. To Austria they conceded Hungary and Transylvania, with the exception of the Banat, a wedge of territory lying between the Tisza, Tamiš, Danube and Mureş rivers that included the

fortress of Timişoara, the defence of which had been such a heavy logistic burden.[122]

The Polish–Lithuanian Commonwealth's foremost aim in joining the Holy League had been to regain Podolia, the province lost to the Ottomans in 1672. A number of attempts to recapture the strong fortress of Kamenets made during the course of the war had been frustrated thanks in large measure to the support provided the Ottomans by the Tatar troops of the Crimean khans and their frequent raids across the land around the fortress and into the Commonwealth itself. In contrast to Austria and its great territorial gains at the expense of the Ottomans, the Polish–Lithuanian Commonwealth had made none and had, moreover, suffered greatly. By the terms of the treaty between the Ottomans and the Commonwealth the principle of uti possidetis was modified and Podolia was to be returned to the Commonwealth in exchange for an undertaking not to interfere in Moldavia.[123]

The Ottoman fleet had been stretched to the utmost against Venice during the years of the war. The fortress of Euboea on the island of the same name had withstood a Venetian siege in 1688,[124] and although in 1691 the Venetian captain-general Domenico Mocenigo had expressed the opinion that defence of the Peloponnese – where, he said, the Ottoman navy was unlikely to appear in the foreseeable future – was a more realistic aim than attempting to regain Crete and the Aegean islands,[125] Chania on Crete was besieged by an allied fleet in 1692 when the garrison on the island of Gramvousa (which had remained Venetian after 1669) surrendered to the Ottomans. Reinforcements were sent from the Cretan mainland and the siege was raised.[126] The Venetians had considered an attack on Chios in 1691 and the island was briefly in their hands in the winter of 1694–5, until it was won back by a fleet under the command of Amcazade Hüseyin Pasha.[127] Bozcaada and Lesbos were subjected to unsuccessful Venetian attacks in 1697 and 1698 respectively,[128] and along the Ottoman–Venetian frontier in Dalmatia forts were besieged and changed hands regularly during these years. Austrian troops pressing hard from the north and north-west on occasion forced Ottoman Bosnia to defend itself on two fronts. By the Treaty of Karlowitz the Venetians were confirmed in their possession of the Peloponnese and their Dalmatian strongholds.[129]

Muscovy's late accession to the Holy League in 1686 had signalled a change in its generally non-belligerent policy towards the Ottoman Empire. In the same year it had resolved by treaty with the Polish-Lithuanian Commonwealth the problems which had been setting them against one another, in particular confirming Muscovy's 1667 suzerainty over Left Bank Ukraine – and Kyiv, which had initially been conceded by the Commonwealth for only

two years. One of the undertakings Muscovy had given in return in this so-called Treaty of Eternal Peace was to wage war on the Crimea,[130] whose Tatar population was an unpredictable menace for both parties. Muscovy's overriding aims were to put an end to their raids for ever, and establish indisputable control in Right Bank Ukraine: in 1687, Muscovy provoked a war with the Tatars with an inflammatory demand for the cession of the Crimean peninsula, the resettlement of the Tatar population in Anatolia, and a payment of two million gold pieces. The ensuing military expedition, under the command of Prince Vasily Golitsyn, was followed by another in 1689: both foundered ignominiously in the logistical problems of unfamiliar terrain as the Tatars burned the steppe, denying supplies to the Muscovite troops.[131]

Peter the Great had become co-tsar in 1682, at the age of ten, sharing the throne with his feeble-minded elder half-brother Ivan. In 1689 the regency of his half-sister Sophia was overthrown, as a consequence in part of the failure of her favourite, Golitsyn, in the Crimea. In 1695 Peter led a two-month siege of the Ottoman fort of Azov at the mouth of the river Don; it failed, but in 1696 he returned, having spent the intervening winter months hiring foreign engineers and other experts and building a fleet to prevent the Ottoman Black Sea fleet from relieving Azov.[132] This time he succeeded. Tsar Peter entered the Karlowitz negotiations unwillingly, feeling more than capable of continuing to fight; but from a position of strength derived from their prior agreement with Austria the Ottomans were able at least to some extent to dictate terms. A two-year truce was agreed at Karlowitz with a lasting peace to be negotiated at a later date.[133] By 1700 Peter's focus had switched from the south of his domains to the north; in order to pursue the 'Great Northern War' against Sweden[134] he now sought peace with the Ottomans and a treaty was duly agreed.[135] Signed between equals, it overturned the diplomatic hierarchy whereby the Ottoman sultan had viewed the Tsar of Muscovy as his subordinate, and signified that Muscovy was now a major power, one Ottoman diplomacy could ill afford to ignore. For the first time, a Muscovite ambassador resided permanently in Istanbul.

The Ottoman Empire of 1699 was a very different place from that of 1683. If a treaty-dictated loss of territory was the most visible sign of change, the manner of its happening heralded a new era in Ottoman diplomacy. In the accords agreed at Karlowitz all parties declared their respect for the concept of territorial integrity: the Ottoman–Habsburg treaty was to last for 25 years, those with the Commonwealth and with Venice indefinitely, and that agreed with Muscovy in 1700 for 30 years.[136] This indicated rather

more than a mere lull in a notionally permanent state of war with a non-Muslim power, and this intention to adhere to the emerging tenets of international law was an incongruous undertaking for a state for which the ideal of continuous warfare was one of its ideological foundations. Guided by the principle that 'peace was the continuation of war by other means',[137] Ottoman negotiators sought to justify their concessions as being within the ambit of 'holy war', on the grounds that in view of the overwhelming coalition ranged against it, it was beneficial for the state to seek peace at this juncture. The provisions of the treaties were to be carried out according to a strict timetable: the garrison troops at Kamenets, for instance, were notified by sultanic edict that they should evacuate the castle by May 1699 – some four months only after agreement was reached at Karlowitz; by late summer they had been reassigned elsewhere.[138]

The physical demarcation of borders between the Ottomans and their neighbours had a long history. A Polish member of a border-marking party describes how his Ottoman colleagues went about their business in 1680, during the minor border changes made as a result of the treaty of 1676 between the Ottoman Empire and the Commonwealth:

> When it came to raising a mound, the Turks, using spades attached to their saddles, in the twinkling of an eye raised a mound of turf after digging around a big oak trunk [that was] in the middle. Then, after finishing the job their superiors climbed on top of it and ululated like dogs with their faces turned up, praising God that they had conquered so much with the sword.

The Ottomans, said the Polish official, set a wooden pile in the shape of a turbaned head atop each mound while the Poles used a cross.[139]

The Habsburg general and polymath Count Luigi Marsigli, a native of Bologna, who had spent a decade mapping the Balkans, advised the Habsburg delegation to the Karlowitz conference and was appointed by Emperor Leopold to head the boundary commission. Thanks to Marsigli's obsession and skill as a cartographer and geographer, the border demarcations after Karlowitz incorporated topographical features in addition to man-made mounds, to a greater extent than had hitherto been the case.[140] From the Ottoman side, the report of the governor of the northern Black Sea province of Özi, the Ottoman official responsible for fixing the border with the Commonwealth after 1699, gives an insight into how the system worked:

> Then we set out for the place where the river Jahorlyk [a tributary of the Dniester] rises, and mounds were raised on two sides opposite each other in fitting and suitable places; while raising the boundary marker ... we reached the source of the said river; then, two great mounds facing each other were again raised by the two sides; then, following the main valley of the Jahorlyk,

boundary mounds were raised by the two sides in fitting and suitable places in the manner described; near the place called 'Pitchfork' where the afore-mentioned Jahorlyk ends there is a bifurcation on the right side of the valley . . . Then, after following the said valley for an hour we crossed the 'Nomad track' at the source of the river Kujal'nyk [where] a large [hill called] 'Lamb Hill' is situated; as there is no hill similar to this one in this neighbourhood, it has been reckoned as a boundary marker.[141]

As the new borders were established, groups of peasants affected by them were resettled further behind the Ottoman frontier, to avoid any risk of harassment from the other side and, it was hoped, to counter the depop-ulation that had blighted whole areas during the war years. The Karlowitz treaty imposed a curb on the sort of raiding that had persisted as a way of life for many groups since the early days of the Ottoman Empire. In the northern steppe borderlands of the empire the Tatars, in particular, had long furnished a large part of their livelihood by prolonged forays into the Commonwealth and Muscovy. Earlier truces between the Polish-Lithuanian Commonwealth and the Ottoman Empire had called in vain for each state to restrain the raiding activity of its client Cossacks and Tatars; Ottoman determination to adhere to the letter of the accords in 1699 imposed a more final constraint, and central government directives that the Tatars desist from raiding activity provoked open revolt in Crimea. The khan of the time renounced his status as an Ottoman vassal and, in the usual response to such insubordination, a more compliant khan was installed. Tatar methods of warfare had hitherto been viewed as an asset available to support Ottoman military aspirations; in the new post-Karlowitz world they were seen as a liability.[142]

The negotiations at Karlowitz cast a long shadow in the matter of the Christian Holy Sites in Jerusalem and elsewhere: from the vantage point of the nineteenth century, a time when the status of non-Muslims in the Ottoman Empire had become an issue in great power politics and one of the principal constituents of 'the Eastern Question', it was possible to iden-tify them as a pretext for the intervention of the Christian powers in the internal politics of the empire. With the place of non-Muslims in the state a matter of legal regulation, the Ottoman attitude towards the Christian Holy Sites in Jerusalem and elsewhere had long been pragmatic; their seizure was justified by casuistry and, where it was plausible, on the grounds that they had formerly been Muslim sites. Two, however, remained inviolate – the Church of the Holy Sepulchre in Jerusalem, and the Church of the Holy Nativity in Bethlehem. These were of such particular significance for the Christian world that the Ottomans were careful not to interfere with them.[143]

The contest for jurisdiction over these two sites had therefore never lain between the Ottoman authorities and their Christian subjects, but between Latin Christians – specifically the Franciscan Order – and Orthodox Christians. The Franciscans were traditionally the guardians of most of the shrines attached to both the Church of the Holy Sepulchre and the Church of the Nativity, but once Ottoman conquest had reunited the four patriarchates of the ancient Byzantine Church – Constantinople, Antioch, Jerusalem and Alexandria – under one ruler, the Orthodox Church had sought to revive its rights over the Holy Sites. They won some support from Sultan Murad IV in 1637 and were awarded the most important by Mehmed IV in 1675, but following the debacle of the 1683 siege of Vienna, the Ottoman authorities established a commission to enquire into the guardianship of the Holy Sites in a bid to win French support against the Holy League. Although no change was made at the time, in 1690 Fazıl Mustafa Pasha, hoping to secure French backing as he prepared to retake Belgrade from the Austrians, restored the Franciscan pre-eminence. By intervening at this time at the behest of a foreign power to bestow guardianship on one group rather than another, the Ottomans unwittingly established a principle of admitting outside interference in what had hitherto been a domestic matter, opening the door for claims on behalf of their coreligionists by other European powers.[144]

The Ottoman negotiators at Karlowitz were however able to refuse the Muscovite envoy's demand for the restoration of the Orthodox Church to the pre-eminence it had enjoyed in the Holy Sites between 1675 and 1690. To have conceded would have been even more dangerous, as a recent study makes plain:

> . . . whereas the Catholic powers intervened . . . on behalf of their own subjects [resident in the Ottoman Empire], the Russian opposition to the Catholic church and support for the Greek Orthodox interest in these sanctuaries concerned a . . . church, the vast majority of whose adherents were still Ottoman subjects.[145]

Once internal revolt was suppressed, the appointment of Köprülü Mehmed Pasha to the grand vezirate in 1656 brought stability abroad and at home. During the six years that he was in office he took over the reins of power, and in matters of state Sultan Mehmed IV and his mother were content to defer to him. This pattern continued during his son Fazıl Ahmed Pasha's tenure between 1661 and 1676, when ministers were united in their goals and remained in office for many years. Although he held office for less than two years, Fazıl Mustafa Pasha made significant fiscal and other changes with the aim of winning the war for the Ottomans, but too many of the

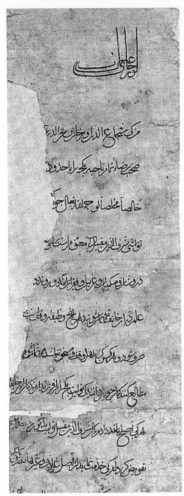

Above: The beheading of the companions of Johann Schiltberger, captured by the Ottomans on the crusade that culminated in the battle of Nicopolis (Nikopol) in 1396. Schiltberger was spared on account of his youth

Above: First third of an endowment charter for a dervish lodge established by Sultan Orhan. The *tuğra*, or 'imperial signature', at the top reads 'Orhan, son of Osman'. Dated 1324 and written in Persian, this is the earliest surviving Ottoman document

Right: An Ottoman official and his assistant register Balkan Christian boys selected for the youth-levy. The official takes a tax to cover the price of the boys' new red clothes and the cost of transport from their home, while the assistant records their village, district and province, parentage, date of birth and physical appearance. Miniature, mid-sixteenth-century

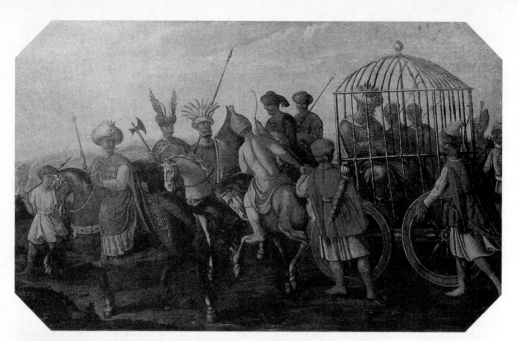

Above: Bayezid I held in a cage following his capture by Tamerlane at the battle of Ankara, 1402. Panel from a cycle of ceiling paintings at Schloss Eggenberg, Graz (once close to the Ottoman-Habsburg border), 1670

Left: Equestrian statue of Emperor Justinian that stood outside Hagia Sophia in Byzantine times. The nine-metre-high statue was set atop a thirty-metre column until pulled down by Mehmed II soon after his conquest of Constantinople. Drawing by Cyriacus of Ancona and Giovanni Dario, 1430s

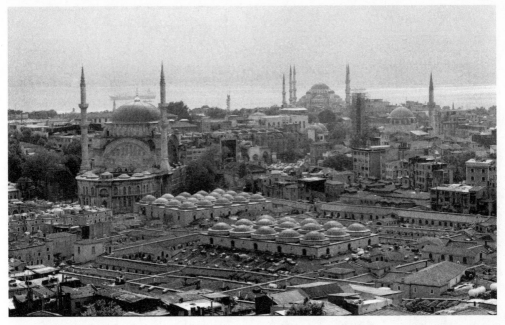

View over the Covered Bazaar taken from the Beyazit fire tower; the inner core of the bazaar was built by Mehmed II in the early 1460s. On the left is the mid-eighteenth-century Nuruosmaniye mosque, and in the distance the Sultanahmet mosque

The Tiled pavilion in the outer gardens of Topkapı Palace, completed in 1472–3. The pavilion was built in the Timurid style by craftsmen brought to Istanbul following Mehmed II's defeat of the Karamanid dynasty

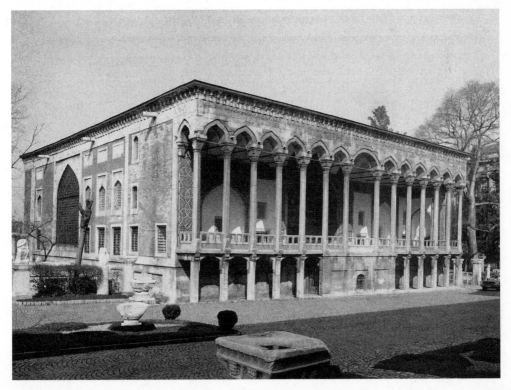

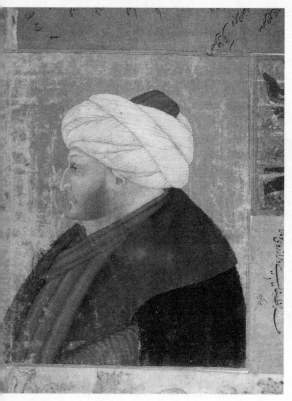

Portrait of Mehmed II, dated 1481; it is closely related to a medal of the Sultan by the Venetian artist Constanza da Ferrara

The Grand Master of the Knights Hospitallers receives Cem Sultan on his arrival on Rhodes, 29 July 1482

The Castle of Bourganeuf where Cem Sultan was held in 1484 and 1486–8; the letter B indicates the tower where he was imprisoned. The appearance of the castle is little different today from how it looked in this mid-eighteenth-century drawing

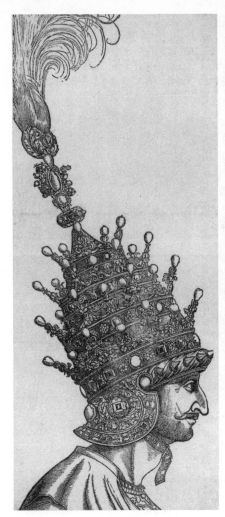

Above: Süleyman I wearing the helmet-crown commissioned for him by Grand Vezir İbrahim Pasha. Venetian woodcut, *c.*1532

Above right: The coffin of Grand Vezir İbrahim Pasha (who was executed in 1536) being carried out of Topkapı Palace to be borne away in a waiting caique. Miniature, 1587–8

Right: The sacred shrine at Mecca. Miniature illustrating an early sixteenth-century Persian verse text describing the stations of the pilgrimage and other holy places. The text was illustrated for the first time in this copy made for Süleyman I, *c.*1540

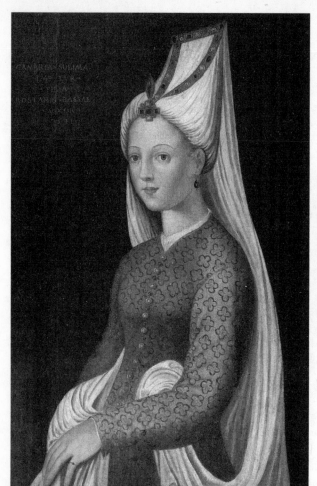

Left: Mihrimah Sultan, daughter of Süleyman I and Hürrem Sultan, and wife of Rüstem Pasha. An inscription in the top left-hand corner dates the portrait to 1541

Above: Underglaze-painted İznik tile from a decorative panel. Dating from *c.*1570–80, the tile's colour scheme is blue, black, turquoise-green and red

Detail from a miniature showing three Kızılbaş being presented with caftans on giving up the red bonnets symbolizing their 'heretical' status. The miniature, painted *c.*1583, comes from a manuscript recounting the festivities held in the Hippodrome in 1582 to celebrate the circumcision of the future Mehmed III

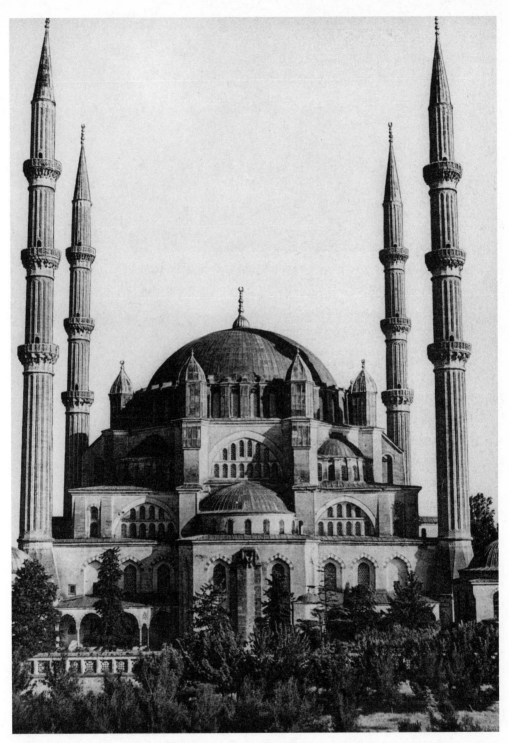

The Selimiye, the mosque of Selim II in Edirne. Built by Sinan in the late 1560s, this is
considered the architect's greatest work. The photograph is by Istanbul photographers Pascal
Sébah and Policarpe Joaillier whose studio operated between 1888 and 1908

A couple apprehended by janissaries as their wine cools in a stream. Miniature, early 1600s

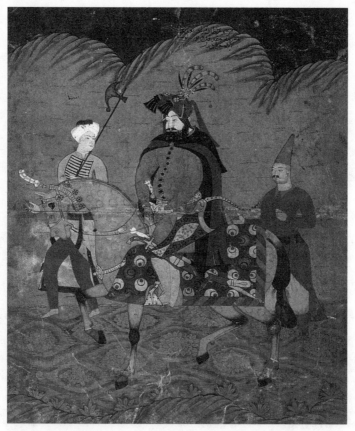

Murad IV setting out on the Baghdad campaign of 1638. The Sultan is dressed as an Arab warrior, in a gesture of homage to the Prophet Muhammad's cavalry. Miniature, mid-seventeenth-century

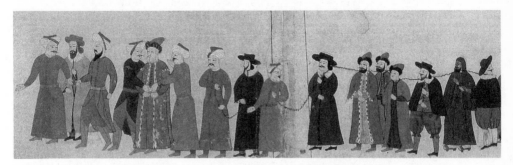

The Venetian bailo in Istanbul, Giovanni Soranzo, and his delegation, are led away in chains to imprisonment following Venice's refusal to cede Crete. This happened in 1649, four years after the start of the Ottoman-Venetian war for the island. Miniature, mid-seventeenth-century

The New mosque built by Turhan Sultan in the port district of Istanbul in the mid-1660s. The domed structure on the right of the mosque is the Egyptian (Spice) market

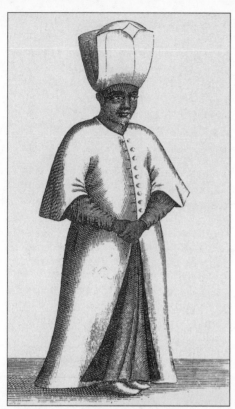

Left: The Chief Black Eunuch. This drawing was commissioned by Sir Paul Rycaut, English consul at İzmir, to illustrate his *The Present State of the Ottoman Empire*, first published in 1666

Below: The strangulation of Grand Vezir Merzifonlu Kara Mustafa Pasha following the Ottoman rout at Vienna in 1683. The legend (omitted here) describes the scene: Kara Mustafa reads the Sultan's order as an agha waits to execute him; another agha positions the small square for the Grand Vezir to pray; a crimson velvet bag lies ready to receive his head

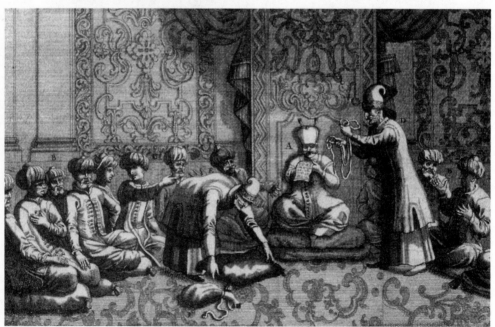

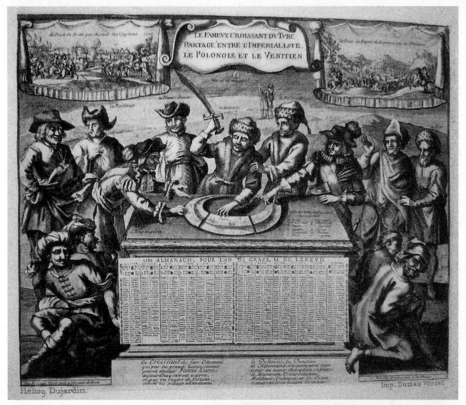

Above: 'Le fameux croissant du Turc partage entre l'Imperialiste, le Polonois et le Venitien'. The powers ranged against the Ottomans at the start of the 1683–99 war dream of dividing the empire. Battle scenes in the top left and right corners depict the fall of Buda to the Habsburgs, and of Napoli de Romania (Nafplio) to the Venetians, both in 1686. An accompanying note indicates that this scene was drawn in 1686 or 1687

Right: Three sons of Ahmed III being escorted to their circumcision feast in 1720. The Chief Black Eunuch Beşir Agha leads the way as they cross the third court of Topkapı Palace, past the Hall of Petitions and Ahmed III's library. Miniature, *c.*1721

Left: Tulip varieties 'That increases the Pleasure of Ahmed Efendi's Banquet' and 'Source of Joy'. From an album of fifty tulip paintings prepared at court around 1725

Below left: Detail of the monumental fountain built by Ahmed III outside Topkapı Palace, 1728–9. The photograph was taken around 1880 by the Swedish photographer Guillaume Berggren

Below: Patrona Halil and fellow rebels painted by Jean-Baptiste Vanmour (*d.* 1737), an artist of Flemish extraction who was a long-time resident of Istanbul. In the background is the gate of the first court of Topkapı Palace

Opposite page, top: Detail from a scroll illustrating the route of the water supply from outside the city to Topkapı Palace (shown here). Buildings fed by branches off the main supply are indicated by name. The 1098 cm-long scroll records repairs and upgrading of the water system. Miniature dated 1748

An Ottoman and a Russian official discuss the Dardanelles. This scene was engraved in Germany at the time of the Ottoman-Russian wars of the second half of the eighteenth century, when control of the Straits was a burning issue. The legend (omitted here) reads:

The Dardanelles, or the Fortresses that are the keys to Constantinople
The Turk: There, insolent Russian, are the insurmountable locks by which the Turk holds the passage to the Divan [imperial council, i.e. Istanbul]. You see, from a distance four volcanoes [i.e. fortresses]. Be fearful of them, lest their gullets spew death on your miserable fleet.
The Russian: Haughty Turk! If one day my sails shall carry me within reach of those walls you call insurmountable, then will it be my fate that neither the mighty position of those fortresses nor your oriental threats shall suffice to keep us from punishing you for your ambition and cruelty

Above left: Mehmed Ali Pasha of Egypt. Frontispiece to an album of lithographs from sketches made in the early 1840s by Sir David Wilkie during his visit to the Ottoman Empire

Above right: Sultan Abdülmecid in uniform at the time of the Crimean War. He wears the decoration known as 'The Blazing Decoration of our Lord, His Imperial Majesty'

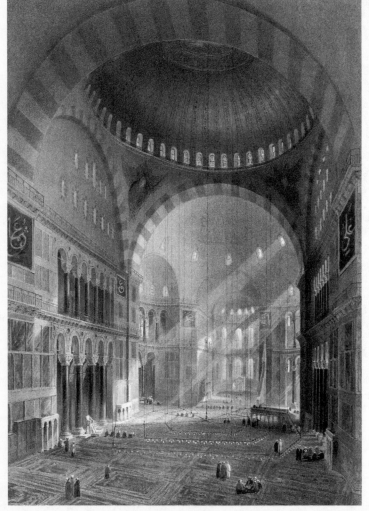

Left: Interior view of Ayasofya, restored by the Swiss architects the Fossati brothers on the orders of Sultan Abdülmecid in 1847–9. The restoration was recorded in an album of lithographs based on Fossati drawings

Right: Reverse of a medal issued by Sultan Abdülaziz. Commissioned in 1866, it was presented to people working to ease the plight of cholera victims. One of the trees being sheltered by the oak is a palm, intended to signify the Arab provinces of the empire. The legend reads: 'The lineage of Osman, the highest of trees'

Below: Ottoman military cadets, *c.*1900. The photograph is by the Armenian Ottoman Abdullah Frères, court photographers to Sultans Abdülaziz and Abdülhamid II

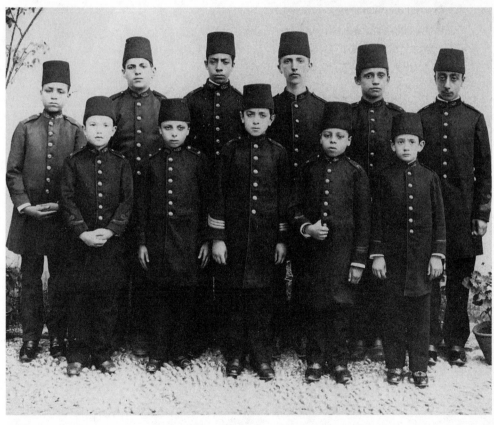

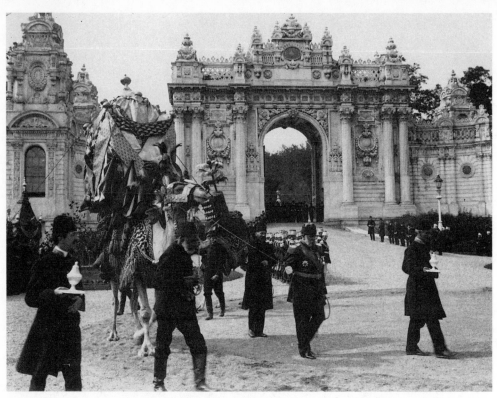

The palanquin symbolizing the Sultan's presence and bearing his gifts emerges from Dolmabahçe Palace during the festivities accompanying the departure of the annual pilgrimage to Mecca. The gifts were formerly sent overland by camel caravan, from around 1870 by steamship, and after 1890 by train. The ceremony was performed for the last time in 1919 following an interval during the First World War. The photograph may be by Sébah and Joaillier

Kaiser Wilhelm II being rowed on the Bosporus in autumn 1917, when he visited Istanbul and the battlefields of the Dardanelles. The Kaiser is seated on the port side, next to a naval officer who may be Admiral von Rebeur-Paschwitz, successor to Admiral Suchon as commander of the Ottoman fleet

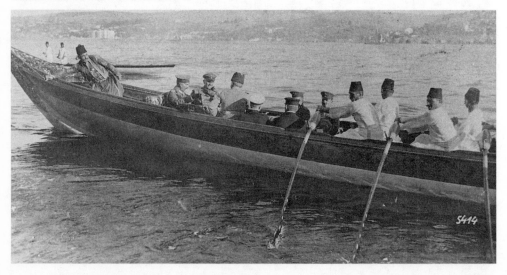

other grand vezirs who held office after Merzifonlu Kara Mustafa Pasha's Vienna fiasco of 1683 were not military men at all, while even those who were capable of conducting a campaign found themselves unable to cope with the serious disciplinary problems endemic in the empire's fighting forces.

Ottoman resources were stretched to the limit between 1683 and 1699 as the army tried to defend frontiers far-distant from Edirne and Istanbul. The struggle to finance and man the war effort overrode all other considerations during the final years of the seventeenth century, and thus masked the profound changes that had been taking place since mid-century. After the dominance of Köprülü Mehmed Pasha and his sons, and particularly after the deposition of Mehmed IV in 1687, sultans engaged themselves more closely in the day-to-day running of the empire and enjoyed at least the illusion of ruling as well as reigning, supporting the complex bureaucratic reforms undertaken during the war years. These, although initiated in response to pressing needs, in the long term often had a significant effect on the apportionment of rights and responsibilities in Ottoman society. Effective military leadership may have been lacking during much of the war, but high-ranking bureaucrats demonstrated a considerable will to find workable solutions to the financial problems besetting the state.

One change which set the pattern for the future was the ending by the final years of the century, of the traditional exemption from taxation of charitable endowments.[146] The 'war contributions tax' which had been introduced in 1686 was levied throughout the war, after which it lapsed – until the next one. A controversial tax that was initially intended to be a 'one-off' demand for loans from those with accumulated wealth was soon levied on the foundations of the Sultan and leading statesmen in particular, and began with time and the chronic insolvency of the treasury to take on the character of a wealth tax from which even the highest in the land were not exempt.[147] The rich and powerful had always made contributions to the common good – whether loans by vezirs to meet temporary shortfalls in military salaries,[148] or Turhan Sultan's underwriting of the costs of fortifying the Dardanelles during the Cretan War – and as the century progressed private wealth was increasingly appropriated for public ends. Individuals would henceforth be asked more regularly for substantial contributions to the public purse: particularly common during the latter years of the 1683–99 war was the confiscation for the treasury of the estates of disgraced statesmen, and this trend would continue.[149] Another form of taxation for war was the obligation to raise troops, and in 1696, for instance, three Ottoman statesmen, including the eldest son of Fazıl Mustafa Pasha, Köprülüzade Numan Bey, were each required to provide five hundred infantry at their own expense.[150]

The reform which over time proved to have the greatest effect on Ottoman society, by expanding the number of the super-rich, was the introduction of life-term tax-farming – the long-term transfer into private hands of this particular source of state income. Previously entitlements to farm taxes had been resubmitted for auction every three years, thus in theory allowing different individuals and groups a turn and thereby ensuring that none became too wealthy and influential. Life-term tax-farming was introduced by a decree of 10 January 1695; the government had become dissatisfied with the prevailing system, recognizing that tax-farmers tended to take the short-term view, making no investment in their 'resource', with the result that peasants had to borrow to pay for seed and other necessities and became so indebted to moneylenders that they could no longer work the fields from whose produce the treasury derived taxes. Moreover, the exorbitant demands of tax-farmers sometimes caused villagers to flee, further exacerbating the all-too-familiar problem of abandoned, depopulated lands.[151]

The successful bidder for a life-term tax-farm enjoyed greater security than the previous system had offered. The capital sum he paid the treasury at auction to acquire his asset was equivalent to between two and eight times its anticipated annual net profit, and the treasury thus benefited each time a life-term tax-farm was auctioned – in effect, a form of internal borrowing by the state from those who had wealth to invest which was a great help in meeting the critical shortfall of state income during the war.[152] It took time for the system to become firmly established, however, and its effects only gradually became apparent. Life-term tax-farming was first applied in some provinces of south-east Anatolia and the Arab provinces[153] before being extended elsewhere, and the choice of these predominantly Muslim provinces for its introduction served to spread the burden of taxation more equitably through the empire; the reformed poll-tax, for example, another of the state's main sources of income, fell mainly on the Christian population – which was the majority in the Balkans – and west and central Anatolia.[154]

The desperate years of war showed that neither the loyalty to the dynasty of the ruling class nor the loyalty of the notables of outlying provinces to the central state could be taken for granted. The new tax-farming system introduced in these years altered the basis of access to the bounty of the state; anyone powerful enough to challenge the Ottoman dynasty for power could now be neutralized, at least for a while, by offering them the possibility of inclusion in the ruling establishment as state patrimony was dispersed ever wider.

Although the Köprülü were among the most prominent beneficiaries of

the new tax arrangements, even before the introduction of life-term tax-farming they had accumulated enough wealth to establish generous charitable endowments which brought them a prestige to match that of the Ottoman dynasty. Between the reign of Ahmed I and the mid-eighteenth century the Ottoman house withdrew from its earlier prominence as a patron of impressive mosque complexes proclaiming its might, and only three or four large mosques were built by its members. The beneficence of the Köprülü was more apparent, and Istanbul no longer the preferred location. In 1658–9, for instance, Köprülü Mehmed Pasha raised a fortress at the mouth of the gulf protecting the Aegean city of İzmir, to safeguard the port from Venetian attack during the ongoing Cretan war; İzmir had developed from a village in the sixteenth century into a cosmopolitan commercial centre for the export of the agricultural products of the west Anatolian interior to Europe, and with this castle the authorities could more effectively monitor the trading vessels from which customs dues were collected. Fazıl Ahmed Pasha was interested in stimulating commerce as well as collecting taxes, both in the new provinces he conquered for the empire and closer to home: during the 1670s he sponsored the building of the infrastructure needed to turn İzmir into a booming entrepôt – a market, a caravansaray, public baths and a vast customs house; he also built an aqueduct to bring water to the city and paved its main thoroughfares.[155]

Beyond the requirement that charitable endowments should be directed to pious ends, the stipulations concerning their management were often loose and left much to the discretion of those responsible for running them. Moreover, the requirement that the property or money endowed be alienated was only observed in the breach, and over the years cash 'leaked' from foundations back into the hands of grandee households such as the Köprülü, enabling them to protect their great wealth from confiscation, and to pass it on to their heirs.[156] One measure of their power was the fact that during 38 out of the 47 years following Köprülü Mehmed Pasha's appointment to the office in 1656 the grand vezirate was held by members of his or his relatives' households.[157] The subject awaits further research, but there is evidence that in the late seventeenth century households less prominent than the Köprülü also endowed charitable foundations both in Istanbul and across the empire for the purpose of perpetuating their control of financial assets – since such foundations were supposedly exempt from tax.[158] The growing trend for sons to inherit their fathers' appointments in the central administration and as provincial governors enabled minor households, having attained the first rung on the ladder of power, to consolidate their position and rise in prominence.[159]

The picture of Köprülü Mehmed Pasha handed down to posterity has

been strongly influenced by the chronicle of Mustafa Naima, whose partisanship is beguiling. However, it must be remembered that Naima's patron was another Köprülü, Amcazade Hüseyin Pasha, who appointed him to the post of official historian when he became grand vezir in 1697, and that his History was commissioned some forty years after Köprülü Mehmed came to power. Naima represents Köprülü Mehmed's acceptance of the grand vezirate as a 'contract' between Sultan and Grand Vezir whereby Köprülü Mehmed dictated various conditions to the eight-year-old Mehmed IV when he accepted the post. First of all, he wanted absolute authority in matters of state, even over the will of the Sultan; second, he would decide all state appointments; third, his decisions were not to be limited in scope by the opinions of other statesmen; and fourth, any who tried to undermine him were to be ignored.[160] This picture of the circumstances of Köprülü Mehmed's appointment to the grand vezirate – embellished with details not found in any of the contemporary accounts on which it is supposedly based – is considered an invention by modern historians who see it as approximating the situation prevailing when Naima was writing, at the turn of the seventeenth to eighteenth century, and the interests of his patron after decades of Köprülü dominance. Monarchy had become institutionalized and depersonalized and the Ottoman dynasty per se was of little real importance by then,[161] the sultan scarcely more than a symbolic node, a primus inter pares at the heart of the system of power and wealth that began to develop over the next century. Having survived the war of 1683–99 and the subsequent loss of territory enshrined in the Karlowitz treaty, the empire recovered, albeit painfully, as it adapted to meet new circumstances.

I I

The perils of insouciance

A LTHOUGH ANOTHER KÖPRÜLÜ briefly held the office of grand vezir in 1710, the heyday of this household ended soon after the conclusion of the Karlowitz treaty. Ill health forced Amcazade Hüseyin Pasha to resign in 1702 after five years,[1] and thereafter senior members of the household more usually held office in provincial than in central government. Amcazade Hüseyin met his nemesis in Sheikhulislam Feyzullah Efendi, former pupil and son-in-law of Vani Mehmed Efendi who had owed his own career to the patronage of Feyzullah's father, the highest-ranking cleric in Erzurum.[2] Feyzullah Efendi had been Sultan Mustafa's tutor and mentor since childhood, and had first come to prominence during the military rebellion of 1687–8 when he was briefly sheikhulislam following the accession of Sultan Süleyman II; shortly after Mustafa's accession he was again elevated to head the religious hierarchy. If the manner of his appointment was unusual, the power and patronage he exercised were unprecedented, and total: his eldest son held the office of Registrar of the Descendants of the Prophet, his second son was chief justice of Anatolia, his third son had formerly been a judge in Bursa, his fourth son was tutor to one of the royal princes, and his brother-in-law was chief justice of Rumeli.[3] Government ministers such as Amcazade Hüseyin came to play a much reduced role in running the state. Marriage alliances between the Ottoman dynasty and the households of the Köprülü and Feyzullah Efendi did not serve to contain the tensions. In the autobiography he wrote describing the fates and fortunes of his family until the year 1702 Feyzullah Efendi stated that he was the Sultan's most intimate confidant and that his advice was sought in all matters,[4] but he was to enjoy his monopoly of influence for only a short time longer: his flagrant refusal to acknowledge any limits to his power or self-aggrandisement eventually brought suppressed discontents into the open, and in 1703 he was murdered in a violent uprising which also forced Mustafa's deposition.

Edirne had been the favourite seat of the Ottoman court since the reign of Sultan Mustafa's father Mehmed IV; the uprising which occurred in

1703 is referred to as the 'Edirne Incident', and may be ascribed to the frustrations which had been building up in Ottoman society during the years of warfare which had so recently ended. It was twenty years since Merzifonlu Kara Mustafa Pasha's defeat at the siege of Vienna, and although the Ottomans had enjoyed some military successes even in the latter stages of the war, in his willingness to accede to the terms of the Treaty of Karlowitz Mustafa II was seen by many as compromising Muslim honour. The implications of the treaty became evident only gradually, since the demarcation of the new, shrunken borders of the empire in Europe was a lengthy process still under way in 1703, but it had come to exemplify Mustafa's military failure.

On Tuesday 17 July the mutiny in Istanbul of troops ordered to a distant Ottoman vassal state in western Georgia to put down a rebellion soon attracted wide support.[5] A high-ranking cleric handed down the extraordinary juridical opinion that the Friday prayer should not be performed, an act of defiance signifying that the Sultan had lost the allegiance of members of the clerical establishment as well as of the military.[6] New leaders emerged to replace those compromised by their association with Mustafa II and Feyzullah Efendi, and a brother-in-law of Amcazade Hüseyin Pasha was put in place to head a caretaker government set up in Istanbul in opposition to that in Edirne.[7] When the rebel demand that Feyzullah Efendi be handed over, and that the Sultan and his court return permanently to the capital, was reported to Mustafa in Edirne he had the delegation bearing the petition arrested and, having sent Feyzullah Efendi and his family to a secure location outside the city, he made preparations to confront the rebels.[8] The grand vezir at the time was Rami Mehmed Pasha, one of the two Ottoman negotiators at Karlowitz. He had been a protégé of Feyzullah Efendi but their relationship had soured, and he was seen by the rebels as a moderate.[9]

Events took on an almost revolutionary cast with the establishment of the alternative government in Istanbul – but this was revolution in the Ottoman style, of which the typical ingredients were deposition followed by the succession of another member of the dynasty, rather than a full-blown overthrow of the prevailing system of government. Memories of the bloody uprisings of recent times – such as the months during the winter of 1687–8 when mutinous troops brought chaos to Istanbul – must have inclined the rebels to a degree of caution, an attitude exemplified in the need they felt for clerical sanction at each stage of the insurrection. Further delegations to Edirne from Istanbul met with no response, causing the rebels to suspect that the Sultan was preparing for a showdown. The rebel forces were greatly superior to those the Sultan was able to muster, and on 19

August, in a battle near Havsa, half-way between Edirne and Istanbul, his troops deserted and he fled back to Edirne. It was plain that he retained the loyalty of none.[10] On 24 August Mustafa II's brother Ahmed became sultan in his place, and Sultan Mustafa lived out his life – six months remained to him – in the Boxwood apartments of Topkapı Palace[11] where he had been incarcerated when his father Mehmed IV was deposed. Mustafa's memorialist Silahdar Fındıklılı Mehmed Agha held the Sultan's senior officials to be guilty of treason, accusing them of having come to an understanding with the putative vezirs of the government-in-waiting and then disappearing from view, deserting the deposed sultan when he needed them most.[12]

Anarchy ensued as the rebels turned their attention from the certainties of their cause to focus on the future. The transfer of power from Mustafa's supporters to Ahmed III's was bedevilled, even after Ahmed's enthronement, by the problem of whose authority was to be accepted as legitimate while government and court officials fled Edirne for the countryside. Silahdar Fındıklılı Mehmed Agha reported that Feyzullah Efendi and his family travelled from Edirne to Varna on the Black Sea coast, and that while they were looking for a boat to take them to Trabzon en route to Feyzullah Efendi's home town of Erzurum, he was captured by agents sent by the rebels, and imprisoned in the castle of Varna. Feyzullah Efendi was able to get a message secretly to Rami Mehmed Efendi who convinced the new sultan that the former sheikhulislam be exiled to Euboea. He set out but before he had gone very far there was a moment of danger, as rebels bearing a contrary order of the deposed Sultan Mustafa tried to seize him; Sultan Ahmed's order was upheld by the local authorities, however, and Feyzullah Efendi and his party made for Edirne. A day's journey outside the city, as they were spending the night in a caravansaray, officials charged with recording Feyzullah Efendi's estate arrived – under the direction of Defterdar Sarı Mehmed Pasha, chronicler of the 1683–99 war, now serving the first of his seven stints as chief treasurer of the empire, a position he was shortly to lose in the turmoil of these months.[13] The implication was clear. Cursing him with the accusation that he was a Kızılbaş – a heretic – the officials began their work. Feyzullah Efendi, his sons and those with them were stripped to their underwear, and put in simple ox-carts under the watchful eye of a posse of janissaries who heaped curses on them all the way to Edirne where they were thrown in gaol. For three days and nights they were tortured, but neither he nor his sons would reveal where their wealth was secreted; the Sultan was informed of the situation after still more agonizing torture failed to bring results, and a juridical opinion was handed down for the execution of the former sheikhulislam. Feyzullah Efendi was

brought from his cell, put on a draught horse and, reproached by a mob consisting of men of religion, janissaries, rebels and the riffraff of the city, was forced to ride to the flea market where he was beheaded. The feet of his corpse were bound to his severed head, and some three hundred non-Muslims, including priests – who had been assembled only by force – walked through the city dragging Feyzullah Efendi's dismembered body behind them. After an hour and a half the corpse was thrown into the Tunca river that runs through the city: Feyzullah Efendi's head was stuck on a stick and paraded around the janissary barracks before also being thrown in the river. Silahdar Fındıklılı Mehmed Agha was, we should not forget, a faithful servant of Mustafa II and by default a partisan of Feyzullah Efendi – he only related these events, he said, to illustrate the utterly disastrous situation in the empire. One of the most striking details of this grisly theatre is his observation that braziers of incense were burned as the body of the former sheikhulislam was dragged through the town – to make it clear that he could in no way be considered to have died as a Muslim.[14] The clerical establishment felt scant sympathy, considering that his accelerated rise to power and disregard for the limits to the authority of the office of sheikhulislam had set him apart from them. An anonymous author who was clearly close to events reported that Feyzullah Efendi's identifiable assets were seized for the treasury and used in part to appease the vociferous demands of the military for their arrears of pay and the customary accession bonus; the remainder of the large sum needed was provided from the revenues of the Egyptian treasury and the income of the crown lands of the new sultan, his mother, the Grand Vezir, and others.[15] Feyzullah Efendi's eldest son, whom Mustafa II had designated Feyzullah Efendi's successor,[16] was executed in Istanbul, and his body thrown into the sea; two sons of the Kadızadeli preacher Vani Mehmed Efendi were murdered in the same purge.[17]

The ringleaders of the uprising who had formed themselves into an alternative government were soon exiled or executed, but the explosive events of 1703 continued to have repercussions: in 1706 some middle-ranking officers of state who had joined the rebellion and been dismissed in its aftermath plotted to depose Sultan Ahmed and replace him with one of his sons, but they were informed upon, and the soldiers among them were strangled and their bodies thrown into the sea – this was risky, because in 1649 a similarly ignominious end, the denial of a Muslim burial, had prompted the rebellion of Gürcü Abdülnebi. A few months later a pretender to the Ottoman throne made an appearance. Proclaiming himself a son of Sultan Mehmed IV, and thus brother to Mustafa II and Ahmed, he sailed from North Africa to Chios carrying papers which purported to confirm

his story; rumours reaching Istanbul suggested that he might rally the disaffected in Anatolia and be proclaimed sultan in Bursa. He was beheaded at Sultan Ahmed's command, and his head displayed outside Topkapı Palace.[18]

If the Karlowitz treaty brought domestic turmoil in its wake, it also altered the relationship of the Ottoman state to the outside world. An early sign of the shift in the empire's relationship with the world beyond its borders was that the treaty was negotiated by the highest-ranking Ottoman bureaucrat and not, as hitherto, by a pasha, a military man; thereafter, the use of chancery officials as negotiators became standard practice.[19] The European states came to realize that the Ottoman Empire no longer had the strength to challenge them as it had before and, as the eighteenth century wore on, diplomacy rather than military might increasingly set the terms of the Ottoman encounter with its European neighbours, as negotiation began to prevail over aggression as a way of resolving international differences. Between 1739 and 1768 diplomatic initiatives brought peace on the empire's western frontiers – but not before the Ottomans had become embroiled in a number of conflicts not entirely of their own making.

Under Peter the Great Muscovy, customarily referred to as Russia from this time, was an expansive power without, as yet, the resources to sustain full-scale military operations on widely-distant fronts. To the west Sweden, a formidable opponent, barred Russia's access to the Baltic Sea, which was crucial to Tsar Peter's plans for the development of his territories, as was access to the south, to the Black Sea and the warmer seas beyond. In 1699 he allied himself with Denmark and the Polish-Lithuanian Commonwealth with the aim of forcing a route through to the Baltic; the news that peace had been concluded with the Sultan prompted him to declare war on Sweden in August 1700, joining his allies in what became known as the Great Northern War. Despite the long-standing good relations between them, the Ottomans rejected Swedish appeals for assistance. Having relieved Narva on the Gulf of Finland, besieged by a poorly-supplied and outnumbered Russian army which received no help from its allies, the twenty-year-old King Charles XII of Sweden – known to the Ottomans as 'Iron-Headed' Charles – marched south against Augustus II of Poland.[20] While he was thus occupied, in 1701 and 1702 the Russians made frequent incursions into Livonia – today, the south of Estonia and north of Latvia – and in May 1703 they took a small fort at the mouth of the river Neva. Peter had gained his foothold on the Baltic, and of the wooden village that began to rise there, one modern historian asserts that 'the founding of Petersburg . . . was tantamount to a declaration that . . . Charles XII, while unbeaten on the battlefield, had lost the war'.[21]

In the spring of 1706 a report reached Istanbul from the Crimean Khan, apparently solicited by Grand Vezir Baltacı ('Halberdier') Mehmed Pasha, that the Russians were threatening the Ottoman Black Sea frontier, and a fleet sailed to his aid.[22] Ottoman–Russian relations were tense, and the hostility between Russia and Sweden began to impinge on Ottoman concerns in the wake of Charles XII's campaign into Russia in 1708. In May 1708 Charles marched across Lithuania, lured ever eastwards by the retreating Russian army, but Peter had ordered the destruction of everything that could sustain the Swedish troops, and they crossed the Dnieper and turned south into Ukraine where the supply situation was expected to be more favourable. Ivan Mazepa, the Cossack hetman of Left Bank Ukraine – all of Ukraine that remained to the Cossacks after the abolition of the hetmanate in Right Bank Ukraine by Poland in 1700 – defected to Charles in early November, but his headquarters at Baturyn, some 150 kilometres north-east of Kyiv, was mercilessly sacked by the Russians and the hoped-for supplies destroyed.[23]

The winter of 1708–9 was extraordinarily cold and Charles found himself immobilized on the steppes of Ukraine as hundreds of his men froze to death. Although the Zaporozhian Cossacks (the Cossacks of the lower Dnieper) declared for Charles in March 1709, their headquarters was destroyed by a Russian force in May and any hopes that their support might turn the tide were dashed. Finally, in July, Charles besieged the town of Poltava, south-east of Kyiv, at Mazepa's urging; Tsar Peter arrived to raise the siege, and at the end of the month routed the Swedes.[24] Charles sought refuge first at the Ottoman fortress at Ochakiv at the mouth of the Dnieper, moving later to Tighina on the Dniester, where he built a settlement outside the city. From his self-imposed exile he continued to rule Sweden, but his defeat at Poltava signalled the end of its 'great power' status.[25] The battle of Poltava sealed Ukraine's fate, as Russian control of the Cossack state on the left bank of the Dnieper intensified.

The Russians protested that in allowing the Swedish King to remain on their soil the Ottomans were acting contrary to the provisions of their treaty of 1700, but Sultan Ahmed and his grand vezir Çorlulu Ali Pasha hoped to use Charles's presence as a bargaining counter to improve the terms of the peace agreed with Russia. Diplomacy worked against Charles's interests at first, leading to a renewal of the peace early in 1710 and agreement on the conditions of his return to Sweden. Charles refused to leave Tighina, however, and plotted against Çorlulu Ali, whom he held responsible for the Ottoman policy of appeasement towards Russia.[26] Intrigues connected with the presence of Charles and his supporters on Ottoman soil brought about the dismissal of several high-ranking officials, including the Grand Vezir, who was subsequently executed.

The influence of Charles and other 'Northerners' who had taken refuge with the Ottomans was in part responsible for a more aggressive policy towards Russia. When he moved south into Ukraine late in 1708 Charles had hoped that Ottoman support might be forthcoming;[27] it was clearly in the interests of Charles and his fellows, who saw themselves as victims of Russian might, to encourage the Ottomans in the belief that they had a common interest in hindering Russia's military advance. Although the Ottoman government in general was reluctant to confront Russia, there were those who argued for action, foremost among them the Crimean khan Devlet Giray II: the anti-Russian policy he forged, independently of the Ottomans, was as intransigent as Sweden's.[28] The khans had long shown themselves ready to manipulate the sensitivities of the Istanbul government in the interests of their own subjects, and were appointed and replaced according to the extent to which their activities contributed to the wider strategic needs of the moment. On this occasion the Ottoman clerical establishment bent an encouraging ear to Devlet Giray's pleas on behalf of those who found themselves in the path of Russia's southward expansion, and the janissaries were eager to avenge the loss of Azov in 1696 – on which Peter was lavishing almost as much attention as he devoted to Petrograd – St Petersburg, his 'window on the west'.[29]

Reports from the Ottoman Empire's northern frontier only served to confirm the threat posed by Peter,[30] and in November 1710 the Ottomans declared war on Russia. After a winter spent in making preparations, on 19 July 1711 the advance guards of the two armies, Russia's led by Tsar Peter himself, confronted one another across the Prut, a tributary of the Danube. That night, Tatar forces swam the river to engage the Russians while Ottoman engineers secured the bridges across the river, allowing the rest of the vastly superior Ottoman army to cross. Peter's troops retreated a distance from the fighting on the river, but although he found himself surrounded and short of supplies, his men at first resisted the Ottoman onslaught on their positions. On 22 July, after an attack on the Russians by forces led by the grand vezir and commander-in-chief, Baltacı Mehmed Pasha, Peter proposed terms to which Baltacı Mehmed readily agreed.[31] Between Russian prevarication and Ottoman indecision as to whether to continue the war,[32] however, the Treaty of Adrianople, as it is known in the West, was not ratified until 1713; under its terms, Russia lost all it had gained in 1700.[33] The reason for Baltacı Mehmed's failure to pursue his undoubted advantage has remained a matter for conjecture, as has the question of whether a more resolute Ottoman stance would have changed the course of history. The argument that the Ottomans lacked either the resources or the will to involve themselves in another and perhaps prolonged

war cannot have persuaded the Sultan, who dismissed and imprisoned Baltacı Mehmed. Many years later, in 1763, Frederick the Great asked the consummate Ottoman politician and envoy to Berlin, Ahmed Resmi Efendi, about this battle on the Prut: he was told that the Ottomans' withdrawal from the fray had been dictated by the Sultan's magnanimity.[34]

Charles XII and the other vociferous 'Northerners' with him – Mazepa having died at Tighina, these now included his successor as Cossack hetman, Pylyp Orlik, and Charles's Polish envoy to the Sultan, Stanislav Poniatowski – finally left Ottoman territory in October 1714, taking their quarrels with them, but not before they had exhausted the patience of their hosts. Early in 1713 Charles's court outside Tighina had been attacked by local Ottoman and Crimean forces and he and a number of his men taken prisoner – the Sultan expressed anger at the excessive violence employed, but Charles and his men were taken first to Didymoteicho in Thrace, then to Edirne where Charles was detained as a bargaining counter until the peace with Russia was ratified. The Great Northern War did not end until 1721; Charles was killed in Norway fighting the Danes in 1718, and Peter died in 1725; neither was succeeded by a sovereign as able as themselves.[35]

The story of Charles XII's relations with the Ottomans did not end with his departure, however, nor even with his death. He left Ottoman territory financially indebted to the Sultan and private moneylenders alike, and in 1727–8 and 1733 envoys were sent to Stockholm for the purpose of scheduling repayment of the Sultan's portion of the debt – amounting to some three million silver thalers. In 1738 an arrangement was finally worked out: the Ottoman treasury was paid one-third of the outstanding amount, and requested a fully-equipped warship, a seventy-gun frigate and 30,000 muskets in lieu of the remainder. The warship was wrecked off Cádiz en route to Istanbul, but another Swedish ship did reach its destination and this, with its cargo of explosives and 10,000 muskets, was acceptable to the Ottomans. The remaining debt was considered to have been discharged when they accepted a Swedish offer of 6,000 muskets.[36]

The origin of the Ottoman war against Venice in the Peloponnese between 1715 and 1717 has been traced to rebellions against Ottoman rule in Montenegro which were incited by Peter the Great's appeals for help to his co-religionists in the Balkans (similar to those the Habsburg emperor Leopold had made in 1690 at the height of his long war with the Sultan, and Peter himself had done early in 1711).[37] Following Peter's defeat on the Prut, the Montenegrins found refuge from the Ottoman authorities in Venice's Dalmatian territories.[38] The governor of Bosnia, Numan Pasha (son of former general and grand vezir Köprülü Fazıl Mustafa Pasha, who had himself been

grand vezir briefly after Çorlulu Ali Pasha's dismissal), was ordered to subdue the Montenegrins, and he reported to Istanbul that Venice was in breach of the conditions of the Karlowitz treaty. The Ottomans declared war in January 1715, and for a campaign that would depend primarily on naval power, the preparedness of the fleet was accorded special attention.[39]

Redress for these complaints, and for Ottoman loss of the Peloponnese under the terms of the treaty, was accomplished by the capitulation or capture of some of the most strategic fortresses in that peninsula.[40] Venice, however, had entered into a mutual defence pact with Austria, which feared that Ottoman gains would threaten its border in Croatia; rather than capturing Venice itself following their successes in the initial campaign, as the Sultan dreamed of doing,[41] the Ottomans found themselves fighting on two fronts – not at all what the government had anticipated. Negotiation proving fruitless, in 1716 Grand Vezir Silahdar Ali Pasha led an army to Belgrade, while the fleet sailed to besiege Corfu.[42]

The views of those in the Ottoman government who thought it folly to go to war against Austria were ignored.[43] Mobilization was slow and troop numbers insufficient, and when the opposing armies met on 5 August at Petrovaradin, the Austrian forward base during the latter stages of the 1683–99 war, their forces under the command of Prince Eugene of Savoy took only five hours to rout the Ottomans, and Silahdar Ali Pasha was killed. Matters went badly also at Corfu, where news of the Petrovaradin defeat so discouraged the Ottomans that they abandoned the siege.[44] From Petrovaradin, Prince Eugene marched into the Banat and the fortress of Timişoara capitulated within a few weeks. In 1717 he led the Austrian army to a great victory against superior forces by once again expelling the Ottomans from Belgrade, and went on to advance south along the Balkan river valleys deep into Ottoman territory, causing the populations along their route to disperse and flee in panic to Istanbul.[45]

For eight years the Transylvanian prince Francis II Rákóczi had struggled to secure from the Habsburgs toleration for his Calvinist supporters and recognition of Transylvanian independence, but in February 1711 he had been forced to flee to Poland, and since 1713 had been living in France. Early in 1718 he was invited to Edirne and an audience with the Sultan produced a plan that he should attempt to reclaim the principality of Transylvania – but the Ottomans agreed peace terms with Austria before this could happen.[46] Although he had been of no practical help to the Ottoman cause in Hungary, from August 1718 until his death in 1735 he remained with his retinue as guests of the Ottomans in the town of Tekirdağ (Rodosto), to the west of Istanbul on the north coast of the Sea of Marmara, preoccupied with anti-Habsburg schemes.[47]

With the appointment in May 1718 of a new grand vezir, Nevşehirli Damad İbrahim Pasha, the Ottoman government was ready to consider peace; negotiations took place at Požarevac (Passarowitz), south-east of Belgrade, mediated, as at Karlowitz, by the British and Dutch ambassadors to the Sultan. At the expense of the Ottomans, Austria kept Belgrade and Timişoara and advanced its border to Niš. This settlement restored the borders of Hungary and Croatia to their positions before the campaigns of Sultan Süleyman I,[48] and codicils improved Austria's access to trade with Ottoman domains.[49] Austria's ally Venice was left at even more of a disadvantage than the Ottomans: the Ottomans retained the Peloponnese while Venice kept the conquests it had made in Dalmatia.

Its troops might be engaged on far-distant frontiers, but the day-to-day business of government of the Ottoman Empire did not come to a standstill. Once the more violent expressions of the 1703 uprising had subsided and the court returned to Istanbul, a new equilibrium in government and in public life was gradually established. Vezirs were dismissed and appointed, while foreign envoys arrived, as was customary, to present their sovereigns' congratulations to the new sultan; the Shah of Iran sent 'an enormous elephant'.[50]

Though they had destroyed old certainties, the shock of Karlowitz and the crisis of the 'Edirne Incident' gradually receded from memory. The authority of the Köprülü household had not after all been replaced by that of Feyzullah Efendi, for the concession of such a position to a clerical dynasty would have required an unimaginably radical transformation in the world-view of both the Ottoman ruling class and the sultan's subjects. The principle that grandee households had a legitimate part to play in government had been established when in the painful years of the mid-seventeenth century a succession of members of the Köprülü dynasty proved themselves capable of dealing with the havoc caused by the struggles of janissaries, palace aghas and the disaffected military men of the provinces to assert their own claims to a share in the exercise of power. In the early eighteenth century the monopoly they had formerly enjoyed from their close association with the Ottoman house broke down, and the Köprülü became only one among the most prominent grandee households who shared power.

Sultan Ahmed sought to balance the power of the grandee households and also to mould their interests to coincide with those of the Ottoman house. In addition to his several sons, Ahmed III had thirty daughters, and many pages of the chronicles for this period carry reports of their births and weddings – and their deaths, for many died young. Unlike Ottoman

princes, who had suffered seclusion in the palace for a century, Ottoman princesses were now allotted a public role for the first time.[51] The time-honoured practice of assuring the loyalty of statesmen to the Ottoman dynasty by marrying them to princesses was carried to new lengths as the princesses were wed, often more than once if they were widowed, to leading members of the new grandee households. Six of Ahmed's daughters contracted seventeen marriages between them: the most-married was Saliha Sultan, who had five husbands.[52] The international landscape that began to develop after Karlowitz made it necessary for the character and constituents of Ottoman power to be redefined domestically as well as externally, and in this respect Ahmed III's fecundity facilitated the extension of the old practice of princess–statesman marriages, promoting stability among the grandee households who now shared in the authority of the Ottoman house.

The unwritten compact between the Sultan and the grandees gave the latter, in exchange for their loyalty, access to the rewards of association with the royal dynasty, enabling them to satisfy the demands of their own burgeoning households. Thus, to the expenses of warfare, traditionally the greatest drain on state revenues, were now added the expenses of the upkeep and perpetuation of the many independent households spawned by the marriages of the Sultan's daughters. Cash was needed to support their extravagance, and innovative solutions were sought to finance both the luxuries they considered their right and the charitable works they considered their obligation. The restructuring of taxation which had begun in the 1690s in response to the financial drain of the war – most notably through the devices of reform of the poll-tax and life-term tax-farming – coincided with a pronounced increase in regional trade during the first half of the eighteenth century, and this helped the Ottoman state recover and enabled its wealthier members to enrich themselves further.

The system of life-term tax-farming instituted in 1695 was still at an experimental stage when Ahmed came to the throne. Although in theory any male could bid for a tax-farm, it soon became apparent who were the long-term beneficiaries of the new fiscal arrangements. Since a potential buyer needed access to existing assets to fund his bid at the auctions held to distribute life-term tax-farms, it was easier for those who were already well-off – high-ranking officers of the military and clerical establishments, for instance – to get their hands on these state assets. Those with insufficient personal capital to buy on their own account could do so in partnership with other family members or business associates or borrow from the non-Muslim financiers – mostly Istanbul-based and Armenian – who with their access to European capital underwrote much of the Ottoman

economy: indeed, their participation was an essential component of the system.[53]

There was no shortage of buyers for potentially lucrative tax-farms, and competition pushed up the auction price, to the advantage of the treasury.[54] Within only two years of the introduction of the system, the treasury's ongoing search for cash to finance the continuing war had led the authorities to widen the range of investments being auctioned as life-term tax-farms. Initially the system had been intended merely to reorganize the financial administration of imperial estates, already farmed on short-term (typically three-year) contracts; now, veziral estates and land-holdings originally intended to support garrison or cavalry troops were brought within the scope of the new arrangements.[55]

Those who bought the title to life-term tax-farms were satisfied with promise of a secure income, but it was soon realized that the easy terms under which the system had been introduced were over-generous, and in 1715, shortly after the declaration of war on Venice, the titles to most life-term tax-farms were abrogated. In 1717, shortly before the appointment of Nevşehirli Damad İbrahim Pasha as grand vezir, another change of policy returned them to their previous holders, at a fee half of that with which they had originally secured title.[56] Investors were particularly attracted to liquid assets – that is, the revenues derived from such non-agricultural tax-farms as the various customs and excise dues, which were growing as trade expanded. By the time of Ahmed's accession, however, it was striking how a system intended also to revitalize agriculture in Eastern Anatolia and the Arab provinces had become geographically skewed: the most valuable – and, therefore, the most desirable – life-term tax-farms proved to be in the Balkans rather than in the east.[57]

Another alteration to the system meant that after 1714 members of the traditional tax-paying class were no longer eligible to bid for life-term tax-farms, even if they had sufficient means to do so.[58] As a result, the main beneficiaries of the system were members of the Muslim elite – about a thousand bureaucrats, soldiers and clerics, most of them based in Istanbul, far from the sources of their income.[59] The many daughters of Ahmed III and his successors were also major beneficiaries – princesses were the only females able to hold life-term tax-farms[60] – with land-holdings and entitlement to customs dues in the Balkans in particular.[61] The administration of provincial tax-farms was undertaken by men knowledgeable about local conditions whose cut of the tax 'take' gave them a financial interest in the rewards of the enterprise.[62] The access of even the most wealthy provincials to the rewards of tax-farming at this time was only marginally enhanced by the introduction of auctions in centres outside Istanbul, for these auctions

did not include commercial and urban tax-farms such as market dues, but were confined to village and agricultural revenues.[63] They did, however, allow small investors a place in the market: given good fortune, they too could accumulate a measure of wealth, and this encouraged them to regard the new financial arrangements, and hence the activities of the state, with favour. The support Ahmed enjoyed from the grandees during his reign indicated that this new distribution of rewards at the state's disposal was deemed satisfactory by those who might otherwise have been in a position to challenge the government's authority.

The export of raw materials – predominantly grain, wool, cotton and dried fruits – to the nascent processing industries of western Europe was one of the marks of the new economic interdependency in which the Ottoman Empire was now beginning to share. Since the early seventeenth century the export trade had flowed mainly from İzmir, and Thessalonica gradually became the second largest export centre. During the eighteenth century cotton overtook wool as the leading Ottoman export commodity.[64] For domestic consumption the Ottomans produced simple, inexpensive textiles in small workshops, but in the early eighteenth century also tried to reproduce the finer or more specialized cloths coming from Europe, both to reduce reliance on imports and to meet shortages. The rebellion of 1703 curtailed the manufacture of woollen cloth begun under the auspices of Rami Mehmed Efendi but production began again in 1709 and continued until it was eventually abandoned in 1732 because the quality was not sufficiently fine and the price could not compete with that of imports. State manufacture of sailcloth for the navy began in 1709 and continued through various vicissitudes into the nineteenth century. From 1720 the state also became involved in the production of silk, the preferred cloth of the rich, but could not compete with privately-produced domestic silk after mid-century.[65]

Relations with England were traditionally cordial, but early in the eighteenth century France replaced the English as the Ottomans' dominant trading partner, a development that was mirrored in a further strengthening of diplomatic relations. France and the Ottomans had a long history of strategic association based on their common interest in countering Habsburg power, and King Louis XIV's talented minister Jean-Baptiste Colbert's reorganization of French trade after 1670 enabled French merchants to take advantage of the ending of hostilities in 1699.

After the wars of the Holy League and the Spanish Succession, after the Great Northern War, after Karlowitz, the 1703 uprising and wars with Russia, Austria and Venice, there was peace in western Europe and peace

along the Ottoman Empire's western frontiers. Now it was not only war that prompted the Sultan to send ambassadorial missions to his European peers. It was to Paris that Yirmisekiz ('Twenty-eight') Çelebi Mehmed Efendi – so called because he had belonged to the 28th janissary regiment – set out in 1720 with the news that the Sultan had granted France permission to repair the Church of the Holy Sepulchre in Jerusalem. This was information that could as easily have been conveyed with considerably less pomp, even through the French envoy in Istanbul – but Yirmisekiz Çelebi Mehmed was instructed by Grand Vezir Nevşehirli Damad İbrahim Pasha 'to visit fortresses and factories, and to make a thorough study of the means of civilization and education, and report on those suitable for application in the Ottoman Empire'.[66] In effect, he was the first official Ottoman cultural envoy; he obeyed his instructions, and reported his experiences fully on his return. Damad İbrahim had himself travelled to Vienna the previous year, to ratify the Treaty of Passarowitz, and was well aware of all that could be learnt from beyond the Ottoman borders.[67]

Yirmisekiz Çelebi Mehmed Efendi's observations were influential in encouraging those now coming to power in the state to appreciate the usefulness of peaceful contact with the West. The Ottomans had always been receptive to technological innovation if it seemed to answer a practical need and could be accommodated within existing cultural mores – early examples were their use of cannon even before the siege of Constantinople, and of hand-held firearms from the sixteenth century. To the consternation of the governments of the time, as the latter became widely available they upset the balance of power within the empire, bringing considerable social upheaval to Anatolia in particular, as armed men roamed the land. European clocks and watches, porcelain and fashions, by contrast, were trifles only affordable and readily assimilated by the wealthy, mere novelties, with no obvious potentially adverse impact on the existing social order. Exchange of such goods between the empire and the West had a long history stretching back to the Renaissance, and in the years of Nevşehirli Damad İbrahim Pasha's grand vezirate, they became available in greater profusion than ever before, thanks to the upturn in trade.

The alacrity with which such consumer goods were adopted by those who could afford them was only one manifestation of a renewed vitality in social life. Sultan Ahmed III used public display and ostentatious patronage to forward his aim of reviving the fortunes of the Ottoman dynasty. Lavish ceremony marked the wedding of his eldest daughter, five-year-old Fatma Sultan (who later married Nevşehirli Damad İbrahim Pasha), to the almost forty-year-old Silahdar Ali Pasha in 1709.[68] Damad İbrahim, who became grand vezir in 1718, encouraged the Sultan in his exploitation of public

ceremony and display as a tool for impressing both the ruling class and the ruled. A splendid fifteen-day festival celebrated the circumcision of four of Ahmed's surviving sons in 1720, and two sumptuously illustrated prose manuscripts – one copy for the Sultan and the other for the Grand Vezir – were produced to record the event. The text was from the pen of Seyyid Hüseyin Vehbi and the illustrations the work of the painter known as Levni, the foremost court painter of his day. The volume was only the second but also the last to be devoted to a royal festival: the first was that produced to celebrate the circumcision of the future Mehmed III in 1582. The celebrations of 1720 carried echoes of the past two centuries, such as the wedding of Sultan Süleyman's ill-fated grand vezir İbrahim Pasha in 1523, the circumcision of the Sultan's sons in 1530, and the departure of Sultan Murad IV to reconquer Baghdad from the Safavids in 1638. One of the main spectacles of the pageantry of 1720 was a procession of the guilds, like the one described by Evliya Çelebi in the previous century, which enabled tradesmen to show off their wares – both the mundane and luxurious – to potential customers watching the parade, whether Ottoman grandees, European ambassadors or the common people of Istanbul.[69]

The mosque of Rabia Gülnüş Emetullah Sultan hinted at a restatement of the role of the queen-mother in expressing the legitimacy of the dynasty. Rabia Gülnüş, as mother of both Mustafa II and Ahmed III, was queen-mother from Mustafa's accession in 1695 until her death in 1715. According to a list dating from 1702 the estates she held were worth almost three times those of the Grand Vezir (after whom came princesses of the royal house, followed by vezirs and members of the dynasty of the Crimean khans),[70] and in 1708 she embarked on the building of a prominently-situated mosque complex at the landing-stage in Üsküdar, opposite that of Süleyman I's daughter Mihrimah Sultan; it was completed two and a half years later, just before the army set out on campaign against Russia.[71] In 1722, seven years after her death, it was granted the privilege of suspending lights between its minarets to mark the holy month of Ramadan, thus marking it as the equal in status of the greatest mosques of Istanbul – Süleymaniye, Sultan Ahmed and Yeni Valide.[72]

With power more widely dispersed among the Ottoman grandees than at any time since the earliest days of the state, it rapidly became clear that the aspirations of the new order would not and could not be confined within the purlieus of Topkapı Palace. Having grown up in the freer atmosphere of Edirne, Ahmed III himself resented the constraints forced upon him once the court returned to Istanbul. Writing a century later, in 1837, Miss Julia Pardoe, a visiting English gentlewoman, recorded the vehemence with

which Sultan Mahmud II responded to his chief architect's efforts to convince him that Topkapı was more splendid than any palace to be found in Europe: 'None save a rogue or fool could class that palace . . . hidden beneath high walls and amid dark trees, as though it would not brave the light of day, with . . . light, laughing palaces, open to the free air and pure sunshine of heaven'.[73] Sultan Mahmud may or may not have spoken so feelingly, but it seems likely that Ahmed III felt much the same. Sultans and their ministers had always had hunting-grounds and gardens along the shores of the Bosporus, with modest pavilions and villas of wood and stone for informal use, but the eighteenth century saw a change as multi-storeyed, waterfront palaces were built, their impressive façades extending along the shore.[74] A letter from Lady Mary Wortley Montagu, wife of the British ambassador, who visited Istanbul in 1717–18, refers to 'some hundreds of magnificent palaces' along the Bosporus alone;[75] even allowing for exaggeration, this is an indication that the building boom was well advanced before the 1720s. The earliest of the Bosporus waterside palaces of which a portion – a small part of the public rooms – remains standing is that built in wood in the village of Anadolu Hisarı in 1699 by Köprülü grand vezir Amcazade Hüseyin Pasha.

The nouveaux riches Ottoman grandees of the 1720s had the leisure to enjoy themselves and the money to indulge their whims. The social gatherings of this 'fashionable society' were frequent, ostentatious, and conducted beyond the confines of the old walled city of Istanbul. Banquets and entertainments often lasting several days were held at Ahmed's own palaces and those of his extended family and other prominent households. For the first time, according to a modern architectural historian, 'an introvert society' was introduced to an 'urban and extrovert' way of life.[76] This greater sociability had its effect on the local economy, prompting shifts in previous patterns of consumption of, for instance, food, clothing and furnishings. In the case of food, olive oil, seafood and vegetable dishes were used to a greater extent than before. People were also ready to experiment with new dishes, and patterns of entertaining began to change as consumption of coffee and desserts (made possible by increased use of sugar, where honey had formerly predominated), in particular, fostered novel modes of social relationship outside the 'dining-room', in spaces reserved for the enjoyment of these foods.[77]

Ahmed abandoned the tradition of enhancing the mystique of the dynasty by retreating to the seclusion of the suburban gardens and parklands, choosing instead to appear openly before his subjects. He made royal progresses by water, visible to all, just as Elizabeth of England had a century and a half earlier. Simon Schama, writing of the way Elizabeth 'us[ed] the river

[Thames] as a stage on which to embrace all of her subjects [in] a brilliantly calculated triumph of public relations', quotes a contemporary chronicler who describes her as 'shewing herself so freely and condescending unto the people, she made herself dear and acceptable to them'.[78]

The Sultan could not simply abandon Topkapı, however, for it was the traditional centre of government. The palace had not been the sultan's regular residence for half a century, so it was natural that Ahmed, even if he hoped to live there as little as possible, should have the private apartments redecorated. The centrepiece of these renovations was his chamber in the *harem*, whose every wall is covered with murals of fruit and flowers, the vibrant architectural decoration of the age. Such naturalistic motifs were ubiquitous, whether rendered in marble or on paper in manuscripts. Portrait painting also changed as the influential artist Levni portrayed the sultans during whose reigns he worked – Mustafa II and Ahmed III – in greater close-up. His portraits are particularly striking for their faithful record of the character of the sitter, whose individuality seems to have been accentuated to make him more human: the distance between sultan and observer seems to have shrunk.[79]

The future court chronicler Mehmed Raşid Efendi was a cleric in Istanbul at the time,[80] with close knowledge of the finances of the empire. He noted that around 1720, for the first time in years, the treasury's balance of payments began to show a surplus: it seemed that the financial reforms were proving effective.[81] The next year Sultan Ahmed gave orders for the construction of the most splendid palace of all, that of Sa'dabad – 'Abode of Felicity' – in meadows upstream from where the Kağıthane stream, the 'Sweet Waters of Europe', feeds into the Golden Horn near Eyüp. Grandees liked to build their palaces along the Golden Horn as well as the Bosporus, and the Kağıthane meadows had long been a refuge from the city, a place where people would gather for entertainment and celebration. Ahmed III's Sa'dabad took the idea of the 'garden pavilion' to new lengths. The Kağıthane stream was tamed to flow through the park in a marble-lined canal (remnants of which are still visible), and along the straight axis thus imposed lay the continuous, symmetrical façades of the palaces of dignitaries and courtiers: the Sultan's own palace stood on thirty marble columns with a pool before it.[82] The palaces were given fanciful names: The Elephant's Bridge, The First Waterfall, The Silver Canal, The Hall of Paradise, and so on.[83]

Like that of Sultan Süleyman I in the sixteenth century, the reign of Ahmed III paralleled in many ways those of his European contemporaries (or near-contemporaries), and it is hardly possible to avoid comparison of Sa'dabad with the Versailles of the recently-dead Louis XIV, or the Summer Palace and Gardens of Peter the Great in Petrograd – or, indeed, the

suburban palaces around Peter's capital. Like Peter, who brought back from his visit to western Europe in 1716–17 an album of views of Louis XIV's garden palaces of Versailles and Fontainebleau, and announced on his return to Petrograd that a new palace he was building there must 'vie with Versailles',[84] Yirmisekiz Çelebi Mehmed Efendi also came home bearing a souvenir of his time in France – twelve engravings of Versailles, now in the collection of Topkapı Palace.[85] Like Tsar Peter, Sultan Ahmed took a close personal interest in the execution of his building projects.[86] The circumstances of his own youth provided inspiration for Sa'dabad: like Edirne, it was to be a refuge where he could enjoy the unencumbered life sought by recent sultans away from Istanbul. The flavour of Iran detectable in the names of the Kağıthane palaces reflected the influence of the Safavid court, as pervasive in Sa'dabad and in the wider artistic endeavours of the age as that of Versailles.

Ordinary people benefited from the extravagances of the rich, and not only from the increased demand for goods and services. Patronage, particularly that of the Sultan and Grand Vezir, provided such public services as the numerous, large and intricately-decorated fountains throughout greater Istanbul.[87] The illumination of the imperial and veziral mosques of Istanbul on more nights than ever before had the effect of expanding and reshaping public space and relaxing constraints on personal mobility, enabling even the poor to move about the city when previously they had been confined to their homes during the hours of darkness. This new freedom was a key aspect of what is called, in a twentieth-century coinage, the 'Tulip Age'.[88]

Tulips there were – and in abundance. This oriental bulb, whether it reached Europe in the mid-sixteenth century through the agency of Ogier Ghislain de Busbecq, Habsburg ambassador at the court of Sultan Süleyman I, or even earlier, as has recently been proposed,[89] had long been as popular among the notables of Istanbul as it became among their counterparts in Europe. Tulips had been woven into textile designs, drawn on pottery and tiles, painted on manuscripts, and sculpted on fountains since the sixteenth century, and Evliya Çelebi wrote in the 1630s of the tulip gardens of the Bosporus, even referring to a tulip named for Kağıthane in his time.[90] Now, almost a hundred years on, tulips once again became an indulgence to console the Ottomans for the deprivations of war – but the thousands of bulbs Ahmed III imported came from the United Provinces, centre of the tulip trade. Most prized by Ottoman tulip-fanciers, the form they sought to bring to perfection, was an 'almond-shaped, dagger-petalled' tulip. The Ottomans were aware of the havoc an unregulated market could cause, and sale of the very many varieties available had to be controlled through

a system of official pricing to dampen the inevitable speculation in this most sought-after of commodities[91] – the Dutch had experienced such tulipomania in the late 1620s and 1630s,[92] immortalized by Alexandre Dumas in his novel *The Black Tulip*. Writing in 1726, the French ambassador to Istanbul described one of Grand Vezir Nevşehirli Damad İbrahim Pasha's tulip extravaganzas:

> There are 500,000 bulbs in the Grand Vezir's garden. When the Tulips are in flower and the Grand Vezir wants to show them off to the Grand Seigneur, they take care to fill in any spaces with Tulips picked from other gardens and put in bottles. At every fourth flower, candles are set into the ground at the same height as the tulips and the pathways are decorated with cages of all sorts of birds. All the trellis-work is bordered with flowers in vases and lit up by a vast number of crystal lamps of various colours ... The colours and reflections of the lights in mirrors make a marvellous effect. The illuminations are accompanied by noisy music and Turkish music lasts through all the nights that the tulips are in flower. All this is at the expense of the Grand Vezir, who during the whole of tulip time, lodges and feeds the Grand Seigneur and his suite.[93]

But the 'Tulip Age' was not only about pleasure. The sacred complement to the ostentatious banquets, audiences and progresses of Ahmed III's reign were the visits he and his retinue of state dignitaries paid to the chamber housing the sacred mantle of the Prophet. Before the eighteenth century, visits to the mantle had been regular only at the accession of a new sultan; under Sultan Ahmed visiting the mantle became an elaborate state ceremony that took place annually on 15 Ramadan, the full moon on the middle day of the holiest month in the Islamic calendar. The previous day the Sultan would take part in the ritual cleaning of the chamber and in preparing the mantle for display. Contemporary 'Books of Ceremonies' give precise details of the ritual – who was to participate, with their order of precedence sketched in diagrammatic fashion, what they must wear, and the prayers to be performed.[94]

Another opportunity for Sultan Ahmed to remind his subjects that religion was an essential component of Ottoman dynastic life presented itself on the occasion of the ritual ceremony symbolizing the religious instruction of his young sons, which took place with great pomp shortly after their spectacular circumcision feast in 1720. The younger princes – Mehmed, Mustafa and Bayezid – were only three and four years old when the Sultan and the highest officials of state, both secular and religious, attended the ceremony in the Pearl Pavilion on the coast below Topkapı Palace.[95] The Sultan's concern for his people was demonstrated when five thousand poor boys were circumcised at the same time as his sons.[96]

In another gesture underlining the attachment of those in power to the sacred calendar, Damad İbrahim Pasha gave a more extravagant form to the feasts which traditionally marked the end of the month of Ramadan. Soon after he came to the grand vezirate, in 1721, he held a feast at Eyüp, he and his retinue returning to Istanbul afterwards with great pomp. Such feasts became more splendid as time went by,[97] perpetuated throughout the century by Mahmud I and his successors as a means of impressing upon the court and people the sultan's piety and continuing relevance as head of state.*

If the clerical profession had their doubts about the comportment of court society, they were nevertheless easily co-opted. Lectures were held in the presence of Damad İbrahim Pasha during Ramadan at which leading clerics engaged in learned disputation on a passage from the Koran or the Traditions of the Prophet. The text to be debated was carefully chosen: among the Koranic passages discussed during the 1720s were those concerning 'Victory' – an appropriate topic in the context of the Iranian campaigns that began in 1722.[98]

As the identification of the clerical profession with the goals of the dynasty grew closer it was manipulated to enhance the legitimacy of the Sultan, and develop a coterie of allies. The role of the clerical profession also changed in more subtle ways as it became increasingly more of a 'closed shop'. There were families who in the past had furnished more than one sheikhulislam; now, what were essentially clerical dynasties began to enjoy a monopoly on this and other high religious offices, and the principle of dynastic succession to the pinnacle of the hierarchy became entrenched. Sheikhulislam Feyzullah Efendi may have been murdered, but his descendants would be rehabilitated and rise to the top again once a new sultan succeeded Ahmed III. Between 1703, the year of Sheikhulislam Feyzullah Efendi's murder and of Ahmed III's accession, and 1839, three families, including the Feyzullahzade, contributed 13 of the 58 sheikhulislams in this period and, since sheikhulislams were frequently dismissed and later reappointed, 20 out of 76 tenures of the office.[99] Such clerical dynasties had their counterparts in the military and in the bureaucracy, and while significant numbers of children of military men and bureaucrats were to be found among high-ranking clerics, legislation in 1715 restricting entry into the clerical profession to the advantage of the sons of clerics gave nepotism official sanction. And just as the grandees of Istanbul enjoyed what was tantamount to a monopoly of the life-term tax-farm system, so in the non-

* To this day, evening banquets are held during Ramadan by politicians hoping to win votes, and businessmen wishing to impress with their largesse.

secular sphere, the imperial capital was granted a monopoly on educating recruits to the clerical career.[100] The 'new nepotism' cut across the traditional state 'orders' to produce a privileged class – a veritable aristocracy – united by common interests against such challenges to their power and the sultan's as had blighted government during the seventeenth century.

The relationship of Grand Vezir Nevşehirli Damad İbrahim Pasha to Sultan Ahmed bore echoes of that of Sheikhulislam Feyzullah Efendi to Sultan Mustafa II at the beginning of the century, and he was able to use it in the same way to the advantage of his extended family. Members of Damad İbrahim's household, the Nevşehirlizade, wielded significant influence as offices in the imperial council were monopolized by his men: one son-in-law was his proxy as grand vezir and another was grand admiral. He himself married Sultan Ahmed's eldest daughter Fatma Sultan, and other members of his family wed the next three surviving princesses. Even before he became grand vezir, Damad İbrahim had been arranging marriages between members of his household and the Ottoman dynasty, and building up his network of patronage. He brooked no rivals: members of the Köprülü household – Abdullah Pasha and Esad Pasha (sons of Fazıl Mustafa Pasha), and former grand vezir Numan Pasha – were assigned to positions in distant corners of the empire, as had been their fate during the years of Feyzullah Efendi's ascendancy.[101]

Nevşehirli Damad İbrahim Pasha was grand vezir for twelve years, a rare period of stability in government office to match Fazıl Ahmed Pasha's tenure as grand vezir. Sheikhulislam Yenişehirli Abdullah Efendi also held office for twelve years; Damad İbrahim's son-in-law, the grand admiral, held office for nine years, the finance minster, Hacı İbrahim Efendi, for ten years, and Chancellor Üçanbarlı ('Three Storehouses') Mehmed Efendi for twelve years. However, the longest-serving of all those in the Sultan's circle was the chief black eunuch, Hacı Beşir Agha, who despite – or perhaps on account of – his venality, held his post from 1717 for an unprecedented 29 years.

Although Nevşehirli Damad İbrahim Pasha was admired by European visitors to Istanbul (as he is by many modern writers) as an enlightened reformer who tried to drag the Ottomans into the contemporary world, Ottoman commentators of the time were less generous. His evident commitment to peace certainly did not satisfy some sections of society, for whom a more defensive stance on the part of the Ottoman state was a betrayal of everything it stood for. At best, most Ottoman chroniclers of the eighteenth and nineteenth centuries considered Damad İbrahim to have been responsible for introducing alien ideas, and for over-taxation and nepotism; they saw him as having been profligate with state resources and overly

permissive in his attitude to the relaxed parks-and-palaces social life of the grandees, and at worst, responsible for giving licence to a sexual profligacy which upset relations between men and women. That ordinary people had some opportunity to share in these entertainments and to imitate their betters was also regretted by the chroniclers.[102]

The diplomatic settlements of Karlowitz in 1699 and Passarowitz in 1719 brought peace to the western and northern frontiers of the Ottoman Empire, and bought the rich and powerful time to savour the pleasures of Sa'dabad and the new Bosporus palaces of the 'Tulip Age'. It seemed that Sultan Ahmed was winning the hearts and minds of his subjects, and that he and Nevşehirli Damad İbrahim Pasha had been correct in their assessment that satisfying the curiosity of the public about the lives of the royal family and the grandees was beneficial for Istanbul society at large.[103] Events were soon to prove them wrong, however. The significant changes in the demographic landscape seen during the War of the Holy League as the Habsburgs pushed forward into Ottoman territory, and following the fixing of new borders after Karlowitz, and again following Passarowitz, forced desperate Ottoman Muslims who found themselves on the wrong side of the frontiers agreed by these treaties to move south-east through the Balkans towards the capital. The Peloponnese was returned to the Ottomans at Passarowitz, but the intervening years had seen migrations from that region to compound those resulting from the permanent loss of Hungary, Transylvania and Podolia. Where once Ottoman wars had been fought on enemy soil, after 1683 they were fought within the empire's borders, exacerbating the displacement of the Ottoman population, and in a city where the maintenance of public order was difficult at the best of times, these new arrivals were not welcome. They formed an underclass whose presence impinged directly upon the tradesmen and artisans of Istanbul – as the immigrants sought employment, the long-established complained bitterly of the undermining of their jealously-guarded privileges.[104] Throughout the 1720s it was repeatedly decreed that immigrants to Istanbul should return whence they had come, and local authorities in Rumeli were ordered to regulate their movement, but mere admonitions, however strongly worded, were to little avail.[105]

With a growing underclass of the displaced and dispossessed, and simmering resentment among established tradespeople, social differences became ever more marked, and violent expressions of popular anger showed that the gulf between the ostentatiously rich and the rest was becoming dangerously wide. In 1726 a crowd stoned Sultan Ahmed's palace at Beşiktaş over ten nights, forcing him to move to one of his residences on the Golden Horn.[106] In İzmir, the years 1727 and 1728 saw a clash between janissaries

and the troops of the government representative in the city over their respective spheres of authority; it developed into a prolonged revolt which drew in the discontented from various walks of life, prompting intervention from Istanbul but ending with the escape of the ringleaders.[107] As for life-term tax-farming, while it brought greater wealth to those already rich enough to bid at the auctions, and also benefited their agents, and people like traders and artisans providing goods and services for those with the money to pay for them, for those who paid the taxes this system opened the way both to ever more excessive demands, and also to jurisdictional disputes over tax-collection rights in which they were the inevitable losers. In truth, the insouciance of the Ottoman court and grandee households was becoming increasingly resented, and by the time statesmen came to appreciate this, it was too late to deflect popular restiveness.

Apart from the flurry of military activity attending Peter the Great's capture of Azov in 1696, little had occurred to disturb the peace in the east established by the 1639 Ottoman–Safavid treaty of Zuhab. In the first decades of the eighteenth century Iran had its own domestic troubles, and in 1720 the Sultan, eager for information about events there, sent an ambassador, Ahmed Dürri Efendi, to Shah Husayn.[108] The formal, ostensible purpose of the visit was to consult with the Safavids over the Ottoman–Habsburg trade agreement of 1718, which contained a clause regulating the passage of Iranian merchants through Ottoman territory.[109] In 1721 Sunni Afghan tribes invaded Iran from the east, taking the Safavid capital of Isfahan the next year; the Shia Safavid dynasty fell and Russia agreed to assist the rump Safavid state in its struggle against the Afghans in return for territorial concessions. The Ottomans, fearing the instability would spread to their own Caucasian frontier with Russia, and putting forward as justification the age-old charge that the Safavids were not true Muslims, profited from the confusion to reoccupy the north-west Iranian provinces they had held at various times before 1639. A clash between the Ottomans and Russia threatened, but diplomacy prevailed, and in 1724, under the terms of an Ottoman–Russian partition of north-west Iran mediated by French negotiators,[110] the Ottomans won Russian recognition of their gains. A curious aspect of the agreement with Russia was that, notwithstanding the Ottomans' religious justification of their campaign, it specified support for the restoration of the Safavids rather than the Afghans.[111]

But Iran was not peaceful for long. There was no hope for the Safavids in the face of the Afghan advance; and the Afghans were bold enough to use the Ottomans' own casuistry against them, appealing to the Sultan to recognize them as the rightful rulers of Iran on the grounds that the Shia

were heretics and had been branded as such by the Ottomans. This plea cut no ice in Istanbul: the Afghans were considered rebels, and the two years of fighting that ensued[112] ended in 1728 when Mehmed Raşid Efendi – now retired from the post of court chronicler which he held between 1714 and 1723 – was sent to Iran by Ahmed III to confirm an Ottoman–Afghan peace.[113] The Afghans were soon overthrown by Nadir Khan, also known as Tahmasp Quli Khan, of the Turcoman Afshar tribe, an energetic military leader who confronted the Ottomans and on 12 August 1730 took from them Tabriz which they had won in 1725.[114] Like the earlier wars in the west, this war with Iran made its own contribution to the waves of rural immigrants making their way to Istanbul.

Conscious of the currents set in motion by the opening of a new period of warfare with Iran, Nevşehirli Damad İbrahim Pasha proposed that to boost public morale Sultan Ahmed should ride at the head of his army on the campaign of 1730. It would not be the first time he had accompanied his army: in 1715 at the outset of the struggle against Venice for possession of the Peloponnese, and again in 1717, the year of the loss of Belgrade, he had set out with his men – but had remained far behind the front line.[115] The army began to assemble at the mustering-ground at Üsküdar by the end of July 1730, and by 3 August the troops were drawn up, waiting for the Sultan to cross the Bosporus from Istanbul. When he made no move to do so, Damad İbrahim could only assume that he had decided not to lead his troops eastwards and immediately hastened to his side to beg him not to delay, reminding him that a janissary revolt would certainly be the result if he failed to appear. Emulating his forebears on the eastern frontier was a very different proposition from doing so in the Balkans, and it was only after much pleading that Damad İbrahim, in consultation with the commander-in-chief of the janissaries, could persuade Ahmed to appear in Üsküdar – which he did with great pomp, after a progress to Eyüp, where before an audience which included foreign ambassadors he had been ceremonially girded with a sword, as if for a coronation.[116]

By an unfortunate coincidence, just at this time news of the fall of Tabriz to Nadir Khan reached Istanbul. Only the previous month, the Ottoman commander of the fortress of Hamadan had deserted his post; now the commander of Tabriz was reported to have done the same. As rumours that the campaign was about to be called off ran through the capital, the army remained immobilized at Üsküdar – neither Sultan nor Grand Vezir seemed eager to provide leadership, both withdrawing from the mustering-ground to their palaces on the Bosporus. Such was the level of public discontent that they then feared to leave the city, for it was certain that an uprising would follow. Clerics and janissaries alike nursed their grievances

against Nevşehirli Damad İbrahim Pasha, the former on account of his nepotism, the janissaries because not for the first time they found it difficult to adapt to change, and to the new climate of diplomacy and conciliation with an erstwhile enemy.[117]

Still the army waited at Üsküdar, increasingly restive, and having received little reassurance that any attention had been paid to the essential logistical underpinnings of the campaign. The tradesmen and artisans were particularly aggrieved. From earliest times Ottoman tradesmen had accompanied the troops on campaign, taking their wares with them to sell. This year, however, they fell victim to an onerous tax of recent invention: they were required to pay a levy on what they expected to earn on campaign, and at a rate which they considered excessive; the tax proved the more injurious since no one was buying – the tradesmen had invested in goods to sell to the soldiers, but found no customers.[118] On 8 September the Sultan roused himself from his torpor to announce that the Grand Vezir would lead the army on campaign.[119]

There were many in Istanbul who had reason to be unhappy with their lot, but the protagonists of the uprising that began on 28 September 1730 were a motley crew of tradesmen and former soldiers, numbering some 25–30 men in all. Some had taken part in earlier disturbances, such as that at İzmir in 1727–8, a harbinger of the troubles which now beset Istanbul. Their initial attempts to rally support in the bazaar and from the janissaries met with only limited success, and European observers in the city at the time agreed that the uprising could have been suppressed had it been stamped on at once. When news of it reached the Sultan he summoned his advisers to his palace in Üsküdar; the same evening, in great fear and trepidation, the Sultan and state dignitaries crossed the Bosporus under cover of darkness to the greater safety of Topkapı Palace – but they could reach no decision on what action to take.[120]

The next day was Friday, the holy day on which it was customary to express grievances and political protest after the midday prayer. The rebels had grown bolder now; at first it was the dispossessed, those for whom there was no place in the life of the city, who joined the swelling crowd, but the janissary rank-and-file were soon persuaded to align themselves on their side. However, as so often in the past in cases of rebellion, the rebels felt the need to grace their deeds with legal sanction, and soon obtained a juridical opinion from a biddable, low-ranking cleric who was willing to endorse their actions. Unable to trust his troops, the Sultan sent some officers of the palace to enquire of the rebels what their grievances were, and to order them to disperse. They refused, demanding that 37 officials be handed over to them to answer charges: the wanted men included the

Grand Vezir and one of his sons-in-law; the other, the Grand Admiral, had shown some sympathy for the plight of the rebels.[121] This rebellion followed the usual pattern, its participants making no clear statement of their grievances, demanding only to lay their hands on the Sultan's men.

The Sultan set up the Prophet's sacred standard and called upon all God-fearing Muslims to rally to it, a ruse successfully resorted to by his grandfather Sultan Mehmed IV at the time of the 1651 uprising in Istanbul. On this occasion it was of no avail, and the rebels repeated their demands that Nevşehirli Damad İbrahim Pasha and Sheikhulislam Yenişehirli Abdullah Efendi be handed over to them. Ahmed was reluctant to abandon Damad İbrahim, but there were those around him who thought that the Grand Vezir's deposition would save their own skins. On the third day of the rebellion the rebels cut the water supply to Topkapı Palace and blocked the delivery of food. Chief Black Eunuch Hacı Beşir Agha caused the Grand Vezir's seal of office to be taken from him by force, and the Sultan had no other recourse than to order the execution of Damad İbrahim and both his sons-in-law – the reason why both were by now targets of rebel wrath is unclear. Damad İbrahim had alienated many in government circles, and at this time of crisis discovered that he could not count upon even his closest allies. When it was learned that the rebels were attacking the palace, a hasty inventory of the condemned men's estates was made and the sentences were carried out. The three bodies were delivered to the mob, who displayed them in the city. There was some confusion as to whether one was indeed Damad İbrahim's corpse, or whether he remained hidden in the palace.[122]

Despite the murder of Damad İbrahim Pasha and his sons-in-law, the crowd still did not disperse. Now they demanded the removal of Sultan Ahmed himself. When informed of this ultimatum, the Sultan calmly went to Mahmud, son of his brother Mustafa II, brought him and his own two eldest surviving sons Süleyman and Mehmed out of the *harem*, and ordered the palace officials to swear the oath of allegiance to Mahmud as his successor. This orderly handover of the sultanate was mirrored in the city, where there was remarkably little material damage and, since Sultan Ahmed had no trustworthy troops to call upon to put down the rebellion with force, scant loss of life.[123] One of the most eminent victims of the uprising was the Ottoman envoy who had visited Versailles, Yirmisekiz Çelebi Mehmed Efendi: like others associated with the regime of Ahmed III he was distanced from court; he was exiled to Cyprus, and died in 1732.[124]

The rebels formed a parallel administration by nominating their own candidates to fill the state offices made vacant by the removal of Ahmed's closest advisers. The new sultan warily issued an invitation to the rebel leader, one Patrona Halil (an Albanian after whom the uprising came to

be called – his epithet derived from a ship on which he had once served), to state his grievances at the palace. In response, the Sultan abrogated some of the taxes imposed by Nevşehirli Damad İbrahim Pasha; but calm was not so easily bought. One of Damad İbrahim's economies had involved reducing the number of supernumeraries in the sultan's troops – the rebels now opened the rolls to any who wished to enlist, and thousands did so, undoing Damad İbrahim's good work. A witness to these events of whom nothing is known but his name, Abdi, wrote that 'however many people there were in a household – female, male, bastards in the womb – all were individually registered and then signed-up to the sultan's troops; thus the public treasury was robbed'. By comparison with the few days leading up to the deposition of Ahmed III, the situation was now far more dangerous, for real authority in Istanbul and at the heart of the state now lay in the hands of Patrona Halil and his associates.[125]

Patrona Halil presented himself as a man of the people, as well as their protector, and the Ottoman establishment was deeply offended by his uncouth appearance. At the customary ceremony in Eyüp at which the new sultan was girded with the sword, he rode before Sultan Mahmud in the procession in simple clothes and with bare feet. The Sultan's mother was beguiled by his Rasputin-like charms, referring to him as 'my second son' and showering favours on him when he visited her palace. The streets were thronged with his partisans and appointees, who were appeased with hand-outs from the treasury. Eight days after Mahmud came to the throne, he deemed it time to restore order. A compromise was reached: the crowds agreed to disperse on the understanding that no one would be punished for their part in the rebellion, and that the rebels were allowed to keep a small force under arms. But their parallel administration successfully interfered in the process of appointing his own men to state office which was the prerogative of a new sultan: the rebel leaders had not previously aspired to the highest positions themselves, but now began to see their formal integration into the state apparatus as their only hope of salvation and demanded the right to make such appointments themselves. Patrona Halil himself, apparently eager to return to sea, wanted to be grand admiral.[126]

A month after the revolt began, tensions between the rebel leaders and the janissaries became apparent – and the murder of a janissary officer on 5 November clinched it. The palace found itself of one mind with the janissaries in wanting to put an end to the reign of the plebeian, and public opinion, too, was at last turning. In secret meetings the government decided that open suppression of Patrona Halil and his associates was out of the question, since it might increase their following. Aware that a plot was being formulated, the rebel leaders made it known that if war was

declared on Iran or Russia, they would leave Istanbul for the front. But this was unacceptable to Mahmud's government, and a more elaborate solution was planned: Patrona Halil and the other leaders, about thirty men in all, were invited to attend a meeting at which, they were told, their demands for government office would be met. As they arrived at the palace they were divided into small groups and as they waited – so they thought – for the Sultan to award them the robes of honour to mark their appointment to the posts they had been promised, first the ringleaders and then the rest were murdered by the Sultan's men. The waiting crowd began to wonder what had happened when none returned from the audience, until they saw the bloody bodies of the rebel leaders being brought out from the palace. This was enough to sap the courage of those who still entertained hopes that their cause would triumph, and many fled the city or disappeared from sight. The Sultan issued orders that any rebels who had fled were to be apprehended wherever they might be found. The French ambassador, the Marquis de Villeneuve, estimated that more than a thousand people were killed during the four days following the massacre in the palace.[127]

The chronicler Şemdanizade ('Son of the Candlestick Maker') Fındıklılı Süleyman Agha was no more than a child when these events took place and must have heard them retold by his father who worked as a state official; he especially mentions one Kabakulak ('Swollen-eared') İbrahim Pasha, a man who had gained a reputation for ruthlessness during his many years of service in Egypt, as having been largely responsible for putting down the Patrona Halil rebellion, comparing him to two earlier grand vezirs: Kuyucu Murad Pasha,[128] who achieved military success against the revolt of Canbuladoğlu Ali Pasha in Syria in 1607 and against the Celalis in 1609, and Tabanıyassı Mehmed Pasha, who suppressed the Istanbul uprising of 1632. Kabakulak İbrahim was grand vezir for a few months from January 1731, but was dismissed in the autumn of the same year.

Many of the rebels escaped retribution and in March 1731 avenged the death of their comrades by looting the city before marching on the barracks of the janissaries and the sultan's other regiments, then on to the palace. The witness known as Abdi noted among those now joining the protest recent arrivals in Istanbul whom he evidently considered to be the dregs of society – Laz (from the eastern Black Sea), gypsies, Armenians, Ottoman Greeks, Jews, Kurds, Bosnians, Anatolian Muslims (Turks), and unsophisticated Muslims from the Balkans.[129] This time, however, the sacred standard worked its magic: many rallied to it at the Sultan's call, and the rebels were unable to rouse any support among the people of the city. When a shot from a firearm hit the standard, the crowd turned on the rebels; those

bringing severed heads to the palace as evidence of rebels killed were richly rewarded.[130]

Except in cases where populations were relocated at the direction of the state, it had always been Ottoman policy to discourage migration because land without people to work it did not contribute to state revenues. The Patrona Halil rebellion seemed to demonstrate a further disadvantage of the uncontrolled movement of people – that migration into Istanbul had severe social consequences. Migrant Albanians were blamed for inciting the unrest in 1730, and their role officially noted in edicts subsequently sent to the military and civil authorities in the western Balkans; following a minor uprising in Istanbul in September 1731, the authorities were strictly enjoined to prevent further migration. Patrona Halil was Albanian – it is unclear how many of his fellow rebel-leaders shared his origins, but Albanians in general made convenient scapegoats. A further crackdown in 1734 admonished the authorities of the villages on the northern shore of the Sea of Marmara to ensure that any Albanians – Muslim or non-Muslim – trying to reach Istanbul illegally by water be denied a boat, and be sent bound to Istanbul.[131] Thus had the city's needs changed over time: Sultan Mehmed II had encouraged, indeed required, provincial populations to move to Istanbul to make it a flourishing imperial capital; Sultan Mahmud I introduced stringent regulations to keep people from the provinces out of the city, but was unable to enforce them effectively.

Anatolia could not remain untouched by the human consequences of the wars of this period: whereas in the Balkans the outcome was migration to Istanbul, provoked by the redrawing of the borders of the empire, Anatolia was once more affected by the ravages of a disorderly soldiery. The most undisciplined units of irregular troops had been ordered to disband following the end of the war with Austria and Venice in 1718,[132] but the Iranian war of the 1720s gave them a chance to reassemble; Silahdar Fındıklılı Mehmed Agha articulated the view prevailing in ruling circles when he described the Anatolian provinces as the 'lair of brigands'.[133] Anatolia was hardly sharing in the economic growth which was bringing prosperity to some, and the plight of those in rural areas was becoming steadily worse. The inspiration behind the introduction of life-term tax-farming in the empire's eastern provinces had in part derived from the need to revitalize agriculture, but most of Anatolia was not initially included, probably because it was not anticipated that these provinces would attract bidders. There was some life-term tax-farm investment in western Anatolia in 1703, but only 5 per cent was in village lands.[134] The failure to attract investors to bid for the title to agricultural lands offers some clue to rural conditions at the time.

Nevşehirli Damad İbrahim Pasha's government had been well aware of the distress being experienced by the people of the Anatolian provinces, and had by no means neglected them. Efforts to assuage rural misery by enabling people to make a living lay behind the establishment of new settlements or improvement of those existing, especially along the pilgrimage route through south-eastern Anatolia where security had long been a problem. Caravansarays were built or rebuilt, with villages around them in which tribesmen or villagers from particularly poor areas were resettled, a policy that continued into Mahmud I's reign, and beyond.[135] The most ambitious of Damad İbrahim's projects was the transformation of the central Anatolian village of Muşkara, where he was born, into the town of Nevşehir ('New City') (today, the administrative centre for the tourist region of Cappadocia). Here he built two mosques, a theological college, a soup-kitchen, a school, a library, a covered market, two bath-houses and eight fountains, which still form the commercial heart of the modern city.[136]

Far to the east and south of Istanbul, beyond the core territory of Anatolia, were the Arab provinces of the empire. They had become part of the Ottoman realm at various dates during the sixteenth century, and most were initially administered according to a law-code tailored to local customs and conditions under a governor exercising authority in the sultan's name. Two systems of land-holding prevailed: in the province of Mosul, and in the Syrian provinces of Aleppo, Damascus and Tripoli, for instance, land-grants were awarded in return for military service as in most of Anatolia and the Balkans; and in Basra, Baghdad, Egypt and Habeş, for instance, and in the north African coastal provinces of Algiers, Tunis and Tripoli, which were only loosely connected to the centre, tax-farming predomi-nated. In addition to these two systems, significant territory remained under the control of tribal chiefs – such as the Kurdish chiefs – who, although also subject to some central regulation, enjoyed a greater measure of inde-pendence than other land-holders. Over time the methods by which these provinces were governed – like other provinces formed as territorial conquest allowed, and as administrative priorities evolved – might diverge radically from the model imposed on conquest, but what they always had in common was that the degree to which central control was enforced waxed and waned, as locally-based groups accumulated – or temporarily relinquished – power at the expense of Istanbul.

Egypt was the largest province of the empire and, from its strategic loca-tion on the main trade routes, the richest. It also had a special place in the empire, owing to its responsibility for ensuring the smooth functioning of

the pilgrimage and supplying grain and financial support to the Muslim Holy Places. Customs dues contributed the greatest share of the revenue of the Egyptian treasury, and its agriculture and its towns thrived under the Ottomans; after meeting local expenses including, most notably, those of the annual pilgrimage to Mecca, a surplus was sent each year to the central treasury in Istanbul. There were inevitable problems associated with the grafting-on of the alien Ottoman regime to that of the defeated Mamluks, but Ottoman rule in Egypt was fairly stable until the latter part of the sixteenth century, a period marked by a rash of rebellions against the governor's authority.[137] During the seventeenth century the tensions inherent in the conflict between central and local interests were played out in a series of factional struggles for control of the lucrative posts of provincial treasurer and commander of the pilgrimage, and the role of the Istanbul-appointed governor was reduced to that of a mediator between the factions. The attempt by the Köprülü vezirs to strengthen central authority in Egypt was short-lived,[138] and by the early eighteenth century the janissaries – some of them on temporary assignment from the sultan's regiments, others of local origin – were the strongest power in the province, fully integrated into the networks of tax-farming and household-based politics which were the route to wealth and power. In 1711 a particularly bloody revolt rooted in a janissary struggle erupted, drawing in the dominant households of Fiqari and Qasimi, competitors for control of the rich grain trade of Upper Egypt. The favoured Ottoman tactic of divide and rule failed to restore equilibrium: in 1730 these rival factions were again in open conflict, and in 1736 the Ottoman governor had many leaders of the Fiqari murdered.[139]

A prominent challenger of the writ of Istanbul was Çerkes Mehmed Bey, who became leader of the Qasimi faction in the 1720s but was driven from Cairo by the leader of the Fiqari; he took ship across the Mediterranean to Trieste, and sought refuge at the Habsburg court – denied him following a strongly-worded letter from the Sultan to the Emperor. He fled back to Tripoli on the north African coast. The mere act of seeking sanctuary with the Sultan's enemy was enough to have Çerkes Mehmed branded a traitor, and orders went out through the Muslim world for his capture and execution. The vehemence with which they were phrased testifies to the added severity with which an attempt to solicit such help from a foreign power was viewed by the Ottomans. In the event, Çerkes Mehmed managed to re-enter Egypt, and was reported to have drowned in the Nile mud while fleeing his Fiqari adversaries.[140]

As long as the province's military and financial obligations were met and local disturbances did not get out of hand, the central government allowed the notable families of Syria, too, latitude in their affairs. Many thousands

of the faithful crossed Syria each year on the pilgrimage, and their security was a mark of the sultan's legitimacy in the region. During the 1690s local officials proved inadequate to their responsibilities in this respect, and the case for a reorganization of the province became inescapable. In 1708 one Nasuh Pasha was appointed governor of the province of Damascus and commander of the pilgrimage, which from this time on was subject to direct supervision by Istanbul. But Nasuh Pasha's considerable skills as an administrator were outweighed by his propensity for self-aggrandisement, and by 1713 members of his household held most of the sub-governorships in Damascus; this was too much for Istanbul – an army was sent against him from Aleppo, and he was killed. The al-'Azm family held the governorship on several occasions during the rest of the century, benefiting financially from this political-administrative role.[141] Other prominent families were the Ma'n and Shihab in Mount Lebanon[142] and the Zaydani in Galilee.[143] Sheikh Zahir al-'Umar was a leading Zaydani tax-farmer who held sway in the coastal province of Sidon, where he grew rich following the growth in trade during the first half of the century, monopolizing the cotton market. In the 1740s he secured the customs revenues of Acre, thereby formalizing his position as the most powerful magnate of the area.[144]

In 1720 Sultan Ahmed III ordered the restoration of the Dome of the Rock and the al-Aqsa mosque in Jerusalem, together with that of some dozen other Muslim shrines in the area which had received little attention since the time of Sultan Süleyman I. The European states had vied for authority over the Christian Holy Sites in Jerusalem and Bethlehem during the negotiations which culminated in the Treaty of Karlowitz of 1699, and while authority over these shrines was still technically in the gift of the sultan, in practice he was now more than ever constrained by diplomatic considerations. It may be that behind Ahmed's repair programme lay a wish to signal Ottoman interest in the Muslim sacred monuments, as a counter to the heightened interest of foreign powers in the Christian shrines; the repair of the Muslim shrines, like the government's attempt to improve administration in Syria, was a gesture aimed at reinforcing the loyalty of local Muslims and further restoration of Muslim shrines in Jerusalem took place under Mahmud I in 1742 and in 1753–4.[145] By Sultan Mahmud's time, the audience at whom these appeals were directed was, increasingly, the local magnates on whom the central government depended for the smooth functioning of Ottoman administration in outlying regions of the empire like the Syrian provinces.

As in Egypt and elsewhere, the Damascene military establishment included many janissaries of both central and local origin. These two corps coexisted unhappily in the garrisons of the province and in 1740, when tensions

became too great, those of the central forces were withdrawn from the city of Damascus for six years. A third group with which the central state had to deal were the Bedouin tribesmen, and these it continued to seek to contain by a policy of settlement reinforced by a degree of incorporation into the local administration, especially by means of employing them to protect and supply the pilgrimage caravans.[146]

The Ottoman Empire's north African provinces of Algiers, Tunis and Tripoli usually received even less attention than Egypt and Syria from central government. In the sixteenth century they had played an essential role providing bases for the naval forces fighting on behalf of the Ottomans against the Spanish Habsburgs; during the seventeenth century, they were left largely to their own devices but from the early eighteenth century the three provinces were ruled by officials descended from men who had seized control locally and established dynasties recognized by Istanbul – with occasional reminders that these provinces were part of the empire. The increased reliance on diplomacy that marked the eighteenth century impinged upon life in these provinces because the main source of their revenue – privateering – was proscribed once Sultan Mustafa II had agreed to guarantee the safety of Christian shipping from corsair attack. Skirmishes between the corsairs and Spanish vessels continued through the century, and the Ottoman government was rarely able to exert influence on the unruly seafarers who were theroretically the sultan's subjects. When circumstances demanded, the sultan could bring his will to bear in these provinces – but it required continual effort. By the terms of an Austrian–Ottoman navigation convention of 1727 the Ottomans undertook to ensure that Habsburg shipping was protected from the corsairs of their north African provinces, and when, between 1729 and 1731, the Algerian ruler allowed his ships to attack Austrian shipping in the Mediterranean, sanctions were applied to make him see sense – among them the denial to the province of military and financial assistance, the closing of Ottoman harbours in the eastern Mediterranean to Algerian shipping, and prohibition of recruitment of Anatolian manpower to the Algerian army and navy.[147]

The seventeenth-century Russian statesman Afanasii Ordin-Nashchokin had proposed three main strategic goals for an expanding Muscovy. The first was to reach the Baltic, the second was to reunite the Belarussian and Ukrainian lands and bring them under Muscovite rule, and the third was to open Muscovy to the Black Sea.[148] Access to the Baltic had been won by Peter the Great, while the incorporation of Belarussia and Ukraine would not be entirely achieved until 1795 with the Third Partition of Poland; as the modest Muscovite state began to evolve into the Russian Empire, however, the

Ottomans now found themselves hard-pressed to prevent the third, Russian access to the Black Sea and the warmer waters beyond. In 1726 Russia and Austria concluded a mutual defence pact – Russia wanted assistance against the Ottomans, Austria against its old rival France and the emerging power of the kingdom of Prussia – and it served both sides well in 1733 when Russia intervened to secure the Polish throne for its preferred candidate, initiating the War of the Polish Succession which convulsed western Europe for the next two years. The Polish-Lithuanian Commonwealth's weakness diminished the chances of an attack on Russia's western frontier, and it seemed the time was ripe for a new stage of Russian southward expansion. In May 1735 Russia declared war on the Ottomans, and in July 1736 took the Crimean capital, Bakhchisaray; the Black Sea fortress of Kinburun, on a sand spit opposite Ochakiv at the mouth of the river Dnieper, also fell to them, and was razed. In July 1737 they took Ochakiv itself, and an Ottoman attempt to retake the fortress in October failed because of torrential rain, desertion, and insufficient effort on the part of the Ottoman fleet. Russia's further ambitious plans foundered on their continuing inability to overcome the logistical demands of campaigning in the steppe region; their only other success was the recapture of Azov, which they had forfeited in 1713 by the Treaty of Adrianople. Peace negotiations held in 1737–8 came to nothing. Russia's demands reflected its long-term aims: it claimed the Crimea, the Kuban steppe, and the Black Sea coast from the Dnieper west to the Danube; it further demanded the independence under Russian protection of areas where there were large numbers of Orthodox Christians – in Moldavia and Wallachia, along the Danube, and around the northern shores of the Black Sea – the first assertion of Russian claims to Ottoman territory on the grounds of the inhabitants' religion. Campaigning continued in 1738, extending to the western Black Sea region, but soon ended in a stalemate.

The mutual defence pact with Russia had dragged Austria into the war in 1737. The Ottomans sought to protect themselves from these two formidable opponents by means of agreements with Sweden in 1737 and 1739 – the latter included a mutual defence pact against Russia.[149] The war was a disaster for Austria, and by 1739 it too was ready for a respite. Under the terms of the Treaty of Belgrade – negotiated with French mediation and concluded in the same year – Austria lost Belgrade and most of the territory gained in the Treaty of Passarowitz some twenty years earlier. Russia sacrificed all its conquests except Azov; it had lost some 100,000 men during the war, mostly from sickness exacerbated by the meagre diet on which its troops were forced to subsist.[150] The resolve of the Sultan's negotiators over the matter of who should possess Belgrade was an important element in ensuring the favourable outcome for the Ottomans of the peace

treaties that ended this war.[151] French mediation put the Ottoman Empire in the debt of France, and for the first time France did not have to accept a gracious bestowal of trading privileges from the sultan, but was in a position to demand them – a new treaty was agreed in 1740. As it happened, the impossibility of controlling the volatile and poorly-coordinated Ottoman market meant that France was unable to take full advantage of its new privileges, but nevertheless the fact remained that a foreign power was no longer a supplicant to the Ottoman sultan in commercial affairs.[152]

While Central Europe was plunged into two vicious conflicts sparked by the expansionist policies of Frederick the Great of Prussia – the War of the Austrian Succession (1740–8) and the Seven Years' War (1756–63) – on the northern and western frontiers of the Ottoman Empire a long period of peace followed the wars with Russia and Austria. Things were different in the east, however. The Ottomans had enjoyed almost a century of peace with Iran, as a result of the stability of the late Safavid period, until the appearance of Nadir Khan. Having captured Tabriz in 1730, he besieged Baghdad for several months in 1733, and forced the Ottomans to enter into peace negotiations. Because their bargaining power was circumscribed by Nadir Khan's treaty of alliance with Russia in 1735 and their own defensive need to counter the Russian push southwards, the Ottomans thought that the best they could expect to salvage was a settlement imposing a return to the borders of 1639. In 1736, as the Ottomans defended themselves against the Russian advance on the Black Sea, Nadir Khan declared himself the first shah of the Afshar dynasty; he followed this with proposals for redefining the character of Iranian Islam so that the Twelver Shiism adopted around 1500 as the religion of the Safavid state by its first shah, Isma'il, would now be considered a fifth school of Sunni Islam, alongside the four long-established schools – Hanafi, Hanbali, Shafi'i and Maliki. The Ottoman negotiators were nonplussed: there were no precedents to assist them in arriving at a decision on such a radical suggestion and, despite Nadir Khan's supplicatory and co-operative stance, they rejected his request. Fortunately for the Ottomans, Nadir soon turned east to pursue his conquests against the Afghans, the Mughals of India and the Özbeks of Transoxiana, his career reminiscent of that of Tamerlane, three and a half centuries before.[153]

The return of Nadir Shah to Iran in 1740 directly affected Ottoman strategic interests in the region. His demeanour towards his western neighbour was more aggressive now, and he reasserted his proposal for the reorganization of religion – but it was still unacceptable to the Ottomans. Campaigning first in the Caucasus, he went on the offensive and by 1743 was in Iraq, where he besieged the fortress of Mosul which the Ottomans could hold only with great effort, and in 1745 marched on Yerevan.[154] In

Istanbul there were fears that another rebellion might ensue, and new controls on public assembly were introduced, relaxed only in 1746 when an Ottoman–Iranian peace treaty was at last achieved.[155] Both sides were ready for peace: the Ottoman–Russian war had taken its toll, and Nadir Shah had now dropped his proposals concerning religion. The latter were not without effect, however, for the 1746 treaty established a completely new basis for relations between the Ottomans and Iran, the essence of which was that Iran was no longer to be considered a pariah state of Shia heretics, against which Ottoman aggression could always be justified by sophistry, but was to be accepted as a fellow Muslim state on an equal footing with all other Muslim states – a compromise clearly to the advantage of both Ottomans and Iranians.[156]

The first decade of Sultan Mahmud's reign was spent in not altogether successful attempts to grapple with the frustrations that had produced the 1730 rebellion. Successive Ottoman governments were well aware of the consequences of shortages, so that ensuring adequate food supplies for the people of Istanbul was always a prime concern. The Venetian blockade of Istanbul in the 1650s had caused anxiety, but the accelerated migration to the city in the eighteenth century brought problems of a different order. The immediate aftermath of the 1730 rebellion saw the Sultan write to officials in İzmir of food shortages and plague in the capital.[157]

Migration could be tackled at source as well as in the migrants' destination of Istanbul. In 1740, following the war with Austria and Russia, and at the start of a new period of hostilities with Iran, demobilized irregulars were again running amok in Anatolia and government forces were ordered to attack them if they continued their insurgency.[158] The same year a decree directed at secular officials ordered them not to make overly onerous or illegal exactions from the tax-payers of Anatolia. The underlying purpose of these decrees was to prevent further movement of people to Istanbul[159] which was what alarmed the Sultan and his vezirs most of all. On 6 June 1740 an incident in Istanbul that began with a crowd looting shops soon snowballed into cries for an uprising. As at the time of the 1730 rebellion, neither the Sultan nor the Grand Vezir was in evidence and the initiative lay with the janissary officers, who prevented the unrest from spreading, but bloodily. The city was searched for those considered to be implicated: Albanians were again the prime suspects, and those who had lived in Istanbul for less than ten years were ordered to return whence they had come. The British ambassador put the death toll resulting from these events at 3,000.[160] There were disturbances in Istanbul again in May 1748, and again they were violently suppressed; more deportations followed, and a near-complete

ban on migration was introduced, but despite the severe penalties for infringement[161] there is ample evidence that migrants, including Albanians, were present and earning their living quite peacefully in Istanbul around the middle of the century.[162]

Yet the wars and uprisings which punctuated the era – and the social consequences they brought in their wake – did little to dent the confidence of the Ottomans. Though domestic peace was only an illusion during the middle years of the eighteenth century, it was a period of consolidation for the social order that had been establishing itself since the early years of the century. The revival of architectural patronage on the part of the sultan and his family begun during Ahmed III's reign continued alongside that of the grandees, and pleasure palaces, libraries and fountains remained the dominant forms – Ahmed's fountains outside the walls of Topkapı Palace and at the landing-stage at Üsküdar are among the most imposing monuments of Istanbul. Mahmud had symbolically dissociated himself from the 'Tulip Age' at the start of his reign: within three days of his accession he had ordered its most potent symbol, the palaces at Sa'dabad, to be razed by their royal and grandee owners.[163] This was not the end of Sa'dabad, however: in 1740, an officer belonging to the embassy sent from Vienna to ratify the 1739 Treaty of Belgrade made a series of drawings of the palace as he saw it when the ambassador's retinue was entertained there by the Sultan and his vezirs. From these it is clear that much had survived the events of 1730; documentation still exists of the repairs which restored the palace to its former splendour, and made Sa'dabad once again the scene of pageantry.[164] In 1743 the Sultan ordered repairs to the marble basins of the water cascades[165] which had given Ahmed III's playground its unique character.

It was almost 150 years since a sultan had last sponsored the building of a new and impressive mosque complex, that of Ahmed I early in the seventeenth century; Mahmud's – named the Nuruosmaniye, or 'Light of Osman', named for his successor who completed it in 1755 – was situated at the entrance to the Covered Bazaar.[166] The mid-eighteenth century was also a period of mosque-building in the provinces – in the cities of Aydın and Erzurum, for instance.[167] Mahmud I continued the work his predecessor had begun in providing the ever-growing population of Istanbul with a new system of dams and aqueducts in the Belgrade Forest, north-west of Istanbul,[168] to bring water to the fountains which were springing up on every corner; Mahmud's most striking fountain was (and is) on the south-west corner of Taksim Square in Istanbul. *Taksim* means 'distribution', and it was to this point that waters from the countryside were channelled for distribution to the inhabitants of the Ottoman capital, which was expanding

as never before – the wall on the west side of Taksim Square conceals the water distribution pipes.

Mosque complexes had always included libraries but during the eighteenth century libraries increasingly became independent structures designed expressly to house manuscript collections – Fazıl Ahmed Pasha had been the first patron of a purpose-built library.[169] Sultan Ahmed III and his circle had founded many libraries, a tradition continued by Mahmud and his court, both in the provinces and in Istanbul. The golden pickaxe with which Ahmed turned the soil for the foundations of his library in the third court of Topkapı Palace was said to be the same one his great-grandfather Sultan Ahmed I had used when initiating the building of his imperial mosque in 1609.[170] The pickaxe was until recently exhibited in the library,[171] and the priceless manuscript collection of Ahmed III and his successors is now housed in the nearby mosque first established in Mehmed II's reign, where it is available to scholars.

The Ottoman literate were afforded a new experience during the 'Tulip Age' with the establishment of the first Arabic-script printing press in the empire in 1727. Printing had had a chequered history in the Ottoman Empire. Jewish refugees from Spain and Portugal had brought this relatively new technology with them when they settled in Istanbul and elsewhere in 1492, but according to contemporary Jewish sources, Sultan Bayezid II soon banned all printing and his order was reiterated by Sultan Selim I in 1515 – the crime was punishable by death. Thereafter, the production of printed books for the Armenian, Greek and Jewish communities of the empire was not without problems – at some time in the sixteenth century Jesuit missionaries in Istanbul banned the operation of a press run by a Cephalonian bishop in Istanbul, while in 1698 an Armenian press was destroyed by the janissaries.[172] The seventeenth-century Ottoman chronicler İbrahim of Peç, a Hungarian by origin, had wondered why printed books were not available to readers of the Arabic and Ottoman languages, and it was a fellow countryman of his, İbrahim Müteferrika (who had arrived in Istanbul as a slave and was appointed translator to Francis Rákóczi during his exile in Tekirdağ), who took the initiative and set up the first press. He began by printing maps, and in 1726 submitted a treatise detailing his project to Grand Vezir Nevşehirli Damad İbrahim Pasha. The juridical opinion of the Sheikhulislam was favourable, and the Sultan's blessing followed.[173]

The order which Sultan Ahmed addressed to İbrahim Müteferrika and his partner in the enterprise, Yirmisekiz Çelebi Mehmed Efendi's son Mehmed Said Efendi (who had accompanied his father on his embassy to France in 1720), made it clear that the Sultan did not find it difficult to

justify the introduction of printing. Since the dawning of the Islamic era, he wrote, the doctors of religion had produced many books of various sorts, from Korans to dictionaries, but

> Because most literary works have perished or been lost with the passage of time and the conflicts of the years, and in the rebellions of Genghis Khan, the Troublemaker and Hulagu Khan, the Undiscerning [this refers to Genghis Khan's grandson who sacked Baghdad in 1258], and the occupation of the land of Andalusia by the dissolute Franks [this refers to the expulsion of the Muslims from southern Spain from the late fifteenth century], and in other wars and massacres and in conflagrations, lexicons and works of onomancy [i.e. divination from names] and Arabic grammars and dictionaries and history books and substantial volumes of copies of the Traditions of the Prophet and great essential works are rare today in the lands of Islam; and furthermore clerks and copyists are lethargic and lack zeal, and what they write is not without errors and blunders.[174]

The innovation of printing in Arabic characters had mixed fortunes after a promising start. In partnership with Mehmed Said Efendi – who since his visit to France with his father in 1720 had visited Sweden in 1733 in pursuit of the money owed by Charles XII to the Ottoman treasury – İbrahim Müteferrika printed seventeen books before his death in 1745. Most were Ottoman chronicles, but there were also an Arabic–Ottoman dictionary, a Persian–Ottoman dictionary, an Ottoman–French grammar, and a history of Afghanistan (the Sultan had banned the printing of religious books in order that scribes should not be put out of business).[175] The Müteferrika press operated only sporadically after its founder's death and was eventually closed down in 1796–7, having printed only 24 titles (most print runs numbered 500 copies) in its 64 years of existence. Its demise seems not to have been a consequence of overt opposition to printing in Arabic characters, but rather to a lack of interest among the small number of those who could read,[176] who seem to have preferred the more sensuous pleasures of manuscript books.*

The way those who wielded power in the Ottoman Empire responded to the new influences of the eighteenth century is usually illustrated by accounts

* The market for printed books in Peter the Great's Russia had also been less than buoyant, despite his personal enthusiasm for the printing press and his realization of its power to educate and reform. He encouraged the publication of books of all sorts, from histories to instruction manuals to law-codes to belles-lettres; this was in stark contrast to the situation before his time, when between the establishment of the Moscow printing press in the 1560s and the start of his reign, only three books that were 'not specifically religious' in character were published (Hughes, *Russia in the Age of Peter the Great* 316–25).

of various people considered by modern writers to have been agents of change. Yirmisekiz Çelebi Mehmed Efendi and his fellow ambassadors formed one such group, while the printer İbrahim Müteferrika represented another. The advisers who brought the latest European military methods to the Ottomans made up a third group, epitomized by the French renegade Comte Claude-Alexandre de Bonneval, who had fought alongside Prince Eugene of Savoy when the Habsburgs defeated the Ottomans at Petrovaradin in 1716, and then in 1729, having fallen out with Prince Eugene, sought asylum in the Ottoman Empire. The Ottomans were aware that changes in methods of waging war had tipped the balance against them, and one of the first works published by İbrahim Müteferrika's press after the accession of Sultan Mahmud I in 1730 was a pamphlet on military organization written by Müteferrika himself.[177] The next year Mahmud invited Bonneval to Istanbul and encouraged him to initiate the modernization of the army. Humbaracı ('Bombardier') Ahmed Pasha, as he was known in his adopted land after his conversion to Islam, wrote a treatise recommending the adoption of western methods by the army, emphasizing in particular the need for improved training. Though his efforts were undermined as much by the French ambassador (who saw him as a turncoat) as by squabbling vezirs, he succeeded in reorganizing the corps of bombardiers and was involved in the modernization of the imperial cannon and weapons foundries and of gunpowder production. The school of military engineering he founded in 1734 was closed in 1750, however, as a result of clerical pressure, and janissary opposition put paid to his plans to enlarge the bombardier corps.[178]

The changes which occurred in the Ottoman Empire in the first half of the eighteenth century were complex, and the life-stories of prominent men such as these who took advantage of what the modern world had to offer go only part of the way to explaining them. The relative tranquillity of relations between the empire and other nations at mid-century can in part be attributed to the calibre of the statesmen who held office during these years. This was an interlude during which there was a better chance than hitherto that international misunderstandings and disputes could be resolved through diplomacy rather than war, a trend manifest in the downgrading of the military to the advantage of the administrative profession, the inevitable outcome of the longer-term transformation of the empire from a militant state to one more concerned with defence. A career in the upper reaches of the Ottoman administration now brought a man greater prominence than one in the army; military heroism was now exemplified by the stubborn defence of a beleaguered fortress rather than the triumphant occupation of new territories.

The growth of diplomacy as a means of resolving differences brought

greater prominence to the chancellor, whose responsibilities had evolved to include the all-important area of the conduct of foreign affairs. The Ottoman negotiator at Karlowitz, Rami Mehmed Pasha, was chancellor for a total of almost eight years before reluctantly and briefly serving as grand vezir, and the career of Koca Ragib Pasha followed a similar path. Koca Ragib participated in the peace negotiations with Nadir Shah and also those leading up to the Treaty of Belgrade of 1739; he became chancellor in 1741,[179] and was grand vezir from 1757 until his death seven years later. Koca Ragib was also a son-in-law of the Sultan, and thus an early beneficiary of the trend for high-level bureaucrats to be so favoured, which continued until the end of the empire. A further five men who held the post of chancellor before 1768, and the outbreak of a new phase of war with Russia, were subsequently appointed grand vezir – a man of military background was no longer given preference.[180]

Unlike warfare, diplomacy encourages an interest in and knowledge of one's fellows, simply because those responsible for diplomatic relations need a constant flow of information on which to base policy decisions. In the case of the Ottoman Empire, individual embassies such as that of Yirmisekiz Çelebi Mehmed Efendi to France in 1720–1 were one-off opportunities to provide the chancellor's office with description of strange and distant worlds. Many other such reports followed, from Ottoman envoys sent to Russia, Austria, Poland, Sweden and Iran. The customary but irregular exchange of envoys with Mughal India continued, the activities of Nadir Shah in Iran providing the impetus in the 1740s.[181] The conveyance of greetings from a new sultan to his fellow rulers also offered an excuse for an embassy, one accorded all the pomp and circumstance due his representative. In a style that was reminiscent of the reports Venetian envoys to Istanbul had filed on their return home in earlier centuries, Ottoman envoys paid especially close attention to the politics and culture of the countries they visited, and the cultural exchange, in particular, worked both ways – during these years more curious Europeans than ever before travelled both to Istanbul and deeper into Ottoman territory, to see the empire for themselves.

Many in high places who had the means were happy to experiment with ideas and fashions which stimulated their curiosity, but there was no uncritical emulation of the West in Ottoman ruling circles at this time; there are limits to the adaptability and flexibility of every society, and it was never likely that ever-closer Ottoman contact with Europe would result in deep cultural transformation. Historians of the Ottomans have often stigmatized them for a conservatism which declined to embrace western ways, as though the western path to the modern world was so inevitable that all who rejected

it were by definition guilty of opposition to reform and enlightenment. But the janissaries opposed reorganization and modernization for the good reason that it materially threatened their privileged position, while the clerics could see the incipient changes of the time as a challenge to their monopoly of education – a science such as military technology required teachers with a non-traditional education and thus threatened the clerical 'closed shop'. Peter the Great is renowned for his manipulation of the old order for the purpose of dragging his state into the modern world, but this was not the Ottoman way. The eighteenth-century Ottoman Empire may have been fully involved in European trade, but not all the novelties brought back by ambassadors and merchants from the exotic West, whether artefacts or ideas, were likely to take firm root in a state so fundamentally different in outlook from its European neighbours. A need to compensate for the damage inflicted on the self-esteem of the Ottoman Empire by the disastrous wars of the later seventeenth century perhaps lay behind the renewed emphasis on the Islamic quality of the sultan and his realm that ran parallel with the increased consumerism and apparent openness to western ideas that characterized the eighteenth century. Although designed as much for internal as for external consumption, this redefinition of the Ottoman imperial image so evident in the reigns of eighteenth-century sultans was at the same time very much in tune with the spirit of the age, one in which in other states across Europe respect for and adherence to a single officially-defined religion was still a touchstone of loyalty, whether it was Catholic France and Austria, Protestant Britain and Prussia, or Orthodox Russia.

During the eighteenth century the empire was no longer able to choose whether to accept or reject foreign influence, but used the means at its disposal to resist what were deemed its harmful effects. One aspect of the retreat into traditional certainties that accompanied this time of increasing consumption was a renewed emphasis on sumptuary laws as a tool to maintain an ordered society. Military men, bureaucrats, clerics and peasants could be distinguished by their dress, but most striking were the differences in the dress of non-Muslims – regulated in style and colour – that helped to confine them to their appropriate, subordinate place. Like non-Muslims, women were also subject to restrictions on how they could behave and what they might wear, especially in public – they were expected to be untouched by any hint of scandal and anonymous in appearance. During the last decade of Ahmed III's reign the people of Istanbul – and especially women of all classes – enjoyed greater freedom of movement and opportunity to appear outside their homes than ever before, a fact that did not go unrecognized by the authorities. In 1726, at the height of the 'Tulip Age', Nevşehirli Damad İbrahim Pasha acted to shore up the familiar moral order before it was irrevocably undermined,

issuing a set of regulations aimed at curbing the stylish excesses of fashionable female society and reimposing norms of decorum:

> While the government was at Edirne preparing for the approaching military campaign, and occupied with matters of general importance, some good-for-nothing women took the opportunity to embellish and ornament their garb, and behave coquettishly in the streets; they copied the headgear of infidel women in all its strange forms, resulting in many shameful styles completely at odds with chaste observance. They must avoid rending the curtain of honour and disturbing their costume by such shameful acts, and making unsuitable proposals to their husbands and disturbing [man's respect for woman] with evil innovations. Hereafter, women must not go out into the street in a dustcoat with a collar greater in width than a hand-span or a kerchief [composed] of more than three squares (which is the limit of sobriety), with a head-band wider than a finger-breadth, and if they do, their collars will be cut.[182]

These regulations do not seem to have been enforced, however, but subsequent governments did not give up the struggle to confine women to their allotted place in society. Both Mahmud I and his brother and successor Sultan Osman III (1754–7) issued numerous sumptuary regulations designed to reverse the drift towards unseemly deportment among women apparently condoned by their uncle Ahmed III.[183]

Osman's reign, as one modern historian would have it, was memorable for little else than the restrictions he placed on the public life of women and his sumptuary laws affecting both women and non-Muslims; this was certainly one of the cornerstones of his approach to the problem of redefining the dynasty in keeping with the pervading religiosity. Though non-Muslims were less prominent than formerly in the public arena, many had acquired considerable wealth, often through their commercial association with Europeans, and in aspiring to the status enjoyed by similarly successful Muslims were ready to disregard the sartorial markers of their inferior station: the chronicles of the time record numerous hangings, beatings and drownings for infringements.[184] Osman's successor, Mustafa III, added more sumptuary laws of his own, as did Sultan Abdülhamid I who reigned between 1774 and 1789[185] – these impositions carried echoes of the puritanical concerns of the Kadızadelis. The many levels of exchange fostered by diplomacy and trade were matched and counterbalanced by an impulse to protect what was unique to Ottoman political and cultural life, particularly the religious substructure on which it rested, for this, like the temporal power of the dynasty, was in danger of being undermined by the empire's ever closer involvement with Europe.

12

The power of the provinces

THE SECOND HALF of the eighteenth century, from the succession of Sultan Osman III in 1754 to the end of the reign of his cousin Sultan Abdülhamid I in 1789, is one of the least-known periods in Ottoman history. Perhaps the most significant event of Osman's short reign was the great fire of 5/6 July 1756, one of many during the eighteenth century. Beginning in the Cibali neighbourhood on the Golden Horn, it spread through the walled city of Istanbul and, according to the contemporary chronicler Şemdanizade Fındıklılı Süleyman Efendi, raged for 48 hours, reducing 130 theological colleges, 335 mills, 150 mosques, 77,400 dwellings, 34,200 shops and 36 bath-houses to ashes.[1] The next Sultan, Osman's cousin Mustafa, was, until shortly before he came to the throne in 1757, only the second surviving son of Sultan Ahmed III, and there was no reason to expect that he would succeed Osman. But in 1756 Mustafa's brother Mehmed (then almost 40, and barely a few days his elder) was poisoned by Osman and it was only by the exercise of constant vigilance that Mustafa avoided the same fate. No prince had been murdered by a sultan for a century: one of Osman's grand vezirs was dismissed for opposing the murder of Mehmed, another when the deed became public knowledge.[2]

There is a wealth of sources for the second half of the eighteenth century, but most of the Ottoman chronicles are still available only in manuscript, and the rich archival documentation is still largely unread and unevaluated. The life of the senior statesman Ahmed Resmi Efendi, however, provides a glimpse of contemporary shifts in the practice of governance.[3] Ahmed Resmi served with distinction in various chancery posts, and as Sultan Mustafa's envoy visited Maria Theresa's Vienna in 1757–8 and Frederick the Great's Berlin in 1763–4. His reports are wide-ranging and incisive – in the case of his first embassy, for example, he analyses the causes of the Seven Years' War then raging in Europe as well as describing Vienna and the other cities he passed through on his journey. The Berlin embassy was prompted by the possibility of an Ottoman–Prussian alliance. Ahmed Resmi's admiration of Frederick's character shines through his account of their meeting:

Night and day he reads of the deeds and exploits of rulers of the past such as the great Alexander and Timur. He stays far from the troubles and frustrations of his family and does not get involved in matters of religion and creed. All his thoughts and deeds are confined to and expended in pushing back the frontiers of his domains and winning glory and fame.[4]

His implied criticism of recent Ottoman sultans is palpable, as is his dissatisfaction with the Ottoman military machine and his sympathy for the lot of the Prussian infantryman:

Frederick's officers send the rank-and-file soldiers from castle to castle and from guard post to guard post night and day, and at certain times they drill within the city of Berlin or in its environs at special parade grounds. They are taught three hundred at a time to hold a musket, to load and discharge it, to walk close to one another like a wall, and never to break the pattern of their lines whether they are brave or frightened. Night and day the commanders oppress these soldiers, who have their muskets in hand, their bandoliers around their waist and everything precisely in its place; they are in a deplorable condition and treated worse than slaves, with only a crust of bread, sufficient to prevent death.[5]

The Ottomans had been at peace with their European neighbours since 1739. By the mid-1760s Austria was weakened, war-weary, wary of Frederick the Great, and without an ally prepared to back any Austrian adventure against the Ottomans in the Balkans.[6] Peter the Great had bankrupted his country, and it was not until the indomitable Catherine II came to the throne in 1762 that Russia was again in a position to seize the initiative. When Ottomans and Russians next came to blows, their confrontation was of a quite different order from those that had gone before: Russia learned the lessons of past weaknesses, and had made military reforms which enabled its army to fight and to win in the steppelands north of the Black Sea. Ahmed Resmi Efendi was a participant in the first of the two great Ottoman–Russian wars of the second half of the eighteenth century, that of 1768–74, which with the war of 1787–92 paved the way for the antagonisms which underlay Ottoman–Russian relations during the nineteenth century.

At the root of Russia's renewal of conflict with the Ottomans lay its policy vis-à-vis the Polish-Lithuanian Commonwealth. Despite fierce pressure from France, the Ottomans had doggedly resisted the many appeals from the Commonwealth for their support against Russia following the 1739 Treaty of Belgrade. Ahmed Resmi Efendi passed through Poland on his embassy to Berlin just at the time of the death of Augustus III in 1763, and in the

following year, Catherine the Great of Russia secured the election of her former lover Stanislaw Poniatowski to the Polish throne. Prussia and Austria, while equally disturbed by Russian interference in Polish-Lithuanian affairs, preferred that someone else – the Ottomans – should find a military solution to the problem.[7] Early in 1768, close to the Ottoman border in the town of Bar in the province of Podolia, formerly Ottoman Kameniçe, certain Polish nobles opposed to foreign (that is, Russian) interference in the Commonwealth formed a confederacy.[8] It lacked both leadership and a clear programme – it was indeed as weak and disorganized as the movements of Imre Thököly or Francis II Rákóczi, those Transylvanian nobles of an earlier age who had appealed to the Ottomans for help against the Habsburgs – yet it played its part in provoking a war from which only Russia emerged stronger. The confederacy issued a strong appeal to the Sultan, and to France. Russia ignored a subsequent Ottoman ultimatum for the withdrawal of its troops from the Commonwealth and in October 1768 the Sultan declared war.

Russia's intentions with regard to Poland were one Ottoman concern; another was the Crimea, where Russia had enjoyed some military success during the 1736–9 war and which it had not ceased to covet. In 1763 Russia persuaded the Khan to accept the establishment of a consulate in his capital of Bakhchisaray, but the consul lacked discretion, and when it became clear that St Petersburg was receiving information which could have come from no other source, he was expelled after only two years. As well as Prussia and Austria, it still suited France to encourage the Ottomans into war with Russia, and when in 1767 Baron de Tott, a Hungarian artillery officer serving in the French army who had lived in Istanbul between 1755 and 1763 before returning west, was sent by France to the Crimea as extraordinary consul, Catherine was immediately suspicious – there was no trade to speak of between France and the Crimea, and to her de Tott's real intentions were all too evident.[9] In the opinion of Ahmed Resmi Efendi, the Crimean Tatars were responsible for bringing Russia and the Ottomans to the point of war after so many years; he cited their constant forays into Russian territory as the reason why Russia did not respect peace treaties with the Ottomans.[10]

Russia's strategy was carefully considered: at the outset of the war one Russian army marched across Right Bank Ukraine while another shadowed it further to the south.[11] During the six years until the peace of 1774 the Ottomans suffered several disastrous defeats on the Danubian front at the hands of the Russians, most notably the siege and capture in 1769 of Khotin, south of Kamenets on the Dniester, and the field battle at Kagul, on the Prut, the following year.[12]

In 1770, for the first time and to the great consternation of the Ottomans,

a Russian fleet made the long voyage from the Baltic port of Kronstadt via the English Channel and the Bay of Biscay, to execute a daring foray into the Mediterranean and Aegean. The purpose of the Kronstadt fleet – which included a squadron under the command of the British naval officer Rear-Admiral Elphinston, who had recently entered Russian service – was to assist Russia's Orthodox co-religionists in the Balkans to rise against the Ottomans. Localized revolts broke out in Montenegro, Bosnia, Herzegovina and Albania, and another was instigated in the poorly-defended and long-neglected region of the Peloponnese. In this last case it was intended to disembark and combine with local leaders (and with Russian agents, who had been fomenting discontent for some years).[13] By June the Ottoman grand admiral Hüsameddin Pasha was off the Peloponnese with his fleet, in preparation for what was intended to be a joint operation with the land forces of the military governor in the region, former grand vezir Muhsinzade ('Son of the Benefactor') Mehmed Pasha. When this failed to go according to plan, Hüsameddin Pasha withdrew to the safety of the Anatolian coast, north of the port of Çeşme, near İzmir, to where the Russian fleet pursued him, and battle was joined on 5 July. The Ottoman ships were forced to retreat into the Çeşme roadstead where they were confined by the Russians who two days later set them ablaze. Some 5,000 Ottoman sailors lost their lives; only the Grand Admiral's ship escaped, and he was dismissed. The hero of the Çeşme disaster was one of his naval commanders, Cezayirli ('Algerian') Hasan Pasha, who was promoted to grand admiral after driving the Russian fleet from the island of Lemnos in the northern Aegean, which it had captured and was intending to use as a base from which to blockade the Dardanelles.[14] In the Peloponnese, meanwhile, the Muslim population took matters into their own hands; the disorder provoked by Muhsinzade Mehmed Pasha's forces and those of provincial notables hastily summoned from Macedonia and Thessaly spelled doom for Russia's plans.[15] This, at least, was a welcome success for the Ottomans.

The shock of the Russian naval attack at Çeşme reminded the Ottomans that they neglected naval preparedness at their peril – they were also reminded of the role the distant north African provinces could have played in the defence of the empire when the heartland was threatened in such a manner. Diplomatic missions sent in 1787 at the outbreak of another phase of war with Russia to enlist the help of Morocco and Spain failed, however – Morocco had no ships available, while Spain saw no reason to help a traditional enemy.[16]

From 1769 until the end of the war Ahmed Resmi Efendi served at the front against Russia, mostly as second-in-command to the Grand Vezir, commander-in-chief of the army. The appointment of a senior bureaucrat

like Ahmed Resmi to military command was unusual; with it, he became a pasha and a partner in strategic decision-making which aimed to salvage Ottoman honour from the crushing defeats the empire had suffered. The Ottomans rejected Russian peace overtures made in late 1770; in this, like another senior bureaucrat and chronicler of these years, Ahmed Vasıf Efendi (who was captured by the Russians on the Crimean front in 1771 and held as prisoner of war in St Petersburg), Ahmed Resmi found himself at odds with his government. From 1771 he served as deputy to Muhsinzade Mehmed Pasha, once again grand vezir, for whom he had the highest regard, and who, like him, saw clearly the great toll the war was taking on the empire. Both men were keen to settle on favourable terms as soon as possible.[17]

Following the destruction of the Ottoman fleet at Çeşme, Russia had remarkable success in another theatre of war. In 1771 a Russian army invaded Crimea, for so long a vassal state of the Ottoman Empire, and through a devious blend of 'carrot and stick' tactics, in 1772 obtained the agreement of Sahib Giray Khan that the Crimea should henceforth be regarded as an independent state comprising the steppe between the Dniester and Boh rivers, and between the Dnieper and the Sea of Azov, the Crimean peninsula, and the Kuban steppe.[18] Throughout the Crimea's long history successive khans had played upon the depth of sentiment with which the Ottomans regarded this outpost on the front line with Russia, at the same time not hesitating to pursue their own direction in foreign policy when they saw fit.

In 1771 Austria and the Ottomans reached an agreement whereby the Ottomans would cede territory in return for Austria's military assistance against Russia, but the next year, while Russia and the Ottomans were engaged in peace talks mediated by Austria and Prussia, Austria abandoned its alliance with the Ottomans, and in July 1772 joined Russia and Prussia in what is known as the first partition of Poland (there were to be two more, in 1793 and 1795). Sahib Giray's treaty with Catherine was signed four months later, and the peace negotiations foundered on the 'Crimean question'. Ahmed Resmi's warning that the Ottoman state should settle for realistic borders was at first ignored by Istanbul, but an inconclusive season of warfare on the Danube in 1773, followed in 1774 by two disastrous battles at Suvorovo and Shumen, south of the Danube, forced the Ottomans back to the negotiating table.[19] Sultan Mustafa had died in January 1774, not before expressing his apprehensions regarding the events of the time:

> The world is in decay, do not think it will be right with us;
> The state has declined into meanness and vulgarity,
> Everyone at the court is concerned with pleasure;
> Nothing remains for us but divine mercy.[20]

Mustafa was succeeded as sultan by his brother Abdülhamid. Ahmed Resmi, appointed to represent Ottoman interests at the peace negotiations of July 1774, found himself party to terms even more humiliating than those of Karlowitz in 1699, and his role as a signatory to the treaty known to the Ottomans as the Treaty of Küçük Kaynarca – from the village of Kaynardza, 25 kilometres south-east of Silistra on the Danube, where it was signed – brought about his fall from grace.

Ahmed Resmi Efendi's assessment of the Ottoman war effort against Russia in the confrontation of 1768–74, as revealed in his three reports, illustrates the contrast between the Ottoman and the Russian approach. Catherine's war cabinets debated strategy in depth, studying previous campaigns in order to learn the lessons of past failure. At the outbreak of war in 1768, for instance, a three-year operational plan was discussed in St Petersburg, including four alternative schemes for the pursuit of the first year's campaign, designed to deal with various possible Ottoman actions.[21] The Ottoman approach was very different. Ahmed Resmi had first-hand experience of Istanbul's failure to take the advice of front-line commanders, and of the way lack of co-ordination prolonged the war. Following the disastrous first season of campaigning he made trenchant criticisms of military operational procedures, later turning his attention to the wider context of Ottoman–Russian relations and arguing in favour of fixed borders between the two states, and peace perpetuated through the tools of diplomacy and negotiation. His third report, written in 1781, reasserted that peace was preferable to war, illustrating his theme with historical examples ranging from early Islamic times until the late war when the Ottomans had refused the peace proposal of Catherine's general Peter Rumiantsev in 1771 while the Russians were in a far stronger position.[22]

In 1765 Rumiantsev had reiterated a number of strategic goals dear to those who favoured Russian expansionism, of which two are particularly significant: the incorporation of the Crimean khanate into the Russian state, and the extension of the Russian frontier to the Black Sea coast.[23] Under the terms of the Treaty of Küçük Kaynarca, they were all but achieved. The Khan of the Crimea had thrown off Ottoman suzerainty and the region was now under Russian influence, while three centuries of Ottoman control of the Black Sea ended with Russia in possession of Kinburun at the mouth of the river Dnieper, and of Kerch and Jenikale at the mouth of the Sea of Azov. Russia also acquired rights for its commercial shipping to sail freely in the Black Sea, with access to the Mediterranean, and was permitted to establish consulates in Ottoman territory, and a permanent embassy in Istanbul.[24] For the first time ever, under the terms of a secret article, the Ottomans agreed to pay a war indemnity, spread

over the next three years;[25] their consolation was the return of Russia's gains in the Danube region.

A contemporary Ottoman author from the Peloponnese recorded a dream he had when the Russian ambassador arrived at the Sultan's court to arrange the details of the peace, and how he drew strength from it – mistakenly, as it turned out:

> I was in Beyoğlu in my dream and it seemed that I saw vast pavilions built to receive the Russian ambassador; he was a man of some eighty years of age, judging from his grizzled appearance, and was sitting on a chair in a large, high pavilion, and the Sultan's high officials were standing and serving the ambassador. However many instruments and games and amusements there are at court, all were in evidence and were played one by one, and bears and monkeys performed. After a little while the ambassador's face assumed an inhuman aspect and was transformed into that of a great lion, of a red colour, darker than roof tiles, and in order to see roundabouts, he came to the edge of the pavilion, saying 'When the ambassador's face is as that of a lion, it indicates the power of Muscovy' and when, crying as I dreamt, I saw this insult to the officials of the Sublime State, a man came up to me where I was, at the foot of a tree, saying 'Don't be troubled. This figure you see is not a real lion but rather one of cardboard, made from paper, and if some water were to be spilled on it, it would soften and be ruined'.[26]

The extent to which the Treaty of Küçük Kaynarca would be implemented was always extremely doubtful, because of the inherent ambiguity of a number of its clauses and also as a consequence of Ottoman reluctance to accept the magnitude of what they had signed away. While the Sultan had abandoned any pretension to political influence in the Crimean lands, the treaty enshrined his spiritual authority over his erstwhile vassal subjects, recognizing him as the 'Caliph of all Muslims' – a title rarely used by the Ottoman sultans but one which, formalized in terms which fitted western rather than Islamic conceptions of religious authority, expressed the Sultan's claim to pre-eminence among Muslim princes as realized by Selim I with his victory over the Mamluks in 1517. The degree to which the clauses of the treaty accorded Russia the similar privilege of spiritual authority over the sultan's Orthodox subjects has always been a matter of interpretation and controversy. The view that the treaty gave Russia the right to intervene – more precisely, to make 'representations' – on behalf of all Orthodox Christians in the Ottoman Empire is open to question, since the notorious articles 7 and 14 of the treaty refer specifically to only one congregation, that of a Russian ('Russo-Greek' in the Italian and Ottoman texts, 'Greco-Russian' in the Russian version) Orthodox church in Beyoğlu, the main throughfare of the old Genoese suburb of Galata, in Istanbul – which was never built.[27]

The privilege of protecting a single congregation of their co-religionists in Beyoğlu had already been conceded to the Catholic powers of France and Austria, although not to Protestant England and Prussia, and the new Orthodox church was to be 'protected' on the same model.[28]

In addition to the proposed Russian church in Beyoğlu, the Ottomans were enjoined, under various articles of the treaty, not to oppress Christians in the Aegean Archipelago, the Danubian Principalities of Moldavia and Wallachia, and western Georgia. Franz Thugut, the Austrian diplomat representing the Emperor's interests in Istanbul at the time of the peace negotiations, characterized the clauses relating to Russian claims to protect all Ottoman Orthodox Christians as emblematic of 'Russian skill' and 'Turkish imbecility'. But Thugut was guessing the contents of the treaty, and wrote these words before he had a chance to see it in its final form; responsibility for asserting that Russia had hoodwinked the Ottomans may be laid at the door of a historian writing at the height of the nationalist, anti-Ottoman fervour of the late nineteenth century who, concealing the circumstances of Thugut's observation, cited him as his unimpeachable authority. Such an interpretation, with the implication that Russia did indeed win the right to intervene in the empire's internal affairs in 1774, found favour in the post-Crimean War world of the second half of the nineteenth century, and has been repeated ever since.

The treaty did lend itself to misinterpretation, though: it was in three, inconsistent originals – in Russian, Ottoman and Italian – and it was a French translation of the Russian version of the treaty issued by Catherine's government in 1775 that became the tool of European diplomacy.* This textual confusion, together with Catherine's claims to be the protector of Ottoman Orthodox subjects, introduced further ambiguities in interpretation which favoured Russia. Thugut's other, hysterical, assertion that Russia's backing for the 'schism' of Orthodoxy would spell the imminent end of Catholicism in the Middle East was not uncommonly heard among his co-religionists as Russia extended its influence in the Balkans; but when Prince Metternich, Austrian foreign minister at the time of the Greek revolt against Ottoman rule in 1821, scrutinized the treaty he dismissed it as a basis for Russian right of protection over Ottoman Orthodox Christians.[29] Whatever the letter of the Treaty of Küçük Kaynarca, its subsequent interpretation was what mattered – and Russia proved all too adept at playing on every ambiguity and inconsistency.

<div align="center">★</div>

* The Treaty of Küçük Kaynarca was apparently not translated into English until 1854, the time of the Crimean War (Treaties (Political and Territorial) 131ff).

The post-war years were a time of great instability in the Crimean lands as Russian-supported contenders for the khanate vied with those favoured by the Ottomans. In April 1777 Catherine's candidate Şahin Giray, who had greatly impressed her with his good looks and Venetian education when he was in St Petersburg to arrange the independence treaty of 1772 on behalf of his brother Sahib Giray Khan, became khan. He tried to establish the military and administrative institutions required by a state no longer in thrall to an imperial master, but his apparent preference for the non-Muslim minorities of the Crimea as the vanguard of his intended modernization provoked an insurrection, and a Russian army was soon sent to his aid. This force was in no hurry to return home, especially since Şahin Giray had completely lost the support of his Muslim subjects; the Christians, for their part, feared Muslim reprisals should the Russians leave, and many of them were resettled in Russian territory. Encouraged by Tatar exiles in Istanbul, in 1778 the Sultan sent a fleet under the command of the north-central Anatolian notable Canikli Hacı Ali Pasha to unseat Şahin Giray, but it failed to achieve anything and, perforce, he recognized Şahin as khan.[30]

In 1779 the Russian army withdrew from the Crimea as it was obliged to do under the terms of an agreement with the Ottomans. Şahin Giray's reforms continued falteringly, but his territorial ambitions in the region at the expense of the Ottomans, and his inability to impose his authority over even his rivalrous brothers, led to a revolt in the Kuban in 1782. Catherine again sent troops, but this time they did not leave – realizing that a stable and independent Crimea was impossible to achieve, she proclaimed the annexation of the khanate on 8 April 1783.[31] Şahin Giray spent the next four years in Russian custody, planning how to escape his captivity for Istanbul. He petitioned both Sultan and Empress, but found himself merely a pawn in their political manoeuvrings. In 1787 Catherine permitted him to leave, and with the promise of an estate in Thrace – the customary prerogative of Crimean khans – he travelled to Edirne in the early summer. When Sultan Abdülhamid heard he was approaching the city, he saw the moment to take his revenge for Şahin Giray's perfidy, and directed him to proceed instead to exile in Rhodes – and secretly ordered that 'this infidel scoundrel, this trickster' be executed with all haste. The former khan managed to stay alive for another two months, however: further edicts for his execution went astray, and the official guarding him on the voyage to Rhodes did not have the courage to kill him. Once on Rhodes he took refuge in the French consulate, but was eventually removed by force and the sentence of death carried out – an ignominious end to three hundred years of shared history of the Crimean khans and the Ottoman sultans.[32]

Thereafter began intensive Russian colonization and settlement of the

steppe and the building of a Black Sea fleet based at Kherson, in the Dnieper estuary, only two and a half days' sail from Istanbul. Empress Catherine had not been in a hurry to annex the Crimean lands: in 1770 the Russian state council issued a statement that 'the Tatars could never become useful subjects of Her Imperial Majesty, and . . . would form a poor defence on the frontier against their co-religionists, the Turks', and her opinion had altered little over the years. Even in 1778, the year of the second revolt against Şahin Giray, she seemed inclined to leave the Crimea independent – despite pressure from her advisers. But times had changed: her lover and favourite Gregory Potemkin is credited with persuading her to annex the khanate in 1783, justifying the action on the grounds that Russia had not received its due in the Küçük Kaynarca settlement.[33]

The loss of the Crimean lands was a blow to the Ottomans of a magnitude that would in earlier times have led to an immediate declaration of war. That this did not happen was an acknowledgement of their weakened military position, the emptiness of the treasury, and the ascendancy of statesmen who advocated peace at all costs. Conflicting points of view inside the ruling establishment – whether to seek reconquest, or to accept the loss with equanimity in the interests of the wider welfare of the state – reflected the painful process of adjusting to a world in which the ideology of the 'ever-expanding frontier' no longer served Ottoman interests. Violations of the Treaty of Küçük Kaynarca and its codicils occurred on both sides, but Ahmed Resmi Efendi found another champion of his pacifist stance in Grand Vezir Halil Hamid Pasha, who served from 1782 to 1785, and ordered improvements to the northern defences of the empire but at the same time argued for resigned acceptance of the loss of the Crimea.[34] In 1784 Russia pressured Sultan Abdülhamid to sign an acknowledgement of Ottoman acquiescence to the new situation – a deed that would have been widely unpopular had it become known; it was signed secretly, and not only by the Sultan, his vezirs and senior clerics but also, at Russia's behest, by the heir-apparent, his nephew Selim (later Selim III).[35]

Halil Hamid Pasha lost his position (and his head) when implicated by his rivals at court in a plot to depose Sultan Abdülhamid I in favour of Selim. Of Halil Hamid's closest associates, the then governor of the Peloponnese and a former janissary commander-in-chief were also executed, and the Sheikhulislam was exiled. Influence now rested with the clique around the long-serving Grand Admiral. Cezayirli Hasan Pasha was in the process of undertaking naval reforms the counterpart of those Halil Hamid had proposed for the land army, but their relationship was not close and their common interests did not extend to the deposition of the Sultan.[36]

It has long been open to debate whether Catherine the Great or any of

her statesmen seriously envisaged the partition of the Ottoman Empire. Russia and Austria had already each seized part of Poland, and it was widely believed that the secret agreement reached between Catherine and Joseph II of Austria tended to further Catherine's so-called 'Greek project', a re-establishment of the Byzantine Empire centred on 'Constantinople'. A potent symbol of this dream was the use of an image of Hagia Sophia on a medal struck to mark the birth of her grandson Constantine Pavlovich in 1779.[37] Rumours of Russia's intentions had reached Istanbul in 1782,[38] and gained added credibility when in the spring of 1787 Catherine met Joseph II outside Kherson where Empress and Emperor entered the city through a triumphal arch bearing in Greek the legend, 'The Way to Byzantium'. Whether or not Catherine was really committed to the 'Greek project', Sultan Abdülhamid took it seriously and feared that Russia's next step would be the seizure of Anatolia; he took steps to strengthen the North Anatolian coastal fortresses of Sinop and Samsun,[39] and to protect Istanbul from possible attack built two new forts on the upper Bosporus in addition to the five already constructed after 1774.[40]

For three years from 1786 responsibility for decision-making was in the hands of the hawkish grand vezir Koca Yusuf Pasha. All avenues for resolving the dispute with Russia by diplomacy had been exhausted by the time of Catherine's royal progress through her new province in the Crimea, and her subsequent demand for Ottoman withdrawal from Georgia met with insistence on recognition of eastern Georgia as an Ottoman vassal, on the right to search Russian ships in the Black Sea, on the closure of some sensitive Russian consulates (in Jassy, Bucharest and Alexandria) and, most critically, on the return of the Crimea. This last, in particular, Catherine could not concede.[41] In August 1787 the Ottomans declared war.

While Ottoman opinion had undoubtedly considered the loss of the Crimea a disaster, the prospect of war was unpopular, and for the first time the people of Istanbul were prompted to express their opposition by means of posters, stuck up on public buildings – such as the palace – or distributed in the mosques. One broadside left at the Admiral's Fountain near the home-base of the fleet in the Karaköy quarter opened with the following words:

> Sultan Abdülhamid, we have just about run out of patience. You have not yet realized the error of your ways. You have seen that Yusuf Pasha [who was a Georgian by birth, and a convert] is unable to perform his service properly. Why have you let yourself be deceived by his words and turned the empire over to the infidel?

The Sheikhulislam and the Grand Vezir's proxy were also charged with not being true Muslims, and the diatribe continued:

You should immediately venture out in public in disguise and mingle with
your subjects to get a sense of the public mood and initiate negotiations for
peace. Recall the standards from the battlefield and bring the troops home –
or, by God, you will later regret it. Yusuf Pasha cannot do his job, and you
will suffer the negative consequences. You have made a fool of yourself. Court
chamberlains [Yusuf Pasha had served as a court chamberlain] are not up to
the task of carrying out the business of the empire.

Like many sultans Abdülhamid was indeed in the habit of going around the
city incognito, and he was able to see the posters for himself. His first reac-
tion was to blame 'infidels' in general for the poster, but there was also
suspicion that the grand admiral Cezayirli Hasan Pasha might be behind it.[42]

Ahmed Resmi Efendi's perception that the Crimean Tatars were responsible
for precipitating the war of 1768–74 may be open to dispute, but the Crimea
was certainly the casus belli in 1787. The timing of the war was awkward for
both Austria (which declared war early in 1788) and Russia – Joseph was
apprehensive of Russian aims but preoccupied both by Prussia and by domestic
unrest resulting from his administrative reforms,[43] while in 1788 Catherine
had to deal with an attack on her Swedish border – but the Ottomans had
taken on foes who could combine to engage their forces from Dalmatia to
the Caucasus. Campaigning against Russia in late 1787 and 1788 centred on
the Ottoman fortress of Ochakiv and nearby Russian Kinburun, at the mouth
of the Dnieper, the scene of much fierce fighting in 1736–9. Sweden's war
effort was too feeble to engage Russia for long; Russian troops on the Black
Sea were reinforced and Ochakiv fell after a siege. On the Austrian front,
Koca Yusuf Pasha crossed the Danube into Hungary but winter prevented
consolidation of this promising advance, and the Austrians occupied Khotin.

Soon after the outbreak of war the Sultan ordered that new coinage be
marked 'Struck in Istanbul', rather than 'Struck in Constantinople' – perhaps
in response to Catherine's numismatic challenge – and also that imperial
decrees should henceforth refer to the Ottoman capital by this name.[*44]
The bellicosity displayed by Koca Yusuf Pasha and Sultan Abdülhamid –
who was even accorded the epithet to which all sultans aspired, that of
'Warrior for the Faith'[45] – was out of touch with the mood of the times:
both the people of Istanbul and other senior statesmen viewed peace as

* A perusal of Ottoman coin catalogues demonstrates that the name 'Constantinople' is
indeed replaced by 'Istanbul' – in the form 'Islambol' – on coins struck during the reign
of Abdülhamid and his successor Selim III, although 'Constantinople' was again used there-
after. Mahmud I had issued a similar order on coming to the throne in 1730, and coins of
that time were also stamped 'Islambol' (Pere, *Osmanlılarda Madenî Paralar*; Refik, *Onikinci
Asr-i Hicri'de* 185).

essential for the well-being of the state. Catherine, however, was also war-minded: even before the fall of Ochakiv, she refused to consider the mediation offered by the Triple Alliance of Britain, Prussia and the United Provinces in August 1788.[46]

Sultan Abdülhamid died in the spring of 1789 and was succeeded by his nephew Selim, the 28-year-old son of Mustafa III. Selim's first priority was to achieve a victorious conclusion to the war. Despite the reappraisal of tried and tested Ottoman practices then favoured in government circles he resorted to the traditional method of retaining the commitment of his troops by paying them generously, and also – perhaps in emulation of Emperor Joseph II's brief assumption of command of the Habsburg army[47] – gave some thought to a proposal that he should lead his forces himself. Determined to avenge the humiliations suffered by the Ottoman state, his aim was nothing less than the return of the Crimean lands – a dream that was to haunt the Ottomans for another century. Coming to the throne at such a critical time, Selim, well aware of the need to secure the loyalty of leading statesmen, initially kept Koca Yusuf as grand vezir and appointed as sheikhulislam a man who was less than competent but widely favoured by the clerical establishment.

Sultan Selim did not after all lead his army in battle. It was an idea put forward by the Grand Vezir's proxy, and in a letter to him Selim made very plain his irritation at the way it had been seized upon as though he had committed himself to such a course of action:

> When we discussed the matter earlier, you told me it was my duty to go on campaign and I said I would go – but it was not my idea initially: the idea was yours, and you had an imperial decree written, and it is because of this that the matter is now on the tongues of all the world. The Swedish ambassador expressed his pleasure at the decree. I will not be seen as a teller of untruths and a habitual liar by such European powers, and by the military corps and the public. You know what happens to a lying sultan. It is clear to me that your conduct has hindered and obstructed my going on campaign. But because the *padişah* cannot go with only scant supplies it is necessary to get ready immediately – yet you have made no preparations. It befits monarchs to keep their word: whether it is war or peace I will certainly move to Edirne or further in the spring. I will not be scorned by the ignorant. If you create an impediment to my going, and prevent me doing so, and thereby disgrace me in front of the whole world and in Europe, you should know that I swear I will disgrace all of you who were at the meeting where the matter was discussed.[48]

The campaign of 1789 was a disaster for the Ottomans. Although he left high-ranking military commanders like the Grand Vezir in place, the

disruption caused by Selim's succession was enough to undermine what little momentum had been achieved by a campaigning army already short of money and provisions. The Austrians advanced into Bosnia and Serbia and, after a fifty-year interval, retook Belgrade. Russia occupied Wallachia, restored to Ottoman suzerainty in 1774 but increasingly unreliable since. That winter the Sultan rejected an offer of peace. Russia's wider strategic interests were drawing its attention westwards: it needed peace to attend to the war with Sweden (with whom Selim had agreed an alliance shortly after his accession[49]), and to make the most of the opportunity to profit from the distraction of its neighbours that the revolution in France seemed to offer.

Possession of Belgrade allowed Austria's army to move south-east through the Balkans to Niš as it had exactly a century earlier: it was expected in Istanbul that it might get as far as Sofia. In Prussia the Ottomans found an ally eager to take the place so long held by France. Prussia had courted the Ottomans for half a century, ever since Frederick the Great's accession in 1740, and a treaty of trade and friendship between the two powers had been signed in 1761, but it was only in 1790 that a full alliance was realized.[50] Its achievement further disinclined the Sultan to consider peace, and set him at odds with his recently-appointed grand vezir, Cezayirli Hasan Pasha, trusted but aged, and still such a convinced pacifist that he boldly defied the Sultan and initiated peace negotiations on his own authority.

In 1790, the Russians were disappointed in their plans for an attack across the Danube in co-ordination with the Austrian army, but managed nevertheless to occupy the main Ottoman fortresses of the lower Danube.[51] That same year the Ottomans negotiated with Poland a mutual defence pact in the event of attack by Russia, but it was never ratified.[52] On the death of Emperor Joseph II and accession of Leopold II, also in 1790, Austria settled its differences with Prussia,[53] and in the face of more pressing concerns Prussia unilaterally set aside the treaty of alliance on which the Ottomans had pinned their hopes of a chance to recover the Crimea. In the same year Russia responded favourably to Cezayirli Hasan Pasha's overtures for peace, offering rather attractive terms for a disengagement, but Sultan Selim rejected them – he was counting on Prussia's promise to intervene against Austria, unaware of the deal his new ally was doing with Austria for its own purposes. This was doubly unfortunate, since later in the same year Russia agreed peace with Sweden, which thereby also broke its treaty with the Ottomans.[54] On the plus side the change of Habsburg policy led in 1791 to an Austrian–Ottoman peace agreement, the Treaty of Sistovi, whereby Austria returned the Ottoman territories it had won, including Belgrade.[55] The web of international

diplomacy was seldom more tangled than at this period. Russia had by now replaced Habsburg Austria as the Ottomans' main adversary, and in 1791 consolidated the progress made in the Danube region the previous year.

To the east, in the Caucasus, Russia was fast encroaching in a region of petty principalities over which Iran had traditionally struggled with the Ottomans for influence and control. Ottoman hopes of mobilizing the tribes of the Kuban under the leadership of the exiled Tatar khans for the purpose of retaking the Crimean lands were dashed as the logistical problems were found to be insurmountable and local tribes proved unwilling to identify with Ottoman aims in the region. Nor were the chiefs of the southern Caucasus of much assistance.[56] The Ottomans, like the Russians when they sought compliance from the peoples of their eastern and southern frontiers, found that the opportunistic support of populations whose strategic interests and priorities differed markedly from their own could only – if then – be won by means of lavish gifts and inducements.

For the 1789 campaigning season the Ottomans had mobilized troops and requisitioned provisions from north Anatolia to counter Russian advance on the Ottoman fortress of Anapa, on the north-eastern Black Sea coast east of the outlet of the Sea of Azov; battle-lines hardened as the Russians fortified and garrisoned a defensive line on the river Kuban. A Russian attack on Anapa left the Ottomans little choice but to buy the essential participation in the defence of the region of Battal ('Clumsy') Hüseyin Pasha, son of the Anatolian notable Canikli Hacı Ali Pasha, by conferring on him the province of Trabzon. Battal Hüseyin's avowed aim was nothing less than to drive the Russians from the Caucasus and retake the Crimean lands, but his ambition was confounded when his army was pursued by the Russians south from the Kuban to the Black Sea coast in the autumn of 1790; the Caucasian peoples who had been fighting with him were abandoned as he surrendered, and he and his son Tayyar ('Mercurial') Mahmud Bey spent nine years as prisoners of the Russians. A new commander from the Canikli household was appointed to the Caucasian front; the Russians besieged Anapa in July 1791, occupying it within two weeks, and the commander was executed for this loss – he had not even left Trabzon.[57]

The Ottomans were ready for peace. The Treaty of Jassy in January 1792 reinforced and compounded Ottoman losses suffered by the Treaty of Küçük Kaynarca, by fixing the borders between the Ottoman and Russian empires on the Dniester in the west and the Kuban in the east. Anapa was restored to the Ottomans, but they were to be held responsible for the good behaviour of the peoples living south of the Kuban, and required to pay an indemnity if these should raid across the river and cause

any damage to life or property on the Russian side of the border. Like the Cossacks, however, the Caucasian peoples did not consider themselves bound by this treaty and their nominal suzerain had to make good the losses incurred by their raids; this clause was activated in 1798, for instance, and the Ottoman treasury required to pay.[58]

Anapa was repaired and strongly fortified, but the reconquest of the Crimea began to seem less pressing after 1792, as did the assertion of Ottoman influence in the Caucasus – until Iran began to demonstrate renewed interest in the region as Agha Muhammad Khan of the Qajar dynasty embarked in 1795 on a campaign to reconquer former Safavid territories between the Aras and Kura rivers. Although eastern Georgia had been a Russian protectorate since 1783 and a mutual defence pact against Iran and the Ottomans was still theoretically in force, Russia was slow to react to requests for assistance against Agha Muhammad from one of the Georgian rulers.[59] Indeed, after Catherine the Great's death on 6 November 1796 her successor Tsar Paul I almost immediately made peace with Iran.[60]

Agha Muhammad Khan's incursions into the Caucasus called for an Ottoman response, too: Azerbaijan and Dagestan, both bordering the Caspian Sea, were in the Ottoman sphere of influence, and the Caucasian rulers appealed to Istanbul for help against the Qajars, whom they characterized as Kızılbaş. This was at first refused, but when Agha Muhammad Khan sacked Tbilisi in September 1795 the governor of Erzurum was appointed to command the Caucasian front. Sultan Selim's initial reluctance to help his Caucasian flock demonstrated inconsistency, at the least, in view of the fact that only a few years earlier his predecessor, Abdülhamid, had considered seeking financial assistance from another group of Muslim states – those in North Africa – whose loyalty to and expectations of the Ottoman sultan were strengthened as a result of Abdülhamid's adoption of the title of caliph in 1774.[61]

War, as ever, spelled ruin for the finances of the Ottoman Empire. A decline in trade from the 1760s left the treasury barely able to pay for the hostilities of late-century. As the frontiers of the empire shrank the Ottomans lost not only territory but centres of production and markets to Russia, and matters were only exacerbated by incidental factors such as the indemnity paid by the Ottomans to Russia following the 1768–74 war (which was equivalent to perhaps half of the annual cash receipts of the treasury)[62] and the epidemics which were a concomitant of war. As a final blow to the economy, trade with the Ottoman Empire's main commercial partner also collapsed as the wars in which revolutionary France was involved began to take their toll.[63]

With much tax-gathering in the hands of life-term tax-farmers, the central treasury was so short of funds that the state was barely able to fulfil some of its essential tasks, in particular the raising of troops for war, and by the last decades of the century it had become more dependent than ever before on the provincial grandees – some of whom were the self-same tax-farmers – who alone had the resources to bear the financial burden of military campaigns.[64] During the 1768–74 war provincial governors and grandees bore much of the responsibility for provisioning the army – and profited from it through their control of the market. During this war, Grand Vezir and Commander-in-Chief Muhsinzade Mehmed Pasha was deeply involved in tortuous negotiations with the provincial notables of the Balkans and Anatolia concerning the raising of local troops from the areas over which they had authority.[65] In gradually devolving one of its basic functions, the defence of the realm, into the hands of newly-wealthy and newly-powerful provincial magnates, the state made it easy for them to act in their own interests and ignore government writ when it suited them to do so. The need to mobilize resources for war – the 'management of warfare' – was perhaps now, more than ever, one of the most important catalysts of change in the Ottoman Empire.

Traditional solutions, too, were employed in the effort to cope with the financial crisis – increasing taxes, debasing the coinage, melting down valuable objects, and confiscating the estates of disgraced, high-ranking officials, a practice greatly extended from the 1780s to include those of other wealthy individuals, on the thinnest of pretexts.[66] In 1775, the year after the Treaty of Küçük Kaynarca, a system of public borrowing designed to draw those of lesser means into the financial market was adopted, but the system was subject to frequent modification as the treasury struggled to meet the interest payments.[67]

In 1784, matters having apparently reached the point where the wealthy of the Ottoman Empire were either unwilling or unable to finance the state any longer, the government discussed for the first time the possibility of borrowing from abroad. European states had long been in the habit of meeting any shortfall in their domestic budget by borrowing from international moneylenders or banking houses, but the Ottomans had always hitherto relied on inventive ways of squeezing internal sources of revenue. They had no institutions able to guarantee any loan raised in this novel way, and it was proposed instead that between five and ten thousand individuals should stand surety for the money, which would be paid back in instalments. France, the Dutch and Spain were considered as possible sources of funds, but Morocco appeared to offer the most attractive prospect. Morocco had recently sent an ambassador to Istanbul and he – as a gambit

to win Ottoman friendship – had hinted at financial assistance, a vague promise that gave rise in some quarters to the opinion, gratifying to those who held that a loan should be sought only from a Muslim country, that Morocco was in a position to lend to the Ottomans.[68]

Discussions about the possibility of raising a foreign loan went no further at this time, but after 1787, when the Ottomans were again at war with Russia, the need for money once more became acute – and not only for their own campaigns: desperate as the financial situation was, the Ottomans promised Sweden a hefty subsidy if she would attack Russia's western front (the Swedish–Russian peace of 1790 subsequently relieved it of this obligation).[69] Realizing that after all nothing was to be expected from Morocco, the government turned to Algiers and Tunis. It was hoped that describing the loan as 'aid for holy war' would make it attractive to their co-religionists, but such was not the case. The Sheikhulislam gave a juridical opinion that the gravity of the crisis legitimized negotiations with a non-Muslim state, and overtures were made to the United Provinces; the Dutch ambassador, however, said it would be more appropriate for the Ottomans to seek a private loan, from a merchant rather than from the government.[70] In the aftermath of the French Revolution, the approach to the United Provinces failed, as did another to Spain.[71]

During his childhood and early adolescence, while his father Mustafa III was still alive, Selim's life had been comparatively unrestricted, and he carried with him into adulthood a more open habit of mind than did most princes of the preceding two centuries, who had lived entirely within the palace, sometimes for decades before their accession. Until deprived of his freedom on Sultan Abdülhamid's accession, the young prince had attended meetings of the imperial council and at a time when the necessity for military reform was beginning to preoccupy Ottoman statesmen in earnest, had reviewed his father's troops. Although further confined following the discovery of the plot to depose Abdülhamid in 1785, Selim managed to maintain his links with the outside world, and these helped him recognize that change was inevitable, and would be better actively introduced than faced with resignation or resistance. From the time of the first Ottoman–Russian war until his accession Selim corresponded intermittently with Louis XVI concerning military reform; he made plain his admiration for France as a model state, but blamed the French for pushing the Ottomans into war in 1768 and then failing to support them, and, barely concealing his desire to take revenge on Russia, wrote of his hope for Louis's help in regaining the territory lost since that time.

Coming to the throne in the middle of a debilitating war, Sultan Selim III

dealt with his army in the customary way by paying the accession donative, but only a month later he summoned some two hundred high-ranking state officials – military men, bureaucrats and clerics – to a consultative assembly to discuss the future of his crumbling empire. In addressing itself to the very survival of the empire, rather than to any one specific issue, Selim's initiative was something new in the process of government. Following the peace agreed at Jassy in 1792 he reviewed the reports on the state of the empire commissioned from his statesmen, of which more than twenty survive, mainly concerning measures to improve the performance of the Ottoman army in its struggle with Europe – and with Russia in particular. Traditional values, the essayists acknowledged, must be adapted so that the Ottomans could take advantage of modern methods and technology. Similar views put forward in previous years by Ahmed Resmi Efendi (among others) had paved the way: now the debate had been widened and his successors were able to make their contributions in a more receptive climate. Statesmen and bureaucrats had always offered their views to the sultan, but now they were actively sought – as was a wider range of opinions than had customarily been the case. Among Sultan Selim's most influential advisers were the leading cleric Tatarcık ('Little Tatar') Abdullah Efendi and Ebubekir Ratib Efendi, ambassador to Vienna in 1792 and later chancellor, whose reports dealt with many areas of Ottoman governance apart from the purely military.

There was a conservative strain in the recommendations for a return to the ways of old, before basic and uniquely Ottoman institutions – primarily the janissaries – became, as the statesmen saw it, fatally corrupted; but parallel to these recommendations went proposals for the creation of new military corps or the upgrading of those already established during the course of the century. The reports illustrate a conscious acceptance in ruling circles of the need to borrow from the infidel the things which made him strong, combined with a recognition that this must be done within the familiar idiom of Ottoman Islam.[72]

Military reform came at a time when Russian might had sent shockwaves through the Ottoman establishment. Western assistance came particularly from the French, and the figure most closely identified with it in retrospect was Baron de Tott. After his removal from his post as extraordinary consul in the Crimea in 1767, he was summoned to serve Sultan Mustafa III following the defeat of the Ottoman navy by the Russian fleet at Çeşme in 1770. Under what amounted to a programme of French technical assistance, he organized activities which ranged from refortifying the Dardanelles against possible Russian naval attack on Istanbul, to advising on the setting-up of various military professional schools and a rapid-fire

artillery regiment. Such was de Tott's talent for self-promotion, and so popular did the memoirs he wrote after he left Istanbul become, that attention has always been focused on the reforms which took place under foreign guidance, to the neglect of those initiated by the Ottomans themselves, particularly those affecting provincial rather than central troops.[73]

One such was Sultan Abdülhamid I's abolition of the locally-mustered *levend* irregulars who formed a parallel infantry to the janissaries numbering between 100,000 and 150,000 men – who had failed to distinguish themselves in the 1768–74 war.[74] Ahmed Resmi Efendi saw them in action in 1769 and was particularly scathing about them, characterizing them as an uncontrollable rabble who would better have stayed at home.[75] The term *levend* had pejorative connotations dating back at least two centuries, having originally been one of the labels applied to the disbanded irregulars who had been responsible for so much unrest in Anatolia in the last quarter of the sixteenth century.* As other sultans had before him Abdülhamid issued a ban on the use of the term *levend* – in 1775, following the end of the war – a symbolic measure aimed at marking a new beginning.[76]

Under Selim the sultan's regiments were also the focus of attention. Ever since mid-century when Frederick the Great of Prussia's reforms had set a standard to be emulated, the problem of achieving a disciplined and highly-trained army had exercised every European monarch, and Selim and his statesmen hoped to reorganize the janissaries and the other corps of the sultan's regiments and also to create an entirely new body of troops funded by its own treasury. This experiment in military modernization was aimed at moulding a disciplined, professional force with greatly improved fire-power and training.

In earlier times the janissaries were recruited from Christian-born youths who converted to Islam and underwent training for service in this most elite of the sultan's military corps, but over the centuries this 'purity' was gradually vitiated and the youth-levy abandoned; instead, Muslim-born men were recruited into the corps, and it became more of a militia than a force confined to its barracks when not on active duty, and training and discipline suffered accordingly. The numbers had swollen over the years and included many 'paper janissaries', individuals long dead or deserted, or who had never actually been part of the fighting forces. The chronicler Şemdanizade Fındıklılı Süleyman Efendi, employed to muster troops for the 1768–74 war, remarked that anyone who claimed to be a janissary was accepted as such.[77] The sale of warrants had been permitted since the reign of Mahmud I, and control over the rolls of enlisted men had slackened to the point where there was a

* The term was also applied to a class of seamen.

thriving market in these documents proving an individual's status as a member of the corps, and thus entitling him to salary and benefits and the tax-free status enjoyed by the military. Abuse of the system reached the highest levels: following the dismissal in 1779 of a grand vezir promoted to this post from janissary commander-in-chief, his confiscated estate included warrants worth a sum equivalent to the daily pay of some 1,600 janissaries. In 1782–5 Grand Vezir Halil Hamid encountered violent opposition when he tried to stream-line the corps by ascertaining the numbers of men actually serving and by forbidding the sale of warrants.[78]

Like the traditional janissary forces, Selim's 'New Order' army was to be forged from raw recruits – all Muslim-born, now, not Christian – who were to receive specialized training to equip them for service in the modern army which he envisaged. Before men could be recruited, however, funds had to be assigned for their support, and a new treasury was set up for the purpose by a decree of 1 March 1793, and the first troops recruited from the unemployed youth of Istanbul. Only on 18 September 1794 did Selim publicly proclaim the regulations for his 'New Order' army.[*] From then on men were recruited from Anatolia, and within six years 90 per cent of the men in the 'New Order' army were peasants or tribesmen from this region. They had the full complement of regulations and markers of difference from other units and from what had gone before – barracks, uniforms and the like – but of course they had no traditions at all to compare with the proud history of the janissaries, and unsurprisingly the janissaries refused to serve with them. It was no new thing for the janissaries to refuse to accommo-date previously untapped sources of manpower in the cause of military reform – in 1622 Osman II had been murdered because they feared he was plotting to create a parallel army. Nor was it always their military short-comings that prompted moves to reform or augment the janissaries: during the reign of Sultan Abdülhamid I the creation of an alternative force came under consideration when it was thought that the janissaries were respon-sible for starting the fires which so often blighted Istanbul, rather than acting as agents of civil law and order,[79] the peace-time role expected of them before the establishment of independent fire and police forces in the nine-teenth century. A contemporary source tells us that Abdülhamid would go in disguise to the site of the many fires which broke out in Istanbul during his reign, often spending the night in houses close by to observe their progress, and rewarding those fighting the fire.[80]

Sultan Selim and his advisers were well aware that the strength of entrenched

[*] The term 'New Order' was applied at this time exclusively to military reorganization, and only later to other reforms (Shaw, 'The Origins of Ottoman Military Reform' 292).

interests would make any thoroughgoing overhaul of the janissary corps impossible. Tatarcık Abdullah Efendi cannily couched his reform proposals in terms of an appeal to the honour of the corps in its glorious heyday under Sultan Süleyman I[81] – long before it had become an anachronism in European warfare and a threat to public order at home – but his ambitious plans were of necessity scaled down. The only possible solution, it seemed, was to leave the organization of the janissaries untouched, and to train them in the use of more modern European-style rifles – but they rioted whenever they were required to drill and their numbers continued to swell.

The 'New Order' army, by contrast, seemed destined for success, and 500 of its number, in action for the first time, took part in the defeat of Napoleon Bonaparte's army at Acre in Syria in 1799. In Anatolia in 1802 a form of conscription was introduced whereby provincial officials and notables had to provide a certain number of men for training in the 'New Order' army, and in 1805 recruitment was extended to the Balkans where recruiting agents encountered fierce resistance. By 1806 it comprised more than 22,500 men and 1,500 officers, quartered in Istanbul, Anatolia and the Balkans.

Naval reform was equally slow and fraught with problems. In 1784 a Frenchman named M. Bonneval – not to be confused with the Bonneval who became Humbaracı Ahmed Pasha earlier in the century – wrote a scathing report on the navy that reserved its only kind words for Cezayirli Hasan Pasha's efforts to improve the fleet's performance (which included meeting many of the expenses from his own pocket). Bonneval noted, inter alia, that captains were poorly trained and unmotivated, and that disorder aboard ship and the bad state of repair of both vessels and essential equipment inhibited seaworthiness. The fiasco at Çeşme in 1770 and the certainty that a campaign to retake the Crimea would require a much improved Black Sea fleet prompted Sultan Abdülhamid to urge haste in preparations to take on the Russians once war became inevitable after the loss of the Crimea. In the mid-1780s galleons, brigantines and sloops were built, and a warship was bought from Sweden and a 'copper-bottomed' vessel from England, and when the fleet set sail to the Black Sea and the Mediterranean on 23 April 1788, it comprised 28 ships manned by 263 officers and about 12,500 men.[82] But it arrived too late to enable the existing forces in the area to reduce Kinburun where there was heavy fighting soon after the outbreak of the war, and Russian retention of this highly strategic outpost prevented the fleet from playing a decisive part in the defence of Ochakiv, merely delaying its surrender by some weeks at the cost of 15 ships.[83] The Ottoman government heeded this lesson and between 1789 and 1798 45 large, modern warships came into service, but new ships were only part of the answer: as with the army, manpower was the besetting problem. The poor quality of the captains noted by Bonneval

was addressed by a new system of officer training and the establishment of professional schools where education in naval architecture went hand-in-hand with instruction in the principles of navigation.[84]

Sultan Selim was a man of feeling and spiritual depth as well as a modernizer: in the years before his accession he wrote music and poetry which reflected his pessimism about the state of the empire, and he derived spiritual comfort from his attachment to the Mevlevi order of dervishes. As sultan, like others before him, he was swift to place his chosen spiritual mentor in a position of influence over the ruling circle as well as the wider population. In the mystical poet Sheikh Galib he had a supporter and propagator of his reforming ideals; in 1791 Galib was appointed sheikh of the Mevlevi lodge in Galata, and Selim became a frequent visitor. He enhanced the visibility and influence of the order, supporting Mevlevi activities across the empire and repairing the tomb of the order's thirteenth-century founder, Mevlana Jalal al-Din Rumi, in Konya in central Anatolia. Sheikh Galib, for his part, wrote many poems to commemorate the Sultan's efforts to introduce military reform.[85] Just as Tatarcık Abdullah Efendi referred back to the janissary traditions of Süleyman I's time, so Sheikh Galib sought to make the proposed reforms seem less threatening with vocabulary which employed the familiar concepts of the Ottoman past. A poem beginning:

> His Highness Han Selim who fashions perfect justice in his age,
> Has brought prosperity anew to flourish in our faith and state;
> Illumined by inspiration divine, his comprehending heart
> Creates original conceits of rhyme and reason for the state.
> His effort and his thought are all to restore order to the world,
> He reckons requisites like war like invocations of God's name;
> He registers the army's needs with gold and silver freely spent,
> Divine favour bestows upon his many works success and fame

concluded with a verse describing the barracks newly built for the bombardier corps that it commemorates. Doubtless Selim also saw his Mevlevi propagandist as a counterweight to the Bektaşi order of dervishes associated with the janissaries,[86] and certainly their influence was undermined as that of the Mevlevi grew. The Sultan did not rely on Mevlevi backing alone, however, but was careful to invoke the principles of Islamic law for his reforms as another tactic in playing down their departure from past practices.[87]

The new order envisioned by Sultan Selim was built upon a revised perception of the Ottoman place in the world and involved more than a modernization of the empire's naval and military capabilities. In 1699 the Treaty of Karlowitz had forced the Ottomans to abandon their expectation that

the physical limits of the empire could be expanded indefinitely: the reality of the significant territorial losses suffered at that time forced them to seek a new raison d'être for the empire more in keeping with the times. One symbol of the Ottomans' appreciation of their new place in the European order was their acceptance of third-party mediation in peace negotiations. The wars with Russia between 1768 and 1792 dealt the Ottoman state an even greater blow than its conflict with Habsburg Austria at the end of the seventeenth century, forcing a further revision of its diplomatic relations with the outside world and acceptance by Ottoman statesmen of the necessity to adhere to mutual agreements and treaty obligations in a spirit of reciprocity – as they perceived their European peers to do.

Traditionally, Ottoman sultans had seen themselves as graciously conferring peace on a supplicant adversary, but a period during which the empire was always on the defensive exposed this for the fiction it was. Traditionally, too, peace had been predicated on the principle of 'terminable coexistence', a temporary condition the sultan was at liberty to end when he saw fit.[88] The concept of reciprocity in European diplomacy had been aptly expressed by the Treaty of Westphalia which ended the Thirty Years' War in 1648. Although the arrangements did not work perfectly – and have been characterized by a modern historian as less a harmony of interests than a 'collision of [states'] greed and fear' – the various settlements the treaty comprised recognized the sovereignty and independence of the individual states that made up the Holy Roman Empire, and the framework within which the competing claims of these states were to be regulated and stabilized was a tacit recognition of a shifting balance of power. The first occasion on which the term 'balance of power' actually appeared in a treaty was in the Treaty of Utrecht which concluded the War of the Spanish Succession in 1713.[89] Almost a century later Selim III, seeking to establish his relations with the European powers on a predictable basis, embraced the concepts according to which they had regulated affairs between themselves for so many years.

Selim assumed that if the Ottoman Empire engaged with the other states of Europe according to their rules, it would be accorded equal terms and equal treatment, so that the action of Prussia and Sweden in setting aside their treaties with the Ottomans in 1790 was deeply shocking to the Istanbul government – so incredulous were the Ottomans that they continued to regard the alliance with Prussia as valid until at least 1793.[90] Unfortunately for Selim, the times were against him: just when the Ottoman Empire had a sultan prepared to make sweeping changes the states of Europe were thrown into upheaval, first by the French Revolution, then by the Napoleonic Wars, and forced to reassess their own priorities and the modus vivendi which had served them for so long. The Ottomans were to learn

that in the present state of affairs, European diplomacy reflected their own customary stance – that treaties were considered expendable when realpolitik demanded. It was a bitter lesson.

As the Ottoman–Russian war ended in 1792, the first of the pan-European conflicts triggered by the collapse of the French monarchy began. At the outbreak in 1793 of the war which saw a coalition of Great Britain, Austria, Prussia and numerous smaller states ranged against republican France, the Ottomans declared themselves neutral in a move which was a significant departure from previous practice. When the Prussian ambassador to the Sultan tried to persuade the chancellor, Mehmed Raşid Efendi, that the Ottomans should ban the French within the empire from wearing the cockades that symbolized sympathy for the revolution, he replied:

> They [i.e. France] and the other European states who have treaties with the Sublime State are its friends, and those who reside in Istanbul are its guests. The friendship of the Sublime State for the French is not contingent on its form of government, be it a republic or a monarchy, but it is a friendship for the French people. You name the French who reside in Istanbul as Jacobins whereas we know them as the French. We do not consider their costume and symbols important, and interfering in these matters means disapproving of their conduct. Even disapproving is enough to be deemed to be taking the part of their adversaries, and this is contrary to neutrality.[91]

The Chancellor stated that interference in the dress of the French was forbidden by the capitulations, implying that Ottoman relations with France remained unaltered – whether the state was royal or republican – and no amount of effort by the powers of what is known as the 'First Coalition' could alter this.[92] This was the first time that the Ottomans stated their position in terms of a concept which was current in European international law but had no place in Islamic law[93] – even in its Ottoman version.

In 1798 Napoleon Bonaparte invaded Ottoman Egypt. Such insolence could not be ignored, but the decision to declare war on their long-time ally was not taken lightly. In justifying their response to this French belligerence the Ottoman declaration of war demonstrated their desire to adhere to European norms:

> They [i.e. France] suddenly attacked like a pirate and seized Egypt, the most precious dominion of the Sublime State, in a manner the like of which has never been seen, and which is contrary to international law and to the legal rules that are valid among states.[94]

The requirement for a juridical opinion authorizing these hostilities necessitated the removal of the pro-French party in the imperial council, which

included the Grand Vezir and the Sheikhulislam. One consequence of the French invasion of Egypt was that the Ottomans found themselves allied not only with Great Britain and, briefly, Austria, but also with their nemesis Russia, in the 'Second Coalition'. This too was a novelty – the first time the Ottoman Empire had participated in a coalition with other states.[95]

Selim's reign is also notable for another departure in diplomatic practice. From earliest times foreign envoys from east and west had been received at the Ottoman court but only rarely had they been sent forth; during the eighteenth century at least twenty missions to European capitals are known to have taken place, five of them in the last decade. Selim recognized the advantages of reciprocity, and established permanent embassies. The first was in London in 1793; Vienna and Berlin followed in 1794 and 1795; in 1797, an ambassador was sent to Paris.[96] Although it is clear that Selim intended to send a permanent ambassador to St Petersburg some time between 1793 and 1795, no appointment was made.[97] The turbulence of Europe at this time proved inimical to the experiment, however, and some of the cultural imperatives of Islam can only have been a further constraint – the prohibition of the consumption of alcohol, for example – at a time when an ambassador's full engagement in the social life of the capital to which he was appointed was an essential part of diplomatic intercourse. Bonaparte's stricture to his ministers that they should 'not fail to give good dinners and to pay attention to women' was quite contrary to the dictates of Ottoman comportment, as Selim was well aware:

> The zeal inspired by Islam and the preservation of the honour of the Ottoman State in truth prevent social relations between Muslim ambassadors and their foreign hosts. Thus the main purpose, which is to penetrate secrets and attain benefit, will not be possible.[98]

Selim's desire to be a monarch in the European style was all-consuming, however. Like Mustafa III and Abdülhamid I he commissioned local and European artists to paint his portrait for presentation to family members to hang in their palaces; in 1794 and 1795, moreover, he ordered his ambassador in London, Yusuf Agha Efendi, to arrange for seventy engravings, in both colour and black and white, to be made from his portrait for presentation to dignitaries. He was the first sultan to realize the international political function served by imperial portraiture: he commissioned an album containing engraved portraits of all the sultans from a London printer, and in 1806 presented a portrait of himself to Bonaparte. As he wrote to his grand vezir:

> I am delighted by the French Emperor's gifts, especially the portraits. That he sent me portraits demonstrates great friendship and sincerity, because it is an

important custom for friends to exchange portraits in Europe. You have no idea how happy this makes me. I have a portrait of myself specially painted for him, a large picture. I must send it immediately to my imperial friend.[99]

The way the fabric of central authority in the Ottoman provinces unravelled during the eighteenth century was not simply the result of failures to balance inevitable conflicts between central government and local interests, and the problems it brought were only exacerbated in the last decade of the century by the element of recentralization in some of Selim's reforms, which went against the grain of the tendencies of the preceding years. Few in the provinces were happy with the arrangements for raising and financing the 'New Order' army, for example, since they undermined provincial notables' recently-won responsibility for recruiting troops as well as their financial interests, as revenues for the 'New Revenue' treasury which was to finance the 'New Order' army were raised in part by taking certain tax-farms back into state ownership when they fell vacant.[100] These were investments local notables, as a group, would not willingly relinquish, for the availability of financial resources gave them an opportunity to build political clout. The claw-back of financial assets also hit particularly at those of intermediate means, for the system of life-term tax-farms had tended to greatly increase the numbers of individuals at all levels of provincial life with a stake in or ancillary association with the system. Once the bottom rungs of the ladder of local power had been attained, further aggrandisement could be achieved by a wider geographical spread of investments or by diversification into sectors of the economy less intimately tied to the parlous finances of central government – moneylending, or regional or even international trade.[101] Those who were most successful found themselves in a position to ignore central government demands – and there were many more prepared to join them.

Regional influences that played their part in the general trend towards a measure of provincial autonomy also ensured that the experience of the European provinces of the empire was very different from that of Anatolia and particularly of the Arab lands – indeed, the experience of each province was in many ways unique. Because of their geographical situation the Balkan territories of the empire had always been easy targets for the interventionist designs of European powers, and by the end of the eighteenth century the Ottoman state had lost the loyalty of much of its Balkan Christian population. The wars that convulsed the region over the years had prompted many to seek refuge in the Habsburg domains, but even those who remained were not immune to siren calls from beyond Ottoman borders. But it was not only the Christians who threatened the stability of the Balkans: local Muslim dynasts both here and in western Anatolia were every bit as ambitious and

susceptible to outside blandishments, and the situation was little different in eastern Anatolia, where regional loyalties still exercised a strong pull on the significant Shia populations of the Ottoman provinces bordering Iran.

The Arab world was also changing. After the failure of initial attempts to bind them tightly to a centre both physically and culturally far-distant, Ottoman policy towards the Arab provinces settled for a compromise based on a measure of loyalty from its Arab subjects to the Ottoman dynasty and state and the powerful bond of shared religion. This compromise had provided a sufficient guarantee against separatist tendencies until the late eighteenth century when the degree of independence achieved by the Bosnian adventurer Cezzar ('Butcher') Ahmed Pasha in Syria was exceeded only by that of the Albanian Mehmed Ali Pasha in Egypt, in the wake of the French invasion of 1798, while the Wahhabi Islamic renewal movement which began in the Hijaz in the mid 1770s had the potential to be as much of a threat as the incipient separatist tendencies of Christians in the Balkans.

By the end of the eighteenth century little of Anatolia was administered by officials sent from Istanbul in the time-honoured way; rather, a number of households who had built up fortune and influence over the century acted as intermediaries between the Istanbul government and its provincial agents. Among the most prominent were the Çapanoğulları of central Anatolia, the Karaosmanoğulları of western Anatolia and the Canikli of north-central Anatolia. The Çapanoğulları had sprung from modest beginnings to monopolize local financial and administrative positions in central Anatolia by the time of the war of 1768–74, and for thirty years from 1782 the patriarch of the family, Süleyman Bey, co-operated with central government, providing troops and provisions as requested in return for further rewards. He supported Sultan Selim in the establishment of the recruitment and financing structures of the 'New Order' army, briefly fell from favour during the reign of Selim's successor Mustafa IV, and then again collaborated with the government until his own death in 1813, by which time the holdings of his dynasty comprised interests across central Anatolia and in the Arab provinces of Raqqa and Aleppo.[102] Support for Selim's reforms clearly brought rewards, for during his reign Süleyman Bey and his brother Mustafa were able to build a substantial mosque in Yozgat, east of Ankara, which was further enlarged by Süleyman Bey's son.[103]

The Çapanoğulları had a history of conflict with their neighbours the Canikli, whose lands lay between their own and the Black Sea, and the fortunes of the two dynasties waxed and waned as the state favoured

sometimes the former, sometimes the latter. But the Canikli (as we have seen) proved unreliable as government allies, and their fall from grace worked to the advantage of the Çapanoğulları. Following his release from Russian captivity Tayyar Mahmud Bey refused to support the 'New Order' and in 1806 fled to the Crimea – since 1783 part of the Russian Empire.[104]

The Karaosmanoğulları could trace their history from the seventeenth century, and in the eighteenth century their influence was due largely to their control of the office of governor's proxy in the sub-province of Saruhan. They possessed significant agricultural estates and also some of the richest commercial tax-farms of İzmir and maintained public order in an area whose life-blood was foreign trade. Like the Çapanoğulları they supported the state, providing essential assistance in men and provisions for the 1787–92 Ottoman–Russian war. Karaosmanoğlu Hacı Ömer Agha, who died in 1829, was said to be the richest of all provincial grandees of his time.[105] The dynasty left a significant architectural legacy in the area centred on their seat at Manisa, where mosques, caravansarays, libraries and theological colleges attest to their great wealth and extensive patronage.[106]

In the east, authority in administrative and fiscal matters in Diyarbakır, situated on an important trade route on the river Tigris, was concentrated for some years at the end of the eighteenth century in the hands of the hereditary leaders of the Nakşibendi dervish order, the Şeyhzade family, having previously been shared between government agents and a spectrum of local notables. Until the time of Selim's reforms Diyarbakır's interests broadly coincided with those of the central state, but the arrival in the city in 1802 of a battalion of 'New Order' troops had dire consequences. They had been recruited from outside the province but their salaries were to be met from local revenue sources seized from their current beneficiaries and transferred to the 'New Revenue' treasury for the purpose. This peremptory imposition on an economy already suffering from the general economic downturn of the second half of the eighteenth century provoked an uprising. Deportations played a part in the government's efforts to quell the disturbances, and among those removed were 71 members of the Şeyhzade family.[107]

There was no 'typical' Anatolian dynasty, as this brief account demonstrates, but by the eighteenth century Anatolian notables had abandoned the rebellions – usually characterized by the government as 'sedition and disorder' – so endemic in the seventeenth. The Balkans offered almost a mirror-image of the Anatolian experience, less affected than Anatolia by rebellions during the seventeenth century, more during the eighteenth. The intense periods of warfare against Austria in the late seventeenth century and then against Russia, in particular, in the eighteenth, had placed an

intolerable strain on the people of the Balkans. A few had found and seized an opportunity to profit, but the majority had been consigned to a miserable existence. Much of the fighting had taken place on Ottoman territory, precipitating significant refugee movements, and disease had also taken its toll of a population in distress.

As in seventeenth-century Anatolia, so in the late eighteenth-century Balkans the line between a brigand and a rebellious notable was often very finely drawn. Among a host of minor contenders, the main players – who certainly fell into the second of these categories – were Pasvanoğlu Osman Pasha of Vidin and Tirsiniklioğlu İsmail Agha of Ruse, both on the Danube, Tepedelenli Ali Pasha of Ioannina and the Bushatli clan of northern Albania who each controlled and administered huge territories. These magnates were men with their roots in the provinces. Their interests in life-term tax-farms were extensive, and they had supplied the army with men and provisions during the 1787–92 war. As in Anatolia, friction between these powerful households was inevitable: the Bushatli vied with Tepedelenli Ali as their respective ambitions brought them into territorial conflict in Albania; on the Danube, Pasvanoğlu Osman and Tirsiniklioğlu İsmail competed for resources and influence. Istanbul needed these notables for the vital part they played in the war effort but, although willing to reward them with economic power in their respective regions, tried to deny them the political power they craved – and rebellion was the result. When the interests of these men conflicted with those of central government, armies were raised against them – but with little success.

To take the example of Pasvanoğlu Osman Pasha: his father Ömer's estates had been confiscated in 1788 when he was executed for inciting the population of the Vidin area against the state. Part of this territory was returned to Osman after he distinguished himself in the war of 1787 to 1791 against Austria, enabling him to build up sufficient funds to attract to his side a militia composed of demobilized troops and other troublemakers who had been caught up in the recent war. His subsequent raids into Serbia and Wallachia brought him the Sultan's censure, but he was pardoned on the promise that he would become a loyal servant of the state. In 1792, however, he seized the fortress of Vidin from its Ottoman governor for which he was ordered to be executed. Pardoned once more thanks to the support of the local people, he continued to build up his following and, profiting particularly from a share of the region's trade with Austria, by 1794 was the most powerful magnate in Rumeli, controlling territory from Belgrade to Edirne. Repeated government attempts to appease him failed. He was permanently at odds with the commander of the fortress of Belgrade, Hacı Mustafa Pasha, and in 1796–7 he seized lands from his rival on the Danube, Tirsiniklioğlu

İsmail Agha of Ruse; following the rout in 1797 by Tepedelenli Ali Pasha of Pasvanoğlu Osman's more than 12,000-strong militia – composed of Turks, Albanians, Bulgarians and Bosnians – Selim sent over 80,000 troops under the command of a coalition of royalist Rumelian notables and statesmen of central government against him in Vidin. After eight months the siege of Vidin was raised, and Pasvanoğlu Osman was pardoned yet again by the Sultan who needed to turn his attention elsewhere.[108]

The government did not hesitate to set these provincial magnates against one another, or to employ them to contain those viewed in Istanbul as 'brigands' – rapacious officials, demobilized soldiers and anonymous riff-raff – but whose methods of operation on occasion differed little from theirs. The lesser notables of the Balkans were known as 'mountain brigands' in Istanbul, and the government first moved against them in 1791, as the war with Russia was winding down. Several frustrated attempts to reduce their activities revealed them to be adept at manipulating the government for their own purposes, and the old ploy of encouraging loyalty and conformity by the distribution of provincial governorships proved only intermittently effective.[109] The loyalty to the central state displayed by the most prominent Anatolian families found no echo in the Balkans, where all were opposed to the 'New Order' – as were the men called to join up. As one contemporary remembers it, when enlistment orders went out in the Balkan provinces, they were greeted with blunt refusal to comply: 'We are janissaries and our forefathers were janissaries; we will not accept the 'New Order'.[110]

In the volatility of the international situation during Selim III's reign, as the French Revolution and the Napoleonic Wars transformed the balance of power in Europe, foreign powers found scope for intervention on the periphery of Ottoman domestic affairs that was potentially more damaging than hitherto. Russia, and to a lesser extent Austria, continued to exert influence in the provinces of the west and north; as the need to safeguard British trade routes to the east brought Great Britain closer involvement in Middle Eastern affairs, it too began to emerge as a force for the Ottomans to reckon with. At a time when their relationship with central government was changing, Balkan notables – particularly in Montenegro and Albania, which had never fully acquiesced to Ottoman authority – found it tempting to seek to further their own interests by means of alliance with one European power or another. Those whose territories lay on the borders of the Adriatic and the Danube were most susceptible to external offers of assistance in advancing their aims – often an assertion of greater independence – in exchange for their connivance in the game of Great Power politics.

Even before Bonaparte's invasion of Egypt there was potential for hostile

French intervention in Ottoman affairs. In 1797 the Treaty of Campo Formio between Austria and France – the culmination of Bonaparte's efforts in Italy – awarded France the Ionian islands and the port cities of southern Albania and Epirus, giving France, by virtue of its possession of Venice's Dalmatian colonies, a border with the Ottoman Empire. Talleyrand, the French minister for foreign affairs, had plans to use Tepedelenli Ali Pasha of Ioannina and Pasvanoğlu Osman Pasha in a bid to overthrow the Sultan. Tepedelenli Ali clearly did not feel confident enough to disavow his allegiance to Selim,[111] who to secure his loyalty, promoted him and promised to reward him; Pasvanoğlu Osman was not only reported to be involved in discussions with the French but in 1798 established contacts with the Russian and Austrian consuls in Bucharest.

While most of the troops of the Ottoman Balkans were engaged in Egypt following Bonaparte's invasion, Pasvanoğlu Osman gave his support – not for the first time – to the janissaries rebelling against Hacı Mustafa Pasha in Belgrade who were, in reality, an ill-disciplined and opportunistic militia rather than a reliable fighting force loyal to the Sultan. The extra taxes Hacı Mustafa found it necessary to levy in order to defend the province against the janissaries' depredations raised protests among local Serbs, who had been granted a degree of autonomy by Selim in the effort to conciliate them after the recent war with Austria.[112] Resorting to the most cost-effective solution, Mustafa Pasha permitted the Serbs to take up arms to defend themselves, further inflaming the situation, and he was soon forced by a juridical opinion delivered by the senior cleric of Belgrade to permit the janissaries, and other disruptive elements whom he had earlier exiled from the province, to return. They had taken refuge with Pasvanoğlu Osman Pasha in Vidin, and in 1801, once more in control of the fortress of Belgrade, they executed Hacı Mustafa.[113] By 1804 opposition to the militia from the population suffering at its hands – Christian and Muslim alike – was such that a juridical opinion to the effect that resistance to the abuses of the militia was licit was handed down and, supplied with munitions by the Ottoman governor of Niš, a force of some 30,000 Serbs under the leadership of George Petrović, also known as Kara ('Black') George, successfully besieged the fortress of Belgrade. Similar attacks on the janissary militia took place in other strongholds where they were holding out. The Serbs appealed for help to Russia, who offered some clandestine support, but the Austrian government remained neutral: both had more pressing concerns elsewhere. Serbs of the Austrian military border did, however, come to the aid of their beleaguered fellows.[114]

Although local Christians and Muslims were united in a common purpose of bringing down the janissary regime, the Istanbul government was soon

sufficiently alarmed by the Serbs' success to send an army against them – the usual response to any over-ambitious provincial power. The Serbs under Kara George won the confrontation and went on to bring the whole province under their control, finally occupying the fortress of Belgrade on 6 January 1807. With the Orthodox Christian Serbs now ranged against the forces of the Ottoman state – rather than merely a discredited local militia – it seemed there had never been a better opportunity for Russia to intervene in the Balkans on behalf of her co-religionists. Russia was at war with the Ottoman Empire from late 1806 over control of Moldavia and Wallachia, and in June 1807 Russia sent an envoy to Belgrade to broker a convention with the Serb authorities: throwing in their lot with their Orthodox protector, the Serbs agreed to accept Russian military advisers and the establishment of Russian garrisons in the province, and were promised a constitution. But the full-blown intervention that seemed so inevitable did not materialize: Russia's peace treaty with Napoleon at Tilsit in 1807 included a French offer to mediate between Russia and the Ottomans, effectively precluding Russian support for the Sultan's Orthodox subjects.[115]

The Serb revolt had repercussions for Austria because the population of its Balkan border with Ottoman territory was predominantly Slav and Orthodox. Austria was a Catholic empire, and securing the loyalty of these people considered schismatics by the Church was a matter of particular concern in Vienna, for fear lest 'their faith [make] them look to the Tsar of Russia for protection'. The time-honoured compromise between Catholic government and Orthodox subjects exemplified by the Uniate Church – whose adherents recognized the Pope as their spiritual authority while retaining Orthodox liturgy and ritual – still held in theory, but whenever the Ottoman threat receded – after the Treaty of Passarowitz in 1718, for example – the Catholic Church was allowed a freer hand: then, Orthodox Christians were persecuted and their religious freedoms further curtailed, and refugees who had travelled northwards across the border following the war returned to their former homes in Ottoman territory. The pattern repeated itself: Austria's poor performance in the war of 1737–9 led to another period of Orthodox repression, this time involving the Jesuits,[116] and forcible conversion, the mere rumour of which prompted unrest along the border and renewed flight into Ottoman territory – and, incited by Russian agents, into Russian territory.[117] By the 1770s, Austria's border with the Ottomans in the Balkans was a tightly-controlled, fortified line stretching from the Adriatic to the Carpathians, whose management became even more of a challenge once Russia began to play an active role in the internal politics of the region. Emperor Joseph II cherished a hope that a policy of religious toleration and the Austrian alliance with Russia from

1788 would win the loyalty of his Orthodox subjects; and his successor, Leopold II, between 1790 and 1792 repealed all legislation discriminating against them.[118]

The Serb revolt did not just rekindle doubts about the loyalties of Austria's Orthodox subjects – it also raised the spectre of Slav nationalism, uniting the Orthodox Slavs with their Catholic Slav fellows of southern Hungary, Slavonia and Croatia, who felt aggrieved by Austria's failure to intervene in the revolt, and aided their fellow Slavs when they were able. The Austrian government was now anxious lest this community of South Slav interest cutting across the religious divide should prejudice the loyalty of even the Catholic defenders of the Habsburg southern border with the Ottomans.[119] The Ottomans, too, had much to fear from those professing a common Slav identity.

During the course of the eighteenth century, the Orthodox Christian Danubian Principalities – on the lower Danube between the Ottoman and Russian empires – became a focus of Russian interest as the wars involving the Ottomans, Russia and Austria gradually weakened Ottoman authority in the region. The indigenous ruling class of the Principalities had customarily provided candidates for prince-governor, but this system had ended in 1711 following the defection of the Moldavian prince Dimitri Cantemir to Peter the Great in expectation that Russia would triumph in its war of 1710–12 with Cantemir's suzerain, Sultan Ahmed III. The last indigenous prince of Wallachia, Constantin Brâncoveanu, failed to assist Peter on the Prut, choosing instead to turn his supplies over to the Ottoman army,[120] but subsequently fell victim to the scheming ambition of Cantemir's successor in Moldavia, Nicholas Mavrocordato – son of Alexander, who had been one of the negotiators of the Treaty of Karlowitz – and was executed in Istanbul in 1714 with his four sons and his counsellor; their heads were exposed before the gate of Topkapı Palace.[121] Thereafter began the century-long 'Phanariot' period in the history of the Principalities as Greeks originating in the wealthy and influential merchant and banking community of the 'Phanar' district of Istanbul – known as 'Fener' in Turkish, and still the seat of the Orthodox Patriarch as it has been since 1587 – became the preferred candidates for prince-governor, exercising their authority from their splendid courts at Jassy in Moldavia or Bucharest in Wallachia.

Like their indigenous predecessors the Phanariot prince-governors were answerable to Istanbul, but their primary loyalty was to the sultan rather than to local interests. Ottoman concerns in this buffer region were essentially strategic, for Russia's power was on the rise. There were few constraints on how a prince-governor and his followers were able to make themselves rich at the expense of the local people, but any suspicion of treasonous

dealings with Russia was reason enough for removal, and few prince-governors held the post for very long. The ultimate sanction of execution on the sultan's orders continued to be enforced during the Phanariot period as it had been before.[122]

Jassy and Bucharest were occupied by the troops of Catherine the Great during the Ottoman–Russian war of 1768–74, but the Treaty of Küçük Kaynarca had restored Moldavia and Wallachia to the Ottomans, albeit under conditions favourable to Russian influence in their internal affairs. The war of 1787–92 further weakened Ottoman influence in the Principalities: under the terms of the Treaty of Jassy the border between Russia and Moldavia was set at the Dniester – previously the Dnieper had marked their common frontier. In 1802, Russia won the right to approve Ottoman candidates for prince-governor of Moldavia and Wallachia, and their term of office was set at seven years. For the Ottomans, this strengthening of Russian authority cast a long shadow over their hopes of maintaining the integrity of their European territories.

Reluctant to alienate either France or Russia, Sultan Selim tried to steer a path through the insistent diplomatic activity of their ambassadors in Istanbul. The Ottomans had recognized revolutionary France when it became impossible to do otherwise but failed to send any official acknowledgement when Bonaparte was crowned Emperor Napoleon I in 1804, and this led to a suspension of diplomatic relations between the two states. Russia moved to fill the void: Selim agreed that Russian ships could sail through the Bosporus into the Mediterranean, and conceded the right to appoint Russophile prince-governors in the Danubian Principalities. Napoleon's victories against Austria at Ulm and Russia at Austerlitz late in 1805 caused Selim to change tack, however, and in February 1806 he recognized Napoleon as the equal of the emperors of Russia and Austria. In August 1806 the Ottomans yielded to French insistence and unilaterally dismissed the governors of Moldavia and Wallachia, which provoked Russian military intervention in the Principalities; in December the Ottomans declared war. In May 1807 Napoleon agreed with the Shah of Iran that France would help Iran recover Georgia, annexed by Russia in 1801;[123] but in July of that year he signed the Treaty of Tilsit with Tsar Alexander of Russia. Napoleon's intentions in the east appear to have been to create a diversion with a threat to British interests in India, and either to distract Russia – with trouble on its southern borders – or, by offering the opportunity for further expansion, to bring Russia into alliance with France.

Distant as they were from events in Europe, it was yet inevitable that the Arab provinces of the Ottoman Empire should feel the effects of the profound

changes wrought by Great Power politics. The Baghdad–Basra borderlands of the Ottoman Empire with Iran were semi-autonomous, their administration in the hands of the Sunni al-Da'ud household for much of the period between 1723 and 1831. Istanbul could attempt to assert its authority through the appointment of governors, but although central control was more than usually desirable in a region where the potential for friction with neighbouring Iran was limitless, it was also more difficult to impose on a diverse population of settled peasants, Arab and Kurdish tribesmen, Iranian Shiites, merchants and traders, and pilgrims travelling to the Hijaz. War broke out on this frontier in 1774, just as the Treaty of Küçük Kaynarca obliged the Ottomans to acknowledge their weakened military position in the west. Western Iran was in the hands of the energetic Shia Zand dynasty of Shiraz and the south-west Caucasus was controlled by Georgia, nominally an Ottoman vassal, but allied with Russia from 1783. The Tigris–Euphrates basin was thus the remaining strategic bulwark against further Zand expansion at a time when the Ottoman imperial army was scarcely in a position to assist local forces to defend it.[124]

Ömer Pasha al-Da'ud, governor of Baghdad between 1764 and 1775, was a man more interested in consolidating his own power than fulfilling his duties as an agent of the Ottoman sultan. The Shah complained of his independent actions to Sultan Abdülhamid, but there was little Istanbul was either able or prepared to do. When in 1775 the rich Gulf port of Basra was besieged by the Zand, Ömer Pasha feared they would move on to attack Baghdad, and offered little assistance – the siege ended a year later with the capitulation of the starving garrison. Even before the fall of Basra an Ottoman army composed of forces loyal to the Sultan attacked Baghdad, dislodging and killing Ömer Pasha, and following its loss the Ottomans declared war on the Zand. The sanctioning juridical opinion cited the attack on Basra as casus belli and dwelt on the arrogance and duplicity of the Zand, a demonstration that the principle of justifying war against Iran on the grounds that Shia Muslims were schismatics – first departed from in the treaty with Nadir Shah in 1746 – had indeed been abandoned.[125] Subsequent hostilities were brief, however, and peace negotiations began in 1777.

The most famous scion of the al-Da'ud dynasty was Süleyman Pasha, 'the Great', commander-in-chief at the siege of Basra and governor of Baghdad between 1780 and 1802. To the undoubted relief of Sultan Selim, he accepted the 'New Order' in his domains.[126] Others in the region did not, notably the al-Jalili and other leading households of Mosul who controlled territories to the north of Baghdad. These notables had established a monopoly over agricultural production in the area, and consistently

diverted to their own purposes resources to which Istanbul laid claim. They were disenchanted with the central authority, particularly with the poor Ottoman performance on the Russian front after 1768, and Süleyman Pasha al-Jalili, governor of Kirkuk and then of Mosul, ignored instructions to furnish provisions during the siege of Basra – and subsequent government efforts to employ him as a supplier of provisions for the army were equally unsuccessful. The Mosul notables were limited in their ambitions only by the increasing power of the Baghdad governors around the turn of the century, and the imposition of the 'New Order'.[127]

Late eighteenth-century Syria was also in the hands of local notable house-holds, though circumstances varied between provinces. Aleppo, for instance, threw up no one pre-eminent family; rather, factional alliances among different families manoeuvred for control of local resources and revenues as a basis for political and economic strength. Here, bloody confrontation was likely to erupt in the rivalry between 'paper janissaries' – men on the janissary rolls who had no military role or intentions – and privileged local dignitaries. The province of Damascus was controlled for much of the eighteenth century by the al-'Azm household, whose members benefited financially from the office of governor,[128] but as the Iranian silk trade contracted, Damascus lost impor-tance to the province of Sidon and its commercial port of Acre, where Sheikh Zahir al-'Umar held sway from the 1740s, impervious to repeated attempts by the central authorities to curb his activities.[129] In 1771, during the Russian–Ottoman war of 1768–74, Sheikh Zahir al-'Umar co-operated with the de facto ruler of Egypt, Bulutkapan ('Cloud-snatcher') Ali Bey, when he embarked upon a campaign to conquer Syria, carefully justifying his conduct as a defensive measure.[130] This pretext was belied when, following the destruction of the Ottoman fleet off Çeşme in western Anatolia and the subsequent attack on Ottoman ships and land positions in the northern Aegean,[131] some ships of the Russian fleet sailed to assist the rebels on a promise received from Bulutkapan Ali to hand over Jerusalem and the Christian Holy Sites. Bulutkapan Ali was betrayed by his client Mehmed Bey Abu al-Dhahab (who was also his brother-in-law and successor), and his successes proved ephemeral, but in 1772 he joined Sheikh Zahir in Syria where, with the naval support of the Russians who bombarded the city from the sea, they besieged Beirut, a seat of the Druze loyalist clan of the Shihab.[132] While occupied by the war with Russia in the west and north, the Ottoman central government could only hope to defuse this dangerous rebellion by pacifying Sheikh Zahir with control of the financial assets of the province of Sidon; once the war was over, however, Mehmed Bey (now governor of Egypt) led an expedition against Sheikh Zahir in 1775. Although Mehmed Bey died of illness while on this campaign, Sheikh Zahir was overthrown.[133]

Sheikh Zahir al-'Umar's successor as the predominant notable of northern Syria was a man of very different origins. Cezzar Ahmed Pasha, a Bosnian by birth, had reached Cairo in 1756 in the entourage of the Italian renegade, three times grand vezir and then governor of Egypt, Hekimoğlu ('Son of the Doctor') Ali Pasha.[134] He entered Bulutkapan Ali Bey's household but left his service in 1769 and subsequently distinguished himself by going to the aid of the Shihab when Beirut was under siege by Sheikh Zahir. Rewarded with the governorship of Sidon in 1775, he held it until his death in 1804, bringing much of greater Syria under his sway – he was additionally appointed governor of Damascus in 1785 – and controlling the revenues of the region which primarily derived from the trade in cotton and grains. Central government efforts to limit his authority by appointing him to govern provinces such as Bosnia, far from his financial base in Syria, were in vain, but whatever Istanbul's misgivings about his quasi-autonomy, he was punctilious in observing the formalities of his relationship with the sultan, including forwarding the annual remittance to the central treasury, and ensured the safety of pilgrims by subduing other, less compliant, local forces.[135] The economic life of Syria prospered under Cezzar Ahmed Pasha's regime as commercial revenues fuelled the development of the towns of Acre, Beirut and Sidon in particular; he built extensively in his seat at Acre – six mosques, two bazaars and many caravansarays, fountains, bath-houses and watermills.[136]

Peace and economic prosperity came to Egypt in the middle years of the eighteenth century, as the powerful Kazdağlı faction established itself as the leading household in the province. This was a time when many new buildings were erected in Cairo and other centres by rulers who were at first content with the extent of their autonomy within the Ottoman Empire. Bulutkapan Ali Bey was head of the household from 1760; his invasion of Syria in 1771, in pursuit of even greater independence from Istanbul than he already enjoyed, gives an indication of the scale of the resources at his command, and the impotence of the Istanbul government to prevent him – albeit that it failed because he was betrayed by Mehmed Bey Abu al-Dhahab.[137]

By 1786 the deteriorating security situation in Egypt prompted the central government to intervene to restore order to a province riven by factional infighting since the death of Bulutkapan Ali Bey in 1773 and of Mehmed Bey Abu al-Dhahab two years later. Two other members of the Kazdağlı household – İbrahim Bey and Murad Bey – shared power uneasily and discordantly. They had recently deposed two Ottoman governors, no remittances were being paid over to the central treasury, and they were suspected of collaborating with Russia.[138] Moreover, local French merchants who had suffered at their hands had appealed to the Sultan for protection against

Murad Bey's attacks on their churches, and threatened to call upon the French government to intervene if the Sultan would not.[139] The Istanbul government commissioned a report on conditions in Egypt from Cezzar Ahmed Pasha; in it he described Cairo and the Egyptian countryside, and the military forces of the province, and recommended that the Sultan should send an expedition to reassert the power of central government and better organize the administration of Egypt:

> A total of twelve thousand soldiers will suffice for the expedition from Gaza . . . and the total time required for this trip [to Cairo] is eighty-three hours. During the trip . . . the new governor of Egypt must continually present gifts to the soldiers, on various minor pretexts, in order to attract their support, for since ancient times the people of Egypt have been expert in deceit and treachery. The varieties of stratagems and deceits used against ancient kings and former princes are well known . . . Also among the necessary prerequisites for this governor is that he must have gone to Egypt in advance, stayed there for several years, and participated in important affairs there.[140]

In 1786 a naval force was dispatched under the command of Grand Admiral Cezayirli Hasan Pasha, but this ended in a strategic withdrawal after the troops he landed failed to corner the troublemakers who retreated into the hinterland, and the Admiral was recalled to Istanbul the following year after the declaration of war against Russia. İbrahim Bey and Murad Bey were pardoned by the Sultan and continued to divert the revenues of the province into their own coffers. The uncertain conditions of the 1780s and 1790s also had an adverse effect on the profits of the French merchants in Egypt.[141]

Bonaparte's invasion of Egypt in 1798 shocked the Ottomans profoundly, just as the appearance of the Russian fleet in the Aegean in 1770 had. The French rationalized their invasion of the territory of a nominally friendly power with a proclamation echoing the language of Ottoman diplomacy, asserting that they were the 'enemies of [the Sultan's] enemies' – that is, of the quarrelsome households who ruled Egypt so erratically. Bonaparte's expectation was that once the corrupt military leaders at their head had been removed, the people would embrace the new regime the French intended to establish.[142] Cezzar Ahmed Pasha's recommendations had run along similar lines – though with the aim of restoring the power of Istanbul, not imposing that of Paris.[143]

Cezzar Ahmed Pasha proved his continuing commitment and value to the Ottoman state in 1799 when Syria came under attack from Bonaparte. In November 1798 Bonaparte protested his peaceful intentions to Cezzar Ahmed,[144] but then set out towards Syria to pre-empt the possibility of forces commanded by Cezzar Ahmed combining with any Ottoman expedition that might be sent to relieve Egypt, and reached Acre by mid-March

1799. Some of Cezzar Ahmed's local rivals joined the French in their siege of Acre, but he was supported by a British naval force including two men-of-war. The siege dragged on until the arrival of an Ottoman fleet and convoy and the spread of plague among the French forces combined to influence Bonaparte to withdraw during the night of 20/21 May.[145]

The Ottomans themselves suffered defeat at Bonaparte's hands at Abouqir Bay, when an army was landed there in July 1799, but the next month Bonaparte secretly left his new conquest for France. Holding on to Egypt proved difficult after his departure. Lower-ranking clerics uneasy with French pledges to respect Islam gave a focus to popular opposition, and the French army was close to mutiny. In Cairo itself, French rule could only be restored after a siege of the city lasting for several weeks in spring 1800, and in March 1801 British and Ottoman forces landed at Abouqir Bay as an Ottoman land army under the command of the Grand Vezir reached Egypt through Syria (the route Selim I had taken in his conquest of Mamluk Egypt in 1517). Cairo was surrounded, the French surrendered, and the British held Egypt until it was restored to the Ottomans by the Treaty of Amiens in 1802.[146]

Factions which had not supported the French were favoured by the British, but they found the establishment of sovereign authority in Egypt as elusive a goal as had the Ottomans and the French. Conditions were wretched for a population exhausted by factional fighting and war, and did not immediately improve when the British withdrew in 1803. The governor appointed by Istanbul was frustrated in his attempt to establish a modern army in the French style, and in 1803 he was caused to flee by a mutiny in an Albanian regiment, part of an Ottoman expeditionary force sent to Egypt two years earlier to eject the French. Repeated failures to restore order enabled the young commander of the Albanian regiment, one Mehmed Ali of Kavala, on the northern Aegean coast, to outmanoeuvre all other contenders for power and Istanbul, unable to impose any other solution, appointed him governor in 1805.[147]

This was to prove no short-lived expedient. Before long Mehmed Ali had successfully quashed opposition to his governorship from the factions who struggled to restore themselves to their pre-1798 eminence, and had built up his own household, inviting family and loyal allies from his homeland to join him. Whether he was prompted by sincerity or self-interest may be open to question, but he respected the Sultan's sole right to mint coins and to have his name honoured in the Friday prayer – and, moreover, remitted to Istanbul the surpluses of the Egyptian treasury.[148] Mehmed Ali's metamorphosis into a model servant of the Ottoman state was soon accomplished.

Istanbul's interests in the Arab lands were complicated from the last decades of the eighteenth century by the emergence of a puritanical Islamic

sect originating in an inaccessible tribal area in the centre of the Arabian peninsula, far beyond the practical limits of Ottoman authority. Building on its appeal as a renewal movement rejecting the accretion of un-Islamic practices over the centuries – cults of holy men, superstition, sacrifice and the like – the eponymous founder of the Wahhabi sect, Muhammad bin 'Abd al-Wahhab, attracted political and religious support and opprobrium in equal measure. By the 1770s the Wahhabi, with their religious practices so different from those promoted at the heart of the Ottoman Empire, were intervening in territory which came under the authority of the Sharifs of Mecca, and before long were pushing into Iraq. By the time of Muhammad bin 'Abd al-Wahhab's death in 1792, the stage was set for the foundation of a state based on his teachings under the leadership of a tribal chief, 'Abd al-'Aziz bin Muhammad bin Su'ud.

Territorial and spiritual ambitions soon brought the new Saudi-Wahhabi state into conflict with Ottoman concerns, but only slowly did Istanbul realize that reports from this distant corner of the empire should be taken seriously. The sharif of Mecca of the 1790s, Sharif Ghalib, organized expeditions against the Wahhabi and their tribal allies, but his forces tended to defect and his appeals for assistance to Ottoman governors in Syria and Iraq, and then to Istanbul, fell on deaf ears. In 1798 Sharif Ghalib's army was defeated, and he was forced to cede extensive territory.[149] The 'infidel' Bonaparte's success in Egypt in 1798 further diminished the Ottoman Sultan-Caliph's prestige as protector of the Holy Places and leader of the Muslim community (so carefully nurtured over the centuries), and confirmed the Wahhabi in their view that only they could preserve Islam. In 1802 they took the holy Shia pilgrimage city of Karbala' in Iraq but, preoccupied for an extended period with the Egyptian crisis, only in 1803 did the Istanbul government order a formal campaign against them. Troops and supplies failed to materialize in adequate quantity, however, and the Saudi advance continued. In 1803 the Saudis occupied Mecca until ousted by Sharif Ghalib; in 1805 they sacked Medina, and in 1806 recaptured Mecca.[150] Aware of his gravely weak position, Sharif Ghalib hoped at least for a measure of coexistence between the traditional order and this aggressive new sect, but the Saudis disdained his attempts at accommodation and closed the Hijaz to the Ottoman pilgrimage caravans in 1807. Su'ud bin 'Abd al-'Aziz, successor to 'Abd al-'Aziz bin Muhammad bin Su'ud, substituted his own name for that of the Sultan in the Friday prayers, usurping the most important prerogative of sovereignty in the Islamic world. The humiliation of Sultan Selim was complete, his claims to be supreme Islamic ruler now barely sustainable.

13

From the 'New Order' to the 'Re-ordering'

THE CHAOTIC SITUATION in the Balkan provinces of the empire at the turn of the century was closely related to the Great Power realignment of the time. Following Ottoman recognition of Napoleon as emperor in February 1806, he sent his envoy General Sebastiani to Istanbul to negotiate an alliance with the Ottomans against Russia; Napoleon intended Selim's army to act as a buffer, permitting further French advance into the Balkans to consolidate his victories at Ulm and Austerlitz late the previous year – his wild dream for Iran to be the third party to the alliance, thus offering him a passage to India, was realized the following spring.

In June 1806 there was upheaval close to Istanbul, when a force of 'New Order' troops recruited in Anatolia marched from the capital towards Edirne with the intention of intimidating the janissaries of the area – who to a man opposed Selim's military reorganization – into accepting it. The people of the region refused to supply provisions for the force on the orders of a local magnate, Dağdevirenoğlu ('Son of the Overturner of Mountains') Mehmed Agha, who had the support of his fellow notables who like him objected both to Sultan Selim's new army and to his plans for recruitment in the Balkans. In Edirne, the official who proclaimed the Sultan's recruitment plans was lynched, and the Sultan's name was omitted from the Friday prayer across the region. Grand Vezir İsmail Pasha was secretly in contact with the rebels, however, and tried to persuade the Sultan not to insist on imposing the 'New Order' in the Balkans – but to no avail. As Dağdevirenoğlu Mehmed summoned his fellows (including the Ruse magnate Tirsiniklioğlu İsmail Agha) to Edirne, the people of the town of Çorlu, halfway between Istanbul and Edirne, barred the road to the 'New Order' troops sent from the capital,[1] who pounded Çorlu with cannonfire, causing great losses to both sides.[2] Selim gave orders for his troops to proceed no further, no more blood was spilt, but the incident marked the beginning of the end of the 'New Order' project.[3]

Selim was seduced by the restoration of good relations with France; this greatly disturbed the British who in February 1807, forcing the Dardanelles in the teeth of heavy fire from the Ottoman batteries on its shores, sailed

several ships as far as the Princes' Islands, off the coast of Istanbul. But heavy seas permitted only one vessel to advance and drop anchor off Topkapı Palace, and plans to bombard the city on 22 February were dropped at the last minute; bad weather and resolute diplomacy on the part of the British conspired to force the fleet's withdrawal, and it sailed away having achieved nothing – except for bolstering Selim's confidence in his alliance with France.

At war with Russia since December 1806, in April 1807 the Ottoman government again sent its forces into the Balkans, to Silistra on the Danube, effectively the front line against this aggressive foe. During the intervening months Selim had pursued further innovations intended to improve the morale and performance of the army, provoking further anti-'New Order' disturbances in Edirne; these disturbances spread to Rumeli as conscription proceeded, and as local notables saw how the power they had accumulated could all too easily be swept away. Meanwhile, in Istanbul, the Sultan announced that he wished to wear the European-style uniform of the 'New Order' troops to the mosque for the Friday prayer and as he took the salute; moreover, he expressed a desire that the militia of the Upper Bosporus fortresses guarding the Black Sea approaches to Istanbul should also wear it. Some of his advisers warned that this was a misguided notion, but the opinion of the overseer responsible for the security of the Bosporus that the men would even wear headgear as outlandish as a hat if the Sultan wished them to do so won the day. On Monday 24 May the superintendent of these fortresses, former chancellor Mahmud Raif Efendi (called 'İngiliz' because he had spent time in London between 1793 and 1797 as first secretary to the first permanent Ottoman ambassador there), read out to the assembled men the Sultan's decree that they must accept the 'New Order' and adopt its uniform, examples of which he and his deputy had with them.[4]

The matter of the 'New Order' aroused such violent passions among contemporaries as to colour their accounts, which also vary in their detailed relation of the sequence of events; what cannot be doubted is that the militia who garrisoned the fortresses of the Upper Bosporus were not promising material for recruitment into Selim's new army, having more in common with the unruly forces who had precipitated the Serb revolt. In the 'Hungarian Bastion' on the Asian shore of the Upper Bosporus[5] the leader of the garrison troops drew his pistol and shot Mahmud Raif Efendi's deputy in the stomach, according to one witness. Reckoning that they might as well be hung for a sheep as a lamb, the rebels also determined to kill Mahmud Raif, whom they held responsible for the innovation being forced upon them; they must have known him as a convinced proponent

of the 'New Order' reforms, and may have been aware that he had published a work in Ottoman, French and German explaining Selim's military and naval reforms to the world at large.[6] Word of their intentions reached Mahmud Raif at the fortress of Rumeli Kavağı across the Bosporus, and he fled, but the militia men crossed the water, caught up with him and shot him too.[7] By the time news of these murders reached the Sultan, the mutinous troops had managed to enlist the support of the janissaries, who declared common cause with them. The only units capable of restraining the insurgents were the reduced number of 'New Order' troops at Levent Çiftliği in the Rumelian Bosporus hills and at Harem in Üsküdar, but the Grand Vezir's proxy, Köse ('Beardless') Musa Pasha, who had remained in Istanbul while his superior – İbrahim Hilmi Pasha, successor to İsmail Pasha – went off on campaign, was a conservative, and confined them to barracks. By Wednesday night the rebels had marched unimpeded down the Bosporus shore to Tophane, the cannon foundry below Galata, only a short boat-ride from the palace.[8]

At this moment of crisis, Sultan Selim proved himself hesitant and frightened. In audience at Topkapı Palace with a number of janissary leaders, he denied that he had been trying to force the Bosporus militia to become 'New Order' troops and offered to abandon his cherished project to reform his military forces, but when this was reported to their rank-and-file, they refused to believe the Sultan who, they said, had refused to disband his 'New Order' army so far, despite the trouble it had caused across Rumeli and Anatolia. The Bosporus militia spread through the city, attracting all manner of malcontents to their side. Government officials fled as the mob arrived at the janissary barracks in the city, and the Sultan told clerics who thought to seek refuge in the palace to remain where they were, in the grand vezir's office. Required to order their men to stamp out the uprising, retired janissary leaders meeting in the courtyard of the Süleymaniye mosque vacillated, suggesting that the sheikhulislam, Şerifzade Seyyid Mehmed Ataullah Efendi, and the chief justices of Rumeli and Anatolia should meet them in their barracks.[9]

With the Grand Vezir and the janissary commander-in-chief away on campaign, the task of dealing with the militia and the janissaries allied with them fell most heavily on the Sheikhulislam, the Grand Vezir's proxy Köse Musa Pasha, and the janissary second-in-command, Mehmed Arif Agha. Both Seyyid Mehmed Ataullah Efendi and Köse Musa had sympathized with the rebellion against the 'New Order' in Edirne the year before[10] and Ataullah Efendi had been appointed sheikhulislam – as a conservative who might make the reforms more palatable – in the wake of events there. It was true that Köse Musa's refusal to order the 'New Order' troops to nip

the Bosporus uprising in the bud had avoided a bloody confrontation – but it had also denied the Sultan a military solution.

The pattern of the rebellion was a familiar one. The janissary parade ground seethed with janissaries and men belonging to the armourers' corps and the militia. The cauldrons in which the janissaries' food was cooked were brought out onto the square and overturned, the customary gesture of defiance against a sultan. Deliberations inside the barracks had produced a list of twelve high-ranking officials whom the rebels held responsible for their grievances, and some of them marched to the Hippodrome to demand that these men be handed over, on the way murdering a clerk of the janissary corps who was foolhardy enough to suggest moderation. The janissary leaders tried to calm the mob, but they wanted to get their hands on the officials on the list, have the 'New Order' dissolved and all traces of it expunged. Fearfully, Sultan Selim agreed to comply with these demands, promising a return to the system of sultan's infantry and cavalry which had prevailed in the days of Sultan Süleyman I.[11]

When rumours of the imminent disbandment of the 'New Order' reached their barracks at Harem and Levent Çiftliği, Selim's cherished troops simply left their posts and wandered off. Some of the government officers whose names were on the rebels' list were discovered in hiding, taken to the janissary parade ground and murdered, and the Sultan, in a bid to save himself, had others executed in the palace and their heads sent out to the janissaries. That evening the rebellious soldiers announced that the safety of the heirs to the throne – Selim's cousins, Sultan Abdülhamid I's sons Mustafa and Mahmud, who were in their twenties – needed to be ensured, implying that Selim might do them harm. The proclamation the Sultan had read out in the office of the grand vezir and at the janissary parade ground brought tears even to the eyes of the rebels according to one witness to these events:

> I have no children. The Princes are my sons and the light of my eye. God forbid that I should be the cause of extinguishing and annihilating the state and dominion of the Ottoman dynasty and the pure Ottoman line by assassinating them. I could never entertain such thoughts. Pray God that day will never come. Let God give them long life![12]

It was Thursday 28 May and both the clerics and the janissary leaders – at pains throughout these events to disassociate themselves from the rank-and-file – assumed that Selim's sentimental appeal of the previous night had brought the uprising to an end: the Sultan had, after all, acceded to the demands of the rebels, the 'New Order' army had been disbanded, and many of the government officers named on the list of twelve had been murdered. The men of the Bosporus militia could be conciliated with

money, they thought, their leaders with the customary robes of honour and award of ranks. When this offer was put before the militia, however, their leader Kabakçı ('Pumpkin-seller') Mustafa protested that they had one further demand – the removal of Sultan Selim and the succession of Prince Mustafa: they no longer accepted Selim as either their temporal or their spiritual leader. Asked what was to become of Selim, those speaking for the militia informed the Sheikhulislam that they had no intention of harming him and reminded him that Sultan Ahmed III had lived out his days in peace in the palace after his deposition in 1730. The appropriate Koranic invocation for the succession was read forthwith, prayers were said, and the sound of massed voices assenting 'So be it' welled up from the parade ground below.[13] Sheikhulislam Ataullah Efendi was afraid of going alone to convey the news of his deposition to Selim and effect the enthronement ceremony, but he accepted an escort of 2,000 men and moved towards the palace in the midst of a growing crowd. The palace gate was closed, so a letter was sent inside, to the Chief Black Eunuch, stating that the mutinous soldiers would not disperse until Selim stepped down and the oath of allegiance to the new sultan, Mustafa IV, was concluded.[14]

A crowd of 50,000 filled the area outside the palace and around Ayasofya, chanting 'We want Sultan Mustafa'. As the Sheikhulislam and the Grand Vezir's proxy and their entourages waited outside the palace, the Chief Black Eunuch delivered the deposition ultimatum to Selim in the Circumcision pavilion in the Hanging garden (today, the fourth court). In despair, but knowing what he must do, Selim went into the *harem* to find his cousin Mustafa who emerged hesitantly after his long years of confinement. The new sultan was set upon a throne before the Gate of Felicity, and his statesmen swore the oath of allegiance to mark his accession.[15]

Sultan Mustafa IV was enthroned after sunset on the day of Selim's deposition; the next day, Friday 29 May, prayers were held in Ayasofya. The Bosporus militia had secured their new sultan – but they held out for more. Their leaders demanded, and were awarded, positions of command; the rank-and-file clamoured for pay rises; the militia leader Kabakçı Mustafa was appointed overseer of the Bosporus castles on the European shore. The new sultan issued an edict confirming the disbanding of the 'New Order' troops and requesting an undertaking from the militia that they would never again mutiny, in return for which they would be pardoned without recrimination. By the first days of June the uprising was over; the janissaries and militia received a generous accession bonus, and all military men returned to barracks.[16]

Like Sultan Osman II in 1622, Sultan Selim III was brought down in response to his plans to reorganize military manpower – if this is indeed

what Osman intended, about which there is some doubt. In the popular imagination the fate of both sultans has a tragic quality about it – but Selim's reign, at least, was not all hard work. His private secretary wrote a detailed and personal record of his sovereign's reign, a day-by-day account of court life uncontaminated by cares of state, of royal progresses along the waterways of the city, of picnics and hunting parties, of musical soirées and royal audiences, as much as of military reviews.[17] For all his serious purpose, Selim – who was himself a composer of talent – and his circle were as much inclined to the pursuit of pleasure as Ahmed III and his courtiers.

There were other parallels with the reign of Ahmed III. Like that of 1730, the revolt of 1807 was named for the man who emerged as the first to voice demands for the deposition of the Sultan: in 1730 it was Patrona Halil who had this distinction, and in 1807 Kabakçı Mustafa. Like Patrona Halil, Kabakçı Mustafa was from the underclass of Ottoman society; he came from the north-central Anatolian region of Kastamonu, and numbered Georgians and Albanians among his closest associates. He and his cohorts, having signed up as militia, were not given the training necessary to make an armed and unruly rabble into the disciplined soldiers the state needed, and the concessions they gained did nothing to make a compliant force of them: on the pretext of patrolling the Bosporus, they got drunk and looted and got into fights, and made money illicitly by bringing prostitutes back to the castle.[18]

A week after his enthronement, Sultan Mustafa celebrated Friday prayer at the New mosque on the waterfront in the Eminönü district and visited the nearby tomb of his father Sultan Abdülhamid I. Six days later he visited the tomb of Sultan Mehmed II, and that of Ayyub Ansari at the head of the Golden Horn, where he was girded with the sword believed to be that of Osman, the first Ottoman sultan, and the following Friday attended prayers in the mosque of Sultan Bayezid II and visited his tomb. This careful observance of time-honoured rituals did not, however, endow Mustafa with the moral authority and legitimacy he sought. In the weeks following his accession he tried to strengthen his position by ordering the exile or murder of many of Selim's officials, but not all his attempts to remove key figures associated with the violent demise of the 'New Order' were successful. Köse Musa Pasha was dismissed but briefly reinstated two weeks later, and janissary discontent with the new appointment to the office of sheikhulislam also brought the reinstatement of Ataullah Efendi. Others were less fortunate, however. The second-in-command of the janissaries, Mehmed Arif Agha, who had played a crucial role in conciliating the rebels and bringing the recent uprising to a conclusion, was accused

of financial irregularity. He was removed from office and exiled from Istanbul, his wealth confiscated and used to pay the janissaries; as he passed through Bursa on his way to undertake the pilgrimage to Mecca he was murdered, and his head sent to Istanbul. The janissaries also forced the sacking of Grand Vezir İbrahim Hilmi Pasha who was absent at the Danubian front, and secured the appointment of their own candidate as janissary commander-in-chief.[19]

On 18 October 1807, the north Anatolian grandee and opponent of the 'New Order' Canikli Tayyar Mahmud Pasha returned to Istanbul from the Crimea where he had fled in 1806.[20] He was soon appointed proxy to the new grand vezir Çelebi Mustafa Pasha but was dismissed within a few months, having antagonized and threatened key statesmen: most significantly, it was said that the janissaries did not want him. In March 1808 he was exiled with a large entourage to Didymoteicho in western Thrace, but his estate was not forfeit, and Sultan Mustafa sent him a pension.[21]

With the failure of Tayyar Mahmud Pasha's bid to play a leading part in government in the post-'New Order' regime, another provincial grandee sought to take the state into his own hands. The magnate Bayrakdar Mustafa Pasha had come to prominence following the murder in summer 1806 of the powerful and disruptive Tirsiniklioğlu İsmail Agha, to whom he had been second-in-command on the Danubian front. Tirsiniklioğlu İsmail's domains in the Silistra area had passed to Bayrakdar Mustafa, and the commander of the 'New Order' army was instructed to limit his influence, but – as was so often the case with the empire's provincial strongmen – the Sultan was effectively left with little choice but to accept him as the dominant power in the region,[22] for Bayrakdar Mustafa's services were essential to the empire's defence against the Russians in the phase of warfare that had just begun. On 3 February 1807 he was appointed military commander on the Danube front, and governor of the province of Silistra.[23]

The providentially strategic location of the territories he controlled brought Bayrakdar Mustafa Pasha great responsibilities and rewards, and at the end of the 1807 campaigning season several high-ranking statesmen who had found themselves on the Danube front when Selim was deposed had chosen to remain with him in Ruse rather than return to Istanbul. All proponents of the 'New Order', they planned to restore the reforming sultan. When Bayrakdar Mustafa heard news that Grand Vezir Çelebi Mustafa Pasha had invited rival Danubian notables to meet him in Edirne as he returned from campaign, he marched towards the city with 10,000 men in a display of strength which struck fear into the population not just there

but in Istanbul. Through an ally who acted as intermediary he reached an understanding with the Grand Vezir who, hoping to defuse this potentially dangerous situation, sent Bayrakdar Mustafa's rivals away from Edirne and invited him into the city on the pretext of discussing the condition of the army. Sultan Mustafa had neither anticipated nor sanctioned Çelebi Mustafa's action, and could not understand why Bayrakdar Mustafa had abandoned his responsibilities at the front in the middle of a war with Russia[24] – albeit that an armistice had been agreed in August 1807 following the Treaty of Tilsit.

Bayrakdar Mustafa Pasha had in fact a great deal to say about the condition of the Danubian army. In a devastating report forwarded to the Grand Vezir's proxy in Istanbul on 4 July 1808, he complained of a shortage of troops – only a fraction of those requested had reported for duty, as had also been the case the previous year – and of supplies: once local provisions and those from the further Balkans had been consumed, there was such a critical shortage that in the 1807 season he had had to use the produce of his own estates to feed his men; furthermore, at great personal expense he had bought food from the peasants north of the Danube. He pointed out that the Ottoman peasants were suffering under the demands made upon them and, following the example of the Serbs (whose rebellion was under way at this time), were refusing to provide food and fodder for the army. Without troops, provisions and money, he said, it was impossible to conduct the war against Russia. He was scathing about the numbers of non-combatants who accompanied the army, and complained in particular of the 30,000–40,000 soldiers deemed necessary to escort the sacred standard 'to impress the enemy', all of them demanding to be fed; he had suggested the previous year that the sacred standard should either not accompany the army at all, or at least remain at Edirne, but to no avail. Soldiers, he said, were needed for fighting.[25]

The exasperation that underlay Bayrakdar Mustafa Pasha's words was evident. He stressed that he would not have travelled to Edirne unless he had thought it essential to discuss these matters with the Grand Vezir – every hour, he said, cost him money. His sole motivation was the well-being of the state, and the service of the Sultan. He needed provisions and troops – including militia, which he considered an essential component of the campaigning army – for both the Russian and the Serbian fronts, and he needed them now. He saw discipline as one of the main problems beset-ting the Ottoman war effort, and recommended that trustworthy vezirs be appointed to each stretch of the Danube to co-ordinate the activities of the men under his overall command; he needed a reliable fighting force,

not thousands of what he deemed totally worthless pen-pushers. Desertion was another serious problem, said Bayrakdar Mustafa, especially among soldiers from Anatolia.[26]

Like so many Ottoman provincial malcontents before him, Bayrakdar Mustafa Pasha stated his desire to present his respects to the Sultan personally. Even had he wished to, the Grand Vezir could not have resisted this inevitability; he wrote to one of Sultan Mustafa's closest confidants, a black eunuch in the *harem*, of Bayrakdar Mustafa's intentions, but they amounted to a fait accompli. Searching for a way of delaying Bayrakdar Mustafa's arrival in Istanbul, Sheikhulislam Ataullah Efendi and the Grand Vezir's proxy suggested the Sultan write to the Grand Vezir to remind him of the customary rituals to be observed on the return of the sacred standard to Istanbul with the army. Whatever their apprehensions, however, they were determined not to provoke a confrontation which could only have a bloody outcome, so the response to the Grand Vezir made it clear that Bayrakdar Mustafa did have the Sultan's permission to travel to the city.[27]

As Bayrakdar Mustafa Pasha approached Istanbul, Kabakçı Mustafa was hunted down and murdered – on whose orders, whether those of Bayrakdar Mustafa or Sultan Mustafa, is unclear. On 19 July 1808 the Sheikhulislam and the Grand Vezir's proxy rode out from Istanbul with their retinues to play their part in the ceremony of receiving the sacred standard from the returning army. Sultan Mustafa went to the customary site to the west of Istanbul, near the mustering ground of Daud Pasha, and formally accepted the standard from Grand Vezir Çelebi Mustafa Pasha. Handing it over to the standard bearer, he then returned to the palace ahead of Çelebi Mustafa. Although Bayrakdar Mustafa had reached Daud Pasha, he remained in his tent and did not observe the ceremony.[28]

The delay occasioned by the ceremony of receiving the sacred standard from the returning army had still not allowed the Sultan and his advisers enough time to devise a plan to confront Bayrakdar Mustafa Pasha. Two days later Bayrakdar Mustafa entered a city whose people watched and waited apprehensively to see what would transpire. He first made his way to the grand vezir's office and there dismissed Çelebi Mustafa Pasha – for having broken the pact they had agreed in Edirne to restore Sultan Selim to the throne. Çelebi Mustafa had been manipulated by Bayrakdar Mustafa for his own ends – and finally outwitted. On Bayrakdar Mustafa's orders, Sheikhulislam Ataullah Efendi and other high-ranking clerics were dismissed and exiled. Bayrakdar Mustafa next went with his men to the palace, and demanded that the former sultan be produced. Sultan Mustafa's courtiers knew well enough what this portended, and told their master what he already knew – that as long as Selim lived, his own position was insecure.

On the pretext of bringing Selim before Sultan Mustafa, Mustafa's men went into the deposed sultan's quarters and, when he refused to come out, murdered him – when Bayrakdar Mustafa entered the palace he found he was too late. He asked the new Sheikhulislam whether Sultan Mustafa, murderer of an innocent, could any longer be considered the legitimate ruler; receiving the answer he anticipated, he had Mustafa's brother Mahmud brought from his quarters. Bayrakdar Mustafa and all the senior statesmen swore allegiance to the new Sultan Mahmud II, who offered Bayrakdar Mustafa the grand vezir's seal of office taken from Çelebi Mustafa Pasha; after initially demurring, he accepted the honour. Those officials held responsible for murdering Selim were executed and their heads displayed at the outer gate of the palace, each with a placard identifying them as 'traitors to religion and state who had dared to martyr Sultan Selim'.[29] Tayyar Mahmud Pasha was another victim of the rise of Bayrakdar Mustafa Pasha; his star shone briefly during the reign of Mustafa, who soon after exiling him to Thrace had appointed him to command the fortress of Varna, on the Black Sea coast south of the Danube, but he was executed shortly after the Sultan was deposed.[30]

The sudden deposition of Mustafa IV and accession of 23-year-old Prince Mahmud on 28 July 1808 surprised everyone. He had no natural allies, and was a mere pawn in the hands of Bayrakdar Mustafa Pasha, who had come to Istanbul to reinstate Selim as sultan. Two months after Mahmud's accession Bayrakdar Mustafa presided over an unusual assembly which brought together members of the central government, including the commanders of the sultan's regiments and the Sheikhulislam, and some of the leading provincial notables, Bayrakdar Mustafa's erstwhile peers – a total of 25 men.[31]

The pact which resulted from their deliberations consisted of seven articles imposing a set of obligations on the 25, who pledged allegiance to the new sultan and recognized Grand Vezir Bayrakdar Mustafa Pasha as his representative, to whom they undertook to defer as long as he acted justly. They proposed to stamp on janissary or other disorder in Istanbul, and agreed to provide troops for the army and observe the financial demands of the state. All swore to act justly in all matters, guaranteed that their absent fellows would observe their obligations, and undertook to act against them if they did not. In recompense for these solemn promises, the notables awarded themselves the right to pass their lands on to their successors in perpetuity. It was a blatant attempt to formalize the independence from Istanbul for which the notables had struggled so tenaciously, and it was presented to Sultan Mahmud as a fait accompli.[32] Only four of the 25 men

who signed the pact were provincial notables, those who were supposed to be party to the form of government and power-sharing it laid out; the others were officers of the central government. Mahmud was powerless to resist; the empire was still at war with Russia, the statesmen on whom he might have relied for support against the notables were signatories to the pact – and he could only append his own signature. The original signed document no longer survives, however: it seems that Sultan Mahmud had it destroyed at the first opportunity.[33]

The text of the pact survives only in the works of contemporary historians. Two of the four signatories represented the Cebbarzade (Çapanoğulları), and Karaosmanoğulları dynasties, both supporters of Selim's 'New Order'.[34] Among those provincial notables whose signatures do not appear was Tepedelenli Ali Pasha of Ioannina, who had for so long set out to thwart the authority of Istanbul, and who did not approve of Bayrakdar Mustafa Pasha setting the terms of their future relationship with the Sultan and with each other. In the event, the pact never came into effect. Within a few weeks, on 15 November, Bayrakdar Mustafa was killed in a violent janissary revolt which erupted in response to his plans for the creation of a new military corps together with reorganization of the janissaries and curtailment of their privileges. Janissary efforts to secure the restoration of Mustafa IV came to nothing: Mahmud had him murdered as they marched on the palace after setting fire to the mansions of leading statesmen.[35] Mahmud was thus left as the only male of the Ottoman dynasty.

Istanbul was yet again the scene of bloody fighting, and even after Bayrakdar Mustafa Pasha's death it took some days of decisive action to bring the janissaries under control. Ayasofya came under attack and the water supply to the palace was cut. Barely able to hold their own, troops loyal to Mahmud hunted down the rioting janissaries wherever they were to be found – in all, some 5,000 janissaries and 600 loyal troops were said to have lost their lives. The navy bombarded the janissary barracks from the Golden Horn, causing much destruction, and fires consumed large areas of the city.[36] The price of janissary submission was the disbandment of the new military units organized by Bayrakdar Mustafa as a thinly-disguised alternative to Sultan Selim's 'New Order' troops and the murder of those of Bayrakdar Mustafa's close associates who could be found; many others were sent into internal exile.[37] Despite their high losses, the janissary corps survived: their elimination, considered to be the defining event of Mahmud's sultanate, was not undertaken until 1826. The legal and bureaucratic reforms of his reign, of which the so-called *Tanzimat* 're-ordering' of Ottoman public life was a logical outcome and continuation, began earlier, however, and made a far deeper impression than the reforms of Selim III, which had

been directed primarily towards enhancing Ottoman military effectiveness.

The piecemeal adoption of infidel armaments and training methods, both early in Selim III's reign and before that, had singularly failed to bring the Ottomans the victories they sought. The more radical innovations of Selim's 'New Order', seen by him as a first step towards the creation of a modern, disciplined army, failed because they struck at the core of the Ottomans' perception of their own identity. The pivotal importance of the army, and of the janissaries in particular, to the continuing existence of the state was one of the foundations of this sense of identity, for over the centuries they had been instrumental in making a Sunni Islamic whole out of sprawling and disparate territories. The creation of a new, parallel force seen to be favoured over the traditional guardians of the Ottoman state threatened to undermine their privileged position in society, and the essential role played by these numerous and vociferous troops and the militia who aspired to share their prestige and rewards. Their antipathy to Selim's reforms was further exacerbated by their inability to make a living, for they were as deeply affected as the rest of the population by the economic downturn of this period.

That fewer policy-makers and power-wielders should have supported Selim's reform efforts than opposed them is not surprising. Western weaponry was an obviously useful tool in the achievement of specific aims common to both the Ottomans and their rivals – yet there was a body of opinion which would have agreed with an anonymous commentator writing towards the end of the 1768–74 Russian war when he questioned why the Ottomans should have to resort to western military methods, when the infidels had always claimed it was the religious zeal of the Ottomans that made them unbeatable.[38] Even among those willing to embrace technological changes seen to be advantageous, however, there were few ready to countenance the cultural transformation implied by the importation of alien ways. For reform to succeed, the impetus had to come from inside Ottoman society – or at least be represented as having done so – otherwise it was unlikely to gain acceptance beyond a limited circle of statesmen and intellectuals. Over the course of the eighteenth century the concept of the 'ever-victorious frontier of the expanding empire' had given way to that of the 'welfare of religion and state' as a more realistic raison d'être. By the end of the century, diplomacy and the conduct of war were largely the preserve of bureaucrats in the Ottoman state, as they were in Europe, a change in the administrative and cultural landscape that further emphasized the irrelevance of such ancient institutions as the janissaries.

The task of writers at this time who favoured reform was to rationalize change in state and society and present it within an Islamic context; the

idea that the welfare of religion and state could – and often should – imply peace rather than war only gradually won wide acceptance, and in this transitional period was rejected by many in ruling circles as well as by those who controlled the means of violence.[39] Few stood to gain materially from reform, and Selim's efforts went too far, too fast: the line between an acceptable and an unacceptable level of imposed change was a very fine one. Over the past hundred years the central government had relinquished administrative and financial authority in a bid both to raise money for the treasury and to expand the class with a vested interest in the perpetuation of the empire, and this had had unforeseen consequences for domestic politics. In some instances the devolution of power to local notables was sufficient to retain their loyalty, but on the periphery of the empire in particular, and where it was accompanied or followed by Great Power meddling, the pressures compounded to exert a decentralizing tendency. Selim had too many disparate interests to satisfy; his loss of legitimacy may be attributed to his misjudgement of the limits of the possible.

By the summer of 1808 the Ottoman Empire was already afflicted by the 'Western Question' that eventually brought about its destruction: the Great Powers had abandoned any pretence of respecting the balance-of-power framework within which relations between states had been conducted since the seventeenth century, and instead gave free rein to their all-consuming rivalries – acting them out largely on Ottoman soil. The new strategic configurations of the Napoleonic age meant that the assumptions on which the Ottoman special relationship with France had been based could no longer be taken for granted. The ties that bound Egypt to Istanbul had been weakened still further as a result of the French invasion of 1798, and France was now not averse to discussing partition of the sultan's domains with Russia. The Ottoman–Russian war which had begun in 1806 dragged on: Ottoman efforts to negotiate a peace settlement had failed, and the status of Moldavia and Wallachia remained in dispute. The Serb revolt also continued. There had been a lull in the fighting while Tsar Alexander of Russia attempted to reach a modus vivendi with Napoleon and to agree with him a common vision of how Europe and the Ottoman Empire might look in the future. As both emperors came to realize, however, each had strategic concerns which prevented a workable relationship, so that the Treaty of Tilsit in fact created more problems than it solved. Nevertheless, the thaw in relations between France and Russia briefly gave Russia hope of an ally to support its territorial claims in the Principalities.

Britain was also beginning to enter the politics of the Near East, although to little effect as yet. British relations with France, Russia and Austria were

of greater importance to it than those with the Ottomans, and the 'phoney war' of 1807 – occasioned by a British naval show of strength off Istanbul in protest at the diplomatic ascendance of France's ambassador, but compounded by an expedition intended to prevent the return of the French to Egypt – was concluded by a peace between Britain and the Ottomans in January 1809.[40] By 1808 Russia occupied Moldavia and much of Wallachia, and in 1810 the Russian army advanced south across the Danube, capturing fortresses essential to Ottoman security as it went; by the end of 1811 Sultan Mahmud was seeking peace. Russia, now itself threatened by Napoleon's invasion, agreed to settle and under the terms of the Treaty of Bucharest of 1812 acquired no more of the Principalities than Bessarabia – the part of Moldavia between the Dniester and the Prut rivers – and certain territories she had won in the Caucasus, which were to prove a continuing source of conflict with the Ottomans.[41] Again, as in the wars of the eighteenth century, the Ottomans were committed to paying reparations to the Russians and although the first of the three instalments was waived, the second and third could be paid only by means of expensive loans negotiated by local and foreign money-brokers.[42]

Russia's increased influence in the Balkans was mirrored by her advances against the Muslim states of the Caucasus, where the Ottoman sultans had lost prestige through their unwillingness or inability to protect their co-religionists from Russian encroachment.[43] In the Arab provinces, and as a result of a Muslim rather than a Christian challenge – extremely damaging to the sultan as protector of the Holy Places – Mecca and Medina were no longer in Ottoman hands. Egypt itself was under the control of a governor – Mehmed Ali Pasha – who was establishing a personal dominion destined to change the relationship with Istanbul for ever. The Ottomans felt beleaguered, as though their empire was no more than a pawn in the politics of the Great Powers. Like other victims of Great Power expansionism – the Polish-Lithuanian Commonwealth, Sweden, Hungary and Venice, for instance – they felt themselves to be suffering, and they offered asylum to fellow sufferers: Poles fleeing the Third Partition of the Commonwealth between Russia, Austria and Prussia in 1795 were only the first of many such immigrants[44] who followed in the footsteps of Charles XII of Sweden, driven by the Russians to seek asylum at Tighina in 1709, and the Transylvanian prince Francis Rákóczi, when his homeland was finally annexed by the Habsburgs in 1710.

Peace with Russia had its consequences for the Serbian struggle against the Ottomans. Like the Principalities, Serbia had enjoyed a measure of respite while Russia and France argued, but in 1809 an Ottoman army took back much lost territory. Outside events sealed the fate of the rebels,

for Serbia was of secondary importance to Russia when war with Napoleon was in prospect. The Treaty of Bucharest provided for a settlement in Serbia, giving the Ottomans the right to reoccupy the territory in return for concessions to the Serbs regarding self-administration.[45] Resistance continued, however, and was only gradually suppressed, in part because local Ottoman notables refused to co-operate with Istanbul. Belgrade was retaken by the Ottomans in the autumn of 1813 but the pacification of Serbia eluded them: another uprising broke out in 1815, in protest at the harsh policies of the Ottoman governor of Belgrade.

Ottoman incompetence in the Russian war and the events surrounding his accession demonstrated two things to Sultan Mahmud: first, the incontrovertible fact that the janissaries were as unsuited to the task of defending Ottoman frontiers as they were dangerous when idle in Istanbul; second, that the power of the provincial notables exceeded all reasonable bounds. The capital experienced episodes of disorder provoked by janissary uprisings in 1809, 1810 and 1811; most of those called up to serve on the 1811 campaign deserted almost before they had left Istanbul, and Mahmud soon introduced some measures to improve discipline in the corps.[46] Like that of the janissaries, the performance of the Balkan provincial notables in the 1806–12 war had been less than commendable: although some had given the government the assistance it sought, others, especially those on the Danubian front, had refused to co-operate and had surrendered territory to the Russians without putting up any serious defence.[47]

Mahmud inherited the knotty problem of Mehmed Ali of Egypt, the provincial dynast who most resolutely resisted any attempt by Istanbul to reassert central authority. Of all the quasi-independent territories within the Ottoman Empire, Mehmed Ali's Egypt had gone furthest down the road to full autonomy. Mahmud must have looked on with a mixture of envy and dismay as this former Albanian soldier ruthlessly eradicated opposition. One of his more notorious acts was the destruction of the military class which had dominated Egypt before his arrival there: in 1811, 450 men assembled for a ceremonial occasion were bloodily massacred, another thousand were murdered by a military expedition led to Upper Egypt by his son İbrahim Pasha, and their tax-farms were appropriated for the treasury.[48]

Mehmed Ali's example demonstrated that centralization of power made for a strong state. The restructuring of Ottoman finances which had begun at the end of the seventeenth century with the introduction of life-term tax-farming had facilitated the growth of a magnate class, in Istanbul and in the provinces. The provincial magnates whom the state came to rely on to furnish troops and supplies from the time of the Russian wars of the later eighteenth century, in particular, all too frequently disregarded Istanbul's

authority and acted on their own initiative – with unpredictable conse-
quences for the Ottoman political order. Sultan Selim had taken the first
faltering steps to regain power for the central authority, but Sultan Mahmud
proposed more resolute measures to deprive the magnates of the resources
on which their power rested, and at the same time to both lighten the
burden imposed on the peasantry by these tax-farmers and strengthen the
government's financial foundation by redirecting provincial revenues from
the pockets of local dynasts to the central treasury. From 1813, accord-
ingly, tax-farms that came up for auction could be bid for only by senior
administrators of the area where they were situated.[49] One notable family
reined in by this means was the Çapanoğulları of central Anatolia: when
Süleyman Bey, head of the dynasty, died in 1813, his domains were awarded
to officers of the state to administer.[50] Although several other notables were
subdued at this time,[51] this first attempt to starve provincial strongmen of
funds was in general less than successful.[52] The Egyptian model was clearly
unsuited to the unwieldy territories of an empire.

Mehmed Ali was securely entrenched in Egypt, and Mahmud was power-
less to dislodge him. The governorship of Thessalonica offered him in 1806
proved insufficiently alluring,[53] and in truth he was needed to retrieve
Ottoman honour in the Hijaz, where Wahhabi expansion was every bit as
unwelcome to Mehmed Ali as to the central government. A campaign was
mounted in 1811 for which Mehmed Ali was given responsibility – though
with some anxiety as to whether he could be trusted not to retake Mecca
and Medina on his own account. The campaign dragged on until 1813, by
which time both Mecca and Medina were recovered from the Wahhabi.
Mehmed Ali's son İbrahim Pasha was appointed commander-in-chief of
the forces in the Hijaz: by 1818 he had captured the Sa'udi capital at al-
Dir'aiyah, now a suburb of Riyadh, which was razed to the ground, and
the Sa'udi emir 'Abd Allah bin Su'ud, who was sent to Istanbul and beheaded.
İbrahim was appointed governor of the Hijaz as his reward.[54]

Accounts of the Ottoman nineteenth century have too often treated the
emergence of nationalism in the Balkans as though it were the inevitable
result of Ottoman 'misrule' in the region – as though Balkan Christians
had heroically resisted their Ottoman masters for centuries while awaiting
the right moment to break free. This, however, is to ignore both the
complicated historical processes that led to the dismemberment of the empire,
and events particular to the formation of each successor state created during
the nineteenth and early twentieth centuries. There was more to the history
of the times than the separatist national movements of Ottoman Balkan
Christian subjects, but they loom so large in the historical accounts of these

nations as to lend weight to this reductionist understanding of the later years of the empire.

The path that led to the creation of the modern Greek state was very different, for example, from the events that resulted, fitfully, in an independent Serbia. No doubt the people of the Peloponnese remembered the anti-Ottoman uprising of 1770 in that region, but by the early nineteenth century Russia had other preoccupations and was no more inclined to foment trouble again among her Orthodox co-religionists in this distant and backward corner of the empire than she was to aid the Serbians. Tepedelenli Ali Pasha, who had held sway in Ioannina from the late 1780s, was quasi-sovereign in the territories he controlled, which at the peak of his power included much of present-day continental Greece and Albania. In his territories the economy was healthy and the social scourges of piracy and banditry were kept in check; although he pursued his own, often independent line in trade and foreign relations,[55] he was generally conciliatory in his dealings with Istanbul. Despite Sultan Mahmud's policy of subduing provincial notables, therefore, the government was wary of attacking him: when Ottoman statesmen discussed the matter in 1819, there were those who detected the portents of rebellion in the Peloponnese and Euboea, and feared the consequences of neglecting these in order to fight Tepedelenli Ali. In 1820, however, after much deliberation in his councils of state, the Sultan declared Tepedelenli Ali a rebel and sent an army against him, prompting him to call for an anti-Ottoman uprising in Greece and Albania. The Sultan's army became bogged down in the effort to subdue Tepedelenli Ali, but ignoring advice from its commander-in-chief in the area, Ahmed Hurşid Pasha, the government insisted that he stick to this objective rather than send forces to deal with the unrest in the Peloponnese – which took the form of attacks on Muslim communities and symbols of the Ottoman authorities, as well as an increased level of brigandage.[56]

Traditionally, 1821 marks the start of the movement for Greek independence from the Ottoman Empire. Intent on its policy of suppressing the Balkan notables, the government in Istanbul seemed unaware of the perils of the resulting power vacuum at the local level; nor did it comprehend that with its forces tied up in subduing Tepedelenli Ali Pasha, few men were available to stamp out unrest elsewhere. Greek independence is now annually celebrated on 25 March, in commemoration of the day in 1821 when Germanos, metropolitan of Old Patras, raised the Cross in defiance of the Ottoman authorities at Kalavryta in the northern Peloponnese. Dissatisfied with the reaction of his ministers to the revolt, Mahmud dismissed his grand vezir and sheikhulislam at the end of March. The government called upon the Orthodox Patriarch, Gregory V, to excommunicate the

rebels, and the Church was enlisted to use its influence to restore order.[57] Once the scope of the uprising in the Peloponnese became clear, however, he was unceremoniously hanged – on Easter Saturday, 22 April 1821 – at the gate of the Patriarchate in Istanbul; he was deemed to have forfeited the trust placed in him by the Sultan as leader of the Orthodox subjects of the empire – to have broken the compact with the sultans which dated back to the days of Mehmed the Conqueror.[58]

In March 1821, as Tepedelenli Ali Pasha was resisting Ottoman forces in the western Balkans, an aide-de-camp to the Tsar, General Prince Alexander Ypsilantis, who claimed descent from the Byzantine princely dynasty of the Comnenus, led a small force south across the Prut, hoping to gain support from anti-Ottoman elements in Moldavia and Wallachia. When news reached Istanbul of his audacious move, the Patriarch anathematized him and his followers as 'impious leaders, desperate fugitives and destructive traitors'[59] – but it did not prevent his hanging. The Ottoman government was taken quite by surprise, and took measures to disarm and register the sizeable Greek Orthodox population of Istanbul and Edirne and other large cities – though at the same time the Sultan issued an edict intended to prevent Muslim mobs attacking them.[60] Ypsilantis was briefly able to take over the government of Moldavia, but Wallachia was in turmoil – in the throes of an anti-boyar revolt under the militia leader Tudor Vladimirescu – and in late June his meagre forces were defeated by an Ottoman army. The Russian government did not back him, and the Serbian prince Miloš Obrenović – Kara George's successor – failed to respond to his proposal for combined resistance to the Ottomans.[61] Indeed, it is uncertain whether Ypsilantis's expedition was co-ordinated with the disturbances in the Peloponnese, or whether it was simply a quixotic gesture by a man who dreamed of a recreated Byzantine Empire in the Ottoman Balkans in which Orthodox Christianity replaced Islam.

In February 1822 Tepedelenli Ali Pasha was murdered. His part in the inception of the Greek revolt is still debated, but when his severed head was exposed in a dish in the first courtyard of Topkapı Palace it was accompanied by a detailed narrative of his crimes, describing him as 'a traitor to our religion . . . who has sent huge sums to the infidels of the Morea [i.e. the Peloponnese] . . . to encourage them to revolt against the Muslims'.[62] His nemesis, the vezir Halet Efendi, whose insistence that Tepedelenli Ali was a rebel had led to the campaign against him in 1820,[63] had betrayed the undertaking of Commander-in-Chief Ahmed Hurşid Pasha that Tepedelenli Ali would be left alive if he surrendered.[64] By a sweet irony, Halet Efendi met with a similar fate: his crime, according to the bill pinned up beside his head, was his propensity to intrigue and discord.[65] Halet

Efendi had been Mahmud's favourite, winning the Sultan's trust in the early years of his reign in the struggle against the provincial magnates. He traded on his influence to amass a great fortune, and secretly worked to inhibit Mahmud's proposed reforms of the janissary corps by warning him that they would provoke disorder, and directing his attention to other affairs of state. A measure of Halet Efendi's influence is that in 1821 his bold proposal to issue more arms to the janissaries was accepted by the state authorities. The next year, however, widespread discontent following Ottoman failure in the Peloponnese caused the Sultan to question his faith in him – the system of selling offices to buy janissary support which had served the Vezir for so long began to unravel. When janissary leaders appealed to Mahmud to remove Halet Efendi, he took the request seriously and dismissed his favourite before ordering his execution.[66]

Even if the 1770 uprising in the Peloponnese and Russia's part in it were not direct antecedents of later Greek anti-Ottoman revolts, since the Treaty of Küçük Kaynarca in 1774 Russia had seen itself as the protector of Orthodox Christians under Ottoman sovereignty, and the Crimea – quasi-independent under Russian protection after 1774, then annexed by Russia in 1783 – provided a base for further resistance against Ottoman rule. Greeks moved into the Crimea at Russia's behest as refugees from the Peloponnese fiasco, brought there by Catherine's general Orlov to man the fortresses at the outlet of the Sea of Azov,[67] and the numbers of Greek merchants in Black Sea, as well as in Aegean and Adriatic ports, grew during the last quarter of the eighteenth century. Educated Greeks were receptive to the revolutionary ideas emanating from America and France in the 1770s and 1790s, and to the notions of liberalism and nationality circulating in Europe during and after the Napoleonic Wars. The far-flung mercantile communities thrived, and funded the establishment of churches and schools and libraries and publishing houses, which they set up more freely than in Ottoman territory. The first stirrings of a liberation movement among Greek intellectuals emanated from Odessa where a secret society, Philiki Etairia or the 'Friendly Society', was founded in 1814, dedicated to fostering Greek patriotism. It was influenced by the work of an İzmir-born scholar who passed more than half his life in France, Adamantios Korais, and a Hellenized Vlach, Rigas Velestinlis. Korais's translations of Greek classics into a more demotic language brought the sense of an inspiring Greek past to his readers, while Rigas sought inspiration in the model of a new Byzantium with the governing institutions of republican France.[68]

The struggle that took place in the Peloponnese over the next years was bloody and, in territorial terms, inconclusive. A first republican

constitution was declared at Epidavros in January 1822, but following the promulgation of a revised version the following year, civil war broke out as the leaders of the revolt competed for power, adding further horror to the inter-communal massacres taking place in the Peloponnese and the islands.[69] Opposed to those who dreamed of nationhood were those who considered their interests best served by a continuance of the status quo – the upper echelons of the Greek Church who enjoyed status and privilege under the Ottomans, and prominent Greeks in Istanbul or the provinces; nor could anything be expected from the uneducated rank-and-file of the faithful.[70] Russia maintained a cautious stance vis-à-vis the Greek revolt,[71] its desire to encourage co-religionists in their struggle against the Ottomans perhaps tempered by an awareness that such encouragement might serve as an example to its own aggrieved Muslim subjects. The other European powers, reluctant to see Russia gain advantage in the Balkans, were adamant in their refusal to co-operate in schemes which might result in the partition of the Ottoman Empire. The Ottomans themselves were handicapped in their response by hostilities on their eastern frontier where intermittent border incursions by the Qajars led to war against Iran between 1820 and 1823, which further limited the number of troops available to put down the Greek uprising. In 1824 Mahmud took the desperate step of inviting Mehmed Ali of Egypt to assist with his modernized army and navy, in return for which İbrahim Pasha was to be awarded the governorship of the Peloponnese. İbrahim Pasha set sail in July from Alexandria, but was not able to land in the bay of Methoni until February 1825 because of Greek superiority at sea. First capturing several key coastal strongholds in the Mani, the Egyptian expeditionary force soon controlled most of the Peloponnese; on the Greek mainland, Missolonghi, at the entrance to the Gulf of Corinth, fell in April 1826 after a siege of fifteenth months, and Athens a year later – little territory remained in the hands of the rebels. İbrahim Pasha's success served only to concentrate the attention of the European powers, however; Britain, France and Russia set aside their differences, and two years of complex diplomatic moves culminated in the Sultan's refusal of a mediated armistice and the decision of the Powers to blockade the Peloponnese.[72] On 20 October 1827 the Ottoman–Egyptian fleet was destroyed in the battle of Navarino by a combined Anglo-French–Russian fleet at Pylos in the south-western Peloponnese, and İbrahim Pasha's troops were evacuated. The Ottoman defeat made Great Power intervention in the incipient Greek state inevitable.

In May 1826 Sultan Mahmud issued an edict for the formation of a new military corps, initially numbering in excess of 7,500 men, to be recruited

by drawing 150 men from each of 51 janissary companies in Istanbul – around one-fifth of the total number of janissaries on active duty. Unlike Selim's 'New Order' troops, they were not intended to form a parallel army; the hope was, rather, to reform the janissary corps from within, by means of restructuring, and providing them with the drill and other military skills they sorely needed if they were to have any chance of standing up to the might of Russia. Just before the proclamation of the edict, senior clerics, janissary officers, and other high-ranking officials both of the court and of the auxiliary military forces were required to sign an undertaking that they would all accept Mahmud's reform plan and do nothing to undermine its chance of success.[73]

The passions aroused by the creation of the 'New Order', and the terrible consequences of the failure of Selim's reforms to take hold at that time, were a salutary lesson to Sultan Mahmud that he must prepare the ground before embarking on his own innovations. Following the removal of Halet Efendi in 1822 he began to gather around him men he could trust, and to win over all groups which might threaten his intended reform of military manpower, but it was another four years before he felt secure enough to proceed. İbrahim Pasha's victory at Missolonghi in April 1826 seemed to indicate that the tide was turning in favour of the Ottomans, and gave a necessary boost to the Sultan's confidence.[74]

Determined to succeed where Selim had not, Mahmud continued the tradition established by his predecessors of requiring leading clerics to debate matters of religion in his presence as a means of keeping informed of currents of thought outside the palace.[75] In general, high-ranking clerics had been inclined to support the mostly military reform measures of the later eighteenth century, but their subordinates tended to be more conservative and had more influence among the common people – janissary opposition to reforms, for example, had often been buttressed by the traditionalism of low-ranking clerics[76] – and it was necessary for the Sultan to conciliate these lower echelons and the common people, by visibly displaying his sincere commitment to religion and his view of it as a cornerstone of the state which he had no intention of jeopardizing by the reforms he had in mind. To this end he attended religious gatherings, enjoined the observation of prayers, endowed foundations, and built mosques in Istanbul and in the provinces.[77] Implementation of the edict for the reorganization of the janissaries was declared to be a religious duty, and an imam was assigned to each newly-established company to lead them in their religious observance.[78]

The clerical establishment was easier to win over than the janissaries themselves. Religious symbolism was used by the Ottomans' imperial

neighbours, Russia and Austria, to boost the morale of their military manpower – Tsar Alexander I tried to persuade his cannon fodder to believe in a religious Utopia, while on the Habsburg frontier with the Ottomans, Catholics and Orthodox alike went to war under the banner of the Virgin Mary – and Mahmud tried to employ Muslim symbolism to similar ends.[79] A year earlier the imperial press had issued an Ottoman-language translation of a well-known, ninth-century Arabic treatise on the law of war in Islam; this was the first occasion on which the example of the Prophet Muhammad was invoked to encourage the janissaries to fight more enthusiastically – and it met with resistance from them.[80] Nevertheless, Mahmud persevered in seeking ways to cloak his reforms in familiar language: in order that the revamped janissary army be considered Muslim rather than western in inspiration, drill was to be based explicitly on that used by Mehmed Ali's army which had, it was said, proved its worth in the Hijaz and in the Peloponnese.[81] (Interestingly, in 1822, Mehmed Ali had ordered İbrahim Pasha to adopt the 'New Order' model of Selim III.)[82] In a calculated appeal to tradition, Mahmud named the new corps *eşkinci* after one that had been important in the time of Sultan Mehmed II.[83]

Murmurings of dissent among the janissary rank-and-file were evident from the time of the proclamation of the edict for their reform: they were not impressed by the Sultan's proposals for a new corps to be created within their ranks. Nevertheless, the first drill of the *eşkinci* corps, on 12 June 1826, went off without trouble, albeit in an atmosphere of great apprehension; shortage of uniforms and equipment meant that the number of men present to be put through their paces was only several hundred out of the 5,000 already enrolled. The next day's drill also passed off completely without incident.[84]

The following evening, barely two weeks after Sultan Mahmud had proclaimed his reform of the janissaries, an insurrection began. On the night of 14 June small bands of janissaries began to gather at their parade ground; some among them roamed the streets of Istanbul, firing guns and starting fires and looking for their commander-in-chief whom they felt had sold them out. He managed to evade them,[85] but at dawn the many hundreds by now assembled at the parade ground – one eyewitness dubbed them 'prattling curs'[86] – overturned their cauldrons in the traditional gesture of defiance. Again they surged through the city, looting as they went; one group sacked Grand Vezir Selim Mehmed Pasha's mansion, and the women of his household escaped only by hiding in an underground cavern in the garden.[87] The Sultan was at his palace in Beşiktaş when the insurrection broke out. Some of his predecessors, apt to hide at the first sign of a janissary mutiny, would have stayed where they were, but Mahmud

took a caique down the Bosporus to Topkapı Palace. So inevitable had been a janissary uprising against the reforms, and such pains had the Sultan taken to ensure that they succeeded, that a contingency plan had already been prepared.[88] State officials gathered in the palace and held an emergency council before the trouble could get out of hand; when they sent to ask the janissary rebel leaders the cause of their dissatisfaction, the answer came back:

> We will not do this sort of drill. Our ancient practice and drill for war is to hit earthenware jugs with rifle shot, and to hack at felt matting with the sabre. We want [to lay our hands on] those responsible for this innovation.[89]

Contemporary sources suggest that more than 13,000 loyal troops were with the statesmen and officials in the palace; some put the figure as high as 23,000 – or even 60,000. The Sultan made a stirring speech on his arrival there, and following the Sheikhulislam's juridical opinion to the effect that Islamic law permitted such an uprising to be put down with force, Mahmud went into the treasury and brought out the sacred standard of the Prophet. The standard was duly taken from the palace and hung up on the pulpit in the mosque of Sultan Ahmed on the Hippodrome. It worked its magic, and as criers went around the city calling all true Muslims to assemble beneath it, the populace hurried to do so. Officers of state who gathered in the mosque to discuss how to proceed decided to reject negotiation. A body of loyal troops – artillerymen, sappers and bombardiers – made for the janissary barracks, but the gates were shut fast against them as the rebel janissaries barricaded themselves inside. The imperial cannoneers opened fire, and the barracks were soon ablaze; those who could, fled, to engage in hand-to-hand battle with the loyal troops waiting outside – the rest burned inside.[90]

Mahmud had not intended to wipe the janissaries off the face of the earth in such a violent manner, but both his care in preparing for the introduction of his reform of the corps, and the realism that demanded a contingency plan should matters go awry, meant that when he found himself with no other option, he could resolutely bring the operation to its grisly conclusion. Both an Ottoman witness and the British ambassador Stratford Canning put the number of dead at around 6,000.[91] In addition to those killed in the attack on the janissary barracks – which according to another Ottoman witness lasted only 21 minutes[92] – many thousands more were hunted down in the succeeding days. Roads and ports were strictly controlled so that news of the 'Auspicious Incident', as it was called, and of the new edict formally abolishing the janissary corps, could not get out before provincial governors had received their instructions on how to proceed.

They were ordered to confiscate all janissary equipment they could lay their hands on, and evacuate the janissary garrisons from all forts, replacing them with their own men; the word 'janissary' was to be expunged from the vocabulary – a typical Ottoman compromise. Men who called themselves janissaries had been bringing disorder to provinces all over the empire for years, and people everywhere embraced the chance to take revenge: many local janissary leaders were executed, but many of the rank-and-file must have melted back into the civilian life they had never truly forsaken. Although its members had played no part in the janissary rebellion, the militia garrisoning the Bosporus forts – which had proved its unreliability with its rebellion against Sultan Selim's 'New Order' – was dissolved. The government also took the opportunity to cleanse Istanbul of those it considered undesirable – people of the underclass of the crowded city, who needed little encouragement to join in any disorder. During the two and a half months following the liquidation of the janissaries 20,000 people were expelled and sent back to their native provinces – and they were forbidden to return.[93]

Mahmud quickly set about creating a new army. The 'Victorious Soldiers of Muhammad' was initially to consist of 12,000 infantry and some 1,550 cavalrymen in Istanbul, with further units in the provinces. Detailed regulations governed their conditions of service – they would serve for a minimum of twelve years, with a right to leave once a year – and their dress, which was European-style.

> At the appointed times, majors will each be allocated by the state treasury a heavy jacket with frogging of gilt thread and a pair of full-fashioned trousers, close-fitted to the top of the shins, of dark red broadcloth, and a loose-fitting robe and, for the head, a quilted calpac-type cap ornamented with gilt thread and a Lahore shawl [i.e. of fine wool]; these will be replaced as necessary, on the occasion of the payment of salary. On 6 May each year, adjutant majors will each be allotted a short heavy jacket and a short loose-fitting robe and a quilted calpac-type cap ornamented with gilt thread and a Baghdad shawl [i.e. probably of silk or cotton] in a floral pattern and, to the captains and lieutenants and standard-bearers and sergeants, the aforementioned garments minus the shawl; and to each of the rank-and-file soldiers and scribes a full-length heavy jacket of broadcloth blended with raw silk. The uniform of the rank-and-file will also consist of a plain quilted calpac-type cap and a drill cloak of strong coarse wool and a short loose-fitting robe and full trousers, snug up to the top of the shins, of homespun wool, and drawers, and a light half-boot.[94]

Traditionally the janissary corps had been made up of Christian converts to Islam, and no doubt converts had continued to join even after Muslim-born men came to form its backbone; the law-code for the new 'Victorious

Soldiers of Muhammad' laid down that no converts should be enlisted. Non-Muslims were found among the dead janissaries in Istanbul, identified by the sign of the Cross tattooed on their arms; the Sultan maintained they had been spies, Christians masquerading as Muslims.[95]

The janissary barracks in Istanbul were razed, and the new army was quartered outside the city at Levent Çiftliği, Üsküdar and Daud Pasha, where Selim III had built barracks for his 'New Order' troops. The military and naval engineering schools, the medical school and other such institutions were expanded to support the new forces. Unlike his forebears, Mahmud involved only a handful of foreign advisers in the establishment of his new army – the Ottomans had few European friends at this time, and the canny governor of Egypt, Mehmed Ali Pasha, when approached by the Sultan, claimed that his own drill officers were not yet ready for the task – while his foreign instructors 'had become accustomed in Egypt to high salaries and expensive uniforms, and their presence in Istanbul would be obstructive to the Ottoman army'.[96]

One of the handful of foreigners to get involved was Signor Calosso, a former officer of the Piedmontese cavalry who had been living in Istanbul for some years, who taught Sultan Mahmud to ride in the European style. As the Scottish traveller Charles Macfarlane wrote in 1828 when he visited the city:

> The difference of this from the Turkish style of equitation is so immense as to offer no trifling difficulty to one accustomed to the latter, with huge saddles like cradles, and short and almost immoveable stirrups that tuck up the knees in close contact with the groin. Indeed, so considerable is this difficulty, that but few of the regular imperial guard could yet keep a steady seat with their long stirrups . . . Mahmood was indisputably the best horseman *à la Européen* in his army; and this acquirement, together with another proficiency he was fast arriving at, viz. that of commanding and manoeuvring a squadron of horse, formed then his pride and glory.[97]

The abolition of the janissaries was followed within a month by a government attack on the Bektaşi, the dervish order most closely associated with them – the eponymous founder was patron saint of the corps, which was, indeed, often referred to as the 'Bektaşi corps'. Leaders of dervish orders acceptable to the government – the Nakşibendi, Kadiri, Halveti, Mevlevi and Sa'di – were co-opted to adduce arguments for the suppression of the Bektaşi. Whatever degree of reluctance they may have felt about pronouncing on the fate of their fellows, they had no choice but to rubber-stamp what was in effect a political decision, presented as a religious one. The charge levelled against the Bektaşi was traditional enough – that of

heterodoxy, so often used historically to justify politically expedient action against Muslims whose orthodox Sunni credentials were in doubt. Prominent members of the order were executed, and Bektaşi property in Istanbul was destroyed, or confiscated and sold, or converted to other uses. The ruling applied not only in the capital: throughout Rumeli and Anatolia the break with the past was pitilessly emphasized with the redirection of revenue from Bektaşi lands to the treasury of Mahmud's new army.[98]

Rumour and misinformation fed the purges: many of those anathematized as such were not Bektaşi at all, and this applied to both high and low. The grand vezir, Selim Mehmed Pasha, was made responsible for rooting out Bektaşi adherents in Istanbul – but it came to the ears of the contemporary court chronicler Ahmed Lutfi Efendi that Selim Mehmed Pasha was himself a Bektaşi.[99] From the upper strata of the religious establishment, Şanizade Ataullah Efendi – a former court chronicler, and author of important medical works – was accused in 1826 of being a Bektaşi sympathizer, and exiled from Istanbul; he died of a broken heart – so it was said – before the Sultan's order of exile could reach him.[100] The practice of affiliation to more than one dervish order was so common, and the attempt to eradicate Bektaşism at this time so vehement, that sheikhs of other orders were also rounded up and sent into internal exile. Largely because of their infiltration into and acceptance by other orders, however, especially the officially-favoured Nakşibendi order – on whom their properties were bestowed – the Bektaşi were able to survive clandestinely, and by mid-century they were again finding open favour in elite circles.[101]

Association with the janissaries also brought execution for the politically-influential heads of the three wealthiest Jewish families in Istanbul – Adjiman, Carmona and Gabbai. Isaiah Adjiman was banker to the janissary corps at the time, as his predecessors had been before him; the other two were said also to have links with janissary finances. Their estates were confiscated, and doubtless the resulting treasury windfall was a consideration sealing their fate.[102] Apologists for this treatment of Jews see matters differently, however, blaming their deaths on Armenian–Jewish rivalry over lucrative financial posts.[103] (Wealthy Armenian bankers had themselves suffered execution and dispossession at times: a notable case was that of Yakub Houvanessian, who had managed the financial affairs of Mahmud I's long-serving chief black eunuch Hacı Beşir Agha in the mid-eighteenth century.)[104]

The summary execution of the Jewish bankers and the suppression of the Bektaşi brought widespread complaint – although Mahmud had stopped short of formally proscribing the Bektaşi order – and the costs of his reforms were biting: all the officials on whom he had relied for the success of his

plans to improve his army were handsomely rewarded, and new taxes were levied on the artisans of the city to make up the shortfall. The people of Istanbul were numbed by the events of these months – insecure, and harassed by the authorities, they watched in horror as dead bodies, 'many of them torn, and in part devoured by dogs', washed up on the shore below Topkapı Palace; plague broke out in the city in late July as the number of corpses mounted. On 31 August 1826, by which time he thought his victory over the janissaries complete, the Sultan replaced the sacred standard in the treasury. Almost immediately a terrible fire began to rage through the city, whose houses were dry as tinder because of the summer heat; former janissaries who had escaped the purge were held responsible by many for setting the blaze.[105]

Within months of the defeat of the Ottoman–Egyptian fleet in the battle of Navarino, Russia declared war on the Ottomans; in April 1828 the Russian army crossed into Moldavia, and by July 1829 had reached Edirne – only 200 kilometres from Istanbul – while their Caucasian forces had taken north-eastern Anatolia as far as Erzurum and Trabzon, seizing many other fortresses along the way. The Ottomans sued for peace, which was concluded with the Treaty of Adrianople (Edirne). As one of the terms of the peace the Ottomans acquiesced in the establishment of an independent Greek state comprising the Peloponnese and part of mainland Greece together with some islands. In May 1832 the fledgling Greek republic officially became a kingdom, under the 'protection' of Britain, France, Russia, and Bavaria – the last of which provided the seventeen-year-old Catholic Prince Otto, son of Ludwig I of Bavaria, to be its king. This recognition of the new state marked the beginning of the European involvement in Greece which was to last throughout the nineteenth century. Under the Treaty of Adrianople Russia won the right to trade within the borders of the Ottoman Empire, its occupation of part of Georgia and Armenia was recognized and, of particular significance, so was Russian influence in the Danubian Principalities.[106] To Britain, especially, this development was an unwelcome milestone in Russia's achievement of control in the Balkans and over the Ottoman Empire: she was beginning to see Russia as a significant potential threat to her growing interests in the east. Over the coming years Great Power politics underwent a realignment at the heart of which lay Britain's determination to prevent the break-up of the Ottoman Empire to the benefit of Russia.[107]

Despite the onerous provisions of the peace treaty and the accompanying loss of prestige, Sultan Mahmud survived defeat by Russia. For him it was merely a demonstration that the war had come too soon: the benefits

of his military reforms were not yet sufficiently far-reaching. For lower-ranking clerics, however, it demonstrated yet again that western-inspired innovations were inimical to the tenets of Islam. They not only withdrew their support but encouraged the people of the provinces to join their protests. The popular uprisings that swept through Anatolia in 1829 and 1830 were an opportunity for erstwhile janissaries to make their continuing nuisance value felt.[108] Against this background of external humiliation and internal disquiet, Mahmud pursued reform with renewed urgency. His ambitions, unlike those of his predecessors, were not limited to the military sphere alone: it was evident to him that no piecemeal enhancement of military effectiveness was of itself sufficient to maintain Ottoman integrity and sustain an active role for the Ottoman Empire in international decision-making. His aim, therefore, was nothing less than a transformation of society – a re-ordering or *Tanzimat*, 'the Auspicious Re-ordering' as he called it in an edict written shortly before his death.[109]

Accordingly, Mahmud turned his attention to the administration of the empire, aiming to recentralize it as he had the army and the treasury. But first he needed an accurate idea of the empire's resources. In 1830–31, therefore, Rumeli, Anatolia and the Aegean Islands were subjected to their first modern census, designed to count and categorize Ottoman subjects with a view to ascertaining their military and tax obligations; it was completed within a year and, to make it almost impossible to escape the census-taker's register, was intended to be repeated every six months.[110]

Mahmud was the first Ottoman sultan to tour his domains for the purpose of seeing for himself how his subjects lived. Between 1830 and his death in 1839 he made five trips, to Tekirdağ on the north coast of the Sea of Marmara in January 1830; to the Dardanelles and Edirne in June 1831 – when he stayed away from Istanbul for a full month; to Gemlik and İzmit to visit the naval dockyards for a week in September 1833; a second visit to İzmit in November 1836 to launch a new ship of the line; and in April 1837 he spent more than a month touring Rumeli, visiting Varna on the Black Sea coast, Silistra and Ruse on the Danube, and Shumen, Veliko Tŭrnovo, Kazanlŭk and Stara Zagora in Bulgaria. On each journey he visited shrines and military installations, inspected public works and promised state aid in building more, met local dignitaries, and lent an ear to the concerns of the common people, both Muslim and non-Muslim.[111]

Ottoman administration had evolved to meet the demands of the changing functions it was called upon to fulfil, and traditionally there had been a fluidity between its three main branches – military, civil and judicial-religious – with many prominent statesmen starting their careers in the last-named branch and moving across into the military or civil branch. In the final two years of his

reign, beginning in 1837, Mahmud established three ministries which, although they proved to be short-lived, set an important precedent for the future: the ministry of the interior, headed by the grand vezir (from this time on sometimes also referred to as prime minister); the foreign ministry, which had emerged as a separate branch of government during the late seventeenth century; and the ministry of justice. A hierarchical structure was introduced for civil servants, the old system of annual appointments was dropped, and salaries replaced the customary and much-abused system of fees. The supreme council of justice set up by Mahmud's government in 1838 to prepare and implement legislation was later expanded, and remained the principal legal body of the empire.[112]

The pages of Ottoman history are filled with accounts of expropriations and executions of high-ranking officials – including, in the seventeenth century, members of the supposedly-exempt religious establishment – summarily punished at the whim of the sultan and often at the instigation of rivals for power; victims were frequently led to believe they had attracted the lesser punishment of exile only to find the executioner in hot pursuit. The last bureaucrat to suffer this fate was Pertev Pasha, head of the ministry for civil affairs (soon to become the ministry of the interior), in 1837. In a case of factional antipathy combining elements of international diplomacy and conflicting directions in policy-making, his rival Akif Pasha, head of what was shortly renamed the foreign ministry, persuaded the Sultan of Pertev's perfidy, accusing him in particular of closeness to the British. Mustafa Reşid Pasha, known simply as Reşid Pasha, Mahmud's most brilliant ambassador and a protégé of Pertev Pasha, had become foreign minister by the time of his patron's death, but could not save him: instead he pressed for the abolition of these extra-judicial punishments and expropriations, and this was accepted as one aspect of the penal code for officials and judges of 1838.[113]

Not content with rationalizing government procedures, Mahmud sought also to remove the visible markers of difference between individuals – this was an extraordinary measure, for external appearances had always counted in the Ottoman Empire, and the sumptuary laws governing the dress proper to an individual's status in society were enforced, or allowed to lapse, or rewritten, as political circumstances demanded. As recently as 1814 Mahmud himself had warned the people of Istanbul that they must wear appropriate garb 'because it has become impossible to differentiate one class from another':

> The people of the Exalted Abode of the Sultanate [i.e. Istanbul] are divided into numerous classes and every class has its own costume; they should go

about wearing that costume, with everyone observing established custom and knowing their place, and honouring and respecting their betters and military officers and obeying them . . . And those in the retinues of pashas, and members of the imperial guard and the constabulary and tradesmen must not wrap a shawl and cotton embroidered in silk around their heads like galleon sailors, and whatever their status and the peculiarities of their dress, they must garb themselves appropriately. For some time . . . a blind eye has been turned, and the spendthrift of all classes have abandoned their former dress and the garments peculiar to them, and they have dressed in a recklessly extravagant manner according to whatever enters their heads . . . most palace officials and the military class and tradesmen have altered their ancient costume and their essential appearance.[114]

The fez condemned by Mustafa Kemal (Atatürk) – first president of the Turkish Republic – in 1925 as a relic of the Ottoman past had been introduced by Mahmud II a century earlier. His imposition of the new headgear on his new army proved remarkably problem-free – the fez was already worn by the military forces of the Magrebi provinces and Egypt, as it was by troops in the retinue of the Sharif of Mecca, so it was abundantly clear that there was no canonical objection to it. It had in fact already made its appearance in the Ottoman army, worn by musketeers fighting against the rebellious Balkan notable Pasvanoğlu Osman Pasha of Vidin. The wearing of the fez was extended to government employees in 1829; the support of the religious establishment was sought, and mosque preachers were enlisted to convince the people that the fez was acceptable.[115]

The sumptuary laws had distinguished people by religion as well as by rank, and those whose only claim to superiority was their status as Muslims were strongly opposed to Mahmud's demands for uniformity, by which this religious distinction became invisible. Non-Muslims, on the other hand, even those who were not bureaucrats, were keen to embrace this symbol of a new age, one in which they hoped to co-exist on equal terms with Muslims.[116] Clerics proved steadfastly immune to sultanic blandishments, and rejected outright Mahmud's demand that they too adopt the new headgear in place of their turbans.[117] Mahmud's own adoption of the trousers and frock-coat – in a modified version known as *istanbulin* – of his fellow monarchs in Europe demonstrated the sincerity of his commitment to this break with the past.

Cultural displays in the western idiom became all the rage in the rarefied circles in which Ottoman Muslims and non-Muslims mingled, but did not stop there. Mahmud invited the composer Giuseppe Donizetti, brother of the better-known Gaetano, to Istanbul as master of the sultan's music, with the task of training the military band (first founded by Selim III for his

'New Order' troops) which had replaced the janissary band whose sound had once struck fear into the hearts of their infidel foes. Contemporary Italian music soon became popular at court.[118] Since about the middle of the eighteenth century sacred architecture had displayed a westernizing, baroque tendency – as exemplified in the Nuruosmaniye mosque built in the 1750s – of which perhaps the last example was the Mosque of Victory (Nusretiye), built between 1823 and 1826 and named for Mahmud's triumph over the janissaries. Mahmud continued the very un-Islamic and un-Ottoman practice of having his portrait painted, and presenting copies – possibly in cameo form – to his own statesmen and to foreign dignitaries. He was bolder than Selim, however, and in addition ordered his portrait to be hung on view in public places such as barracks and government offices, just as other European monarchs of the time did. The religious establishment strongly disapproved of such display of the royal person, but in 1832 he nevertheless presented a bejewelled portrait of himself to the sheikhulislam of the time.[119] Reflecting on the splendid ceremonial accompanying the hanging of the royal portrait in the Selimiye barracks at Harem in Üsküdar in 1836, the court historian Ahmed Lutfi Efendi countered possible canon-ical objections with the arguments that it was beneficial to preserve the likeness of the truly great – such as Sultan Mahmud – and that the prac-tice conformed to ancient custom. He also noted, however, that when Mahmud's portrait was presented to Arab notables, any religious formulae were omitted,[120] in order to avoid further upsetting people whose support he needed and to whom the very fact of figural representation might have been offensive.

In Egypt, Mehmed Ali had gone further than Mahmud down the road of overhauling his domains, but his reforms were achieved at great cost and the results were not always as successful as he had hoped: changes in the military, financial and agricultural spheres – of which an extensive irriga-tion programme was an integral component – were pushed through at the expense of the peasantry, while his new army had singularly failed to impress in the Navarino campaign of 1827. Mehmed Ali promptly took further measures to improve both his army and his navy.[121]

France was disappointed in its hopes of using Mehmed Ali for its own purposes in the Sultan's Magrebi provinces – for he was convinced that his interests lay in the eastern Mediterranean, not in the west[122] – and acted on its own, progressively occupying the Ottoman satellite province of Algiers from the 1830s. As compensation for his losses at the hands of the Great Powers in the Peloponnese Mehmed Ali requested of Sultan Mahmud the Syrian provinces, rich in natural and human resources; the Sultan awarded

him instead the governorship of Crete, but he rejected it, aware that the costs of keeping order on the island would be a drain on his finances. In 1831 he launched land and sea campaigns against Syria. Commanding the revitalized Egyptian army, his son İbrahim Pasha routed the Ottoman forces and advanced into Anatolia where he met with an eager response from the local population. Such an act of open revolt could not be tolerated by Istanbul: like insubordinate governors before them down the ages, with Tepedelenli Ali Pasha of Ioannina only the latest example, Mehmed Ali and İbrahim were branded rebels, and an army under the grand vezir, Reşid Pasha, was sent against them. When the two armies met outside Konya, the Ottoman army was defeated and the Grand Vezir taken prisoner.[123]

Possibly Mehmed Ali had no intention of declaring independence of the Sultan at this time[124] – his ambitions certainly drove him to test the boundaries of his vassalage to their limits, but in all probability he had no idea of operating outside the framework of the empire; he was, after all, an Ottoman. İbrahim Pasha saw matters differently. Even as Mehmed Ali wrote to Mahmud asking forgiveness – at the same time demanding that he be allowed to keep the extensive territories he had won – İbrahim was insisting that his father should mint coins in his own name and have his name used in the Friday prayer.[125] Yet again, it seemed, the greatest threat to the empire's integrity was found to come from within it: by January 1833 İbrahim had advanced to Kütahya, within striking distance of Bursa. Supplies for Istanbul were partly cut off by the Egyptian advance and famine threatened in the city. Failing to gain definite promises of help from either Britain or France, Sultan Mahmud was forced to call upon Tsar Nicholas for help, and in February 1833 the Russians established a bridgehead up the Bosporus from Istanbul.[126] Such an appeal for assistance against one of the Ottoman Empire's own governors to a long-time adversary whose motives for intervention could only be self-serving was unprecedented and a measure of the empire's weakness.

Mehmed Ali emerged from this adventure with profit. Repeated attempts to appease him had brought him, by April 1833, the governorships of Egypt, Aleppo, Damascus, Tripoli (in Syria), Acre, Crete, Beirut, Safed, Jerusalem and Nablus; İbrahim Pasha was to govern Jiddah, Habeş and Mecca, and at the beginning of May was appointed revenue-collector of the Anatolian province of Adana, from whose forests he hoped to extract timber to build up his fleet. In July a so-called mutual defence pact between Russia and the Ottoman Empire was signed, the Treaty of Hunkar İskelesi, named for the upper Bosporus base of the Russian fleet during the summer of 1833. The devil was in the detail of a secret article by which the Ottomans in effect agreed to close the Dardanelles, should Russia request it, to the

warships of other foreign powers.[127]

Mahmud resented the concessions which had been the price of peace. Despite all he had secured, Mehmed Ali also considered himself to have done badly: İbrahim's appointment was subject to annual review, Egypt was still expected to pay an annual remittance to the Ottoman exchequer, and possession of the Syrian territories proved less advantageous than he had envisaged because of local resistance to İbrahim's administration. Sliding cotton prices depressed the Egyptian economy, and Egypt's oppressed people signalled their simmering opposition to the manner and pace of Mehmed Ali's reforms by refusing to serve as conscripts in the army.[128]

His dissatisfaction with his achievements and the setbacks he suffered in the years that followed served only to increase Mehmed Ali's ambition. To the alarm of both the Sultan – who would thereby lose even nominal control of the Holy Places – and the western powers, in May 1838 he made it clear he wanted independence. In 1839 an Ottoman army was again sent to deal with İbrahim Pasha and again, Mahmud's improvements notwithstanding, it failed. İbrahim won a decisive field battle at Nizip, south-east of Gaziantep, on 24 June; within a week Mahmud was dead and his son Abdülmecid was sultan. The Grand Admiral chose this moment to defect to Mehmed Ali, sailing to Alexandria and taking the imperial fleet with him. The new sultan's government prepared to come to terms.[129]

The war with Mehmed Ali was an internal Ottoman problem, but it was resolved through European adjudication. After much disagreement between themselves, Britain, Russia, France, Austria and Prussia, presenting a united front, warned the Grand Vezir against rushing into a settlement with the rapacious governor. On 22 August, Istanbul responded by authorizing the Powers to negotiate a settlement on the empire's behalf, and the diplomatic manoeuvring that ensued revealed the nub of the 'Eastern Question': each of the Powers was suspicious of the influence wielded by the others in the Ottoman Empire, and particularly fearful lest another Power should gain an untoward advantage – whether strategic, territorial or commercial. By contrast with the Greek case, where European interests came down firmly against the Ottomans and were instrumental in bringing independence, in 1839 fear of Russia drove the diplomacy: the entrenched position of Russia in Ottoman affairs following the Hunkar İskelesi treaty of 1833 and what it might portend was a cause to Britain especially of great concern.[130]

A great deal of intricately nuanced negotiation eventually resulted in July 1840 in a compromise – the Convention for the Pacification of the Levant – signed by Britain, Austria, Prussia, Russia and the Ottoman Empire;

445

France refused to be party to the inevitable coercive measures against Mehmed Ali. Under the terms of this agreement, the other provinces Mehmed Ali held were lost to him, but the governorship of Egypt was confirmed as hereditary for him and his heirs – a solution to which he had aspired for many years. From the Ottoman perspective, Egypt remained part of the empire. Mehmed Ali at first refused to withdraw from the territories he was no longer permitted to control, and looked forward to obtaining more favourable terms with the mediation of France. A revolt against İbrahim Pasha's regime in Syria gave the Powers the opportunity they sought to intervene and expel him; Mehmed Ali agreed to return the Ottoman fleet, and the Sultan tried to attach strict conditions to his hereditary governorship of Egypt but was dissuaded by his partners to the convention – within a year Mehmed Ali was subdued. The imperial decree embodying the revised status of the province of Egypt included a proviso that all treaties concluded by the Ottoman government with other states should apply equally to Egypt, and this curbed Mehmed Ali's potential for further trouble-making: his power had been largely funded by the operation of state monopolies, but these had been banned under the terms of the commercial convention known as the Baltalımanı Convention, after the Bosporus village where it was signed between Britain and Sultan Mahmud in 1838.[131] In July 1841 France, Britain, Russia, Austria, Prussia and the Ottomans signed the Straits Convention, under which the principle was accepted that the Dardanelles and the Bosporus should remain closed to foreign warships in time of peace.[132]

From this time, British influence and intervention in the Near East burgeoned. It was not long before other European states were accorded similar trading privileges, but it was the British, with their advanced industrialization and financial institutions, who were best placed to profit from the commercial opportunities now available to them. The long-term effects of this liberalization of trade were mixed: foreign merchants had the advantage over Ottoman merchants, who continued to pay internal customs dues; the volume of trade increased, but at the cost of undermining Ottoman domestic production and, primarily because of the loss of income from tariffs, of weakening still further the finances of the empire. As one historian sees it, 'the Ottoman Empire turned into a virtual British protectorate'.[133]

14

A crisis of identity

O N 3 NOVEMBER 1839 in the Gülhane, or 'Rose Bower', in the outer
gardens of Topkapı Palace, Sultan Abdülmecid promulgated what
became known as the Gülhane Edict, which formally inaugurated the era
known as the *Tanzimat*, or 'Re-ordering'. Mahmud II's reform programme
had proceeded as circumstances allowed; the Gülhane Edict was a public
pronouncement that the old ways had failed to fit the empire for the modern
age, and also an unequivocal statement of the ideological framework that
underlay the legal and administrative changes of the recent past and would
guide those of the future. Although foisted on the population from the
pinnacle of power, the Edict was a document by which the Sultan committed
himself and his government to a contractual partnership with his subjects.
It would affect them all, and all were expected to subscribe to its precepts.
The new medium of the press conveyed the Edict to the literate – the text
was printed in the official gazette, *Takvîm-i vakâyi* – and, more tradition-
ally, provincial governors and sub-governors were instructed to arrange
ceremonial readings in the public squares of the empire's towns and cities.[1]

The Edict was proclaimed by Mustafa Reşid Pasha, the foreign minister,
in the presence of the Sultan and an assemblage of statesmen, clerics and
foreign ambassadors. Its preamble blamed the Ottoman Empire's descent
from greatness during the past 150 years on a failure to observe both the
sacred and the sultanic law – a situation that could be remedied, it continued,
by means of good administration founded on the principles of security of
life, protection of honour and property, and new measures in the fields
of taxation and military service: guarantees regarding security of life and
property would encourage loyalty to the state; new sources of taxation
were being sought to replace the income from tax-farms and the 'accursed
monopolies from which the domains had recently been liberated';[2] a fair
system of taxation would be established and the uses to which this money
would be put – the expenses of the army and navy demanding the largest
share – would be regulated by law; military mobilization was to be regu-
larized to distribute the burden equitably, and a limit of four to five years'
conscript service was set. For the first time these principles were to be

447

applied to all Ottoman subjects, both Muslim and non-Muslim. The bribery that plagued the bureaucracy would be outlawed, and a penal code introduced to punish those derelict in observation of the laws, whomsoever they were, and in accordance with their rank. The concluding promise, to which all Ottoman subjects and friendly states were invited to bear witness, was of thoroughgoing administrative change. The Edict was firmly and explicitly couched in the language of Islamic law, and the laws which it would engender would not conflict with this, while this essentially religious character was symbolically confirmed when the Sultan swore to it in the Chamber of the Holy Mantle in the presence of high-ranking clerics and bureaucrats.[3]

It was customary for a new sultan to make a proclamation of his intention to rule justly, and Abdülmecid had done so on his accession four months earlier. It was unusual for that statement of intent to be so soon followed by another – and the timing was not coincidental. An unfortunate combination of domestic and external events – in particular, the threat posed by Mehmed Ali and the shifting strengths and interests of the Great Powers with respect to Ottoman affairs – found the empire on the defensive by the end of the 1830s despite Sultan Mahmud's wide-ranging reforms. If the Baltalimanı commercial convention of 1838 was the price the Ottomans had to pay for British support in the settlement with Mehmed Ali, the proclamation of the Gülhane Edict was the cost of securing this self-interested support in the longer term. The Tanzimat had, in effect, been initiated by Mahmud during the last years of his reign, but Abdülmecid's promulgation of the Gülhane Edict was a gesture intended to demonstrate to the European powers the sincerity of Ottoman intentions to modernize their state. The evidence it gave of a renewed vigour at the heart of the empire was calculated to impress upon the Powers the empire's determination and capacity to participate on equal terms – inviting them to display good will in their support for Ottoman reform efforts – and at the same time to demonstrate a willingness to accommodate their often vociferously-expressed concerns about the welfare of the Sultan's non-Muslim subjects.

Sultan Abdülmecid was only sixteen when he came to the throne, and the approach to reform embodied in the Gülhane Edict – so different from his father's – is generally ascribed to the initiative of Reşid Pasha. A product of theological college, he had subsequently transferred to the civil bureaucracy and gained wide experience of the world of international politics. He had negotiated with both Mehmed Ali and his son İbrahim Pasha when their expansionist policies were threatening the empire, and had been ambassador in both Paris and London. During his time in London he had

won British support for Ottoman resistance to Mehmed Ali, a success that initiated a pro-British outlook among the group of reformers closest to him.[4]

The prominence of Reşid Pasha as a conduit for the British influence subsequently manifested in Ottoman legislation has tended to overshadow the homegrown aspects of the Edict. Reşid Pasha had a hand in the drafting of the Edict, and members of the religious hierarchy were also prominent in its formulation, an involvement that seems to have precluded any sense of a need for a juridical opinion to sanction its proclamation and suggests that they saw no conflict with the precepts of Islamic law. The Sultan himself had grown up in an orthodox Islamic environment fostered by his tutors and his mother. In his accession proclamation he had not only referred to himself as 'Commander of the Faithful and [God's] Caliph on the face of the earth' but had announced that no toleration would be shown towards those who did not pray five times a day, in keeping with their religious obligation. He wrote to his grand vezir: 'The Caliphate has been passed on to us by inheritance and by right . . . it is our wish to see that the exalted [Islamic law] is applied in all matters'. Like his forebears, he was an adherent of a dervish order, in his case the Halidi branch of the Nakşibendi order, as were a number of his closest advisers. Unlike the Bektaşi, the Halidi, noted for the centrality of the sacred law in their teachings, found acceptance in conservative ruling circles; they benefited – as did the Nakşibendi and the Mevlevi – from the demise of the Bektaşi after 1826. In Damascus, at the site of the tomb of Sheikh Halid Baghdadi, the founder of the order, Abdülmecid had a mausoleum and dervish convent constructed in the early 1840s. His pronouncements and his acts were those of a pious man – in 1851 he ordered a mosque to be built in the Fatih district of Istanbul to house a second mantle of the Prophet Muhammad (the first being that kept in Topkapı Palace)[5] – and one in whom an understanding of the need for continuing reform within the framework of Islamic law underlay the search for a more viable state expressed in the Gülhane Edict.[6]

Each reform effort in the history of the Ottoman Empire had provoked opposition, but where its containment had hitherto been a purely domestic issue, one consequence of the Gülhane Edict was to bring internal Ottoman tensions onto the international stage. By responding to outside pressure in the timing and tone of the Edict, the government laid the reform process open to foreign monitoring, and this tended to throw into relief the profound differences in outlook between Christian European and Islamic Ottoman culture. Debates about the nature and speed of change were complicated and the resolution of internal conflict became far more difficult as the

demands of the European powers, which were often incompatible with one another, clamoured to be satisfied.

At first reading there was little remarkable in the Gülhane Edict's statement of intent regarding a desire for better administration and a healthier state treasury. A new dimension, however, was the emphasis on law to provide the framework within which administrative reforms were to be carried out: this reflected a development of Mahmud's aim that impersonal, rational decision-making should replace the unregulated application at whim of either sacred or sultanic writ. A general penal code passed into law in 1840; in the same year tax-farming was abolished, at least in theory: in practice, the intentions of the legislators could not fully be realized, and it was still flourishing in the early twentieth century.[7] But the application of the *Tanzimat* was very uneven across the empire. Lack of personnel trained to carry out the reforms, inertia combined with an instinctive resistance to change imposed from above, an insolvent treasury, an underdeveloped infrastructure, a largely illiterate population, the problems of communicating the new values across far-flung and diverse lands – all these factors bedevilled the implementation of the reforms.

Explicit manipulation of the overlapping categories according to which Ottoman society had traditionally functioned, and of the rights and duties proper to and expected of each individual by virtue of his membership of a particular group, lay at the root of much of the unrest generated by the Gülhane Edict.[8] The promise of equality for all before the law was not one to be easily assimilated in the Ottoman milieu, since Islam itself enshrines three significant inequalities: those of believer and unbeliever, master and slave, male and female.[9] Inequality between believer and unbeliever set the terms of the fundamental structure of every Islamic society, and Ottoman society had in the past also been further defined by the now blurred distinction between the ruling class and the ruled – that is, between the tax-exempt and the taxed. Pragmatism and compromise were characteristic of many spheres of Ottoman activity, in that these distinctions were not always and everywhere rigidly enforced, but public articulation of the principle of equality for all Ottoman subjects was too much for many to countenance with equanimity – particularly when an uncomfortable dimension of the new arrangements was that any failure or backsliding was sure to invite foreign recrimination.

The most obvious expression in Ottoman society of the inequality between Muslim and non-Muslim was the poll-tax paid by the latter. This particular distinction was not one that could be abolished at a stroke, but even the administrative changes made at this time required a juridical opinion from the Sheikhulislam.[10] To bring the status of non-Muslims into line with that of Muslims – that is to say, to relieve non-Muslims of the requirement

to pay a poll-tax – would have been to deprive the state of important revenues, as well as conflicting with the principle of the 'second-class' status of non-Muslims in a Muslim state, so 'equality' was effected, rather, by bringing the status of the Muslim population more in line with that of non-Muslims; Muslim and non-Muslim peasants alike were now required to pay a graduated tax, according to the value of their land-holding.[11] Some of the new regulations to centralize and regularize tax collection had in fact been laid down during the final year of Mahmud II's reign; they were intended to remove the abuses which had blighted the lives of the subject population, but poorer Muslims were nevertheless unhappy with the imposition of a regular tax payable in cash where they had previously been liable for a number of different taxes, some of them payable in kind, as were certain other groups of Muslims who had long enjoyed special exemption from taxation in return for the performance of specific services for the state, and were now to be taxed instead.[12]

As was to be expected, Ottoman Christians and their European champions, who had eagerly looked forward to the removal of the social and financial disabilities which exemplified the second-class status of non-Muslims, interpreted the continuing existence of the poll-tax as being contrary to the *Tanzimat* promise of equality for all. Ignoring the inconvenient fact that like any state the Ottoman Empire needed tax revenues to be able to function, wherever the shortcomings of the *Tanzimat* were discussed in the European press, the unsatisfactory nature of its taxation system was the main preoccupation.[13] As for the Jewish population of the empire, their complaints were less easily heard than were those of Christians, for there was no Great Power ready to intervene on their behalf in Ottoman domestic affairs – although in the 1830s Britain had sought recognition as the protector of Ottoman Jewry, to match Russia's claims to protect Orthodox Christians and France's in respect of Catholics, and had looked to settle Jews in Ottoman Palestine and Syria. Since their numbers were small and they were more widely dispersed than the Christian communities, the Ottoman authorities did not see Jews as a threat to the state. In an attempt to give the appearance of pluralism, however, the government had in 1835 for the first time appointed a leader of the Jewish community, counterpart in principle to the Orthodox and Armenian patriarchs. But this appointment sat uneasily with the reluctance of Judaism to recognize such an all-supreme figure: he was at first regarded with suspicion, and only gradually came to be accepted.[14]

During the 1830s a series of uprisings had taken place in the area of Niš, near the western Ottoman border with Serbia. The Serbian leader Miloš Obrenović refused to support the rebels, and skilfully worked instead to

further administrative reform in partnership with the Ottoman authorities. In 1839 he abdicated, however, and his place as hereditary prince was soon taken by his sixteen-year-old son Michael. Two years later trouble broke out as tax reform began to be implemented: the land-holding class was Christian, the peasantry mixed Muslim and Christian, and all were unhappy not only with the new tax rates but with the fact that some taxes which had theoretically been abolished were still being demanded from them. The representations made by the Christian peasants of the Niš area to Michael Obrenović in that year bore scant trace of any yearning for independence, but simply sought improvement in the conditions under which they lived – 'people are not revolting against the legitimate government of the Sultan, rather they want that the benevolent terms of the Gülhane Edict be faith-fully and exactly carried out', one such petition took care to note.[15] Resistance coalesced along communal lines, however, and local Ottoman administrators called upon Albanian troops – Muslims – to quash the distur-bances. They did so, violently, until Istanbul intervened. The religious over-tones of the conflict were not lost on the champions of the Ottoman Orthodox: Russia protested and a commission was duly sent from Istanbul to determine what lay behind the incident. The Ottoman government was of the opinion that the Serbian leadership had instigated the disturbances, but fearing that such tax-related protests might spark further intercommunal unrest in what was a highly sensitive region, decided to pacify the Christians by ransoming those of their fellows seized by the Albanian irregulars, retrieving their stolen livestock and other moveable goods, and distributing money to those caught up in the violence; gradually, those who had fled made their way home.[16]

The event which most publicly demonstrated that reform, albeit incom-pletely and falteringly, was moving too far, too fast for most upper-echelon bureaucrats as well as for the people at large was Reşid Pasha's dismissal from the post of foreign minister in March 1841, apparently as a result of bribes offered to his enemies by Mehmed Ali who saw him as responsible for the Convention for the Pacification of the Levant agreed the previous year.[17] The government was in the hands of the conservative in outlook, and the cabinet decided unanimously that many newly-introduced measures should be countermanded[18] – which only added to the confusion. A factor that contributed to Reşid Pasha's downfall was clerical disapproval of his introduction of a commercial code based on the French model which owed nothing to the precepts of Islamic law: instead, it dealt with partnerships and bankruptcies and the like – and was soon suspended.

Reform cost money, as Sultan Mahmud had discovered. His adminis-tration had resorted to debasement of the coinage, thereby provoking one

of the most inflationary periods ever experienced in Ottoman history. The amount of silver in the widely-used coin known as the *kuruş* had not changed between 1789 and his accession in 1808, but during the 30 years of his reign it decreased by some 80 per cent; in gold coins the decrease in precious metal was below 20 per cent. Two periods of devaluation can be identified: between 1808 and 1822, and again between 1828 and 1831. The second, faster period encompassed both the Russian war of 1828–9 and the burden of the subsequent reparations payments imposed on the Ottomans. The suppression of the janissaries in 1826 having removed the group most vociferous in its opposition to debasement of the coinage, this second phase was largely successful, leaving the treasury in a better position to meet its obligations.[19]

But debasement alone could not provide an adequate solution to long-term financial needs, and the state was overly indebted to the money-brokers of Galata. In 1840 a hitherto untried financial instrument, paper money, was introduced. Although in character this was closer to treasury bonds – it was redeemable only after eight years, at an interest rate in the interim of 12.5 per cent per annum – circulated only in Istanbul, and was subject to counterfeiting, it gradually came to be accepted as a medium of exchange comparable to the coinage, as the government had intended, and was to some extent successful in augmenting treasury funds.[20] In 1844 a bimetallic standard setting a fixed rate for the conversion of silver with gold was introduced: this also contributed to stabilizing the coinage. Like so many Ottoman innovations of these years, the inspiration came from Egypt.[21]

Soon after his dismissal in 1841 Reşid Pasha had returned to Paris as ambassador; he was recalled in 1845 and re-appointed foreign minister, and the following year he became grand vezir. His tenure, which lasted intermittently until his death in 1858, was long for the times, and reversed the downgrading the office had suffered during the reign of Mahmud II. It took the young Sultan Abdülmecid some time to establish his authority – the more so, from the problems attending the implementation of the *Tanzimat* – but with the respected Reşid Pasha at his side he gained the stature to proceed with the reform programme, which had fallen victim to the conservatives who had taken over in 1841.

One necessary administrative measure of the years of Reşid Pasha's absence was the initiation in 1843 of a survey of the rural resources of the empire, with the aim of informing central government of the potential of the provinces. Following his reinstatement, far-reaching reforms were introduced in the fields of law and education in particular – commercial courts serving both Muslims and non-Muslims in 1847; in 1850 a revamped French-inspired commercial code to replace that which had contributed to Reşid

Pasha's dismissal nine years earlier; and the foundation of a ministry of education and of secular schools for boys aged between ten and fifteen.[22] While this establishment of structures which were not anchored in Islamic mores was advantageous to modernization of the state in the long run, there were inevitable contradictions and conflicts with the still-functioning traditional system which were not easily resolved. Moreover, the innovations were few in number.

Despite reform, the pace of change in rural areas was slow. Landlords with large agricultural holdings did not disappear overnight but continued to order affairs largely to suit themselves, and found it easy to subvert the best intentions of the reformers. In its dynamics, an uprising in 1850 in Vidin, on the Danube, may be typical of other areas. The Muslim landlords here were angered by the abolition of the corvee, the system of forced labour imposed on the predominantly Christian peasants who tenanted their land. Outlawed in 1838, it had continued, de facto, along with other unremunerated and onerous services the peasants were called upon to perform. Armed peasant resistance prompted the landlords to petition the government: the government's response was that corvee had indeed been abolished and the matter should be settled locally. However, the forum for resolution of such disputes was the local council, and since the very landlords who had mounted the petition formed a majority of its members, the issue was resolved in their favour and there was little change in the situation on the ground.[23] Evidence suggests that the attitude of Russia and Serbia was one of caution to the point of restraint regarding events in Vidin, and that there was no question of the Vidin disturbances embodying a bid for Bulgarian independence from the Ottoman Empire.[24] It did appear, however, as though any optimism in Ottoman ruling circles that the *Tanzimat* reformulation of state ideology would arrest agitation among the Christian minorities of the empire was likely to prove ill-founded.

Surprisingly, perhaps, even before Reşid Pasha's return to the grand vezirate a faltering start had been made in implementing one of the most contentious propositions of the Gülhane Edict, but a key part of the Ottomans' new programme of equality for all – the conscription of non-Muslims into the fighting forces of the empire. The Sheikhulislam gave the opinion that there was no canonical impediment to non-Muslims serving in the military and there was a compelling reason why they should do so – the empire needed troops, and, from a variety of causes, battlefield losses among them, the Muslim population was in relative decline. The cabinet wondered whether it might be better to employ non-Muslims only on land, and not in the confined quarters of a warship, where it was unlikely that they would mix easily with the Muslim sailors. Nevertheless, the necessary regulatory frame-

work was in place by 1843, and conscription of Christians into the navy took place in 1845 and 1847 – even though the reformist party was not in power at the time. The government made efforts to rein in officials who treated the conscripts harshly, but the British complained nonetheless, and feared that the next step would be to take Christians into the army. No Christian sailors were recruited between 1848 and 1851; in 1851 many Macedonian Christians fled to the Peloponnese to avoid conscription into the navy, while Christians in Trabzon sought documents showing them to be under the protection of the local Greek and Russian consuls, even foreign passports. Concessions such as offering Christians conscripted into the navy work in the imperial dockyard rather than at sea failed to resolve the impasse at this time.[25]

Despite the many setbacks encountered in implementing the laws which derived from it, the Ottoman reformers who supported the precepts of the Gülhane Edict saw themselves as equal partners of the European powers in a new world order, an equality symbolized by participation in such events as the world fairs of the nineteenth century. The warmth of Ottoman–British relations, as notably exemplified by Reşid Pasha's contacts with Stratford Canning – ambassador in Istanbul from 1825 to 1827, and again between 1842 and 1858 – doubtless encouraged the Ottomans to seize the opportunity to take part in the first of these, the Great Exhibition held in London in 1851 (they also participated in the World Fairs of 1855 and 1867 in Paris, 1862 in London and 1863 in Istanbul – and others later in the century). The purpose of participation, according to an official announcement, was to demonstrate the productivity of the Ottoman lands and the capabilities of the Ottoman people in the fields of agriculture, industry, and arts and crafts. Some 700 producers displayed their wares and a number, particularly from the quasi-independent provinces of Egypt and Tunis, were awarded prizes.[26]

The years from 1839 until the beginning of the hostilities leading up to the outbreak of the Crimean War in 1853 were ones of international peace for the empire as it eagerly embraced the outside world. The gradual introduction into the Ottoman lands of technical innovation in manufacturing and agriculture meant an increase in production for both the domestic and international markets. In the case of international trade, the rights won by foreign merchants to trade freely within the empire, and the ending of monopolies, made for a regime that was one of the most liberal in the world.[27]

Britain emerged as the foremost among the Great Powers during the 1840s as Russia was apparently forced onto the defensive with regard to the

Ottoman Empire, but there were soon signs that Russia was actively seeking the partition of the empire, using the pretext of protecting its Orthodox Christian subjects as a means to destabilize it.[28] Catholic and Orthodox rivalry in the Holy Sites of Palestine provided fruitful grounds for foreign intervention, as it had for centuries – the Franciscans having gained the upper hand in 1690 and had their position confirmed in 1740 following French support of the Ottomans in the Treaty of Belgrade, before losing it to the Russian-backed Orthodox in 1757.[29] In the 1840s the issue blew up again as the question of the Holy Sites became an element in the wider rivalry between France and Russia. Russian pilgrims greatly outnumbered both their Ottoman co-religionists and Catholic pilgrims, and Tsar Nicholas I displayed an active interest in the Sites. The Ottoman government was harangued by Russia and France over the next few years as each sought to win international prestige and popular support at home by espousing the cause.

Another building of broad religious significance came into prominence during this period – the basilica-mosque of Ayasofya, the Hagia Sophia of Orthodox Byzantium. When Sultan Abdülmecid commissioned major restoration works in 1847 the building was in such an obvious state of disrepair that visitors to Istanbul dwelt on its neglected condition, both structurally and decoratively.[30] Mahmud I, in the mid-eighteenth century, had been the last sultan to renovate Ayasofya. From the later eighteenth century, initially in response to their claims to religious authority over their co-religionists in the Crimea who came under Russian rule at this time, successive sultans began to emphasize their identity as the Caliph of Islam and Ayasofya took on a new role as the 'symbolic seat of the Ottoman caliphate', complete with a set of myths to account for this new interpretation.[31] The restoration work commissioned in 1847 was entrusted to the Swiss Fossati brothers, who had been in Istanbul ever since arriving in 1837 to build the Russian Embassy; they had remained after its completion, building a wide range of structures, from country villas to government offices to Catholic churches. The Sultan had some concerns about clerical reaction to the project – but nevertheless paid several visits to Ayasofya during the course of the works. His order for the repairs was issued at a time when the most reactionary clerics were away from Istanbul on the pilgrimage to Mecca.[32]

Abdülmecid celebrated the completion of the Ayasofya repairs in 1849 by ordering the casting in Paris of a medal with his own cypher on one side and a depiction of the basilica-mosque on the other,[33] achieving wide recognition for the building and enhancing its symbolic significance. It was a time, as the Ottomans understood very well, when it was necessary to

play an active part in forging the image they presented to the outside world. Through his work on Ayasofya Abdülmecid was both addressing his domestic constituency and at the same time making a statement of goodwill to the Christian world in a language it understood. The Sultan's attention to this particular monument in a city they coveted must have irritated the Russians quite as much as another move calculated to please the Ottomans' British allies, the asylum offered to Polish and Hungarian refugees from the failed anti-absolutist revolutions of 1848, in which the Russia of the autocratic Nicholas I had interested itself. It was a gesture not without benefit to the Ottomans, for many of the refugees went into the military or the bureaucracy; some converted to Islam, but many retained their religion.

In 1850, as president of the French Republic, Prince Louis-Napoleon renewed his claim to custody of the Holy Sites in a bid to gain the support of his country's clerics. Protracted negotiations resulted in 1852 in the keys of the Church of the Nativity in Bethlehem being awarded to the Catholics. Their use was hedged around with restrictions intended to satisfy Russia, but early in 1853 an indignant Tsar discussed with the British ambassador to St Petersburg his plans for the partition of what he referred to for the first time as 'the Sick Man of Europe'. Tsar Nicholas hoped to gain the Danubian Principalities, Bulgaria and Serbia, the British would have Egypt and Crete, and Istanbul would become a free port. There was little reaction from London, however, and taking this for tacit agreement, in late February 1853 a Russian envoy, Prince Alexander Menshikov, brought the Sultan an ultimatum demanding continuing Russian pre-eminence in the Holy Sites and recognition of Russia's rights over Ottoman Orthodox subjects. The Tsar's demands were rejected, and early in July Russian forces began to cross the river Prut into Moldavia. In September Britain and France sent four warships through the Dardanelles towards Istanbul, and after further fruitless diplomatic manoeuvring the Ottomans sent an army across the Danube on 27 October. Thus the opening moves in what became the Crimean War. It was not until March 1854 that war was formally declared, after Russian bombardment of the Ottoman fleet at Sinop in November of the preceding year brought Britain and France, ever-dubious about Russia's intentions with regard to the Ottoman Empire, hastening to its aid. The Ottomans had found themselves allies in their struggle against their northern neighbour and the Crimean War had begun.[34]

Austria stood to be affected as much as the Ottoman Empire by Russia's occupation of the Danubian Principalities, and played a role as mediator among the four Powers enmeshed in the war. In June 1854 the Russian troops were forced to withdraw, and Austrian troops arrived to take their place, according to the terms of a treaty with the Sultan who thereby

transferred his sovereign rights in the Principalities to Austria for the duration of the war. Passage through the Principalities thus denied to the belligerents, the focus of the war shifted to the Crimea, where Britain and France saw an opportunity to destroy Russia's fleet and naval installations, and put an end to the bitter wrangling over the 'Straits Question' for ever. The port city of Sevastopol was the three allies' goal, but it was a year before they could finally reduce it in September 1855. By November Russian forces had advanced through the Caucasus to take the fortress of Kars in north-east Anatolia, while in December Austria threatened to enter the war on the allied side if Russia refused to sue for peace. Negotiations soon resulted in the Treaty of Paris of 30 March 1856.[35]

The Treaty of Paris recognized the Ottoman Empire as a member of equal standing with the other Powers of the Concert of Europe and, in guaranteeing its territorial integrity, seemed to signal that it would no longer be a victim of Russian – or any other – territorial designs. The Ottoman Empire had at last won the acceptance for which sultans had striven since the reign of Selim III. Russia had underestimated Britain's influence in the region and its hopes of controlling the Black Sea were dashed: it was to be open for all to trade in, and none to militarize. The Principalities and Serbia were returned to nominal Ottoman sovereignty, and European guarantee.[36] The apocalyptic language employed by Russia's generals following the signing of the treaty – one wrote 'it [is] impossible any longer to hide behind the curtain of official self-congratulation' – was justified by the admission of its foreign minister Prince Alexander Gorchakov eleven years later that the Russian Empire had been in very real danger of collapse during the Crimean War.[37]

Reference was made in the Treaty of Paris to the so-called 'Reform Edict' which, promulgated by the Sultan on 18 February 1856, dwelt at length on matters relating to the Ottoman Empire's non-Muslim population whose condition was of intense interest to the Powers. In this Edict, the vague undertakings of the Gülhane Edict were spelt out in full. Sultan Abdülmecid guaranteed his subjects freedom of religious observance and undertook that distinctions based on 'religion, language or race' should 'be forever effaced from administrative protocol'. The door was opened for all creeds to enter the new civil and military schools, and to seek state employment, an area where Muslims had traditionally predominated. The Edict repeated the intention that direct tax collection should replace tax-farming. New legal procedures would guarantee a more even-handed application of justice. The Edict also promised efforts to modernize the infrastructure of the state by establishing banks and reforming the financial system, by improving communications, and by public works. In regard to these last,

the Edict stated that means should be sought 'to profit by the science, the art and the funds of Europe'.[38] The right of foreign powers to intervene in Ottoman domestic matters was specifically rejected in the Treaty of Paris, but its possibility was implicit in every phrase of the Reform Edict.

The promised reforms appeared to be developments of the programme that had been under way since the latter years of the reign of Mahmud II, but they were announced under extreme pressure from and the strong influence of the empire's European allies, whose determination to under-mine Russia's claims to protection of the Ottoman Orthodox – and the instability in the Balkans that might follow therefrom – they reveal. Reşid Pasha, who had been out of office since 1855 and played no part in the Edict's formulation or in the Paris negotiations, was extremely vexed by it. He accepted the necessity for the empire to adapt to changing times, and the need to address the position of non-Muslims, but was critical of the notion that changes must be made all at once, and at the behest of foreign powers. What worried him most, however, was his apprehension that the Muslim population of the empire would feel it had been completely ignored in the Edict, and that this peremptory overturning of centuries of shared history would have repercussions in relations between Muslim and non-Muslim: he warned the government to be prepared to deal with what he saw as the inevitable tension.[39]

The terms of the Treaty of Paris may have freed the empire from the threat of Russia's territorial ambitions, but outside pressure continued in another guise, as Britain pressed for compliance with the Sultan's under-takings. The intellectual and statesman Ahmed Cevdet Pasha reported the reaction of many Muslims when the Edict was proclaimed: 'Today we have lost the sacred, communal rights which our ancestors won with their blood. The Muslim community is the ruling community but it has been deprived of its sacred rights. This is a day of grief and sorrow for the Muslim people.'[40] Although in theory both Edicts offered a better life for all Ottoman subjects, Muslim and non-Muslim alike, the perception of their effect was very different. The living conditions of ordinary Ottoman subjects of all creeds were hardly enviable, and resentment mounted among Muslims as non-Muslims pushing for their new-found 'rights' at every opportunity sought to make the most of the measures relating to their communities. The same administrative reforms that benefited the one seemed only to further oppress the other. In the months and years following the promulgation of the Reform Edict, riots and disturbances between Muslims and non-Muslims erupted across the empire; troops had to be sent in to restore order, and many were killed.[41]

One early sign of dissatisfaction with the reform process was the unrest

that occurred in Istanbul in 1859. It united army officers and clerics, including devotees of the conformist Nakşibendi-Halidi sect[42] – of which Sultan Abdülmecid was a member – against the legislative changes that affected them. Whether it was the intention of the conspirators to bring down the government or remove the Sultan is unclear. They were arrested and tried at the military school of Kuleli on the Bosporus after which the incident is named, and were exiled or imprisoned at the direction of Grand Vezir Mehmed Emin Ali Pasha.[43]

The promises in the 1856 Edict regarding freedom of religious observance for all Ottoman subjects included the assertion that 'no one shall be compelled to change their religion'.[44] Unlike Christianity in its various forms, Islam has seldom gone out of its way to proselytize, and the Ottoman attitude to conversion always tended to non-intervention – attributed by some to the fact that, prior to the *Tanzimat* reforms, a significant non-Muslim population was necessary for the poll-tax revenues it brought the treasury. Even apostasy from Islam to another of the 'religions of the book' – Christianity or Judaism – was generally tolerated at this time, as long as it had not been forced upon the individual. Official Ottoman wrath was reserved instead for Sunni Muslims who inclined towards Shia beliefs – a similar attitude to that of Nicholas I's Russia, which disdained 'Old Believers', who like adherents of Shiism in the Ottoman Empire were labelled 'schismatics' and persecuted.[45] The principle of equality of all before the law first promulgated in the Gülhane Edict upset the Ottoman state's traditional composure in these matters, however, and foreign intervention in cases of conversion and apostasy in the succeeding years undoubtedly contributed to the defensive tone of the explicit statements regarding religion embodied in the Reform Edict of 1856.[46]

One result of the 1856 Edict was that Christian missionaries became more active in the empire. The rights of all confessional groups to open their own schools became a dangerous weapon in the hands of these messengers of the western Churches, both Catholic and Protestant, and a cause of concern to the Orthodox of the empire as well as to Muslims. Catholic proselytizing among the Ottoman Orthodox – whether of the Greek, Armenian or Syrian rite – had long been a cause of concern, as repeated references in early eighteenth-century imperial edicts to the 'turning' of Orthodox Armenians from their customary rites attest.[47] An anti-Protestant backlash among the Orthodox of the Balkans in the 1840s had led the Protestants to concentrate their efforts further east, where their activities and their scarcely-concealed belief in the inherent inferiority of the eastern Churches – whom the missionaries sought to introduce to 'a higher and more perfect development of Christianity' – had for some years sorely vexed

the Maronite and Armenian patriarchs.[48] Their activity was also of concern to the Ottoman authorities, for after 1856 they felt free to convert Muslims as well as other Christians, and saw every objection of their Ottoman hosts as a violation of the undertakings given in the Edict.[49] After the proclamation of the Gülhane Edict in 1839 the realization began to dawn that Muslims might convert to Christianity, and after 1856 the possibility became a reality: faced with the potential loss of Muslim souls to Christianity, to add to those lost in battle defending the empire, the government was forced to forsake its earlier pragmatism and assert a 'policy' that conversion was not permitted. Many Muslim converts to Christianity, moreover, sought the protection of one or other foreign power. Notwithstanding the Great Powers' attempts to influence the Sultan by taking official cognizance of the response to every case of conversion, the Ottomans preserved their dignity and their right of sovereignty in their domains by introducing procedures to be followed by those who would convert to Islam, and the authorities were pragmatic when objections were raised concerning whether the act was voluntary or coerced. In cases where individuals left Islam for Christianity, they could be arrested and punished. The Ottomans' posture in all cases of conversion and apostasy was that it was their concern, and not the concern of outsiders.[50]

The issue of conscription became a matter of urgency when the losses of the Crimean War resulted in a severe shortage of military manpower. In this time of crisis Ottoman Christian community leaders set aside their objections and offered their firm support to the war effort – in October 1853, even before the formal declaration of hostilities, the Armenian community declared its members prepared to serve 'even in the army' – while Britain and France, as allies aware of the need for manpower to fight the Russians and happy to see the consequent abandonment of the poll-tax, abandoned their scruples and welcomed Christian conscription. In 1855, however, during the war, thousands of potential Christian conscripts fled the Niš area for neighbouring Serbia, and the policy had to be modified to exclude the Ottoman borderlands. Once the war was over, official recognition of how unwelcome the requirement that all must serve in the army was to Muslim and non-Muslim alike led to a compromise. Provision had already been made for particular cases in which individual non-Muslims would be permitted to send a substitute in their place; the 1856 Edict specifically admitted substitution as a general principle, and provided for the purchase of exemption. Thus the poll-tax, abolished by the Gülhane Edict, in effect continued to be collected, but under a new name – as an exemption tax which relieved eligible non-Muslims of the duty of military service.[51] Muslim honour was thereby satisfied by the maintenance of a distinction

between themselves and their inferiors, and non-Muslims were not forced to share a burden they found distasteful, however logically it formed part of the price of equality. It was blatant casuistry, of course, but as well as being acceptable to those directly concerned it enabled the Ottoman state to collect revenues which in the guise of a poll-tax had attracted western objections on the score of inequality, but which the state could not afford to lose.

Reşid Pasha was proved right in his expressions of concern about the Reform Edict. With the best will in the world, there was no way the multi-confessional, geographically incoherent and economically backward Ottoman Empire, whose institutions and legal framework had evolved to accommodate the demands of its own particular culture and concerns, could hope to implement within any short space of time promises exacted by foreign powers under conditions of extreme pressure.

The mantle of Reşid Pasha had passed to Mehmed Emin Ali Pasha, known simply as Ali Pasha, and Keçecizade ('Son of the Felter') Fuad Pasha, who held the offices of grand vezir and foreign minister by turns from the middle years of the century. Apart from an interval of 46 months, one or other was grand vezir continuously between May 1855 and September 1871. With their coterie, they monopolized executive power. In 1856, Ali Pasha was grand vezir, Fuad Pasha the Sultan's foreign minister.

Both men were products of the translation bureau, a government office set up in the wake of Greek independence. Hitherto Ottoman Greeks had acted as translators in essential government business, but the Greek uprisings of 1821 marked the end of this pre-eminence: many signed up to fight for independence, others were hunted down as traitors, and there were few translators to be found in Istanbul. By the 1830s – the beginning of the era of close foreign involvement in Ottoman internal affairs – the new translation bureau was functioning, staffed almost exclusively by Muslims. This expanding office nourished the talents of many young bureaucrats who later in the century were among those who most eagerly promoted reform. The translators' work, which was mostly diplomatic, gave them a window on the world denied to their colleagues in other branches of government.[52] The direction in which the careers of Ali and Fuad led distanced them from tacit acceptance of the values of traditional society; the rational values of the ideal bureaucrat with which they became imbued inclined them to the view that good government would resolve the problems that preoccupied the Powers who held the empire in thrall. They acknowledged the importance of religion as a 'cultural anchor', but thought the benefits of education and commerce would diminish its role in society.[53]

The pace of new legislation grew hectic. A long section of the 1856

Edict concerned internal reforms in the Greek, Armenian and Jewish communities: many people within each had long wanted to lessen clerical control and reduce opportunities for corruption among the clergy, and although change did not come without further prompting from the Ottoman authorities, greater representation of lay members in the internal affairs of the communities was eventually the result.[54] Other reforms inspired by the Edict were concerned with improvements to infrastructure: the survey of the empire's rural resources initiated in 1843 resulted in the publication in 1858 of an agrarian code which dealt with such matters as private property in the countryside, tax relief on the income from certain crops such as tobacco and cotton whose cultivation was to be encouraged, and the improvement of communications in rural areas. The maritime code of 1863 typified others that rationalized existing laws providing, like the commercial code, a legal framework for a range of new activities hitherto alien to customary Ottoman practice. In 1868 the council of state – which had taken over the legislative functions of the supreme council of justice set up under Mahmud II – established five commissions, for domestic and military affairs, finance, justice, public works and commerce and agriculture, and education. Non-Muslims were represented on these, as were provincial delegates and business interests. At a time when the empire was being pressured by the Powers into reforming its economic and commercial infrastructure, its leading statesmen were prepared to embrace the process wholeheartedly as a means of preserving the empire and making it modern. As Ali Pasha noted in the political testament he wrote in 1871 for Sultan Abdülmecid's successor, Abdülaziz,

> We had to establish stronger relations with Europe. It was essential to identify Europe's material interests with our own. Only then could the integrity of the Empire become a reality rather than a diplomatic fiction. In making the European states interested directly and materially in the conservation and defence of the country, we entered into many partnerships necessary for the regeneration of the Empire and the development of its riches.[55]

Implementation of the moves towards reform of provincial administration prefigured in the 1839 Gülhane Edict had been slow. The individual most closely identified with provincial reform was the statesman Midhat Pasha, who subsequently won a special place in Ottoman history as the 'father' of the constitution promulgated in 1876. Midhat had held appointments on various of the commissions and councils of the early *Tanzimat* years, but in 1855 his presentation to the then grand vezir Reşid Pasha of his ideas on provincial reform set the future course of his career. Between 1855 and the introduction of new provincial regulations in 1864 he served

(from 1861 to 1864) as governor of the province of Niš on the Serbian border. Here his vocation was revealed, for he proved both imaginative and efficient; his first-hand experience of the problems of life on the periphery of the empire provided the inspiration for the law he drafted with Grand Vezir Fuad Pasha.[56]

The testing-ground for the law of 1864 was to be the newly-created Danube province – a 'super-province' formed from the three smaller provinces of Niš, Vidin and Silistra – and Midhat Pasha was appointed its governor. He embarked on an ambitious public works programme, improving security, starting factories, and creating agricultural credit co-operatives which enabled peasants to borrow at low rates of interest. The latter, in particular, was a radical measure at a time when such institutions hardly existed in Europe, and their records show that they served Muslims and non-Muslims equally. Midhat Pasha also set up local administrative councils to which members were elected and on which all religious groups were represented – although Muslims were usually in the majority. The first official provincial newspaper in the empire, named *Tuna* ('Danube') after the province, was started in 1865; it was bilingual – in Ottoman and Bulgarian – and published official decrees, Midhat's speeches to the provincial assembly, and gave detailed accounts of reforms both present and envisaged.[57] Midhat Pasha encountered opposition from all sides, however, when he tried to set up mixed Muslim and non-Muslim schools. The Bulgarian-language press of Istanbul was generally appreciative of his administration, until wariness of the rising tide of Bulgarian nationalism prompted him to resort to repressive measures for which he was strongly criticized locally.[58] In 1867 he was recalled to Istanbul to consult on proposals for a number of new laws, but he fell out with Ali Pasha (who was then grand vezir) and was sent as governor to the province of Baghdad where he spent five years attempting to introduce reforms like those he had embarked upon in the Danube province. In 1870 Sultan Abdülaziz, who had succeeded his brother Abdülmecid in 1861, appointed Midhat Pasha grand vezir, but he held the office only briefly because his open criticism of existing government practices and personnel and his single-minded pursuit of his own vision of reform soon made him powerful enemies.[59]

Concessions to non-Muslims and the manipulation in their favour of the distinctions between them and Muslims signally failed to bear the anticipated fruit of strengthening their loyalty to the Ottoman state by encouraging them to see themselves as Ottomans first, and only secondly as Christians or Jews. Nor did the new regulations governing provincial administration satisfy them. The Cretans, for example, made their desire for union with Greece abundantly clear in periodic uprisings, most notably

that of 1866–8, while clashes in Serbia in 1862 between the Ottoman garrison of the border fortress of Belgrade and the local townsfolk eventually brought about a withdrawal of Ottoman troops in 1867. For centuries this strategic stronghold had loomed large in the Ottoman psyche but Ali Pasha, ever the pragmatist, saw this retreat as the concession of an enclave that was a cause of constant difficulty and expense.[60]

It was not only in the Balkans that sectarian strife brought bloody consequences. Antagonism between Maronite and Druze in Lebanon which had been manifest at the time of İbrahim Pasha's withdrawal from Syria in 1840 flared again in 1860, leaving thousands dead. Although the regime subsequently introduced by the central government inaugurated a long period of peace and to that extent was a success, the manner of quelling the disturbances was harsh.[61]

During Mahmud II's reign the government had been unable to extend its reach into Cilicia in south-east Anatolia, where the most prominent of the local dynasties, the Küçükalioğulları and the Kozanoğulları, continued to defy central authority until mid-century, jealously seeking to maintain a measure of independence. The Küçükalioğulları had resisted the forces of the royalist Çandaroğulları, sent to subdue them early in the century, but were temporarily beaten by the troops of the governor of Adana in 1817. Situated as they were at the point where the Ottoman and Egyptian spheres of influence intersected, the local tribes were, as in earlier times, able to defy both. Profiting from the confusions inherent in the struggle of Mehmed Ali Pasha and İbrahim Pasha against the Sultan, they had extended their territorial control and engaged with impunity in the banditry which was their main financial support – the plundering of caravans, in particular the richly-laden pilgrimage caravans from Istanbul to Mecca. Abdülmecid's recognition in 1840 of Mehmed Ali as hereditary governor of Egypt led to a cessation of hostilities in the region, and once İbrahim Pasha had left Syria, Cilicia experienced a period of benign neglect by the Ottoman government. By 1865, however, the prevailing spirit of reform and the notion that good governance would solve the problems besetting the empire required the establishment of central control in this lawless region; the government's strategy was one of conciliation – but the threat of violence implicit in the presence of a large, specially-commissioned force meant that its aims were achieved with a minimum of confrontation. Anti-governmental activity and tax-evasion were pardoned, and tribal lords, execrated as bandits and outlaws before the campaign, were now brought into the Ottoman fold. Some were exiled to Istanbul, others were appointed to administrative posts in distant corners of the empire. Their followers saw the benefits of compliance, even where it meant accepting a sedentary life.[62]

Over the centuries the Ottomans were remarkably consistent in their policy of preferring to incorporate or reincorporate provincial troublemakers into the 'establishment', only employing the iron fist where there was no sign of compromise in the errant party.

Ottoman pragmatism was similarly apparent in another issue that struck at the very roots of the Islamic canon. While the poll-tax had been dealt with by transmuting it into a payment for exemption from military service, and equality between the sexes was of concern neither to the *Tanzimat* reformers nor to their European mentors, the third of the canonical inequalities, that between master and slave, became a burning topic at a time when the emancipation of slaves was high on the British agenda. Great Britain abolished the slave trade in 1807 (following the example of Denmark and the United States), and slavery in 1833; in 1840 the recently-founded British and Foreign Anti-Slavery Society declared universal abolition of the slave trade and slavery one of its main objectives. But slavery simply could not be abolished in the Ottoman Empire, in view of its canonical status: it remained legal until the end of the empire and in the matter of reform, the issue of slavery serves to illustrate what was culturally feasible, and what was not.

The solution arrived at by the Ottomans was more or less adequate to placate foreign interests but proved unacceptable to many at home. The first step towards restricting the activities of those engaged in the slave trade was the closure in 1846 of the centuries-old Istanbul slave market, apparently on the orders of Sultan Abdülmecid, and for reasons that are not entirely clear – nevertheless, the British could not fail to be delighted. Measures were taken in 1847 to suppress the black slave trade in the Persian Gulf, and in Tripoli in North Africa in 1849, and against the trafficking of white slaves from Georgia and Circassia during the Crimean War – under British pressure, and with the intention, on the Ottoman side, of 'disrupt[ing] the flow of slaves to the empire as little as possible'.[63] When news of these moves reached Jiddah, an uproar ensued. Fearing that the lucrative black slave trade would soon be outlawed, some merchants addressed themselves to the Sharif of Mecca and to leading clerics, maintaining that the reforms were contrary to Islamic law. The head of the Mecca clerical establishment delivered a juridical opinion excoriating this and other *Tanzimat* reforms which he considered contrary to sacred law, and holy war was declared against the 'Turks', who were pronounced to be 'polytheists' and 'apostates': 'battle must be joined with them and their supporters; those who are with us will go to heaven, and those who are with them to hell; their blood will be spilt in vain, and their goods are legitimate booty'.[64] The

Ottoman government reacted vigorously to suppress this outburst and prevent further deterioration of a tense situation.[65]

The Hijaz protesters' worst fears were realized in 1857, when a general prohibition on the black slave trade came into force. During the discussions leading up to this, the Ottoman cabinet decided that since the Circassians were 'brought into civilization from barbarism' and, by virtue of their good fortune in entering the Ottoman world, moved from 'poverty and need' to 'welfare and happiness', the trade in Circassian slaves was not comparable with the trade in black slaves. The ban on the black slave trade satisfied the British, who turned a blind eye to the continuing Circassian slave trade at this time. In order to pacify the Hijaz, the general ban on the trade in black slaves was not implemented there; in the regions where it was introduced it was not successful, and had to be reiterated in 1877 and again thereafter.[66]

Russia tightened its grip on the Caucasus following the Crimean War and there was a significant movement of Muslim Circassians into Ottoman territory as much of the indigenous population was systematically expelled and forced across the Black Sea to the ports of north Anatolia and the Balkan ports of Constanţa and Varna. Apart from the problem the authorities faced in accommodating hundreds of thousands of immigrants, there was the delicate matter that many were slaves. Although the Ottomans had resisted British pressure to prevent the Circassian slave trade, the arrival on Ottoman soil of those already enslaved presented a problem of a different sort. It was estimated that about a quarter of the 600,000-plus immigrant Circassians were of slave status; most of these were involved in agricultural slavery, which was little practised by the Ottomans. When they reached Ottoman territory many of the slaves demanded their freedom, but their owners resisted. The authorities were unprepared for the violence that ensued and public order was threatened. The issue was a sensitive one, for the immigrant communities as well as for the guardians of the sacred law, and the authorities moved cautiously, setting up a refugee commission in 1860. This dealt with three main issues: the settlement of and allocation of land to the refugees; the resolution of disputes between masters and slaves; and the sale as slaves of weaker Circassians by their more powerful countrymen. By bringing such matters before the refugee commission as well as before the courts, the government was able to bring arguments to bear which had nothing to do with the Islamic law which was traditionally applied in such cases. In 1867 a clear policy on slavery among the Circassian immigrants was formulated, based on the principle that the Circassian slaves deserved to be free on two counts: the *Tanzimat* reforms had extended freedom to all Ottoman subjects, and the enslavement of free-born Muslims

was canonically unacceptable. In practice this meant, not immediate manumission of the Circassian agricultural slaves, but their gradual emancipation, and compensation for their masters with awards of vacant state land. The implementation of this policy was far from consistent, but in the long term it was broadly successful. One of the most obvious anomalies was that immigrant Circassian girls continued to become slaves in the *harems* of those able to afford them – a practice the Ottomans did not consider to be slavery at all.[67]

Traditionally Ottoman statesmen and judges had demonstrated flexibility in the execution of Islamic law; rarely were the canonically-prescribed penalties exacted in full in criminal cases, and rarely was a compromise position not achievable in other matters that fell within its purview. The eventual banning of the slave trade, rather than of slavery itself, was such an instance, as was the adjudication of punishments for conversion and apostasy without recourse to the full panoply of doctrinal rigour. In the nineteenth century, however, this customary inclination to compromise on points of Islamic law alienated many whom the government hoped to win over to the cause of reform, as Ottoman Muslims became increasingly concerned at the way the European-inspired programme of change appeared to be undermining their religious and cultural identity. At the same time, reform went at too slow a pace to satisfy the Powers, and in particular too slowly for Ottoman non-Muslims in the Balkans, some of whom had already tasted the heady elixir of national self-determination.

The Islamic ordering of society which regarded non-Muslims as legally different from the Muslim population contained within it the seeds of the destruction of the Ottoman Empire, although it was the intervention of outside forces prepared to emphasize this 'separateness' that caused the logic of the arrangement to work itself out. For centuries many Orthodox Christians had prized the freedom to practise their religion by and large guaranteed under the Ottoman Empire, and had displayed little inclination to subject themselves to the often less tolerant rulers of the Latin West, but this era had ended even before the nineteenth century, in large part as a result of the appearance of an Orthodox power – Russia – on the world stage. Nevertheless, Greece was the only region of the Ottoman Empire that achieved full independence before the *Tanzimat* – albeit that the Greek state of that time was small, and much of the territory of modern Greece remained an integral part of the Ottoman domains throughout the nineteenth century. In an age of poor communications and low literacy most Ottoman Christians remained indifferent as to the identity of their sovereign and had little idea of the world beyond the locality in which they lived.

Ottoman relations with the outside world had since the earliest times been defined by the special privileges commonly known as 'capitulations' granted to friendly foreign states by successive sultans. Initially these were diplomatic and commercial concessions intended to secure reciprocal political advantage and ensure the abundance of scarce but essential goods in the Ottoman market-place. By the eighteenth century the fiction that foreigners were the supplicants in these arrangements was being routinely exposed, in the way they were seen to use their diplomatic and commercial muscle to introduce clauses serving their own interests and quite alien to the original spirit of the capitulations, which the Ottoman government was often forced to accept.

Throughout the course of the eighteenth century an increasing number of non-Muslim Ottomans managed to acquire the extra-territorial privileges afforded by the capitulations to the diplomats and merchants of friendly foreign states living and working in the empire, even though by the terms of the capitulatory agreements of the late seventeenth century the only Ottoman subjects entitled to such a protected status, which included freedom from taxation and other burdens imposed by the state, were the interpreters who served foreign consulates and embassies. By degrees, foreign protection came to be extended to other Ottoman subjects working for foreign states – who were usually non-Muslims because the work demanded linguistic capabilities few Muslims were likely to have had the opportunity to acquire. On this topic the most detailed studies have been made of the situation in Syria, and in Aleppo in particular: here the British were initially circumspect, but France, for instance, fully cognizant of the advantages to be wrung from the capitulatory system, had habitually offered protection to numbers of Ottoman Orthodox converts to Catholicism from early in the seventeenth century.[68] As the empire's bargaining power declined, abuses of these privileges became more flagrant.

It is not easy to determine exactly how many Ottoman subjects availed themselves of the opportunity to enjoy foreign protection, but statistics seem to suggest a significant loss of confidence in the empire among its non-Muslim subjects. Austria, for instance, is said to have had 260,000 protégés in Moldavia and Wallachia by the end of the eighteenth century,[69] while the estimate that 120,000 Ottoman Greeks had benefited from Russian protection by 1808[70] may not be an exaggeration. Those seeking foreign protection usually came from the upper echelons of society: not only was the state deprived of their taxes, but the fact that they had the ear of foreign diplomats called into question their loyalty to the sultan. Selim III and Mahmud II were well aware of the problem, and each introduced measures intended to limit the number of foreign protégés. Ottoman Muslims ceased

to have a dominant share in the empire's commerce from the eighteenth century, when trade with the East had declined as that with the West grew;[71] for Ottoman non-Muslims integrated into the long-distance diplomatic and commercial networks of the time, and especially for those who had foreign protection, it was easy to leave the empire and make a life elsewhere – and many did.

In the nineteenth century the economic position of Muslims was thus relatively weak in comparison with that of non-Muslims, who could reap substantial rewards from international trade or as middlemen between western and Ottoman commercial interests. When it came to the political stage, however, it was as true as it always had been that non-Muslims had less chance of success than Muslims – although it was open to anyone to convert to Islam and thus gain access, and there were exceptions. Both groups were frustrated, Muslims because their control of domestic trade could never win them the riches non-Muslim Ottomans could acquire from their links with international commerce, and non-Muslims because they were excluded from real power and had no outlet for the political ambitions fostered by their commercial success.[72] These respective specializations served to drive a wedge between Muslims and non-Muslims that only added to the differences implicit in the separate and inferior status customarily accorded to non-Muslims in a Muslim state.

The *Tanzimat* reforms clearly exacerbated the growing rift between Muslim and non-Muslim and contributed to the disaffection of both communities. It did not take much for non-Muslims to imagine that they might be better off outside the Ottoman state, and the readiness of foreign powers to champion their cause made this dream seem realizable. Contrary to the reformers' intentions, measures aimed at 'good government' were in some respects counter-productive, because permitting a measure of autonomy to the provinces militated against the centralization Mahmud II had tried to enforce, and in regions where non-Muslims predominated gave added momentum to their hopes of a future existence elsewhere. The example of Greece demonstrated that such hopes could become reality.

The intractable problems thrown into relief by the *Tanzimat* were evident to the statesmen of the time, but the solutions they proposed were inadequate. In the political testament he wrote for Sultan Abdülaziz, Ali Pasha observed:

> The [unequal] privileges enjoyed by different communities arise from inequalities in their obligations. This is a grave inconvenience. The Muslims are absorbed almost entirely in the service of government. Other people devote themselves to professions which bring wealth. In this way the latter establish an effective and fatal superiority over Your Majesty's Muslim subjects. In

addition [only the Muslims serve in the army]. Under these circumstances the Muslim population, which decreases at a frightening rate, will be quickly absorbed and become nothing more than a tiny minority, growing weaker day by day ... What is a man good for when he returns to his village after spending the most vigorous part of his life in the army barracks or camps? ... The Muslims must, like the Christians, devote themselves to [commercial] agriculture, trade, industry and crafts. Labour is the only durable capital. Let us put ourselves to work, Sire, that is the only way to safety for us. There is still time to liberate the Muslim population from obligations which benefit the Christians ... Let the Christians furnish soldiers, officers and government functionaries in proportion to their numbers.[73]

Evidence of the deleterious effects of unequal conscription, and of the introduction of western concepts of private property with the enactment of the land law of 1858, soon became visible. In the 1860s, for instance, British reports noted that Muslims were losing their land to Christians who had the money to buy it[74] – and, moreover, were not absent at the front but safe at home.

Unlike many European monarchs, Ottoman sultans had never travelled far from the empire's capital except at the head of an army. In 1863, shortly after İbrahim Pasha's son İsmail came to power as hereditary governor of Egypt, Sultan Abdülaziz visited the province in peacetime, with the intention of impressing on İsmail that he should rein in his ambition[75] (but to little effect: only three years later İsmail secured an edict sanctioning succession by primogeniture in his line, in place of the seniority principle which had prevailed hitherto. He also won another concession that had eluded Mehmed Ali and İbrahim Pasha, the right to conclude treaties on his own account and to raise loans; his new title of khedive signified his enhanced status, superior to that of other provincial governors of the empire.[76] Khedive İsmail proved a jealous guardian of the tentative progress towards independence initiated by Mehmed Ali, and like his grandfather's, İsmail's rivalry with his sovereign continued unabated). Abdülaziz was clearly influenced by his visit to Egypt, for when he came home he decorated his new palace at Beylerbeyi on the Bosporus in an eclectic style drawing on Moorish, oriental and faux-Mamluk elements he must have seen in Cairo. It was an exuberant antidote to the interminable gloom of his brother's palace at Dolmabahçe, and the North African influence persisted in the decoration of the Çırağan Palace, completed for him in 1871.

If Ottoman sultans rarely left their capital except at the head of an army, still less did they travel outside the borders of the empire. Abdülaziz undertook the first and last overseas visit by an Ottoman sultan in 1867, when

he spent six weeks in France at the invitation of Napoleon III to attend the Paris Exhibition, then went on to London for eleven days as the guest of Queen Victoria, visiting military installations, parliament, and institutions such as the Royal Asiatic Society and the Royal College of Surgeons; he went home by way of Belgium, Germany, Austria and Hungary.[77] Khedive İsmail was at the Paris Exhibition too, and was accorded an equally splendid reception. It was obvious to Abdülaziz that he was in danger of being upstaged. Indeed, İsmail was more familiar with Europe than the Sultan, having studied in Paris between 1846 and 1848, and undertaken a diplomatic mission there in 1855.[78] Like Abdülaziz, İsmail too wished to demonstrate that his domains were rapidly modernizing, and to strengthen ties with France; his efforts paid off, for the next year France made a substantial loan to Egypt.[79]

In 1859 work had begun on the Suez canal. Opened in 1869, the canal redirected the focus of British and French interest away from the Istanbul-centred Ottoman Empire to the possibilities now opening up beyond the Near East. It also gave the Ottomans easier access to the Yemen, where from mid-century they had been prosecuting an unpopular war intended to subjugate this former province.[80] The canal project brought Khedive İsmail considerable prestige, and its opening was the occasion of lavish pomp and circumstance. This time Europe visited the Orient – and was thoroughly impressed. The all-expenses-paid, three-week-long celebrations encompassed ceremonies, feasts and entertainments both during the progress of the many visitors – the procession of ships down the canal was led by Empress Eugénie in the French imperial yacht – and in the lavish setting of the newly-built town of Isma'iliya.[81] Khedive İsmail's ostentation provoked the Sultan's open displeasure, and only sumptuous gifts secured a reconfirmation of the privileges bestowed on him.[82]

The years from the mid-1850s to the mid-1860s were a time of great prosperity as Egypt enjoyed a cotton boom when the American Civil War caused US cotton to disappear from the world market, and Khedive İsmail invested heavily in railways as well as the canal and other public works. The collapse of the boom meant debt for Khedive and peasant alike, and Egypt resorted to extensive borrowing – encouraged by her western partners – which by 1875 had brought the country to the verge of bankruptcy.[83]

İsmail was not the only one of Mehmed Ali's line to give Abdülaziz and his advisers cause for anxiety, nor was Abdülaziz the only one vexed by İsmail. The Khedive's younger brother Mustafa Fazıl Pasha was a senior Ottoman bureaucrat, and Sultan Abdülaziz's bestowal of the hereditary title to Egypt on İsmail's direct descendants confounded Mustafa Fazıl's hopes of succession. The dynastic struggle between the brothers was played out

in Istanbul where Mustafa Fazıl, when finance minister in 1863–4, alienated Grand Vezir Fuad Pasha and became persona non grata in governing circles. In 1866 he left Istanbul for Paris, where he played a leading part in the émigré opposition, bankrolling their activities and condemning the Ottoman government in open letters to the Sultan.[84]

Like his grandfather, İsmail had ambitions to expand his domains southwards. The departure of European slave traders from the Upper Nile region, in part as a result of İsmail's anti-slavery campaign, left a vacuum which he hoped to fill. In the wake of international acclaim for his programme of modernization in Egypt, British agents working on his behalf made efforts between 1869 and 1885 to bring this area under Egyptian administration, but local resistance compelled his expeditionary forces to withdraw. The Mahdist revolt of 1881, which occurred two years after İsmail's deposition by the Sultan at the insistence of France and Britain, saw the Egyptian army annihilated, and eventually forced Egypt to relinquish its territories in the African interior – in parts of what are today Sudan, Somalia, Eritrea and Ethiopia – where İsmail had been intent on building his own empire.[85]

A curious footnote to the rivalry between Khedive İsmail and Abdülaziz is the story of the bronze equestrian statue cast for the Sultan in 1872. There had, apparently, been projects – and even designs – for non-figural monuments to be erected in Istanbul to commemorate the Gülhane and Reform Edicts, but neither had been realized. On his visits to London and Paris in 1867 Abdülaziz must have seen the public statuary in these capitals, as well as the sculptures gracing the various pavilions at the Paris Exhibition, which İsmail also attended. On his return İsmail had commissioned a large equestrian statue of his father İbrahim Pasha, which still stands in Cairo's Azbakiyya Square, İbrahim's finger pointing menacingly to the north-west. Even before the statue of İbrahim was erected in Cairo in 1872, news of the commission and a description of the statue were published in the Istanbul press in 1868, and in 1869 Sultan Abdülaziz commissioned the English sculptor Charles Fuller, who was visiting the capital, to sculpt his bust. His mother objected, however, and Fuller continued his work furtively, watching Abdülaziz when he appeared in public, and the Sultan co-operated by passing by Fuller's workshop as if by chance, so that the artist could more accurately mould his likeness. Fuller was so pleased with the result that he decided to make a half-life-size bronze equestrian statue instead of the modest bust, and had the Sultan's favourite horse measured; his client was also gratified, and he ordered the statue to be cast in bronze. The casting was done in Munich; but when the boat carrying the statue reached the Bosporus the Sultan's mother had the offending object thrown overboard. It was rescued, however, and set up in the palace at Beylerbeyi

where bulls and deer and other beasts commissioned around this time roam the gardens. But the Sultan was upstaged yet again by the Khedive: not only was the statue of İbrahim life-size and on very public display, but even as Fuller was working in Istanbul İsmail commissioned a second massive equestrain statue, of Mehmed Ali, which was unveiled in Alexandria in 1873.[86]

Sultan Abdülaziz's rivalry with Khedive İsmail over monumental equestrian statues apart, he also showed himself to be thoroughly in tune with the crowned heads of Europe: even before Sultan Abdülhamid made the Ottoman heartland at Söğüt a shrine to Osman I and his warriors, Abdülaziz had already 'invented' an Ottoman dynastic tradition appropriate to the times. All monarchs revel in the bestowing and receiving of orders and decorations, and the Ottomans had adopted western forms as soon as changes from traditional costume early in the nineteenth century rendered the breast flat, providing a surface on which to pin them. Abdülmecid had created his own order, the Mecidi, but Abdülaziz named his the Osmani. His intentions were plain: the reverse of the decoration bore an image of drums and crossed banners, and the date 699 of the Islamic calendar (1299–1300 CE), with the clear implication that this was the date of the foundation of the Ottoman Empire. In April 1862 the Sultan travelled to Bursa to lay a particularly richly-bejewelled version of the Osmani Order, First Class, on the sarcophagus of his illustrious ancestor, the eponymous founder of the dynasty. This gesture symbolized his desire to demonstrate to his fellow monarchs that the Ottoman house, like their own, had a long history whose beginnings were not lost in the mists of time, but traceable to a precise and seminal moment of origin.[87]

With the emergence in 1865 of a secret society known as the Patriotic Alliance – a small and amorphous but influential group of dissenters whose members later came to be called the 'Young Ottomans' – the Ottoman state experienced something new, the first stirrings of a politics of ideas which would gradually be transformed into action in the public arena. Unlike the protesters of past times – such as the disgruntled pashas of seventeenth-century Anatolia, or janissaries throughout the ages, or vulgar populists like Patrona Halil and Kabakçı Mustafa – these men were intellectuals, and several had served in the translation bureau. What united such very different personalities as the poet and journalist Namık Kemal, Khedive İsmail's brother Mustafa Fazıl Pasha, the journalists Şinasi Bey and Ali Suavi, and the poet Ziya Bey (later Pasha), to name only a few of the leading Young Ottomans, was the desire to define a patriotic Ottoman identity as a counterpart to the national identities which they saw emerging in Europe.

Divided as they were over the most basic questions of a common programme and inconsistent as was their political theory, the Young Ottomans were of one mind in regarding Islam as the essential framework within which reform must take place.[88]

As they pursued their efforts to blur the distinctions which divided society along traditional lines, the reforming statesmen of the 1856 generation had also seen the desirability of a new basis for loyalty to the empire: Ali Pasha, for instance, realized that if the empire could not satisfy the needs of its population – and here he had in mind the non-Muslims in particular – they would seek an alternative.[89] Like that envisaged by the Young Ottomans, the basis for patriotism that he and his colleagues came to suppose might resolve the tensions between Muslim and non-Muslim subjects of the sultan was European in inspiration, and came to be known as 'Ottomanism': it too was an attempt to supersede ethnic and religious loyalties with allegiance to the state based on equal citizenship[90] – but its emphasis was rather different, and to the Young Ottomans these statesmen seemed to be jettisoning much of the Islamic component of the Ottoman state and to be over-eager to appease the Great Powers by making concessions to Ottoman Christians.

The Young Ottomans maintained that 'Ottomanism' could not guarantee the integrity of the empire, and that Ali Pasha's recipe of enlightened despotism and good government was not sufficient to arrest the separatist tendencies of the Christian population. As the most appropriate form of government they proposed instead a participatory constitutional liberalism, but rather than taking it over as a product of the European Enlightenment they sought to root it within Islam, vehemently emphasizing the continuing and essential validity of Islam as the basis of Ottoman political culture. The new medium of the press was the forum in which the Young Ottomans publicized their ideas and expressed their criticism of the government and the European powers alike, and the price of their boldness was censorship and exile. Fuad Pasha died in 1869, and following the death of Ali Pasha in 1871, the exiles were free to return to Istanbul.[91]

The value the Young Ottomans placed on Islamic ideology gave renewed prominence to the clerical establishment, whose influence had to some extent been eroded. Earlier in the century high-ranking clerics had been compliant partners in the reform measures of Selim III, and in 1826 had allowed Mahmud II to co-opt them in the suppression of the janissaries and the formation of his new army. However, in the same year, the pious foundations which contributed to the support of the clerical establishment were brought together under the aegis of a new ministry, and further bureaucratization followed in the latter part of Mahmud's reign with the

establishment of a separate office of the sheikhulislam in 1837 which restricted this official's purview to matters with a religious component.[92] Furthermore, the effect of the new law codes introduced as the century progressed – the penal code of 1840 and the commercial code of 1850, for instance, and in particular the civil code for which preparations began in 1868 – was to limit the remit of Islamic law to matters of family, inheritance and marriage. With regard to education, the other sphere in which the clerical establishment had a traditional monopoly, an alternative to the theological colleges had first been established in the eighteenth century with the technically-oriented vocational schools intended to provide trained personnel for the army and navy. During the nineteenth century the number and range of such schools continued to widen: would-be bureaucrats were turned out by the mixed Muslim and non-Muslim civil service school founded in 1859, and by the lycée of Galatasaray – which was also mixed – founded in 1868 on the site of a school that had trained pages for the palace since the sixteenth century.[93]

This was education for the few, however: initially it was not the intention of the *Tanzimat* reformers to educate the masses. A small number of ordinary people benefited from the few schools established after 1839 to bridge the years between primary school and entry into the professional schools, but it was only in 1869 that a programme of general education intended to 'mould [subjects] into citizens'[94] was introduced. The 1869 regulations, though not successfully applied until after the accession of Abdülhamid II in 1876, introduced a system of primary, secondary and further education that seemed to narrow yet further the functions of the clerics.[95] Nevertheless, the shortage of qualified personnel to implement the *Tanzimat* reforms, in conjuction with the fact that few reforms were aimed at the clerical establishment per se, meant that clerics continued to hold legal posts at all levels and were able to maintain their position as educators in the traditional system. There was also a place for them in the parallel modernizing system, teaching such subjects as religion, law, and the Arabic and Ottoman languages. As long as they retained a presence in government, and reform could be accommodated under the umbrella of Islam, clerics were prepared to take part in the process of modernization – and there was markedly less opposition to reform in the nineteenth century than there had been in earlier centuries, when far less significant innovations were in question.[96]

The work on the new Ottoman civil code continued for some years. Its architect, the intellectual, statesman and historian Ahmed Cevdet Pasha, was both high-ranking cleric and *Tanzimat* reformer. Poised to achieve the pinnacle of the clerical career as sheikhulislam, he was denied this office

by his rivals and in 1866, in his forties, was forced to transfer to the bureau-cracy, where his long immersion in Islamic law and culture served as a solid foundation for his continuing contribution to the re-ordering of Ottoman government. Reform as he understood it was a process that enabled Islam to incorporate western scientific and technical concepts.[97] This was a goal which had inspired reformers in the past – the difference now, in the nineteenth century, was that the need for directed change was widely accepted in ruling circles. Ahmed Cevdet's essentially conservative programme had much to recommend it to those who saw the dangers of an unconsidered imitation of western ways. But the dilemma remained: how much westernization, and of what sort?

Ahmed Cevdet Pasha was a protégé of Reşid Pasha, and his work was informed by the familiarity with western ideas and mores this association brought him. There had been talk of adopting the French civil code, but those critics who saw it as too alien an importation won the debate: the new civil code was to be based on the familiar principles of Islamic law. Where the new civil code differed from Islamic law as previously applied was in its enactment as a law of the state: it therefore applied to all subjects, Muslim and non-Muslim alike.[98] Non-Muslims were, in fact, no strangers to Islamic courts: they had always had their own courts, but had often preferred to use the Islamic courts if they anticipated a more favourable judgement – such as in cases of inheritance where Islamic law provided for fixed shares of the deceased's estate to pass to specific descendants, rather than allowing division of an estate at the whim of the deceased. The drafters of the civil code took the corpus of Islamic jurisprudence and fashioned it into 1,851 articles presented in an ordered and accessible format; the new code altered the implementation of Islamic law by codifying provisions to eliminate rulings based on individual interpretation and commentary. The drafters' characterization of Islamic law as 'an ocean without shores' was an eloquent statement of the scope of their task, for the corpus that had served the Ottomans for so long had come to seem amorphous and unfath-omable, and out of keeping with the spirit of modernization blowing through government circles.[99] Yet not everybody found Ahmed Cevdet Pasha's painstaking efforts convincing: in 1870 the conservative sheikhulislam Hasan Fehmi Efendi succeeded, albeit for a brief time, in bringing the project within the ambit of his own department of government and obtaining Ahmed Cevdet Pasha's dismissal, and his obdurate opposition to the impor-tation of any western cultural values reflected the views of others of his profession at this time.

Until the *Tanzimat* reforms became embedded in the institutions of government and their full effect became apparent, Islam was an integral,

organic facet of both public and private life. The creeping *Tanzimat* restriction on the administrative role of the clerical establishment brought the raison d'être of the clerics into question, and in so doing heightened the emphasis placed on their religious role. Islam, according to a modern writer, 'had stopped being something that was lived and not questioned. Secularizing reforms had made Islam become more "Islamic" . . . This postulated cultural core was now considered as important and as characteristically Islamic as the ritual side of Islam.'[100] As the old order passed and people came to realize what had been lost during the *Tanzimat* decades, they felt themselves stranded in unfamiliar terrain where their cultural values no longer had their former currency[101] – not the least of the factors contributing to this sense of disorientation was the pace at which their physical environment was being transformed, as the Industrial Revolution impinged upon their lives in diverse ways. What the Young Ottomans sought to emphasize and preserve was the Islamic 'core' at the heart of Ottoman culture.

The imperial capital to which the Young Ottoman exiles returned after Ali Pasha's death was not the liberal haven they had hoped to find. Ali and Fuad had kept the Sultan isolated, exercising power on his behalf: in 1863, soon after his accession, they and the group of vezirs around them had tendered their resignations when Abdülaziz would not allow them to introduce the financial measures they deemed necessary to balance the budget, a battle of wills that led briefly to a change of grand vezir before first Fuad and then Ali was reinstated.[102] Their monopoly of power left no obvious successor to the highest offices of state, however, and with these two men gone Abdülaziz reclaimed his role as the arbiter of state affairs, supported by his new grand vezir Mahmud Nedim Pasha, long an advocate of sultanic absolutism. Mahmud Nedim had in common with the Young Ottomans an insistence on the Islamic character of the Ottoman state, but there the similarity ended.[103]

Despite Fuad Pasha and Ali Pasha's best efforts, by 1871 the finances of the Ottoman Empire were in ruins. Banks were first established in the empire from the 1840s as trade with Europe grew following the commercial conventions of the late 1830s, and during the Crimean War the Ottoman government resorted for the first time to foreign loans. The costs involved in implementing reforms, restructuring the economy, and servicing the loans were high – and debt mounted inexorably. Sultan Abdülaziz's reign was notable particularly for his attention to the Ottoman fleet; he intended it to be the equal of those of France and Britain, and by the end of his reign in 1876 it comprised 20 battleships, 4 ships of the line, 5 frigates, 7 corvettes and 43 cargo ships. The first short stretches of rail track – in the

İzmir area and between Cernavoda on the Danube and Constanţa on the Black Sea coast – had been laid during the reign of Abdülmecid; Abdülaziz expanded the network, awarding an Austrian company the concession for a proposed Istanbul–Paris line – of which the section from Istanbul to Sofia opened in 1873, as did a line connecting Istanbul and İzmit. Internal communications were further strengthened with the improvement and building of roads in Rumeli, Anatolia and Syria; merchant shipping transported goods along the lengthy coasts of the empire, and on the great rivers such as the Tigris and the Euphrates; and the telegraph system, first used during the Crimean War, was subsequently expanded to reach deep into the provinces.[104] With this rapidly developing communications network the agricultural crops and minerals so eagerly sought by European merchants could easily be brought from their source for transport onwards to the capitalist economies of the industrial West.

Under the impact of the *Tanzimat* and with the exposure of the Ottomans as never before to the rest of the world and to the transformations that were affecting it, the Ottoman sense of identity was being undermined as old certainties were called into question. The sense of foreboding felt throughout Muslim society – from the Young Ottoman intellectuals and the clerical establishment to the peasants whose lot was not in any way improved by what appeared to them to be unwarranted concessions to their non-Muslim fellows – was fed by the deepening financial crisis, exacerbated by an international stock market crash in 1873 which made it impossible for the Ottoman government to raise further external loans. Floods and drought brought famine across Anatolia – and the deaths that followed in their wake deprived the treasury of tax revenues. In 1875 the government announced that it could not meet its debt repayments, and declared a moratorium.[105]

The outcome of the Franco-Prussian war of 1870–71 saw France defeated and Britain left alone to champion the preservation of the Ottoman Empire and, in particular, the neutrality of the Straits. Russia seized its chance and, citing violations of the Treaty of Paris of 1856, achieved the abrogation of those clauses that had prevented Russian warships from entering the Black Sea. The conservative Powers were now in the ascendant: in 1872 the emperors of Austria-Hungary and Russia travelled to Berlin to honour the first emperor of Germany, at which time these three absolutist states reached an informal understanding interpreted elsewhere in Europe as a gesture against the rising tide of liberalism. But in the Balkans the interests of two of these three powers were in conflict: while Russia dreamed of bringing all Slavs under her influence, not excluding those in

Austria-Hungary, Austria-Hungary was fearful of nationalist agitation among these same populations. Since the Crimean War Austria had faced this dilemma – whether to align herself with France and Britain whose liberalism implied self-determination for minorities, or with Russia, whose size and Orthodoxy threatened to overshadow her and whip up Slav agitation.

The troubles of flood, drought and famine that beset rural Anatolia in the early 1870s had their effect in the towns and cities of the Balkans, where the drop in tax revenues from the stricken areas to the east of Istanbul due to the collapse of their agricultural economy led to increased taxation to compensate. In July 1875 an uprising against the increased taxation broke out in the Ottoman border province of Herzegovina, and soon spread to neighbouring Bosnia, which was of immediate concern to Austria-Hungary. Russia and Austria-Hungary intervened diplomatically, proposing a number of administrative reforms in these two provinces, but although Sultan Abdülaziz was forced to accept that reforms must be made this failed to stem the unrest, merely demonstrating to his subjects yet again that the Ottoman sultan was unable to stand up to outside pressure.[106]

The profound cultural dislocation and humiliation being experienced by the majority of Ottoman Muslims found expression at this juncture in strident criticism of the government for its appeasement of foreign powers. In March 1876 there appeared in Istanbul a clandestinely-published pamphlet entitled 'Manifesto for Muslim Patriots' calling for a representative, consultative assembly; it is likely that Midhat Pasha, who had become one of the foremost advocates of constitutional reform, had a hand in it.[107]

Among the theological students who were the 'Muslim Patriots' in question the demands of the Young Ottomans for a constitution had found an audience, as during the early days of May thousands of them massed on the streets of Istanbul, like discontented janissaries and artisans before them. They held impassioned meetings in the main mosques, criticizing the government and clamouring for the dismissal of the pro-Russian grand vezir Mahmud Nedim Pasha and Sheikhulislam Hasan Fehmi Efendi. The palace acceded to their demands – after some hesitation – but this did not calm the agitation, and the Sultan himself was maligned. In an effort to stop the spread of news and rumour which was inflaming the situation he ordered the imposition of press censorship and the suspension of telegraphic communication, to no avail: at the end of a month during which the tension in Istanbul threatened an outbreak of violence at any moment, Sultan Abdülaziz was deposed.[108]

Several leading state officials were complicit in the plot to remove Abdülaziz; those most closely involved were the conservative minister of war Hüseyin Avni Pasha, the president of the military council Redif Pasha, and the director of the military academy Süleyman Hüsnü Pasha. The

frustration and apprehension felt at the centre of power were palpable, and Hüseyin Avni expressed one area of concern in conversation with Süleyman Hüsnü when the possibility of removing Abdülaziz was broached:

> The rumour that Mahmud Nedim Pasha will again become Grand Vezir is gaining strength. There is no doubt that the country will suffer the oppression and invasion of Russia. Sultan Abdül Aziz is a Russophile. The signs of collapse and peril in state affairs strike the eye.[109]

In his subsequent account of these events and of his part in them, from which this quotation comes, Süleyman Hüsnü Pasha related that Hasan Fehmi Efendi's successor as sheikhulislam, Hayrullah Efendi, had a dream he interpreted as divine sanction for the deposition, expressing his concern that the plotters should not later be accused of having carried out an illegitimate act. The dream allowed Hayrullah Efendi to issue a favourable juridical ruling for Abdülaziz's deposition, and this enabled Süleyman Hüsnü to assert that 'our objective will be quite legal and easily accomplished in a manner that will not permit of attack'.[110]

The coup d'état was carefully planned. Abdülaziz was at the waterside palace of Dolmabahçe, as was the next-in-line, Abdülmecid's eldest son Murad: the problem for the conspirators was how to bring Prince Murad out from his quarters, so that he could be proclaimed sultan, without arousing suspicion. Before daybreak on 30 May, Süleyman Hüsnü Pasha and his military escort entered the palace to find Prince Murad – who had been kept abreast of the deposition plans – waiting for them; they concealed him in a carriage and took him to a caique, which crossed the water to Sirkeci, from where he continued in another carriage to the war ministry in the Bayezid quarter of the city (the building now houses the rector's office of Istanbul University). Here the oath of allegiance was sworn by Grand Vezir Mehmet Rüştü Pasha, Hüseyin Avni Pasha, Hayrullah Efendi, Midhat Pasha, and a number of other statesmen including 'Abd al-Muttalib, the Sharif of Mecca. Next, it was necessary to remove Abdülaziz from Dolmabahçe before Sultan Murad returned. Under cover of darkness the palace was surrounded by troops on the landward side, and a naval cordon held the Bosporus: cannon fired from these vessels according to the conspirators' carefully co-ordinated plans woke Abdülaziz, and news of his deposition was brought to him. He and his household, including his two eldest sons, his mother and his under-chamberlain Fahri Bey, were put in caiques and ferried in the pouring rain to the shore below Topkapı Palace, where a mean carriage and a pack-animal waited to convey the party to its new quarters in the palace.[111] Meanwhile, Sultan Murad V crossed the water back to Dolmabahçe.[112]

The conspirators were indeed lucky that their actions were not discovered.

Just before he left the palace, Murad sent a note to his brother Abdülhamid saying: 'They are taking me away and I do not know how or why. I entrust my children and household first to God and secondly to you'; the terrified Abdülhamid feared a similar attempt on his own life and called for weapons to be brought so that he could defend himself. This ruse succeeded but Murad's departure from Dolmabahçe with Süleyman Hüsnü Pasha and his men was observed by Sultan Abdülaziz's servants from the windows of the palace; they assumed, however, that the prince was being taken away because he had committed a crime for which they expected that he would be banished or executed.[113]

With a new sultan came expectations that a new era was about to begin. As Süleyman Hüsnü Pasha recounted in his memoir, on the very day of Murad's accession, Midhat Pasha – at the time minister without portfolio – presented to his colleagues a draft accession speech he had prepared, by which Murad V would proclaim his promise of constitutional rule and ministerial responsibility. The opposition of the Grand Vezir and Hüseyin Avni Pasha to so bold a change in the direction of the state resulted in the final version containing only vague references to this sensitive issue, however, and heated exchanges between leading statesmen who subsequently met to discuss the future left the way ahead no clearer than it had been before the deposition of Abdülaziz.[114]

Still more dramatic events were to come. Abdülaziz did not like Topkapı Palace, and four days after his arrival there he and his immediate household were moved to Feriye Palace, on the Bosporus shore north of Çırağan Palace (his rejection of Sultan Murad's offer of Beylerbeyi pleased Hüseyin Avni Pasha, who considered it too hard to police).[115] Ahmed Cevdet Pasha noted wryly in his memoirs that the apartments in which Abdülaziz lodged had been built by him for Murad and were constructed as stoutly as a fortress, as though the deposed sultan had prepared a prison for himself; and he saw further irony in the fact that having lavished so much money on his passion of building up a modern fleet, Abdülaziz should have found himself under naval blockade.[116] But even on the Bosporus life was intolerable. In his intimate account of his master's humiliation, Fahri Bey described how those guarding the former sultan taunted him, and denied him and his household even the bare essentials of life such as clean drinking water.[117] Within a few days Abdülaziz was found dead, and suicide was the unanimous verdict of the nineteen eminent physicians who examined the corpse.[118]

At a meeting of ministers at the house of Midhat Pasha on 15 June an army officer whose late sister had been one of Abdülaziz's concubines burst in and shot both Hüseyin Avni Pasha and the foreign minister, Mehmed Raşid Pasha. The officer, Çerkes ('Circassian') Hasan, had been aide-de-

camp to Abdülaziz's eldest son, Prince Yusuf İzzeddin, and the accession of Murad destroyed his hopes that Yusuf would ever become sultan.[119] So rattled were Ottoman statesmen by this insolent murder that they and their families took to carrying a revolver or dagger wherever they went. Çerkes Hasan was strung up in a tree in Bayezid Square.[120]

With Hüseyin Avni Pasha removed from the scene, those who favoured the introduction of a liberal constitution were in the ascendant, their cause championed by Midhat Pasha. Although his intellectual background was very different from theirs and the relations between them were at times uneasy, Midhat Pasha shared with the Young Ottomans the conviction that a constitutional assembly was an essential component of reform; he also maintained that the deposition of Abdülaziz as a precursor to constitutional reform was in accordance with the popular will.[121] But the new sultan seemed incapable of action: the circumstances of his sudden elevation to the sultanate under armed escort, followed by the shock of the untimely deaths of Abdülaziz and two of his ministers, had apparently left him mentally paralysed. The realization began to dawn on his statesmen that he was quite unsuited to rule over the empire at this time of crisis.[122]

Sultan Murad V occupied the throne for only three months before the advice of doctors who diagnosed him as unfit to rule and a juridical opinion legitimizing the removal of a sultan who was insane paved the way for his deposition. As a contemporary jingle put it, 'In [year] '93 [of the Islamic calendar] he was *padişah* of the world for 93 days; [then,] Sultan Murad the disappointed went into retirement'. In the years before he found himself caught up in the political turmoil of the Ottoman succession, his mental health had not been in question. He had led the unfettered life of any European heir-apparent, travelling to Egypt and Europe with Abdülaziz in the 1860s, and taking part in the fashionable salon life of Istanbul where he met intellectuals, society belles and visiting foreigners alike. He loved music and was an accomplished composer, as well as a woodworker and furniture-maker. In the early 1870s, when Young Ottoman intellectuals returned from Paris on the death of Ali Pasha, Murad had lent an eager ear to one of their leading thinkers, Namık Kemal.* On 31 August 1876 Murad's brother took his place, as Sultan Abdülhamid II; Murad was kept under house arrest in the Çırağan Palace.

<div align="center">*</div>

* When Murad came to the throne Namık Kemal returned from three years' internal exile on Cyprus, occasioned by the rapturous reception accorded to *The Fatherland*, a play he had written about the Muslim and Turkish peoples' embrace of the concept of patriotism – a notion that Abdülaziz found too threatening, especially when the audience began to call for Murad (Sakaoğlu, art. Murad V, *İst. Ansik.* 5.510–12).

During these very months, and in part as a consequence of these very events, the Ottomans were in danger of losing the support of the one ally on whom they had counted since the beginning of the century. Britain, so long regarded as a true friend of the empire, put her faith in the post-Crimean War settlement as the best hope of restraining Russian expansionism. But Ottoman state bankruptcy, nationalist uprisings and the speedy deposition of two sultans could only reinforce the opinion of critics of Britain's long-standing policy that it was time for that policy to change. Britain's relations with the Ottoman Empire had of course never been purely disinterested; what finally tilted the balance was the indignation of British public opinion at news of the violent suppression in April 1876 of a Bulgarian popular uprising in the Plovdiv area, midway between Edirne and Sofia, by irregular forces of Circassians who had been displaced from the Muslim states of the Caucasus after 1864 following Russian seizure of their homeland, and settled near Plovdiv by the Ottomans. The massacres of Christians in the Plovdiv area were indeed greater than any that had gone before, but the number of dead in the 'Bulgarian atrocities', as they were referred to in the contemporary British press and thereafter, was exaggerated with the connivance of Russia's ambassador in Istanbul, Count Nikolai Ignatiev – and Gladstone added his voice to the outcry, without pausing to consider the historical circumstances which had brought the Circassians to the Balkans. As one modern historian reminds us,

> [The Circassians] must have developed a distrust, perhaps hatred, of Christians because of their experiences in the Caucasian wars and their forced exile from their homeland. Circassians had also been subjected to torture and other atrocities by Bulgarians fighting in Serbia and Bosnia. To them the enemy was easily identified. The Russians, whom they had long known and hated, and the Bulgarians must have appeared little different from one another.[123]

Not for the first time, the agitated British and other Europeans ignored the inconvenient fact that there were also many Muslims dead at the hands of the rebels.[124]

The massacres provoked particular outrage in Russia. For all its militant posturing with regard to Ottoman Orthodox Christians and Ottoman Slavs, Russia had until now hesitated to champion nationalist causes lest they encourage its own significant non-Russian populations to seek an independent future[125] – but when Serbian and Montenegrin troops crossed into Bulgaria from the west in July 1876 and were defeated by Ottoman forces, Russia mobilized for war. Britain now saw little utility in continuing to prop up the Ottoman Empire, and intervened to organize a conference of

the Powers to settle the matter. The proposals put forward by this confer-
ence would have had the effect of confining Ottoman rule in Europe to
Albania, the north Aegean coast and eastern Thrace; the Ottoman govern-
ment rejected them and made peace with Serbia, even as the Powers were
paring down their demands to a vaguely-expressed hope for reforms in
Bulgaria and Bosnia-Herzegovina. Russia refused to demobilize and,
following her declaration of war on 24 April 1877, the region was plunged
into a conflict during the course of which Russian troops advanced through
Ottoman territory to Edirne – meeting strong resistance only at the fortress
of Pleven, in northern Bulgaria – while in the east her forces advanced
towards Erzurum. The war ended on 31 January 1878 with an armistice
concluded at Edirne. Since the end of the Crimean War the Ottomans had
enjoyed almost twenty years of international peace; the renewed struggle
with Russia was to cost them dear.

Neither Austria nor Britain was prepared to concede Russia's success; a
few days after the Russian–Ottoman armistice a British fleet moved to anchor
off the Princes' Islands off Istanbul, prompting the Russian army in the
Balkans to advance to the seaside town of Yeşilköy (San Stefano), close by
the modern city's main airport, with orders to occupy the capital if the British
ships moved into the Bosporus. War between Britain and Russia threatened
– but was avoided. The terms Russia imposed on the Ottomans in the Treaty
of San Stefano were severe: Bulgaria – stretching from the Black Sea to the
Aegean – was to be autonomous, as were Bosnia and Herzegovina; Romania
(the state founded in 1861 comprising the former Ottoman vassal states of
Wallachia and Moldavia), Serbia and Montenegro would all receive Ottoman
territory and be independent; while in the east the provinces of Kars, Ardahan,
Batum and Doğubayezid would become Russian. Greece was particularly
alarmed at Russia's unilateralist stance since Macedonia and other regions
considered 'Greek', rather than Slav, were included in the new Bulgaria
Russia sought to create; and Britain and Austria registered their anger.
Diplomatic necessity was on the side of the objectors, however, because the
far-reaching territorial reorganization in the Balkans envisaged by Russia was
so radical a modification of the Treaty of Paris that it required consultation
with the signatories to that treaty. The terms Russia dictated to the Ottomans
at San Stefano were diluted to some extent at the Congress held in Berlin
between 13 June and 13 July 1878, attended by representatives of Britain,
Austria-Hungary, Russia, the Ottoman Empire, Germany, Italy and France;
the Congress resulted in the Treaty of Berlin, which effectively marked the
end of centuries of Ottoman sovereignty in the Balkans.

Under the terms of the Treaty of Berlin Bulgaria was partitioned three
ways: Russian influence was assured in the newly-autonomous northern

section, a semi-autonomous province of Eastern Rumeli was created in the central region, and the southern part remained under Ottoman rule. Russia also acquired southern Bessarabia, together with Batum, Kars and Ardahan. Russia might have been able to overcome the Ottoman army as a result of the improvements in armaments and military administration, and the widening of military service introduced since the Crimean War, but was not powerful enough to withstand pressure from Britain and Austria. In yielding to them in Berlin Russia has been said by modern historians to have lost the peace.[126] Nevertheless, Russia managed to impose a war indemnity on the Ottomans, amounting to 802.5 million French Francs, in lieu of territory it had won and then withdrawn from under the terms of the treaty. Russia had no investments in the empire and therefore no share in the Ottoman debt, and saw the indemnity as an opportunity to share in the financial rewards enjoyed by the other Powers at the expense of its erstwhile foe. By claiming that Russia had a first call on any available funds successive Russian ambassadors were able to counter investment projects of rival Powers and of the Ottoman government itself, which might have brought some prosperity to the empire.[127]

Austria-Hungary was not itself involved in the war of 1877–8, but the stability of the Balkans required that it receive gains to balance those of Russia, and it was accordingly awarded Bosnia and Herzegovina. The independence of Serbia, Romania and Montenegro was formally recognized at Berlin but, as was perhaps inevitable, the way in which their boundaries were determined left these states dissatisfied. Before the Congress met in Berlin the Sultan had relinquished control of Cyprus to Britain in exchange for an annual payment and a vaguely-worded promise concerning military assistance against future Russian aggression in eastern Anatolia – and for fear that the British would not otherwise support the Ottomans at Berlin.[128] Britain thus acquired a Near Eastern 'forward base' from which to counteract any potential threat to the Ottoman Empire from Russia in the east – for Russia, its territorial ambitions in the Balkans curbed, now shifted its strategic focus to Central Asia, and the fate of the Ottoman Empire became linked more closely than ever before to the security of British routes to India.

The war of 1877–8 and the Treaty of Berlin that ended it hastened the culmination of a process begun with the defeats suffered by the Ottomans at the hands of the Habsburgs in the last years of the seventeenth century: the empire lost more than a third of its territory, and much of its non-Muslim population. The only significant remaining non-Muslim communities, the Greeks and Armenians, were less clearly concentrated than the

Serbs, Bulgarians and others, and did not apparently present the same threat of further geographical separatism. Nevertheless, the Ottoman pledge of reform in the Armenian provinces of east and north-east Anatolia, discussed with the British in negotiations over the Cyprus Convention and included in the Treaty of Berlin following Armenian lobbying of European statesmen, boded ill for the future, although reform was a mere shadow of the independence or autonomy some had sought.[129] Many Ottoman Greeks had benefited economically from the reforming edicts of 1839 and 1856, but there were those nevertheless who deserted the empire for independent Greece. Some who did so found life in their 'homeland' less satisfying than what they had left behind – Athens at independence was a provincial town in ruins, with nothing to offer sophisticated Ottoman Greeks comparable with the culture and financial rewards of such cities as Istanbul, Thessalonica and İzmir – and they later returned.[130]

Austria-Hungary's occupation of Bosnia and Herzegovina after the Treaty of Berlin was not altogether satisfactory; it proved to be a liability for Vienna, upsetting the delicate internal equilibrium of the Habsburg Empire by bringing under Austrian administration a population that was largely Serb and Orthodox, and therefore susceptible to the blandishments of Russia's new creed of pan-Slavism. Hungary's experience since 1867 in attempting to 'Magyarize' its own Slav population made its leaders uneasy at the prospect of accepting political and administrative control over still more. Not only that, the many Muslims in Bosnia and Herzegovina also now came under Vienna's control – the Ottoman headache of competing nationalisms had spread to Austria-Hungary.[131] Austria-Hungary was now, like the Ottoman Empire, a state of diverse nationalities and religions; and, again like the Ottoman Empire, too weak to resist Russia, with which it was allied. Britain's loss of patience with the Ottomans was in part a response to the fact that following the Treaty of Berlin there was little Ottoman Balkan territory left to be protected against Russian or Austrian designs. Now, the conundrum for all the Powers with interests in the region was how to find a new framework to ensure the stability of the often less than viable independent or semi-autonomous Balkan states that succeeded the Ottoman Empire.

15

The Islamic empire

ABDÜLHAMID II HAS been more harshly judged by history than any other sultan. His life is as obscured by myth as that of Sultan Süleyman I – 'The Magnificent' in western parlance. But whereas Süleyman is universally admired as the epitome of sultans, Abdülhamid exemplifies all that the West found most reprehensible about the Ottoman Empire. The picture of him as 'Abdul the Damned', or the 'Red Sultan', as the cruel and paranoid scion of a dynasty whose days were numbered, echoes the views of the European statesmen whose eyes were covetously trained on his domains and has survived to today. In 1876, following the intercommunal massacres that year in Bulgaria, William Gladstone condemned the Sultan and his people with the words 'from the first black day they entered Europe, they [have been] the one great anti-human specimen of humanity'.[1]

In modern Turkey there are two competing views of Abdülhamid: a historian of his age has recently written that the political actors of the time should be 'rescued both from their Kemalist denigrators and their "fans" on the lunatic fringe of the Turkish Right', as well as from Abdülhamid's western detractors.[2] The 'Kemalist denigrators' are those who view the last years of the Ottoman Empire as an obscurantist and somewhat shameful past from which their country was delivered by the leadership and vision of Mustafa Kemal [Atatürk]; to the Kemalists, Abdülhamid's reign serves as a counterpoint to the new age that dawned with the final collapse of the empire and the establishment of the Turkish Republic in 1923. To 'the lunatic fringe of the Turkish Right', by contrast, Abdülhamid is a hero, the sultan who reverted to a more conservative path after the experimentation of the *Tanzimat*, re-emphasizing the Islamic character of the Ottoman state and championing Muslims against the other peoples of the empire, the non-Muslims being seen in this reading as the root of the crisis which brought about the empire's collapse.

If the western judgement of Abdülhamid and his times derives from the characterization of the late Ottoman Empire as supine,[*] the homegrown

[*] Eric Hobsbawm has described it, jarringly, as 'the most obvious evolutionary fossil' by the standards of nineteenth-century liberalism (Deringil, *The Well-Protected Domains* 6).

versions 'spin' aspects of the period which suit modern political purposes. Nevertheless, these contrasting verdicts do provide signposts indicating significant events such as the dénouement of the so-called Eastern Question, Abdülhamid's use of Islam as a cement to hold together his disintegrating empire, and the agonies that surrounded the end of that empire and the search for a new and secure format for the national state that replaced it. They must be examined in the context of their times, however, not stressed to support a particular modern agenda.

The origins of Abdülhamid's suspicious personality remain obscure. Nevertheless, whatever influences may have shaped his life before he came to the throne, the violent circumstances of his accession would have been enough to rattle the most stable character. In the opinion of one modern specialist,

> He was a striking amalgam of determination and timidity, of insight and fantasy, held together by immense practical caution and an instinct for the fundamentals of power. He was frequently underestimated. Judged on his record, he was a formidable domestic politician and an effective diplomat.[3]

Abdülhamid appreciated drama and European music, and built a charming theatre at his palace at Yıldız in which to enjoy them; like Murad V he was a skilled woodworker, and furniture attributed to him can still be seen in Beylerbeyi and Yıldız Palaces; and he enjoyed nothing more than having the detective adventures of Sherlock Holmes read to him before going to bed. To the Hungarian scholar and British agent Arminius Vámbéry, who knew him well, he was 'the very personification of the bourgeois monarch'.[4]

In the heat of the clamour which preceded the removal of Sultan Abdülaziz, Murad, as heir-apparent, had suggested that he would be favourable to a constitution once he was sultan. When it became clear that he could not long remain on the throne, a similar undertaking was wrung from the reluctant Abdülhamid. Although any reference to a constitution was absent from the speech made immediately upon his accession,[5] the new sultan kept his promise, and held meetings to discuss the merits of various constitutional arrangements. It seemed that the aspirations of the Young Ottomans – few in number though they were – might at last be realized. They were not united in their aims or methods, but their ideas could be characterized as 'a defence of liberal values with Islamic arguments' in contrast to what they saw as the *Tanzimat* bureaucrats' imitation of western norms which had set Ottoman political culture adrift from its Islamic roots. On 23 December 1876, three months after his accession, and even as the Powers

were deliberating resolution of the Bosnia-Herzegovina and Bulgarian crises, Abdülhamid proclaimed an Ottoman constitution and the creation of an Ottoman parliament.

Midhat Pasha chaired the commission charged with producing the constitution, and expended determined efforts to frame it so as to ensure that the new political arrangements would work. Four days before its promulgation he was appointed grand vezir; only six weeks later, however, he was exiled from Istanbul to Brindisi, in a rare instance of exile abroad rather than to a distant location within the empire. Abdülhamid had always mistrusted Midhat, a man who had deposed two sultans.[6] Moreover, the constitution of 1876 – unlike the Edicts of 1839 and 1856 – failed to appease the Powers who were deciding the empire's fate, and Russia was still mobilized for war. Midhat's legacy survived until 14 February 1878, when, as the British fleet entered the Sea of Marmara and peace negotiations with the Russians were about to take place, Sultan Abdülhamid suspended the constitution and, less than a year after its official opening on 19 March 1877, prorogued the first Ottoman parliament. It did not seem to him that an untried and imperfectly understood form of government could rescue the empire from the crises which now enveloped it. Salvation, he considered, could only be achieved by a reversal of the liberal and constitutional currents represented by Midhat Pasha and his fellows, and a restoration to the sultanate of the powers which had passed to the government and the bureaucracy as a result of *Tanzimat* reforms. Abdülhamid's overriding priority was to hold on to what remained of the Ottoman domains, and his subsequent policies were directed to this end.

One member of the Young Ottomans made a startling appearance on the public stage, when in May 1878 the radical journalist Ali Suavi masterminded a plot to restore Murad V. This was the third attempt of Abdülhamid's reign to restore the former sultan – and the most dramatic. After returning to Istanbul from exile in Paris on Abdülhamid's succession, Ali Suavi was appointed to government office but soon fell from grace; he began speaking out in public and writing in the press about the parlous condition of the empire, and on 20 May 1878 stormed Çırağan Palace at the head of a band of some 250 fighters – disaffected men who had been forced to migrate from Bulgaria to Istanbul by the recent Russian–Ottoman war. Murad had been informed of the plot and was dressed and waiting for them, but Ali Suavi and 23 of his fellows were killed by palace guards, 30 more were wounded and many were apprehended; Murad was removed first to a pavilion in the grounds of Yıldız Palace in the hills above Çırağan before being held under strict supervision in the Feriye Palace, where

490

Abdülaziz had met his end. In the subsequent inquiry into the incident, the intellectuals and statesmen found to be complicit in the plot were sentenced to three years' hard labour, to monetary fines, or to imprisonment or internal exile.[7]

For Sultan Abdülhamid the Treaty of Berlin was a conspiracy against the Ottoman Empire and Islam.[8] Under its terms, 8 per cent of the empire's territory — much of it rich and productive — and almost 20 per cent of its population were forfeit. Christians formed the majority of the estimated 4.5 million people who were no longer Ottoman subjects.[9] The corollary of this was that Muslims now formed a higher proportion of the empire's population, a proportion that had been increased still further by the influx during and after the war of 1877–8 of Muslim refugees from the Caucasus, the Crimea, Kazan and Azerbaijan. It became ever clearer to many in power as well as in opposition that unity at home was a prerequisite of any effective resistance to further territorial dismemberment of the empire by the Great Powers and their Balkan clients, and that with the altered demography of the empire post-Berlin a new basis for loyalty to the state was needed – the 'Ottomanism' of the *Tanzimat* reformers, intended to counter the desire for self-determination of an empire of diverse religions and national aspirations, was no longer appropriate for a state whose population was three-quarters Muslim.

Recent events had revealed once again how ephemeral European protestations of friendship could be, and in particular those of Britain, whose aid in the war against Russia the Ottomans had hoped for in vain.[10] Nevertheless, at one level Ottoman confidence remained undented: like their predecessors, Abdülhamid and his statesmen still considered themselves the equal of their European fellows, and the Ottoman state the peer of the European Powers. The liberal ethos of the constitutional monarchies of Britain and France seemed to give rein to any with secessionist ideas, so Abdülhamid preferred to portray himself as a proud autocrat in the mould of the German Kaiser or the Austrian Emperor – although any resemblance to the equally autocratic Tsar Alexander II of Russia was downplayed. Most tellingly, the Sultan and his circle presented themselves and their world as 'modern', and deserving of respect as such: any public manifestations of 'Ottoman-ness' – as in the tableaux and stalls at the World Fairs in which the Ottomans participated – that might be construed by spectators as exotic or uncivilized were strictly forbidden, on the grounds that they laid the empire open to ridicule.[11] Where the Ottoman Empire clearly differed from European states was in the matter of religion, but this the Ottomans in no way considered a mark of inferiority. To the contrary: Abdülhamid made a virtue of it, bending the Islamic faith of the majority of his subjects to provide a

parallel to the ethnic and linguistic nationalisms espoused by his European peers.

Recognizing that the *Tanzimat* notion of the disparate peoples of the empire embracing a common identity as Ottoman subjects was outworn even before his accession, and with the example of Russia's pan-Slavism – not to mention pan-Hellenism and pan-Germanism – before him, Abdülhamid supported the formulation of a new and more relevant ideological principle. He took the latent notion of the Ottoman sultan as caliph and refashioned it to command the allegiance not just of his own people but of all Muslims, asserting more insistently than any Ottoman sultan before him the potency of his identity as caliph, and the appropriateness of Islam as a focus of loyalty for the state. In the opinion of Sir Henry Layard, British ambassador in Istanbul between 1877 and 1880, Abdülhamid considered his position as caliph superior to that of sultan and accorded it more importance.[12] If this was the case, it was because he saw no other way of saving the empire.

It was traditional for a sultan to emphasize his devotion to Islam at the outset of his reign, and the choice of sword used in the girding ceremony that had become part of Ottoman accession ritual from the time of Sultan Selim II in 1566 had a significance that cannot have been lost on contemporaries. In recent times, Sultan Mahmud II had been girded with two swords on his accession in 1808, those supposedly belonging to the Prophet Muhammad and to Osman I – the first of the Ottoman sultans – in a statement of his parallel dynastic and religious claims; his choice of the sword of Osman – known to posterity as 'Gazi', 'Warrior' – rather than that of any other sultan, may be interpreted as symbolizing his intention to restore the military might of the empire. In 1839, however, Abdülhamid's pious father Abdülmecid chose to be girt only with the sword of the Caliph 'Umar, second caliph of Islam, who had adopted the title of 'Commander of the Faithful' to indicate his spiritual authority over the emerging Muslim community. Sultan Abdülaziz had chosen likewise in 1861, but Abdülhamid was, like Mahmud, girt with the sword of Osman as well as that of Caliph 'Umar. Abdülmecid had asserted the Islamic character of the Gülhane Edict promulgated soon after his accession; the constitution Abdülhamid promulgated referred to an Ottoman claim to the 'supreme Islamic caliphate'.[13]

The title of caliph had been used by Ottoman sultans from the time of Selim I, but in an ill-defined and not overtly political sense. Ottoman claims to inherit the caliph's spiritual authority over all Muslims rested on the belief not only that Selim had brought back the relics of the Prophet from his campaign to conquer Egypt in 1517–18, but that he

had also been invested with the office of caliph by the last Abbasid incumbent.[14] The idea that the Ottoman sultan was caliph, the 'representative of God on earth', was given contemporary force by Ahmed Cevdet Pasha who, writing of the girding ceremony of Sultan Abdülaziz, stated that,

> When Sultan Selim [I] conquered Egypt and brought the Abbasid Caliph to Istanbul, the Abbasid Caliph girded Sultan Selim with this sword [of 'Umar] and thus transferred the Islamic Caliphate to the house of Osman.[15]

Ahmed Cevdet Pasha's elaboration of this myth was prescriptive. He was Sultan Abdülhamid's guide in many aspects of his politics of Islam, and his copious writings on the issue of the caliphate were reflected in the Sultan's policies.[16]

The issue of the sultan's political-legal role as caliph had been aired from time to time in the centuries since Selim's conquest of Egypt – during the reigns of Süleyman I and Mehmed IV for instance – but what prompted the Ottomans to emphasize the religious authority over Muslims everywhere of the sultan as caliph were the Austrian and Russian assaults on Ottoman territory of the later eighteenth century.[17] A heightened consciousness of the Ottoman sultan's function as caliph began when the Crimea was lost to the empire and came under strong Russian influence: the sultan's spiritual authority over the Tatars – in his capacity as 'Caliph of all Muslims' – was enshrined in the Treaty of Küçük Kaynarca of 1774. In 1783 Empress Catherine declared the annexation of the Crimea by Russia, and one result of the shock of this loss of Muslim territory was Ottoman insistence on the sultan's role as protector of all Muslims regardless of who their temporal ruler might be. It did not take long for the notion to appear in print; one of the earliest mentions of the formal transfer of the caliphate to Selim I appeared very shortly after 1774, in 1787, in the celebrated *Tableau général de l'Empire othoman* by the Istanbul Armenian İgnatius Mouradgea d'Ohsson, who began his career as dragoman at the Swedish Legation and rose to become minister plenipotentiary and head of the legation.

Despite the lingering hostility between the two states, the Russian tsar's deference to the sultan-caliph in matters concerning Islam in the Crimea continued to be symbolized intermittently between 1863 – or possibly earlier – and 1914 by the sultan sending a high-ranking envoy, whenever the tsar visited his summer residences at Livadya* near Yalta, or Sevastopol, or Odessa, to welcome him to territory where the sultan was spiritual

* The Livadya Palace was the site of the Yalta conference where Churchill, Roosevelt and Stalin redrew the map of Europe in 1945.

leader.[18] The European Powers referred to the sultan as caliph when it suited their purpose: more often, however, it was the Islamic leaders of Asia, whose states were becoming European colonies, who appealed to him as caliph, as their protector.[19]

A potential stumbling-block to the imposition of Sultan Abdülhamid's new orthodoxy was the historic preference that the caliph must be a descendant of the Qurayshi tribe of the Hijaz, to which the Prophet Muhammad had belonged. But the Ottoman state espoused the Hanafi school of Islamic jurisprudence which was lenient on this issue, and the other schools – Shafi'i, Hanbali and Maliki – had long since put no obstacles in the way.[20] Ahmed Cevdet Pasha argued that in the past the caliph had come from the Qurayshi tribe only because they were in the majority.[21] The rumblings of discontent with Ottoman rule that occurred across the Arab world from time to time were a cause of concern to Abdülhamid on two counts in particular: he feared the Arabs might raise objections to his caliphate on the grounds of his non-Arab descent; and, more worryingly, that the British might use any hint that a rival Arab caliphate was in the making to foment a movement for Arab separatism from the empire. Events in Egypt in 1881–2 – when what began as a military mutiny gathered wide support from a civilian population united in a desire to throw off European control of the economy, but was then followed by British occupation of this still nominally Ottoman province – only served to feed a fear of British interference elsewhere.[22]

Abdülhamid's fear of collusion between the British and a rival Arab candidate for the caliphate was not unfounded: almost at the start of Abdülhamid's reign his ambitious representative in the Hijaz, Sharif Husayn, had been found to be making overtures to the British behind a mask of loyalty to the Sultan.[23] The sacred places of Mecca and Medina had been saved from the Wahhabis early in the nineteenth century with the assistance of Mehmed Ali of Egypt, but the Ottoman hold on the soil the sultan must possess in order to claim pre-eminence in the eyes of the Muslim community clearly needed reinforcing. Because thousands of pilgrims visited the Holy Places every year, the question of their possession had implications throughout the Islamic world. It was the responsibility of the Ottoman sultan and his agents to provide for the security and well-being of the pilgrims, and it was clear that more attention must now be paid both to the pilgrimage, and to the sultan's Arab subjects, hitherto the objects of usually benign neglect by Istanbul.

The early 1880s accordingly saw great material and infrastructural improvements in the Hijaz undertaken by the energetic governor Osman Nuri Pasha, whose aim was to extend the government's reach into this

distant and sensitive area. Government buildings were constructed all over the province, and barracks and military hospitals were built. Osman Nuri engaged in public works, printed provincial almanacs, and repaired the shrine at Mecca and its water system.[24] Suspicions of British intentions were compounded by the fact that local Bedouin tribes were unruly, reluctant to submit to the authority of any but their own leaders. The 'stick' of increased central government presence in the Hijaz and elsewhere in the Arab lands was accompanied by the 'carrot' of listing the Arab provinces ahead of those in the Balkans and Anatolia in official registers, and the payment of higher salaries to governors of Arab provinces[25] – a modern variant on the old Ottoman policy of offering inducements to foster co-operation among local leaders whose allegiance could not be taken for granted.

The role of the Ottoman sultan as the chief benefactor of the Muslim Holy Places was more important than ever now that 'Islamism' had replaced Ottomanism, and Abdülhamid's jealousy in respect of the Holy Places led him to feel threatened whenever other Islamic leaders offered gifts to these shrines: he forbade the practice, and also refused them permission to acquire property in the Hijaz.[26] The building of the Hijaz railway from Damascus to Medina between 1900 and 1908 represented a further Ottoman commitment to Muslims the world over, making the pilgrimage incomparably easier.

Abdülhamid made an 'Islamic Vatican' of his palace at Yıldız. As part of his policy of building Arab support for his pretension to the caliphate as well as for increased central government involvement in the Arab lands, he invited Arab religious leaders to live in Istanbul as his advisers, and employed them on missions to the Arab provinces. Like earlier 'hostages' at court, they were also responsible for the good behaviour of their constituencies at home. Few Arabs had been intimates of a sultan, so they were a curious sight to Abdülhamid's contemporaries; they were assumed by their detractors to be soothsayers and astrologers. One among them was Sheikh Muhammad Abu'l-Huda al-Sayyadi, a Syrian who, besides serving Abdülhamid's purposes in his writings – which included the proposition that absolute government had originated with the rise of Islam – used his position of authority to fabricate genealogies for his followers in Syria which would enable them to claim the greatly-enhanced status that accompanied descent from the Prophet. Abdülhamid acknowledged these mythical genealogies and exempted Abu'l-Huda al-Sayyadi's clients from military service – as was the right of descendants of the Prophet. Another consequence of these closer contacts between the Sultan and Arab religious leaders was generous state support for certain dervish orders, largesse that served

to reinforce the provincial reverence for the Sultan-Caliph expressed in Abu'l-Huda al-Sayyadi's pamphlets.[27]

In Syria, however, the thirty years since the promulgation in 1856 of the Reform Edict, with its promise of equal civil and political rights for Muslim and non-Muslim alike, and the decentralizing provincial reforms of the 1860s, had seen the gradual formation of a Syrian consciousness based on geographical and linguistic rather than on denominational grounds. This had been assisted by the combining of the three Syrian provinces of Damascus, Sidon and Tripoli into a single 'super-province' encompassing Syria as a single geographical and administrative unit. So, too, the *Tanzimat* reforms had succeeded better here than they had in many other places in integrating people professing different religions, because all spoke a single language and were encouraged by local intellectuals to think of themselves as Arabs rather than as members of different faiths. Abdülhamid's insistence on Islam as the foundation of loyalty to the Ottoman state sat uneasily with this development, and influential propagandists like Abu'l-Huda al-Sayyadi had a vital role to play in supporting the implementation of his 'Islamist' policy in Syria, especially after Midhat Pasha's tenure as governor between 1878 and 1880. Dissemination of 'Islamist' propaganda was aided by the censorship of the Syrian press and control of local publishing output, which had to be submitted to Istanbul for vetting; Abdülhamid's manipulation of provincial boundaries also helped to sever people from their identity as members of a Syrian whole.[28]

Abdülhamid's calculated assumption of the caliph's political authority brought a break with the practice of his recent predecessors, who had valued public appearances before their subjects in all the panoply of pomp and circumstance as valuable expressions of the temporal power of the sultan. Fostering the notion of the sanctity of the Sultan-as-Caliph was another matter, and Abdülhamid's was in any case a character predisposed to seclusion. He hid himself away in Yıldız Palace and appeared in public only rarely – on his way to Friday prayers in the mosque which he had built nearby for the purpose, for instance – glimpses intended to enhance his mystique. His fear of deposition was justified: in addition to the attempted coups early in his reign, opposition groups tried to remove him in 1895, 1896 and 1902–03, for instance, and concocted assassination plots in 1899 and 1905.[29]

Although by this time overwhelmingly Muslim, the Ottoman Empire was far from homogenous. Its official faith had to have resonance for all – Turk and Kurd, Arab and Albanian, Sunni and Shia, and the shades of belief and practice which fitted none of these overlapping categories. The creed of Shiism was as potentially subversive in the Sunni Ottoman state

as the nationalism of the Balkan Christians, and the beliefs of the Turcoman population of eastern Anatolia had indeed been a matter of official concern in earlier times: the course of Ottoman–Iranian relations had historically revolved around Istanbul's heavy-handed efforts to win over those suspected of Shia sympathies, and much of the population of the Ottoman provinces of Basra, Baghdad and Mosul was Shia, as were the Zaydis of Yemen. As well as buying loyalty to the Sultan-Caliph on the part of the Shia and those professing beliefs at odds with Sunnism by the award of honours and gifts, an official version of Islam was spread by missionary and educational efforts.[30] Outright conversion to Sunni Islam was also attempted, and was met in these same provinces by efforts emanating from the Shia holy cities of Karbala' and Najaf to 'turn' the nominally Sunni tribes of the area to Shiism.[31] Closer to home, the ignorance of the Muslim population of the Anatolian heartland required the despatch of preachers 'to teach religion and to correct beliefs'.[32] During anti-government rebellions in Erzurum in 1906–7, it was decided that an elementary school should be built there 'to correct the religious precepts of the Alawites* and to thwart their conspiracy'.[33] The widespread Christian missionary activity which flourished following the commitment to freedom of religion contained in the 1856 Reform Edict only made the saving of Sunni Muslim souls before they were lost for ever seem a matter of the greatest urgency.

For non-Ottoman Muslims, acceptance of Abdülhamid as their caliph and protector seemed to offer an allegiance with which to challenge the colonizing European empires. Appeals to the Sultan by the Muslim rulers of Indian Ocean states for help against the Portuguese in the sixteenth century were a precursor of those which now emanated from the Muslim subjects of the imperial powers – of the French in Algeria and Tunisia (as we may now call them), the Dutch in Indonesia and Malaysia, the British in India and in occupied Egypt, and the Russians in central Asia. Previous Ottoman sultans had not invariably put Muslim wishes first: when the British appealed to Sultan Abdülmecid during the Indian Mutiny, only a year after he had obliged them with the proclamation of the Reform Edict, he co-operatively responded with a letter to be read out in Indian mosques enjoining the people to remain calm.[34]

Africa's Muslim populations were now almost all outside the Ottoman Empire: following the establishment of French protectorates in the province of Algiers in 1830 and in Tunis in 1881, and British occupation of Egypt

* The Alawites (Alevis in Turkish) practise a form of Islam whose adherents, like the Shia, revere the Prophet's grandson 'Ali.

in 1882, Tripoli* was the only North African territory still nominally under Ottoman rule. Relations with Muslim leaders in Central and East Africa were considered to be especially important, not least because the region had recently become of interest to the European powers who were already an established presence in North Africa. The use of Islam as a tool with which to build allegiance to the Sultan-Caliph was therefore extended, and a new foreign policy devised to strengthen what remained of Ottoman influence in the continent. Little justification was needed: the author of a book written at the behest of the palace noted that Africa was a 'dark continent' where 'civilized' powers sent colonists and, further, that it was beneficial to spread 'the light of Islam' into these 'savage' regions.[35] The Ottomans were not initially invited to the 1884–5 Berlin conference on the future of Africa but they asserted their right to attend, and their delegate was instructed to defend their historic rights, their material and moral interests, and 'the sacred rights of the great Caliphate'. The Ottomans did not, however, seek to exert direct control over their fellow Muslims, who appreciated their restraint.[36] Insignia and honours were lavished on foreign Muslim leaders, from the Sultan of Zanzibar who received the Mecidi Order of Sultan Abdülmecid in 1880[37] to lesser African tribal leaders who were presented with Ottoman flags in 1894 by a special agent sent from Istanbul on an information-gathering mission. This agent recommended that the chiefs should receive robes of honour, an imperial edict and a copy of the Koran, in exchange for which they would be expected to include the Sultan's name in their Friday prayers.[38] Russian and Chinese Muslims were also targets: as Russia pushed further into central Asia, the Ottomans sought to subvert its efforts by reinforcing their appeal to the Muslims of central Asia; and in 1901 the young military officer who would later win notoriety as Enver Pasha visited Shanghai, leaving behind the two clerics who had accompanied him. Following the visit of another delegation sent by the Sultan in 1907, a Hamidiye Institute of higher education was founded in Beijing.[39]

In 1903 a proposal reached the Ottoman government suggesting the commemoration, in due course, of the four-hundredth anniversary of the transfer of the caliphate from Abbasid to Ottoman hands: 'We seem to have somehow missed this sacred occasion three times and if we let it go by again a hundred years will elapse before we get another chance'. The

* The Ottoman province of Tripoli nominally extended eastwards across the vast desert towards Egypt. In nineteenth-century European usage the western part of the province was called Tripolitania and the eastern Cyrenaica. The name Libya is of ancient origin, revived as a geographical designation by the Italians in the first years of the twentieth century: after Italy had wrested Tripolitania and Cyrenaica from the Ottomans in 1911, the combined territories were thenceforward referred to as 'Libya'.

suggested participants were Muslim leaders from around the world, including 'the Islamic leaders of Australia'.[40] The conference never materialized, because in 1917 Europe was in chaos and the Ottoman world was fast disappearing. The transfer of the caliphate had not previously been celebrated simply because it had not been regarded as of great importance.

Sultan Abdülhamid's design for preserving what remained of the Ottoman Empire was conservative in its approach to government as well as in its ideological underpinnings and although he eschewed the innovations in bureaucratic organization characteristic of the preceding years, yet his conservatism allowed for measures he considered would bring prosperity to his realm. He knew that a strong economy was essential to the achievement of his aims, for without modernization of infrastructure and communications the potential of Ottoman agricultural and industrial resources would remain untapped. Nevertheless, while military and administrative expenditures increased during his reign – and averaged about 60 per cent of government expenditure – the amount spent by the state on public works, education, health, agriculture and trade accounted, together, for a rather insignificant average 5 per cent of the annual budget. What proved a debilitating handicap in realizing Abdülhamid's dreams was that almost 30 per cent of annual expenditure went towards servicing the public debt.[41]

The stability of the grand vezirate during the *Tanzimat* years, when the office alternated between Fuad Pasha and Ali Pasha, vanished after Ali's death in 1871. In the nearly five years between 1871 and the deposition of Sultan Abdülaziz the office changed hands nine times, as factional struggle and the Sultan's whim again subverted the work of government. Abdülhamid frequently changed his grand vezir: of the sixteen terms served by various holders of the office during the first six years of his sultanate, only one was longer than a year. Between 1882 and his deposition in 1909 there was greater stability, and Mehmed Said Pasha, Mehmed Kamil Pasha, Ahmed Cevad Pasha, Halil Rifat Pasha and Mehmed Ferid Pasha served for longer periods. Unlike Abdülaziz, who left affairs in the hands of his two vezirs for most of his reign, Abdülhamid interested himself closely in the government of his empire, and engaged in detailed and often heated debates over policy with his grand vezirs. If he prevailed in argument – and dismissal was the price for questioning his final decision – his most prominent vezirs nevertheless felt able to express their views vigorously.[42] What made it possible for him to exert his will over his closest advisers was, in the words of one historian,

... the failure [of government] to reach a consensus concerning the 'structure of authority', or an organisational framework within which to reconcile

conflicting interests under the new circumstances created by the Western challenge [as] existing principles of legitimacy faded.[43]

It was part of the Ottoman ethos for the sultan to demand unquestioning personal loyalty from state servants and this was truer than ever under Abdülhamid. In the past, those who failed to live up to this ideal had been punished by execution or exile, while those who repented were brought back into the fold. Despite their vehement displays of opposition to the ruling order, the contrite among the rebellious governors of seventeenth-century Anatolia, for instance, had been offered new posts, often on the far side of the empire: the unrepentant, however, had been hunted down. The nineteenth-century version of this was the bestowal of state office on figures in the political opposition – the leading Young Ottoman Namık Kemal, for example, who like Midhat Pasha had been involved in the preparation of the constitution, was imprisoned in 1877 and then exiled to government posts on a succession of Aegean islands – Lesbos, then Rhodes, and finally Chios, where he died.

Concentration of power in his own person was the ultimate expression of Abdülhamid's fear of the decentralization of authority which in his view had presented the Balkan provinces with the opportunity to secede from the empire. This prescription for ensuring the continued survival of the empire was diametrically opposed to that of Midhat Pasha, a true representative of *Tanzimat* optimism, who believed that separatist tendencies could best be countered by demonstrating the benefits of 'good government'.

Abdülhamid's treatment of Midhat Pasha was among the sorriest episodes of his reign. From his exile in Brindisi Midhat Pasha travelled widely in Europe but in 1878 was allowed to return to internal exile on Crete. It was not long before he was invited to re-enter the ranks of the Ottoman bureaucracy as provincial governor of Syria, where he endeavoured to undertake reforms similar to those he had set in train in the Danubian province and in Baghdad some fifteen years before. Receiving reports that led him to believe Midhat Pasha to be seeking to arrogate to himself powers beyond those appropriate to a governor, Abdülhamid removed him from Syria to become governor of Aydın province in western Anatolia: nearer at hand, he would be less of a threat. On 17 May 1881, after only a few months in that post, Midhat Pasha was arrested. Ahmed Cevdet Pasha, now justice minister, travelled to İzmir to bring him back to Istanbul, where with thirteen other suspects he was put on trial for the murder of Sultan Abdülaziz[44] – a remarkable turn of events, for the verdict of suicide had been generally accepted, even by Ahmed Cevdet,[45] now one of his accusers.

The interrogation and court proceedings took place at Yıldız. Some of

the suspects were tortured to obtain a confession – Abdülaziz's under-chamberlain Fahri Bey left a chilling description of his own ordeal in which, he said, Abdülhamid himself participated.[46] Eleven men were found guilty, including Midhat Pasha, Fahri Bey and two of Abdülhamid's brothers-in-law, Damad Mahmud Celaleddin and Damad Mehmed Nuri; these named and five others were condemned to death, the remaining two to ten years' hard labour. The sentences were reviewed, and although a majority, including Ahmed Cevdet Pasha, favoured their implementation, the Sultan commuted them to life imprisonment, fearing the adverse reac-tion the executions were bound to arouse.[47] The convicted men were sent to Ta'if in the Hijaz, imprisoned in a fortress in the most uncomfortable conditions and denied all contact with the outside world;[48] Sheikhulislam Hasan Hayrullah Efendi, who had given the juridical opinion for Abdülaziz's deposition, was already incarcerated there. In 1884 Midhat Pasha and Damad Mahmud Celaleddin were murdered on the Sultan's orders;[49] only three men, including Fahri Bey, returned alive to Istanbul in 1908 when Abdülhamid's regime was overturned.[50]

The murder of Midhat Pasha, a man feared by Abdülhamid as the focus of a constitutional movement which he viewed as setting limits on his authority, reveals the depths of the Sultan's insecurity. Abdülhamid was well aware that it was an unacceptable act – and it was covered up. Midhat's murder was the first of a leading statesman since 1837, when the revulsion engendered by the execution of Mahmud II's grand vezir Pertev Pasha had prompted legislation to outlaw this sultanic prerogative. That the influence of the *Tanzimat* was not to be negated at the mere whim of the Sultan had already been demonstrated by the fate of the 1876 constitution: it was not abrogated but suspended, it remained on the statute books, and continued to be referred to in the annual state almanac.

If the loss of most of the predominantly Christian Balkan territories of the empire in the Treaty of Berlin of 1878 had already proved Midhat Pasha's plans for provincial reform idealistic, the emergence of a separatist move-ment among the Albanians, of whom some 70 per cent were Muslim, could but reinforce this judgement; and if Arab susceptibility to British blan-dishments proved a shock to the Ottoman body politic, Albanian unrest was even more so, since the Albanians were traditionally among the most loyal of Ottoman populations. The Albanian separatist movement had its roots in sentiments not dissimilar to those which prompted Sharif Husayn's overtures to the British – apprehension that further territorial dismember-ment of the empire would not long be delayed.[51]

The borders of the sub-province of Albania established by the Ottomans

in 1432 underwent many modifications over time, and by 1878 'Albania' denoted a region inhabited by ethnic Albanians – predominantly Muslim, but also Catholic and Orthodox – consisting of territory falling within the provinces of Shkoder, Kosovo, Monastir and Ioannina. In the north of the region lived the Ghegs, and in the south the more sedentary Tosks.[52] Since the loyalty of the Albanians had long been taken for granted, scant consideration had been given to their 'national' inclinations during the administrative reorganizations made earlier in the nineteenth century to accommodate the more militantly nationalist Greeks, Serbs and Bulgarians.

On 10 June 1878, three days before the Congress of Berlin was convened, a number of activists attended a meeting in Prizren, where they formed the 'Albanian League' to protest against the possibility of Albanian-populated territories being occupied by a foreign power. At first the activists won encouragement in Istanbul, but the spectacle of the Austrian occupation of Bosnia-Herzegovina and the award of Ottoman territory to Greece and Montenegro soon set the League and the government at odds, and the League's aspirations for national autonomy were encouraged by Britain. When the time came for implementation of outstanding clauses of the Berlin treaty, which did indeed include forfeit of Ottoman land in the Albanian provinces, an armed uprising broke out over a wide area and by September 1881 had been put down by the Sultan's army. The League was then disbanded after three years of activity.[53]

Violence in eastern Anatolia in the mid-1890s again made Abdülhamid's government particularly unpopular abroad. In the disappointment that followed the Treaty of Berlin a number of Armenian organizations with nationalist ambitions had been formed. Two – the Hunchaks, founded by émigrés in Geneva in 1887, and the more anti-Russian Dashnaks, founded in Tiflis in 1890 – espoused violence as a means of securing Armenian independence and were not averse to provoking Muslim reprisals as a way of attracting foreign attention.[54] In 1891, concerned about possible Russian designs in the remote and barely-governed east Anatolian provinces, Abdülhamid raised the 'Hamidiye' irregular cavalry regiments among the Kurds to police the region and provide a security force of first resort. The Kurdish tribes were jealously independent, and forging them into a formal organization would, he hoped, also serve to restrain their lawlessness and increase their loyalty to the distant government in Istanbul.[55] The timing of this intervention could scarcely have been more unfortunate: coinciding as it did with increased Armenian revolutionary activity, it upset the existing if imperfect balance of power in the region. The Hamidiye regiments became participants in the turmoil, and in 1894 particularly savage encounters between Hamidiye and the Armenians at Sason in Bitlis province prompted Britain, France and Russia to intervene

with proposals of administrative reforms; they could not agree among themselves, however, and the Sultan was not party to the deliberations. Frustrated by the lack of progress, the Hunchaks took their cause to Istanbul and, hoping to influence the outcome of the discussions then under way, on 30 September 1895 tried to force their way to the headquarters of the government to present a petition. They clashed with troops on the way, and many Istanbul Armenians were killed by Muslim mobs in the ensuing chaos.[56]

International reaction to this incident forced Abdülhamid to concede some reforms in the eastern provinces, recognizing the place of non-Muslims in local administration and agreeing that the Hamidiye regiments would be armed only when on active duty. His concessions were made reluctantly, and he did not publish the decree for a year: he considered his own understanding of the situation and of the possibility of adverse reaction on the part of the Muslim population of the region to be superior to that of the Powers, and in this he was proved correct. During the remaining months of 1895 and on into 1896 there was terrible violence as government authorities, Armenians, Kurds and Turks fought one another, ensuring – thanks to the wealth of despatches sent from the region by consuls (mostly British) and missionaries (mostly American) describing the suffering they witnessed – that the names of the towns of Harput and Zeytun (now Süleymanlı), to cite only the best-known, would long be remembered as the sites of intercommunal massacres. In August 1896 the Dashnaks in their turn attacked the headquarters of the Ottoman Bank in Istanbul in another bid to attract outside attention, and conducted a bombing campaign in the city. Again there were reprisals against the Armenians of Istanbul in which hundreds if not thousands were killed. Fearful that foreign intervention might be the response, Abdülhamid published the decree regarding the reforms he had conceded the previous year, extending them to cover all his domains except the Hijaz,[57] thus further alienating the Muslim population of the empire whose allegiance he needed so desperately to retain. Many Ottoman Armenians were themselves deeply uneasy about the turn events were taking, as Russian Armenians who had come to Anatolia and Istanbul as agitators in the 1890s threatened and on occasion even assassinated them for not providing financial support or for continuing to assert their allegiance to the Ottoman state.[58]

Armenians and Albanians were not the only subjects of the Sultan to express their deep discontent violently during the final years of the nineteenth century. Crete was still an Ottoman province, and revolts there were not infrequent. King George of Greece was of one mind with Greek nationalists in wishing to annex the island, and in 1897 sent a fleet and soldiers there. Great Power pressure forced Abdülhamid to offer Crete autonomy

under Ottoman sovereignty, but soon Greek troops were mobilizing in Thessaly, Greece's northern border with the empire. Following Ottoman humiliation under the terms of the Treaty of Berlin, Abdülhamid had turned to Germany, the one Great Power with no tradition of interest in the Near East, for support against the rest; German civilian and military advisers had been active ever since, as Germany replaced Britain as the Power most trusted by the Sultan.[59] The Greek forces were no match for the German-trained and German-equipped Ottoman army called against them, and were soon defeated. Furthermore, Greece was required to pay a hefty war indemnity to compensate the Ottomans for the territory won by them in Thessaly and returned under the terms of the peace, and payment of interest on the Greek debt came under the oversight of an international financial commission. Abdülhamid's offer of autonomy for Crete was now accepted by the Powers.[60]

Intellectuals were in full agreement with Abdülhamid's aim of saving what remained of Ottoman territory, but were unsympathetic to his efforts, frustrated as much by his autocratic style of government as by his too-obvious failure to resist the partition of the empire. In the early part of his reign dissent came from many quarters – from romantic liberals and constitutionalists, from clerics, from freemasons, from bureaucrats and palace officials. This opposition was as disorganized and disunited as the Young Ottomans had been, and initially unsuccessful as much for this reason as any other – although the ministry of police founded in 1880 was aided in its work by an unofficial network of spies responsible to the palace, and this web of informers betrayed the dissidents.

Only in 1889 did another form of opposition to Abdülhamid and his policies – which would in the long run prove to be as disruptive as the violence of the Armenian activists – find the beginnings of an organizational structure. In that year, some students in the military medical college founded a secret society which aimed to restore the constitution and parliament. The society was discovered, however, and those of its members who evaded arrest fled to Paris where they continued their opposition to the Sultan. Resistance to Abdülhamid's rule coalesced in 1894 when a variety of underground factions adopted the umbrella name 'Committee of Union and Progress' (CUP), popularly known as the 'Young Turks'.[61]

Over the next years the activity of the Young Turk opposition developed from an intellectual into a pragmatic political endeavour; periods of great vitality alternated with periods of infighting and intrigue among the members of the CUP at home and, increasingly, in exile. As might be expected during a time of extreme political ferment, they espoused a variety

of often competing ideas, and the removal of Abdülhamid was the only cause on which all could agree. CUP members were of all ethnic and religious backgrounds, and the organization soon had branches across the empire and in Europe, but it was very much an elitist enterprise and did not seek to mobilize a mass following.[62]

Abdülhamid was quite successful in suppressing the activities of the CUP inside the empire, and tried to do the same abroad. In 1899, through the good offices of his German allies, he requested of the European states where the CUP was active that they, too, take measures against them – the Swiss agreed to investigate, the French were less than enthusiastic. In December of the same year the Sultan's brother-in-law Damad Mahmud Celaleddin Pasha (his name was identical with that of another brother-in-law who had been murdered in Ta'if in 1884) left Istanbul with his sons Prince Sabaheddin and Prince Lutfullah for Europe, where they became involved in the opposition movement.[63] With the CUP in a parlous state, Sabaheddin and Lutfullah proposed a congress of those opposed to the Ottoman regime, and it was held in Paris in 1902 after the French government – the focus of much lobbying by the Princes and French deputies, journalists and statesmen persuaded of their cause – had condemned the Ottoman government and issued the necessary licence. Participation in the congress was closely controlled by Prince Sabaheddin – or Sabaheddin Bey as he was commonly known. The delegates included members of Armenian opposition organizations who allied themselves with Sabaheddin's faction – which shared their conviction that outside intervention was the remedy for the empire's ills – against that headed by Ahmed Rıza, a polymath and former bureaucrat who categorically rejected foreign intervention in Ottoman affairs. Although they were in the minority at the congress, Ahmed Rıza and his supporters had been dominant in the CUP since its foundation, whereas Sabaheddin Bey's group, though part of the numerical majority, had only recently allied itself to the organization. The European press naturally applauded the pro-interventionist faction, but events were to prove Ahmed Rıza and his fellows the more resilient.[64]

Sabaheddin Bey's faction maintained strong links with Armenian and also with Albanian and Macedonian opposition groups following the Paris congress, and was execrated by its opponents for soliciting outside help to overthrow Abdülhamid's regime. The Sultan mounted a determined campaign against them, to which they responded by plotting, with British support, an elaborate coup attempt. Ahmed Rıza's coalition, on the other hand – their ideology in stark contrast to that of Sabaheddin Bey's faction – worked hard to provide a sound organizational basis for the future. This invited the participation of all peoples of the rump empire – or at least of

the revolutionary groups deemed to represent them; Ahmed Rıza and his followers favoured 'Turk' rather than 'Ottoman' to describe a subject of the sultan, and declared all attempts to find a common purpose with the non-Turkish – by which they meant non-Muslim – opposition to be fanciful. They valued Islam not as a religion but as a vehicle to focus incipient national consciousness.[65]

Ahmed Rıza's programme was one of gradual change, and those in his coalition who preferred a more activist approach initially had little influence. This changed in 1905 when Bahaeddin Şakir, doctor to Prince Yusuf İzzeddin who was second in line to the throne, was exiled to Erzincan because of his links with the CUP and fled from there to join the organization in Paris. His aim was to forsake evolution for revolution and engage in some form of common action with the revolutionary Armenian groups, but the Armenians rejected his approach.[66] In January 1906 he named his faction the Committee of Progress and Union (CPU) and it was not long before its members made the critical decision to invite the military to play a role in the movement, an idea apparently derived from the Prussian soldier and writer Colmar, Freiherr von der Goltz.[67] Von der Goltz had spent more than ten years reorganizing the Ottoman army (in which he achieved field rank) in the 1880s and 1890s, and continued to maintain close ties with it. Though eighteenth- and nineteenth-century reformers had tried to unravel the relationship, the military and the political had been intertwined throughout the Ottoman centuries, so the idea of military participation in political activity was not hard to accept; it did, however, leave at a disadvantage those in the CUP who rejected it in principle.

Events abroad engendered optimism in those struggling to remove Abdülhamid. The first Russian revolution of 1905 had shaken Tsar Nicholas II and forced him to concede a degree of constitutional reform; it also left Russian liberal groups who favoured gradual change out of step with the peasants and workers, who saw that something – but not enough – had been achieved by means of strikes and protests and the murder of policemen. Iran had won a written constitution and an elected assembly from its Qajar rulers following the almost non-violent, Tehran-based revolution of 1905–6. This movement had drawn inspiration from the Young Turk opposition to Abdülhamid, and its success encouraged the CPU to think the time had come for greater urgency in their own efforts.

Between 1905 and 1907, popular dissatisfaction with the government erupted in widespread rebellion in the Ottoman heartland of Anatolia. Here as elsewhere in the empire at this time able-bodied men were being conscripted for a new phase of an unpopular war in Yemen – which the Ottomans

had reoccupied in 1872, but where their forces came under constant attack from the local Arabs: this mobilization caused wide popular discontent, and the costs of the Yemeni campaign were a drain on the Ottoman budget.[68] The rebellions demonstrated that when it came to the lives of his subjects as individuals, Abdülhamid's studied campaign to enhance his sanctity as caliph was worth little and his efforts to enforce his autocratic rule were less than successful. Not for the first time, taxation was one of the chief grievances of the rural and urban population of Anatolia as the burden imposed by a state trying vainly to meet the costs of servicing its public debt and modernizing its infrastructure and armed forces became ever more onerous.[69]

Abdülhamid had been well aware since his accession of the need to ameliorate the desperate lot of the majority of his subjects, and one of his first actions had been to set up a financial commission to consider the reorganization of the rural tax system. Administrative problems and the bureaucracy's imperfect knowledge of the rural economy prevented the orderly implementation of its recommendations, however, and resulted in misappropriation by those appointed to collect the taxes, whether government agents or tax-farmers. Early in the twentieth century two new rural taxes were introduced in addition to the agricultural tithe – which, theoretically set at 10 per cent of agricultural production, was the largest single item of state revenue. Both were, of course, unpopular: the new poll-tax was seen as overburdening the poor at the expense of the better-off, while taxes on livestock were raised arbitrarily rather than in line with market values. To compound these problems, Ottoman producers were finding it increasingly difficult to compete in world markets as prices for agricultural goods and, especially and most critically, cereals fell, and this in turn discouraged further investment.[70]

Against the general background of deep-seated grievance felt by the people of eastern Anatolia as the result of the conditions of their everyday lives, the immediate and particular causes of the insurrections that broke out in a number of Anatolian towns were various. In the two years following the first revolt, in Diyarbakır, in August 1905 – this one began as a reaction to the rapacity of a local Kurdish tribal leader – there were violent disturbances in Erzurum, Sinop, Kastamonu, Trabzon, Samsun, Giresun, Sivas, Kayseri, Van, to name only some.[71]

The revolt in Erzurum in 1906–7 was particularly alarming to the authorities. Here, Armenians and Muslims alike joined in protesting against the poll-tax and livestock taxes. On 31 March 1906, three weeks after the revolt began, protesters cut the telegraph line linking Erzurum to the army headquarters in Erzincan. Troops were sent to Erzurum to investigate: the

governor was replaced, and the new livestock tax was lifted. When this failed to quell the protests the new governor promised to lift the poll-tax as well, but this verbal undertaking was not backed by the government, which insisted that a way must be found to collect both taxes. News of the governor's arrest of three of the ring-leaders leaked out, and he was seized and held hostage by the demonstrators before being exchanged for the three. The government declared an amnesty, and in March 1907 both taxes were abolished throughout the empire. Deprived of their casus belli the protesters were quick to adopt new forms of disobedience: rural Armenians converted to Islam en masse, robbing the state of taxes peculiar to non-Muslims, and in the Erzurum garrison soldiers mutinied for their arrears of pay. The bankrupt treasury was unable to meet the soldiers' demands and further violence ensued, but when representatives of the central government melted away and locals took over the administration, it completely subsided. A grain shortage some months later brought a new round of unrest; this was eventually quashed by government forces and those held to have been responsible for the eighteen months of insurrection were tried and sentenced.[72]

The CPU played no part in the Anatolian revolts; the 'League of Private Initiative and Decentralization' did. Unlike the CPU which targeted bureaucrats, intellectuals and army officers, this Paris-based organization formed by Sabaheddin Bey in response to the breaking-away of the CPU had forged links with provincial leaders in Anatolia and had agents in the region; his co-operation with the Dashnaks ensured that Armenians and Muslims were united against the government not just in Erzurum but also in other places that experienced disturbances in 1905–7.[73] According to a recent authority, 'we may confidently contend that the Young Turks abroad and in Eastern Anatolia were responsible for turning regional disturbance[s] into a fully-fledged constitutional movement'.[74]

In 1907 a second congress of the Ottoman opposition took place in Paris, under the presidency of Ahmed Rıza, Sabaheddin Bey, and Khachatur Maloumian of the Dashnaks. The atmosphere of the congress was tense, and CPU mistrust of alliance with an Armenian organization – indeed the insincerity of their collaboration from the start – was subsequently made very clear by the CPU leaders in their writings.[75] This failed attempt to unite the leading Young Turk organizations was in any case overtaken by events as the torch of protest passed from expatriate organizations forced to disseminate their message through the written word to activists inside the empire. Young Turk involvement in the Anatolian rebellions of 1905–7 was only a sign of what was to come.

The establishment in Thessalonica in September 1906 of a secret

organization known as the Ottoman Freedom Society (OFS) gave the CPU a new base, within the empire. A leading figure in the OFS was a postal official, (Mehmed) Talat Bey, and other founder members – many of whom had been members of the old CUP – included a landowner, an accountant, and a lieutenant. Other officers of the Third Army based in Thessalonica were also attracted to the OFS, among them one Major (İsmail) Enver. In September 1907 the OFS merged with the CPU, losing its name but continuing its existence as an autonomous organization. The document laying out the conditions under which the two bodies merged stated that the 'essential purpose' of the merged committee was 'to bring about the implementation of the Constitution of Midhat Pasha proclaimed in [1876]'.[76]

The merger enabled the CPU to build upon the strong presence of the OFS in Thessalonica, and gave it a new orientation and sense of urgency in seeking the removal of Abdülhamid and the restoration of constitutional government. The revitalized CPU modelled its regulations on those of the activist Dashnaks and also of the Internal Macedonian Revolutionary Organization (IMRO) founded in 1893 in Thessalonica, its object to establish a Macedonian state in the wedge of land comprising the multi-ethnic Ottoman provinces of Kosovo, Monastir and Thessalonica which cut a swathe across the southern Balkans from present-day Albania to Thrace.[77] In 1895 IMRO had spawned a breakaway faction intent on liberating Macedonia from the Ottomans and making it part of a united Greater Bulgaria, and the recently-created states of Bulgaria, Serbia and Greece, bordering Macedonia, put forward conflicting territorial claims which IMRO sought to counter. The struggle by these neighbour states to assert national rights over Macedonia was at first religious and cultural, and spearheaded by institutions which could concentrate confessional loyalty. A Bulgarian exarchate had been created in 1870 and Greek interests had the support of the Oecumenical Patriarch in Istanbul; Serbia, whose position was weakest, achieved formal religious independence from the Oecumenical Patriarch in 1902 with the creation of the Skopje bishopric. The aggressive propaganda contest for the allegiance of the Christians of these Ottoman provinces was a cause of real concern to Abdülhamid's government, for it realized that Great Power intervention would not be long delayed.[78]

Meanwhile, the CPU was becoming a truly revolutionary organization, recruiting individuals prepared to sacrifice themselves for the cause, encouraging assassinations, and authorizing the killing of anyone deemed 'hazardous'. Nevertheless, its rituals were rather comical: new members were inducted blindfold, with one hand on the sacred book of the candidate's religion, and the other on a dagger or revolver, or on an Ottoman flag. The CPU also adopted a coat of arms described thus by its most recent historian:

On top rested the constitution in the form of a book under a shining sun. Pennants reading 'pen' and 'weapon' hung from spears flanking the right and left sides respectively. From beneath each spear jutted a cannon. Unlike the cannon of the Ottoman imperial coat of arms* this pair of cannons were being fired, symbolizing ideological dynamism. In the centre stood a large upturned crescent reading 'fraternity, freedom, equality'. The word 'justice' hung above the middle of the crescent. Below the crescent snaked a ribbon emblazoned 'Ottoman Committee of Progress and Union', while at the bottom of the coat of arms, below the ribbon, two clasped hands symbolized mutual understanding among the Ottoman peoples.[79]

IMRO guerrilla practice provided a model for a strike force of CPU military officers, while Muslim guerrilla bands were organized along the lines of the anti-IMRO bands already operating in Macedonia – and the latter put their experience at the disposal of the CPU for the purpose of saving the remaining European provinces of the empire from further dismemberment. In the space of just over a year from the merger of the OFS and the CPU, the CPU had established branches in more than 75 Balkan towns and cities as well as in Istanbul and, less successfully, in Anatolia. The revamped CPU considered revolution impossible without the participation of the army, in which it had total faith. It planned carefully and specifically targeted its propaganda at the regular army troops serving on the Anatolian west coast, knowing they would be used to put down the revolution when it began.[80]

The 'Macedonian Question' was one of the most intractable of the territorial issues facing the Ottoman government. There was nothing common to the three provinces on which to base Macedonian identity, and the Ottoman security forces were unequal to the task of controlling the violence between the various ethnic and religious groupings. In 1897 Tsar Nicholas II of Russia and Franz Joseph of Austria had defined their spheres of interest in the Ottoman Balkans; a fierce uprising incited by IMRO in 1903 brought Tsar and Emperor together again. The result of their deliberations – which took note of British recommendations – was a proposal that a Russian and an Austrian adviser be appoined to the governors of each of the three Macedonian provinces; that a European should command the security forces in Macedonia; that the security forces be composed of Christians and Muslims in proportion to their numbers in the general population; and that Russia and Austria should each be responsible for ensuring calm in a part of Macedonia. The Ottomans were forced to accept this

* This was adopted early in Abdülhamid's reign, and served as a model for the CPU coat of arms.

proposal in principle but by means of tenacious diplomacy and prevarication were able to subvert its implementation.[81] April 1905 saw rebellions against the poll-tax and livestock taxes in Macedonia comparable to those in Anatolia.[82]

Fears that Abdülhamid would be forced to accede to European pressure fed into the momentum for change being generated in the CPU. The CPU's Paris-based journal concentrated almost exclusively on the Macedonian Question, and this and other extensive propaganda efforts convinced Muslims and non-Muslims alike that revolution was inevitable. The CPU addressed itself to the population of the region at large as well as to Muslims in particular, well aware that an appeal to Muslims – or Turks – alone would have been counter-productive, serving only to alienate the large Christian population of Macedonia.* By 1908 earlier appeals to 'Turks' as the vanguard of the movement that must save the empire had been joined by appeals to 'Ottomanist' and 'Islamist' identity, a fluidity that assisted the CPU aim of forging links with a variety of revolutionary groups in Macedonia.[83]

The rapid growth of the CPU that followed its move to Thessalonica and the success of its propaganda efforts meant it could no longer remain entirely underground. The Ottoman government had long been aware of the clandestine organizations ranged against it, and a number of arrests had been made during the early months of 1908. On 13 May the true ambition and capability of the CPU, and the scale of the threat it posed, were revealed when the government received an ultimatum warning the Sultan that if the constitution was not restored 'blood will be shed and the dynasty will be in danger'. The Minister of War was told to resign, or face the possiblity of assassination. The dire situation in Macedonia was discussed at a meeting between Tsar Nicholas II and King Edward VII between 9 and 12 June 1908 at Tallinn (Reval), the Estonian capital, for further deliberations on the 'Macedonian Question'. Suspecting the imminent intervention of Russia and Britain, the CPU revolution entered its active phase, with a campaign of assassinations and guerrilla activity against government agents in the three provinces – the CPU continued to insist, nevertheless, on its liberal intentions.[84]

Appropriating the methods of Balkan fighters against a hated regime, bands of mutinous troops and armed civilians took to the hills in early July, spreading

* Reliable population figures are hard to come by. The Ottoman census of 1906–7 shows Muslim and Christian populations as almost equal, at around one million each, with Christians slightly in the majority. Statistics submitted to the British Foreign Office prior to the Berlin Congress in 1878, however, inflated the number of Christians for political purposes, showing them to be double the number of Muslims (Karpat, *Ottoman Population* 45–6, 166).

the demand for constitutional government as they moved through the region. Major Enver of the Third Army was one of the middle-ranking officers who figured most prominently in the adoption of these guerrilla tactics as government authority dissolved and, with the assistance of the Third Army, the CPU was able to take control in Macedonia. The Monastir branch of the CPU was in charge of the details of the revolution: after two days of feverish activity during which the town came entirely under CPU control, the Monastir committee instructed all its branches to complete the revolution by 23 July, from which date, it informed governors and other senior provincial officials, the Ottoman constitution would be reinstated by force. An ultimatum to the government demanded the restitution of the constitution, and threatened a march on Istanbul on 26 July if it were not complied with. In a gesture of conciliation Abdülhamid dismissed the Grand Vezir and the commander-in-chief of the army – but this proved insufficient. Following urgent meetings with his advisers, he issued a decree, published in the press on 24 July, ordering the restoration of the constitution and the holding of elections.[85] As news of the revolution and its outcome spread gradually to the distant provinces of the empire, initial reactions varied from enthusiasm to disbelief.

Thus began what historians of modern Turkey call 'the second constitutional period': Abdülhamid remained on the throne, but as a constitutional monarch. After the euphoria had died down, it became plain to the CUP – the name to which the CPU reverted after the revolution – that the task of arresting the collapse of the Ottoman Empire required a new strategy that would utilize the idealistic expectations which had inspired the revolution to the ends they had envisaged. The difficulty was that while the call for a constitution also implied the re-opening of parliament, an institution designed to restrain the excesses of the powerful, the CUP, in the view of its most recent historian, 'had no desire for a pluralist political system in which various parties and societies would pursue their particular agendas. Rather, its leaders envisaged an umbrella organization under which all ethnic, religious and social groups would work together within limits carefully drawn by the CUP'.[86] Although very ready to harness popular sentiment in the weeks leading up to their coup, the CUP leaders saw parliament merely as 'an extension of the modern bureaucratic apparatus under the control of an enlightened governing élite'.[87]

During the remaining months of summer 1908 a variety of political proposals were put forward by the CUP. There was nothing remarkable in the CUP's desire to complete the modernization of the state by reforming finance and education and promoting public works and agriculture, nor in its espousal of the principles of equality and justice revealed when its manifesto, issued prior to the parliamentary elections held in October and

November 1908, reasserted the equality of the obligations and rights of all Ottoman citizens without regard to race or religion. The Christian communities of what remained of the Ottoman Balkans did not feel that the CUP any longer represented their aspirations, however, and expressed their hope for full implementation of the rights promised them – so they understood – under the *Tanzimat* reforms.[88] Those in the vanguard of reform had appropriated the notion of Ottomanism, but the contradictions implicit in the practical realization of this ideology – in persuading Muslims and non-Muslims alike that the achievement of true equality between them entailed the acceptance by both of obligations as well as rights – posed them a problem.

October 1908 saw the new regime suffer a significant blow with the irrevocable loss of three territories over which the empire still exercised nominal sovereignty. During the first week of the month Ottoman Bulgaria declared its independence of the empire and its union with independent Bulgaria (semi-autonomous Eastern Rumelia had already become part of Bulgaria as the result of a coup in 1885–6), Austria-Hungary formally annexed Bosnia-Herzegovina, and Crete, which had been under Greek administration for ten years, announced its union with Greece. The only crumbs of comfort were that the Ottomans could expect to be compensated by the winners for these territorial losses, and that the Sultan-Caliph's continuing religious authority over the Muslims of these regions was recognized.

Elections for a new parliament went ahead under laws carefully prepared and detailed in their provisions, and were keenly contested in a spirit of elation. CUP-sponsored candidates were opposed by the newly-formed Liberal Union (LU), to which some of those hostile to the CUP were attracted. Sabaheddin Bey, who returned from his long exile in September 1908, was not a founding member of the LU but he was its éminence grise and it espoused his view that in non-homogeneous provinces decentralized government was best. The party was poorly organized in the provinces, however, and failed to convince many minority candidates that they should contest the election under its banner; lacking organization, it also failed to tap into the continuing support for the old regime in less developed areas.[89] CUP candidates won a majority of the seats, and a bi-cameral parliament was opened by Sultan Abdülhamid on 17 December 1908.[90]

The Sultan and his closest advisers must have hoped that the cool reception accorded his opening speech did not mirror the general mood, but the reaction among the liberal classes to the grudging manner in which Abdülhamid had dealt with the re-opening of parliament was so unenthusiastic that it was decided to invite the deputies to a banquet at Dolmabahçe Palace at which

the Sultan's good intentions could be presented to them more clearly. His chief secretary Ali Cevad Bey was able to prevail on his master as to the content of the speech in which this was to be done: as he records in his account of the events of 1908–9, the deputies applauded without reservation. The press was not satisfied, however, and continued to attack the Sultan; he in his turn, feeling that he had done his duty, refused to descend from Yıldız Palace to the Çırağan Palace on the shore below for the customary Bayram reception, or to appear before parliament on occasions when protocol demanded his presence.[91]

Hand in hand with the dramatic developments of the summer of 1908 went an unprecedented liberalization in social and economic expression, particularly in the cities and above all in Istanbul. In 1901 women had again been the target of sumptuary laws detailing the length and thickness of the all-enveloping veil they were required to wear – even in a car, for those lucky enough to be driven in one – and, once such restrictive laws were relaxed, educated women eagerly seized freedoms they had hitherto been denied, dressing as they chose, becoming more visible in public life, attending meetings and setting up philanthropic and educational associations. It was in 1908 that the prominent intellectual and activist Halide Edip founded 'The Society for the Elevation of Women', which had links with Britain's suffragette movement. But old attitudes died hard and the empire's impotence in the face of the territorial losses of October 1908 brought crowds out onto the streets demanding the closure of theatres and taverns, prohibition on photography and – even as many were throwing off the veil – the re-covering of women: there were calls for nothing less than a return to the full implementation of Islamic law.

Another group which now felt free to protest against their conditions of existence were the workers. Ottoman subjects had always had the right to petition the authorities for the redress of perceived wrongs, and this means of defending their interests had persisted when other, non-traditional avenues of worker protest, arising from the unfamiliar forms and conditions of employment which were arriving in the empire as the industrialization of the economy proceeded, were proscribed in 1845 by a law – translated from a French law of 1800 – banning trades unions and strikes. This law had never entirely prevented episodes of intransigence and violence, and in 1908 protesters were prepared to risk reprisals on the part of police and troops in order to express grievances which had hitherto had no outlet. The protests multiplied as workers went on strike for wage increases and improved conditions in the mines, factories and railways where they laboured. The first anti-strike legislation since

1845 was passed by the government in October 1908 – even before parliament was opened – after a strike on the Anatolian Railway. In the three months following the revolution there were more than a hundred strikes: these were mainly in Istanbul and Thessalonica, but few regions of the empire remained unaffected and it is estimated that three-quarters of the industrial labour force of between 200,000 and 250,000 (comprising both men and women) went on strike at this time.[92] The 1908 strike wave was an indication that the aggrieved were no longer willing to be subservient as they had been in the past, and the retreat of Abdülhamid's repressive regime provided an opportunity, albeit limited, for the individual to seek an improvement in his conditions of life and work. According to a recent historian of the period, however, Ottoman strikers were 'crushed by gunboats, battalions and anti-strike laws, their paths of action curbed and the domination of the state reasserted'.[93] Like Abdülhamid and his predecessors, the CUP had little time to listen to the voices of 'the people', and saw any disturbance of public order as a threat to the tranquillity of the state – and gave its agents licence to suppress it.

For many of his subjects Sultan Abdülhamid still remained a being above criticism, the 'shadow of God on earth': at the time of the Anatolian tax revolts in 1905–7, for example, the population rejoiced and prayed for his long life whenever he intervened to dismiss bureaucrats and administrators they deemed corrupt. Such esteem and veneration forced political activists to find other causes to mobilize anti-government opinion.[94] The months of February and March 1909 were troubled as opposition to the new order built up: the liberal opposition in parliament vociferously accused the CUP of authoritarianism and in late March an association called the Muslim Union was founded, which through its mouthpiece, the newspaper *Volkan* ('Volcano'), incited Muslims to rise against the CUP.

On the day remembered by Turkish historians as 31 March 1909 – in fact, 13 April of the Gregorian calendar – a counter-coup began; this was based on the traditional alliance between disaffected clergy and disaffected troops – in this case, men of the First Army stationed in Istanbul and light infantry of the Third Army based in Thessalonica. The Third Army light infantry had gained notoriety six months earlier, when some of their number quartered in Istanbul put down a mutiny of soldiers who refused to embark for the ongoing campaign in Yemen. In mid-March 1909 they had been called upon again, this time to suppress a mutiny of Albanian troops stationed at the Yıldız Palace who refused to accept Anatolian troops serving with them. The women of the *harem* witnessed the arrival of the Third Army infantry and, anticipating the blood-bath which would surely ensue, screamed out in alarm, causing the order to fire to be rescinded: a volatile situation

was defused before a shot could be fired.[95] Now, however, disgruntled troops streamed into the Old City from their barracks across the Golden Horn to gather with other malcontents in the Hippodrome – scene of so many rebellions in the past. Their destination was no longer the Topkapı Palace, but the parliament building which lay hard by. Gradually the news came out that soldiers of the First Army and infantrymen of the Third Army had taken their officers prisoner. The cry which galvanized them as they marched on the city was a call for the restitution of Islamic law:[96] under the modernizing regime of which the army was the agent, the mutinous troops claimed, they were allowed no time for religious observance. Abdülhamid's preference had always been for officers who had risen through the ranks: he thought them more conservative, less likely to harbour liberal aspirations. Many such officers had been dismissed by the CUP after the 1908 revolution – which was spearheaded by graduates of the military academy rather than men up from the ranks. The dispossessed now seeking redress shared the same social background as the middle- and lower-ranking clergy who joined in their protest: these men were fast losing their role in public life as the empire changed. Moreover, since military service had been reduced to two years for those serving in particularly unhealthy climates such as Iraq and Yemen, rumours were rife that in order to raise more manpower, students at theological colleges were for the first time to become liable for conscription – this added extra tinder to the fire.[97]

The mob called for the heads of high-ranking CUP statesmen; the Sheikhulislam, acting as an intermediary, was informed of five demands: the dismissal of the Grand Vezir, the Minister of War and the President of the parliament; the removal of certain prominent CUP members; the full implementation of Islamic law; the dismissal of officers who were graduates of the military academies and the reinstatement of those who had come up through the ranks; and a promise from the Sultan that they would not be punished.[98] Resolution of the confrontation of 13 April was speedy: the government resigned, the rebels were pardoned, and the Sultan promised greater attention to Islamic law. The counter-coup, seen by some historians as the work of Abdülhamid and the palace – since members of the Ottoman family, among them one of the Sultan's sons and one of his nephews, and high-ranking palace functionaries, were apparently behind the '31 March Incident' and involved in planning its aftermath[99] – had apparently been successful.

The CUP reacted swiftly to what was perceived as a deal between Abdülhamid and the rebels. It was true that the government had tendered its resignation – albeit under duress – but the actions of the Sultan were those of an autocrat bound by no constitution and in defiance of parliament. Ten days later the Sultan and his staff found themselves isolated in

Yıldız Palace and under siege by what was referred to as the 'Action Army' – troops mostly drawn from the main body of the Third Army, under its commander Mahmud Şevket Pasha, hurriedly marched from Thessalonica. According to Ali Cevad Bey, by 27 April soldiers with bayonets were thronging every corner of the palace except for the *harem*, whose denizens were isolated and crying out in hunger. Mahmud Şevket protested that his troops had not come to depose the Sultan but the next day, following heated discussions in parliament, a delegation of deputies consisting of Aram Efendi, an Armenian, Karasu Efendi, a Jew from Thessalonica, and two Muslims, Arif Hikmet Pasha and Esad Pasha, arrived at the palace and announced that 'the people' had deposed the Sultan. Requesting that he be allowed to retire to Çırağan Palace, Abdülhamid, unable to accept that he was responsible for his own downfall, turned to Ali Cevad and chided him for being present when the oath of allegiance was sworn to his brother Reşad who now became sultan. Ali Cevad reports how he wept bitter tears as he protested his loyalty to Abdülhamid and the nation. Ali Cevad expected Abdülhamid to move to Çırağan the next day and was surprised when, that night, army officers attached to Mahmud Şevket arrived at Yıldız and ordered him to inform the Sultan of his immediate departure, 'for his own safety', to Thessalonica – home to the Third Army and headquarters of the CUP. Abdülhamid, carrying a small bag, and his immediate house-hold – his youngest son Mehmed Abid Efendi, his fifth son Abdurrahim Hayri Efendi and a number of concubines – climbed into four carriages and set off for the railway station to begin their journey into internal exile. It was recorded in the press that the deposed sultan drank a glass of water at the station, rewarding the man who brought it to him with a generous tip. Pained by his master's ingratitude, Ali Cevad Bey watched them go and in the morning retired to his house in the Bosporus village of Bebek.[100]

The constitution neither provided for the deposition of a sultan nor recognized the principle that sovereignty lay with the people: parliament therefore did not have sole power to sanction Abdülhamid's removal. The CUP saw itself as the repository of the people's will by virtue of its respon-sibility for the restoration of the constitution and its reimposition of order following the counter-coup, but lacked any legal justification for this view. The constitution did however declare Islam to be the religion of the state – so Islam could still be used to sanction the actions of those directing the state. The decision to depose Abdülhamid was therefore given legitimacy by resort to the solution acceptable in Islamic law: a juridical opinion of the Sheikhulislam.[101] The delegation that went to Yıldız to inform the Sultan of his deposition bore this with them.[102]

Whereas the counter-coup – the '31 March Incident' – had been almost

bloodless, the CUP retribution that followed was merciless. Among the almost 80 men court-martialled and hanged in the immediate aftermath were more than 50 soldiers, two pashas and the publisher of the newspaper *Volkan*, Derviş Vahdeti, as well as members of Abdülhamid's household. Many others were imprisoned, and common soldiers who had participated in the rebellion were sent to build roads in the Balkans.[103] The '31 March Incident' was not without repercussions in the provinces. During a mutiny of troops in Erzincan on 13 April – prompted by rumours that Islamic law was going to be re-instituted – the local CUP office was destroyed. Between 14 and 16 April, in circumstances that remain incompletely understood, thousands of Armenians were massacred in Adana and elsewhere in the area, and much of the city was burned. It was said at the time, on the basis of apparently reliable information, that the Sultan himself gave the order for the massacres and for the elimination of the local CUP, which still embraced the ideal of Ottomanism and counted on the support of Christians as much as of Muslims, and that agents provocateurs were sent to incite the Muslim population. In the city of Adana at least, Muslim religious leaders denounced the massacres and expressed their solidarity with the Armenian Church.[104]

Abdülhamid's brother Reşad came to the throne as Sultan Mehmed V. Parliament recognized that the Ottoman constitution was out of date, and in the revised version produced in the summer of 1909 – taking account of the tests to which it had been put by recent events – it made itself the pre-eminent source of authority in the empire. The powers of the sultan were officially restricted so that he no longer ruled, but reigned, and his function in government was limited to confirming the decisions made by parliament or the cabinet.[105] This was a very significant break with the past. One strong man emerged from the '31 March Incident' – Mahmud Şevket Pasha, who now enjoyed significant power as inspector-general of the First, Second and Third armies, based respectively in Istanbul, Edirne and Thessalonica, a position that put him, in effect, both above parliament and also above the CUP, whose instrument he had been in master-minding Abdülhamid's deposition. Parliament's newly-won sovereignty had been infringed even before it was established, by the imposition of martial law at the time of Mahmud Şevket's march on Istanbul to depose Abdülhamid: martial law remained in force for much of the following years.[106]

With the sultan rendered impotent in government, the next years saw competition between new contenders for power. Mahmud Şevket Pasha was never a CUP member, and insisted that the army should not be influenced by politics: he soon made plain his intention to act without

constitutional restraint. The CUP had won a majority in parliament in the elections held in 1908, fielding candidates in its identity as an 'association for the public good', but the lines between its political and military membership were blurred, as were those between the recognized deputies who had gained their seats by means of CUP patronage and the 'invisible' men of the extra-parliamentary, underground Committee. Resolution of these contradictions began in 1909, when the Committee officially abandoned its secrecy and became a formal political party – the Party of Union and Progress, known as the Unionist Party.[107]

CUP leaders considered that maintaining the empire intact called for draconian methods, and measures passed in late 1909 that included a further anti-strike law and laws limiting freedom of assembly effectively curbed expressions of opposition to the government.[108] Most significantly, a law for the conscription of non-Muslims was passed. As in past times, this again raised protest among minority community leaders, who demanded that their men serve in separate units from Muslim troops – and exemption could still be bought by those who could afford it.[109]

Parliament was slowly learning its role, but disagreement over the state budget in 1910 demonstrated where power really lay. Appointed to the cabinet as minister of war in the hope that this would limit his independence of action, Mahmud Şevket Pasha argued forcefully against a reduction in military expenditure – financial resources were scarce, and his colleagues wished to divert them to other ends – and had his way. He also triumphed in the matter of the fate of the treasures of Yıldız Palace: the military were suspected of having helped themselves freely when occupying the palace at the time of Abdülhamid's deposition, but Mahmud Şevket successfully blocked calls for an inquiry.[110]

If the civilians in parliament could not entirely control the military as represented by Mahmud Şevket Pasha, neither could the CUP entirely control the political process. Soon after the establishment of the CUP as a political party, a group calling itself the People's Party splintered off from the parliamentary Party of Union and Progress; outside parliament CUP repressions engendered opposition in the form of a number of political groupings which resembled one another only in their distaste for the CUP's centralizing, heavy-handed conduct. The murder of a liberal journalist in June 1910 signalled another round of anti-opposition activity, however. A similar murder had occurred only a few days before the '31 March Incident', and the authorities were wary. Arrests followed, and a story was put about of a plot afoot to overthrow the government.[111]

In November 1911 a party calling itself the Liberal Union – dissolved and reformed since it was founded in 1908 – had become the focus of

opposition to the government, and in an Istanbul by-election it won the seat; determined to strengthen its grip on parliament still further, at a time when wars were under way in Yemen and Libya, the CUP responded by using its parliamentary majority to force the dissolution of parliament. Resorting to intimidation and electoral fraud, the CUP was again returned as the majority party in the elections of early 1912.[112] Opposition voices had by now learnt from the CUP that unconstitutional actions achieved swifter results than waiting patiently for parliament to gain the confidence to assert itself without outside interference, and in July 1912 a secret organization of officers strongly opposed to the CUP forced the dissolution of parliament once more.[113] The Sultan announced new elections, but before they could be completed the empire had been plunged into war in the Balkans. The elections were cancelled, and it was more than a year before they could be held again.[114]

Adjusting to the new concepts of governance introduced by the establishment of a constitutional sultanate was a painful process exacerbated by continuing tension in the provinces and foreign pressure on Ottoman territory. Like many other ethnic and confessional groups Albanians had been members of the clandestine CUP in the years leading up to the 1908 revolution; indeed the revolution is said to have begun on 3 July – more than two weeks before the events in Istanbul – when an Albanian, Captain Ahmed Niyazi, with 200 men, took to the mountains between Ohrid and Monastir from where, in his own name, he issued a demand for the restoration of the constitution.* The removal of censorship after the revolution gave Albanians, like other subjects of the empire, freedom of expression, and the lively press resulting seized the opportunity to stimulate the growth of a national consciousness. Albanians of all faiths and political persuasions put forward a number of vociferous demands for greater self-determination, but following the counter-coup of 1909, however, the CUP leadership in Istanbul became suspicious of the Albanian national movement, and stoutly resisted it: to have conceded its demands would have been to acknowledge that the supposedly united Muslim community was at odds with itself. Concessions were also unthinkable for strategic reasons: Albania was the buffer which protected the heart of the empire from the covetous Europeans. An Albania whose loyalties could not be counted on was a source of great anxiety for the government. The issue around which matters coalesced was a CUP ruling outlawing the use of the Latin alphabet for

* The 1908 revolution is commonly known as the 'Young Turk' revolution, and the part played in it by non-Turks, such as Albanians, is only grudgingly acknowledged by Turkish nationalist historians.

the Albanian language in the public arena; this heavy-handed action drove a wedge between the formerly united Christian and Muslim communities, and resulted in armed resistance by both against government authorities in the region.[115]

The CUP decided to make use of the Sultan-Caliph himself to secure the loyalty of the inhabitants of this troublesome region which in past centuries had provided the empire with many of its most prominent statesmen and its most courageous soldiers. On 5 June 1911, Sultan Mehmed V went from Istanbul by sea to Thessalonica, where he sent his secretary to visit Abdülhamid in his exile and held numerous audiences with local notables and government officers. Here he received the 'honoured fighter' Captain Niyazi, before travelling inland by train to Skopje and on to Priština. On 15 June, anniversary of the defeat of the Serbian King Lazar and his army by Sultan Murad I at Kosovo Polje in 1389, he led the Muslim congregation in prayer at the site of the battle. He had been greeted by large crowds as he progressed through the Balkans, but fewer people than expected turned up at Kosovo Polje to see him. Newspaper editorials greeting his arrival back in Istanbul opined that he had 'returned with the keys to the hearts of the people of Rumelia',[116] but in truth neither his visit nor the attendant concessions made to local demands – such as the granting of amnesty to all convicts except murderers – served to forestall further unrest.

As in Albania, so in the Arab provinces of the empire both local and regional identities tended to prove more unifying than narrowly religious considerations. Consciousness of and pride in Arab culture had found expression since the *Tanzimat*, and particularly during Abdülhamid's reign when Arabs, historically excluded from high office in central government, were courted by him to give legitimacy to his Islamist claims as much as to forestall Arab moves towards independence from the empire. Arab opinion regarding the changes that took place in faraway Istanbul following his removal was ambivalent. More than a quarter of the approximately 280 deputies in the 1908 Parliament were Arabs.[117] Like the Armenians, many Arabs who participated in formal politics – either locally or in Istanbul – showed themselves more receptive to liberalism than to the radicalism and even violence of the CUP. As the CUP became more strident in its centralizing policies and, in keeping with its aim of forging an 'Ottoman' loyalty, in its refusal to recognize local diversities as a basis for representation, Arab sensibilities were offended. CUP imposition of Turkish in the secondary schools and law courts of the empire gave rise to the perception in some Arab circles that this struck not just at the very root of their Arabness but at the sanctity of the religion that united Turk and Arab, and this perception was used to bolster awareness of the threat CUP policies were seen

to pose to the great measure of autonomy traditionally enjoyed by the Arab provinces.[118] Ahmed Cevdet Pasha had warned Abdülhamid of the importance of respecting the Arabs, since their language was the language of Islam, and had pointed out the damage wrought by state officials who insulted Arabs by referring to them as 'fellahin', peasants.[119]

Attempts on the part of the CUP and the government to extend central government authority into areas hitherto controlled by local tribal chiefs resulted in serious uprisings in 1910 and 1911 in Syria and the Arabian Peninsula, in particular. Arab response to the drama being played out in Istanbul was diverse: Egyptian intellectuals, for instance, looked to the capital for inspiration in their struggle against the alien British, emphasizing their allegiance to the Sultan-as-Caliph, while the feelings of Syrian intellectuals who had left their homeland for Cairo to escape the encroachment of Ottoman central government on their traditional freedoms were quite otherwise.[120]

Abdülhamid's hopes of pre-empting European colonial designs in North Africa failed. Italy was unified in 1870, and following French occupation of Tunis in 1881 the Italian government began to state its interest in the region, and the Italian press to urge occupation of Tripoli. Italian claims continued to be repeated throughout the 1890s, and in 1902 local representatives met the Italian consul in Cairo to sound out Italy's intentions should it occupy the province. The consul replied that Italy sought merely to prevent encroachment by other European powers, but that should occupation be necessary, it would respect Islam; soon the Italians began to arm local people who were fighting the French. To the chagrin of the CUP, Italian business interests were quick to gain a foothold in Tripoli, and Italy began to compete with the empire for influence. A new Ottoman governor was sent to the province in 1910, but the Italians complained that he was obstructing their interests; in late 1911, keen not to lose out in the increasingly competitive struggle for colonial possessions, Italy invaded.[121] The Ottoman military forces of the province had been sent to fight in Yemen, where yet another rebellion was taking its course, and the defence of Tripoli – which, as War Minister Mahmud Şevket Pasha admitted, was indefensible – was undertaken by officers drawn from the CUP, including a young officer called Mustafa Kemal, and Major Enver, who encouraged local Sanusi tribesmen in a guerrilla war in the east of the province.[122] Enver entertained fantasies of the province as his own 'kingdom', leading Friday prayers and even printing paper money bearing his signature, and he held out until the autumn of 1912.[123] In April of 1912 Italian warships bombarded the Dardanelles, and in May went on to occupy the Dodecanese.[124] The Treaty of Ouchy (near Lausanne) of October 1912 formalized the loss of the Ottoman province of Tripoli to the Italians. From now on, the Ottomans

would be fighting a defensive war – almost without interruption – until 1923 and the end of the empire.

Hardly had the empire concluded its war in the Yemen – in 1911 – and begun peace negotiations with Italy, than a far more deadly struggle began in the Balkans, where the small, newly-created states in this volatile region vied with one another, even while feigning co-operation, to press their own national claims. Various alliances agreed between Serbia, Montenegro, Greece and Bulgaria following the outbreak of the war with Italy were translated into action early in October 1912 when these states, having demanded far-reaching administrative reforms in the Ottoman Balkan provinces, mobilized against the ill-prepared Ottomans. Thus began the First Balkan War.[125] The remaining Ottoman Balkan territories were of immeasurably greater significance to the empire than Tripoli, and Enver left North Africa for the Balkans late in 1912, confident that he could save them. But by the time he and his fellow officers reached Istanbul, the Ottoman army had retreated to the Çatalca lines some 50 kilometres west of Istanbul – established in 1877–8 to defend the capital from Russian attack. The lines held, and in December the Balkan allies agreed a cease-fire. Deliberations at a subsequent peace conference in London were protracted by the irreconcilable claims of the various Balkan states.[126]

Some of the terms of the proposed treaty became clear at an early stage, however, among them that Edirne, still under siege by the Bulgarians, should pass to their possession. The Ottoman government headed by Grand Vezir Kamil Pasha (known as 'İngiliz' – 'English' – Kamil, from his close relations with Britain over more than twenty years) favoured concessions so unthinkable as to again prompt the military, as 'guardians of the state', to take action to compensate for the perceived failings of the parliament. On 23 January 1913, a contingent of troops led by Enver burst into the cabinet chamber, shot dead the war minister Nazım Pasha, and elicited Kamil's resignation at gunpoint; Enver and his closest allies then requisitioned the Sheikhulislam's car and drove to the palace where they forced the Sultan to appoint Mahmud Şevket Pasha grand vezir in Kamil's place. He also became war minister again, having lost the office a few months previously.[127] This precipitate and unconstitutional action left the course of domestic politics and the task of rebuffing the attacks of external enemies in Mahmud Şevket Pasha's hands: his government rejected the peace terms emerging from the London Conference, and the Bulgarians resumed their bombardment of Edirne. Enver proposed to Mahmud Şevket that he lead an attack on the Bulgarians from the west but this plan to relieve the city ended in fiasco, and it surrendered to the Bulgarians on 24 March 1913; a peace agreement was signed in London on 30 May.[128]

Enver's coup had overthrown the government, but it did nothing to enhance the ability of the Ottoman army to defend the empire's borders, and it seemed likely that the CUP would lose support. The disaster of the First Balkan War discredited Mahmud Şevket Pasha. On 11 June 1913 he was assassinated, and the twelve men allegedly responsible for his death were hanged – this was an opportunity for the CUP to round up opponents. The Second Balkan War had begun when an outbreak of fighting between Bulgaria, Serbia and Greece over the division of territory caused Bulgaria to transfer forces from her new eastern border in Thrace to Macedonia. Ottoman troops moved westwards to fill the vacuum left by the Bulgarian retreat and won the CUP a chance to show its mettle. Edirne was retaken – Enver rode into the city at the head of the triumphant troops, upsetting the corps which had liberated the city – and the army pushed west across the Maritsa–Tunca line. The subsequent peace between the empire and Bulgaria left Edirne in Ottoman hands, and settled the western border of Turkey as it is today.[129]

The aftermath of the January 1913 coup left leading CUP members with a stranglehold on government, but the party had lost its Macedonian power-base in the Balkan Wars. British propaganda emanating from their base in Egypt was ever more strident in its denuciation of the Turks, and blatant in its efforts to drive a wedge between them and the Arabs. It was apparent to the Istanbul government that the single largest non-Turkish group in the empire must be conciliated. An article in the *Egyptian Gazette* on 22 April 1913 demonstrated this to be a matter of the utmost urgency:

> The struggle is between Semitic Mohammedan and Turk Mohammedan. Race is the fundamental fact. And the Turk physically differs from the Arab as a drayhorse differs from a Derby winner. Greater still is the difference intellectually and spiritually, between the slow, placid, steady, autocratic, materialistic, unspeculative, unaesthetic Turk, and the quick-witted, restless, democratic, political, romantic, artistic, versatile Arab.[130]

The Istanbul government worked hard – and, considering its previous stance, surprisingly sensitively – to accommodate Arab demands for a more acceptable style of provincial rule. The reinstatement of Arabic in law courts and secondary schools, and in petitions and official communications, elicited much positive response: it was only a few years since the use of Turkish as the common language of the empire had been seen as a tool of integration, but the requirement to use it had been a cause of considerable bitterness among the Sultan's Arab subjects. Another proposal under consideration for a time was to abandon Istanbul, so strategically vulnerable, for a more central, possibly Arab, capital. This idea had been

favoured by Mahmud Şevket Pasha who was from Baghdad. He had thought Aleppo to be the location that would redress Arab feelings of estrangement from the Ottoman government; others, fearing that the Arabs would not in any case long remain within the empire, suggested an Anatolian capital.[131]

But the greatest compromise forced upon the CUP government in 1913 by the logic of prevailing circumstances was that it must use Islam as a political instrument to cement Arab allegiance to the Ottoman state and its caliph, and thus as a brake on separatist tendencies. This echoed Abdülhamid's tactical use of religion: given that loss of territory had rendered 'Ottomanism' little more than an anachronism, there seemed no alternative to a version of 'Islamism' attuned to contemporary circumstances as a means of ensuring the loyalty of the Muslim Arabs of the empire. The 1914 elections saw better representation of Arabs in parliament than ever before.[132] Like many another community alienated by an overbearing central government, Ottoman Arabs as a whole were nevertheless as yet unable to envisage a different framework for their existence: even the Libyan war and its exposure of the manifest inability of the Ottoman army to protect Arab Islamic lands from foreign aggression barely shook Arab allegiance to the empire.

The loss of western Thrace, Macedonia and Albania in the wake of the Balkan Wars was a body-blow to the Ottoman Empire which had controlled much of these territories since the fourteenth century. The refugee crises of the nineteenth century were re-enacted afresh as Balkan Muslims fled towards Istanbul. One who left Macedonia well in advance of his former subjects was the deposed Sultan Abdülhamid. In October 1912 he was put aboard a German ship in Thessalonica and taken to Istanbul, to the Bosporus palace of Beylerbeyi, where he lived out his days. It was not as secluded as Yıldız; at Beylerbeyi he was unable to shut out the world which was changing dramatically before his very eyes.

16

The storm before the calm

THE ECONOMIC CRISES of the nineteenth century, coupled with aggressive exploitation and tutelage on the part of industrializing European states, had forced a semi-colonial status on the Ottoman Empire. Many of the new economic and infrastructural enterprises of Abdülhamid's reign – such as insurance companies and banks, ports and railways – were foreign-owned, sometimes in partnership with Ottoman non-Muslims; the high cost of servicing the public debt consumed much state revenue and the debt was, moreover, administered by a council of seven, of whom five members were foreign. By providing a scapegoat for the ills of the empire these inescapable signs of humiliation worked to the advantage of the CUP; more positively, revision of the disastrous peace terms being discussed in London in December 1912 – brought about by the retaking of Edirne early in 1913 – had a similar effect. The liberal opposition, having flexed its muscles with the forced dissolution of parliament in 1912, had been crushed by means of the executions that followed Mahmud Şevket Pasha's assassination in June 1913. The execution of former officials had been an exception since the 1840s; exile had been considered sufficient punishment – and was frequently followed by rehabilitation. Seventy-five years later, during the second and third constitutional periods of the Ottoman Empire, the fate of those in public life could be far more brutish.

In January 1914 Enver, now promoted pasha, became minister of war; the military governor of Istanbul, (Ahmed) Cemal Pasha, who had been responsible for exacting revenge against the liberals after Mahmud Şevket's assassination, became minister for the navy; and former postal official Talat, for long a pivotal figure in the civilian wing of the CUP, served as minister of the interior. The parliament that emerged from the elections in 1914 reflected better than hitherto the ethnic composition of the Ottoman population, with more Arab deputies – some of them in the CUP – than in previous parliaments.[1] The CUP was in the majority, and thus preserved from effective political challenge: it put forward coercive measures as 'the will of parliament', and the result was authoritarian government.[2] For the next four years, any other input into the political process was restricted still

further by the outbreak of the First World War. A recent writer has summed up the situation with this question and answer: 'Could the Ottoman government of 1914 be described as a personal dictatorship under Enver, a single-party state under the Union and Progress party [CUP], or a straightforward military regime? The answer probably lies between all three.'[3]

On 28 June 1914 the Habsburg heir-apparent Archduke Franz-Ferdinand was assassinated by a Serbian nationalist in Sarajevo. Austria declared war on Serbia on 28 July and Russia decreed a general mobilization on 31 July, prompting Germany to declare war on Russia on 1 August. On 2 August Germany invaded Luxembourg, and on 3 August declared war on France. Germany marched into Belgium on 4 August, and that same day Britain declared war on Germany.

The Ottoman Empire was taken into the First World War as the result of diplomacy as secret as most CUP activity. On 22 July, before it was certain that war was inevitable, Enver Pasha had proposed an Ottoman–German alliance to Baron von Wangenheim, the German ambassador in Istanbul, and the grand vezir Said Halim Pasha had made similar propositions to the Austro-Hungarian ambassador. Neither diplomat received the proposals with much enthusiasm, but as events brought the likelihood of war closer, an agreement committing the empire to support Germany – were Russia to intervene in Austria-Hungary's dispute with Serbia, and Germany therefore be required to support its ally Austria-Hungary – was negotiated, and received the Sultan's blessing before being signed on 2 August. The government's official stance was one of armed neutrality, leaving the other Great Powers guessing as to Ottoman intentions.[4]

Following the Balkan Wars attempts made by the CUP to forge closer links with Britain, Russia and France had received no positive response,[5] but it was nevertheless not a foregone conclusion that the empire would align itself with Germany, despite Germany's close and long-standing military and economic influence. Enver had been military attaché in Berlin from 1909 to 1911, but his relations with the German military mission in Istanbul were far from easy, and in particular those with its chief, Otto Liman von Sanders: as a patriot he put his faith in the Turkish soldier and the Turkish army, and deeply resented German instruction.[6]

Military experts from Prussia were advising on the modernization of the Ottoman army as early as the 1830s. In 1880, in the uncertainty following the Treaty of Berlin, Sultan Abdülhamid had asked the German chancellor Otto von Bismarck to provide him with military and civilian advisers. To the Sultan, Bismarck's Germany, a nation that eschewed alliance with either Britain or Russia, was neutral with regard to the Ottoman Empire: this

was not entirely the case but the fiction served the interest of both parties. Military contacts continued, and Ottoman officers visited Germany for training – Mahmud Şevket Pasha, for instance, spent ten years there. These contacts had paid dividends in improving Ottoman military performance, and the importance of this in a state so heavily reliant on the army for its survival was such that the assistance Britain provided to the navy and France to the gendarmerie could not hope to yield equal influence. In its turn, German assistance to the Ottomans boosted German domestic industry, particularly armaments and steel; the most visible and prestigious German investment in the Ottoman Empire was the Berlin–Baghdad railway, for which German industry largely provided both rolling stock and rails. The concessions for the two main sections across Ottoman territory, from Konya to Baghdad and Baghdad to the Persian Gulf, were awarded in 1888 and 1903 respectively, and Germany was glad to be paid by the kilometre to assist the Ottomans against what was seen as British encroachment in the Gulf, and in the extension of Istanbul's writ in the empire's furthest provinces. Kaiser Wilhelm II, the only European head of state received by Abdülhamid, visited Istanbul in 1889 and both Istanbul and Syria in 1898.[7]

Peremptory action by Britain also had a part in inclining the Ottomans to the German side. Aware that the Istanbul government was unlikely to be allied with the British in the impending war, on 28 July 1914 Winston Churchill ordered the seizure of two warships being built for the Sultan's navy in British shipyards. Having been paid for by public subscription, these ships already belonged to the Ottomans – and the public was duly outraged. On 10 August two German cruisers – the *Breslau* and the *Goeben* – were permitted to enter the Dardanelles to escape the British ships pursuing them, and were soon turned over to the Ottoman navy as some recompense for the vessels held by the British.[8]

The imminence of war in Europe inspired Ottoman statesmen to take a number of defiant steps symbolizing a bid to free the empire from its thraldom to western economic interests. On the day of the signing of the alliance with Germany, the government announced the ending of foreign debt repayments.[9] The German ambassador in Istanbul proposed a joint protest with the empire's other creditor-states, on the grounds that international regulations must not be unilaterally abrogated, but no agreement could be reached on the text of the protest note; the Ottoman government would make no concessions and the matter soured Ottoman–German relations throughout the war.[10] Another issue guaranteed to mobilize Muslim opinion against western interests was that of the capitulations, which had long served as a convenient scapegoat for the ills of the Ottoman state. Successive governments since 1908 had sought their abolition but the Great

Power beneficiaries of the status quo had resisted. On 9 September 1914 they were unilaterally abolished, to expressions of popular support, both spontaneous and CUP-sponsored.[11]

On 29 October, with the *Breslau* and the *Goeben* – renamed *Midilli* (the Ottoman name for Lesbos) and *Yavuz* ('Stern') *Sultan Selim* – under his command, Admiral Souchon of the German navy, commander since 9 September of the Ottoman navy, shelled the Russian ports of Odessa, Nikolayev and Sevastopol, sinking many Russian warships. This action sealed the Ottoman Empire's fate – Russia declared war on 2 November, and Britain and France on 5 November. On 11 November 1914 Sultan Mehmed V Reşad declared war on Britain, France and Russia. Two days later, in the chamber housing the relics of the Prophet at Topkapı Palace, at a ceremony in the Sultan's presence, 'holy war' was proclaimed.[12] Five juridical opinions legitimized the call, for the first time addressed to all Muslims – particularly those in territories ruled by the colonial powers of Britain, France and Russia – to rise against the infidel. There was some enthusiasm for this appeal to the Muslim community at large among Arab clerics, but one of the key individuals whose support was critical, the Sharif of Mecca, Sharif Husayn, refused to associate himself with the Sultan's rallying cry on the grounds that were he to rouse local Muslim sentiment, he might provoke a blockade, and possibly bombardment, of the ports of the Hijaz by the British – who occupied Egypt and controlled shipping in the Red Sea. Reaction from elsewhere in the Islamic world was muted – in Egypt and India, for instance, juridical opinions asserted that it was obligatory to obey the British.[13]

Between the Ottoman army's headquarters in Istanbul and many of the theatres of war in which that army was involved lay the great land mass of Anatolia. Communications had improved greatly over the past fifty years, but the road and rail network was hardly adequate to the demands of wartime: the mobilization and supply of troops posed insurmountable logistical difficulties. It took more than a month to reach Syria from Istanbul, for example, and nearly two months to reach Mesopotamia. Railway-building proceeded apace, but inevitably there were gaps in the system, and troops and supplies were forced to rely on boat, truck and camel. The border with Russia was no better served: the head of the railway was only 60 kilometres east of Ankara, and it was 35 days' march to Erzurum from this point.[14] Roads were poor, and the sea lanes risky owing to the presence of the British navy in the Mediterranean, and of the Russian in the Black Sea. The Ottoman Empire was an agricultural state which had thrown itself into an industrialized war. It could raise an army but lacked the capacity to support it adequately.[15]

The defence of the Ottoman Empire against enemy aggression was

concentrated at different times on four widely separated fronts: east Anatolia and the Caucasus, the Dardanelles, Iraq, and Syria and Palestine. The early months of the war did not bode well for the Ottomans, for German support did little to ensure their success. The British captured Basra in November 1914, and marched north into Iraq. The army led by Cemal Pasha – as commander of the Fourth Army – to eject the British from Egypt was stopped at the Suez canal in February 1915, and again the next summer. In the snows of north-eastern Anatolia in January 1915 Enver Pasha lost almost 80,000 of the men he commanded, in battle against Russian forces at Sarıkamış, in an attempt to avenge the territorial losses of the 1877–8 war; 60,000 Ottoman soldiers died in the winter of 1916–17 on the Muş–Bitlis section of the front. Ottoman victories were few and Pyrrhic: the repulse of British forces in Palestine in the spring of 1917 was followed by the loss of Jerusalem in December of the same year, and though what remained of the British army besieged at Kut-al-Imara in southern Iraq between December 1915 and April 1916 was taken captive, Baghdad fell to the British only six months later. While Kut still figures in the Turkish imagination as an Ottoman victory, the only lasting military success achieved by the empire's army was the defence of the Dardanelles in 1915–16 – the Gallipoli campaign – which was not only a tremendous strategic victory but provided a necessary psychological boost, and somewhat vindicated the Ottomans in the eyes of their German allies. Ottoman losses at Gallipoli were terrible: statistics give some 90,000 dead with 165,000 wounded – but this is undoubtedly an underestimate.[16]

Ottoman loss of life over the four-year war as a whole was equally horrific, and many more died of illness than of their wounds. Estimates put the number of soldiers killed in action at 325,000, while the number of wounded – of whom some 60,000 subsequently died – varies from 400,000 to 700,000. A further 400,000 men died of disease, bringing the total number of Ottoman combatants who died to almost 800,000. The number of effectives fell by half between March 1917 and March 1918, from 400,000 to 200,000, and was halved again by the time of the armistice in October 1918, when the number of Ottoman men under arms was only 15 per cent of what it had been in early 1916 when the army was at maximum strength of 800,000. Tens of thousands deserted. The main burden of providing combat manpower fell on the Turkish peasantry of Anatolia, which accounted for some 40 per cent of total Ottoman population at the outset of the war.[17] One result of the enormous loss of life was a shortage of manpower to work the land. At a time when the army's requirements took precedence over civilian needs, those left at home often endured conditions as miserable as those serving at the front.

The war tested to the limit the empire's relations with its Arab popula-

tion. Although Ottoman Arabs largely retained their traditional loyalties – the most deep-seated being to the sultan as caliph of Islam – the exigencies of the war were fostering new attitudes. Returning humiliated from his Egyptian campaign in February 1915 to Syria, where he exercised absolute power in both military and civil affairs, Cemal Pasha convinced himself that an uprising amongst local Arabs was imminent, and instituted a reign of terror. Leading Arabs were executed, and notable families deported to Anatolia in the cause of eliminating those he deemed hostile to the CUP; in defiance of current CUP policy, the exclusive use of Turkish was reimposed. Cemal's policies did nothing to alleviate the famine that was gripping Syria; rather it was exacerbated by a British and French blockade of the coastal ports, the requisitioning of transports, profiteering and – strikingly – Cemal's preference for spending scarce funds on public works and the restoration of historic monuments. Already by 1914 the burden of financing the government and administration of the empire had begun to fall ever more heavily on the Arab (and Anatolian) provinces as a consequence of the empire's loss of territory – and taxes – in the Balkans.[18] Cemal's harsh regime in Syria made for widespread Arab resentment, though this had yet to take the form of nationalism as it was understood by the European powers with their long experience of stirring up Ottoman subjects in the Balkans.

The British had not hitherto interested themselves particularly in the Arab lands between Egypt and the Arabian Peninsula – regions critical for control of the route to India – but the continuing chronic instability in Istanbul led them to reconsider their role in the Near East, and to explore ways in which anti-Ottoman Arab sentiment could be manipulated to their advantage. At the same time, they could not afford to ignore the interest France was displaying in the region. The suggestion of some Arabs that choosing an Arab caliph would enable them to distance themselves from the Ottomans was therefore quite acceptable to British policy-makers, for whereas Christian Arabs in general inclined to France, the Muslims, who in Syria were the majority, inclined to the British. In June 1916 the so-called 'Arab Revolt' broke out in the Hijaz: its origins lay in an opportunistic bid by Sharif Husayn to expand his influence. In August he was replaced by Sharif Haydar, but in October he proclaimed himself king of Arabia and in December was recognized by the British as an independent ruler. There was little Istanbul could do to influence the course of events, other than try to prevent news of the uprising spreading, lest it demoralize the stricken army or act as a spur to anti-Ottoman Arab factions.[19] It was strange enough that the Ottomans were allied in a holy war with Germany, an infidel power; to have invited German troops to assist in the defence of the Muslim Holy Places would have been out of the question.

The course of events in the Arab lands during the First World War is still the subject of debate – and a full treatment is outside the scope of this book. For too long, British romanticization of the Arabs and demonization of the Turks predisposed an eager audience to believe T. E. Lawrence's fictionalized account, and to ignore historians' analysis of the reality on the ground. As in the nineteenth century the Powers mistrusted one another, and inasmuch as they saw in the war an opportunity to reduce what remained of the Ottoman Empire still further, they also knew that they must be vigilant against one another's claims: intense diplomacy as well as fighting continued throughout the war. Britain's strategic concerns at this time have been characterized thus:

> The scenario commonly envisaged by British planners was of a post-war situation in which the dominant fact in the Near East would be the Ottoman–German alliance, a view shared by German planners. British plans were made with the notion of limiting the possible damage to their interests from such an alliance; the most obvious way was by limiting Ottoman authority over parts of the empire.[20]

As each Power manoeuvred to achieve its ends, various plans and agreements resulted, which would be signed and sealed at the peace conference that would inevitably follow the end of the war. In the series of diplomatic exchanges known as the Constantinople Agreement – concluded in March–April 1915 – Britain and France promised Russia the Straits and Istanbul following victory in the war; the Treaty of London of the following month recognized Italy's claim to influence in south-west Anatolia; France and Britain both put forward claims to Syria, and as these and other agreements regarding the Arab provinces of the empire were discussed, Russia demanded Ottoman territory on its border in north-east Anatolia. Post-war arrangements for Syria were complicated by the question of Palestine, and Britain, fearful of the effect an Ottoman sultan-caliph might have on the millions of Muslims under British rule, opened discussions with Sharif Husayn about an Arab caliphate and an independent Arab state. The details of the proposed Ottoman partition and how this Arab state might look were worked out during 1915 in the correspondence between Husayn and the British High Commissioner in Egypt, Sir Henry McMahon, and in the agreement between a British negotiator, Mark Sykes, and his French opposite number, François Georges-Picot. Although these two documents were broadly compatible, they differed in essentials about such matters as the status of Palestine and the extent and degree of independence of a future Arab state. Arrangements made early in the war could hardly have been expected to stand the test of time: the course of the war and shifting national priorities – by 1917 the Ottoman military effort was collapsing, and Russia

was in the throes of the Bolshevik Revolution – had rendered these partly (although not entirely) void. In 1917, also, the United States entered the war, and President Woodrow Wilson's doctrine of self-determination for new states began – perforce, if almost imperceptibly at first – to influence the colonial attitudes of the Great Powers who had never before paid much heed to the wishes of those whose fate they were deciding.[21]

The First World War altered Ottoman society in ways no political or ideological programme had succeeded in doing – and in the long run brought the empire's dissolution. Each stage of the territorial dismemberment of the Ottoman domains had consequences for the ethnic and religious make-up of the state, as successive waves of people arriving from predominantly Muslim regions forfeited by the empire compensated for the loss of many, though certainly not all, non-Muslim Ottoman Christians – the Greeks, Bulgars and Serbs who saw a rosier future in their own national states.

Ottoman Jews subscribed to the idea of 'Ottomanism' for longer, continuing to hold prominent positions in the CUP even after the 1908 revolution.[22] In the early years of the century about half of all Ottoman Jews lived in Thessalonica – where many had settled after their expulsion from Spain and Portugal at the end of the fifteenth century; they had shown little interest in Zionist efforts to establish a Jewish homeland in Palestine during the reign of Abdülhamid, and few chose to go there when Thessalonica was lost to Greece in 1912, migrating instead to France, Britain, Egypt, Brazil, South Africa and the United States.[23] Following the 1908 revolution, a branch of the World Zionist Organization was established in Istanbul; until the First World War its activities focused on cultural matters, although political aims were never absent from its programme.[24] Zionists supported the survival of the empire until the early stages of the war – they tried to form a group to provide medical assistance to the Ottoman army during the Balkan Wars of 1912–13, and to assist the war effort after 1914; Zionist groups also offered to contribute towards the cost of the Hijaz railway. Many of them saw a homeland within the Ottoman Empire as the best guarantor of their security.[25]

Whether they favoured gradual or revolutionary change, Armenians too had had close, if uneasy, relations with the CUP; like other non-Muslim groups, they came to prefer the liberal wing of the Committee, and after 1911 usually sided with the opposition. Many, however, saw a chance of achieving an independent state if Russia won the war, and Russian propaganda encouraged them in this hope; in the event, the Armenian population of Anatolia barely survived. During the first year of the war Russia armed Armenian insurgents who fought against their own government in

north-east Anatolia – and who were accordingly regarded as traitors by Istanbul. Following Enver Pasha's vainglorious defence of the Ottoman front at Sarıkamış and in the face of a Russian advance, on 25 February 1915 the order was given for Armenian soldiers in the regular army to be disarmed, lest they go over to the Russians and fight with them. Transferred to auxiliary battalions responsible for providing the fighting arm with logistic and other services, they found themselves at the mercy of armed Muslim soldiers detailed to keep order among them.[26] In eastern Anatolia attacks on Ottoman government offices, on representatives of the government, and on Muslim civilians alike went on throughout the early months of the war and, with the war effort in peril on all fronts, the government decided on 24 April 1915 to deport the Armenians of eastern Anatolia to Syria and Iraq, well away from the Ottoman–Russian front line. Matters became yet more alarming for the Ottomans when in mid-May a Russian–Armenian army reached Van – driving out the garrison and massacring the population before setting up an Armenian 'state'[27] – and on 27 May the government passed the 'Deportation Law', whereby the military authorities were authorized to relocate the Armenians around Lake Van and in the province of Van southwards into south-east Anatolia, to break up concentrations of Armenian population considered breeding-grounds for anti-Ottoman rebellion. Government orders included strict instructions on ensuring the safe conduct of the Armenian deportees,[28] yet eyewitness reports from foreign consuls, missionaries and soldiers in eastern Anatolia told of terrible suffering as thousands died on the march and thousands more were massacred. Detailed regulations were also given for the protection of these people's property,[29] but in the autumn of 1915 legislation passed the Ottoman parliament for expropriation of the assets of the Armenian deportees.[30]

Of the multitude of controversies in Ottoman history, 'the Armenian question' is the one least open to detached debate on the part of either the inquiring layman or the historian. The 'question' today has come to focus exclusively on whether the massacres constituted genocide – itself a term whose very meaning is the subject of acrimonious debate, the provisions of the 1948 UN Convention on Genocide notwithstanding – and all other aspects of this acutely sensitive matter tend to be scrutinized for their value in clarifying this central point. This focus, and the thicket of argument and counter-argument which attends it, bedevil any wider understanding of the history of the fate of Ottoman Armenians. For most Armenians – a people who exist today in an impoverished landlocked state in the Caucasus, or as besieged minorities in their former homelands in the Middle East, or in communities scattered across the globe – it is an article of faith that the wartime Ottoman government was seeking their extinction. They cite millions

of dead, point out that Armenians living blameless lives far away from the front were also killed or forced to leave their homes, and accuse successive Turkish governments of failing to make the contemporary archives fully available to researchers – even of having destroyed the evidence. The Turkish case rests on a number of contentions: that the whole idea that the government of the time ordered the massacres is a nonsense; that more Turks – for 'Turks', read 'Muslims' – than Armenians were killed in the war; that the fifth column activities of some Armenians made their deportation inevitable; that an Armenian community still exists in Istanbul, demonstrating that the extermination of a whole population was never intended and that the term genocide is therefore inapplicable; that the military tribunal subsequently set up to try those suspected of war crimes was illegitimate since the Allies occupied Istanbul at the time; and that the desperate situation in eastern Anatolia in the early years of the war set Kurd against Armenian in a civil war within the larger conflict as they struggled for dwindling resources.

The 1948 Convention on Genocide outlaws the destruction 'in whole or in part' of a national, ethnic, racial or religious group, 'as such'. That terrible massacres took place on both sides is not in doubt; the devil is in the detail, and only genuinely disinterested historical research will establish whether the deportation and death of the Armenians of Anatolia constituted a genocide or not – if that is what must be determined. No 'smoking gun' has been found in the Ottoman archives, but this cannot be taken as evidence that no order was given: documents can be lost perfectly innocently, as well as removed. Some who accept Ottoman culpability suggest that the massacres were ordered by the 'Special Organization', a secret society of military men inside the CUP which was started by Enver Pasha and under his control at the start of the war, but its records no longer exist. A contemporary anti-CUP journalist and popular historian, Ahmed Refik (Altınay), writing in 1915 following the massacre of Muslims in Van, lent this view credence:

> At the beginning of the war numerous bands were sent from Istanbul to Anatolia. They consisted of murderers and thieves freed from prison. They were trained for a week in the War Ministry square and then sent to the front with the help of the Special Organisation. It is these bands which committed the worst crimes in the Armenian atrocities.[31]

Ahmed Refik's testimony would seem to shift the burden of guilt to a clandestine body, but does not thereby necessarily exonerate a government whose relations with the Special Organization remain unclear. Circumstantial evidence does not constitute proof, however, and judgement must await the completion of research: the 'narrative gap in Ottoman Armenian history',[32] whereby the story of the intercommunal violence that took place

in Anatolia and Syria during the First World War is told predominantly from one side – the Armenian – certainly demands redress. What is clear, however, is that the issue of the 'Armenian genocide' not only continues to bedevil Turkish foreign relations around the world but consigns Armenia, which borders Turkey and is officially at war with another of its neighbours, Turkey's ally Azerbaijan, to a wretched existence.

It is also clear that the war devastated the already weakened Ottoman economy. The economic policies – or the 'national economy' – instituted at the outset of the war, in a complete reversal of the liberal regime which had pertained for centuries, had two main components. The immediate purpose of the abolition of capitulations and the cancellation of foreign debt repayments was to reduce the foreign stranglehold on the Ottoman economy; a second purpose – and one to which great political weight was attached – was to extirpate non-Muslims from the economy by transferring assets to Muslim Turks and encouraging their participation with government contracts and subsidies. From this grew a class of Muslim businessmen of whom the most enterprising prospered by exploiting the extraordinary demand created by the war, and the inflation, speculation and opportunities for profiteering that it brought. Some received lands and business expropriated from Armenians and Greeks. The majority did not, however, and the economy took many years to recover.[33]

Great Power politics had changed irrevocably by the end of the First World War. The empires of Russia, Austria-Hungary and the Ottomans had either collapsed or were so weak as to be of no strategic consequence, and the fortunes of the Allies – Britain, France and Italy, which had entered the war in 1915 – were in the ascendant. The war exhausted all parties, however, and the victors had more pressing concerns closer to home than the immediate fate of the Ottoman Empire, so a militarily-imposed post-war solution was out of the question. On the other hand, multi-ethnic empires had manifestly failed to satisfy the aspirations of large numbers of their subjects for many years, and national states were widely viewed as the wave of the future. Mandates and spheres of influence within a nation-state were seen to be the answer, allowing the Allies to continue to reap the economic and political rewards they desired, just as they had in the Balkans in the nineteenth century. Another critical factor in determining the configuration of the post-war settlement in the Ottoman Empire was the perceived opportunity to punish the Muslim state that had for so long defied European designs. To this end, 'the Turk', as the jingoistic idiom of the day in Britain, for instance, designated the Ottoman Muslim population, must be crushed for ever, and the remaining Christian

and Jewish subject peoples of the empire set on the road to self-determination.

For the Ottomans the end of the war followed the collapse of their ally Bulgaria in September 1918, which left Istanbul open to an Allied advance. The cabinet sought an armistice, and negotiations were concluded on 30 October 1918 aboard a British ship moored off Moudros on the island of Lemnos in the northern Aegean. The most immediately alarming of the calculatedly vague provisions was Article 7, giving the victors the right to occupy 'any strategic points in the event of a situation arising which threatens the security of the Allies', while Article 24 allowed for Allied occupation, 'in case of disorder', of the six Armenian provinces in eastern Anatolia[34] – Sivas, Elazığ (Mamuretülaziz), Diyarbakır, Bitlis, Erzurum and Van. Two days later leading CUP figures – Talat, Cemal and Enver among them – fled Istanbul for the Crimea, from where they went on to Berlin.[35] On 13 November the Allies arrived to occupy Istanbul,[36] in apparent contravention of the implications of an undertaking given by Admiral Calthorpe, Royal Navy commander in the Mediterranean and one of the two British principals in the negotiations, to inform the British government that this would not happen as long as the Ottoman government was able to ensure the security of Allied lives and possessions there.[37]

The Allies moved swiftly to establish their occupation of Istanbul; the British were first, and soon followed by the French and the Italians. In due course each power was allocated a district of the city to police: the British occupied Pera, Galata and Şişli, the French occupied Istanbul proper and the suburbs to the west, and the Italians the Asian shore of the Bosporus – but they were at odds with one another.[38] Their inability to resolve even administrative matters in an amicable fashion was symbolized by the curious episode of the movement that emerged almost immediately to convert Ayasofya – occupied since before the Allied occupation by Turkish troops – back to a church from the mosque it had been for over four and a half centuries. Militant Christian opinion saw in the occupation a chance to reclaim the former Byzantine basilica, and the return of the building to the Oecumenical Patriarch, under the impetus of philhellenic sentiment in Britain, was seen as a means of cementing a strategic alliance with Greece. The first intimation that division between Orthodox and Latin Christians retained all its power to excite passions came with an unexpected proposal that the church should not be Greek Orthodox at all, but Greek Uniate, in union with Rome. The argument for this rested on an assertion that at the time of the conquest of Constantinople by Sultan Mehmed II in 1453, Constantinople had been in communion with Rome – moreover, since the rupture with Rome had occurred in the eleventh century, the church

had been Catholic longer than it had been Orthodox. Ultra-Protestant champions of the Greek Orthodox position detected a popish plot, while some with more political feeling saw an attempt by their Italian or French allies to gain the upper hand. The propaganda war that ensued in Britain had strong overtones of the anti-Muslim rhetoric of the Crusades – the Foreign Office was cautious, the do-gooders strident. Most circumspect and anxious of all was the India Office, where officials fully realized the effect the dispossession of the Sultan-Caliph by the British might have on Indian Muslims. Another interested party soon showed its hand: a British pro-Ottoman pressure group, the Anglo-Ottoman Society, concurred with the India Office line of Britain as the protector of Muslims.[39]

On 24 May 1915 – as the Ottoman government decided that only through deportation of the Armenians of eastern Anatolia could it suppress the domestic insurgency which made fighting in an international conflict so much more intractable – the Allies had declared their intention to pursue 'all members of the Ottoman government and those of their agents who are implicated in [the] massacres [of Armenians]'. Sultan Mehmed V Reşad died on 3 July 1918 and before the end of the year the new Sultan, his brother Mehmed VI Vahdeddin, had authorized the setting-up of military tribunals to try those responsible for economic crimes, and for the 'deportations and massacres' of Armenians – the fear of the defeated Ottoman government was that failure to punish war criminals would incite the Allied occupation forces to retaliate with a harsh application of the terms of the peace. In January 1919 began the preliminary investigations that led to the first war-crimes trials in history, and the proceedings were reported irregularly in the official government gazette, the *Takvîm-i vakâyi*. The trial of some 120 wartime cabinet ministers and top CUP functionaries began on 28 April 1919; the indictment was based on the testimony of Ottoman Muslims and on documentary evidence. It claimed that the massacres had been carried out with official complicity; Talat Pasha was named as the mastermind; the deportations and killings were said to have been carried out by CUP functionaries in the provinces, in particular by members of the clandestine, extra-legal Special Organization – as Ahmed Refik had reported at the time. The indictment noted that any state officials who had resisted orders were dismissed, while ordinary Muslims who sheltered Armenians had been threatened with death. A week later the court was informed that further crimes against the Armenian population had come to its notice, crimes committed in Istanbul as well as in the provinces, rape, torture and massacre among them. The court concluded that the deportations had been engineered by the CUP central committee, and at the end of May 1919 67 of those in custody were transferred to the British colony

of Malta, for there was concern that the Istanbul prison where they were being held might be stormed and the accused released; another 41 suspects were freed at this time. Talat, Cemal, Enver and four other CUP leaders who had all fled Istanbul were found guilty in absentia in early July, and sentenced to death. A number of other trials relating to massacres in specific provincial locations – Trabzon, Harput, Mosul, for instance – followed. By October 1919, however, the momentum of the courts martial had abated, and a year later proceedings ceased altogether.[40]

The continuing presence of Allied forces in Istanbul and the surrounding area was ostensibly a temporary measure while peace terms were being agreed in Paris. In fact it seemed that what remained of the empire was already being divided, and that the majority Turkish population might be deprived of any territory where it was sovereign. By May 1919 the French were in occupation of Adana, the British were in Kilis, Urfa, Maraş and Gaziantep (all of which the French would take over from them by the end of the year), and the Italians occupied Antalya.[41] On 15 May forces from mainland Greece landed at İzmir – the main city of Aegean Anatolia, an area with a significant Ottoman Greek population – with the encouragement of the British whose aim was to prevent further Italian advance.[42] The Greek landing was contrary to Ottoman hopes, since in addition to his reassurances that there would be no military occupation of Istanbul, Admiral Calthorpe had told the Ottoman negotiatiors at Moudros that their request that Greek troops not be allowed to land either in Istanbul or İzmir had been forwarded to London.[43] The landing caused alarm to all the parties to the Ayasofya dispute, for it raised fears that the Turkish army units in occupation of the basilica-mosque might destroy it rather than let it fall into the hands of the Greeks, should they move on to Istanbul; it spelled the end of the proposal to turn the mosque back into a church.[44]

The Ottoman government was supine in the face of the post-war crisis and Allied occupation of much of Anatolia, the Grand Vezir, Vahdeddin's brother-in-law Damad Ferit, considering its task to be merely that of re-establishing order. A high-ranking officer and war hero, Mustafa Kemal, tried unsuccessfully in November 1918 to influence the political process against the occupation from behind the scenes through his contacts in parliament. Although he had long been a member of the CUP, he was untainted by association with the darkest wartime deeds of the Committee's leaders or its associated underground organizations, and was known to be an opponent of Enver Pasha. With his closest allies – Ali Fuat, Refet (Bele), Rauf (Orbay) and Kazım Karabekir, hero of the eastern front, all of whom also disagreed with government policy, or lack of it – Mustafa Kemal laid secret plans for a military solution.[45]

Like its Aegean coast, the eastern half of Anatolia's Black Sea coast was an area with sizeable Ottoman Greek communities, and thousands more Greeks fleeing the Bolshevik revolution arrived here after 1917 causing tensions with the local Muslim population to run high. British troops had arrived in March 1919 to restore order but had neither men enough nor the will to do so. When the Interior Minister suggested sending Mustafa Kemal to investigate, the cabinet agreed, and he was duly appointed inspector of the Ninth Army – whose base was at Erzurum – making him, in effect, the government's commissioner in all of eastern Anatolia east of Ankara. On 16 May 1919 Mustafa Kemal boarded a steamer at Istanbul and arrived at Samsun, on the Anatolian Black Sea coast, three days later.[46]

During the course of the war Anatolia had armed itself under the guidance of the Special Organization, a task taken over after November 1918 by its successor, the equally secretive Karakol ('Guardpost'), whose leaders were prominent CUP members.[47] Besides his mission to calm the disturbances on the eastern Black Sea coast, Mustafa Kemal was also charged with disarming the population of the region under his aegis, and supervising the disarmament of the troops of the Ninth Army as required under the terms of the Moudros armistice. As soon as Mustafa Kemal had departed for Samsun, however, the British became suspicious that there was more to his mission than met the eye, and at their urging the Ottoman cabinet ordered his recall. During these same weeks Greek troops pushed forward from İzmir and the Aegean coast – with the consent of the Allies – to seize territory they considered their birthright; despite all they had suffered in the recent war, the Muslim population of western Anatolia mobilized again, determined not to allow them an inch.[48]

Mustafa Kemal disobeyed orders. Kazım Karabekir and Refet (Bele), his close associates and designated subordinates in his disarmament mission, had preceded him to the east and were based at Erzurum and Sivas respectively; the three men now set off down a path which led irrevocably to a severing of the link between the anti-occupation cause and the authority of the Istanbul government. An important element of this was the forging of an independent resistance movement, to which end Mustafa Kemal and his associates made extensive use of the telegraph to communicate with military officers all over Anatolia and in Thrace to disseminate their message.[49] People from all walks of life responded, and congresses of 'nationalists', as they referred to themselves, were held at various locations in Anatolia, the most important being those in Erzurum and Sivas in the summer of 1919. The principles agreed amounted to a programme for future action: that the Ottoman lands should retain their independence and integrity within the armistice lines; that there should be no minority privileges and that Greek

and Armenian territorial claims should be resisted; and that foreign aid was acceptable as long as it was freely given. It was intended that the Sultan-Caliph should continue to command the allegiance of the people – but the will of the people was supreme.[50]

In November 1918 the CUP had dissolved itself, and many of its members were under arrest as suspects in the ongoing war-crimes trials. In the elections for the new parliamentary session which opened in Istanbul in January 1920, only candidates sanctioned by the Society for the Defence of National Rights, the superior organ of the many such local societies founded from late 1918 by Muslims all over what remained of the empire to assert the principle of Ottoman national self-determination, had a chance to stand. The defiant sentiments of the Erzurum and Sivas congresses were reiterated in the new parliament on 17 February and adopted as a 'national pact' which demanded the inviolability and independence of the territories occupied by the Ottoman Muslim majority, making special reference to Istanbul and the Sea of Marmara; and the holding of plebiscites in areas with an Arab majority, in western Thrace, and in the areas lost to Russia under the Treaty of Berlin. Further, the pact required that the rights of minorities be subject to treaty arrangements.[51] The idea of resistance to the occupation was slowly catching on in the corridors of power in Istanbul.

There were two significant features of this vision of the future. The name 'Turkey', by which the Ottoman state had for centuries been known in Europe, was adopted in the national pact to signify the territory remaining to the post-war empire. However, although it was now recognized as an inescapable fact – given the readiness of Armenian and Greek subjects of the empire to appeal for foreign support against their own government – that the non-Muslim population was a dangerous liability, and Ottomanism was therefore jettisoned as a legitimizing principle, it was not 'Turkism' which replaced it but a sincere appeal to Muslim sentiment. And as Mustafa Kemal made clear in a speech in December 1919, since the Arab future clearly lay elsewhere, it was specifically to the Muslim sentiment of Turks and Kurds that this appeal was directed.[52] For the resistance movement at this time, nationalism meant that Muslim Turks and Kurds were the heirs to the Ottoman Empire.

The British were vehement in their condemnation of the nationalists and wary of the widening appeal and clandestine modus operandi of the resistance both in Istanbul and in Anatolia. The endorsement of the national pact by parliament gave it constitutional recognition, and determined the British to impose control in Istanbul in the hope that they could thereby control the government. They obtained approval from the other Allies, but

the plan was leaked to the nationalists by French and Italian sympathizers. Nevertheless, on 15/16 March 1920 five leading nationalist deputies including Rauf (Orbay) and Kara Vasıf, leader of Karakol, were arrested by British troops in the parliament building: like the war-crimes suspects the previous year, they and sixteen other nationalists were deported to Malta. Parliament dissolved itself in protest, and 84 of its members fled the capital for the small walled city of Ankara, centrally-located on the Anatolian plateau on the railway line from Istanbul,[53] and the headquarters of a nationalist committee that hoped to take over power when the increasingly redundant Istanbul government was no longer able to function.

On 23 April a Grand National Assembly composed of the parliamentarians who had made their way from Istanbul met for the first time in Ankara. The election of Mustafa Kemal as president of this parliament-in-waiting confirmed him as foremost among the nationalists, a development unwittingly connived at by the British in rounding up his associates. The lingering traces of the political Islam promoted by Abdülhamid II were slow to disappear, however. The Ankara nationalists proclaimed their loyalty to Sultan and Caliph – as yet, they offered no viable alternative to this regime – and used the rhetoric of this loyalty to good effect by celebrating the opening of the Assembly with customary verve. Sheep were sacrificed, the Koran was recited and relics of the Prophet were carried in procession.[54]

The convening of the Grand National Assembly was a momentous event: only twelve days earlier the Sheikhulislam had issued a juridical opinion execrating the nationalists as unbelievers and enjoining true believers to kill them. On 1 May Mustafa Kemal and his companions were condemned to death in absentia. But the Allies were hard-pressed and impotent, and as support for the Grand National Assembly in Ankara widened it came to be seen as a viable alternative to the parliament in Istanbul. With the Greek advance into Anatolia apparently unstoppable during the summer of 1920 – and Edirne and Bursa already captured – on 2 July Mustafa Kemal called the people to rise in a 'holy war'.[55] The counter-appeals of the organs of state in Istanbul – the Allies, the Sultan and the government – which aimed to rouse the people against the nationalists through the state's claims to Islamic legitimacy, were thereby rendered ineffective.

While events in Turkey were moving fast, the Allies and the non-Turkish Ottoman parties with an interest in the partition of the empire were leisurely debating its future; the peace negotiations began in Paris in 1919, and continued in London and San Remo. The views of the vanquished Ottomans were barely considered: after much bargaining among the participants, an Ottoman delegation was summoned to Sèvres, outside Paris, to sign the treaty hammered out by the victors. At the ceremony on 10 August 1920

the Ottoman signatories agreed on behalf of their countrymen that Thrace be ceded to Greece, and that Greece would be sovereign in the İzmir area for five years – after which the League of Nations would decide whether it became a full part of Greece; the frontiers of an independent Armenian state were to be determined by the US President Woodrow Wilson; the Kurdish areas of south-eastern Anatolia were to remain under Ottoman sovereignty for the present, with the question of whether the Kurds might become independent left to the decision of the League of Nations; and so on. The empire had shrunk to comprise Istanbul and northern Anatolia – large swathes of which were presently under occupation. The capitulations revoked at the outbreak of the war were reinstated, and the Allies prepared to implement the harsh regime they had imposed on the defeated empire.

It was necessary for the Ottoman parliament to ratify the Sèvres treaty – but parliament had been dissolved. It was clear that nothing could be done without the agreement of the nationalists, but they were determined to make the treaty unworkable. The military threat facing the rump empire was very real: only the presence of the British prevented the Greeks from pushing on towards Istanbul, and Bolshevik Russia wanted the east Anatolian provinces of Van and Bitlis, where there had formerly been a significant Armenian population, to become part of an Armenian state.

The credit for masterminding the defence of Turkey must go to Mustafa Kemal as president of the Grand National Assembly, and for carrying it out to the exhausted Muslim conscript army and the people of Anatolia. Refusing Russia's demands, Mustafa Kemal gave Kazım Karabekir orders to move against the Armenian forces in north-eastern Anatolia. On 30 October 1920 Karabekir and his troops took Kars – which had been lost to the Russians in 1878 – then continued their advance and forced the Armenians to surrender. Yet again Allied plans were set at nought by events on the ground: it was four days after this victory that President Wilson decided that the Armenian state he had been charged with defining should encompass a large area of north-eastern and eastern Turkey extending to Trabzon, Erzurum, Van and Bitlis: this determination was never published, however, so embarrassing was it thought to be. On 2 December the Bolsheviks declared what remained of Armenia a Soviet republic; their former differences with the Grand National Assembly were set aside and a treaty of friendship was signed in March 1921 by which it was agreed that the Turkish–Armenian border should be that decided after the Armenian defeat of the previous winter.[56]

British support for Greek aggression in Anatolia was particularly galling to the nationalist resistance: the Greeks already had a national state which the Turks did not, and the participation of this aggressor as an equal partner in

the peace negotiations seemed unjust. Moreover, the Greek army, unlike the Armenians who had no reliable support in the region where they sought to establish their state, was well-supported locally and therefore far more dangerous to the defenders of Anatolia. Everywhere there was guerrilla fighting between irregulars of all complexions, bandits were ubiquitous, and local Muslims fled to Istanbul. The nationalists used the troops and armed bands whose support they could command to oppose those, whether they be royalists or foreign occupiers, who defied them. From Britain's point of view, however, the Greek advance of 1920 isolated the nationalists in Anatolia, leaving the British unhindered to tutor the Ottoman government in Istanbul. The various Allies had different intentions with regard to their own future in Anatolia, which only served to deepen the rift between them apparent in their administration of occupied Istanbul. France and Italy were wary of British determination to put the Sèvres treaty fully into effect, and saw the Greeks as pawns in a plan for British control over the eastern Mediterranean. They showed themselves willing to negotiate with the nationalists in Ankara: in June 1921 Italy left its last base on the Anatolian mainland at Anatalya, and by the autumn, after coming under sustained attack from the nationalist forces in Cilicia, France had withdrawn from Anatolia, content with an undisputed mandate in Syria.

The Greeks themselves insisted on their rights in Anatolia as outlined in the Sèvres treaty. The war with the Greeks in 1921–2 – known to the Turks as the War of Independence – was a continuation of the bloody guerrilla struggle that had been going on since the invasion of May 1919. In March 1921 the Greek army suffered its first setback north of Eskişehir but soon regrouped, then in September, having advanced to within 80 kilometres of Ankara, again fell back to the west of the river Sakarya, after a 21-day battle along a 100-kilometre front. In this alien territory the Greeks were harassed on all sides by an unexpectedly tenacious resistance.[57]

The Greeks were the only party who succeeded in taking by force the territory promised them at Sèvres – and much more besides. That the Sèvres treaty was unenforceable and that the nationalists could no longer be ignored was slowly becoming apparent to Britain, which had for so long been the most dogged supporter of the Sultan and his government, and which saw the nationalists as so unpredictable that it was difficult for its politicians to make the necessary leap of diplomatic imagination and abandon the 'legitimate' Ottoman authority. Yet British policy gradually came to favour compromise, and in April 1921, together with France and Italy, Britain declared neutrality in the struggle between the Greeks and the Turkish nationalists.[58] In August 1922 the Greeks were defeated by the nationalists and retreated to İzmir, which the victorious Turkish army entered on 9 September and set alight. About three-quarters of some 200,000 Ottoman

Greeks who had left western Anatolia after the Balkan wars of 1912–13 had returned following the Greek occupation of the region in 1919; now, both they, and another quarter of a million who had remained throughout, fled to Greece for ever.[59] Within ten days of the arrival of the Turkish forces in İzmir, all Greek troops had departed from Anatolia.[60]

The British were shaken by the nationalist victory, for the road to Istanbul was now open to the doughty defenders of Anatolia. It was the perspicacity of the nationalist commander İsmet (İnönü) and the Allied commander-in-chief in Istanbul, General Harington, rather than the London government, that was responsible for the conclusion of the warfare which had beset the Ottoman Empire intermittently for so many years. On 11 October 1922 an armistice was signed at Mudanya on the south coast of the Sea of Marmara, a short boat-trip from Istanbul. That the empire was represented by İsmet (İnönü), the commander of the western front and a loyal ally of Mustafa Kemal, and not by an envoy from Istanbul, demonstrated the redundancy of the sultan. History had moved on. A month later, the Assembly in Ankara voted to abolish the sultanate, and Sultan Mehmed VI Vahdeddin was succeeded as caliph by his cousin Abdülmecid, the eldest surviving male of the dynasty, who was elected to the office by the Assembly. Long and difficult negotiations with the Powers resulted in the Treaty of Lausanne, signed on 24 July 1923, by which Turkey acquired its present borders – with minor subsequent adjustments – and equal status with its longtime besiegers. All remaining detainees awaiting trial for the massacres of Armenians were released[61] – a door had truly been closed on the past. The aspirations expressed in the national pact of 1920 were almost entirely achieved at Lausanne, more than vindicating the nationalists' struggle, and on 23 August 1923, the Lausanne treaty was ratified by the Grand National Assembly. On 2 October the Allies evacuated Istanbul; on 13 October Ankara was proclaimed the capital; and on 29 October the Republic of Turkey was founded, with Mustafa Kemal as president and İsmet (İnönü) as prime minister.

The refusal of the nationalists to accept the humiliating future designed for Turkey by the architects of the Sèvres treaty was a more dramatic and prolonged expression of the same determination that had driven the Ottoman army to retake Edirne against the odds in 1913. The shadow of Sèvres hangs over Turkey to this day in the lingering fear that foreign enemies and their collaborators inside Turkey may again seek to divide the state which was defended with such tenacity and at such cost. Attitudes in some quarters of Turkish society to the possibility of entry to the European Union are also coloured by the spectre of Sèvres, and European intentions are closely scrutinized for signs of duplicity.

★

On 3 March 1924, six months after the foundation of the Turkish Republic, the Assembly voted to abolish the caliphate and ordered the Ottoman dynasty – some 120 members altogether[62] – into exile. It was a decision that split the Assembly, for some of its members continued to esteem the Caliph and had been upset by the way the faction around Mustafa Kemal had pushed through the proclamation of the constitution. The abolition of the caliphate poisoned relations between more determined nationalists like Mustafa Kemal himself, and moderates like Rauf (Orbay) and Kazım Karabekir who had both visited Caliph Abdülmecid shortly before the office was abolished. It was only the most visible sign of the increasingly autocratic hold Mustafa Kemal and his most trusted colleagues exercised over the Assembly.[63]

Reaction to the abolition of the caliphate came from across the Muslim world – from India, Egypt and the Far East. Indian Muslims were the most numerous group to express their outrage, a reaction condemned by the more radical of the Turkish nationalists as foreign interference in domestic affairs.[64] A proposal for Mustafa Kemal to adopt the title of caliph fell on deaf ears and others, such as the Imam of Yemen and the King of Afghanistan, were put forward as possible candidates. Abdülmecid, deposed and exiled to Switzerland, used his caliphal titles in inviting Islamic leaders to a congress – it never met, but his temerity provoked strong condemnation in Turkey.[65] The devotion of most Muslims to their religion and to the Caliph was sincere; the abolition of the caliphate deprived the new republic's citizens, at a single stroke, of a familiar focus of loyalty just at the time when the Assembly's distaste for religiosity in general was deepening their sense of alienation from the radical project of modernization – which was equated with westernization – being directed from Ankara. Initially, indeed, the project of modernizing Turkey was, like that of reforming the Ottoman Empire, peculiar to an elite group, one with which many people had little reason to identify: it was easy for them simply to resent it, even while acknowledging that they had finally gained a secure homeland once more.

The trauma of defeat in the Balkan Wars convinced the Ottomans that they must defend Anatolia at all costs, or perish; this imperative had far-reaching demographic consequences, as lands forcibly abandoned by the Armenians of Anatolia were settled by Muslim refugees from the Balkans, who had themselves lost everything. The exchange of populations between Greece and Turkey which followed the Treaty of Lausanne was the final phase in an exodus of Muslims from former Ottoman territory now in the hands of Christian nation-states – or of avowedly atheist ones, in the case of the Soviet Union. By 1923 the population of what remained of the Ottoman Empire – the Republic of Turkey – was about 13 million, of which 98 per cent was Muslim; before the First World War it had been

80 per cent Muslim. With the disappearance of the more highly urbanized Christian communities, the population had also become more rural: before the war, 25 per cent had lived in towns of over 10,000 inhabitants; after the war the figure was 17 per cent.[66]

Official Ottoman and Turkish census figures illustrate the dramatic decline between 1900 and 1927 in the numbers of non-Muslims in major cities. The most striking statistic is that for Erzurum, at one time the home of many Armenians: here, the non-Muslim population decreased from 32 per cent of the total to 0.1 per cent. In Sivas the decrease was from 33 per cent to 5 per cent. In Trabzon, where historically there was a large Greek population, non-Muslims had declined from 43 per cent to 1 per cent of the total. The non-Muslim population of İzmir fell from 62 per cent to 14 per cent between 1900 and 1927. In Istanbul the change was less striking: the percentage of non-Muslims fell from 56 in 1900 to 35 in 1927.[67] The success of the new nationalist republic in avenging itself on the Ottoman Armenians and Greeks who, as the victors saw it, had so treacherously turned against their Muslim compatriots was manifest.

Although the Muslim majority of Turkey included significant populations of Kurds, Arabs, Circassians, Georgians, Abhazians, Laz, Albanians and others, those who were ethnically Turkish predominated as empire gave way to republic. Once the caliphate had been so imperiously despatched, Islamism could have no further relevance: the future was redefined as secular, and religion was relegated to the private sphere of people's lives. The idea that the Turks were the chosen people of the new republic, yet at the same time that this new republic – the final successor state to the Ottoman Empire – was not created to accommodate the identity of all the peoples within it but that they must conform to its requirements, was slow to mature. In its final form it was the result of political and social engineering drawing on long-existing strands in Ottoman Turkish culture as well as on contemporary western thought and a pragmatism appropriate to the times.

For legal and administrative purposes religion rather than ethnic origin had traditionally been the primary marker of the Ottoman subject population. For example, the only clue to ethnicity in the tax registers which were the backbone of Ottoman bureaucracy was the names recorded: the tax-payers' ethnicity could be guessed at by assuming that the names they bore – Slav, Greek, Armenian or Turkish, for instance – accurately reflected their origins; it was clearer, however, that those bearing Slav, Greek and Armenian names were Christian, and those with Turkish names were Muslim. The Ottoman dynasty did indeed claim descent from the Turkic Oğuz clan, and a sense of being Turkish had existed from earliest times, but the dynasty had ceased to dwell on this facet of Ottoman identity from

the sixteenth century onwards, when such emphasis became redundant as the rival dynasties claiming Central Asian antecedents were defeated. Ethnic categories were also employed in Ottoman writings, where the term 'Turk', like 'Kurd', and 'Arab', was typically used disparagingly – often with the qualifiers 'ignorant' or 'dishonest'. At times 'Turk' had been used to denote the aberrant, those who resisted the dictates of the state, such as the adherents of the Safavid Shah Isma'il in the sixteenth century, or those who raised the standard of rebellion against central government in the seventeenth. The seventeenth-century traveller Evliya Çelebi, for instance, referred to the Turkish peasants he encountered on his journeys as 'witless Turks'.[68]

The insights of those who were inquiring into the Turkish past in the years around 1900 offered access to the cultural roots of the Turks, and led to a more positive idea of Turkishness; in this they were assisted by western orientalists preoccupied for some time past with the study of the history of 'exotic' peoples, their racial origins and their languages. The Ottoman press made the case for a more 'Turkish' language, shorn of its Persian and Arabic accretions, and dictionaries and grammars and geographies and histories of the Turks were published. The Young Ottoman Namık Kemal, whose patriotic writings seem to have inspired Mustafa Kemal,[69] saw Turks as the inheritors of a proud past rather than as the vanguard of an emerging nation,[70] while Sultan Abdülhamid II also appreciated those who were of 'pure Turkish blood', and honoured the Ramazanoğulları clan[71] which had been established in the Adana region for as long as the Ottomans had been in Anatolia. In the view of his contemporary, the statesman Ahmed Cevdet Pasha, 'the real strength of the Sublime State lies with the Turks. It is an obligation of their national character and religion to sacrifice their lives for the House of Osman until the last one is destroyed. Therefore it is natural that they be accorded more worth than other peoples of the Sublime State.'[72]

The 1908 revolution aimed to rescue the remnants of the Ottoman Empire rather than establish a national state. As a basis for political community rather than merely an abstract idea, 'Turkishness' had been entertained in CUP writings in the first years of the century but was then downplayed[73] until, after the events of 1908, intellectuals felt freer to explore the concept further; cultural and patriotic societies with names including the word 'Turk' began to proliferate. The notion that Turkishness could be divorced from the Ottoman context came from abroad, from Russian Muslim intellectuals who were ethnically Turks – of Turkic origin, that is, rather than citizens of the Turkish Republic – and were trying to define a basis for their own identity in the turmoil of the final decades of the Russian Empire. Some settled in Istanbul, and were immensely influential in demonstrating to Ottoman Turkish intellectuals that Turkish identity could transcend the

framework of the Ottoman Empire. An appeal to ethnic Turks outside Ottoman frontiers, in China, Iran, Iraq and particularly in Russia, who were also struggling to resist imperialism, was one strand of this new identity.[74] As a political programme this pan-Turkism was of rather little importance in the Ottoman Empire, existing more as an aspiration in the imaginings of the romantically-inclined; it did not long outlast the empire, and was explicitly condemned by Mustafa Kemal in 1921.[75] Its most enthusiastic adherent in Ottoman governing circles was Enver Pasha; thoroughly seduced by the idea, he met his end in 1922 leading a Muslim force against the Red Army in what is today Tajikistan.

The usefulness of the idea of Turkishness in promoting a new national consciousness became apparent after the First World War, when the 'treachery' of all other Ottoman peoples – Ottoman Christians at least – was revealed. The concept that what remained of the Ottoman Empire – Turkey – must be the homeland for the Turks was infinitely more durable than pan-Turkism; Turkish nationalism as a political force was efficiently built up and impressed upon the population by means of the iron fist – the crushing of opposition and political difference – in the velvet glove of mass education and military conscription. In the early years of the republic, nationalist intellectuals worked hard to define values that could be instilled in the people to provide a focus of loyalty to the new Turkish state, and at the same time employed to legitimize its creation.

The way Kurdish identity was subsumed within Turkish is an instructive example of the most extreme form taken by the redefinition of the population of the Republic of Turkey as entirely Turkish. The Treaty of Sèvres in 1920 had allowed for the possibility of a Kurdish state but there had been no reference to this in the Lausanne treaty signed three years later; in the same way, earlier plans for local Kurdish autonomy received no mention in the constitution of the new republic promulgated in 1924. No delegation representing the interests of the defeated Ottoman Empire had been invited to the negotiations leading up to the Sèvres treaty; at the Lausanne peace conference the foreign minister of the republic, İsmet (İnönü), led the Turkish nationalist delegation. The unravelling of the empire dissolved the bonds that had united Turks and Kurds – the sultanate, Islamic law and the caliphate – and the modern secular Turkey Mustafa Kemal hoped to create could not countenance a self-governing ethnic group, under leaders wed to their traditional ways: they must be dragged into the new era. The principle of the equality of all citizens without discrimination provided ideological justification for the policy of building a homogeneous nation, and Kurds thus became Turks by decree.[76]

The meaning of the Turkishness that is the cornerstone of the modern

Turkish state is frequently misunderstood by those who fail to realize that it is not a marker of ethnicity but a commitment to membership of an 'imagined' nation of Turks in which all are supposedly equal. Since the only minorities historically recognized by the Ottoman state were non-Muslim, the Kurds – as Muslims and citizens of the Turkish Republic – are deemed to be as Turkish as any pure-blooded Turk. European Union recognition of a Kurdish minority is thus incomprehensible to many Turks.

The so-called Sheikh Said revolt that broke out north of Diyarbakır in February 1925 was only the first in a long series of rebellions in the Kurdish provinces between that date and 1930. It prompted the passage of a draconian law for the maintenance of public order subsequently used to silence political opposition to Mustafa Kemal and his close associates. The possibility of organizing an uprising had been under discussion by an underground Kurdish group since 1923; the abolition of the caliphate was only one grievance voiced by rebels interrogated by the British in 1924 – in addition to this, the use of the Kurdish language had recently been forbidden in public places; the use of Turkish in education prevented Kurds from being educated; the word 'Kurdistan' was banned from geography books; and Turkish soldiers raided Kurdish villages, taking away animals and food without paying for them. The rebellion began on 13 February when ten tribesmen of the Nakşibendi Sheikh Said of Palu refused to surrender to gendarmes sent to apprehend them for what officialdom termed 'banditry'. The stand-off continued for three weeks during which a number of Kurdish tribes supported the rebels, and by 7 March they had the city of Diyarbakır under siege. The uprising extended over a wide area of eastern Anatolia to the west of Lake Van; local military forces proved unable to suppress it and martial law was imposed, but when this too proved inadequate, troops were brought in from elsewhere, and the uprising was put down with much bloodshed. The besiegers of Diyarbakır surrendered on 15 April, and by the end of May the rebellion had been stamped out. The rebellion – which was overtly both Kurdish and Islamist in character – was a response to the consequences of change – the apprehension felt by the large sheikhly landowners in the region that they would be the victims in the republican revolution now under way. Many Kurds were hanged, and many others were deported westwards. It has been said that the Turkish army lost more men in the suppression of the Sheikh Said rebellion than during the War of Independence.[77]

In the wake of the rebellion, opposition to the regime headed by Mustafa Kemal and İsmet (İnönü) was effectively silenced. Emergency measures to last two years were embodied in the 'Law for the Maintenance of Order' passed by the Assembly: many newspapers were closed; martial law continued in the east; the 'independence tribunals' set up to try those not convinced

of the nationalist cause in 1920 were again pressed into service, and many dissidents were hanged – a minimum of 240 out of some 2,500 arrested by one reckoning,[78] 660 out of 7,500 by another.[79] In 1924 the Progressive Republican Party had broken away from Mustafa Kemal's People's Party (founded in September 1923); it included many of his erstwhile close colleagues – among them Kazım Karabekir and Rauf (Orbay) – who were disillusioned with the uncompromising turn which politics was taking, and offered the only formal opposition in the Assembly. At the beginning of June 1925 the cabinet decided to close it down.[80]

With repression came fundamental changes intended to reorganize Turkish society, and it was in the east, again, that these innovations aroused a heightened public response. Even the enforced change of headgear from fez to brimmed hat had its victims, for it was as offensive to many as the earlier replacement of the turban by the fez under Sultan Mahmud II in the late 1820s. In the same week in November 1925 that the hat law came into effect, another ordinance closed dervish lodges and the graves and shrines of holy men and sultans – all of which had always played an important part in the everyday lives of ordinary people.* That December, the lunar Muslim calendar was abandoned in favour of the international Christian-era calendar, and the 24-hour clock replaced the system of numbering hours from sunset. The next year saw major legal reforms as foreign law-codes were borrowed from the West. The new civil code was Swiss in origin and allowed, inter alia, for sweeping changes in the position of women, awarding them a greatly improved status both at home and in the work-place. It is for this that the women of today's Turkey express their lasting gratitude to Mustafa Kemal.[81]

For the two years from 1925 during which the Law for the Maintenance of Order was energetically applied, the press was intimidated: liberal and conservative, religious and communist papers alike were closed down – recalling Abdülhamid II's periodic bouts of censorship; only those extolling the government line could be published.[82] An attempt on Mustafa Kemal's life in 1926 provided him with a pretext to rid himself of the last remnants of the old CUP. Although the party was officially defunct, some of its members had continued their activities through the period of resistance to Allied occupation and beyond. Their last burst had been a meeting of the party's former leaders in 1923 which resulted in a manifesto proposing co-operation with Mustafa Kemal, an offer he rejected. Since all political opposition had effectively been outlawed in 1925, it was easy to manipulate the

* The government was ultimately as little successful as Mahmud II – the orders are again, today, a vibrant part of Turkish life.

assassination attempt into an excuse for the trial and execution of leading CUP members. The tribunal trying them claimed that the 1923 meeting was the origin of the assassination plot.[83]

Over 36 hours between 15 and 20 October 1927, on the occasion of the first congress of the successor to the People's Party, the Republican People's Party (which was to monopolize power until after the Second World War), Mustafa Kemal delivered a speech replete with rhetorical and polemical passages in which he set forth his version of the story of the demise of the Ottoman Empire and the birth of the Turkish Republic. The chief protagonist in the drama was, of course, Mustafa Kemal himself. The speech is not a straightforward narrative history of events between 1919 and 1927 but begins on 19 May 1919, the day he reached Samsun from Istanbul. Its most reliable English edition runs to 724 pages, of which the first 657 take the story up to 29 October 1923 and the proclamation of the republic.[84] In what remained of the speech Mustafa Kemal castigated those who were less than enthusiastic about the new order, including journalists (for giving space to expressions of opposition) and, in particular, his once close associate, Rauf (Orbay).[85] Rauf and Kazım Karabekir and their fellows – in a section of the speech prefaced 'Now . . . I will tell you something about a great plot' – were also criticized at length for founding the breakaway Progressive Republican Party which had dared to challenge his authority in 1924. The forced dissolution of the PRP and, by implication, Mustafa Kemal's inalienable right to set the terms of political debate 'in accordance with the will of the people' were thereby justified.[86]

The history of the Turkish Republic, whether written by Turks or foreigners, has invariably ignored the repression that accompanied the creation of the post-Ottoman state, and emphasized Mustafa Kemal's part in it to the almost complete neglect of the other equally estimable individuals, from peasants to women to military commanders, who resisted the partition of the empire proposed by the Treaty of Sèvres and worked to save what remained of it to establish a homeland for the Turks. Yet until he won unreserved acclaim for masterminding the victory over the Greek insurgents in western Anatolia in 1921–2 it was not inevitable that Mustafa Kemal would emerge as Turkey's undisputed political leader, or that he would achieve the power to dispose of those who did not wholeheartedly concur with his vision of the future. According to recent studies, the resistance struggle that followed the First World War was planned and carried out by the CUP: Mustafa Kemal and his supporters were not at first among its leaders. In the cause of throwing the figure of Mustafa Kemal into high relief, the extent of the break with the past associated with the transition

from late empire to early republic has also been exaggerated. While the republic was in many ways very different from the empire – in its territorial extent and demography, for instance – there were also significant continuities from the Young Turk period, in political leadership, bureaucracy, and the army. Some other aspects, such as ideology, are more difficult to analyse: both Ottomanism and Islamism were jettisoned in favour of the pre-eminence of the Turks; the state was deemed supreme, and the voice of the individual or group was correspondingly diminished; elitism and a concomitant distrust of the people were manifest; and an emphasis on education and a belief in progress were aspects of late Ottoman thought that were retained at the core of republican ideology.[87]

Public life in modern Turkey is framed by the ideology known as 'Kemalism', the particular version of Turkish nationalism manifested in Mustafa Kemal's actions and words and interpreted by the military 'guardians' of the state. To separate the man from the myth is no easy task. Mustafa Kemal promoted a cult centred on himself by encouraging the erection of statues in his honour across Turkey – commemorating, in particular, key events in the creation of the republic[88] – and the practice has been continued by the keepers of his legacy to the almost total exclusion of any other heroes of the resistance and the early republic – indeed, of any other famous man or woman. During Mustafa Kemal's lifetime the talented military commander Kazım Karabekir, a man to whom the republic also owes a large measure of gratitude for its existence, tried to publish a memoir of his part in the post-war struggle; it was promptly suppressed; and when an extended version of his memoirs was produced in 1960 (the year of the first of three military coups since the founding of the republic, the others being in 1971 and 1980) the publisher was sued, and the memoirs impounded and only released when the trial ended nine years later.[89] Since 1953 the mortal remains of Mustafa Kemal have lain in a monumental mausoleum overlooking the city of Ankara, the focus of much state protocol; few remember the final resting-place of his associates, except of his henchman İsmet (İnönü). Such a staunchly Kemalist inclination on the part of the Turkish Republic has not, however, been a constant phenomenon; it acquired exclusive pervasiveness in public life with the military coup of 12 September 1980.

A section of the speech Mustafa Kemal made in 1927 was devoted to the abolition of the caliphate, which as he realized was still a highly controversial issue. In a briefer section, the banning of the fez and the proscription of dervish orders were justified as attacks on ignorance, and the legitimacy of adopting draconian measures such as the 'independence tribunals' and the Law for the Maintenance of Order was asserted.[90]

Employing an argument which has echoed down the years in the wake of successive military coups, he maintained that

> We never used the exceptional measures, which were in any case legal, to set ourselves in any way above the law. On the contrary, we applied them to restore peace and quiet in the country . . . as soon as the necessity for the application of the exceptional measures to which we had turned no longer existed, we did not hesitate to renounce them.[91]

The military and their civilian supporters who appointed themselves to share the burden of guarding the Turkish state and the fanning of the flame of Kemalism perpetuate and interpret Mustafa Kemal's legacy to convince the citizens of the modern republic to conform to the values which he embodied – not only its secularism and forward-looking modernity in public life, but also such authoritarian inclinations as the crushing of dissent and constraints on the freedom of speech. Mustafa Kemal's actions were informed by the perils of the years during which he was in power; but times have changed, and solutions prompted by the ideals and fears of the 1920s are not best suited to the problems and challenges of the twenty-first century. The past weighs heavily, however, and many Turks would disagree with the disparaging western view associating Kemalism with 'militarism, author-itarianism and ethnic nationalism': for them, Kemalism is 'synonymous with progress and, therefore, with freedom'.[92] There are encouraging signs today, however, that greater diversity of expression is becoming acceptable and the place of the military in Turkish public life is receding.

Like the Ottoman Empire, for which the vision of the future embodied in Osman's dream supplied legitimation, the young Turkish Republic required a founding myth – and the speech made by Mustafa Kemal in 1927 provided it. He and his unsung allies achieved a great triumph in wresting victory from the jaws of despair, and gave the republic an unas-sailable legitimacy. The version of history so cogently expressed by Mustafa Kemal in his speech has survived great political changes in Turkey. A histo-rian of the future, looking back and seeing the present as merely an instant in the longue durée, might find that the Turkish Republic eventually discovered it no longer had any need to emphasize Mustafa Kemal's dream, and let it slip into history – alongside Osman's dream and the various other myths that had sustained the Ottoman Empire before it.

Sultans of the Ottoman Empire

Osman I	?–c.1324
Orhan I	c.1324–62
Murad I	1362–89
Bayezid I, the Thunderbolt	1389–1402
Interregnum	1402–13
Mehmed I	1413–21
Murad II (abdicated)	1421–44
Mehmed II	1444–6
Murad II	1446–51
Mehmed II, the Conqueror	1451–81
Bayezid II (deposed)	1481–1512
Selim I	1512–20
Süleyman I, the Magnificent, the Lawgiver	1520–66
Selim II	1566–74
Murad III	1574–95
Mehmed III	1595–1603
Ahmed I	1603–17
Mustafa I (deposed)	1617–18
Osman II (murdered)	1618–22
Mustafa I (deposed)	1622–3
Murad IV	1623–40
İbrahim I, the Crazy (executed)	1640–48
Mehmed IV, the Hunter (deposed)	1648–87
Süleyman II	1687–91
Ahmed II	1691–5
Mustafa II (deposed)	1695–1703
Ahmed III (deposed)	1703–30
Mahmud I	1730–54
Osman III	1754–7
Mustafa III	1757–74
Abdülhamid I	1774–89
Selim III (deposed)	1789–1807

Mustafa IV (deposed)	1807–8
Mahmud II	1808–39
Abdülmecid I	1839–61
Abdülaziz I (deposed)	1861–76
Murad V (deposed)	1876
Abdülhamid II (deposed)	1876–1909
Mehmed V Reşad	1909–18
Mehmed VI Vahdeddin (abdicated)	1918–22
Abdülmecid II (Caliph only)	1922–4

Chronology

Reigning Sultan		Notable events (use of italics denotes non-Ottoman events)	
		1054	Byzantines branded schismatics by the Pope
		1071	Battle of Malazgirt: Seljuk Turks rout Byzantine army
		1176	Battle of Myriocephalum: Seljuk Turks rout Byzantine army
		1187	Jerusalem falls to Saladin
		1204–61	Latin occupation of Constantinople
		1243	Mongol victory over Seljuk Turks at Kösedağ
		1258	Mongol sack of Baghdad, seat of the caliphate
?–c.1324	Osman I	1301	Battle of Bapheus: Osman's forces rout Byzantine army
		1306	*Knights Hospitallers establish their base in Rhodes*
c.1324–62	Orhan I	1326	Ottoman capture of Bursa
		1326–7	Earliest dated Ottoman coin
		1329	Battle of Pelecanum: Orhan's army routs Byzantine forces
		1330s	Karesi Turks cross Dardanelles into Thrace
		1331	Ottomans take İznik
		1337	Ottomans take İzmit
		c.1345	Ottomans annex emirate of Karesi
		1346	Orhan marries Theodora, daughter of John VI Cantacuzenus
		1352	Orhan's treaty with Genoa
		1352	Ottomans move into Thrace
		1354	Earthquake and fall of Gelibolu to the Ottomans
		1360s	Ottomans capture Edirne

Reigning Sultan		Notable events (use of italics denotes non-Ottoman events)	
		1361	Gazi Evrenos captures Komotini
1362–89	Murad I	1366	Gelibolu seized by Latin naval force
		1369	*Emperor John V Palaeologus seeks aid from the Pope*
		1371	Battle of Çirmen: Ottomans defeat Serb and Bulgarian lords
		1373	Revolt of Savcı and Andronicus
		1380s	Ottomans annex emirate of Hamid
		1386	Ottomans take Niš from Serbia
		1386	First Ottoman clash with Karaman
		1387	Byzantine Thessalonica accepts Ottoman sovereignty
		1388	Battle of Bileća: Ottoman forces defeated by Bosnian army
		1389	Battle of Kosovo Polje: Murad killed
1389–1402	Bayezid I	1390s	Ottomans complete annexation of west Anatolian emirates
		1391	Serbia becomes Ottoman vassal
		1393–4	Bayezid summons his Byzantine vassals to Serres
		1393	Ottoman annexation of the lands of John Sishman of Bulgaria
		1394–1402	Ottoman siege of Constantinople
		1394	Gazi Evrenos begins push into Greece
		1394	Ottoman occupation of Thessalonica
		1395	Ottomans rout Mircea of Wallachia
		1396	Battle of Nikopol: Ottomans rout Crusader armies
		1397–1403	*Emperor Manuel II seeks help in Europe*
		1397	Karaman loses independence
		1398	Ottoman campaign against Kadı Burhan al-Din at Sivas
		1402	Battle of Ankara: Tamerlane routs Ottomans; Anatolian emirates regain independence
1402–13	Interregnum	1402–13	Years of strife between the sons of Bayezid
1413–21	Mehmed I	1416	Sheikh Bedreddin uprising
		1417	Gazi Evrenos dies
1421–44	Murad II	1421–2	Revolt of 'False Mustafa'
		1422	Thessalonica besieged by the Ottomans
		1423	*Thessalonica ceded to Venice by Byzantines*

Reigning Sultan	Notable events (use of italics denotes non-Ottoman events)	
	1425	Ottoman re-annexation of west Anatolian emirates
	1427	*Hungarians take Belgrade from Serbia*
	1427	Ottomans win Golubac
	1430	Thessalonica falls to Ottomans
	1437–9	*Council of Ferrara-Florence: union of Orthodox and Catholic Churches*
	1438–9	Ottoman campaign against Serbia
	1440	Ottoman failure to take Belgrade
	1444	Crusade of Varna: Ottomans defeat Crusader army
1444–6 Mehmed II	1444	Debasement of Ottoman asper
1446–51 Murad II	1448	Second battle of Kosovo Polje: Ottomans rout Hungarians and Wallachians
	1449	*Constantine XI crowned as Byzantine emperor*
1451–81 Mehmed II	1451–2	Construction of Bosporus fortress of Boğazkesen
	1453	Conquest of Constantinople by the Ottomans
	1454–5	Campaigns against Serbia
	1455	Ottoman seizure of Genoese colonies begins
	1456	Failure of Ottoman siege of Belgrade
1456–68 Mahmud Pasha Angelović as grand vezir		
	1457–8	Construction of fortress of Yedikule and Old Palace
	1458	*Matthias Corvinus succeeds to Hungarian throne*
	1458–60	Ottoman conquest of Peloponnese
	1459	Serbia fully incorporated into Ottoman Empire
	1459	Construction of Topkapı Palace begins
	1460–1	Construction of Covered Bazaar begins
	1461	Comnene (Byzantine) kingdom of Trebizond conquered
	1462	Construction of opposing Dardanelles fortresses
	1463–79	Ottoman–Venetian war
	1463	Construction of mosque-complex of Mehmed II begins

Reigning Sultan	Notable events (use of italics denotes non-Ottoman events)	
	1463	Ottomans annex Bosnia and Herzegovina
	1466	Ottoman campaign against Scanderbeg
	1467	Akkoyunlu Uzun Hasan annexes Karakoyunlu lands
	1468	Karaman campaign: many people deported to Istanbul
	1472–3	Ottoman–Akkoyunlu war over Karaman
1472–4	Mahmud Pasha Angelović as grand vezir	
	1474	Ottomans re-annex Karaman
	1475	Genoese colony of Caffa annexed by Ottomans
	1478	Crimean Tatars accept Ottoman suzerainty
	1480	Ottomans capture Otranto
	1480	Failure of Ottoman siege of Rhodes
1481–1512 Bayezid II	1481	Ottoman surrender of Otranto
	1481	Cem Sultan takes refuge at the Mamluk court
	1482	Cem Sultan sails to Rhodes, then France
	1485–91	Ottoman–Mamluk war
	1489	Cem Sultan moved to Rome
	1492	*Fall of Islamic kingdom of Granada to Ferdinand and Isabella*
	1492	Spanish Jews given sanctuary in the Ottoman Empire
	1495	Cem Sultan dies
	1497	*Vasco da Gama rounds Cape of Good Hope*
	1499	Cem Sultan's body returned to Istanbul
	1499–1502	Ottoman–Venetian war
	1501	*Foundation of Safavid state by Shah Isma'il*
	1502	Bayezid takes first measures against the Kızılbaş
	1510–12	Succession struggle among Bayezid's sons
	1510	Ottoman naval assistance to Mamluks against Portuguese
	1511	Şahkulu rebellion
1512–20 Selim I	1514	Battle of Çaldıran: Ottomans rout Safavid army
	1515	Emirate of Dulkadır falls to the Ottomans
	1516–17	Ottomans annex Syria and Egypt from Mamluk sultanate

Reigning Sultan		Notable events (use of italics denotes non-Ottoman events)
		1520s Ottoman–Portuguese rivalry in the Indian Ocean
		1520 Şah Veli rebellion
1520–66	Süleyman I	**1521** Ottoman conquest of Belgrade
		1522 Ottoman conquest of Rhodes
1523–36	İbrahim Pasha as grand vezir	
		1526–7 Tax revolt in Cilicia; spreads in eastern Anatolia
		1526 Battle of Mohács: end of Hungarian medieval kingdom; beginning of Ottoman–Habsburg rivalry in Hungary
		1529 Failure of Ottoman siege of Vienna
		1530 *Charles V crowned Holy Roman Emperor*
		1530s Ottoman–Habsburg rivalry in North Africa begins
		1534 Süleyman marries Hürrem Sultan
		1534 Ottomans occupy Tabriz and capture Baghdad
		1535 Tentative establishment of province of Yemen
		1538 Ottoman campaign against Moldavia; annexation of north-west Black Sea coast
		1541 Much of Hungary comes under Ottoman rule
1544–53	Rüstem Pasha as grand vezir	
		1546 Basra becomes a province
		1547 *Ivan IV crowned Tsar of all Russia*
		1548 Hostility with Safavids, esp. in Caucasus, is renewed
		1550s Cossack attacks against Ottomans and Crimean Tatars in Ukraine
		1550–9 Construction of Süleymaniye mosque complex
		1552 *Ivan IV seizes khanate of Kazan*
		1552 Part of Transylvania comes under Ottoman rule
		1552 Failure of Piri Reis expedition to capture Hormoz and Bahrain
		1555 Treaty of Amasya between Ottomans and Safavids

Reigning Sultan	Notable events (use of italics denotes non-Ottoman events)	
	1555	Establishment of province of Habeş
1555–61 Rüstem Pasha as grand vezir		
	1556	*Ivan IV seizes khanate of Astrakhan*
	1558	Death of Hürrem Sultan
	1558	Rivalry begins between Süleyman's sons Bayezid and Selim to succeed him
1565–79 Sokullu Mehmed Pasha as grand vezir		
	1565	Failure of Ottoman siege of Knights Hospitallers base on Malta
1566–74 Selim II	1568–71	Suppression of rebellion in Yemen
	1568	Ottoman–Austrian Habsburg peace treaty
	1569	Failure of Don–Volga canal project
	1571	Ottoman capture of Cyprus from Venice
	1571	Battle of Lepanto: Ottomans defeated by Holy League
	1572	Major repairs undertaken to Ayasofya
1574–95 Murad III	1574	Construction of observatory in Galata begins
	1575	Completion of Selimiye mosque complex in Edirne
	1575	*Spain declares state bankruptcy*
	1578–90	War against Safavids in Caucasus
	1578	Sokullu Mehmed Pasha orders sultans' portraits series from Venice
	1580s	Murad greatly expands the sultans' private household – enlarges *harem* of Topkapı Palace; enhances role of chief black eunuch
	1580	Razing of Galata observatory
	1580	Ottoman–Spanish Habsburg truce in western Mediterranean
	1585–6	Debasement of Ottoman asper
	1588	Death of Sinan the architect
	1589	Janissary revolt in response to debasement of the coinage
	*c.*1590	Ottomans begin to raise irregular infantry from peasantry
	1590s	Provincial revolts against Ottoman central authority; start of Celali revolts in Anatolia

	Reigning Sultan		Notable events (use of italics denotes non-Ottoman events)
		1591–2	Islamic millennium
		1593–1606	War against Austrian Habsburgs
1595–1603	Mehmed III		
1603–17	Ahmed I	1603–18	War against Safavids
		1606–7	Rebellion of Canbuladoğlu Ali Pasha in Syria
		1609–17	Construction of Ahmed I mosque complex
		1609	End of first phase of Celali revolts
1617–18	Mustafa I		
1618–22	Osman II	*1618–48*	*Thirty Years' War in Europe*
		1621–2	Ottoman campaign against Poland-Lithuania
1622–3	Mustafa I	1622–8	Revolt of Abaza Mehmed Pasha
1623–40	Murad IV	1623–32	Murad's mother Kösem Sultan acts as regent
		1624–39	War against Safavids
		1624	Baghdad lost to Safavids
		1624	Ukrainian Cossacks sack Bosporus villages, raid Trabzon
		1627–8	Ottomans intervene in Crimean khanate power struggle
		1630	Ottoman failure to retake Baghdad
		1631	Puritanical Kadızadeli movement takes off
		1632	Murad begins programme of reform
		1633	Kadızadeli-inspired disturbances in Istanbul
		1635	Ottoman withdrawal from Yemen
		1636–41	Azov held by Don Cossacks
		1638	Ottomans recover Baghdad
1640–8	İbrahim I	1640–4	Financial reforms of Grand Vezir Kemankeş Kara Mustafa Pasha
		1640–8	Kösem Sultan resumes role as regent
		1642–3	Rebellion of Nasuhpaşazade Huseyin Pasha, governor of Aleppo
		1644–69	War against Venice over Crete
		1647–8	Rebellion of Varvar Ali Pasha, governor of Sivas, and others
		1648	Revolt of sultan's regiments forces İbrahim's deposition
1648–87	Mehmed IV	*1648–57*	*Cossack revolt led by Hetman Khmelnytsky*

Reigning Sultan	Notable events (use of italics denotes non–Ottoman events)	
	1649	Rebellion of Gürcü Abdülnebi Agha
	1651	Uprising of Istanbul tradesmen; Kösem Sultan murdered
	1656	Violent revolt in Istanbul provoked by payment of sultan's regiments in debased coin
1656–61	Köprülü Mehmed Pasha as grand vezir	
	1657–8	Campaign to subdue Ottoman vassal Rákóczi of Transylvania
	1658–9	Rebellion of Abaza Hasan Pasha and others against Köprülü Mehmed
	1659	Royal progress to the Dardanelles; completion of fortresses sponsored by Turhan Sultan
	1660	Province of Varad created in north-west Transylvania
	1660	Great fire in Eminönü quarter of Istanbul; building of Turhan Sultan's 'New' mosque commences
1661–76	Köprülü Fazıl Ahmed Pasha as grand vezir	
	1664	Province of Uyvar created north-west of Buda
	1665	Vani Mehmed Efendi becomes spiritual adviser to Fazıl Ahmed: new wave of Kadızadeli activity
	1665	Sabbatai Zvi declares himself Messiah
	1667	*Ukraine divided between Polish-Lithuanian Commonwealth and Muscovy*
	1669	Crete falls to Ottomans; the island is created a new province
	1669	Hetman Doroshenko of Right Bank Ukraine submits to Ottoman suzerainty
	1671–2	War against Poland-Lithuania
	1672	Province of Kamenets created in Polish province of Podolia
	1674	Campaign to save Hetman Doroshenko's capital at Chyhyryn from Muscovy

Reigning Sultan	Notable events (use of italics denotes non-Ottoman events)	
1676–83	Merzifonlu Kara Mustafa Pasha as grand vezir	
	1676	Hetman Doroshenko transfers allegiance from sultan to tsar
	1677–8	War against Muscovy
	1681	Treaty of Bakhchisaray between Ottomans and Muscovy recognizes Ottoman suzerainty over Right Bank Ukraine
	1683–99	War against Austrian Habsburgs, Venice, Poland and Muscovy
	1683	Failure of second siege of Vienna
	1684	*Peace agreed between France and Austrian Habsburgs*
	1686	Ottomans lose Buda and large part of Hungary
	1687	Muscovite army moves south into Crimea: retreats in disarray
	1687	Ottomans lose battle at Mohács; Grand Vezir Sarı Süleyman Pasha flees
1687–91	Süleyman II 1687–8	Militia mutiny; uprising among sultan's regiments in Istanbul
	1688	William of Orange initiates peace negotiations between Ottomans and Habsburgs
	1688	Belgrade falls to Habsburgs
	1688–97	*War of the League of Augsburg*
	1689	Muscovite army moves south into Crimea: retreats in disarray
1689–91	Köprülü Fazıl Mustafa Pasha as grand vezir	
	1690	Financial reforms of Fazıl Mustafa begin
	1690	Ottomans retake Belgrade and other strongholds
1691–95	Ahmed II 1695	Introduction of life-term tax-farming
1695–1703	Mustafa II 1697	Ottoman army routed at Senta
1697–1702	Amcazade Hüseyin Pasha as grand vezir	
	1699	Treaty of Karlowitz brings peace between Ottomans and Austria and its allies
	1703	'Edirne Incident' provokes deposition of Mustafa II

Reigning Sultan	Notable events (use of italics denotes non-Ottoman events)		
1703–30	Ahmed III	*1703*	*Peter the Great founds St Petersburg*
		1709–14	*Charles XII of Sweden takes refuge with Ottomans following his defeat at Poltava*
		1710–11	War against Russia
		1715–18	War against Venice and Austria
		1717	Belgrade falls to Austria; Ottoman–Habsburg border set at Niš in subsequent peace talks
1718–30	Nevşehirli Damad İbrahim Pasha as grand vezir		
		1720s	'Tulip Age'
		1720–1	Yirmisekiz Çelebi Mehmed Efendi visits France as cultural envoy
		1720	Lavish festivities accompany circumcision of Ahmed III's sons
		1721	Construction of Sa'dabad Palace begins
		1722	Fall of Safavid dynasty; Ottoman and Russian forces move into north-west Iran
		1724	Ottomans and Russians agree to partition north-west Iran
		1724–46	Ottomans at war against Iran
		1727	Establishment of first Arabic-script printing press in the empire
		1730	'Patrona Halil' uprising
1730–54	Mahmud I	1736	Russia seizes Crimean khan's seat at Bakhchisaray
		1737	Russia takes northern Black Sea fortress of Ochakiv; Austria joins in war
		1739	Treaty of Belgrade: Austria loses Belgrade
		1740–75	Sheikh Zahir al-'Umar holds sway in Acre and area
		1740	Ottoman–French trade treaty
		1740	Violent disturbances in Istanbul
		1748	Violent disturbances in Istanbul
1754–7	Osman III	1755	Completion of Nuruosmaniye mosque complex in Istanbul
		1756	Great fire in Istanbul
1757–74	Mustafa III	*1762*	*Catherine II, the Great, comes to the Russian throne*
		1763–5	Russian consulate opened in Bakhchisaray
		1768–74	War against Russia

Reigning Sultan		Notable events (use of italics denotes non-Ottoman events)	
	1770s	First stirrings of puritanical Wahhabi sect in Arabia	
	1770	Russian fleet bests Ottoman fleet off Çeşme	
	1771	Russia invades Crimea	
	1772	Crimean khan Sahib Giray declares Crimea independent	
	1772	Siege of Beirut by Bulutkapan Ali and Zahir al-'Umar, assisted by Russian navy	
	1772	*First Partition of Poland between Russia, Prussia and Austria*	
1774–89	Abdülhamid I	1774	Treaty of Küçük Kaynarca ends war with Russia
	1775–1804	Cezzar Ahmed Pasha holds sway in Syria	
	1783	Russia annexes Crimean khanate	
	1786	Ottoman naval expedition to suppress disorder in Egypt	
	1787–92	War against Russia	
	1787	Tepedelenli Ali Pasha becomes governor of Ioannina	
	1788–91	War against Austria	
1789–1807	Selim III	1789	Selim consults his statesmen about the future of the empire
	1789	*French Revolution*	
	1789–91	Austria holds Belgrade	
	1791	Ottoman government forces begin to move against lesser notables of Balkans	
	1792	Balkan notable Pasvanoğlu Osman Pasha seizes Vidin	
	1792	Selim reviews statesmen's reports on the state of the empire	
	1793	Ottoman embassies first established in European capitals	
	1793	*Second Partition of Poland, between Russia and Prussia*	
	1793	Ottomans declare neutrality in European war against France	
	1793–4	Establishment of 'New Order' army and treasury	
	1795	*Third Partition of Poland between Russia, Prussia and Austria*	
	1798	Napoleon Bonaparte invades Egypt	

Reigning Sultan		Notable events (use of italics denotes non-Ottoman events)	
		1798	Wahhabi forces defeat army of Sharif Ghalib
		1799	*Bonaparte returns to France*
		1801–2	*British hold Egypt*
		1802	'New Order' conscription in Anatolia
		1803	Ottoman campaign against Wahhabis; Wahhabis briefly occupy Mecca
		1804	Ottoman government and Serb forces eject janissary militia from Belgrade
		1805	'New Order' recruitment extended to Balkans
		1805	Wahhabis sack Medina
		1805	Mehmed Ali of Kavala appointed governor of Egypt
		1806–12	War against Russia
		1806	Selim I recognizes Napoleon I as emperor; presents him with portrait
		1806	Wahhabis recapture Mecca
		1806	Violent opposition to 'New Order' recruitment in Edirne
		1807	Serb forces occupy Belgrade
		1807	British navy forces Dardanelles
		1807	Violent end to 'New Order'
		1807	*Treaty of Tilsit: France and Russia agree partition of much Ottoman Balkan territory*
		1807	Wahhabis close Hijaz to Ottoman pilgrimage caravans
1807–8	Mustafa IV	1808	Bayrakdar Mustafa Pasha comes to Istanbul; soon murdered
		1808	Murder of Selim III
1808–39	Mahmud II	1811–18	Mehmed Ali Pasha and İbrahim Pasha subdue Wahhabis
		1813	Mahmud II begins to deprive provincial notables of wealth
		1814	*'Philiki Etairia' ('Friendly Society') founded in Odessa*
		1820–3	War against Qajar Iran
		1821	Start of movement for Greek independence
		1822	Murder of Tepedelenli Ali Pasha
		1824–7	Ottoman attempts to suppress Greek independence movement

| Reigning Sultan | | Notable events (use of italics denotes non–Ottoman events) | |
| --- | --- | --- |
| | | 1826 | Mahmud's abolition of the janissaries; creation of a new army; gradual start to reforms |
| | | 1828–9 | War against Russia |
| | | 1829 | Government employees required to wear the fez |
| | | 1830–31 | First Ottoman census |
| | | 1830 | France creates protectorate of Algiers |
| | | 1831 | Mehmed Ali Pasha attacks Syria |
| | | 1833 | İbrahim Pasha advances to Kütahya, retreats |
| | | 1838 | Baltalimanı trade convention forces Ottomans to ban monopolies |
| | | 1839 | Battle of Nizip: İbrahim Pasha routs the Ottoman army |
| 1839–61 | Abdülmecid I | 1839 | Gülhane Edict inaugurates the *Tanzimat* |
| | | 1840 | Mehmed Ali Pasha recognized as hereditary governor of Egypt |
| | | 1846 | Closure of Istanbul slave market |
| | | 1847–9 | Restoration of Ayasofya |
| | | 1847 | Anti-slave trade measures initiated |
| | | 1850 | Uprising in Vidin |
| | | *1851* | *Great Exhibition in London* |
| | | 1853–6 | Crimean War |
| 1855–71 | Grand vezirates of Ali Pasha and Fuad Pasha (for most of period) | | |
| | | 1856 | Reform Edict; Treaty of Paris |
| | | 1859 | 'Kuleli Incident' |
| | | 1860 | Establishment of refugee commission |
| 1861–76 | Abdülaziz I | 1863 | Establishment of the Imperial Ottoman Bank |
| | | 1863 | Abdülaziz visits Egypt; begins to build Beylerbeyi Palace |
| | | 1864 | Russia forces migration of Caucasian Muslims |
| | | 1865 | Patriotic Alliance founded; soon known as 'Young Ottomans' |
| | | 1867 | Abdülaziz visits France and England |
| | | 1869 | Opening of Suez canal |
| | | 1870s | Flood, drought and famine in Anatolia |

Reigning Sultan		Notable events (use of italics denotes non-Ottoman events)	
		1870–1	*Franco-Prussian war*
		1872	Reoccupation of Yemen
		1873	Opening of first stretch of Istanbul–Paris rail line
1876	Murad V		
1876–1909	Abdülhamid II	1876	'Bulgarian atrocities'
		1876	Declaration of Ottoman constitution
		1877–8	War against Russia
		1878	Constitution suspended
		1878	Failure of attempt to restore Murad V
		1878	Congress and Treaty of Berlin
		1881	French protectorate of Tunisia created
		1881	Suppression of armed uprising in Albania
		1881	Creation of Ottoman Public Debt Administration
		1882	British occupation of Egypt
		1884–5	Berlin conference on future of Africa
		1884	Murder of former grand vezir and 'father of the constitution', Midhat Pasha, at Ta'if
		1888	Death of Young Ottoman writer and bureaucrat Namık Kemal
		1889	Kaiser Wilhelm II visits Istanbul
		1891	Raising of 'Hamidiye' regiments to police eastern Anatolia
		1893	Internal Macedonian Revolutionary Organization founded
		1894	Violent clashes in Bitlis between Hamidiye regiments and local Armenians
		1894	Underground factions unite as Committee of Union and Progress, or 'Young Turks'
		1895	Death of intellectual and statesman Ahmed Cevdet Pasha
		1895	Armenian revolutionary 'Hunchak' organization provokes clashes in Istanbul
		1896	Further violence in eastern Anatolia begins
		1896	Armenian revolutionary 'Dashnak' organization attacks Ottoman Bank HQ in Istanbul
		1897	War against Greece
		1897	Tsar Nicholas II and Emperor Franz

Reigning Sultan	Notable events (use of italics denotes non-Ottoman events)	
		Joseph define their spheres of influence in the Ottoman Balkans
	1897	Crete becomes autonomous
	1898	Kaiser Wilhelm II visits Istanbul and Syria
	1902	First congress of CUP opposition in Paris
	1905–7	Anti-government unrest in Anatolia
	1905	Tax revolts in Macedonia
	1906	Split in CUP; CPU takes more radical lead
	1906	CPU unites with Ottoman Freedom Society of Thessalonica
	1907	Second opposition congress in Paris
	1908	Tsar Nicholas II and King Edward VII meet at Reval to discuss the 'Macedonian Question'
	1908	Young Turk revolution
	1908	Ottomans lose Bulgaria, Bosnia-Herzegovina and Crete
	1908	Ottoman parliament reopens
	1909	Counter-coup: '31 March Incident'; Abdülhamid exiled to Thessalonica
1909–18	Mehmed V Reşad	
	1910–11	Arab tribal unrest in Syria and Hijaz
	1911	Mehmed Reşad travels to Balkans
	1911	Italy invades Tripoli
	1911	Partial Ottoman withdrawal from Yemen
	1912–13	First Balkan War: Edirne lost
	1912	Abdülhamid returns to Istanbul
	1913	CUP coup: Mahmud Şevket Pasha becomes grand vezir; soon assassinated
	1913	Second Balkan War: Edirne regained
	1914	*Assassination of Archduke Franz-Ferdinand in Sarajevo*
	1914–18	First World War: Ottomans allied with Germany
	1914	British capture Basra, march north into Iraq
	1915	Enver Pasha defeated by Russian army at Sarıkamış
	1915	Disarming of Ottoman Armenian troops
	1915	Government orders deportation of Armenians of eastern Anatolia

Reigning Sultan		Notable events (use of italics denotes non-Ottoman events)	
		1915–16	Ottoman victory over Allied forces at Gallipoli
		1916	Start of 'Arab Revolt' in Hijaz
1918–22	Mehmed VI Vahdeddin		
		1918	Moudros armistice
		1918	Allied occupation of Istanbul begins
		1919	Mustafa Kemal and associates commence movement for national liberation
		1919	War-crimes trials held in Istanbul and provinces
		1920	Grand National Assembly convened in Ankara
		1920	Greek advance into western Anatolia
		1920	Treaty of Sèvres: little territory left to the Ottomans
		1921–2	Turkish nationalists fight and win War of Independence against Greece
		1921	France and Italy withdraw from Anatolia
		1922	Mudanya armistice
		1922	Grand National Assembly abolishes Ottoman sultanate
1922–4	Abdülmecid II (caliph)		
		1923	Treaty of Lausanne gives Turkey almost its present form
		1923	Allies evacuate Istanbul
		1923	Declaration of Turkish Republic
		1924	Abolition of caliphate; Ottoman dynasty exiled
		1925–30	Kurdish rebellions in eastern Anatolia
		1925–7	Law for the Maintenance of Order in effect
		1925	'Hat Law'; closure of dervish lodges; introduction of CE calendar
		1926	Adoption of Swiss civil code
		1927	Mustafa Kemal makes six-day speech

Notes

In order to reduce end-notes I have not cited some basic texts in each instance that I have referred to them. Two such volumes of general applicability are R. Mantran (ed.), *Histoire de l'empire ottoman* and Michael Cook (ed.), *A History of the Ottoman Empire to 1730*. When writing of the first century and a half of the empire I have rarely cited D. Nicol, *The Last Centuries of Byzantium, 1261–1453* and Colin Imber, *The Ottoman Empire 1300–1481*, both of which I have used extensively; similarly, M. Balivet's *Islam mystique et révolution armée dans les Balkans ottomans* and A. Y. Ocak's *Zındıklar ve Mülhidler* were indispensable for the religious currents of that time. Kenneth Setton's *The Papacy and the Levant (1204–1571)* provided invaluable European and Mediterranean factual background up to 1600, complementing Andrew Hess's 'The Evolution of the Ottoman Seaborne Empire' and 'The Ottoman Conquest of Egypt', and Setton's *Venice, Austria, and the Turks* continues the story up to 1700. I have constantly referred to but infrequently cited Leslie Peirce's *The Imperial Harem: Women and Sovereignty in the Ottoman Empire*. Frank Sysyn was kind enough to allow me to use his typescript 'The Great Ukrainian Revolt' for Cossack history of the mid-seventeenth century. Stanford Shaw, *Between Old and New*, provided a narrative line for the late eighteenth to early nineteenth centuries, and for the final chapters I took as my basic texts M. S. Anderson, *The Eastern Question, 1774–1923*, Malcolm Yapp, *The Making of the Modern Near East, 1792–1923*, Paul Dumont, 'La période des *Tanzimât* (1839–1878)' and François Georgeon, 'Le dernier sursaut'. Elsewhere, I have tried to indicate my sources clearly, and despite the numerous anomalies in modern Turkish spelling and transliteration in particular, have endeavoured to preserve the original orthography of each source in the end-notes and bibliography.

Chapter One: First among equals

1. Lindner, *Nomads and Ottomans* 37
2. Martinez, 'Bullionistic Imperialism' 173
3. İnalcık, 'Osman Ghazi's Siege' 77ff
4. Wittek, *The Rise of the Ottoman Empire*
5. Mélikoff, art. Germiyān-oghulları, *EI2* II.989
6. Uzunçarşılıoğlu, *Anadolu Beylikleri* 3
7. Yavaş, art. Eşrefoğlu Camii *İA2* 11.479–80
8. Varlık, *Germiyan-oğulları Tarihi* 31–2
9. Konyalı, *Âbideleri ve Kitâbeleri* 706–8
10. Ayverdi, . . . *Osmanlı Mi'mârîsinin İlk Devri* 167
11. Artuk, 'Osmanlı Beyliğinin Kurucusu' 27ff
12. Pamuk, *A Monetary History* 30–31
13. Lefort, 'Tableau de la Bithynie' 101ff
14. İnalcık, 'Osman Ghazi's Siege' 77ff
15. Lindner, *Nomads and Ottomans* 26–7
16. Oikonomides, 'The Turks in Europe' 159ff
17. Kafadar, *Between Two Worlds* 61
18. Uzunçarşılı, 'Gazi Orhan Bey vakfiyesi' 277ff
19. Ayverdi, . . . *Osmanlı Mi'mârîsinin İlk Devri* 18–20
20. Lowry, *The Nature of the Early Ottoman State* 72–8
21. Barkan, 'Osmanlı İmparatorluğunda Bir iskan' 279ff; Aktepe, '. . . Rumeli'nin türkler' 299ff
22. Beldiceanu-Steinherr, 'Le règne de Selīm Ier' 37; Eyice, '. . . Dinî – İçtimaî Bir Müessesesi' 3ff
23. Kiel, 'Observations on the History' 426–8; Kiel, 'The Oldest Monuments' 127–33, 138a
24. Uzunçarşılı, 'Gazi Orhan Bey vakfiyesi' 280–81
25. Kafadar, *Between Two Worlds* 76
26. Mantran, 'De la titulature' 208–9
27. Imber, 'What Does *Ghazi* Actually Mean?' 165ff
28. Lowry, *The Nature of the Early Ottoman State* 43
29. Lowry, *The Nature of the Early Ottoman State* 57, 95–6, 102
30. Kafadar, *Between Two Worlds* 67–71
31. Philippidis-Braat, 'La captivité de Palamas' 204–6
32. Lowry, *The Nature of the Early Ottoman State* 115–30
33. Imber, 'The Ottoman Dynastic Myth' 7ff
34. Flemming, 'Political Genealogies' 123ff
35. Lowry, *The Nature of the Early Ottoman State* 78–9
36. İnalcık, 'How to Read 'Ashik Pasha-Zāde's History' 148–9, 153
37. Ayverdi, . . . *Osmanlı Mi'mârîsinin İlk Devri* 2–3, 14
38. Deringil, *The Well-Protected Domains* 31–2
39. İnalcık, 'Osman Ghazi's Siege' 90–91; İnalcık, art. Bursa *EI2* I.1333–4
40. ibn Battūta, *The Travels of ibn Battūta* 2.450
41. Peirce, *The Imperial Harem* 51, 300
42. ibn Battūta, *The Travels of ibn Battūta* 2.453
43. Zachariadou, 'The Emirate of Karasi' 225ff
44. Luttrell, 'Latin Responses' 121
45. İnalcık, 'The Rise of the Turcoman' 316–19
46. Bryer, 'Greek Historians' 471ff
47. Zachariadou, 'Histoires et légendes' 53–4
48. Luttrell, 'Latin Responses' 122
49. Luttrell, 'Latin Responses' 122–3
50. Oikonomides, 'From Soldiers of Fortune' 239ff
51. Zachariadou, 'The Emirate of Karasi' 233–4
52. Zachariadou, 'Natural Disasters' 8–11
53. Ayverdi, . . . *Osmanlı Mi'mârîsinin İlk Devri* 45–8
54. Konyalı, *Ankara Camileri* 13–14
55. Mantran, 'De la titulature' 209–10
56. Ayverdi, . . . *Osmanlı Mi'mârîsinin İlk Devri* 18–216
57. Lowry, *The Nature of the Early Ottoman State* 58–66
58. Mélikoff, art. Ewrenos Oghulları, *EI2* II.720
59. Kiel, 'The Oldest Monuments' 117ff; Kiel, 'Observations on the History' 426–8; Kiel, 'Yenice-i Vardar' 300ff

60. Charanis, 'The Strife among the Palaeologi and the Ottoman Turks' 294–305
61. Kiel, 'Observations on the History' 429–32
62. Ménage, art. Djandarlı EI2 II.444
63. Reinert, 'From Niš to Kosovo Polje' 184, 191–4, 206, 209–11; Kiel, 'Mevlana Neşrī' 167–8
64. Reinert, 'From Niš to Kosovo Polje' 205–6
65. Reinert, 'A Byzantine Source' 252, 253
66. Luttrell, 'Latin Responses' 134
67. Reinert, 'A Byzantine Source' 269–72

Chapter Two: A dynasty divided

1. Peirce, The Imperial Harem 29
2. Lowry, The Nature of the Early Ottoman State 141–2
3. Zachariadou, 'From Avlonya to Antalya' 231
4. Peirce, The Imperial Harem 40
5. Dennis, The Letters of Manuel II Palaeologus 44–6
6. Barker, Manuel II Palaeologus 112
7. Chrysostomides, Manuel II Palaeologus 136
8. Zachariadou, 'Marginalia on the History of Epirus and Albania' 195ff; Loenertz, 'Pour l'histoire du Péloponnèse' 186–96
9. İnalcık, review of Barker, Manuel II Palaeologus 277–8
10. Fodor, 'The View of the Turk' 71–127
11. Housley, The Later Crusades 74–7
12. Schiltberger, The Bondage and Travels 5–6
13. Setton, The Papacy and the Levant I.359–69
14. Schiltberger, The Bondage and Travels 8
15. Rypka, art. Burhān al-Dīn, EI2 I.1327
16. Zachariadou, 'Manuel II Palaeologos' 475–6
17. Nicol, 'A Byzantine Emperor in England' 214
18. Nicol, 'A Byzantine Emperor in England' 204ff
19. İnalcık, 'Periods in Ottoman History' 21
20. Alexandrescu-Dersca, La campagne de Timur 35–8, 41–7
21. Schiltberger, The Bondage and Travels 21
22. Alexandrescu-Dersca, La campagne de Timur viii, 36, 68, 70, 112–15; Ménage, art. Devshirme, EI2 II.210–11; Imber, The Ottoman Empire 54
23. Alexandrescu-Dersca, La campagne de Timur 129–30
24. Schiltberger, The Bondage and Travels 21
25. Yınanç, art. Bayezid I (Yıldırım), İA 2.386
26. Lowry, The Nature of the Early Ottoman State 26–9
27. Imber, 'Paul Wittek's "De la défaite d'Ankara"' 73
28. Zachariadou, 'Süleyman çelebi in Rumili' 269
29. Köprülü, 'Yıldırım Beyazid'in esareti' 591ff
30. Schiltberger, The Bondage and Travels 21
31. Yinanç, art. Bayezid I (Yıldırım), İA 2.388–9
32. Ayverdi, . . . Osmanlı Mi'mârîsinin İlk Devri 464–9
33. Doukas, Decline and Fall 115
34. Denny et al., Court and Conquest 6–9
35. Uzunçarşılı, 'Çandarlı Zâde Ali Paşa Vakfiyesi' 559–60
36. Necipoğlu, 'Ottoman Merchants in Constantinople' 158–9
37. Zachariadou, 'Süleyman çelebi in Rumili' 274–83
38. Lowry, The Nature of the Early Ottoman State 141
39. Zachariadou, 'Süleyman çelebi in Rumili' 283–91
40. Imber, art. Mūsā Čelebi EI2 VII.644–5
41. Imber, art. Mūsā Čelebi EI2 VII.644–5
42. İnalcık, art. Mehemmed I, EI2 VI.975
43. Heywood, art. Mustafā, EI2 VII.710–11

44. İnalcık, art. Mehemmed I, *EI2* VII.976
45. İnalcık, 'The Ottoman Succession' 57
46. İnalcık, art. Mehemmed I, *EI2* VII.976
47. İnalcık, art. Mehemmed I, *EI2* VII.976
48. Balivet, 'Deux partisans' 376–7
49. Tietze, 'Sheykh Bali Efendi's Report' 115ff
50. Göksu and Timms, *Romantic Communist* 127–31
51. Doukas, *Decline and Fall* 132
52. Heywood, art. Mustafā, *EI2* VII.711; Heywood, '824/"8224" = 1421: the "False" (Düzme) Mustafa' 165
53. Heywood, art. Mustafā, *EI2* VII.711
54. Heywood, art. Mustafā, *EI2* VII.712–13
55. İnalcık, 'The Ottoman Succession' 60
56. Kafadar, 'Osmān Beg and his Uncle' 157ff
57. Ayverdi, ... *Osmanlı Mi'mârîsinin İlk Devri* 49–56, 104, 110–11
58. Kafadar, *Between Two Worlds* 136
59. İnalcık, 'The Conquest of Edirne' 204–5
60. İnalcık, 'The Ottoman Succession', 40–41, 47
61. Heywood, '824/"8224" = 1421: the "False" (Düzme) Mustafa' 174
62. Imber, *The Ottoman Empire* 98
63. Vryonis, 'The Ottoman Conquest of Thessaloniki' 281ff; Kiel, 'Notes on the History' 124–7
64. İnalcık, *Hicrî 835 Tarihli*
65. Kiel, *Ottoman Architecture in Albania* 18–19
66. Sümer, art. Karāmān-oghulları *EI2* IV.624
67. İnalcık, 'The Ottoman Succession' 44–6
68. Nicol, *The Immortal Emperor* 23–4
69. Setton, *The Papacy and the Levant* II.86
70. İnalcık. '1444 Buhranı' 1ff
71. İnalcık, 'Fatih Sultan Mehmed'in' 55ff
72. Kolodziejczyk, *Ottoman–Polish Diplomatic Relations* 100–109

73. İnalcık, '1444 Buhranı' 37–8
74. İnalcık and Oğuz, *Gazavât-i Sultân Murâd* 37–9
75. Pamuk, *A Monetary History* 40, 47–58
76. İnalcık, 'İstanbul'un Fethinden Önce' 92–6
77. İnalcık, 'İstanbul'un Fethinden Önce' 90–93, 96
78. İnalcık, 'İstanbul'un Fethinden Önce' 105

Chapter Three: An imperial vision

1. İnalcık, 'Istanbul: an Islamic City' 249
2. İnalcık, 'İstanbul'un Fethinden Önce' 123
3. Nicol, *The Immortal Emperor* 51–2
4. İnalcık, 'İstanbul'un Fethinden Önce' 90–91
5. İnalcık, 'Istanbul: an Islamic City' 249
6. Özgüven, 'Barut ve Tabya' 60–77
7. Nicol, *The Immortal Emperor* 57–61
8. Tursun Bey, *Târîh-i Ebü'l-Feth* 55–6; Vatin, 'Tursun Bey assista-t-il au siège' 317ff
9. İnalcık, 'Eyüp Projesi' 1–2
10. Nicol, *The Immortal Emperor* 82, 92–4
11. Doukas, *Decline and Fall* 232
12. Köprülü and Uzun, art. Akşemseddin, *İA2* 2.300
13. Necipoğlu, 'The Life of an Imperial Monument' 197, 202–4
14. Ahmed Lûtfî Efendi, *Vak'anüvîs Ahmed Lûtfî Efendi Tarihi* 5.883
15. Necipoğlu, 'The Life of an Imperial Monument' 211–13, 217–18, 221
16. Malalas, *The Chronicle* 287
17. Yerasimos, 'Ağaçtan Elmaya' 304–12
18. Raby, 'Mehmed the Conqueror' 141ff, 142
19. İnalcık, 'Istanbul: an Islamic City' 252
20. Yerasimos, *La fondation de Constantinople*; İnalcık, 'Istanbul: an Islamic City' 249–50
21. Necipoğlu, 'Dynastic Imprints' 2.25
22. Yılmaz, art. Yedikule Hisarı ve Zindanı, *İst. Ansik.* 7.460–61

23. İnalcık, 'The Hub of the City' 4, 11

24. Necipoğlu, *Architecture, Ceremonial and Power* 4–6

25. Necipoğlu, *Architecture, Ceremonial and Power* 242–50

26. Necipoğlu, *Architecture, Ceremonial and Power* 15–22, 251

27. Özcan, 'Fâtih'in teşkilât kānûn-nāmesi' 29–56

28. Necipoğlu, *Architecture, Ceremonial and Power* 22

29. Necipoğlu, *Architecture, Ceremonial and Power* 212–17

30. Kafescioğlu, 'Heavenly and Unblessed' 212

31. Lowry, '"From Lesser Wars"' 325

32. İnalcık, 'The Policy of Mehmed II' 237–8

33. İnalcık, art. Istanbul, *EI2* IV.238–9

34. İnalcık, 'The Policy of Mehmed II' 237

35. İnalcık, art. Istanbul, *EI2* IV.230–33

36. İnalcık, 'Ottoman Galata' 280–82

37. Mitler, 'The Genoese in Galata' 74

38. Words by Jimmy Kennedy; music by Nat Simon

39. Housley, *The Later Crusades* 99ff

40. Ostapchuk, 'The Ottoman Entry' 9

41. Imber, *The Ottoman Empire* 162

42. Fisher, *The Crimean Tatars* 12–14

43. Stavrides, *The Sultan of Vezirs* 73–98, 108, 121–8

44. İnalcık, 'Mehmed the Conqueror' 102–3

45. Stavrides, *The Sultan of Vezirs* 140–43

46. Stavrides, *The Sultan of Vezirs* 146–50, 157–60

47. Babinger, *Mehmed the Conqueror* 222

48. Šabanović, art. Hersek-zāde, *EI2* III.340–42

49. Peirce, *The Imperial Harem* 30, 294

50. Mihalović, *Memoirs of a Janissary* 117–19

51. Peirce, *The Imperial Harem* 30

52. Stavrides, *The Sultan of Vezirs* 86–90

53. Raby, 'Mehmed the Conqueror's Greek Scriptorium' 24

54. Setton, *The Papacy and the Levant* II.249–52

55. Stavrides, *The Sultan of Vezirs* 155–7, 212–13

56. İnalcık, art. Iskender Beg, *EI2* IV.138–40; Kiel, *Ottoman Architecture* 108–37

57. Woods, *The Aqquyunlu* 106

58. Woods, *The Aqquyunlu* 109–14

59. Woods, *The Aqquyunlu* 114

60. Imber, *The Ottoman Empire* 198

61. Woods, *The Aqquyunlu* 112–16, 124

62. İnalcık, art. Mehmed II, *İA* 7.514

63. Sourdel, art. Khalīfa, *EI2* IV.945

64. Woods, *The Aqquyunlu* 128

65. Imber, 'The Ottoman Dynastic Myth' 19

66. Imber, *The Ottoman Empire* 209

67. Woods, *The Aqquyunlu* 120, 130

68. Woods, *The Aqquyunlu* 131–4

69. Woods, *The Aqquyunlu* 134, 137

70. Kiel, art. Gedik Ahmed Paşa *İA2* 13.543

71. Bostan, *Osmanlı Bahriye Teşkilâtı* 14

72. İnalcık, 'Mehmed the Conqueror' 108

73. Fisher, *The Crimean Tatars* 8–12

74. Fisher, *The Crimean Tatars* 11–12

75. Ostapchuk, 'The Human Landscape' 27–31

76. Murphey, *Ottoman Warfare* 35; Lowry, *The Nature of the Early Ottoman State* 51–4

77. Tursun Bey, *Târîh-i Ebü'l-Feth* 180

78. Setton, *The Papacy and the Levant* II.343–5

79. Turan, 'Fatih'in İtalya Seferi' 140

80. Vatin and Veinstein, 'La mort de Mehmed II' 187–90

81. Özcan, 'Fâtih'in teşkilât kānûn-nāmesi' 46

82. İnalcık, 'The Ottoman State' 218–28, 236–40

83. İnalcık, . . . *The Customs Registers of Caffa* 121–4

84. Berindei, 'Le role des fourrures' 89–92

85. Fisher, 'Muscovy and the Black Sea Slave Trade' 31–4

86. Ostapchuk, 'The Human Landscape' 23–37

87. İnalcık, 'The Ottoman State' 193–4

88. Vryonis, 'Laonicus Chalcocondyles' 423ff

89. İnalcık, 'The Ottoman State' 88

90. İnalcık, 'The Ottoman State' 120–31

91. İnalcık, 'The Ottoman State' 126–7
92. Özel, 'Limits of the Almighty' 242–3
93. Pamuk, *A Monetary History* 48
94. Özcan, art. Devşirme, *İA2* 9.255
95. Demetriades, 'Some Thoughts' 29
96. Mélikoff, art. Ewrenos Oghulları, *EI2* II.721
97. Kiel, 'Das türkische Thessalien' 150–51
98. Babinger, art. Mīkhāl-oghlu, *EI2* VII.34
99. Lowry, *The Nature of the Early Ottoman State* 141
100. İnalcık, 'İstanbul'un Fethinden Önce' 124–7
101. Stavrides, *The Sultan of Vezirs* 63–7
102. Babinger, 'Bajezid Osman' 349ff
103. Kafescioğlu, 'Heavenly and Unblessed' 211–12, 217
104. Özcan, art. Cülûs, *İA2* 8.110
105. İnalcık, art. Mehmed II *İA* 7.512
106. de Groot, art. Mehmed Pasha Karamāni, *EI2* VI.995–6
107. İnalcık, 'Suleiman the Lawgiver' 109
108. Özel, 'Limits of the Almighty' 226–7
109. Stavrides, *The Sultan of Vezirs* 63
110. Stavrides, *The Sultan of Vezirs* 63, 101, 116ff
111. Imber, *The Ottoman Empire* 199
112. Stavrides, *The Sultan of Vezirs* 329–33
113. İnalcık, 'The Policy of Mehmed II' 240–47
114. Stavrides, *The Sultan of Vezirs* 173–81; Lowry, *The Nature of the Early Ottoman State* 116
115. Uzunçarşılı, 'Fatih Sultan Mehmed'in' 719ff; cf. Stavrides, *The Sultan of Vezirs* 344–52
116. Sagundino, 'Orazione al serenissimo principe' 131–3
117. Kritovoulos, *History of Mehmed the Conqueror* 3
118. Kritovoulos, *History of Mehmed the Conqueror* 181
119. Raby, 'Mehmed the Conqueror's Greek Scriptorium' 18, 21

Chapter Four: Sultan of the faithful

1. Kappert, *Die osmanischen Prinzen* 19–67
2. Vatin and Veinstein, 'Les obsèques des sultans ottomans' 217
3. Vatin and Veinstein, 'La mort de Mehmed II' 193–9
4. Necipoğlu-Kafadar, 'Dynastic Imprints' 2.26–7
5. Kreiser, 'Istanbul, die wahre Stadt' 2.20
6. Vatin, *Sultan Djem* 18
7. Tansel, *Sultan II. Bâyezit'in Siyasî Hayatı* 25, 30–34
8. Vatin, *Sultan Djem* 128
9. Tansel, *Sultan II. Bâyezit'in Siyasî Hayatı* 34–5
10. Peirce, *The Imperial Harem* 47
11. Vatin, *Sultan Djem* 130–41
12. Uzunçarşılı, 'Otranto'nun zaptından sonra' 595ff
13. Tansel, 'Yeni vesikalar karşısında Sultan İkinci Bayezit' 189
14. Vatin, *Sultan Djem* 30–31, 142–3
15. Vatin, *L'Ordre de Saint-Jean-de-Jérusalem* 161–3
16. Vatin, *Sultan Djem* 19
17. Gibb, *A History of Ottoman Poetry* 2.75
18. Vatin, *L'Ordre de Saint-Jean-de-Jérusalem* 161–72, 174–8
19. Gibb, *A History of Ottoman Poetry* 2.77
20. Uzunçarşılı, 'Değerli Vezir Gedik Ahmet Paşa' 495
21. Uzunçarşılı, 'Otranto'nun zaptından sonra' 595ff
22. Vatin, *Sultan Djem* 25–6
23. Vatin, 'Itinéraires d'agents de la Porte' 29ff
24. Ménage, 'The Mission of an Ottoman Secret Agent' 118
25. Ménage, 'The Mission of an Ottoman Secret Agent' 118–19, 127
26. Vatin, *L'Ordre de Saint-Jean-de-Jérusalem* 209–10
27. İnalcık, 'A Case Study in Renaissance Diplomacy' 211, 218–19
28. Vatin, *L'Ordre de Saint-Jean-de-Jérusalem* 222
29. Tansel, 'Yeni vesikalar karşısında Sultan İkinci Bayezit' 188

30. Vatin, *Sultan Djem* 38, 42
31. İnalcık, 'A Case Study in Renaissance Diplomacy' 212–16
32. Vatin, *Sultan Djem* 49
33. Tansel, 'Yeni vesikalar karşısında Sultan İkinci Bayezit' 220
34. Vatin, *Sultan Djem* 206–7
35. İnalcık, 'A Case Study in Renaissance Diplomacy' 223
36. Setton, *The Papacy and the Levant* II.422–4
37. İnalcık, 'Ottoman Galata' 325
38. Kiel, 'Notes on the History' 142
39. Housley, *The Later Crusades* 303–4
40. Benbassa and Rodrigue, *Sephardi Jewry* 7
41. Levy, *The Sephardim in the Ottoman Empire* 4, 11
42. Setton, *The Papacy and the Levant* II.447–8
43. Setton, *The Papacy and the Levant* II.456
44. Setton, *The Papacy and the Levant* II.454–7, 467–81
45. Imber, 'A Note on "Christian" Preachers' 60–64
46. Vatin, 'Macabre trafic' 231ff
47. Conway Morris, *Jem*
48. Fodor and Dávid, 'Hungarian-Ottoman Peace Negotiations' 13–14
49. Vatin, *Sultan Djem* 142
50. Sümer, art. Karāmān-oghulları *EI2* IV.624
51. Har-El, *Struggle for Domination* 124–7
52. Tekindag, 'II. Bayezid Devrinde Cukur-Ova'da Nüfuz Mücâdelesi' 348
53. Tansel, *Sultan II. Bâyezit'in Siyasî Hayatı* 99–100
54. Har-El, *Struggle for Domination* 141–2
55. Tansel, *Sultan II. Bâyezit'in Siyasî Hayatı* 121–3
56. Tekindağ, 'II. Bayezid Devrinde Çukur-Ova'da Nüfuz Mücâdelesi' 361–2
57. Vatin, *L'Ordre de Saint-Jean-de-Jérusalem* 207–8
58. Tekindag, 'II. Bayezid Devrinde Çukur-Ova'da Nüfuz Mücâdelesi' 361–8
59. Tansel, *Sultan II. Bâyezit'in Siyasî Hayatı* 113–15
60. Setton, *The Papacy and the Levant* II.514–17
61. Setton, *The Papacy and the Levant* II.514, 520–22
62. Setton, *The Papacy and the Levant* II.514, 524–32, 538
63. Tansel, 'Yeni vesikalar karşısında Sultan İkinci Bayezit' 204
64. Brummett, *Ottoman Seapower* 92–5
65. Brummett, *Ottoman Seapower* 111–17; Vatin, *L'Ordre de Saint-Jean-de-Jérusalem* 294ff
66. Nasr, art. Ithnā 'Asharriya, *EI2* IV.277
67. Morgan, *Medieval Persia* 108
68. Morgan, *Medieval Persia* 109
69. Allouche, *The Origins and Development* 41–6
70. Tansel, *Sultan II. Bâyezit'in Siyasî Hayatı* 236
71. Beldiceanu-Steinherr, 'Le règne de Selīm Ier' 41
72. Tansel, *Sultan II. Bâyezit'in Siyasî Hayatı* 231, 235
73. Bacqué-Grammont, *Les Ottomans, les Safavides* 17
74. Walsh, 'The Historiography of Ottoman–Safavid Relations' 208
75. Mélikoff, 'Le problème kızılbaş' 50
76. Allouche, *The Origins and Development* 155–6
77. Mélikoff, 'Le problème kızılbaş' 50, 51
78. Bacqué-Grammont, *Les Ottomans, les Safavides* 18
79. Martin, 'A Short History of the Khalwati' 277–82
80. Allouche, *The Origins and Development* 86–8
81. Bacqué-Grammont, *Les Ottomans, les Safavides* 21–3
82. Allouche, *The Origins and Development* 80–81
83. Tansel, *Sultan II. Bâyezit'in Siyasî Hayatı* 245
84. Zarinebaf-Shahr, 'Qızılbash "Heresy"' 7
85. Bacqué-Grammont, *Les Ottomans, les Safavides* 24
86. Uluçay, 'Yavuz Sultan Selim' VI/9.75
87. Bacqué-Grammont, *Les Ottomans, les Safavides* 25

88. Tansel, *Sultan II. Bâyezit'in Siyasî Hayatı* 248
89. Uluçay, 'Yavuz Sultan Selim' VI/9.61–3
90. Bacqué-Grammont, *Les Ottomans, les Safavides* 25–6
91. Uluçay, 'Yavuz Sultan Selim' VI/9.65
92. Tekindağ, 'Şah Kulu Baba Tekeli İsyanı' 1/3.34ff
93. Tekindağ, 'Şah Kulu Baba Tekeli İsyanı' 1/4.55
94. Tekindağ, 'Şah Kulu Baba Tekeli İsyanı' 1/4.55–6
95. Uluçay, 'Yavuz Sultan Selim' VI/9.68–74
96. Tekindağ, 'Şah Kulu Baba Tekeli İsyanı' 1/4.58
97. Bacqué-Grammont, *Les Ottomans, les Safavides* 18
98. Uluçay, 'Yavuz Sultan Selim' VI/9.77
99. Uluçay, 'Yavuz Sultan Selim' VI/9.85
100. Uluçay, 'Yavuz Sultan Selim' VI/9.82–6
101. Uluçay, 'Yavuz Sultan Selim' VI/9.86–90
102. Uluçay, 'Yavuz Sultan Selim' VII/10.117–20
103. İnalcık, 'A Case Study in Renaissance Diplomacy' 218; Sebastian, 'Ottoman Government Officials' 326
104. Uluçay, 'Yavuz Sultan Selim' VII/10.121–6
105. Uluçay, 'Yavuz Sultan Selim' VII/10.125–6, VIII/11–12.185–6
106. Ocak, 'Quelques remarques' 74–5
107. cf. Kiel, art. Dimetoka, *İA2* 9.305–8
108. Uluçay, 'Yavuz Sultan Selim' VII/10.131–7
109. Uluçay, 'Yavuz Sultan Selim' VII/10.137–42
110. Bacqué-Grammont, *Les Ottomans, les Safavides* 36–7
111. Uluçay, 'Yavuz Sultan Selim' VIII/11–12.191–7
112. Uluçay, 'Yavuz Sultan Selim' VIII/11–12.188–90
113. Uzunçarşılı, 'II nci Bayezid'in oğullarından Sultan Korkut' 585–90
114. Uluçay, 'Yavuz Sultan Selim' VII/10.142, VIII/11–12.191–200
115. Uluçay, 'Yavuz Sultan Selim' VII/10.123, 127–31
116. Bacqué-Grammont, *Les Ottomans, les Safavides* 45; Kolodziejczyk, *Ottoman–Polish Diplomatic Relations* 115; Fodor and Dávid, 'Hungarian–Ottoman Peace Negotiations' 37–8
117. Khadduri, art. Harb, *EI2* III.180
118. Bacqué-Grammont, *Les Ottomans, les Safavides* 51–2; cf. Tekindağ, '... Yavuz Sultan Selim'in İran Seferi' 54–5, docts I, I/a
119. Tekindağ, '... Yavuz Sultan Selim'in İran Seferi' 55, 77–8
120. Walsh, 'The Historiography of Ottoman–Safavid Relations' 204–5, 207
121. Zarinebaf-Shahr, 'Qızılbash "Heresy"' 7
122. Tekindağ, '... Yavuz Sultan Selim'in İran Seferi' 56
123. Bacqué-Grammont, '... Notes et documents sur la révolte' 5ff
124. Bacqué-Grammont, '... Notes sur le blocus' 68ff; Bacqué-Grammont, 'Notes sur une saisie de soie' 245
125. Tekindağ, '... Yavuz Sultan Selim'in İran Seferi' 63–9; Bacqué-Grammont, *Les Ottomans, les Safavides* 45–9, 146ff; Varlık, art. Çaldıran Savaşı, *İA2* 8.193–4
126. Peirce, *The Imperial Harem* 37
127. Tansel, *Yavuz Sultan Selim* 73–4, 80–81, 101–7
128. Beldiceanu-Steinherr and Bacqué-Grammont, 'A propos de quelques causes' 76–81
129. Beldiceanu-Steinherr and Bacqué-Grammont, 'A propos de quelques causes' 77
130. İnalcık, 'Suleiman the Lawgiver' 127
131. Bacqué-Grammont, *Les Ottomans, les Safavides* 75–6, 82–3, 87
132. Bacqué-Grammont, *Les Ottomans, les Safavides* 74, 128–45
133. Bacqué-Grammont, *Les Ottomans, les Safavides* 189–93
134. Bacqué-Grammont, *Les Ottomans, les Safavides* 194–5

135. Bacqué-Grammont, *Les Ottomans, les Safavides* 191, 195–7
136. Repp, *The Müfti of Istanbul* 213–14
137. Tansel, *Yavuz Sultan Selim* 135–9; Bacqué-Grammont, *Les Ottomans, les Safavides* 195
138. Tansel, *Yavuz Sultan Selim* 118, 145, 147ff
139. Lowry, *The Nature of the Early Ottoman State* 96
140. Sourdel, art. Khalīfa, *EI2* IV.945
141. Bacqué-Grammont, '. . . Notes sur le blocus' 79–84
142. Bacqué-Grammont, *Les Ottomans, les Safavides* 225–8, 231–4
143. Setton, *The Papacy and the Levant* III.175–80
144. Setton, *The Papacy and the Levant* III.183ff
145. Jennings, *Christians and Muslims* 4
146. Fodor and Dávid, 'Hungarian–Ottoman Peace Negotiations' 9
147. Kolodziejczyk, *Ottoman–Polish Diplomatic Relations* 115
148. Bacqué-Grammont, '. . . Notes et documents sur la révolte' 5ff, 26–7
149. Gibb, *Ottoman Poems* 33
150. Allouche, *The Origins and Development* 86–7
151. Bacqué-Grammont, *Les Ottomanes, les Safavides* 274

Chapter Five: Possessor of the kingdoms of the world

1. Imber, *Ebu's-su'ud* 75
2. Fisher, 'The Life and Family' 2
3. İnalcık, 'Suleiman the Lawgiver' 110
4. Sourdel, art. Khalīfa, *EI2* IV.945
5. Kafadar, 'The Myth of the Golden Age' 40–41
6. Fisher, 'The Life and Family' 3
7. Fleischer, 'The Lawgiver as Messiah' 159ff
8. Housley, *The Later Crusades* 311
9. Khodarkovsky, *Russia's Steppe Frontier* 40, 103
10. Sen, 'East and West' 33
11. Kolodziejczyk, *Ottoman–Polish Diplomatic Relations* 225

12. Bacqué-Grammont, 'The Eastern Policy' 222–3
13. Emecen, 'The History of an Early Sixteenth Century Migration' 77ff
14. Vatin, 'La conquête de Rhodes' 447–8, 454
15. Housley, *The Later Crusades* 230
16. Vatin, *L'Ordre de Saint-Jean-de-Jérusalem* 374
17. Abou-el Haj, 'Aspects of the Legitimation' 371ff
18. Bacqué-Grammont, *Les Ottomans, les Safavides* 292–3
19. Behrens-Abouseif, *Egypt's Adjustment* 38–41
20. Murphey, 'Frontiers of Authority' 3
21. İnalcık, 'The Ottoman State' 319–25; Özbaran, 'A Turkish Report' 99ff
22. Soucek, art. Pīrī Re'is, *EI2* VIII.308–9
23. Özbaran, 'Ottoman Naval Policy' 61
24. Özbaran, 'The Ottomans in Confrontation' 96
25. Ingrao, *The Habsburg Monarchy* 4–5
26. Setton, *The Papacy and the Levant* III.238, 245–6
27. Fodor, 'Ottoman Policy towards Hungary' 285–93
28. Rogers, 'The Arts under Süleymân the Magnificent' 259–60; Rogers, *The Topkapı Saray Museum* 13
29. Setton, *The Papacy and the Levant* III.314
30. Fodor, 'Ottoman Policy towards Hungary' 296
31. Barta, 'A Forgotten Theatre of War' 105, 109, 122–3; Fodor, 'Ottoman Policy towards Hungary' 296–8
32. Fodor, 'Ottoman Policy towards Hungary' 299
33. Housley, *The Later Crusades* 131–2
34. Bacqué-Grammont, 'Ubaydu-llah han de Boukhara' 485ff
35. Bacqué-Grammont, 'The Eastern Policy' 227–8
36. Braune, art. 'Abd al-Kādir al-Djīlānī, *EI2* I.69–70
37. Streck and Dixon, art. Kāzimayn, *EI2* IV.855
38. Gökbilgin, 'Venedik Devlet Arşivindeki' 111–13

39. Murphey, 'Süleyman's Eastern Policy' 244
40. Housley, *The Later Crusades* 304–8
41. Setton, *The Papacy and the Levant* III.359
42. İnalcık, art. Imtiyāzāt, *EI2* III.1183; Matuz, 'À propos de la validité' 183ff
43. Theunissen, 'Ottoman–Venetian Diplomatics' 161
44. Setton, *The Papacy and the Levant* III.431; Necipoğlu, 'Süleymân the Magnificent' 175
45. Theunissen, 'Ottoman–Venetian Diplomatics' 163–8
46. Chaudhuri, *Trade and Civilisation* 72–3; Harrison, art. Diū, *EI2* II.322; Orhonlu, art. Khādim Süleymān Pasha, *EI2* IV.901
47. Özbaran, 'Osmanlı İmparatorluğu ve Hindistan yolu' 98–101; Özbaran, 'Ottoman Naval Policy' 61–3
48. İnalcık, *The Ottoman Empire* 41
49. Dávid, 'Administration in Ottoman Europe' 88–9
50. Peirce, *The Imperial Harem* 74
51. Necipoğlu, *Architecture, Ceremonial and Power* 23, 79–84, 96–110
52. Gilles, *The Antiquities of Constantinople* 22
53. Valensi, *The Birth of the Despot* 37, 46; Fodor, 'The View of the Turk' 83–4
54. Necipoğlu, 'Süleymân the Magnificent' 163ff
55. Gökbilgin, art. İbrahim Paşa, *İA* 5/II.909
56. İnalcık, 'Sultan Süleymân: the Man' 93
57. Peirce, *The Imperial Harem* 74; Necipoğlu, 'Süleymân the Magnificent' 182
58. Peirce, *The Imperial Harem* 62
59. Peirce, *The Imperial Harem* 59
60. Peirce, *The Imperial Harem* 59–61
61. Peirce, *The Imperial Harem* 38–9, 42–3, 44; Schick, 'Gynaeceum and Power' 151–3
62. Necipoğlu, *Architecture, Ceremonial and Power* 162–3
63. Peirce, *The Imperial Harem* 64
64. Hegyi, 'The Ottoman Military Force' 133; Veinstein, art. Sokullu

Mehmed Pasha, *EI2* IX.707
65. Ágoston, 'Limits of Imperial Authority'; Ágoston, 'A Flexible Empire' 24–6
66. Walsh, 'The Revolt of Alqās Mīrzâ' 75–8; Savory, art. Alkās Mīrzā, *EI2* I.406; Murphey, 'Süleymân's Eastern Policy' 245
67. Hess, *The Forgotten Frontier* 74–5
68. Williams, 'Mediterranean Conflict' 49, 52–3
69. Özbaran, 'The Ottoman Turks and the Portuguese' 125–32
70. Özbaran, 'Bahrain in 1559' 179ff; Özbaran, 'The Ottoman Turks and the Portuguese' 138, 140
71. Alexander, 'The Turks on the Middle Nile' 15–16; Özbaran, 'A Turkish Report' 108–9; Ménage, 'The Ottomans and Nubia' 143–4; Özbaran, 'The Ottomans in East Africa' 193, 195
72. İnalcık, 'The Ottoman State' 327–31, 345–6
73. İnalcık, 'Power Relationships' 182–3
74. İnalcık, 'The Ottoman State' 278–80; Khodarkovsky, *Russia's Steppe Frontier* 40, 103
75. Khodarkovsky, *Russia's Steppe Frontier* 104–10, 191
76. Bostan, *Osmanlı Bahriye Teşkilâtı* 18
77. Necipoğlu, 'A Kânûn for the State' 198
78. Flemming, 'Public Opinion under Sultan Süleymân' 54; Turan, *Kanunî'nin Oğlu Şehzâde Bayezid* 24ff
79. Forster, *The Turkish Letters* 81–3; Kappert, *Die osmanischen Prinzen* 115–16
80. Kappert, *Die osmanischen Prinzen* 118–22
81. Repp, *The Müfti of Istanbul* 284–6
82. Kappert, *Die osmanischen Prinzen* 123–5, 126–30
83. Turan, *Kanunî'nin Oğlu Şehzâde Bayezid* 205
84. Kappert, *Die osmanischen Prinzen* 140–49; Turan, *Kanunî'nin Oğlu Şehzâde Bayezid* 148–57
85. Bacqué-Grammont, 'Un rapport inédit' 156ff; Ocak, 'Quelques remarques' 73–4

86. Imber, 'A Note on "Christian" Preachers' 65; Repp, *The Müfti of Istanbul* 234–6
87. Ocak, 'Kanûnî Sultan Süleyman devrinde' 49ff; Repp, *The Müfti of Istanbul* 236–8
88. Zarinebaf-Shahr, 'Qızılbash "Heresy"' 8; Imber, 'The Persecution of the Ottoman Shī'ites' 271; Repp, *The Müfti of Istanbul* 237–8
89. Gökbilgin, 'Rüstem Paşa' 10ff
90. Yerasimos, 'Sinan and his Patrons' 214, 215
91. Necipoğlu, 'A Kânûn for the State' 195ff
92. Necipoğlu-Kafadar, 'The Süleymaniye Complex' 92ff
93. Imber, *Ebu's-su'ud* 103–6; Imber, 'Süleymân as Caliph' 179ff
94. Imber, 'The Ottoman Dynastic Myth' 12, 23–4
95. Imber, *Ebu's-su'ud* 24, 30–32, 35–6
96. Fleischer, *Bureaucrat and Intellectual* 199
97. Zilfi, 'Sultan Süleymân' 109ff; Fodor, 'Sultan, Imperial Council, Grand Vizier' 77
98. Behrens-Abouseif, *Egypt's Adjustment* 38
99. Fleischer, *Bureaucrat and Intellectual* 217–18
100. Fleischer, 'The Lawgiver as Messiah' 173
101. Woodhead, 'An Experiment in Official Historiography' 159–60, 172
102. Gibb, *Ottoman Poems* 43
103. Fodor, 'Sultan, Imperial Council, Grand Vizier' 79–80; Necipoğlu, *Architecture, Ceremonial and Power* 102
104. Necipoğlu, 'The Süleymaniye Complex' 113
105. Peirce, *The Imperial Harem* 199–200
106. Singer, *Constructing Ottoman Beneficence* 46–7
107. St Laurent and Riedlmayer, 'Restorations of Jerusalem' 77
108. Faroqhi, *Pilgrims and Sultans* 28, 100–101, 103–5, 108
109. Peri, *Christianity under Islam* 179
110. Chesnau, *Le Voyage de Monsieur d'Aramon* 118–19
111. Fodor, 'State and Society' 223–4
112. Fodor, 'Sultan, Imperial Council, Grand Vizier' 80–81
113. Fisher, 'The Life and Family' 6
114. Selânikî Mustafa Efendi, *Tarih-i Selânikî* 1.35–9

Chapter Six: The sedentary sultan

1. Selânikî Mustafa Efendi, *Tarih-i Selânikî* 1.40, 42, 43–4, 46
2. Selânikî Mustafa Efendi, *Tarih-i Selânikî* 1.39, 46–8
3. Vatin and Veinstein, 'Les obsèques' 222–5, 230, 233–42
4. Vatin, 'Aux origines du pèlerinage' 92, 95–9
5. Selânikî Mustafa Efendi, *Tarih-i Selânikî* 1.50–56
6. Woodhead, art. Selīm II, *EI2* IX.131
7. Selânikî Mustafa Efendi, *Tarih-i Selânikî* 1.84
8. Veinstein, art. Sokullu Mehmed Pasha, *EI2* IX.706–11
9. Blackburn, art. Özdemir Pasha, *EI2* VIII.235
10. Blackburn, 'Two Documents' 223ff
11. Fleischer, *Bureaucrat and Intellectual* 45–54; Smith, *Lightning over Yemen*
12. BOA/Mühimme Defteri vol. 7 no. 721
13. Khodarkovsky, 'Of Christianity, Enlightenment and Colonialism' 395
14. Kurat, 'The Turkish Expedition to Astrakhan' 13
15. Kurat, 'The Turkish Expedition to Astrakhan' 7ff
16. Kurat, 'The Turkish Expedition to Astrakhan' 7ff
17. Kurat, 'The Turkish Expedition to Astrakhan' 7ff
18. Bennigsen, 'L'expédition turque contre Astrakhan' 441–4
19. Hess, *The Forgotten Frontier* 87–90
20. İnalcık, 'Ottoman Galata' 326
21. Jennings, *Christians and Muslims* 11–12
22. Imber, *Ebu's-su'ud* 84–5; Fotić, 'The Official Explanations' 33ff
23. Imber, *Ebu's-su'ud* 85
24. Imber, *Ebu's-su'ud* 159–62; Fotić, 'The Official Explanations' 33ff
25. Danişmend, *İzahlı Osmanlı Tarihi Kronolojisi* 2.439

26. İnalcık, 'Lepanto in the Ottoman Documents' 185ff
27. Setton, *The Papacy and the Levant* IV.1052–9
28. Soucek, art. 'Ulūdj 'Ali, *EI2* X.811
29. Lesure, 'Notes et documents' 134ff
30. Theunissen, 'Ottoman–Venetian Diplomatics' 174, 490–95 (Ottoman text of treaty)
31. Roth, *The House of Nasi* 17, 41, 46–8, 142, 145
32. Zarinebaf-Shahr, 'Qızılbash "Heresy"' 9–13
33. Jennings, *Christians and Muslims* 212–39
34. Hess, 'The Moriscos' 17–21
35. Hess, *The Forgotten Frontier* 95
36. Osman, *Edirne Sarayı* 18
37. Wortley Montagu, *The Turkish Embassy Letters* 96
38. Evliyâ Çelebi, *Seyahatnâme* 3.246
39. Vatin and Veinstein, 'Les obsèques' 230–31
40. Necipoğlu-Kafadar, 'The Süleymaniye Complex' 113
41. Necipoğlu, 'Challenging the Past' 175–6
42. Necipoğlu, 'The Life of an Imperial Monument' 205–7
43. Necipoğlu, 'The Life of an Imperial Monument' 207–8
44. Faroqhi, *Pilgrims and Sultans* 101–2
45. Peirce, *The Imperial Harem* 261
46. Vatin and Veinstein, 'Les obsèques' 226
47. Necipoğlu, 'The Life of an Imperial Monument' 208
48. Austin, *Domenico's Istanbul* 37
49. Fodor, 'The Grand Vizieral *Telhis*' 137, 154–63
50. Fleischer, *Bureaucrat and Intellectual* 46, 56
51. Necipoğlu, *Architecture, Ceremonial and Power* 164
52. Arbel, 'Nur Banu' 241ff
53. Soranzo, 'Relazione e Diario' 237
54. Peirce, *The Imperial Harem* 126, 188
55. Necipoğlu, *Architecture, Ceremonial and Power* 164–75
56. Peirce, *The Imperial Harem* 121, 259
57. Necipoğlu, *Architecture, Ceremonial and Power* 174
58. Ahmed Resmî Efendi, *Hamîletü'l-Küberâ* 44–5
59. Fleischer, *Bureaucrat and Intellectual* 295
60. Tezcan, 'Searching for Osman' 156
61. de Groot, art. Murād III, *EI2* VII.596
62. Flemming, art. Khōdja Efendi, *EI2* V.27, 29
63. Gökbilgin, 'Kara Üveys Paşa'nın Budin Beylerbeyliği' 18ff
64. Winter, 'Ottoman Egypt' 17
65. Clayer, *Mystiques, état et société* 84, 107–11
66. Hess, *The Forgotten Frontier* 95–9
67. Murphey, 'Frontiers of Authority' 28
68. Özbaran, 'Ottoman Naval Policy' 69
69. Fleischer, *Bureaucrat and Intellectual* 76–9
70. Kortepeter, *Ottoman Imperialism* 51–61
71. Fleischer, *Bureaucrat and Intellectual* 85–7
72. Fleischer, *Bureaucrat and Intellectual* 89
73. Kütükoğlu, *Osmanlı-İran Siyâsî Münâsebetleri* 113ff
74. Kortepeter, *Ottoman Imperialism* 55, 68–70
75. Kortepeter, *Ottoman Imperialism* 85–90
76. Selânikî Mustafa Efendi, *Tarih-i Selânikî* 1.190–91
77. Parry, art. Čighāla-zāde (Yūsuf) Sinān Pasha, *EI2* II.33–4
78. Khodarkovsky, 'Of Christianity, Enlightenment and Colonialism' 406, 409
79. Rothenburg, *The Austrian Military Border* 40–56
80. Rothenburg, *The Austrian Military Border* 56–8
81. Fodor, 'Between Two Continental Wars' 90ff
82. Fodor, 'Between Two Continental Wars' 92
83. Ágoston, 'Habsburgs and Ottomans' 131–6; Hegyi, 'The Ottoman Military Force' 134–6
84. Selânikî Mustafa Efendi, *Tarih-i Selânikî* 2.548–9
85. Schmidt, 'The Egri Campaign' 125ff

86. Glover, 'The Journey of Edward Barton Esquire' 318

87. Finkel, *The Administration of Warfare* 17

88. Bayerle, 'The Compromise at Zsitvatorok' 5ff

89. Pamuk, *A Monetary History* 122–3, 131

90. Parrott, 'The Ottoman Conflict' 76

91. Kafadar, 'Les troubles monétaires' 386, 387

92. Terzioğlu, 'The Imperial Circumcision' 85, 88

93. Selâniki Mustafa Efendi, *Tarih-i Selâniki* 2.716

94. Murphey, *Ottoman Warfare* 45

95. Griswold, *The Great Anatolian Rebellion* 83–5, 122, 128–53

96. Salibi, art. Fakhr al-Dīn, *EI2* II.750–51

97. Winter, 'Ottoman Egypt' 17–20

98. Selâniki Mustafa Efendi, *Tarih-i Selâniki* 1.225

99. Fodor, 'Between Two Continental Wars' 96

100. Selâniki Mustafa Efendi, *Tarih-i Selâniki* 1.222

101. Griswold, *The Great Anatolian Rebellion* 49

102. Beldiceanu-Steinherr and Bacqué-Grammont, 'A propos de quelques causes' 82

103. Cook, *Population Pressure* 36

104. Imber, 'The Persecution' 245ff, 246

105. Imber, 'The Persecution' 251–4

106. Griswold, *The Great Anatolian Rebellion* 24–34; Tezcan, 'Searching for Osman' 124

107. Griswold, *The Great Anatolian Rebellion* 34–44

108. Griswold, *The Great Anatolian Rebellion* 44–6

109. Peçevî İbrahim Efendi, *Tarîh-i Peçevî* 2.275

110. Akdağ, *Celali İsyanları* 250–57

111. Veinstein, 'L'occupation ottomane d'Očakov' 128–55; Veinstein, 'Prélude au problème cosaque' 329ff

112. Ostapchuk, 'The Human Landscape' 45–9

113. Burian, *The Report of Lello* 23

114. Griswold, *The Great Anatolian Rebellion* 55

115. Griswold, *The Great Anatolian Rebellion* 54–6

116. Griswold, *The Great Anatolian Rebellion* 168–80

117. Andreasyan, 'Bir Ermeni kaynağına göre' 41

118. Griswold, *The Great Anatolian Rebellion* 182

119. Griswold, *The Great Anatolian Rebellion* 182–97

120. Eskandar Beg Monshi, *History of Shah 'Abbas* 2.969–73

121. Griswold, *The Great Anatolian Rebellion* 203–8

122. Andreasyan, 'Celâlilerden Kaçan Anadolu Halkının' 45–9

123. Morgan, *Medieval Persia* 134–7

124. Kütükoğlu, *Osmanlı-İran Siyâsî Münâsebetleri* 246–59

125. Kütükoğlu, *Osmanlı-İran Siyâsî Münâsebetleri* 259–74

126. Kütükoğlu, *Osmanlı-İran Siyâsî Münâsebetleri* 276–8

127. Eskandar Beg Monshi, *History of Shah 'Abbas* 2.1081–3, 1087–94

128. Eskandar Beg Monshi, *History of Shah 'Abbas* 2.1155

129. Fleischer, 'Royal Authority' 206, 209–10, 212–13

130. Elliott, *Richelieu and Olivares* 34

131. Fodor, 'Sultan, Imperial Council' 78

132. Peirce, *The Imperial Harem* 168–72

133. Abou-El-Haj, *Formation of the Modern State* 38

134. Fodor, 'State and Society' 238

135. Finkel, *The Administration of Warfare* 36–7

136. Fodor, 'State and Society' 238

137. Sayılı, *The Observatory in Islam* 289–305

138. Fleischer, *Bureaucrat and Intellectual* 160

139. İnalcık, art. Kānūnnāme, *EI2* IV.566

140. Tezcan, 'Searching for Osman' 105–9, 116–24

141. Tezcan, 'Searching for Osman' 125–6, 349

142. Fodor, 'An Anti-Semite Grand Vizier?' 192

143. Fodor, 'An Anti-Semite Grand Vizier?' 196–9

144. Thys-Şenocak, 'The Yeni Valide Mosque Complex' 63–4

145. Selâniki Mustafa Efendi, *Tarih-i Selâniki* 2.761

146. Eyice, art. Fethiye Camii, *İst. Ansik.* 3.300

147. Heyd, *Ottoman Documents on Palestine* 175

148. Kiel, 'Notes on the History' 146–7, 148b

149. Schreiner, 'John Malaxos' 203ff

150. Necipoğlu, 'The Life of an Imperial Monument' 210–20

151. Necipoğlu-Kafadar, 'The Süleymaniye Complex' 113

152. Crane, 'The Ottoman Sultan's Mosques' 204

153. Avcıoğlu, 'Ahmed I and the Allegories of Tyranny' 218–23

154. Woodhead, 'An Experiment' 157ff

155. Raby, 'From Europe to Istanbul' 150–63; Çağman, 'Portrait Series' 164–87; Necipoğlu, 'A Period' 202–7; Bağcı, 'The Spread' 216–19; Mahir, 'Portraits' 298–307

156. Mahir, 'Portraits' 299–301

157. Decei, art. Hotin, *İA* 5/1.568

Chapter Seven: Government by faction

1. Peirce, *The Imperial Harem* 99

2. Kâtib Çelebi, *Fezleke* 1.385

3. Peirce, *The Imperial Harem* 232

4. Tezcan, 'Searching for Osman' 131–3

5. Peçevî İbrahim Efendi, *Tarîh-i Peçevî* 2.361

6. Tezcan, 'Searching for Osman' 172–4

7. Peçevî İbrahim Efendi, *Tarîh-i Peçevî* 2.371

8. Kolodziejczyk, *Ottoman–Polish Diplomatic Relations* 129–31

9. Ostapchuk, 'An Ottoman Gazānāme' 488

10. Peçevî İbrahim Efendi, *Tarîh-i Peçevî* 2.375

11. Peçevî İbrahim Efendi, *Tarîh-i Peçevî* 2.374–5

12. Ostapchuk, 'The Human Landscape' 35

13. Ostapchuk, 'An Ottoman Gazānāme' 490–91

14. Kolodziejczyk, *Ottoman–Polish Diplomatic Relations* 376–87

15. Yücel, 'Yeni Bulunan II. Osman Adına' 313ff

16. Kâtib Çelebi, *Fezleke* 2.9–12

17. Peçevî İbrahim Efendi, *Tarîh-i Peçevî* 2.380–81

18. Peçevî İbrahim Efendi, *Tarîh-i Peçevî* 2.381–2

19. Hüseyin Tuği, *Tuği Tarihi* 498

20. Peçevî İbrahim Efendi, *Tarîh-i Peçevî* 2.383–5

21. Peçevî İbrahim Efendi, *Tarîh-i Peçevî* 2.385–8

22. Hüseyin Tuği, *Tuği Tarihi* 493–4, 502

23. Peirce, *The Imperial Harem* 99–101

24. Peçevî İbrahim Efendi, *Tarîh-i Peçevî* 2.391

25. Solak-zâde, Mehmed Hemdemî Çelebî, *Solak-zâde Tarihi* 2.499–500

26. Andreasyan, 'Abaza Mehmed Paşa' 132–5

27. Peçevî İbrahim Efendi, *Tarîh-i Peçevî* 2.389–90

28. Kâtib Çelebi, *Fezleke* 2.35–6

29. Andreasyan, 'Abaza Mehmed Paşa' 135

30. Solak-zâde, Mehmed Hemdemî Çelebî, *Solak-zâde Tarihi* 2.511–12

31. Peirce, *The Imperial Harem* 191, 264

32. Mustafa Na'ima, *Ravzatu'l-Hüseyn* 2.229

33. Eskandar Beg Monshi, *History of Shah 'Abbas* 2.1208–9

34. Peçevî İbrahim Efendi, *Tarîh-i Peçevî* 2.391–3

35. Peçevî İbrahim Efendi, *Tarîh-i Peçevî* 2.401

36. Parry, art. Hāfiz Ahmed Pasha, *EI2* III.58

37. Eskandar Beg Monshi, *History of Shah 'Abbas* 2.1275–80

38. Eskandar Beg Monshi, *History of Shah 'Abbas* 2.1228–49

39. de Groot, art. Khalīl Pasha Kaysariyyeli, *EI2* IV.971

40. Solak-zâde, Mehmed Hemdemî Çelebî, *Solak-zâde Tarihi* 2.519–20

41. de Groot, art. Khalīl Pasha Kaysariyyeli, *EI2* IV.971

42. Eskandar Beg Monshi, *History of Shah 'Abbas* 2.1238–9, 1286–7, 1298–9
43. İnalcık and Repp, art. Khosrew Pasha, *EI2* V.33–4
44. Kâtib Çelebi, *Fezleke* 2.139
45. Peirce, *The Imperial Harem* 244–5
46. Peçevî İbrahim Efendi, *Tarîh-i Peçevî* 2.420
47. Kâtib Çelebi, *Fezleke* 2.139–40
48. Peçevî İbrahim Efendi, *Tarîh-i Peçevî* 2.422–3
49. İnalcık and Repp, art. Khosrew Pasha, *EI2* V.34
50. Andreasyan, 'Abaza Mehmed Paşa' 138–9, 140–41
51. Evliyâ Çelebi, *Seyahatnâme* 1.96–7
52. Andreasyan, 'Abaza Mehmed Paşa' 131, 142
53. Peirce, *The Imperial Harem* 244–5
54. Abu-El-Haj, 'Fitnah, Huruc ala al-Sultan and Nasihat' 185ff
55. Fodor, 'State and Society' 231–3
56. Peçevî İbrahim Efendi, *Tarîh-i Peçevî* 2.427–8; Kâtib Çelebi, *Fezleke* 2.144–7
57. Murphey, 'The Veliyyuddin Telhis' 554–5
58. Howard, 'The Ottoman Timar System' 211, 214–15, 223
59. Murphey, 'An Ottoman View' 333–4
60. Andreasyan, 'Celâlilerden Kaçan Anadolu Halkının' 49–53
61. Murphey, *Regional Structure*
62. İnalcık, 'Tax Collection' 335–9; Salibi, art. Fakhr al-Dīn, *EI2*. II.751
63. Thomas, *A Study of Naima* 140–45
64. Brouwer, 'A Stockless Anchor' 173–5
65. Yılmaz, 'Osmanlı İmparatorluğunda Tütün Tarımı'
66. Baer, 'Honored by the Glory of Islam' 152–4
67. Kâtib Çelebi, *Fezleke* 2.155
68. Kâtib Çelebi, *Fezleke* 2.154–5
69. Zilfi, 'The Kadızadelis' 260–61
70. Zilfi, 'The Kadızadelis' 257–8
71. Clayer, *Mystiques, état et société* 66
72. Kafadar, 'Eyüp'te Kılıç Kuşanma Törenleri' 59
73. Zilfi, *The Politics of Piety* 140
74. Zilfi, 'The Kadızadelis' 258
75. İpşirli, art. Ahîzâde Hüseyin Efendi, *İA2* 1.548–9
76. Zilfi, *The Politics of Piety* 114
77. Kâtib Çelebi, *Fezleke* 2.151, 153–4
78. Kâtib Çelebi, *Fezleke* 2.160–61
79. Murphey, 'An Ottoman View' 331
80. Kâtib Çelebi, *Fezleke* 2.164–5
81. Evliyâ Çelebi, *Seyahatnâme* 1.208
82. Tavernier, *Les six voyages* 1.36
83. Kâtib Çelebi, *Fezleke* 2.186
84. Kâtib Çelebi, *Fezleke* 2.190–91
85. Evliyâ Çelebi, *Seyahatnâme* 1.217–317
86. Kâtib Çelebi, *Fezleke* 2.205
87. Faroqhi, *Pilgrims and Sultans* 113–20
88. Decei and Gökbilgin, art. Erdel, *EI2* II.704
89. Setton, *Venice, Austria, and the Turks* 81, 157
90. Faroqhi, 'The Venetian Presence' 321–2
91. Ostapchuk, 'An Ottoman Gazānāme' 492–3
92. Ostapchuk, 'The Human Landscape' 27ff
93. Ostapchuk, 'The Ottoman Black Sea Frontier' 79
94. Ostapchuk, 'The Human Landscape' 79
95. Ostapchuk, 'The Ottoman Black Sea Frontier' 62ff
96. Ostapchuk, 'The Human Landscape' 44, 50–58
97. Ostapchuk, 'The Ottoman Black Sea Frontier' 62, 68, 72–3, 113–16
98. Ostapchuk, 'The Ottoman Black Sea Frontier' 82
99. Ostapchuk, 'The Ottoman Black Sea Frontier' 28
100. Ostapchuk, 'The Ottoman Black Sea Frontier' 149–64
101. Ostapchuk, 'Five Documents' 90–91
102. Mustafa Na'ima, *Ravzatü'l-Hüseyn* 4.4, 5–6
103. Fuller, *Strategy and Power* 1–14
104. İnalcık, 'Power Relationships' 198–9
105. Faroqhi, 'The Venetian Presence' 320
106. Setton, *Venice, Austria, and the Turks* 108–10; Theunissen, 'Ottoman–Venetian Diplomatics' 183

Chapter Eight: Revenge of the pashas

1. Peirce, *The Imperial Harem* 250
2. Darling, *Revenue-Raising and Legitimacy* 94–6
3. Kâtib Çelebi, *Fezleke* 2.232
4. Yücel, *Es'ar Defteri*
5. Kâtib Çelebi, *Fezleke* 2.226
6. Hasan Vecîhî, 'Vecîhî Ta'rîhi' 19v
7. Kâtib Çelebi, *Fezleke* 2.226–8
8. Solak-zâde, Mehmed Hemdemî Çelebi, *Solak-zâde Tarihi* 2.556–8
9. Aktepe, art. Mehmed Paşa, *İA* 7.606
10. Zilfi, *The Politics of Piety* 97–100
11. Kâtib Çelebi, *Fezleke* 2.233–4
12. Setton, *Venice, Austria, and the Turks* 112–17
13. Setton, *Venice, Austria, and the Turks* 116
14. Kâtib Çelebi, *Fezleke* 2.239
15. Setton, *Venice, Austria, and the Turks* 126
16. Kâtib Çelebi, *Fezleke* 2.260
17. Gökbilgin, art. İbrahim, *İA* 5/II.883
18. Setton, *Venice, Austria, and the Turks* 142–3, 148–9
19. Kâtib Çelebi, *Fezleke* 2.357
20. Setton, *Venice, Austria, and the Turks* 149–50
21. Goffman, *Britons in the Ottoman Empire* 152
22. Hrushevsky, *History of Ukraine-Rus'* 8.263–6
23. Hrushevsky, *History of Ukraine-Rus'* 8.266–9
24. Hasan Vecîhî, 'Vecîhî Ta'rîhi' 27v
25. Uluçay, 'Üç Eşkiya Türküsü' 85ff
26. Aktepe, 'İpşir Mustafa Paşa' 45
27. İnalcık, art. Haydar-oghlu, *EI2* III.317–18
28. Uluçay, 'Üç Eşkiya Türküsü' 89–90
29. Mustafa Na'ima, *Ravzatü'l-Hüseyn* 4.239–40
30. Evliyâ Çelebi, *Seyahatnâme* 2.192
31. Evliyâ Çelebi, *Seyahatnâme* 2.198
32. Evliyâ Çelebi, *Seyahatnâme* 2.231–2, 235–6, 238–40
33. Soucek, review of M. Dukanović, *Rimovana autobiografija Varvari Ali-Paše* 290ff
34. Hasan Vecîhî, 'Vecîhî Ta'rîhi' 30v
35. Peirce, *The Imperial Harem* 264
36. Kâtib Çelebi, *Fezleke* 2.327
37. Hasan Vecîhî, 'Vecîhî Ta'rîhi' 30v–31r
38. Kâtib Çelebi, *Fezleke* 2.329
39. Kâtib Çelebi, *Fezleke* 2.330
40. Hasan Vecîhî, 'Vecîhî Ta'rîhi' 32r
41. Peirce, *The Imperial Harem* 251
42. Peirce, *The Imperial Harem* 251
43. Hasan Vecîhî, 'Vecîhî Ta'rîhi' 32v–34r
44. Abdurrahman Abdi Paşa, 'Abdurrahman Abdi Paşa Vekâyi'nâme'si' 7–8, 14–15
45. Mustafa Na'ima, *Ravzatü'l-Hüseyn* 4.408
46. Abdurrahman Abdi Paşa, 'Abdurrahman Abdi Paşa Vekâyi'nâme'si' 15–16
47. Abdurrahman Abdi Paşa, 'Abdurrahman Abdi Paşa Vekâyi'nâme'si' 16
48. Mustafa Na'ima, *Ravzatü'l-Hüseyn* 4.412–13
49. Abdurrahman Abdi Paşa, 'Abdurrahman Abdi Paşa Vekâyi'nâme'si' 16–17
50. Orhonlu, art. Kâtırdjı-oghlı Mehmed Pasha, *EI2* IV.766
51. Mustafa Na'ima, *Ravzatü'l-Hüseyn* 4.413–14
52. Mustafa Na'ima, *Ravzatü'l-Hüseyn* 4.410, 415
53. Abdurrahman Abdi Paşa, 'Abdurrahman Abdi Paşa Vekâyi'nâme'si' 22
54. İpşirli, art. Derviş Mehmed Paşa, *İA2* 9.193–4
55. Dankoff, *The Intimate Life* 9
56. Evliyâ Çelebi, *Seyahatnâme* 1.190, 5.89
57. Kunt, 'Ethnic-Regional (*Cins*) Solidarity' 237–8
58. Kâtib Çelebi, *Fezleke* 2.373–4
59. Abdurrahman Abdi Paşa, 'Abdurrahman Abdi Paşa Vekâyi'nâme'si' 28
60. Mustafa Na'ima, *Ravzatü'l-Hüseyn* 5.98
61. Kaya, art. Karaçelebizâde Abdülaziz Efendi, *İA2* 24.382
62. Mustafa Na'ima, *Ravzatü'l-Hüseyn* 5.99
63. Karaçelebizâde Abdülaziz Efendi, 'Zeyl-i Ravzatü'l-Ebrâr' 41v–43r

64. Karaçelebizâde Abdülaziz Efendi, 'Zeyl-i Ravzatü'l-Ebrâr' 43r–44r
65. Mustafa Na'ima, *Ravzatü'l-Hüseyn* 5.99–102
66. Dankoff, *The Intimate Life* 82
67. Mustafa Na'ima, *Ravzatü'l-Hüseyn* 5.103–5
68. Mustafa Na'ima, *Ravzatü'l-Hüseyn* 5.107–11
69. Mustafa Na'ima, *Ravzatü'l-Hüseyn* 5.102; cf. Thomas, *A Study of Naima* 102
70. Mustafa Na'ima, *Ravzatü'l-Hüseyn* 5.114–15; cf. Thomas, *A Study of Naima* 101–2
71. Mustafa Na'ima, *Ravzatü'l-Hüseyn* 5.118–21
72. Mustafa Na'ima, *Ravzatü'l-Hüseyn* 5.122–7
73. Mustafa Na'ima, *Ravzatü'l-Hüseyn* 5.130–44
74. Abdurrahman Abdi Paşa, 'Abdurrahman Abdi Paşa Vekâyi'nâme'si' 32
75. Kâtib Çelebi, *Fezleke* 2.343
76. Abdurrahman Abdi Paşa, 'Abdurrahman Abdi Paşa Vekâyi'nâme'si' 36
77. Mustafa Na'ima, *Ravzatü'l-Hüseyn* 5.215–21
78. Mustafa Na'ima, *Ravzatü'l-Hüseyn* 5.221–2
79. Murphey, 'Solakzade's Treatise of 1652' 27ff
80. Mustafa Na'ima, *Ravzatü'l-Hüseyn* 5.271–2
81. Dankoff, *The Intimate Life* 107
82. Dankoff, *The Intimate Life* 108
83. Kunt, 'Derviş Mehmed Paşa' 202
84. Dankoff, *The Intimate Life* 107
85. Aktepe, 'İpşir Mustafa Paşa' 45–47
86. Aktepe, 'İpşir Mustafa Paşa' 47–52
87. Murphey, 'Forms of Differentiation' 161–2
88. Setton, *Venice, Austria, and the Turks* 163–4
89. Setton, *Venice, Austria, and the Turks* 172–82
90. Abdurrahman Abdi Paşa, 'Abdurrahman Abdi Paşa Vekâyi'nâme'si' 79–80
91. Mustafa Na'ima, *Ravzatü'l-Hüseyn* 6.182
92. Ostapchuk, 'Ukraine between' 8, 11–16
93. Andreasyan and Derin, 'Çınar Vak'ası' 58–60
94. Andreasyan and Derin, 'Çınar Vak'ası' 61–8
95. Andreasyan and Derin, 'Çınar Vak'ası' 70–71
96. Andreasyan and Derin, 'Çınar Vak'ası' 70–71
97. Andreasyan and Derin, 'Çınar Vak'ası' 71–3
98. Kâtib Çelebi, *Fezleke* 2.225
99. Andreasyan and Derin, 'Çınar Vak'ası' 73
100. Setton, *Venice, Austria, and the Turks* 184
101. Mustafa Na'ima, *Ravzatü'l-Hüseyn* 6.205
102. Andreasyan and Derin, 'Çınar Vak'ası' 65
103. Mustafa Na'ima, *Ravzatü'l-Hüseyn* 6.206–7
104. Mustafa Na'ima, *Ravzatü'l-Hüseyn* 6.207–8

Chapter Nine: Rule of the grandees

1. Gökbilgin and Repp, art. Köprülü, *EI2* V.256–63; Heywood, art. Karā Mustafā Pasha, Merzifonlu *EI2* IV.589–92; Köprülü, art. ('Amūdjazāde) Husayn Pasha, *EI2* III.626–7
2. Abdurrahman Abdi Paşa, 'Abdurrahman Abdi Paşa Vekâyi'nâme'si' 80
3. Abdurrahman Abdi Paşa, 'Abdurrahman Abdi Paşa Vekâyi'nâme'si' 74
4. Mustafa Na'ima, *Ravzatu'l-Hüseyn* 6.138
5. Mustafa Na'ima, *Ravzatu'l-Hüseyn* 6.135, 209, 212
6. Thomas, *A Study of Naima* 101–2
7. Kunt, 'Naîmâ, Köprülü and the Grand Vezirate' 62
8. Dankoff, *The Intimate Life* 204
9. Zilfi, 'The Kadızadelis' 258, 259–60
10. Mustafa Na'ima, *Ravzatü'l-Hüseyn* 6.218–20
11. Zilfi, *The Politics of Piety* 147

12. Baer, 'Honored by the Glory of Islam' 157–8
13. İlgürel, art. Hüseyin Paşa (Deli), *İA2* 19.6
14. Abdurrahman Abdi Paşa, 'Abdurrahman Abdi Paşa Vekâyi'nâme'si' 81
15. Mustafa Na'ima, *Ravzatü'l-Hüseyn* 6.237–49
16. Abdurrahman Abdi Paşa, 'Abdurrahman Abdi Paşa Vekâyi'nâme'si' 87
17. Mustafa Na'ima, *Ravzatü'l-Hüseyn* 6.266ff
18. Setton, *Venice, Austria, and the Turks* 188–9
19. Kolodziejczyk, *Ottoman–Polish Diplomatic Relations* 142; Gökbilgin and Repp, art. Köprülü, *EI2* V.257–8
20. Mustafa Na'ima, *Ravzatü'l-Hüseyn* 6.329
21. Abdurrahman Abdi Paşa, 'Abdurrahman Abdi Paşa Vekâyi'nâme'si' 98
22. Abdurrahman Abdi Paşa, 'Abdurrahman Abdi Paşa Vekâyi'nâme'si' 104
23. Mustafa Na'ima, *Ravzatü'l-Hüseyn* 6.329–33, 379
24. Mustafa Na'ima, *Ravzatü'l-Hüseyn* 6.333
25. Abdurrahman Abdi Paşa, 'Abdurrahman Abdi Paşa Vekâyi'nâme'si' 105
26. Mustafa Na'ima, *Ravzatü'l-Hüseyn* 6.335
27. Mustafa Na'ima, *Ravzatü'l-Hüseyn* 6.336
28. Mustafa Na'ima, *Ravzatü'l-Hüseyn* 6.336–8
29. Mustafa Na'ima, *Ravzatü'l-Hüseyn* 6.338; cf. Woods, *The Aqquyunlu* 116–17
30. Abdurrahman Abdi Paşa, 'Abdurrahman Abdi Paşa Vekâyi'nâme'si' 110–11
31. Mustafa Na'ima, *Ravzatü'l-Hüseyn* 6.361–7
32. Mustafa Na'ima, *Ravzatü'l-Hüseyn* 6.368–75
33. Mustafa Na'ima, *Ravzatü'l-Hüseyn* 6.375–8

34. Abdurrahman Abdi Paşa, 'Abdurrahman Abdi Paşa Vekâyi'nâme'si' 114, 115–16
35. Mustafa Na'ima, *Ravzatü'l-Hüseyn* 6.402–5
36. Mustafa Na'ima, *Ravzatü'l-Hüseyn* 6.397–401; cf. Necipoğlu, *Architecture, Ceremonial and Power* 151–2
37. Mustafa Na'ima, *Ravzatü'l-Hüseyn* 6.407–8; Abdurrahman Abdi Paşa, 'Abdurrahman Abdi Paşa Vekâyi'nâme'si' 121
38. Peirce, *The Imperial Harem* 196
39. Kunt, 'The Waqf as an Instrument' 193–4
40. Kunt, 'The Waqf as an Instrument' 193, 195–6
41. Gökbilgin and Repp, art. Köprülü, *EI2* V.259
42. Kopčan, 'Einige Bemerkungen' 163
43. Decei and Gökbilgin, art. Erdel, *İA* 4.303
44. Fodor, 'The View of the Turk' 98–9
45. Decei and Gökbilgin, art. Erdel, *İA* 4.303–4
46. Kopčan, 'Ottoman Narrative Sources' 91
47. Kopčan, 'Ottoman Narrative Sources' 91–3
48. Gökbilgin and Repp, art. Köprülü, *EI2* V.259
49. Evliyâ Çelebi, *Seyahatnâme* 7.29ff
50. Evliyâ Çelebi, *Seyahatnâme* 7.36
51. Defterdar Sarı Mehmed Paşa, *Zübde-i Vekayiât* 8–9
52. Evliyâ Çelebi, *Seyahatnâme* 7.53ff; cf. Unat, *Osmanlı Sefirleri* 47–9
53. Evliyâ Çelebi, *Seyahatnâme* 7.116
54. Abdurrahman Abdi Paşa, 'Abdurrahman Abdi Paşa Vekâyi'nâme'si' 134–70, 141, 152, 163–4, 172
55. Silâhdâr Fındıklılı Mehmed Ağa, *Silâhdâr Ta'rîhi* 1.393–5
56. Silâhdâr Fındıklılı Mehmed Ağa, *Silâhdâr Ta'rîhi* 1.411–12
57. Abdurrahman Abdi Paşa, 'Abdurrahman Abdi Paşa Vekâyi'nâme'si' 206–7
58. Silâhdâr Fındıklılı Mehmed Ağa, *Silâhdâr Ta'rîhi* 1.411–12; Setton,

Venice, Austria, and the Turks 194–5
59. Setton, *Venice, Austria, and the Turks* 206ff
60. Setton, *Venice, Austria, and the Turks* 220–24
61. Setton, *Venice, Austria, and the Turks* 224–8; Silâhdâr Fındıklılı Mehmed Ağa, *Silâhdâr Ta'rîhi* 1.513–14
62. Greene, *A Shared World* 50, 54, 110ff
63. Greene, *A Shared World* 80–81
64. Evliyâ Çelebi, *Seyahatnâme* 8.460–61
65. Bierman, 'The Ottomanization of Crete' 53ff
66. Greene, *A Shared World* 78ff
67. Bierman, 'The Ottomanization of Crete' 61–3
68. Kolodziejczyk, *Ottoman–Polish Diplomatic Relations* 141–5
69. Ostapchuk, 'Ukraine between' 12–13, 19–20
70. Ostapchuk, 'Ukraine between' 21–2
71. Kolodziejczyk, *The Ottoman Survey Register* 6–7
72. Silâhdâr Fındıklılı Mehmed Ağa, *Silâhdâr Ta'rîhi* 1.574
73. Abdurrahman Abdi Paşa, 'Abdurrahman Abdi Paşa Vekâyi'nâme'si' 325–8
74. Silâhdâr Fındıklılı Mehmed Ağa, *Silâhdâr Ta'rîhi* 1.576
75. Abdurrahman Abdi Paşa, 'Abdurrahman Abdi Paşa Vekâyi'nâme'si' 329, 336, 340–44, 347–8
76. Kolodziejczyk, *The Ottoman Survey Register* 59–65
77. Kolodziejczyk, *The Ottoman Survey Register* 13, 16–17
78. Metin Kunt, oral communication
79. Kolodziejczyk, *Ottoman–Polish Diplomatic Relations* 148, 494–580
80. Silâhdâr Fındıklılı Mehmed Ağa, *Silâhdâr Ta'rîhi* 1.648–9, 653
81. Kolodziejczyk, *Ottoman–Polish Diplomatic Relations* 149
82. Ostapchuk, 'Ukraine between' 23–4
83. Hezarfen Hüseyin Efendi, *Telhîsü'l-Beyân* 207–46
84. Hezarfen Hüseyin Efendi, *Telhîsü'l-Beyân* 208
85. Baer, 'Honored by the Glory of Islam' 167
86. Baer, 'Honored by the Glory of Islam' 107–8
87. Kolodziejczyk, *The Ottoman Survey Register* 60, 61
88. Zilfi, 'The Kadızadelis' 263–4; Zilfi, *The Politics of Piety* 149
89. Baer, 'Honored by the Glory of Islam' 142–6
90. Covel, *Voyages en Turquie* 88–90
91. Baer, 'Honored by the Glory of Islam' 132–7
92. Zilfi, *The Politics of Piety* 157
93. Peirce, *The Imperial Harem* 206–7
94. Thys-Şenocak, 'The Yeni Valide' 66–8; Baer, 'Honored by the Glory of Islam' 125–7
95. Baer, 'Honored by the Glory of Islam' 85–7
96. Refik, *Onikinci Asr-i Hicrî'de* 88–9
97. Thys-Şenocak, 'The Yeni Valide' 67
98. Baer, 'Honored by the Glory of Islam' 296
99. Abdurrahman Abdi Paşa, 'Abdurrahman Abdi Paşa Vekâyi'nâme'si' 215–16
100. Baer, 'Honored by the Glory of Islam' 304–6
101. Zilfi, *The Politics of Piety* 154–6
102. Baer, 'Honored by the Glory of Islam' 168–75, 181–91, 205ff
103. Gökbilgin and Repp, art. Köprülü, *EI2* V.260–61
104. Heywood, art. Karā Mustafā Pasha, Merzifonlu, *EI2* IV.589–90
105. Ostapchuk, 'Ukraine between' 24–5
106. Defterdar Sarı Mehmed Paşa, *Zübde-i Vekayiât* 91
107. Defterdar Sarı Mehmed Paşa, *Zübde-i Vekayiât* 109
108. Defterdar Sarı Mehmed Paşa, *Zübde-i Vekayiât* 110, 119; Kolodziejczyk, *Ottoman–Polish Diplomatic Relations* 152; Ostapchuk, 'Ukraine between' 26
109. Kann, *A History of the Habsburg Empire* 72–3
110. Stoye, *The Siege of Vienna* 43–4
111. Silâhdâr Fındıklılı Mehmed Ağa, *Silâhdâr Ta'rîhi* 1.743
112. Refik, *Türk Hizmetinde Kiral Tököli İmre* 8–10
113. Silâhdâr Fındıklılı Mehmed Ağa, *Silâhdâr Ta'rîhi* 1.757–8

114. Stoye, *The Siege of Vienna* 45
115. Silâhdâr Fındıklılı Mehmed Ağa, *Silâhdâr Ta'rîhi* 1.757–8
116. Defterdar Sarı Mehmed Paşa, *Zübde-i Vekayiât* 137
117. Defterdar Sarı Mehmed Paşa, *Zübde-i Vekayiât* 139, 141–2
118. Silâhdâr Fındıklılı Mehmed Ağa, *Silâhdâr Ta'rîhi* 2.5–6
119. Defterdar Sarı Mehmed Paşa, *Zübde-i Vekayiât* 146–8
120. Stoye, *The Siege of Vienna* 120–49, 174–5
121. Silâhdâr Fındıklılı Mehmed Ağa, *Silâhdâr Ta'rîhi* 2.39
122. Defterdar Sarı Mehmed Paşa, *Zübde-i Vekayiât* 151
123. Stoye, *The Siege of Vienna* 150–73
124. Kolodziejczyk, *Ottoman–Polish Diplomatic Relations* 153–4
125. Stoye, *The Siege of Vienna* 200–27
126. Stoye, *The Siege of Vienna* 243–64
127. Silâhdâr Fındıklılı Mehmed Ağa, *Silâhdâr Ta'rîhi* 2.87–8
128. Defterdar Sarı Mehmed Paşa, *Zübde-i Vekayiât* 163
129. Stoye, *The Siege of Vienna* 158–61
130. Defterdar Sarı Mehmed Paşa, *Zübde-i Vekayiât* 159–60
131. Silâhdâr Fındıklılı Mehmed Ağa, *Silâhdâr Ta'rîhi* 2.119–21
132. Silâhdâr Fındıklılı Mehmed Ağa, *Silâhdâr Ta'rîhi* 2.124
133. Silâhdâr Fındıklılı Mehmed Ağa, *Silâhdâr Ta'rîhi* 2.123
134. Gabriel, 'Die Türkenbeute in Österreich' 101ff
135. Silâhdâr Fındıklılı Mehmed Ağa, *Silâhdâr Ta'rîhi* 1.757–8
136. Silâhdâr Fındıklılı Mehmed Ağa, *Silâhdâr Ta'rîhi* 2.120
137. Zilfi, *The Politics of Piety* 157
138. Defterdar Sarı Mehmed Paşa, *Zübde-i Vekayiât* 210

Chapter Ten: The empire unravels

1. Silâhdâr Fındıklılı Mehmed Ağa, *Silâhdâr Ta'rîhi* 2.126–7
2. Setton, *Venice, Austria, and the Turks* 273–4
3. Silâhdâr Fındıklılı Mehmed Ağa,
Silâhdâr Ta'rîhi 2.231–2
4. Gökbilgin and Repp, art. Köprülü, *EI2* V.261; Silâhdâr Fındıklılı Mehmed Ağa, *Silâhdâr Ta'rîhi* 2.127
5. Setton, *Venice, Austria, and the Turks* 273–6
6. Defterdar Sarı Mehmed Paşa, *Zübde-i Vekayiât* 166, 179–80, 206–7
7. Defterdar Sarı Mehmed Paşa, *Zübde-i Vekayiât* 211, 212, 213–14
8. Silâhdâr Fındıklılı Mehmed Ağa, *Silâhdâr Ta'rîhi* 2.228
9. Silâhdâr Fındıklılı Mehmed Ağa, *Silâhdâr Ta'rîhi* 2.236–7, 240–41, 243
10. Atasoy, art. Hırka-i Saâdet, *İA2* 17.375
11. Silâhdâr Fındıklılı Mehmed Ağa, *Silâhdâr Ta'rîhi* 2.238–9
12. Silâhdâr Fındıklılı Mehmed Ağa, *Silâhdâr Ta'rîhi* 2.249–53
13. Setton, *Venice, Austria, and the Turks* 277, 280–81, 282–3
14. Silâhdâr Fındıklılı Mehmed Ağa, *Silâhdâr Ta'rîhi* 2.262–4; cf. Defterdar Sarı Mehmed Paşa, *Zübde-i Vekayiât* 221
15. Setton, *Venice, Austria and the Turks* 287, 309–12
16. Defterdar Sarı Mehmed Paşa, *Zübde-i Vekayiât* 230–31
17. Silâhdâr Fındıklılı Mehmed Ağa, *Silâhdâr Ta'rîhi* 2.292
18. Defterdar Sarı Mehmed Paşa, *Zübde-i Vekayiât* 232–3
19. Defterdar Sarı Mehmed Paşa, *Zübde-i Vekayiât* 233–7
20. Defterdar Sarı Mehmed Paşa, *Zübde-i Vekayiât* 237–8
21. Defterdar Sarı Mehmed Paşa, *Zübde-i Vekayiât* 238–42
22. Defterdar Sarı Mehmed Paşa, *Zübde-i Vekayiât* 243–5
23. Defterdar Sarı Mehmed Paşa, *Zübde-i Vekayiât* 213, 214, 245–7
24. Defterdar Sarı Mehmed Paşa, *Zübde-i Vekayiât* 246, 247, 248–9
25. Defterdar Sarı Mehmed Paşa, *Zübde-i Vekayiât* 228–9, 232–5, 237
26. Defterdar Sarı Mehmed Paşa, *Zübde-i Vekayiât* 251–3
27. Silâhdâr Fındılılı Mehmed Ağa, *Silâhdâr Ta'rîhi* 2.291, 295
28. Defterdar Sarı Mehmed Paşa, *Zübde-i*

Vekayiât 254

29. Silâhdâr Fındıklılı Mehmed Ağa,
 Silâhdâr Ta'rîhi 2.296–8
30. Defterdar Sarı Mehmed Paşa, *Zübde-i
 Vekayiât* 438–9
31. Defterdar Sarı Mehmed Paşa, *Zübde-i
 Vekayiât* 265, 268–71
32. Defterdar Sarı Mehmed Paşa, *Zübde-i
 Vekayiât* 271, 272, 273–4, 275
33. Defterdar Sarı Mehmed Paşa, *Zübde-i
 Vekayiât* 275–7
34. Defterdar Sarı Mehmed Paşa, *Zübde-i
 Vekayiât* 280–81
35. Defterdar Sarı Mehmed Paşa, *Zübde-i
 Vekayiât* 282–5
36. Defterdar Sarı Mehmed Paşa, *Zübde-i
 Vekayiât* 285–6, 288–9
37. Defterdar Sarı Mehmed Paşa, *Zübde-i
 Vekayiât* 245, 288
38. Defterdar Sarı Mehmed Paşa, *Zübde-i
 Vekayiât* 288–9, 290, 293, 315
39. Defterdar Sarı Mehmed Paşa, *Zübde-i
 Vekayiât* 287
40. Pamuk, *A Monetary History* 145–6,
 155–8
41. Silâhdâr Fındıklılı Mehmed Ağa,
 Silâhdâr Ta'rîhi 2.365
42. Silâhdâr Fındıklılı Mehmed Ağa,
 Silâhdâr Ta'rîhi 2.365–6; Defterdar
 Sarı Mehmed Paşa, *Zübde-i Vekayiât*
 291–2
43. Defterdar Sarı Mehmed Paşa, *Zübde-i
 Vekayiât* 305
44. Silâhdâr Fındıklılı Mehmed Ağa,
 Silâhdâr Ta'rîhi 2.371–4
45. Heywood, 'English Diplomacy' 65
46. Defterdar Sarı Mehmed Paşa, *Zübde-i
 Vekayiât* 305, 308–10
47. Defterdar Sarı Mehmed Paşa, *Zübde-i
 Vekayiât* 312–13, 314
48. Defterdar Sarı Mehmed Paşa, *Zübde-i
 Vekayiât* 312–13
49. Defterdar Sarı Mehmed Paşa, *Zübde-i
 Vekayiât* 320–21, 329–30, 338
50. Setton, *Venice, Austria, and the Turks*
 389–90
51. Defterdar Sarı Mehmed Paşa, *Zübde-i
 Vekayiât* 322
52. Defterdar Sarı Mehmed Paşa, *Zübde-i
 Vekayiât* 330
53. Heywood, 'An Undiplomatic
 Anglo-Dutch Dispute' 64
54. Heywood, 'English Diplomacy'

78–80

55. Defterdar Sarı Mehmed Paşa, *Zübde-i
 Vekayiât* 330–33
56. Yılmaz, 'The Life of Köprülü Fazıl
 Mustafa Pasha' 35
57. Defterdar Sarı Mehmed Paşa, *Zübde-i
 Vekayiât* 333, 334, 336, 338,
 339–40
58. Gökbilgin and Repp, art. Köprülü,
 EI2 V.261
59. Gökbilgin and Repp, art. Köprülü,
 EI2 V.261
60. Defterdar Sarı Mehmed Paşa, *Zübde-i
 Vekayiât* 339–40
61. Defterdar Sarı Mehmed Paşa, *Zübde-i
 Vekayiât* 341, 343ff
62. Yılmaz, 'The Life of Köprülü Fazıl
 Mustafa Pasha' 24–7
63. Yılmaz, 'The Life of Köprülü Fazıl
 Mustafa Pasha' 27–31
64. Halaçoğlu, art. Evlâd-i Fâtihan, *İA2*
 11.524–5
65. Defterdar Sarı Mehmed Paşa, *Zübde-i
 Vekayiât* 366–7
66. Defterdar Sarı Mehmed Paşa, *Zübde-i
 Vekayiât* 367–8, 370–71
67. Defterdar Sarı Mehmed Paşa, *Zübde-i
 Vekayiât* 369, 371–3, 374–5, 376
68. Heywood, 'English Diplomacy'
 117
69. Defterdar Sarı Mehmed Paşa, *Zübde-i
 Vekayiât* 379
70. Finkel, *The Administration of Warfare*
 17
71. Defterdar Sarı Mehmed Paşa, *Zübde-i
 Vekayiât* 377–8
72. Defterdar Sarı Mehmed Paşa, *Zübde-i
 Vekayiât* 298–9, 343, 345
73. Yılmaz, 'The Life of Köprülü Fazıl
 Mustafa Pasha' 19–20
74. Yılmaz, 'Osmanlı İmparatorluğunda
 Tütün Tarımı'
75. Tabakoğlu, *Gerileme Dönemine
 Girerken Osmanlı Maliyesi* 274–5;
 Defterdar Sarı Mehmed Paşa, *Zübde-i
 Vekayiât* 632–3
76. Halaçoğlu, *XVIII. yüzyılda Osmanlı
 İmparatorluğu'nun iskan siyaseti* 4–6
77. Orhonlu, *Osmanlı İmparatorluğunda
 Aşiretleri İskân Teşebbüsü* 30
78. Halaçoğlu, *XVIII. yüzyılda Osmanlı
 İmparatorluğu'nun iskan siyaseti* 4–6
79. Orhonlu, *Osmanlı İmparatorluğunda*

Aşiretleri İskân Teşebbüsü 43ff

80. Orhonlu, *Osmanlı İmparatorluğunda Aşiretleri İskân Teşebbüsü* map

81. Orhonlu, *Osmanlı İmparatorluğunda Aşiretleri İskân Teşebbüsü* 43ff

82. Silahdar Fındıklılı Mehmed Ağa, *Nusretnâme* 1.246–50; Defterdar Sarı Mehmed Paşa, *Zübde-i Vekayiât* 627–8

83. Orhonlu, *Osmanlı İmparatorluğunda Aşiretleri İskân Teşebbüsü* 89–90

84. Murphey, 'Ottoman Census Methods' 120

85. Yılmaz, 'The Life of Köprülü Fazıl Mustafa Pasha' 46–7

86. Rossitsa Gradeva, personal communication

87. Yılmaz, 'The Life of Köprülü Fazıl Mustafa Pasha' 48

88. Yılmaz, 'The Life of Köprülü Fazıl Mustafa Pasha' 48–53; Tabakoğlu, *Gerileme Dönemine Girerken Osmanlı Maliyesi* 136–49

89. Silâhdâr Fındıklılı Mehmed Ağa, *Silâhdâr Ta'rîhi* 2.567–9

90. Silâhdâr Fındıklılı Mehmed Ağa, *Silâhdâr Ta'rîhi* 2.569–70

91. Defterdar Sarı Mehmed Paşa, *Zübde-i Vekayiât* 398

92. Murphey, 'Continuity and Discontinuity' 419ff

93. Murphey, art. Süleymān II, *EI2* IX.842

94. Defterdar Sarı Mehmed Paşa, *Zübde-i Vekayiât* 399–400, 405

95. Defterdar Sarı Mehmed Paşa, *Zübde-i Vekayiât* 377, 403

96. Defterdar Sarı Mehmed Paşa, *Zübde-i Vekayiât* 404, 407

97. Heywood, 'An Undiplomatic Anglo-Dutch Dispute' 66

98. Ingrao, *The Habsburg Monarchy* 79

99. Defterdar Sarı Mehmed Paşa, *Zübde-i Vekayiât* 421–2, 424, 430–32, 438

100. Heywood, 'An Undiplomatic Anglo-Dutch Dispute' 73–91

101. Heywood, 'English Diplomacy' 216

102. Heywood, 'English Diplomacy' passim

103. Defterdar Sarı Mehmed Paşa, *Zübde-i Vekayiât* 440, 445, 450–54, 456–63, 465, 492–4

104. Defterdar Sarı Mehmed Paşa, *Zübde-i Vekayiât* 522–3

105. Defterdar Sarı Mehmed Paşa, *Zübde-i Vekayiât* 549, 553

106. Silahdar Fındıklılı Mehmed Ağa, *Nusretnâme* 1.57

107. Defterdar Sarı Mehmed Paşa, *Zübde-i Vekayiât* 554–5, 555–6, 558, 566, 570

108. Silahdar Fındıklılı Mehmed Ağa, *Nusretnâme* 1.133

109. Defterdar Sarı Mehmed Paşa, *Zübde-i Vekayiât* 588, 591–4

110. Silahdar Fındıklılı Mehmed Ağa, *Nusretnâme* 1.277–9

111. Köprülü, art. ('Amūdja-zāde) Husayn Pasha, *EI2* III.627

112. Defterdar Sarı Mehmed Paşa, *Zübde-i Vekayiât* 622

113. Silahdar Fındıklılı Mehmed Ağa, *Nusretnâme* 1.280

114. Silahdar Fındıklılı Mehmed Ağa, *Nusretnâme* 1.277–8

115. Defterdar Sarı Mehmed Paşa, *Zübde-i Vekayiât* 622–3

116. Silahdar Fındıklılı Mehmed Ağa, *Nusretnâme* 1.294–9

117. Silahdar Fındıklılı Mehmed Ağa, *Nusretnâme* 1.299–300

118. Defterdar Sarı Mehmed Paşa, *Zübde-i Vekayiât* 639–41, 643–5, 649–50

119. Defterdar Sarı Mehmed Paşa, *Zübde-i Vekayiât* 645, 650

120. Heywood, 'English Diplomacy' 257

121. Defterdar Sarı Mehmed Paşa, *Zübde-i Vekayiât* 653–4

122. Defterdar Sarı Mehmed Paşa, *Zübde-i Vekayiât* 654–62

123. Defterdar Sarı Mehmed Paşa, *Zübde-i Vekayiât* 662–7 (Ottoman text of treaty with Poland-Lithuania); Kolodziejczyk, *Ottoman–Polish Diplomatic Relations* 593–8 (English translation of Ottoman text of treaty with Poland-Lithuania)

124. Setton, *Venice, Austria, and the Turks* 354–8

125. Setton, *Venice, Austria, and the Turks* 380–86

126. Setton, *Venice, Austria, and the Turks* 386–7

127. Köprülü, art. ('Amūdja-zāde) Husayn Pasha, *EI2* III.627

128. Defterdar Sarı Mehmed Paşa, *Zübde-i*

Vekayiât 620, 646–7

129. Defterdar Sarı Mehmed Paşa, *Zübde-i Vekayiât* 667–72 (Ottoman text of treaty with Venice)

130. Hughes, *Russia in the Age of Peter the Great* 10

131. Fuller, *Strategy and Power* 14ff

132. Hughes, *Russia in the Age of Peter the Great* 8–11, 17–18

133. Silahdar Fındıklılı Mehmed Ağa, *Nusretnâme* 1.375–7 (Ottoman text of truce with Muscovy)

134. Hughes, *Russia in the Age of Peter the Great* 26

135. Defterdar Sarı Mehmed Paşa, *Zübde-i Vekayiât* 692–8 (Ottoman text of treaty with Muscovy)

136. Abou-El-Haj, 'The Formal Closure' 467

137. Abou-El-Haj, 'The Narcissism of Mustafa II' 123

138. Abou-El-Haj, 'The Formal Closure' 467, 470–71

139. Kolodziejczyk, *Ottoman–Polish Diplomatic Relations* 61–2

140. Stoye, *Marsigli's Europe* 164ff; Kolodziejczyk, *Ottoman–Polish Diplomatic Relations* 57

141. Kolodziejczyk, *Ottoman–Polish Diplomatic Relations* 634

142. Abou-El-Haj, 'The Formal Closure' 471–5

143. Peri, 'Islamic Law and Christian Holy Sites' 97–104

144. Peri, *Christianity under Islam* 98, 101, 105–9, 111–12, 153

145. Peri, *Christianity under Islam* 201

146. Abou-El-Haj, *Formation of the Modern State* 126

147. Tabakoğlu, *Gerileme Dönemine Girerken Osmanlı Maliyesi* 266–7

148. Finkel, *The Administration of Warfare* 260–63

149. Tabakoğlu, *Gerileme Dönemine Girerken Osmanlı Maliyesi* 295–9

150. Defterdar Sarı Mehmed Paşa, *Zübde-i Vekayiât* 581

151. Genç, 'Osmanlı Maliyesinde Malikane Sistemi' 285–8

152. Genç, 'A study of the feasibility' 348

153. Genç, 'Osmanlı Maliyesinde Malikane Sistemi' 285–8; Defterdar Sarı Mehmed Paşa, *Zübde-i Vekayiât* 512–13

154. Salzmann, 'Measures of Empire' 136

155. Goffman, 'İzmir: from village' 107–9

156. Abou-El-Haj, *Formation of the Modern State* 122–3

157. Abou-El-Haj, 'The Ottoman Vezir and Paşa Households' 443–4

158. Abou-El-Haj, *Formation of the Modern State* 126–7

159. Abou-El-Haj, 'The Ottoman Vezir and Paşa Households' 439–43

160. Kunt, 'Naîmâ, Köprülü and the Grand Vezirate' 58–9

161. Murphey, 'Continuity and Discontinuity' 425

Chapter Eleven: The perils of insouciance

1. Köprülü, art. ('Amūdja-zāde) Husayn Pasha, *EI2* III.626–7

2. Faroqhi, 'An Ulama Grandee' 199ff

3. Silahdar Fındıklılı Mehmed Ağa, *Nusretnâme* 2.162–3

4. Türek and Derin, 'Feyzullah Efendi'nin kendi kaleminden' 24.69ff, 89; cf. Türek and Derin, 'Feyzullah Efendi'nin kendi kaleminden' 23.205ff; Derin, 'Şeyhülislâm Feyzullah Efendi'nin nesebi' 97ff

5. Abou-El-Haj, *The 1703 Rebellion* 16ff, 115–17

6. Abou-El-Haj, *The 1703 Rebellion* 24

7. Abou-El-Haj, *The 1703 Rebellion* 30–1

8. Abou-El-Haj, *The 1703 Rebellion* 33ff, 62–3

9. Baykal, art. Râmî Mehmed Paşa, *İA* 9.623–4; Abou-El-Haj, *The 1703 Rebellion* 72–5

10. Abou-El-Haj, *The 1703 Rebellion* 65–74, 77–8

11. (Anonymous), *Anonim Osmanlı Tarihi* 275

12. Silahdar Fındıklılı Mehmed Ağa, *Nusretnâme* 2.184

13. Özcan, art. Defterdar Sarı Mehmed Paşa, *İA2* 9.98

14. Silahdar Fındıklılı Mehmed Ağa, *Nusretnâme* 2.193–5

15. (Anonymous) *Anonim Osmanlı Tarihi*

249–51

16. Tayşi, art. Feyzullah Efendi (Seyyid), İA2 12.527
17. Silahdar Fındıklılı Mehmed Ağa, Nusretnâme 2.181–97
18. Silahdar Fındıklılı Mehmed Ağa, Nusretnâme 2.235, 239–40
19. Aksan, An Ottoman Statesman 18–19
20. Frost, The Northern Wars 226ff, 263ff
21. LeDonne, The Russian Empire 24
22. Silahdar Fındıklılı Mehmed Ağa, Nusretnâme 2.229
23. Frost, The Northern Wars 286–8, 372–3
24. Frost, The Northern Wars 288–94
25. Theolin, The Swedish Palace 32, 33
26. Kurat, Prut Seferi 1.124, 133–5
27. Frost, The Northern Wars 287
28. Ortaylı, 'Une proclamation universelle' 105–9
29. Hughes, Russia in the Age of Peter the Great 46
30. Silahdar Fındıklılı Mehmed Ağa, Nusretnâme 2.265–6
31. Aksan, Ottoman Warfare ch. 3
32. Silahdar Fındıklılı Mehmed Ağa, Nusretnâme 2.276ff, 287ff
33. LeDonne, The Russian Empire 91
34. Aksan, An Ottoman Statesman 89–90
35. Theolin, The Swedish Palace 35–40
36. Theolin, The Swedish Palace 41–4
37. Hughes, Russia in the Age of Peter the Great 46–7, 352; cf. Aktepe, '1711 Prut seferi' 23–4
38. Darkot, art. Karadağ, İA 6.225
39. Silahdar Fındıklılı Mehmed Ağa, Nusretnâme 2.324–6
40. Aksan, Ottoman Warfare ch. 3
41. Silahdar Fındıklılı Mehmed Ağa, Nusretnâme 2.336–8
42. Kurat and Bromley, 'The Retreat of the Turks' 210–11
43. Silahdar Fındıklılı Mehmed Ağa, Nusretnâme 2.344–5
44. Kurat and Bromley, 'The Retreat of the Turks' 211–12
45. Silahdar Fındıklılı Mehmed Ağa, Nusretnâme 2.366–71
46. Silahdar Fındıklılı Mehmed Ağa, Nusretnâme 2.374–5
47. Gökbilgin, 'II. Rakoczi Ferencz' 595ff
48. Rothenburg, The Austrian Military Border 103
49. Ortaylı, 'Ottoman–Habsburg Relations' 290
50. Silahdar Fındıklılı Mehmed Ağa, Nusretnâme 2.227
51. Artan, 'From Charismatic Leadership' 53ff
52. Öztuna, Devletler ve Hanedânlar 220–27
53. Salzmann, 'Measures of Empire' 194ff
54. Genç, 'A study of the feasibility' 349
55. Salzmann, 'Measures of Empire' 170
56. Genç, 'Osmanlı Maliyesinde Malikane Sistemi' 245
57. Salzmann, 'Measures of Empire' 172–3
58. Genç, 'Osmanlı Maliyesinde Malikane Sistemi' 239
59. Genç, 'A study of the feasibility' 356
60. Genç, art. Esham, İA2 11.377
61. Artan, 'Periods and Problems' 22–5
62. Genç, 'A study of the feasibility' 356
63. Salzmann, 'Measures of Empire' 181
64. McGowan, 'The Age of the Ayans' 734–5
65. Genç, 'Ottoman Industry' 69–82
66. Göçek, East Encounters West 4
67. Unat, Osmanli Sefirleri 52–3
68. Silahdar Fındıklılı Mehmed Ağa, Nusretnâme 2.250–52; Uluçay, 'Fatma ve Safiye' 139–48
69. Atıl, 'The Story of an Eighteenth-Century Ottoman Festival' 181ff; İrepoğlu, Levnî 87ff
70. Artan, 'From Charismatic Leadership' 62
71. Silahdar Fındıklılı Mehmed Ağa, Nusretnâme 2.269–70
72. Mehmed Râşid Râşid Ta'rîhi 5.307–8
73. Necipoğlu, Architecture, Ceremonial and Power 258
74. Necipoğlu, 'The Suburban Landscape' 32ff
75. Wortley Montagu, The Turkish Embassy Letters 140
76. Kuban, Istanbul 336
77. Artan, 'Aspects of the Ottoman Elite's Food Consumption' 107ff

78. Schama, *Landscape and Memory* 329
79. İrepoğlu, 'Innovation and Change' 380–85, 408–11
80. Özergin, art. Râşid, Mehmed, *İA* 9.632
81. Mehmed Râşid, *Râşid Ta'rîhi* 5.185–6, 311–15
82. Göçek, *East Encounters West* 76
83. Aktepe, 'Kâğıdhâne'ye Dâir Bâzı Bilgiler' 339–43, 353
84. Hughes, *Russia in the Age of Peter the Great* 218
85. Göçek, *East Encounters West* 75–7
86. Hughes, *Russia in the Age of Peter the Great* 217–18; Göçek, *East Encounters West* 75
87. Hamadeh, 'Splash and Spectacle' 123ff
88. Zilfi, 'Women and Society' 295–6
89. Pavord, *The Tulip* 58–62
90. Evliyâ Çelebi, *Seyahatnâme*, 1.206
91. Aktepe, 'Damad İbrahim Paşa' 91–126
92. Pavord, *The Tulip* 137ff
93. Pavord, *The Tulip* 43–55, esp. 50
94. Necipoğlu, *Architecture, Ceremonial and Power* 151–2
95. Mehmed Râşid, *Râşid Ta'rîhi* 5.320–28
96. İrepoğlu, *Levnî* 87
97. Aktepe, *Patrona İsyanı* 62
98. Zilfi, 'A Medrese for the Palace' 186, 189
99. Zilfi, 'Elite Circulation' 320
100. Zilfi, 'Elite Circulation' 326, 340–41
101. Aktepe, *Patrona İsyanı* 104ff
102. Zilfi, 'İbrahim Pasha and the Women' 555ff
103. Zilfi, 'Women and Society' 294–8
104. Olson, 'The Esnaf' 336
105. Aktepe, 'XVIII. asrın ilk yarısında İstanbul'un' 2–9
106. Isma'il Âsım Efendi, *Âsım Ta'rîhi* 397–8
107. Aktepe, '1727–1728 İzmir isyanına dâir' 71ff
108. Unat, *Osmanlı Sefirleri* 59–61
109. Aktepe, 'Dürrî Ahmet Efendi'nin İran Sefareti' 1/1.58
110. Olson, 'The Ottoman–French Treaty' 349
111. Tucker, 'The Peace Negotiations' 21
112. Tucker, 'The Peace Negotiations' 21–2
113. Baysun, 'Müverrih Râşid Efendi'nin İran Elciliğine Dâir' 145ff; Aktepe, 'Vak'anüvis Raşid Mehmed Efendi'nin' 155ff
114. Tucker, 'The Peace Negotiations' 22
115. Silahdar Fındıklılı Mehmed Ağa, *Nusretnâme* 2.333, 334, 364
116. Aktepe, *Patrona İsyanı* 92–5
117. Aktepe, *Patrona İsyanı* 91, 96–7, 99–100, 118–21
118. Tabakoğlu, *Gerileme Dönemine Girerken Osmanlı Maliyesi* 275; Aktepe, 'Ahmed III. devrinde Şark seferine' 17ff
119. Aktepe, *Patrona İsyanı* 101
120. Aktepe, *Patrona İsyanı* 133–40
121. Aktepe, *Patrona İsyanı* 140–42, 143–5
122. Aktepe, *Patrona İsyanı* 145, 147–9, 150–54
123. Aktepe, *Patrona İsyanı* 155–7
124. Veinstein, art. Mehmed Yirmisekiz (Çelebi Efendi), *EI2* VI.1006
125. Aktepe, *Patrona İsyanı* 158–60
126. Aktepe, *Patrona İsyanı* 161–9
127. Aktepe, *Patrona İsyanı* 169–80
128. Şem'dânî-zâde Fındıklılı Süleyman Efendi, *Mur'i't-Tevârih* 1.16–21
129. Abdi, *Abdi Tarihi* 62
130. Şem'dânî-zâde Fındıklılı Süleyman Efendi, *Mur'i't-Tevârih* 1.17–19
131. Aktepe, 'XVIII. asrın ilk yarısında İstanbul'un' 10–16
132. Mehmed Râşid, *Râşid Ta'rîhi* 5.123
133. Silahdar Fındıklılı Mehmed Ağa, *Nusretnâme* 2.415
134. Salzmann, 'Measures of Empire' 175–6
135. Halaçoğlu, *XVIII. yüzyılda Osmanlı İmparatorluğu'nun iskan siyaseti* 96–108
136. Aktepe, 'Nevşehirli Damad İbrahim Paşa'ya âid iki vakfiye' 151
137. Winter, 'Ottoman Egypt' 17–20
138. Hathaway, 'Egypt in the seventeenth century' 42, 48, 49ff
139. Crecelius, 'Egypt in the eighteenth century' 70–73
140. Hathaway, 'Çerkes Mehmed Bey' 108ff
141. Barbir, *Ottoman Rule in Damascus*

xv, 44-55

142. Tekindağ, 'XVIII. ve XIX. asırlarda Cebel Lübnan' 31ff

143. Cohen, Palestine in the 18th Century 8-11

144. Cohen, Palestine in the 18th Century 30-42

145. St Laurent and Riedlmayer, 'Restorations of Jerusalem' 77-9, 84

146. Barbir, Ottoman Rule in Damascus 89-93, 97-107

147. Hess, 'The Forgotten Frontier' 74ff; Ortaylı, 'Ottoman–Habsburg Relations' 290-92

148. Kolodziejczyk, Ottoman–Polish Diplomatic Relations 162

149. Theolin, The Swedish Palace 55-8

150. LeDonne, The Russian Empire 99-100, 233-4; Aksan, Ottoman Warfare ch. 3

151. Aksan, Ottoman Warfare ch. 3

152. Eldem, 'Istanbul: from imperial', 190-4

153. Tucker, 'The Peace Negotiations' 24-32

154. Olson, 'The Ottoman–French Treaty' 350

155. Aktepe, 'XVIII. asrın ilk yarısında İstanbul'un' 23-4

156. Tucker, 'The Peace Negotiations' 34-7

157. Aktepe, 'XVIII. asrın ilk yarısında İstanbul'un' 10

158. Özkaya, 'XVIII inci Yüzyılda Çıkarılan Adalet-nâmelere göre' 461-2

159. Özkaya, 'XVIII inci Yüzyılda Çıkarılan Adalet-nâmelere göre' 459-60

160. Olson, 'Jews, Janissaries, Esnaf' 193-7

161. Aktepe, 'XVIII. asrın ilk yarısında İstanbul'un' 25-8

162. Faroqhi, 'Migration into Eighteenth-Century' 163ff

163. Abdi, Abdi Tarihi 45

164. Eldem, Sa'dabad 22ff

165. Aktepe, 'Kâğıdhâne'ye Dâir Bâzı Bilgiler' 358

166. Kuban, art. Nuruosmaniye Külliyesi, İst. Ansik. 6.100-103

167. Goodwin, A History of Ottoman Architecture 377, 387, 400-402

168. Goodwin, A History of Ottoman Architecture 375

169. Erünsal, Türk Kütüphaneleri Tarihi 61ff

170. Silahdar Fındıklılı Mehmed Ağa, Nusretnâme 2.384-5

171. İrepoğlu, Levnî 23

172. Mystakidis, 'Hukûmet-i 'Osmâniye' 324-5

173. Kut, art. Matba'a, EI2 VI.800

174. Refik, Onikinci Asr-i Hicrî'de İstanbul Hayatı 89-90

175. Refik, Onikinci Asr-i Hicrî'de İstanbul Hayatı 90

176. Kut, art. Matba'a, EI2 VI.801

177. Kut, art. Matba'a, EI2 VI.800

178. Özcan, art. Humbaracı Ahmed Paşa, İA2 18.351; Levy, 'Military Reform' 232-3; Hitzel, 'Relations interculturelles et scientifiques' 1.304-5

179. Aksan, An Ottoman Statesman 8-9

180. Itzkovitz, 'Eighteenth Century Ottoman Realities' 86

181. Unat, Osmanlı Sefirleri 62ff

182. Refik, Onikinci Asr-i Hicrî'de İstanbul Hayatı 87

183. Zilfi, 'Women and Society' 298-301

184. Zilfi, 'Women and Society' 301

185. Sarıcaoğlu, Kendi Kaleminden Bir Padişahın Portresi 254-5

Chapter Twelve: The power of the provinces

1. Şem'dânî-zâde Fındıklılı Süleyman Efendi, Mur'i't-Tevârih 2/A.9

2. Altundağ, art. Osman III, İA 9.449

3. Aksan, An Ottoman Statesman

4. Atsız, Ahmed Resmî Efendi'nin 71

5. Atsız, Ahmed Resmî Efendi'nin 73

6. Ingrao, The Habsburg Monarchy 192-4

7. Aksan, An Ottoman Statesman 78, 115-17

8. Kolodziejczyk, Ottoman–Polish Diplomatic Relations 164

9. Fisher, The Russian Annexation 27-8, 29-30

10. Aksan, An Ottoman Statesman 119

11. LeDonne, The Russian Empire 104

12. Aksan, An Ottoman Statesman 144-69

13. Nagata, 'Greek Rebellion of 1770'

103ff

14. Anderson, *Naval Wars* 278–91; Aktepe, art. Çeşme Vak'ası, *İA2* 8.288–9

15. Nagata, 'Greek Rebellion of 1770' 103ff

16. Hess, 'The Forgotten Frontier' 83–4

17. Aksan, *An Ottoman Statesman* 104–8, 111–14

18. Fisher, *The Russian Annexation* 40–51, 160

19. Aksan, *An Ottoman Statesman* 153–66

20. Gawrych, 'Şeyh Galib and Selim III' 94

21. Fuller, *Strategy and Power* 140–41

22. Aksan, *An Ottoman Statesman* 109–10, 188–99

23. Fuller, *Strategy and Power* 137

24. LeDonne, *The Russian Empire* 105–6; Hurewitz, *Diplomacy in the Near and Middle East* 1.54–61 (Engl. translation of treaty)

25. Heywood, art. Küçük Kaynardja, *EI2* V.313; Sarıcaoğlu, *Kendi Kaleminden Bir Padişahın Portresi* 163

26. Süleyman Penah Efendi, 'Mora İhtilali Tarihçesi' 156–7

27. Davison, 'The "Dosografa" Church' 51ff

28. Davison, '"Russian Skill and Turkish Imbecility"' 35

29. Davison, '"Russian Skill and Turkish Imbecility"' 28ff

30. Fisher, 'Şahin Giray, the Reformer Khan' 93ff

31. Fisher, 'Şahin Giray, the Reformer Khan' 93ff

32. Emecen, 'Son Kırım Hânı Şâhin Giray'ın' 315ff

33. Fisher, 'Şahin Giray, the Reformer Khan' 94–5, 109, 119

34. Aksan, *An Ottoman Statesman* 180–84

35. Beydilli, 'Bonnaval'in izinde' 74

36. Uzunçarşılı, 'Sadrâzam Halil Hamid Paşa' 239–55

37. Bruess, *Religion, Identity and Empire* 238

38. Aksan, *An Ottoman Statesman* 179

39. Sarıcaoğlu, *Kendi Kaleminden Bir Padişahın Portresi* 175

40. Uzunçarşılı, 'Kaynarca Muahedesinden Sonraki' 514–15

41. LeDonne, *The Russian Empire* 110

42. Sarıcaoğlu, *Kendi Kaleminden Bir Padişahın Portresi* 249–50

43. Ingrao, *The Habsburg Monarchy* 207

44. BOA/Hatt-i hümayun no. 8231

45. Sarıcaoğlu, *Kendi Kaleminden Bir Padişahın Portresi* 260

46. Aksan, *Ottoman Warfare* ch. 4

47. Ingrao, *The Habsburg Monarchy* 207–8

48. Karal, *Selim III'ün Hatt-i Hümayunları* 28–9

49. Naff, 'Ottoman Diplomatic Relations' 105–6

50. Aksan, 'An Ottoman Portrait' 205–6

51. Aksan, *Ottoman Warfare* ch. 4

52. Kolodziejczyk, *Ottoman–Polish Diplomatic Relations* 167, 644–59

53. Ingrao, *The Habsburg Monarchy* 209–10

54. Naff, 'Ottoman Diplomatic Relations' 105–6

55. Ingrao, *The Habsburg Monarchy* 209–10

56. Gökçe, '1787–1806 yılları arasında Kafkasya'da' 4–12

57. Gökçe, '1787–1806 yılları arasında Kafkasya'da' 19–33

58. Gökçe, '1787–1806 yılları arasında Kafkasya'da' 34–8, 52–3

59. LeDonne, *The Russian Empire* 108–9

60. Gökçe, '1787–1806 yılları arasında Kafkasya'da' 46–50

61. Sarıcaoğlu, *Kendi Kaleminden Bir Padişahın Portresi* 168–9, 211–14

62. Genç, art. Esham, *İA2* 11.377

63. Eldem, *French Trade* 59

64. Aksan, 'The One-eyed Fighting the Blind' 228–9

65. Aksan, 'Feeding the Ottoman Troops' 1ff

66. Cezar, *Osmanlı Maliyesinde Bunalım* 110

67. Genç, art. Esham, *İA2* 11.376ff

68. Cezar, *Osmanlı Maliyesinde Bunalım* 89–92; cf. Sarıcaoğlu, *Kendi Kaleminden Bir Padişahın Portresi* 167–9, 211–14

69. Eldem, *French Trade* 188–9

70. Cezar, *Osmanlı Maliyesinde Bunalım* 137–8; cf. Sarıcaoğlu, *Kendi Kaleminden Bir Padişahın Portresi*

167–9, 211–14

71. Cezar, *Osmanlı Maliyesinde Bunalım* 137–8; cf. Sarıcaoğlu, *Kendi Kaleminden Bir Padişahın Portresi* 167–9

72. Aksan, 'Ottoman Political Writing' 63

73. Aksan, 'Breaking the Spell' 253ff

74. Aksan, 'Whatever happened to the Janissaries' 28–9

75. Aksan, *An Ottoman Statesman* 189–90

76. Aksan, 'Whatever happened to the Janissaries' 35–6

77. Aksan, 'Whatever happened to the Janissaries' 33

78. Özcan, art. Esame, *İA2* 11.356

79. Sarıcaoğlu, *Kendi Kaleminden Bir Padişahın Portresi* 191, 234–42

80. Karal, 'Nizâm-i Cedid'e dair lâyi-halar' 237

81. Karal, 'Nizâm-i Cedid'e dair lâyi-halar' 418

82. Sarıcaoğlu, *Kendi Kaleminden Bir Padişahın Portresi* 180–83

83. Aksan, *Ottoman Warfare* ch. 4

84. Panzac, 'The Manning of the Ottoman Navy' 50–53

85. Gawrych, 'Şeyh Galib and Selim III' 102, 105–9

86. Holbrook, *The Unreadable Shores of Love* 107–10

87. Beydilli, *Türk Bilim ve Matbaacılık* 223

88. Kissling, *Rechtsproblematiken* 10

89. Gönen, 'The Integration of the Ottoman Empire' 16

90. Gönen, 'The Integration of the Ottoman Empire' 121–3

91. Gönen, 'The Integration of the Ottoman Empire' 67, 69

92. Gönen, 'The Integration of the Ottoman Empire' 63–75, 120

93. Khadduri, *War and Peace* 251–2

94. Gönen, 'The Integration of the Ottoman Empire' 79

95. Gönen, 'The Integration of the Ottoman Empire' 145

96. Unat, *Osmanlı Sefirleri*; Naff, 'Reform and the Conduct of Diplomacy' 303–4

97. Gönen, 'The Integration of the Ottoman Empire' 86

98. Gönen, 'The Integration of the

Ottoman Empire' 88–9

99. Renda, 'Searching for New Media' 451ff; Karal, *Selim III'ün Hatt-i Hümayunları* 92–3

100. Cezar, *Osmanlı Maliyesinde Bunalım* 155ff

101. Salzmann, 'Measures of Empire' 408–9

102. Mert, art. Çapanoğulları, *İA2* 8.221–2

103. Goodwin, *A History of Ottoman Architecture* 400–402

104. Mert, art. Canikli Hacı Ali Paşa Ailesi, *İA2* 7.151–3

105. Orhonlu, art. Karā 'Othmān-oghlı, *EI2* IV 592–3; Nagata, art. Karaosmanoğulları, *İA2* 24.468–9

106. Kuyulu, *Kara Osman-oğlu Ailesine Ait Mimari Eserler*

107. Salzmann, 'Measures of Empire' 212, 428, 434ff, 453, 461

108. Zens, 'Pasvanoğlu Osman Paşa' 89–99

109. Özkaya, *Osmanlı İmparatorluğunda Dağlı İsyanları*

110. Derin, 'Yayla İmamı Risalesi' 217

111. Fleming, *The Muslim Bonaparte* 82–94

112. Jelavich, *History of the Balkans* 195

113. Zens, 'Pasvanoğlu Osman Paşa' 100–103

114. Rothenburg, *The Military Border* 102–4

115. Jelavich, *History of the Balkans* 198–9

116. Rothenburg, *The Austrian Military Border* 105–7, 118–19

117. Rothenburg, *The Military Border* 31–2

118. Rothenburg, *The Military Border* 7, 81–2

119. Rothenburg, *The Military Border* 103, 105, 106, 107

120. Hughes, *Russia in the Age of Peter the Great* 48

121. Cazacu, 'La "mort infâme"' 259–61

122. Cazacu, 'La "mort infâme"' 253ff

123. Yapp, *The Making of the Modern Near East* 52

124. Perry, 'The Mamluk Paşalik of Baghdad' 59, 62–3, 66

125. Perry, 'The Mamluk Paşalik of Baghdad' 65, 67, 68

126. Salzmann, 'Measures of Empire'

426–7

127. Khoury, *State and provincial society* 69–72

128. Holt, *Egypt and the Fertile Crescent* 107–9, 132–3

129. Cohen, *Palestine in the 18th Century* 7–19

130. Cohen, *Palestine in the 18th Century* 52

131. Anderson, *Naval Wars* 291–9

132. Tekindağ, 'XVIII. yuzyılda Akdeniz'de Rus donanması' 37ff

133. Cohen, *Palestine in the 18th Century* 45–53; Crecelius, 'Egypt in the eighteenth century' 82

134. Emecen, art. Cezzâr Ahmed Paşa, *İA2* 7.516

135. Cohen, *Palestine in the 18th Century* 53–77

136. Emecen, art. Cezzâr Ahmed Paşa, *İA2* 7.518

137. Crecelius, 'Egypt in the eighteenth century' 73–82

138. Hathaway, *The politics of households* 118

139. Crecelius, 'Egypt in the eighteenth century' 84

140. Shaw, *Ottoman Egypt in the Eighteenth Century* 11–13

141. Crecelius, 'Egypt in the eighteenth century' 84–6

142. Dykstra, 'The French occupation of Egypt' 117–21

143. Shaw, *Ottoman Egypt in the Eighteenth Century* 7

144. Uzunçarşılı, 'Bonapart'ın Cezzar Ahmed Paşa'ya Mektubu' 451–4

145. Tekindağ, 'Yeni kaynak ve vesikarların ışığı' 1ff

146. Dykstra, 'The French occupation of Egypt' 131–2

147. Fahmy, 'The era of Muhammad 'Ali Pasha' 140–44

148. Fahmy, 'The era of Muhammad 'Ali Pasha' 144–6

149. Abir, 'The "Arab Rebellion" of Amir Ghalib' 188–9

150. Peskes, art. Wahhābiyya, *EI2* XI.42

Chapter Thirteen: From the 'New Order' to the 'Re-ordering'

1. Gökçe, 'Edirne Âyanı Dağdevirenoğlu Mehmed Ağa' 97ff

2. Derin, 'Yayla İmamı Risalesi' 218

3. Gökçe, 'Edirne Âyanı Dağdevirenoğlu Mehmed Ağa' 109

4. Derin, 'Yayla İmamı Risalesi' 221–3

5. Derin, 'Tüfengçi-başı Ârif Efendi Tarihçesi' 386

6. Beydilli and Şahin, *Mahmud Râif Efendi*

7. Derin, 'Tüfengçi-başı Ârif Efendi Tarihçesi' 386

8. Derin, 'Yayla İmamı Risalesi' 223–4

9. Derin, 'Tüfengçi-başı Ârif Efendi Tarihçesi' 389–92

10. Gökçe, 'Edirne Âyanı Dağdevirenoğlu Mehmed Ağa' 101

11. Derin, 'Tüfengçi-başı Ârif Efendi Tarihçesi' 393–5; Derin, 'Yayla İmamı Risalesi' 229

12. Derin, 'Tüfengçi-başı Ârif Efendi Tarihçesi' 395–9

13. Derin, 'Tüfengçi-başı Ârif Efendi Tarihçesi' 399–401

14. Derin, 'Tüfengçi-başı Ârif Efendi Tarihçesi' 402–3

15. Derin, 'Tüfengçi-başı Ârif Efendi Tarihçesi' 404–5

16. Derin, 'Tüfengçi-başı Ârif Efendi Tarihçesi' 406, 408–15

17. Arıkan, *III. Selim'in Sirkâtibi Ahmed Efendi*

18. Derin, 'Tüfengçi-başı Ârif Efendi Tarihçesi' 388, 438

19. Derin, 'Tüfengçi-başı Ârif Efendi Tarihçesi' 415–18, 423ff

20. Derin, 'Tüfengçi-başı Ârif Efendi Tarihçesi' 443

21. Uzunçarşılı, *Meşhur Rumeli Âyanlarından* 92–4

22. Shaw, *Between Old and New* 347–8

23. Uzunçarşılı, *Meşhur Rumeli Âyanlarından* 57–8

24. Uzunçarşılı, *Meşhur Rumeli Âyanlarından* 95–7, 101–2

25. Uzunçarşılı, *Meşhur Rumeli Âyanlarından* 104–7

26. Uzunçarşılı, *Meşhur Rumeli Âyanlarından* 107–11

27. Uzunçarşılı, *Meşhur Rumeli Âyan-larından* 112–16, 221–3
28. Uzunçarşılı, *Meşhur Rumeli Âyan-larından* 113–14, 116–17, 118–19
29. Derin, 'Yayla İmamı Risalesi' 242–7
30. Uzunçarşılı, *Meşhur Rumeli Âyan-larından* 92–4
31. İnalcık, 'Sened-i İttifak' 604–6; Lewis, art. Dustūr, *EI2* II.640–41
32. İnalcık, 'Sened-i İttifak' 604–6; Lewis, art. Dustūr, *EI2* II.640–41
33. Ortaylı, *İmparatorluğun En Uzun Yüzyılı* 29–30
34. Uzunçarşılı, *Meşhur Rumeli Âyan-larından* 143–4
35. Derin, 'Yayla İmamı Risalesi' 252–60
36. Sakaoğlu, art. Alemdar Olayı, *İst. Ansik.* 1.186
37. Derin, 'Yayla İmamı Risalesi' 260–63, 266
38. Aksan, 'Ottoman Political Writing' 60
39. Aksan, 'Ottoman Political Writing' 53ff
40. Yapp, *The Making of the Modern Near East* 55
41. LeDonne, *The Russian Empire* 114–15
42. Kazgan, '2. Sultan Mahmut Devrinde Enflasyon' 122–3
43. Gökçe, '1787–1806 yılları arasında Kafkasya'da' 57ff
44. Kolodziejczyk, *Ottoman–Polish Diplomatic Relations* 168
45. Anderson, *The Eastern Question* 46
46. Reed, 'The Destruction of the Janissaries' 40–45
47. Levy, 'Ottoman Attitudes' 333–4
48. Fahmy, 'The era of Muhammad 'Ali Pasha' 146–9
49. Cezar, *Osmanlı Maliyesinde Bunalım* 242–3
50. Mert, *XVIII. ve XIX. Yüzyıllarda Çapanoğulları* 66–8
51. Reed, 'The Destruction of the Janissaries' 20–24
52. Cezar, *Osmanlı Maliyesinde Bunalım* 242–3
53. Fahmy, 'The era of Muhammad 'Ali Pasha' 145
54. Ibrahim, 'The Egyptian empire' 200–202
55. Fleming, *The Muslim Bonaparte* 36–56
56. Levy, 'Ottoman Attitudes' 336–9
57. Levy, 'Ottoman Attitudes' 338, 339
58. Cazacu, 'La "mort infâme"' 281–2
59. Clogg, *A Short History* 54
60. Levy, 'Ottoman Attitudes' 338
61. Anderson, *The Eastern Question* 52–3
62. Cazacu, 'La "mort infâme"' 282–5
63. Levy, 'Ottoman Attitudes' 337
64. Bowen, art. 'Alī Pasha Tepedelenli, *EI2* I.399
65. Cazacu, 'La "mort infâme"' 286–8
66. Reed, 'The Destruction of the Janissaries' 48, 53–61
67. Fisher, *The Russian Annexation* 90–91
68. Clogg, *A Concise History* 23–32
69. Anderson, *The Eastern Question* 54–5
70. Clogg, *A Concise History* 29
71. Anderson, *The Eastern Question* 60–61
72. Kutluoğlu, *The Egyptian Question* 44–5
73. Reed, 'The Destruction of the Janissaries' 122, 153, 155–8
74. Reed, 'The Destruction of the Janissaries' ch. II, 109–11
75. Zilfi, 'A *Medrese* for the Palace' 188
76. Levy, 'The Ottoman Ulema' 13–14
77. Heyd, 'The Ottoman 'Ulemā' 93
78. Reed, 'The Destruction of the Janissaries' 150; Levy, 'The Ottoman Ulema' 18–19
79. Aksan, 'Breaking the Spell' 277
80. Hagen, 'The Prophet Muhammad' 151–2
81. Ahmed Lûtfî Efendi, *Vak'anüvis Ahmed Lûtfî Efendi Tarihi* 1.94
82. Fahmy, 'The era of Muhammad 'Ali Pasha' 154
83. Özcan, art. Eşkinci, *İA2* 11.470
84. Reed, 'The Destruction of the Janissaries' 169–76, 186
85. Reed, 'The Destruction of the Janissaries' 189–92
86. Şirvânlı Fatih Efendi, *Gülzâr-i Fütûhât* 10
87. Ahmed Lûtfî Efendi, *Vak'anüvis Ahmed Lûtfî Efendi Tarihi* 1.101
88. Reed, 'The Destruction of the Janissaries' 196
89. Reed, 'The Destruction of the Janissaries' 199
90. Reed, 'The Destruction of the Janissaries' 202–8, 210ff

91. Reed, 'The Destruction of the Janissaries' 236–7
92. Şirvânlı Fatih Efendi, *Gülzâr-i Fütûhât* 13
93. Reed, 'The Destruction of the Janissaries' 249, 254ff, 279, 282
94. Ahmed Lûtfî Efendï, *Vak'anüvïs Ahmed Lûtfî Efendi Tarihi* 1.140–41
95. Erdem, 'Recruitment' 194
96. Levy, 'The Officer Corps' 22
97. Macfarlane, *Constantinople in 1828* 1.504
98. Barnes, *An Introduction to Religious Foundations* 87–8, 90–91
99. Ahmed Lûtfî Efendi, *Vak'anüvïs Ahmed Lûtfî Efendi Tarihi* 1.125
100. Reed, 'The Destruction of the Janissaries' 96, 238
101. Zarcone, *Mystiques, Philosophes et Francs-Maçons* 90, 92–3, 96–7
102. Levy, '*Millet* Politics' 427–8
103. Shaw, *The Jews of the Ottoman Empire* 148–9
104. Eldem, 'Istanbul: from imperial' 164–74
105. Reed, 'The Destruction of the Janissaries' 330, 335–41
106. LeDonne, *The Russian Empire* 121–3
107. Yapp, *The Making of the Modern Near East* 70
108. Levy, 'The Ottoman Ulema' 30
109. Kaynar, *Mustafa Reşit Paşa ve Tanzimat* 191
110. Aydın, 'Sultan II. Mahmud Döneminde' 81ff
111. Özcan, 'II. Mahmud Memleket Gezileri' 361ff
112. Findley, *Bureaucratic Reform* 140–47
113. Findley, *Ottoman Civil Officialdom* 70–80; Findley, *Bureaucratic Reform* 145
114. Refik, *Onüçüncü Asr-i Hicrî'de İstanbul Hayatı* 11
115. Uzunçarşılı, 'Asâkir-i Mansure-ye fes giydirilmesi' 224ff
116. Quataert, 'Clothing Laws, State' 412–21
117. Heyd, 'The Ottoman 'Ulemā' 70
118. Spatar, art. Muzika-i Hümayun, *İst. Ansik.* 6.11–12
119. Heyd, 'The Ottoman 'Ulemā' 70
120. Ahmed Lûtfî Efendi, *Vak'anüvïs*

Ahmed Lûtfi Efendi Tarihi 5.882; Kreiser, 'Public Monuments' 104–5, 115
121. Fahmy, 'The era of Muhammad 'Ali Pasha' 159–65
122. Fahmy, 'The era of Muhammad 'Ali Pasha' 165–6
123. Kutluoğlu, *The Egyptian Question* 55–6, 61ff
124. Kutluoğlu, *The Egyptian Question* 189–90
125. Fahmy, 'The era of Muhammad 'Ali Pasha' 167
126. Kutluoğlu, *The Egyptian Question* 93–4
127. Kutluoğlu, *The Egyptian Question* 101–7
128. Fahmy, 'The era of Muhammad 'Ali Pasha' 168, 170–72
129. Kutluoğlu, *The Egyptian Question* 125ff
130. Kutluoğlu, *The Egyptian Question* 146ff
131. Hurewitz, *Diplomacy in the Near and Middle East* 1.110–11 (Engl. translation of Convention)
132. Kutluoğlu, *The Egyptian Question* 161ff
133. Akarlı, 'The Problems of External Pressures' 13

Chapter Fourteen: A crisis of identity

1. İnalcık, 'Application of the *Tanzimat*' 97–8
2. Kaynar, *Mustafa Reşit Paşa ve Tanzimat* 178
3. Hurewitz, *Diplomacy in the Near and Middle East* 1.113–16 (Engl. translation of the Gülhane Edict); İnalcık, 'Sened-i İttifak' 611–14; Kaynar, *Mustafa Reşit Paşa ve Tanzimat* 174–85
4. Zürcher, art. Reshīd Pasha, Mustafa, *EI2* VIII.484–5
5. Atasoy, art. Hırka-i Saâdet, *İA2* 17.377; Tanman, art. Hırka-i Şerif Camii, *İA2* 17.378
6. Abu-Manneh, 'The Islamic Roots' 182–8, 189, 194; Algar, art. Nakshbandiyya, *EI2* VII.937

7. Quataert, 'The Age of Reforms' 854–5

8. İnalcık, 'Application of the Tanzimat' 98ff

9. Imber, Ebu's-su'ud 31–2

10. İnalcık, 'Application of the Tanzimat' 105

11. İnalcık, 'Application of the Tanzimat' 116

12. Shaw, 'The Nineteenth-Century' 421–4

13. İnalcık, 'Application of the Tanzimat' 106

14. Levy, 'Millet Politics' 425ff

15. Pinson, 'Ottoman Bulgaria' 109

16. İnalcık, 'Application of the Tanzimat' 115–24; Pinson, 'Ottoman Bulgaria' 105–13

17. Zürcher, art. Reshīd Pasha, Mustafa, EI2 VIII.485

18. İnalcık, 'Application of the Tanzimat' 113–14

19. Pamuk, A Monetary History 193–6, 198

20. Davison, 'The First Ottoman Experiment' 60ff

21. Pamuk, A Monetary History 207–8

22. Zürcher, art. Reshīd Pasha, Mustafa, EI2 VIII.485

23. İnalcık, 'Application of the Tanzimat' 105, 124–7; Pinson, 'Ottoman Bulgaria' 113ff

24. Pinson, 'Ottoman Bulgaria' 119–21, 132, 145

25. Gülsoy, Osmanlı Gayrimüslimlerinin Askerlik Serüveni 39–42, 46–55

26. Önsoy, 'Osmanlı İmparatorluğu'nun Katıldığı' 195–9

27. Quataert, 'The Age of Reforms' 826

28. LeDonne, The Russian Empire 125–6

29. Peri, Christianity under Islam 202

30. Mango, Materials for the Study 10–11

31. Necipoğlu, 'The Life of an Imperial Monument' 220–21

32. Mango, Materials for the Study 8, 12, 135–6

33. Necipoğlu, 'The Life of an Imperial Monument' 224–5

34. LeDonne, The Russian Empire 126–7

35. LeDonne, The Russian Empire 126–7

36. Hurewitz, Diplomacy in the Near and Middle East 1.153–6 (Engl. text of Treaty of Paris)

37. Fuller, Strategy and Power 265–8

38. Hurewitz, Diplomacy in the Near and Middle East 1.149–53 (Engl. translation of Reform Edict)

39. Gülsoy, '1856 Islâhât Fermanı'na Tepkiler' 446–7

40. (Ahmed) Cevdet Paşa, Tezakir 1.68

41. Bozkurt, Alman-İngiliz Belgelerinin 71–83; Gülsoy, '1856 Islâhât Fermanı'na Tepkiler' 448–58

42. Zarcone, Mystiques, Philosophes et Francs-Maçons 94

43. Davison, Reform in the Ottoman Empire 100–102

44. Hurewitz, Diplomacy in the Near and Middle East 1.151

45. Hosking, Russia: People and Empire 236–8

46. Deringil, '"There is no Compulsion in Religion"' 114–19

47. Refik, Onikinci Asr-i Hicrî'de İstanbul Hayatı 21–2, 32–3, 35, 160–63

48. Salt, Imperialism, Evangelism 32–3

49. Salt, Imperialism, Evangelism 34–5

50. Deringil, '"There is no Compulsion in Religion"' 119–30

51. Gülsoy, Osmanlı Gayrimüslimlerinin Askerlik Serüveni 55ff

52. Findley, Bureaucratic Reform 132–5

53. Mardin, Religion and Social Change 113

54. Davison, art. Tanzīmāt, EI2 X.205

55. Akarlı, 'The Problems of External Pressures' 16

56. Davison, art. Midhat Pasha, EI2 VI.1032

57. Todorova, 'Midhat Paşa's Governorship' 116, 120

58. Todorova, 'Midhat Paşa's Governorship' 119–26

59. Davison, art. Midhat Pasha, EI2 VI.1032–3

60. Akarlı, 'The Problems of External Pressures' 15

61. Akarlı, The Long Peace 22–33

62. Dumont, 'La pacification du Sud-Est anatolien' 108ff; Gould, 'Lords or Bandits?' 485ff

63. Erdem, Slavery in the Ottoman Empire 94–107

64. (Ahmed) Cevdet Paşa, Tezakir 1.111–12

65. Toledano, *The Ottoman Slave Trade* 129–35

66. Erdem, *Slavery in the Ottoman Empire* 107–13; Toledano, *The Ottoman Slave Trade* 135

67. Toledano, *Slavery and Abolition* 81ff

68. Masters, 'The Sultan's Entrepreneurs' 586; Masters, *The Origins of Western Economic Dominance* 94, 96–7

69. Naff, 'Ottoman Diplomatic Relations' 103

70. Quataert, 'The Age of Reforms' 838

71. Masters, 'The Sultan's Entrepreneurs' 579, 594

72. Eldem, 'Istanbul: from imperial' 194

73. Akarlı, 'The Problems of External Pressures' 20

74. Issawi, 'Introduction' 8

75. Küçük, art. Abdülaziz, *İA2* 1.180

76. Hunter, 'Egypt under the successors' 193

77. Şehsuvaroğlu, 'Sultan Abdülaziz'in Avrupa Seyahatı' 41–51

78. Vatikiotis, art. Isma'il Pasha, *EI2* IV.192

79. Çelik, *Displaying the Orient* 32–6

80. Yapp, *The Making of the Modern Near East* 175

81. Çelik, *Displaying the Orient* 145–51

82. Vatikiotis, art. Isma'il Pasha, *EI2* IV.192

83. Hunter, 'Egypt under the successors' 186–94

84. Davison, *Reform in the Ottoman Empire* 197–217; Kuran, art. (Mustafā) Fādil Pasha (Misirli), *EI2* II.728

85. Ibrahim, 'The Egyptian empire' 210–15

86. Kreiser, 'Public Monuments' 103ff

87. Eldem, *Pride and Privilege* 216–22, 230–34

88. Mardin, *The Genesis* 10ff

89. Akarlı, 'The Problems of External Pressures' 21–2

90. Karpat, 'The Transformation' 261

91. Mardin, *The Genesis* 10ff, 115–16

92. Mardin, *Religion and Social Change* 107

93. Kuran, 'Répercussions sociales' 144–6

94. Deringil, *The Well-Protected Domains* 93

95. Kuran, 'Répercussions sociales' 146

96. Kushner, 'The Place of the Ulema' 63–6, 69–74

97. Halaçoğlu and Aydın, art. Cevdet Paşa, *İA2* 7.444, 445, 447

98. Mardin, *Religion and Social Change* 114–15; Findley, art. Medjelle, *EI2* VI.971–2

99. Messick, *The Calligraphic State* 54

100. Mardin, *Religion and Social Change* 117–18

101. Mardin, *Religion and Social Change* 117–18

102. Köprülü, art. Fuad Paşa, Keçecizâde, *İA2* 13.203

103. Abu-Manneh, 'The Sultan and the Bureaucracy' 257ff

104. Küçük, art. Abdülaziz, *İA2* 1.181

105. Pamuk, *A Monetary History* 214

106. Yasamee, *Ottoman Diplomacy* 13–14

107. Davison, art. Midhat Pasha, *EI2* VI.1033

108. Davison, *Reform in the Ottoman Empire* 318ff

109. Devereux, 'Süleyman Pasha's "The Feeling"' 3, 14

110. Devereux, 'Süleyman Pasha's "The Feeling"' 15–16

111. Baykal, *İbretnümâ* 4

112. Devereux, 'Süleyman Pasha's "The Feeling"' 16ff

113. Devereux, 'Süleyman Pasha's "The Feeling"' 26, 27

114. Devereux, 'Süleyman Pasha's "The Feeling"' 31–2

115. Baykal, *İbretnümâ* 5–6

116. (Ahmed) Cevdet Paşa, *Tezakir* 4.156

117. Baykal, *İbretnümâ* 6–14

118. Baykal, *İbretnümâ* 19

119. Davison, *Reform in the Ottoman Empire* 346

120. (Ahmed) Cevdet Paşa, *Tezakir* 4.160

121. Uzunçarşılı, *Midhat ve Rüştü Paşaların Tevkiflerine* 54

122. Davison, *Reform in the Ottoman Empire* 342ff

123. McCarthy, *Death and Exile* 60

124. McCarthy, *Death and Exile* 33–6, 59–61, 94–5

125. Fuller, *Strategy and Power* 271

126. Fuller, *Strategy and Power* 323–7; LeDonne, *The Russian Empire* 141–2
127. Noradounghian, *Recueil d'actes internationaux* 4.206–7; Milgrim, 'An Overlooked Problem' 519ff
128. Yasamee, *Ottoman Diplomacy* 58–9
129. Salt, *Imperialism, Evangelism* 57–8
130. Ortaylı, 'Greeks in the Ottoman Administration' 165
131. Sked, *The Decline and Fall* 243–4

Chapter Fifteen: The Islamic empire

1. Salt, 'The Narrative Gap' 34
2. Deringil, *The Well-Protected Domains* 2
3. Yasamee, *Ottoman Diplomacy* 20
4. Yasamee, *Ottoman Diplomacy* 20
5. Davison, *Reform in the Ottoman Empire* 338ff; Yasamee, *Ottoman Diplomacy* 15
6. Davison, art. Midhat Pasha, *EI2* VI.1033–4
7. Küçük, art. Çırağan Vak'ası, *İA2* 8.306–9
8. Yasamee, *Ottoman Diplomacy* 61–2
9. Akarlı, 'The Problems of External Pressures' 191; Karpat, *Ottoman Population* 28
10. Yasamee, *Ottoman Diplomacy* 16, 17
11. Deringil, *The Well-Protected Domains* 139, 150ff
12. Özcan, art. Hilâfet, *İA2* 17.548
13. Karateke, *Padişahım Çok Yaşa!* 52–6; Lewis, 'The Ottoman Empire' 292–3
14. Özcan, art. Hilâfet, *İA2* 17.548
15. (Ahmed) Cevdet Paşa, *Tezakir* 2.152; cf. Lewis, 'The Ottoman Empire' 293
16. Özcan, 'Sultan II. Abdulhamid'in "Pan-Islâm"' 123ff
17. Ortaylı, *İmparatorluğun En Uzun Yüzyılı* 63
18. Aydın, 'Livadya Sefâretleri' 321ff; Ortaylı, 'Reforms of Petrine Russia' 47
19. Özcan, art. Hilâfet, *İA2* 17.547
20. Deringil, *The Well-Protected Domains* 48; Haddad, review of Deringil, *The Well-Protected Domains* 209
21. Özcan, art. Hilâfet, *İA2* 17.547

22. Yasamee, *Ottoman Diplomacy* 27, 87ff
23. Buzpınar, 'The Hijaz, Abdulhamid II' 99ff esp. 106, 114
24. Ochsenwald, *Religion, Society* 188–9
25. Kayalı, *Arabs and Young Turks* 32
26. Deringil, *The Well-Protected Domains* 57–60
27. Abu-Manneh, 'Sultan Abdulhamid II' 138–42
28. Abu-Manneh, 'Sultan Abdulhamid II' 143–8
29. Hanioğlu, *The Young Turks* 74–5, 63, 64, 84–6, 106–7, 130–31
30. Deringil, 'Legitimacy Structures' 347–9
31. Haddad, review of Deringil, *The Well-Protected Domains* 209
32. Deringil, *The Well-Protected Domains* 77
33. Hanioğlu, *Preparation for a Revolution* 115
34. Özcan, art. Hilâfet, *İA2* 17.548
35. Deringil, *The Well-Protected Domains* 148
36. Deringil, 'Les Ottomans et le partage' 43ff; Karpat, *The Politicization of Islam* 258ff
37. (Ahmed) Cevdet Paşa, *Tezakir* 4.195
38. Deringil, 'Legitimacy Structures' 352–3
39. Broomhall, *Islam in China* 291–3; Sırma, 'II. Abdülhamid'in Çin müslümanlarını' 559ff
40. Deringil, 'Legitimacy Structures' 350, 358
41. Akarlı, 'The Problems of External Pressures' 182, 202–3
42. Akarlı, 'The Problems of External Pressures' 96, 104–36
43. Akarlı, 'The Problems of External Pressures' 77
44. Davison, art. Midhat Pasha, *EI2* VI.1034
45. (Ahmed) Cevdet Paşa, *Tezakir* 4.156–7
46. Baykal, *İbretnümâ*
47. Uzunçarşılı, *Midhat Paşa ve Yıldız Mahkemesi* 307–8, 321–9
48. Baykal, *İbretnümâ* 63–7
49. Uzunçarşılı, *Midhat Paşa ve Tâif Mahkûmları* 22–4, 56ff
50. Baykal, *İbretnümâ* viii–ix

51. Buzpınar, 'The Hijaz, Abdulhamid II' 105–6
52. Gawrych, 'Ottoman Administration' 3
53. Gawrych, 'Ottoman Administration' 24ff; Yasamee, *Ottoman Diplomacy* 63–4, 76–8
54. Salt, *Imperialism, Evangelism* 61–4
55. Duguid, 'The Politics of Unity' 144–8
56. Salt, *Imperialism, Evangelism* 72–93
57. Salt, *Imperialism, Evangelism* 93–110
58. Fatma Müge Göçek, personal communication
59. Yasamee, *Ottoman Diplomacy* 73–5
60. Clogg, *A Short History* 93–4
61. Hanioğlu, *The Young Turks* 71–7
62. Hanioğlu, *The Young Turks* 78ff
63. Hanioğlu, *The Young Turks* 126–36, 142–6
64. Hanioğlu, *The Young Turks* 173ff
65. Hanioğlu, *Preparation for a Revolution* 8ff, 39–46
66. Hanioğlu, *Preparation for a Revolution* 130–36
67. Hanioğlu, *Preparation for a Revolution* 136ff, 294
68. Hanioğlu, *Preparation for a Revolution* 106ff, 121, 123
69. Kansu, *The Revolution of 1908* 36, 38; Akarlı, 'The Problems of External Pressures' 155–73
70. Kansu, *The Revolution of 1908* 36, 38; Akarlı, 'The Problems of External Pressures' 155–73
71. Kansu, *The Revolution of 1908* 41–2; Hanioğlu, *Preparation for a Revolution* 104–9
72. Hanioğlu, *Preparation for a Revolution* 109–14; Kansu, *The Revolution of 1908* 44–9
73. Hanioğlu, *Preparation for a Revolution* 91–5, 114–20
74. Hanioğlu, *Preparation for a Revolution* 120
75. Hanioğlu, *Preparation for a Revolution* 191ff
76. Zürcher, *The Unionist Factor* 37–41; Hanioğlu, *Preparation for a Revolution* 215–16
77. Hanioğlu, *Preparation for a Revolution* 217
78. Jelavich, *The Establishment* 207–13
79. Hanioğlu, *Preparation for a Revolution* 218
80. Hanioğlu, *Preparation for a Revolution* 217–32
81. Anderson, *The Eastern Question* 271–3
82. Kansu, *The Revolution of 1908* 41–2
83. Hanioğlu, *Preparation for a Revolution* 232–61, 296
84. Hanioğlu, *Preparation for a Revolution* 263–4, 266–71
85. Hanioğlu, *Preparation for a Revolution* 273–5
86. Hanioğlu, *Preparation for a Revolution* 283
87. Hanioğlu, *Preparation for a Revolution* 311
88. Kansu, *The Revolution of 1908* 160–62
89. Kansu, *The Revolution of 1908* 184–92
90. Kayalı, 'Elections and the Electoral Process' 267–73
91. Unat, *İkinci Meşrutiyetin İlânı* 25–30, 31–3, 35–6, 39–41, 42–3
92. Karakışla, 'The 1908 Strike Wave' 154–6, 168, 173–5
93. Quataert, 'Ottoman Workers' 37
94. Hanioğlu, *Preparation for a Revolution* 121
95. Unat, *İkinci Meşrutiyetin İlânı* 19, 44
96. Farhi, 'The Şeriat as a Political Slogan' 275
97. Zürcher, 'Ottoman Labour Battalions'
98. Farhi, 'The Şeriat as a Political Slogan' 276
99. Kansu, *Politics in Post-Revolutionary Turkey* 69, 77ff
100. Unat, *İkinci Meşrutiyetin İlânı* 68–75, 78, 80–87, 97–100, 145–6, 148–54
101. Farhi, 'The Şeriat as a Political Slogan' 291–4
102. Unat, *İkinci Meşrutiyetin İlânı* 82
103. Mango, *Atatürk* 89; Kansu, *Politics in Post-Revolutionary Turkey* 137–47
104. Kansu, *Politics in Post-Revolutionary Turkey* 118–25
105. Ahmad, *The Young Turks* 58–9
106. Hale, *Turkish Politics and the Military* 41; William Hale, personal communication
107. Ahmad, *The Young Turks* 48–9, 54

108. Ahmad, *The Young Turks* 61–3
109. Zürcher, 'The Ottoman Conscription System' 89–90
110. Ahmad, *The Young Turks* 73
111. Ahmad, *The Young Turks* 55, 82–3
112. Kayalı, 'Elections and the Electoral Process' 272–7
113. Kansu, *Politics in Post-Revolutionary Turkey* 398–408
114. Kayalı, 'Elections and the Electoral Process' 277–8
115. Gawrych, 'Ottoman Administration' 103–4, 287ff
116. Zürcher, 'Kosovo Revisited' 26ff, 36
117. Kayalı, *Arabs and Young Turks* 84; cf. Kansu, *The Revolution of 1908* 238, 239
118. Kayalı, *Arabs and Young Turks* 91–4, 96–100
119. Özcan, 'Sultan II. Abdulhamid'in "Pan-Islam"' 128, 139
120. Kayalı, *Arabs and Young Turks* 108–11, 124–5
121. Anderson, 'Nineteenth-century Reform' 338–9, 341–3
122. Mango, *Atatürk* 101
123. Haley, 'The Desperate Ottoman' 1–15
124. Anderson, *The Eastern Question* 290–91
125. Dumont and Georgeon, 'La mort d'un empire' 604–7
126. Anderson, *The Eastern Question* 293–6
127. Dumont and Georgeon, 'La mort d'un empire' 608
128. Mango, *Atatürk* 117–20
129. Mango, *Atatürk* 120–22
130. Kayalı, *Arabs and Young Turks* 130–34
131. Kayalı, *Arabs and Young Turks* 135–7, 139
132. Kayalı, *Arabs and Young Turks* 176

Chapter Sixteen: The storm before the calm

1. Kayalı, 'Elections and the Electoral Process' 279, 280
2. Tanilli, 'Le *tournant* de 1913' 348–51
3. Hale, *Turkish Politics and the Military* 49
4. Mango, *Atatürk* 133–4
5. Ahmad, 'The Late Ottoman Empire' 15
6. Haley, 'The Desperate Ottoman' 24–45
7. Yasamee, *Ottoman Diplomacy* 73ff; Trumpener, 'Germany and the End' 111ff
8. Mango, *Atatürk* 134–5
9. Mango, *Atatürk* 134
10. Tanilli, 'Le *tournant* de 1913' 352
11. Ahmad, 'The Late Ottoman Empire' 17
12. Mango, *Atatürk* 135, 136
13. Peters, *Islam and Colonialism* 90–94
14. Zürcher, 'Between Death and Desertion' 250–53
15. Zürcher, 'The Ottoman Empire and the Armistice of Moudros'
16. Zürcher, 'Between Death and Desertion' 242–4
17. Zürcher, 'Between Death and Desertion' 239–46; Zürcher, 'The Ottoman Empire and the Armistice of Moudros'
18. Kayalı, *Arabs and Young Turks* 126, 192–6, 198–200
19. Kayalı, *Arabs and Young Turks* 124–5, 128, 196–9
20. Yapp, *The Making of the Modern Near East* 275
21. Yapp, *The Making of the Modern Near East* 266ff
22. Hanioğlu, 'Jews in the Young Turk Movement' 519ff
23. Olson, 'The Young Turks and the Jews' 233
24. Benbassa, 'Associational Strategies' 463–4
25. Ortaylı, 'Ottomanism and Zionism' 532–4
26. Zürcher, 'Ottoman Labour Battalions'
27. Sonyel, *The Ottoman Armenians* 291–300
28. Süslü, *Armenians and the 1915 Event* 100–106 (Engl. text)
29. Süslü, *Armenians and the 1915 Event* 106–10
30. Dadrian, 'The Documentation' 565
31. Mango, 'A Speaking Turkey' 161
32. Salt, 'The Narrative Gap' 19ff

33. Keyder, 'Manufacturing in the Ottoman Empire' 128–30, 133–7
34. Hurewitz, *Diplomacy in the Near and Middle East* 2.37
35. Mango, *Atatürk* 190
36. Criss, *Istanbul under Allied Occupation* 60ff
37. Zürcher, 'The Ottoman Empire and the Armistice of Moudros'
38. Criss, *Istanbul under Allied Occupation* 60ff
39. Goldstein, 'Holy Wisdom and British Foreign Policy' 36ff
40. Dadrian, 'The Documentation' 552, 554, 556–60, 561–2, 571 n.33
41. Andrew Mango, personal communication
42. Mango, *Atatürk* 217
43. Zürcher, 'The Ottoman Empire and the Armistice of Moudros'
44. Goldstein, 'Holy Wisdom and British Foreign Policy' 60–61
45. Mango, *Atatürk* 198–201, 207–9, 211
46. Mango, *Atatürk* 212–21
47. Zürcher, *Political Opposition* 14–15; Criss, *Istanbul under Allied Occupation* 98ff
48. Mango, *Atatürk* 195, 221, 225, 227, 228
49. Mango, *Atatürk* 221, 230
50. Mango, *Atatürk* 238–41, 244–9
51. Zürcher, *Turkey* 143, 144, 157–8
52. Mango, *Atatürk* 264, 269
53. Mango, *Atatürk* 269–73
54. Mango, *Atatürk* 276–7
55. Mango, *Atatürk* 275, 279, 282
56. Mango, *Atatürk* 287–97, 558
57. Mango, *Atatürk* 310–21
58. Andrew Mango, personal communication
59. Zürcher, 'From empire to republic'
60. Mango, *Atatürk* 344
61. Dadrian, 'The Naim-Andonian Documents' 336–8
62. Mango, *Atatürk* 406
63. Zürcher, *Political Opposition* 32ff
64. Zürcher, *Political Opposition* 32–8, esp. 36
65. Özcan, art. Hilâfet, *İA2* 17.551–2
66. Zürcher, 'From empire to republic'
67. McCarthy, 'Foundations of the Turkish Republic' 142
68. Matthews, 'The Ottoman Inheritance Inventory' 100–101
69. Mango, *Atatürk* 37, 109
70. Mardin, *The Genesis* 326–8, 331
71. Deringil, *The Well-Protected Domains* 32
72. Deringil, *The Well-Protected Domains* 170
73. Hanioğlu, *Preparation for a Revolution* 295–9
74. Eissenstadt, 'Turkic Immigrants/Turkish Nationalism' 25ff
75. Georgeon, 'Les Foyers Turcs' 197–202
76. Mango, 'Atatürk and the Kurds' 1ff
77. Tunçay, *Türkiye Cumhuriyeti'nde Tek-Parti* 134–44, 172–3, 178–9; van Bruinissen, *Agha, Shaikh and State* 265ff
78. Tunçay, *Türkiye Cumhuriyeti'nde Tek-Parti* 173
79. Zürcher, *Turkey* 181
80. Zürcher, *Political Opposition*
81. Mango, *Atatürk* 433–8
82. Zürcher, *Political Opposition* 86
83. Zürcher, 'The Last Phase' 371–7; Mango, *Atatürk* 445–53
84. Mustapha Kemal, *A Speech Delivered*
85. Mustapha Kemal, *A Speech Delivered* 658–80
86. Mustapha Kemal, *A Speech Delivered* 686–721
87. Zürcher, 'From empire to republic'
88. Gür, 'Atatürk heykelleri' 147ff
89. Mango, *Atatürk* 462–3
90. Mustapha Kemal, *A Speech Delivered* 680–86, 721–3
91. Mustapha Kemal, *A Speech Delivered* 721
92. Mango, 'A Speaking Turkey' 157

Bibliography

AAS *Asian and African Studies*
AHR *American Historical Review*
AO *Archivum Ottomanicum*
AOASH *Acta Orientalia Academiae Scientiarum Hungaricae*
BMGS *Byzantine and Modern Greek Studies*
BTTD *Belgelerle Türk Tarihi Dergisi*
BSOAS *Bulletin of the School of Oriental and African Studies*
DOP *Dumbarton Oaks Papers*
İED *İstanbul Enstitüsü Dergisi*
IHR *International History Review*
IJMES *International Journal of Middle Eastern Studies*
IJTS *International Journal of Turkish Studies*
JAOS *Journal of the American Oriental Society*
JESHO *Journal of the Economic and Social History of the Orient*
JMH *Journal of Modern History*
JTS *Journal of Turkish Studies*
MES *Middle Eastern Studies*
NPT *New Perspectives on Turkey*
OA *Osmanlı Araştırmaları* (also known as *Journal of Ottoman Studies*)
SI *Studia Islamica*
TB *Toplum ve Bilim*
TD *Tarih Dergisi*
TED *Tarih Enstitüsü Dergisi*
TM *Türkiyat Mecmuası*
TSAB *Turkish Studies Association Bulletin*
TULP *Turkology Update Leiden Project Working Papers Archive*
VD *Vakıflar Dergisi*
WZKM *Wiener Zeitschrift für die Kunde des Morgenlandes*

İA *İslam Ansiklopedisi* (Istanbul 1965–88)
İA2 *Türkiye Diyanet Vakfı İslam Ansiklopedisi* (Istanbul 1988–)
EI2 *Encyclopedia of Islam*, 2nd edition (London 1960–)
İst. Ansik. *İstanbul Ansiklopedisi* (Istanbul 1993–4)

art. article
ch. chapter
ed., eds editor, editors
edn edition
esp. especially
n.p. no place of publication listed

n.s.	new series
pbk	paperback
prep.	prepared for publication by
publ.	published
repr.	reprint
Univ.	University
unpubl.	unpublished
vol., vols	volume, volumes

Abdi, *Abdi Tarihi (1730 Patrona İhtilâli Hakkında Bir Eser)*, prep. F. R. Unat, Ankara (repr. 1999)

Abir, M., 'The "Arab Rebellion" of Amir Ghalib of Mecca (1788–1813)', *MES* 7 (1971) 185–200

Abdurrahman Abdi Paşa, 'Abdurrahman Abdi Paşa Vekâyi'nâme'si', prep. Fahri Çetin Derin, Unpubl. Ph.D. thesis, Istanbul Univ. (1993)

Abou-El-Haj, Rifa'at A., 'Ottoman Diplomacy at Karlowitz', *JAOS* 87 (1967) 498–512

Abou-El-Haj, Rifa'at A., 'The Formal Closure of the Ottoman Frontier in Europe: 1699–1703', *JOAS* 89 (1969) 467–75

Abou-El-Haj, R. A., 'The Narcissism of Mustafa II (1695–1703): A Psychohistorical Study', *SI* 40 (1974) 115–31

Abou-El-Haj, Rifaat Ali, 'The Ottoman Vezir and Paşa Households, 1683–1703: a Preliminary Report', *JOAS* 94 (1974) 438–47

Abou-El-Haj, Rifa'at Ali, *The 1703 Rebellion and the Structure of Ottoman Politics*, Istanbul (1984)

Abou-El-Haj, Rifaat Ali, 'Aspects of the Legitimation of Ottoman Rule as Reflected in the Preambles to two Early *Liva Kanunnameler*', *Turcica* XXI–XXIII (1991) 371–83

Abou-El-Haj, Rifa'at 'Ali, *Formation of the Modern State. The Ottoman Empire, Sixteenth to Eighteenth Centuries*, Albany (1991)

Abu-El-Haj, Rifa'at Ali, '*Fitnah, Huruc ala al-Sultan* and *Nasihat*: Political Struggle and Social Conflict in Ottoman Society 1560s–1700s', in J.-L. Bacqué-Grammont and E. van Donzel (eds), Proceedings of Comité international d'études pré-ottomanes et ottomanes, VIth Symposium, Cambridge 1–4 July 1984, Istanbul (1987) 185–91

Abu-Manneh, B., 'Sultan Abdulhamid II and Shaikh Al-Sayyadi', *MES* 15 (1979) 131–53

Abu-Manneh, Butrus, 'The Sultan and the Bureaucracy: the anti-Tanzimat Concepts of Grand Vizier Mahmud Nedim Paşa', *IJMES* 22 (1990) 257–74

Abu-Manneh, Butrus, 'The Islamic Roots of the Gülhane Rescript', *Die Welt des Islams* 34 (1994) 173–203

Ágoston, Gábor, 'Ottoman Artillery and European Military Technology in the Fifteenth and Seventeenth Centuries', *AOASH* XLVII/1–2 (1994) 15–48

Ágoston, Gábor, 'Habsburgs and Ottomans: Defense, Military Change and Shifts in Power', *TSAB* 22 (1998) 126–41

Ágoston, Gábor, 'Limits of Imperial Authority and the Impact of Frontier Defense: the Ottoman and Habsburg Frontiers in Hungary, 1541–1699', paper presented at 116th Annual Meeting of the American Historical Association, 3–6 January 2002, San Francisco (typescript)

Ágoston, Gábor, 'A Flexible Empire: Authority and its Limits on the Ottoman Frontiers', *IJTS* 9 (2003) 15–32

Ahmad, Feroz, *The Young Turks. The Committee of Union and Progress in Turkish Politics, 1908–1914*, Oxford (1969)

Ahmad, Feroz, 'The Late Ottoman Empire', in Marian Kent (ed.), *The Great Powers and the End of the Ottoman Empire*, London (1984) 5–30

(Ahmed) Cevdet Paşa, *Tezakir*, 4 vols, Ankara (1953–67)

Ahmed Lûtfî Efendi, *Vak'anüvîs Ahmed Lûtfî Efendi Tarihi*, 8 vols, Istanbul (1999)

Ahmed Resmî Efendi, *Hamîletü'l-Küberâ*, prep. Ahmet Nezihî Turan, Istanbul (2000)

Akarlı, Engin Deniz, 'The Problems of External Pressures, Power Struggles, and Budgetary Deficits in Ottoman Politics under Abdülhamid II (1876–1909): Origins and Solutions', unpubl. Ph.D. thesis, Princeton Univ. (1976)

Akarlı, Engin Deniz, *The Long Peace. Ottoman Lebanon, 1861–1920*, Berkeley (1993)

Akdağ, Mustafa, *Celali İsyanları (1550–1603)*, Ankara (1963)

Aksan, Virginia, 'The One-eyed Fighting the Blind: Mobilization, Supply and Command in the Russo-Turkish War of 1768–1774', *IHR* XV (1993) 221–38

Aksan, Virginia, 'Ottoman Political Writing, 1768–1808', *IJMES* 25 (1993) 53–69

Aksan, Virginia, *An Ottoman Statesman in War and Peace. Ahmed Resmi Efendi, 1700–1783*, Leiden (1995)

Aksan, Virginia, 'Feeding the Ottoman Troops on the Danube, 1768–1774', *War and Society* 13 (1995) 1–14

Aksan, Virginia, 'Whatever Happened to the Janissaries? Mobilization for the 1768–1774 Russo-Ottoman War', *War in History* 5/1 (1998) 23–36

Aksan, Virginia, 'An Ottoman Portrait of Frederick the Great', in *The Ottoman Empire in the Eighteenth Century*, Oriente Moderno XVIII (LXXIX) n.s. (1999) 203–15

Aksan, Virginia, 'Ottoman Military Recruitment Strategies in the Late Eighteenth Century', in Erik J. Zürcher (ed.), *Arming the State. Military Conscription in the Middle East and Central Asia 1775–1925*, London (1999) 21–39

Aksan, Virginia, 'Breaking the Spell of the Baron de Tott: Reframing the Question of Military Reform in the Ottoman Empire, 1760–1830', *IHR* XXIV (2002) 253–77.

Aksan, Virginia, *An Empire Besieged: Ottoman Warfare, 1700–1870*, Harlow (2006)

Aktepe, M. Münir, 'XIV. ve XV. asırlarda Rumeli'nin türkler tarafından iskânına dair', *TM* X (1951–53 [1953]) 299–312

Aktepe, M. Münir, 'Damad İbrahim Paşa devrinde lâle', *TD* IV/7 (1952 [1953]) 85–126; *TD* V/8 (1953) 85–104; *TD* VI/9 (1954) 23–38

Aktepe, M. Münir, 'Ahmed III. devrinde Şark seferine iştirak edecek ordu esnafı hakkında vesikalar', *TD* VII/10 (1954) 17–30

Aktepe, M. Münir, 'Vak'anüvis Raşid Mehmed Efendi'nin Eşref Şah Nezdindeki Elçiliği ve Buna Tekaddüm Eden Siyasî Muhabereler', *TM* XII (1955) 155–78

Aktepe, M. Münir, '1727–1728 İzmir isyanına dâir bâzı vesikalar', *TD* VIII/11–12 (1955 [1956]) 71–98

Aktepe, M. Münir, *Patrona İsyanı (1730)*, Istanbul (1958)

Aktepe, M. Münir, 'XVIII. asrın ilk yarısında İstanbul'un Nüfus Mes'elesine Dâir Bâzı Vesikalar', *TD* IX/13 (1958) 2–30

Aktepe, M. Münir, 'Nevşehirli Damad İbrahim Paşa'ya âid iki vakfiye', *TD* XI/15 (1960) 149–60

Aktepe, Münür, 'Dürrî Ahmet Efendi'nin İran Sefareti', *BTTD* 1/1 57–60, 1/2 60–3, 1/3 64–6 (1967); 1/4 60–2, 1/5 63–56, 1/6 82–4 (1968)

Aktepe, M. Münir, 'İpşir Mustafa Paşa ve kendisile ilgili bâzı belgeler', *TD* 24 (1970) 45–58

Aktepe, M. Münir, 'Kâğıdhâne'ye Dâir Bâzı Bilgiler', in *Ord. Prof. İsmail Hakkı Uzunçarşılı'ya Armağan*, Ankara (1976) 335–63

Aktepe, M. Münir, '1711 Prut seferi ile ilgili ba'zi belgeler', *TD* 34 (1983–84 [1984]) 19–54

Aktepe, M. Münir, art. Mehmed Paşa (Sultan-zâde, Civan Kapıcı-Başı, Semîn), *İA* 7.605–7

Aktepe, M. Münir, art. Çeşme Vak'ası, *İA2* 8.288–9

Alexander, John, 'The Turks on the Middle Nile', *Archéologie du Nil Moyen* 7 (1996) 15–35

Alexandrescu-Dersca, M. M., *La campagne de Timur en Anatolie (1402)*, London (1977)

Algar, Hamid, art. Nakshbandiyya, *EI2* VII.934–7

Allouche, Adel, *The Origins and Development of the Ottoman–Safavid Conflict (906–962/1500–1555)*, Berlin (1983)

Altundağ, Şinâsî, art. Osman III, *İA* 9.448–50

Anderson, Lisa, 'Nineteenth-century Reform in Ottoman Libya', *IJMES* 16 (1984) 325–48

Anderson, M. S., *The Eastern Question, 1774–1923*, London (1966)

Anderson, R. C., *Naval Wars in the Levant, 1559–1853*, Liverpool (1952)

Andreasyan, Hrand D., 'Bir Ermeni kaynağına göre Celâlî isyanları', *TD* XIII/17–18 (1962–63 [1963]) 27–42

Andreasyan, Hrand D., 'Abaza Mehmed Paşa', *TD* XVII (1967 [1968]) 131–42

Anderasyan, Hrand D., 'Celâlilerden Kaçan Anadolu Halkının Geri Gönderilmesi', in *Ord. Prof. İsmail Hakkı Uzunçarşılı'ya Armağan*, Ankara (1976) 45–53

Anderasyan, Hrand, and Derin, Fahri Ç., 'Çınar Vak'ası (Eremya Çelebi Kömürcüyan'a göre)', *İED* III (1957) 57–83

(Anonymous) *Anonim Osmanlı Tarihi (1099–1116/1688–1704)*, prep. Abdülkadir Özcan, Ankara (2000)

Arbel, Benjamin, 'Nur Banu (c.1530–1583): a Venetian Sultana?', *Turcica* XXIV (1992) 241–59

Arıkan, V. Sema (prep.), *III. Selim'in Sirkâtibi Ahmed Efendi Tarafından Tutulan Rûznâme*, Ankara (1993)

Artan, Tülay, 'From Charismatic Leadership to Collective Rule. Introducing Materials on the Wealth and Power of Ottoman Princesses in the Eighteenth Century', *Toplum ve Ekonomi* 4 (1993) 53–94

Artan, Tülay, 'Periods and Problems of Ottoman (Women's) Patronage on the Via Egnatia', in E. Zachariadou (ed.), *The Via Egnatia under Ottoman Rule (1380–1699)*, A Symposium held in Rethymnon, 9–11 January 1994, Institute for Mediterranean Studies, Halcyon Days in Crete II, Rethymnon (1996) 19–43

Artan, Tülay, 'Aspects of the Ottoman Elite's Food Consumption: Looking for "Staples", "Luxuries", and "Delicacies" in a Changing Century', in D. Quataert (ed.), *Consumption Studies and the History of the Ottoman Empire, 1550–1922, an Introduction*, Albany (2000) 107–200

Artuk, İbrahim, 'Osmanlı Beyliğinin Kurucusu Osman Gazi'ye Ait Sikke', in O. Okyar and H. İnalcık (eds), *Social and Economic History of Turkey (1071–1920)*, Papers presented to the First International Congress on the Social and Economic History of Turkey, Hacettepe University, July 11–13 1977, Ankara (1980) 27–31

Atasoy, Nurhan, art. Hırka-i Saâdet, *İA2* 17.374–7

Atıl, Esin, 'The Story of an Eighteenth-Century Ottoman Festival', *Muqarnas* 10 (1993) 181–211

Atsız, Bedriye (prep.), *Ahmed Resmî Efendi'nin Viyana ve Berlin Sefaretnameleri*, Istanbul (1980)

Austin, M., *Domenico's Istanbul*, London (2001)

Avcıoğlu, Nebahat, 'Ahmed I and the Allegories of Tyranny in the Frontispiece to George Sandys's *Relation of a Journey*', *Muqarnas* 18 (2001) 203–26

OSMAN'S DREAM

Aydın, Mahir, 'Livadya Sefâretleri ve Sefâretnâmeleri', *Belgeler* XIV/18 (1989–92 [1992])
321–57
Aydın, Mahir, 'Sultan II. Mahmud Döneminde Yapılan Nüfûs Tahrirleri', in Sultan II.
Mahmud ve Reformları Semineri, 28–30 Haziran 1989, IUEF Tarih Araştırma
Merkezi, Istanbul (1990) 81–106
Ayverdi, Ekrem Hakkı, *İstanbul Mi'mârî Çağının Menşe'i: Osmanlı Mi'mârîsinin İlk Devri
630–805 (1230–1402)*, Istanbul (1966)
Babinger, Franz, '*Bajezid Osman* (Calixtus Ottomanus), ein Vorläufer und Gegenspieler
Dschem-Sultans', *La nouvelle Clio* 3 (1951) 349–88
Babinger, Franz, *Mehmed the Conqueror and his Time*, Princeton (1978)
Babinger, Fr., art. Mīkhāl-oghlu, *EI2* VII.34–5
Bacqué-Grammont, Jean-Louis, 'Etudes turco-safavides I. Notes sur le blocus de
commerce iranien par Selîm Ier', *Turcica* VI (1975) 68–88
Bacqué-Grammont, Jean-Louis, 'Notes sur une saisie de soie d'Iran en 1518', *Turcica*
VIII/2 (1976) 237–53
Bacqué-Grammont, J.-L., 'Etudes Turco-Safavides III. Notes et documents sur la révolte
de Şah Velî b. Şeyh Celâl', *AO* 7 (1982) 5–69
Bacqué-Grammont, Jean-Louis, 'Un rapport inédit sur la révolte anatolienne de 1527',
SI 62 (1985) 156–71
Bacqué-Grammont, Jean-Louis, *Les Ottomans, les Safavides et leurs voisins*, Istanbul (1987)
Bacqué-Grammont, Jean-Louis, 'Ubaydu-llah han de Boukhara et Soliman le Magnifique.
Sur quelques pièces de correspondance', in G. Veinstein (ed.), *Soliman le magnifique
et son temps*, Actes du Colloque de Paris, Galeries Nationales du Grand Palais, 7–10
mars 1990, Paris (1992) 485–504
Bacqué-Grammont Jean-Louis, 'The Eastern Policy of Süleymân the Magnificent
1520–1533', in H. İnalcık and C. Kafadar (eds), *Süleymân the Second and his Time*,
Istanbul (1993) 219–28
Baer, Marc, 'Honored by the Glory of Islam: the Ottoman State, Non-Muslims, and
Conversion to Islam in Late Seventeenth-Century Istanbul and Rumelia', unpubl.
Ph.D. thesis, Univ. of Chicago (2001)
Bağcı, Serpil, 'The Spread and Liberation of the Royal Image', in *The Sultan's Portrait.
Picturing the House of Osman*, Istanbul (2000) 216–19
Balivet, Michel, 'Deux partisans de la fusion religieuse des Chrétiens et des Musulmans
au XVe siècle: Le turc Bedreddin de Samavna et le grec Georges de Trebizonde',
Byzantina 10 (1980) 361–400
Balivet, Michel, *Islam mystique et révolution armée dans les Balkans ottomans. Vie du Cheikh
Bedreddîn le 'Hallaj des Turcs' (1358/59–1416)*, Istanbul (1995)
Barbir, Karl K., *Ottoman Rule in Damascus, 1708–1758*, Princeton (1980)
Barkan, Ömer Lutfi, 'Osmanlı İmparatorluğunda Bir iskan ve kolonizasyon metodu
olarak Vakıflar ve Temlikler: I. İstilâ devirlerinin Kolonizator Türk dervişleri ve
zâviyeleri', *VD* 2 (1942) 279–386
Barker, John W., *Manuel II Palaeologus (1391–1425): A Study in Late Byzantine
Statesmanship*, New Brunswick (1969)
Barnes, John Robert, *An Introduction to Religious Foundations in the Ottoman Empire*,
Leiden (1986)
Barta, Gábor, 'A Forgotten Theatre of War 1526–1528 (Historical Events preceding
the Ottoman–Hungarian Alliance of 1528)' in G. Dávid and P. Fodor (eds),
*Hungarian–Ottoman Military and Diplomatic Relations in the Age of Süleyman the
Magnificent*, Budapest (1994) 93–130
Bayerle, Gustav, 'The Compromise at Zsitvatorok', *AO* 6 (1980) 5–53

614

Baykal, Bekir Sıtkı, (prep.), *İbretnümâ. Mabeynci Fahri Bey'in Hatıraları ve İlgili Bazı Belgeler*, Ankara (repr. 1989)

Baykal, Bekir Sıtkı, art. Râmî Mehmed Paşa, *İA* 9.623–4

Baysun, M. Cavid, 'Müverrih Râşid Efendi'nin İran Elciliğine Dâir', *TM* IX (1946–51 [1951]) 145–50

Behrens-Abouseif, Doris, *Egypt's Adjustment to Ottoman Rule*, Leiden (1994)

Beldiceanu-Steinherr, Irène, 'Le règne de Selīm Ier: Tournant dans la vie politique et religieuse de l'Empire ottoman', *Turcica* VI (1975) 34–48

Beldiceanu-Steinherr, Irène, and Bacqué-Grammont, Jean-Louis, 'A propos de quelques causes de malaises sociaux en Anatolie Centrale', *AO* 7 (1982) 71–116

Benbassa, Esther, 'Associational Strategies in Ottoman Jewish Society in the Nineteenth and Twentieth Centuries', in A. Levy (ed.), *The Jews of the Ottoman Empire*, Princeton (1994) 457–84

Benbassa, Esther, and Rodrigue, Aron, *Sephardi Jewry*, Berkeley (2000)

Bennigsen, Alexandre, 'L'expédition turque contre Astrakhan en 1569 d'après les Registres des "Affaires importantes" des Archives ottomanes', *Cahiers du Monde russe et soviétique* VIII (1967) 427–46

Berindei, Mihnea, 'Le rôle des fourrures dans les relations commerciales entre la Russie et l'empire ottoman avant la conquête de la Sibérie', in Ch. Lemercier-Quelquejay et al. (eds), *Passé turco-tatar, présent soviétique, Études offertes à Alexandre Bennigsen*, Louvain (1986) 89–98

Beydilli, Kemal, 'Bonnaval'in izinde: Muhtedî Osman Bey veya Avusturyalı firârî General Karlo de Kotzi', *OA* 11 (1991) 73–104

Beydilli, Kemal, *Türk Bilim ve Matbaacılık Tarihinde Mühendishâne Matbaası ve Kütüphânesi (1776–1826)*, Istanbul (1995)

Beydilli, Kemal, and Şahin, İlhan, *Mahmud Râif Efendi ve Nizâm-i Cedîd'e Dâir Eseri*, Ankara (2001)

Bierman, Irene, 'The Ottomanization of Crete', in I. Bierman et al. (eds), *The Ottoman City and its Parts, Urban Structure and Social Order*, New York (1991) 53–75

Blackburn, J. R., 'Two Documents on the Division of Ottoman Yemen into two Beglerbegliks (973/1565)', *Turcica* XXVII (1995) 223–36

Blackburn, J. R., art. Özdemir Pasha, *EI2* VIII.235–6

BOA/Hatt-i hümayun no. 8231: Başbakanlık Osmanlı Arşivi (Prime Minister's Ottoman Archives, Istanbul)

BOA/Mühimme Defteri vol.7 no.721: Başbakanlık Osmanlı Arşivi (Prime Minister's Ottoman Archives, Istanbul), publ. as *7 Numaralı Mühimme Defteri (975–976/1567–1569)*, Ankara (1997–8)

Bostan İdris, *Osmanlı Bahriye Teşkilâtı: XVII. Yüzyılda Tersâne-i Âmire*, Ankara (1992)

Bowen, H., art. 'Alï Pasha Tepedelenli, *EI2* I.398–9

Bozkurt, Gülnihâl, *Alman–İngiliz Belgelerinin ve Siyasi Gelismelerin Işığı Altında Gayrimüslim Osmanlı Vatandaşlarının Hukukî Durumu (1839–1914)*, Ankara (repr. 1996)

Braune, W., art. 'Abd al-Kādir al-Djīlānī, *EI2* I.69–70

Broomhall, Marshall, *Islam in China. A Neglected Problem*, London (1910)

Brouwer, C. G., '*A Stockless Anchor and An Unsaddled Horse*: Ottoman Letters Addressed to the Dutch in Yemen, First Quarter of the 17th Century', *Turcica* XX (1988) 173–242

Bruess, Gregory, *Religion, Identity and Empire: a Greek Archbishop in the Russia of Catherine the Great*, Boulder (1997)

Brummett, Palmira, *Ottoman Seapower and Levantine Diplomacy in the Age of Discovery*, Albany (1994)

Bryer, Anthony, 'Greek Historians on the Turks: the Case of the first Byzantine–Ottoman Marriage', in R. H. C. Davis and J. M. Wallace-Hadrill (eds), *The Writing of History in the Middle Ages*, Oxford (1981) 471–94

Burian, Orhan (prep.), *The Report of Lello, Third English Ambassador to the Sublime Porte*, Ankara (1952)

Buzpınar, Ş. Tufan, 'The Hijaz, Abdulhamid II and Amir Hussein's Secret Dealings with the British, 1877–80', *MES* 31 (1995) 99–123

Çağman, Filiz, 'Portrait Series of Nakkaş Osman', in *The Sultan's Portrait. Picturing the House of Osman*, Istanbul (2000) 164–87

Cazacu, Matei, 'La "mort infâme". Décapitation et exposition des têtes à Istanbul (XVe–XIXe siècles)', in G. Veinstein (ed.), *Les Ottomans et la mort*, Leiden (1996) 245–89

Çelik, Zeynep, *Displaying the Orient. Architecture of Islam at Nineteenth-Century World's Fairs*, Berkeley (1992)

Cezar, Yavuz, *Osmanlı Maliyesinde Bunalım ve Değişim Dönemi (XVIII. yy dan Tanzimat'a Mali Tarih)*, Istanbul (1986)

Charanis, Peter, 'The Strife among the Palaeologi and the Ottoman Turks, 1370–1402', *Byzantion* 16/1 (1942 [1944]) 286–314

Chaudhuri, K. N., *Trade and Civilisation in the Indian Ocean. An Economic History from the Rise of Islam to 1750*, Cambridge (1985)

Chesnau, Jean, *Le Voyage de Monsieur d'Aramon*, Paris (1887)

Chrysostomides, J. (prep.), *Manuel II Palaeologus Funeral Oration on his Brother Theodore*, Corpus Fontum Historiae Byzantinae XXVI, Thessalonica (1985)

Clayer, Nathalie, *Mystiques, état et société: les Halvetis dans l'aire balkanique de la fin du Xme siècle à nos jours*, Leiden (1994)

Clogg, Richard, *A Short History of Modern Greece*, Cambridge (repr. 1987)

Clogg, Richard, *A Concise History of Greece*, Cambridge (repr. 1995)

Cohen, Amnon, *Palestine in the 18th Century*, Jerusalem (1973)

Conway Morris, Roderick, *Jem: Memoirs of an Ottoman Secret Agent*, London (1988)

Cook, Michael, *Population Pressure in Rural Anatolia, 1450–1600*, London (1972)

Cook, Michael (ed.), *A History of the Ottoman Empire to 1730*, Cambridge (1976)

Covel, Dr John, *Voyages en Turquie, 1675–1677*, prep. Jean-Pierre Grélois, Paris (1998)

Crane, Howard, 'The Ottoman Sultan's Mosques: Icons of Imperial Legitimacy', in I. Bierman et al. (eds), *The Ottoman City and its Parts, Urban Structure and Social Order*, New York (1991) 173–243

Crecelius, Daniel, 'Egypt in the eighteenth century', in M. W. Daly (ed.), *The Cambridge History of Egypt*, vol. 2: *Modern Egypt from 1517 to the end of the twentieth century*, Cambridge (1998) 59–86

Criss, Bilge, *Istanbul under Allied Occupation, 1918–1923*, Leiden (1999)

Dadrian, Vahakn, 'The Naim-Andonian Documents on the World War I Destruction of Armenians: the Anatomy of a Genocide', *IJMES* 18 (1986) 311–60, 550

Dadrian, Vahakn, 'The Documentation of the World War I Armenian Massacres in the Proceedings of the Turkish Military Tribunal', *IJMES* 23 (1991) 549–76

Danişmend, İsmail Hami, *İzahlı Osmanlı Tarihi Kronolojisi*, 4 vols, Istanbul (1947–55)

Dankoff, Robert, (prep., with a historical introduction by Rhoads Murphey), *The Intimate Life of an Ottoman Statesman. Melek Ahmed Pasha (1588–92) as Portrayed in Evliya Çelebi's Book of Travels*, Albany (1991)

Darkot, Besim, art. Karadağ, *İA* 6.221–30

Darling, Linda T., *Revenue-Raising and Legitimacy. Tax Collection and Finance Administration in the Ottoman Empire 1560–1660*, Leiden (1996)

Dávid, Géza, 'Administration in Ottoman Europe', in M. Kunt and C. Woodhead (eds), *Süleyman the Magnificent and his Age*, London and New York (1995) 71–90

Davison, Roderic, *Reform in the Ottoman Empire, 1856–1876*, Princeton (1963)

Davison, Roderic, '"Russian Skill and Turkish Imbecility": the Treaty of Kuchuk Kainardji Reconsidered', in R. Davison, *Essays in Ottoman and Turkish History, 1774–1923*, Austin (1990) 29–50. (First publ. in *Slavic Review* 35/3 (1976) 463–83)

Davison, Roderic, 'The "Dosografa" Church in the Treaty of Küçük Kaynarca', in R. Davison, *Essays in Ottoman and Turkish History, 1774–1923*, Austin (1990) 51–9. (First publ. in *BSOAS* 42/1 (1979) 46–52)

Davison, Roderic, 'The First Ottoman Experiment with Paper Money', in R. Davison, *Essays in Ottoman and Turkish History, 1774–1923*, Austin (1990) 60–72. (First publ. in O. Okyar and H. İnalcık (eds), *Social and Economic History of Turkey (1071–1920)*, Papers presented to the First International Congress on the Social and Economic History of Turkey, Hacettepe University July 11–13 1977, Ankara (1980) 243–51)

Davison, R. H., art. Midhat Pasha, *EI2* VI.1031–5

Davison, R. H., art. Tanzīmāt, *EI2* X.201–9

Decei, Aurel, art, Hotin, *İA* 5/1.567–71

Decei, Aurel, and Gökbilgin, M. Tayyib, art. Erdel, *İA* 4.293–306

Decei, Aurel, and Gökbilgin, M. Tayyib, art. Erdel, *EI2* II.703–5

Defterdar Sarı Mehmed Paşa, *Zübde-i Vekayiât*, prep. Abdülkadir Özcan, Ankara (1995)

de Groot, A. H., art. Khalīl Pasha Kaysariyyeli, *EI2* IV.970–2

de Groot, A. H., art. Mehmed Pasha Karamāni, *EI2* VI.995–6

de Groot, A. H., art. Murād III, *EI2* VII.595–7

Demetriades, Vassilis, 'Some Thoughts on the Origins of the Devşirme', in E. Zachariadou (ed.), *The Ottoman Emirate (1300–1389)*, A Symposium held in Rethymnon, 11–13 January 1991, Institute for Mediterranean Studies, Halcyon Days in Crete I, Rethymnon (1993) 23–31

Dennis, George T., (prep.), *The Letters of Manuel II Palaeologus*, Corpus Fontum Historiae Byzantinae VIII, Washington (1977)

Denny, Walter, et al., *Court and Conquest. Ottoman Origins and the Design for Handel's Tamerlano at the Glimmerglass Opera*, Kent, Ohio (1998)

Derin, Fahri Ç., 'Şeyhülislâm Feyzullah Efendi'nin nesebi hakkında bir risâle, *TD* X/14 (1959) 97–104

Derin, Fahri Ç., (prep.), 'Yayla İmamı Risalesi', *TED* 3 (1972 [1973]) 213–72

Derin, Fahri Ç., (prep.), 'Tüfengçi-başı Ârif Efendi Tarihçesi', *Belleten* XXXVIII (1974) 379–443

Deringil, Selim, 'Legitimacy Structures in the Ottoman State: the Reign of Abdülhamid II (1876–1909)', *IJMES* 23 (1991) 345–59

Deringil, Selim, *The Well-Protected Domains; Ideology and the Legitimation of Power in the Ottoman Empire, 1876–1909*, London (1998)

Deringil, Selim, 'Les Ottomans et le partage de l'Afrique, 1880–1900', in S. Deringil, *The Ottomans, the Turks, and World Power Politics*, Istanbul (2000) 43–55. (First publ. in S. Kuneralp (ed.), *Studies on Ottoman Diplomatic History* V (1990) 121–33)

Deringil, Selim, '"There is no Compulsion in Religion": on Conversion and Apostasy in the Late Ottoman Empire, 1839–1856' in S. Deringil, *The Ottomans, the Turks, and World Power Politics*, Istanbul (2000) 101–30. (First publ. in *Comparative Studies in Society and History* 42/3 (2000) 547–75)

Devereux, Robert, 'Süleyman Pasha's "The Feeling of the Revolution"', *MES* 15 (1979) 3–35

Doukas, *Decline and Fall of Byzantium to the Ottoman Turks*, prep. Harry J. Magoulias, Detroit (1975)

Duguid, Stephen, 'The Politics of Unity: Hamidian Policy in Eastern Anatolia', *MES* 9 (1973) 139–55

Dumont, Paul, 'La pacification du Sud-Est anatolien en 1865', *Turcica* V (1973) 108–30

Dumont, Paul, 'La période des *Tanzimât* (1839–1878)', in R. Mantran (ed.), *Histoire de l'empire ottoman*, Paris (1989) 459–522

Dumont, Paul, and Georgeon, François, 'La mort d'un empire', in R. Mantran (ed.), *Histoire de l'empire ottoman*, Paris (1989) 577–647

Dykstra, Darrell, 'The French occupation of Egypt, 1798–1801', in M. W. Daly (ed.), *The Cambridge History of Egypt*, vol. 2: *Modern Egypt from 1517 to the end of the twentieth century*, Cambridge (1998) 113–38

Eissenstadt, Howard, 'Turkic Immigrants/Turkish Nationalism: Opportunities and Limitations of a Nationalism in Exile', *TSAB* 25/26 (2001–2) 25–50

Eldem, Edhem, *French Trade in Istanbul in the Eighteenth Century*, Leiden (1999)

Eldem, Edhem, 'Istanbul: from imperial to peripheralized capital', in E. Eldem et al., *The Ottoman City between East and West*, Cambridge (1999) 135–206

Eldem, Edhem, *Pride and Privilege. A History of Ottoman Orders, Medals and Decorations*, Istanbul (2004)

Eldem, Sedat H., *Sa'dabad*, Ankara (1977)

Elliott, J. H., *Richelieu and Olivares*, Cambridge (repr. 1991)

Emecen, Feridun, 'Son Kırım Hânı Şâhin Giray'ın îdâmı mes'elesi ve buna dâir vesikalar', *TD* 34 (1983–84 [1984]) 315–46

Emecen, Feridun, 'The History of an Early Sixteenth Century Migration – Sirem Exiles in Gallipoli', in G. Dávid and P. Fodor (eds), *Hungarian–Ottoman Military and Diplomatic Relations in the Age of Süleyman the Magnificent*, Budapest (1994) 77–87

Emecen, Feridun, art. Cezzâr Ahmed Paşa, *İA2* 7.516–18

Erdem, Y. Hakan, *Slavery in the Ottoman Empire and its Demise, 1800–1909*, Basingstoke (1996)

Erdem, Hakan, 'Recruitment for the "Victorious Soldiers of Muhammad" in the Arab Provinces, 1826–1828' in Israel Gershoni et al. (eds), *Histories of the Modern Middle East. New Directions*, Boulder (2002) 189–206

Erünsal, İsmail E., *Türk Kütüphaneleri Tarihi II. Kuruluştan Tanzimat'a Kadar Osmanlı Vakıf Kütüphaneleri*, Ankara (1988)

Eskandar Beg Monshi, *History of Shah 'Abbas the Great*, 2 vols, prep. R. M. Savory, Boulder (1978)

Evliyâ Çelebi, *Seyahatnâme*, 8 vols., prep. Y. Dağlı et al., Istanbul (1996–2004)

Eyice, Semavi, 'İlk Osmanlı Devrinin Dinî – İçtimaî Bir Müessesesi Zâviyeler ve Zâviyeli–Camiler', *İstanbul Üniversitesi İktisat Fakultesi Mecmuası* 23 (1962–3) 3–80

Eyice, Semavi, art. Fethiye Camii, *İst. Ansik.* 3.300–301

Fahmy, Khaled, 'The era of Muhammad 'Ali Pasha, 1805–1848', in M. W. Daly (ed.), *The Cambridge History of Egypt*, vol. 2: *Modern Egypt from 1517 to the end of the twentieth century*, Cambridge (1998) 139–79

Farhi, David, 'The Şeriat as a Political Slogan – or the "Incident of the 31st March"', *MES* 7 (1971) 275–99

Faroqhi, Suraiya, 'The Venetian Presence in the Ottoman Empire, 1600–30', in Huri İslamoğlu-İnan (ed.), *The Ottoman Empire and the World-Economy*, Cambridge (1987) 311–44

Faroqhi, Suraiya, 'An Ulama Grandee and his Household', *OA* IX (1989) 199–208

Faroqhi, Suraiya, *Pilgrims and Sultans. The Hajj under the Ottomans 1517–1683*, London (1994)

Faroqhi, Suraiya, 'Migration into Eighteenth-Century "Greater Istanbul" as Reflected in the Kadi Registers of Eyüp', *Turcica* XXX (1998) 163–83

Findley, Carter, *Bureaucratic Reform in the Ottoman Empire. The Sublime Porte, 1789–1922*, Princeton (1980)

Findley, Carter, *Ottoman Civil Officialdom*, Princeton (1989)

Findley, Carter, art. Medjelle, *EI2* VI.971–2

Finkel, Caroline, *The Administration of Warfare: the Ottoman Military Campaigns in Hungary, 1593–1606*, Vienna (1988)

Fisher, Alan W., *The Russian Annexation of the Crimea, 1772–1783*, Cambridge (1970)

Fisher, Alan, 'Muscovy and the Black Sea Slave Trade', in A. Fisher, *A Precarious Balance: Conflict, Trade and Diplomacy on the Russian–Ottoman Frontier*, Istanbul (1999) 27–46. (First publ. in *Canadian-American Slavic Studies* VI (1972) 575–94)

Fisher, Alan, *The Crimean Tatars*, Stanford (1987)

Fisher, Alan, 'The Life and Family of Süleyman I', in H. İnalcık and C. Kafadar (eds), *Süleymân the Second and his Time*, Istanbul (1993) 1–19

Fisher, Alan, 'Şahin Giray, the Reformer Khan, and the Russian Annexation of the Crimea', in A. Fisher, *Between Russians, Ottomans and Turks: Crimea and Crimean Tatars*, Istanbul (1998) 93–121

Fleischer, Cornell, 'Royal Authority, Dynastic Cyclism, and "Ibn Khaldûnism" in Sixteenth-Century Ottoman Letters', *AAS* XVIII (1983) 198–220

Fleischer, Cornell, *Bureaucrat and Intellectual in the Ottoman Empire. The Historian Mustafa Âli (1541–1600)*, Princeton (1986)

Fleischer, Cornell, 'The Lawgiver as Messiah: the Making of the Imperial Image in the Reign of Süleymân', in G. Veinstein (ed.), *Soliman le magnifique et son temps*, Actes du Colloque de Paris, Galeries Nationales du Grand Palais, 7–10 mars 1990, Paris (1992) 159–77

Fleming, K. E., *The Muslim Bonaparte. Diplomacy and Orientalism in Ali Pasha's Greece*, Princeton (1999)

Flemming, Barbara, 'Political Genealogies in the Sixteenth Century', *OA* VII–VIII (1988) 123–37

Flemming, Barbara, 'Public Opinion under Sultan Süleymân', in H. İnalcık and C. Kafadar (eds), *Süleymân the Second and his Time*, Istanbul (1993) 49–56

Flemming, B., art. Khōdja Efendi, *EI2* V.27–9

Fodor, Pál, 'State and Society, Crisis and Reform in 15th–17th Century Ottoman Mirror[s] for Princes', *AOASH* XL/2–3 (1986) 217–40

Fodor, Pál, 'Ottoman Policy towards Hungary, 1520–1541', *AOASH* XLV/2–3 (1991) 271–345

Fodor, Pál, 'Sultan, Imperial Council, Grand Vizier: Changes in the Ottoman Ruling Elite and the Formation of the Grand Vizieral Telhīs', *AOASH* XLVII/1–2 (1994) 67–84

Fodor, Pál, 'Between Two Continental Wars: the Ottoman Naval Preparations in 1590–1592', in Ingeborg Baldauf and Suraiya Faroqhi (eds) with the collaboration of Rudolf Veselý, *Armagan, Festschrift für Andreas Tietze*, Prague (1994) 90–111

Fodor, Pál, 'The Grand Vizieral Telhis. A Study in the Ottoman Central Administration 1566–1656', *AO* XV (1997) 137–88

Fodor, Pál, 'The View of the Turk in Hungary: the Apocalyptic Tradition and the Legend of the Red Apple in Ottoman–Hungarian Context', in P. Fodor, *In Quest of the Golden Apple*, Istanbul (2000) 71–103. (First publ. in B. Lelouche and S. Yerasimos (eds), *Les traditions apocalyptiques au tournant de la chute de Constantinople*, Actes de la Table Ronde d'Istanbul (13–14 avril 1996), Paris (1999) 99–131)

Fodor, Pál, 'An Anti-Semite Grand Vizier? The Crisis in Ottoman–Jewish Relations in 1591–1592 and its Consequences', in P. Fodor, *In Quest of the Golden Apple*, Istanbul (2000) 191–206

Fodor, Pál, and Dávid, Géza, 'Hungarian–Ottoman Peace Negotiations in 1512–1514', in G. Dávid and P. Fodor (eds), *Hungarian–Ottoman Military and Diplomatic Relations in the Age of Süleyman the Magnificent*, Budapest (1994) 9–45

Forster, E. S., (prep.), *The Turkish Letters of Ogier Ghiselin de Busbecq*, Oxford (1927)

Fotić, Aleksandar, 'The Official Explanations for the Confiscation and Sale of Monasteries (Churches) and their Estates at the Time of Selim II', *Turcica* XXVI (1994) 33–54

Frost, Robert, *The Northern Wars, 1558–1721*, Harlow (2002)

Fuller, William C., *Strategy and Power in Russia, 1600–1914*, New York (1992)

Gabriel, Erich, 'Die Türkenbeute in Österreich', in Christine Wessely (ed.), *Die Türken und was von ihnen bleib*, Vienna (1978) 101–6

Gawrych, George Walter, 'Ottoman Administration and the Albanians, 1908–1913', unpubl. Ph.D. thesis, Univ. of Michigan (1980)

Gawrych, George W., 'Şeyh Galib and Selim III: Mevlevism and the Nizam-i Cedid', *IJTS* 4 (1987) 91–114

Genç, Mehmet, 'Osmanlı Maliyesinde Malikane Sistemi', in O. Okyar (ed.), *Türkiye İktisat Tarihi Semineri*, Metinler/Tartışmalar, 8–10 Haziran 1973, Ankara (1975) 231–96

Genç, Mehmet, 'A study of the feasibility of using eighteenth-century Ottoman financial records as an indicator of economic activity', in Huri İslamoğlu-İnan (ed.), *The Ottoman Empire and the World-Economy*, Cambridge (1987) 345–73

Genç, Mehmet, 'Ottoman Industry in the Eighteenth Century: General Framework, Characteristics and Main Trends', in D. Quataert (ed.), *Manufacturing in the Ottoman Empire and Turkey, 1500–1950*, Albany (1994) 59–86

Genç, Mehmet, art. Esham, *İA2* 11.376–80

Georgeon, François, 'Les Foyers Turcs à l'époque kémaliste (1923–1931)', *Turcica* XIV (1982) 168–215

Georgeon, François, 'Le dernier sursaut', in R. Mantran (ed.), *Histoire de l'empire ottoman*, Paris (1989) 523–76

Gibb, E. J. W., *Ottoman Poems Translated into English Verse in the Original Forms*, London (1882)

Gibb, E. J. W., *A History of Ottoman Poetry*, 6 vols, London (repr. 1958–63)

Gilles, Pierre, *The Antiquities of Constantinople*, Ithaca (repr. 1988)

Glover, Thomas, 'The Journey of Edward Barton Esquire, her Majesties Ambassador with the Grand Signior otherwise called the Great Turke, in Constantinople, Sultan Mahumet Chan. Written by Sir Thomas Glover then Secretarie to the Ambassador, and since employed in that Honourable Function by his Majestie, to Sultan Achmet . . .', in S. Purchas (ed.), *Hakluytus Posthumus or Purchas his Pilgrimes etc.*, Glasgow (1905–7) VIII.304–20

Göçek, Fatma Müge, *East Encounters West. France and the Ottoman Empire in the Eighteenth Century*, New York (1987)

Goffman, Daniel, *Britons in the Ottoman Empire, 1642–1660*, Seattle (1998)

Goffman, Daniel, 'Izmir: from village to colonial port city', in E. Eldem et al., *The Ottoman City between East and West*, Cambridge (1999) 79–134

Gökbilgin, Tayyib, 'II. Rakoczi Ferencz ve Tevabiine Dair Yeni Vesikalar', *Belleten* V (1941) 577–95

Gökbilgin, M. Tayyib, 'Kara Üveys Paşa'nın Budin Beylerbeyliği (1578–80)', *TD* II/3–4 (1950–51 [1952]) 18–34

Gökbilgin, M. Tayyib, 'Rüstem Paşa ve hakkındaki ithamlar', *TD* VIII/11–12 (1955 [1956]) 10–50

Gökbilgin, M. Tayyib, 'Venedik Devlet Arşivindeki Türkçe Belgeler Kolleksiyonu ve Bizimle İlgili Diğer Belgeler', *Belgeler* V–VIII (1968–71 [1971]) 1–151

Gökbilgin, Tayyib, art. İbrahim, *İA* 5/II.880–5

Gökbilgin, M. Tayyib, art. İbrahim Paşa, *İA* 5/II.908–15

Gökbilgin, M. Tayyib, and Repp, R., art. Köprülü, *EI2* V.256–63

Gökçe, Cemal, 'Edirne Âyanı Dağdeviren-oğlu Mehmed Ağa', *TD* XVII/22 (1967 [1968]) 97–110

Gökçe, Cemal, '1787–1806 yılları arasında Kafkasya'da cereyan eden siyasi olaylar', *TD* 26 (1972) 1–66

Göksu, Saime, and Timms, Edward, *Romantic Communist. The Life and Work of Nazım Hikmet*, New York (1999)

Goldstein, Erik, 'Holy Wisdom and British foreign policy 1918–1922: the St Sophia redemption agitation', *BMGS* 15 (1991) 36–64

Gönen, Yasemin Saner, 'The Integration of the Ottoman Empire into the European State System during the Reign of Selim III', unpubl. MA thesis, Boğaziçi Univ. (1991)

Goodwin, Godfrey, *A History of Ottoman Architecture*, London (pbk 1987)

Gould, Andrew G., 'Lords or Bandits? The Derebeys of Cilicia', *IJMES* 7 (1976) 485–506

Greene, Molly, *A Shared World. Christians and Muslims in the Early Modern Mediterranean*, Princeton (2000)

Griswold, Thomas, *The Great Anatolian Rebellion, 1000–1020/1591–1611*, Berlin (1983)

Gülsoy, Ufuk, '1856 Islâhât Fermanı'na Tepkiler ve Maraş Olayları', in *Prof. Dr Bekir Kütükoğlu'na Armağan*, Istanbul (1991) 443–58

Gülsoy, Ufuk, *Osmanlı Gayrimüslimlerinin Askerlik Serüveni*, Istanbul (2000)

Gür, Faik, 'Atatürk heykelleri ve Türkiye'de resmî tarihin görselleşmesi', *TB* 90 (2001) 147–65

Haddad, Mahmoud, review of S. Deringil, *The Well-Protected Domains* (London) 1998, *Middle East Studies Association Bulletin* 33 (1999) 208–10

Hagen, Gottfried, 'The Prophet Muhammad as an Exemplar in War: Ottoman Views on the Eve of World War I', *NPT* 22 (2000) 145–72

Halaçoğlu, Yusuf, *XVIII. yüzyılda Osmanlı İmparatorluğunun iskan siyaseti ve aşiretlerin yerlestirilmeşi*, Ankara (repr. 1991)

Halaçoğlu, Yusuf, art. Evlâd-i Fâtihan, *İA2* 11.524–5

Halaçoğlu, Yusuf, and Aydın, M. Akif, art. Cevdet Paşa, *İA2* 7.443–50

Hale, William, *Turkish Politics and the Military*, London (1994)

Haley, Charles D., 'The Desperate Ottoman: Enver Paşa and the German Empire – I', *MES* 30 (1994) 1–51

Hamadeh, Shirine, 'Splash and Spectacle: the Obsession with Fountains in Eighteenth-Century Istanbul', *Muqarnas* 19 (2002) 123–48

Hanioğlu, M. Şükrü, 'Jews in the Young Turk Movement to the 1908 Revolution', in A. Levy (ed.), *The Jews of the Ottoman Empire*, Princeton (1994) 519–26

Hanioğlu, M. Şükrü, *The Young Turks in Opposition*, New York (1995)

Hanioğlu, M. Şükrü, *Preparation for a Revolution. The Young Turks, 1902–1908*, Oxford (2001)

Har-EI, Shai, *Struggle for Domination in the Middle East. The Ottoman-Mamluk War, 1485–91*, Leiden (1995)

Harrison, J. B., art. Diũ, *EI2* II.322

Hasan Vecîhî, 'Vecîhî Ta'rîhi', MS, Topkapı Palace Library, Emanet Hazinesi 1425

Hathaway, Jane, *The politics of households in Ottoman Egypt*, Cambridge (1997)

Hathaway, Jane, 'Egypt in the seventeenth century', in M. W. Daly (ed.), *The Cambridge History of Egypt*, vol. 2: *Modern Egypt from 1517 to the end of the twentieth century*, Cambridge (1998) 34–58

Hathaway, Jane, 'Çerkes Mehmed Bey: Rebel, Traitor, Hero?', *TSAB* 22/1 (1998) 108–15

Hegyi, Klára, 'The Ottoman Military Force in Hungary', in G. Dávid and P. Fodor (eds), *Hungarian–Ottoman Military and Diplomatic Relations in the Age of Süleyman the Magnificent*, Budapest (1994) 131–48

Hess, Andrew, 'The Moriscos: an Ottoman Fifth Column in Sixteenth-Century Spain', *AHR* 74/1 (1968) 1–25

Hess, Andrew, 'The Evolution of the Ottoman Seaborne Empire in the Age of Oceanic Discoveries, 1423–1525', *AHR* 75/7 (1970) 1892–1919

Hess, Andrew, 'The Ottoman Conquest of Egypt (1517) and the Beginning of the Sixteenth-Century World War', *IJMES* 4 (1973) 55–76

Hess, Andrew, 'The Forgotten Frontier: the Ottoman North African Provinces during the Eighteenth Century', in T. Naff and R. Owen (eds), *Studies in Eighteenth Century Islamic History*, Carbondale (1977) 74–87

Hess, Andrew, *The Forgotten Frontier*, Chicago (1978)

Heyd, Uriel, *Ottoman Documents on Palestine, 1552–1615*, Oxford (1960)

Heyd, Uriel, 'The Ottoman 'Ulemā and Westernization in the Time of Selim III and Mahmūd II', *Scripta Hierosolymitana* IX (1961) 63–96

Heywood, Colin, 'English Diplomacy between Austria and the Ottoman Empire in the War of the Sacra Liga, 1684–1699, with special reference to the period 1689–1699', unpubl. Ph.D. thesis, London Univ. (1970)

Heywood, Colin, '824/"8224" = 1421: the "False" (Düzme) Mustafa and his Ephemeral Coinage', *Arab Historical Review for Ottoman Studies* 15–16 (1997) Part 1 (= *Mélanges Halil Sahillioğlu*, ed. Abdeljelil Temimi), Zaghouan (1997) ii.159–75

Heywood, Colin, 'An Undiplomatic Anglo-Dutch Dispute at the Porte: the Quarrel between Coenraad Van Heemskerck and Lord Paget (1693)', in Alexander Hamilton et al. (eds) *Friends and Rivals in the East. Studies in Anglo-Dutch Relations in the Levant from the Seventeenth to the Early Nineteenth Century*, Leiden (2000) 59–94

Heywood, C. J., art. Karā Mustafā Pasha, Merzifonlu, *EI2* IV.589–92

Heywood, C. J., art. Küçük Kaynardja, *EI2* V.312–13

Heywood, C. J., art. Mustafā, *EI2* VII.710–13

Hezarfen Hüseyin Efendi, *Telhîsü'l-Beyân fî Kavânîn-i Âl-i Osmân*, prep. Sevim İlgürel, Ankara (1998)

Hitzel, Frédéric, 'Relations interculturelles et scientifiques entre l'empire ottoman et les pays de l'Europe occidentale, 1453–1839', 2 vols, unpubl. Ph.D. thesis, Univ. de Paris-Sorbonne (1994)

Holbrook, Victoria Rowe, *The Unreadable Shores of Love. Turkish Modernity and Mystic Romance*, Austin (1994)

Holt, Peter M., *Egypt and the Fertile Crescent 1516–1922. A Political History*, London (1966)

Hosking, Geoffrey, *Russia: People and Empire, 1552–1917*, London (1997)

Housley, Norman, *The Later Crusades. From Lyons to Alcazar 1274–1580*, Oxford (1992)

Howard, Douglas, 'The Ottoman Timar System and its Transformation, 1563–1656', unpubl. Ph.D. thesis, Indiana Univ. (1987)

Hrushevsky, Mykhailo, *History of Ukraine-Rus'*, vol. 8: *The Cossack Age, 1626–1650*, Edmonton (2002)

Hughes, Lindsey, *Russia in the Age of Peter the Great*, New Haven (pbk 2000)

Hunter, F. Robert, 'Egypt under the successors of Muhammad 'Ali', in M. W. Daly (ed.), *The Cambridge History of Egypt*, vol. 2: *Modern Egypt from 1517 to the end of the twentieth century*, Cambridge (1998) 180–97

Hurewitz, J. C., *Diplomacy in the Near and Middle East. A Documentary Record: 1553–1914*, 2 vols, Princeton (1956)

Hüseyin Tuği, *Tuği Tarihi*, prep. M. Sertoğlu, *Belleten* XI (1947) 489–514

ibn Battūta, *The Travels of ibn Battūta, A.D. 1325–1354*, prep. H. A. R. Gibb, Cambridge (1962)

Ibrahim, Hassan Ahmed, 'The Egyptian empire, 1805–1885', in M. W. Daly (ed.), *The Cambridge History of Egypt*, vol. 2: *Modern Egypt from 1517 to the end of the twentieth century*, Cambridge (1998) 198–216

İlgürel, Mücteba, art. Hüseyin Paşa (Deli), *İA2* 19.5–6

Imber, Colin, 'The Persecution of the Ottoman Shī'ites according to the mühimme defterleri, 1565–1685', *Der Islam* 61 (1979) 245–73

Imber, Colin, 'Paul Wittek's "De la défaite d'Ankara à la prise de Constantinople"', *OA* 5 (1986) 65–81

Imber, Colin, 'The Ottoman Dynastic Myth', *Turcica* XIX (1987) 7–27

Imber, Colin, 'A Note on "Christian" Preachers in the Ottoman Empire', *OA* 10 (1990) 59–67

Imber, Colin, *The Ottoman Empire 1300–1481*, Istanbul (1990)

Imber, Colin, 'Süleymân as Caliph of the Muslims: Ebû's-Su'ûd's Formulation of Ottoman Dynastic Ideology', in G. Veinstein (ed.), *Soliman le magnifique et son temps*, Actes du Colloque de Paris, Galeries Nationales du Grand Palais, 7–10 mars 1990, Paris (1992) 179–84

Imber, Colin, *Ebu's-su'ud. The Islamic Legal Tradition*, Stanford (1997)

Imber, Colin, 'What Does *Ghazi* Actually Mean?', in Ç. Balım-Harding and C. Imber (eds), *The Balance of Truth: Essays in Honour of Professor Geoffrey Lewis*, Istanbul (2000) 165–78

Imber, Colin, art. Mūsā Čelebi, *EI2* VII.644–5

İnalcık, Halil, '1444 Buhranı', in H. İnalcık, *Fatih Devri Üzerinde Tetkikler ve Vesikalar I*, Ankara (1954) 1–53

İnalcık, Halil, 'Fatih Sultan Mehmed'in İlk Culûsu', in H. İnalcık, *Fatih Devri Üzerinde Tetkikler ve Vesikalar I*, Ankara (1954) 55–67

İnalcık, Halil, 'İstanbul'un Fethinden Önce Fatih Sultan Mehmed', in H. İnalcık, *Fatih Devri Üzerinde Tetkikler ve Vesikalar I*, Ankara (1954) 69–136

İnalcık, Halil, *Hicrî 835 Tarihli Sûret-i Defter-i Sancak-i Arnavid*, Ankara (1954)

İnalcık, Halil, 'Sened-i İttifak ve Gülhane Hatt-i Hümayun', *Belleten* XXVIII (1964) 603–22

İnalcık, Halil, 'Suleiman the Lawgiver and Ottoman Law', *AO* 1 (1969) 105–38

İnalcık, Halil, 'The Policy of Mehmed II toward the Greek Population of Istanbul and the Byzantine Buildings of the City', *DOP* 23–24 (1969–70) 231–49

İnalcık, Halil, review of J. W. Barker, *Manuel II Palaeologus (1391–1425): A Study in Late Byzantine Statesmanship* (New Brunswick, 1969), *AO* 3 (1971) 272–85

İnalcık, Halil, 'The Conquest of Edirne (1361)', *AO* 3 (1971) 185–210

İnalcık, Halil, 'Application of the *Tanzimat* and its Social Effects', *AO* 5 (1973) 97–127

İnalcık, Halil, 'Lepanto in the Ottoman Documents' in Gino Benzoni (ed.), *Il Mediterraneo nella seconda metà del '500 alla luce di Lepanto*, Florence (1974) 185–92

İnalcık, Halil, *The Ottoman Empire. The Classical Age 1300–1600*, London (repr. 1975)

İnalcık, Halil, 'A Case Study in Renaissance Diplomacy. The Agreement between Innocent VIII and Bayezid II on Djem Sultan', *JTS* 3 (1979) 209–30

İnalcık, Halil, 'The Hub of the City: the Bedestan of Istanbul', *IJTS* I (1979–80) 1–17

İnalcık, Halil, 'Power Relationships between Russia, the Crimea and the Ottoman Empire as Reflected in Titulature', in Ch. Lemercier-Quelquejay et al. (eds), *Passé turco-tatar, présent soviétique, Études offertes à Alexandre Bennigsen*, Louvain (1986) 175–211

İnalcık, Halil, 'Tax Collection, Embezzlement and Bribery in Ottoman Finances', *TSAB* 15 (1991) 327–46

İnalcık, Halil, 'Sultan Süleymân: the Man and the Statesman', in G. Veinstein (ed.), *Soliman le magnifique et son temps*, Actes du Colloque de Paris, Galeries Nationales du Grand Palais, 7–10 mars 1990, Paris (1992) 89–103

İnalcık, Halil, 'Osman Ghazi's Siege of Nicaea and the Battle of Bapheus', in E. Zachariadou (ed.), *The Ottoman Emirate (1300–1389)*, A Symposium held in Rethymnon, 11–13 January 1991, Institute for Mediterranean Studies, Halcyon Days in Crete I, Rethymnon (1993) 77–99

İnalcık, Halil, 'The Rise of the Turcoman Maritime Principalities in Anatolia, Byzantium and the Crusades', in H. İnalcık, *The Middle East and the Balkans under the Ottoman Empire*, Bloomington (1993) 309–41. (First publ. in *Byzantinische Forschungen, Internationale Zeitschrift für Orientalistik* IX (1985) 179–217)

İnalcık, Halil, 'The Ottoman Succession and its Relation to the Turkish Concept of Sovereignty', in H. İnalcık, *The Middle East and the Balkans under the Ottoman Empire*, Bloomington (1993) 37–69. (First publ. as 'Osmanlılarda Saltanat Verâseti Usûlü ve Turk Hakimiyet Telâkkisiyle İlgisi', *Siyasal Bilgiler Fakültesi Dergisi* XIV (1959) 69–94)

İnalcık, Halil, 'The Ottoman State: Economy and Society, 1300–1600', in H. İnalcık with D. Quataert (eds), *An Economic and Social History of the Ottoman Empire, 1300–1914*, Cambridge (1994) 9–409

İnalcık, Halil, 'How to Read 'Ashik Pasha-Zāde's History', in C. Heywood and C. Imber (eds), *Studies in Ottoman History in Honour of Professor V. L. Ménage*, Istanbul (1994) 139–56

İnalcık, Halil, 'Eyüp Projesi', in Tülay Artan (ed.), *Eyüp: Dün/Bugün*, Sempozyum 11–12 Aralık 1993, Istanbul (1994) 1–23

İnalcık, Halil, *Sources and Studies on the Ottoman Black Sea*, vol. I: *The Customs Registers of Caffa, 1487–1490*, ed. V. Ostapchuk, Cambridge, MA (1996)

İnalcık, Halil, 'Mehmed the Conqueror (1432–1481) and his Time', in H. İnalcık, *Essays in Ottoman History*, Istanbul (1998) 87–109. (First publ. in *Speculum* XXXV (1960) 408–27)

İnalcık, Halil, 'Ottoman Galata, 1453–1553', in H. İnalcık, *Essays in Ottoman History*, Istanbul (1998) 275–376. (First publ. in Edhem Eldem (ed.), *Première Rencontre Internationale sur l'Empire Ottoman et la Turquie Moderne*, Institut National des Langues et Civilisations Orientales, Maison des Sciences de l'Homme, 18–22 janvier 1985, Istanbul (1991) 17–105)

İnalcık, Halil, 'Periods in Ottoman History', in H. İnalcık, *Essays in Ottoman History*, Istanbul (1998) 15–28

İnalcık, Halil, 'Istanbul: an Islamic City', in H. İnalcık, *Essays in Ottoman History*, Istanbul (1998) 249–71. (First publ. in *Journal of Islamic Studies* I (1990) 1–23)

İnalcık, H., art. Mehmed II, *İA* 7.506–35

İnalcık, H., art. Bursa, *EI2* I.1333–6

İnalcık, Halil, art. Haydar-oghlu, Mehmed, *EI2* III.317–18

İnalcık, Halil, art. Imtiyāzāt, *EI2* III.1178–89

İnalcık, H., art. Iskender Beg, *EI2* IV.138–40

İnalcık, H., art. Istanbul, *EI2* IV.224–48

İnalcık, H., art. Kānūnnāme, EI2 IV.562–6

İnalcık, H., art. Mehemmed I, EI2 VI.973–8

İnalcık, Halil, and Oğuz, Mevlûd, (prep.), Gazavât-i Sultân Murâd b. Mehemmed Hân, Ankara (1978)

İnalcık, H., and Repp, R. C., art. Khosrew Pasha, EI2 V.32–5

Ingrao, Charles, The Habsburg Monarchy, 1618–1815, Cambridge (1994)

İpşirli, Mehmet, art. Ahîzâde Hüseyin Efendi, İA2 1.548–9

İpşirli, Mehmet, art. Derviş Mehmed Paşa, İA2 9.193–4

İrepoğlu, Gül, Levnî. Painting, Poetry, Colour, Ankara (1999)

İrepoğlu, Gül, 'Innovation and Change', in The Sultan's Portrait. Picturing the House of Osman, Istanbul (2000) 378–439

Isma'il Âsım Efendi, Çelebizâde, Âsım Ta'rîhi, Istanbul (1282/1865–6)

Issawi, Charles, 'Introduction', in D. Gondicas and C. Issawi (eds), Ottoman Greeks in the Age of Nationalism: Politics, Economy and Society in the Nineteenth Century, Princeton (1999) 1–16

Itzkovitz, Norman, 'Eighteenth Century Ottoman Realities', SI XVI (1962) 72–94

Jelavich, Charles and Barbara, The Establishment of the Balkan National States, 1804–1920, Seattle (1977)

Jelavich, Barbara, History of the Balkans, Eighteenth and Nineteenth Centuries, Cambridge (repr. 1985)

Jennings, Ronald C., Christians and Muslims in Ottoman Cyprus and the Mediterranean World, 1571–1640, New York (1993)

Kafadar, Cemal, 'Les troubles monétaires de la fin du XVIe siècle et la prise de conscience ottoman du déclin', Annales ESC 46e année/1 (1991) 381–400

Kafadar, Cemal, 'The Myth of the Golden Age', in H. İnalcık and C. Kafadar (eds), Süleymân the Second and his Time, Istanbul (1993) 37–48

Kafadar, Cemal, 'Eyüp'te Kılıç Kuşanma Törenleri', in Tülay Artan (ed.), Eyüp: Dün/Bugün, Sempozyum 11–12 Aralık 1993, Istanbul (1994)

Kafadar, Cemal, 'Osmān Beg and his Uncle: Murder in the Family?' in C. Heywood and C. Imber (eds), Studies in Ottoman History in Honour of Professor V. L. Ménage, Istanbul (1994) 155–63

Kafadar, Cemal, Between Two Worlds. The Construction of the Ottoman State, Berkeley (1995)

Kafescioğlu, Çiğdem, 'Heavenly and Unblessed, Splendid and Artless: Mehmed II's Mosque Complex in Istanbul in the Eyes of its Contemporaries', in C. Kafescioğlu and L. Thys-Şenocak (eds), Essays in Honor of Aptullah Kuran, Istanbul (1999) 211–22

Kann, Robert A., A History of the Habsburg Empire, 1526–1918, Berkeley (1974)

Kansu, Aykut, The Revolution of 1908 in Turkey, Leiden (1997)

Kansu, Aykut, Politics in Post-Revolutionary Turkey, 1908–1913, Leiden (2000)

Kappert, Petra, Die osmanischen Prinzen und ihre Residenz Amasya im 15. und 16. Jahrhundert, Istanbul (1976)

Karaçelebizâde Abdülaziz Efendi, 'Zeyl-i Ravzatü'l-Ebrâr', MS, Istanbul Univ. Library, İbnülemin 2986

Karakışla, Yavuz Selim, 'The 1908 Strike Wave in the Ottoman Empire' TSAB 16/2 (1992) 153–77

Karal, Enver Ziya, 'Nizâm-ı Cedid'e dair lâyihalar, 1792', Tarih Vesikaları (1941–2) 414–25

Karal, Enver Ziya, Selim III'ün Hatt-i Hümayunları, Nizam-ı Cedit, Ankara (1942)

Karateke, Hakan T., Padişahım Çok Yaşa! Osmanlı Develetinin Son Yüz Yılında Merasimler, Istanbul (2004)

Karpat, Kemal, 'The Transformation of the Ottoman State, 1789–1908', *IJMES* 3 (1972) 243–81

Karpat, Kemal H., *Ottoman Population 1830–1914. Demographic and Social Characteristics*, Madison (1985)

Karpat, Kemal H., *The Politicization of Islam. Reconstructing Identity, State, Faith and Community in the Late Ottoman State*, Oxford (2001)

Kâtib Çelebi, *Fezleke*, 2 vols, Istanbul (1286–7/1869–71)

Kaya, Nevzat, art. Karaçelebizâde Abdülaziz Efendi, *İA2* 24.381–3

Kayalı, Hasan, 'Elections and the Electoral Process', *IJMES* 27 (1995) 265–86

Kayalı, Hasan, *Arabs and Young Turks. Ottomanism, Arabism, and Islamism in the Ottoman Empire, 1908–1918*, Berkeley (1997)

Kaynar, Reşat, *Mustafa Reşit Paşa ve Tanzimat*, Ankara (1954)

Kazgan, Haydar, '2. Sultan Mahmut Devrinde Enflasyon ve Darphane Amiri *Kazaz* Artin', *TB* 11 (1980) 115–30

Keyder, Çağlar, 'Manufacturing in the Ottoman Empire and in Republican Turkey ca. 1900–1950', in D. Quataert (ed.), *Manufacturing in the Ottoman Empire and Turkey, 1500–1950*, Albany (1994)

Khadduri, Majid, *War and Peace in the Law of Islam*, Baltimore (1955)

Khadduri, Majid, art. Harb, *EI2* III.180–81

Khodarkovsky, Michael, 'Of Christianity, Enlightenment, and Colonialism: Russia in the North Caucasus, 1550–1800', *JMH* 71/2 (1999) 394–430

Khodarkovsky, Michael, *Russia's Steppe Frontier. The Making of a Colonial Empire, 1500–1800*, Bloomington (2002)

Khoury, Dina, *State and provincial society in the Ottoman Empire. Mosul, 1540–1834*, Cambridge (1997)

Kiel, Hedda Reindl, art. Gedik Ahmed Paşa, *İA2* 13.543–4

Kiel, Machiel, 'Observations on the History of Northern Greece during the Turkish Rule, Historical and Architectural Description of the Turkish Monuments of Komotini and Serres, their Place in the Development of Ottoman Turkish Architecture, and their Present Condition', in M. Kiel, *Studies on the Ottoman Architecture of the Balkans*, Hampshire, UK (1990) III. (First publ. in *Balkan Studies* 12 (1971) 415–44)

Kiel, Machiel, 'Yenice-i Vardar (Vardar Yenicesi–Giannitsa): a Forgotten Turkish Cultural Centre in Macedonia of the 15th and 16th Century', in M. Kiel, *Studies on the Ottoman Architecture of the Balkans*, Hampshire, UK (1990) IV. (First publ. in *Studia Byzantina et Neohellenica Nederlandica* 3 (1971) 300–29)

Kiel, Machiel, 'The Oldest Monuments of Ottoman–Turkish Architecture in the Balkans', in M. Kiel, *Studies on the Ottoman Architecture of the Balkans*, Hampshire, UK (1990) XIV. (First publ. in *Sanat Tarihi Yıllığı* 12 (1983) 117–38)

Kiel, Machiel, 'Notes on the History of some Turkish Monuments in Thessaloniki and their Founders', in M. Kiel, *Studies on the Ottoman Architecture of the Balkans*, Hampshire, UK (1990) I. (First publ. in *Balkan Studies* 11 (1970) 123–48)

Kiel, Machiel, *Ottoman Architecture in Albania 1385–1912*, Istanbul (1990)

Kiel, Machiel, 'Mevlana Neşrī and the Towns of Medieval Bulgaria', in C. Heywood and C. Imber (eds), *Studies in Ottoman History in Honour of Professor V. L. Ménage*, Istanbul (1994) 165–87

Kiel, Machiel, 'Das türkische Thessalien: Etabliertes Geschichtsbild versus Osmanische Quellen', in R. Lauer and P. Schreiner (eds), *Die Kultur Griechenlands in Mittelalter und Neuzeit*, Goettingen (1996) 109–96

Kiel, Machiel, art. Dimetoka, *İA2* 9.305–8

Kissling, Joachim, *Rechtsproblematiken in den christlich-muslimischen Beziehungen vorab im Zeitalter der Türkenkriege*, Graz (1974)

Kolodziejczyk, Dariusz, *Ottoman–Polish Diplomatic Relations (15th–18th Century). An Annotated edition of 'Ahdnames and Other Documents*, Leiden (2000)

Kolodziejczyk, Darius, (prep.), *The Ottoman Survey Register of Podolia (ca. 1681). Defter-i Mufassal-i Eyalet-i-Kamaniçe*, Cambridge, MA (2004)

Konyalı, İ. H., *Âbideleri ve Kitâbeleri ile Karaman Tarihi. Ermenek ve Mut Âbideleri*, Istanbul (1967)

Konyalı, İ. H., *Ankara Camileri*, Ankara (1978)

Kopčan, Vojtech, 'Ottoman Narrative Sources to the Uyvar Expedition 1663', *AAS* VII (1971) 89–100

Kopčan, Vojtech, 'Einige Bemerkungen zur Versorgung der osmanischen Armee während des "Uyvar Seferi" im Jahre 1663', in Hans Georg Majer and Raoul Motika (eds), *Türkische Wirtschafts- und Sozialgeschichte von 1071 bis 1920*, Akten des IV. Internationale Kongresses, Wiesbaden (1995) 163–9

Köprülü, M. F., 'Yıldırım Beyazid'in esareti ve intiharı hakkında', *Belleten* I (1937) 591–603

Köprülü, Orhan F., art. ('Amūdja-zāde) Husayn Pasha, *EI2* III.626–7

Köprülü, Orhan F., art. Fuad Paşa, Keçecizâde, *İA2* 13.202–5

Köprülü, Orhan F., and Mustafa Uzun, art. Akşemseddin, *İA2* 2.299–302

Kortepeter, C. Max, *Ottoman Imperialism during the Reformation. Europe and the Caucasus*, New York (1972)

Kreiser, Klaus, 'Istanbul, die wahre Stadt der Muslime', in Jean-Louis Bacqué-Grammont and Aksel Tibet (eds), *Cimetières et traditions funéraires dans le monde islamique*, 2 vols, Ankara (1996) 2.9–21

Kreiser, Klaus, 'Public Monuments in Turkey and Egypt, 1840–1916', *Muqarnas* 14 (1997) 103–17

Kritovoulos, *History of Mehmed the Conqueror*, prep. C. T. Riggs, Westport (1954)

Kuban, Doğan, *Istanbul. An Urban History*, Istanbul (1996)

Kuban, Doğan, art. Nuruosmaniye Külliyesi, *İst. Ansik.* 6.100–103

Küçük, Cevdet, art. Abdülaziz, *İA2* 1.179–85

Küçük, Cevdet, art. Çırağan Vak'ası, *İA2* 8.306–9

Kunt, Metin, 'Naîmâ, Köprülü and the Grand Vezirate', *Boğaziçi University Journal* I (1973) 57–64

Kunt, Metin İbrahim, 'Ethnic-Regional (*Cins*) Solidarity in the Seventeenth-Century Ottoman Establishment', *IJMES* 5 (1974) 233–9

Kunt, İbrahim Metin, 'Derviş Mehmed Paşa, *Vezir* and Entrepreneur: A Study in Ottoman Political-Economic Theory and Practice', *Turcica* IX/1 (1977) 197–214

Kunt, İ. Metin, 'The Waqf as an Instrument of Public Policy: Notes on the Köprülü Family Endowments', in C. Heywood and C. Imber (eds), *Studies in Ottoman History in Honour of Professor V. L. Ménage*, Istanbul (1994) 189–98

Kuran, Ercümend, 'Répercussions sociales de la réforme de l'éducation dans l'Empire ottoman', in J.-L. Bacqué-Grammont and Paul Dumont (eds), *Économie et Sociétés dans l'empire ottoman (Fin du XVIIIe – Début du XXe siècle)*, Paris (1983) 144–6

Kuran, E., art. (Mustafā) Fādil Pasha (Mısırlı), *EI2* II.728

Kurat, Akdes Nimet, *Prut Seferi ve Barışı, 1123 (1711)*, 2 vols, Ankara (1951, 1953)

Kurat, A. N., 'The Turkish Expedition to Astrakhan in 1569 and the Problem of the Don–Volga Canal', *Slavonic and East European Review* 40 (1961–2) 7–24

Kurat, A. N., and Bromley, J. S., 'The Retreat of the Turks', in M. Cook (ed.), *A History of the Ottoman Empire to 1730*, Cambridge (1976) 178–219

Kushner, David, 'The Place of the Ulema in the Ottoman Empire in the Age of Reform (1839–1918), *Turcica* XIX (1987) 51–74

Kut, Günay, Alpay, art. Matba'a (in Turkey), *EI2* VI.799–803

Kutluoğlu, Muhammed H., *The Egyptian Question (1831–1841). The Expansionist Policy of Mehmed Ali Paşa in Syria and Asia Minor and the Reaction of the Sublime Porte*, Istanbul (1998)

Kütükoğlu, Bekir, *Osmanlı-İran Siyâsî Münâsebetleri (1578–1612)*, Istanbul (repr. 1993)

Kuyulu, İnci, *Kara Osman-oğlu Ailesine Ait Mimari Eserler*, Ankara (1992)

LeDonne, John P., *The Russian Empire and the World, 1700–1917. The Geopolitics of Expansion and Containment*, New York (1997)

Lefort, Jacques, 'Tableau de la Bithynie au XIIIe siècle', in E. Zachariadou (ed.), *The Ottoman Emirate (1300–1389)*, A Symposium held in Rethymnon, 11–13 January 1991, Institute for Mediterranean Studies, Halcyon Days in Crete I, Rethymnon (1993) 101–17

Lesure, Michel, 'Notes et documents sur les relations vénéto-ottomanes, 1570–1573, I', *Turcica* IV (1972) 134–64

Levy, Avigdor, 'The Ottoman Ulema and the Military Reforms of Sultan Mahmud II', *AAS* VII (1971) 13–39

Levy, Avigdor, 'The Officer Corps in Sultan Mahmud II's New Ottoman Army, 1826–39', *IJMES* 2 (1971) 21–39

Levy, Avigdor, 'Ottoman Attitudes to the Rise of Balkan Nationalism', in Béla Király and Gunther E. Rothenburg (eds), *War and Society in East Central Europe*, vol. 1: New York (1979) 325–45

Levy, Avigdor, 'Military Reform and the Problem of Centralization in the Ottoman Empire in the Eighteenth Century', *MES* 18/3 (1982) 227–49

Levy, Avigdor, *The Sephardim in the Ottoman Empire*, Princeton (1992)

Levy, Avigdor, '*Millet* Politics: the Appointment of a Chief Rabbi in 1835', in A. Levy (ed.), *The Jews of the Ottoman Empire*, Princeton (1994) 425–38

Lewis, Bernard, 'The Ottoman Empire in the Mid-Nineteenth Century: A Review', review of R. Davison, *Reform in the Ottoman Empire, 1856–76* (Princeton, 1963), *MES* 1 (1964) 283–95

Lewis, B., art. Dustūr (Turkey), *EI2* II.640–47

Lindner, Rudi, *Nomads and Ottomans in Medieval Anatolia*, Bloomington (1983)

Loenertz, R., 'Pour l'histoire du Péloponnèse au XIVe siècle', *Etudes Byzantines* I (1943) 152–96

Lowry, Heath, '"From Lesser Wars to the Mightiest War": the Ottoman Conquest and the Transformation of Byzantine Urban Centers in the Fifteenth Century', in A. Bryer and H. Lowry (eds), *Continuity and Change in Late Byzantine and Early Ottoman Society*, Papers given at a Symposium at Dumbarton Oaks in May 1982, Birmingham (1986) 323–38

Lowry, Heath W., *The Nature of the Early Ottoman State*, Albany (2003)

Luttrell, Anthony, 'Latin Responses to Ottoman Expansion before 1389', in E. Zachariadou (ed.), *The Ottoman Emirate (1300–1389)*, A Symposium held in Rethymnon, 11–13 January 1991, Institute for Mediterranean Studies, Halcyon Days in Crete I, Rethymnon (1993) 119–34

McCarthy, Justin, 'Foundations of the Turkish Republic: Social and Economic Change', *MES* 19 (1983) 139–51

McCarthy, Justin, *Death and Exile. The Ethnic Cleasing of Ottoman Muslims, 1821–1922*, Princeton (1995)

Macfarlane, Charles, *Constantinople in 1828*, 2 vols, London (second edn 1829)

McGowan, Bruce, 'The Age of the Ayans, 1699–1812', in H. İnalcık with D. Quataert (eds), *An Economic and Social History of the Ottoman Empire, 1300–1914*, Cambridge (1994) 637–758

Mahir, Banu, 'Portraits in New Context', in *The Sultan's Portrait. Picturing the House of Osman*, Istanbul (2000) 298–312

Malalas, John, *The Chronicle of John Malalas*, prep. Eliz. Jeffreys et al., Melbourne (1986)

Mango, Andrew, 'A Speaking Turkey. A Review Article', *MES* 33 (1997) 152–70

Mango, Andrew, 'Ataturk and the Kurds', *MES* 35 (1999) 1–25

Mango, Andrew, *Atatürk*, London (1999)

Mango, Cyril, *Materials for the Study of the Mosaics of St Sophia at Istanbul*, Washington (1962)

Mantran, Robert, (ed.), *Histoire de l'empire ottoman*, Paris (1989)

Mantran, Robert, 'L'Etat ottoman au XVIIIe siècle: la pression européenne' in R. Mantran (ed.), *Histoire de l'empire ottoman*, Paris (1989) 265–86

Mantran, Robert, 'De la titulature des derniers seldjoukides à celle des premiers ottomans. Brèves remarques sur les données épigraphiques', *Mélanges offerts à Louis Bazin*, Paris (1992) 207–11

Mardin, Şerif, *The Genesis of Young Ottoman Thought*, Princeton (1962)

Mardin, Şerif, *Religion and Social Change in Modern Turkey, The Case of Bediüzzaman Said Nursi*, Albany (1989)

Mardin, B. G., 'A Short History of the Khalwati Order of Dervishes' in N. Keddie (ed.), *Scholars, Saints and Sufis*, Berkeley (1972) 275–305

Martinez, A. Peter, 'Bullionistic Imperialism: the Il-Xanid Mint's Exploitation of the Rum-Saljuqid Chancery, 654–695 H./1256–96 A.D.', *AO* 13 (1993–4) 169–276

Masters, Bruce, *The Origins of Western Economic Dominance in the Middle East. Mercantilism and the Islamic Economy in Aleppo, 1600–1750*, New York (1988)

Masters, Bruce, 'The Sultan's Entrepreneurs: the *Avrupa Tüccari*s and the *Hayriye Tüccari*s in Syria', *IJMES* 24 (1992) 579–97

Matthews, Joyce Hedda, 'The Ottoman Inheritance Inventory as an Exercise in Conceptual Reclamation (ca. 1600–1675)', unpubl. Ph.D. thesis, Binghamton Univ. (2001)

Matuz, Joseph, 'À propos de la validité des capitulations de 1536 entre l'Empire ottoman et la France', *Turcica* XXIV (1992) 183–92

Mehmed Râşid, *Râşid Ta'rîhi*, 5 vols, Istanbul (1282/1865–6)

Mélikoff, Irène, 'Le problème kızılbaş', *Turcica* VI (1975) 34–48

Mélikoff, I., art. Ewrenos Oghulları, *EI2* II.720–21

Mélikoff, I., art. Germiyān-oghulları, *EI2* II.989–90

Ménage, V. L., 'The Mission of an Ottoman Secret Agent in France in 1486', *Journal of the Royal Asiatic Society* (1965) 112–32

Ménage, V. L., 'The Ottomans and Nubia in the Sixteenth Century', *Annales Islamologiques* 24 (1988) 137–54

Ménage, V. L., art. Devshirme, *EI2* II.210–13

Ménage, V. L., art. Djandarlı, *EI2* II.444–5

Meriwether, Margaret L., 'Urban Notables and Rural Resources in Aleppo, 1770–1830', *IJTS* 4 (1987) 55–73

Mert, Özcan, *XVIII. ve XIX. Yüzyıllarda Çapanoğulları*, Ankara (1980)

Mert, Özcan, art. Canikli Hacı Ali Paşa Ailesi, *İA2* 7.151–4

Mert, Özcan, art. Çapanoğulları, *İA2* 8.221–4

Messick, Brinkley, *The Calligraphic State. Textual Domination and History in a Muslim Society*, Berkeley (1993)

Mihalović, Konstantin, *Memoirs of a Janissary*, prep. S. Soucek and B. Stolz, Ann Arbor (1975)

Milgrim, Michael R., 'An Overlooked Problem in Turkish–Russian Relations: the 1878 War Indemnity', *IJMES* 9 (1978) 519–37

Mitler, Louis, 'The Genoese in Galata: 1453–1682', *IJMES* 10 (1979) 71–91

Morgan, David, *Medieval Persia, 1040–1797*, London (1988)

Murphey, Rhoads, 'The Veliyyuddin Telhis: Notes on the Sources and Interrelations between Koçi Bey and Contemporary Writers of Advice to Kings', *Belleten* XLIII (1979) 547–71

Murphey, Rhoads, *Regional Structure in the Ottoman Economy. A Sultanic Memorandum of 1636 AD concerning the Sources and Uses of the Tax-Farm Revenues of Anatolia and the Coastal and Northern Portions of Syria*, Wiesbaden (1987)

Murphey, Rhoads, 'Ottoman Census Methods in the Mid-Sixteenth Century', *SI* 71 (1990) 115–26

Murphey, Rhoads, 'Solakzade's Treatise of 1652: A Glimpse at Operational Principles Guiding the Ottoman State During Times of Crisis', Proceedings of V. Milletlerarası Türkiye Sosyal ve İktisat Tarihi Kongresi, Istanbul, 21–25 Ağustos 1989, Ankara (1990) 27–32

Murphey, Rhoads, 'Süleymân's Eastern Policy', in. H. İnalcık and C. Kafadar (eds), *Süleymân the Second and his Time*, Istanbul (1993) 229–48

Murphey, Rhoads, 'Continuity and Discontinuity in Ottoman Administrative Practice during the Late Seventeenth Century', *Poetics Today* 14/2 (1993) 419–43

Murphey, Rhoads, 'An Ottoman View from the Top and Rumblings from Below: the Sultanic Writs (*Hatt-i Humayün*) of Murad IV (r. 1623–40)', *Turcica* XXVIII (1996) 319–38

Murphey, Rhoads, *Ottoman Warfare, 1500–1700*, London (1999)

Murphey, Rhoads, 'Forms of Differentiation and Expression of Individuality in Ottoman Society', *Turcica* XXXIV (2002) 135–70

Murphey, Rhoads, 'Frontiers of Authority: the Interplay between Sultanic and Private Initiative in the Creation of New Ottoman Frontiers in the Mediterranean between 1515 and 1575', paper presented at 116th Annual Meeting of the American Historical Association, 3–6 January 2002, San Francisco (typescript)

Murphey, R., art. Süleymān II, *EI2* IX.842

Mustafa Na'ima, *Ravzatü'l-Hüseyn fî Hulâsâti Ahbari'l-Hâfikayn*, 6 vols, Istanbul (1280/1863–4)

Mustapha [Mustafa] Kemal, *A Speech Delivered by Ghazi Mustapha Kemal* [Atatürk] *in October 1927, Nutuk*, Istanbul (repr. 1985)

Mystakidis, B. A., 'Hukûmet-i 'Osmâniye tarafından ilk te'sîs olunan Matba'a ve bunun Sirâyeti', *Târîh-i Osmânî Encümeni Mecmuası* I (1911) 322–8

Naff, Thomas, 'Reform and the Conduct of Diplomacy in the Reign of Selim III, 1789–1807', *JAOS* 83 (1963) 295–315

Naff, Thomas, 'Ottoman Diplomatic Relations with Europe in the Eighteenth Century: Patterns and Trends', in T. Naff and R. Owen (eds), *Studies in Eighteenth Century Islamic History*, Carbondale (1977) 88–107

Nagata, Yuzo, 'Greek Rebellion of 1770 in the Morea Peninsula', in Y. Nagata, *Studies on the Social and Economic History of the Ottoman Empire*, İzmir (1995) 103–18

Nagata, Yuzo, art. Karaosmanoğulları, *İA2* 24.468–70

Nasr, S. H., art. Ithnā 'Asharriya, *EI2* IV.277–9

Necipoğlu-Kafadar, Gülru, 'The Süleymaniye Complex in Istanbul: an Interpretation', *Muqarnas* 3 (1985) 92–117

Necipoğlu, Gülru, *Architecture, Ceremonial and Power; the Topkapı Palace in the Fifteenth and Sixteenth Centuries*, Cambridge, MA (1991)

Necipoğlu, Gülru, 'The Life of an Imperial Monument: Hagia Sophia after Byzantium', in R. Mark and A. Çakmak (eds), *Hagia Sophia from the Age of Justinian to the Present Day*, Cambridge, MA (1992)

Necipoğlu, Gülrü, 'A Kânûn for the State, A Canon for the Arts: Conceptualizing the

Classical Synthesis of Ottoman Art and Architecture', in G. Veinstein (ed.), *Soliman le magnifique et son temps*, Actes du Colloque de Paris, Galeries Nationales du Grand Palais, 7–10 mars 1990, Paris (1992) 195–216

Necipoğlu, Gülrû, 'Süleymân the Magnificent and the Representation of Power in the Context of Ottoman–Habsburg–Papal Rivalry', in H. İnalcık and C. Kafadar (eds), *Süleymân the Second and his Time*, Istanbul (1993) 163–94

Necipoğlu, Gülru, 'Challenging the Past: Sinan and the Competitive Discourse of Early-Modern Islamic Architecture', *Muqarnas* 10 (1993) 169–80

Necipoğlu-Kafadar, Gülru, 'Dynastic Imprints on the Cityscape: the Collective Message of Imperial Funerary Mosque Complexes in Istanbul', in Jean-Louis Bacqué-Grammont and Aksel Tibet (eds), *Cimetières et traditions funéraires dans le monde islamique*, 2 vols, Ankara (1996) 2.23–36

Necipoğlu, Gülru, 'The Suburban Landscape of Sixteenth-Century Istanbul as a Mirror of Classical Ottoman Garden Culture', in Attilio Petruccioli (ed.), *Gardens in the Time of the Great Muslim Empires*, Leiden (1997) 32–71

Necipoğlu, Gülru, 'A Period of Transition: Portraits of Selim II', in *The Sultan's Portrait. Picturing the House of Osman*, Istanbul (2000) 202–7

Necipoğlu, Nevra, 'Ottoman Merchants in Constantinople during the First Half of the Fifteenth Century', *BMGS* 16 (1992) 158–69

Nicol, D., 'A Byzantine Emperor in England. Manuel's Visit to London in 1400–1', *University of Birmingham Historical Journal* XII/2 (1971) 204–25

Nicol, Donald, *The Last Centuries of Byzantium, 1261–1453*, Cambridge (2nd edn 1993)

Nicol, Donald, *The Immortal Emperor. The Life and Legend of Constantine Palaiologos, Last Emperor of the Romans*. Cambridge (1994)

Noradounghian, Gabriel, *Recueil d'actes internationaux de l'empire ottoman*, 4 vols, Paris (1897–1903)

Ocak, A. Yaşar, 'Quelques remarques sur le rôle des derviches kalenderis dans les mouvements populaires et les activités anarchiques aux XVe et XVIe siècles dans l'empire ottoman', *OA* 3 (1982) 69–80

Ocak, Ahmet Yaşar, 'Kanûnî Sultan Süleyman devrinde Osmanlı resmî düşüncesine karşı bir tepki hareketi: Oğlan Şeyh İsmail-i Mâsûkî', *OA* 10 (1990) 49–58

Ocak, Ahmet Yaşar, *Zındıklar ve Mülhidler (15–17. Yüzyıllar)*, Istanbul (1998)

Ochsenwald, William, *Religion, Society and the State in Arabia. The Hijaz under Ottoman Control, 1840–1908*, Columbus (1984)

Oikonomides, Nicolas, 'The Turks in Europe (1305–13) and the Serbs in Asia Minor (1313)', in E. Zachariadou (ed.), *The Ottoman Emirate (1300–1389)*, A Symposium held in Rethymnon, 11–13 January 1991, Institute for Mediterranean Studies, Halcyon Days in Crete I, Rethymnon (1993) 159–68

Oikonomides, Nicolas, 'From Soldiers of Fortune to Gazi Warriors: the Tzympe Affair', in C. Heywood and C. Imber (eds), *Studies in Ottoman History in Honour of Professor V. L. Ménage*, Istanbul (1994) 239–47

Olson, Robert W., 'The Esnaf and the Patrona Halil Rebellion of 1730: a Realignment in Ottoman Politics', *JESHO* XVII (1974) 329–44

Olson, Robert W., 'Jews, Janissaries, Esnaf and the Revolt of 1740 in Istanbul', *JESHO* XX/2 (1977) 185–207

Olson, Robert, 'The Young Turks and the Jews: a Historiographical Revision', *Turcica* XVIII (1986) 219–35

Olson, Robert, 'The Ottoman–French Treaty of 1740: a Year to be Remembered?', *TSAB* 15/2 (1991) 347–55

Önsoy, Rifat, 'Osmanlı İmparatorluğu'nun Katıldığı İlk Uluslararası Sergiler ve Sergi-i Umumi-i Osmani (1863 İstanbul Sergisi)', *Belleten* XLVII (1984) 195–235

Orhonlu, Cengiz, *Osmanlı İmparatorluğunda Aşiretleri İskân Teşebbüsü (1691–1696)*, Istanbul (1963)

Orhonlu, C., art. Karā 'Othmān-oghlı, *EI2* IV.592–4

Orhonlu, Cengiz, art. Kātırdjı-oghlı Mehmed Pasha, *EI2* IV.765–6

Orhonlu, C., art. Khādım Süleymān Pasha, *EI2* IV.901–2

Ortaylı, İlber, 'Ottoman–Habsburg Relations, 1740–70, and Structural Changes in the International Affairs of the Ottoman State', in Jean-Louis Bacqué-Grammont et al. (eds), *Türkische Miszellen, Festschrift Robert Anhegger*, Istanbul (1987) 287–98

Ortaylı, İlber, 'Reforms of Petrine Russia and the Ottoman Mind', in Bernard Lewis et al. (eds), *Raiyyet Rüsûmu. Essays presented to Halil İnalcık on his Seventieth Birthday by his Colleagues and Students, JTS* 11 (1987) 45–8

Ortaylı, İlber, 'Une proclamation universelle du khanat de Crimée de janvier 1711', *Studies on Ottoman Diplomatic History* I, Istanbul (1987) 105–9

Ortaylı, İlber, 'Ottomanism and Zionism during the Second Constitutional Period, 1908–1915', in A. Levy (ed.), *The Jews of the Ottoman Empire*, Princeton (1994) 527–46

Ortaylı, İlber, *İmparatorluğun En Uzun Yüzyılı*, Istanbul (repr. 1995)

Ortaylı, İlber, 'Greeks in the Ottoman Administration during the Tanzimat Period', in D. Gondicas and C. Issawi (eds), *Ottoman Greeks in the Age of Nationalism: Politics, Economy and Society in the Nineteenth Century*, Princeton (1999) 161–79

Osman, Rifat, *Edirne Sarayı*, prep. Süheyl Ünver, Ankara (1957)

Ostapchuk, Victor, 'Five Documents from the Topkapı Palace Archive on the Ottoman Defense of the Black Sea against the Cossacks (1639)', in Bernard Lewis et al. (eds), *Raiyyet Rüsûmu, Essays presented to Halil İnalcık on his Seventieth Birthday by his Colleagues and Students, JTS* 11 (1987) 49–104

Ostapchuk, Victor, 'The Ottoman Black Sea Frontier and the Relations of the Porte with the Polish-Lithuanian Commonwealth and Muscovy, 1622–1628', unpubl. Ph.D. thesis, Harvard Univ. (1989)

Ostapchuk, Victor, 'An Ottoman Gazānāme on Halīl Paša's Naval Campaign against the Cossacks (1621)', in *Adelphotes: a Tribute to Omeljan Pritsak by his Students*, Harvard Ukrainian Studies XIV/3–4 (1990) 481–521

Ostapchuk, Victor, 'The Human Landscape of the Ottoman Black Sea in the Face of the Cossack Naval Raids', in Kate Fleet (ed.), *The Ottomans and the Sea*, Oriente Moderno XX (LXXXI) n.s. (2001) 23–95

Ostapchuk, Victor, 'The Ottoman Entry into the Black Sea' (typescript)

Ostapchuk, Victor, 'Ukraine between the Polish-Lithuanian Commonwealth, Muscovy and the Ottoman Empire: the Struggle for a New Order in Eastern Europe, 1648–1681' (typescript)

Özbaran, Salih, 'Osmanlı İmparatorluğu ve Hindistan yolu', *TD* 31 (1977 [1978]) 65–146

Özbaran, Salih, 'The Ottoman Turks and the Portuguese in the Persian Gulf, 1534–1581', in S. Özbaran, *The Ottoman Response to European Expansion. Studies on Ottoman–Portuguese Relations in the Indian Ocean and Ottoman Administration in the Arab Lands during the Sixteenth Century*, Istanbul (1994) 119–57. (First publ. in *Journal of Asian History* 6/1 (1972) 45–87)

Özbaran, Salih, 'A Turkish Report on the Red Sea and the Portuguese in the Indian Ocean (1525)', in S. Özbaran, *The Ottoman Response to European Expansion. Studies on Ottoman–Portuguese Relations in the Indian Ocean and Ottoman Administration in the Arab Lands during the Sixteenth Century*, Istanbul (1994) 99–109. (First publ. in *Arabian Studies* IV (1978) 81–8)

Özbaran, Salih, 'Bahrain in 1559. A Narrative of Turco-Portuguese Conflict in the Gulf', in S. Özbaran, *The Ottoman Response to European Expansion. Studies on Ottoman–Portuguese Relations in the Indian Ocean and Ottoman Administration in the Arab Lands during the Sixteenth Century*, Istanbul (1994) 179–88. (First publ. in *OA* 3 (1982) 91–104)

Özbaran, Salih, 'The Ottomans in Confrontation with the Portuguese in the Red Sea after the Conquest of Egypt in 1517', in S. Özbaran, *The Ottoman Response to European Expansion. Studies on Ottoman–Portuguese Relations in the Indian Ocean and Ottoman Administration in the Arab Lands during the Sixteenth Century*, Istanbul (1994) 89–97. (First publ. in *Studies on Turkish–Arab Relations* I (1986) 207–14)

Özbaran, Salih, 'The Ottomans in East Africa', in S. Özbaran, *The Ottoman Response to European Expansion. Studies on Ottoman–Portuguese Relations in the Indian Ocean and Ottoman Administration in the Arab Lands during the Sixteenth Century*, Istanbul (1994) 189–97. (First publ. in *Studies on Ottoman Diplomatic History* V (1990) 147–55)

Özbaran, Salih, 'Ottoman Naval Policy in the South' in M. Kunt and C. Woodhead (eds), *Süleyman the Magnificent and his Age*, London (1995) 55–70

Özcan, Abdülkadir, 'Fâtih'in teşkilât kânûnnâmesi ve Nizâm-i âlem için kardeş katli meselesi', *TD* 33 (1980–81 [1982]) 7–56

Özcan, Abdülkadir, 'II. Mahmud Memleket Gezileri', in *Prof. Dr Bekir Kütükoğlu'na Armağan*, Istanbul (1991) 361–79

Özcan, Abdülkadir, art. Cülûs, *İA2* 8.108–14

Özcan, Abdülkadir, art. Defterdar Sarı Mehmed Paşa, *İA2* 9.98–100

Özcan, Abdülkadir, art. Devşirme, *İA2* 9.254–7

Özcan, Abdülkadir, art. Esame, *İA2* 11.355–6

Özcan, Abdülkadir, art. Eşkinci, *İA2* 11.469–71

Özcan, Abdülkadir, art. Humbaracı Ahmed Paşa, *İA2* 18.351–3

Özcan, Azmi, 'Sultan II. Abdulhamid'in "Pan-Islâm" Siyasetinde Cevdet Paşa'nin Tesiri', in *Ahmed Cevdet Paşa Vefatının 100. Yılına Armağan*, Ankara (1997) 123–31

Özcan, Azmi, art. Hilâfet, *İA2* 17.546–53

Özel, Oktay, 'Limits of the Almighty: Mehmed II's "Land Reform" Revisited', *JESHO* 42 (1999) 226–46

Özergin, M. Kemâl, art. Râşid, Mehmed, *İA* 9.632–4

Özgüven, H. Burcu, 'Barut ve Tabya: Rönesans Mimarisi Bağlamında Fatih Sultan Mehmed Kaleleri', unpubl. Ph.D. thesis, İstanbul Teknik Univ. (1997)

Özkaya, Yücel, 'XVIII inci Yüzyılda Çıkarılan Adalet-nâmelere göre Türkiye'nin İç Durumu', *Belleten* XXXVIII (1974) 446–90

Özkaya, Yücel, *Osmanlı İmparatorluğunda Dağlı İsyanları (1791–1808)*, Ankara (1983)

Öztuna, Yılmaz, *Devletler ve Hanedânlar* vol. 2: *Türkiye (1074–1990)*, Ankara (1969)

Pamuk, Şevket, *A Monetary History of the Ottoman Empire*, Cambridge (2000)

Panzac, Daniel, 'The Manning of the Ottoman Navy in the Heyday of Sail (1660–1850)', in Erik J. Zürcher (ed.), *Arming the State. Military Conscription in the Middle East and Central Asia 1775–1925*, London (1999) 41–57

Parrott, David, 'The Ottoman Conflict in European History', review of Jan Paul Niederkorn, *Die europaischen Mächte und der "Lange Türkenkrieg" Kaiser Rudolfs II. (1593–1606)* (Vienna, 1993), in *Journal of Early Modern History* I (1999) 75–9

Parry, V. J., art. Čighāla-zāde (Yūsuf) Sinān Pasha, *EI2* II.33–4

Parry, V. J., art. Hāfiz Ahmed Pasha, *EI2* III.58–9

Pavord, Anna, *The Tulip*, London (1999)

Peçevî İbrahim Efendi, *Tarîh-i Peçevî*, 2 vols, Istanbul (1283/1866–7)

Peirce, Leslie, *The Imperial Harem: Women and Sovereignty in the Ottoman Empire*, New York (1993)

Pere, Nuri, *Osmanlılarda Madenî Paralar*, Istanbul (1968)

Peri, Oded, 'Islamic Law and Christian Holy Sites: Jerusalem and its Vicinity in Early Ottoman Times', *Islamic Law and Society* 6/1 (1999) 97–111

Peri, Oded, *Christianity under Islam in Jerusalem. The Question of the Holy Sites in Early Ottoman Times*, Leiden (2001)

Perry, John R., 'The Mamluk Paşalik of Baghdad and Ottoman–Iranian Relations in the Late-Eighteenth Century', in Sinan Kuneralp (ed.), *Studies on Ottoman Diplomatic History* I, Istanbul (1987) 59–70

Peskes, Esther, art. Wahhābiyya, *EI2* XI.39–45

Peters, Rudolph, *Islam and Colonialism, The Doctrine of Jihad in History*, The Hague (1979)

Philippidis-Braat, Anna, 'La captivité de Palamas chez les Turcs: dossier et commentaire', *Travaux et Mémoires* 7 (1979) 109–221

Pinson, Mark, 'Ottoman Bulgaria in the First Tanzimat Period – The Revolts in Nish (1841) and Vidin (1850)', *MES* 11 (1975) 103–46

Quataert, Donald, 'The Age of Reforms, 1812–1914', in H. İnalcık with D. Quataert (eds), *An Economic and Social History of the Ottoman Empire, 1300–1914*, Cambridge (1994) 759–943

Quataert, Donald, 'Ottoman Workers and the State, 1826–1914', in Zachary Lockman (ed.), *Workers and Working Classes in the Middle East*, Albany (1994) 21–37

Quataert, Donald, 'Clothing Laws, State, and Society in the Ottoman Empire' *IJMES* 29 (1997) 403–25

Raby, Julian, 'Mehmed the Conqueror's Greek Scriptorium', *DOP* 37 (1983) 15–34

Raby, Julian, 'Mehmed the Conqueror and the Byzantine Rider of the Augustaion', *Topkapı Sarayı Müzesi*, Yıllık 2 (1987) 141–52

Raby, Julian, 'From Europe to Istanbul', in *The Sultan's Portrait. Picturing the House of Osman*, Istanbul (2000) 136–63

Reed, Howard A., 'The Destruction of the Janissaries by Mahmud II in June 1826', unpubl. Ph.D. thesis, Princeton Univ. (1951)

Refik, Ahmet, *Türk Hizmetinde Kiral Tököli İmre (1683–1705)*, Istanbul (1932)

Refik, Ahmed, *Onikinci Asr-i Hicrî'de İstanbul Hayatı (1689–1785)*, Istanbul (repr. 1988)

Refik, Ahmed, *Onüçüncü Asr-i Hicrî'de İstanbul Hayatı (1786–1882)*, Istanbul (repr. 1988)

Reinert, Stephen W., 'From Niš to Kosovo Polje. Reflections on Murad I's Final Years', in E. Zachariadou (ed.), *The Ottoman Emirate (1300–1389)*, A Symposium held in Rethymnon, 11–13 January 1991, Institute for Mediterranean Studies, Halcyon Days in Crete I, Rethymnon (1993) 169–211

Reinert, Stephen W., 'A Byzantine Source on the Battles of Bileća (?) and Kosovo Polje: Kydones' Letters 396 and 398 reconsidered', in C. Heywood and C. Imber (eds), *Studies in Ottoman History in Honour of Professor V. L. Ménage*, Istanbul (1994) 250–72

Renda, Günsel, 'Searching for New Media in Eighteenth Century Ottoman Painting', in Sabine Prätor and Christoph K. Neumann (eds), *Arts, Women and Scholars. Studies in Ottoman Society and Culture, Festschrift Hans Georg Majer* vol. 2, Istanbul (2002) 451–90.

Repp, R. C., *The Müfti of Istanbul. A Study in the Development of the Learned Hierarchy*, London (1986)

Rogers, Michael, *The Topkapı Saray Museum. The Albums and Illuminated Manuscripts*, Boston (1986)

Rogers, Michael, 'The Arts under Süleymân the Magnificent', in H. İnalcık and C. Kafadar (eds), *Süleymân the Second and his Time*, Istanbul (1993) 257–94

Roth, Cecil, *The House of Nasi. The Duke of Naxos*, Philadelphia (1948)

Rothenburg, Gunter Erich, *The Austrian Military Border in Croatia, 1522–1747*, Urbana (1960)

Rothenburg, Gunter Erich, *The Military Border in Croatia, 1740–1881*, Chicago (1966)

Rypka, J., art. Burhān al-Dīn, *EI2* I.1327–8

Šabanović, H., art. Hersek-zāde, *EI2* III.340–42

Sagundino, Nicola, 'Orazione al serenissimo principe e invitto re Alfonso', in Agostino Pertusi (prep.), *La Caduta di Constantinopoli*, 2 vols., n.p. (1976)

St Laurent, Beatrice, and Riedlmayer, András, 'Restorations of Jerusalem and the Dome of the Rock and their Political Significance, 1537–1928', *Muqarnas* 10 (1993) 76–84

Sakaoğlu, Necdet, art. Alemdar Olayı, *İst. Ansik.* 1.185–6

Sakaoğlu, Necdet, art. Murad V, *İst. Ansik.* 5.510–13

Salibi, Kamal, art. Fakhr al-Dīn, *EI2* II.749–51

Salt, Jeremy, *Imperialism, Evangelism and the Ottoman Armenians, 1878–1896*, London (1993)

Salt, Jeremy, 'The Narrative Gap in Ottoman Armenian History', *MES* 39 (2003) 19–36

Salzmann, Ariel, 'Measures of Empire: Tax Farmers and the Ottoman Ancien Regime, 1695–1807', unpubl. Ph.D. thesis, Columbia Univ. (1995)

Sarıcaoğlu, Fikret, *Kendi Kaleminden Bir Padişahın Portresi, Sultan I. Abdülhamid (1774–1789)*, Istanbul (2001)

Savory, Roger, art. Alkās Mīrzā, *EI2* I.406

Sayılı, Adnan, *The Observatory in Islam*, Ankara (1960)

Schama, Simon, *Landscape and Memory*, London (pbk 1996)

Schick, Irwin Cemil, 'Gynaeceum and Power: the "Sultanate of Women" Reconsidered', review of Leslie Peirce, *The Imperial Harem* (New York, 1993), in *NPT* 12 (1995) 145–55

Schiltberger, Johann, *The Bondage and Travels of Johann Schiltberger, a Native of Bavaria, in Europe, Asia and Africa, 1396–1427*, reprint of Hakluyt, London edn of 1879, Frankfurt (1995)

Schmidt, Jan, 'The Egri Campaign of 1596: Military History and the Problem of Sources', in Andreas Tietze (ed.), *Habsburgisch-osmanische Beziehungen*, Colloque sous le patronage du Comité international des études pré-ottomanes et ottomanes, Wien, 26–30. September 1983, Vienna (1985) 125–44

Schreiner, Peter, 'John Malaxos (16th Century) and his Collection of *Antiquates Constantinopolitanae*', in Nevra Necipoğlu (ed.), *Byzantine Constantinople: Monuments, Topography and Everyday Life*, Leiden (2001) 203–14

Sebastian, Peter, 'Ottoman Government Officials and their Relations with the Republic of Venice in the Early Sixteenth Century', in C. Heywood and C. Imber (eds), *Studies in Ottoman History in Honour of Professor V. L. Ménage*, Istanbul (1994) 319–38

Şehsuvaroğlu, Bediî, 'Sultan Abdülaziz'in Avrupa Seyahatı', *BTTD* 1 (1967) 41–51

Selânikî Mustafa Efendi, *Tarih-i Selânikî*, prep. Mehmet İpşirli, 2 vols, Istanbul (1989)

Şem'dânî-zâde Fındıklılı Süleyman Efendi, *Mur'i't-Tevârih*, prep. M. Münir Aktepe, 2 vols/3 parts, Istanbul (1976, 1978, 1980)

Sen, Amartya, 'East and West: the Reach of Reason', *New York Review of Books* XLVII n.12 (20 July, 2000) 33–6

Setton, Kenneth M., *The Papacy and the Levant (1204–1571)*, I *The Thirteenth and Fourteenth Centuries*, Philadelphia (1976); II *The Fifteenth Century*, Philadelphia (1978); III *The Sixteenth Century to the Reign of Julius III*, Philadelphia (1984); IV *The Sixteenth Century from Julius II to Pius V*, Philadelphia (1984)

Setton, Kenneth M., *Venice, Austria, and the Turks in the Seventeenth Century*, Philadelphia (1991)

Shaw, Stanford, (prep.), *Ottoman Egypt in the Eighteenth Century; the* Nizâmnâme-i Mısır *of Cezzâr Ahmed Pasha,* Cambridge, MA (1964)

Shaw, Stanford, 'The Origins of Ottoman Military Reform: the Nizam-i Cedid Army of Sultan Selim III', *JMH 37* (1965) 291–306

Shaw, Stanford, *Between Old and New,* Cambridge, MA (1971)

Shaw, Stanford, 'The Nineteenth-Century Ottoman Tax Reforms and Revenue System', *IJMES* 6 (1975) 421–59

Shaw, Stanford, *The Jews of the Ottoman Empire and the Turkish Republic,* London (1991)

Silâhdâr Fındıklılı Mehmed Ağa, *Silâhdâr Ta'rîhi,* 2 vols, Istanbul (1928)

Silahdar Fındıklılı Mehmed Ağa, *Nusretnâme,* prep. İsmet Parmaksızoğlu, 2 vols, Istanbul (1962, 1966)

Singer, Amy, *Constructing Ottoman Beneficence. An Imperial Soup Kitchen in Jerusalem,* Albany (2002)

Sırma, İhsan Süreyya, 'II. Abdülhamid'in Çin müslümanlarını sünni mezhebine bağlama gayretlerine dâir bir belge', *TD* 32 (1979) 559–62

Şirvânlı Fatih Efendi, *Gülzâr-ı Fütûhât,* prep. Mehmet Ali Beyhan, Istanbul (2001)

Sked, Alan, *The Decline and Fall of the Habsburg Empire, 1815–1918,* London (1989)

Smith, Clive, *Lightning over Yemen. A History of the Ottoman Campaign (1569–71),* London (2002)

Solak-zâde, Mehmed Hemdemî Çelebî, *Solak-zâde Tarihi,* prep. V. Çabuk, vol. 2, Istanbul (1989)

Sonyel, Salahi Ramsdan, *The Ottoman Armenians. Victims of Great Power Diplomacy,* London (1987)

Soranzo, Jacopo, 'Relazione e Diario del Viaggio di Jacopo Soranzo Ambasciatore della Repubblica di Venezia per il Ritaglio di Mehemet Figliuolo di Amurat Imperatore dei Turchi L'anno 1581', in E. Albèri (ed.), *Relazioni degli Ambasciatori Veneti al Senato,* Ser. III vol. 2, Florence (1844) 209–53

Soucek, S., review of M. Dukanović, *Rimovana autobiografija Varvari Ali-Paše* (Beograd, 1967), *AO* 3 (1971) 290–301

Soucek, S., art. Pīrī Re'is, *EI2* VIII.308–9

Soucek, S., art. 'Ulūdj 'Ali, *EI2* X.810–11

Sourdel, D., art. Khalīfa, *EI2* IV.937–47

Spatar, M. Halim, art. Muzika-i Hümayun, *İst. Ansik.* 6.11–12

Stavrides, Theoharis, *The Sultan of Vezirs. The Life and Times of the Ottoman Grand Vezir Mahmud Pasha Angelović (1453–1474),* Leiden (2001)

Stoye, John, *The Siege of Vienna,* London (1964)

Stoye, John, *Marsigli's Europe, 1680–1730,* New Haven (1994)

Streck, M., and Dixon, A. A., art. Kāzimayn, *EI2* IV.854–6

Süleyman Penah Efendi, 'Mora İhtilali Tarihçesi veya Penah Ef. Mecmuası, 1769', prep. Aziz Berker, *Türk Tarih Vesikaları* II (1942–3) 63–80, 153–160, 228–40, 309–320, 385–400, 473–80

Sümer, F., art. Karāmān-oghulları, *EI2* IV.619–25

Süslü, Azmi, *Armenians and the 1915 Event of Displacement,* Ankara (1994)

Sysyn, Frank, 'The Great Ukrainian Revolt: The Khmel'nyts'kyi Uprising, 1648–1658' (typescript)

Tabakoğlu, Ahmet, *Gerileme Dönemine Girerken Osmanlı Maliyesi,* Istanbul (1985)

Tanilli, Server, 'Le tournant de 1913 dans l'histoire de l' "Union et Progrès"', in Edhem Eldem (ed.), *Première Rencontre Internationale sur l'Empire Ottoman et la Turquie Moderne,* Institut National des Langues et Civilisations Orientales, Maison des Sciences de l'Homme, 18–22 janvier 1985, Istanbul (1991) 347–54

Tanman, Baha, art. Hırka-i şerif Camii, İA2 17.378–82

Tansel, Selâhattin, 'Yeni vesikalar karşısında Sultan İkinci Bayezit hakkında bazı mütalâlar', Belleten XXVII (1963) 185–236

Tansel, Selâhattin, Sultan II. Bâyezit'in Siyasî Hayatı, Istanbul (1966)

Tansel, Selâhattin, Yavuz Sultan Selim, Ankara (1969)

Tavernier, Jean Baptiste, Les six voyages de Jean Baptiste Tavernier, Ecuyer Baron d'Aubonne, en Turquie, en Perse, et aux l'Indes, 2 vols, [Paris] (1676)

Tayşi, Mehmet Serhan, art. Feyzullah Efendi (Seyyid), İA2 12.527–8

Tekindağ, M. C. Şehabeddin, 'XVIII. ve XIX. asırlarda Cebel Lübnan Şihâb-oğulları', TD IX/13 (1958) 31–44

Tekindağ, M. C. Şahabeddin, 'Yeni kaynak ve vesikaların ışığı altında Bonaparte'ın Akkâ muhasarası', TD XV/20 (1965) 1–20

Tekindağ, M. C. Şehabeddin, 'Yeni kaynak ve vesikaların ışığı altında Yavuz Sultan Selim'in İran Seferi', TD XVII/22 (1967 [1968]) 49–78

Tekindağ, Şahabettin, 'Şah Kulu Baba Tekeli İsyanı', BTTD 1/3 (1967) 34–9; 1/4 (1968) 54–9

Tekindağ, Şehabettin, 'II. Bayezid Devrinde Çukur-Ova'da Nüfuz Mücâdelesi. İlk Osmanlı-Memlüklü Savaşları (1485–1491)', Belleten XXXI (1967) 345–73

Tekindağ, Şahabettin, 'XVIII. yuzyılda Akdeniz'de Rus donanması ve Cezzar Ahmed Bey'in Beyrut savunması', BTTD 1/5 (1967) 37–45

Terzioğlu, Derin, 'The Imperial Circumcision Festival of 1582: an Interpretation', Muqarnas 12 (1995) 84–100

Tezcan, Baki, 'Searching for Osman: A Reassessment of the Deposition of the Ottoman Sultan Osman II (1618–1622)', unpubl. Ph.D. thesis, Princeton Univ. (2001)

Theolin, Sture, The Swedish Palace in Istanbul, Istanbul (2000)

Theunissen, H., 'Ottoman–Venetian Diplomatics: the 'ahd-names. The Historical Background and the development of a Category of Political-Commercial Instruments together with an Annotated edition of a Corpus of relevant Documents', unpubl. Ph.D. thesis, Utrecht Univ. (1991)

Thomas, Lewis, A Study of Naima, New York (1972)

Thys-Şenocak, Lucienne, 'The Yeni Valide Mosque Complex at Eminönü', Muqarnas 15 (1998) 58–70

Tietze, Andreas, 'Sheykh Bali Efendi's Report on the Followers of Sheykh Bedreddīn', OA 7 (1988) 115–22

Todorova, Maria, 'Midhat Paşa's Governorship of the Danube Province', in Caesar E. Farah (ed.), Decision-making in the Ottoman Empire, Kirksville, MO (1993) 115–28

Toledano, Ehud, The Ottoman Slave Trade and its Suppression, Princeton (1982)

Toledano, Ehud, Slavery and Abolition in the Ottoman Middle East, Seattle (1998)

Treaties (Political and Territorial) Between Russia and Turkey, 1774–1849 (Great Britain, House of Commons, Sessional Papers, 1854, vol. 2) 131–211

Trumpener, Ulrich, 'Germany and the End of the Ottoman Empire', in Marian Kent (ed.), The Great Powers and the End of the Ottoman Empire, London (1984) 111–40

Tucker, Ernest, 'The Peace Negotiations of 1736: a Conceptual Turning Point in Ottoman–Iranian Relations', TSAB 20/1 (1996) 16–37

Tunçay, Mete, Türkiye Cumhuriyeti'nde Tek-Parti Yönetimi'nin Kurulması (1923–1931), Istanbul (repr. 1999)

Turan, Şerafeddin, 'Fatih'in İtalya Seferi', VD 4 (1958) 139–47

Turan, Şerafettin, Kanunî'nin Oğlu Şehzâde Bayezid Vak'ası, Ankara (1961)

Türek, Ahmed, and Derin, F. Çetin, 'Feyzullah Efendi'nin kendi kaleminden hâl tercümesi', TD 23 (1969) 205–19; 24 (1970) 69–92

Tursun Bey, *Târîh-i Ebü'l-Feth*, prep. Mertol Tulum, Istanbul (1977)

Uluçay, Çağatay, 'Yavuz Sultan Selim nasıl padişah oldu?', *TD* VI/9 (1954) 3–90; VII/10 (1954) 117–42; VIII/11–12 (1955 [1956]) 185–200

Uluçay, Çağatay, 'Fatma ve Safiye Sultanların Düğünlerine Ait Bir Araştırma', *İED* 4 (1958) 135–66

Uluçay, M. Çağatay, 'Üç Eşkiya Türküsü', *TM* XIII (1958) 85–100

Unat, Faik Reşit, (prep.), *İkinci Meşrutiyetin İlânı ve Otuzbir Mart Hâdisesi*, Ankara (1960)

Unat, Faik Reşit, *Osmanlı Sefirleri ve Sefaretnameleri*, Ankara (1968)

Uzunçarşılı, İsmail Hakkı, 'Sadrâzam Halil Hamid Paşa', *TM* V (1935 [1936]) 213–67

Uzunçarşılıoğlu, İ. Hakkı, *Anadolu Beylikleri ve Akkoyunlu, Karakoyunlu Devletleri*, Ankara (1937)

Uzunçarşılı, İ. Hakkı, 'Gazi Orhan Bey vakfiyesi, 724 Rebiülevvel–1324 Mart', *Belleten* V (1941) 277–88

Uzunçarşılı, İsmail Hakkı, 'Çandarlı Zâde Ali Paşa Vakfiyesi', *Belleten* V (1941) 549–76

Uzunçarşılı, İsmail Hakkı, *Meşhur Rumeli Âyanlarından Tirsinikli İsmail, Yılık Oğlu Süleyman Ağalar ve Alemdar Mustafa Paşa*, Istanbul (1942)

Uzunçarşılı, İ. Hakkı, 'Asâkir-i Mansure-ye fes giydirilmesi hakkında Sadr-i Âzamın Takriri ve II. Mahmud'un Hatt-i Hümâyunu', *Belleten* XVIII (1954) 224–30

Uzunçarşılı, İ. Hakkı, 'Otranto'nun zaptından sonra Napoli Kıralı ile dostluk görüşmeleri', *Belleten* XXV (1961) 595–608

Uzunçarşılı, İ. Hakkı, 'Fatih Sultan Mehmed'in Vezir-i Âzamlarından Mahmud Paşa ile Şehzade Mustafa'nın Araları Neden Açılmıştı?', *Belleten* XXVIII (1964) 719–28

Uzunçarşılı, İ. Hakkı, 'Bonapart'ın Cezzar Ahmed Paşa'ya Mektubu ve Akkâ Muhasarasına Dair Bir Deyiş', *Belleten* XXVIII (1964) 451–7

Uzunçarşılı, İ. H., 'Değerli Vezir Gedik Ahmet Paşa II. Bayezid Tarafından Niçin Katledildi?', *Belleten* XXVIV (1965) 491–7

Uzunçarşılı, İsmail Hakkı, 'II nci Bayezid'in oğullarından Sultan Korkut', *Belleten* XXX (1966) 539–601

Uzunçarşılı, İsmail Hakkı, 'Kaynarca Muahedesinden Sonraki Durum İcabı Karadeniz Boğazının Tahkimi', *Belleten* XLIV (1980) 511–33

Uzunçarşılı, İsmail Hakkı, *Midhat ve Rüştü Paşaların Tevkiflerine Dâir Vesikalar*, Ankara (repr. 1987)

Uzunçarşılı, İsmail Hakkı, *Midhat Paşa ve Tâif Mahkûmları*, Ankara (repr. 1992)

Uzunçarşılı, İ. Hakkı, *Midhat Paşa ve Yıldız Mahkemesi*, Ankara (repr. 2000)

Valensi, Lucette, *The Birth of the Despot, Venice and the Sublime Porte*, Ithaca (1993)

van Bruinissen, Martin, *Agha, Shaikh and State. The Social and Political Structures of Kurdistan*, London (1992)

Varlık, Mustafa Ç., *Germiyan-oğulları Tarihi (1300–1429)*, Ankara (1974)

Varlık, Mustafa Ç., art. Çaldıran Savaşı, *İA2* 8.193–4

Vatikiotis, P. J., art. Isma'il Pasha, *EI2* IV.192–3

Vatin, Nicolas, 'Itinéraires d'agents de la Porte en Italie (1483–1495): Réflexions sur l'organisation des missions ottomanes et sur la transcription turque des noms de lieux italiens', *Turcica* XIX (1987) 29–50

Vatin, Nicolas, 'La conquête de Rhodes', in G. Veinstein (ed.), *Soliman le magnifique et son temps*, Actes du Colloque de Paris, Galeries Nationales du Grand Palais, 7–10 mars 1990, Paris (1992) 435–54

Vatin, Nicolas, 'Macabre trafic: la destinée *post-mortem* du Prince Djem', *Mélanges offerts à Louis Bazin*, Paris (1992) 231–9

Vatin, Nicolas, *L'Ordre de Saint-Jean-de-Jérusalem, l'Empire ottoman et la Méditerranée orientale entre les deux sièges de Rhodes (1480–1522)*, Paris (1994)

Vatin, Nicolas, 'Aux origines du pèlerinage à Eyup des sultans ottomans', *Turcica* XXVII (1995) 91–9

Vatin, Nicolas, *Sultan Djem. Un prince ottoman dans l'Europe du XVe siècle d'après deux sources contemporaines: Vâki'ât-i Sultan Cem, Oeuvres de Guillaume Caoursin*, Ankara (1997)

Vatin, Nicolas, 'Tursun Beg assista-t-il au siège de Constantinople en 1453?', *WZKM* 91 (2001) 317–29

Vatin, Nicolas, and Veinstein, Gilles, 'Les obsèques des sultans ottomans de Mehmed II à Ahmed Ier (1481–1616), in G. Veinstein (ed.), *Les Ottomans et la mort*, Leiden (1996) 207–44

Vatin, Nicolas, and Veinstein, Gilles, 'La mort de Mehmed II', in G. Veinstein (ed.), *Les Ottomans et la mort*, Leiden (1996) 187–206

Veinstein, Gilles, 'L'occupation ottomane d'Očakov et le problème de la frontière lituano-tatare, 1538–1544', in Ch. Lemercier-Quelquejay et al. (eds), *Passé turco-tatar, présent soviétique, Études offertes à Alexandre Bennigsen*, Louvain (1986) 123–55

Veinstein, Gilles, 'Prélude au problème cosaque à travers les registres de dommages ottomans des années 1545–1555', *Cahiers du Monde russe et soviétique* XXX (1989) 329–62

Veinstein, G., art. Mehmed Yirmisekiz (Čelebi Efendi), *EI2* VI.1004–6

Veinstein, G., art. Sokullu Mehmed Pasha, *EI2* IX.706–11

Vryonis Jr., Speros, 'Laonicus Chalcocondyles and the Ottoman Budget', *IJMES* 7 (1976) 423–32

Vryonis Jr., Speros, 'The Ottoman Conquest of Thessaloniki in 1430', in A. Bryer and H. Lowry (eds), *Continuity and Change in Late Byzantine and Early Ottoman Society*, Papers given at a Symposium at Dumbarton Oaks in May 1982, Birmingham (1986) 281–321

Walsh, J. R., 'The Revolt of Alqās Mīrzâ', *WZKM* 68 (1976) 61–78

Walsh, J. R., 'The Historiography of Ottoman–Safavid Relations in the Sixteenth and Seventeenth Centuries', in B. Lewis and P. Holt (eds), *Historians of the Middle East*, Oxford (1982) 197–211

Williams, Ann, 'Mediterranean Conflict', in M. Kunt and C. Woodhead (eds), *Süleyman the Magnificent and his Age*, London (1995) 39–54

Winter, Michael, 'Ottoman Egypt, 1525–1609', in M. W. Daly (ed.), *The Cambridge History of Egypt*, vol. 2: *Modern Egypt from 1517 to the end of the twentieth century*, Cambridge (1998) 1–33

Wittek, Paul, *The Rise of the Ottoman Empire*, London (1938)

Woodhead, Christine, 'An Experiment in Official Historiography: the Post of Şehnāmeci in the Ottoman Empire, c.1555–1605', *WZKM* 75 (1983) 157–82

Woodhead, Christine, art. Selīm II, *EI2* IX.131–2

Woodhead, art. Silāhdār Fındıklılı Mehmed Agha, *EI2* IX.610

Woods, John L., *The Aqquyunlu. Clan, Confederation, Empire*, Minneapolis (1976)

Wortley Montagu, (Lady) Mary, *The Turkish Embassy Letters*, London (1994)

Yapp, M. E., *The Making of the Modern Near East, 1792–1923*, London (1987)

Yasamee, F. A. K., *Ottoman Diplomacy. Abdülhamid II and the Great Powers, 1878–1888*, Istanbul (1996)

Yavaş, Doğan, art. Eşrefoğlu Camii, *İA2* 11.479–80

Yerasimos, Stéphane, *La fondation de Constantinople et de Sainte-Sophie dans les traditions turques, légendes d'Empire*, Paris (1990)

Yerasimos, Stefanos, 'Sinan and his Patrons: Programme and Location', *Hommes et idées dans l'espace ottoman*, Analecta Isisiana XXIX, Istanbul (1997) 211–15. (First published in *Islamic Environmental Design* V (1987 [1990]) 124–31)

Yerasimos, Stefanos, 'Ağaçtan Elmaya: Apokaliptik Bir Temanın Soyağacı', *Cogito* 17 (1999) 291–332

Yılmaz, Fehmi, 'The Life of Köprülü Fazıl Mustafa Pasha and his Grand Vizierate', unpubl. MA thesis, Bilkent Univ., Ankara (1996)

Yılmaz, Fehmi, 'Osmanlı İmparatorluğunda Tütün Tarımı: Siyasi, Sosyal ve İktisadi Tahlili, 1600–1883', unpubl. Ph.D. thesis, Marmara Univ., Istanbul (2005)

Yılmaz, art. Yedikule Hisarı ve Zindanı, *İst. Ansik.* 7.460–62

Yınanç, Mükrimin H., art. Bayezid I (Yıldırım), *İA* 2.369–92

Yücel, Yaşar, 'Yeni Bulunan II. Osman Adına Yazılmış Bir "Zafer-name"', *Belleten* XLIII (1979) 313–64

Yücel, Yaşar, *Es'ar Defteri (1640 Tarihli)*, Ankara (1992)

Zachariadou, Elizabeth A., 'Manuel II Palaeologos on the Strife between Bāyezid I and Kādī Burhān al-Dīn Ahmad', *BSOAS* 43 (1980) 471–81

Zachariadou, Elizabeth, 'Süleyman çelebi in Rumili and the Ottoman chronicles', *Der Islam* 60 (1983) 268–96

Zachariadou, Elizabeth, 'Marginalia on the History of Epirus and Albania (1380–1418)', *WZKM* 78 (1988) 195–210

Zachariadou, Elizabeth, 'The Emirate of Karasi and that of the Ottomans: Two Rival States', in E. Zachariadou (ed.), *The Ottoman Emirate (1300–1389)*, A Symposium held in Rethymnon, 11–13 January 1991, Institute for Mediterranean Studies, Halcyon Days in Crete I, Rethymnon (1993) 225–36

Zachariadou, Elizabeth, 'Histoires et légendes des premiers Ottomans', *Turcica* XXVII (1995) 45–89

Zachariadou, Elizabeth, 'From Avlonya to Antalya: Reviewing the Ottoman Military Operations of the 1380s', in E. Zachariadou (ed.), *The Via Egnatia under Ottoman Rule (1380–1699)*, A Symposium held in Rethymnon, 9–11 January 1994, Institute for Mediterranean Studies, Halcyon Days in Crete II, Rethymnon (1996) 227–32

Zachariadou, Elizabeth, 'Natural Disasters: Moments of Opportunity', in E. Zachariadou (ed.), *Natural Disasters in the Ottoman Empire*, A Symposium held in Rethymnon, 10–12 January 1997, Institute for Mediterranean Studies, Halcyon Days in Crete III, Rethymnon (1999) 7–11

Zarcone, Thierry, *Mystiques, Philosophes et Francs-Maçons en Islam*, Paris (1993)

Zarinebaf-Shahr, Fariba, 'Qızılbash "Heresy" and Rebellion in Ottoman Anatolia during the Sixteenth Century', *Anatolia Moderna* VII (1997) 1–15

Zens, Robert, 'Pasvanoğlu Osman Paşa and the Paşalık of Belgrade', *IJTS* 8 (2002) 89–104

Zilfi, Madeline C., 'Elite Circulation in the Ottoman Empire: Great Mollas of the Eighteenth Century', *JESHO* XXVI/III (1983) 318–63

Zilfi, Madeline C. 'The Kadızadelis: Discordant Revivalism in Seventeenth-Century Istanbul', *Journal of Near Eastern Studies* 45/2 (1986) 251–69

Zilfi, Madeline C., *The Politics of Piety: the Ottoman Ulema in the Postclassical Age (1600–1800)*, Minneapolis (1988)

Zilfi, Madeline C., 'Sultan Süleymân and the Ottoman Religious Establishment', in H. İnalcık and C. Kafadar (eds), *Süleymân the Second and his Time*, Istanbul (1993) 109–20

Zilfi, Madeline C., 'A *Medrese* for the Palace: Ottoman Dynastic Legitimation in the Eighteenth Century', *JAOS* 113 (1993) 184–91

Zilfi, Madeline C., 'İbrahim Pasha and the Women', in Daniel Panzac (ed.), *Histoire économique et sociale de l'Empire ottoman et de la Turquie (1326–1960)*, Actes du sixième congrès international tenu à Aix-en-Provence du 1 er au 4 juillet 1992, Paris (1995) 555–9

Zilfi, Madeline C., 'Women and Society in the Tulip Era, 1718–1730', in Amira El Azhary Sonbol (ed.), *Women, the Family, and Divorce Laws in Islamic History*, Syracuse (1996) 290–303

Zürcher, Erik, Jan, *The Unionist Factor: the Role of the Committee of Union and Progress in the Turkish Nationalist Movement 1905–1926*, Leiden (1984)

Zürcher, Erik Jan, *Political Opposition in the Early Turkish Republic. The Progressive Republican Party 1924–1925*, Leiden (1991)

Zürcher, Erik Jan, 'The Last Phase in the History of the Committee of Union and Progress (1923–1924)', in Edhem Eldem (ed.), *Première Rencontre Internationale sur l'Empire Ottoman et la Turquie Moderne*, Institut National des Langues et Civilisations Orientales, Maison des Sciences de l'Homme, 18–22 janvier 1985, Istanbul (1991) 369–77

Zürcher, Erik Jan, 'Between Death and Desertion. The Experience of the Ottoman Soldier in World War I', *Turcica* XXVIII (1996) 235–58

Zürcher, Erik Jan, 'The Ottoman Empire and the Armistice of Moudros', *TULP*, (www.let.leidenuniv.nl/tcimo/tulp/research/LIDDLE.htm). Publ. in Hugh Cecil and Peter H. Liddle (eds), *At the Eleventh Hour: Reflections, Hopes, and Anxieties at the Closing of the Great War, 1918*, London (1998) 266–75

Zürcher, Erik J., *Turkey. A Modern History*, London (revised edn, 1998)

Zürcher, Erik Jan, 'The Ottoman Conscription System in Theory and Practice', in Erik J. Zürcher (ed.), *Arming the State. Military Conscription in the Middle East and Central Asia 1775–1925*, London (1999) 79–94

Zürcher, Erik-Jan, 'Kosovo Revisited: Sultan Reşad's Macedonian Journey of June 1911', *MES* 35/4 (1999) 26–39

Zürcher, Erik J., 'Ottoman Labour Battalions in World War I', *TULP*, (www.let.leidenuniv.nl/tcimo/tulp/research/ejz14.htm) (2002)

Zürcher, Erik-Jan, 'From empire to republic – problems of transition, continuity and change', *TULP*, (www.let.leidenuniv.nl/tcimo/tulp/research/Fromtorep.htm) (n.d.)

Zürcher, E. J., art. Reshīd Pasha, Mustafa, *EI2* VIII.484–6

Index

Abaza Hasan Pasha, 257–62
Abaza Mehmed Pasha, 202–8, 229–31, 257
'Abbas I, Safavid Shah, 172, 176, 180, 187–9, 206, 216
Abbasids, 111, 493
'Abd al-'Aziz bin Muhammad bin Su'ud, 412
'Abd Allah bin Su'ud, Sa'udi Emir, 428
Abdi (unidentified), 355–6
Abdülaziz, Sultan: Ali Pasha's testament for, 463, 470; appoints Midhat Pasha grand vezir, 464; visits Egypt and western Europe, 471–2; bronze equestrian statue, 473–4; creates orders and decorations, 474; and budget measures, 478; and Balkan reforms, 480; deposed, 480–2; death, 482, 500
Abdülhamid I, Sultan: reign, 372, 377, 389; adopts title of caliph, 378, 387; conflicts with Russia, 380–3; orders execution of Şahin Giray, 380; death, 384; seeks North African help, 387; army/naval reforms, 391–3
Abdülhamid II, Sultan: and Söğüt, 12; returns spoils to Hungary, 123; mosque reconstruction, 140; educational reforms, 476; and brother Murad's accession, 482; accession, 483, 489; reputation, 488–9; agrees to then suspends constitution, 489–90; character and interests, 489; claims monarchical-spiritual supremacy, 491–7, 507, 513, 515; and Treaty of Berlin, 491; and African Muslims, 498; autocratic government, 499–500, 504, 514; torture methods, 501; and provincial unrest, 503–4; opposition to, 504–6, 508–11; financial reorganization, 507; and Macedonian Question, 511–12; decrees restoration of constitution, 512; opens parliament (1908), 513–14; shuns parliament, 514; and counter-coup (1909), 516; deposed and exiled, 517; returns to Istanbul from Macedonia, 525; requests German military assistance, 527; visited by Kaiser Wilhelm II, 528; on Turkish identity, 548
Abdullah Pasha (Köprülü), 349
Abdülmecid I, Sultan: accession, 445, 449; proclaims reforms, 447–8, 450, 492; religious observance, 449, 460; administration, 453–5, 457; restores Hagia Sophia, 456–7; recognizes Mehmed Ali as hereditary governor of Egypt, 465; closes Istanbul slave market, 466; enthronement ritual, 492
Abdülmecid II, Caliph, 545–6
Abdurrahim Hayri Efendi, Abdülhamid II's son, 517
Abdurrahman Abdi Pasha, 256–8, 260, 264, 270–1, 274, 277, 281
Abkhazia, 239–40
Abouqir Bay, 411
Abu'l-Huda al-Sayyadi, Muhammad, Sheikh, 495–6
Abu Hanifa: tomb in Baghdad, 126 & n, 217

Abu Sa'id, Timurid ruler, 65
Abyssinia, 137–8
Aceh, 138
Acre (Akka), 409, 411
Adam of Usk, 27
Adana, 83, 91–2; Armenians massacred (1909), 518
Aden, 128, 136
Adjiman, Isaiah, 438
Adrianople, Treaty of (1713), 335, 362; (1829), 439
Adriatic, 127, 161, 222
Aegean: Ottomans seize Genoese colonies in, 61; islands census (1830–1), 440
Afghans: capture Isfahan (1721), 351
Africa: Muslims in, 497
Agha Muhammad Khan, 387
Ahizade Hüseyin Efendi, Sheikhulislam, 215, 251
Ahmad Jalayir, Sultan of Baghdad, 28
Ahmed I, Sultan: accession, 184; illness, 184–5; buildings and improvements, 193–4; death, 196, 204; bans tobacco, 212, 214; Varvar Ali serves, 231–2; mosque, 279; mausoleum, 315
Ahmed II, Sultan, 202, 276, 312, 315
Ahmed III, Sultan: accession, 202, 331; executes pretender, 333; protects Charles XII of Sweden, 334; imprisons Baltacı Mehmed, 336; daughters' role and marriages, 338–9, 342; relations with grandee families, 338–9, 341; administration and reforms, 339–41, 370–1; public display and ceremony, 342–5, 347; palaces and court life, 343–5; building programme, 345–6, 365; portraits, 345; religious observance, 347–8; and social unrest, 350–1, 418; and military campaign in Iran, 352; confirms Ottoman–Afghan peace, 352; deposed, 354–5; orders restoration of Dome of the Rock, 360; founds libraries, 366; and Dimitri Cantemir, 405
Ahmed, Bayezid II's son, 100–3
Ahmed Cevad Pasha, Grand Vezir, 499
Ahmed Cevdet Pasha, 459, 476–7, 482, 493–4, 500–1, 522, 548
Ahmed Dürri Efendi, 351
Ahmed Hurşid Pasha, 429–30
Ahmed Lutfi Efendi, 53, 438, 443
Ahmed Niyazi, Captain, 520–1
Ahmed Pasha, governor of Egypt, 20
Ahmed Refik (Altınay), 535, 538
Ahmed Resmi Pasha, 336, 372–7, 381, 383, 390–1
Ahmed Rıza, 505–6, 508
Ahmed Şemseddin Efendi, Sheikhulislam, 190
Ahmed Vasıf Efendi, 376
Akbar, Mughal Emperor, 115, 117
Akif Pasha, 441
akına (light cavalry), 69
Akkoyunlu tribal confederation/state, 12, 64–5, 67, 81, 95–7, 130

INDEX

Akşemseddin, Sheikh, 52, 54
Alaeddin, Murad II's son, 44
Alaeddin Bey, Emir of Karaman, 22–3, 26, 30, 38
Alaüddevle, ruler of Dulkadır, 83, 90–2, 106, 108
Alawites (Alevis; religious sect), 497
al-'Azm family, 360
Albania: Ottomans in, 42, 69; Murad II attempts conquest of, 47; migrants from, 357, 364; disaffection in, 401–2; Tepedelenli Ali Pasha rules, 429; nationalist separatism in, 501–3, 520–1; and revolution of 1908, 520 & n; lost to Ottomans, 525
Albanian League, 502
Albuquerque, Affonso d', 108
Alcazar, battle of (1578), 169
al-Da'ud family, 407
Aleppo, 109, 111, 137, 179, 399, 408, 469; massacre (1659), 261
Alexander I, Tsar of Russia, 406, 425, 434
Alexander II, Tsar of Russia, 491
Alexander VI, Pope, 88–9
Alexander the Great, 80, 130
Alfonso, King of Aragon and Naples, 50, 63, 89
Algiers, 135, 169, 261; France occupies, 443
al-Gilani, 'Abd al-Qadir, 126, 217
Ali Bey, governor of Dulkadır, 108, 113
Ali Cevad Bey, 514, 517
Ali Fuat, 539
'Ali, Imam, the Prophet's son-in-law and cousin, 96, 126
Ali Pasha (Mehmed Emin Ali Pasha), Grand Vezir, 460, 462–5, 470, 475, 478, 499
Ali Suavi, 474, 490
al-Jalili household, 407
al-Musta'in, Caliph, 111
al-Mutawakkil, Caliph, 111, 116
Alparslan, Seljuk Sultan, 3
Alqas Mirza, 135, 141
Amasra (Amastris), 61
Amasya, 71, 81–2, 97, 100, 102–3, 106–7, 141, 182, 231, 252, 264; Treaty of (1555), 135, 142, 169, 215
Amcazade Hüseyin Pasha (Köprülü), Grand Vezir, 253, 311, 313, 317–18, 320, 328, 329–30, 344
Amiens, Treaty of (1802), 411
Amirutzes, George, 62
Anadolu Hisarı, 344
Anapa, 386–7, 400, 419
Anatolia: Turcomans in, 3–8, 62; geography and climate, 6; Mehmed II contends for, 64–6, 96; supports Cem, 84; Bayezid II campaigns in, 91; revolts against Bayezid II, 98–9; Kızılbaş disaffection in, 104; Selim I in, 107; Kızılbaş depradations in, 113; peasant troops from, 178; Celali rebellions, 180–6, 202; Abaza Mehmed Pasha's revolt in, 202–6; discontent with Ottoman centralisation, 202–4; Murad IV's reforms in, 210–12; unrest under İbrahim I, 229–31; unrest under Mehmed IV, 238–9; revolts against Köprülü Mehmed and Mehmed IV, 257–61; conscription into army, 307; tribes resettled in Cyprus and Syria, 310; economic deprivation, 357–8; migration to Istanbul, 357; administration under Selim III, 398–401; first census (1830–1), 440; popular uprisings (1829–30), 440; floods and droughts (1870s), 479–80; rebellions against Abdülhamid II, 502, 506–8, 514; Greek aggression in, 540, 542–4; and post-First World War

settlement, 540, 543; in 1920 peace agreement, 543; resettled, 546
Andronicus II Palaeologus, Byzantine Emperor, 8
Andronicus III Palaeologus, Byzantine Emperor, 13–14
Andronicus, Despot of Thessalonica, 40
Andronicus, John V Palaeologus' son, 19
Angelović, Michael, 59–60
Anglo-Ottoman Society (British), 538
Ankara: battle of (1402), 17, 26n, 27–30, 33, 38, 40, 84; Prince Süleyman gains, 32; Grand National Assembly established (1920), 542; proclaimed capital, 545
Ankaravi Mehmed Efendi, Sheikhulislam, 294–5
Anna Comnene, Byzantine Princess, 62
Antalya (Adalia), 4, 22, 66, 539, 544
Apafi, Michael, 266, 283, 313
Arab Receb Pasha, Grand Vezir, 305–6, 308
Arabacı Ali Pasha, Grand Vezir, 312–13
Arabian peninsula: uprising (1911), 412, 522, see also Hijaz
Arabian Sea, 136
Arabic language, 521–2, 524
Arabs: prejudice against, 305; Abdülhamid II invites to Istanbul, 495, 521; in parliament, 521, 525; differences with Turks, 524; revolt in First World War, 531–2
Ardabil, 95
'Arifi Fethullah Çelebi, 147
Armenians: and Treaty of Berlin, 487; nationalism, 502–3; rebel against Abdülhamid, 507–8; massacred in Adana (1909), 518; independence ambitions, 533–4, 543; relations with CUP, 533; relocated and massacred (1915), 534–6, 538; form Soviet republic, 543
Artukids, 3
Aşıkpaşazade, 29, 78–9
Asmara, 138
Astrakhan, 139, 156–7, 172
astronomy, 190
Atatürk see Mustafa Kemal (Atatürk)
Ataullah Efendi see Şerifzade Seyyid Mehmed Ataullah Efendi
Athens, 61, 293
Aubusson, Pierre d', Grand Master of Knights Hospitallers of St John, 84–6
Augustus III, King of Poland, 373
Aurangzeb, Mughal Emperor, 302
Austria-Hungary: Ottoman raids into, 69; mutual defence pact with Venice, 337; defence pact with Russia (1726), 362; losses in war with Russia (1739), 369, 404; and Ottoman war with Russia (1771), 376; peace agreement with Ottomans (1791), 385; recovers Belgrade (1789), 385; and Serbs' resistance to janissaries, 403; border with Ottomans, 404; and Orthodox Christians, 404–5; occupation of Danubian Principalities, 457–8; offers protection to Ottoman Christians, 469; and Slav threat, 479–80; and Russian success against Ottomans (1878), 485; awarded Bosnia and Herzegovina, 486–7; national and religious diversity, 487; annexes Bosnia-Herzegovina (1908), 513; in First World War, 527; empire collapses (1918), 536; see also Habsburg dynasty; Hungary
Austrian Succession, War of (1740–8), 363
Ayasofya see Hagia Sophia
Aydın, 17, 48, 365, 500
Ayşe Sultan, Ahmed I's daughter, 206, 246

Ayyub Ansari: tomb, 54, 126; Selim II makes pilgrimage to shrine, 153; see also Eyüp
Azerbaijan, 387, 536
Aziz Mahmud Hüdayi, Sheikh, 214
Aziz Mehmed Efendi, 280; see also Zvi, Sabbatai
Azov (Azak; Tana), 16, 221, 225, 321, 335, 351, 362
Azov, Sea of, 156–7

Baghdad: as seat of caliph, 111; surrenders to Süleyman I, 125–6; Safavid sympathisers in, 181; Safavids recover from Ottomans (1624), 205–6; Murad IV captures, 217, 232; Ottomans retain, 222; Nadir Khan besieges, 363; in Iran-Ottoman disputes, 407; captured by British in First World War, 530
Bahadur Shah, Sultan of Gujarat, 128
Bahaeddin Şakir, 506
Bahai Mehmed Efendi, Sheikhulislam, 255
Bahrain, 136–7
Bakhchisaray, 362, 374; Treaty of (1681), 282
Balkans: Ottomans colonize, 9, 40; Ottomans' first stronghold in, 16; Bayezid I campaigns in, 25–6; Murad II in, 41–2; Mehmed II's policy in, 59–61; army conscription in, 307; migration to Istanbul, 357; Russians assist anti-Ottoman rising in, 375; Christian separatism and nationalism in, 398–9, 428–9, 497; insurgency and disaffection in, 401–5, 414; militia disruptions in, 403; sectarian strife, 465; great power conflict over, 479; taxes increased, 480; independent and semi-autonomous states in, 486–7, 501, 509; Austro-Russian partition proposals, 510; wars (First, 1912–13), 520, 522; (Second, 1913), 524
Baltacı Mehmed Pasha, Grand Vezir, 334–5
Baltalimanı Convention (1838), 446, 448
Baltic: and Russian expansionism, 361
Bapheus, battle of (1301), 5
Bar, 374
Barak (seaman), 86–7
Barbaro, Niccolò, 50
Barbarossa see Hayreddin Reis
Barton, Sir Edward, 175
Basra, 136–7, 407–8, 530
Battal Hüseyin Pasha, 386
Baybars, Mamluk general, 111
Bayezid I, Sultan ('the Thunderbolt'): accession, 21, 39; campaigns and conquests, 22–6; marriages, 22–3; fails to take Constantinople, 24, 26, 28, 49; Tamerlane defeats at Ankara, 27–30, 38, 84; fate, 30; sons and succession, 39–40; and youth-levy, 75
Bayezid II, Sultan: and peopling of Istanbul, 57; succeeds father, 71, 79, 81–2; land policy, 74, 107; education and intellectual interests, 81; conflict with brother Cem over succession, 82–7, 90; agreement with popes, 87–8; welcomes Spanish Jews, 88; demands return of Cem's body, 89; diplomatic arrangements with European states, 90; war with Mamluks, 91; offensive against Venice, 92–3, 100; alliance with Mamluks, 93–4; improves navy, 93; suppresses Kızılbaş, 97; mystical interests, 97; offspring, 97n, 100; son Selim defies, 98; succession question, 100–2; deposition and death, 102, 140; survives assassination attempt, 102; law-codes, 146; mosque, 279, 418; bans printing, 366
Bayezid Osman (pretender), 76
Bayezid Pasha, vezir, 37
Bayezid, Murad IV's brother, 223 & n

Bayezid, Süleyman I's son, 139–42, 154
Bayrakdar Mustafa Pasha, 419–23
Bedouin, 310, 361, 495
Bedreddin, Sheikh, 34–7, 45, 95, 143
Beijing: Hamidiye Institute, 498
Beirut, 408–9
Bektaşi order (dervishes), 9, 278; suppressed, 437–8, 449
Belarussia, 361
Belgrade: Murad II besieges, 43; Mehmed II besieges, 59; Süleyman I captures, 118, 123; troops demand donative on accession of Selim II, 153; Habsburgs capture (1688), 302–3, 306; Ottomans recover (1690), 308; Ottomans defend against Habsburgs (1691–6), 312–18; peace talks in, 319; Austria retains, 338; Ottomans regain from Austria (1739), 362; Austria recovers (1789), 385; Austria returns to Ottomans (1791), 385; janissaries seize, 403–4; Serbs seize (1807), 404; Ottomans retake (1813), 427
Belgrade, Treaty of (1739), 362, 365, 373, 456
Berlin conference (1884–5), 498
Berlin, Congress (and Treaty) of (1878), 485–7, 491, 501–2, 527, 542
Berlin–Baghdad railway, 528
Bessarabia, 129
Bethlehem, 112, 323–4, 360
Bethlen, Gabriel, Voyvode of Transylvania, 198, 217
Beylerbeyi Palace, 471, 474, 482, 525
Beyoğlu, 378–9
Bileća, battle of (1388), 20–1
Bilhorod-Dnistrovs'kyy (Akkerman; Cetatea Alba), 58, 71
Bismarck, Prince Otto von, 527
Black Sea: Ottoman naval forces in, 68; Ottomans annex Latin colonies, 69, 71; Ottomans dominate, 71–2; Cossacks in, 218–19, 222, 228; Russian ambitions for access to, 361–2; Russians gain access to, 377; Ottoman fleet developed, 393; opened for trade (1856), 458
Boğazkesen see Rumeli Hisarı
Bonneval, Comte Claude-Alexandre de (Humbaracı Ahmed Pasha), 368
Börklüce Mustafa, 35
Boşnak Husrev Pasha, Grand Vezir, 206–7, 210
Boşnak Sarı Süleyman Agha see Sarı Süleyman Pasha
Bosnia: Mehmed II invades, 60; Matthias Corvinus recaptures, 63; Ottoman actions in under Murad III, 173; Varvar Ali governs, 233; in Habsburg-Ottoman war, 308; tax revolts, 480; European powers demand reforms in, 485; granted autonomy, 485; awarded to Austria-Hungary, 486; Austria-Hungary annexes (1908), 513
Bosporus: Cossack activities in, 218–19
Boucicaut, Jean, 26–7
Boynueğri (or Boynuyaralı) Mehmed Pasha, Grand Vezir, 249, 251–2, 254
Bozcaada (Tenedos), 227, 251, 256–7, 264, 320
Bozoklu Mustafa Pasha, Grand Vezir, 315
Brâncoveanu, Constantin, 306, 405
Branković, George, Serbian Despot, 42, 44–5, 48, 59
Breslau (German–Ottoman cruiser, renamed Midilli), 528–9
brigandage, 229, 304
Britain: involvement in Near and Middle East, 402, 425–6, 445–6, 531–2; penetrates Dardanelles, 413–14; peace with Ottomans (1809), 426; opposes

break-up of Ottoman Empire, 439; supports Ottomans against Mehmed Ali, 448–9; protects Ottoman Jewry, 451; Great Power status, 455; in Crimean War, 457; and Ottoman reforms after Crimean War, 459; abolishes slave trade, 466; and Bulgarian atrocities, 484; calls conference to restrain Ottomans in Europe, 485; gains Cyprus, 486; and Russian success against Ottomans (1878), 488; fleet enters Sea of Marmara (1878), 490; Muslim suspicion of, 494–5; occupies Egypt (1882), 494; supports Albanian separatist movement, 502; declares war on Germany (1914), 527; activities in First World War, 529–30; in occupation of Turkish territories (1918–19), 537, 539–40; condemns Turkish nationalists, 542–3; supports Greek advance in Anatolia, 543–4; declares neutrality in Greek war with Turks, 544

Bucharest, 405–6

Buda, 123–4, 129, 134, 266, 289, 291

Bulgaria: nationalism, 464; granted autonomy and partitioned, 485–6; exarchate created, 509; declares independence (1908), 513; in Balkan Wars (1912–13), 523–4; collapse at end of First World War, 537

Bulgarian atrocities (1876), 484

Bulutkapan Ali Bey, 408–9

Burhan al-Din, Kadı, 26, 27

Bursa, 9, 13, 17, 31–2, 37–8, 102–3, 105, 111, 116, 263

Busbecq, Baron Ogier Ghislain de, 140, 193, 346

Bushatli clan (Albania), 401

Byzantine Empire: and split with Roman Empire, 3; relations with Seljuks, 4; under threat from Bulgars and Ottomans, 13–14, 18, 24, 48; schism with Latin Church, 14–15, 18, 43; internecine quarrels, 40; strategic weakness, 40; pays tribute to Murad II, 41; union of Catholic and Orthodox churches (1439), 48, 50; fragments survive, 61

Caffa see Feodosiya

Cairo, 4, 109–11, 411; see also Egypt

Çaldıran, battle of (1514), 106–8, 112–13, 172, 222

calendar: Islamic, 2 & n; reformed, 551

Çalık Ali Pasha (Köprülü), Grand Vezir, 253

Caliphate, 111, 492–4, 496–8, 513, 522, 542; abolished, 546

Calixtus III, Pope, 76

Calosso, Signor, 437

Calthorpe, Admiral Sir Somerset Arthur Gough-, 537, 539

Cambrai, Peace of (1529), 124

Campo Formio, Treaty of (1797), 403

Canbeg Giray, Crimean Khan, 220, 248

Canbulad clan (Kurdish), 179

Canbuladoğlu Ali Pasha, 179, 185

Çandarlı family, 45, 75–6

Çandarlı Ali Pasha, Grand Vezir, 20, 29, 31

Çandarlı Halil Pasha, Grand Vezir, 45–7, 49, 76–8

Çandarlı, Kara Halil Hayreddin, Grand Vezir, 19–20, 76

Çandaroğulları family, 465

Canikli family, 399

Canikli Hacı Ali Pasha, 380

Cankerman see Ochakiv

Canning, Stratford (later 1st Viscount Stratford), 435, 455

Cantemir, Dimitri, 405

Çapanoğulları family, 399–400, 423, 428

capitulations (trading privileges), 127, 469, 528–9

Carmona family, 438

Catalan Grand Company, 8

Catherine II (the Great), Empress of Russia, 373–4, 376–7, 379–84, 406, 493; death, 387

Catholic Church: schism with Eastern Church, 14–15, 18, 43; relations with Orthodox Church, 404–5; missionary activities, 460

Caucasus, 169–73, 386–7, 467, 458

Cebbarzade dynasty see Çapanoğulları family

Celal, Sheikh, 113, 180

Celali rebellions, 180–7, 202–3

Celalzade Mustafa Çelebi, 146–7

Çelebi Mustafa Pasha, Grand Vezir, 419, 421–2

Cem Sultan, Mehmed II's son: contends for succession, 71, 81–5; exile, custody and travels in Europe, 84–90, 92; death and burial, 89–90

Cemal Pasha (Ahmed Cemal Pasha), 526, 530–1, 537, 539

census: instituted (1830–1), 440

Çerkes Hasan, 483

Çerkes Mehmed Bey, 359

Cesarini, Cardinal Giuliano, 49

Çeşme: Russian naval attack on, 375–6, 390, 408

Cezayirli Hasan Pasha, 375, 381, 385, 393, 410

Cézy, Count de, 223n

Cezzar Ahmed Pasha, 399, 409–11

Chalcocondylas, Laonicus, 39, 73

Chania (Canea; Hanya), 227

Charles II, King of Spain, 318

Charles V, Holy Roman Emperor: rivalry with Francis I of France, 113, 122, 127; and Süleyman I, 115; revives Holy Roman Empire, 117; ambitions to rule Jerusalem, 118; and Knights Hospitallers, 119; inheritance, 122; and Ferdinand's accession to Hungarian throne, 123; forms Holy League with Venice, 128; coronation, 130; attempts to capture Algiers, 135; rivalry with Ottomans, 145; Ferdinand succeeds, 151

Charles VI, King of France, 21, 26–7

Charles VIII, King of France, 86–7, 118, 122

Charles X Gustav, King of Sweden, 256

Charles XII, King of Sweden, 333–6, 367, 426

Charles, Duke of Lorraine, 286, 291

Charles, Duke of Savoy, 86

Châteauneuf, Marquis Castagnères de, 305, 308

China: Muslims in, 498

Chios (Sakız), 61

Christians: in Ottoman Empire, 213, 278–9, 310–11; Holy Sites in Ottoman lands, 323–4, 360; in Balkans, 398–9, 428–9; conscription into armed forces, 454–5, 461–2; in forced labour, 454; missionary activities, 460–1

Churchill, (Sir) Winston, 528

Chyhyryn, 282

Çiçek Hatun, 83, 86

Cigalazade Sinan Pasha, 172, 187

Cihangir, Prince, Süleyman I's son, 139–40

Cilicia, 5, 83, 142, 465; see also İç-il

Cinci Hüseyin Hoca, 225–6

Çırağan Palace, 471

Circassians, 466–8, 484

Çirmen, battle of (1371), 18

Civan Kapucubaşı Sultanzade Mehmed Pasha, 225, 227

Clement VII, Pope, 131

Çoban Mustafa Pasha, 120

coffee, 309
coinage: debased, 46, 74, 176–8, 240, 249, 452–3; shortage, 301–2; and tax payments, 311; bears name Istanbul, 383 & n
coins: from Osman I's time, 7
Colbert, Jean-Baptiste, 341
Columbus, Christopher, 117
Colyer, Jacobus, 314, 318–19
Committee of Progress and Union (CPU): formed, 506, 508; merges with OFS, 509–10; revolutionary practices and rituals, 509–12; and Macedonian Question, 511–12
Committee of Union and Progress see Young Turks
Commonwealth (Polish-Lithuanian) see Poland-Lithuania
Comnene family, 61–3
concubines, 132–3, 166–7
Constantine I (the Great), Roman Emperor, 3, 82
Constantine XI, Byzantine Emperor (earlier Despot of the Morea), 44, 47, 49–50, 52, 85
Constantine Dragaş, Prince of Serres, 24
Constantinople see Istanbul
Constantinople Agreement (1915), 532
Convention for the Pacification of the Levant (1840), 445, 452
Corfu, 93, 128, 337
Corinth, 25, 61
Çorlu, 413
Çorlulu Ali Pasha, Grand Vezir, 334, 337
corvee (forced labour system), 454
Cossacks: location, 138; raids across Black Sea, 183–4, 198, 219–20, 222, 228, 248; corporate identity, 184; support Poland-Lithuania, 199, 219, 228; lose Azov (1642), 225; alliance with Tatars, 248–9; rebel against Poland, 248, 273; support Charles XII of Sweden, 334
Counter-Reformation, 176, 283
Covel, Dr John, 276, 278
Crete: Venice occupies, 93, 119; and Maltese corsairs, 225–6; 1645–69 war over, 226–8, 244, 247–8, 251, 256, 265, 270; Ottomans recover, 271–3; in war with Habsburgs and Venice, 320; seeks union with Greece, 464; revolts against Ottoman rule, 503–4; achieves union with Greece (1908), 513
Crimea: Tatar khanate in, 58–9, 138, 156, 182–3, 205; Ottoman naval campaign against, 68; Muscovy undertakes to wage war on, 321; and Russo-Ottoman war of 1768–74, 374, 376–7; Russo-Ottoman disputes over, 380–5, 387; annexed by Russia, 431, 493; see also Tatars
Crimean War (1854–6), 456–8
Critoboulos of Imbros (Gökçeada), 80
Croatia, 337–8
Crusades, 3, 16, 48, 112
Cüneyd of Aydın, 33–8, 182
Cyprus, 91, 93, 113, 119, 158–60, 161–2, 486–7

Dağdevirenoğlu Mehmed Agha, 413
Dagestan, 387
Dalmatia, 127
Damad Ferit, 539
Damad Mahmud Celaleddin, Abdülhamid II's brother-in-law, 505
Damad Mahmud Celaleddin (murdered 1884), 501, 505
Damad Mehmed Nuri, 501
Damascus (Şam), 360–1

Dandolo, Vincenzo, 182
Danishmendids, 3
Danube province: created, 464
Danubian Principalities, 405–6, 425, 439, 457–8
Dardanelles: Mehmed II fortifies, 61; Venetians breach fortifications, 66; Venetians blockade (1648), 227, 234, 256; Ottoman-Venetian battles in, 247–8, 251, 256, 263; agreed closure to foreign warships in peacetime, 444–6; Britain protects neutrality of, 479; bombarded by Italians (1912), 522; in First World War, 530
Dashnaks, 502, 503, 508–9
Daud Pasha, Grand Vezir, 91
Daud Pasha, Grand Vezir, 200–1, 203
Debbağzade Mehmed Efendi, Sheikhulislam, 297, 299, 303
Defterdar Sarı Mehmed Pasha, 298, 305, 315, 331
Defterdarzade Mehmed Pasha, 230–1, 240
Deli Hasan, 182
Deli Hüseyin Pasha, 244, 254–5
Demetrius, Despot of Mesembria, 43
Demetrius Palaeologus, co-Despot of Morea, 50, 61
Derviş Mehmed Pasha, Grand Vezir, 239, 245–7
Derviş Vahdeti, 518
dervishes, 8–9, 77, 214, 278, 437, 551; see also Bektaşi order; Halidi dervishes; Halveti order; Hurufi dervishes; Mevlevi dervishes; Kalenderi sect Nakşibendi dervishes
Devlet Giray II, Crimean Khan, 335
Didymoteicho (Dimetoka), 17, 102, 140, 419
Diu, 128, 134
Diyarbakır (Amid), 27, 106, 109, 142, 186–8, 203, 205, 217, 223, 232, 259, 289, 400, 507, 537, 550
Dodecanese, 522
Don, river: canal to Volga, 156–7, 190
Donizetti, Giuseppe, 442
Dönme (converted Jews), 280n
Doria, Andrea, 125
Doroshenko, Hetman Petro, 273, 275, 282
Doukas (Byzantine historian), 30, 36, 52
Druzes, 179, 212, 246, 408, 465
Dukakinzade Ahmed Pasha, 106
Dulkadır emirate, 5, 42, 90, 97, 103, 106, 108, 113, 130
Dulkadıroğulları see Dulkadır emirate
Dutch: as peace negotiators, 302, 314, 318–19; tulipomania, 347

'Eastern Question', 323, 445, 489
Ebubekir Ratib Efendi, 390
Ebülhayr Mecdeddin Abdülmecid see Sivasi Efendi
Ebusaid Efendi, Sheikhulislam, 243
Ebüssuud Efendi, Sheikhulislam, 143–7, 158, 164, 168, 190
Edebali, Sheikh, 2, 12
Edirne (Adrianople): court in, 13, 329–30; Musa captures, 32; False Mustafa occupies, 37; ten-year truce (1444), 44–5; civil unrest in, 46; Selimiye mosque, 162–3; Murad IV marches to, 216; Mehmed IV in, 263, 276, 281, 298, 329; palace, 292; 'Incident' (1703 uprising), 330–2, 338; 'New Order' troops advance on, 413–14; Russo-Ottoman armistice at (1878), 485; lost to Bulgaria, 523; Ottomans regain, 524, 526
education: reforms and developments, 454, 476
Edward VII, King of Great Britain, 511
Eger, 175
Egypt: Selim I conquers, 94, 108–11, 117; as

Ottoman province, 119–20; commercial and territorial interests, 120–1; western trading privileges in, 127; Ottoman territorial limits in, 138; law code, 146; revolt against Kara Üveys, 168; revolts against Ottoman rule, 180; status as province, 358–9; Bonaparte invades, 396–7, 402–3, 410–11; Mehmed Ali governs, 399, 411, 426–8, 465; economic prosperity, 409; Ottomans send naval force to (1786), 410; British defeat Bonaparte in, 411; relations with Ottomans weaken, 425; advance on Syria and Anatolia, 444; Mehmed Ali demands independence for, 445; revised provincial status, 446; borrowing after economic boom, 472; hereditary governorship, 472–3; surrenders African interior territories, 473; British occupation of (1882), 494; anti-British feelings in, 522; disaffection towards Ottomans (1913), 524; stance in First World War, 529–30; see also Mamluks
Elmas Mehmed Pasha, Grand Vezir, 316–18
Elphinston, Rear Admiral John, 375
Eminönü, 144, 279–80
Emirgün (Mirgune Tahmasp Quli Khan), 216
Enez (Enos), 61
Enver Pasha (Captain İsmail Enver), 498, 509, 512, 522–4, 526–7, 530, 534–5, 537, 539, 549
Eremya Çelebi Kömürcüyan, 249–51
Ertuğrul, 7, 11
Erzurum, 170–1, 202–3, 206, 208, 259, 365, 507–8, 537
Esad Efendi, Sheikhulislam, 168, 197–9
Esad Pasha (Köprülü), 349
Eskandar Monshi, 186, 188, 206
Esmahan Sultan, Selim II's daughter, 154, 168
Eşrefoğulları dynasty, 7
Esztergom, 290
Eternal Peace, Treaty of (1686), 320–1
Euboea (Ağrıboz; Negroponte), 320, 429
Eugene, Prince of Savoy, 317, 337, 358
eunuchs: role and status, 167
European Union: prospective Turkish entry, 545
Evliya Çelebi, 163, 207–8, 217, 230–1, 239–41, 245, 267–9, 272, 346, 548
Evrenosoğulları family, 19, 22, 45, 75
Eyüp, 214, 299, 345, 348, 352, 255; see also Ayyub Ansari

Fahri Bey, 481–2, 501
Fakhr al-Din Ma'n, 179, 212
Fatma Sultan, Ahmed III's daughter, 342, 349
Fazıl Ahmed Pasha (Köprülü), Grand Vezir, 253, 265–74, 277, 281–3, 306, 324, 366
Fazıl Mustafa Pasha (Köprülü), Grand Vezir, 253, 281, 289–90, 295–6, 299, 306–13, 324
Feodosiya (Caffa, Kefe), 16, 68, 71–2, 98, 157
Ferdinand I, Duke of Tuscany, 179
Ferdinand III, Holy Roman Emperor, 302
Ferdinand, King of Aragon, 87
Ferdinand, King of Hungary and Archduke of Austria, 122–5, 129, 134, 151
Ferrante, King of Naples, 70, 84–5
Ferrara, Council of (1437), 43
Feyzullah Efendi, Sheikhulislam, 253, 299–300, 303, 315, 318, 329–32, 338, 348
fez: introduced by Mahmud II, 442, 551
Fiqari household, 359
First World War (1914–18): outbreak, 527; conduct of, 528–30; Arab involvement in, 531–2; effect on Ottoman Empire, 533, 536–7

Florence, Council of (1439), 43
Foça (Phokaia), 61
Fossati brothers (Swiss architects), 456
France: on crusade, 25, 44; Ottoman envoys in, 90; in league against Ottomans (1501), 93; besieges Naples, 124; trading privileges in Syria and Egypt, 127; neutrality in Ottoman-Habsburg conflict, 284–5; renews peace with Ottomans (1685), 289; Holy League turns against, 302, 313; proposed alliance with Ottomans, 305; helps repair Belgrade, 308; as Ottoman trading partner, 341, 363; mediates in Russo-Ottoman war (1739), 362–3; coalition against (1793), 396; gains from Campo Formio treaty, 403; intervenes in Ottoman affairs, 403; revolutionary regime recognized by Ottomans, 406; interests in Egypt, 409–10; improving relations with Russia, 425; special relations with Ottomans, 425; interest in North Africa, 443; refuses coercive measures against Mehmed Ali, 446; in Crimean War, 457; offers protection to Ottoman Christians, 469; interest in Near East, 531; in occupation of Istanbul and Adana (1918–19), 537; withdraws from Anatolia, 544; see also Napoleon I (Bonaparte)
Francis I, King of France, 112–13, 118, 122, 124, 127–8
Franco-Prussian War (1870–1), 479
Franz Joseph, Austro-Hungarian Emperor, 510
Franz-Ferdinand, Archduke of Austria, 527
Frederick II (the Great), King of Prussia, 336, 363, 372–3, 385, 391
Frederick III, Holy Roman Emperor, 76
Frederick V, King of Bohemia, 198
Frederick, Prince of Naples, 89
French Revolution, 395, 402
Fuad Pasha, Keçecizade, 462, 464, 473, 475, 478, 499
Fuller, Charles, 473
Funj, 137–8

Gabbai family, 438
Galata (Pera), 14, 57, 190
Galib, Sheikh, 394
Gallipoli campaign (1915–16), 530
Gama, Vasco da, 93
gāzī: defined, 10
Gazi Evrenos Bey, 9, 19, 31, 33, 75
Gedik Ahmed Pasha, Grand Vezir, 67–8, 70, 79, 83, 85
Gelibolu (Gallipoli), 16, 18, 32, 66, 68; treaty (1403), 31
Genghis Khan, 4, 26–7, 59, 69
Gennadios see Scholarius, George, 50
Genoa: traders support Orhan, 14; rivalry with Venice, 16, 24, 49; trading rights under Prince Süleyman, 31; interests threatened by Murad II, 40; Galata colony surrenders to Mehmed II, 57; and fall of Constantinople, 58; Aegean colonies fall to Ottomans, 61; granted 'capitulations' by Ottomans, 127
George I, King of Greece, 503
Georgia, 382, 387, 406
Germanos, Metropolitan of Kalavryta, 429
Germany: rise to power, 479; supports Ottomans, 504–5, 527–8; in First World War, 527
Germiyan emirate, 5–6, 17, 22–3, 38, 48
Ghalib, Sharif of Mecca, 412
Ghazan, Ilkhanid Khan, 8
Gilles, Pierre, 53, 130
Giray Tatars see Crimea; Tatars

Gladstone, William Ewart, 484, 488
Glover, Thomas, 175
Goeben (German–Ottoman cruiser, renamed *Yavuz Sultan Selim*), 528–9
Golden Horde, 59, 222
Golitsyn, Prince Vasily, 321
Goltz, Colmar, Freiherr von der, 506
Gorchakov, Prince Alexander, 458
Granada, 87–8, 117
Grand Alliance (Austria-England-United Provinces), 305
grand vezirate: decline under Murad III, 165, 167–8; office moved away from palace, 254
Great Exhibition, London (1851), 455
Greece: independence movement, 429–32, 445, 462, 470; becomes independent kingdom (1832), 439, 468; provides translators, 462; and Treaty of San Stefano, 485; Ottoman Greeks migrate to, 487; seeks control of Crete, 503–4; union with Crete, 513; in Second Balkan War, 523; aggression in Anatolia (1919), 539, 540, 542–4; granted 5-year sovereignty in İzmir (1920), 543; war with Turkey (1921–2), 544–5; population exchanges with Turkey, 546
Gregory V, Orthodox Patriarch, 429–30
Gregory Palamas, Archbishop of Thessalonica, 10
Grigor of Kemah, 185–6, 203, 208, 211
Gülhane Edict (1839), 447–50, 452, 454–5, 458, 460–1, 463, 473, 490, 492
Gürcü Abdülnebi Agha, 236–9, 244, 258, 332
Gürcü Mehmed Pasha, Grand Vezir, 267–8
Güzelce Ali Pasha, Grand Vezir, 198
Győr (Raab; Yanık), 266, 284, 287

Habeş province *see* Abyssinia
Habsburg dynasty: conflict with Ottomans, 122–4, 126–7, 134–5, 151, 158, 162; and peace of 1580, 169; Ottoman war with (1593–1606), 173–5; in Thirty Years' War, 217–18, 220; Ottomans maintain peaceful relations with, 222; counters Ottoman campaign (1663–4), 266–7; hegemony in Hungary, 283; Ottoman war with (1683–99), 284–92, 300–7, 312–18, 325; victory at Vienna (1683), 288; advances in Hungary, 290; rejects Ottoman peace overtures, 291–2; in War of the League of Augsburg, 304; peace negotiations and treaty with Ottomans (1699), 314, 318–19; and North African corsairs, 361; *see also* Austria-Hungary
Hacı Bektaş, 142
Hacı Beşir Agha, Chief Black Eunuch, 349, 354, 438
Hacı Giray, Crimean Khan, 68
Hacı İbrahim Pasha, 180
Hacı Mustafa Pasha, 401, 403
Hacı Ömer Agha (Karaosmanoğulları), 400
Hadım Ali Pasha, Grand Vezir, 91–2, 99–101
Hadım Hasan Agha, 135
Hadım Mehmed Pasha (Gürcü), Grand Vezir, 202–3
Hadım Süleyman Pasha, 121, 128
Hadice Sultan, Mehmed IV's daughter, 276
Hadice Sultan, Süleyman I's sister, 120, 130, 276
Hafiz Ahmed Pasha, Grand Vezir, 203, 205–8, 246n
Hafsa Sultan, Süleyman I's mother, 148
Hagia Sophia (Ayasofya), Istanbul: Ottomans convert to mosque, 52–3; Selim II repairs, 163–4; Ahmed I repairs, 193; prominence, 279; restoration (1847–9), 456; proposed reconversion to church, 537–9

Halet Efendi, 430–1, 433
Halid Baghdadi, Sheikh, 449
Halide Edip, 514
Halidi dervishes, 449, 560
Halil, Sultan Orhan's son, 17, 39
Halil Hamid Pasha, Grand Vezir, 381, 392
Halil Rifat Pasha, Grand Vezir, 499
Halveti order (dervishes), 97, 168, 214
Hamid emirate, 5, 22–3
Hamidiye regiments (Kurdish), 502–3
Hanafi school (Islamic), 494
Handel, George Frederick: *Tamerlano*, 30
Hanefi Efendi, 243
Harborne, William, 30
harem: defined, 132; expanded under Murad III, 166–8, 170; status of women in, 166
Harington, General Sir Charles, 545
Harput, 503
Has Murad Pasha, 57
Hasan Bey (Turahanoğulları), 75
Hasan Fehmi Efendi, Sheikhulislam, 477, 480–1
Hasan Hayrullah Efendi, Sheikhulislam, 501
Hasan Pasha, governor of Bosnia, 173
Hasan Vecihi, 233
Hat Law (1925), 551
Havsa, battle of (1703), 331
Haydar, Sharif of Mecca, 531
Haydar, Sheikh, 97
Hayreddin Reis ('Barbarossa'), 125, 127–8, 166
Heemskerck, Coenraad van, 314
Hekimoğlu Ali Pasha, Grand Vezir, 409
Helen, Demetrius Palaeologus' daughter, 61
Helen, co-Regent of Serbia, 60
Henry IV, King of England, 27
Hersekzade Ahmed Pasha, Grand Vezir, 60–1, 82, 91–2, 106
Herzegovina, 60, 480, 485–7, 513; *see also* Bosnia
Hexamilion wall (Corinth), 44, 47
Hezarfen Hüseyin Efendi, 276
Hezarpare Ahmed Pasha, Grand Vezir, 230–1, 233–5
Hierosolimitano, Domenico, 165
Hijaz, 494–5, 531
Hoca Sadeddin Efendi, 168, 191
Hocazade Mesud Efendi, Sheikhulislam, 243–5, 250–1
Holy League: (1530s), 128, 133; (1684), 289, 291–2, 300, 305, 350
Holy Roman Empire: Ottoman envoys to, 90; Charles V revives, 117; *see also* Austria-Hungary; Habsburg dynasty
holy war *see jihād*
Hormoz, 136–7
Houvanessian, Yakub, 438
Hulagu Khan, 367
Humayun, Mughal Emperor, 128
Humbaracı Ahmed Pasha *see* Bonneval, Comte Claude-Alexandre de
Hunchaks, 502–3
Hungary: conflict with Bayezid I, 25; Venice seeks alliance with, 41; war with Murad II, 41, 43; Varna defeat, 45–6; and Mehmed II's Balkan campaigns, 59–60, 64; in league against Ottomans (1501), 93; Selim I's relations with, 104; peace treaty with Ottomans (1513), 113; Süleyman's campaigns against, 118, 121, 123–5, 134; religious division in, 134, 283; in war of 1593–1606, 174; and Oradea statues, 266; Mehmed IV's 1663

campaign in, 267; Habsburg hegemony in, 283–4; Habsburg advances in, 290–2, 300, 303–4; Holy League troops transferred to fight French, 302; Ottoman advance in (1690), 307–8; Ottomans withdraw from, 313; Ottomans concede to Austria, 319; borders restored (1718), 338, 350; refugees from 1848 revolution, 457; and occupation of Bosnia and Herzegovina, 487; *see also* Austria-Hungary

Hunkar İskelesi, Treaty of (1833), 444–5

Hunyadi, John, Voyvode of Transylvania, 43–7, 48, 50, 59

Hürrem Sultan (Roxelana), 13, 139–40, 143, 149–50, 153, 166

Hurufi dervishes, 45

Hüsameddin Pasha, 375

Husayn, Imam, Imam 'Ali's son, 98, 126

Husayn, Shah of Iran, 351

Husayn, Sharif of Mecca, then King of the Hijaz, 494, 501, 529, 531

Hüseyin Avni Pasha, 480–3

Hüseyin, Fakhr al-Din Ma'n's son, 75, 212

ibn Battuta, 13

İbrahim I, Sultan ('the Crazy'), 202, 209, 223–8, 233–6

İbrahim Bey, (Kazdağlı), 409–10

İbrahim Bey, Emir of Karaman, 42, 49, 55, 64, 68

İbrahim Hilmi Pasha, Grand Vezir, 419

İbrahim Müteferrika, 366–8

İbrahim Pasha, Grand Vezir: lifestyle, 116; background and career, 120–1; campaign against Safavids, 125; execution, 127, 131–2, 140, 149; marries Süleyman's sister, 130, 276, 343; and Ottoman display, 130–1; and Süleyman, 131–2, 143, 154–5, 200; Hürrem's jealousy of, 133; crushes revolt in Anatolia, 142; and imperial image, 145

İbrahim Pasha, Mehmed Ali's son, 427–8, 432–3, 444–6, 448, 465, 473–4

İbrahim of Peç, 182, 197, 203, 205, 207, 210, 366

İbrahim, Sultan Orhan's son, 39

İç-il (province), 90, 259; *see also* Cilicia

Ignatiev, Count Nikolai, 484

Ilkhanid dynasty, 4, 7

İlyas Pasha, vezir, 38

India: Napoleon's ambitions for, 413; British routes to, 486, 531; follows Britain in First World War, 529

Indian Mutiny (1857–8), 497

Indian Ocean: Portuguese-Ottoman conflict in, 93–4, 108, 112, 121

Innocent VIII, Pope, 87–8

Inquisition, Holy, 88

Internal Macedonian Revolutionary Organization (IMRO), 509–10

Ionian islands, 69, 403

İpşir Mustafa Pasha, Grand Vezir, 229–31 239–40, 246–7, 252, 257

Iraklion (Candia), 227, 271–3

Iran: challenges Ottoman legitimacy, 94; trade blockade under Selim I, 111; Süleyman campaigns in, 125; war in Caucasus with Ottomans, 169; Özbeks attack, 172; military strategy, 174; welcomes Celali rebels, 186; resumes war with Ottomans (1603), 187; Shah 'Abbas's private troops, 187; declines support for Ottomans against Holy League, 291; Afghans invade, 351–2; wars

with Ottomans (1722–45), 352, 363; peace treaty with Ottomans (1746), 364; in Caucasus, 386–7; Napoleon supports in recovery of Georgia, 406; borders with Ottomans, 407; Napoleon seeks alliance with, 413; written constitution, 506; *see also* Safavid state

Iraq, 126, 135; in First World War, 530

Irene, Emperor John V's daughter, 17

İsa, Bayezid I's son, 30–1

Isabella, Queen of Castile, 87

Isfahan, 351

İsfendiyar emirate, 5, 23, 62

İsfendiyaroğulları *see* İsfendiyar emirate

İshak, İbrahim of Karaman's son, 64

İshak Pasha, Grand Vezir, 82

Isidore, Cardinal Bishop of Kiev, 43, 50

İskender Bey *see* Scanderbeg

İskender Pasha, warden of Istanbul, 85

İskenderun (Alexandretta), 92

Islam: and Holy War, 5–6; internal conflicts, 94–7, 104; Holy Places, 110, 120–1, 145, 149, 164, 167, 359, 412, 426, 428, 494–5; predominance in Ottoman Empire, 110; millennium, 117, 177; and heretical teachings, 142–3; conversions to, 280–1, 470; schools of, 363; and laws of war, 434; enshrines inequalities, 450, 468; and apostasy, 460–1; acceptance of slavery, 466; Young Ottomans and, 475, 478, 489; and civil code, 477; and secularizing reforms, 478; worldwide, 496–9; CUP embraces, 525

İslam Giray III, Tatar Khan, 248

İsmail (pretender), 40

Isma'il, Safavid Shah: conflict with Selim I, 94–9, 101–9, 111–14, 115, 215; and Islamic millennium, 117; relations with Süleyman I, 118; death, 125; pretender appears among Turcomans, 181; and 'Turks', 548

Isma'il Pasha, Grand Vezir, 262, 267–8, 300

İsmail Pasha, Khedive of Egypt, 471–4

Isma'iliya, 472

İsmet (İnönü), 545, 549–50

Istanbul (Constantinople): founded, 3; proximity to Ottomans, 7; Bayezid I besieges, 24, 26, 28, 49; blockade lifted (1403), 29; Musa besieges (1411), 32; Demetrius attacks, 43; Mehmed II besieges and captures, 48–52, 114; Mehmed II recreates and rebuilds, 53–6, 71, 74; resettled, 56; names, 57–8, 383; consequences of fall for west, 58; earthquake (1509), 100; Hippodrome, 130, 132; improvements and rebuilding, 130, 144, 345, 365–6; libraries in, 193, 366; Blue Mosque, 194; 'Description of', 217; Murad IV's processions in, 217; and army rebellion under Mehmed IV, 236–8; Şehzade mosque, 279; Yeni Valide Camii (mosque), 279; famine (1686), 290; militia mutiny in (1687–8), 298–300, 330; palaces and mosques, 343–5; social dissatisfactions under Ahmed III, 350–1; rebellion of 1730, 353–5; migration to, 357, 364–5; food shortages and plague under Mahmud I, 364; violent disturbances (1740, 1748), 364; Nuruosmaniye mosque, 365, 443; violence after Bayrakdar Mustafa's death, 423; fires: (1660), 279; (1756), 372; (1826), 439; plague, 439; slave market closed, 466; rail links, 479; proposed removal of capital from, 525; Allies occupy (1918), 537; Allies evacuate (1923), 545; non-Muslim population, 547; *see also* Hagia Sophia; Topkapı Palace

Italy: trade with east, 71; Süleyman attacks, 127–8; African colonialism, 522; in occupation of Istanbul and Antalya (1918–19), 537, 539; withdraws from Anatolia, 544
Ivan IV ('the Terrible'), Tsar of Russia, 117, 138–9, 156–7, 173
İzmir (Smyrna), 15, 66, 539, 543, 544, 547
İzmit (İznikmid; Nicomedia), 14, 224, 260
İznik (Nicaea), 3, 8, 13–14, 17

Jalal al-Din Rumi, Mevlana, 78, 394
Janbardi al-Ghazali, 110, 119–20
janissaries (yeniçeri): in Bayezid I's forces, 28; revolts after debasement of coinage, 46, 74, 177; in standing army, 73, 75, 77; control of, 77; kill Karamani Mehmed, 82; in Bayezid II succession rivalries, 101–2; unrest towards Selim I, 106; criticize Süleyman I, 151; mutiny against Selim II, 153; sultans' dependence on, 153; unrest under Murad III, 177–8; revolt against Osman II and restore Mustafa I, 200–1; depose sultans, 201–2; Abaza Mehmed exacts vengeance on, 203; land-grants to, 210; numbers reduced, 224; in deposing of İbrahim I, 234, 236; role and influence, 234, 236; rebellions under Mehmed IV, 236–8, 241–2, 249–51, 298–9; payments to, 240; and Kösem Sultan's murder, 242–4; domination ended, 244; support Köprülü Mehmed, 256; discipline tightened, 307; power in Egypt, 359; resist modernization, 370, 424; reforms under Selim III, 391–3, 402, 413, 436; in Balkans, 401, 403–4; rebel against Selim III, 415–16; eliminated (1826), 423, 435–7, 439, 453; and killing of Bayrakdar Mustafa, 423; incompetence, 427; and Halet Efendi, 431; rebel at Mahmud II's reforms, 433–5
Jassy: Treaty of (1792), 386–7, 406; court, 405–6
Jerusalem (Kudüs): falls to Muslims (1187), 24; as prospective refuge for Cem, 83–4; Selim I visits, 110; Ottomans capture, 112; Christian claims to, 117–18; Dome of the Rock, 149, 360; Hürrem Sultan's foundation in, 149; Christian Holy Sites, 323–4, 360, 408, 456; in First World War, 530
Jews: in Ottoman Empire, 88, 191–2, 278–80, 311, 451, 533; bankers executed, 438; community leader appointed, 451; and Palestine homeland, 533
jihād, 5, 10, 529
Jihanshah, Karakoyunlu leader, 95
John III Shishman, Bulgarian ruler, 20, 25
John V Palaeologus, Byzantine Emperor, 17–20
John VI Cantacuzenus, Byzantine Emperor, 13, 15–16, 19
John VII Palaeologus, Byzantine Emperor, 20, 23
John VIII Palaeologus, Byzantine Emperor, 41, 43, 45, 47
John of Austria, Don, 160–2
Joseph II, Holy Roman Emperor, 382–5, 404
Junayd, Sheikh, 95–6
Justinian, Roman Emperor: statue, 53, 265

Kabakçı Mustafa, 417–18, 421, 474
Kabakulak İbrahim Pasha, Grand Vezir, 356
Kabiz, Molla, 142
Kadızade Mehmed, 213–14, 278
Kadızadeli movement, 214–15, 225, 254–5, 277–9, 371
Kagul, battle of (1770), 374
Kalender Shah, 142

Kalenderi sect, 102
Kalenderoğlu Mehmed, 185–6
Kamenets-Podol'skiy (Kameniçe), 273–5, 293, 305, 320, 322
Kamil Pasha ('İngiliz'), Grand Vezir, 523
Kara Çavuş Mustafa Agha, 241, 243–4
Kara Halil Hayreddin Çandarlı see Çandarlı, Kara Halil Hayreddin
Kara Haydar, 229
Kara İbrahim Pasha, Grand Vezir, 287, 289–90, 294
Kara Mehmed Pasha, 269
Kara Murad Pasha, Grand Vezir, 236–7, 247
Kara Üveys Çelebi, 168
Kara Üveys Pasha, 180
Kara Vasıf, 542
Karaçelebizade Abdülaziz Efendi, Sheikhulislam, 240–1, 243–4, 255
Karagöz Mehmed Pasha, 91
Karahaydaroğlu Mehmed, 229
Karakol (organization), 540, 542
Karakoyunlu tribal confederation/state ('Black Sheep'), 28, 65
Karaman emirate, 4, 5–6, 17, 26, 33, 36, 38–9, 42, 48–9, 62, 64–8; ruled by Ottomans, 90
Karamani Mehmed Pasha, 77–8, 81–2
Karaosmanoğulları family, 399–400, 423
Karayazıcı Abdülhalim, 181, 182
Karbala', 126, 412, 497
Karesi emirate, 5, 14–17
Karlowitz, Treaty of (1699), 319, 321–3, 328, 330, 333, 338, 350, 360, 369, 394
Kars, 171, 458, 543
Kasım Bey, Karamanid Prince, 83–5, 90
Kasım Pasha, 157
Kastriota clan (Albania), 89
Katib Çelebi, 184, 196, 206–7, 210, 213, 224–6, 234
Katırcıoğlu Mehmed, 236–8
Kay-Khusraw II, Seljuk Sultan, 4
Kayseriyeli Halil Pasha, Grand Vezir, 197, 199, 206
Kazan khanate, 139, 156–7
Kazdağlı faction (Egypt), 409
Kazım Karabekir, 539–40, 543, 546, 551–3
Kemah, 106
Kemalpaşazade, Sheikhulislam, 104, 142, 147
Kemankeş Kara Mustafa Pasha, Grand Vezir, 223–6, 246
Kemény, John, 266
Kenan Pasha, 248, 258–9, 261–2
Khayr Bak, 109, 119–20
Kherson, 381
Khiva, 156
Khmelnytsky, Hetman Bohdan, 248–9, 273, 282
Khotin: siege of (1621), 199, 218; Polish forces defeat Ottomans at (1673), 275; siege and capture of (1769), 374
Kılıç (or Uluç) Ali Pasha, 158, 161, 171
Kilijarslan II, Seljuk Sultan, 4
Kiliya, 71
Kinburun, 383, 393
Kızılbaş, 94, 97–100, 102–5, 107, 112–13, 125, 143, 162, 169, 181, 387
Knights Hospitallers of St John of Jerusalem: on Rhodes, 24–5, 33; Mehmed II attacks, 69; hold Cem, 84–6; renew peace treaty with Ottomans, 85; leave Rhodes for Malta, 119, 123; support Mamluks, 120; hold Tripoli, 135–6; and security of Mediterranean, 158

Koca Halil Pasha, 312
Koca Mahmud Agha, 307
Koca Mustafa Pasha, Grand Vezir, 101
Koca Ragib Pasha, Grand Vezir, 369
Koca Sinan Pasha, Grand Vezir, 155, 170–1, 173–5, 192, 280
Koca Yusuf Pasha, Grand Vezir, 382–4
Koçu Bey, 209–10
Konya (Iconium), 3–4, 83, 141; battle of (1831), 444
Köprülü household, 253, 272, 289, 327, 329, 338, 349, 359
Köprülü Mehmed Pasha, 231, 239, 246, 252, 253–63, 281, 324–5; death and achievements, 264, 327–8
Korais, Adamantios, 431
Korkud, Bayezid II's son, 82, 85, 94, 98–9, 101–3
Köse Mihal, 75
Köse Musa Pasha, 415, 418
Kösedağ, battle of (1243), 4
Kösem Sultan (Mahpeyker), İbrahim I's mother: authority and influence, 197–8, 208, 235, 254; and Hafiz Ahmed Pasha, 206, 208; intercedes with Sultan, 211, 215; and İbrahim's excesses, 233–5; refuses use of sacred standard, 237–8; and Melek Ahmed Pasha's dismissal, 241; murdered, 242–3, 247; mutineers demand life of, 249; and defence of Straits, 263
Kosovo Polje: battle of (1389), 13, 21, 22, 39, 59, 122, 521; second battle of (1448), 47
Kőszeg (Güns), 125
Kozanoğulları dynasty, 465
Kraloğlu İshak Bey, 60
Krujé, 64, 69
Küçük Kaynarca, Treaty of (1774), 377–9, 381, 386, 406–7, 431, 493
Küçükalioğulları dynasty, 465
Kuleli Incident (1859), 460
Kurdish language, 550
Kurdistan, 172, 502–3
Kurds: and post-First World War settlement, 543; identity, 549–50; Sheikh Said revolt (1925), 550
Kut-al-Amara, 530
Kütahya, 99, 260, 444
Kuyucu Murad Pasha, Grand Vezir, 179, 185–6, 188, 194, 207

La Goletta, 158, 162
Lahsa province, 137
Lala Mustafa Pasha, 155, 159, 170–1
land-grants, 210–11, 301, 358
Lausanne, Treaty of (1923), 545–6
Law for the Maintenance of Order (1925–7), 550–1, 553
Lawrence, T.E., 532
Layard, Sir Austen Henry, 492
Lazar, Serbian Prince, 20–1, 521
League of Augsburg, War of the (Grand Alliance; Nine Years' War, 1688–96), 304
League of Nations, 543
League of Private Initiative and Decentralization, 508
Lebanon, 179, 465
Lello, Henry (Sir), 184
Lemnos, 251, 256–7, 264, 375
Leo X, Pope, 112
Leonard, Archbishop of Chios, 50
Leopold I, Holy Roman Emperor, 266, 269–70, 283, 291, 302

Leopold II, Holy Roman Emperor, 385, 405
Lepanto see Nafpaktos
Lesbos (Midilli), 61, 63, 80, 93, 320
Levni, 345
Liberal Union (LU), 513, 519
Libya, 498n, 520, 525
Liman von Sanders, Otto, 527
Lithuania see Poland-Lithuania
Livadya see Yalta
London, Treaty of (1915), 532
Longo, Giovanni Giustiniani, 50
Louis II, King of Hungary and Bohemia, 121–3
Louis XI, King of France, 85
Louis XIV, King of France, 271, 302, 304, 345–6
Louis XVI, King of France, 389
Lucas Notaras, Grand Duke, 52
Lutfi Pasha, Grand Vezir, 145, 150–1
Lutfullah, Prince, 505

Macedonia: Bayezid I conquers, 25; Bulgaria claims part, 485; nationalist movement in, 509–12; Christian population, 511 & n; lost to Ottomans, 525
Macfarlane, Charles, 437
McMahon, Sir Henry, 532
Mahdist revolt (1881), 473
Mahfiruz, Osman II's mother, 197
Mahidevran (concubine of Süleyman I), 133, 139
Mahmud I, Sultan: accepts Swedish muskets, 336; accession, 354–5; and Patrona Halil uprising, 355–6; rules against migration to Istanbul, 357; reforms and modernizations, 358; rural resettlement policy, 358; restores Muslim shrines in Jerusalem, 360; administration, 364; rebuilding and development programme, 365–6; sumptuary regulations, 371
Mahmud II, Sultan: mausoleum, 36; on Topkapı Palace, 344; when Prince, 416; accession, 422, 492; presented with fait accompli, 422–3; and ineptness of janissaries, 427; and Mehmed Ali's rule in Egypt, 427–8; administration and reforms, 428, 438–41, 447–8, 451, 470; and Greek independence movement, 429–30; and provincial notables, 429; seeks support from Mehmed Ali, 432; forms new military corps, 433; religious symbolism, 433–4; eliminates janissaries, 434–6, 439; creates new army ('Victorious Soldiers of Muhammad'), 436–7, 440; horsemanship, 437; tours empire, 440; building programme, 443; portraits, 443; death, 445; and protected non-Muslims, 469
Mahmud Bey, Karamanid leader, 7
Mahmud Nedim Pasha, Grand Vezir, 478, 480–1
Mahmud Pasha Angelović, Grand Vezir, 57, 59–60, 62–3, 78–9, 131
Mahmud, Abdülhamid I's son see Mahmud II
Mahmud, Mehmed I's son, 37
Mahmud Raif Efendi ('İngiliz'), 414–15
Mahmud Şevket Pasha, Grand Vezir, 517–19, 522–6, 528
Malatya, 91
Malaxos, John, 193
Malazgirt (Manzikert), battle of (1071), 3–4
Malchi, Esperanza, 177, 191
Malipiero, Domenico, 65–6
Maloumian, Khachatur, 508
Malta: Knights Hospitallers in, 119, 123, 135; Ottomans besiege (1565), 135; corsairs attack Ottoman ships, 225–6; fleet supports Venice in war against Ottomans, 247

Mamluk sultanate: opposes Ilkhanids, 4; Tamerlane invades, 28; Karaman's relations with, 36, 42; supports Uzun Hasan, 64–5; Uzun Hasan invades territory, 66–7; war with Ottomans (1485–8), 90–2; alliance with Bayezid II, 93–4; naval weakness, 93–4; Selim I's treaty with, 104; fails to aid Alaüddevle, 106; Selim I attacks and defeats, 108–11, 119; Sunni affiliations, 109; and caliphate, 111; trade and economy, 112; under Ottoman rule, 119; hostage princes displayed, 130; embellishes Holy Places, 149
Ma'n family, 360; see also Fakhr al-Din Ma'n
Manisa, 103, 154; mosque, 193
Manuel I Comnenus, Byzantine Emperor, 4
Manuel II Palaeologus, Byzantine Emperor, 19–20, 23–4, 26–7, 31–4, 37, 39, 41
Mara, Murad II's wife, 42, 44
Maria Theresa, Holy Roman Empress, 372
Marj Dabik, battle of (1516), 109
Marlowe, Christopher: Tamburlaine the Great, 30
Maronites, 465
Marsigli, Count Luigi, 322
Martinuzzi, George, Bishop of Grosswardein, 129, 134
Mary, Louis II's wife, 122
Maşuki, Sheikh İsmail, 142–3
Matthew Cantacuzenus, Byzantine Emperor, 16
Matthias Corvinus, King of Hungary, 59, 63, 76, 87, 123, 131–2
Mavrocordato, Alexander (Alexander İskerletzade), 302–3, 314, 319
Mavrocordato, Nicholas, 405
Maximilian I, Holy Roman Emperor, 112, 122
Maximilian II, Holy Roman Emperor, 151
Maximilian Emanuel, Elector of Bavaria, 303
Mazepa, Hetman Ivan, 334, 336
Mecca, 149–50, 164, 198; see also Islam: Holy Places
Medici, Lorenzo de', 86
Medina see Islam: Holy Places
Mediterranean: conflict in, 125, 127–8, 134–5, 158, 162, 174; Murad III's policy in, 168–9
Mehmed I, Sultan: conflicts with brothers, 30–4; accession as sultan, 33; rebellions against, 34–6, 45; death and succession, 36–7; and division of Ottoman lands, 39; conflict with Serbs, 42; executes Sheikh Bedreddin, 96; mosque, 312
Mehmed II, Sultan: succeeds on father's abdication, 44–6; debases coinage, 46, 74; rule, 46–7; removed from power, 47; returns to full powers, 47; besieges and captures Constantinople, 48–52, 114; preserves Hagia Sophia, 53; recreates and rebuilds Istanbul, 53–6, 71, 74; Balkan campaigns, 59–61, 64, 69, 123; campaign against Trebizond, 62–3; defends eastern frontiers, 64–7, 96; develops navy, 68; raids in central Europe, 69; aspires to conquest of Rome, 70; death and succession, 70–1, 81–2; commercial achievements, 80; administrative system and officers, 76–80; relations with janissaries, 77; law codes, 78, 145–6; accomplishments and interests, 80; burial, 81–3; deal with Constantine XI, 85; receives Andalusian Muslim delegation, 88; aspires to be universal sovereign, 131; relations with Mahmud Pasha Angelović, 131; court ritual, 148; mosque, 150, 279
Mehmed III, Sultan: succeeds, 165, 174; circumcision, 166, 178, 276, 343; in war against Austrian Habsburgs, 174–5, 198, 237n; death, 176,

184, 196; governs province before sultanate, 189; and treatment of Jews, 192; burial and mausoleum, 193
Mehmed IV, Sultan ('the Hunter'): succeeds father as minor, 202, 235–6; and Karaçelebizade Abdülaziz, 241; troops demand undertakings from, 249–51, 295; leads army in person, 252; and Abaza Hasan's revolt, 258–60, 262; hunting, 262–3, 270, 281; ceremonies and progresses, 263–4, 276; encourages Abdurrahman Abdi's writing, 270–1; campaign against Poland-Lithuania, 273–5; temperance, 278; and conversions to Islam, 281; and campaign against Muscovy, 282; on campaign against Austrian Habsburgs, 284–5, 294; and defeat at Vienna, 287; and Holy League against Ottomans, 289–90; plots against, 294–5; succession to, 294, 296–8; troops demand deposition, 296, 298, 325; death and burial, 298; proposal to reinstate, 311; advised by Köprülü Mehmed as child, 328; and caliphate, 493
Mehmed V Reşad, Sultan, 518, 521, 538
Mehmed VI Vahdeddin, Sultan, 538, 545
Mehmed Abid Efendi, Abdülhamid II's son, 517
Mehmed Ali Pasha: governs Egypt, 399, 411, 426–8, 443, 445, 465; Mahmud II invites to Istanbul, 432; and training of Mahmud II's new army, 437; improves army and navy, 443; attacks Syria, 444; demands independence, 445, 448, 465; European powers intervene against, 445–6; offers bribes to Reşid Pasha's enemies, 452; saves Muslim sacred places, 494
Mehmed Arif Agha, 415, 418–19
Mehmed, Bayezid II's grandson, 101
Mehmed Bey Abu al-Dhahab, 408–9
Mehmed Birgevi, 214
Mehmed Emin Ali Pasha see Ali Pasha
Mehmed Ferid Pasha, Grand Vezir, 499
Mehmed Giray II, Crimean Khan, 171
Mehmed Giray III, Crimean Khan, 220–1
Mehmed Kamil Pasha, Grand Vezir, 499
Mehmed Neşri, 38, 78, 145
Mehmed, Mustafa III's brother, 372
Mehmed, Süleyman I's son, 130, 139–40, 154, 279
Mehmed Raşid Efendi, 345, 352
Mehmed Raşid Efendi, 396
Mehmed Raşid Pasha, 482
Mehmed Said Efendi, 366–7
Mehmed Said Pasha, Grand Vezir, 499
Mehmet Rüştü Pasha, Grand Vezir, 481
Melek Ahmed Pasha, Grand Vezir, 217, 239–41, 245, 250, 255,
257
Meleki Hatun, 249
Mengli Giray, Crimean Khan, 68, 98
Menshikov, Prince Alexander, 457
Menteşe emirate, 5, 17, 38, 48
Merzifonlu Kara Mustafa Pasha, Grand Vezir, 253, 274–5, 278, 281–8, 289, 325, 330
Mesih Pasha, Grand Vezir, 70
Metternich, Prince Clemens Lothar Wenzel, 379
Mevlevi dervishes, 78, 262, 278, 394, 449
Mezőkeresztes (Haçova), battle of (1596), 175, 191, 198, 237n
Michael Shishman, Bulgarian Tsar, 13
Midhat Pasha, Grand Vezir, 463–4, 480–3, 490, 496; tried and murdered, 500–1
Mihaloğulları dynasty, 75
Mihrimah Sultan, Süleyman I's daughter, 134, 143, 148, 151, 153, 170, 343

INDEX

Milan, Francesco Sforza, Duke of, 76
Minkarizade Yahya Efendi, Sheikhulislam, 277, 281
Mircea, Voyvode of Wallachia, 25, 32–3, 36
Missolonghi, 432–3
Mistras, 25
Mits'iwa, 138
Mocenigo, Domenico, 320
Mohács, battles of: (1526), 121–4; (1687), 292–3
Moldavia (Boğdan), 129–30, 183–4, 198, 257, 406, 425–6, 430, 469, 485
Mongols, 4, 26, 39, 111, 188
Montagu, Lady Mary Wortley, 163, 344
Montecuccoli, General Raimondo, 266, 283
Montenegro (Karadağ), 336, 402, 484–6
Morea, 61; see also Peloponnese
Morocco, 158, 169; hopes to borrow from Ottomans, 388
Morosini, Francesco, 271, 292
Mosul, 363
Moudros armistice (1918), 537, 539–40
Mozambique, 169
Mudanya armistice (1922), 545
Müezzinzade Ali Pasha, 160–1
Mughal Empire, 188, 369
Muhammad bin 'Abd al-Wahhab, 412
Muhammad the Prophet: prophesies capture of Constantinople, 48; and caliphate, 145; sacred standard, 237–8, 435; sacred mantles, 347, 449; sword, 492
Muhsinzade Mehmed Pasha, Grand Vezir, 375–6, 388
Murad I, Sultan: killed, 13, 21–2, 39; succeeds to sultanate, 17, 39; campaigns and conquests, 19–21, 23–4, 122, 521; raises janissaries, 28; in Albania, 42; and youth-levy, 75
Murad II, Sultan: succeeds father, 36–7, 39; conflict with Mustafas, 37–8; reign, 38, 40, 60; in Balkans, 41–3, 47; and Shah-Rukh's overlordship, 42; abdicates, 44; leads army against Hungarians, 46; death, 47; recalled, 47; Junayd sends tribute to, 96
Murad III, Sultan: has brothers killed, 164–5; succeeds, 164; decline of grand vezirate under, 165; reign and administration, 165–6; household and lifestyle, 166–8; aggressive policies in North Africa and Mediterranean, 168; interest in mysticism, 168; death, 174, 196; and army unrest, 177–8; builds observatory at Galata, 190; Manisa mosque, 193; as literary/art patron, 194
Murad IV, Sultan: accession, 204–5; and Abaza Mehmed's execution and burial, 207–8; concedes to mutinous troops, 207; authority and administration, 208–12, 224, 228; campaigns against Safavids, 209, 215–17, 343; social/moral programme, 212–14; laws on non-Muslims, 213; attitude to dervishes and clerics, 214–15; victory entry into Istanbul, 217; peace with Safavids (1639), 222; death, burial and succession, 223–4; Varvar Ali serves, 232; and Yeni Cami mosque complex, 279; and Ferdinand III, 302
Murad V, Sultan, 481–3, 489–91
Murad Bey (Kazdağlı), 409–10
Murad, Cem Sultan's son, 108
Murad, Prince Ahmed's son, 103
Murteza Pasha, 259–61
Musa, Bayezid I's son, 29–30, 32–6, 75, 84
Musa Çelebi, 207
Musahib Mustafa Pasha, 274, 276, 278
Muscovy see Russia
Muslim Union, 515

Mustafa I, Sultan: first enthroned and deposed, 197–8; restored (1622) and again deposed (1623), 200–5; death, 223
Mustafa II, Sultan: and succession to Mehmed IV, 194, 296, 312; accompanies army against Poland, 274; circumcision, 276; accession, 315; leads army on campaign, 315–18; wears 'sword of David', 316; deposed, 329–31; portraits, 345; proscribes corsair activity against Christian ships, 361
Mustafa III, Sultan, 371–2, 376–7
Mustafa IV, Sultan, 416–23
Mustafa Ali of Gelibolu, 148, 167, 188, 191, 193
Mustafa Efendi of Selanik, 152, 163, 168, 178
Mustafa Fazıl Pasha, 472–4
Mustafa, Bayezid I's son ('False Mustafa'), 30, 33–5, 37, 40, 75
Mustafa, Mehmed I's son ('Little Mustafa'), 38–40
Mustafa, Mehmed II's son, 71, 79
Mustafa, Süleyman I's son, 130, 133, 139–41, 143
Mustafa Kemal (Atatürk): assumes presidency, 1, 545; achievements and influence, 488, 552–4; in defence of Tripoli, 522; post-war plans for national liberation, 539–43; condemned to death in absentia, 542; elected president of parliament-in-waiting, 542; organizes defence of Turkey, 543; and abolition of caliphate, 546; proclaims constitution, 546; condemns pan-Turkism, 549; silences political opposition, 550–1; assassination attempt on, 551–2; six-day speech (1927), 552–3
Mustafa Naima: and Giray plots, 205; on Hüseyin, Fakhr al-Din's son, 212; on demand on Sivas, 230; on Gürcü Abdülnebi's rebellion, 236–8; on Varvar Ali Pasha, 240n; on Karaçelebizade Abdülaziz, 241; praises Kösem Sultan, 242, 254; on Köprülü Mehmed, 257, 260, 328; on killing of Abaza Hasan, 261; on Venetian blockade of Straits, 263
Myriocephalum, battle of (1176), 4

Nadir (Khan) Shah (Tahmasp Quli Khan), 352, 363–4, 369, 407
Nafpaktos (Lepanto), 63, 69, 92–3, 125; battle of (1571), 158, 160–1, 164
Nagykanisza (Kanije), 175, 308
Najaf, 126, 497
Nakşibendi dervishes, 400, 438, 449, 460
Namık Kemal, 474, 483, 500, 548
Naples: Mehmed II attacks territory of, 69; regains Otranto, 85; Charles VIII of France seizes, 122; besieged by French, 124
Napoleon I (Bonaparte), Emperor of the French, 393, 396–7, 402–4, 406, 410–11, 413, 427
Napoleon III, Emperor of the French (earlier Louis-Napoleon), 457, 472
Napoleonic Wars, 395–7, 402, 413
Nasi, Joseph, 161–2, 191
Nasrid dynasty, 87
Nasuh Pasha, Grand Vezir, 186, 188, 224, 246n, 360
Nasuhpaşazade Hüseyin Pasha, 224–5, 229–30
Navarino (Pylos), battle of (1827), 432, 439
Naxos, 61, 247
Nazım Hikmet: Epic of Sheikh Bedreddin, 35–6
Nazım Pasha, 523
Nefise Sultan, Alaeddin Bey of Karaman's wife, 22
Nevşehir (formerly Muşkara), Anatolia, 358
Nevşehirli Damad İbrahim Pasha, Grand Vezir, 175, 338, 340, 342, 347–50, 352–5, 358, 366, 370

'New Order' army, 390–4, 413–15, 419, 423–4, 433, 436
Nice, 85
Nicholas I, Tsar of Russia, 444, 457, 460
Nicholas II, Tsar of Russia, 506, 510–11
Nicholas V, Pope, 50
Nikopol (Nicopolis), battle of (1396), 25, 44
Nile, river: canal link to Red Sea, 121, 137–8
Niš, 20, 306–8, 338, 385, 451–2, 461, 464
Nizip, battle of (1839), 445
North Africa: Spanish Reconquista in, 126; Habsburg conflict with Ottomans over, 127, 162; Murad III's policy in, 168–9; Muslims in, 498; Italian colonialism in, 522
Nové Zámky (Neuhausel; Uyvar), 266–7, 269, 283, 291, 295
Novo Brdo, 59
Nubia, 137
Numan (Bey) Pasha (Köprülü), Grand Vezir, 253, 325, 336
Nurbanu Sultan, Murad III's mother, 166, 170, 242

Obrenović, Michael, 452
Obrenović, Miloš, 430, 451
Ochakiv (Cankerman; Ochakov; Özi), 383–4, 393
Oğuz, Cem Sultan's son, 85, 181, 221, 290
Oğuz Turks, 42, 188
Ohsson, Ignatius Mouradgea d', 493
Ökuz Mehmed Pasha, Grand Vezir, 188
Olivera, Bayezid I's wife, 22
Ömer Bey (Turahanoğulları), 61, 75
Ömer Efendi, 197–201
Ömer Pasha al-Da'ud, 407
'oneness of being' doctrine, 34–5, 143
Oradea (Grosswardein; Varad), 265
Ordin-Nashchokin, Afanasii, 361
Orhan, Sultan, 9, 11–17, 24, 38
Orhan, Prince Süleyman's son, 32–3, 49
Orlik, Hetman Pylyp, 336
Orlov, General Vladimir, 431
Orthodox Church: in Ottoman Empire, 159, 192–3, 468; and Christian Holy Sites, 324; and Küçük Kaynarca treaty, 378–9; relations with Catholic Church, 404–5; and Russian intervention in Balkans, 404; status in Austria, 404–5; and Greek independence, 430; and Serbian unrest, 452; anti-Protestantism, 460–1
Osijek, 292, 308
Osman I, Sultan: dream, 2, 11–12; origins, 6–7, 12; defeats Byzantines (1301), 8; Muslim faith, 10; reputation, 11; death and burial, 12–13; memorial mosques, 17; rise to power, 38
Osman II, Sultan: campaign dress, 195; age at father's death, 197; enthroned, 197; in Thirty Years' War, 198–9, 218; murdered, 200–3, 205, 239, 392, 417–18; bans tobacco, 213; Varvar Ali serves, 232
Osman III, Sultan, 371–2
Osman Nuri Pasha, 494–5
Osman, Prince Ahmed's son, 103
Osmani order, 474
Otranto, 69–70, 84–5, 128
Otto I, King of Greece, 439
Ottoman Empire: ends (1923), 1; power and extent, 1–2; founding date (1299), 2; myth of origins, 11–12; Red Apple symbol of world conquest, 48, 195; trade and prosperity under Mehmed II, 71–2;

standing army, 73, 75, 77; warrior families support, 75; law-codes, 78, 145–6; marriage alliances, 78; diplomatic relations with other powers, 90, 113, 333, 342, 368–9; war with Mamluks (1485–8), 90–2; rivalry with Portuguese, 93–4, 108, 112, 136, 169; struggle for dominance in Islamic world, 94; and system of prince-governorships, 100 & n, 189, 196; defeats Mamluks, 109; Islamic predominance in, 110; controls trade routes, 111; conflict with Habsburgs, 122–4, 126–7, 134–5, 151, 162; 'capitulations' (privileges) to foreign states, 127, 469, 528–9; fleet sails to India, 128; conquests in Hungary, 134; expansion eastward and southward, 136–8; relations with Muscovy, 138–9, 321, 334–5; and religious heresy, 143, 497; classical art and architecture in, 144; dynastic law (kânûn), 145–7; as protector of Holy Places, 145, 149; court ritual, 148; agreement with Ivan IV, 157; in western Mediterranean, 158, 162; war with Iran in Caucasus, 169–71; offensive against Habsburgs (1593–1606), 173–7; economic/financial instability in late 16th century, 176–8; army unrest under Murad III, 177–8; early 17th-century revolts and rebellions, 179–85; renews war with Safavids (1603–16), 187–8; non-Muslims in, 188, 191–2, 213, 278–9, 310, 323, 370, 450, 458–60, 462–4, 469–70, 547–8; campaign leaders and responsibilities, 189; sultan's role and status in, 189–90, 204, 209, 328; officers and administration, 190–1, 209–10; religious puritanism under Ahmed I, 191–3; princes' diminished role, 196; bureaucratic centralism, 202; advice manuals, 209–10; intellectuals in, 209; army reforms, 210–11, 224, 236, 423–4; in Thirty Years' War, 217, 219–20; peace with Safavids (1639), 222; war with Venice (1638–69), 225–8, 247–8, 251–2, 256, 263; Caucasian and Balkan officials in, 239–40; patronage, 264–5, 346; campaign in central Europe (1663–4), 266–9; treaty with Habsburgs (1664), 269; recovers Crete, 271–2; campaign against Poland-Lithuania (1671–2), 273–5; war with Muscovy (1677–8), 282; treaty with Muscovy (1681), 282; war with Austrian Habsburgs and Holy League (1683–99), 284–92, 300–7, 312–18; defeat at Vienna (1683), 286–8; Christian alliance against (1684), 289; war taxes, 292, 325; army conscription, 307; resettlement programme under Fazıl Mustafa, 309–10; tax reforms, 309–11, 326–7, 339–40, 450–1, 458, 466, 507; peace negotiations and treaties (1699–1700), 314, 318–22; border demarcation, 322–3, 350; Christian Holy Sites in, 323–4; wealth tax, 325; protects Charles XII of Sweden, 334–5; war with Russia (1710), 335; war with Venice in Peloponnese (1715–17), 336–7; princesses' revised role and status in, 339–40; economic and trade development (18th century), 340–1; receptiveness to technological innovations, 342; food and drink, 344; social life, 344; religious observance, 347–8, 496–7; Muslim population displacement, 350; social differences and unrest, 350–1; and Afghan invasion of Iran, 351–2; war with Iran (1722–30), 352; rebellion against Ahmed III, 353–6; migration in, 357; Arab provinces, 358–61, 399, 406–12, 426, 521, 524; war with Russia (1735–8), 362; conflict with Nadir Khan, 363; peace treaty with Iran (1746), 364; modernization (18th century), 368; limits Western influences, 369–71; sumptuary laws in,

370–1, 441–2; wars with Russia (1768–74 and 1787–92), 373–7, 382–7, 393; treaty with Russia (1774), 377–9; peace agreement with Austria (1791), 385; peace with Russia (1792), 386; trade and financial crisis after wars with Russia, 387–8; borrows abroad, 388–9, 478; military/naval reforms under Selim III ('New Order' troops), 390–4, 413–15; Black Sea fleet expanded, 393; accepts third-party mediation in peace negotiations, 395; in Second Coalition against France (1798), 397; provincial disaffection and powers, 398–406, 427, 429, 465–6; war with Russia (1806–12), 404, 414, 425–7; early 19th-century reforms, 424–5; and 'Western Question', 425; new army ('Victorious Soldiers of Muhammad') formed, 436–7; war with Russia (1828–9), 439; administrative reforms under Mahmud II, 440–1; first provincial censuses (1830–1), 440; dress and class differences, 441–2; penal code and abolition of extra-judicial punishments, 441, 450, 476; western cultural influences in, 442–3; and 'Eastern Question' for European powers, 445; British patronage of, 446; European demands on, 449–50; social-religious inequalities, 450–1; inflation and devaluation under Mahmud II, 452–3; introduces paper money and bimetallism, 453; survey of rural resouces (1843), 453; conscription of non-Muslims into forces, 454–5, 461–2; in Crimean War, 457–8; as 'Sick Man of Europe', 457; effect of Reform Edict (1856), 458–62; wins recognition in Treaty of Paris (1856), 458; legislative reforms (1864), 462–4, 476; constitution (1876), 463, 489–90; foreign influences and status in, 469; land rights, 471; civil code revised, 476–7; financial disorder under Abdülaziz I, 478–9; naval development under Abdülaziz I, 478, 482; war with Russia (1877–8), 484–5; loses territory in Treaty of Berlin, 486, 491; Russians impose war indemnity on, 486; western disparagement of, 488–9; demographic changes, 491; Muslim diversity in, 496–7; and overseas Muslims, 497–9; constitution restored (1908), 512; loses Bulgaria, Bosnia-Herzegovina and Crete (1908), 513; parliamentary elections (1908), 513; social and economic liberalization, 514–15; strikes, 514–15; army counter coup (1909; '31 March Incident'), 515–18; constitution revised (1909), 518; loss of Balkan territories, 525; proposed removal of capital from Istanbul, 525; economic-commercial changes in 19th century, 526; elections (1914), 526; supports Germany in First World War, 527, 529–30; military assistance from Germany, 528–9; defence in First World War, 529–30; casualties in First World War, 530; effect of First World War on, 533, 536–7; armistice (Moudros 1918), 537, 539–40; initiates war crimes trials (1919), 538–9; elections (1920), 541; post-First World War settlement and partition, 542–5; ethnicity, 547

Ottoman Freedom Society (OFS), 509–10

Ottomans (pre-Empire): first recorded, 5–6; uphold Islamic faith, 9–11; attack co-religionists, 15; territorial expansion, 16–19; in Thrace, 16; dynastic marriages, 22; recruit Christian youths for military service, 28n; defeated by Tamerlane, 30–1; dynastic struggles, 38; fratricide, 38–9, 49, 164–5, 196–7, 223; regional unity and dominance, 39–40; succession practices, 39; use of gunpowder

and firearms, 52n, 67, 94, 106, 109–10, 342; fleet in Black Sea, 58; naval development, 68, 93; annex western Black Sea colonies, 69; naval attacks against Rhodes, 69–70; economic system, 72–3; administrative system and governing class, 73–4, 77–9; standing army, 73; claim Islamic legitimacy, 94–5, 104, 188–9; as heirs to Prophet, 145

Ouchy, Treaty of (1912), 522

Özbek state, 105, 107, 118, 125, 156, 188

Özdemir Pasha, 138, 155

Özdemiroğlu Osman Pasha, Grand Vezir, 170–2

Paget, William, 6th Baron, 314, 318–19

Palestine: Christian rivalry in, 456; and post-First World War settlement, 532–3

Papacy: in league against Ottomans (1501), 93; see also Holy League

Pardoe, Julia, 343

Paris: congresses of Ottoman opposition: (1902), 505; (1907), 508

Paris Exhibition (1867), 472

Paris, Treaty of (1856), 458–9, 479, 485

parliament: parties and opposition in, 519–20

Party of Union and Progress (Unionist Party), 519

Passarowitz, Treaty of (1719), 338, 342, 350, 362, 404

Passi, David, 192

Pasvanoğlu Osman Pasha, 401, 403, 442

Patrona Halil rebellion (1730), 354–7, 418, 474

Paul I, Tsar of Russia, 387

Pavia, battle of (1525), 122

Peloponnese: Ottoman-Venice war (1715–17), 336–7; returned to Ottomans, 350; in Russo-Ottoman war of 1768–74, 375; and Greek independence, 429–32; see also Morea

People's Party, 519

Persian Gulf, 136–7

Pertev Pasha, 441, 501

Pest, 134, 175

Peter I (the Great), Tsar of Russia, 220, 321, 333–6, 345–6, 351, 361, 370, 373, 405

Petrovaradin, 306, 313, 315–17, 319, 337

Petrović, George ('Kara George'), 403–4

Petru Rareş, Voyvode of Moldavia, 129

Phanariots, 405

Philiki Etairia ('Friendly Society'), 431

Philip II, King of Spain, 118, 122, 158, 169

Philip III, King of Spain, 189

Picot, François Georges–, 532

Pir Ahmed, İbrahim of Karaman's son, 64–6, 79, 83

piracy and corsairs: in eastern Mediterranean, 93, 118, 158, 222, 361; in Adriatic, 222; Maltese, 225–6

Piri Mehmed Pasha, Grand Vezir, 120

Piri Reis, 121, 136–7

Pirot, 307–8

Pius II, Pope, 76

Piyale Pasha, 153, 160

Plovdiv (Filibe), 484

Podolia province (Kameniçe), 275, 285, 289, 291, 320, 350, 374

Poland-Lithuania: Selim I's treaty with, 104, 113; and Cossacks, 183–4; in Thirty Years' War, 198, 216; Moldavia ceded to, 199; peace treaty with Ottomans (1623), 219; relations with Muscovy, 221; conflict with Crimean Tatars, 227–8, 248–9, 323; Cossacks revolt against, 248–9, 273; Rákóczi's expeditions against, 257; Mehmed IV campaigns against, 273–6; supports Austrian Habsburgs,

Poland-Lithuania: (*cont.*)
 285–6; plans to recover Podolia, 289, 291;
 demands levelling of Kamenets fortress, 305; and
 peace agreement with Ottomans (1699), 320;
 treaty with Muscovy (1686), 320; alliance with
 Peter the Great, 333; third partition (1795), 361,
 376, 426; Ottomans support against Russian threat,
 373–4; first partition (1772), 376, 382; refugees
 from 1848 revolution, 457
Polish Succession, War of (1733–5), 362
Poltava, battle of (1709), 334
Portugal: expansion in Indian Ocean, 93–4, 108, 112,
 137, 169; in Red Sea, 121, 138; North African
 outposts, 126; agreement with Ottomans, 128–9,
 134, 136; fortress at Diu, 128; in Persian Gulf,
 136–7; rivalry with Ottomans, 136–8, 156, 169,
 497; blockades Aceh, 138; invades Morocco, 169
Potemkin, Prince Gregory, 381
press censorship, 551
Preveza, 134
printing: in Arabic script, 366–8
privateering *see* piracy
Progressive Republican Party, 551–2
Prussia, 363, 374, 385, 389, 396
'Pseudo-Mustafa' (pretender, 1555), 140, 154
Ptolemy (Claudius Ptolemaeus), 63

Qa'it Bay, Mamluk Sultan, 65, 83, 86–7, 90–1
Qajars, 387, 432
Qansawh al-Gawri, Mamluk Sultan, 103, 108–9
Qasimi household, 359
Qurayshi tribe, 145, 494

Rába, river, 267–9, 317
Rabia Gülnüş Emetullah, 274, 284; mosque, 343
Racine, Jean: *Bajazet*, 223n
Radul Drakul, 60
railways, 478–9, 495, 528–9
Rákóczi, Francis II, 337, 366, 374, 426
Rákóczi, George II, 256–7, 262, 264–5
Ramazanoğulları, 5, 83, 90, 548
Rami Mehmed Pasha, Grand Vezir, 318–19, 330,
 341, 369
Raqqa province, 258, 399
Rauf (Orbay), 539, 542, 546, 551–2
Raydaniyya, battle of (1517), 110
Receb Pasha, 294–5, 298–9
Red Sea: canal link to Nile and Mediterranean, 121,
 155, 190; Portuguese-Mamluk rivalry in, 121;
 Ottomans control, 129, 137
Refet (Bele), 539–40
Reform Edict (1856), 458–62, 490
Republican People's Party, 552
Reşid Pasha (Mustafa Reşid Pasha), Grand Vezir,
 441, 444, 447–9, 452–5, 459, 462–3, 477
revolutions of 1848 (European), 457
Rhodes: Knights Hospitallers in, 24, 69; Mehmed II
 attacks, 69–70; Cem Sultan in, 84–5, 90; and
 Ottoman-Mamluk war, 91; Ottoman designs on,
 113; surrenders to Süleyman I, 118, 120; Knights
 Hospitallers leave, 119, 123; supports Mamluks,
 120
Roe, Sir Thomas, 218–19
Romania: autonomy and independence, 485–6
Romanus IV Diogenes, Byzantine Emperor, 3
Rome: and schism with Byzantine Orthodox
 Church, 43; Mehmed II aspires to conquer, 70;
 Charles V sacks, 124

Roxelana *see* Hürrem Sultan
Rudolf II, Holy Roman Emperor, 175
Rum (Byzantium), 4
Rum Mehmed Pasha, Grand Vezir, 78–9
Rumeli, 13, 19, 37, 82; army conscription in, 307;
 first census (1830–1), 440
Rumeli Hisarı, 49–50
Rumiantsev, General Peter, 377
Russia (Muscovy): and access to Black Sea, 36;
 Ottoman envoys in, 90; protects Ottoman
 Christians, 111, 468–9; relations with Ottoman
 Empire, 138–9, 157; expansion into Muslim lands,
 139, 156, 170, 172–3; proposed riverine canals,
 156–7; and siege of Azov, 220; pays tribute to
 Crimean Tatars, 221; denies help to Khmelnytski,
 249; and Ukraine Cossacks, 273, 275–6, 282, 320;
 Ottoman war with (1677–8), 282; treaty with
 Ottomans (1681), 282; plans attack on Crimea
 (1684), 289; representatives at 1699 peace
 negotiations, 319; in Holy League against
 Ottomans, 320; Great Northern War against
 Sweden, 321, 333–4, 336; peace agreement with
 Ottomans (1700), 321; threatens Black Sea
 frontier, 334; Ottoman war with (1710), 335; aids
 Safavids against Afghans, 351; expansionist strategy,
 361–2; defence pact with Austria (1726), 362; war
 with Ottomans (1735–8), 362; wars with
 Ottomans (1768–74 and 1787–92), 373–9, 382–6,
 393; Baltic fleet sails into Mediterranean (1770),
 375; gains from 1774 treaty, 377–9; and Crimean
 khanate, 380; expansion into steppe, 380–1;
 develops Black Sea fleet, 381; and proposed
 partition of Ottoman Empire, 382, 456–7; in
 Caucasus, 386–7, 426, 458, 467; peace treaty with
 Ottomans (1792), 386; and Balkan disaffection,
 404, 429, 431; war with Ottomans (1806–12), 404,
 414, 425–7; and Moldavia-Wallachia, 406; and
 Treaty of Tilsit with Napoleon, 406; wins
 concessions from Selim III, 406; improving
 relations with France, 425; in Napoleonic wars,
 427; and Greek independence movement, 432;
 war with Ottomans (1828–9), 444; mutual defence
 pact with Ottomans (1833), 444; supports
 Mahmud II against Ibrahim Pasha, 444; in
 Crimean War, 457–8; and revolutions of 1848,
 457; pan-Slavism ambitions, 479–80; and Bulgarian
 atrocities, 484; war with Ottomans (1877–8),
 484–5; and autonomy in Balkan states, 485; and
 Treaty of Berlin (1878), 485–6; imposes war
 indemnity on Ottomans, 486; interest in Central
 Asia, 486; revolution (1905), 506; in First World
 War, 527, 529–30; and Constantinople Agreement,
 532; Bolshevik Revolution (1917), 533; empire
 collapses (1917), 536; post-First World War
 demands, 543
Rüstem Pasha, Grand Vezir, 134–5, 140–1, 143–4,
 147, 192

Sa'di dynasty, 158
Sabaheddin, Prince (Sabaheddin Bey), 505, 508, 513
Sa'dabad Palace, 345–6, 350, 365
Safavid order, 34, 95–6
Safavid state: rise, 94–7; unrest in Anatolia, 104;
 Selim I's hostility to, 105, 107–8; power struggle
 on death of Isma'il, 125; Süleyman I and, 125,
 133–5; agreement with Ottomans (1555), 135,
 142; Ivan IV supports, 156; Caucasian war with
 Ottomans, 170–1; under Shah 'Abbas, 180; renews

war with Ottomans (1603), 187–8; recovers Baghdad from Ottomans (1624), 205–6; Murad IV campaigns against, 209, 215–17; dynasty falls (1721), 351; Zuhab treaty with Ottomans (1639), 351; see also Iran

Safi al-Din Ishak, Sheikh, 95

Safi, Safavid Shah, 216

Safiye Sultan, Mehmed III's mother, 166–7, 177, 191–2, 279–80

Sagundino, Niccolò, 80

Şah Veli, 113

Sahib Giray, Crimean Khan, 376, 380

Şahin Giray, Crimean Prince, 219–20, 221, 248

Sahin Giray, Crimean Khan, 380–1, 399

Şahkulu (Karabıyıkıoğlu Hasan Halife), 98–101, 103–4, 113

Said, Sheikh, of Palu, 550

Said Halim Pasha, Grand Vesir, 527

St Petersburg (Petrograd), 333, 345–6

Salignac, M., 185

Salih Pasha, Grand Vezir, 228, 230

Saltukids, 3

Samsun, 540

Şanizade Ataullah Efendi, 438

San Stefano, Treaty of (1878), 485

Sanudo, Marino, 121

Sarajevo: Franz-Ferdinand assassinated in, 527

Sarı Süleyman Pasha, Grand Vezir, 287, 290–5, 300

Saruca Pasha, 45, 49

Saruhan emirate, 5, 17, 98, 100

Sa'udi dynasty, 412, 428

Savcı Murad I's son, 19, 140

Scanderbeg (İskender Bey), 44, 47, 63–4, 89

Schiltberger, Johann, 25–6 & n, 28–30, 53

Scholarius, George (Gennadios), 50

Sebastian, King of Portugal, 169

Şehzade mosque complex, 140, 143

Selim I, Sultan: conquers Syria and Egypt, 94, 109–12, 117; hostility to Safavids, 97, 105, 107–8; and Kızılbaş, 98, 104–5; in contest for throne, 100–3, 110; challenges father, 101; relations with European states, 104, 113; religious assertiveness, 104–5; campaigns, 105–8, 215; Çaldıran victory over Isma'il, 106; troops' disaffection, 106–7, 112; dominance, 110; controls trade routes, 111–12; moves to and retires from Euphrates, 112; poetry, 113–14; death, 114; ruthlessness, 114, 147; reputation, 147; and Islamic Holy Places, 149; mosque, 279; bans printing, 366; and caliphate, 493

Selim II, Sultan: circumcision, 130; and succession, 139; conflict with brother Bayezid, 140–2; accession, 151–3, 156, 492; janissaries revolt against, 153; background and training, 154; restricts travel, 154; relations with Muscovy, 156; naval activity, 158; confiscates Church lands, 159; death and funeral, 162, 164, 178; Edirne mosque, 162–3, 193; improves Istanbul, 163; uninterested in historical manuscripts, 194

Selim III, Sultan: signs secret agreement with Russia, 381; accession, 384; and war with Russia, 384–5; rejects Russian peace offers, 385; character and interests, 389, 394, 418; administration and reforms, 390–4, 398–9, 413–14, 423–5, 428, 433; diplomatic practices and foreign policy, 395–7, 406; portraits, 397; and Balkan insurgents, 402; loses Islamic leadership, 412; and army rebellion against 'New Order' reforms, 415–17, 436;

deposed, 417–19; and Bayrakdar Mustafa, 421–2; murdered, 422; and protected non-Muslims, 469

Selim Mehmed Pasha, Grand Vezir, 434, 438

Seljuk Turks, 3, 11–12

Selman Reis, 121, 137–8

Şemdanizade Fındıklılı Süleyman Efendi, 356, 372, 391

Semiz Ahmed Pasha, Grand Vezir, 170–1

Senta, battle of (1697), 317–18

Sephardim (Spanish Jews), 88

Serbia: Ottomans defeat at Çirmen, 18; defeated at Kosovo Polje, 21, 59; ends as kingdom, 40; Murad II attacks, 41–2; Mehmed II conquers, 59, 61; and rebellious janissaries, 403; revolts and seizes Belgrade, 404–5, 425; Ottomans recover territory, 426–7; border uprisings, 451–2; tax reforms, 451–2; Christian conscripts flee to, 461; Ottoman troops withdrawn from (1867), 465; defeated by Ottomans in Bulgaria, 484–5; granted autonomy, 485; religious independence, 509; in Second Balkan War, 523; in First World War, 527

Şerif Mehmed Pasha, 180

Şerifzade Seyyid Mehmed Ataullah Efendi, Sheikhulislam, 415, 417–18, 421

Serres, 23–4

Sevastopol, 458

Seven Years' War (1756–63), 363

Sèvres, Treaty of (1920), 542–5, 549, 552

Seydi Ahmed Pasha, 250–1, 256

Şeytan-Melek İbrahim Pasha, 289, 291, 295

Seyyid Hüseyin Vehbi, 343

Seyyid Mustafa Pasha, 294

Shah-Rukh, 34, 42, 149

Sharaf al-Din Yazdi, 31

sheikhulislam (müfti): status, 146

Shia Islam: and rise of Safavids, 94–5; creed, 95–7, 496–7; and rebel movements, 181; Twelver, 363; in Iran, 407, 497; and religious differences, 460

Shihab family, 360

Shiraz, 65

Shirvan province, 171

Shkodër (İşkodra), 69

Shumen, battle of (1774), 376

Sicily, 158

Sidon, 409

Sigismund I, King of Poland-Lithuania, 117

Sigismund, King of Hungary, 25, 41, 44

Sigismund Tomašević see Kraloğlu İshak Bey

Şihabeddin Şahin Pasha, 45–6

Silahdar Ali Pasha, Grand Vezir, 337, 342

Silahdar Fındıklılı Mehmed Agha, 283–5, 287–8, 290, 292, 296, 316–18, 331–2, 357

Silahdar Yusuf (Agha) Pasha, 226–7

Silistra, 464

silk, 111, 116, 341

Sinan (architect), 140, 144, 148–9, 163

Sinanpaşazade Mehmed Pasha, 181–2

Sinop, 139

Sistovi, Treaty of (1791), 385

Sivas, 113, 537

Sivasi Efendi, 213–14

Siyavuş Pasha, Grand Vezir, 171

Siyavuş Pasha, Grand Vezir, 241–2, 244, 250–1, 254

Siyavuş Pasha (Köprülü), Grand Vezir, 253, 293–6, 299

Slankamen, battle of (1691), 312

slavery, 72, 79–80, 466–8, 473

Slavs: nationalism, 405

Smederevo (Semendre), 43, 59–60
Sobieski, Hetman Jan, 273, 286–93
Society for the Defence of National Rights, 542
Society for the Elevation of Women, 514
Sofu Mehmed Pasha, Grand Vezir, 197, 235
Söğüt, 12–13, 474
Sokullu Mehmed Pasha, Grand Vezir, 134, 151–8, 164–6, 168–71, 190, 193–4
Sokullu Mustafa Pasha, 168
Sokulluzade Hasan Pasha, 182
Solakzade Mehmed Hemdemi Çelebi, 204
Soranzo, Jacopo, 166
Souchon, Admiral Wilhelm Anton Theodor, 529
Spain: Moors driven from, 87–8; crusades against Muslims, 117, 126; conflict with Ottomans, 158; treaty with Ottomans (1580), 169, 174
Sphrantzes, George, 50
Sremski Karlovci see Karlowitz
Stanislaw Poniatowski, King of Poland, 336, 374
Stephen Dušan, King of Serbia, 18
Stephen Lazarević, Serbian Despot, 22–5, 28–9, 32–3, 41
Stephen Tomašević, Bosnian King, 60
Straits Convention (1841), 446
Suakin, 137–8
Şuca, Sheikh, 168
Suez canal: opened, 472; see also Nile; Red Sea
Süleyman I, Sultan ('the Magnificent'; 'the Lawgiver'): as prince-governor of Feodosiya, 98; father advances, 100; as regent in Istanbul, 102; accession, 114–15; status and reign, 115–17; as legislator, 116, 145–6, 189; campaigns in west, 118, 120–1, 127–9, 134, 151, 183; offensive against Hungary, 118, 121, 123–5; negotiates release of Francis I, 122–3; alliance with Zápolya, 124; reaches Vienna, 124; in Baghdad, 126; conflict with Habsburgs, 127; festivals and display, 130–1, 148; marriage and children, 131–3, 139–40; campaigns against Iran, 135; and succession, 140–1, 154; sends sons to distant parts, 141; and religious dissent, 142–3; image, 144–5, 147, 150; building programme, 148, 162, 194; court ritual, 148; embellishes Islamic Holy Places, 149; reign assessed, 150–1; death and burial, 151–3, 279; remoteness from people, 151; favours Hürrem Sultan, 166; reputation, 488; and caliphate, 493
Süleyman II, Sultan: succeeds brother Mehmed IV, 202, 242, 295–7, 299–300; leads troops on campaign, 304–5; illness and death, 311–12; administration, 312
Süleyman Agha, Chief Black Eunuch, 200–1, 242, 244
Süleyman Bey (Çapanoğulları), 399, 428
Süleyman Hüsnü Pasha, 480–2
Süleyman Pasha, Sultan Orhan's son, 16–17, 19
Süleyman Pasha al-Jalili, 408
Süleyman Pasha al-Da'ud (the Great), 407
Süleyman, Bayezid I's son, 29–32
Sultan: as caliph, 54, 492–4, 496–8, 513, 522, 542; role, 189–90, 209; status declines, 204; as benefactor of Holy Places, 495; powers reduced (1909), 518; office abolished (1922), 545
Sultan Hatun, wife of Bayezid I, 22–3
Sünbül Agha, Chief Black Eunuch, 225
Sunni Islam: mosques used by dervishes, 9; as Ottoman orthodoxy, 11, 496–7; and 'oneness of being', 34; creed, 94–5; in religious power struggle, 94, 96, 460; schools of, 363

Sürmeli Ali Pasha, Grand Vezir, 315
Su'ud bin 'Abd al-'Aziz, 412
Suvorovo (Kozluca), battle of (1774), 376
Sweden: attacks Poland-Lithuania, 273; in Great Northern War with Russia, 321, 333; pays Charles XII's compensation to Ottomans, 336; Ottoman agreements with (1737 and 1739), 362; peace with Russia (1790), 385, 389; Ottomans offer subisidy for military aid against Russia, 389; see also Charles XII, King of Sweden
Sykes, Sir Mark, 532
Syria: Selim I conquers, 94, 108–9, 111–12, 117; western trading privileges in, 127; as province, 359–61; local dignitaries and rule in, 408–9; Bonaparte attacks, 410; Mehmed Ali attacks, 443–4; İbrahim Pasha's rule in, 446; Druze-Maronite antagonism in, 465; western influence in, 469; unity, 496; uprising (1910), 522; in First World War, 531; French-British claims to, 532
Szentgotthárd, 267
Szigetvár, 151–2

Tabanıyassı Mehmed Pasha, Grand Vezir, 209, 216–17, 224
Tabriz, 95, 106–7, 125, 135, 172, 187, 216, 352, 363
Tahmasp, Safavid Shah, 125, 135, 139, 141–2, 169
Talat Pasha (Mehmed Talat Bey), 509, 526, 537, 538–9
Talleyrand, Charles Maurice de, 403
Tamar, George Sphrantzes's daughter, 61
Tamerlane (Timur): defeats Bayezid I at Ankara, 26–30, 33, 40, 84, 96; occupies Anatolia, 31, 40, 44; death, 34; Uzun Hasan evokes, 64–5; visits Ardabil, 96
Tana see Azov
Tanzimat (reforms), 423, 440, 447–8, 450–1, 453–4, 460, 463, 466, 468, 470, 476–9, 488–9, 491–2, 496, 500–1
Tarhoncu Ahmed Pasha, Grand Vezir, 244–5, 247
Tatarcık Abdullah Efendi, 390, 394
Tatars: relations with Ottomans, 58–9, 68–9, 138–9, 198; status, 69; slave raids to north, 72; threatened by Muscovy, 139, 156; raid Moscow, 157; in Ottomans' Caucasian war with Iran, 170–1; support Ottomans in wars against Habsburgs, 175, 268, 293, 319–20; relations with Cossacks, 183–4; alliance with Cossacks against Ottomans, 219–20; Muscovy pays tribute to, 221; conflict with Poland, 227–8; support Cossacks against Poland-Lithuania, 249; save Doroshenko, 275; in offensive against Vienna, 285; border-raiding, 323; Russians disavow, 381; see also Crimea
Tavernier, Jean Baptiste, 216
Tavukçu Mustafa Pasha, 237–8
tax-farming, 177, 326–7, 339–41, 351, 357, 388, 401
Tayyar Mahmud (Bey) Pasha (Canikli), 386, 400, 419, 422
Tayyarzade Ahmed Pasha, 258, 261
Tbilisi (Tiflis), 387
Teke emirate, 5; province, 98
Tekirdağlı Bekri Mustafa Pasha, 284, 289, 293–4, 300–1, 306–7
Temeşvar province, 134, 179; see also Timişoara
Tepedelenli Ali Pasha, 401–3, 423, 429–30, 444
Theodora, Sultan Orhan's wife, 15
Theodore, Despot of the Morea, 23–4, 25
Thessalonica (Selanik): falls to Ottomans, 19–20; Manuel II gains, 31; ceded to Venice, 40–1;

Murad regains, 41, 43; mosques in, 88; Ottoman Freedom Society formed in, 508–9
Thirty Years' War (1618–48), 198–9, 217, 395
Thököly, Imre, 283–4, 286, 303, 313, 374
Thomas Palaeologus, co-Despot of Morea, 50, 61
Thrace: Ottomans establish base in, 16–17; western, lost to Ottomans, 525; proposal to cede to Greece, 543
Thugut, Franz, 379
Tiepolo, Giovanni, 228
Tighina (Bender), 129, 334, 336, 426
Tilsit, Treaty of (1807), 404, 406
Timișoara (Temeşvar), 134, 316–18, 320, 337–8
Timurids, 12, 188
Tirsiniklioğlu İsmail Agha, 401–2, 413, 419
tobacco, 212–14, 309
Tocco, Carlo 40; family, 69
Topkapı Palace, 54–5, 130, 343–5
Torcello, Giovanni, 76
Torlak Kemal, 35
Tott, François, Baron de, 374, 390–1
Trabzon, 98, 100, 547; see also Trebizond
trade unions, 514
Transcaucasia, 156
Transylvania (Erdel): Ottoman raids into, 69; under Ottoman rule, 129–30; Ferdinand regains, 134; sovereignty contested, 217; Rákóczi invades, 256–7, 262, 264–5; Ottomans recover and retain, 265–6, 269; Hungarian exiles in, 283; accepts Habsburg suzerainty, 313, 350, 426; Ottomans withdraw from, 315; Ottomans advance on (1696), 317; Ottomans concede to Austria, 319
Trebizond, 61–2, 64, 66; see also Trabzon
Tripoli, North Africa, 135–6, 169, 180, 361, 498, 522
Tripoli, Syria, 119
tulips (and 'Tulip Age'), 346, 350, 366
Tuman-Bay, Mamluk Sultan, 110
Tunis, 162, 168, 169, 180, 361
Turahan Pasha, 50, 75
Turcomans, 3–8, 96
Turhan Sultan, Mehmed IV's mother, 235, 242–4, 249, 254, 262–4, 274, 279–80, 325
Turk: as term, 250, 506, 548; identity, 548–50
Turkey: adopted as name, 542; Grand National Assembly convened (1920), 543; war with Greece ('War of Independence', 1921–2), 544–5
Turkish language: imposed in schools, 521, 531
Turkish names, 265
Turkish Republic: established (1923), 1–2, 488, 545; prospective membership of EU, 545; population and composition, 546–7, 549; repressive measures, 550–2; reforms and modernization, 551; continuities with Ottoman Empire, 553; Kemalism in, 553–1; military coup (1980), 553
Tursun Bey, 51, 53, 65, 70

Üçanbarlı Mehmed Efendi, 349
Ukraine, 183, 273, 275, 282, 320, 334, 361
Umur Bey, Emir of Aydın, 15
Uniate Church, 404
Unionist Party see Party of Union and Progress
United States of America: enters war (1917), 533
Urfa (Edessa), 181
Uskoks (corsairs), 222
Üstüvani Mehmed Efendi, 54–5, 260, 278
Utrecht, Treaty of (1713), 395
Uyvar see Nové Zámky

Uzun Hasan, Akkoyunlu ruler, 55, 61–2, 64–7, 69, 73, 79, 81, 95–7

Vámbéry, Arminius, 489
Van, 28, 135, 187, 216, 232, 277, 507, 534–5, 537, 543
Vani Mehmed Efendi (Mehmed ibn Bistan), 277–80, 288, 329; sons killed, 332
Varna: battle of (1444), 46; poll tax, 311
Varvar Ali Pasha, 230–3, 239–40, 246
Vasvar, Treaty of (1664), 269, 271, 283
Velestinlis, Rigas, 431
Venice: rivalry with Genoa, 16, 49; Bayezid I opposes, 24; granted trading rights by Ottomans, 31, 127; interests threatened by Murad II, 40–1; Thessalonica ceded to, 40; proposes alliance with Hungary, 41; confirms treaty with Mehmed II, 48; and fall of Constantinople, 58; colonies annexed by Mehmed II, 62–3; war with Mehmed II (1463), 63–4, 66–7; alliance with Uzun Hasan, 64; Mehmed II attacks, 69; defends Cyprus, 91; Bayezid II's offensive against, 92–3, 100; Isma'il proposes alliance with, 97; Selim I's treaty with, 104, 108, 113; relations with Isma'il, 108; joins Holy League against Süleyman, 128; negotiates peace (1540), 128; loses Cyprus to Ottomans (1571), 158–60; negotiates peace (1573), 161; agreement with Ottomans in Thirty Years' War, 217–18; acts against corsairs, 222, 225–6; war with Ottomans (1648–69), 225–8, 234, 247–8, 251–2, 256, 263; blockades Istanbul (1650s), 227, 234, 256, 364; rejects Fazıl Ahmed's demands, 270; loses Crete to Ottomans (1669), 271–2; in Holy League against Ottomans (1684), 289–90, 292, 307, 317, 320; conquests on Ionian coast and Dalmatia, 305; Amcazade Hüseyin's successes against, 317; and peace agreement (1699), 319–20; war with Ottomans in Peloponnese (1715–17), 336–7; diplomats' report on Ottomans, 369; France annexes territories, 403
Veronese, Paolo, 195
Vidin, 401–3, 454, 464
Vienna: Süleyman I advances on, 124, 129; in war of 1593–1606, 175; siege of (1683), 253, 284–6, 324–5; Fazıl Ahmed marches on, 266; Evliya Çelebi reports on, 269–70; Ottoman defeat at, 286–8
Villeneuve, Marquis de, 356
Vivaldi, Antonio: Bayezid, 30
Vize (Bizye), 18
Vlad Drakul ('the Impaler'), 36, 60
Vladimirescu, Tudor, 430
Vlorë (Avlonya; Valona), 222, 225, 308
Volga, river: canal to Don, 156–7, 190
Volkan (newspaper), 515, 518
Vyshnevetsky, Dmytro, Cossack leader, 183–4, 218

Wahhabi movement, 399, 412, 428, 494
Wallachia (Eflak): False Mustafa in, 37; Murad II attacks, 41, 43; as Ottoman vassal state, 129–30; revolt against Ottoman rule, 255; supports Rákóczi, 257; Poland-Lithuania plans to seize, 289; Russia occupies (1789), 385; restored to Ottomans, 406; and Russo-Ottoman war of 1806–12, 425–6; and Greek independence, 430; Austria protects Christians in, 469; becomes part of Romania, 485
Wangenheim, Hans, Baron von, 527

Westphalia, Treaty of (1648), 395
White Mountain, battle of the (1620), 198
Wilhelm II, Kaiser of Germany, 528
William III (of Orange), King of England, Scotland and Ireland, 302, 304–5, 314, 318
Wilson, Woodrow, 533, 543
wine: banned by Vani Efendi, 278; tax repealed, 309
Wladyslaw I and III, King of Hungary and Poland, 44–6
Wladyslaw IV, King of Poland, 228, 248
women: and birth control, 132; in *harem*, 132; royal, 148–9; restrictions on, 370–1; restrictions relaxed, 514; position in Turkish Republic, 551
woollen cloth, 341
world fairs: Ottoman participation in, 455

Yakub, Bayezid I's brother, 21, 39
Yalta, 493 & n
Yeğen Osman Pasha, 295–6, 298, 300–5
Yemen province, 121, 128, 137, 155, 212, 506–7, 514, 520, 522–3
Yenişehir, 13
Yenişehirli Abdullah Efendi, Sheikhulislam, 349, 354
Yerevan (Revan), 171, 188, 216–17, 363
Yeşilköy (San Stefano), 485
Yirmisekiz Çelebi Mehmed Efendi, 342, 346, 354, 366, 368–9
Young Ottomans: formed (as Patriotic Alliance), 474–5; Islamic basis, 475, 478, 489; and westernization, 479; demand constitution, 480, 483, 489
Young Turks (Committee of Union and Progress; CUP): formed, 504–6; exploit regional disturbances, 508; reform programme in second constitutional period, 512–13, 521; parliamentary majority, 513, 519–20, 526; repressive and authoritarian actions, 515, 526–7; and counter-coup (1909), 516–18; established as Unionist Party, 519; and Balkan Wars, 523–4; Islamic principles, 525; tried as war criminals, 538–9; party dissolved, 542, 551; exploit economic decline, 626
youth-levy, 74–5, 231, 233, 239–40, 391
Ypsilantis, General Alexander, 430
Yunus al-Din Ma'n, 179
Yusuf Agha, Chief Black Eunuch, 287
Yusuf Agha Efendi, 397
Yusuf İzzeddin, Prince, 483, 506
Yusuf Mirza, 66
Yusuf, Bayezid I's son, 30
Yusuf, Mehmed I's son, 37

Zaganos Mehmed Pasha, Grand Vezir, 45, 49, 78
Zahir al-'Umar, Sheikh, 360, 408–9
Zand dynasty, 407
Zápolya, John, King of Hungary, 123–4, 129
Zápolya, John Sigismund, 129
Zaydani family, 360
Zaydi clan, 212
Zekeriyazade Yahya Efendi, Sheikhulislam, 214, 223, 225
Zeytun (Süleymanlı), 503
Zionism, 533
Ziya (Bey) Pasha, 474
Zsitvatorok, Treaty of (1606), 175, 217
Zuhab, Treaty of (1639), 222, 351
Zülfikar Efendi, 302–5, 318
Zvi, Sabbatai, 280–1